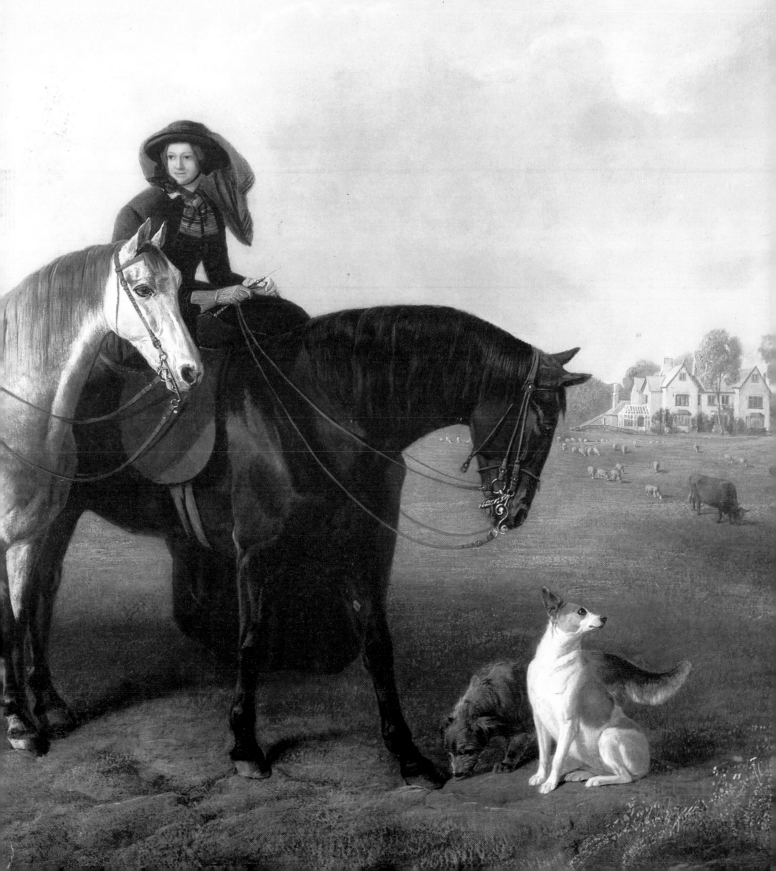

The Dictionary of
PORTRAIT PAINTERS
IN BRITAIN
up to 1920

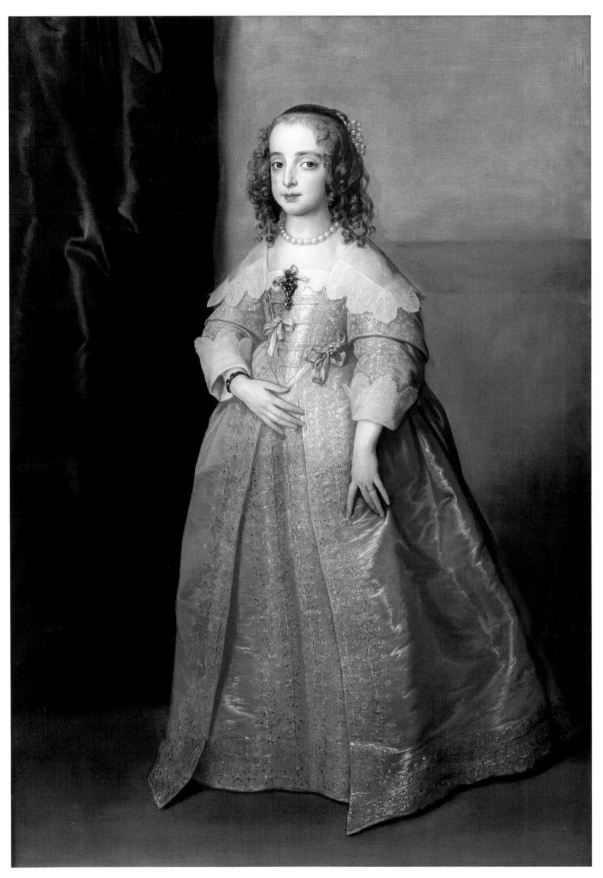

Frontispiece
ANTHONY VAN DYCK (1599-1641). Mary, Princess Royal. 61 x 42ins (154.9 x 106.7cm)

Christie's

The Dictionary of
PORTRAIT PAINTERS
IN BRITAIN
up to 1920

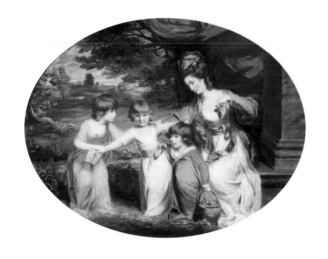

Brian Stewart
&
Mervyn Cutten

ANTIQUE COLLECTORS' CLUB

First published 1997
© 1997 Brian Stewart and Mervyn Cutten
World copyright reserved

ISBN 1 85149 173 2

British Library Cataloguing-in-Publication Data
A catalogue record for this book is available from the British Library

Title page illustration. DANIEL GARDNER. Rebecca, Lady Rushout with her children. Pastel. 26 x 33ins (66 x 83.8cm) *Richard Green Galleries, London*

Page 9 illustration. THOMAS LAWRENCE. A lady. Chalks on prepared canvas. 30 x 25ins (76.2 x 63.5cm) *Sotheby's*

Printed in England on Consort Royal Era Satin paper from the Donside Paper Company, Aberdeen,
by the Antique Collectors' Club Ltd., Woodbridge, Suffolk IP12 1DS

This book is dedicated to

Ian Stewart 1949-1993

and

David Julian Cutten 1951-1996

Colour Plate 1
ARTHUR DEVIS (1712-1787). Michael Warden of Sergison family, Cuckfield Park, Sussex. Signed and dated 1751. 30 x 25ins (76.2 x 63.5cm)
Richard Green Galleries, London

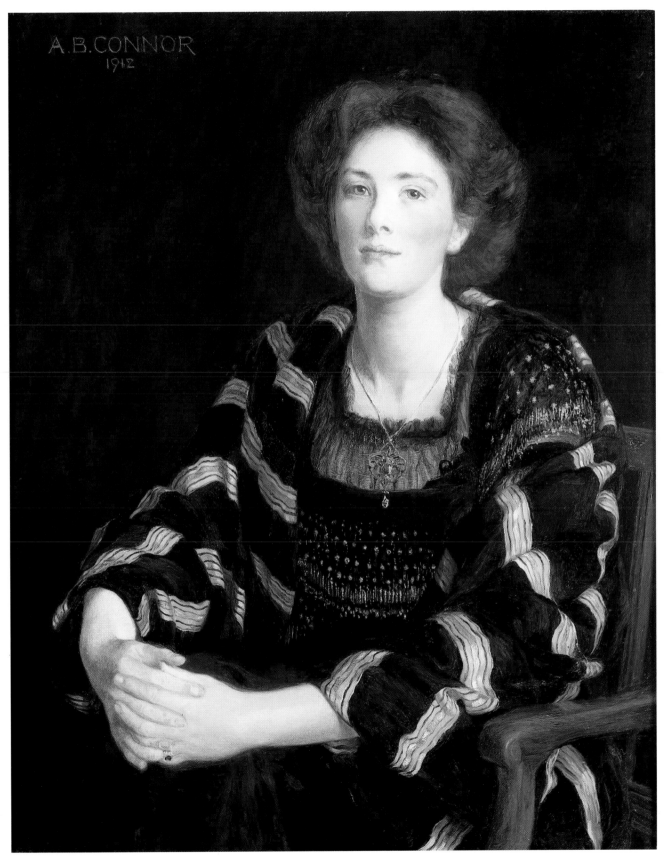

Colour Plate 2
ARTHUR BENTLEY CONNOR (1880-1960). Miss Nancy Nesbitt (Anna de Lillis). Signed and dated 1912. Panel. 17¾ x 13¾ins (45.1 x 34.9cm)

Christopher Wood Gallery, London

Acknowledgements

We would like to thank the many people who assisted in the production of this book. We are especially grateful to Carole Makeham and Daphne Cutten for their constant support, and to John Steel, who was kind enough to commission the book and was encouraging throughout. Eileen Willis slaved for many hours over the proof-reading. Margie Christian of Christie's gave tremendous assistance in her usual cheerful manner, and the book would not have been possible without her. Richard Green has always encouraged our projects from the earliest stages and has been an enormous help. Brian Allen boosted morale at various stages when spirits were flagging. Similarly, Philip Mould and Piers Davies of Historical Portraits Ltd have been a continual encouragement.

We would also like to acknowledge the kind assistance of the following individuals:

Martin Beizley, Brian Bellinger, Hugh Belsey, Michael Bennett, Derek Bird, S. Booth, Peter Brady, Julian Brookstone, Christopher Brown, Anne Buckner, Ron Chadwick, Jonathan Clark, R. Aquilla Clarke, Tom Conway, Sandra E. Cumming, John Dabney, Piers Davies, Rev Peter Dennison, Jane Foster, A. W. Furse, Kenneth Garlick, Alex Gill, James Harvey, Margot Heller, Marit Hendriks, Tamesin Hichens, Caroline Higginson, Sheila Hillsdon, Rev Francis Vere Hodge, Tom Hodgson, Jane Hollond, Deborah Hunter, Ron Iden, M. Oswald Jones, Amanda Kavanagh, Diana Kay, Gilly Kinloch, Lionel Lambourne, David Lay, Sarah Lay, Stephen Lloyd, Rupert Maas, Jane McKenzie, Nicholas Maclean, John and Audrey Makeham, Steven Marshall, Barbara Milner, Peter Mitchell, Sophie Money, Angela and Dave Moss, John Orbell, Richard and Leonee Ormond, Ron Parkinson, David Posnett, Anthony Pratt, Graham Price, Simon Puzey, Ken Reedie, Jeremy Rex-Parkes, Sogyal Rinpoche, Anna Robertson, Robert Sadler, Rosemary Sadler, Leslie Sayers, Steve Silk, Miss J. T. Smith, Ed Snyder, Chris Sohanta, Kathleen Soriano, Mik and Sheila Sparrow, Lawrence Stewart, Valmira Stewart, Dr and Mrs V. O. Stewart, Nigel Surry, Father David Sutcliffe, Lucy Tate, Michael Trasenster, Jennifer Vacher, C. and I. Ward, Andrew Webster, Rosemary and Brian 'Gong' West, Kenneth J. Westwood, Julius White, Christopher Wood.

And the following organizations and institutions:

Christie's; Phillips; Sotheby's; Paul Mellon Centre for British Art, London; Witt Library; Kent Institute of Art and Design Library; National Portrait Gallery Archives; Canterbury Public Library; Christ Church College Library, Canterbury; Essex Record Office; Nottingham Record Office; West Sussex Record Office; Chichester Public Library; International Genealogical Index and the Society of Genealogists.

Sadly some friends have passed away before seeing the final publication that they so enthusiastically supported: Frances Aitken, Richard Buckner III, David Cutten, Fred Hills, Jeremy Maas, Frank Makeham, Professor Alastair Smart, Ian Stewart, Nicholas Wadham.

The staff at the Antique Collectors' Club have been efficient and helpful, and we were particularly fortunate that Diana Steel assigned Cherry Lewis as editor of this project, and Sandra Pond as designer.

Finally, the cats Gulliver and Whisky were kind enough to sit on most of the research papers used in compiling this book.

Brian Stewart
Mervyn Cutten

Contents

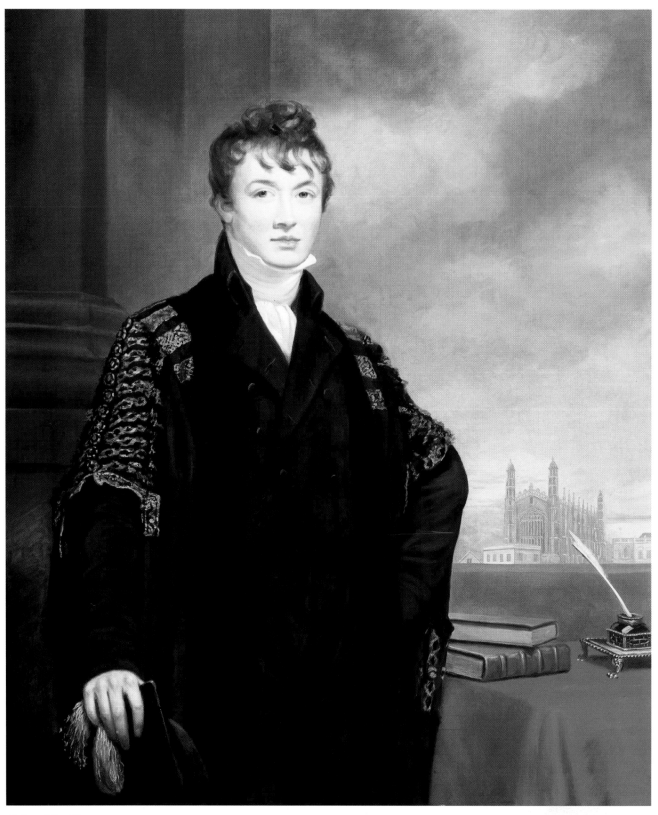

Colour Plate 3
JAMES NORTHCOTE (1746-1831). William Frederick Baylay of Emmanuel College, Cambridge with a view of King's College
beyond. Signed and dated 1800. 50 x 40ins (127 x 101.6cm) *Richard Green Galleries, London*

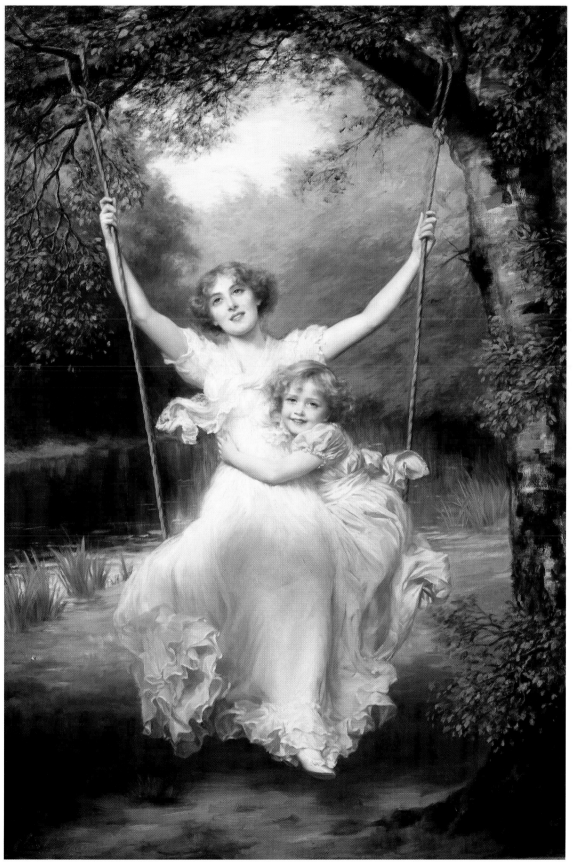

Colour Plate 4
CHARLES VIGOR (1860-1930). The swing. Signed. 54½ x 36ins (138.4 x 91.5cm) *Richard Green Galleries, London*

Bibliography

M.Archer, *India and British Portraiture 1770-1825*, 1979

E.Bénézit, *Dictionnaire des Peintres, Sculpteurs, Dessinateurs et Graveurs*, 10 vols, 1976

M.Bryan, *Dictionary of Painters and Engravers*, 1903-5

B. Buckeridge in R. de Piles' *The Art of Painting and the Lives of the Painters...*, 1706

J.L.Caw, *Scottish Painting Past and Present*, 1908

E.Clayton, *English Female Artists*, 2 vols, 1876

A.Crookshank, *Irish Portraits 1660-1869*, NGI exh.cat. 1969

H.A.E.Day, *East Anglian Painters*, 3 vols, 1967-68

R.Dorment, *British Art in the Philadelphia Museum of Art*, 1986

E.Edwards, *Anecdotes of Painters*, 1808

T.Fawcett, *The Rise of English Provincial Art 1800-30*, 1974

D.Foskett, *Miniatures – Dictionary and Guide*, 1987

W.Gaunt, *Court Painting in England from Tudor to Victorian Times*, 1980

A.Graves, *The British Institution 1806-1867*, 1969

A.Graves, *The Royal Academy of Arts – A Complete Dictionary of Contributors and their Work from its Foundation in 1769 to 1904*, 1970

G. Greer, *The Obstacle Race*, 1979

R.Gunnis, *Dictionary of British Sculptors 1660-1851*, 1951

M.Hall, *The Artists of Cumbria*, 1979

M.Hall, *The Artists of Northumbria*, 1982

J. Holloway, *Patrons and Painters – Art in Scotland 1650-1760*, SNG exh. cat. 1989

J.Ingamells, *The English Episcopal Portrait 1559-1835*, 1981

J.Johnson, Works *Exhibited at The Royal Society of British Artists 1824-1893*, 1975

R.Lister, *The British Miniature*, 1951

B.S.Long, *British Miniaturists*, 1929

J.Maas, *The Victorian Art World in Photographs*, 1984

K.McConkey, *The Royal Society of Portrait Painters' Centenary Exhibition*, 1991

Peter J. McEwan, *Dictionary of Scottish Art and Architecture*, 1995

H.L.Mallalieu, *The Dictionary of British Watercolour Artists up to 1920*, 3 vols, 1976, 1979, 1990

O.Millar, *The Tudor, Stuart and Early Georgian Pictures in the Collection of Her Majesty the Queen*, 2 vols, 1963

P.Murray, *The Dulwich Picture Gallery*, 1980

F.O'Donoghue, *Catalogue of Engraved British Portraits preserved in the Department of Prints and Drawings in the British Museum*, VI Volumes, 1908-25

R.Ormond, E*arly Victorian Portraits*, NPG 1973

H.Ottley, *Biographical and Critical Dictionary of Recent and Living Painters and Engravers*, 1866

A.Pasquin, *An Authentic History of the Professors of Painting, Sculpture and Architecture who have practised in Ireland ...*, 1796

M. Pilkington, A *General Dictionary of Painters*, Vols I, II, 1829

G. Popp & H. Valentine, *Royal Academy of Arts Directory of Membership from the Foundation in 1768 to 1995*, 1996

S.Redgrave, *A Dictionary of Artists of the English School*, 1878

F.Rinder, *The Royal Scottish Academy 1826-1916*, 1975

J.L.Roget, *History of the Old Water-Colour Society*, 1891, reprint 1972

R.Simon, *The Portrait in Britain and America*, 1987

H.Smailes, The Concise Catalogue of the Scottish National Portrait Gallery, 1990

A.M.Stewart, *Royal Hibernian Academy of Arts – Index of Exhibitors 1826-1979*, 1986

B.Stewart & M.Cutten, *Chichester Artists 1530-1900*, 1987

W.G.Strickland, *Dictionary of Irish Artists*, 2 vols, 1913

R. Strong et al., *The British Portrait 1660-1960*, 1991

Thieme-Becker, *Algemeines Lexicon der Bildendun Kunstler*, Leipzig 1927

G. Vertue, *The Notebooks of George Vertue*, published in Walpole Society

H. Walpole, *Anecdotes of Painting in England*, 4 vols, 1765-71

Walpole Society, annual volumes

E.Waterhouse, *The Dictionary of British 18th Century Painters in Oils and Crayons*, 1981

E.Waterhouse, *The Dictionary of 16th and 17th Century British Painters*, 1988

G.M.Waters, *Dictionary of British Artists*, 1975

C.Wood, *The Dictionary of Victorian Painters*, 1978

K.K.Yung, *National Portrait Gallery – Complete Illustrated Catalogue*, 1981

Introduction

> To produce a fine and effective portrait is perhaps the most difficult task in the whole range of the profession. Ten fail for one who succeeds. It requires qualities rarely combined and such as have only been obtained by persons of the very highest genius.
>
> *Art Journal* 1839 p.67

The British national character has revealed an unquenchable thirst for portraits of themselves, their families, friends and colleagues. Such pictures can account for as much as a third of a standard auction sale of British paintings. Moreover, there are galleries devoted exclusively to portraiture in London, Edinburgh and Dublin – an indication of an enthusiasm unmatched by other European countries, or indeed anywhere in the world.

Portraiture, despite some accounts to the contrary, has remained strong in Britain from the earliest court paintings to the present day. It has also resisted the threat from photography. Indeed, during the 19th century, when photography first emerged as an art form, portraiture positively flourished. As Christopher Wood pointed out: 'The Victorian period used not to be generally thought of as a great epoch for portrait painting, but this can now be seen as a myth'.

The most notable portraits of any period are full of animation and life. The great 17th century sculptor Gian Lorenzo Bernini was quoted by his son as saying: 'If a man stand still and immobile, he is never as much like himself as when he moves about. His movements reveal all those personal qualities which are his alone.' These movements, however slight and subtle, are often the key to a portrait's success, a fact not lost on the young Lawrence when painting Queen Charlotte in 1790. It is recorded that while painting the portrait he suggested to the Queen that she talk in order to look more animated. The Queen thought him 'rather presuming', but the portrait was so well received that Lawrence was quite forgiven.

Those portrait painters who were successful at their craft were paid handsomely by their contemporaries, but many have been later ignored and neglected by art historians. Attention has been focused on a favoured few, mostly court painters, but seldom has the full spectrum of the profession with its wealth of talent, been examined. This talent not only included native born artists, but also the many gifted foreign painters who were attracted to these isles by the huge demand for commissions.

In recent times there has been a surge of interest in the subject, with some excellent exhibitions doing much to change attitudes. The National Art-Collections Fund has supported museum purchases of portraits and has helped raise the profile of this important art form. A huge number of portraits change hands every year, but collectors, dealers and auction houses have been frustrated with the scant amount of coverage in most general dictionaries given to the large numbers of men and women artists who specialized in what is arguably the most difficult of all subject matter to paint. It is hoped that this first dictionary devoted exclusively to portrait artists will provide much needed help.

At the outset, one of the most difficult tasks was to decide who was to be regarded as a portraitist. Many genre painters, for example, produced accomplished portraits. If these works appear to be commissioned then the artist merited an inclusion. Those who only painted selected models, whom they paid, were normally excluded. Artists who painted only in miniature were also omitted. They have been admirably covered in Daphne Foskett's *Miniatures – Dictionary and Guide*. One deviation from our guidelines, since there is no evidence that he

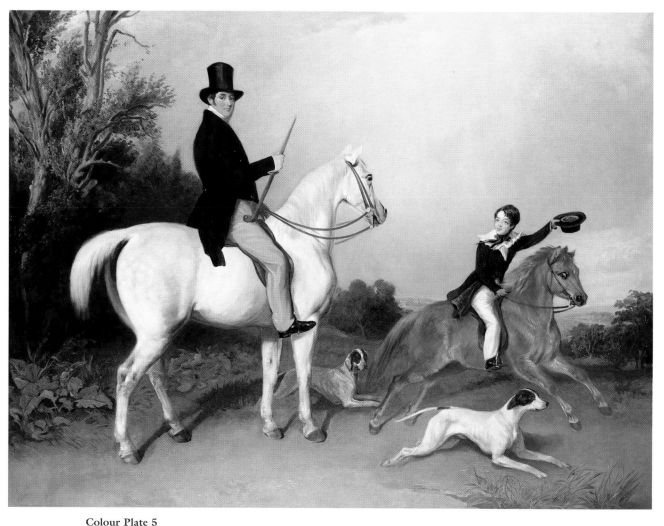

Colour Plate 5
JAMES PARDON (c.1794-1862). A gentleman on a grey hunter. Signed and dated 1848. 30 x 38ins
(76.2 x 96.5cm) *Richard Green Galleries, London*

ever visited this country, is an entry for Pompeo Batoni, simply because he painted
so many British sitters and was hugely influential.

For practical reasons, and to prevent the book from becoming unmanageable, we
decided on a cut-off date of 1920. To be included, an artist must have produced
a commissioned portrait by this date. This cut-off date was first chosen by H. L.
Mallalieu in his excellent *Dictionary of British Watercolour Artists up to 1920*, and
is sympathetic to the way that the leading auction houses structure their picture
sales for the convenience of dealers and collectors. There have been many able
practitioners since 1920, and we hope to deal with them in a separate book.

The length of an entry does not necessarily reflect the ability of the artist. We felt
it important to include original research on minor provincial painters. Where
information on a painter is readily available, we have tried to keep the entry pithy
and include suggested reading. In a few cases, where this would become too bulky,
suggestions are limited to sources which include full bibliographies.

To help researchers we have listed, where possible, the day and month of births,
baptisms and deaths. These should be treated with great caution as early records
often prove to be inaccurate.

Where known, engravers employed by artists are also listed. Their inclusion can

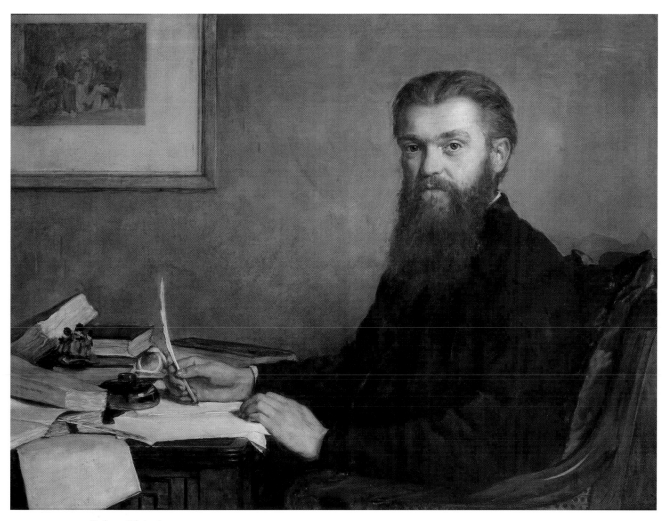

Colour Plate 6
JOHN COLLIER (1850-1934). William Kingdon Clifford. 34 x 44ins (86.4 x 111.7cm)

The Royal Society, London

give an indication to the accessibility of an artist's work and help the diligent researcher identify anonymous sitters.

The illustrations are largely provided by the British art trade. This is mainly for economic reasons, although it has the advantage of featuring many less well-known works, often by less well-known artists, rather than those which are readily available and often seen in other publications. We have not necessarily illustrated an artist's best work, but concentrated on featuring the type of work that may be found in private collections.

Most leading portrait painters employed studio assistants and the majority of large-scale commissions invariably contain some underpainting and accessories by assistants working under supervision. Where known, apprentices and assistants have been listed in the text.

Unless otherwise stated all works reproduced are painted in oil on canvas, measurements are given in height by width; dates of portraits illustrated are given where known. Details have often been provided by busy auction rooms, and should be regarded as a close guide rather than a precise record.

A book of this sort can never hope to be fully comprehensive. The authors would be delighted to hear of additional information on artists who have been included, or details of artists who have been omitted.

Abbreviations

A	Associate	OWS	Old Water-Colour Society founded 1804 (see RWS)
AG	Art Gallery		
b.	born	P	President
Bart	Baronet	PS	Pastel Society
BI	British Institution 1806-1867	RA	Royal Academy founded 1768
BM	British Museum	RBA	Royal Society of British Artists from 1887 (previously SBA)
BWS	British Watercolour Society		
c.	circa	RBC	Royal British Colonial Society of Artists
cat.	catalogue	RBS	Royal Society of British Sculptors
CAG	City Art Gallery	RBSA	Royal Birmingham Society of Artists from 1827
d.	died	RCA	Royal College of Art
DA	*The Dictionary of Art,* Jane Turner (ed), 34 vols, 1996	RDS	Royal Dublin Society founded in 1731
		RE	Royal Society of Painter-Etchers and Engravers
DG	Dudley Gallery 1865-1882	RHA	Royal Hibernian Academy founded in 1823
DNB	*Dictionary of National Biography*	RI	Royal Institute of Painters in Water-Colours from 1863 (previously NWS)
exh.	exhibition		
F	Fellow	RIA	Royal Irish Academy
fl.	floruit (flourished)	RMI	Royal Manchester Institution from 1827
FS	Free Society of Artists 1761-1783	RMS	Royal Society of Miniature Painters
		ROI	Royal Institute of Oil Painters founded 1883
GG	Grosvenor Gallery 1877-1890	RP	Royal Society of Portrait Painters founded 1891
GI	Glasgow Institute of Fine Arts	RSA	Royal Scottish Academy founded 1826 (including Edinburgh Exhibition Society and Institution for the Encouragement of the Fine Arts in Scotland)
H	Honorary		
HMQ	Collection of Her Majesty The Queen		
IS	International Society of Sculptors, Painters and Gravers	RSMA	Royal Society of Marine Artists
		RSW	Royal Scottish Society of Painters in Water-Colours
LA	Liverpool Academy of Arts from 1810		
MA	Museum of Art	RWA	Royal West of England Academy
MFA	Museum of Fine Art	RWS	Royal Society of Painters in Water-Colours from 1881 (previously OWS)
MS(S)	Manuscript(s)		
NA	National Academy of Design, New York	SA	The Society of Artists of Great Britain 1760-1791
n.d.	No date	SBA	Society of British Artists founded 1824 (see RBA)
NEAC	New English Art Club founded 1886		
NG	National Gallery	SM	Society of Miniaturists
NMM	National Maritime Museum	SNG	Scottish National Gallery
NGI	National Gallery of Ireland	SNPG	Scottish National Portrait Gallery
NPG	National Portrait Gallery	SNT	Scottish National Trust
NPS	National Portrait Society	SSA	Society of Scottish Artists
NS	National Society of Painters, Sculptors and Gravers	SWA	Society of Women Artists founded 1857
		Tate	Tate Gallery
NSA	New Society of Artists	VAM	Victoria and Albert Museum
NT	National Trust	VE	Various exhibitions
NWG	New Gallery founded 1888	VP	Vice-President
NWS	New Water-Colour Society founded 1831 (see RI)	WIAC	Women's International Art Club
		YALE	Yale Centre for British Art, Yale University

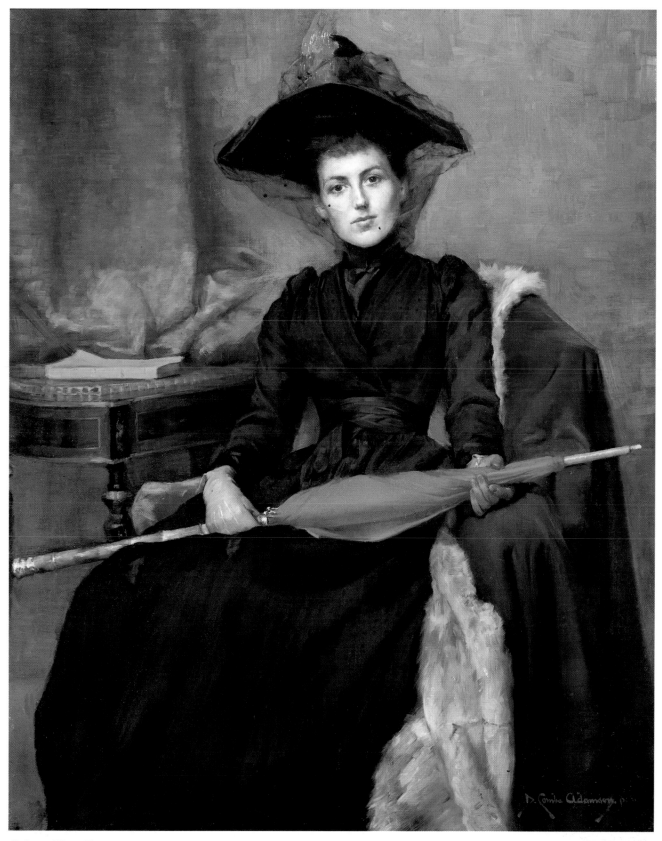

Colour Plate 7
DAVID COMBA ADAMSON (1859-1926). The scarlet parasol. Signed and inscribed 'Paris'. 36 x 28ins (91.5 x 70.8cm)
Richard Green Galleries, London

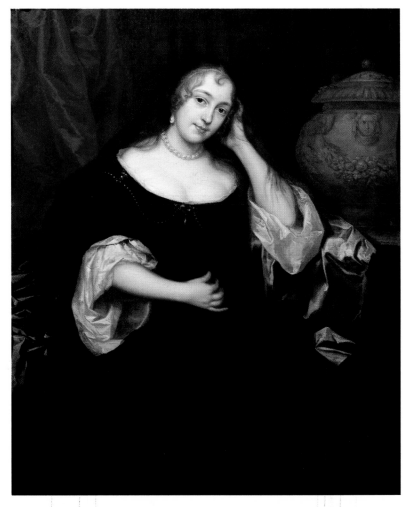

Colour Plate 8
HENRY ANDERTON (c.1630-1665). A lady. 50
x 40ins (127 x 101.6cm)
Philip Mould/Historical Portraits Ltd

Colour Plate 9
HENRY BARRAUD (1811-1874). Queen Victoria
and the Marchioness of Douro . . . in Windsor
Great Park. Signed and dated 1845. 43 x 72ins
(109.2 x 182.9cm) *Richard Green Galleries, London*

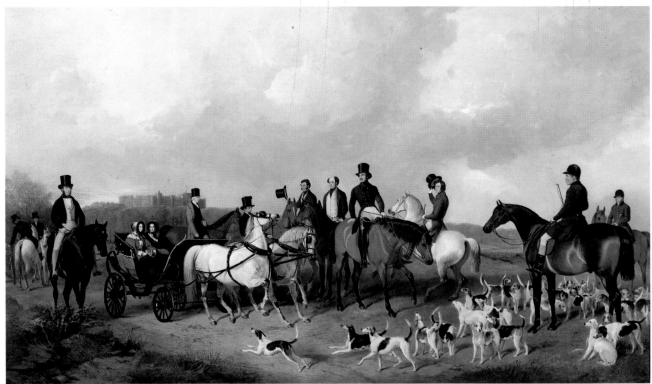

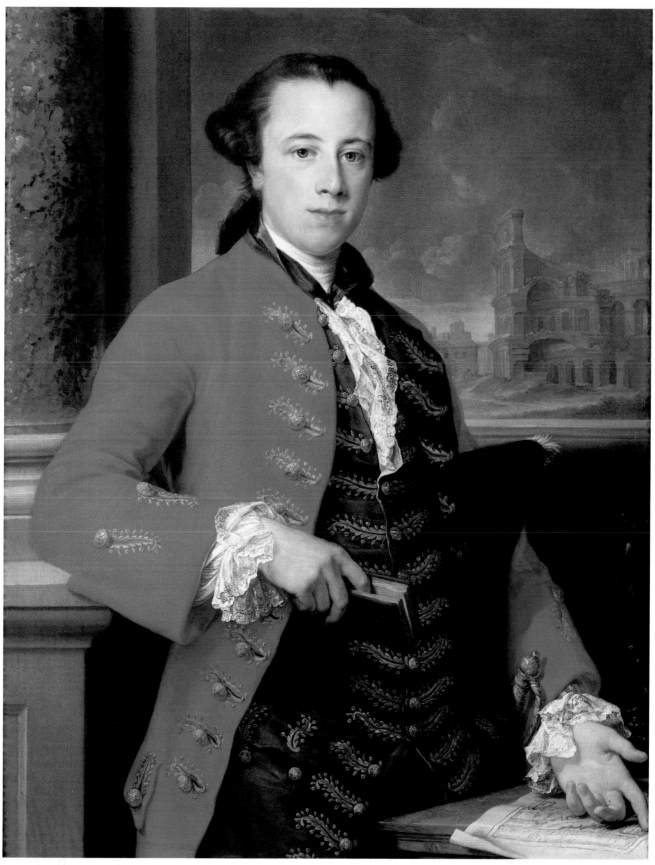

Colour Plate 10
POMPEIO GIROLAMO DE BATONI (1708-1787). A gentleman at Rome. 40 x 30ins (101.6 x 76.2cm) *Leger Galleries Ltd, London*

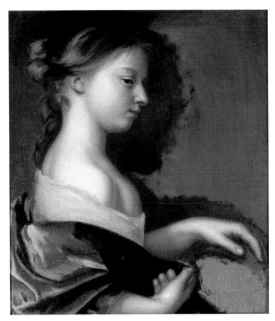

Colour Plate 11
MARY BEALE (1633-1699). A young girl. 21 x 18ins
(53.3 x 45.7cm)

Philip Mould/Historical Portraits Ltd

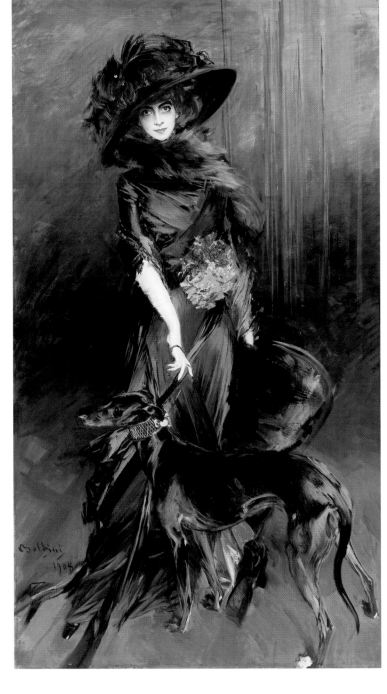

Colour Plate 12
GIOVANNI BOLDINI (1842-1931). The Marchesa
Casati with a greyhound. Signed and dated 1908. 92½
x 55½ins (235 x 141cm)

Christie's New York

Colour Plate 13
WILLIAM BEECHEY (1753-1839). Harriet Beechey, the artist's daughter. Signed with initials and dated 1816. 56 x 44ins (142.2 x 111.8cm)

Phillips

Colour Plate 14
RICHARD BUCKNER (1812-1883). Portrait of a lady, possibly Agnes Wilson. Signed. 54 x 39ins (137.1 x 99.1cm)

Jeremy Maas

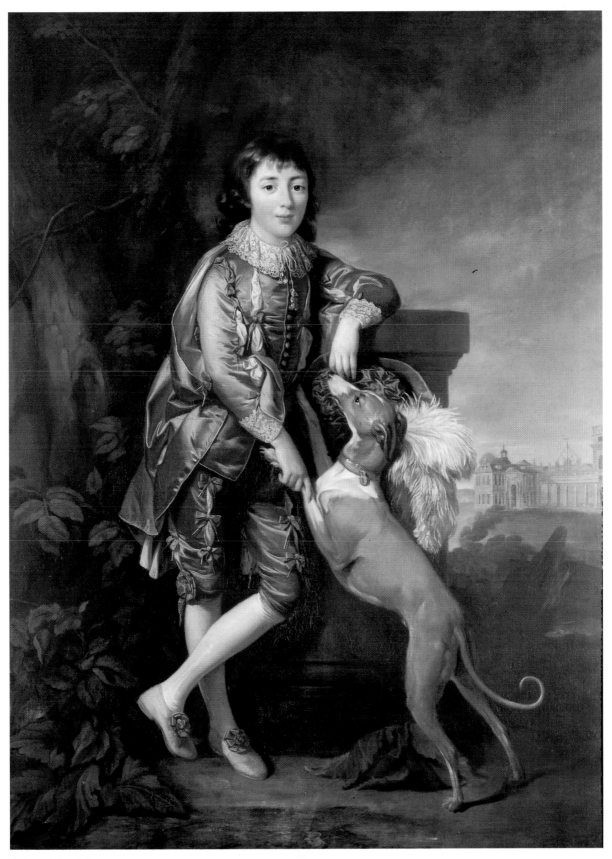

Colour Plate 15
RICHARD BROMPTON (c.1734-1783). Frederick William Blomberg. Inscribed. 71 x 50ins (180.3 x 127cm) *Christie's*

Colour Plate 16
GEORGE CHINNERY (1774-1852). Lord Arthur Chichester.
35¼ x 27¾ins (89.5 x 70.5cm)

Richard Green Galleries, London

Colour Plate 17
STEPHEN POYNTZ DENNING (c.1795-1864). A
sportsman. Signed and dated 1830. Panel. 27 x 21¾ins
(68.6 x 55.3cm) *Richard Green Galleries, London*

Colour Plate 18
DENIS DIGHTON (1792-1827). Boy with a badminton racquet and shuttlecock near Dane John, Canterbury. Signed with monogram.
12 x 9½ins (30.5 x 24cm)
Canterbury Museums

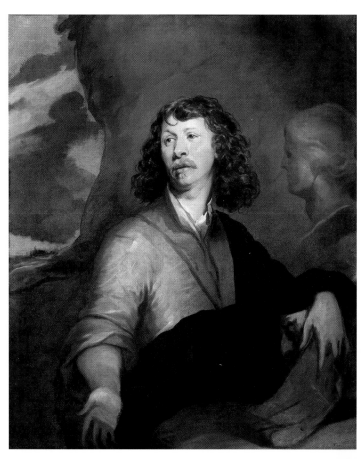

Colour Plate 19
WILLIAM DOBSON (1610/11-1646). A gentleman. 42¾ x
35ins (108.6 x 88.9cm)

Philip Mould/Historical Portraits Ltd

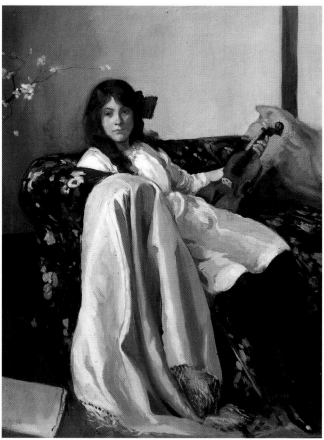

Colour Plate 20
JAMES DURDEN (1878-1964). Anabelle, the artist's daughter.
Signed. 27 x 20ins (68.6 x 50.8cm)

Richard Green Galleries, London

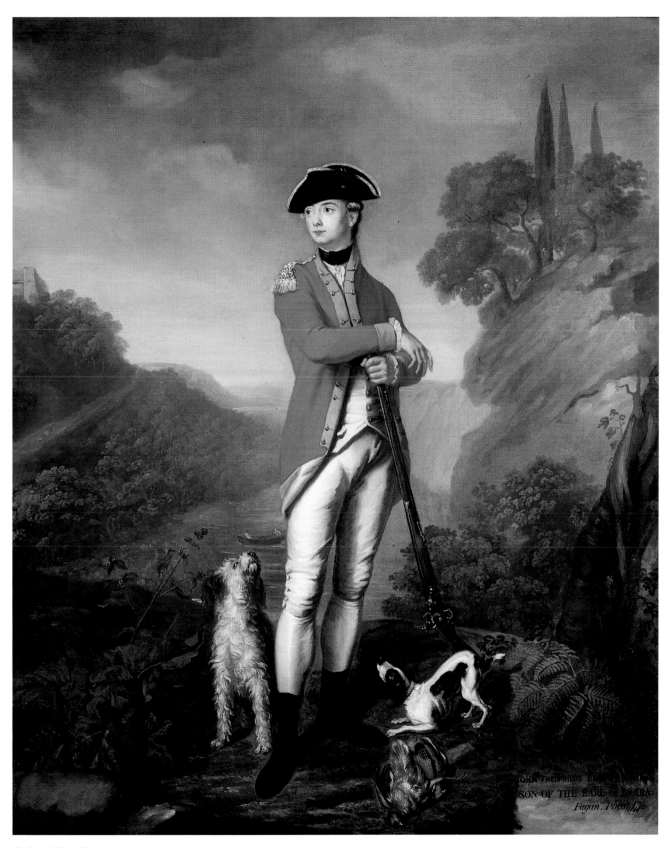

Colour Plate 21
Attributed to ROBERT FAGAN (d.1816). The Hon John Theophilus Rawden-Hastings. Inscribed. 34½ x 27½ins (87.6 x 69.9cm)
Richard Green Galleries, London

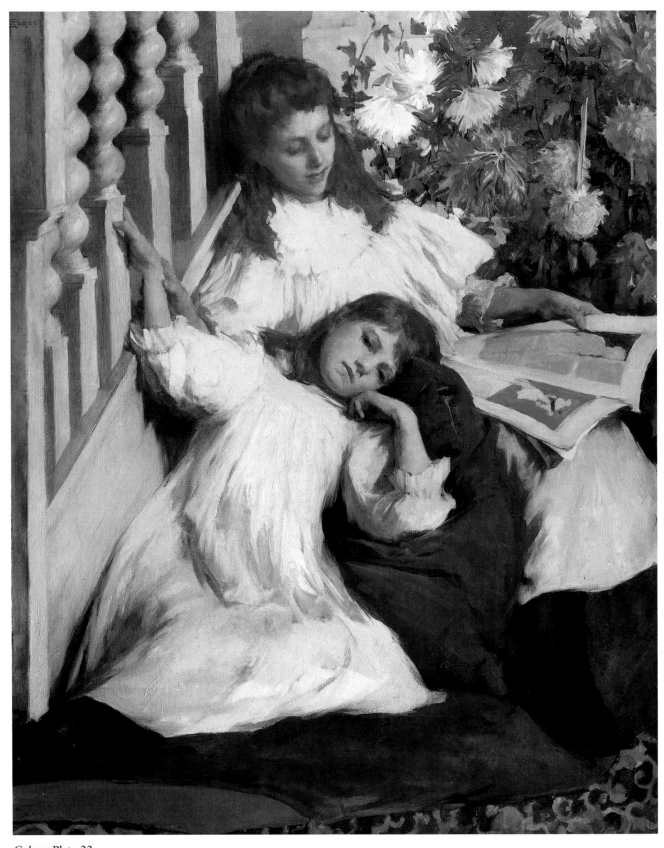

Colour Plate 22
ELIZABETH ADELA STANHOPE FORBES (1859-1912). A fairy story. Exhibited 1896. Signed. 48 x 38ins (121.9 x 96.5cm)
Richard Green Galleries, London

Colour Plate 23
ISAAC FULLER (1606-1672). Self-portrait.
50 x 40ins (127 x 101.6cm)
Philip Mould/Historical Portraits Ltd

Colour Plate 24
CHARLES WELLINGTON FURSE (1868-1904). The
artist's sister – Mary Theresa Abraham in 1890. Signed. 33½ x
27½ins (85.2 x 69.8cm).
Private collection. Derek Bird, Family Copies, London

Colour Plate 25
DANIEL GARDNER (1750-1805). Rebecca, Lady Rushout with her children. Pastel. 26 x 33 inches (66 x 83.8cm)
Richard Green Galleries, London

Colour Plate 26
THOMAS GAINSBOROUGH (1727-1788). Richard Ottley. 30 x 25ins (76.2 x 63.5cm) *Richard Green Galleries, London*

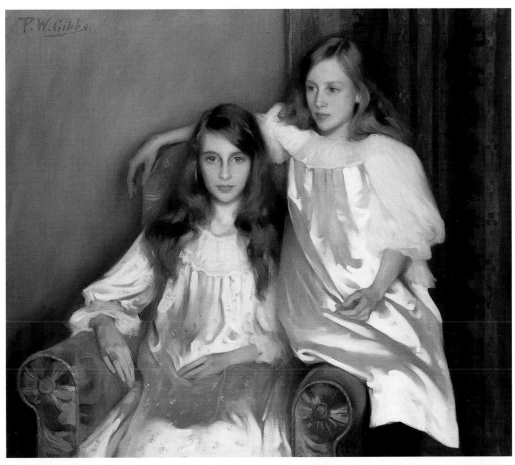

Colour Plate 27
PERCY WILLIAM GIBBS
(fl.1894-1937). Valerie and
Muriel, daughters of G. A.
Phillips. Signed. 40 x
46ins (101.6 x 116.9cm)
Richard Green Galleries,
London

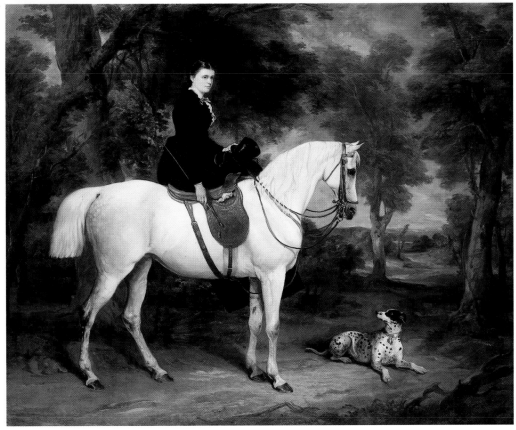

Colour Plate 28
FRANCIS GRANT (1803-
1878). Mrs Roller on a
grey hunter. Exhibited
1872. 56 x 68ins (142.2 x
172.7cm)
Richard Green Galleries,
London

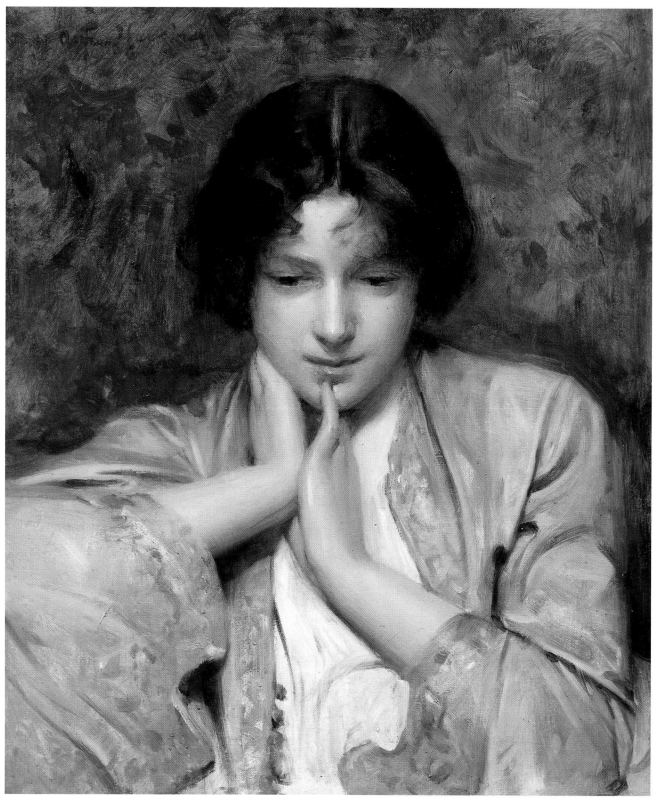

Colour Plate 29
ARTHUR HACKER (1858-1919). A girl. Signed and dated 1896. 18 x 15ins (45.7 x 38.1cm) *Richard Green Galleries, London*

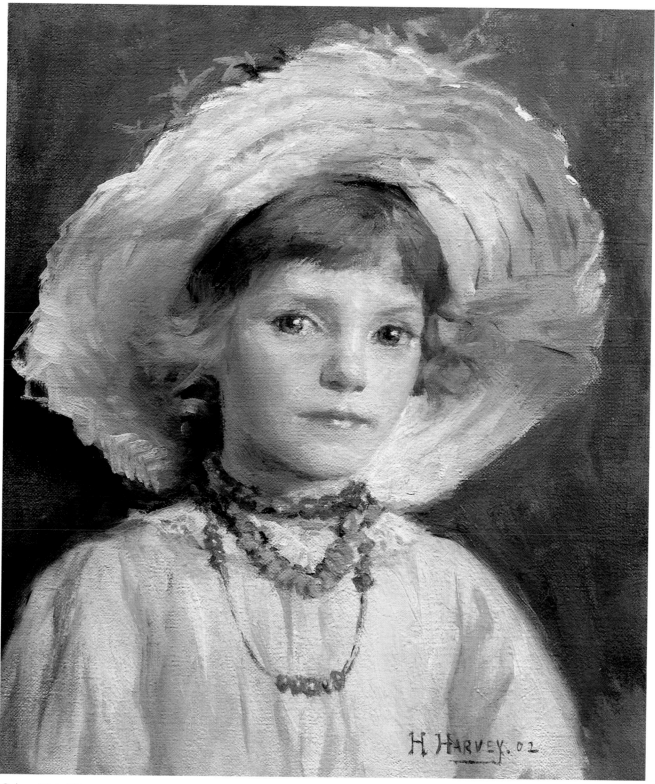

Colour Plate 30
HAROLD C. HARVEY (1874-1941). The straw hat. Signed and dated 1902. 12 x 10ins (30.5 x 25.4cm)

Richard Green Galleries, London

33

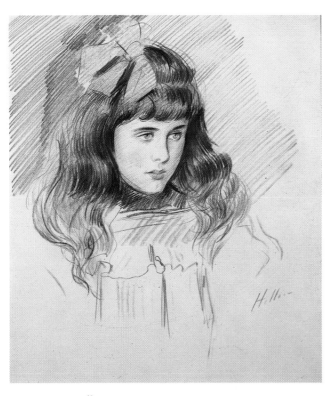

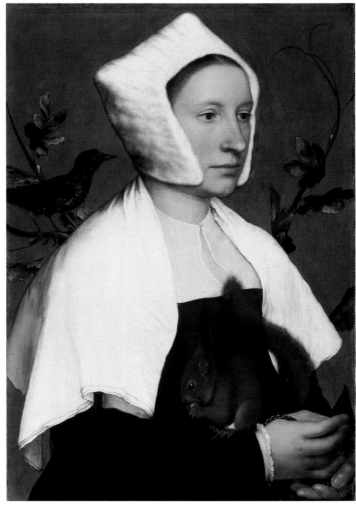

Colour Plate 33
THOMAS HUDSON (1701-1779). Richard Ray.
Signed and dated 1747. 50 x 40ins (127 x 101.6cm)
Christie's

Colour Plate 34
JOHN JACKSON (1778-1831). A gentleman.
Watercolour. Signed and dated 1813 on the reverse.
9½ x 8⅛ins (24.2 x 20.6cm) *Private collection*

Colour Plate 35
GWENDOLEN MARY JOHN (1876-1939). Young
woman in a red shawl. 17¾ x 14ins (45.2 x 35.5cm)
Christie's

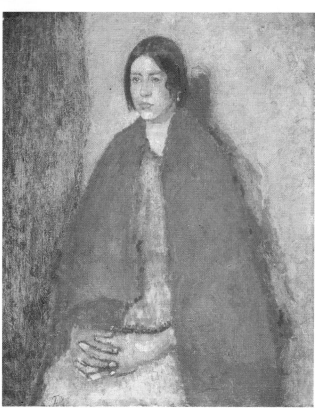

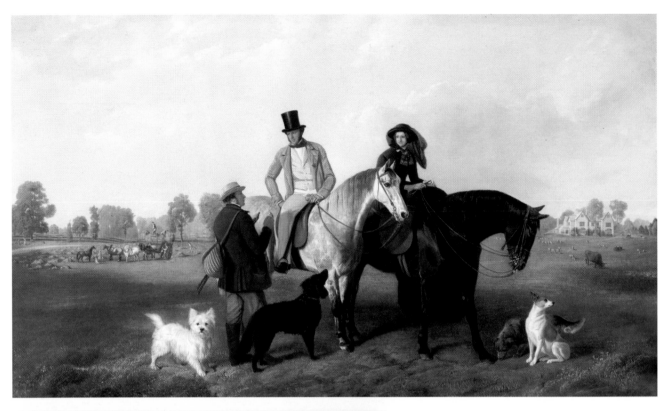

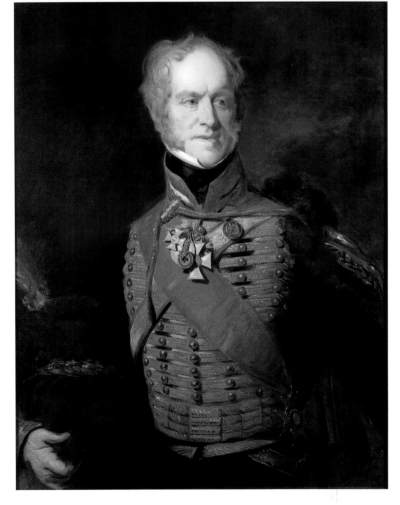

Colour Plate 36
FRIEDRICH WILHELM KEYL (1823-1871). Mr and Mrs Sam Gurney with a view of the Culver, Carshalton. Signed and dated 1851. 22 x 37ins (55.9 x 94cm) *Richard Green Galleries, London*

Colour Plate 37
JOHN PRESCOTT KNIGHT (1803-1881). General the Marquess of Anglesey KG. Exhibited 1840. 36 x 28ins (91.5 x 71.1cm)

Philip Mould/Historical Portraits Ltd

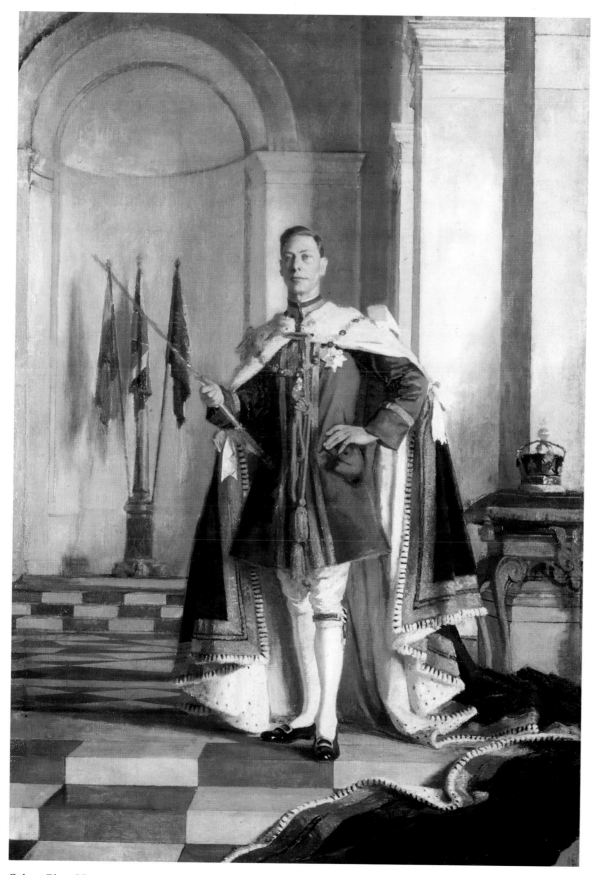

Colour Plate 38
GERALD FESTUS KELLY (1879-1972). George VI. 31 x 21ins (78.8 x 53.3cm)

Christie's

Colour Plate 39
HAROLD KNIGHT (1874-1961). In the studio. Signed. 24 x 20ins (61 x 50.8cm)

Richard Green Galleries, London

Colour Plate 40
LAURA KNIGHT (1877-1970). The convalescent – study for Juanita 1927. Signed. Pastel and chalk. 15 x 11¼ins (38.1 x 28.6cm)
Richard Green Galleries, London. (© Dame Laura Knight, reproduced by permission of Curtis Brown Group Ltd, London)

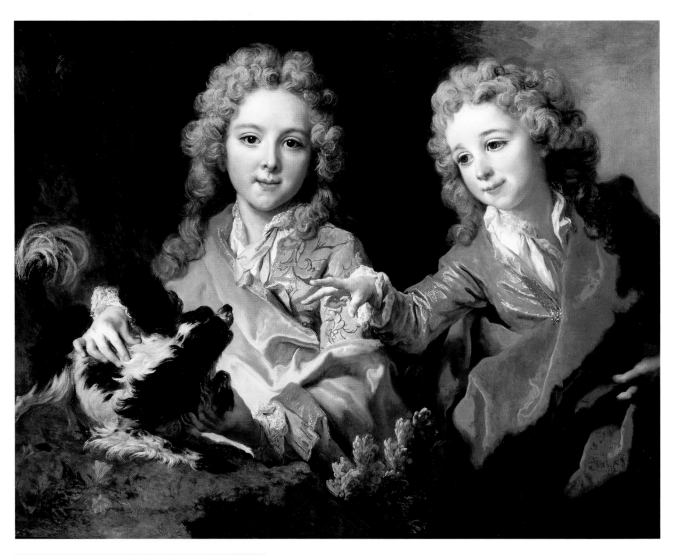

Colour Plate 41
NICOLAS DE LARGILLIÈRRE (1656-1746). The twins, Francis and Yves-Joseph-Charles Pommyer, playing with a King Charles spaniel. 30 x 40ins. (76.2 x 101.6cm) *Richard Green Galleries, London*

Colour Plate 42
SAMUEL LAURENCE (1812-1884). The 1st Duke of Wellington. Chalks. 14½ x 10½ins (36.8 x 26.7cm) *Philip Mould/Historical Portraits Ltd*

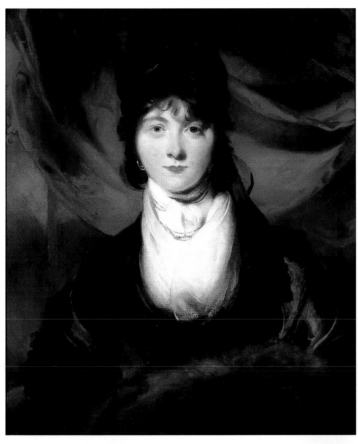

Colour Plate 43
THOMAS LAWRENCE (1769-1830). Felicity Trotter. 30 x
25ins (76.2 x 63.5cm) *Richard Green Galleries, London*

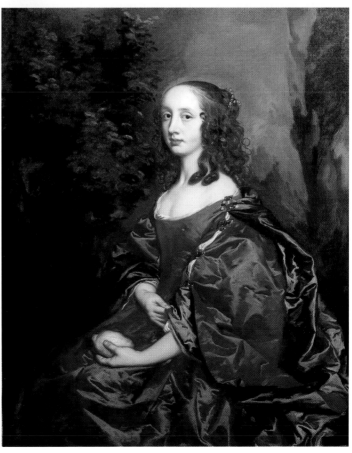

Colour Plate 44
PETER LELY (1618-1680). A lady with a lemon. 50 x
40ins (127 x 101.6cm)

Philip Mould/Historical Portraits Ltd

Colour Plate 45
FREDERIC LEIGHTON (1830-1896). Lady Sybil Primrose. Exhibited 1885. 48 x 34¼ins (121.9 x 87cm) *Christie's*

Colour Plate 46
JOHN LUCAS (1807-1874). Captain Edmund Brown, an officer of the Hon East India Company's Bengal
Engineers. Exhibited 1832. 94 x 58ins (238.8 x 147.3cm) *Christie's*

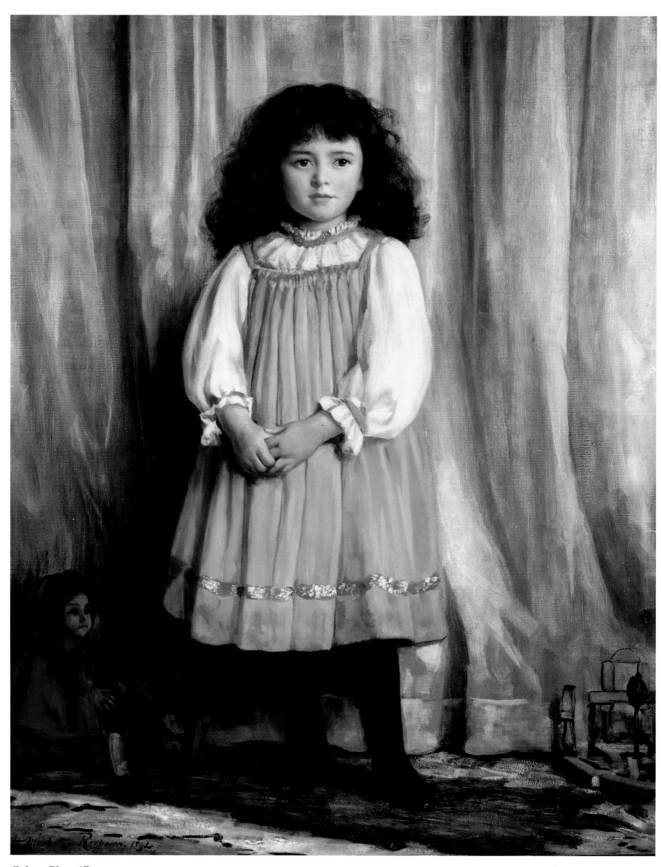

Colour Plate 47
HENRY MACBETH-RAEBURN (1860-1947). The yellow pinafore. Signed and dated 1892. 44 x 43ins (111.8 x 109.2cm)
Christopher Wood Gallery, London

Colour Plate 48
THOMAS FALCON MARSHALL (1818-1878). A lady. Signed. 17 x 14ins (43.2 x 35.6cm)

Richard Green Galleries, London

Colour Plate 49
ARTHUR AMBROSE McEVOY (1878-1927). Messrs Baring Brothers & Co, 1926, from left to right 2nd Lord Revelstoke, Cecil Baring, Gaspard Farrer and Alfred Mildmay. Signed 50 x 60ins (127 x 152.4cm)
ING Barings

Colour Plate 50
BENJAMIN MARSHALL (1768-1835). The Corbett family of Yns y Maengyn. 36 x 28ins (91.5 x 71.1cm) *Richard Green Galleries, London*

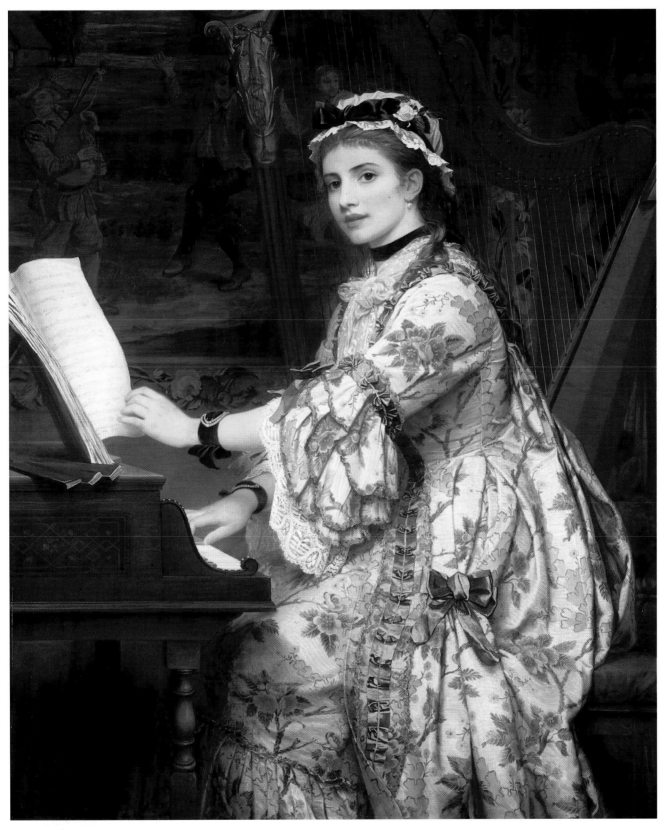

Colour Plate 51
JOHN EVERETT MILLAIS (1829-1896). A young lady. Signed in monogram and dated 1886. 48 x 38½ins (121.9 x 97.8cm)
Richard Green Galleries, London

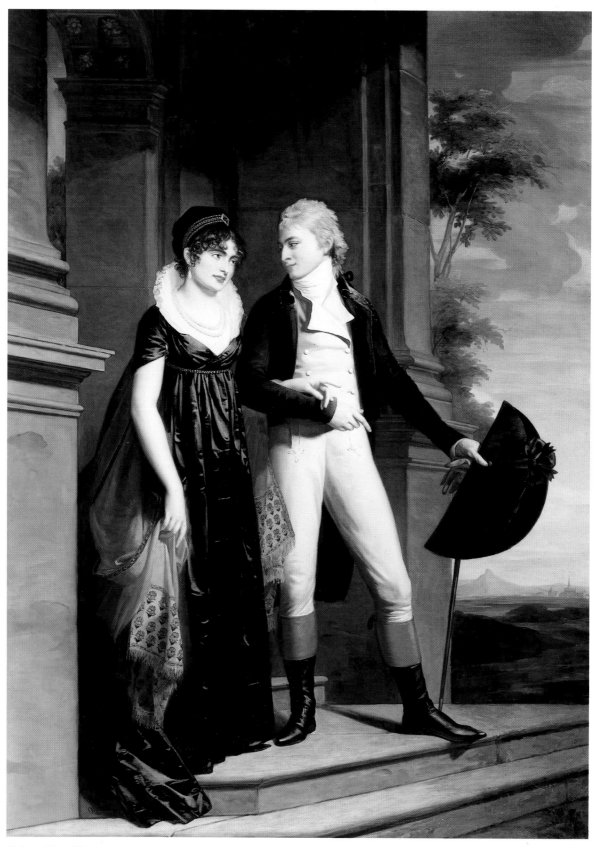

Colour Plate 52
JEAN-LAURENT MOSNIER (c.1743/4-1808). Moritz Christian Johann, Graf von Fries and his wife Maria Theresia Josepha,
Prinzessin zu Hohenlohe-Waldenburg-Schillingsfurst. Signed and dated 1801. 99 x 69⅜ins (251.5 x 176.2cm)
Richard Green Galleries, London

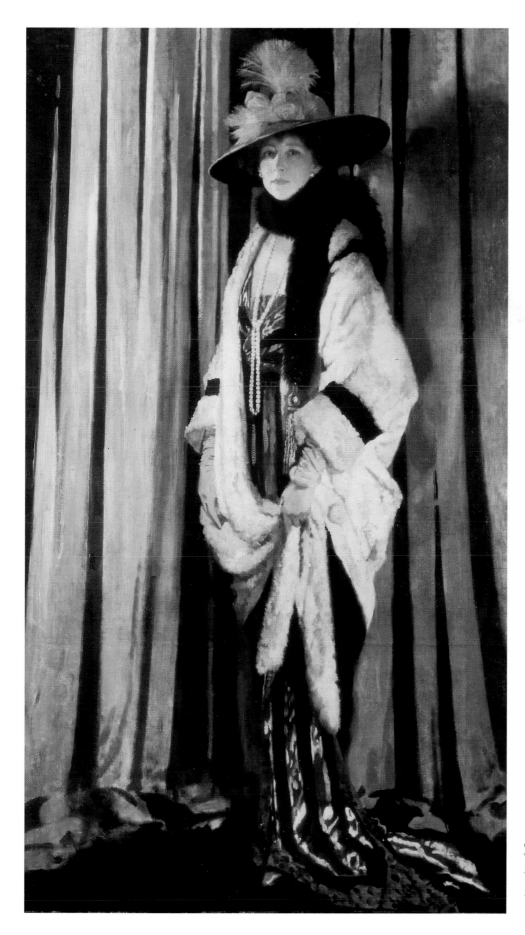

Colour Plate 53
WILLIAM NEWENHAM
MONTAGUE ORPEN (1878-
1931). Mrs St George. 84 x
36ins (213.4 x 91.5cm)
Christie's

49

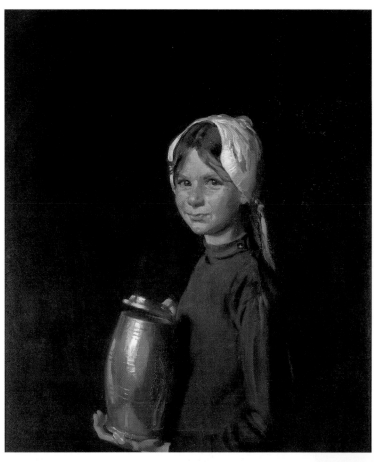

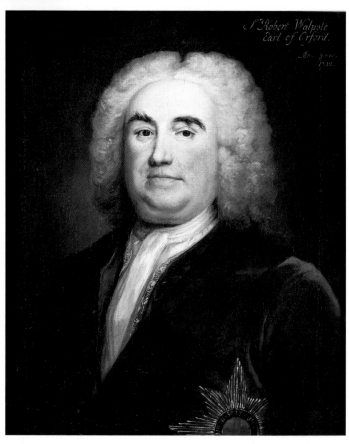

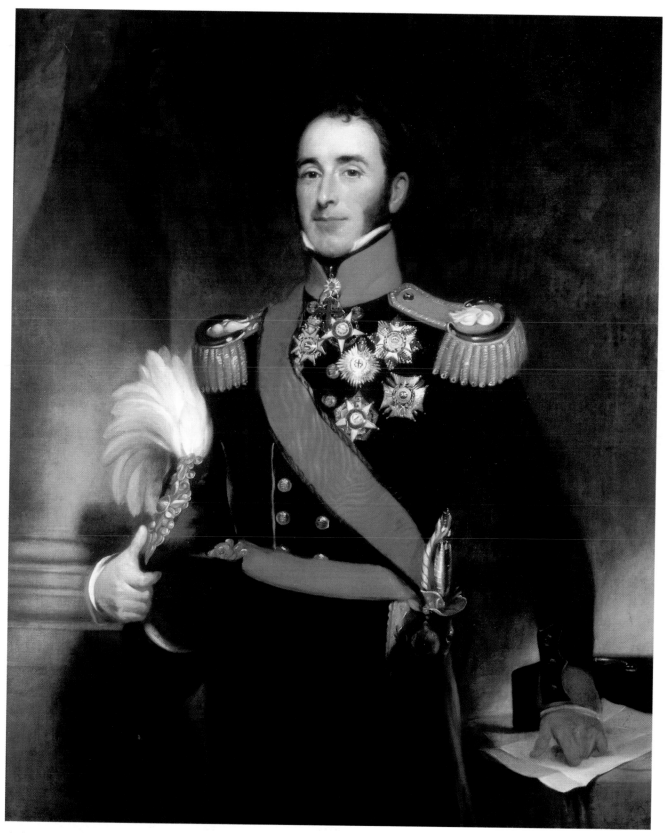

Colour Plate 56
HENRY WILLIAM PICKERSGILL (1782-1875). Sir John Conroy. Exhibited 1837. 65 x 44ins (165.1 x 111.8cm) *Private collection*

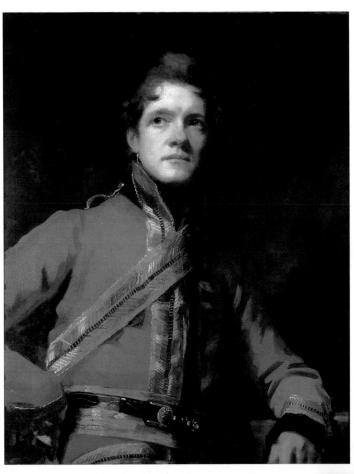

Colour Plate 57
HENRY RAEBURN (1756-1823). Lieutenant Colonel Morrison of 7th Dragoon Guards. 35 x 27ins (88.9 x 68.6cm)
Christie's

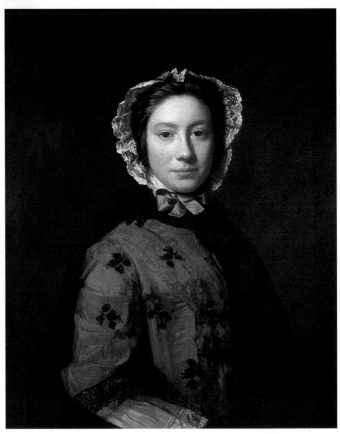

Colour Plate 58
ALLAN RAMSAY (1713-1784). Rosamund Sargent (née Chambers). Signed and dated 1749. 30 x 25ins (76.2 x 63.5cm) *Holburne Museum & Crafts Study Centre, Bath*

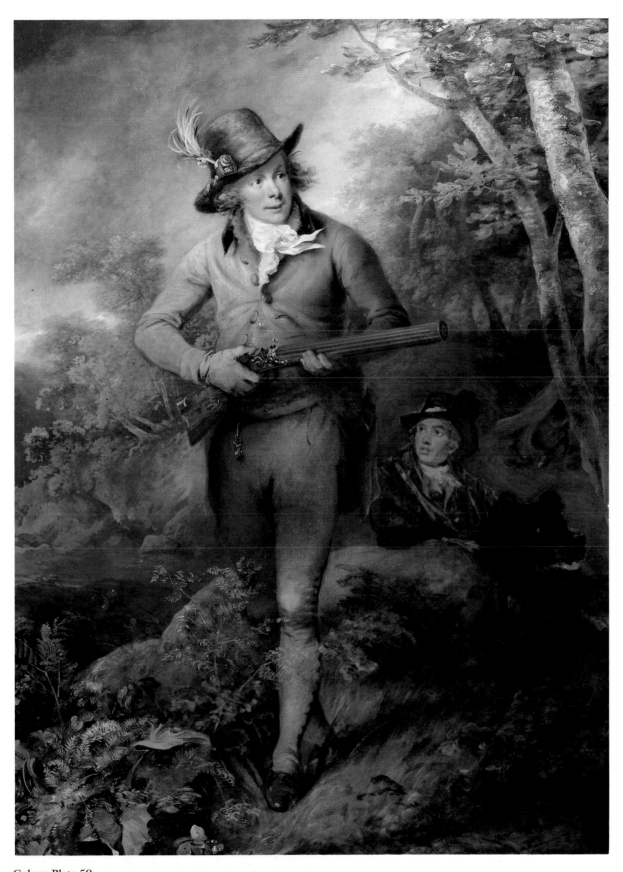

Colour Plate 59
PHILIP REINAGLE (1748-1833) (landscape by Sawrey Gilpin). Colonel Thornton of Thornville Royal. Painted 1786. 82 x
59ins (208.3 x 149.9cm)
Richard Green Galleries, London

Colour Plate 60
GEORGE RICHMOND (1809-1896). A gentleman, from the Templeton family, Castle Upton, County Antrim. Watercolour. 15¾ x 12⅛ins (40 x 31.1 cm)
Private collection

Colour Plate 61
JOHN RILEY (1646-1691). William Chiffinch. 30 x 25ins (76.2 x 63.5cm) *Philip Mould/Historical Portraits Ltd*

Colour Plate 62
JOSHUA REYNOLDS (1723-1792). William Charles, 1st Viscount Milsington. Painted in 1759. 30 x 25ins (76.2 x 63.5cm)

Leger Galleries Ltd, London

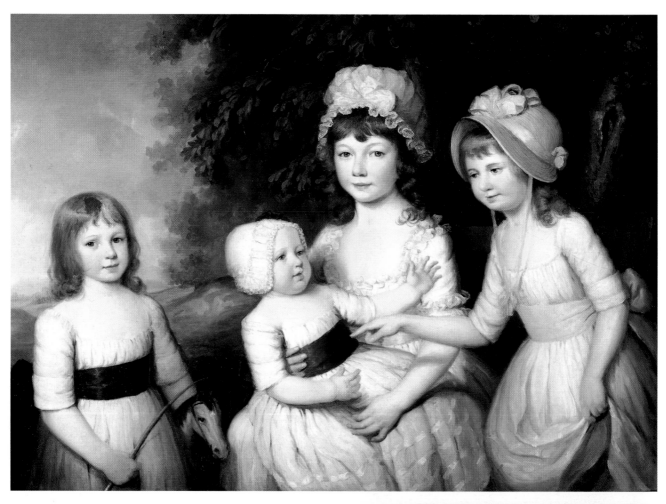

Colour Plate 63
JOHN RUSSELL (1745-1806). Grace Theodosia Watson and her three sisters. 26 x 34ins (66 x 86.3cm)

Richard Green Galleries, London

Colour Plate 64
RICHARD ROTHWELL (1800-1868). Rt Hon W. Huskisson. 36 x 28ins (91.5 x 71.1cm) *Philip Mould/Historical Portraits Ltd*

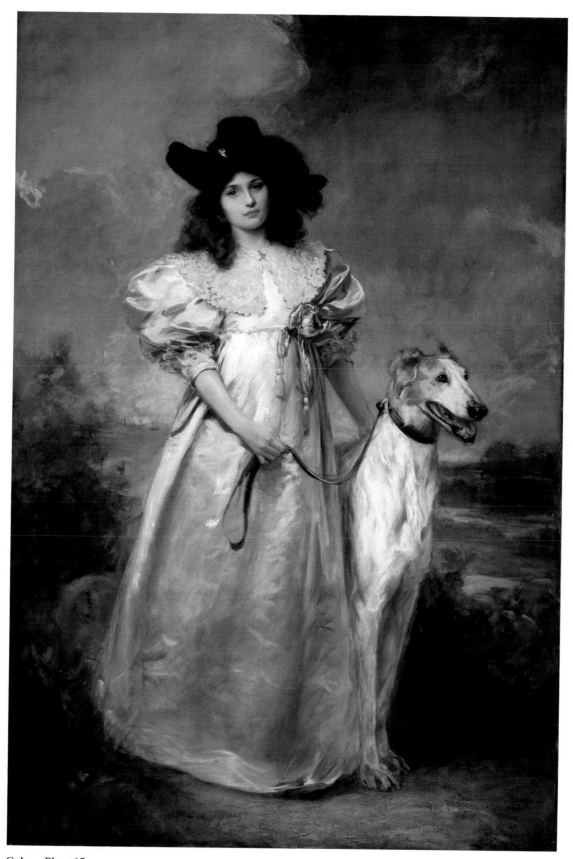

Colour Plate 65
ROBERT HERRMAN SAUBER (1868-1936). Constance Shepherd, the artist's niece, with her borzoi. Exhibited 1907. Signed. 76½ x 51½ins (194.3 x 130.8cm)

Owen Edgar Gallery, London

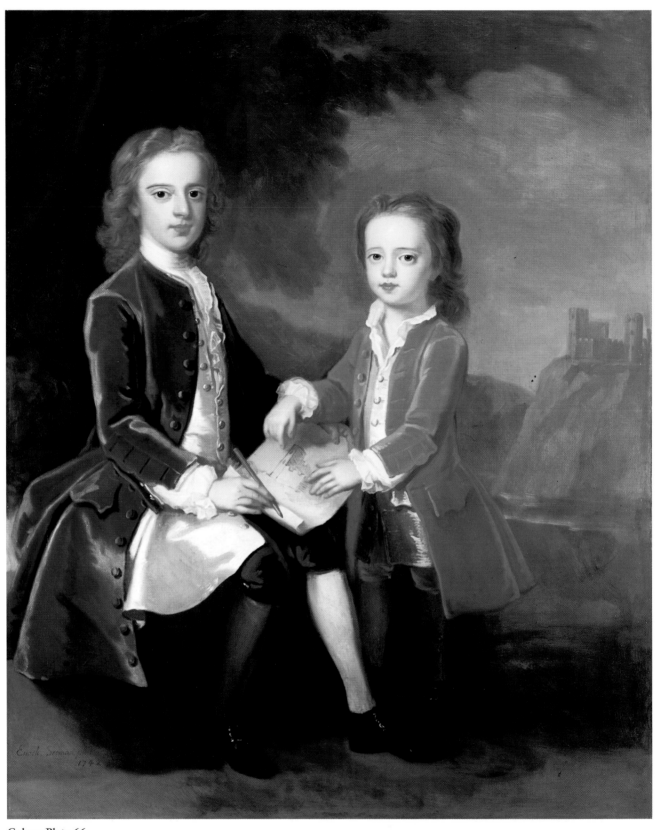

Colour Plate 66
ENOCH SEEMAN (c.1694-1744). George and John Campbell. Signed and dated 1742. 50 x 40ins (127 x 101.6cm)
Richard Green Galleries, London

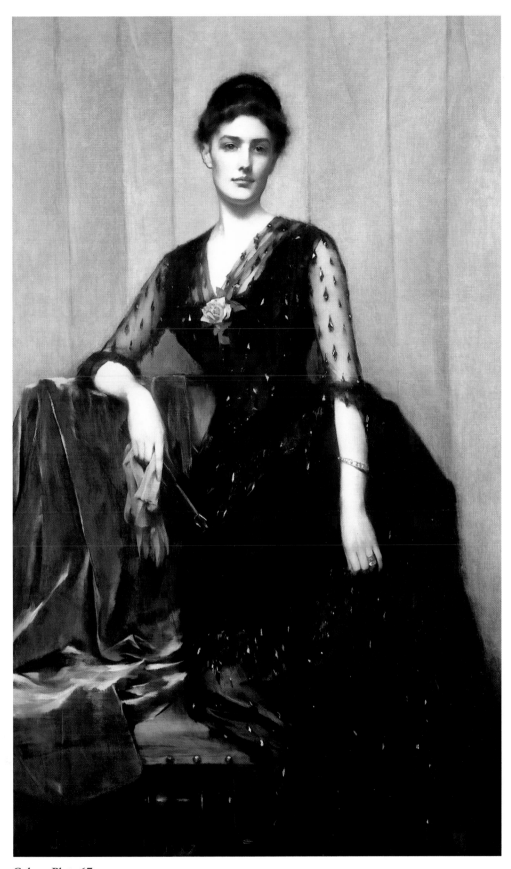

Colour Plate 67
JAMES JEBUSA SHANNON (1862-1923). Mrs Agnes Williamson. Signed and dated 1887. 67¾ x
40ins (172.1 x 101.6cm)
Richard Green Galleries, London

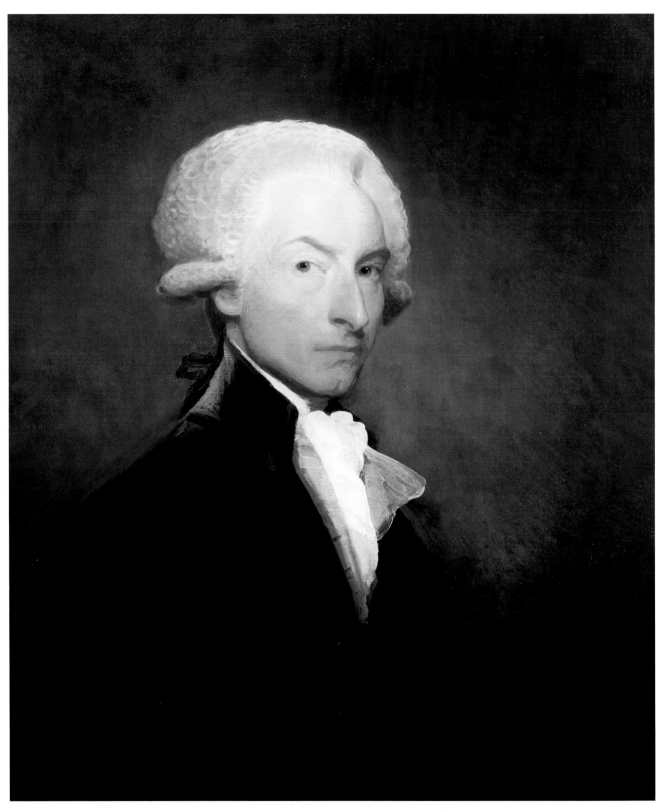

Colour Plate 68
GILBERT CHARLES STUART (1755-1828). Johnstone Hannah of Balcaris and Tores. 30 x 25ins (76.2 x 63.5cm)

Philip Mould/Historical Portraits Ltd

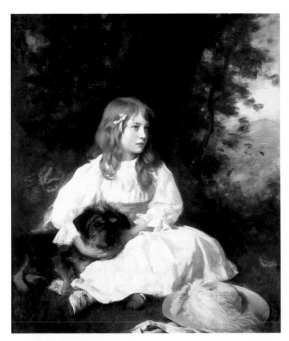

Colour Plate 69
WILLIAM ROBERT SYMONDS (1851-1934). Heather.
Signed and dated 1904. 44 x 37ins (111.8 x 94cm)

Christie's

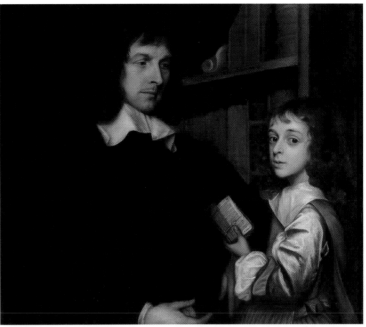

Colour Plate 70
ROBERT WALKER (c.1599-c.1658). A tutor and his pupil. Inscribed
'Aetatis Suae 9'. 33 x 36ins (83.9 x 91.4cm)

Philip Mould/Historical Portraits Ltd

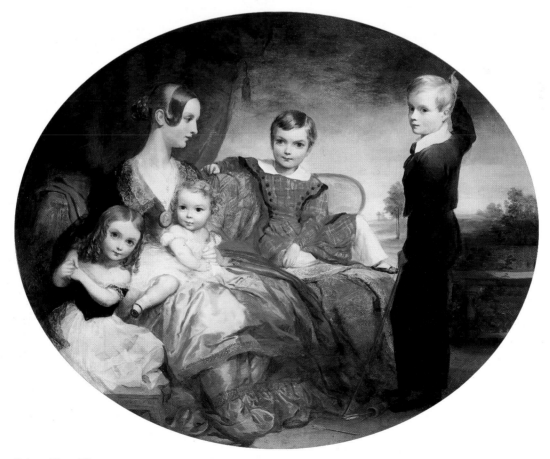

Colour Plate 71
GEORGE FREDERIC WATTS (1817-1904). A lady and her four children. Signed and dated 1843. 20 x 24ins
(50.8 x 61cm)

Julian Simon Fine Art, London

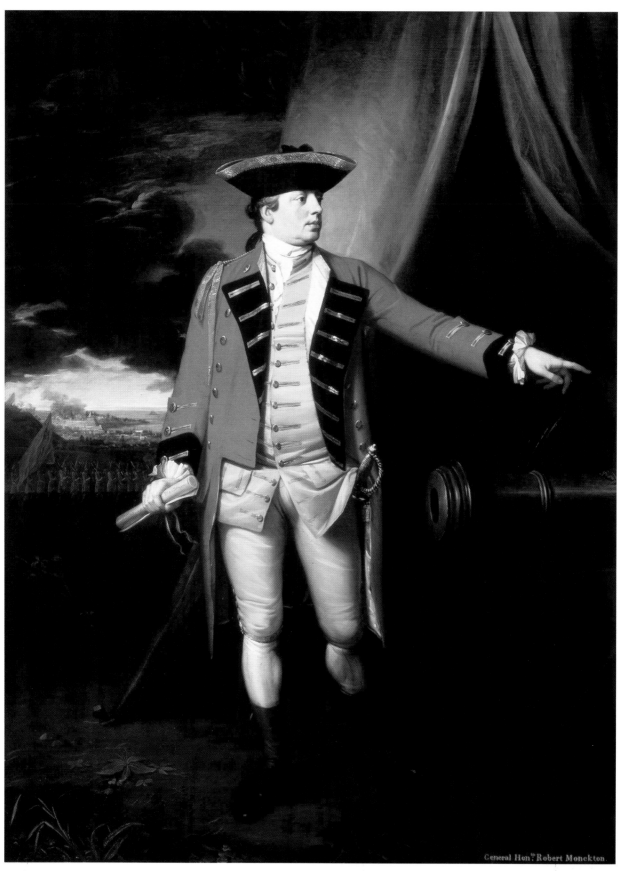

General Hon. Robert Monckton.

Colour Plate 72
BENJAMIN WEST (1738-1820). General the Hon Robert Monckton. 94½ x 69ins (240 x 175.3cm)

Christie's

Colour Plate 73
WILLIAM CLARKE WONTNER (d.1930). Edith Francis Moir (Connie). Signed and dated 1898. 27 x 20⅝ins (68.6 x 52.7cm)
Christopher Wood Gallery, London

Colour Plate 74
FRANZ XAVER WINTERHALTER (1805-1873). A
child. Signed and dated 1840. 36 x 28¾ins (91.5 x
73cm) *Richard Green Galleries, London*

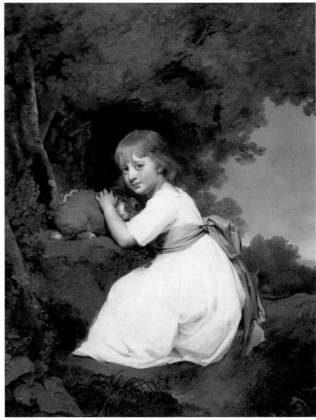

Colour Plate 75
JOSEPH WRIGHT OF DERBY (1734-1797). Miss Bentley with
her rabbit. 50 x 40ins (127 x 101.6cm) *Christie's*

A

ABBEY, Edwin Austin RA RWS RI PS 1852-1911
Born Philadelphia 1 April 1852. Studied there at Academy of
Fine Arts 1869-71. Illustrated for *Harper's Weekly*. Sent to
England 1878 and stayed in Worcestershire for two years.
Returned to America for eight months and then settled in
England. Exhibited at RA (25) 1885-1910. Elected RI 1883,
ARA 1896, RA 1898. Travelled extensively on the Continent.
Died London 1 August 1911.
Represented: Tate. **Engraved by** F.Laguillermie. **Literature:**
E.V. Lucas, *E.A.A., RA*, 2 vols, 1921; Wood.

ABBOTT, (Francis) Lemuel c.1760-1802
Born Leicestershire, son of a clergyman (probably Rev Lemuel
Abbott, Vicar of Thornton). Studied under Hayman c.1774, but
after Hayman's death returned to his parents. Settled in London
c.1780. Exhibited at RA (15) 1788-1800. Very successful and
painted a large number of naval officers. Among his sitters were
Admiral Nelson and the poet Cowper. Ben Marshall was
apprenticed to him for three years from 1791. Abbott married a
woman of 'very absurd conduct' which is said to have
contributed to his own instability and by July 1798 he became
incurably insane (although dated portraits continue until 1799).
Died London 5 December 1802 (not 1803). His art is usually
of a consistently high standard and sensitively painted. Female
portraits by him are less common. Many of his prints are marked
'Francis Lemuel Abbott', but it is not known why he assumed
this additional forename. Abbott's wife was, according to
Farington's *Diary* 18 August 1803, a Roman Catholic bigot
who insisted on her son, Edward Francis Abbott, becoming a
Roman priest. When her son refused she would scarcely see him.
The son eventually studied with sculptor Joseph Nollekens.
Represented: NPG London; SNPG; Tate; BM; NMM.
Engraved by W. Barnard, G. Baxter, W. Bond, A. Cardon,
G.S. Facius, A. Geiger, R. Graves, J. Golding, J. Heath, H.
Hudson, J. Fittler, S. Freeman, J. Gisborne, V. Green, H.
Meyer, J. Minasi, J. Ogborne, C. Picart, W. Read, W. Ridley,
P. Roberts, T. Ryder, W. Sharp, W. Skelton, J.T. Smith,
R.S. Syer, Thornthwaite, C. Townley, C. Turner, J. Vendramini,
W. Ward, J.T. Wedgewood. **Literature:** A.C.Sewter,
Connoisseur CXXV April 1955 pp.178-83; DA.

ABBOTT, Richmond fl.1861-1866
Exhibited at RHA (8), SBA (4), BI (2) 1861-6 from Liverpool
and Horsley Hall, Gresford, near Wrexham, North Wales.

ABERCROMBIE, James fl.1723
Native of Glasgow. Served in the army in colonies. Appointed
Second King's Limner for Scotland on the death of George
Ogilvie.
Literature: McEwan.

ABERCROMBIE, John Brown 1843-1929
Exhibited at RA (4) 1873-96 from Edinburgh and RSA (95).
In 1899 exhibited a portrait of the artist G.W. Johnstone RSA.
Literature: McEwan.

ABERCROMBIE, Lady Julia 1840-1915
Lady Julia Janet Georgina Duncan, only daughter of Adam,
2nd Earl of Campertown. Married 4th Baron Abercrombie 9
October 1858. Painted watercolour portraits and copies.
Represented: NPG London.

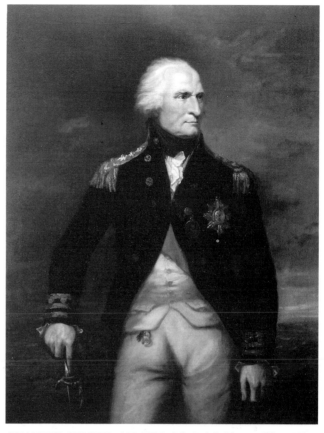

(FRANCIS) LEMUEL ABBOTT. Admiral Bridport. 50 x 40ins
(127 x 101.6 cm) *Philip Mould/Historical Portraits Ltd*

ABERCROMBIE, Miss M.C. fl.1891-1892
Exhibited NWS (3), NWG (1) 1891-2 from London.

ABERRY (ABERY), J. fl.1738-1753
Lord Egmont recorded in his diary for 5 April 1738 'Dr
Courayer Sitting for His Portrait to Mr Abery'. Also an
engraver. Signed an etching after Hudson's portrait of Sir
Watkin Williams Wynne 1753.

ABRAHAM, Richard F. b.c.1797
Born Hackney. Listed in 1851 census as a carver, gilder aged
54. Exhibited at RA (11), BI (6) 1846-53 from London.

ABSOLON, John RI 1815-1895
Born Lambeth 6 May 1815. Left school aged 14 to study art
under Ferrigi. Aged 16 he earned his first £8 for four
watercolour portraits. Married aged 21. Employed as a scene
painter at Drury Lane and Covent Garden, and worked with
T.Grieve on his first diorama. Went to Paris 1835 for three years
painting miniatures. Exhibited at RA (16), RHA (7), BI (7),
SBA (22), NWS (660) 1832-74. Resigned from NWS 1858 to
visit Italy and Switzerland, but rejoined 1861 and was treasurer
for many years. On his retirement he enjoyed a civil list pension
obtained through the influence of the Earl of Caernarvon, one
of his former pupils. Died Highgate 26 June 1895.
Represented: BM; VAM; Ashmolean Museum; Leeds CAG;
Grundy AG, Blackpool; Sydney AG; Ulster Museum.
Literature: *Art Journal* October 1862; Ottley.

ACKERLEY, Chamberlayne fl.1830
Painted a portrait of James Chapman, Clerk to Board of
Guardians in Southampton Record Office.

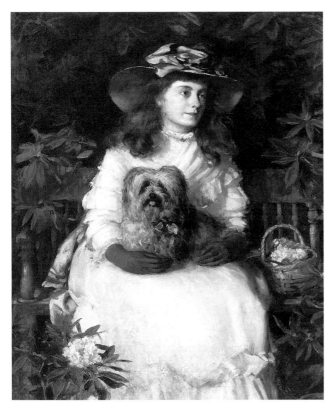

PATRICK WILLIAM ADAM. La Jeunesse. Signed and dated 1884. 45 x 36ins (114.3 x 91.5cm)
Christopher Wood Gallery, London

ACRAMAN, B. fl.1747
A portrait of a lady in the Dutch style was signed and dated 1747.

ACRES, John Edward d.c.1826
Exhibited at RA (8) 1800-13 from London. Went to Sydney, Cape Breton County 1818 to see about an inheritance. Worked in Halifax, Nova Scotia c.1815-16, Sydney c.1817 and Halifax again before 1823. Painted miniatures in Halifax 1826. Committed suicide there soon after.
Literature: Foskett.

ACRET, John F. fl.1884-1902
Exhibited portraits and miniatures at RA (9), SBA (3) 1884-1902 from Hampstead.

ADAM, Patrick William RSA 1854-1929
Born Edinburgh 12 October 1854, son of a well-known lawyer. Studied at RSA Schools under G.P.Chalmers and W.McTaggart, winning Maclaine Watters medal 1878. Began as a portraitist before specialising in landscape painting and genre. Exhibited at RSA (147), RHA (26), RA (49) 1872-1929 from Edinburgh, Roslyn and North Berwick. Elected ARSA 1883, RSA 1897. Died North Berwick 27 December 1929.
Represented: SNPG; Glasgow AG; Aberdeen AG.
Literature: P.J. Ford, *Interior Paintings of P.W.A.*, 1920.

ADAMS, Arthur Christopher RMS b.1867
Born Southampton 4 December 1867, son of Walton Adams, a photographer. Educated at New College, Romsey. Studied at Reading University. Exhibited at RA, RI, RMS, Toronto and Paris Salon 1910-35 from Reading, Parkstone and London. Signed work 'Chris Adams'.

ADAMS, Bernard RP ROI NS FRSA d.1965
Born London, son of designer R.H.Adams. Educated at Chapel Royal, Savoy. Studied at Westminster School of Art, under George Harcourt, Phillip de Laszlo and at Antwerp Academy. Won medals and Allan Fraser scholarship. Exhibited at RA (2), RP, ROI from London and Buckland Common. Elected RP 1919, ROI 1923. Died London 10 April 1965.

ADAMS, Chris see ADAMS, Arthur Christopher

ADAMS, Miss Elinor Proby d.1945
Born Sudbury. Studied at Slade, where she was awarded scholarships. Exhibited at RA (4), RI, NEAC 1917-41 from Coulsdon, Surrey. Lived at Sevenoaks for some years. Died 18 December 1945.

ADAMS, Miss Jane fl.1821-1851
Exhibited at RA (5), BI (7) 1822-51 from London.

ADAMS, John b.1881
Born 'St. George's, Middlesex'. Listed as a portrait painter in London.

ADAMS, Mrs Laura G. fl.1916-1954
Exhibited at RA (6) 1916-54 from Monkseaton, Northumberland.

ADAMS, Miss Lucy fl.1815-1843
Exhibited at RA (14), SBA (47), NWS (1) 1819-43 from Billericay. Painted a portrait of Francis Trollope. May have been author of *Ben Saunders, A Tale for Mothers*, 1852. Her sisters Caroline and Charlotte were also artists.
Represented: BM.

ADAMS, T. fl.1799
Hampshire Telegraph 21 September 1799 reported the marriage of T.Adams, an eminent Portsmouth portrait painter to Miss Gilbert.
Engraved by C. Spooner.

ADAMS, William Dacres NPS 1864-1951
Son of Rev William Fulford Dacres and Catherine Adams. Educated at Radley College and Exeter College, Oxford. Studied at Herkomer's School, Bushey and in Munich. Exhibited at RA (28), RHA (2), ROI, NPS and in France 1892-1940 from London and Lewes. Died 17 August 1951.

ADAMSON, David Comba 1859-1926
Born Ayrshire. Studied in Glasgow and Edinburgh. Visited Antwerp and Paris, where he studied under B.Constant and Carolus-Duran. Began his career at Cambuslang near Glasgow. Moved to Paris 1890-1908. Exhibited at Paris Salon, RA, RSA, Royal Glasgow Institute of Fine Arts, Dundee Fine Art Exhibitions. Settled in Dundee, where he died. A considerably talented artist.
Represented: Dundee AG.
Colour Plate 7

ADAMSON, John RBA 1865-1918
Born August 1865. Studied at RA Schools. Exhibited at RA (12), SBA 1890-1917 from Hornsey and Haverstock Hill. Died 12 December 1918.

ADAMSON, William fl.1832-1834
Listed as portrait painter at 121 Aldersgate Street, London.

ADDEY, Joseph Pool c.1854-1922
Exhibited at RHA (134) 1877-1914 from Ireland and Kingston-upon-Thames. Died Watford 18 October 1922. Left effects of £2,168.13s.6d.

ADNEL fl.1710
Somerset and Dorset Notes and Queries XXII (1938), 199 recorded payments at Wells by Dr Calver Morris to Mr Benjamin Taylor and Mr Fry for completing unfinished portraits by Mr Adnel.

ADOLPH(US), Joseph Anton 1729-c.1765
Born Mikulov, Czechoslovakia 8 October 1729. Studied art at Vienna Academy. Arrived in London (via Paris) c.1750. While in England he painted 'George III as Prince of Wales on Horseback' (engraved by G.Bockman). Said by Bénézit to have died Vienna 1762, but apparently produced two full-length civic portraits for St Andrew's Hall, Norwich (1764) and signed and dated works in Suffolk 1765.
Represented: Castle Museum, Norwich; Lord Cranworth; Marquis of Lothian.

ADOLPHE, Edgar fl.1839-1845
Painted a watercolour portrait of J.M.W.Turner 1839. Listed as portrait painter at 4 East Street, Brighton 1845.

AGAR, Charles fl.1855
Listed as a portrait artist at 104 King Street, Manchester.

AGASSÉ, James Laurant (Laurent) 1767-1849
Born Geneva 24 March 1767. Studied there as an animal painter at École du Calabri. Went to Paris 1786 and trained under Jacques-Louis David. Persuaded by Hon George Pitt to settle in London c.1800. Exhibited at RA (29), BI (7), SBA (5) 1801-45. Patronised by George IV, Lord Moreton, Lord Rivers, Lord Heathfield and George Booth. Painted mainly animal and important sporting paintings, but his few portraits are accomplished. Died London 27 December 1849.
Represented: Tate. **Engraved by** M.Gauci; J.Porter. **Literature:** C.F.Hardy, 'The Life and Work of J.L.A.', *Connoisseur* January 1917; *J.L.A.*, Tate exh. cat. 1989; DA.

AGLIO, Augustino jnr c.1816/7-1885
Born Kensington, son of artist Agostino Aglio. Exhibited at RA (2), BI (5), SBA (19) 1836-75 from London. Also a drawing master. Married Margaret, daughter of John Absolon. Often confused with his father.

AGNENI, Eugenio 1819-1888
Born Sutri, near Rome. Studied under Franc Coghetti. Painted mainly historical scenes. Travelled to Paris 1852. Exhibited at RA (5) 1859-62 from London. Painted a large picture of Queen Victoria and her family dressed for a masked ball. Decorated rooms in the Louvre and at Covent Garden. Died Rome.
Literature: Bénézit.

AGNETTI, Miss fl.1774
Exhibited at SA (1) in 1774 from York.

AIKEN, John MacDonald RSA RI ARE ARCA
1880-1961
Born Aberdeen. Studied there at Gray's School of Art, then at RCA under G.Moira and in Florence. Head of Gray's School 1911-14. Served four years in the 1st World War. Exhibited at RA (25), RSA (125), RI (8), RE (18), Paris Salon (Silver Medal winner 1928) 1907-38 from Aberdeen and London. Elected ARSA 1923, ARE 1924, RSA 1935, RI 1944.
Represented: Aberdeen AG; Dundee AG, Perth AG; Leith Hall NT. **Literature:** K.McConkey, *Edwardian Portraits – Images of Opulence*, 1987 p197; McEwan.

AIKMAN, George ARSA RSW c.1830-1905
Born Edinburgh 20 May 1830 or 1831 (conflicting sources). Educated at Royal High School, Edinburgh. Studied as an engraver, working for many years for *Encyclopaedia*

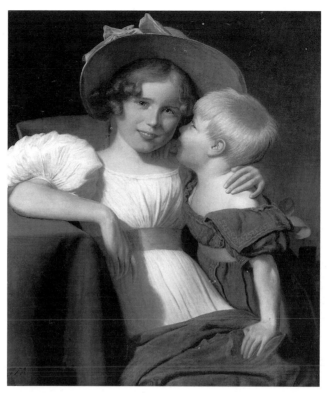

JAMES LAURANT AGASSÉ. The important secret – Georgina and George Booth. Signed with initials. Exhibited 1845. 30 x 25ins (76.2 x 63.5cm) *Richard Green Galleries, London*

Britannica. Exhibited RA (5), RSA (144), RSW (19) 1866-1905. Also produced portraits and worked from the former studio of G.Watson PRSA. Died Edinburgh 8 January 1905.
Engraved by J.Smith. **Literature:** McEwan.

AIKMAN, John 1713-1731
Son of William Aikman. There are a few studies etched by him after Van Dyck, two or more on a plate. Showed much promise. Died aged 17/18 in 1731.
Literature: Redgrave.

AIKMAN, William 1682-1731
Born Cairnie, Forfar 24 October 1682, son of William Aikman, the Laird of Cairnie. Graduate of University of Edinburgh and was intended for law. Took to art with encouragement from his uncle Sir John Clerk of Penicuik. Became a pupil and assistant of Sir John Baptist de Medina, who was then in Edinburgh. Moved to London 1704-7 and sold the family estate, travelling to Rome about 1707-10 (where he copied Carlo Marratta) as well as visiting Constantinople and Smyrna. Returned to work in Edinburgh (after the death of Medina) by March 1711, where he had a successful practice, charging 5 guineas for a head and 10 guineas for a half-length portrait. Moved to London for an experimental six months during the winter of 1720-1, aware that Kneller was now an old man. Settled in London c.1723, encouraged by the Duke of Argyll, and raised his prices for a head to 8 guineas. A friend of Pope, Gray and Thompson and other literary figures. Painted portraits of Lord Burlington, Sir Robert Walpole and many Scotsmen. Also a close friend of Allan Ramsay, who later wrote an eclogue to his memory. The demand for his work continued to grow and by 1728 he was accomplished enough to charge 40 guineas for a full-length portrait. Painted the royal family for Lord Burlington 1730 when his health deteriorated, and died at his house in Leicester

EDWARD ALCOCK. Portrait of a lady. Signed and dated 1769.
17 x 11½ins (43.2 x 29.2cm) *Phillips*

Fields 14 January (not June) 1731. Said to have been broken
hearted by the death of his son aged 17/18. Both were buried
in the same grave at Grey Friars Church, Edinburgh.
Represented: SNPG; NPG London; BM; University of
Edinburgh; Uffizi Gallery, Florence **Engraved by**
G.Bickham, J.Cooke, R.Cooper, S.Freeman, Gwyn, T.Kyte,
C.Lasinio, P.A.Pazzi, P.Rothwell, R.Scott, G.White.
Literature: J.E.Holloway, *W.A., Scottish Masters*, 1988;
J.Wilton-Ely, 'Lord Burlington and the Virtuoso Portrait',
Architectural History, Vol 27 1984; DNB; McEwan; DA.

AINSLIE, John **fl.1807-1835**
Edinburgh painter. Won Second Premium at the Trustees'
Academy 1807 and painted a number of portraits for the
Duke of Buccleuch at Bowhill.
Literature: McEwan.

AIRD, Reginald James Mitchell **b.1890**
Born London 14 January 1890, son of David Alfred Aird, a
barrister. Studied at École Nationale et Spéciale des Beaux-
Arts, Paris and Spain. Exhibited at RA (2), Brighton AG, GI,
NPS and lived in London. Among his sitters were Duchess of
York, Princess Marie of Rumania, Princess Nina of Russia and
Sir Percival Phillip KCB.
Represented: VAM (textiles).

AIRY, Anna RI RP PS RE ROI **1882-1964**
Born Greenwich 6 June 1882, daughter of Wilfred Airy.
Studied at Slade under Brown, Steer, Tonks and Russell

1899-1903. Awarded a Slade scholarship 1903 and many
prizes. Exhibited at RA (80) 1905-56. Elected PS 1906, ARE
1908, ROI 1909, RP 1913, RE 1914, RI 1918. Married
Geoffrey Buckingham Pocock 18 February 1916. Died
Playford, Ipswich 23 October 1964. A highly gifted artist.
Represented: VAM; NG South Wales; Walker AG, Liverpool;
Leeds CAG; Huddersfield AG; Imperial War Museum.
Literature: Christchurch Mansion, Ipswich exh. cat. 1985.

AITCHISON, H. **fl.1884**
Signed and dated a chalk portrait of 'William Stubbs, Bishop
of Chester and Oxford'.
Represented: NPG London.

AITKEN, H. **fl.1849-1850**
Exhibited at RHA (7) 1849-50 from Dublin.

AKERS, John **fl.1855**
Listed as a portrait painter at Royal Exchange Arcade,
Manchester. May be the John Akers in Oxford 1826-44.

AKERS, William S. **fl.1821-1826**
Exhibited at RA (2) 1821 from Mile End Road, London.

ALAIS, William Wolfe **fl.1829-1833**
Exhibited at RA (3) 1829-33 from London. His portrait of
Queen Victoria was engraved.

ALBETRIN, L. **fl.1832-1833**
Exhibited at SBA (6) 1832-3 from 40 Seymour Street, London.

ALCOCK, Edward **fl.1750-1780**
Itinerant portrait painter practising in Bath (1757),
Birmingham (1759-60), Bristol and London. Also a
miniaturist and genre painter. Chatterton wrote a poem
about him 1769. Exhibited at RA (1), FS (6) 1757-78.
Influenced by Rembrandt and was fond of strong shadows,
but retained a naïve feel to his work.
Represented: NPG London; Lord Neidpath Collection.

ALCOCK, Miss Harriet (Mrs Easthead, Easthed)
 fl.1832-1836
Exhibited portraits and miniatures at RA (3) 1832-6 from
Herne Hill, Dulwich and Kensington. Married c.1835-6.

ALDIS, C.M. **fl.1835-1842**
Exhibited at RA (9), BI (4), SBA (8) 1835-42 from
Bloomsbury.

ALDOUS, W. **fl.1824-1834**
Exhibited at RA (2) 1824-5 from Bloomsbury. Listed as a
portrait painter 1832-4. Graves 1970 mistakenly records only
one exhibit.

ALDRICH (ALDRICK), William **fl.1826-1834**
Listed as a portrait painter at 39 Old Street Road, London.

ALDRIDGE, Edward Westfield **1739-c.1778**
Entered RA Schools 1773. Exhibited at RA (3) 1775-8 from
London.

ALDWORTH, Miss Jane D.S. **fl.1895-1906**
Exhibited at RHA (5) 1895-1906 from Dublin and Dorking.

ALEFOUNDER, John **1757-1794**
Born September 1757, possibly son of a goldsmith and frame
maker. Entered RA Schools 4 October 1776 ('aged 19 last
September') as an architectural student, winning a silver
medal three years in succession. Produced an architectural
design for a lunatic hospital (RA 1777) and then

JOHN ALEFOUNDER. A lady, her daughter and Indian servant.
Signed and dated 1786. 30 x 25ins (76.2 x 63.5cm) *Christie's*

COSMO ALEXANDER. Master E. Gordon. Signed and dated
Paris 1752. 24 x 20ins (61 x 50.8cm) *Christie's*

concentrated on portraiture and miniature painting.
Exhibited at RA (30) 1771-93. Horace Walpole noted that
one of his exhibits in 1794 was 'good, very simple'.
Alefounder encouraged and advised Richard Westall.
Travelled to India arriving in Calcutta October 1785, where
he met with considerable success. While there he went
'melancholy mad' and could not recognise anyone. During
his illness his materials were sold, but he made a recovery and
advertised for them back. Committed suicide in Calcutta 20
December 1794.
Engraved by Bartolozzi, C.N.Hodges. **Literature:** Archer;
Sir W.Foster, Walpole Society, Vol XIX pp.5-7.

ALEXANDER, Charles **fl.1893-1894**
Exhibited at RA (3) 1893-4 from Alderley, Wotton-under-
Edge.
Represented: Indian Institute, Oxford.

ALEXANDER, Cosmo **1724-1772**
Born Scotland (probably Aberdeen), son and pupil of John
Alexander, a Jacobite. Painting copies by 1742. Took up arms
for Prince Charles Edward Stuart 1745 and subsequently fled
abroad. Recorded in Rome until 1751, when he left via
Bologna and Venice for Paris 1752. Came to London by
1754, when he inherited the house of the architect James
Gibbs, a fellow Aberdonian and Roman Catholic. The
following year he was employed by Aberdeen Town Council
to paint portraits. During the late 1750s and early 1760s he
appears to have moved between Scotland and London,
painting portraits in both places. Worked in Holland from
1763 and was fined in The Hague for not paying his dues to
the guild of painters (the confrérie). Exhibited at SA (1) 1765
from London. Travelled to America 1766, painting the
Scottish community in Philadelphia before moving north to
New York 1767. During the winter of 1768-9 he stayed with
the governor of New Jersey, William Franklyn, and then
moved on to Newport, Rhode Island. First teacher of Gilbert

Stuart, who accompanied Alexander on a tour of the southern
states and to Edinburgh 1771. Died Edinburgh.
Represented: Chicago Art Institute; Fogg Art Museum,
Cambridge, Massachusetts; SNPG; SNG. **Literature:**
P.Geddy, 'C.A.'s Travels and Patrons in America', *Antiques*
112 November 1977; G.M.Goodfellow, 'The Art, Life and
Times of C.A.', MA Thesis, Oberlin University, Ohio 1961;
G.M.Goodfellow, 'Cosmo Alexander in America', *Art
Quarterly* XXVI Autumn 1963; G.M.Goodfellow, 'C.A. in
Holland', *Oud Holland* LXXIX 1965 1, 85; McEwan.

ALEXANDER, Francis **1800-1881**
Born Killingly, Connecticut. Studied with Alexander
Robertson c.1820. Introduced by Trumbull to Gilbert
Stuart. Went to Boston c.1827, where he was very successful.
Painted Charles Dickens 1842. Settled in Florence 1853,
where he concentrated on dealing. Experimented with the
earliest portrait lithographs in America.
Represented: Boston MFA, Harvard; NG Washington.
Literature: C.W.Pierce, *Old-Time New England* XLIV
October-December 1953 pp.29-46.

ALEXANDER, J.B. **fl.1878**
Listed as a portrait and landscape painter at 11 Rose Hill,
Garnethill, Glasgow.

ALEXANDER, John **1686/8-c.1766**
Born Scotland, son of an Aberdeen Jacobite doctor and
maternal-grandson of George Jamesone. Practised in London
1710 copying Scottish historical portraits. The following year he
painted his self-portrait in miniature at Leghorn, *en route* to
Florence and Rome (SNPG). There he painted British tourists
including Lord Chief Justice Coke (1714) and probably studied
under Chiari. Worked for the Jacobite Earl of Mar and for the

DAVID ALLAN. Three boys. 47 x 58½ins (119.3 x 148.6cm) *Christie's*

exiled Stuart court. Made several engravings after Raphael before returning to Britain c.1719. Painted a large historical work for the staircase ceiling in Gordon Castle 1720. Married the granddaughter of Jamesone in Aberdeen 1723, where he was residing. His son Cosmo was born the following year. Settled in Edinburgh where he had a good practice, but also worked in Aberdeen. Returned to Italy to avoid Jacobite persecution after taking part in the 1745 uprising and was declared a 'wanted man' 1746. Back working openly by 1748. At the time of his death he was painting the 'Escape of Mary Queen of Scots, from Loch Leven Castle'. His daughter married Sir George Chambers 1768. Died near Edinburgh 1760 or c.1766 (conflicting sources). Often signed and dated on the reverse.
Represented: SNPG; BM. **Engraved by** A.Bell. **Literature:** McEwan.

ALIAMET, François Germain 1734-1790
Born Abbéville, brother of Jacques Aliamet. Listed in London as a history and portrait painter. Exhibited engravings at FS (5) 1762-5. Died London 5 February 1790.
Literature: Bénézit.

ALISON, D. b.1783
Son of a Perth Baillie. Pupil of Raeburn. His portrait of Alexander Wood is in SNPG.
Represented: Gordon Highlanders' Museum. **Literature:** McEwan.

ALISON, David RSA RP 1882-1955
Born Dysart, Fifeshire 18 February 1882, son of Walter Alison. Educated at Kilcaldy High School. Studied at Glasgow School of Art, and in Paris and Italy. Exhibited at RA (40), RSA (95), RP 1906-49. Elected ARSA 1916, RP 1917. Worked in Edinburgh, Dysart, Fife and London. Died Edinburgh 14 January 1955.
Represented: Dundee AG. **Literature:** McEwan.

ALISON, Miss Mary L. fl.1917-1918
Exhibited at RA (2) 1917-18 from Wandsworth Common.

ALLAN, David 1744-1796
Born prematurely in Alloa 13 February 1744, son of a shore master (his mother died a few days after the birth). The Cathcart family became his patrons and helped pay for him to study at the Foulis Academy in the College of Glasgow from 1755-62. Visited Naples and Rome (with good introductions), and was befriended by Lady Cathcart's brother, Sir William Hamilton. Influenced by the work of Batoni, but also produced portraits that border on the caricature for which he gained the name of the 'Scottish Hogarth'. Studied with Gavin Hamilton and absorbed the heroic tradition of history painting. Exhibited at RA (12), FS (4), SA (3) 1771-81. Worked in London 1777-80 and then settled in Edinburgh. Helped introduce into Scotland family conservation pieces and small portraits of cabinet size. Succeeded Alexander Runciman as Master of Trustees' Academy, Edinburgh 1786, a post he held until his death on 13 February 1796 or 6 August 1796 (Waterhouse or DNB). Among his pupils was H.W.Williams.
Represented: SNPG; NPG London; Glasgow AG; BM; Earl Cathcart Collection; Yale. **Engraved by** Cunego, P.Sandby. **Literature:** T.C.Gordon, *D.A. – The Scottish Hogarth*, 1951; *The Indefatigable Mr A.*, Scottish Arts Council exh. cat. 1973; McEwan.

ALLAN, J. McGregor b.c.1830
Exhibited portraits and enamels at RA (5) 1854-6 from London and Peckham.

ALLAN, Sir William RA PRSA 1782-1850
Born Edinburgh, son of a macer in the Court of Sessions. Educated at High School, Edinburgh before being apprenticed as a coach painter. Studied under Graham at Trustees' Academy with David Wilkie, Alexander Fraser and John Burnet. Entered RA Schools. Influenced by Opie and had success painting portraits of the Dutch Consul and others. Through introductions by Sir Alexander Crichton, then physician to the Imperial family, he proceeded to St Petersburg

WILLIAM ALLAN. Sir Alan Chambré. 55 x 43ins (139.7 x 109.2cm)
Christie's

JOSEPH ALLEN. The younger children of John and Anne Johnson of Arley with Brown George the school pony aged 40. Signed and inscribed. Exhibited 1808. 77 x 59ins (195.6 x 149.9cm)
Christie's

1805 and spent several years in the Ukraine, making excursions to Turkey, Tartary and elsewhere. Witnessed the horrors of the French invasion 1812. Returned to Edinburgh arriving 1814. Befriended by novelist Sir Walter Scott and under his influence produced a number of pictures of Scottish history. Among his sitters were J.M.W.Turner and Sir Walter Scott. Exhibited at RA (48), RHA (2), RSA (54), BI (2) 1803-50. Elected ARA 1825, RSA 1829, RA 1835, PRSA 1837-50, Knighted 1842, Limner to Her Majesty for Scotland 1841-50. Died in his studio in Edinburgh 22 or 23 February 1850.
Represented: SNPG; NPG London; VAM; Tate; BM; Huntington Library & AG. **Engraved by** J.Burnet, E.Burton, L.Dickinson, E.Goodall, J.Horburgh, W. & D. Lizars, H.Meyer. **Literature:** *Art Journal* 1849; Ottley; McEwan; DA.

ALLCOCK, S.A. fl.1821-1822
Exhibited at RA (2) 1821-2 from London.

ALLCOTT, Walter Herbert RBSA RSA 1880-1951
Born Birmingham 21 January 1880, son of Henry Allcott, engineer's draughtsman. Studied at Birmingham School of Art. Began as a portrait painter, but was obliged by illness to give up living in Birmingham and moved to the countryside, specialising as a landscape painter. Exhibited at RBSA, RI, RA (13) from 1898. Elected RSA 1921. Lived for a time at Chipping Campden before settling at Haslemere, where he died 13 January 1951.
Represented: Haslemere Museum.

ALLDRIDGE, R. Lincoln fl.1866-1877
Exhibited at RA (6), RHA (3), SBA (2) 1866-77 from Old Charlton, Kent and London. Painted a portrait of dealer Martin H.Colnaghi.

ALLEN, Andrew fl.c.1730
Believed to have been of Scottish origin. Practised with some repute in Edinburgh c.1730. A portrait of one of the Lords of Sessions is engraved as is also his self portrait.
Represented: SNPG.

ALLEN, Miss Annie C. fl.1881-1883
Exhibited at SBA (2) 1881-3 from London.

ALLEN, G. fl.1830
Honorary exhibitor at RA (1) 1830.

ALLEN, George fl.1712-1755
Thought to have been a pupil of Kneller. Member of St Martin's Lane Academy. Worked for Duke of Kent at Wrest Park. Published *Some Occasional Thoughts on Genius... Observations in the Art of Painting*, 1750.
Represented: Wrest Park, Bedfordshire.

ALLEN, Joseph 1769-1839
Born Birmingham 12 January 1769. After designing for japanned trays he entered RA Schools 23 November 1787 (gaining a Silver Medal 1789). Exhibited at RA (50), BI (2), LA 1792-1822 from London and Wrexham. Founder LA 1810. His clients were mainly successful industrialists and merchants in and around the Midlands. Retired to Erdington, near Birmingham in comfortable circumstances. Died there 19 November 1839. He was capable of communicating considerable character.
Represented: Manchester CAG; Walker AG, Liverpool.
Engraved by W.Bond, S.W.Reynolds, E.Scriven, W.Skelton, B.Smith, E.Smith, W.Ward, W.H.Worthington.

WILLIAM ALLISON OF SOUTHAMPTON. A family group. Signed and dated 1817. 40 x 50ins (101.6 x 127cm) *Christie's*

ALLEN, Miss Margaret HRHA fl.1853-1894
Exhibited at RHA (53) 1853-94 from Dublin and Manchester.

ALLEYNE, Francis fl.1774-1790
Itinerant portrait painter, visiting country houses mainly in the south-east of England. Most of his paintings are inscribed on the reverse. Exhibited at SA (1), FS (1), RA (1) 1774-90. Specialised in small, oval three-quarter lengths. These can be highly sensitive with considerable charm.
Represented: Mellon Collection; Marylebone Cricket Club.

ALLINGHAM, Charles fl.1802-1812
Exhibited at RA (15), BI (2) 1802-12 from London.
Represented: NGI. **Engraved by** T.O.Barlow, S.Freeman, J.Morrison, S.W.Reynolds, W.Ridley, J.Wedgewood.

ALLISON, John William RBA c.1866-1934
Born Hull. Studied at RCA and in Paris and Italy. Exhibited at RA (1), RI, SBA from 1908. Head of Putney and Penzance Schools of Art and Principal of Portsmouth Municipal School of Art. Retired to Yorkshire. Died Barmby on Moor 15 March 1934 aged 68.

ALLISON, William, of Southampton b.1794
Baptised 23 November 1794, son of William and Mary Allison. Worked as a portrait and miniature painter in High

Street, Southampton. Exhibited at RA (1) 1817. Among his sitters was the Duchess of Kent. His wife Mary was buried 1 November 1815. An affair with Sophia Cape produced an illegitimate son, William (baptised 11 December 1826, aged 8). Shared premises with John Allison, 'perfumer and elastic wig maker'.

ALLPORT, Curzona Frances Louise (Lily) 1860-1949
Born Hobart, daughter of Morton Allport. Studied in London under Hubert Vos. Exhibited at RA (11) 1891-1917, at Paris Salon and British Academy of Fine Arts, Rome.
Represented: Allport Library; Hobart Museum.

ALLPORT, John fl.1831-1850
Exhibited at SBA (4), BI (5) 1831-50 from London.

ALLSTON, Washington ARA 1779-1843
Born Waccamaw, South Carolina 5 November 1779. Spent his childhood in Rhode Island. Studied at Harvard. Visited England 1801 with miniaturist Malbone. Studied at RA Schools with Benjamin West. Exhibited at RA (9), BI (8) 1802-19. Travelled to France, working in Paris under John Vandelyn 1804, where he was influenced by neo-classicism, and then travelled to Italy for four years. Wrote on art, painted portraits and miniatures, historical, religious and allegorical subjects. Returned to America 1808/9, where he married in Boston a sister of Dr Channing. Visited England

LAWRENCE ALMA-TADEMA. Sientje Tadema 1860. 11 x 9ins
(28 x 22.9cm) *Christie's*

again 1811, accompanied by his pupil Samuel Morse. In
Bristol 1814 and remained in England until 1818 (the same
year he was elected ARA) when he returned to America.
During his latter years he suffered much from ill health. Died
Cambridge, Massachusetts 8/9 July 1843.
Represented: NPG London; Boston MFA; Yale; Amhurst
College, Massachusetts; Cleveland MA. **Engraved by**
S.Cousins. **Literature:** E.P.Richardson, *W.A.: A Study of the
Romantic Artist in America*, Chicago 1948; *Art Union* 1843
p.244; W.H.Gerdts & T.E.Stebbings jnr, *A Man of Genius –
The Art of W.A.*, 1979; DA.

ALLSWORTH, William **fl.1836-1863**
Exhibited at RA (10), BI (2) 1836-56 from London. Worked
in Camden Town 1863.

ALMA-TADEMA, Miss Anna **c.1865-1943**
Daughter of Sir Lawrence Alma-Tadema RA. Exhibited at RA
(15), RHA (1), NWS, GG, NWG 1885-1928. Had an
apartment in Paris. Died unmarried in London 5 July 1943
aged 78. Wood writes: 'Her pictures are painted with great
delicacy and poetry'.
Literature: W.Shaw Sparrow, *Women Painters of the World*,
1905.

ALMA-TADEMA, Lady Laura (née Epps) **1852-1909**
Daughter of Dr George Napoleon Epps and second wife of
Sir Lawrence Alma-Tadema. Exhibited at RA (24), RHA (2),
GG, NWG 1873-1909. In 1878 she was one of only two
women artists asked to contribute to the International
Exhibition in Paris. Won a gold medal in Berlin 1896 and a
silver medal at Paris Universal Exhibition 1900. Died
Hindhead 15 August 1909. Left £41,519.6s.10d. to her
husband. Buried Kensal Green Cemetery. Sir E.J.Poynter and
Sir Philip Burne-Jones attended her funeral. Gained a
reputation for portraits of children (often in Dutch 17th
century costume) and portraits in pastel.
Represented: NPG London. **Literature:** *Art Journal* 1883
pp.345-7.

ALMA-TADEMA, Sir Lawrence OM RA RP 1836-1912
Born Holland 8 January 1836, son of Pieter Tadema a notary.
Originally intended for medicine, before entering Antwerp
Academy 1852, where he was influenced by Louis de Taye,
Professor of Archaeology. Became pupil and assistant to Baron
Hendrik Leys 1860. Settled in London 1870. Exhibited at RA
(83), RSA (18), RHA (2), SBA (1), OWS, RP (11), GG,
NWG, RP 1869-1912. Elected ARA 1876, HRSA 1877, RA
1879, RP 1892. Knighted 1899, OM 1905. Art dealer Ernest
Gambart promoted him and contracted him to paint a certain
number of pictures each year. Painted mainly recreation scenes
of Greek and Roman subjects, but also occasionally portraits.
Among his sitters were E.A.Waterlow ARA and Alfred
Waterhouse RA. Awarded Royal Gold Medal by RIBA 1906
for his promotion of architecture in painting. His own house
in St. John's Wood was designed in the style of a Pompeian
villa. Died Kaiserhof Hotel, Wiesbaden, Germany 25 June
1912. Left £58,834. He numbered most of his works in
Roman numerals: Opus Number I was in 1852 and his last
work was opus CCCCVIII in 1912. Forgeries of his works do
exist and many are numbered CCCXXXVIII or CCCXXVIII.
Represented: NPG London; VAM; Brighton AG; Walters AG,
Baltimore; Tate; Philadelphia MA. **Engraved by** M.Cormack.
Literature: V.G.Swanson, *The Biography & Catalogue Raisonné
of the Paintings of Sir L.A-T.*, 1990; *Art Journal* 1875, 1883;
Strand Magazine Vol 18 No.108 December 1899; H.Zimmern,
L.A-T. RA – His Life and Work, 1886; P.C.Standing, *Sir L.A-T.*,
1905; R.Ash, *A-T.: An Illustrated Life of Sir L.A-T.*, 1973;
A.Goodchild, *Sir L.A-T. OM, RA*, 1976; DA.

ALMENT, Mary Martha **1834-1908**
Literature: Strickland

ALMOND **fl.1783**
Painted a number of small portraits and miniatures of servants
at Knole 1783. May be the William Almond who was a
painter-stainer of St Albans.

ALPENNY, Joseph (John) Samuel **1787-1858**
Studied in London. From 1805-8 is recorded as Joseph
Samuel Halfpenny, but then John Samuel Alpenny. Worked in
Ireland 1810 and was based in Dublin 1812-24, where he
was a prolific exhibitor. Exhibited at RA (17), SBA (4) 1805-
53 from Kew, Richmond and Clapham. Published *Alpenny's
New Drawing Book of Rustic Figures*, 1825. Died Clapham 12
August 1858, having survived his wife Sarah.
Represented: NGI.

ALSOP, George **fl.1722-1730**
Painted a portrait of 'William Hisland d.1732 aged 112'
1730 (Royal Hospital, Chelsea) and 'Richard Townsend,
High Sheriff of Staffordshire' 1722 (VAM).

ALSOP, J.J. **fl.1892-1916**
Exhibited at RA (2), SBA (5) 1892-1916 from London.

ALSOP, John **1789-1849**
Studied under George Sheffield snr. Painted portraits and
miniatures in Whitehaven. Painted altarpiece for New
Catholic Chapel at Warrington 1826.
Literature: Hall 1979.

ALSOP, William Culmer **fl.1775-1785**
Exhibited at the FS (9) 1775-80 from Wandsworth.
Favoured small full-lengths. He and his wife Elizabeth had at
least nine children (two sets of twins) of which eight survived.

ALSTON, Edward Constable **d.1939**
Exhibited at RA (5), SBA (1), ROI, NEAC 1886-1901 from
London.

CHARLES E. AMBROSE. An officer in the 12th (Prince of Wales) Royal Lancers. Signed and dated 1837. 36¼ x 28¼ins (92.1 x 71.8cm) *Christie's*

ALTSON, Aby (Abbey) b.1864
Born Middlesbrough, elder brother of Daniel Meyer Altson. Moved to Australia 1882. Studied at Melbourne NG School 1884-90 and Académie Colarossi, Paris 1890-3. Began as an illustrator before developing a successful portrait practice. Exhibited at RA (9) 1894-1917 from London. Through London dealers he painted Indian princes and travelled between India and London, before moving to America 1937.
Represented: NG Victoria; Melbourne Museum.

ALTSON, Daniel Meyer 1881-1965
Born Middlesbrough 10 May 1881, brother of Aby Altson. Studied at Melbourne NG School where he was awarded a scholarship at the age of 16. Studied at École des Beaux Arts and Académie Colarossi, Paris. Painted portraits in Florence and Europe from 1902, settling in London 1925. Exhibited at RA (5), Paris Salon and in the provinces. Lost his sight through a wound while serving as a gunnery inspector at Woolwich Arsenal during 2nd World War. Died London.
Represented: NG Victoria.

ALVES, James 1738-1808
Scottish portraitist in crayon and miniature. Awarded a gold medal by Edinburgh Society of Arts 1756, by which time he was 'abroad to improve his painting'. Stayed in Rome eight years and became a strong Roman Catholic. In Inverness 1773 and met Boswell and Johnson. Johnson recalls that he had previously met Alves in Rome 1765. Exhibited mainly small crayon portraits at RA (7) 1775-9. Also painted history subjects. Died Inverness 27 November 1808.
Literature: McEwan.

ALWOOD, John fl.18th century
Painted a charming oval portrait of a boy (private collection). Possibly the Allwood that exhibited at SA (12) 1776 from Chelsea.

AMBROS d.1550
Painted for the Queen of Navarre 1492-1549. Visited England briefly in 1532. May be Ambrosius Benson, portrait and religious painter of Lombard origin and Master at Bruges 1518, where he worked until his death.
Represented: HMQ.

AMBROSE, Charles E. fl.1824-1848
Exhibited at RA (30), BI (2), SBA (49) 1824-48. Worked in London and Birmingham. Painted a portrait of dramatist James Sheridan Knowles.
Engraved by J.W.Gear, E.Scriven, C.Turner.

AMERLING, Friedrich von 1803-1887
Born Vienna 14 April 1803. Studied at Vienna Academy and Prague Academy. Came to London and studied under Lawrence 1827 and Horace Vernet in Paris 1828. Also visited Rome. Died Vienna 15 January 1887. His work was much admired.
Represented: Berlin, Graz, Munich and Vienna. **Literature:** Thieme-Becker; G.Probszt, *F.v.A*, 1927.

AMERSLEY, John fl.1855
Listed as a portrait artist at 4 Darling Place, Bury New Road, Manchester.

AMES, Mrs fl.1785
Advertised in *Birmingham Gazette* 19 September 1785: 'Takes likenesses of any size 2s to 5s each. Likenesses painted on glass'.

AMICONI, Bernardo fl.1859-1876
Italian. Exhibited at RA (22), RHA (3), BI (2), SBA (3) 1859-76 from London. A gifted artist.

AMIGONI (AMICONI), Jacopo c.1675-1752
Born, possibly in Naples, of Venetian parents in 1675 or 1682 (conflicting sources). Travelled to Germany before working in England 1729-39 as a history and decorative painter (producing mythological subjects for Moor Park, Rickmansworth), theatrical scene-painter and portrait artist. His skill at portraiture attracted the patronage of Queen Caroline and other members of the Royal Family. Became one of the favourite painters of Frederick, Prince of Wales. Married in England 1738. Attempted with Joseph Wagner to run a print shop, but they both returned to Venice 1739. Amigoni became court painter in Spain from 1747. Died Madrid 21 or 22 August 1752.
Represented: Mellon Collection; Graves AG, Sheffield; NPG London; Tate; Hardwick Hall NT; Wrest Park, Bedfordshire; Lord Barnard Collection. **Engraved by** F.Aliamet, B.Baron, G.Bockman, Sysang, A.Vanhaecken, G.Vertue. **Literature:** A.Baird, *Burlington Magazine* CXV November 1973.

AMSCHEWITZ (AMSHEWITZ), John (Jacob) Henry RBA 1882-1942
Born Ramsgate 19 December 1882, son of A.Amschewitz (a learned rabbi and lecturer) and Sarah née Epstein. Studied at RA Schools 1902-7 under J.S.Sargent and S.J.Soloman. A friend of Frank Brangwyn, who influenced his work. Won a competition to do frescoes for Liverpool City Hall 1907. Exhibited at RA (16) 1905-33 and SBA, NEAC, RP. Elected RBA 1914. Worked in South Africa 1916-22, where he was based at Johannesburg and painted many portraits. Produced caricatures for the Johannesburg *Sunday Times* and *Rand Daily Mail*. Worked in England 1922-36, before returning to

South Africa. Died Muizenberg 6 December 1942. On 16 September 1943 Lord Harlech opened a large commemorative exhibition of his work in Johannesburg City Hall.
Represented: NPG London; VAM; Ferens AG, Hull; Brighton AG; South African NG, Cape Town; The Africana Museum, Johannesburg; Pretoria AG; Durban AG; Rhodes University. **Literature:** *Dictionary of South African Biography.*

AMYOT, Mrs Caroline Catherine (née Englehart)
 1845-1926
Born Denmark 6 February 1845, daughter of Herr Englehart, Chief de Bureau of the National Bank, Copenhagen. Exhibited at RA (9), SBA (2) 1879-90 from Diss, Norfolk and Earls Court, London. Married Thomas H.Amyot GP on 16 May 1878 in the chapel at the British Embassy, Paris. He died 1903 and she moved to Margate. Died Sèvres, France 1 January 1926.

ANDERSON, Charles **fl.1835**
Listed as a portrait painter at New Smenton, Nottinghamshire.

ANDERSON, Charles Goldsborough **1865-1936**
Born Tynemouth, Northumberland. Studied at RA Schools. Worked in London and Sussex. Exhibited at RA (18), SBA, ROI, GG, NWG 1888-1917. Painted a panel for the Royal Exchange 1910. Died Rustington 13 or 16 February 1936.
Represented: Balliol College, Oxford; Laing AG, Newcastle; Lord Scarsdale Collection.

ANDERSON, Edgar **fl.1884-1902**
Exhibited at RA (7), RHA (1) 1884-1902 from London.

ANDERSON, Miss Isobel C. **fl.1894**
Exhibited at RA (1) 1894 from Woodlands, Hadley Woods, Hertfordshire.

ANDERSON, James Bell RSA **1886-1938**
Born Edinburgh 14 July 1886, son of Charles Anderson, master plumber. Studied at Edinburgh School of Art, Hospitalfield and in Paris. Exhibited at RA (3) 1913-30 and RSA from Glasgow. Died Glasgow 19 November 1938.
Literature: McEwan.

ANDERSON, Percy **c.1851-1928**
Exhibited NWS 1886. Produced portraits of Joseph Conrad and Stephen Phillips.
Represented: NPG London; Brighton AG.

ANDERSON, Mrs Sophie (née Gengembre)
 1823-1912
Born Paris, daughter of Charles A.C.Gengembre, French architect and engineer. Studied under Steuben. After the outbreak of the 1848 Revolution she and her family left for America, settling in Cincinnati. There she established herself as a successful portrait artist and contributed illustrations to Henry Howe's Historical Collection of the Great West 1851. After moving to Manchester, near Pittsburgh she married English artist Walter Anderson (d.1903). Moved to England 1854. Exhibited at RA (28) BI (3), SBA (14), RHA (2), NA, GG 1855-96 from London and Bramley near Guildford. Moved to Capri because of ill health, but returned to England to live in Falmouth. Died London 30 August 1912 (not 1903). A highly sensitive painter whose best works are quite outstanding.
Represented: Forbes Magazine Collection, New York.

ANDERSON, T.Percy **b.1885**
Born York. Studied at York School of Art and at Fraser Art College, Arbroath. Had a successful practice in York, but after

serving in the 1st World War he settled in London and later Brighton. Contributed many portrait studies to illustrated magazines.

ANDERSON, Miss Winifred **fl.1905-1916**
Exhibited at RA (3) 1905-16 from Farnham and Golders Green.

ANDERTON, Henry **c.1630-1665**
Studied under Robert Streater, before going to Rome about the 1660s. Settled in London as a portrait painter, where he is said to have enjoyed court patronage through the support of Frances Stuart, Duchess of Richmond. Many of his unsigned works have been ascribed to Sir Peter Lely. Died 1665 according to Bénézit. Colour Plate 8

ANDRÉE, Miss **fl.1825-1833**
Honorary exhibitor at RA (8) 1825-33 from 47 Hatton Gardens, London.

ANDREWS, D.R. **fl.1820**
Exhibited at RA (1) 1820 from 10 Warwick Court, Gray's Inn, London. Painted miniatures and oil portraits.

ANDREWS, Mrs Doris G. **fl.1911-1925**
Exhibited at RA 1911-25 from Nottingham, Bournemouth and London.

SOPHIE ANDERSON. Toklihile. Signed. 40 x 26ins (101.6 x 66cm)
Christie's

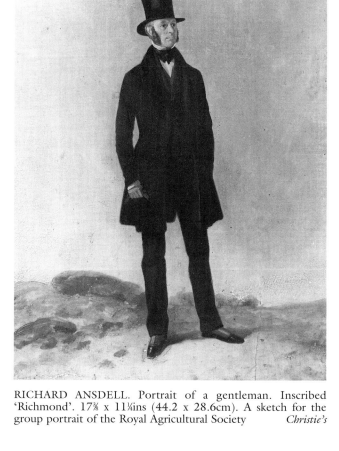

HEINRICH VON ANGELI. Two children. Signed and dated 1873. 73½ x 45⅝ins (186.7 x 116.2cm)
Christopher Wood Gallery, London

RICHARD ANSDELL. Portrait of a gentleman. Inscribed 'Richmond'. 17⅜ x 11¼ins (44.2 x 28.6cm). A sketch for the group portrait of the Royal Agricultural Society *Christie's*

ANDREWS, Edward William　　　　　**fl.1860-1897**
Exhibited at RA (5), BI (1), SBA (3), NWS 1860-97 from London. Among his sitters were John Ruskin and Cardinal Manning. Possibly the Edward William Andrews who died Middlesex 30 January 1915 aged 75.

ANDREWS, James　　　　　　　　**1798-1875**
Born London, son of Samuel Andrews, a clerk of the Bank of England. Practised as a portrait painter in London. Married Sarah Nind 1831, but she died six months later. Andrews moved to Chichester where he met with considerable success, painting many portraits, including those of the Duke of Richmond, Charles Crocker the poet, Dr Forbes and Dr McCarogher. *Hampshire Telegraph* 3 August 1840 reported: 'We learn with regret that J.Andrews Esq, the most talented artist that has been known in Chichester for some time intends shortly to terminate his visits to this city. His studio which has been a place of fashionable resort to hundreds will in a few weeks be closed.' Worked in Carlisle, but returned to Chichester 12 July 1842 to marry Eliza, daughter of banker William Stiles. Recorded in Newcastle 1846 and appears in the census for St Luke, Chelsea 1851, and was successful enough to afford two servants. Worked in Maidenhead 1871, where he died 13 May 1875 from 'ulceration of the intestines and chronic diarrhoea'. Exhibited at

RA, North of England Society for the Promotion of Fine Arts, Newcastle, Carlisle Athenaeum. Inextricably confused in exhibition catalogues with floral artist James Andrews (1801-1876) and is also listed as 'John Andrews'.
Represented: NPG London; Royal College of Physicians; Earl of Rosebery Collection. **Literature:** *Brighton Herald* 18 September 1840; Stewart & Cutten.

ANDREWS, Robert　　　　　　　**fl.1845-1853**
Listed as a portrait painter at 72 High Street, Colchester 1845 and in Weymouth 1852-3.

ANGELI, Baron Heinrich von　　　**1840-1925**
Born Sopron, Oedenburg, Austria 8 July 1840. Studied in Vienna and Düsseldorf. Worked in Munich 1859-62 and then travelled to Vienna. Abandoned history painting and became a European Court portrait painter. Exhibited at RA (6), GG (3) 1874-80. Painted portraits of Queen Victoria and Stanley the explorer.
Represented: HMQ; Wallace Collection; Berlin Museum.

ANGELIS (ANGELLES), Peter　　　**1685-1734**
Born Dunkirchen 5 November 1685. Worked in Antwerp, Düsseldorf and England.
Represented: NPG London; Tate. **Literature:** Thieme-Becker.

ANNING-BELL, Laura **1867-1950**
Born France, of English parents. Studied under Legros.
Exhibited in France 1902-40, winning medals.
Represented: NPG London.

ANSDELL, Richard RA **1815-1885**
Born Liverpool 11 May 1815, son of Thomas Griffith
Ansdell, a blockmaker. Educated at Bluecoat School and from
there to 'W.C.Smith profile and portrait painter, Chatham,
Kent'. May have worked in Holland and painted for a period
with a travelling show. Entered LA Schools in October 1835.
Exhibited at RA (149), BI (30), LA, RMI and in Paris 1835-
55. Elected ALA 1837, LA 1838, PLA 1845-6, ARA 1861,
RA 1870. Married Marie Romer of Liverpool 1841, by whom
he had 11 children. Painted the monumental group portrait
of 'A Country Meeting of Royal Agricultural Society of
England at Bristol' measuring 70 x 200ins. (now at Salford
AG) in 1843. Also painted large group portraits of 'The
Caledonian Coursing Club' and 'The Waterloo Cup Course
Meeting'. His portraits are of an extremely high standard
although he is known mostly for his animal and sporting
pictures which reflect the influence of Landseer. Collaborated
with John Phillip (with whom he visited Spain in 1856),
W.P.Frith and Thomas Creswick. Died Collinwood Tower,
Farnborough 20 April 1885. Left the considerable sum of
£49,568.8s.9d.
Represented: Preston AG; Tate; Walker AG, Liverpool.
Engraved by S.W.Reynolds jnr. **Literature:** *R.A.*, Richard
Green, London exh. cat.1985; DA.

ANSLEY, Mrs Mary Anne (née Gandon) **d.1840**
Exhibited at RA (22), BI (21) 1812-33 from Otto House,
North End. Married Colonel Ansley. Spent some time in
Italy. Died Naples.

ANSON, Miss Minnie Walters RMS **b.1875**
Born London 20 February 1875. Studied at Lambeth School
of Art. Exhibited at RA (10), RMS and in the provinces from
Parkstone, Dorset and signed her works 'Walters Anson'.

APPLEBY, Ernest W. **fl.1885-1907**
Exhibited at RA (15), SBA (11), RHA (2), GG 1886-1904
from London. Painted a portrait of Quintin Hogg.

APPLEYARD, Frederick RWA **1874-1963**
Born Middlesbrough 9 September 1874. Studied at
Scarborough School of Art under Albert Strange, RCA and
RA Schools. Exhibited at RA (41), Royal West of England
Academy 1900-35. Worked for a short time in South Africa.
Died Alresford, Hampshire 22 February 1963.
Represented: Tate; Laing AG, Newcastle. **Literature:** Hall
1982.

ARBRINGEN, J.H. **fl.1838**
Exhibited a portrait at RA (1) in 1838.

ARCEDECKNE, Robin **fl.1745**
Cornish portrait painter who painted in the style of Michael
Dahl. Signed with initials.

ARCHER, Archibald **fl.1810-1845**
Exhibited portraits (including HRH Princess Augusta) and
religious subjects at RA (16), BI (6), SBA (1) 1810-45 from
London.
Represented: BM. **Engraved by** S.Cousins, D.Lucas,
H.A.Ogg.

ARCHER, Miss Edith **fl.1901-1921**
Exhibited portraits and miniatures at RA (7) 1901-21 from
London and Eastbourne.

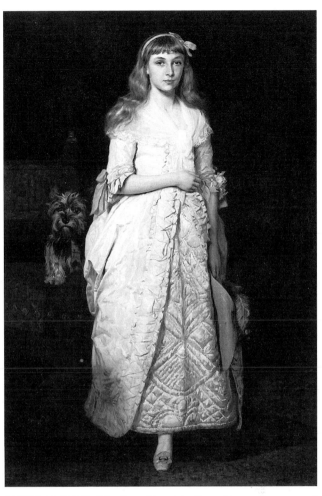

JAMES ARCHER. Miss Rose Fenwick. Signed in monogram and
dated 1877. 69 x 44¼ins (175.3 x 112.4cm)
Christopher Wood Gallery, London

ARCHER, James RSA **1822-1904**
Born Edinburgh 10 June 1822, son of Andrew Archer, a
dentist, and Ann (née Gregory). Trained at Trustees'
Academy under Sir William Allan and Thomas Duncan. His
early portraits were often in chalk, but later he concentrated
on oils. Also painted histories, genre and landscapes and was
influenced by the Pre-Raphaelites. From 1862 he was based
in Milford and London. Exhibited at RA (119), RSA (220),
RHA (2), BI (1), SBA (4) 1840-1904. Elected ARSA
1850/1, RSA 1858. Among his sitters were Henry Irving, Sir
William Quiller Orchardson, John Pettie, W.E.Lockhart and
Sir Edwin Arnold. Worked in America 1884 and India 1886,
returning to London 1889. Lived for a time at Haslemere,
Surrey. Died 3 September 1904. Helped popularize
children's portraits in period costume. Often signed with the
monogram JA, punningly transfixed by an arrow.
Represented: SNPG; RSA; Leeds CAG; Manchester CAG.
Engraved by J.Le Conte. **Literature:** *Art Journal* 1871
pp.97-9.

ARCHER, Jasper **fl.1779-1791**
Exhibited at SA (3), FS (11) 1779-91 from London.

ARCHER, Miss Janet **fl.1873-1916**
Studied at Herkomer's School in Bushey. Exhibited at RA
(10), SBA (10), NWS 1873-1916 from Croydon, Chelsea
and Watford.

ARMITAGE, Edward RA **1817-1896**
Born St Pancras, London 20 May 1817, son of James
Armitage of Leeds. Became favourite pupil and assistant of
Paul Delaroche in Paris from 1837. Won a £300 prize in
1845 in the Westminster Hall Competition and in 1847 his
'Battle of Meanee' won a £500 prize and was purchased by
the Queen. The success led him to be commissioned to paint
two frescoes in the upper waiting hall of the House of Lords.
Visited Rome. Exhibited at RA (83), RHA (5), Paris Salon
1842-93. Elected ARA 1867, RA 1872, Professor of RA
1875 (his lectures were published 1883). In the Crimea
during the war. Died from apoplexy caused by pneumonia at
Tunbridge Wells 24 May 1896. Buried at Brighton.
Represented: Leeds Town Hall; Walker AG, Liverpool; Tate;
Church of St John, Islington. **Literature:** Ottley; DNB;
J.P.Richter, *Pictures and Drawings Selected from the Work of
E.A., RA,* 1897; DA.

ARMOUR, George Denholm OBE **1864-1949**
Born Waterside, Lanarkshire 30 January 1864. Studied at St
Andrews, Edinburgh School of Art and RSA Schools. Settled
in London. Illustrated for *Punch, Tatler* and *The Graphic.*
Exhibited at RA (17), RSA (63) 1884-1928 from Edinburgh,
London and finally Wiltshire. Commanded the Remount
Depot in Salonica 1917-19. Awarded OBE 1919. Died 17
February 1949.
Represented: SNPG; Glasgow AG; VAM. **Literature:**
McEwan.

ARMSTRONG, Augustus **fl.1717-1743**
Portrait painter mentioned by Vertue (i.48). Produced a
crayon portrait of Sir Andrew Fountaine, Warden of the
Mint.
Engraved by W.C.Edwards, J.Faber.

HARRY ASHBY. John Walker, Professor of Elocution. Exhibited
1802. 50 x 40ins (127 x 101.6cm) *Phillips*

ARMSTRONG, Miss Caroline **fl.1885-1903**
Exhibited at RA (11) 1885-1903 from London.

ARNOLD, Mrs Annie (née Merrylees) **fl.1901-1934**
Exhibited portraits and miniatures at RA (22) 1901-34 from
London. Married artist Reginald Edward Arnold RBA.

ARNOLD, J.J. **fl.1799**
An honorary exhibitor of a portrait of Dr Ayrton at RA (1)
1799.

ARNOLD, John **fl.1698-1745**
Nephew of artist J. van der Vaart. Assisted his uncle for 30
years, until van der Vaart died 1727. His own sale took place
3-4 February 1745/6.

ARNOLD, Miss May **fl.1898-1911**
Exhibited at RA (13) 1898-1911 from London and
Horsham.

ARNOLD, Richard **fl.1788-1791**
Portrait and miniature painter. Exhibited at RA (1), SA (1)
1791 from London.

ARNOLD, Samuel James **fl.1800-1808**
Exhibited portraits (including those of Major Hamilton and
Dr Arnold) at RA (10) 1800-8 from London. Produced
panoramas.
Represented: NPG London. **Engraved by** B.Pym, W.Ridley,
W.P.Sherlock.

ARROWSMITH, Thomas **b.1772**
Born London 25 December 1772. Deaf and dumb. Attended
RA Schools from 1789. Practised as a portrait artist and
miniaturist in Liverpool and Manchester. Exhibited at RA
(16) 1792-1829 including portraits of Flaxman and the
Bishop of Hereford. The BM has an engraved self portrait.
Despite an undoubted sophistication, his portraits often
retain a provincial charm.
Represented: Walker AG, Liverpool; Royal Artillery
Institution, Woolwich.

ARTAUD, William **1763-1823**
Born London 24 March 1763 (baptized 12 April 1763), son
of Stephen Artaud, a jeweller and his wife Elizabeth. Awarded
silver palettes by SA 1775/6 and 1777. Attended RA Schools
from 1778 (gold medallist 1786). Won RA studentship 1795
and visited Rome, Naples, Florence and Dresden. Arrived
back in England October 1799 and gave evidence in the
Delatre v. Copley case in the King's Bench 2 July 1801. Made
regular itinerant portrait tours of the Midlands and joined an
artists' volunteer corps 1803. Exhibited portraits and
histories at RA (85) 1780-1822. Among his sitters was
F.Bartolozzi.
Represented: NPG London; BM; Leicester AG; Castle
Museum, Nottingham. **Engraved by** R.Dunkarton, W.Say,
P.W.Tomkins, C.Turner. **Literature:** A.C.Sewter, Ph.D
Manchester University 1952; *Gentleman's Magazine* August
1801 p.760.

ARTHUR, J. **fl.1816-1824**
Exhibited at RA (7) 1816-24 from London.

ARTHUR, Reginald **fl.1881-1896**
Exhibited at RA (9) 1881-96 from London.

ASHBY, Harry **1778-1847**
Baptized St Martin-in-the-Fields 26 April 1778, son of Harry
Ashby, an eminent engraver of bank notes, and his wife Sarah.
Exhibited at RA (69), BI (8) 1794-36. Worked in London

attracting a mostly middle class and clerical clientele, but by 1810 had moved to Surrey, first Lower Tooting, then Mitcham. Died Plymouth 13 June 1847 aged 69. His cause of death was listed as 'disease of the spinal cord with paralysis of lower limbs and bladder, many years'. Sometimes confused with H.Ashby 1744-1818. His son Harry Pollard Ashby was also an artist.
Represented: NPG London. **Engraved by** G.Clint, Holl, C.Turner, J.Young. **Literature:** *Country Life* 18 April 1991.

ASHBY, Robert **b.1774**
Baptized St Martin-in-the-Fields 9 October 1774, brother of Harry Ashby. Worked as a painter and engraver.

ASHFIELD, Edmund **d.c.1700**
Described as 'a sober person and suspected to be Roman Catholick'. A pioneer in England of portraits in pastel 1669-76, which he succeeded in bringing 'to ten punds price'. Thought to have been a pupil of John Michael Wright and the teacher of Edward Luttrell. Also painted in oils, and was a competent and sensitive artist.
Represented: Ashmolean; BM.

ASHLEY, Mrs **fl.1768-1772**
Exhibited at SA (1), FS (16) 1768-72 from Lincoln's Inn Fields.

ASHMORE, Miss Sibyl M. **fl.1912-1919**
Exhibited at RA (10), RHA (7) 1912-19 from Ross-on-Wye and London.

ASHTON, Matthew **fl.1718-1728**
Painted portraits of Archbishop Boulter and poet Ambrose Philips.
Engraved by P.Audinet, T.Cook.

ASSEN, Francis **fl.1779-1780**
Exhibited at FS (3) 1779-80 from King Street, Soho.

ASTLETT, G. **fl.1807**
Exhibited at RA (1) 1807 from 42 Margaret Street.

ASTLEY, John **1724-1787**
Baptized Wem, Shropshire 6 April 1724, son of Richard Astley, a surgeon and his wife Margaret. Studied under Thomas Hudson in the early 1740s at the same time as Reynolds. Travelled to Rome c.1747, where he knew Richard Wilson. The following year he visited Florence, where he was patronized by Sir Horace Mann. Returned to Rome 1750, where he studied with Mann's recommendation under Batoni for a brief period. Painted copies of old masters in Florence 1751, and was further patronized there by Mann, whose portrait he painted and who recommended him to Horace Walpole. Returned to England via Paris by 1752. Had a successful portrait practice first in London, and then in Dublin 1756-9. Married first a 'beautiful Irish girl'. Said to have earned £3000 in three years, and was able to command 20 guineas for a half-length portrait. Later married Lady Dukinfield-Daniell, a rich widow 7 December 1759. She died 1762 and left him a fortune and the Dukinfield property in Cheshire. He largely gave up painting after her death, but took on J.K.Sherwin as an apprentice to help decorate Schomberg House, which he purchased. Retired to his estate, Dukinfield Lodge, Cheshire 1777. Died there 14 November 1787. By the late 1750s his works showed much greater freedom of brushwork.
Represented: Ulster Museum, Belfast; Lewis Walpole Library, Farmington, Connecticut; Lyme Park. **Engraved by** J.Watson. **Literature:** M.Webster, *Connoisseur* CLXXII December 1969 pp.256-61; *European Magazine* December 1787 XII pp.467-8; Pasquin.

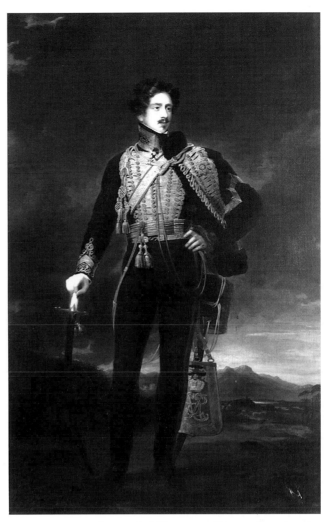

JAMES ATKINS. George, 3rd Marquess of Donegal wearing the uniform of 7th Hussars. Signed and dated 1824. 92 x 57¼ins (233.7 x 145.4cm) *Christie's*

ASTLEY, Mrs Rhoda **1725-1757**
Born London 1 July 1725, daughter of Francis Blake-Delaval. Married Edward Astley 1751. An amateur painter. Died near Bath 21 October 1757.
Engraved by McArdell.

ATKINS, James **1799-1833**
Born Belfast, son of James Atkins of Stranraer, Scotland. Assisted his father as an heraldic coach painter. Studied at Belfast Academical Institution 1814-18 and under Gaetano Fabbrini. Awarded a medal for oil painting 1818. Specialized in painting portraits and miniatures. Exhibited at Belfast Academical Institution. His work attracted the attention of the Marquess of Londonderry who, with others, sent him to Italy 1819 to copy the works of the old masters in Rome, Florence and Venice. Remained on the Continent for 13 years. Exhibited at RA (2) from Rome 1831-3. Went to Constantinople to paint a portrait of the Sultan 1832. On his way home, whilst undergoing quarantine in Malta, he contracted consumption and died there December 1833. Influenced by Lawrence.
Represented: Queen's University, Belfast.

ATKINSON, Charles **fl.1879-1881**
Exhibited portraits at GG 1879-81 from Datchet, near Windsor.

ATKINSON, Charles Gerard b.1879
Born 28 April 1879 at Seaford, Sussex. Studied at Liverpool under Walter Hilton. Exhibited at RBSA, RSW. Worked in Somerset and Westmorland.

ATKINSON, George fl.1825-1828
Listed as a 'miniature and portrait painter to His Majesty' in Brighton.
Represented: Brighton AG. **Engraved by** E.Scriven.

ATKINSON, James 1780-1852
Son of wool-comber, who began as a house painter. Recorded as taking 'strong likenesses' at Darlington in the late 18th century. Published a series of letters on art addressed to James Barry (2nd ed. Edinburgh 1800). Gave up to become a surgeon in India and was so successful that he was able to send his parents £200 a year for their lives.
Represented: NPG London; SNPG. **Literature:** Hall 1982.

ATKINSON, Miss Maud T. fl.1906-1937
Exhibited at RA (16) 1906-37 from London.

ATKINSON, Richard 1750-1776
Entered RA Schools 1769. Exhibited at RA (4), SA (1) 1772-6 from London.

ATWOOD, John fl.1760-1763
Listed in the directories 1760-3 as a history and portrait painter and a 'Teacher of Drawing in all its branches' at Bentinck Street in Berwick Street, Soho, London. Also an accomplished flower painter.

AUBREY, John 1626-1697
Studied under Jacob de Valke, and although he became an eminent antiquary he continued to paint the occasional portrait.

AUDINET, Philipp 1766-1837
Born London of a French family. Apprenticed to engraver John Hall. Exhibited watercolour portraits at SBA (6) 1826-8 from Bloomsbury. Among his sitters were W.H.Freemantle MP, Duke of Norfolk, Earl of Clarendon and Earl of Rochester. Died London 18 December 1837.

AUDLEY, Frederick George fl.1867
Listed as a portrait painter and engraver at High Street, Watford.

AUGUSTA, HRH Princess Sophia 1768-1840
Sixth child of George III, who painted a number of watercolour portraits, often with thin washes of colour.
Represented: BM. **Literature:** D.M.Stuart, *The Daughters of George III*, 1939.

AUSTIN, Mrs fl 1835-1886
Exhibited at RA (5), SBA (1) 1835-8 from Bristol and London.

AUSTIN (AUSTEN), Miss F. Roberts fl.1886
Exhibited at GG 1886 from London.

AUSTIN, William Frederick 1833-1899
Born Bedford. In business with his father in Oxford by 1866 under the name of 'J.Austin & Son'. Earned his living painting topographical drawings. Made many drawings of pubs in Oxford, Derby, Reading and Norwich, with which he paid the landlords' bills. Also made a number of pencil portraits. Died Reading.
Represented: Derby AG; King's Lynn AG; Reading AG; St Giles's Church Hall.

AVELING, H.J. fl.1839-1842
Exhibited at SBA (5) 1839-42 from Amville Street, Pentonville, London.

AYLING, Albert William RCA d.1905
Brought up in Guernsey, where he was a pupil of P.J Naftel. Worked as a drawing teacher. Exhibited at RA (18), SBA (40), RHA (6), NWS 1853-92. Lived in London and Chester, before moving to Liverpool c.1883 and Conway 1886. Died Deganwy, Caernarvonshire 13 January 1905.

AYLING, John fl.1823-1842
Exhibited at RA (31), BI (1), SBA (2) 1823-42 from London. Advertised in the directories as a portrait painter and had mainly a middle class practice.
Engraved by G.Stodart.

AYLMER, Francis fl.1855
Listed as a portrait painter at 5 Herbert Street, Strangeways, Manchester.

AYLMER, John fl.1845-1854
Exhibited miniatures and watercolour portraits at RHA (53) 1845-54 from Dublin.

B

BACCANI, Attilio Eetorepio b.1823
Born Italy. Settled in London, painting large scale society portraits in a continental style. Exhibited at RA (34), SBA (2) 1859-82 from London. Among his sitters were 'Signor Mario as Don Giovanni' and R.Westmacott RA. Portraits were recorded 1896. His daughter, Italia Baccani, was also a painter.
Represented: University of London; United Services & Royal Aero Club.

BACCANI, Miss Italia b.1866
Exhibited at GG (1) 1885 from London.

BACH, Edward fl.1873-1893
Exhibited at RA (13), SBA (16), RHA (44) 1873-93 from London. Also worked in Ireland.

BACH, Guido R. RI 1825-1905
Born Annaberg. Studied in Dresden. Settled in England 1862. Exhibited at RA (2), GG, RI 1880-3 from London. Elected ANWS 1865, NWS 1868. Travelled extensively, visiting Cairo 1876. Died London 10 September 1905.
Represented: BM.

BACK (BACH), William Henry b.1809
Baptized Camberwell 6 December 1809, son of William and Mary Back. Studied under Thomas Christopher Holland (in whose house Mather Brown lived and died). A beneficiary in Mather Brown's will. Exhibited landscapes at RA (24), SBA (7), BI (2), NWS 1829-59 from London.

BACKHOUSE, Mrs Margaret (née Holden) b.1818
Born Summerhill, near Birmingham, daughter of Rev H.Augustus Holden. Went to school in Calais. Studied art in Paris under Troivaux and Grenier. On her return to London she attended Sass's Academy. Also had advice from Mulready and engraver Goodall. Exhibited at RA (15), SBA (30), NWS 1846-82. Member of Society of Lady Artists. Some of her pictures were issued as chromolithographs by Rowney. Her daughter Mary was also an artist.
Literature: Clayton.

BACKLER, Joseph 1815-1897
Born England. Emigrated to Australia, where he painted the portraits of prominent citizens. Died Sydney.

BACON, C.J. fl.1828-1836
Exhibited watercolour portraits at RHA (5) 1828-36 from Dublin.

BACON, Henry-Lynch fl.1919-1921
Son of J.C.Bacon. Exhibited at RA (4) 1919-21 from London.

BACON, John Henry Frederick ARA RP c.1865-1914
Born London in 1868 (Thieme-Becker) or 1865 (*Who Was Who*). Studied at Westminster Art School. His best known work is 'The City of London Imperial Volunteers Return to London from South Africa on Monday 29 October 1900' (Guildhall, London). Painted 'Coronation of King George V and Queen Mary 1911' (Buckingham Palace). Exhibited at

RA (75) 1889-1914. Elected ARA 1903. Also an illustrator. Died London 24 January 1914. Studio sale held Christie's 27 April 1914. Sometimes signed works 'J.H.F.B.'.
Represented: Tate; BM; Walker AG, Liverpool.

BACON, Sir Nathaniel 1587-1627
Born August 1587 (Thieme-Becker says 1585), youngest son of Sir Nicholas Bacon. An accomplished amateur painter of portraits and dead game. His work shows a strong Dutch influence, and he may have studied there. Some of his pictures remained with his descendants at Gorhambury. A palette and brushes appear on his tomb.
Represented: NPG London. **Engraved by** T.Chambers, R.Cooper.

BAEN, Jacobus de 1673-c.1700
Born the Hague March 1673, son of Jan de Baen. In 1693 left for England, visiting France and Italy.
Represented: Amsterdam Museum.

BAEN, Jan de 1633-1702
Born Haarlem 20 February 1633. Influenced by his uncle Heinrich Piemann. Moved to Amsterdam c.1654, where he worked for three years with Jacob Backer. Visited England on invitation of Charles II and painted his portrait. Died 8 March 1702.
Represented: NPG London; Amsterdam Museum.
Literature: Bénézit.

BAGG, William b.1804
Born London, son of wood engraver Thomas Bagg. Exhibited at RA (8), BI (2) 1827-9 from Bloomsbury.

BAILEY, E. fl.1796
Exhibited at RA (1) 1796 from 18 Duke Street, St James's.

BAILEY, Mrs Ethel P. fl.1908-1927
Exhibited at RA (12) 1908-27 from London.

BAILEY, Thomas fl.1840
Listed as a portrait and miniature painter in Seller Street, Chester.

BAINES, Henry 1823-1894
Born King's Lynn. Studied under William Etty, Sir Edwin Landseer and RA Schools. Exhibited at BI (1) 1851 from 69 Upper Seymour Street. Died King's Lynn 7 January 1894.
Represented: King's Lynn Museum & AG.

BAINES, Thomas jnr fl.1914-1933
Exhibited at RA (4) 1914-33 from Putney and Leatherhead.

BAIRD, Nathaniel Hughes John ROI
 1865-after 1935
Born Yetholm, Roxburghshire. Studied art at Edinburgh, London and France. Exhibited at RA (32), SBA, ROI 1883-1935 from Dawlish, Exeter, Henley and near Lewes. Elected ROI 1897.

BAIRD, Miss Nina d.1909
Exhibited at RA (5) 1906-9 from Urie, Stonehaven.

BAKE, Willem Archibald c.1821-1845
Born Holland. Studied under J.J.Eeckhout and Pieneman. Showed considerable promise, but died prematurely at Aricia 24 January 1845.

BAKER, Mrs fl.1677
Welbeck Archives 15 September 1677 recorded payment of £6.15s. to Mrs Baker for a portrait of 2nd Duke of Newcastle.

BAKER, Alfred Rawlings b.1865
Born Southampton November 1865. Studied there at Hartley School of Art, and later at Académie Julian, Paris. Exhibited at RA (12), SBA, RHA (15), RI 1885-1931 from Southampton and Belfast.

BAKER, Miss Alice E.J. fl.1876-1882
Exhibited at RA (3) 1876-82 from London.

BAKER, Francis (Mrs Kennedy Cahill) fl.1904-1917
Exhibited at RHA (14) 1904-17 from Sligo, Ballysodare and Dublin.

BAKER, George A. NA 1821-1880
Born New York. Studied at NA. Travelled in Europe 1844-6. Elected NA 1851. Died 2 April 1880. Specialized in portraits of women and children.

BAKER, Miss Gladys Marguerite b.1889
Born Bloomsbury 14 October 1889. Studied at St John's Wood and RA Schools. Exhibited at RA (9), RI, NPS and abroad 1916-47 from London.

BAKER, Miss Julia fl.1910
Exhibited at RA (1) 1910 from Fulham.

BAKER, Miss L. Barrington fl.1914
Exhibited at RA (1) 1914 from Kensington.

BAKER, William M. fl.1825-1849
Exhibited at RA (9), BI (10), SBA (29), RBSA 1826-43 from London and East Bridgford, Nottinghamshire. Listed as a portrait painter at Hollowstone, Nottingham 1848.

BAKKER (BACKER, BAKER, BECKER), John James fl.c.1685-c.1725
Accompanied Kneller to Brussels 1697 and painted draperies and copies for him until 1727. Two copies of Kneller portraits of

William III and Mary were formerly at Melville House and were signed 'J.J.Bakker'. Also worked with Sir James Thornhill, and painted portraits on his own. Believed to have died in London.
Engraved by J.Lutma, J.Simon.

BALACA, José 1810-1869
Born Cartagena. Studied at School of Painting, Madrid from 1836. Established himself in Lisbon 1844 as a portraitist and miniaturist, before working in England and France. Settled in Madrid and exhibited there from 1852. His sitters included the Queen of Portugal. Died Madrid 19 November 1869.

BALDREY, Harry fl.1887-1890
Exhibited at RA (6), NWS, GG 1887-90 from London. Among his sitters were Hon. Henry Bridgeman, son of Lord Newport and 9th Earl of Scarborough.
Represented: Weston Park.

BALDREY, John (i) fl.1775-c.1809
Crayon portraitist in Norwich. Father of John Baldrey ii, with whom he formed a firm of print publishers at Cambridge (J. & J. Baldrey) from c.1799-1809.

BALDREY, John Kirby (ii) 1754-1823
Baptized Norwich 5 June 1754, son of John Baldrey i and Ann. Entered RA Schools as an engraver 1781, and with his father began a firm of print publishers c.1799-1809. Exhibited at RA (3) 1793-4 from Holborn. Worked in Cambridge 1807. Worked mostly as an engraver, before retiring to Hatfield 1821, where he died.
Represented: VAM.

BALDRY, Alfred Lys 1858-1939
Born Torquay. Educated at Oxford University. Studied at RCA and for four years under Albert Moore in his studio. Exhibited at SBA, PS. Married Annie Lilian Brocklehurst 1887. Art critic for the *Globe* and the *Birmingham Daily Post*, as well as a writer of works on Albert Moore, John Everett Millais, Hubert von

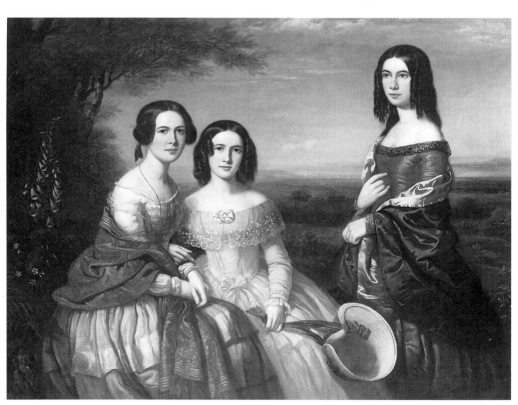

WILLIAM M. BAKER.
Three ladies.
Signed and dated 1849.
52 x 69ins
(132.1 x 175.3cm)
Christie's

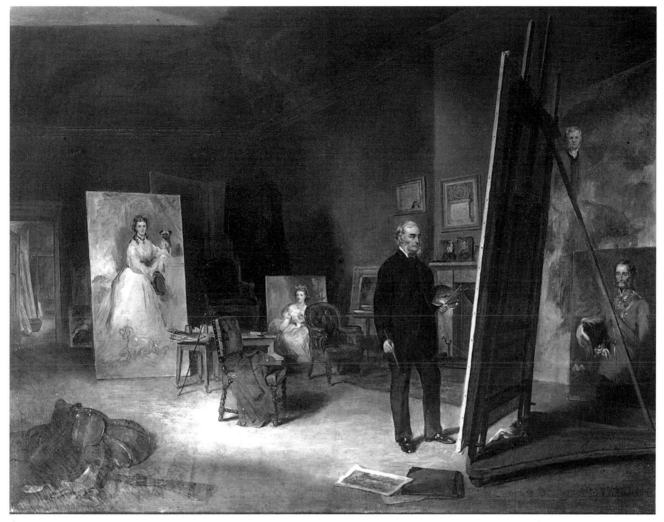

JOHN BALLANTYNE. Sir Francis Grant PRA in his studio. Signed and dated 1866. 28 x 36¼ins (71.1 x 92.1cm) *Christie's*

Herkomer, Marcus Stone, and George Henry Boughton. Lived at Marlow, Buckinghamshire. Died there 18 May 1939. **Represented:** NPG London. **Literature:** Who's Who 1908.

BALDWIN, Benjamin **fl.1826-1847**
Exhibited portraits at RA (3) 1841-5 from London. Painted a portrait of the Duke of Brunswick.
Represented: NPG London.

BALFOUR, Maxwell **fl.1905**
Exhibited at RA (2) 1905 from 118 Cheyne Walk, Chelsea.

BALL, G. Meyer **fl.1899**
Exhibited at RA (1) 1899 from 12 Park Street, Windsor.

BALL, Mrs Louisa Frances (née Noel) **d.1863**
Daughter of artist Amelia Noel. Married John Ball c.1807, a Dublin silk manufacturer, who died 24 July 1810. In that year she was giving lessons to ladies on drawing on velvet, painting on glass and 'every style of painting in oil, water-colours, crayons etc', and stated that she was patronized by the King, the Princesses and the Duchess of Rutland (*Freeman's Journal* January 1810). Exhibited in Dublin 1809-11 and lived in London with her mother for a time. Married Michael Furnell of Cahirelly Castle, Co. Limerick 1 September 1820. Died 23 February 1863.

BALL, Miss Maude **fl.1910-1935**
Exhibited at RHA (54) 1910-35 from 28 Waterloo Road, Dublin.

BALLANTYNE, Miss Edith **fl.1866-1887**
Exhibited at RA (11), SBA (2), RSA 1866-84 from Totteridge, London and Melksham, Wiltshire.

BALLANTYNE, Jean (Mrs Lowis) **fl.1906-1910**
Exhibited portraits and miniatures at RA (3) 1906-10 from London. Married Arthur Lowis.

BALLANTYNE, John RSA **1815-1897**
Born Kelso. Studied at Edinburgh under Sir William Allan. Also studied in London, Paris and Rome. Taught at Trustees' Academy. Moved to London 1832 and is best remembered for a series of portraits of artists in their studios, engraved by H.Graves & Co. They include J.Noel Paton, Daniel Maclise, Edwin Landseer, Clarkson Stanfield, Thomas Faed, W.P.Frith, Francis Grant, Holman Hunt, John Phillip and David Roberts. Exhibited at RA (49), SBA (5), RHA (7), RSA (166) 1831-87. Elected ARSA 1841, RSA 1860. Collaborated with Heywood Hardy. Died Melksham, Wiltshire 12 May 1897.
Represented: NPG London; SNPG. **Engraved by** J.Thomson. **Literature:** E.Quayle, *Ballantyne the Brave*, 1967; McEwan; Christie's 11 June 1993, pp.140-1.

BALLARD, James d.1792
Studied at Dublin Society's School, winning prizes 1753, 1754 and 1756. Exhibited portraits and miniatures in Dublin 1766-77. A drawing teacher of some repute.
Represented: National Museum, Dublin.

BALMFORD, Hurst b.1871
Born Huddersfield 8 June 1871. Studied at Leicester College of Art, RCA and Académie Julian, Paris. Became Principal of Morecambe School of Art. Later lived in Blackpool, but kept a studio in St. Ives. Exhibited at RA (8) 1917-38.

BALY, Miss Gladys M. fl.1903
Exhibited at RA (1) 1903 from 6 Queen's Mansions, Brook Green, London.

BAMBOROUGH, James fl.1878
Listed as a portrait painter at 15 Leven Terrace, Edinburgh.

BAMBOROUGH, William 1792-1860
Born Durham. Went to America 1819, settling in Columbus, Ohio. A friend of J.J.Audubon with whom he travelled 1824-32. Reported to be in Shippenport 1830, Louisville 1832, Ohio 1844 and Columbus 1850.

BAMBRIDGE, Arthur L. fl.1891-1893
Exhibited portraits, including those of 'HRH Princess Ferdinand of Roumania' (Princess Marie of Edinburgh) and 'HRH The Duke of Edinburgh', at RA (4) 1891-3 from London.

BANNER, Delmar Harmwood 1896-1983
Born Freiburg-im-Breisau 28 January 1896. Educated Cheltenham and Oxford. Studied at Regent's Street Polytechnic School of Art. Exhibited at RA (9), RI, RP 1925-64. Moved to Little Langdale, near Ambleside with his sculptor wife, Josephine de Vasconcellos. Died there 8 November 1983. Left £70,861. Among his best known portraits are 'Beatrix Potter' and 'Sir Charles Wheeler PRA'.
Represented: NPG London; VAM; Fitzwilliam; Ashmolean; Aberdeen AG; Nottingham AG.

BANNER, Hugh Harmood b.1865
Born Glasgow 14 October 1865, son of an art teacher. Studied at Glasgow School of Art and City of London School. Exhibited at RP, GI. Worked in Glasgow, Maxwelltown, Dumfries and Carlisle.

BARBER, Charles W. fl.1908-1914
Exhibited at RA (5) 1908-14 from Stoke Newington.

BARBER, Christopher 1736-1810
Member of SA. Exhibited at SA (3), FS (9), RA (20) 1763-1808 from London. His portraits were celebrated for their brilliancy, due to the special attention he devoted to the preparation of magilp. Died Marylebone 8 March 1810.

BARBER, D. fl.1828-1837
Exhibited at RA (4), SBA (8) 1828-37 from London, Brighton and Paris.

BARBER, Reginald fl.1885-1893
Exhibited at RA (10), SBA (1), RHA (1), NWS and in Paris 1885-93 from Fallowfield, Manchester.

BARBER, Rupert fl.1736-1772
Born Dublin, son of Jonathan Barber, a woollen draper and his wife Mary, a poetess. Studied in Bath c.1736 and returned to Dublin by 1743 painting portraits, miniatures and enamels. Worked in London 1748 and Bath 1752. Married Miss Wilson 'a pretty and prudent woman' in March 1742 and had a daughter and a son. Awarded a premium by Dublin Society 1753 for making phials and green glass. Became involved in a distillery investment by which he incurred heavy debt. Recorded in Dublin 1772.

BARBER, Thomas, of Nottingham snr c.1771-1843
Born 28 March 1771 (1768 Bénézit). Had a wide practice in the Midlands and North of England, where most of his pictures remain. Exhibited portraits, including that of Mrs Siddons, at RA (12), RHA (1) 1810-29 from Nottingham and Derby. Died Parkside, Nottingham.
Represented: Hardwick Hall, NT; Birdsall; Lord Middleton and Earl of Lichfield collections. **Engraved by** S.Freeman, W.T.Fry, M.Gauci, T.Gaugain, T.Hodgetts, S.F.Ravenet, S.W.Reynolds, W.Say, C.Turner, C.E.Wagstaff, B.Wilson, J.Young.

BARBER, Thomas, of Nottingham jnr 1798-1826
Son and pupil of Thomas Barber snr. Showed great promise, but died young.
Represented: Nottingham AG.

BARBIER, G.P. fl.1792-1795
French portrait, miniature and genre painter. Exhibited at RA (22) 1792-5 from London.
Engraved by Orme.

BARBOR, H. c.1780-c.1840
Exhibited at RA (1) 1815 from Nottingham.

BARBOR (BARBER), Lucius d.1767
Reportedly born Sweden. Settled in London. Exhibited at SA 1763-6. Painted portraits, miniatures and enamels. Died Haymarket 31 October 1767, leaving his widow in distressed circumstances.
Represented: NGI. **Literature:** *Lloyd's Evening Post* 2 November 1767.

BARCLAY, John Maclaren RSA 1811-1886
Born Perth. Worked there and in Edinburgh. Painted large scale full-lengths and group portraits. Exhibited at RSA (169), RA (13), SBA (2) 1835-86. Elected ARSA 1863, RSA 1871, Treasurer 1884-6. Died 11 December 1886. His pictures were usually highly finished and he occasionally used free impasto handling with the paint applied thickly. Also listed as 'James'.
Represented: Perth AG; SNPG; SNG. **Engraved by** E.Burton. **Literature:** McEwan.

BARDWELL, Thomas 1704-1767
Born East Anglia. Recorded as a decorative painter 1728, shortly before settling in Bungay, running a decorative painting firm, which his brother Robert took over 1738. From c.1729 he began painting overmantels and views of country houses. A few conversation pieces date from 1736-40 and large scale portraits from c.1741. Visited London in the 1740s and 1750s. Visited Yorkshire and Scotland painting portraits 1752/3. Wrote *The Practice of Painting and Perspective Made Easy*, 1756, which he dedicated to Lord Rochfield, a Suffolk peer whose portrait he painted. Settled in Norwich, from 1759, where he enjoyed a successful practice. Died Norwich 9 September 1767 (not c.1780). His best work has much charm.
Represented: Beaulieu; NPG London; SNPG; Castle Museum, Norwich; Ashmolean; Russell Cotes Museum, Bournemouth. **Engraved by** P.Audinet, W.C.Edwards, J.Faber jnr, P.S.Lamborn, Parr. **Literature:** Talley, Walpole Society, XLVI 1978, pp.91-163.

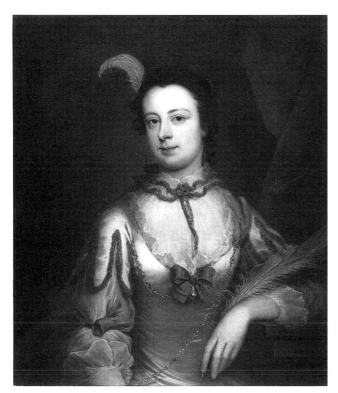

THOMAS BARDWELL. Lady Harriet Vernon. Signed and dated 1751. 30 x 25ins (76.2 x 63.5cm) *Christie's*

THOMAS BARKER OF BATH. Priscilla Jones. 30 x 25ins (76.2 x 63.5cm) *Holburne Museum & Crafts Study Centre, Bath*

BARKER, Miss A.E. fl.1858-1870
Honorary exhibitor at RA (2), SBA (1) 1858-70 from Brighton.

BARKER, Miss Adeline Margery fl.1917-1937
Studied at Blackheath Art School, Goldsmiths and under Byam Shaw and W.T.Wood. Exhibited at RA (12), RI, RP, Paris Salon 1917-37 from London.
Represented: Brighton AG.

BARKER, B. fl.1841
Exhibited at RA (2) 1841 from London.

BARKER, Benjamin, of Bath 1776-1838
Brother of Thomas Barker of Bath. Painted mainly landscapes, but also some portraits. Exhibited at RA (18), BI (144), RHA (6), SBA (40) 1800-38 from Bath. Left Bath 1833 to live with his daughter in Totnes, where he died. Among his pupils was H.V.Lansdown.
Represented: VAM; Victoria AG, Bath; Grosvenor Museum, Chester; Leeds CAG; Newport AG. **Literature:** P.Bishop & V.Burnell, *The Barkers of Bath*, Victoria AG, Bath exh. cat. 1986.

BARKER, Charles fl.1629-1633
Portraitist employed by Lord William Howard at Naworth Castle 1629-33.

BARKER, J.S. fl.1841-1858
Exhibited at RA (4) 1841-58 from 27 Cadogan Place, London.

BARKER, Miss Lucette E. fl.1853-1874
Probably daughter of J.S.Barker. Exhibited at RA (4), BI (1) 1853-60 from London. Also lived in Thirsk. Painted a portrait of Ellen, daughter of R.Westmacott RA.

BARKER, Marion fl.1889
Exhibited at RA (1) 1889 from Manchester. Often signed in monogram.

BARKER, Robert 1739-1806
Born Kells, County Meath. Practised unsuccessfully in Dublin. Set himself up in Edinburgh as a portrait and miniature painter. Invented a mechanical system of perspective, which he taught. Produced a panoramic view of Edinburgh 1787, which was exhibited in London the following year. Encouraged with this success he painted panoramas and built a theatre for them in Leicester Place, London. Died Lambeth 8 April 1806.
Literature: McEwan.

BARKER, Thomas, of Bath 1767-1847
Baptized at Trosnant 1767 (not 1769), son of artist Benjamin Barker I and his wife Anne. Settled with the family in Bath c.1782 and his precocious talent was recognised by a wealthy Bath coach builder and property developer, Charles Spackman. He paid Benjamin a small allowance for the loss of his son's earnings in exchange for the rights to his work. He trained the boy by getting him to copy old masters and enhanced his precociousness by bringing his birth date forward two years to 1769. After holding an exhibition of his work in 1790, paid for him to visit Italy c.1790-3. Also greatly influenced by Gainsborough. Exhibited at RA (18), BI (97), SBA (1) 1791-1847. Held a one man show in London 1797. Through his art he amassed a considerable fortune and built a large house at Sion Hill, Bath, where he painted a 30 x 12ft. fresco. Died Bath 11 December 1847 aged 79. His quality is variable, but his best work is of a high standard. Extremely popular in his day, and his art was extensively reproduced as prints, pottery and linens. This led to much imitation, to the detriment of his reputation. Produced comparatively few portraits, but they are usually

painted with freshness and vitality and are full of character. His brother, B.Barker (1776-1838) and son, T.J.Barker were also painters.
Represented: Tate; Yale; Bristol AG; National Museum of Wales; Southampton CAG; NGI; VAM; Leeds CAG; Ulster Museum; Victoria AG, Bath; Holburne Museum, Bath. **Engraved by** W.N.Gardiner. **Literature:** M.Holbrook, *Apollo* XCVII, November 1973; P.Bishop & V.Burnell, *The Barkers of Bath*, Victoria AG, Bath exh. cat. 1986; DA.

BARKER, Thomas Jones c.1813-1882
Born Bath 1813 (Bishop & Burnell) or 1815 (DNB), eldest son of Thomas Barker of Bath. Studied under Horace Vernet in Paris 1834. Exhibited at Paris Salon, RA (29), BI (34), RHA (6), SBA (15) 1835-76. His work was greatly appreciated by the French. Received the Cross of the Legion of Honour from Louis-Philippe, a large Gold Medal of Musée Royal and about 24 silver and other medals from different provincial towns in France. Returned to England 1845 and established a successful portrait practice, including Disraeli among his sitters. Died Haverstock Hill, London 27 March 1882.
Represented: NPG London; SNPG; NGI; Leeds CAG; Victoria AG, Bath; Southampton CAG; Duke of Wellington Collection. **Engraved by** F.Bacon, C.G.Lewis, W.H.Simmons. **Literature:** P.Bishop & V.Burnell, *The Barkers of Bath*, Victoria AG, Bath exh. cat. 1986; DA.

BARKER, W. Bligh fl.1833-1850
Exhibited at RA (6), BI (3), SBA (10) 1833-50 from London. His wife was also an artist.

BARLOW, Miss fl.1852-1855
Exhibited at RA (1), BI (2) 1852-5 from Clapton.

BARNARD, Anthony 1514-1619
Son of Lambert Barnard. Assisted his father in work commissioned by Bishop Sherbourne and the Dean and Chapter of Chichester Cathedral. Probably painted the portrait of James I in the series of 'Kings' situated in the south transept of Chichester Cathedral. Lived in Chichester in the parish of All Saints, where the birth of his son Lambert Barnard II and six daughters are registered. Buried December 1619 aged 105.

BARNARD, Lambert d.1567/8
Father of Anthony Barnard. Head of a remarkable school of early English Renaissance painting in Chichester encouraged by the munificence of Bishop Robert Sherbourne, who spent large sums of money beautifying the cathedral. Most of Barnard's paintings during Sherbourne's reign were probably paid for out of the privy purse, for no record of them exists in the Chapter Accounts. From 1558-63 Barnard was occupying a tenement with a garden on the south side of East Street, Chichester. Barnard's surviving works include the painted vaults of Chichester Cathedral and two large painted panels in the cathedral. Painted the panelled ceiling of the hall in the Bishop's Palace, as well as the decorated portrait panels of the Queen's Room at Amberley Castle (now at Pallant House Gallery). His work shows a strong influence from The Netherlands. His technique, however, was very English. An analysis of his pigments carried out by NG London showed that at a time when oil was generally used throughout Europe, Barnard preferred the traditional English medium of distemper, not only on plaster but also on panel. His will dated 11 December 1567 left goods to his children and half his tools to his understudy John Foster.
Literature: Stewart & Cutten.

BARNARD, Philip Augustus b.1813
Born Portsea. Exhibited at RA (16) 1840-84 from London and Southampton. Married miniaturist Hebe Saunders.

BARNARD, Thomas fl.c.1730-1780
Established a practice in Bury St. Edmunds. Painted the Bacon family.

BARNE, George Hume b.1882
Born Bristol. Studied in Paris. Exhibited portraits and other subjects in London and Paris. Author of *The Three Orders of Perspective*, 1924.

BARNES, Archibald George RI ROI RP b.1887
Born Sandon 19 March 1887. Studied at St John's Wood and RA Schools. Exhibited at RA (20), ROI, RP 1913-34. Elected RP 1923, RI 1924, ROI 1925.

BARNES, Miss Isabella d.c.1955
Born Knightsbridge. Studied at Lambeth School of Art and RCA. Exhibited at RA (3), SBA (1) 1890-1942 from London.

BARR, Allan 1890-1959
Born London 10 January 1890. Studied at London School of Art. Settled in Canada after serving in 1st World War. Died Toronto 14 August 1959.
Represented: NG Ottawa.

BARRABLE, George Hamilton fl.1873-1887
Exhibited at RA (13), RHA (1), SBA (16) 1873-87 from London.

BARRACLOUGH, James P. d.1942
Exhibited at RA (12), ROI 1915-40 from London.

BARRALET, John James c.1747-1815
Of French descent. Studied at Dublin Society Schools under James Mannin. Visited London 1770, where he set up a drawing academy. Returned to Dublin 1779. Became a temporary master at Dublin Society Schools. Moved to America 1795. Died Philadelphia. Most of his work was for engravers of topographical scenes, but he was capable of accomplished portraits.
Literature: Strickland.

BARRATT, Thomas E. b.c.1814
Born England. Moved to America after 1833 and settled in Philadelphia painting portraits and miniatures. Remained based at Philadelphia until at least 1854. Exhibited at Artists' Fund Society and Pennsylvania Academy 1837-48.

BARRAUD, Francis d.1924
Son of artist Henry Barraud. Studied at RA Schools, Heatherley's and in Antwerp. Exhibited at RA (12), SBA (15), NWS 1878-1918. Died 29 August 1924.
Represented: Marylebone Cricket Club, London.

BARRAUD, Henry 1811-1874
Eldest son of William Francis Barraud, Prime Clerk in the London Customs House. Probably studied under J.G.Middleton. Collaborated and lived with his brother William. Exhibited at RA (17 on his own and 15 with William), BI (29 on his own and 19 with William), RHA (1), SBA (13 on own and 4 with William) 1833-68 from London. Mainly a sporting painter and photographer. A few portraits are known, and they are normally highly finished and detailed. Married Anne Maria Rose 1842 and had nine children. Became a Roman Catholic c.1858. Died London 17 June 1874. Studio sale held 1875.
Represented: National Army Museum; Royal College of Surgeons. **Engraved by** W.Backshell, W.T.Davey, J.H.Engleheart, W.Giller, E.Hacker, C.C.Hollyer, T.Sanger, W.H.Simmons. **Literature:** C.Lane & P.Burnard, *British*

Sporting Art Trust, Essay 18 Autumn 1987; Mrs E.M.Barraud, *Barraud – The Story of a Family,* 1967; F.Gordon Roe, 'The Brothers Barraud', *British Racehorse* September 1965; E.M.Barraud, 'Artists of the Barraud Family', *Country Life* 21 October 1965; Philip H.F.Barraud's private notes 1987. Colour Plate 9

BARRAUD, William **1810-1850**
Born March 1810, son of William Francis Barraud. Began his career in the London Customs House, but then studied under Abraham Cooper. Lived and collaborated with his brother Henry. Exhibited at RA (44 on his own and 15 with Henry), BI (17 on his own and 19 with Henry), SBA (33 on own and 4 with Henry) 1829-50 from London. Married Mary Ratcliff 1842 (she died 1844). Published *Book of Animals Drawn from Nature* 1846 and posthumously with Henry *Sketches of Figures and Animals.* Died of typhoid 1 October 1850 in his fortieth year.
Represented: VAM, NPG London. **Engraved by** H.Beckworth, H.R.Cook, W.T.Davey, Duncan, J.H.Engleheart, T.Fairland, W.Giller, E.Hacker, T.Lupton, G.Paterson, J.Scott, J.Webb. **Literature:** see under Barraud, Henry.

BARRETT, Jeremiah **d.1770**
Son of a Dublin silversmith (his father died Dublin 1723). Worked in the west of Ireland in a manner reminiscent of Highmore. Died Dublin November 1770.
Represented: NGI. **Engraved by:** A.Miller, J.Watson.

BARRETT, Jerry (Jeremiah) **1814-1906**
Exhibited at RA (17), BI (1), SBA (20) 1851-85 from Brighton, London and Rome. Titles at RA include 'Meeting of Queen Victoria with the Royal Family of Orleans', 'Mrs Fothersgill' and 'Lady Mary Wortley Montague in Turkey'. His most famous works, which became extremely popular through engravings, were 'Florence Nightingale Receiving the Wounded at Scutari in 1856' and 'Queen Victoria Visiting the Military Hospital at Chatham'. Married Marianne Foster. Died Harrow 21 January 1906 aged 82.
Represented: NPG London; Brighton AG; Walker AG, Liverpool. **Engraved by** J.Watson.

BARRETT, Mrs Marianne (née Foster) **fl.1872**
Exhibited at RA (1) 1872 from Rome and c/o Mrs Foster, 149 The Grove, Camberwell. Married the artist Jerry Barrett.

BARRIBAL, William H. **fl.1917-1919**
Exhibited at RA (2) 1917-19 from London.

BARRON, Hugh FSA **c.1745/7-1791**
Born London. Began as a musical prodigy showing an early talent for the violin. Chose portraiture for a career, despite being considered the best amateur violinist of his time. Apprenticed to Reynolds about 1764-6. Exhibited at SA (22), RA (4) 1766-86. Elected FSA 1771. Visited Lisbon 1770/1 on his way to Rome October 1772-c.1778. Returned to London to settle in Leicester Fields. Will proved September 1791. Influenced by Reynolds and Zoffany.
Represented: Corcoran Gallery, Washington; Tate; Dunham Massey NT. **Engraved by** V.Green, Page, C.Knight.

BARROW, Miss E. **fl.1829**
Exhibited at RA (1), SBA (1) 1829 from London and Liverpool.

BARROW, Henry **b.c.1811**
Born London. Listed in 1861 census for London as a portrait painter aged 50. He and his wife Hannah had nine children.

BARROW, John **fl.1797-1837**
Exhibited at RA (30), SBA (8) 1812-37 from London. Also produced miniatures and enamels. There was at least one other J.Barrow and it seems probable that they were inextricably confused.
Engraved by G.Maile.

BARROW, Thomas **1737-1822**
Born January 1737, son of Matthew Barrow of Great Eccleston. Exhibited at FS (1), SA (11), RA (12) 1769-1801. Worked under Romney in London 1770, York 1771-4. Entered RA Schools 1777. Worked in Egham from 1801 and painted in a competent provincial style. Buried in the parish church of St. Michael's-on-Wyre, Lancashire. Sometimes confused with engraver T.Barrow.
Engraved by W.Doughty.

BARRY, Miss Edith M. **fl.1893-1897**
Studied under Herkomer. Exhibited at RA (3) 1893-7 from Bushey.

BARRY, James RA **1741-1806**
Born Cork 11 October 1741. Taught himself by copying prints. Went to Dublin 1763, where he studied under Robert West. Patronized by Edmund Burke, who brought him to London where he met Reynolds. Visited Paris and Rome (financed by Burke) 1765-71. Exhibited at RA (15) 1771-6. Elected ARA 1772, RA 1773, but was angered by criticism and ceased exhibiting 1776. Professor of Painting at the Academy from 1782, but his difficult disposition led to his expulsion 1799. During his latter years he became misanthropic. Died London 22 February 1806. Buried St Paul's Cathedral. Preferred painting history pictures and disliked portraiture, but nevertheless produced some highly original portraits combined with history painting such as 'Burke and Barry in the Characters of Ulysses and a Companion fleeing from the Cave of Polyphemus' (c.1776) in Crawford AG, Cork.
Represented: NGI; NPG London; Victoria AG, Bath; Tate; VAM; Yale; Manchester CAG; Royal Society of Arts. **Engraved by** J.Alais, P.Audinet, T.Cheesman, Edwards, W.Evans, J.Fittler, E.Harding, Hall, Heath, R.Hicks, W.Ridley, Roberts, R.W.Sievier, A. & J.R.Smith. **Literature:** Fryer (ed), *The Works of J.B.,* 1809; W.L.Pressly, *The Life and Art of J.B.,* 1981; W.L.Pressly, J.B: *The Artist as Hero,* Tate exh. cat. 1983; DA.

BART, T. **fl.1816-1834**
Exhibited at RA (1) 1816 from Liverpool.
Represented: NPG London.

BARTOLI, F. jnr **fl.1793**
Exhibited at RA (3) 1793 from Charing Cross, London.

BARTON, J. **fl.1854**
Exhibited at RA (1) 1854.

BARTON, Mrs Matilda M. **fl.1888-1889**
Exhibited at RA (2) 1888-9 from London. Married W. Barton.

BARUCCO, F. **fl.1865-1866**
Exhibited portraits, including General Garibaldi and 'HM the King of Italy' at RA (3) 1865-6 from London.

BARWELL, Frederick Bacon **fl.1855-c.1897**
Friend of J.E.Millais and painted in his studio. Exhibited at RA (44), BI (2), RHA (2), SBA (1) 1855-87 from London. His work was admired by Ruskin. Also produced a number of medallion portraits. It is sometimes erroneously stated that he died 1879.
Represented: VAM.

BARWELL, John 1798-1876
Born Norwich. Member of Norwich Society 1813-33. Studied under Zoffany. Exhibited at RA (1) 1835 from Norwich. **Engraved by** T.Lupton.

BARWICK, John fl.1835-1849
Listed as a Teacher and Portrait Painter at Boston, Lincolnshire 1835. Exhibited at RA (2) 1844-9 from Piccadilly, London.

BARZAGHI-CATTANEO, Antoine fl.1893-1898
Exhibited at RHA (5) 1893-8 from Dublin.

BASEBÉ, Athelstone (Altherstane) fl.1882-1889
Exhibited at RA (2) 1882-9 from London and Watford.

BASEBÉ, Charles Jones c.1818-1880
Painted a number of portraits of cricketers. Exhibited portraits and miniatures at SBA (3), RA (32) 1835-79 from London and Brighton. Among his sitters was Prince Albert. May have studied under George Dawe. Died Islington 22 January 1880. Left effects under £300 to his widow, Caroline.
Represented: Marylebone Cricket Club. **Engraved by** C.Hunt.

BASEBÉ, Harold E. fl.1876-1881
Exhibited at RA (4) 1876-81 from London.

BASS, W. fl.1807-1818
Exhibited at RA (8) 1807-18 from London. Reportedly worked at Hinckley and Leicester.

BASTIEN-LEPAGE see LEPAGE, Jules Bastien

BATE, Martin Newland b.1785
Entered RA Schools 2 July 1801 aged 16. Exhibited at RA (1) 1821 from 56 Upper John Street.

BATE, Thomas fl.1692
Painted an oval portrait of '1st Lord Coningsby' reposing full-length in Roman dress, against a view of Hampton Court (Ulster Museum Belfast).

BATEMAN, B. Arthur fl.1885-1894
Exhibited at RA (3), SBA (3) 1885-1894 from Reigate, Penzance and Newlyn.

BATEMAN, L. fl.1775
Exhibited portraits in oils and crayons at SA (3) 1775.

BATES, Frederick Davenport b.1867
Born Manchester. Studied in Paris under Bougereau, Académie des Beaux Arts, Antwerp and Brussels under de Vriendt. Worked from Stockport.

BATES, Miss M. fl.1834-1835
Exhibited at RBSA (3) 1834-5 from Birmingham.

BATH, Luke fl.1664-1698
Worked in Dublin as a 'limner'. Member of the Painter-Stayners and Cutlers, the Guild of St Luke. His son George was baptized at St John's Church 1664.

BATLEY, John V. fl.1826-1827
Listed as a portrait painter in Bloomsbury, London.

BATLEY, Miss Marguerite E. fl.1895-1899
Studied at Herkomer's School. Exhibited at RA (6) 1895-9 from Bushey and London.

BATONI, Baron Pompeio Girolamo de 1708-1787
Born Lucca 25 January 1708. Studied miniature painting under Conca and copied Raphael and the Carracci. Came under the influence of Masucci and Imperiali, and worked in the classical style of Maratta. After 1740 he moved towards the Baroque. Exhibited at SA 1778 from Rome, where he was for many years the leading portraitist. Although he exhibited at SA and painted many British sitters (particularly those on the Grand Tour) there is no evidence that he ever visited Britain. Over 70 portraits of British sitters are known, painted after 1744. Died Rome 4 February 1787. He ranks among the greatest of portrait artists in European art.
Represented: NG London; NPG London; SNPG; NGI; Brighton AG; Uffizi Gallery, Florence; Warsaw Museum; Kenwood House; Leeds CAG; County Hall, Maidstone. **Engraved by** J.Finlayson, V.Green, J.Watson. **Literature:** A.M.Clark, *P.B. – Complete Catalogue*, 1985; DA. Colour Plate 10

BATTERSBY, Mrs fl.1833-1839
An honorary exhibitor at RA (3), SBA (5) 1833-9.

BATTLEY, J.V. fl.1825-1827
Exhibited at RA (4) 1825-7 from Bloomsbury.

BAUERLE, Carl (Karl) Wilhelm Friedrich 1831-1912
Born Württemberg 5 June 1831. Studied in Stuttgart 1859 and Munich 1863. Settled in England 1869. Exhibited royal and society portraits at RA (35), RHA (6) 1870-92 from London and Willesden. In 1870 he exhibited by command of HM The Queen portraits of 'Count Edward and Countess Theodore Gleichen' and 'Prince Albert Victor, Prince George and Princess Louisa of Wales'. A gifted artist.
Represented: Stuttgart Museum. **Engraved by** J.A.Vinter.

BAUGNIET (BAUGUIET), Charles 1814-1886
Born Brussels 27 February 1814. Exhibited portraits and lithographs at RA (9), BI (1) 1847-70 from London and Sèvres. Enjoyed a highly successful society practice. Among his sitters were Sir Charles Napier, Charles Dickens, John Prescott Knight and Daniel Maclise. Died Sèvres 5 July 1886. His best watercolours are outstanding.
Represented: NPG London; BM. **Engraved** a large number of his own works.

BAUMANN, Miss Ida fl.1892
Exhibited at RA (2) 1892 from 7 Chelsea Embankment, London.

BAUMER, Lewis Christopher Edward RI
1870-1963
Born St John's Wood, London 8 August 1870. Studied at RCA, St John's Wood Art School and RA Schools. Member of Pastel Society. Exhibited at RA (43), RI, SBA 1892-1952 from St John's Wood and Henley. Elected RI 1921. Worked as an illustrator for *Punch, Tatler*, etc. Died Coombe Farm, Farnborough 25 October 1963, leaving £49,466.
Represented: Brighton AG.

BAUMGARTEN, Miss Constance fl.1906
Exhibited at RA (1) 1906 from Ealing.

BAUTEBARNE, E. fl.1849
Exhibited at RA (1) 1849 from 24 Welbeck Street, London.

BAXTER, Charles RBA 1809-1879
Born Little Britain, London 9 March 1809, son of a bookclasp maker. Began as a bookbinder and then as a miniature painter. Received guidance from G.Clint from 1834 and studied at Chipstone Street Society 1839. Painted rustic genre and charming pretty girls in the Keepsake

CARL WILHELM FRIEDRICH BAUERLE. The Earl of Burford and his sisters. Signed and dated 1876. 68 x 80ins (172.7 x 203.2cm)
Christie's

tradition. Exhibited at RA (45), BI (3), SBA (153) 1834-79 from London and Edinburgh. Elected SBA 1842. His work is often reproduced and is much collected. Died at Snowden Villa, Hither Green Lane, Lewisham 10 January 1879. Studio sale held Christie's 15 March 1879.
Represented: VAM. **Literature:** *Art Journal* 1864 pp.145-7.

BAXTER, George 1804-1867
Born Lewes 31 July 1804 at 2.30 pm, second son of John Baxter, the first printer to use the inking roller. Went to school at Cliffe House Academy, Lewes under William Button, and then at St Anns. Worked in a bookshop in Brighton, then under a wood engraver and lithographer before producing illustrations to works published by his father. Married his cousin, Mary Harrild 23 August 1827. The couple settled in London. Exhibited 'Christening of the Prince of Wales at Windsor' at RA (1) 1845. Involved in a serious omnibus accident before dying from apoplexy in Sydenham 11 January 1867.
Represented: Marylebone Cricket Club; Leeds CAG; NPG London. **Literature:** C.T.Courtney Lewis, *G.B. – The Picture Printer,* 1894, 1908; DA.

BAXTER, Miss Martha Wheeler b.1869
Born Castleton, USA. Studied at Pennsylvania Academy; Art Students' League, New York; Paris and Venice. Exhibited at RA (1) 1901 from 123 Pall Mall, London.

BAYLIS, W. fl.1660
Painted a portrait previously at Wollas Hall, Pershore.

BAYNES, Matthew fl.1841
Listed as a portraitist at 14 Palace Hill, Scarborough.

BEACH, Ernest George b.1865
Born London 21 June 1865. Studied art in London and Paris. Exhibited at RA (10), SBA 1888-1922. Lived in London, Dover and Hythe. Travelled in France, Holland and Belgium. Worked in most mediums.

BEACH, Thomas 1738-1806
Born Milton Abbas, Dorset. Studied at St Martin's Lane Academy and with Reynolds 1760-2. Moved to Bath by 1772. Exhibited at SA (49), RA (27) 1772-97. Elected FSA 1774, VP of SA 1780. From Bath he travelled round Dorset and Somerset

THOMAS BEACH. Reginald Pearch. Signed and dated 1788. 30 x 25ins (76.2 x 63.5cm) *Christie's*

THOMAS BEACH. Miss Maria Craven with a bullfinch. Signed and dated 1776. 30 x 25ins (76.2 x 63.5cm) *Phillips*

painting portraits. It was his success that is said to have driven Joseph Wright of Derby from Bath in 1777. Painted a number of single portraits in feigned ovals, which were often signed and dated. Noted in his time for strong likenesses. His friend Walpole wrote that his 'portraits never require the horrid question of – Pray whose is that Sir? They always explain themselves'. Gave up painting c.1800 and retired to Dorchester. Died there 17 December 1806. His handling of paint can be vigorous, and his compositions often informal. Used high 'fresh air' colouring to the flesh, and strong yellows and blues.

Represented: NPG London; NGI; Bristol University (loan); VAM; Holborne of Menstrie Museum, Bath; Victoria AG, Bath; Walker AG, Liverpool; Melbury House; Philadelphia Museum of Art; Getty Museum, Malibu. **Engraved by** J.Basire, P.Dawe, W.Dickinson, V.Green, J.Heath, R.Houston, J.Jones, W.Ridley, P.Roberts, W.Sharp, C.Turner. **Literature:** E.S.Beach, *T.B. – A Dorset Portrait Painter, Favourite Pupil of Sir Joshua Reynolds*, 1934.

BEADLE, James Prinsep Barnes **1863-1947**
Born Calcutta 22 September 1863, son of Major-General James Pattle Beadle. Studied at Slade under Legros, École des Beaux Arts in Paris under Cabanel and in London under G.F.Watts. Exhibited at RA (49), RHA (5), GG, NWG, Paris Salon 1884-1929 from Kensington. Won a bronze medal at Paris Universal Exhibition 1889. Died 13 August 1947.

BEALE, Bartholomew **1655/6-1709**
Baptized 14 February 1655/6, son of artists Charles and Mary Beale. Studied under T.Flatman. Assisted his mother with draperies and practised portraiture. Gave up painting professionally to study medicine under Dr. Sydenham and practised at Coventry, where he died.

BEALE, Charles **1660-1714**
Born London 28 May 1660 (DNB) or 16 June 1660 (Waterhouse 1988), son of Charles and Mary Beale. Helped

in his mother's studio, then studied miniature painting with Thomas Flatman from 1677 and had access to Lely's collection. Failing eyesight caused him to revert to the scale of life, and his last known miniatures are dated 1688. Signed portraits are known from 1689 to 1693 and he seems still to have been painting in 1712. Sometimes signed 'C.B.' and 'Carolus Beale fecit' and his portrait style is similar to his mother's, although mostly using plainer feigned ovals. Also worked in red chalk. Died at the house of Mr Wilson, a banker, near St Clement's Church in the Strand. Being in debt, many of his pictures remained in Mr. Wilson's possession.

Represented: VAM; Fitzwilliam; Windsor Castle; Pierpoint Morgan Library, New York; BM. **Literature:** E.Walsh & R.Jeffree, *The Excellent Mrs M.B.*, Geffrye Museum exh. cat. 1975/6; DA.

BEALE, Mrs Mary (née Craddock) **1633-1699**
Baptized Barrow, Suffolk 23 or 26 March 1633, daughter of Rev John Craddock, rector of Barrow and his wife Dorothy. Married Charles Beale, Lord of the Manor of Walton, Buckinghamshire 8 March 1652. Possibly studied under Robert Walker, and was certainly influenced by her friend Peter Lely, whose work she copied and whose patterns she used. Through him she gained access to paintings by Van Dyck. One of her earliest known paintings is a group portrait of 'Herself, Husband and Elder Son' painted c.1633/4 (Geffrye Museum, London). Her active practices in London only began c.1670, when her prices were £5 for a half-length and £10 for a three-quarter length. Also painted miniatures and enjoyed considerable success during the 1670s and early 1680s. Her husband kept detailed notes of her studio bookings and the notebooks for 1677 (Bodleian Library, Oxford) and 1681 (NPG London) survive. Often signed and frequently depicts a stone oval heavily sculpted with fruit or flowers. The eyes tend to be almond shaped and her colouring pure and rich. Her son Charles assisted with her draperies, she collaborated with

Thomas Manby (who painted a landscape background to at least one of her portraits) and Sarah Curtis (later Hoadley) was her pupil. Died Pall Mall, London 1699 (not as stated by Walpole 28 December 1697). Buried under the communion table in St James's Church, Piccadilly 8 October 1699.
Represented: NPG London; Fitzwilliam; Brighton AG; Oxburgh Hall NT; Birdsall; Melbury House, Dorchester; Syon House; Emmanuel College, Cambridge; Dulwich AG; Bridewell Royal Hospital; Leeds CAG; VAM; Manor House Museum, Bury St. Edmunds. **Engraved by** P.Vanderbank, A.Booteling, T.Chambers, R.Clamp, W.Faithorne, Landon, J.McArdell, J.Sturt, C.Watson, R.White. **Literature:** E.Walsh & R.Jeffree, *The Excellent Mrs M.B.*, Geffrye Museum exh. cat. 1975/6; Clayton; C. Reeve, *Mrs M.B., Paintress*, Manor House Museum cat. 1994; DA.
Colour Plate 11

BEALE, Miss Sarah Sophia fl.1860-1889
Exhibited at RA (8), BI (1), SBA (30) 1860-89 from London and Paris.

BEARD, Miss Freda M. fl.1920
Exhibited at RA (2) 1920 from Kensington.

BEARE, George d.1749
A distinguished provincial portrait painter, of which there is little known. In Salisbury 1747 and was probably based there. Often signed his portraits which are of a high standard. He had an eye for detail on drapery, which is lovingly rendered. The *Salisbury Journal* 22 May 1749 reported: 'Died last week near Andover, Hants, Mr Beare, lately an eminent Face Painter, in this city'.
Represented: NPG; Woburn Abbey; Salisbury AG; Tate; Yale; Corpus Christi College, Cambridge. **Engraved by** G.Bockman. **Literature:** N.Surry, *Burlington Magazine* CXXVIII October 1986, pp.745-9; N.Surry, *G.B.*, Pallant House, Chichester exh. cat. 1989; DA.

GEORGE BEARE. Portrait of a lady. Signed and dated 1748. 50 x 40ins (127 x 101.6cm) *Phillips*

BEARNE, Edward H. fl.1868-1895
Worked in Britain, Italy, Germany, France and Holland. Married artist Catherine Mary Charlton 1889. Moved from London to Somerset 1892.

BEATTIE, Lucas fl.1835-1839
Exhibited at RBSA (10) 1835-9 from Wolverhampton.

BEATTIE, Robert 1810-1874
Born Preston 6 October 1810, son of John Beattie. Began his career in a solicitor's office. Studied under Robert Carlisle of Preston, Mr Faulkner of Manchester and Sass's Academy. Founder member of Preston Society of Artists 1835. Hargreaves is said to have persuaded him to go to Liverpool, where he lived 1841-52. Moved to Southport. There he taught drawing, and ran with his son a photographic business. Returned to Preston 1873. Died there March 1874.
Represented: Walker AG, Liverpool.

BEAUCHAMP, Countess Mary Catherine 1844-1876
Only daughter of 5th Earl of Stanhope. Married Frederick 6th Earl of Beauchamp 18 February 1868. Exhibited at RA (1) 1872 from 13 Belgrave Square, London. Died 30 June 1876.

BEAUCLERK, Lady Diana 1734-1808
Eldest daughter of Charles Spencer, 3rd Duke of Marlborough. Married 2nd Viscount Bolingbroke 1757. Divorced 1768 and two days later married Topham Beauclerk who died 1780. Reynolds and Walpole admired her work. Worked in pastel and watercolour. Produced a number of portraits of Duchess of Devonshire.
Represented: BM; VAM. **Engraved by** F.Bartolozzi, W.Humphry, R.Laurie, J.Newton, R.Stewart, V.Green. **Literature:** Mrs S.Erskine, *Lady D.B. – Her Life and Work*, 1903.

BEAUMONT, Miss Anne (Mrs W.Pierce) fl.1820-1835
Exhibited at RA (17), BI (23), SBA (23) 1820-35 from London. Married 1833.

BEAUMONT, Frederick Samuel RI b.1861
Born Lockwood, Huddersfield 23 February 1861. Studied at RA Schools and Académie Julian, Paris. Exhibited at RA (25), SBA, RI 1885-1922 from London and Wimborne. Member of Royal British Colonial Society of Artists.
Represented: Walker AG, Liverpool.

BEAUX, Cecilia NA 1863-1942
Born Philadelphia. Studied under T.Eakins at Pennsylvania, with William Sartain; and at Académie Julian, Paris 1888-9. Visited England and Italy and taught at Pennsylvania Academy of Fine Arts 1895-1915. Exhibited at RA (1) 1890. By 1890 she established herself as a leading society portrait artist. Also worked at Boston and New York City. Elected ANA 1894, NA 1902. Influenced by her friend Sargent. Her work became more official and formal after c.1905. Official portraitist in 1st World War.
Represented: Uffizi Gallery, Florence. **Literature:** 'The Works of C.B.', *Studio* 17 September 1899 pp.215-22; *Art Digest* 17, 1 October 1942 p.20; C.Beaux, *Portrait of an Artist*, 1974; D.Bachmann & S.Piland, *Women Artists*, 1978.

BEAZLEY fl.1846
Exhibited a portrait of Sir George Pollock at RA (1) 1846.

BECK, David 1621-1656
Born Delft, Holland 25 May 1621. Assistant to Van Dyck in London, probably from the late 1630s. Court painter to Queen Christina in Stockholm 1647-51. Visited Rome 1653. Painted in the style of Van Dyck.

WILLIAM BEECHEY. Rev Cornelius Heathcote de Rodes. Signed with initials and dated 1825. 94 x 58ins (238.8 x 147.3cm)
Christie's

BECKER, Ernest August fl.1849-1859
Born Dresden. Settled in London. Exhibited at RA (10), BI (4), SBA (6) 1850-9.

BECKER, Harry 1865-1928
Painter, etcher and lithographer. Exhibited RA (12), RHA (13), SBA (5), NWS 1885-1914 from London and Colchester.
Represented: BM; Manchester CAG.

BECKETT, Fannie fl.1897-1908
Exhibited at RHA (10) 1897-1908 from Dublin.

BECKWITH, James Carrol fl.1885
Signed and dated a competent portrait of 'William Coffin'.

BECKWITH, Thomas FSA 1731-1786
Born Rothwell, near Leeds 21 February 1731, eldest son of Thomas Beckwith, attorney at law and his wife Elizabeth. Apprenticed to house painter George Fleming. Became an antiquarian draughtsman and a Freemason. His 'The Masonic Lodge Board' is at Duncombe Place, York. Married Frances Beckitt, who died from childbirth aged 36 on 29 August 1773. Took out a patent for 'hardened crayons, which would bear the knife', wrote *A Walk in and about York* and was a notable genealogist. Died of pulmonary consumption in York 17 February 1786. Buried on his birthday in South Choir of St Mary Castlegate, York. F.Nicholson was his pupil.
Literature: *Gentleman's Magazine* March 1786; Ingamells, *Connoisseur* LXXX July 1964, 37.

BEDFORD, Mrs Helen Catherine (née Carter) 1874-1949
Born London 6 February 1874, daughter of artist Hugh Carter. Exhibited at RA (15), NEAC, NPS 1909-46 from London, where she died.
Represented: NPG London.

BEDFORD, John Bates b.1823
Born Thornhill, Yorkshire, baptized 16 November 1823. Exhibited at RA (41), BI (5), SBA (3) 1848-86 from London.

BEDINGFIELD, Richard Thackeray 1857-1923
Baptized St Pancras Old Church 16 September 1857, son of Richard William Thomas Bedingfield. In 1878 charged 10 guineas for a 24 x 20in. portrait. Died St Pancras Infirmary 30 August 1923. Left his widow, Ada effects of £354.18s.7d.

BEECH, James fl.1830-1839
Exhibited at RA (6) 1830-9 from Leicester and London.

BEECHAM, William R. fl.1844
Painted a portrait of Herr Hartwig Hess 1844 in Hamburg.

BEECHEY, George Duncan 1798-1852/6
Son of Sir William Beechey. Visited the Nile with Henry W.Beechey 1821-2. Exhibited at RA (24), BI (1) 1817-34. Worked in his father's studio at 13 Harley Street, but was in Calcutta by 1832. Married an Indian lady, Hinda, whose portrait he exhibited at RA 1832. Worked for a time in Lucknow, where he met with considerable success and became Court painter to the King of Oudh. Among his portraits were 'HRH the Duke of Gloucester' and 'The Earl of Sheffield'.
Engraved by H.Meyer.

BEECHEY, Henry William FSA fl.1821-1838
Son of Sir William Beechey. Explored the Nile with his brother, George D.Beechey, surveying the coastline from Tripoli to Derna 1821-2. Elected FSA 1825. Exhibited at RA (1) 1838 from London. Believed to have died in New Zealand.

BEECHEY, Sir William RA FSA 1753-1839
Born Burford, Oxfordshire 12 December 1753. Said by the artist Edward Dayes to have been a house painter originally (later accounts say he was articled to a solicitor at Stowe, then London). Entered RA Schools 1774 (not 1772). Many of his early portraits (c.1776-86) are small scale full-lengths and show a debt to his teacher, Zoffany. After some years in London he moved to Norwich, where he enjoyed a good practice painting conversation pieces, and life-size portraits from c.1783. Returned to London 1787 and worked from Brook Street in the former residence of Vandergucht. Became extremely successful and removed to Hill Street, Berkeley Square, then to George Street, Hanover Square and ultimately to Harley Street, Cavendish Square. Exhibited at SA (3), RA (373), BI (32), SBA (20) 1776-1839 (a total of 59 years – one of the longest careers as an RA exhibitor). His account book from 1789 survives (NPG London). In 1789 he charged 5 guineas for small portraits and 10 guineas for 30 x 25in. (usually half-lengths) which was raised in 1790 to 15 guineas. Became the main rival of Hoppner. Elected ARA 1793 (along with Hoppner), RA 1798, knighted 1798 (the first artist to receive this honour since Reynolds). Appointed portrait painter to Queen Charlotte 1793, and by 1814 Portrait Painter to Her Majesty and to HRH the Duke of Gloucester. Account books

also survive from 1807-26 and in 1825 he was commanding 40 to 60 guineas for a head. Married as his second wife miniaturist Anne Phyllis Jessup 1793. Sold his art collection, books and engravings 1836. Retired to Hampstead, where he died 28 January 1839 aged 86. The *Art Union* 1839 commented: 'His pictures were admired for their accuracy of likeness, the general management and tone of colour'. Reportedly small in stature he was warm, friendly and cheerful throughout his life. Among his pupils were F.Y.Hurlstone, Michael W.Sharp, Isaac Pocock and his sons George D.Beechey and Henry William Beechey. Used fresh, lively colours and his best work is unsurpassed.
Represented: Tate; HMQ; NPG London; SNPG; VAM; Hampton Court; Dulwich AG; BM; Philadelphia Museum of Art; Tatton Park NT; Detroit Institute of Arts. **Engraved by** F.Bartolozzi, E.Bell, S.Bennet, E.Bocquet, M.A.Bourlier, W.Bromley, J.Brown, A.Cardon, T.Cheesman, G.Clint, J.E.Clutterbuck, J.Cochran, J.Collyer, G.Cook, H.R.Cook, R.Cooper, S.Cousins, R.Dunkarton, R.Earlom, W.C.Edwards, W.Evans, E.Finden, Fogg, S.Freeman, T.Hardy, T.Hodgetts, W.Holl, J.Hopwood, C.Knight, H.Landseer, J.B.Lane, T.Lupton, W.Maddocks, R.Meadows, H.Meyer, W.H.Mote, P.Naumann, T.Nugent, T.Park, J.& G.Parker, G.H.Phillips, C.Picart, J.P.Quilley, S.W.Reynolds, W.Ridley, H.Robinson, W.Say, E.Scriven, W.Sharpe, R.W.Sievier, W.Skelton, B.Smith, C.S.Taylor, J.Thomson, F.Tielker, P.W.Tomkins, C.T.Townley, C.Turner, J.Vendramini, C.E.Wagstaff, J.Ward, W.Ward, T.Woolnoth, J.Young. **Literature:** W.Roberts, *Sir W.B. RA*, 1907; *Art Union* 1839 p.4; DA.
Colour Plate 13

BEETHAM, Jane (Mrs Read) b.1774
Daughter of Edward Beetham, a London actor, scene-painter, writer and publisher. Studied under Opie, and was a cited in his divorce. She was prevented from marrying him, and married John Read, a rich solicitor 11 February 1800 at St Dunstan's, London. Exhibited portraits and miniatures at RA (33) 1794-1816.

BEETHAM, William fl.1834-1853
Exhibited at RA (16), SBA (2) 1834-53 from London. Among his sitters were the Earl of Essex and Lord Goderich. **Literature:** *Country Life* 30 November 1989.

BEETON, Alan Edmund ARA NPS 1880-1942
Born Hampstead 8 February 1880. Educated at Trinity College, Cambridge. Studied art in London and Paris. Exhibited at RA (23) 1923-43. Elected NPS 1915, ARA 1938. Died at his residence at Checkendon, Reading 20 December 1942.
Represented: Tate.

BEFFIN, Miss F. fl.1821
Exhibited at RA (4) 1821 from 33 The Strand, London.

BEHNES, William 1795-1864
Son of a pianoforte-maker from Hanover (who settled in London) and his English wife. Taken by his father to Dublin. Studied at Dublin Society Schools. Entered RA Schools 23 March 1813 aged 18 (Silver Medallist 1816, 1817 and 1819). Lodging in the same house in Charles Street was sculptor P.F.Chenu. Behnes decided to adopt the same profession. Awarded Gold Medals from SA 1814 and 1819 for inventing an instrument for transferring points to marbles. Enjoyed a highly distinguished career as a sculptor and was one of the finest Britain has produced (the sculptor Henry Weekes rated him above Chantrey). In his spare time he painted portraits on vellum which the *Art Journal* 1864 described as 'among the most beautiful we have ever seen on that material'. Also produced delightful pencil portraits, heightened subtly with colour, which were equally distinguished. Exhibited at RA (216), RHA (1) 1815-63. Appointed Sculptor in Ordinary to

WILLIAM BEHNES. A lady. Signed and dated 1838. Pencil heightened with watercolour. 7½ x 5⅞ins (19 x 14.9cm)
Private collection

the Queen 1837. His extravagant habits caused him to fall into the hands of money-lenders, and he later began to neglect his pupils and be off-hand with his clients. The *Art Journal* hints that 'his moral reputation began to suffer from irregularities which mark a man even among the "indifferently honest"'. His troubles culminated in bankruptcy 1861. He was found one night 'literally in the gutter with threepence in his pocket' and was taken to the Middlesex Hospital, where he died 3 January 1864. Buried Kensal Green Cemetery. A committee was formed under G.Cruikshank to erect a monument over his grave. George Frederick Watts and Thomas Woolner were his pupils.
Represented: NPG London; Tate; Leeds CAG. **Engraved by** T.Bragg, J.Cochran, H.Cook, R.Cooper, W.Drummond, R.H.Dyer, R.Graves, G.P.Harding, T.F.Hodgkins, W.Holl, T.Illman, R.J.Lane, F.C.Lewis, J.H.Lynch, E.Morton, S.W.Reynolds, W.Skelton, J.Swaine, J.Thomson, Miss Turner, Mrs D.Turner, J.T.Wedgewood. **Literature:** *Art Journal* 1864; S.C.Hall, *Retrospect of a Long Life*, Vol II p.238; Gunnis with list of monuments; DA.

BEHR, Miss Julia fl.1865-1885
Exhibited at RA (3), SBA (1), RHA (1), GG 1865-74 from Antwerp and London.

BELCAMP (BELCOM, BELKAMP), Jan van c.1610-1651
A professional copyist of portraits, chiefly employed by Charles I. Died December 1651 (or at Hampton Court 1653, Bénézit).

BELL, A.R. fl.1851-1853
Exhibited at SBA (2) 1851-3 from London.

BELL, Mrs Catherine fl.1783-1806
Exhibited at RA (37) 1783-1806 from London. Among her sitters were Earl Berkeley, Mr Hamilton and Mrs Wheatley.

BELL, Miss Eleanor fl.1874-1885
Exhibited at RA (4), SBA (5) 1874-82 from London and Munich.

BELL, Mrs Gladys K.M. fl.1910-1956
Studied at Cope and Nichols' School of Art. Exhibited portraits and miniatures at RA (28), RMS, LA, Paris Salon 1910-56 from London and Great Missenden.

BELL, J.H. fl.1798-1808
Studied under J.S.Copley. Lived at 2 Wood Street, Bath 1798-1809, where he was a drawing master, portrait and miniature painter.
Engraved by W.Cook. **Represented:** Victoria AG, Bath.

BELL, Rev James 1804-1894
Born Lancaster. Exhibited at RA (1) 1863 from 5 Devonshire Square, London. Curate of St Botolphs, Bishopsgate. Died Brotton 28 November 1894. Left effects of £310.18s.8d.

BELL, Miss Jane Campbell fl.1850-1863
Exhibited at RA (10), SBA (11) 1850-63 from Portsmouth, Greenwich and St John's Wood.

BELL, John fl.1811
Born Tyneside, son of Joseph Bell. As a child he played with the children of Thomas Bewick. May have been the John Bell listed as a portrait and landscape painter in Newcastle 1811. Bewick's daughter Jane wrote that Bell was '–Very dissipated – died in his prime'.
Literature: Hall 1982.

BELL, John Zephaniah RSA 1794-c.1883
Born Dundee. Studied at RA Schools, then under Martin Archer Shee with whom he travelled to the Continent, and in Paris under Baron Gros and in Rome. Exhibited at RA (28), RSA (23), BI (11), SBA (14) 1824-76 from London, Edinburgh and Manchester (School of Design). Elected RSA 1829 (Hope and Cockburn Award). Showed an interest in Renaissance portrait styles and from the late 1820s a taste for the mediaeval which was ahead of his time.
Represented: Dundee CAG; Airlie Castle; Tate; Mellon Collection. **Literature:** McEwan.

BELL, Joseph 1746-1806
Born Tyneside. A close friend of Thomas Bewick. Worked as a painter and decorator, but also produced portraits. Described by Robert Robinson in *Thomas Bewick – His Life and Times*, 1887, as a 'portrait painter of some ability'. Died Newcastle 26 April 1806 aged 60. Buried St Andrews.
Literature: Hall 1982.

BELL, Laura Anning (née Richard) 1867-1950
Born France of English parents. Studied in Paris under Robert-Fleury and at Slade under Legros. During her first marriage she exhibited under the name Richard-Troney, but later married artist Robert Anning Bell. First exhibited in Paris with some success, but also at RA (12) 1921-43. Died London 25 July 1950.
Represented: Tate.

BELL, Miss Lucy Hilda d.1925
Exhibited at RA (5), SBA (2), NWS 1890-1901 from London. Died Highgate Road, Middlesex 5 March 1925. Left effects of £4700.16s.8d.

BELL, Lady Maria (née Hamilton) d.1825
Sister of William Hamilton RA. Exhibited at RA (8), SBA (4)

ALEXIS SIMON BELLE . Felix Calvert of Albury Hall. Inscribed and dated November 1717 on reverse before relining. 32 x 25ins (81.3 x 63.5cm) *Christie's*

1816-24. Encouraged by Reynolds. Married Thomas Bell, who was knighted 1816 as Sheriff of London. Died 9 March 1825.
Engraved by G.Clint, W.Dickinson, C.Turner.

BELL, Miss Mary Alexandra (Mrs Eastlake)
 fl.1894-1929
Exhibited at RA (17), SBA (1) 1894-1929 from Croydon, St Ives and London.

BELL, Percy F.H. fl.1887-1893
Exhibited at RA (1), SBA (3) 1887-93 from Hounslow.

BELL, Robert Charles 1806-1872
Born Edinburgh 5 or 15 September 1806. Pupil of John Beugo and at Trustees' Academy. Engraved work for the *Art Journal*. Died 7 September 1872. His pencil drawings of John Beugo are in SNPG.

BELL, Robert Purves ARSA 1841-1931
Born Edinburgh 6 February 1841, son of steel engraver, Robert Charles Bell. Studied at RSA Schools. Exhibited at RSA (98) 1863-1907. Elected ARSA 1880. Died Hamilton 22 March 1931.
Represented: SNPG. **Literature:** McEwan.

BELL, William c.1735-1806
Born Newcastle-upon-Tyne, son of a bookbinder. First student to enrol at RA Schools when they began 1769 (he was then aged 34). Won a Gold Medal for 'Venus Entreating Vulcan to Forge Arms for Aeneas', 1771. Exhibited at SA, FS, RA (2). From c.1770-5 he was 'limner' for Sir John Delaval (created Lord 1783). Acted as drawing master to Delaval's children and painted family portraits. Four full-lengths are at Seaton Delaval, and others are at Doddington in Ireland. Based in Newcastle

after 1776, where he opened a drawing school. A friend of Thomas Bewick, whom he painted in the style of Rembrandt. Died Newcastle 26 April 1806. Fond of strong chiaroscuro. **Represented:** NPG London. **Literature:** Hall 1982; P.M.Horsley, *Eighteenth Century Newcastle*, 1971.

BELLE, Alexis Simon　　　　　　　　**1674-1734**
Born Paris 12 January 1674. Studied under de Troy. Visited England, where he produced high quality portraits, often in a feigned sculptural oval. Painted the Old Pretender 1717 and enjoyed Scottish patronage. Died 21 November 1734. **Represented:** NPG London; Louvre; Versailles; St John's College, Cambridge. **Engraved** by F.Chereau. **Literature:** DA.

BELLEROCHE, Count Albert Gustavus de　**NEAC**
1864-1944
Born Swansea 22 October 1864 of Huguenot descent. Studied in Paris under Carolus-Duran. Prior to his marriage in 1911 he worked in France, sharing a studio in Paris with Sargent. A close friend of Brangwyn. Elected NEAC 1894-9. Died Southwell, Nottinghamshire 14 July 1944. **Represented:** Tate.

BELLI, Enrico　　　　　　　　　　　**fl.1862-1885**
Exhibited portraits and Italian genre subjects at RA (3), SBA (8) 1862-85 from London.

BELLIN, Edward　　　　　　　　　　　**fl.1636**
Provincial portrait painter, influenced by Cornelius Johnson.

BELLUCCI, Giovanni Battista　　　**fl.c.1700-1739**
A Venetian portrait painter who came to England 1716 as assistant to Antonio Bellucci (who was either his father or uncle). Remained in this country after Antonio left in 1722. Painted portraits in Scotland for Earl of Haddington from 1722-4, and for Earl of Leven 1739. Walpole says he made a fortune painting portraits in Ireland. Often painted portraits in feigned ovals.

BELSON, Miss　　　　　　　　　　　**fl.1800-1802**
Honorary exhibitor at RA (2) 1800-2 from Soho, London.

BENAZECH, Charles　　　　　　　　　**1767-1794**
Born London, son of engraver and landscape draughtsman Peter Paul Benazech. Studied in Rome 1782. Returned via Paris, where he studied under Greuze and witnessed the start of the Revolution. Elected a member of Florentine Academy. Exhibited at RA (6) 1790-1. Died London. **Represented:** NPG London. **Engraved** some of his portraits.

BENBRIDGE, Henry　　　　　　　　　**1743-1812**
Important American portrait and miniature painter. Born Philadelphia. Had some instruction from Wollaston 1758. In Rome from 1765, where he is believed to have studied with Mengs and Batoni. Commissioned by James Boswell to paint Pascal Paoli in Corsica 1768. The picture was exhibited at SA 1769 and Benbridge arrived in London in December of that year. Became associated with his distant relative West, and exhibited portraits, including Dr Franklin, at RA (2) 1770, when he returned to Philadelphia. Moved to Charleston, South Carolina 1771, where he became the leading portraitist. Apparently retired from painting c.1790, but gave instruction to Sully 1799. Died Philadelphia January 1812. His style is highly finished with a fond use of chiaroscuro. **Represented:** NG London; NPG London; Washington; Metropolitan Museum, New York; Carnegie Institute, Pittsburgh. **Literature:** *H.B. (1743-1812): American Portrait Painter*, NPG Washington exh. cat. 1971; DA.

BENDIXEN, Siegfried Detler　　　　**1786-1864**
Reportedly born Kiel 25 November 1786, although 1851

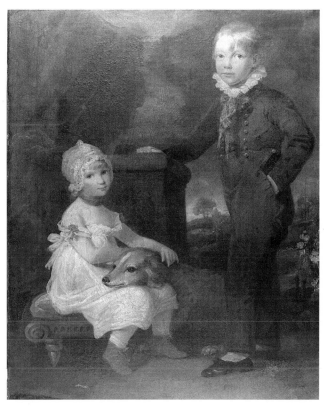

WILLIAM MINEARD BENNETT. Two children and a dog. Signed and dated 1815. 50 x 40ins (127 x 101.6cm)　*Christie's*

census says that he was born Holstein. Listed in census as a widower with two sons Charles and George, who were both born in Hamburg. Settled in London 1832. Exhibited at RA (18), BI (61), SBA (42), NWS 1833-64. Died London. **Engraved by** W.J.Edwards, G.T.Payne.

BENHAM, Thomas C.S.　　　　　　　**fl.1878-1922**
Exhibited at RA (31), RHA (2), NWS, GG 1878-1922 from London and Suffolk.

BENNETT, Elizabeth H.　　　　　　　**fl.1834-1852**
Exhibited at RHA (31) 1834-52 from Dublin.

BENNETT, Frank Moss　　　　　　　**1874-1953**
Born Liverpool. Studied at St John's Wood Art School, Slade, and RA Schools (winning a Gold Medal and a travelling scholarship). Exhibited at RA (31), RI, Paris Salon 1898-1928 from Chislehurst and Croydon. Painted some portraits, but is known mostly for his Elizabethan subjects which have become popular through prints and calendars. Along with Heywood Hardy he painted in the 'New Illustrators' style. **Represented:** NPG London.

BENNETT, John M.　　　　　　　　　**fl.1827-1838**
Exhibited at RA (7), BI (3), SBA (5) 1827-38 from Sheffield, London, Cirencester and Brighton.

BENNETT, Mrs Marjorie　　　　　　　**fl.1915-1937**
Exhibited portraits and miniatures at RA (9) 1915-37 from Sydenham, Tunbridge Wells and Brighton.

BENNETT, William Mineard　　　　　**c.1778-1858**
Exeter portrait painter and miniaturist. Studied under Sir Thomas Lawrence and painted in his manner enjoying a considerable reputation. Also an accomplished musician. His

musical compositions became popular in Paris and Naples. Exhibited at RA (15) 1812-16. Worked in London and Paris 1835-44 (where he attracted the patronage of the Duc de Berri and was decorated by Louis XVIII). A self-portrait, engraved by S.Freeman, was published in *The Monthly Mirror*, 1808. Returned to Exeter 1844, where he died 17 October 1858. His early work was charmingly naïve.
Represented: VAM; BM; Ulster Museum. **Engraved by** A.Cardon, W.C.Edwards, S.Freeman. **Literature:** *Gentleman's Magazine* 1858 ii 647; DNB.

BENOIST, Antoine **1632-1717**
Born Joigny 24 February 1632. Painted portraits and miniatures and executed wax busts, medallions, statues for the Tuileries and a marble decor for a fountain at the Arc de Triomphe. Worked with Legros and Masson. An Agréé of Académie Royale 1663 and a member 1681. Commissioned between 1643 and 1704 to paint a series of miniatures of King Louis XIII, King Louis XIV and members of the royal families (Bibliothèque Nationale). Summoned to England 1684 and modelled wax busts of James II and principal persons at Court. Died Paris 8 April 1717.
Represented: Louvre. **Literature:** DA.

BENSON, Edward **1808-1863**
Listed as a portrait painter in Manchester 1845. Painted a portrait of John Marshall, Mayor 1850 (on deposit at Castle Museum, Norwich). A competent portrait painter with an eye for detail.
Represented: Walker AG, Liverpool. **Engraved by** S.Freeman; J.H.Lynch.

BENSON, Miss Nellie **fl.1897-1901**
Exhibited at RA (7) 1897-1901 from London.

BENTHEM, Martin van **fl.1595-1617**
Native of Emden. Visited England 1595; made a denizen 1607. Painted portraits and other works for the Court.

BENTLEY, Joseph Herbert **b.1866**
Born Lincoln 29 December 1866, son of W.J.Bentley. Studied at Lincoln School of Art and at Antwerp Academy. Exhibited at RA (21), SBA 1885-1917 from Lincoln and Sheffield. Married Janet Louise Ibbotson March 1905. Painted portrait of Queen Victoria c.1897.
Represented: Guildhall, Lincoln.

BENWELL, Miss Mary (Mrs Code) **fl.1762-c.1800**
Exhibited portraits in crayons, oils and miniature at SA (49), RA (38) 1762-91 from London. Listed as a portrait painter in Mortimers Directory. Married an officer named Code c.1782-3. By 1800 had lived 'for some years in widowed retirement' (Edwards).
Represented: VAM. **Engraved by** P.B.Ceechi, R.Houston, C.Knight, C.Lasininio, J.Saunders, C.Spooner.

BENZIGER, August **b.1867**
Born Einsiedein, Switzerland 2 January 1867, son of a publisher. Educated at Downside College and in Brussels, Geneva, Munich, Vienna and Académie Julian, Paris. Painted portraits of Presidents of USA, as well as notable figures in England, France and Switzerland.

BERESFORD, Mrs Daisy Radcliffe (née Clague)
 c.1879-1939
Studied at Heatherley's and RA Schools, winning medals. Awarded Art Class Teachers certificate at the age of 13. Exhibited at RA (9) 1907-38. Married artist Frank Ernest Beresford. Her date of death has been listed as 1924, but she actually died 10 November 1939 'aged 60'.
Represented: VAM.

BERGER, P.P. **fl.1825**
Exhibited at RA (4) 1825 from London. Painted composer J.H.Müller and singer Mlle Cémènova.

BERGSON, Miss Mina **fl.1885-1888**
Exhibited at RA (3) 1885-8 from London.

BERNASCONI, George H. **fl.1861-c.1881**
Believed to have been from Milan. Exhibited at RA (3), BI (5), SBA (6) 1861-6 from London.
Represented: Birmingham AG.

BERNAU, Miss Charlotte A. **fl.1887-1907**
Exhibited at RA (9) 1887-1907 from Croydon, Whytelcafe and Henley.

BERNE, Miss E.B. **fl.1918**
Exhibited at RA (1) 1918 from Henley-on-Thames.

BERRIDGE, John FSA **1740-1804/5**
A native of Lincolnshire. Studied under Reynolds 1766-8 and entered RA Schools 1769. His early works were painted in the manner of Reynolds and Cotes. Exhibited SA (27), RA (9) 1766-97 from London. Elected FSA 1770.
Engraved by E.Fisher, J.R.Smith, J.Watts.

BERRIE, John Archibald Alexander **1887-1962**
Born Fallowfield, Manchester 28 December 1887. Studied at Bootle Art School, Liverpool; at Herkomer's School under Marmaduke Flower and in Paris. Exhibited at RA (5) 1924-32. Member of Liverpool Sketching Club and Royal Cambrian Academy. Died Johannesburg 3 February 1962. Among his exhibited portraits were those of Edward VIII, Rt. Hon. Winston Churchill and Gordon Richards.
Represented: Walker AG, Liverpool.

BERRY, Miss Maude **fl.1880-1885**
Recorded working 1880. Exhibited at RA (1) 1885 from 27 Southampton Buildings.

BERTHON, George Théodore **1806-1892**
Born Vienna. Studied in Europe. Spent 14 years in England. Exhibited at RA (5) 1835-7 from London. Then settled in Toronto c.1841 where he was highly successful as a portraitist. Died Toronto 18 January 1892.
Literature: *Dictionary of Canadian Biography.*

BERTI, Giorgio **fl.1835-1837**
Exhibited at RHA (13) 1835-7 from Clifton, Bristol.

BERTIERI (BERTION), Pilade **b.1874**
Born Turin 1 August 1874. Studied in Turin and Bergamo. A successful Italian society portrait painter. Moved to London. Exhibited at RA (5) 1908-18. Among his sitters were Duke of Newcastle and Countess of Bradford.

BERTRAND, Guillaume **fl.1764-1800**
French portraitist, and pupil of Carle van Loo and N.Halle. Moved briefly to London. Exhibited at FS (4) 1764. Settled in Dublin, where he opened a drawing school 1765. Returned to Paris 1770 and exhibited at Paris Salon. His crayon portraits were much admired.

BERTRAND, Miss Mary **fl.1772-1800**
Studied under Mason Chamberlin 1772-3. Exhibited portraits and miniatures at RA (10) 1772-1800 from London.

BESNARD, Paul Albert HRA **1849-1934**
Born Paris 2 June 1849. Elected HRA 1921. Exhibited at RA (7), RSA (5) 1881-1921 from London and Paris. John S.Sargent purchased his work. Died Paris 4 December 1934. **Represented:** NPG London. **Literature:** DA.

BEST, Thomas **fl.1834-1839**
Exhibited at RA (1), SBA (3) 1834-9 from London.

BESTLAND, Cantlo (Cantelowe, Charles) 1763-c.1837
Born Cantlo Bestland April 1763. Entered RA Schools 25 March 1779 aged '16 next April'. Enjoyed a successful practice. Exhibited at RA (71), BI (37), SBA (7) 1783-1837 from London. Sometimes painted on copper.
Represented: SNG; BM; VAM; Ashmolean. **Engraved by** J.Collimore, R.H.Dyer.

BETHELL, James **fl.1783-1837**
Exhibited at RA (7), BI (9), SBA (3) 1827-35 from London.

BETTES, John (i) **fl.1531-1570**
Portrait, miniature painter and wood engraver. Father of John Bettes (ii) and was probably the Johannes Bett buried London 24 June 1570. His portrait of 'A Man in a Black Cap' (Tate) is close enough in style to Holbein to suggest that he may have worked with the master.

BETTES, John (ii) **fl.1570-1615/6**
Portrait and miniature artist and painter-stainer. Son of John Bettes (i) and reputedly a pupil of Hilliard. Married 1571. Buried London 18 January 1615/6.

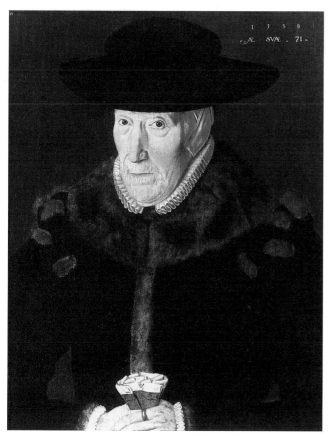

JOHN BETTES (ii). Portrait of a lady. Signed 'I.B.' and dated 1589. 22 x 17ins (55.9 x 43.2cm) *Sotheby's*

BETTES, John (iii) **fl.1616-1660**
Son of John Bettes (ii) and signed 'Betts'.

BEUGO, John **1759-1841**
Born Edinburgh. A friend of Burns. Made watercolours of subjects from Burns as well as engraving illustrations for the 1787 edition of his poems. Produced a number of wash portraits.
Represented: Glasgow AG; SNG; SNPG. **Literature:** McEwan.

BEVAN, J. **fl.1846**
Exhibited at RA (1) 1846 from London.

BEVERLEY, J. **fl.1838**
Exhibited at RA (1) 1838.

BEWICK, William **1795-1866**
Born Hurworth, County Durham 20 October 1795, son of an upholsterer. Studied under George Marks, and Benjamin Robert Haydon (where he met Wordsworth, Shelley, Hazlitt and Keats) 1817-20. Entered RA Schools. Exhibited portraits, histories and genre at RA (4), BI (8), SBA (9), OWS and in Newcastle, Glasgow and Carlisle 1820-41. Practised as a portrait painter in Darlington, Glasgow and Dublin and was later commissioned by Sir Thomas Lawrence to copy Michaelangelo's frescoes in the Sistine Chapel. Remained in Italy about four years. Returned to London to set up as a portrait painter 1829 (painting D.Maclise RA). Following ill health he retired for the last 20 years of his life to Haughton House, Haughton-le-Skerne, where he died 8 June 1866.
Represented: BM; NPG London; SNPG; Darlington AG; Laing AG, Newcastle. **Literature:** T.Landseer, *The Life and Letters of W.B.*, 1871; Hall 1982.

BEYERHAUS(E), E. **fl.1857-1862**
Exhibited at RA (1) 1857 from London and RHA (5) 1862 from Dublin. His paintings can have considerable charm.
Represented: Colchester Museum.

BIANCHI, Nina **fl.1843-1863**
Produced pastel portraits.

BIARD, J. **fl.1824-1825**
Exhibited at RA (6), SBA (7) 1824-5 from Soho, London.

BICKHAM, George **c.1680-1769**
Exhibited at FS 1761-9 from London and was a writing master, engraver, portraitist, writer and book engraver. His stock-in-trade, plates etc, were sold 1767. Died Richmond.

BIDAU (BIDOUZ), J. **fl.1856-1862**
Worked in Brighton 1856. Exhibited at SBA (2) 1861-2 from London.

BIDDLE, Lawrence **b.1888**
Exhibited at RA (1) 1914 from Brighton.

BIEDERMANN, J.C. **fl.1799-1831**
Probably of Swiss origin. Settled in Tetbury, Gloucestershire. Exhibited at RA (16), BI (19) 1799-1831 from London.
Engraved by A.Fogg.

BIELFIELD, Henry **b.1802**
Born Heavitree, Devon (baptized 7 October 1802), son of Dederick Arnol Bielfield and Susannah née Sanders. Exhibited at RA (15), BI (18), SBA (28) 1825-56 from Liverpool, Manchester, Exeter, Devon and London.

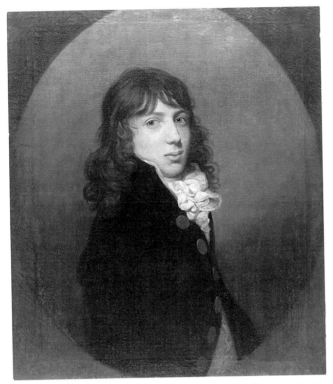

WILLIAM REDMORE BIGG. Langton Denshire aged 15. Signed, inscribed and dated 1791 on reverse. 30 x 24ins (76.2 x 61cm) *Christie's*

BIFFIN, Miss Sarah **1784-1850**
Born Great Quantox-Heath, Somerset 25 October 1784 (baptized 31 October 1784) daughter of Henry and Sarah Biffin. She was deformed and without hands and feet. Painted watercolour portraits and miniatures 'with her shoulder assisted by her mouth'. Her height never exceeded 30 inches. Worked in Brighton, where she lived with her guardian and teacher, Mr Dukes who from 1812 toured with her exhibiting her powers and ingenuity as 'a freak'. The Earl of Morton was impressed by her and showed his miniature to George III, who placed her for further instruction under W.M.Craig, popular for his portraits in the Keepsake. Awarded a medal at SA 1821. Enjoyed royal patronage. Exhibited a portrait at RA (1) 1850. Died Liverpool 2 October 1850 aged 66. Buried St James's Cemetery.
Represented: VAM; Hornby AG, Liverpool. **Engraved by** R.W.Sievier. **Literature:** *Art Journal* November 1850; DNB; Foskett; *Country Life* 19 September 1985.

BIGG, William Redmore RA **1755-1828**
Born Felsted, Essex January 1755. Entered RA Schools 1778 and studied under Edward Penny. A close friend of J.Reynolds and J.Constable. Exhibited FS (1), RA (129), BI (30) 1780-1828 from London. Elected ARA 1787, RA 1814. Produced portraits, small full-lengths, conversation pieces and feigned ovals. Also painted rustic genre in the Wheatley, Morland tradition many of which were popular as engravings. Died in his house in Great Russell Street, London 6 February 1828. C.R.Leslie described him as 'an admirable specimen, both in looks and manner, of an old fashioned English gentleman. A more amiable man never existed'.
Represented: Plymouth AG; VAM; Philadelphia Museum of Art. **Engraved by** J.Grozer, J.Ogborne, W.Ward. **Literature:** DNB; DA.

BIGLAND, Percy RP **c.1858-1926**
Born Birkenhead, son of Edwin Bigland, a Liverpool merchant. Educated at Sidcot, Somerset before studying art in Munich for seven years. Exhibited at RA (38), SBA, RHA (1), GG (3), RP, NWG (8) 1882-1925 from Liverpool, London and Beaconsfield, Buckinghamshire. Elected RP 1891. Among his sitters was Gladstone. Died Jordans, Buckinghamshire 7/8 April 1926 aged 68.
Represented: Walker AG, Liverpool.

BIGWOOD, Mrs Maud see PORTER, Miss Maud

BILLINGHURST, Alfred John RBA **1880-1963**
Born Blackheath. Studied at Slade 1899-1902, Goldsmiths 1900, Académie Julian, Paris 1902 and École des Beaux Arts 1903. Exhibited at RA, RI, SBA, RP, Paris Salon from London. Elected RBA 1921. Died 3 December 1963.

BINDON, Francis **c.1700-1765**
Born c.1690 or c.1700, fourth son of David Bindon MP for Ennis and his wife Dorothy (née Burton). Believed to have studied at Kneller's Academy in London and in Italy. Acquired a reputation in Ireland as a portrait painter and architect. Given freedom of Guild of St Luke, Dublin 1733. Gave up painting c.1758, largely due to failing sight. Among his sitters were the Duke of Dorset, Dr Sheridan, Archbishop Boulter and Jonathan Swift. Died 2 June 1765 'suddenly in his chariot, on his way from Dublin to the Country'. An obituary notice in *Faulkner's Journal* 4-8 June 1765 styles Bindon 'one of the best painters and architects this nation has ever produced. He was a most polite, well-bred gentleman and an excellent scholar, which he improved by his travels abroad'.
Represented: NGI; Howth Castle; Trinity College, Dublin. **Engraved by** J.Brooks, A.Cardon, R.Grave, Mackenzie, A.Miller, J.Pass, C.Picart, N.Schiavonetti, E.Scriven. **Literature:** DNB; Strickland.

BINNIE, Frederick **fl.1771**
Scottish painter. A head of 'Sir William Dick' after a drawing of Ramsay's is at Prestonfield. It is signed 'Fredk Binnie Pxt'.

BINNS, Miss Frances Rachel **fl.1880-1886**
Exhibited at RA (5), SBA (4) 1880-6 from London.

BIRBECK, William **fl.1841-1868**
Listed as a portrait and landscape painter at Stoke-on-Trent.

BIRCH, John **1807-1857**
Born Norton, Derbyshire 18 April 1807, son of a file cutter. Apprenticed to George Eadon, carver and gilder for seven years and then travelled to London, where he studied under H.P.Briggs RA. A friend of Ebenezer Elliott, the corn-law rhymer, and painted many portraits of him. Exhibited at BI (4), SBA (7) 1842-56 from London and Sheffield. Described by Ottley as 'a man of enlarged and liberal views, and of great conversational powers'. Died 20 May 1857.

BIRCH, Miss Sarah **fl.1884-1898**
Exhibited at RA (9), SBA (3), GG (1), NWG (1) 1884-98 from London and Brighton. Capable of painting with great sensitivity.

BIRD, Edward RA **1772-1819**
Born Wolverhampton 12 April 1772, son of a clothier. Apprenticed to a tea-tray maker and japan manufacturers. Moved to Bristol and set up a drawing school 1797. Exhibited at RA (18), BI (13), OWS 1809-18. Elected ARA 1812, RA 1815. Appointed Historical Painter to Princess Charlotte 1813. Crossed from Dover to Calais 1814, on the same boat as Louis XVIII whose portrait he painted. Died

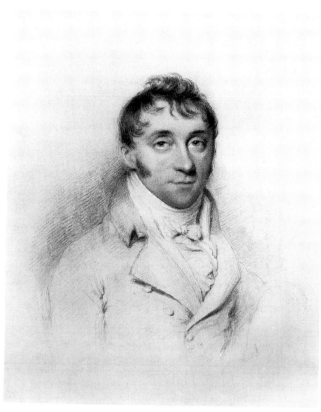

EDWARD BIRD. Robert Hills OWS. Pencil and watercolour. 10 x 8⅛ins (25.4 x 20.6cm) *Phillips*

Bristol 2 November 1819.
Represented: Bristol AG; BM; VAM; Tate; Aberdeen AG; Wolverhampton AG. **Engraved by** H.Meyer, W.Ward. **Literature:** F.Greenacre, *Bristol School of Artists,* exh. cat 1973; *E.B.,* Wolverhampton exh.cat. 1982; DA.

BIRD, George Frederick **1883-1948**
Born Forest Hill 22 March 1883. Studied at RA Schools. Exhibited at RA (17), RP 1905-27 from West Wickham and London. Died 9 April 1948.

BIRD, H.D. **fl.1846**
Exhibited at RA (1) 1846 from London.

BIRD, Isaac Faulkner **fl.1826-1861**
Exhibited RA (15), BI (12), SBA (4) 1826-61 from Exeter, London, Bradford and Leeds. Some of his works show the influence of Gainsborough.

BIRD, W.D. **fl.1840**
Exhibited at SBA (1) 1840 from 36 Paradise Street, London.

BIRD, William **fl.1897-1919**
Exhibited portraits at RA (12) 1897-1919 from London.

BIRKETT, P. **fl.1847-1848**
Exhibited at SBA (2) 1847-48 from Grosvenor Square, London.

BIRLEY, Sir Oswald Hornby Joseph **RP ROI NPS**
 1880-1952
Born Auckland, New Zealand 31 March 1880, son of Hugh and Elizabeth Birley. Educated at Harrow and Trinity College, Cambridge before training in Dresden, Florence, Académie

Julian, Paris (under M.Baschet) and St John's Wood School of Art. Settled in London where he became a fashionable society portraitist. Exhibited at RA (64), RHA (5), RP (101), ROI, NPS, Paris Salon 1904-45. Elected VP of NPS. Enlisted in 10th Battalion Royal Fusiliers September 1914. In France with Intelligence Corps 1916-19 and Sussex Home Guard June 1940-3. In 1943, while serving with the Sussex Home Guard, he lost the sight of an eye in an accident when a weapon exploded. This did not prevent him painting. Among his sitters were Glyn Philpot, the Earl of Birkenhead, King George V and Queen Mary, King George VI and Queen Elizabeth II. Knighted 1949. Died London 6 May 1952. Buried West Dean, Sussex.
Represented: NPG; SNPG; Birmingham CAG; NG New Zealand; Walker AG, Liverpool; Musée Luxembourg, Paris; Royal Naval College, Greenwich; Leeds CAG; HMQ and many country houses. **Literature:** DNB.

BIRNIE, Archibald D. **fl.1820-1834**
Portrait and miniature painter who worked in Aberdeen 1820, Inverness 1822 and London 1834. Visited Elgin, Forres and Tain. Moved to Belfast.
Engraved by W.Holl.

BIRNIE, Rix **fl.1885-1888**
Studied under Whistler. Exhibited at SBA (6) 1885-8 from Westminster and Chelsea.

BISCHOFF, F.H. **fl.1823-1849**
Exhibited at RA (37), BI (2), SBA (5) 1823-49 from London. Among his exhibited portraits was HRH the late Duke of York.
Engraved by T.H.Maguire.

BISHOP, Alfred S. **fl.1847-1889**
Painted the portrait of '4th Marquess of Salisbury on Horseback' (1874) at Hatfield, also a coaching scene in the London Museum.

BISHOP, Harry **fl.1890-1897**
Exhibited at RA (3), SBA (1) 1890-7 from London and St Ives.

BISHOP, Henry RA **1868-1939**
Born London 27 June 1868. Elected ARA 1932, RA 1939. Studied in Paris. Exhibited in London, Brussels and Pittsburgh. Died 5 or 6 March 1939.
Represented: NPG London; Tate.

BISHOP, John **1810/11-1858**
Entered LA Schools 12 November 1827. Exhibited at LA 1830-44. Elected ALA 1837, LA 1842. Moved to Birmingham, where he died.
Represented: Walker AG, Liverpool.

BISSEL, Edward **fl.1835**
Listed as a teacher and portrait painter at Tipton, Staffordshire.

BITTIO, A. de **fl.1772**
Native of Belluno. Moved to Ireland from Italy 1772 to work for the Bishop of Derry (Frederick Hervey, later Earl of Bristol), making topographical drawings.
Represented: NPG London.

BIZO, John **fl.1839-1879**
Exhibited RA (17), BI (8), SBA (4) 1839-79 from London.

BLACK, Miss Emma L. (Mrs Mahomed) fl.1879-1936
Studied at RA Schools. Exhibited at RA (7), SBA (4) 1879-94 from London. Married James Dean Keriman Mahomed 1886. Lived for many years at Elgin.

BLACK, G.B. fl.1855
Exhibited at RA (1) 1855 from 392 Strand, London.

BLACK, Mary 1737-1814
Daughter of London artist Thomas Black. Assistant to both Pond and Ramsay in the early 1760s. A portrait artist in oils and crayons, a copyist, and a fashionable ladies' drawing teacher. Exhibited SA (4) 1768. Her signed and dated portraits of the late 1790s are in the manner of Westall.
Represented: Royal College of Physicians; Earl of Dunraven collection.

BLACK, Thomas d.1777
Portrait, genre and drapery painter. Father of Mary Black. Believed to have been a member of St Martin's Lane Academy. Exhibited at FS (1) 1764.

BLACKBERD, C. fl.1784-1827
Portrait painter and engraver. Exhibited at RA (6) 1784-1810 from London. Listed as a portrait painter in London 1827.

BLACKBURN, John fl.1769-1775
Exhibited at FS (3), RA (5) 1769-75 from London.

BLACKBURN, Joseph fl.1752-1778
First recorded Bermuda October 1752, and may have travelled there from England on commission. Active in New England (mainly Boston) and Portsmouth, New Hampshire up to 1763. His introduction of fashionable poses had considerable influence in Boston, notably on the young Copley. In London 1764 and by 1773 in South Wales, where he painted a large number of portraits. His dated portraits of British sitters range 1764-78. His style is linear and he painted mainly three-quarter lengths. Full-lengths are known, but are rare.
Represented: Boston MFA; Detroit Institute **Literature:** Lawrence Park, *J.B. – A Colonial Portrait Painter, with a Descriptive List of his Works*, Worcester MA, 1923; extension of Lawrence Park, *Descriptive List of the Work of J.B.*, Worcester MA, 1937; R.H. Saunders and E.G. Miles, *American Colonial Portraits*, NPG Washington, 1987; DA.

BLACKBURNE, Miss Helena fl.1880-1899
Exhibited at RA (14), SBA (5), RHA (1), NWS (7) 1880-99 from London.

BLACKESLY, Anna fl.1772
Exhibited at RA (1) 1772 from Greek Street, London.

BLACKMAN, Walter fl.1878-1895
Exhibited at RA (7), SBA (3), GG (1) 1878-95 from London.

BLACKMORE, J. fl.1833-1841
Exhibited at RA (3), SBA (2) 1833-41 from London.

BLADES, Miss Daisy fl.1889-1891
Exhibited portraits, including HRH Princess Victoria of Teck, at RA (2) 1889-91 from Folkestone.

BLAIKLEY, Alexander 1816-1903
Born Glasgow April 1816. Began his career at the age of 10 by cutting out profiles on paper. Studied at Trustees' Academy under W.Allan 1831 and RA Schools 1842. Gained a reputation for painting women and children. Exhibited at RA (27), BI (8), SBA (17), in Glasgow and Edinburgh 1834-67. Painted 'Professor Faraday Lecturing at the Royal Institution'.
Represented: Birmingham AG; SNPG.

BLAKE, Leonard fl.1876-1885
Exhibited at RA (6), NWS (2) 1876-81 from 147 Strand, London.

BLAKE, T. fl.1831
Exhibited at SBA (1) 1831 from Regent's Park, London.

BLAKENEY, Miss Charlotte fl.1898-1904
Exhibited at RA (4) 1898-1904 from Chelsea.

BLAKEY, Nicholas fl.1739-1758
Reportedly born Ireland. Studied and worked in Paris. Listed as an eminent painter in *Universal Magazine* November 1748. Illustrated an edition of Pope's work, and together with Francis Hayman produced some illustrations of English history. Painted a portrait of 'Field Marshall Keith' (Earl of Kintore collection). Often signed with initials.
Represented: BM. **Engraved by** G.Scotin, Vivares.
Literature: DNB.

BLAKISTON, Douglas Y. 1810-1870
Exhibited at RA (18), BI (6), RHA (1), SBA (2) 1853-65 from London and St. Leonards-on-Sea.
Represented: Birmingham AG.

BLAKISTON, Miss Evelyn fl.1889-1848
Exhibited at RA (2) 1889-91 from Kensington.

BLANCHARD, Miss Ann fl.1816-1824
Exhibited at RA (4) 1816-24 from London. A student at BI 1817.

BLANCHARD, J. fl.1818
Honorary exhibitor at RA (1) 1818.

BLANCHE, Jacques Émile RP c.1861/2-1942
Born Paris 1 February 1862 or 1861 (conflicting sources), son of Dr Emile Antoine Blanche. Studied in Paris and England. A successful Parisian society portrait painter. Exhibited at RA (7), RP 1906-35. Elected RP 1905. Among his sitters were Aubrey Beardsley, Thomas Hardy, Charles Shannon, E.Degas, Nijinsky, D.H.Lawrence, Jean Cocteau, Charles Ricketts, Charles Conder, James Joyce and Walter Sickert.
Represented: NPG; Tate; Leeds CAG. **Literature:** J.E.Blanche, *Portraits of a Lifetime*, 1937; H.Frantz, 'J.E.B – Portrait Painter', *Studio* Vol XXX 1903; G.P.Weisberg, 'J.E.B. and the Stylish Portrait 1880-1905', *Arts Magazine* Summer 1985.

BLANDEN, L. fl.1844
Exhibited at RA (1) 1844 from London.

BLANDY, Louise Virenda fl.1880-1894
Her portrait of singer Antoinette Mackinlay is in NPG.

BLAZELEY (BLAZEBY), William fl.1858
Listed as a portrait painter at Bethel Street, Norwich.

BLEADEN, Miss Mary fl.1853-1884
Exhibited at RA (3), BI (8), SBA (16) 1853-84 from London.

BLEMWELL fl.1660
Worked in Bury St Edmunds. A friend of Lely. Painted a portrait of 'John North' which was at Rougham 1890.

BLOOMFIELD, John 1764-1808
Born Dublin. Studied at Dublin Society Schools. Came to England as a miniaturist. Advertised in Dublin 1784 that he would 'paint portraits – bracelet, locket or any size from one to five guineas each'. In Chester 1784. Held in a debtor's prison, where he died suddenly 21 September 1808.

BLOUNT, Juliane **fl.1853**
Exhibited at RA (1) 1853 from 17 Upper Gloucester Place.

BLOXHAM, Miss Joan **fl.1913-1938**
Exhibited at RA (3), RHA (16) 1913-38 from London.

BLUNDELL, Mrs Grace E.M. **fl.1893-1894**
Exhibited at RA (3) 1893-4 from London.

BLYENBERCH, Abraham van **fl.1617-1622**
Visited London 1617-21. Appears in the Guild lists at Antwerp 1622, introducing Theodor van Thulden as his pupil. A signed and dated portrait of '3rd Earl of Pembroke' (1617) is at Powis Castle, NT. Also painted Ben Johnson, and Charles I. His style is very close to that of Mytens.

BOADEN, John **d.1839**
Son of dramatic author and critic, James Boaden. Exhibited at RA (40), BI (90), SBA (59), OWS (4) 1810-40 from London. Had a highly successful middle class practice, and produced a number of theatre portraits. Among his sitters were James Heath ARA and Charles Turner ARA.
Represented: VAM. **Engraved by** T.Cheeseman, R.J.Lane, T.Lupton, C.Marr.

BOADLE, William Barnes **c.1840-1916**
Born Belfast of a Quaker family. Began in commerce. Studied at Slade 1871 under Poynter. Had a successful practice in Liverpool and exhibited at RA (10), LA 1872-1901. Visited Buenos Aires 1888-90. Died Birkenhead 7 June 1916 aged 76. His best work was highly accomplished and he was the most important portrait painter of his time in Liverpool.
Represented: Walker AG, Liverpool.

BOAK, Robert Creswell **b.1875**
Born Letterkenny 31 May 1875, son of Alexander Boak. Studied art in Londonderry, Glasgow School of Art, RCA and in Paris and Rome. Exhibited at RHA.

BOAKE, Miss Evelina **fl.1852-1859**
Exhibited at RHA (18) 1852-9 from Dublin.

BOARD, Ernest **b.1877**
Born Worcester. Studied at RCA and RA Schools. Exhibited at RA (2) 1902-3 from Bristol and Fulham. Also a designer of stained glass.
Represented: Bristol AG.

BOCK, Thomas **1790-1855**
Born Sutton Coldfield. Apprenticed to Thomas Brandard, a Birmingham engraver. Set up as an engraver and miniature painter in London. Awarded a Silver Medal at SA 1817 for engraving of a portrait. Married with five children by April 1823, when he was found guilty at Warwick assizes for administering drugs to a young woman. Sentenced to transportation for 14 years, arriving in Hobart Town January 1824, where he painted portraits and practised engraving. Good conduct gained him a pardon 1832. Commissioned by Lady Franklyn to paint portraits of Tasmanian aborigines (Tasmanian AG, Hobart). Died Hobart 18 March 1855.
Literature: Australian DNB.

BOCKMAN, Gerhard **1686-1773**
Portrait painter and mezzotint engraver. There are nine Kneller copies by Bockman in the Royal Collection. Died 2 April 1773 'the last surviving disciple of Sir Godfrey Kneller, and followed his business to the last year of his life'.
Literature: *London Magazine.*

GIOVANNI BOLDINI. Madame Roger-Jourdain. Signed and dated 1889. 81 x 33ins. (206 x 83.5cm)
Christopher Wood Gallery, London

BOCQUET, E. **fl.1817-1849**
Exhibited RA (12), BI (4), SBA (10) 1817-49 from London. Travelled to Naples and Venice, working in oils and watercolour.

BOEHM, Wolfgang **fl.1850-1869**
Son of medallist Joseph Daniel Boehm and brother of sculptor Sir Joseph Edgar Boehm RA. Exhibited at RA (10), BI (4) 1850-69 from London.

BOGLE, William Lockhart **d.1900**
Born in the Highlands. Educated at Glasgow University and began an apprenticeship to a lawyer. Then studied under Herkomer at Bushey. Exhibited at RA (20), SBA (6), RSA (6), NWG (6) 1886-94. He was also an archaeologist and champion wrestler. Died 20 May 1900.
Represented: Trinity College, Cambridge; NPG London; VAM. **Literature:** McEwan.

BOLDINI, Giovanni **1842-1931**
Born Ferrara 31 December 1842. Highly successful international portraitist. Set up practice in Ferrara, influenced by Zorn. Left for Florence 1862, where he studied at School

of Fine Arts. Visited Paris via Monte Carlo 1869, with the family of Sir Walter Faulkner. Came to London 1870 on invitation of William Cornwallis-West, who placed a studio at his disposal in Hyde Park. Here he painted several portraits, mostly on a small scale. Despite his immediate success, he went back to Italy at the end of the year and then chose to be based in Paris. Exhibited at Paris Salon and in Venice. Among his sitters were Whistler, Duchess of Marlborough and Verdi. Died Paris 11 or 12 January 1931. Painted with a confident bravado and his best works show him to be a true master. **Represented:** NPG. **Literature:** *B.*, Musée Jacquemart-André exh. cat. 1963; E.Cardona, *Life of G.B.*, 1931; C.Ragghianti, *L'opera completa di B.*, 1970; Bénézit; DA. Colour Plate 12

BOLTON, Miss Alice fl.1874-1909
Exhibited at RA (1), SBA (1), RMS 1874-1909 from London.

BOLTON, John Nunn 1869-1909
Born Dublin, son of amateur landscape artist Henry E.Bolton. Studied at Metropolitan School of Art, Dublin and at the RHA. Exhibited at RHA (48), RBSA, RA (1), RMI 1890-1909 and lived in Warwick for some years. Master of Leamington School of Art. Died Warwick.

BONAVIA, George fl.1851-1876
Exhibited at RA (27), BI (5), SBA (17) 1851-76 from London. **Represented:** NPG.

BOND, T. fl.1804-1805
Exhibited at RA (2) 1804-5 from Lancaster.

BOND, William fl.1825-1836
Exhibited at RA (5), SBA (4) 1825-36 from London.

BONE, Henry Pierce 1779-1855
Born Islington 6 November 1779, son and pupil of miniaturist Henry Bone RA and Elizabeth Van Der Meulen. Educated at Tooting. Entered RA Schools 17 March 1796 aged 16. Painted at first portraits and then concentrated on enamels, exhibiting at RA (214), BI (58), SBA (1) 1799-1855 from London. Member of Langham Sketching Club. Enamel Painter to His Majesty and the Duchess of Kent and Princess Victoria 1834. Died London 21 December 1855. **Represented:** VAM; NPG. **Engraved by** R.Cooper, G.F.Storm. **Literature:** VAM manuscripts.

BONE, Robert Trewick 1790-1840
Born London 24 September 1790, son and pupil of Henry Bone. Exhibited at RA (50), BI (73), SBA (25) 1813-41 from London. Died 5 May 1840. **Engraved by** W.Bond.

BONHAM CARTER, Miss Joanna Hilary d.1865
Daughter of John Bonham Carter MP for Portsmouth. Her portrait drawing of 'A.H.Clough' was exhibited at South Kensington Museum 1868 and reproduced as the frontispiece in K.Chorley's *Arthur Hugh Clough: An Uncommitted Mind*, 1962. Died unmarried September 1865.

BONINGTON, Richard 1768-1835
Father of Richard Parkes Bonington. Started as a sailor, then became Governor of Nottingham Gaol, but was forced to tender his resignation after conversing with the prisoners on politics and reading them the forbidden doctrines of Tom Paine. Became a drawing master at his wife's school at Arnold, Nottinghamshire as well as a portrait painter and seller of prints, paper, optical glasses, camera obscura and music. Honorary exhibitor at RA (2) 1797-1808. At the end of 1817, or early 1818, he moved with his family to Calais,

where he set up a lace business, later settling in Paris. **Engraved by** G.Clint. **Literature:** C.Peacock, *R.P.B.*, 1979.

BONNAR, William RSA 1800-1853
Born Edinburgh June 1800, son of a house painter. Followed his father's profession, and helped D.Roberts in decorating the Assembly Hall for the visit of George IV to Edinburgh 1822. Exhibited at RSA (99) 1825-52. Elected RSA 1829. In his latter years he was chiefly engaged in painting portraits, many of which were engraved by his sons. Died Edinburgh 27 January 1853. Influenced by Wilkie. **Represented:** SNPG. **Engraved by** E.Burton. **Literature:** *Art Journal* 1853 p.76; DNB; McEwan.

BONNEMAISON, Féréol 1770-1827
Native of Montpellier. Fled to London from the Revolution. Exhibited at RA (7) 1794-5. Returned to Paris. Exhibited at the Salons 1796-1816. Died Paris.

BONNOR, Miss Rose D. fl.1895-1916
Exhibited at RA (7) 1895-1904 from London.

BOOTH, Dorothy see DAVIS, Mrs Dorothy

BOOTH, Miss Elizabeth fl.1796-1809
Honorary exhibitor at RA (2) 1796-1809. **Represented:** Brinsley Ford Collection.

BOOTH, Joseph d.1789
Recorded as a portrait painter in Lewisham. Invented a mechanical process for copying. Died in Dublin.

BOOTH, William 1807-1845
Born Aberdeen. Entered RA Schools 31 March 1825 aged 17 (silver medallist). Exhibited watercolour portraits and miniatures, including one of John Constable, at RA (123), SBA (15) 1827-45 from London. **Engraved by** W.Sharp; J.Thomson. **Literature:** McEwan.

BOOTY, Edward fl.1840-1850
Worked in Brighton 1840, when his son Frederick William Booty was born. Moved to Scarborough.

BORCKHARDT, Charles fl.1784-1825
Miniature painter and portrait painter in oils and crayons. Exhibited at RA (17), BI (1) 1784-1825 from London. Recorded in Maidstone 1 July 1800. **Represented:** VAM. **Engraved by** Holl.

BORGNIS, Peter M. 1739-after 1810
Son of Italian decorative painter Giuseppe M. Borgnis and moved with his father to England. Entered RA Schools 1778. Exhibited portraits at FS (2) 1783. Ran a general decorator's shop in London and produced ornamental work for Zucchi and Soane.

BOROUGH JOHNSON
 see JOHNSON, Ernest Borough

BORSSELAER (BUSTLER), Pieter fl.1644-1687
A Dutch Roman Catholic. Portrait and history painter. Visited England 1664-79, when he painted the portraits of 'Sir William Dugdale' and 'Lady Dugdale'. Living at The Hague 1681. At Middelburg 1684 and 1687. **Represented:** Tate. **Literature:** DA.

BORTHWICK, Alfred Edward RSA PRSW RBA ARE
 1871-1955
Born Scarborough 22 April 1871. Studied at Edinburgh School of Art, Antwerp and Académie Julian, Paris under Bouguereau and Tony Fleury. Served in Boer War with

PIETER BORSSELAER. A marriage portrait. 40 x 50ins (101.6 x 127cm) *Christie's*

Scottish Sharpshooters and in 1st World War. Exhibited at RA (7), RE, SBA, RSW, RSA, Paris Salon 1895-1924 from Edinburgh. Elected ARE 1909, RSW 1910, RBA 1927, ARSA 1928, RSA 1938. Died 7 December 1955.
Represented: SNPG; Glasgow AG; Paisley AG. **Literature:** McEwan.

BOSDET, H.T. **fl.1876-1885**
Exhibited at RA (1) 1885 from Fitzroy Square, London.

BOSS, W.Graham **fl.1891-1895**
Produced a number of fine pencil portraits, of which a number are in SNPG.

BOSSÉ, Edward **fl.1844-1855**
Exhibited at RA (1) 1855 and RSA from London and Edinburgh.

BOSTOCK, John **c.1808-1872**
Born Newcastle-under-Lyme. Entered RA Schools 31 March 1825 aged 17 years. Exhibited at RA (48), BI (3), SBA (8), OWS (4) 1826-69 from Manchester and London. His wife, Jane, was from Haslington, Lancashire. Enjoyed a successful practice. Elected AOWS 1851, but allowed it to lapse 1855. Died Kensington 9 March 1872. Left under £3000.
Engraved by C.Agar, R.A.Arlett, H.Cousins, W.H.Egleton, W & F.Holl, J.Jenkins, W.H.Mote, S.W.Reynolds jnr, H.Robinson, J.Thomson, C.Turner, G.R.Ward.

BOSWORTH, Richard **b.c.1772**
Entered RA Schools 1791 aged 19. Exhibited at RA (4) 1791-3 from 23 Finch Lane, Cornhill.

BOTT, R.T. **fl.1839-1862**
Exhibited at RA (3), BI (3) 1847-62 from London. His portrait of 'Sir Robert Peel' is in Birmingham AG.

BOUGHTON, George Henry RA RI 1833-1905
Born near Norwich 4 December 1833, son of William Boughton, a farmer. Emigrated with his family to America 1835. Toured Britain briefly 1853, returning to New York to paint landscapes. Studied in Paris where he was assisted by Edward May. Settled London c.1862, where he married Louisa Cullen 9 February 1865. Exhibited at RA (88), SBA (2), BI (4), NWS (7), GG (30), NWG (11) 1862-1905. Elected ARA 1879, RA 1896. Wrote an article on his friend Whistler, entitled 'A Few of the Various Whistlers I Have Known'. Ruskin did not like Boughton's technique and described it as 'executed by a converted crossing sweeper, with his broom, after it was worn stumpy'. Travelled in England, Scotland, France and Holland. Died 19 January 1905 from heart disease at his residence, West House, Campden Hill (built by his friend R.Norman Shaw). Cremated Golders Green. Studio sale held Christie's 15 June 1908.
Represented: VAM; Tate; Ashmolean. **Literature:** A.L.Baldry, 'G.H.B. RA – His Life and Work', *Art Journal* Christmas Annual 1904; *The Times* 21 January 1905; DNB.

EDWARD BOWER(S). Thomas, Lord Fairfax. Signed and dated 1646. 48 x 36ins (121.9 x 91.5cm) *Christie's*

BOUGHTON, H. **fl.1827-1872**
Exhibited at RA (28), BI (10), SBA (4) 1827-72 from London.

BOULTBEE, Thomas **1753-1808**
Baptized 4 June 1753 at Osgathorpe, Leicestershire. Twin brother of John Boultbee, with whom he entered RA Schools 1775. Exhibited at SA (3), FS (3), RA (6) 1775-83 from London.

BOURGUIGNON, Pierre **1630-1698**
Native of Namur. Entered French Academy 1671. Made a denizen in London December 1681. At The Hague Academy 1687 for a short time. Appears in account books of Wemyss Castle June 1696, when he charged £24 for two 30 x 40in. portraits. One of these 'Anne, Duchess of Monmouth' survives.

BOURLIER, Mlle **fl.1800**
Exhibited at RA (3) 1800 from Bloomsbury, London.

BOUSFIELD, John **1793-1856**
Worked in Whitehaven and painted portraits, animals and church decorations in a provincial style.
Represented: Whitehaven Museum.

BOUTIBONNE, E. **fl.1856-1857**
Exhibited royal portraits, including Queen Victoria and Prince Albert, at RA (4) 1856-7 from Paris and London.

BOUVIER, Augustus Jules NWS **c.1827-1881**
Born London, son of artist Jules Bouvier. Painted mainly in watercolour. Studied at RA Schools from 1841 and in France and Italy. Exhibited RA (9), BI (8), SBA (6), NWS (241) 1845-81 from London. Elected ANWS 1852, NWS 1865. Died London.
Literature: *Art Journal* 1881 p.95.

BOUVIER, Joseph **fl.1839-1888**
Exhibited at RA (26), RHA (8), BI (17), SBA (81) 1839-88 from London. Published *A Handbook for Oil Painting* (1885).

BOUWENS, Mrs T. (Amata) **fl.1891-1897**
Exhibited at RA (9) 1891-7 from London.

BOWER(S), Edward **fl.1629-1667**
Believed to have come from Totnes area, and to have been a servant to Van Dyck. Complaints were lodged against him by the Painter-Stainers' Company 1629. Became the Company's Upper Warden 1656 and Master 1661. Had a studio at Temple Bar, London by 1637. In January 1648/9 he made three variant portraits of 'King Charles I at his trial', which were much copied.
Represented: Tate; HMQ; York AG. **Engraved by** G.Glover, M.Vandergucht, W.Hollar, W.Marshall, R.Streater, C.J.Visscher. **Literature:** York Art Gallery cat., II 1963 pp.6-8; *Burlington Magazine* XCI January 1949 p.18.

BOWER, George **1650-1690**
His group portrait of bishops is in NPG London and a commemorative silver medal of Charles I is in SNPG.

BOWERMAN, Richard **b.c.1770**
Worked in Dublin as a portrait painter and miniaturist. Studied at Dublin Society Schools 1782.

BOWIE, John RSA RP **1864-1941**
Born Edinburgh, son of John Bowie MD. Studied at Edinburgh School of Art, RSA, Académie Julian under Bourguereau and Fleury; and in Haarlem and Madrid. Exhibited at RA (10), GI, RSA (133), RP 1882-1919 from Edinburgh and London. Elected ARSA 1903, RP 1905. Died Edinburgh 8 October 1941.
Represented: SNPG. **Literature:** McEwan.

BOWLER, Miss Annie Elizabeth **b.1860**
Daughter of Thomas Bowler, the silk hat manufacturer. Studied at Lambeth School of Art, RA Schools and in Paris. Lived mostly at Barnes. Exhibited at RA (21), SBA, RI 1888-1930.

BOWLES, James **fl.1852-1873**
Exhibited at RA (2), BI (6), SBA (9) 1852-8 from London.
Represented: NPG.

BOWLES, Oldfield FSA **1739-1810**
Matriculated at Queen's College, Oxford 1758 aged 18. Squire of North Astyon, Oxfordshire. Mainly a landscape painter in the style of Richard Wilson, and took lessons from Richard Wilson's pupil, Thomas Jones 1772-4. Exhibited at SA (15), FS (1), RA (2) 1772-95. Elected FSA 1773. Small scale, full-length portraits of himself and his wife are at Clevedon Court, NT. An amateur actor in The Society of St Peter the Martyr, which included Sir G.Beaumont, Benjamin West, Thomas Hearne, George Dance and Joseph Farington.

BOWMAN, James **1793-1842**
Born Allegheny County. Moved to London c.1822. Visited Paris and Rome. Returned to Pittsburgh 1829, working as an itinerant portrait painter. George Whiting Flagg was his pupil.
Represented: State Historical Society of Wisconsin.

BOWMAN, Miss Margaret H. **fl.1892-1921**
Studied at Glasgow School of Art, RA Schools and in Paris. Exhibited at RA (3), RSA (5), Paris Salon, SBA 1892-1921 from Skelmorlie and London.
Literature: McEwan.

BOWNESS, William 1809-1867
Born Kendall. Went to London as a portrait and figurative painter c.1829. Exhibited at RA (35), BI (26), SBA (87), Carlisle Athenaeum 1836-67. Married eldest daughter of John H. Wilson. Died London 27 December 1867.
Represented: Kendal Town Hall; Abbot Hall AG, Kendal.
Engraved by S.Bellin. **Literature:** *Art Journal* 1868 p.34; Hall 1979.

BOWRING, Benjamin b.1751
Entered RA Schools 7 December 1770 when his age was given as '19 last August'. Awarded a Silver Medal 1773. Exhibited miniatures and small portraits at RA (11) 1773-81.

BOWRING, Joseph b.c.1760
Born London. Exhibited miniatures and small portraits at RA (18) 1787-1808 from London and Eton. Often signed with a monogram 'JB', the J extending in both directions over the vertical stroke of the B.
Represented: BM.

BOWRING, Walter Armiger ROI 1874-1931
Born Auckland, New Zealand 11 March 1874. Studied in London under W.Orpen and A.John. Exhibited at RA (1) 1922. Worked in England and New Zealand. Settled in Sydney 1925. Died 3 November 1931.

BOXALL, Sir William RA FRS DCL 1800-1879
Born Oxford 29 June 1800, son of a custom official. Educated at Abingdon Grammar School. Entered RA Schools 1819. Studied in Italy 1827-9. Exhibited at RA (86), BI (11), SBA (7) 1818-66 from Oxford and London. Elected ARA 1851, RA 1863. Director of NG London 1865-74, Knighted 1867. Enjoyed a successful society practice and painted Wordsworth, Daniel Maclise, Thomas Stothard, John Gibson, David Cox, Copley Fielding and Whistler, when Whistler was 14 (University of Glasgow). Ruskin criticised his portrait of Mrs Coleridge (RA 1855) for 'excess of delicacy and tenderness'. Died London 6 December 1879. Studio sale held Christie's 8 June 1880.
Represented: Ashmolean; Tate; NPG; VAM; Birmingham CAG; Inner Temple; Walker AG, Liverpool. **Engraved by** S.Bellin, J.Brown, J.Cochran, S.Cousins, W.Walker.
Literature: *Art Journal* 1880; Lord Coleridge, *Sir W.B. RA*, 1880; DNB; Maas; DA.

BOY, Godfrey 1701-after 1748
Born Frankfurt 20 May 1701. Said to have moved to London as a youth and to have been painter to the English Court at Hanover.

BOYCE, Joanna Mary see WELLS, Joanna Mary

BOYD, John fl.1848
Listed as a portrait and miniature painter in Leicester.

BOYDELL, Josiah 1752-1817
Born near Hawarden, Flintshire 18 January 1752, nephew, partner and successor to John Boydell (1719-1804), who revived the engraving industry in Britain and promoted the Shakespeare Gallery. Studied under B.West. Entered RA Schools 1769. Exhibited at SA (2), RA (10) 1772-9 from London and Houghton, Norfolk. Painted subjects for Shakespeare Gallery. Towards the end of his life devoted his time to publishing. His last years were spent at Halliford, where he died 27 March 1817.
Engraved by V.Green. **Literature:** DNB.

BOYDEN, E. fl.1827
Exhibited at RA (1) 1827 from Walworth.

BOYD-WATERS, Frederick RMS 1879-1967
Born Guelph, Ontario, son of a business man. Moved to San Francisco c.1899, where he trained at Mark Hopkins Institute, followed by Académie Julian, Paris. Served during 1914-18 war in Artists' Rifles Corps, but dyspepsia prevented him serving overseas. Visited America 1928-9, and lived in South of France for many years. Exhibited at Paris Salon and RMS. Died Hawkshead, Westmorland 5 September 1967.
Literature: Foskett.

BOYESON, G.A fl.1830-1832
Exhibited at RA (2) 1830-2 from London.

BOYLE, The Hon Mrs Cerise b.1875
Born Ringwood 6 December 1875, daughter of Sir Clause Champion de Crespigny. Studied at Cope and Nichol School of Art and at Westminster School of Art. Exhibited at RA (2) 1916-23 from Fareham.

BOYLE, Ferdinand Thomas Lee ANA 1820-1906
Born Ringwood, Hampshire. Moved to America as a child studying under H.Inman. Painted Lincoln and Charles Dickens. A founder of Western Academy of Art. Elected ANA 1849, Professor of Art at Brooklyn Inst. Died Brooklyn 2 December 1906.
Represented: Union League Club, New York City.

BOZE, Joseph 1745-1825
Born Martigues. Exhibited at Salon of Correspondence 1782-91. Through the influence of his wife (née Bresse de St. Martin) he had access to Court patronage and painted portraits of Louis XVI, Marie-Antoinette, Robespierre and Mirabeau. Became involved in politics. In October 1793 was imprisoned as a suspect, but was released on his wife's testimony and fled to Holland and then England. Returned to France 1798, where he worked with success. Died Paris 25 January 1825 (Bénézit January 1826). He exaggerated the height of the skull of his sitters and was fond of brown shadows.

BRABY, Newton fl.1898-1907
Exhibited at RA (13) 1898-1907 from Bushey Lodge, Teddington.

BRACEWELL, William Trinnell fl.1848
Listed as a stationer and portrait painter in Winchester High Street. Also painted miniatures.

BRACKEN, John fl.1665-1719
Worked in Cumbria, where he painted local gentry and was employed by Lady Anne Clifford and Sir Daniel le Fleming. Settled in London by 1707, where he was recorded as repairing the great picture for the Barber-Surgeons' Company.
Represented: Abbot Hall AG, Kendal. **Literature:** M.E.Burkett, *J.B.*, Kendal 1982.

BRACKENBURY, Georgina d.1949
Her portraits of Emmeline Pankhurst and 17th Viscount Dillon are in NPG London.

BRADBURY, Arthur Royce ARWA b.1892
Began as a cadet in the Mercantile Marine. Studied at St John's Wood and RA Schools. Exhibited at RA (14), RI, ROI, SBA, RWA 1913-48 from Bournemouth.

BRADFORD, C. fl.1829
Exhibited at RA (2) 1829 from London.

BRADFORD, Louis King ARHA 1807-c.1862
Exhibited at RHA (164) 1827-62 from Dublin. Elected ARHA 1855.

BRADLEY, John **b.1787**
Entered RA Schools 7 January 1814 aged 27. Exhibited portraits and miniatures at RA (32), SBA (19), OWS (2) 1817-43 from London. Had a mainly middle class practice. Painted a number of theatre portraits.
Engraved by R.J.Lane, G.Penry, S.W.Reynolds jnr.

BRADLEY, William **1801-1857**
Born Manchester 16 January 1801. Orphaned aged three. Worked first as an errand boy. Aged 16 set up in a Manchester warehouse, making black portraits at one shilling each and advertising as a 'portrait, miniature and animal painter and teacher of drawing'. Had some guidance from Mather Brown. Moved to London 1823, where he received encouragement from Lawrence. Exhibited at RA (22), BI (13), SBA (7) 1823-46. Reportedly worked for a time in studio of Charles Calvert, whose daughter he is said to have married. Had considerable success with industrial middle classes. Returned to Manchester after ill health 1847. Died there in poverty 4 July 1857. His style shows the influence of Lawrence, Beechey and Margaret Carpenter although it often retains a provincial character. Among his pupils were William Percy and Thomas Henry Illidge. Ottley writes with some justification 'His heads are remarkable for skilful drawing, and he was not second to any man of the day in producing a striking and intellectual likeness'.
Represented: Manchester CAG; VAM; NPG London; BM; Sydney AG; Eton College; Walker AG, Liverpool. **Engraved by** H.Cousins, M.Gauci, T.Lupton, J.Thomson. **Literature:** *Art Journal* 1857.

BRADSHAW, William Henry **fl.1845**
Listed as a portrait painter at 25 Rossmond Street, Chorlton on Medloch.

BRAGGER, Charles **fl.1879-1880**
Exhibited at RA (1) 1880 from 39b Old Bond Street, London.

BRAINE, Thomas **b.1769**
Entered RA Schools 27 March 1788, when he is recorded as being '18 on 21 December last'. Exhibited miniatures and portraits at RA (33) 1791-1802 from London. Exhibited a design for the central panel of a curtain for Theatre Royal, Edinburgh 1793.
Engraved by W.Nutter.

BRAMLEY, Frank **RA** **1857-1915**
Born Sibsey, Lincolnshire 6 May 1857. Studied at Frank School of Art, Lincoln and in Antwerp. Travelled to France and Venice. A member of Newlyn School with Stanhope Forbes and Henry Tuke. A founder NEAC 1886. After 1897 turned increasingly to portraiture. Exhibited at RA (66), RHA (1), SBA (6), GG, NWG 1877-1912. Elected ARA 1893, RA 1911. Died at Chalford Hill, Gloucestershire 9/10 August 1915. His style is often subtly understated and can show an outstanding sensitivity.
Represented: Tate; NPG London. **Literature:** DA.

BRANDIS, Henry **fl.1896**
Listed as a portrait painter at Foundry House, Burnbank Road, Hamilton.

BRANWHITE, Nathan Cooper **1775-1857**
Born Lavenham, eldest son of Peregrine Branwhite, a poet and his wife Sarah Brooke. Studied under Isaac Taylor jnr. Exhibited engravings, miniatures and small portraits at RA (13) 1802-28 from Bristol. A gifted artist who painted his sitters with considerable vitality and character. His sons Nathan and Charles Branwhite were also artists.
Represented: Bristol AG. **Engraved by** T.Blood, W.Holl, R.J.Lane, F.C.Lewis, R.M.Meadows, H.Meyer, T.Phillibrown, W.Ridley, E.Scriven, W.Walker, T.Woolnoth, R.Woodman. **Literature:** F.Greenacre, *The Bristol School of Artists*, exh. cat.1973.

BRASSINGTON, John **fl.1835-1845**
Exhibited at RA (1), SBA (3) 1835-7 from Cheapside. Listed as a portrait painter in Derby 1845. Painted 'Thomas William Coke 1st Earl of Leicester' at Longford.

BREALEY, William Ramsden **RBA ROI** **1889-1949**
Born Sheffield 29 June 1889. Studied at Sheffield College of Art and at RCA. Exhibited at RA (4), ROI, SBA and Société des Artistes 1927-47 from London. Died 23 February 1949.

BREDA, Carl Frederik von (Charles Frederick) **1759-1818**
Born Stockholm 16 August 1759. Trained there as a portrait and history painter under Lorenz Pasch, winning prizes 1780. Enjoyed considerable success. Patronized by Swedish royal family, before moving to London 1787-96, where he was influenced by Reynolds and Beechey. Exhibited RA (26) 1788-96. Painted portraits for the Lunar Society at Birmingham (1792/3) including 'James Watt' (NPG London) and 'William Withering' (Stockholm). Returned to Stockholm 1796 and became Court Painter, Professor at the Academy and leading portraitist in Sweden. Died Stockholm 1 December 1818. Sometimes worked on panel using standard canvas sizes (50 x 40in., 30 x 25in. etc).
Engraved by W.Bond, S.W.Reynolds, W.Ridley. **Literature:** E.Hultmark, *C.F.vB.*, Stockholm 1915; DA.

BREDBURG, Madame Mina **fl.1892**
Exhibited at NWG (1) 1892 from London.

BRENAN, James Butler **RHA** **1825-1889**
Exhibited at RHA (63) 1843-86 from Cork, where he had a successful portrait practice. Elected ARHA 1861, RHA 1871.

BRENNAN, Michael George **c.1839-c.1872**
Probably born Dublin. Exhibited at RHA (3) 1868-70 from Caffe del Greco, Rome. A portrait of the Countess of Kingston was exhibited posthumously at RHA 1873.

BRENNAN, Nicholas **fl.1826-1852**
Exhibited at RHA (42) 1826-52 from Dublin.

BRERETON, Robert **fl.1835-1847**
Exhibited at RA (2), SBA (2) 1835-47 from London and Melton Mowbray.

BREUN, John Ernest **RBA** **1862-1921**
Born London 27 November 1862, son of John Needham Breun, Duc de Vitry. An outstanding student at South Kensington and RA Schools from 1881-4, where he won a number of prizes and medals. Exhibited at RA (14), RHA (4), SBA, NWS (2) 1879-1905 from 4 Greek Street, Soho. Elected RBA 1895. Enjoyed considerable success as a society portraitist and could work on a large scale in a painterly manner. Died 8 July 1921.
Represented: Dunham Massey NT.

BREWER, Mrs Mary (née Jenkins) **fl.1848-1874**
Daughter of J.Jenkins, a Welshman. Long reported that she married Robert Jenkins, but relatives say she was second wife of Marmaduke Brewer of Newport. Exhibited at RA (6) 1848-53 from Worcester (and possibly RA (1) 1830 as M.Jenkins). J.C.Hook, the marine painter was her pupil. Recorded at Tuxfield April 1874. Her miniature of John Jackson RA is in VAM.

ROBERT BRIDGEHOUSE. The four sons of John Owell of Arden House, Cheshire; John on a pony, George, William and Ralph. Signed and dated 1846. 40 x 50ins (101.6 x 127cm) *Christie's*

BREWSTER, H. fl.1823
Exhibited at RA (1) 1823 from London.

BRICARD, Xavier fl.1916
Exhibited at RA (1) 1916 from St Leonards-on-Sea.

BRICKDALE, Miss E.Fortescue 1871-1945
Exhibited at RA (18) 1905-39 from Holland Park Road, London. Died 10 March 1945.

BRIDELL, Mrs Eliza Florence c.1824-1903
(née Fox, later Mrs George Fox)
Daughter of W.J.Fox MP for Oldham. Exhibited at RA (20), BI (2), RHA (3), SBA (14) 1846-83 from London. Married Southampton artist, Frederick Lee Bridell in Rome 1858/9. After his early death from consumption in 1863 she married her cousin George Edward Fox 1871. Died 9 December 1903 (not 1904) aged 79.
Represented: NPG London; SNPG.

BRIDGEHOUSE, Robert fl.1830-1848
Painted portraits of the family of John Orell at Arden House, Cheshire. Listed as a portrait painter in Manchester until 1848. His work is charmingly naïve.

BRIDGES, Charles fl.1670-1747
Born Barton Seagrave, Northamptonshire, brother of John

Bridges FSA (d.1724). Acted as agent for SPCK from its foundation in 1699 until 1713. Travelled to Virginia 1735 with an introduction from his brother to Governor Thomas Gooch (later Bishop Gooch) and painted a number of portraits. Returned to England c.1744-5. His British works are extremely rare.
Represented: Metropolitan Museum, New York; Yale.
Engraved by J.Simons. **Literature:** G.Hood, *C.B. and William Dering,* Williamsburg, 1978; H.W.Foote, *Virginia Magazine of History and Biography,* 60 January 1952.

BRIDGES, John fl.1818-1854
Worked as a portrait painter in Oxford. Some of his portrait groups have charming details of mid-Victorian life. Also painted single portraits mainly of academics and soldiers. Exhibited at RA (23), BI (24), SBA (13) 1818-54 from Oxford and London. Travelled in Italy in the early 1830s. Sometimes confused with his brother, James, a landscape painter.
Represented: Oriel College, Oxford. **Engraved by** H.Cousins, S.Cousins.

BRIDGFORD, Thomas RHA 1812-1878
Born Lancashire 6 April 1812, son of a nurseryman and seedsman. Moved with his family to Ireland c.1817 and admitted aged 12 as a pupil to Royal Dublin Society's Drawing School 1 April 1824. Exhibited at RHA (153), RA

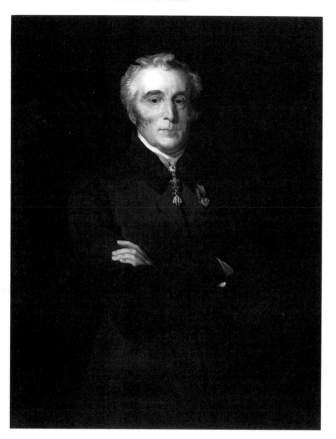

HENRY PERRONET BRIGGS. The Duke of Wellington wearing the order of the Golden Fleece. 44¼ x 34¾ins (112.4 x 88.3cm)
Christie's

(21), BI (3), SBA (4) 1827-79. Elected ARHA 1832, RHA 1851. Married Mary Jane Sawyer 1833. Moved with her to London 1834, where he had a successful practice. Among his sitters were artists Abraham Cooper, William Mulready, E.H.Baily, Sir Augustus Wall Callcott, David Roberts, Sir Martin Archer Shee, Thomas Uwins and Sir Charles Lock Eastlake. Returned to live in Dublin 1844 and taught drawing for a time at Alexandra College. Died 21 November 1878. Buried Mount Jerome.
Represented: NGI; RHA. **Engraved by** E. Dent, S.J.Machen, J.Smyth. **Literature:** Strickland.

BRIDGWATER, Miss Marjorie L.　　　**fl.1918-1927**
Exhibited portraits at RA (4) 1918-27 from London.

BRIDPORT, Hugh　　　**1794-c.1868**
Born London. Exhibited at RA (3) 1813. Entered RA Schools 24 November 1815 aged 21. Studied under C.Wilkin. Encouraged by T.Sully he emigrated to America 1816 and opened a drawing academy in Philadelphia 1817. Exhibited at Pennsylvania Academy and Artists' Fund Society 1817-45 and had a successful practice as a miniature and portrait painter. Died Philadelphia.
Represented: Pennsylvania Academy of Fine Arts.

BRIGGS, Miss E. Irlam　　　**fl.1890-1950**
Studied at Wimbledon Art College, St John's Wood Art School, RA Schools and Académie Julian, Paris. Exhibited at RA (5) 1892-1901 from Parkstone, Dorset.

BRIGGS, Henry Perronet　RA　　　**c.1791/3-1844**
Born Walworth, second cousin to Opie's wife. His father, John H.Briggs, held a lucrative position in the Post Office. While at school he published two engravings in the *Gentleman's Magazine*. Entered RA Schools 1811. Began as a portrait painter and worked in Cambridge 1813 painting mostly college portraits. Settled in London, where he gained a taste for history painting. Copied Reynolds and returned to portraits c.1835, painting a number of studies of Duke of Wellington, but also judges and statesmen. Exhibited at RA (132), RHA (2), BI (21) 1814-44. Elected ARA 1825 and RA 1832. Married a near relation, Elizabeth Alderson 7 August 1830 (she died of consumption 1840). As 'Baron Briggs' he was placed first by Thackeray in his 'List of Best Victorian Painters' (*Fraser's Magazine* 1838). Died of consumption in London 18 January 1844 aged 51. Studio sale held Christie's 25-27 April 1844. Among his pupils were John Birch, Thomas Brigstocke, Thomas Brooks, Thomas Francis Dicksee, Father Edward Mackey and Edward Opie. He had considerable talent and has been greatly underrated.
Represented: NMM; Tate; NPG London; SNPG; Dulwich AG; Chatsworth; Bristol AG; Middle Temple; Burghley House; Norwich Museum; Stratford Saye. **Engraved by** P.Audinet, S.Bellin, J.Cochran, H.Cousins, H.Dawe, G.S.Facius, E.Finden, R.J.Lane, T.Lupton, W.H.Mote, G.T.Payne, G.H.Phillips, J.Porter, S.W.Reynolds, H.Robinson, H.T.Ryall, J.Schubert, J.Skelton, R.Smith, W.Taylor, C.Turner, G.R.Ward, J.T.Wedgewood. **Literature:** *Art Union* 1844 pp.62, 88.

BRIGGS, William Keighley　　　**fl.1842-1860**
Evidently a Yorkshire artist who worked in Leeds and London. Exhibited RA, SBA (2) 1842-58. Simon describes his paintings as 'accomplished and charming'.
Represented: Leeds CAG. **Engraved by** T.Fairland, W.O.Geller.

BRIGHT, Beatrice　　　**1861-1940**
Born Annie Beatrice Bright in London March 1861, daughter of Sir Charles Tilston Bright, an engineer. Studied under Sir Arthur Cope. Exhibited RA (23), Paris Salon 1896-1928. Died Kensington 11 May 1940. Usually signed 'B.Bright'.
Represented: NPG London; Inner Temple; Elton Hall.

BRIGHT, Miss Constance M.　　　**fl.1905-1929**
Exhibited at RA (5) 1905-29 from Upper Norwood.

BRIGHT, William　　　**fl.1828-1834**
Exhibited at RA (2), BI (5), SBA (6) 1828-34 from 109 Minories, London.

BRIGHTY, George M.　　　**fl.1809-1827**
Exhibited portraits and miniatures at RA (18), BI (1) 1809-27 from 45 Red Lion Square, London. Produced a number of charming pencil portraits coloured by thin washes.
Represented: BM; Brighton AG. **Engraved by** J.Romney.

BRIGSTOCKE, Thomas　　　**1809-1881**
Born Carmarthen 17 April 1809, son of David and Mary Brigstocke. Studied from age of 16 at Sass's, RA Schools and under H.P.Briggs and J.P.Knight. Also studied for eight years in Paris, Florence, Rome and Naples. Married Mrs Cridland and had by her one child who died in infancy. Exhibited RA (16), BI (2) 1842-65 from London. In March 1845 he was commanded to appear before Queen Victoria and Prince Albert at Buckingham Palace to exhibit his full-length portrait of General Nott GCB, and her Majesty 'expressed great approbation'. In 1847 he travelled to Egypt for 16 months, where he painted His Highness Mohammed Ali Pasha and members of his family. Died suddenly

London 11 March 1881. Buried Kensal Green Cemetery. **Represented:** NPG London; Oriental Club. **Engraved by** J.Smyth, G.R.Ward.

BRIMMER, Miss Anne fl.1846-1857
Exhibited at RA (5), SBA (13) 1846-57 from London.

BRINDLEY, Charles A. fl.1888-1898
Exhibited at RA (5) 1888-98 from Surbiton.

BRINTON, Miss Edith D. fl.1885-1900
Exhibited at RA (10), SBA (1) 1885-1900 from London.

BRISLEY, Miss Ethel C. fl.1908-1945
Exhibited small portraits and miniatures at RA (42), British Empire Exhibition 1908-45 from Bexhill, London and Richmond.

BRISTOW, Edmund 1787-1876
Painter of portraits, genre, sporting and animal subjects. Baptized Clewer, near Windsor 6 April 1787, son of James Bristow and Ann Rolls. Lived and worked at Windsor, where he was patronized by Duke of Clarence, later William IV. Exhibited at RA (7), BI (12), SBA (8) 1809-29. Very little is known of his life and he was a recluse by nature. Died Eton 12 February 1876. **Represented:** Anglesey Abbey, NT. **Engraved by** W.Giller. **Literature:** *Art Journal* 1876 p.148.

BRISTOWE, Miss Beatrice M. fl.1893-1899
Exhibited at RA (3) 1893-9 from London and Maida Vale.

BRISTOWE, W.H. fl.1830-1835
Exhibited at RHA (6) 1830-5 from Dublin.

BROADBRIDGE, Miss Alma fl.1886-1894
Exhibited at RA (6), SBA (6) 1886-94 from London and Brighton.

BROADHEAD, Miss Marion E. fl.1907-1937
Born Macclesfield. Studied at London School of Art and in Paris. Exhibited at RA (29), Paris Salon 1907-37 from Manchester.

BROCAS, James 1754-1780
Possibly born Dublin, son of Robert Brocas and brother of Henry Brocas snr. Advertised likenesses in profile at half-a-crown each. Studied at Dublin Society School (winning prizes 1772 and 1773). Based in Dublin, where he died September 1780. Buried St Andrew's Churchyard.

BROCAS, William RHA c.1794-1868
Third son of landscape painter, Henry Brocas. Exhibited at RHA (30) 1828-63 from Dublin. Elected ARHA 1854, RHA 1860. Also an engraver and etcher.
Engraved by H.Meyer.

BROCHMER, John fl.1763
Listed as a painter of crayons and miniature at Mr Paul's, Confectioner in Bridges Street, Covent Garden.

BROCK, Charles Edmund RI 1870-1938
Born Holloway 5 February 1870. Went to school at Cambridge. Studied under sculptor Henry Wiles in Cambridge, where he settled. Exhibited (often as Edmund Brock) at RA (70), RI 1897-1938. Elected RI 1908. Illustrated for *Punch, The Graphic, Hood's Comic Poems;* Dent's edition of Jane Austin's works; Lamb's *Essays* and *Gulliver's Travels*. Died 28 February 1938. Left £2,457.18s.3d to his widow Annie Dudley Brock.
Represented: Glasgow AG.

BROCK, William b.1874
Born St John's Wood 7 April 1874. Studied at RA Schools and in Paris at École des Beaux Arts. Exhibited at RA (11), Paris Salon 1897-1914 from London, Brondesbury and Woodbridge, Suffolk.

BROCKBANK, Albert Ernest RBA 1862-1958
Born Liverpool 20 February 1862. Studied at Liverpool School of Art, London and Académie Julian, Paris. Exhibited at RA (42), BI (29), LA and SBA (33) 1886-1926 from Liverpool. Elected RBA 1890, PLA 1912-24, and of Liver Sketching Club. Died Broadgreen Hospital, Liverpool 29 January 1958.
Represented: Walker AG, Liverpool; Preston AG.

BROCKBANK, Miss Elizabeth RMS b.1882
Born Settle, Yorkshire 8 July 1882. Studied at Slade. Exhibited portraits and miniatures at RA (14), RMS, LA, Paris Salon and in North America 1913-37. Member of Lake Artists' Society and LA.

BROCKEDON, William 1787-1854
Born Totnes 13 October 1787, son of a watchmaker. Began as a watchmaker, and after his father's death in 1802 he continued the business for five years. Encouraged by Rev R.H.Froude and A.H.Holdsworth MP he entered RA Schools February 1809. Exhibited at RA (36), RHA (1), BI (29) 1812-41 from London. Awarded 100 guineas premium at BI. Made his first continental visit 1815, travelling through France and Belgium to Italy (1821-2) and painted a number of watercolour views of Venice and Italy. A member of Academies of Florence and Rome. Published *Illustrations of the Passes of the Alps by which Italy Communicates with France, Switzerland and Germany* (1827) and illustrated a number of books. Married Miss Elizabeth Graham 1821. She died in childbirth 23 July 1829, leaving two children. Married Mrs Farweel, a widow from Totnes 8 May 1839. Founded Graphic Society 1831. Also an inventor and improver of steel pens and graphite pencils. Died from jaundice after severe attacks of gall-stones 29 August 1854 at his residence in Devonshire Street, London.
Represented: NPG London; Uffizi Gallery, Florence; BM; VAM. **Engraved by** F.C.Lewis, C.Turner. **Literature:** DNB.

BROCKHURST, Gerald Leslie RA RP RE 1890-1978
Born Birmingham, son of a coal merchant. Studied at Birmingham School of Art and RA Schools 1907 (winning the Landseer Scholarship and a series of prestigious prizes). Exhibited at RA (66), RHA (1), RP (23) 1915-53. Elected RP 1923, ARA 1928, RA 1937. Married Anais Folin 1914. Aged 40 he shocked London by falling in love with 16 year old Kathleen Nancy Woodward, a model in the sculpture class at RA, whom he married 1947. Among his sitters were the Duchess of Windsor and Marlene Dietrich. Able to take on around 20 commissions a year at about 1000 guineas a time. Moved to America 1939. Retired 1957. Died New Jersey 4 May 1978. Capable of stunning work.
Represented: Southampton CAG; Birmingham CAG; Brighton AG; Manchester CAG. **Literature:** M.C.Salaman, 'G.L.B.', *Studio* 1928; *The Lady* 7 May 1987.

BROCKMER, John fl.1758-1776
Exhibited at SA 1762-76. Worked in London and Bath. Produced miniatures and portraits in crayon and Indian ink.

BROCKY, Charles (Karoly) S. ANWS 1807-1855
Born Temesvár, Hungary 22 May 1807, son of a theatrical hairdresser. Arrived in London c.1837/8 (on the invitation of the collector Munro of Novar) after an impoverished period working as a strolling player, cook, barber and painter in

Vienna and Paris. Exhibited at RA (43), BI (16), NWS (3) 1839-54. Elected ANWS 1854. Established a successful portrait practice, including Queen Victoria among his sitters. Also worked as an illustrator and drawing master. Died London 8 July 1855. Buried Kensal Green Cemetery. In his watercolours and miniatures he was fond of brown-red shadows, which he painted in bold crossed brushwork and sometimes used a scraper for the hair.
Represented: NPG; BM; VAM. **Engraved by** M.Gauci, F.Holl. **Literature:** N.Wilkinson, *Sketch of the Life of C.B. the Artist,* London 1870; DA.

BRODIE, James fl.1736-1738
Scottish painter only known for his seven portraits of his own family, five of which are dated 1736-8. May have been the son of Ludovick Brodie of Whytfield, Writer to the Signet, and his wife, Helen Grant. Holloway writes of his work: 'Arresting and distinctive, they are quite unlike any other portraits painted in Britain at that time – in fact their closest parallels are in northern Italy'.
Represented: Dunvegan Castle; Brodie Castle.

BRODIE, John Lamont fl.1848-1881
Exhibited at RA (25), BI (1), SBA (1) 1848-81 from London and Manchester.

BROMAN (BROOMAN), Mrs Sarah fl.1658
Probably Sarah Corker who married William Broman at St Botolph's, Bishopsgate 5 June 1661. Painted oil portraits in the style of Lely.

BROME fl.c.1740
Irish primitive painter. Produced four known portraits at Adare. His work has charm.
Literature: *Irish Portraits 1660-1860,* NGI exh. cat 1969.

BROME, Charles 1774-1801
Son of a London linen-draper. Studied under Skelton. Entered RA Schools as an engraver on 29 March 1790 aged 16½. Exhibited at RA (10) 1798-1801 from London. Also worked in Higham, Suffolk. Drowned in the Serpentine 23 April 1801 aged 27.
Literature: *Gentleman's Magazine* 1801.

BROMPTON, Richard PSA c.1734-1783
Studied under Benjamin Wilson. Travelled to Rome c.1757, where he worked under Mengs the following year. Remained in Italy, painting at Padua the conversation piece of 'Edward Duke of York and His Friends in a Landscape' (six versions, one for each sitter). Returned to London with Dance 1765, and enjoyed royal and aristocratic patronage. Exhibited at SA (23), FS (6), RA (2) 1772-80. Elected FSA 1773, President 1780, RA Professor. Imprisoned for debt 1780, but was rescued from this by Empress Catherine of Russia. Died St Petersburg. Many of his 'more grand' portraits contain a considerable amount of work and fine detail. Walpole described his work as 'Genteel…highly finished'.
Represented: NPG London, Manchester CAG; NMM; HMQ. **Engraved by** J.Corner, E.Fisher, G.Saunders, J.Saunders, C.Towneley, Vangelisti. **Literature:** DA.
Colour Plate 15

BRONCKORST (BROUNCKHORST, BRUNTHURST), Arthur (Arnold) van fl.1565-1598
A Flemish portrait and miniature painter who is known to have lived in Britain from c.1565 onwards. Sent with his cousin Cornelius Devosse by N.Hilliard to prospect for gold in Scotland 1572 under a special licence. He found gold but the Earl of Morton would not let him take it out of Scotland. In 1580 he was made 'one of his majesties sworne servants at ordinary in Scotland, to draw all small and great pictures for his Majesty' (James VI). Received £64 for painting three portraits and 100 marks in gratitude for coming to live in Scotland. Mentioned by Francis Meres amongst the important contemporary painters 1598.
Represented: NPG London; Oakley Park; SNPG; Hatfield House. **Engraved by** J.Colemans, C.Tiebout. **Literature:** McEwan.

BROOK, Joseph fl.1690-c.1725
Bury St Edmunds portrait painter and copyist. Painted for John Hervey, 1st Earl of Bristol. As Fayram succeeded him in 1728 he possibly died about this time.

BROOK, Miss Maria Burnham fl.1872-1885
Exhibited at RA (7), SBA (10) 1872-85 from Peckham.

BROOKE, J. fl.1840
Exhibited a portrait of 'Mr Robert May, an eminent botanist' at RA (1) 1840 from 2 Macclesfield Street, London.

BROOKE, John William 1853-1919
Born Cleckheaton, Yorkshire. Studied under Herkomer at Bushey and in Paris. Lived in London and Leeds, but travelled extensively on the Continent. Exhibited at RA (12) 1894-1917. Died Harrogate 12 April 1919.
Represented: NPG London; Leeds CAG.

BROOKE, Leonard Leslie 1862-1940
Educated at Birkenhead School. Studied art at RA Schools, where he won the Armitage Medal 1888. Exhibited at RA (12), NWS (1) 1887-1919 from Maida Vale, London and Steventon, Berkshire. Died 1 May 1940.
Represented: Manchester CAG.

BROOKE, Robert 1710-1784
Son of Rev William Brooke, rector of Killinkeere and Lettice (née Digby). Lived at Rantavan, County Cavan, with his brother Henry. Painted a portrait of the 'Duke of Cumberland on Horseback' 1748. Married his cousin Honor, daughter of Rev Henry Brooke. Father of Henry Brooke and grandfather of William Henry Brooke.

BROOKE, William Henry ARHA 1772-1860
Started work in a banker's office. Studied art under Samuel Drummond ARA. Established himself as a portrait painter at Adelphi. Exhibited at RHA (16), RA (9), BI (6), SBA (9), NWG (1) 1808-46. Elected ARHA 1828. Illustrated numerous books, including Major's edition of *Isaak Walton, Gulliver's Travels* and Keightley's *Greek and Roman Mythology.* Thomas Stothard considered that Brooke possessed a great artistic genius, but lamented that with such uncommon powers he did not devote himself more to the study of the 'higher' branch of art. Died after a long illness in Chichester 12 January 1860. Buried at Westhampnett Churchyard.
Represented: NPG London; BM; Tate; Leeds CAG. **Engraved by** R.Havell jnr, H.T.Ryall. **Literature:** Stewart & Cutten.

BROOKER, Miss Catherine P. fl.1881-1914
Exhibited 1881-93 at RA (3), SBA, NWS 1881-1914 from London.

BROOKS, Frank 1854-1937
Born Salisbury 31 May 1854, son of artist Henry Brooks snr and brother of Henry Brooks jnr. Studied at Salisbury and Heatherley's School, London. At first painted portraits in Salisbury. Received a commission from the States of Guernsey to paint a portrait of the Bailiff for Royal Court House 1882,

which led to many other commissions on the island. Exhibited at RA (22), RHA (1), SBA, NWS (3) 1880-1934. Visited India 1888 and 1892, painting Indian princes and figures of the Raj, returning to London 1896. Visited Berlin 1900 and 1908. Died Lyndhurst 12 March 1937.
Represented: NPG London; Southampton CAG; Royal Society of Musicians.

BROOKS, Henry Jermyn　　　　　　**1865-1925**
Specialized in large portrait groups. His monumental 'Court of Examiners of the Royal College of Surgeons' (1894) is still with Royal College of Surgeons. Exhibited at RA (5), NWG (2) 1884-1900 from London. His best known work is 'Private View of the Old Masters' Exhibition, 1888, RA' (NPG London), which was influenced by Frith's 'Private View of the RA, 1881'.

BROOKS, Miss Kathleen　　　　　　**fl.1917-1950**
Exhibited at RA (7), RHA (8) 1917-50 from Hornsey and Winchelsea.

BROOKS, Miss Maria　　　　　　**fl.1872-1890**
Exhibited at RA (33), SBA (28) 1872-90 from London.

BROUGH, Robert Barnabas　　　　　**1828-1860**
Born Monmouthshire. Worked as a portraitist from an early age. While in his teens started a satirical paper in Liverpool. Produced satires and burlesques for the London stage with his brother William. Used the *nom de plume* of 'Papernose Woodensconce'.

BROUGH, Robert John　ARSA RP　　**1872-1905**
Born Invergordon, Ross-shire 20 March 1872. First worked for a firm of lithographers. Studied in Aberdeen under Andrew Gibb, RSA 1891, and in Paris under Laurens and Constant (where he was influenced by Whistler). Returned to Aberdeen 1894, where he set up a portrait practice. Moved to London 1897, where he was encouraged by his neighbour J.S.Sargent. Developed impressive brushwork under the influence of Sargent and Boldini. Exhibited at RA (7), NWG, RSA (24), RP in Munich, Paris and Dresden 1897-1906. Elected RP 1900, ARSA 1904. Awarded medals at Munich, Dresden and Paris. His 'brilliant and promising career was suddenly terminated on 21 January 1905 following injuries sustained in a railway accident near Sheffield the previous day'. Buried Old Marchar, Aberdeenshire. A.H.M. writes in DNB: 'Brough gave promise of becoming one of the most notable of Scottish portrait painters. His style was both powerful and original, uniting simplicity with breadth of treatment'.
Represented: NPG London; SNPG; Tate; Hopetown House; Garrick Club. **Literature:** *Scotsman* 23 January 1905; *Dundee Advertiser* 23 January 1905; McEwan.

BROUNOWER, Sylvester　　　　　　**d.c.1699**
Employed by the eminent philosopher John Locke, whose plumbago portrait he produced (NPG London). Letters from his wife written c.1699-1700 acquainted Locke 'with my great loss in Death of my deare and loveing husband'.

BROWN　　　　　　　　　　　**fl.1741-1744**
Agent to 1st Earl of Ilchester at Redlynch Park. Painted small full-lengths of Lady Ilchester 1741 and 'Lord Ilchester and His Son Out Shooting' 1744 now at Melbury.

BROWN, Miss Alice G.　　　　　　**fl.1890-1892**
Exhibited at RA (6) 1890-2 from Bryn Hyfrid, Harrow.

BROWN, Mrs Ann　　　　　　　　**fl.1698-1720**
Employed by 1st Earl of Bristol as a copyist from 1710 to 1720. A portrait of a lady, signed and dated 1698 was recorded.

BROWN, Charles Armitage　　　　　**1786-1842**
His portrait of John Keats is in NPG London.

BROWN, Edward Archibald　　　　　**1869-1935**
Born at Ancaster Hall, Lincolnshire. Studied at Slade School. Exhibited at RA (4), RI 1893-1906 from Hertford and Bedford.
Represented: Hertford Museum.

BROWN, Ford Madox　　　　　　　**1821-1893**
Born Calais 16 April 1821, son of a half-pay ship's purser. Studied at Bruges under Albert Gregorius, Ghent under Pieter van Hanselaer and at Antwerp Academy under Baron Wappers 1837-9. Travelled to Paris 1840-3. Settled in London 1844. Visited Rome 1845-6, where he came under the influence of German Nazarene painters. Exhibited at RA (5), BI (5), LA, DG, RHA (4) 1845-58. Took Rossetti as a pupil 1848, and came into contact with the Pre-Raphaelite Brotherhood. Taught at Camden Town Working Men's College from 1854. A leading designer for William Morris 1861-74. Held a one-man exhibition at Piccadilly 1865. Although he is now remembered for his Pre-Raphaelite genre paintings of 'Work' and 'The Last of England' he painted a number of highly competent portraits. They are usually very detailed and he often signed in monogram. Died London 6 October 1893. Buried Finchley Cemetery.
Represented: BM; VAM; Ashmolean; Cecil Higgins AG, Bedford; NPG London; Cartwright Hall, Bradford; Manchester CAG; Tate; Maidstone AG; Birmingham CAG. **Engraved by** J.M.Johnstone. **Literature:** F.M.Heuffer, *F.M.B. A Record of His Life & Works*, 1896; H.M.M.Rossetti, *F.M.B.*, 1901; *The Pre-Raphaelites*, Tate exh. cat. 1984; D.Cherry, *Selected Letters and Journal of F.M.B.*, Ph.D. University of London 1978; V.Surtees, *A Diary of F.M.B*, 1981; DA; Wood.

BROWN, George Henry Alan　LA　　**b.1862**
Born on a British ship at sea 22 October 1862, son of chemist Jacob A.Brown. Studied at Liverpool School of Art. Exhibited at LA. Elected LA 1905. Worked as a portrait and subject artist in Liverpool.
Represented: Blackburn AG; Liverpool Corporation.

BROWN, George Loring (Claude)　　**1814-1889**
Born Boston 2 February 1814. Apprenticed to a wood engraver. Worked in Boston 1834-6, New York 1837 and Shrewsbury, Worcester and Boston 1838. Visited London, Florence and Rome 1839-59. In New York 1862, Boston 1864. Exhibited at Boston Athenaeum, NA, Maryland Historical Society and Pennsylvania Academy and Artists' Fund Society 1834-74. Died Malden, Massachusetts 25 June 1889.

BROWN, Henry Harris　RP NPS　　**1864-1948**
Born Northamptonshire 29 December 1864. Studied in Paris under Bourguereau and Fleury. Settled in London 1891, where he enjoyed a successful practice. Exhibited at RA (55), RHA (10), SBA, NWG (5), RP, Paris Salon 1876-1938. Elected RP 1900. Also worked in USA and Canada. Died Brompton 28 July 1948. Left £33,385.14s.6d.
Represented: Inner Temple; Jeu de Paume, Paris; Museo Horne, Florence.
(Illustration p.112)

BROWN, J.W.　　　　　　　　　**1842-1928**
Born Newcastle-upon-Tyne. Studied there at Government

HENRY HARRIS BROWN. Lady Gwendolen Guinness, wife of Rupert Guinness, 2nd Earl of Iveagh. Signed and dated 1910. 45 x 33ins (114.3 x 83.8cm) *Christie's*

MATHER BYLES BROWN. Henry Blundell. Signed. 30 x 25ins (76.2 x 63.5cm) *Christie's*

School of Design under William Bell Scott. Served as assistant master to the school. After 1866 moved to London and became acquainted with William Morris, later designing stained glass windows for James Powell and painting portraits and genre. Windows by him were placed in the cathedrals of Salisbury and Liverpool. His work was greatly admired by John Ruskin. Left Powell to set up a studio at Stoke Newington. Ill health forced him to leave the country for Australia. Died Salisbury.
Represented: Laing AG, Newcastle.

BROWN, John c.1749-1787
Born Edinburgh 1749 or 1752, son of Samuel Brown, a jeweller and watchmaker. Studied under Alexander Runciman. Visited Italy and Sicily 1771-81 in the company of David Erskine, Mr Townley and Sir William Young. Returned to Edinburgh, was in London 1786. Died Leith 5 September 1787, after returning from London by ship.
Represented: SNPG. **Engraved by** J.De Claussin, P.Dawe, R.Scott. **Literature:** McEwan.

BROWN, John George 1831-1913
Born Gateshead, but was brought up in Newcastle where his father practised law. Aged 14 apprenticed to a glass maker on Tyneside, attending art classes in his spare time. Moved to Edinburgh to work for Holyrood Glass Company. Studied at RSA, winning a prize for his drawing from the antique. Moved to London 1853 to take up portraiture, but a few months later emigrated to America working for William Owen, the leading glass maker in Brooklyn. Studied at NA, New York. Married

his employer's daughter 1855 and once more practised portraiture. His genre paintings of street urchins, which he exhibited at RA, NA, Boston Athenaeum and Pennsylvania Academy, were very popular. Died New York.
Represented: Metropolitan Museum, New York; Concoran AG, Washington DC. **Literature:** Hall 1982.

BROWN, K. fl.1826
Exhibited at RA (1) 1826 from 11 Sidmouth Street, London.

BROWN, Miss M.C. fl.1800-1807
Exhibited at RA (21) 1800-7 from London.

BROWN, Mather Byles 1761-1831
Born Boston, Massachusetts 5 or 7 October 1761 (not 1762), son of clock-maker Gawen Brown and his wife, Elizabeth née Byles. Baptized 11 October 1761 by his grandfather Rev Mather Byles. His mother died 6 June 1763. Taught drawing by his aunt, Catherine Byles. Studied under Gilbert Stuart c.1773. Practised in Massachusetts before settling in England 1781, where he became a pupil of Benjamin West. Entered RA Schools 7 January 1782 aged '19, 5th last October'. Had a successful practice, mainly with American sitters, but also painted large history pictures becoming historical painter to the Prince of Wales. Exhibited at RA (80), BI (28), SBA (23), LA 1782-1833. Appointed Portrait Painter to Duke of York 1789 and to Duke of Clarence 1791. Painted George III. Repeatedly failed to be elected RA, his last attempt being 1795. His practice declined and he began to move about England in search of commissions, from Buckinghamshire to Bath, Liverpool and Manchester. Finally returned to London 1824. Died London 25 May 1831 (not 1 or 25 January). Will proved 3 June 1831 (Prob11/1786). Among his pupils were Thomas Henry Illidge and William Bradley. His portrait style

was highly coloured (often influenced by B.West's palette) and sharply delineated.
Represented: Ugbrooke Park; Beaverbrook AG, Canada; SNPG; NPG London; Huntingdon Library & AG; Walker AG, Liverpool; Boston Athenaeum; San Marino; American Antiquarian Society. **Engraved by** F.Bartolozzi, W.Bromley, A.Cardon, T.Cheeseman, J.Corner, J.Dean, H.Hudson, J.L.Jones, K.Mackenzie, G.Murray, D.Orme, E. Orme jnr, T.Park, W.Ridley, E.Scott, J.R.Smith, C.Turner, Thornthwaite, W.Ward, C.Warren. **Literature:** D.Evans, Ph.D thesis for Courtauld Institute, Washington; D.Evans, *M.B. – Early American Artist in England*, 1982; DA.

BROWN, N. **fl.1736**
Provincial portrait painter. Painted portrait of 'John Buckler of Warminster' 1736.

BROWN, Nathaniel **fl.1765-1779**
Exhibited at FS (57) 1765-79 from London.

BROWN, Robert **d.1753**
Pupil and assistant of Sir James Thornhill. Practised historical and decorative painting, but also produced some portraits. Taught Hayman. Died 26 December 1753.
Literature: DNB.

BROWN, Thomas Austen RI RSW ARSA 1857-1924
Born Edinburgh 18 September 1857. Studied at RSA Schools. Exhibited at RSA (85), RA (18), RHA (1), RSW, GG 1880-1916 from Edinburgh and Hampstead. Elected ARSA 1889 and from c.1896 painted a number of portraits. Died Boulogne 9 June 1924.
Represented: BM; VAM; Glasgow AG; Brussels AG; Leeds CAG. **Literature:** McEwan.

BROWN, W.B. **fl.1799-1831**
Exhibited at RA (16), BI (2), SBA (1) 1799-1831 from London.

BROWN, W.H. **fl.1790-1797**
Many of his portraits were published in The Senator 1790-7.
Engraved by H.Grainger, J.Hopwood, W.Ridley, C.Thomas, C.Warren.

BROWN, William **fl.1848-1855**
Listed as a portrait painter at 6 Grindle Street, Manchester.

BROWN(E), William Garl jnr **1823-1894**
Son of Leicester landscape painter William G.Brown. Moved to America 1837. Exhibited at NA. Established himself as a portraitist in Richmond, Virginia by 1846. Visited Mexico 1847, painting heroes of the Mexican War. Probably travelled South during the 1850s. Settled in New York 1856-65. Married Mary McFeely of Charleston 1876. Died Buffalo 28 July 1894.
Represented: Virginia Military Institute; Corcoran Gallery. **Literature:** Dictionary of Artists in America 1564-1860.

BROWN, William Morrison **b.c.1809**
Born Kingston, Jamaica. Aged 42 in 1851 census. Exhibited at RA (2) 1813-29 from Covent Garden. Worked Liverpool 1840 and Rainhill 1842. Recorded as a portrait and animal painter in Manchester 1855.

BROWNE, Henriette (pseudonym of Sophie de Sauz, née Bouteiller) **1829-1901**
Daughter of Comte de Bouteiller and his second wife. Studied under Perrin from 1849 and C.Chaplin from 1851. Exhibited at Paris Salon from 1853. Married diplomat Jules de Saux c.1853 and worked under pseudonym of 'Henriette Browne'. She was immensely successful. Awarded a medal in Exposition Universel 1855. Patronized by Napoleon III. Enjoyed a considerable reputation in London. Exhibited at RA (5) 1871-9. From the 1870s she began to produce a number of portraits.
Represented: Russell-Cotes Museum, Bournemouth.
Literature: P.Nunn, *Victorian Women Artists*, 1987.

BROWNE (BROUNE), S. (Samuel?) **fl.1680-1691**
May be the Samuel Browne who, with his wife, came from The Hague to London 1680. They had a child baptized 1685. A group portrait of '1st Duke and Duchess of Beaufort and Their Family' (1685) is in the collection of Duke of Beaufort, Badminton. It shows the influence of Caspar Netscher. He sometimes posed his sitters behind a ledge draped with carpet.

BROWNING, E. **fl.1867-1871**
Exhibited at RA (3) 1867-71 from London.

BROWNING, G.F. **fl.1854-1873**
Exhibited at RA (9) 1854-73 from London. Among his exhibited portraits were Princess Beatrice, Viscountess Dupplin and Marchioness of Bute.

BROWNING, G.T. **fl.1858**
Exhibited a crayon portrait of The Hon Captain Monson at SBA (1) 1858 from 40 Montague Street, London.

BROWNING, George **fl.1826-1853**
Exhibited at RA (8), BI (11), SBA (4) 1826-53 from London and Bushey Heath. Probably the George Browning listed as a portrait painter at 23 Parliament Street, Hull 1828-31, whose work was engraved by S.W.Reynolds.

BROWNING, Mrs Harriet A.E. (née Jackson)
 fl.1803-1834
Honorary exhibitor at RA (24), BI (14) 1803-34 from London. Married John Browning c.1816-25.

BRYAN, Alfred **1852-1899**
Specialized in watercolour portraits and caricatures. Among his sitters were Algernon Swinburne and William Creswick.
Represented: NPG London; Brighton AG.

BRYAN, John **fl.1786-1795**
Honorary exhibitor at SA (3), RA (4) 1786-91 from London. Recorded at Stations Court, Ludgate Street 1795.

BRYCE, Alexander Joshua Caleb RBA 1868-1940
Born Amsterdam 17 October 1868, son of William Bryce, a merchant. Educated in England and Holland. Studied art in Glasgow, Manchester and Paris. Exhibited at SBA, RA (10), GG, RP from London and Witham, Essex. Elected RBA 1914. Died 10 January 1940.
Represented: Manchester CAG.

BRYDEN, Olivia Mary **fl.1918-1923**
Her portrait of F.C.Selous is in NPG London.

BRYDEN, Robert RE **1865-1939**
Born Coylton, Ayrshire. Educated at Coylton and Ayr Academy. Studied at RCA and RA Schools. Exhibited at RA (1), RSA (36), RE (155). Produced a large number of portrait etchings, usually of the middle classes. A number of these are in BM. Died Ayr 22 August 1939.
Represented: SNPG; Glasgow AG. **Literature:** McEwan.

BRYER, S. **fl.1828**
Exhibited at RA (1) 1828 from 12 Frith Street, Soho.

ADAM BUCK. Two ladies. Signed and dated 1823. 15½ x 12ins (39.4 x 30.5cm) *Philip Mould/Historical Portraits Ltd*

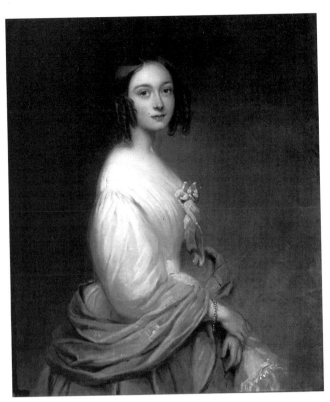

RICHARD BUCKNER. Minnie Seymour, adopted daughter of Mrs Fitzherbert. Signed and inscribed 'Rome'. Painted 1840/1. Panel. 14 x 11ins (35.6 x 28cm) *Christie's*

BUCHEL, Charles A.　　　　　　　　**1872-1950**
Born Germany. Exhibited at RA (20) 1898-1917 from London.
Represented: NPG London. **Literature:** *Windsor Magazine* May 1938.

BUCHSER, E.　　　　　　　　　　　　**fl.1854**
Exhibited at SBA (1) 1854 from Scarborough.

BUCK, Adam　　　　　　　　　　　　**1759-1833**
Born Cork, son of Jonathan Buck, a silversmith. Reportedly studied under Minasi. Had a successful practice in Cork, before travelling to London 1795, where he taught drawing. Exhibited miniatures and watercolour portraits at RA (172), BI (6), SBA (8), NWG (1) 1795-1833. Published *Paintings on Greek Vases*, 1811. Died London. Influenced by neo-classicism. His works have a delicate charm and are usually carefully delineated in pencil and washed in clear thin colours with a concentrated finish on the heads (often using a scraper for the hair). Died Seymour Street, London, and was survived by his wife, Marjory. His sons Alfred and Sidney were also artists.
Represented: VAM; BM; Ashmolean; Manchester CAG; Ulster Museum; Fitzwilliam; NGI; NPG London. **Engraved by** J.Alais, T.Cheeseman, H.R.Cook, M.Gauci, Middlemist, D.Orme jnr, B.Reading, P.Roberts, W.Ridley, C.S.Taylor, Wright & Ziegler. **Literature:** Foskett.

BUCKLAND, Arthur Herbert　RBA　　**b.1870**
Born Taunton 22 January 1870, son of an illustrator. Studied at Académie Julian, Paris (winning medals). Exhibited at RA (19), SBA, RI, ROI, Paris Salon 1895-1927. Painted romantic landscape subjects and genre, as well as portraits.

BUCKLER, William　　　　　　　　**fl.1837-1853**
Painted highly competent watercolour portraits in the Keepsake tradition.
Represented: National Army Museum.

BUCKLEY, John　　　　　　　　　　**fl.c.1835**
Worked in Cork.
Represented: NGI.

BUCKMAN, Percy　RMS　　　　　　　**b.1865**
Born Dorset. Studied at RA Schools. Exhibited at RA (42), RMS, RI, SBA (2) 1886-1937 from London. Art master at Goldsmiths College. Often signed with initials and the year.

BUCKNER, Richard　　　　　　　　**1812-1883**
Born 25 October 1812 at Royal Arsenal, Woolwich, son of Lieutenant-Colonel Richard Buckner of the Royal Artillery and Mary Marsh Peirce. First worked from a studio at the family home in Rumboldswhyke, West Sussex, but after a short spell in the army with 60th Rifles, he went to Rome where he studied under G.B.Canevari. Set up a studio at 95 Piazza Barberini (facing Bernini's Triton fountain and a few yards from the Palace Barberini) and quickly earned a reputation not only for his elegant portraits but also for his delicate water-colours of Italian peasants. Also known to have painted miniatures, which Long describes as 'pretty and delicately painted'. His work attracted the attention of important clients including Queen Victoria and Prince Albert, the Prince of Wales, Queen Adelaide, Lord Kilmorey and Duke of Hamilton. In Rome he was friends with John Gibson and Penry Williams and advised the young Leighton, who painted Buckner's portrait in 'The Death of Brunelleschi' 1852 (Leighton House). Exhibited portraits and Italian figurative subjects at RA (77), BI (32), SBA (44) 1840-77 as well as in Italy and France. Able to

afford a studio in Rome and one in Cleveland Row opposite St James's Palace, but also worked at the family home in Whyke, Chichester. By 1851 Buckner's income was in excess of £2,000 and his first commission for £200 was the portrait of Sir Charles Fitzroy, Governor of Australia (Council Chamber, Sydney). His reputation continued to grow and by the early 1860s his annual income was in excess of £4,000. In 1873 he possibly become too old to travel between Rome and London, for he gave up his studio at Piazza Barberini. Among his collection sold at Christie's at this time were works reputedly by Van Dyck, Nicholas Poussin, Tiepolo, Guardi, Lawrence, Etty and the Smiths of Chichester. Died unmarried in his seventy-second year in London 12 August 1883. Buried Brompton Cemetery. He was an undoubted master in both oil and watercolour, but his work could vary widely in quality and it seems probable that he employed a studio assistant. His oils were usually painted thinly with rapid bravado, adding finishing glazes which gave 'life' to his sitters and his best work has a breathtaking quality. Unfortunately harsh cleaning by bad restorers has removed the finishing glazes of some of his pictures, leaving them flat and coarse. As a colourist he was outstanding, making him the obvious rival to Winterhalter. Maas considers him to be one of the most cultivated of Victorian portrait painters: 'He was one of the few portrait painters of the 19th century whose work could hold its own when hung in country houses alongside the work of Reynolds and Gainsborough'.
Represented: BM; Woburn Abbey; VAM; National Army Museum; Windsor Castle; Osborne; Denne Park, Northamptonshire. **Engraved by** H.Austen, S.Bellin, G.T.Doo, R.J.Lane, W.Walker, G.Zobel. **Literature:** Stewart & Cutten; J.Maas, *Victorian Painters*, 1970; *Apollo* February 1977; *Antique Collector* April 1989; DA.
Colour Plate 14

BUCKSHORN (BOKSHOORN, BOXHORN), Joseph
c.1645-c.1680
Believed to have been born at The Hague and to have come to England c.1670. Acted as a drapery painter for Lely. His portrait of 'Mary Isham' at Lamport Hall owes a strong debt to Lely. Said to have died in London (probably before 1680) aged 35.

BUDD, George fl.1745-1752
Began as a hosier, but turned to art painting portraits, landscapes and still-life. Taught drawing for some years at Dr Newcombe's School, Hackney.
Engraved by McArdell.

BUDD, Herbert Ashwin ROI 1881-1950
Born Ford Green, Staffordshire 10 January 1881, son of Thomas Budd. Studied at Hanley School of Art and RCA 1903-8. Exhibited at RA (34), NEAC, ROI, RP, Paris Salon 1908-48 from London. Married artist Helen Margaret Mackenzie 1915. Served with Queens Westminster Rifles and R.E.Camoulage Section in France. Died 3 June 1950.

BUKOVIC, Vlaho 1855-1923
A Serbo-Croat, who came to England from Paris on the invitation of the art dealers, Vicars Brothers.
Represented: Walker AG, Liverpool.

BULEWSKI, L. fl.1855-1860
Exhibited at RA (2) 1855-60 from London.
Engraved by Swain.

BULKELEY, John fl.1834
Listed as a portrait and miniature painter at 34 Rathbone Place, London.

BULKLEY, William fl.1834
Listed as a portrait and miniature painter at 6 Paddington Green, London.

BULL, Miss Nora fl.1885-1893
Exhibited at RA (5) 1885-93 from Richmond Hill and Wimbledon.

BULLFINCH, John fl.c.1660-1680
Produced small portraits in Indian ink and copies.
Represented: NGI; BM; NPG London. **Engraved by** R.Godfrey.

BULLOCK, George Grosvenor d.1858/9
Exhibited at RA (54), BI (37), SBA (24) 1827-59 from London, where he was listed as a portrait painter.

BULLOCK, Ralph MA 1867-1949
Born Morpeth, son of a greyhound breeder. Studied at Newcastle School of Art and remained there as a member of staff. Exhibited at Bewick Club, Newcastle; Laing AG; RA (2), Newcastle Society of Artists. Received an honorary MA from Durham University in recognition of his contribution to art in Northumbria. Died Forest Hall, Newcastle.
Represented: Laing AG, Newcastle. **Literature:** Hall 1982.

BULMAN, Henry Herbert RBA 1871-1928
Born Carlisle. Moved to London by 1907. Exhibited at RA (17), SBA, NEAC 1807-1929. Elected RBA 1916. Member of Langham Sketching Club. Died London.
Represented: Carlisle AG.

BUNDY, Edgar ARA RBA RI 1862-1922
Born Brighton 29 March 1862. Worked in the studio of Alfred Stevens. Exhibited at RA (62), RHA (4), ROI, SBA, RI 1881-1922 from London. Elected RI, ROI 1891, ARA 1915. Died London 10 January 1922.

BUNNEY, W. fl.1853-1861
Exhibited at RA (4), BI (2), SBA (1) 1853-61 from London.

BURCHER, Frank P. fl.c.1871
His portrait of H.J.Buchan is in Southampton CAG.

BURDEN, J. fl.1796-1814
Exhibited at RA (16), BI (14) 1796-1814 from London and Litchfield.

BURGESS, Miss Adelaide fl.1857-1886
Exhibited at RA (11) 1857-72 and Society of Female Artists from Leamington.
Represented: VAM. **Literature:** Wood.

BURGESS, Miss Eliza Mary RMS ARWA b.1878
Born Walthamstow 2 March 1878. Studied art there and at Royal Female School of Art. Exhibited at RA (45), RMS, RSA, RWA, Paris Salon 1900-51 from Walthamstow. Elected ARWA 1910, RMS 1912.
Represented: Walker AG, Liverpool.

BURGESS, Miss Florence fl.1885-1890
Exhibited at RA (3), SBA (1), NWS (2) 1885-90 from London.

BURGESS, G.H. fl.1871
Exhibited at SBA (1) 1871 from Fitzroy Square, London.

BURGESS, John Bagnold RA 1830-1897
Born Chelsea 21 October 1830, son of landscape painter H.W.Burgess and grandson of portrait painter William Burgess. Studied under Sir W.C.Ross and at Leigh's Academy. Exhibited portraits and Spanish genre subjects at RA (73), BI (15), RHA (1), SBA (4) 1850-96 from London. Elected ARA 1877, RA 1888. Among his sitters were the

sculptor George G.Adams and E.A.Goodall. Influenced by John Phillip. Travelled frequently in Spain with his friend Edwin Long. His Spanish gypsy subjects were extremely popular. Died London 12 November 1897. Left £24,560.12s.7d. Studio sale held Christie's 25 March 1898. **Represented:** Holloway College; NPG London; Worcester CAG. **Literature:** DNB.

BURGESS, John Cart 1798-1863
Exhibited at RA (31), BI (13), SBA (10) 1812-37 from Chelsea. Married Miss Charlotte Smith, daughter of Anker Smith RA 1825. Taught drawing to the royal family. Published on the subject. Died Leamington.
Represented: Newport AG; BM.

BURGESS, John Howard fl.1830-1880
Exhibited at RHA (39) 1830-80 from Dublin, Carrickfergus and Belfast.

BURGESS, Thomas c.1730-1791
Studied at St Martin's Lane Academy. Became a portrait and history painter. Exhibited at FS (18), SA (4), RA (17) 1770-91. His portrait of 'Isaac Polak' (1770) was engraved. Father of artist William Burgess.

BURGESS, William 1749-1812
Son of artist Thomas Burgess. Won a premium at SA 1761 and kept a drawing Academy. Exhibited SA (24), FS (16), RA (46) 1762-1811 from London. Died Sloane Square, Chelsea 12 May 1812, aged 63. His grandson was John Bagnold Burgess RA.
Represented: BM; Newport AG.

BURGHERSH, Lady Priscilla Ann 1811-1879
Born 26 June 1811, daughter of 3rd Duke of Mornington. Married Lord Burghersh (later 11th Earl of Westmorland). Painted a large full-length portrait of Anne Countess of Mornington surrounded by effigies of her sons Marquess Wellesley, Lord Mornington, Duke of Wellington and Lord Cowley (Apsley House). Died 18 February 1879.
Engraved by F.Bromley, T.Hodgetts.

BURGUM, John 1826-1907
Born Birmingham. Began as a coach painter and portraitist. Moved to Concord, New Haven 1850.

BURKE fl.1772-1781
Bath portrait painter. Exhibited portraits in chalks at SA (1), RA (2) 1772-81.

BURKE, Harold Arthur VPRBA 1852-1942
Born London 28 January 1852, son of James St George Burke QC. Educated at Cheltenham College and Liège University. Studied art at RCA, RA Schools and in Paris at École des Beaux Arts under Gérôme and Lecomte. Exhibited at RA (3), RHA (1), SBA from 1890. Elected RBA 1899 and Vice President from 1915-19. Married Beatrix Aveling 1893. Lived in London and at Findon, Sussex. Died 5 January 1942. Left £15,433.19s.9d.

BURKLY, Z. fl.1852
Exhibited at SBA (1) in 1852.

BURLINGTON Dorothy, Countess of 1699-1758
She was Lady Dorothy Savile, elder daughter and co-heir of the Marquess of Halifax. Married Richard, 3rd Earl of Burlington 21 March 1720/1. Vertue (iii, 115) records seeing with approval very many of her crayons, many of them copied from earlier portraits. Sometimes signed 'D.Burlington/pinxt'. Her habit of cursing and blaspheming

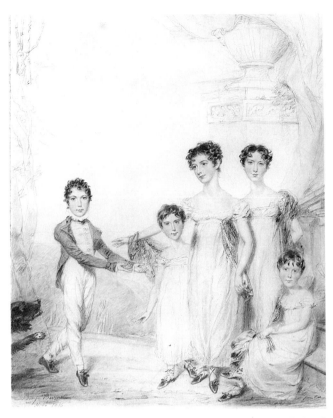

BENJAMIN BURNELL. The Wyld Children. Signed and dated November 1819. Pencil and coloured chalks. 20⅝ x 16¼ins (52.4 x 41.3cm) *Christie's*

was recorded by both Lord Hervey and Horace Walpole, and she once engaged in an abusive dialogue from her box during an opera. Died 21 September 1758.
Represented: Hardwick Hall; Chatsworth. **Engraved by** J.Faber jnr.

BURLISON, Clement 1815-1899
Born Eggleston, son of William Burlison, a clerk of works to an architect. Studied at Mechanics' Institute, Durham. Worked as a coach painter. Practised portrait painting around Stockton-on-Tees and Hartlepool. Visited London, Paris, Rome and Venice copying old masters and painting original works. Exhibited at RA (10), BI (15) and in Newcastle 1846-66. Died Durham.
Represented: Darlington AG; Gray AG & Museum, Hartlepool; Old Town Hall, Durham.

BURNARD, Victor Wyatt RBA RMS 1868-1940
Born Poole, Dorset 14 April 1868, son of William Wyatt Burnard, a chemist. Studied at RCA (diploma 1898) and in Paris. Exhibited at RA (12), SBA, RHA, Paris Salon 1912-40. Also an illustrator. Lived in Guildford. Died Westfield Nursing Home, Guildford 23 September 1940.

BURNE-JONES, Sir Edward Coley ARA OWS 1833-1898
Born Birmingham 28 August 1833, son of Edward Richard Jones, a gilder and frame maker and Elizabeth (née Coley) who died when he was born. Educated at King Edward's Grammar School, Birmingham and Exeter College, Oxford, where he met William Morris. Inspired by Ruskin, encouraged by Rossetti and the Pre-Raphaelites, and until 1877 produced work for Morris & Co. After that date his reputation grew. Exhibited at RA (2), RWS, GG, NWG 1886-94. Elected AOWS 1864, OWS 1868, ARA 1885,

baronet 1894. Died Fulham 17 June 1898. Among his followers were Marie Stillman, Frederick Sandys, Simeon Soloman, J.M.Strudwick, T.M.Rooke, J.R.Spencer Stanhope, Charles Fairfax Murray and Evelyn de Morgan. From the mid-1860s he employed a number of student assistants.
Represented: BM; VAM; Tate; Ashmolean; Brighton AG; Cecil Higgins AG, Bedford; Southampton CAG; Birmingham CAG; Fitzwilliam; Manchester CAG. **Literature:** A.Alexandre, *Sir E.B.J.*, 1894; M.Bell, *Sir E.B.J.*, 1898; A.L.Baldry, *B.J.*, 1909; J.Cartwright, 'The Life and Work of B.J.', *Art Journal* 1894; D.Cecil, *Visionary and Dreamer*, 1969; M.Harrison & W.Waters, *B.J.*, 1973; P.Fitzgerald, *B.J.*, 1975; DNB; *The Pre-Raphaelites*, Tate exh. cat. 1984; J.Hartnoll, *The Reproductive Engravings after Sir E.C.B.J.*, 1988; W.Waters, *B.J.*, Shire 1974; DA.

BURNE-JONES, Sir Philip, Bart 1861-1926
Born 2 October 1861, son of Sir Edward Burne-Jones and Georgina (née Macdonald). Educated at Marlborough and University College, Oxford. Exhibited at GG (2), RA (18), NWG (35), Paris Salon 1898-1918. Among his sitters were Watts, Lord Rayleigh, Sir Walter Gilbey and his cousin Rudyard Kipling. Committed suicide 21 June 1926.
Represented: NPG London.

BURNELL, Benjamin fl.1790-1828
Exhibited at RA (105) 1790-1828 from London. Among his sitters were Lord Henniker, Sir J.H.Astley, Viscountess Fielding and The Hon. General Fitzroy.
Represented: NPG London. **Engraved by** W.Evans.

BURNET, John HRSA FRS 1781-1868
Born Edinburgh March 1781 (Ottley) or Fisherrow 20 March 1784 (McEwan), son of Surveyor-General of Excise for Scotland. Apprenticed to engraver Robert Scott. Studied at Trustees' Academy at the same time as Wilkie and William Allan. Moved to London 1806 and concentrated on engraving. Exhibited at RA (4), BI (30), SBA (5) 1808-62. Published a number of books on art and artists. Died Stoke Newington.
Represented: BM; VAM; SNG; Aberdeen AG; Wolverhampton AG. **Literature:** *Art Journal* 1850, 1868; Ottley; McEwan; DA.

BURNETT, Cecil Ross RI 1872-1933
Born Old Charlton, Kent 27 April 1872, son of W.C.Burnett, a banker. Studied at Blackheath School of Art from 1888 under Joseph Hill, Westminster School of Art, and RA Schools where he won the Turner Gold Medal, a £50 scholarship, and first prize for portrait painting. Exhibited at RA (18), GG (1), ROI 1896-1929. Elected RI 1910. Started Sidcup School of Art c.1898 and was head for many years. Lived at Blackheath and at Amberley, Sussex, where he painted landscape and rustic scenes.
Represented: Brighton AG.

BURNEY, Edward Francesco 1760-1848
Born Worcestershire 7 September 1760, nephew of Charles Burney, and cousin of Fanny Burney, whose book *Evelina* he illustrated. Entered RA Schools 1777. Exhibited at RA (19) 1780-1803 from London. Also designed scenes for lids on snuff boxes and after 1803 worked mainly as a illustrator. Died London 16 December 1848. His style is linear and has considerable charm and delicacy.
Represented: NPG London; Brighton AG. **Engraved by** S.Bull, J.Fittler, J.Heath, H.Meyer, E.Scriven, Thornthwaite, C.Turner, W.Holl. **Literature:** DA.

BURNEY, James see MACBURNEY, James

BURNS, Cecil Laurence 1863-1929
Studied under Herkomer at Bushey c.1887-8. Exhibited at RA (9), SBA (2), NWG 1883-94 from London and Lympne, near Hythe. Principal of Camberwell School of Arts and Crafts 1879-99 and Principal of Bombay School of Art 1899-1918. Died Kensington 26 July 1929. Left £27,232.13s.1d.
Literature: 'Professor Herkomer's Art School', *Art Journal* 1892, pp.292-3.

BURNS, James fl.1840
Listed as a portrait painter at 8 Melbourne Terrace, Manchester.

BURNS, Robert ARSA 1869-1941
Born Edinburgh 9 March 1869. Studied at South Kensington Schools and in Paris, before returning to Edinburgh. Exhibited at RSA (54). Elected ARSA 1902. Died 30 January 1941.
Represented: Aberdeen AG; SNG. **Literature:** McEwan.

BURRAS, Miss Caroline Agnes b.1890
Born Leeds 2 August 1890. Studied at Leeds College of Art. Exhibited portraits and miniatures at RA (8), RMS, Paris Salon 1918-27 from Horsforth, Leeds.

BURRELL, Mrs H. Théonie c.1870-1920
Exhibited portraits and miniatures at Bewick Club, RA (9), SBA, Laing AG and Society of Women Artists 1900-20 from Newcastle. Elected Associate of Society of Women Artists 1905.

BURROUGHS, A. Leicester fl.1881-1916
Exhibited at RA (15), SBA (3), NWS 1881-1916 from London.

BURROW, Miss C.F. Severn fl.1899-1903
Exhibited at RA (3) 1899-1903 from Kensington and Chelsea.

BURROW, J. fl.1800
Exhibited a portrait of Mr Bennet at RA (1) in 1800.

BURT, Albin Roberts 1783-1842
Born 1 December 1783, son of Harry Burt and Mary (née Roberts). His brother was Secretary to Lord Nelson and his mother was intimate with Emma Hamilton. Trained as an engraver under Robert Threw and Benjamin Smith and later turned to portraiture. Exhibited at RA (2), SBA (1) 1807-30 from London. Also worked as an itinerant portrait painter in Bath, Worcester, Birmingham, Warwick, Oxford, Chester, Reading and Southampton painting anybody 'from a lord down to a "boots"'. Married Sarah Jones 1810 and had eight children who he kept in 'good style'. Died Reading 18 March 1842. Charged 3 guineas upwards for miniatures on ivory and 5 to 10 guineas for small full-length portraits. Often signed his works 'Burt' followed by date, or 'A.R.Burt' followed by place and date. His son, Henry W. Burt, was also a portrait painter, who opened a drawing school in Reading c.1830.
Represented: Reading AG. **Engraved by** W.Raddon; J.Skelton. **Literature:** S.Uwins, *A Memoir of Thomas Uwins*, 1858.

BURTON, Miss Alice RBA b.1893
Born Nogent-sur-Oise 21 September 1893. Studied at Byam Shaw and Vicat Cole School of Art and at Regent Street Polytechnic School. Exhibited at RA (17), RP, NPS, Paris Salon 1929-68 from London and Towcester, Northamptonshire.

BURTON, Arthur P. fl.1894-1901
Exhibited at RA (13) 1894-1901 from London.

BURTON, Sir Frederick William **RHA FSA OWS**
 1816-1900
Born Corofin House, Inchiquin Lake, County Clare 8 April
1816, third son of Samuel Frederick Burton and his wife
Hannah (née Mallet). Studied under the Brocas brothers in
Dublin and was influenced by George Petrie. Exhibited at
RHA (102), RA (8), SBA (2), OWS 1832-74. Elected ARHA
1837, RHA 1839, AOWS 1854/5, OWS 1855/6, FSA
1863. Made several visits to Germany and lived in Munich for
seven years from 1851, during which time he made annual
visits to London. Joined Wilde on his ethnological expedition
to the Aran Island 1857. On the Council of RIA and a
founder member of Archaelogical Society of Ireland. Director
of NGI 1874-94. Knighted on his retirement 1894. Died
unmarried in Kensington 16 March 1900. Buried Dublin.
Left £10,451.16s. Often signed in monogram or with initials.
Fond of bright, rich colouring and moved to a manner
influenced by the Pre-Raphaelites.
Represented: NPG London; SNPG; BM; VAM; NGI;
Manchester CAG; Birmingham CAG; Newport AG; Aberdeen
AG. **Engraved by** J.Kirkwood, R.J.Lane. **Literature:** DA.

BURTON, J. fl.1848-1858
Exhibited at RA (2), SBA (1) 1855-8 from 68 Newman
Street, London. Often confused with marine painter James
Burton.

BURTON, John c.1830-1900
Worked Nottingham, where he had a portrait studio in
Portland Road.

BURTON, Mungo **ARSA** 1799-1882
Born Colinton. Exhibited at RSA (172) 1838-80 from
Edinburgh. Elected ARSA 1845. Had an extremely successful
portrait practice. Died 1 November 1882.
Represented: Yale. **Literature:** McEwan.

BURTON, Turham fl.1838-1847
Exhibited at RA (6), BI (2), SBA (1) 1838-47 from London.
Painted a portrait of Hon. Edward R. Petre for the Public
Rooms at Selby, Yorkshire.

BURTON, W.K. fl.1803-1804
An honorary exhibitor at RA (2) 1803-4 from London.

BUSHMAN, J. fl.1820
An honorary exhibitor at RA (1) 1820.

BUSK, Miss E.M. fl.1873-1889
Exhibited portraits including 'The Earl of Selborne, for
Trinity College, Oxford' at RA (13), 1873-89 from 32
Harley Street.

BUSS, Robert William 1804-1875
Born London 4 or 29 August 1804, son of R.W.Buss, an
engraver and enameller. Apprenticed to his father. Studied
under George Clint. First painted theatrical portraits and then
historical genre. Exhibited at RA (25), BI (20), SBA (45),
NWG (7) 1826-55 from London. Entered House of Lords
Competition 1844-5. Editor of *The Fine Art Almanack* and
English Graphic Satire. Among his sitters were Robert Graves
and a number of actors and actresses from Theatre Royal. Died
Camden Town 26 February 1875. Left effects under £400.
Represented: BM; VAM; Fitzwilliam; Newport AG.
Engraved by G.Adcock, G.Hollis, J.R.Jackson,
C.E.Wagstaff, R.Woodman. **Literature:** *Notes and Queries* 24
April 1875 pp.330-31; *Athenaeum* 1875 p.366.

BUSSY, Simon 1870-1954
Born Dôle in the Jura. Studied in Paris under Gustave
Moreau, where Henri Matisse, George Rouault and Albert
Marquet were also pupils. In 1902 moved to London and set
up as a portraitist, with an introduction to Sir Richard and
Lady Strachey, parents of the writer Lytton Strachey. Married
against opposition their daughter, Dorothy, and became part
of the Bloomsbury group. Divided his time between France
and England, exhibiting in London and Paris.
Represented: NPG London; Tate. **Literature:** M. Rogers,
Master Drawings from the NPG, 1993.

BUTLER, Charles Ernest 1864-c.1918
Born St Leonards-on-Sea 10 October 1864. Studied at St
John's Wood School of Art and RA Schools. Exhibited at RA
(22) 1889-1918 from Chelsea, Fulham and Kensington.

BUTLER, Edward fl.1852-1853
Listed as a portrait painter at 9 St Mary's Butts, Reading.

BUTLER, Miss Hester fl.1910-1928
Exhibited at RA (2) 1910-28 from Newmarket and
Petersfield.

BUTLER, J. fl.1820
Produced portraits for Caulfield's *Remarkable Persons* 1820.
Engraved by R.Grave, J.McArdell.

BUTLER, Mrs Violet fl.1918-1937
Exhibited portraits and miniatures at RA (11) 1918-37 from
Middlesex.

BUTTERFIELD, Clement fl.1896
Exhibited at RA (1) 1896 from St John's Wood.

BUTTERY, Thomas C. b.c.1802
Born Portland Street, London. Aged 59 in 1861 census.
Exhibited at RA (6) 1825-9 from Newington. His son
Edwin, was a landscape painter.

BUTTLAR, Mrs fl.1824
Exhibited at RA (1) 1824 from 66 Margaret Street, London.

BUXTON, J. fl.1818
Exhibited at RA (2) 1818 from 6 Norton Street, London.

BYER, Nicholas d.1681
Possibly born Trondheim, Norway. Made a denizen 2
November 1662. Employed in the last years of his life by Sir
William Temple, and died at his house in Sheen.

BYLES, William Hounsom 1872-1928
Born 79 East Street, Chichester 19 February 1872, son of
Edward Byles, a wine merchant and Jessie (née Scott).
Studied at St John's Wood and RA Schools winning prizes.
Exhibited at RA (8), NWG 1894-1916 from London and
Chichester. Illustrated for magazines. Lived in New Zealand
1906-10. Joined 2nd Battalion of Artists' Rifles and served in
France and Russia. Died in his sleep at Westerton, near
Chichester 12 February 1928.
Literature: *West Sussex Gazette* 23 February 1928.

BYNG, Edward c.1674-1753
Baptized Chirton, Wiltshire 12 April 1674, son of Thomas
and Ann Byng and brother of Robert. Assistant and drapery
painter to Kneller from c.1693 and was chief assistant at the
time of Kneller's death in 1723. Charged in Kneller's will to
complete unfinished portraits. Seems to have inherited the
drawings which were left in Kneller's studio, many of which
are now in BM. His will was proved March 1753.

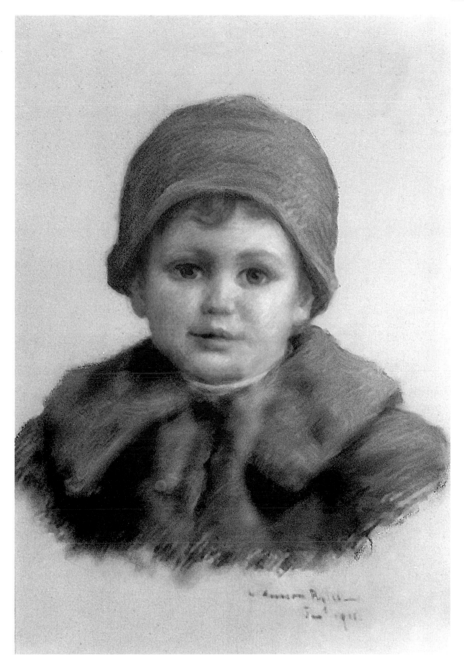

WILLIAM HOUNSOM BYLES. Richard Alexander Sadler. Signed and dated January 1911. Pastel. 11½ x 9½ins (29.2 x 24cm) *Private collection*

BYNG, Robert d.1720
Baptized Wiltshire 11 September 1668, son of Thomas and Ann 'Binge' and brother of Edward. His earliest dated portraits were painted c.1697, and show the influence of Kneller, who may have been his master. Lived in Oxford since before 1714. Buried Oxford 10 August 1720. **Represented:** Bodleian Library. **Engraved by** J.Faber jnr, W.Parsons, R.Williams.

BYRNE, Daniel fl.1836-1880
Exhibited portraits and miniatures at RHA (6), RA (20) 1836-80 from Dublin, London, Wickham and Brighton.

BYRON, William, 4th Lord 1669-1736
Amateur portrait painter and etcher. Born 4 January 1669 and inherited the title 1695. Gentleman of the Bedchamber to Prince George of Denmark. Received lessons from P.Tillemans and his portrait of the '1st Earl of De La Warr' was engraved. Married Mary, daughter of John 3rd Earl of Bridgewater 1703, but she died of smallpox within three months of the marriage. Married Frances, 3rd daughter of William 1st Earl of Portland 1706. His third wife was Frances, second daughter of William, Lord Berkley of Stratton. Died Newstead 8 August 1736.

BYWATER, Miss Katharine D.M. fl.1883-1890
Sister of flower painter Elizabeth Bywater. Exhibited at RA (9), SBA (1) 1883-90 from 5 Hanover Square, London.

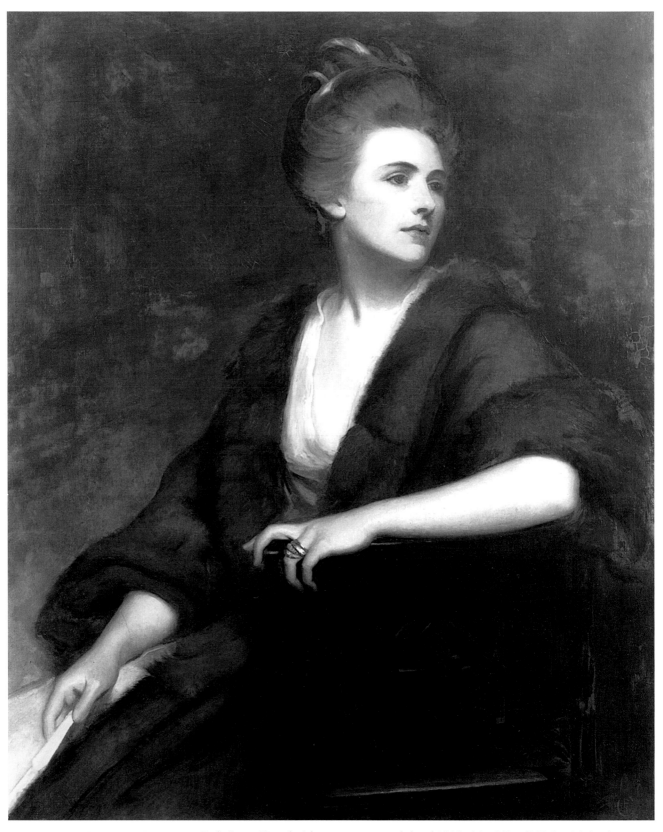

PHILIP HERMOGENES CALDERON. Lady Betty. Signed with a monogram and dated 1890. 44 x 34ins (111.8 x 86.4cm)

Christie's

C

CADDICK, Richard 1748-1831
Born Liverpool 7 June 1748, son of portrait artist William Caddick snr. Member of first Society of Artists in Liverpool 1769. Wrote desiring to study at Academy of SA, London August 1770, when he stated that he was already a portrait painter by profession and well known to Mr Stubbs and Mr Wright. Thought to have retired c.1805, when he is described in directories as 'a gentleman'. Died Liverpool. Buried 27 May 1831. Left Martha, his only surviving daughter, an estate valued at under £4000.
Represented: Walker AG, Liverpool.

CADDICK, William snr 1719-1794
Probably born Liverpool 9 April 1719. A friend of G.Stubbs, the two artists reportedly studying together. Travelled to London with William Clarke 1746, visiting the studios of Joseph Van Aken, Hudson, Ramsay, Rysbrack and William Rice. They met A.Van Aken and Henry Pickering at Queen's Head Tavern, and saw the Bluecoat Hospital and Thornhill's decorations at Greenwich. Said to have married Eliza Wood of the Burslem family of potters. Worked in Chester 1747, but settled in Liverpool, where he became the leading portrait painter. Died Liverpool 29 December 1794. His sons Richard and William jnr were also portrait painters. It is likely the family worked together on portraits as a family business.
Represented: Walker AG, Liverpool

CADDICK, William jnr 1756-1784
Born Liverpool 16 June 1756, son of artist William Caddick. Exhibited at RA (1) 1780 from Liverpool, where he died 12 March 1784.

CADELL, Francis Campbell Boileau RSA RSW
1883-1937
Born Edinburgh 12 April 1883. Encouraged by Arthur Melville. Studied at RSA 1897-9 and in Paris and Munich. Served in 1st World War for 9th Royal Scots and then 8th Argyll and Sutherland Highlanders. Exhibited mainly in Scotland and with P.W.Adam, co-founder of Society of Eight, Edinburgh. RSA (77), RSW (12) 1908-1935. Died of cancer in Edinburgh 6 December 1937.
Represented: Aberdeen AG; Gracefield AG; Dundee AG; Glasgow AG; Greenock AG; Kirkcaldy AG; Paisley AG; Manchester CAG; Rochdale AG; Edinburgh AG. **Literature:** T. Hewlett, *C. – A Scottish Colourist*, 1988; McEwan.

CADENHEAD, James RSA RSW NEAC 1858-1927
Born Aberdeen 12 January 1858, son of George Cadenhead, an advocate. Educated at Dollar Institute, Aberdeen Grammar School and Aberdeen University. Studied at RSA and in Paris under Duran. Exhibited at RSA (148), RSW (4), NEAC 1880-1931. Elected ARSA 1902, RSA 1921, founder NEAC. Died Edinburgh 22 January 1927. Influenced by Japanese art.
Represented: SNPG; Edinburgh AG; Aberdeen AG, Dundee AG; Manchester CAG; Kirkcaldy AG. **Literature:** McEwan.

CAFE, Thomas Smith 1793-after 1840
Listed as a portrait painter at 80 Newman Street, London. Exhibited coastal scenes and landscapes at RA (11), BI (3), SBA (8), NWS (1) 1816-40.
Represented: BM.

CAFE, Thomas Watt RBA 1856-1925
Born London. Educated there at King's College. Studied art at RA Schools. Member of Dudley and Cabinet Picture Society. Wrote articles on art for newspapers. Known mainly for his landscapes and classical 'Alma-Tadema like' scenes, although he did paint a number of portraits, usually of family and friends. Exhibited at RA (21), SBA (4) 1876-1900 from St John's Wood, London. Died April 1925.

CAHUSAC, John Arthur FRS FSA c.1802-1866/7
A portrait drawing by him was engraved and published 1818. Exhibited at RA (19), BI (6), SBA (35), NWS 1827-60 from London. Elected NWS 1834-8, FSA 1840/1.
Engraved by W.Florio.

CALCUTT, Miss fl.1846
Exhibited at RHA (5) 1846 from Gortaclob, Co Clare.

CALDERON, Elwyn fl.1897-1898
Studied at RA Schools. Exhibited from there at RA (3) 1897-8.

CALDERON, Fred fl.1896
Studied at RA Schools. Exhibited from there at RA (2) 1896.

CALDERON, Philip Hermogenes RA 1833-1898
Born Poitiers 3 May 1833, only son of Rev J.Calderon, a Spanish priest and later professor of Spanish literature at King's College, London. Moved to London aged 12. Entered J.M.Leigh's Art School 1850. Visited Paris 1851, studying under F.E.Picot. Exhibited at RA (104), BI (6) 1853-97. Elected ARA 1864, RA 1867. Gold Medal at Paris International Exhibition 1867 (the only English artist to win one that year). Lived in St John's Wood, London and was leader of The Clique. Concentrated on portrait painting from 1870, but continued to produce important subject paintings. Appointed RA Keeper 1887 and managed RA Schools. In 1891 his version of 'The Renunciation of St Elizabeth of Hungary' (Tate) showed her kneeling naked before an altar and gave great offence to Roman Catholics. The picture caused further controversy when a man, in the spirit of Calderon's St Elizabeth, stripped naked in a crowded church in Nottingham to renounce worldliness. A scuffle broke out and he was forcibly removed. Among Calderon's sitters were the Marchioness of Waterford, Mrs Bocklehurst and his friend Henry Stacey Marks. Stephen Smith writes 'He was a man of splendid stature and physique, with the appearance of a Spanish hidalgo'. When questioned as to his nationality he was wont to reply: 'My father was a Spaniard, my mother was French, therefore I am naturally an Englishman'. Died at Burlington House 30 April 1898. Buried Kensal Green Cemetery.
Represented: Tate; Leeds CAG. **Literature:** B.Hillier, 'The St John's Wood Clique' *Apollo* June 1964; Maas; M.H. Stephen Smith, *Art and Anecdote*, nd.; DA; *Wandsworth Observor* 12 November 1892.

CALDERON, William Frank ROI 1865-1943
Born London, son of Philip Hermogenes Calderon RA. Studied at Slade under Le Gros. Founder and Principal of a School of Animal Painting 1894-1916. Exhibited at RA (34), RHA (6), SBA (3) 1882-1921. His first exhibited painting at RA, 'Feeding the Hungry', was bought by Queen Victoria. Published *Animal Painting and Anatomy*, 1936. Died 21 April 1943.

CALDERWOOD, William Leadbetter 1865-1950
Born Glasgow 19 February 1865, son of Henry Calderwood, professor of moral philosophy. Studied zoology at Edinburgh University and in Naples and Germany. Worked for Fishery Board of Scotland, the Marine Biological Association, Plymouth and Inspector of Salmon Fisheries for Scotland. An accomplished amateur painter of portraits. Exhibited in Liverpool and at RSA from Edinburgh. Also painted in Italy, Spain and America. Wrote

a number of books on salmon. Died 2 or 5 May 1950.
Literature: McEwan.

CALDWALL, James **b.1739**
Born London. Studied under Sherwin. Exhibited engravings and portraits at SA (1), FS (29) 1768-80 from Great Windmill Street, London. His portraits included Henry Oxenden, Admiral Keppel, Sir Roger Curtis and Mrs Siddons. Recorded working 1789. His brother, John Caldwall c.1738-1819, was a miniaturist.

CALKIN, Lance RBA ROI **1859-1936**
Born London 22 June 1859, son of George Calkin a musician. Studied at South Kensington, Slade and RA Schools. Exhibited at RA (30), SBA (14), GG, NWG, ROI 1881-1926. Elected RBA 1884, ROI 1895. Among his sitters were Edward VII, George V, William Logsdail, Scott of the Antarctic and Sir John Tenniel. Died 10 October 1936.
Represented: NPG London; HMQ; Guildhall AG, London; Birmingham CAG.

CALLCOTT, Sir Augustus Wall RA **1779-1844**
Born The Mall, Kensington Gravel Pits 20 February 1779, son of a bricklayer and builder. Chorister at Westminster Abbey for six years, before studying at RA Schools from 1797 and under Hoppner. First exhibited mainly portraits, but soon concentrated on genre, coastal and landscape paintings enjoying a considerable popularity. Based in London at Kensington Gravel Pits, he travelled to Holland, the Rhine and Italy. Exhibited at RA (129), BI (14) 1799-1844. Elected ARA 1806, RA 1810. His last exhibited portrait was in 1810. For many years he was keeper of the Royal Collection. Knighted 1837. Died Kensington 25 November 1844. Buried Kensal Green Cemetery. Studio sales held Christie's 8-11 May 1845 and 22 June 1863.
Represented: VAM. **Engraved by** J.Heath, F.C.Lewis. **Literature:** *Art Union* 1845 p.15; J.Dafforne, *Pictures by Sir A.W.C.,* 1878; DA; DNB; *Connoisseur* 184 1973 pp.98-101.

CALLCOTT, J.Stuart **fl.1862-1868**
Exhibited at RA (7), BI (2) 1862-8 from London.

CALLOW, Benjamin **fl.1855**
Listed as a portrait and landscape painter in St Jude's Terrace, Fairclough Lane, Liverpool.

CALTHROP, Claude Andrew **1845-1893**
Born near Spalding, Lincolnshire. Studied under John Sparkes. Exhibited at RA (43), BI (1), SBA (12) 1865-93. Lived for a time at 11 Boulevard de Clichy in Paris. Exhibited at Salon des Société des Artistes Français. Died London. His work was admired by John Ruskin.
Represented: Tate.

CALVER, Henry **fl.1836**
Listed as a portrait painter at 37 London Street, Norwich.

CALVERT, Charles **1785-1852**
Born Glossop Hall, Derbyshire. Gave up a cotton business to work as a painter. Exhibited at RMI. Listed as a portrait painter in Manchester 1825-48. Died Bowness, Westmorland.
Represented: VAM. **Literature:** Wood.

CALVERT, George **fl.1841**
Listed as a portrait painter at Drury Lane, Wakefield, Yorkshire.

CALVERT, Henry **1798-c.1869**
Born Darlton, near Tuxford, Nottinghamshire. Specialized in sporting and animal paintings. Exhibited at RA (4) 1826-54. Listed as a portrait artist at 104 Kings Street, Manchester 1855.

CALZA, E.F. see CUNNINGHAM, Edward Francis

CAMBIER, Nestor **fl.1916-1931**
Brussels painter. Exhibited at RA (3) 1916-31 from Henley-on-Thames.

CAMBRUZZI, de **fl.1775-1777**
Exhibited crayon portraits at RA (2) 1775-7 from London. Probably the Italian Giacomo Cambruzzi 1744-after 1803.

CAMERON **fl.c.1770**
Provincial Scottish portrait painter. His portrait 'Will. Howison' is at Gosford and is listed in the 1771 catalogue.

CAMERON, Alexander **fl.1845**
Signed and dated a portrait of Lady Ochterlong 1845.

CAMERON, Hugh RSA RSW **1835-1918**
Born Edinburgh 4 August 1835. Studied at Trustees' Academy under S.Lauder. Settled in London 1876-88, but later spent the summers at Largo and the winters in Edinburgh. Exhibited at RSA (184), RA (25), SBA (1) 1854-1915. Elected ARSA 1859, RSA 1869, RSW 1878. Died Edinburgh 15 July 1918. Some of his earlier works have a Pre-Raphaelite finish.
Represented: SNG; Paisley AG; Kirkcaldy AG. **Literature:** L. Errington, *Masterclass – Robert Scott Lauder and His Pupils,* SNG exh. cat. 1993; McEwan.

CAMMELL, Bernard Edward **1850-1932**
Born 30 June 1850, son of Archibald Allen Cammell. Educated at Repton and Trinity College, Cambridge. Exhibited at RA (5), GG 1883-1913 from London. Married Jane Wellesley 10 January 1878, grand-niece of 1st Duke of Wellington. Died 19 November 1932.

CAMPANILE, Richard **fl.1832-1834**
Listed as a portrait painter at 5 Montague Street, London.

CAMPBELL, John Hodgson **1855-1927**
Born Newcastle, son of J.T.Campbell. Studied at Newcastle School of Art. Aged 14 apprenticed in William Wailes' stained glass manufactory. Went to Edinburgh and studied at Statue Gallery. On the death of his father in 1880 he returned to Newcastle and set up a portrait practice there. Exhibited in Newcastle and at RA (5), RSA, ROI from 1884. Member of local literary and artistic societies and painted a number of landscapes in watercolour. Died Whickham, near Gateshead.
Represented: Shipley AG; BM; Gateshead AG; South Shields Museum & AG; Laing AG, Newcastle.

CAMPBELL, Reginald Henry **b.1877**
Born Edinburgh 2 December 1877. Studied at RSA Schools receiving Maclaine-Watter's Medal 1899. Exhibited at RA (1), RSA, RP, GI and abroad from London.

CAMPBELL, Ronald **b.c.1814**
Born Hampshire. Listed as a portrait painter aged 37 in 1851 census for Newman Street, London. His three children were born in Edinburgh. Exhibited RSA 1839-1845. Among his sitters was 7th Duke of Argyll.
Engraved by E.Burton.

CAMPLIN, Joseph M. **b.c.1807**
Born Stafford, Warwickshire. Listed in 1851 census for London as a portrait painter aged 44.

CAMPO-TOSTO, Octavia **fl.1871-1882**
Sister of Belgian artist Henry Campo-Tosto. Exhibited at RA (4), RHA (1) 1871-82. Lived with her brother at 7

Kensington Gardens Square, London. Among her sitters was His Excellency the General Mohsin Khan, Persian Minister.

CANAVARI (CANOVARI), Giovanni Baptista **1789-1876**
Born Genoa 4/11 March 1789. Worked as a portrait painter, miniaturist and copyist in Leghorn, Florence, Lucca, Turin, Rome and possibly London. Joined Imperial Guard in Florence and took part in the war against France. On his return to Italy he was patronized by King Carlo and many noble families. Exhibited at RA (2) 1853-4 from 34 Rathbone Place, London and was possibly the S.Canavari who exhibited at RA (4) 1848-71 from Rome. Died Rome 11 June 1876. Schidlof notes that before his death he offered a large number of drawings and sketches to Academy St Luc, Rome. A gifted and accomplished artist. Richard Buckner was a pupil.
Represented: NGI. **Literature:** L.R. Schidlof, *The Miniature in Europe*, 4 vols, 1964.

CANNON, Miss Edith M. **fl.1892-1904**
Painted portraits and domestic figurative subjects. Exhibited at RA (1), SM 1892-1904 from 7 Windsor Road, Ealing.

CANON, Hans **1829-1885**
Born Johann von Straschiripka near Vienna, where he studied at the Academy as a pupil of Waldmuller and Rahl. Became an officer in the Austrian army and travelled in the Orient, England, France and Italy. Died near Vienna. Painted a number of outstanding portraits.

CANOVARI **see CANAVARI, Giovanni Baptista**

CANZIANI, Mme **see STARR, Miss Louisa**

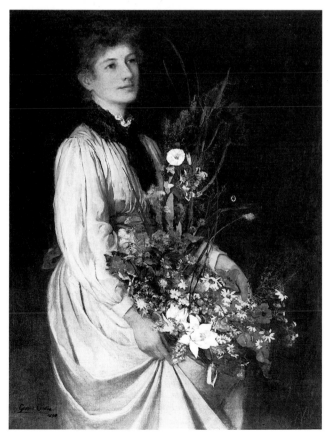

GEORGE F. CARLINE. An apron full of meadow flowers. Signed and dated 1890. 30 x 20ins (76.2 x 50.8cm) *Christie's*

CANZIANI, Estella Louisa Michaela **RBA 1887-1964**
Born London 12 January 1887, daughter of portraitist Louisa Canziani. Studied at Cope and Nichol School and at RA Schools (winning medals). Exhibited at RA, SBA, RI and in Liverpool, Milan, Venice and France. Wrote and illustrated a number of books.
Represented: Birmingham CAG. **Literature:** E.Canziani, *Round About Three Palace Green*, 1939.

CAPON, William **1757-1827**
Born Norwich 6 October 1757. Commenced painting portraits under his father. Shortly gave this up to follow architecture, scene painting and decorative painting. Died London 26 September 1827.
Literature: DNB.

CAPPE, J. **fl.1780**
Exhibited at RA (1) 1780 from Covent Garden, London.

CARBONNIER, Casimir **1787-1873**
Born Beauvais 24 May 1787. Studied under A. van den Berghe, David and Ingres. Exhibited at Paris Salon from 1812 and worked in London exhibiting at RA (14), SBA (6), BI (4) 1815-36. Returned to France 1836 and entered the community of the Lazarists c.1839, where he was known as 'Frère-François'. Died Paris 20 March 1873.
Represented: BM. **Engraved by** J.Thomson, C.Turner.

CARDINALL, Robert **fl.c.1730**
Studied under G.Kneller. Painted religious figures for the reredos of St Peter's, Sudbury c.1730.
Represented: Duleep Singh Gallery, Thetford.

CAREY, Miss Margery H. **fl.1911**
Exhibited at RA (1) 1911 from Burgess Hill.

CAREY, Miss Violet M. **fl.1894-1895**
Exhibited at RA (2) 1894-5 from Hampstead.

CARLETON, John **fl.1635-1637**
Yorkshire portrait and religious painter. Painted portraits of the Danby family 1635, which were formally at Swinton Park. Produced a large copy of Titian's 'Supper at Emmaus' 1636, at Temple Newsam and the following year painted figures for the chapel there. Waterhouse suggests that he may also be the artist who painted the full-length portrait of 'Lord Keeper Williams, Archibishop of York' which is signed and dated 'J.C. 1624', in the Muniment Room at Westminster Abbey.

CARLILE, Mrs Joan (Anne) **c.1606-1679**
Portrait artist and copyist employed by Charles I, who was so warm an admirer of her work that he presented her (along with Van Dyck) with ultramarine to the value of £500. She managed to maintain her public reputation throughout the Commonwealth and the Restoration. Married Lodowick Carlile 1626, a dramatist and one of the keepers at Richmond Park. Buried Petersham 27 February 1769.
Literature: M.Toynbee & G.Isham, *Burlington Magazine* XCVI September 1954 pp.275-7; Greer; DA.

CARLILL, Stephen Briggs **d.1903**
Exhibited at RA (5), NWS, NWG 1888-97 from Hull, St John's Wood and King's Langley. Master of Hull School of Art. His wife, Mary, also painted portraits, exhibiting at RA (3) 1895-6. Later went to farm in South Africa, where he was murdered by Kaffirs.
Represented: VAM.

CARLIN, John **1813-1891**
Born Philadelphia 15 June 1813. Deaf and dumb. Educated at Pennsylvania Institute for the Deaf and Dumb 1821-5. Studied

drawing under John Rubens Smith and painting under John Neagle 1833-4. Exhibited at Artists' Fund Society, Philadelphia 1835-8. Studied at BM 1838 and under Delaroche in Paris. Returned to America 1841 and settled in New York, exhibiting at American Institution and NA 1835-86. With the advent of photography he concentrated on landscape painting.
Literature: *New York Tribune* 23 April 1891.

CARLINE, George F. RBA 1855-1920
Born Lincoln, son of a solicitor. Studied art at Heatherley's, Antwerp and Paris. Exhibited at RA (10), SBA, RI from 1886. Elected RBA 1904. Worked in Lincoln, London, Oxford and Repton, Derbyshire. Died December 1920.
Represented: VAM; Tate.

CARLINE, Sydney William 1888-1929
Born London 14 August 1888, son of George F. Carline. Educated at Repton. Studied art at Slade 1907-10 and in Paris. Official war artist with RAF 1918. Exhibited at RA (4) 1911-27 and with the London Group (elected member 1924). Died 14 February 1929.
Represented: Leicester CAG.

CARLISLE, Mrs Elsie May Cecilia (née Sacret) b.1882
Born Hounslow 20 June 1882. Studied at Torquay, Glasgow and Liverpool. Exhibited at RA (1) and in the provinces. Often signed her work 'C.Carlisle'.

CARLOS, Ernest Stafford 1883-1917
Born 4 June 1883, son of John Gregory Carlos and Anne Chessel (née Buckler). Exhibited at RA (7) 1909-15 from London. Specialized in military portraits and sitters in

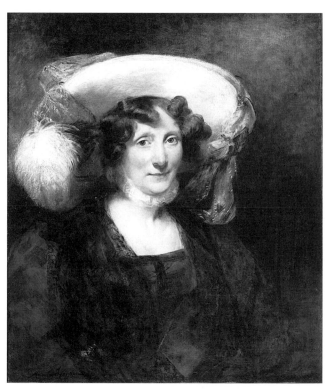

MARGARET SARAH CARPENTER. Mrs John Friend, Lady Robinson. Signed. 30 x 25ins (76.2 x 63.5cm) *Sotheby's*

historical attire. Painted a number of Boy Scouts as well as Cornish scenes. 2nd Lieutenant of 8th Battalion of East Kent Regiment, during 1st World War. Killed in action in France 14 June 1917.

CARLTON, Thomas fl.1670-1730
Worked in Dublin. Named among the Council of the Cutlers, Painter-Stayners and Stationers of Dublin when it was incorporated by a charter of Charles II as the Guild of St Luke the Evangelist 1670. Warden of the Guild 1680. A trustee of the will of herald painter Aaron Crossley 28 February 1723.
Engraved by T.Beard.

CARLYLE, Miss Florence d.1923
Exhibited at RA (9) 1896-1921 from London and Crowborough. Died Crowborough 2 May 1923.

CARLYLE, Robert fl.1855
Listed as a portrait painter 4 Park Place, Bury New Road, Manchester.

CARMICHAEL, Elizabeth fl.1768-1789
Exhibited at FS (1), SA (5), RA (10) 1768-89 from London.

CARMICHAEL, James fl.1767-1774
Exhibited portraits and miniatures at SA 1767-74.

CARNEY, Sir Richard d.1692
Son of Edward Carney, a Dublin tailor. Appointed herald 1658 and Principal Herald of Arms to the whole Dominion of Ireland 1655. Held several appointments after the Restoration. Knighted 1684.

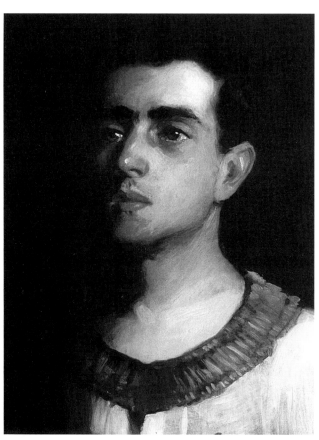

ERNEST STAFFORD CARLOS. Percy Williams in theatrical costume for Julius Caesar. Signed. 21 x 17ins (53.3 x 43.2cm)
Kenneth J. Westwood Collection

CARON, Miss L. fl.1854-1855
Exhibited at RA (2) 1854-5 from London.

CARPENTER, Mrs Margaret Sarah (née Geddes)
1793-1872
Born Salisbury, daughter of artist A.R.Geddes. Her first art studies were made from copying the pictures of Lord Radnor at Longford Castle. Moved to London 1814 and soon established herself as a highly fashionable portrait painter. Exhibited at RA (156), BI (61), SBA (19) 1814-66. Her fluent and accomplished style was influenced by Lawrence, and she finished his portrait of Mrs Brandling. Married William H.Carpenter 1817, Keeper of Prints and Drawings at BM. On his death in 1866 Queen Victoria conferred on her a yearly pension of £100. Among her sitters were William Collins RA (her brother-in-law), the Archbishop of Canterbury (Sumner), John Gibson and R.P.Bonington. W.P.Frith admired her work. A transcript of her list of sitters 1812-64 is in NPG London. Died London 13 November 1872. Her daughter Jane Henrietta and son William were also artists. The best woman portrait painter of her time.
Represented: NPG London; VAM; BM; Eton College; Stourhead NT; Leeds CAG. **Engraved by** T.L.Atkinson, J.Cochran, S.Cousins, J.D.Harding, T.Hodgetts, J.R.Jackson, H.Meyer, J.P.Quilley, E.Scriven. **Literature:** *Art Journal* January 1873; DA.

CARPENTER, William jnr **1818-1899**
Born London, son of artist Margaret Carpenter and William Carpenter, Keeper of Prints and Drawings at BM. Exhibited at RA (25), RHA (1), BI (9), SBA (3) 1840-66. Accompanied the Punjab Irregular Force to Afghanistan 1855. Exhibited several eastern subjects on his return. After 1862 he lived in Boston, USA. Died Forest Hill, Lewisham 17 (not 27) June 1899. Left £12,761.3s.1d.
Represented: BM; VAM; Ashmolean. **Engraved by** M.Gauci.

CARPENTIERS, Adriaen **d.1776**
Believed to be of Flemish origin. Worked in England as an itinerant portrait painter by 1739. His early style was in the manner of Highmore. Recorded in Kent and Buckinghamshire 1739, Bath and London 1743, Oxford 1745, East Anglia from 1751 and Norwich 1757. Believed to have settled in London c.1760, and is recorded in Pimlico. Exhibited at SA (6), FS (8), RA (4) 1760-74. He was friends with many foreign artists working in London. Painted portraits of Zuccarelli (Yale) and Roubiliac (NPG London). Patronized by Sir Francis Dashwood of West Wycombe, whom he painted in a number of amusing guises, and for whom he depicted other members of the Divan Club in costume (West Wycombe Park). Although his death is commonly given as 1778 his will was proved in Middlesex March 1776.
Represented: Bradbourne; Town Hall, Oxford. **Engraved by** J.Faber jnr.

CARR, Miss Bessie **fl.1883-1890**
Exhibited at RA (3), SBA (2) 1883-90 from Paris, London and Worthing.

CARR, Miss Edith **1875-1949**
Born Croydon 24 February 1875, daughter of Henry Carr, a merchant. Studied at Croydon School of Art under Walter Wallis and at Académie Delecluse, Paris under Callot. Exhibited portraits and miniatures at RA (20), SWA, Paris Salon 1907-43 from South Croydon. Died 29 January 1949. Usually signed works 'E.Carr'.
Engraved by A.Cardon.

CARR, Henry **fl.1770-1798**
His watercolour portrait of Anne Seymour Damer is in SNPG.

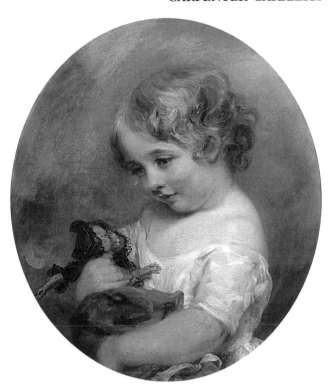

MARGARET SARAH CARPENTER. Portrait of a girl with a doll. Signed and dated 1841. Panel. 20¾ x 17½ins (52.7 x 44.4cm)
Christie's

CARR, Henry Marvell RA RP RBA **1894-1970**
Born Leeds 16 August 1894, son of Matthew and Clara (née Carr). Studied at Leeds School of Art and RCA under Rothenstein. Exhibited at RA (131), NEAC, RP, Paris Salon (Gold Medal 1956) 1921-70. Elected RP 1948, ARA 1957, RA 1966. Served in France during 1st World War in Royal Field Artillery. War artist with 1st Army in North Africa and Italy 1942-5. Published *Portrait Painting*, 1952. Lived in London and Aylesbury. Died 16 March 1970.
Represented: Southampton CAG.

CARR, Miss Kate **fl.1871-1877**
Exhibited portraits at GG 1871-7 from London.

CARRICK, Thomas Heathfield **1802-1875**
Born Upperly, near Carlisle 7 April 1802, son of a glass and china merchant. Educated at Carlisle Grammar School. Began work as a chemist. By 1830 he produced miniatures on marble, which earned him the Silver Isis Medal at SA 1838 and a medal from Prince Albert 1854. Then produced portraits, miniatures and coloured photographs in Carlisle, Newcastle and London. Had an extremely successful practice. Exhibited at RA (140) 1841-66. A friend of Charles Dickens. Among his distinguished sitters were Charles Kean, William Wordsworth, Thomas Carlyle, Longfellow, Sir Robert Peel, Thomas Miles Richardson and leading art dealer E.Gambart. Died Newcastle 31 August 1875.
Represented: Tullie House Museum, Carlisle; Laing AG, Newcastle; BM; VAM. **Engraved by** S.Bellin, J.Egan, W.Holl, J.J.Jenkins, G.H.Phillips, H.Robinson, W.J.Ward.
Literature: DNB; Foskett.

CARRIERA, Rosalba **1675-1757**
Born Venice 7 October 1675. A famous miniaturist and pastellist. Her introduction of ivory as a base revolutionized miniature painting (Bernard Lens III is credited for

introducing it into England in the early 18th century). Reportedly came to England and Ireland, but this has yet to be established. Due to failing eyesight she later concentrated on large crayon portraits. Died Venice 15 April 1757.

CARRINGTON, Dora **1893-1932**
Studied at Slade. Mixed with the Bloomsbury group. Assisted Roger Fry in his Omega Workshop and made woodcuts for Hogarth Press. Had a number of affairs including with Mark Gertler and Lytton Strachey. Married Ralph Partridge. Committed suicide with a borrowed gun. She was the subject of a film by Christopher Hampton.
Represented: NPG London; SNPG; Brighton AG.
Literature: *C. – Letters and Extracts from her Diaries*, 1970; Greer; J. Hill, *Art of D.C.*, 1994; C., Barbican exh. cat. 1995.

CARROLL, Michael William **fl.1795-1807**
Worked as an engraver and portraitist in Hull 1795-1807.

CARRUTHERS, Richard **1792-1876**
Born Crosby-on-Eden, near Carlisle. Went to London at an early age. Studied at RA Schools (winning prizes 1816 and 1817). Exhibited mostly portraits, including that of poet 'William Wordsworth', at RA (12), BI (1) 1816-19 from London. After 1819 he settled for health reasons in South America, where he amassed a considerable fortune. Returned permanently c.1837 and took a leading role in Carlisle Athenaeum 1850. Built his own home, Eden Grove at Crosby, where he spent the remainder of his life fishing and painting.
Engraved by C.Turner. **Literature:** Hall 1979.

CARSE, James **fl.1848**
Listed as a portrait painter at Chapman Street, Hulme, Manchester.

CARTEAUX, Jean Baptiste François **1751-1813**
Born Aillevans. Studied with Doyen. Claimed to be a medallist from Royal Academy of Paris. Exhibited at RA (2) 1776 from London. Died Paris April 1813.
Represented: Versailles. **Literature:** Bénézit.

CARTER, Miss B. **fl.1856-1859**
Exhibited at RA (3) 1856-9 from 6 Whitehall, London.

CARTER, Christopher **fl.1623/4**
Recorded in Chamberlain's accounts for Leicester 1623/4 for 'portraitinge' the '3rd Earl of Huntingdon'.

CARTER, Mrs Eva (née Lawson) **1885-1963**
Born Newcastle. Married John Carter, a schoolmaster. Exhibited at Laing AG, Shipley AG, Gateshead Art Club, RA (5). Wrote several books including *Tales of the North Country*.
Represented: Laing AG, Newcastle; Shipley AG, Gateshead.

CARTER, Frank William ROI PS **1870-1933**
Born London 18 December 1870, son of artist Hugh Carter. Studied at Slade under Legros and in Munich under L.S.Reutte. Exhibited at RA (10), NEAC, Goupil Gallery, Paris Salon 1900-33 from Holland Park, London. Member of Modern Society of Portrait Painters and of Ridley Art Club. Died 14 April 1933. Usually signed his work 'Frank W Carter'.

CARTER, George **1737-1794**
Baptized Colchester 10 April 1737. Began work as a shop assistant. Showed a talent for art and entered RA Schools 1770. Exhibited at SA (22), RA (16) 1769-84. Travelled to Rome with Copley in August 1774, and also visited Gibraltar and St Petersburg. Worked in Calcutta 1786-8 and continued to paint scenes from Indian history after his return. Retired to

Hendon. Buried there 19 September 1794.
Represented: NPG London; Royal Shakespeare Theatre, Stratford-on-Avon. **Engraved by** J.Caldwell & S.Smith; J.R.Smith.

CARTER, Hugh RI **1837-1903**
Born Birmingham. Studied at Heatherley's and in Düsseldorf under E. von Gebhart. Influenced by The Hague School. Exhibited at RA (24), SBA (1), RI 1859-1902. Elected ARI 1871, RI 1875 (resigning 1899).
Represented: NPG London; Tate; VAM.

CARTER, J.H. **fl.1839-1856**
Exhibited at RA (8) 1839-56 from London. Worked for a time in Torquay, with his wife, Matilda, a miniaturist. Painted a portrait of 'King William IV'. Often confused with J.Carter fl.1835-44.
Engraved by M.Gauci.

CARTER, Miss Matilda Austin **b.1840**
Born Bristol. Produced portraits and miniatures. Exhibited at RA (1), SBA (16) 1862-73 Torquay and London.

CARTER, Noel N. **fl.1823-1834**
Listed as a portrait and miniature painter in London. Exhibited at RA (12) 1826-33.

CARTER, Samuel John **1835-1892**
Born Swaffham. Studied in Norwich. An animal painter, but occasionally painted portraits. Exhibited at RA (49), BI (3), SBA (10), GG 1855-90.
Represented: Tate; Preston AG.

CARTER, Sydney **1874-1945**
Born Enfield 2 April 1874. Studied under Connard and RCA. Won BI £100 premium for portraiture with a study of Mrs Riggs of Epping entitled 'The Gainsborough Hat'. Exhibited at RA (1), RHA (6), Paris Salon. Joined the forces 1914. Married Elizabeth Ann Crosse 1922, a school teacher in Exeter, where they lived. Migrated to South Africa October 1923 because of his wife's health, settling in Johannesburg. Died 21 December 1945.
Literature: E.A.Carter, *S.C.*, 1948.

CARTER, Verney **fl.1915**
Exhibited at RA (1) 1915 from Fulham.

CARTER, William RBA RP **1863-1939**
Born Swaffham, Norfolk 4 February 1863, son of artist Samuel John Carter and brother of Egyptologist Howard Carter. Studied at RA Schools, winning many awards. Exhibited at RA (40), RHA (2), SBA, GG, NWG, RP and abroad 1883-1938. Elected RBA 1884, RP 1915. Enjoyed a successful society portrait practice. Among his sitters were Sir Frederick Milbank Bart. MP, Hugh, 1st Duke of Westminster, Leonard Courtney MP, and HSH Prince Alexander George of Teck. Lived at Swaffham, Norfolk and in London. Died 20 December 1939. Usually signed his work 'William Carter' in block letters (early works), in brush (mid-works) and in handwriting (later works).
Engraved by V.Carter, R.Josey.

CARTERET, Lady Mary Ann (née Masters)
 1777-1863
Daughter of Thomas Master of Cirencester Abbey. Married Lord John Thynne, later Lord Carteret 18 June 1801. Lady of the Bedchamber to HRH the Princess Sophia. An amateur artist. Painted a variety of subjects, including portraits. Died Mayfair 22 February 1863.

CARTLEDGE, William RI RSMA **b.1891**
Born Manchester 30 January 1891, son of William Cartledge, a

merchant. Studied at Manchester School of Art, Slade and University of London. Awarded prizes for portrait painting. Exhibited at RA (3), Goupil Gallery, SBA, RI, RSMA and in Bombay. Elected RI 1955, RSMA 1962. Lived in Pudsey, Coleworth, and Birdham, near Chichester. Probably the William Cartlidge who died Dordon, Warwickshire 8 March 1977.

CARTWRIGHT, Frederick William fl.1854-1894
Exhibited at RA (22), BI (3), SBA (21) 1854-94 from Brixton, Camberwell, Dulwich and Streatham.
Represented: Exeter Museum.

CARTWRIGHT, John (A.J.) fl.1763-1808
Signed deed of enrolment to FS 1763. Exhibited at FS (2), RA (21) 1767-1808 from London. Went to Rome, where he became friendly with Fuseli, who lodged with him later in London. His portrait by Fuseli is in the NPG London.
Literature: M. Rogers, *Master Drawings from the NPG*, 1993, pp.62-3.

CARWARDEN, John fl.1636-1660
Herefordshire royalist portrait painter and composer. A member of the private music of Charles I. Petitioned Charles II after the Restoration for a job as a painter. Capable of painting a head with much character and a high standard of competence.
Represented: Examination Schools, Oxford. **Engraved by** W.Faithorne. **Literature:** Stowe MSS 243 f.121.

CARWARDINE, Penelope c.1730-1801
Daughter of John Carwardine of Thinghills Court, Withington, Herefordshire and his wife Anne Bullock. Her father lost the family fortune through extravagance and she took up miniature painting and small portraits to earn a living. Established herself by the age of 24. Exhibited at SA (2) 1771-2 from London. Married Mr Butler, a Westminster organist c.1772. Produced delicate portraits and miniatures in watercolour and in black chalk. Reputedly had lessons from Ozias Humphry.
Represented: Wallace Collection, London.

CARY, Francis Stephen 1808-1880
Born Kingsbury 10 May 1808, son of Rev Henry Francis Cary, translator of Dante. Studied under Henry Sass in Bloomsbury and at RA Schools. For a short time he was in Lawrence's studio. Visited Paris and Munich 1829 and travelled extensively on the Continent 1833-5. Exhibited at RA (34), BI (8) RHA (2), SBA (19) 1837-76. Took over with great success the management of Sass's Art School 1842. He modelled it on the School of the Carracci, Bologna. Many important artists studied there including Cope, Millais, Armstead and Rossetti. Retired to Abinger Wotton 1874, where he died 5 January 1880.
Represented: NPG London.

CASALI, Cavaliere Andrea c.1700-1784
Born Civitavecchia. Studied in Rome under Trevisani. Specialized in history and portrait painting. Made a Cavaliere by Frederick William, King of Prussia. Spent several months in Paris before coming to London, where he remained 1741-66 (except for a visit to Holland and Germany 1748/9). Gave 'Adoration of the Kings' 1748/50 to the Chapel of Foundling Hospital, and c.1755 painted a set of full-length fancy ancestors' portraits for Holkham. Won premiums for history pictures at SA 1760-62 and 1766. Exhibited at SA (7), FS (74) 1760-83. Held a sale 18 April 1766, before his return to Rome where he died 7 September 1784.
Represented: Durham; Burton Constable.

CASEY, William Linnaeus 1835-1870
Born Cork, son of a gardener. Studied at Cork School of Design and at Marlborough House. Appointed second master at Limerick School of Art 1854. Set up as a drawing master in London, his pupils including the royal family. Appointed master of St Martin's Lane Academy. Died London 30 September 1870.
Represented: VAM.

CASSIE, James RSA RSW 1819-1879
Born Keith Hall, Inverurie. After an accident made him lame he turned to painting as a career. Studied under J.W.Giles. Exhibited RA (21), RSA (195) 1840-80. Elected ARSA 1869, RSA 1879. Died Edinburgh 11 May 1879.
Represented: Aberdeen AG. **Literature:** *J.C.*, Aberdeen exh. cat. 1979; McEwan.

CASTELEIN, Ernest 1887-1945
Born Antwerp 3 December 1887, son of Edgard Castelein, President of the Chamber of Commerce in Antwerp. Studied at Antwerp Academy and Institute Supérieur des Beaux Arts. Worked in London and painted a number of notable portraits. Attacked in his studio and as a result died 30 July 1945.

CASTELLI, Madame fl.1825
Exhibited a portrait of 'Madame Ronzi De Begnis in the Character of Helene in the "Lady of the Lake"' at RA (1) 1825 from London.

CASTRO, Laureys de fl.1664-1680
Master in the Guild at Antwerp 1664/5. Moved to London 1680. Specialized in shipping scenes, but also painted portraits. The City and Corporation of London commissioned presentation portraits of the parting Lord Mayor 'Sir Robert Clayton' and his wife 1680.

CASTRUZZI fl.1774
Exhibited crayon portraits at SA (2) 1774 from Charing Cross.

CATON WOODVILLE, Mrs Dorothy (née Ward) ARMS fl.1910-1925
Born Chislehurst, daughter of publisher H.Ward. Educated privately and painted miniatures and portraits in watercolour. Exhibited at RMS, Paris Salon and America from London. Elected ARMS 1910-25. Married artist William Caton Woodville.

CATTERNS, Edward R. fl.1904
Exhibited at RA (1) 1904 from 122 Wellington Street, Glasgow.

CATTON, Charles snr RA 1728-1798
Born Norwich September 1728 (baptized 8 October 1728), son of Richard and Hannah Catton. Trained as an heraldic painter in London and became coach painter to George III. A member of St Martin's Lane Academy. Master of Company of Painters-Stainers 1783. Exhibited at SA (16), RA (43) 1760-98. Founder RA (nominated by George III). Died London 28 August 1798. Buried Bloomsbury Cemetery. His son Charles Catton jnr 1756-1819 was also an artist.
Represented: Felbrigg, NT; VAM; BM; Ashmolean; Yale. **Engraved by** Cook, W.Leney.

CAUTLEY, Ivo Ernest b.1893
Born Dublin 14 June 1893, son of Colonel John Cumberlege Cautley. Exhibited at RHA (12) 1924-41 and in Irish Three Arts Club, London.

CAWKER, Miss Maud fl.1896
Studied at Herkomer's School of Art in Bushey. Exhibited at RA (1) 1896.

CAWSE, Miss Clara Libana b.c.1819
Born Islington. Aged 32 in 1851 census. Exhibited at RA (12), BI (6), SBA (2) 1841-67 from London. Possibly daughter of artist John Cawse.
Represented: Cheltenham AG.

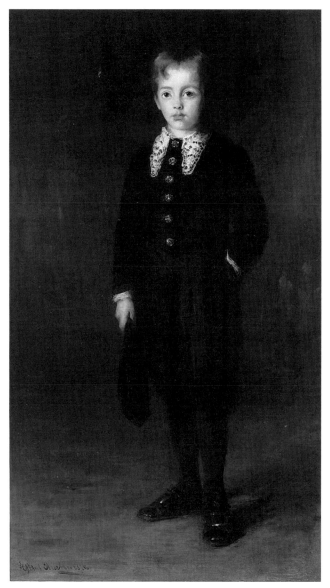

GEORGE PAUL CHALMERS. Master Lindsay Jamieson. Signed. Panel. 59½ x 32¼ins (151.1 x 82cm)

Christopher Wood Gallery, London

CAWSE, John **1779-1862**
Baptized London 27 January 1779, son of Charles Woodruffe Cawse and his wife Ann. Studied under James Northcote RA. Began his career as a portrait artist and Teacher of Drawing, but later concentrated on sporting and literary subjects. Exhibited at RA (24), BI (41), SBA (19), OWS 1801-45 London. Married Mary Fraser 2 August 1807 at St Bride's, Fleet Street, London. Had strong connections with the theatrical world. Published *The Art of Oil Painting* 1840. Died Holborn March 1862. E.M.Ward was his pupil.
Represented: NPG London; BM. **Engraved by** M.Gauci, E.Stalker.

CAZNEAU, Edward Lancelot **b.1809**
Born England. Entered Dublin Society's Schools 1828. Married Margaret Sharp in Dublin 1835. Exhibited at RHA (24) 1833-47. A painter of considerable ability.
Represented: NGI.

CELS, Cornelius **1778-1859**
Born Lier 10 June 1778. Studied under sculptor Pompe and painter P.S.Denis. Exhibited at RA (1) 1836 from London. Died Brussels.
Represented: Amsterdam Museum.

CERVENG, John **fl.1771-1773**
Exhibited at RA (2), SA (5) 1771-3 from London.

CHADBURN, George Haworthe **b.1871**
Born Yorkshire. Exhibited at RA (8) 1906-19 from King's Langley and London.

CHADWICK, Henry Daniel **fl.1879-1896**
Exhibited at RA (12), SBA (2) 1879-96 from London.

CHALMERS, Sir George, Bart **c.1720-1791**
Born Edinburgh, son of heraldic painter and engraver Roderick Chalmers. Reportedly studied in Rome and was in Minorca 1755, where he painted 'General Blakeney' (engraved by McArdell). Claimed to have inherited the baronetcy of Chalmers of Cults c.1764, and from this point signed his pictures 'Geo. Chalmers Equs Barons'. Practised in London, Hull and Edinburgh, where he married the sister of Cosmo Alexander 1768. Exhibited at RA (24) 1775-90. Buried London 15 November 1791. Walpole described his work as 'Good, but hard'. His quality is variable. Some of his best examples show the influence of Nathaniel Hone.
Represented: NPG London; SNG; Edinburgh AG; HMQ (Chequers). **Engraved by** R.Earlom, W.Howison, J.McArdell. **Literature:** McEwan.

CHALMERS, George Paul RSA OWS c.1833-1878
Born Montrose 1833 (Bénézit) or 1836 (DNB), son of a captain of a coasting vessel. Apprenticed to an apothecary. Became clerk to a ship chandler. Moved to Edinburgh aged 20 and studied under R.Scott Lauder at Trustees' Academy, maintaining himself by painting portraits. Settled in Edinburgh. Exhibited at RSA (69), RHA (3), RA (6) 1855-79. Elected ARSA 1867, RSA 1871. Occasionally went on sketching visits to Ireland, Skye, Glenesk and the Continent, sometimes in the company of his friend Joseph Farquharson. Died Edinburgh 20 February 1878, after being attacked and robbed. Influenced by Lauder. Enjoyed representing sitters in dimly-lit interiors with strong use of chiaroscuro and thick impasto. Sometimes collaborated with J.Pettie.
Represented: SNPG; Aberdeen AG; Glasgow AG; Kirkcaldy AG; Paisley AG; Perth AG. **Literature:** *Art Journal* 1897 pp.83-8, 1878 p.124; A.Gibson & J.F.White, *Memories of G.P.C. and the Art of his Times*, 1897; E.Pinnington, *G.P.C. RSA and the Art of his Time*, 1896; DNB.

CHALMERS, Miss J. **fl.1827-1832**
Exhibited at RHA (15) 1827-32 from Dublin.

CHALON, Alfred Edward RA **1780-1860**
Born Geneva 15 February 1780, younger brother of landscape artist John James Chalon and son of a professor of French at Sandhurst Military College. Entered RA Schools 12 August 1797. Specialized in miniatures and small watercolour portraits (usually about 15in.), although he did paint a large number of oils. Appointed Painter to HRH the Duchess of Cambridge 1825. The first to paint Queen Victoria on her accession to the throne. Appointed Portrait Painter to HM the Queen 1837. One of the most fashionable painters of portraits in watercolours of his time. Exhibited at RA (363), BI (21) 1801-60. Elected ARA 1812, RA 1816, honorary member of Society of Arts of Geneva 1853. Founded the Sketching Club with his brother and F.Stevens. Among his sitters were Princess Charlotte of

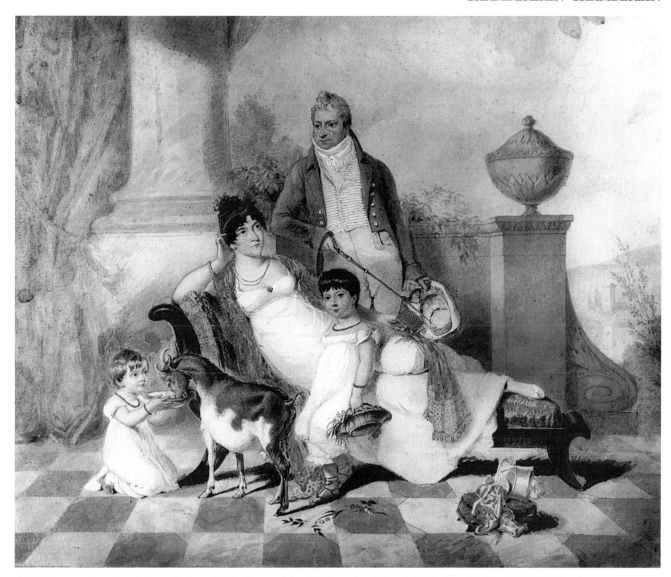

ALFRED EDWARD CHALON. Sir Joseph Mawbey and family. Signed and dated 1805. 12 x 14¾ins (30.5 x 37.5cm) *Phillips*

Wales, The Duchess of Hamilton, Thomas Clarkson MA – author of *History of the Abolition of the Slave Trade*, The Countess of Blessington, Mr and Mrs Charles Kean, Clarkson Stanfield and Professor Leslie RA. Died Kensington 3 October 1860. Buried Highgate Cemetery. His portrait of the Queen was reproduced on many early issues of colonial stamps.
Represented: BM; VAM; NPG London; SNPG; Leeds CAG; Ulster Museum; Ashmolean; Blackburn AG; Castle Museum, Nottingham. **Engraved by** R.A.Artlett, H.Austen, T.Blood, A.Cardon, G.Clint, J.Cochran, H.Cook, R.Cooper, S.Cousins, T.A.Dean, W.J.Edwards, W.H.Egleton, E.Finden, J.Freeman, S.Freeman, M.Gauci, H.Hall, Hardivillier, W.Holl, W.Hollis, J.Jenkins, W.Knight, R.J.Lane, F.C.Lewis, Meuret, H.Meyer, E.Morton, W.H.Mote, S.W.Reynolds, H.Robinson, W.Rolfe, H.T.Ryall, W.Say, W.Taylor, J.Thomson, C.Turner, C.E.Wagstaff, J.& W.Watt, W.J.Ward; T.Wright. **Literature:** DA.

CHAMBERLAIN, William 1771-1807
Born London. Studied at RA Schools from 1790 and under Opie 1794. Exhibited at RA (6) 1794-1803 from

London and Chichester. Practised in Hull, where he died 12 July 1807.
Engraved by Harrison & Co.

CHAMBERLIN, Mason RA 1722-1787
All sources give birth as 1727, but a Mason Chamberlain was baptised in London 7 October 1722, son of Richard and Mary. Began his career in a counting house in the City, but turned to art and studied under Hayman, in whose manner he painted conversation pieces c.1761. A founder RA. Exhibited at SA (25), FS (1), RA (50) 1760-86. Won a premium for a history picture at FS 1764. Painted Benjamin Franklin 1762 (who was extremely pleased with the result), and 'Their Royal Highnesses Prince Edward and Princess Augusta, whole-lengths' in 1771, but mostly had a thriving practice painting tradesmen and the middle classes. Resided at 7 Stuart Street, Spitalfields until 1785. Mary Bertrand was his pupil. Died Holborn, London 26 January 1787. Often signed faintly in a top or bottom corner 'Chamberlin pinxt' and his heads are painted with character and understanding. His son, Mason Chamberlin jnr, was a landscape painter.
Represented: Philadelphia Museum of Art; NPG London;

MASON CHAMBERLIN. Master Simon Dendy. Signed and dated 1783. 50 x 40ins (127 x 101.6cm) *Sotheby's*

Yale; NMM. **Engraved by** J.Collyer, E.Fisher, V.Green, T.Holloway, J.Hopwood, T.Kitchin, W.Pether, J.Romney, E.Scriven, W.Skelton, B.Smith, J.van den Berghe, J.Young. **Literature:** Edwards pp.121-2; DA

CHAMBERS, John **1852-1928**
Born South Shields. Studied there at Union British Schools. Entered the Tyne Pilot Service, but left to enrol at Government School of Design, Newcastle, where he studied under W.C.Way. Then went to Paris, where he worked under Boulanger and Fevre, before settling in North Shields. Exhibited in Newcastle and Gateshead.
Represented: Laing AG, Newcastle; North Tyneside Public Libraries; South Shields Museum and AG. **Literature:** Hall 1982.

CHAMIER, Miss Barbara Dorothy **b.1885**
Born Faizazad, India 14 April 1885, daughter of Major General F.E.A.Chamier. Studied at King's College. Exhibited at RA (27), RMS and in France 1907-60 from East Grinstead.

CHAMPION, Edward. C. **fl.1870-1883**
Painted a portrait of Charles Broderick Scott 1825-96 in the collection of Westminster School. Exhibited at RA (4), SBA (9) 1870-83 from London.

CHANCELLOR, George **1796-1862**
Born Dublin, son of John Chancellor, a watchmaker. Succeeded his father's business and painted miniatures, portraits and landscapes. Exhibited at RHA (17) 1826-9 from Dublin. Died Dublin 5 October 1862.

CHANDLER, John Westbrooke **1764-1807**
Reportedly born 1 May 1764, natural son of 2nd Earl of Warwick. Entered RA Schools 12 November 1784 aged '21 1st May'. Exhibited miniatures at RA (10) 1787-91. Published *Sir Hubert, an Heroic Ballad*, 1800, and left the same year for Aberdeen, and then Edinburgh. Produced many portraits of children, as well as Eton leaving portraits. Influenced by Romney and Hoppner. Finally went mad, attempted suicide. Died in confinement at Edinburgh.
Represented: NPG London; BM; Eton College; Leith Hall SNT. **Engraved by** E.Bell, S.W.Reynolds; T.Trotter.

CHANTERELL **fl.1626**
Evelyn recorded in his diary under 1626 that 'My picture was drawn in oil by Chantrell, no ill painter'.

CHANTREY, Sir Francis Legatt RA **1781-1841**
Born Norton, near Sheffield 7 April 1781, was orphaned as a boy, and worked as a farm labourer. Apprenticed to a wood carver in Sheffield. Started his artistic career making portraits in pencil and miniature, mostly of Yorkshire citizens. Moved to London after visiting Ireland. Married his wealthy cousin (who had a fortune of £10,000) and became a distinguished and brilliant sculptor. Exhibited at RA (124) 1804-42. Elected ARA 1816, RA 1818. Knighted 1835. Painted a highly accomplished portrait of Thomas Creswick. Died London 25 November 1841.
Represented: NPG London; Tate; SNPG; Sheffield AG; BM. **Literature:** G.Jones, *Sir F.C.*, 1849; J.Holland, *Memorials of Sir F.C.*, 1851; A.J.Raymond, *Life & Work of Sir F.C.*, 1904; DA.

CHANTRY, N. **fl.1797-1838**
Exhibited at RA (27), BI (42), SBA (19) 1797-1838 from London.

CHAPMAN, Charles **fl.1776**
Exhibited a frame of four chalk portraits at RA (1) 1776 from 'Mr Bowen's opposite the Haymarket'.

CHAPMAN, George R. **fl.1863-1874**
Exhibited at RA (4) 1863-74 from London. During the early 1860s he was associated with Rossetti, Arthur Hughes and Maddox Brown.

CHAPPELSMITH, J. **fl.1842**
Exhibited at RA (2) 1842 from 6 Smith Square, Westminster.

CHARE, Guliells (William) **fl.1618**
Painted a portrait of 'Sir Charles Brydges' 1618 (46 x 37in., private collection). It is painted in the style of a provincial version of Gheeraerts.

CHARLES, James NEAC **1851-1906**
Born Warrington 5 January 1851, son of Richard Charles a draughtsman and cabinet maker. Studied at Heatherley's School, RA Schools from 1872 and at Académie Julian, Paris. First painted mainly portraits, but later concentrated on landscapes and genre. Exhibited at RA (53), RHA (1), SBA (2), NWG, NEAC, Paris Salon 1875-1906. Visited Italy 1891 and 1905. Lived in Chelsea and Fulham, but moved c.1887 to Harting, Petersfield and then to East Ashling, Chichester. Died after an operation for appendicitis, while staying at Plas Bennett, Denbigh 27 August 1906. Buried Fulham Cemetery. Sometimes recorded in catalogues as John.
Represented: Tate; VAM; Melbourne AG; Manchester CAG; Warrington AG; Johannesburg AG; Bradford AG. **Literature:** DNB.

CHARLESWORTH, Miss Alice **fl.1896-1905**
Exhibited at RA (8) 1896-1905 from Mitfield Court, Surrey.

JOHN WESTBROOKE CHANDLER. Self-portrait. 30 x 25ins
(76.2 x 63.5cm) *Phillips*

CHARLTON, John RBA RI ROI RP 1849-1917
Born Bamburgh, Northumberland. Studied at Newcastle
School of Art under W.B.Scott and at South Kensington.
Worked for some years in the studio of J.D.Watson,
concentrating on figure painting. Exhibited at RA (82), RHA
(6), SBA, NWS, GG, NWG, RP 1870-1917. Elected RBA
1882, RP 1897. Twice commissioned by Queen Victoria to
paint ceremonial group portraits to celebrate her jubilees
1887 and 1897. Illustrated for *The Graphic* and collaborated
with A.S.Cope. Died Banks House, Lanercost, Cumberland 5
November 1917. Left £13,327.3s.6d. A gifted and highly
accomplished artist.
Represented: Laing AG, Newcastle; Shipley AG, Gateshead;
Grays AG, Hartlepool.

CHARRETIE, Mrs Anna Maria (née Kenwell)
 1819-1875
Born London 5 May 1819, daughter of an officer in the
Department of Stamps and Taxes. Studied under Mrs
V.Bartholomew and was an accomplished amateur painter in
oil, watercolour and miniature. Married Captain John
Charretie 1841, who worked for the East India Company,
but took up painting professionally c.1850 after illness
disabled her husband – an invalid for 18 years (died 1868).
Exhibited at RA (40), RHA (8), BI (4), SBA (48), Society of
Lady Artists 1842-75 from London. Enjoyed a reputation for
her portraits of women and children. Died Kensington 5
October 1875 from heart disease.
Literature: *Art Journal* 1876.

CHARTRAN, Théobald 1849-1907
Born Besançon 20 July 1849. Studied in Paris and Rome.
Exhibited miniatures at Paris Salon, RA (5), GG 1872-92

from London and Paris. Contributed to *Vanity Fair* 1878-88.
Awarded many medals. Made Chevalier of the Legion of
Honour. Died Neuilly-sur-Seine 18 July 1907.
Represented: VAM.

CHASE, William Arthur 1878-1944
Born Bristol 17 May 1878, son of George Chase an Inland
Revenue officer. Studied at the City and Guilds School of Art,
London and Regent Street Polytechnic Art School. Exhibited
at RA (7) 1910-33 from London and Blewbury, Berkshire.
Died 29 September 1944.

CHASE, William Merritt NA 1849-1916
Born Williamsburg, Indiana. Pupil of B.F.Hayes 1868.
Studied at NA, New York and at Munich under von Piloty,
where he met Duveneck and adopted a 'Munich School'
style. Travelled on the Continent and met Whistler in
London 1885, who influenced him. Taught at Art Students'
League, Brooklyn, had his own Chase School of Art 1896-
1908. Considered one of the most influential teachers of the
last quarter of the 19th century. Elected NA 1890. Died New
York. Simon writes: 'His brushwork is expressive and precise,
and his style developed under the influence of Impressionism,
with an increase in his range of colour; his dazzling surface
effects are allied to a profound grasp of structure.'
Represented: Cleveland Museum; Detroit Institute; Santa
Barbara Museum; Boston MFA; Century Association, New York.
Literature: R.G.Pisano, *W.M.C.*, 1979; R.G.Pisano, *A Leading
Spirit in American Art*, exh.cat. Henry AG, Seattle 1983; DA.

CHATFIELD, Edward 1802-1839
Studied under B.R.Haydon. Exhibited at RA (14), BI (6),
SBA (8) 1823-38 from London. Among his sitters was 'The
Infant Son of T.Landseer Esq'.

CHAVES, A.R. de fl.1688
Painted a portrait of 'Sir William Gage' 1688 previously at
Hengrave Hall. The signature has also been read as 'de
Charos'.

CHESTER, John b.1761
Born 29 September 1761. Entered RA Schools 1783.
Exhibited at RA (1) 1783 from London.

CHESTERS, Stephen fl.1862-1868
Listed as a portrait painter at Hanley, West Midlands. May
well have been the S.Chesters who exhibited enamels at RA
(13) 1849-85 from London and Scarborough.

CHILD, W. fl.1847-1851
Exhibited at RA (2), BI (4), SBA (5) 1847-51 from London.
Among his sitters was tragedian Henry Betty.

CHILDE, James Warren 1778-1862
Had an extremely successful miniature portrait practice in the
Strand, London. Also painted oil and watercolour portraits.
Exhibited at RA (63), SBA (15) 1815-53. Painted a number
of actors and actresses from the London theatres and his style
can be similar to A.E.Chalon.
Represented: NPG London. **Engraved by** H.Adlard,
H.B.Hall.

CHILDERS, Miss Milly fl.1890-1914
Exhibited at RA (8), SBA, NG London 1890-1914 from
London.

CHINN, Samuel Thomas fl.1833-1848
Exhibited at RA (12), SBA (1) 1833-45 from Derby and
London.
Represented: Guildhall AG, London.

CHINNERY, George **1774-1852**
Born London 5 or 7 January 1774, sixth child of William Chinnery an East India Merchant and amateur artist. Entered RA Schools 1792. Exhibited at RA (26) 1791-1846. First specialized in miniatures, but later produced portraits and landscapes, often on a small scale. Worked in Bristol 1796 and Dublin 1797, where he married Marianne Vigne whom he described as 'the ugliest woman I have ever seen'. This didn't prevent him fathering two children by her. In 1800 he re-organised the moribund Society of Artists in Ireland and became its Secretary. The following year he abandoned his family (although leaving a generous allowance), returned briefly to London and sailed for Madras 1802, working as a fashionable portraitist in Calcutta 1807-25. His wife rejoined him and to escape her (he had by now fathered another two children by a mistress) and debts of about £40,000 he moved to Macao, Hong Kong and Canton. The ban on European women in Canton enabled him to evade his wife again when she attempted to follow him. Died Macao 30 May 1852. He combined Eastern influences with the British style to produce a highly personal style, with a fluid and masterly use of colour. Showed a preference for high flesh colouring, with typical dabs of red about the eyes. His work has for long been highly respected by collectors and dealers alike. Among his pupils were W.Prinsep, T.C.Plowden and Sir Charles D'Oyly. Lamqua Qiaochang followed in his manner.
Represented: BM; Tate; VAM; NPG London; NGI; Brighton AG; Ashmolean; Leeds CAG; Shanghai Bank, Hong Kong; NMM; SNG. **Engraved by** A.R.Burt, W.J.Edwards, J.Heath, W.Holl, T.Lupton, D.J.Pound, S.W.Reynolds, W.Ridley; C.Turner, Mrs D.Turner. **Literature:** Tate exh. cat. 1932; Arts Council exh. cat. 1957; H. & J.Berry-Hill, *G.C. 1774-1852: Artist of the China Coast,* 1963; R.Hutcheon, C., 1989; *The Friends of China and Hong Kong Gazette* 2 June 1852; *Irish Portraits 1660-1860,* NGI exh.cat.1969; W.H.Welpy, *Notes and Queries* CLII 1927 pp.21-4, 39-43, 51-86, 75-8; R.Ormond, *The Connoisseur* CLXVII February 1968 pp.89-93, March 1968 pp.160-4; P. Conner, *G.C.,* 1993; DA.
Colour Plate 16

CHISHOLM, Alexander **AOWS FSA** **c.1792-1847**
Born Elgin. Apprenticed to a weaver in Peterhead. Studied in Edinburgh, where he was patronized by Lord Elgin and the Earl of Buchan. Taught drawing at RSA Schools and married one of his private pupils, Susanna Stewart Fraser. Moved to London 1818, where he set up as a portrait painter. Exhibited at RA (20), BI (15), SBA (11), OWS 1820-46. Elected AOWS 1829. Died Rothesay, Isle of Bute 3 October 1847 while making portrait studies for an ambitious picture of the Evangelical Alliance.
Represented: Walsall AG; BM; VAM. **Engraved by** H.Beckwith, J.Cochran, H.Cook, R.Grave, H.C.Shenton. **Literature:** Ottley; McEwan.

CHITTENDEN, T. **fl.1845-1864**
Exhibited at RA (4), BI (4) 1845-64 from London and Wolverhampton.

CHOLMONDELEY, R. **fl.1856-1867**
Exhibited society portraits at RA (11) 1856-67 from London. Among his sitters were Lieutenant-General Mansfield, the Countess of Durham and Lady Elizabeth Grosvenor.
Represented: SNPG.

CHOWNE, Gerard Henry Tilson **NEAC** **1875-1917**
Born India 1 August 1875, son of Colonel W.C.Chowne. Educated at Harrow. Studied at Slade under Fred Brown and in Paris and Rome. Elected NEAC 1905. Served in 1st World War as Captain in East Lanarkshire Regiment. Died of wounds in Macedonia 2 May 1917. Mallalieu writes: 'His work is free, impressionistic and pleasing'.
Represented: Manchester CAG; VAM; Ulster Museum.

CHRISTIE, Alexander **ARSA** **1807-1860**
Born Edinburgh, eldest son of David Christie. Intended to study law, but the death of his father allowed him to pursue art. Studied at Trustees' Academy under Sir William Allan, at Edinburgh University and briefly in London. Returned to Edinburgh, where he was appointed Director of the Ornamental Department of Trustees' Academy. Exhibited at RSA (72), RHA (2), RA (2), BI (3) 1837-60. Elected ARSA 1848. Died Edinburgh 5 May 1860.
Represented: SNG; SNPG. **Literature:** McEwan.

CHRISTIE, James Elder **1847-1914**
Born Guardbridge, Fifeshire. Studied under William Stewart. Trained at Paisley Art School and South Kensington, and won two Gold Medals at RA in 1876 and 1877. Exhibited at RA (25), RSA (13), SBA (7), NEAC, GG, NWG 1877-1900. Won an honourable mention at Paris Salon 1905. Moved to Glasgow 1893. Died Balham 14 August 1914.
Represented: SNG; Paisley AG; Glasgow Museum. **Literature:** McEwan.

CHRISTIE, Robert **RBA** **fl.1891-1919**
Exhibited at RA (19), SBA 1893-1919 from London. His wife, Lily, was also a painter.

CHUBB, John **1746-1818**
Born Bridgwater 9 May 1746. Moved to London aged 13, to live with his uncle who had a shop in Cheapside. Spent most of his life in Bridgwater painting portraits and topographical views.
Literature: *Country Life* 7 December 1989.

CHUBBARD, Thomas **c.1737/8-1809**
Reportedly born Liverpool, son of Captain John Chubbard, a mariner. Listed as a painter 1767. Member of Liverpool Society of Artists. Exhibited at FS, SA 1771-3. One of Liverpool's leading portrait artists. Died there 'of old age' 30 May 1809. Buried in the family vault at St George's Church.
Represented: Walker AG, Liverpool. **Literature:** *Liverpool Courier* 7 June 1809.

CIPRIANI, Captain Sir Henry **1762-1843**
Son of artist Giovanni Battista Cipriani. Exhibited at RA (1) 1781, but later gave up art. Knighted 13 September 1831 as senior exon of the Yeoman of the Guard. Retired at first to Woolwich Common and then Brighton, where he died 16 April 1843. Bénézit mistakenly lists his death as in London 1820.

CLABBURN, Arthur E. **fl.1875-1879**
Exhibited at RA (3) 1875-9 from Norwich and London.

CLACK, Richard Augustus **c.1804-1881**
Born Devon, son of a clergyman. Studied at RA Schools. Exhibited at RA (27), BI (5), SBA (14) 1827-67 from London and Exeter. Reportedly died Exeter. Could reach a very high standard, often painting particularly attractive landscape backgrounds.
Represented: Stourhead NT.

CLACK, Thomas **1830-1907**
Born Coventry, son of R.A.Clack, a schoolmaster. Lived in Coventry before moving to London. Exhibited at RA (13) 1851-91. Taught at Limerick School of Art. Appointed Master at National Art Training School, Marlborough House. Died Hindhead January 1907.
Represented: VAM; Coventry AG.

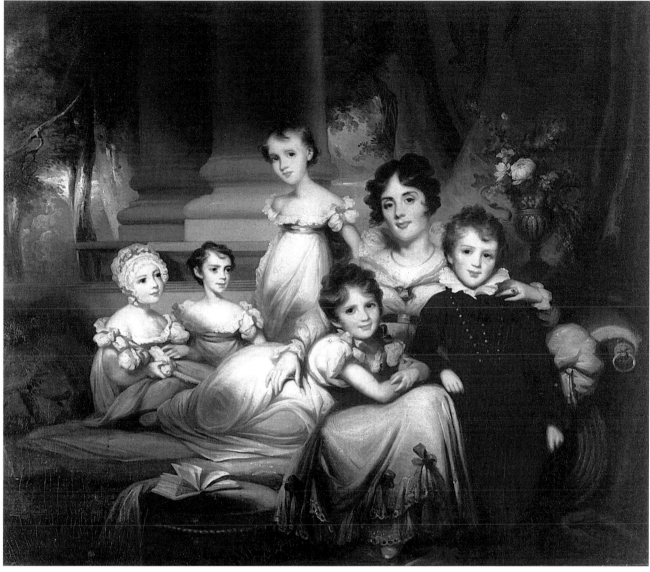

GEORGE CHINNERY. Lady Harriet Paget and children. 21 x 23ins (53.3 x 58.4cm) *Christie's*

CLAGUE, Miss Daisy R. see BERESFORD, Mrs. D.R.

CLAPHAM, Master fl.1768-1771
A pupil of Daniel Dodd. Exhibited crayon portraits and flower pictures at FS (4) 1768-71.

CLARET, Wolfgang William d.1706
London portrait painter, miniaturist and copyist working 1665-90. Copied portraits by Lely and Kneller. Painted full-length baroque portraits of 'William III' and 'Mary II' for Sessions Hall, Northampton 1690. For these two portraits he charged £80, and his prices were at one stage justifiably comparable with those of Lely and Kneller. Painted portrait of 'John, 2nd Earl of Bridgewater'. Died in comfortable circumstances at his house in Lincoln's Inn Fields 1706. He had lived in London 'some forty years' at the time of his death. His will was dated 17 August 1706, proved 5 September 1706.
Represented: NPG London; Lincoln's Inn; HMQ.
Engraved by R.Tompson. **Literature:** G.C.Williamson, *Burlington Magazine* XXXV July 1919 pp.57-8.

CLARK, C.W. fl.1839-1843
Exhibited at RA (8) 1839-43 from London.

CLARK(E), James c.1745/50-1799
Born Inverness, from a poor family. Acquired some training as a portrait painter and was in practice by 1767. Sent to Naples c.1768 by Sir Ludovic Grant and Sir John Dalrymple (later 5th Earl of Stair). Patronized there by Sir William Hamilton. Also made copies for travellers, for whom he acted as antiquary. Died Naples. Left £200 to Lord Stair. His signature shows that he spelt his surname without the final 'e'.
Represented: Oxenfoord; Dalmeny. **Literature:** McEwan.

CLARK, James RI ROI NEAC 1858-1943
Born West Hartlepool and studied there, at South Kensington and in Paris under Bonnat and Gérôme. Moved to London 1877 and was patronized by the royal family. Exhibited at RA (55), SBA, NWS, NEAC, RP, Bewick Club, Laing AG 1881-1938. Elected NEAC 1886, ROI 1893, RI

THEOPHILUS CLARKE. Henry Peter John Layard. Signed and dated 1801. 30 x 25ins (76.2 x 63.5cm) *Phillips*

1903. Also a book illustrator and designer of stained glass. Died Reigate 10 January 1943.
Represented: Pannett AG, Whitby; Sunderland AG; Shipley AG, Gateshead; Laing AG, Newcastle; Gray AG, Hartlepool.
Literature: Hall 1982.

CLARK, John Stewart **1883-1956**
Born Blaydon, near Gateshead, son of J.D.Clark. Exhibited portraits and miniatures at RA (12) 1905-37. Ran a photographic studio in Gateshead. In his later years he worked in the Midlands and the South of England. Died London. It is said that he also exhibited works under the name of Ian Stewart.
Literature: Hall 1982.

CLARK, Joseph Dixon snr **1849-1944**
Born North Shields. Worked in Blaydon painting animal subjects, but also portraits. Exhibited at Bewick Club, Laing AG, RSA. By 1900 he was successful enough to buy a large house at Whickham, near Gateshead, and build a studio at the bottom of his large garden. His last years were spent at Whitley Bay. Died there aged 95.
Represented: Shipley AG, Gateshead; Sunderland AG.
Literature: Hall 1982.

CLARK(E), Thomas **d.1775**
Born Ireland. Entered Dublin Drawing School 1765. Exhibited there before coming to London. Entered RA Schools 1769. Joined Reynolds' studio 1771 on the introduction of Oliver Goldsmith. Exhibited at RA (4) 1769-75. Died at a young age in London, after 'reckless and dissolute habits'.

CLARK, Thomas **c.1814-1883**
Born London, son of Thomas Clark, an artist and Susan (née Ashley). Appointed anatomical draftsman at King's College,

London 1843. Won awards and medals from RSA. Appointed Head of Government School of Design, Birmingham 1846 and taught E.Burne-Jones. Appointed drawing master of King Edward's School of Design and c.1851 left to go to Russia to work for the Tsar. Settled in Victoria, Australia 1852, where he was commissioned to paint the portrait of Sir Henry Barkley, Governor of Victoria (NG of Victoria). Founder member of Victoria Academy of Art 1870. Died South Yarra 21 April 1883 aged 68.
Literature: Australian Dictionary of Biography.

CLARKE, Miss Alice Clementine **fl.1914-1919**
Exhibited at RHA (4) 1914-19 from Ealing.

CLARKE, Rev Charles **b.1845**
Born Sherrington 23 February 1845, son of Rev T.A.Clarke. Studied art under George Rosenberg when at school. Matriculated 20 October 1863 aged 18, BA 1867. Became Vicar of Kington Langley, Wiltshire 1871. On his retirement he concentrated on art. Exhibited at Bath 1910-29.

CLARKE, George Frederick **1823-1906**
Born Carrick-on-Suir 13 April 1823, son of Usher Clarke, a brewer and his wife Sarah (née Corbett). Commenced his artistic career in Dublin but then settled in Chelsea. Exhibited at RHA (5), RA (3), SBA (1) 1845-72. Employed by Sir Francis Grant in making copies of his pictures for engravers. Eventually he had to retire through failing sight. Died 8 March 1906.

CLARKE, J.W. **fl.1831-1836**
Exhibited at RHA (7) 1831-6 from William Street, Dublin.

CLARKE, Miss Josephine **fl.1833-1841**
Exhibited at RHA (9) 1833-41 from Great George's Street, North Dublin.

CLARKE, Mrs Margaret ARHA **d.1961**
Exhibited at RHA (66) 1915-53 from Dublin and posthumously at RHA (5) 1962.
Represented: NGI.

CLARKE, Theophilus ARA **c.1776-c.1832**
Entered RA Schools 22 March 1793 aged 17. Studied under Opie. Exhibited at RA (68), BI (2) 1795-1810. Elected ARA 1803 and remained on ARA's list until 1832. His work shows the influence of Opie, Hoppner, Lawrence and Phillips.
Represented: NPG London; Eton College.

CLARKE, Thomas see CLARK(E), Thomas

CLARKE, William **1815-1905**
Born Carrick-on-Suir 30 August 1815, eighth child of Usher Clarke and brother of G.F.Clarke. Painted for many years in Dublin. Exhibited at RHA (59) 1827-88. Retired to London 1891, dying in Bayswater 12 June 1905.

CLARKSON, Nathaniel **1724-1795**
Began as a coach and sign painter. Worked in Islington and in 1754 painted an altar piece (now destroyed) for the new church there. Exhibited at SA (4) 1762-7. Listed as a portrait painter in Mortimer's Directory. Died Islington September 1795 aged 71. Buried St Mary's Church, Islington.
Literature: DNB.

CLATER, Thomas RBA **1789-1867**
Exhibited at RHA (19), RA (43), BI (91), SBA (192) 1819-62 from Chelsea. Elected RBA 1843. Among his sitters was artist 'H.P.Parker dressed as a Smuggler'.
Represented: Walker AG, Liverpool. **Engraved by** H.Dawe, J.Kennerly.

CLAUSE, William Lionel 1887-1946
Born Middleton, Lancashire 7 May 1887. Studied at Slade under Fred Brown and Henry Tonks. Exhibited at RA (14) 1927-46. Died 9 September 1946.
Represented: Manchester CAG; Leamington AG; Carlisle AG; Bradford AG.

CLAUSEN, Sir George RA RWS RI RP 1852-1944
Born London 18 April 1852, son of George Clausen, a Danish sculptor and decorative painter. Studied at South Kensington. Worked in studio of E.Long RA. Visited Holland, Belgium 1876. Studied at Académie Julian, Paris under Bouguereau and Tony Robert-Fleury. Strongly influenced by Bastien-Lepage and the plein-air school. Concentrated on painting peasants, although he accepted portrait commissions up to c.1910. Exhibited at RA (218), RHA (30), SBA, RP (8), RWS 1876-1943. Elected a founder NEAC, RI 1879, ARA 1895, RP 1928. Professor of Painting at RA Schools 1903-6, RA 1908. Knighted 1927. Published *Six Lectures on Painting*, 1904 and *Aims and Ideals in Art*, 1906. Died Cold Ash, near Newbury 22/3 November 1944 aged 92. His best work is highly sensitive and of the highest quality. His daughter Katharine also painted portraits.
Represented: NPG London; Tate; BM; VAM; Manchester CAG; Cecil Higgins AG, Bedford; NG of Canada; Durban Museum & AG; Aberdeen AG; SNG; Newport AG; Fitzwilliam; Leeds CAG; Blackburn AG; Ulster Museum. **Literature:** G.Clausen, *Royal Academy Lectures on Painting: Sixteen Lectures Delivered to the Students of the Royal Academy*, 1913; K.McConkey, *Sir G.C. RA 1852-1944* Bristol CAG exh. cat. 1980; DNB; DA.

CLAUSEN, Miss Katharine Frances (Mrs O'Brien)
d.1936
Daughter of Sir George Clausen. Studied at RA Schools. Exhibited at RA (25), RHA (32), NEAC 1915-37 from London.

CLAXTON, Marshall 1813-1881
Born Bolton 12 May 1813, son of a Wesleyan minister. Studied under John Jackson RA. Entered RA Schools 1831. Exhibited at RA (32), BI (31), SBA (26) 1832-76. Won medals for portraiture and a prize at Cartoon Competition, Westminster Hall 1843. Visited Italy 1837-42 and travelled to Australia 1850 to begin a School of Art there. Received a commission from the Queen to paint a 'General View of the Harbour and City of Sydney' (HMQ). Also painted a portrait of 'The Queen of the Aborigines'. From Australia he travelled to India, Egypt, the Holy Land and Calcutta. Returned to England c.1857/8. Died Maida Vale, London 28 July 1881.
Represented: NPG London; VAM. **Literature:** Dictionary of Australian Biography.

CLAY, Alfred Barron 1831-1868
Born Walton, near Preston 3 June 1831, second son of Rev John Clay. Articled to a solicitor, but gave up to study art in Liverpool (1852) and at RA Schools. Exhibited at RA (19), BI (1), SBA (2) 1854-69 from London. Married Elizabeth Jane Fayrer 9 April 1856. Died at Rainhill, near Liverpool 1 October 1868 aged 37.
Represented: Walker AG, Liverpool. **Engraved by** J.R.Jackson. **Literature:** DNB.

CLAY, Sir Arthur Temple Felix, Bart 1842-1928
Born London 9 December 1842. An amateur painter of a variety of subjects including portraits. Educated at Trinity College, Cambridge. Exhibited at RA (19), SBA (6), RHA (1), NWS, GG, NWG 1874-92 from London and Guildford. Died 18 March 1928.
Represented: Court of Criminal Appeal, London; War Office; London Museum.

CLAYTON, J. Essex fl.1871-1885
Exhibited at RA (5), SBA (1) 1871-85 from London.

CLEMENTS, Anthony fl.1836
Listed as a portrait painter at Museum Street, Norwich.

CLEMENTS, James fl.1830-1831
Listed as a portrait and miniature painter at 62 Broad Street, Worcester.

CLENNELL, Luke 1781-1840
Born Ulgham, near Morpeth 8 April 1781. Worked in his uncle's grocery and tanning business. Apprenticed to Thomas Bewick at Newcastle 1797. Moved to London by 1804. Received commissions as a wood engraver. Awarded gold palette at SA 1806 and a Gold Medal for an engraving after West 1809, for the diploma of the Highland Society. Concentrated on watercolour painting c.1811, becoming a member of Associated Artists. Exhibited at RA (6), BI, OWS. Won a 150 guineas premium at BI. Commissioned by the Earl of Bridgewater to produce a group portrait of the allied sovereigns and their generals at Guildhall, London 1814. He is known to have completed portrait sketches of almost 400 persons present, but his mental health suffered and he entered an asylum. His wife died shortly afterwards and in an effort to provide for Clennell's three young children the Earl purchased the painting unfinished, commissioning Edward Bird to complete it. Clennell made a good recovery and exhibited at Northumberland Institution and Carlisle Academy. Moved to Tritlington, near Morpeth 1827, but in 1831 he became violent and was placed in an asylum in Newcastle. Although he was allowed out for periods to stay with relatives he died there. He is regarded as Thomas Bewick's most gifted pupil.
Represented: BM; SNPG; VAM; Carlisle AG; Dundee AG; Laing AG, Newcastle; Newport AG; Ulster Museum; Natural History Society of Northumbria. **Literature:** *L.C.*, Laing AG exh. cat. 1981; Hall 1982; DA.

MARSHALL CLAXTON. A boy in red breeches. Signed and dated 1834. 44 x 34ins (111.8 x 86.4cm) *Christie's*

GEORGE CLINT. Miss Foote as Maria Darlington in John Madison Morton's musical entertainment *A Roland for an Oliver* at Covent Garden 1819. Exhibited 1822. 50 x 40ins (127 x 101.6cm) *Christie's*

CLIFFORD, Edward **1844-1907**
Born Bristol, son of Rev Clifford. Studied there and at RA Schools. Exhibited at RA (25), RHA (1), SBA (3), NWS, GG, NWG 1867-92. Among his sitters were Lady Henrietta Ogilvy, the Countess of Pembroke; General Gordon and Lady Castlereagh. He was deeply religious and later worked for the Church Army.
Represented: NPG London; Airlie Castle; Weston Park.

CLINT, Alfred RBA **1807-1883**
Born London, son of George Clint ARA. Studied drawing at an Academy in Drury Lane. Member of Clipstone Society. Began painting portraits, but because of ill health concentrated on landscapes and coastal scenes. Married Emma Buss 29 July 1835 at St Pancras Old Church. Exhibited at RA (24), BI (35), RHA (31), SBA (406) 1828-71. Elected RBA 1843, Secretary 1848, PRBA 1879. Died Kensington 22 March 1883. Left £1,050.17s.11d. Studio sale held Christie's 23 February 1884.
Represented: BM; Tate; VAM; NPG London.

CLINT, George ARA **1770-1854**
Born London 12 April 1770, son of Michael Clint, a hairdresser. Educated in Yorkshire. Apprenticed to a fishmonger. Employed in an attorney's office, before becoming a decorator, working at Westminster Abbey. Set up practice as a miniature painter and then tried portraits in oil

and watercolour as well as engraving, receiving encouragement from Beechey. His studio at 83 Gower Street, London was the rendezvous for many of the leading actors of the day and he painted a series of theatrical portraits. Exhibited at RA (99), BI (9), SBA (15) 1802-47. Elected ARA 1821, but resigned 1836 in disappointment at not being elected RA. His art was much admired by Earl of Egremont, who commissioned a number of paintings from the artist. Died Kensington 10 May 1854. His work was variable, but at its best showed outstanding genius. Among his pupils were R.W.Buss, T.Colley, R.Cooper, W.Coutts, J.Hopwood, S.V.Hunt, J.P.Knight, T.Lupton, C.Penny, C.Picart, S.W.Reynolds jnr, J.H.Robinson, H.Sadd, J.Smyth, J.Thomson, C.Turner, T.Woolnoth and T.Wright. **Represented:** NPG London; BM; Bridlington Library; Tate; Brighton AG; Felbrigg NT; Yale; VAM. **Engraved by** E.Brookes, R.Cooper, S.V.Hunt, T.Lupton, J.Thomson. **Literature:** *Art Journal* July 1854; Ottley; DNB; DA.

CLIVE, Charles d.1794
Painted a full-length of '1st Lord Clive' 1764 (Shrewsbury Museum) and a three-quarter length portrait of the '2nd Lord Clive' (Powis Castle NT) is traditionally attributed to him. Painted to a high standard, in a manner similar to Ramsay. Died Mortlake.

CLIVE, T. fl.1856-1857
Exhibited at RA (3) 1856-7 from London.

CLOSTERMAN, John 1660-1711
Possibly born Osnabrück, son of a painter. Studied in Paris with Henry Tiburin for two years under François de Troy. Settled in London 1681. Associated with John Riley until the latter's death in 1691. At first painted drapery for Riley, but was painting portraits on his own by the mid-1680s. Had a preference for baroque poses, with highly stylized draperies and was considered by Simon to be 'one of the most original Baroque painters working in England'. In the 1690s he attracted the patronage of the Dukes of Marlborough and Somerset. Painted 'The Children of John Taylor of Bifrons Park' c.1696 (NPG London), which Waterhouse considered to be his masterpiece. Accompanied James Stanhope to Madrid 1698, and went on to Rome 1699, where he painted 'Carlo Maratti'. Greatly influenced by the Antique, which was more in accord with his new patron the '3rd Earl of Shaftesbury', c.1700-1 (NPG London). On 6 August 1705 he advertised in the newspapers that he was leaving at Christmas for Hanover, and afterwards to several Courts of Germany, but would finish commissions. He did not leave until April 1706, when he sold his pictures by auction. Believed to have devoted much of his time in his latter years to dealing in old masters. Reported to have married a 'worthless girl, who robbed him of all he possessed, and then ran away: this sent him mad and he soon afterwards died'. Buried London 24 May 1711. **Represented:** NPG London; National Museum of Wales, Cardiff; Royal Society. **Engraved by** C.Baron, T.Bragg, J.Faber jnr, W.Faithorne, R.Grave, S.Gribelin, C.Holl, E.Kirkall, Rivers, E.Sandys, J.Simon, J.Smith, J.Sturt, R.Taylor & Co, G.Vertue, R.White, R.Williams, L.Wilson, G.Zobel. **Literature:** M.Rogers, *J.C.*, London NPG exh.cat. 1981; Walpole Society XLIX 1983 pp.224-80; J.Aston, *Social Life in the Reign of Queen Anne*, 1929; DA.

CLOSTERMAN, John Baptist fl.c.1690-1713
Related to John Closterman, and was probably an assistant. His own signed works are in the same manner, but show a broader and coarser handling. Recorded working in London 1713. **Literature:** M.Rogers, Walpole Society XLIX 1983 p.233; J.D.Stewart, *Burlington Magazine* CVI July 1964 pp.306-9.

CLOVER, Joseph 1779-1853
Born Aylsham, Norfolk 22 August 1779. Studied under Opie 1807-11. Painted a portrait of the Mayor of Norwich 1809 (Castle Museum) and visited Paris 1816. Exhibited at RA (58), BI (12) 1804-36 from London, although he owned property in Norwich. Among his sitters were Miss Brunton of Covent Garden Theatre, Sir W.Curtis, artist James Stark (who painted the background landscape), Thomas Dax, Master of the Exchequer, Mayor of Faversham and Lord Walpole. His early style was provincial, but his later work was accomplished showing slight influences of Lawrence. **Represented:** NG Canada; Royal College of Surgeons. **Engraved by** W.C.Edwards, W.Hutin, T.Overton, E.Scriven, W.Wise & W.Hutin. **Literature:** M.Rajnai, *Norwich Society of Artists & C.*, 1976; J.Walpole, *The Norwich School*, forthcoming.

COATES, George James ROI RP NPS 1869-1930
Born Melbourne 8 August 1869, son of an artist and lithographer. Apprenticed to a firm of stained glass designers. Studied at North Melbourne Art School 1881 and NG of Victoria. Awarded a travelling scholarship 1896 and arrived in England 1897. Exhibited at Paris Salon and studied at Académie Julian, Paris under Laurens 1898-1900. Returned to England, exhibiting at RA (19), RP 1908-30. Elected RP 1913, member of Paris Salon 1927. During the 1st World War he was official war artist to Australia. Died London 27 July 1930. **Represented:** NG Melbourne; Tate; Birmingham CAG.

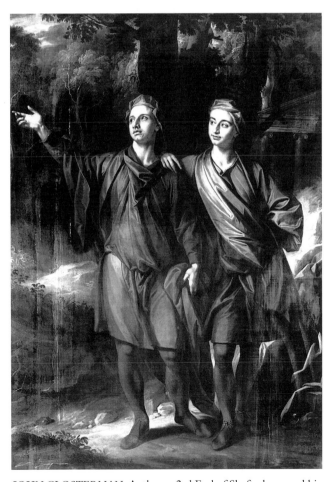

JOHN CLOSTERMAN. Anthony, 3rd Earl of Shaftesbury and his brother the Hon Maurice Ashley. Inscribed and dated 1702. 95 x 67ins (243.1 x 170.2cm) *Christie's*

COBLENZ, Anthony fl.1826-1827
Listed as a portrait painter in London.

COCHRAN, William 1738-1785
Born Strathaven 12 December 1738. Entered Foulis Academy, Glasgow in 1754. Visited Rome about 1761-6, where he painted some history subjects and became a pupil of Gavin Hamilton. Settled as a highly competent portrait painter in Glasgow. Died there 23 October 1785. Buried in the cathedral. He did not exhibit his paintings and seldom signed them. As a consequence his reputation has been underrated.
Represented: Glasgow AG; SNPG. **Engraved by** J.Cochran, V.Green. **Literature:** McEwan.

COCHRANE, Miss Eileen fl.1905
Exhibited at RHA (2) 1905 from South Farnborough.

COCKBURN, Edwin fl.1837-1867
Exhibited at RA (15), BI (16), SBA (33) 1837-67 from London and Whitby.

COCKBURN, Ralph b.c.1779
Son-in-law of Ralph Kirtley, a servant of Sir Joshua Reynolds. Probably the R.Cockburn who entered RA Schools 26 August 1797 aged 18. Exhibited at RA (2) 1802-7 from London. Curator of Dulwich AG 1813.

COCKE, Edward fl.1640s
Painted various portraits of benefactors of the Ironmongers' Company 1640.
Literature: W.Herbert, *The History of the Twelve Great Livery Companies...*, 1836, ii p.603.

COCKERELL, Miss Christabel A. (Lady Frampton)
 b.1860
Daughter of George Russell Cockerell. Exhibited at RA (10), SBA (1) 1884-1903 from London. Married sculptor Sir George Frampton 1893. Meredith Frampton was her son.

COCKERELL, Samuel Pepys b.1844
Son of architect, Sir Charles Robert Cockerell and descendant of Samuel Pepys. Entered Christ Church, Oxford, 12 June 1862 aged 17. BA 1866. Exhibited at RA (29), SBA (2), GG 1875-1903 from London. Also a sculptor and produced with A.Fabbrucci the mural monument to James Stewart Hodgson in Haslemere Church.

COCKING, Edward fl.1830-1862
Exhibited mostly still-lifes at RA (1), BI (2), SBA (8) 1830-48 from Hackney. Listed as a portrait painter at Leamington 1862.

COCKS, Samuel fl.1802-1809
Listed as a portrait, miniature and fancy painter in Birmingham.

CODE, Mrs Mary see BENWELL, Miss Mary

CODNER, Maurice Frederick RP ROI 1888-1958
Born Stoke Newington 27 September 1888, son of William Squires Codner, an iron merchant, and his wife Ada Mary Payne. Educated at Stationers' Company School and Colchester School of Art. Exhibited at RA (45), RP (24), ROI, RI, NEAC, Paris Salon (honorary mention 1938, Silver Medal 1954) 1928-58 from London. Elected RP 1937, honorary secretary RP. Served in France with Royal North Devon Hussars during 1st World War. Painted portraits of King George VI, Queen Elizabeth II and the Queen Mother. Died London 10 March 1958. Buried Dedham.
Represented: Art Workers' Guild, London. **Literature:** DNB.

COHEN, Miss A. Dorothy d.1960
Exhibited at RA (13) 1917-38 from London. Died 17 May 1960.

COHEN, Isaac Michael RP ROI PS 1884-1951
Born Ballarat, Australia. Educated at Melbourne. Studied art at NG of Victoria and in Paris. Exhibited at RA (42), ROI, RP, Paris Salon 1908-51 from London. Died 25 November 1951. His later work was painterly, confident and accomplished.
Represented: NPG London; Preston Manor, Brighton.

COHEN, Minnie Agnes b.1864
Born Eccles. Studied at RA Schools and in Paris under Constant, Bordes and Puvis de Chavaunes. Exhibited at RA (2) 1906-8.
Represented: NPG London.

COLBY, Joseph fl.1851-1886
Exhibited at RA (25), BI (31) 1851-86 from London.

COLE, Alphaeus Philemon 1876-c.1967
Born England July 1876. Studied at Académie Julian Paris under J.P.Laurent and B.Constant 1893-1901 and at École des Beaux-Arts. Exhibited in France and at RA (2) 1904 from Chelsea. Moved to America. Elected NA, President of New York Watercolour Society.
Represented: NPG London; Brooklyn Museum.

COLE, George RBA 1810-1883
Born London 15 January 1810, son of James and Elizabeth Cole. Self-taught artist, who became apprenticed to a house and ship painter at Portsmouth. Employed painting large canvas advertisements for Wombwell's travelling circus. First produced some portraits, but later concentrated on animal and landscape painting. Exhibited at RA (19), BI (35), SBA (222) 1838-83 from Portsmouth. Elected RBA 1850/1. Died 7 September 1883. George Vicat Cole RA was his son.
Represented: Portsmouth AG; Brighton AG; Southampton CAG.

COLE, Miss Mary Ann fl.1841-1861
Exhibited at RA (23), BI (3) 1841-61 from London.

COLE, Philip Tennyson c.1862-1939
Born London. Educated at Chiswick College. Exhibited at RA (7), SBA, NWS 1878-1908 from London. Travelled widely in Australia, New Zealand and Cape Town. Accompanied Dr Carl Peters on his expedition up the Zambesi River 1900. Among his sitters were Edward VII, Cecil Rhodes, the Countess of Iddesleigh, the Duke of Norfolk KG, Sir Frank Green, Bart, Lord Mayor of London, and Lord Milner, GCMG GCB, High Commissioner for South Africa. Died in a London hospital 1 September 1939 aged 77.
Represented: NPG London; St Bartholomew's Hospital, London.

COLE, Sir Ralph, Bart. c.1625-1704
Son of Sir Nicholas Cole of Brancepeth Castle, near Durham. On his father's death became 2nd Baronet of Brancepeth and inherited a considerable fortune, spending the greater part of it on the patronage of artists. Received lessons from Van Dyck and became an amateur painter of portraits, miniatures and subjects. His portrait by Lely was engraved in mezzotint by Francis Place, and Lely may have given Cole advice on painting. Produced a portrait of Charles II, which he engraved himself. Also painted a number of pictures for his home at Brancepeth Castle. Represented Durham in Parliament from 1675-8. Extravagant expenditure forced him to sell the castle 1701. Died 9 August 1704. Buried Brancepeth.
Engraved by R.Tompson. **Literature:** DNB; Hall 1982.

COLE, Soloman fl.1841-1859
Born Worcester. Listed as a portrait painter at Stoke 1841 and 1851. Exhibited at RA (17) 1845-59 from Worcester and London. Painted many clergymen.
Engraved by S.Cousins; Miss Turner.

COLEMAN, Edward d.1867
Born Birmingham, son of portrait painter James Coleman. Remained in Birmingham, painting portraits and other subjects and decorating papier mâché. Exhibited at RA (16) 1813-48, and contributed to RBSA from 1827. Elected RBSA 1826.
Engraved by T.Lupton.

COLEMAN, James fl.1790s
Birmingham portrait painter.

COLEMAN, Rebecca c.1840
Born Horsham. Studied at Heatherley's. Taught English in Germany for three years, returning on the outbreak of Austro-Prussian War 1866. Then painted portraits and enjoyed a reputation as a designer of heads on pottery.

COLERIDGE, Lady Jane Fortescue (née Seymour) d.1878
Daughter of Rev George T.Seymour of Farringford, Isle of Wight. Married Sir John Duke Coleridge 11 August 1846, before he was knighted. Exhibited at RA (15) 1864-78. Among her sitters were William Butterfield and artist William Boxall RA. Died 6 February 1878.

COLLIER, Charles fl.1790s
Third son of John Collier, who practised as a portrait painter. Described as 'eccentric'.

COLLIER, John 1708-1786
Born Urmston 16 December 1708, son of Rev John Collier, a poor country curate. Apprenticed to a Dutch loom weaver. Became an itinerant schoolmaster. Settled at a Free School near Rochdale 1729 and painted portraits 'in good taste' as an amateur, but later concentrated on caricature. Published a number of works, which attracted considerable attention. Died Milnrow 4 July 1786. Buried Rochdale churchyard.
Literature: DNB.

COLLIER, Hon. John OBE VPRP 1850-1934
Born London 27 January 1850, son of Judge Robert Porrett Collier (1st Lord Monkswell). Educated at Eton. Studied art at Slade under Poynter, in Paris under J.P.Laurens and in Munich. Encouraged by Alma-Tadema and Millais. Established a successful society portrait practice producing painterly works with a fresh use of light and colour. Exhibited mostly portraits at RA (85), RHA (4), RP (165) 1874-1934. Published *The Primer of Art*, 1882, *A Manual of Oil Painting*, 1886, *The Art of Portrait Painting*, 1905, and *The Religion of an Artist*, 1926. Among his sitters were W.K.Clifford, Professor Huxley, TRH the Dukes of Cornwall and York, and 'Mrs Kendal, Miss Ellen Terry and Mr Tree in "The Merry Wives of Windsor"'. Married happily, in succession, two daughters of T.H.Huxley. A copy of his sitters' book is in NPG London. Died London 11 April 1934.
Represented: NPG London; NGI; Brighton AG; Clandon Park NT; Southampton CAG; Tate; Athenaeum, London.
Engraved by T.H.Crawford, R.Josey, C.A.Tomkins, J.C.Webb.
Literature: W.H.Pollock, *The Art of Hon. J.C.*, 1914; DA.
Colour Plate 6

COLLIER, Marian (née Huxley) 1859-1887
Daughter of T.H.Huxley. Studied at the Slade. Married artist Hon. John Collier in 1879, with Alma-Tadema among the

HON. JOHN COLLIER. Lady Darling. Signed and dated 1892. 30 x 25ins (76.2 x 63.5cm) *Southampton CAG*

guests. Exhibited RA (3), GG 1880-4 from London. After the birth of her daughter she suffered severe depression and showed signs of 'madness'. She was taken to Paris for treatment but contracted pneumonia and died 18 November 1887.
Represented: NPG London. **Literature:** R.W.Clark, *The Huxleys, 1968*.

COLLIER, William Henry RHA d.1853
Exhibited at RA (1), RHA (65) 1826-53 from London and Dublin from 1830. Had a highly successful practice in Dublin.

COLLINGS, Albert Henry RBA RI d.1947
Born London. Exhibited at RA (30), SBA, RI, Paris Salon 1893-1938 from London. Awarded a Gold Medal for a portrait at Paris Salon 1907. Among his sitters was HRH the Prince of Wales. Died 6 May 1947.

COLLINGS, Robert fl.1883
Exhibited at SBA (1) 1883 from Kensington.

COLLINGWOOD, Dora (Mrs Altounyan) 1886-1964
Born Gillhead, near Windermere, eldest daughter of William and Edith Collingwood. Studied at Cope's studio in London. An accomplished amateur painter of portraits. Had a romantic attachment to author Arthur Ransome, whose portrait she painted (Abbott Hall AG, Kendal). Married Ernest Altounyan, son of an Armenian doctor, and went to live with him in Aleppo, Syria.
Represented: Ruskin Museum, Coniston.

COLLINGWOOD, Mrs Edith Mary 'Dorothy' (née Isaac) 1857-1928
Eldest daughter of Thomas Isaac, a corn merchant in Maldon, Essex. Studied at Slade with her future husband William Gersham Collingwood whom she married 1883, moving to Gillhead. Painted portraits and flower paintings,

JAMES EDGELL COLLINS. John Ford of Wroxall 1854. Signed in monogram. 65¾ x 38½ins (167 x 97.8cm) *Christie's*

JAMES EDGELL COLLINS. Jane Maria Wroxall 1854. Signed in mongram. 65¾ x 38½ins (167 x 97.8cm) *Christie's*

but gradually began to specialize in miniatures. Exhibited at RA (4) 1901-11 and SM from Coniston. Elected SM 1901. Travelled widely abroad during the 1st World War.

COLLINS, Charles Allston **1828-1873**
Born 25 January 1828, son of artist William Collins RA and brother of author Wilkie Collins. Studied at RA Schools. Exhibited at RA (14), BI (2) 1847-55. During the 1850s his work showed the influence of the Pre-Raphaelites, and he was friendly with Millais, with whom he made several painting expeditions. Married Kate, daughter of Charles Dickens, 1860. Gave up painting about this time to concentrate as a writer of novels, travel books and essays. Died in London after a painful illness 9 April 1873.
Represented: NPG London; VAM; Ashmolean; Tate; BM.
Literature: *The Pre-Raphaelites,* Tate exh. cat. 1984; DA.

COLLINS, Hugh **fl.1868-1896**
Born Edinburgh. Listed as a portrait painter at 10 Shore Terrace, Dundee 1878. Exhibited RA (3), SBA (4) 1868-91 from London and Edinburgh.
Represented: SNPG; Victoria AG, Australia.

COLLINS, James Edgell **b.1820**
Born near Bath. Studied at Sass's Academy under W.F.Witherington at same time as Millais. Entered RA Schools 1840. Studied in Paris. Exhibited at RA (23), BI (20), SBA (14) 1841-76 from London. Among his sitters were the Earl of Caernarvon, Mrs F.R.Pickersgill and Sir W.Robert Grove.
Represented: Birmingham AG. **Engraved by** G.H.Every, J.Faed, W.H.Mote, J.Scott.

COLLINS, John **fl.1825-1848**
Listed as a portrait painter at Manchester.

COLLINS, Mrs Kate see PERUGINI, Mrs Kate

COLLINS, R. **fl.1865**
Signed and dated 1865 a competent portrait of a lady in a private collection.

COLLINS, Richard **d.1732**
Son of Peterborough artist Richard Collins. Studied under Dahl. Had a portrait practice in Lincolnshire and Leicestershire. Produced a number of primitive early

conversation pieces and delightful small full-length portraits. Also a topographical draughtsman.
Represented: VAM; Knowle NT. **Literature:** A.C.Sewter, *Apollo* XXXVI September, October 1942 pp.71-3, 103-5.

COLLINS, Simeon　　　　fl.1832-1834
Listed as a portrait painter at 4 St James Street, London.

COLLINS, William　RA　　　1788-1847
Born London 18 September 1788, son of William Collins, biographer of Morland. Received lessons under Morland. Entered RA Schools 1807. Exhibited at RA (124), BI (45) 1807-46. Elected ARA 1814, RA 1820; RA Librarian 1840-2. Married the daughter of Andrew Geddes and sister of Margaret Sarah Carpenter 1822. Travelled in Holland, Belgium, Italy and Germany. Although he is known for his extremely popular landscapes and coastal scenes in fresh, soft colouring, in his earlier years he produced a number of portraits, usually of children (his last exhibited portrait was in 1824). Died London 17 February 1847. Buried St Mary's Church, Paddington. Father of Wilkie Collins and Charles Allston Collins.
Represented: BM; Tate; NGI; VAM; SNG; Portsmouth AG; Newport AG; Towner AG, Eastbourne. **Literature:** Wilkie Collins, *Memoirs of the Life of W.C.*, 2 vols 1848; DNB; DA.

COLLOPY, Timothy　　　　fl.1777-1810
Born Limerick. Started his career as a baker's apprentice. Showed a talent for art and was sent by Limerick catholics to study art in Rome. On his return he painted altar-pieces and portraits in Limerick. Worked Dublin 1777 and 1780. Settled in London c.1783. Exhibited at RA (3) 1786-8. Died London c.1810/11.
Engraved by W.Hincks, W.Ridley.

COLLUCCI, V. or Z.　　　　fl.1860-1861
Exhibited at RA (2), SBA (4) 1860-1 from London.

COLONE, Adam (de)　　　　fl.1622-1628
Born Scotland. Possibly son of artist Adriaen Vanson and Susanna de Colone. Thought to have trained in The Netherlands. In 1623 he was paid for two portraits of 'James I' (possibly those now at Hatfield and Newbattle Abbey). Settled in Scotland by 1624. His name has been attributed to a group of portraits of Scottish upper class sitters, one of which, 'George, 3rd Earl of Winton and His Two Sons' is associated with the payment to 'Adame the painter'. The last was dated 1628. Had a considerable influence on the style of George Jamesone.
Represented: SNPG. **Literature:** D.Thomson, *The Life and Art of George Jamesone*, 1974, with list of attributed portraits.

COLTHURST, Francis Edward　　　b.1874
Born Taunton 28 July 1874, son of a timber merchant. Studied art at Taunton, National Art Training School and RA Schools, where he won medals and scholarships. Exhibited at RA (7), GG and in the provinces from 1905. Lived in Kensington and taught at Regent Street Polytechnic. Sometimes signed his worked in block letters 'Colthurst'.

COMER, Alexander, of York　　　1637-c.1700
Baptized St Martin's in the Fields 3 September 1637, son of Richard and Annae Comer. Recorded in London 1677, but later lived for some years in York, where he was friendly with William Lodge, whose portrait he painted. Paid £18 each for a series of full-length portraits of ladies at Welbeck (1683 and 1685). Also produced crayon copies after Van Dyck for Duke of Hamilton. His work shows some closeness in style with that of Mary Beale, whom he apparently knew. Died in the Charterhouse c.1700 (Vertue).
Represented: York CAG; Welbeck Abbey. **Literature:** N.Gillow, York CAG Preview 98 1972.

COMER, John　　　　fl.1763
Exhibited at FS (1) 1763 from London.

COMERFORD, John　　　　d.1832
Born Kilkenny c.1762 or c.1770, son of a flax dresser. Reportedly copied pictures at Kilkenny Castle and began portraiture at an early age. Visited Dublin 1793. Studied at Dublin Society of Arts and settled there c.1802. Exhibited in Dublin and RA (3) 1800-13. Met Chinnery, and afterwards concentrated with considerable success on miniatures and small portraits in chalk and pencil. In 1811 he was a member of the committee of Dublin Society and its vice-president. His sitters' book 1810-28 (with some reference to earlier material) is in NPG London. Died Dublin 25 January 1832. Reportedly left £16,000. Among his pupils were J.Doyle and T.C.Thompson.
Represented: VAM; NGI. **Engraved by** A.Cardon, J.Carver, F.Deleu, S.Freeman, J.Heath, H.Meyer, T.Nugent, Parker, L.Schiavonetti, S.Watts.

CONDER, Charles Edward　NEAC　　1868-1909
Born London 24 or 26 October 1868, son of a civil engineer. Spent his early years in Eastbourne and India. Moved to Australia 1884, studying art in Melbourne and Sydney. Visited Paris 1890, where he trained at Académie Julian. After 1897 he settled mainly in England, painting landscapes and portraits in oil, although he is best known for his water-colours on silk. Exhibited at Leicester Galleries, GG, NEAC. A founder of the Society of Twelve. Elected NEAC 1901, but gave up painting because of poor health 1906. Died Virginia Water, Surrey 9 February 1909.
Represented: Manchester CAG; NPG London; NGI; BM; Tate; Aberdeen AG; Fitzwilliam; Glasgow AG; SNG; Brighton AG; Leeds CAG; Ulster Museum; Cartwright Hall, Bedford; Leicester CAG. **Literature:** F.G.Gibson, *C.C.*, 1914; J.Rothenstein, *The Life and Death of C.*, 1938; DA.

CONING, Daniel de　　　1668-after 1727
Born Amsterdam in 1668. Apprenticed to Jacob Koninck I in Copenhagen and was working in Oxford by 1690. Produced a number of portraits of the Tracy family at Stanway.
Represented: NPG London.

CONNARD, Philip　RA RWS NEAC NPS
　　　　1875-1958
Born Southport 24 March 1875, son of David Connard. Began work as a house painter, attending evening art classes. Won a scholarship to RCA. Awarded a BI prize 1898. Visited Paris. Taught at Lambeth School of Art, where he was friends with Wilson Steer. Official war artist to the Navy 1916-18. Exhibited at RA (203), NEAC, NPS, RWS 1906-59 from London and Richmond. Elected NEAC 1909, NPS 1911, ARA 1918, RA 1925, ARWS 1932, RWS 1934, RA Keeper 1945. Died Twickenham Hospital 8 December 1958.
Represented: NPG London; Welsh NG, Cardiff; Tate; Manchester CAG; Southport AG; Aberdeen AG; Windsor Castle; Bradford AG. **Literature:** *P.C. RA*, Orleans House Gallery exh. cat. 1973.

CONNOLLY, Michael　　　　fl.1885-1917
Exhibited at RA (7) 1885-1917 from London.

CONNOLLY, William Lane　　　fl.1846-1853
Exhibited at RHA (13) 1846-53 from Dublin.

CONNOR, Arthur Bentley　FSA　　1880-1960
Born Clapham 21 September 1880, son of surgeon James Henthorn Todd Connor and great grandson of Robert Bentley. Blind in the right eye from birth. Studied at Heatherley's 1896-1900. Entered RA Schools 1900. Exhibited at RA (4) 1910-17 from London and Penarth. On

the death of his father in 1917 he ceased exhibiting at RA. A close friend of artist E.H.Shepherd. Illustrated *Highways and Byways of Hampshire*. Painted a portrait of King George V in khaki uniform (HMQ) during 1st World War. Asked by his cousin, serving at the front, to move his preparatory school from Penarth to St Peter's Weston-super-Mare. This he did, and met and married Mary Kathleen Ware, a teacher there, on 18 December 1919. Became headmaster of Petergate School, Weston-super-Mare 1921-38 and combined teaching and painting. A severe illness forced him to retire 1938. Elected FSA 1945, President of Monumental Brass Society 1955-60. Lived in Charmouth, Dorset. Died 28 March 1960, aged 79, while staying with his daughter in Tadworth, Surrey. Left his widow £3,633.13s. After his death his papers on *The Monumental Brasses of Somerset* were published in book form. A remarkably talented artist, influenced by the Pre-Raphaelites. His work was admired by John Ward RA.
Literature: *Pulman's Weekly News* 5 April 1960; *Bridport News* 8 April 1960.
Colour Plate 2

CONOR, William RHA ROI **1881-1968**
Born Belfast 7 May 1881. Studied at Belfast School of Art and in London and Paris. Exhibited at RA (12), NEAC, RHA (198), Paris Salon and in America and Australia 1918-68. Died Belfast 5 February 1968. Among his sitters was the Marquess of Londonderry.

CONRADI, Moritz **fl.1865-1876**
Exhibited at RA (8) 1865-76 from 23 Berners Street, London.

CONSTABLE, James Lawson **b.1890**
Born Hamilton 28 January 1890. Studied at Hamilton Academy and Glasgow School of Art. Exhibited portraits and landscapes at RSA.

CONSTABLE, John RA **1776-1837**
Born East Bergholt 11 June 1776, son of Golding Constable, a prosperous mill owner. Entered RA Schools 1800. Exhibited at RA (104), BI (32), RHA (4) 1802-37. Elected ARA 1819, RA 1829. Along with Turner he is rated as Britain's most important 19th century landscape painter, but he also painted a number of portraits, many of them early commissions of friends or relatives. Died 31 March 1837.
Represented: VAM; Ipswich AG; Tate; NG London; NPG London; RA; Frick Collection, New York; Philadelphia Museum of Art. **Engraved by** D.Lucas; W.J.Ward. **Literature:** C.R.Leslie, *Memoirs of the Life of J.C. Esq R.A,* 1843; R.B.Beckett ed., *J.C.'s Correspondence Vols I-V,* 1962-76; M.Cormack, *C.,* 1986; I.Fleming-Williams, *C. Landscape Drawings,* 1976; R.Gadney, *C. and his World,* 1976; G.Reynolds, VAM, *Catalogue of the C. Collection,* 1973; M.Rosenthal, *C. – The Painter and His Landscape,* 1983; J.Sunderland, *C.,* 1971; L.Parris, *Tate C. Collection,* 1981; L.Parris, I.Fleming-Williams & C.Shields, Tate exh. cat. 1976; A.Smart & A.Brooks, *C. and His Country,* 1976; J.Walker, *J.C.,* 1979; L.Parris & I.Fleming-Williams, *C.,* Tate exh. cat. 1991; DA.

CONSTABLE, Mrs Roddice (née Pennethorne) **b.1881**
Born Wandsworth Prison 19 June 1881, daughter of Captain L.P.Pennethorne of the prison service. Studied art Clapham, Lambeth and London School of Art under Brangwyn. Exhibited miniatures and portraits at RA (1), RMS.

CONSTANTIN, René Auguste **fl.1712-1726**
A member of Painters' Guild at The Hague 1712. Worked as a portrait painter in Germany. Married Susan Bleiberg in St Martin's in the Field, Westminster 24 October 1715. Worked in London. Believed to have been in the household of the Prince of Wales (later George II).

CONTENCIN, Peter jnr **fl.1777-1819**
Exhibited at SA (2), RA (5) 1777-1819 from London.

CONTENCIN, W. **fl.1803**
Exhibited at RA (2) 1803 from Kensington.

COOK, Charles Henry **c.1830-c.1906**
Born Bandon, County Cork. Exhibited at RHA (4) 1864-71. After practising as a portrait artist for some years in Cork, where he lived with his widowed mother, he came to England and was in Bath 1870 (as a portrait and miniature painter). Died Scarborough.

COOK, Henry **1819-1900**
Born London 5 November 1819. Studied under F.R.Say and at Academy of St Luke in Rome. Exhibited at RA (9), BI (2), RHA (4), SBA (2), GG 1840-55. Lived for several years in Italy, where he painted battle scenes for Napoleon III and Victor Emmanuel. Queen Victoria was a patron.
Represented: Quirinal Palace; Capodimonte Museum, Naples.

COOK, J.A. **fl.1883**
Exhibited at GG (2) 1883 from London. May be John A.Cook, born Gloucester, Massachusetts, 1870.

COOK, Richard **fl.1785-1804**
Exhibited at RA (11?), BI from 1785-1804? from London. Appointed Professor of Perspective to Her Majesty and Princesses 1801. Most likely the Richard Cook who married Jane Tuck at St Leonards, Shoreditch 22 July 1784, father of Richard Cook RA 1784-1857. The two artists are inextricably confused.

COOK, Theodore **fl.1881-1894**
Exhibited at RA (6), SBA (4) 1881-94 from London and St Ives, Cornwall.

COOKE, Charles Allan **b.1878**
Born Southsea 18 November 1878. Studied at London School of Art under Philip de Laszlo. Lived in Bath. Exhibited at RI, ROI. Married Frances G. Ramsden.

COOKE, Henry **c.1642-1700**
Studied for five years under Theodore Russel, probably in the 1660s. Started as a portrait painter. There is a payment in the accounts of Elton Hall 1663 'To Mr Cooke the picture drawer'. A portrait of 'Isaac Newton' signed and dated 1669 is in St Catherine's College, Cambridge. After being involved in a homicide he fled the country, and spent two periods, each of seven years, in Italy where he became a pupil of Salvator Rosa. Returned to England after the Revolution. Employed by William III on repairing the Raphael cartoons. During the 1690s he enjoyed some success as a history painter. Died London 8 or 18 November 1700 aged 58. A son Henry Cooke (under 21 in 1700) was also a painter and was a director of Kneller's Academy 1700.
Engraved by W.Faithorne, C.Grignion.

COOKE, J.B. **fl.1829-1835**
Exhibited at RA (1), RBSA (15) 1829-35 from Birmingham, where he had a portrait practice.

COOKE, John **d.1932**
Exhibited at RA (40), SBA, NWG 1887-1927 from London. A friend of Sargent and exhibited a portrait of him at Paris Salon 1887.
Represented: NPG London.

COOKES, Miss Laura **fl.1866**
Exhibited at SBA (1) 1866 from Warwick.

ALFRED EGERTON COOPER. Lady Muriel Ashton. Inscribed on reverse. 46 x 35ins (116.9 x 88.9cm)

Sherwood Fine Art Centre

COOKESLEY, Mrs Margaret Murray c.1850-1927
Born Dorset. Trained in Brussels with Leroy and Gallais. Studied at South Kensington Schools. Exhibited a variety of subjects, including a portrait of 'Miss Ellen Terry as Imogen', at RA (22) 1884-1920 from London. On a visit to Constantinople she obtained a commission for a portrait of the Sultan's son, which brought many honours from the Sultan.

COOLEY, Thomas ARHA 1795-1872
Born Dublin, son of William and Emily Cooley. Deaf and dumb. Studied at RA Schools. Exhibited at SA, RA (52), RHA (60) 1813-46. Elected ARHA 1826. Portrait Painter to the Lord Lieutenant, the Marquess of Anglesey 1828. Worked successfully in London and Dublin and c.1823 charged 30 guineas for a full-length uniform, 50 guineas for a lady, 25 for a half-length and five and seven guineas for bust portraits. Died of smallpox in Dublin 20 June 1872. Buried Mount Jerome Cemetery.
Represented: NPG London. **Literature:** Strickland.

COOPER, Alexander Davis fl.1837-1888
Exhibited at RA (67) 1837-88 from London and Government School of Design, Manchester. His wife was also an artist.
Represented: NPG London. **Engraved by** C.Knight.

COOPER, Alfred Egerton RBA 1883-1974
Born Tattenhall 5 July 1883, son of Alfred Cooper. Studied at Bilston School of Art and at RCA. Exhibited at RA (28), SBA, Paris Salon 1911-70. Elected RBA 1914. Served in Artists' Rifles in 1st World War, during which time the sight in one eye was impaired by chlorine gas. Painted a portrait of George VI 1940 and Sir Winston Churchill 1943. Lived for many years in Chelsea. Died 11 May 1974.
Represented: NPG London.

COOPER, Byron (George Gordon Byron) 1881-1933
Born Manchester, son of author Robert Cooper. Studied at Manchester Academy of Fine Arts, where he was elected a member 1881. Exhibited in Manchester and at RA (7), SBA, RI 1906-29 from Cheshire. Signed 'Byron Cooper'.

COOPER, Miss Edith A. fl.1885-1889
Exhibited at RA (2), GG 1885-9 from London.

COOPER, Frederick Carter fl.1841
Listed as a portrait painter at Trentbridge, Nottingham 1841.

COOPER, J. c.1695-c.1754
Itinerant portrait painter working in a provincial manner derived from Kneller. Works by him have been located in America.
Literature: G.Groce, *Art Quarterly* XVIII Spring 1955 pp.73-82.

COOPER, Nathan b.1802
Born Leicester. Listed there in 1861 census as a widowed portrait artist.

COOPER, W. fl.1846-1862
Exhibited at RA (30), BI (4), SBA (10) 1846-62 from Crouch End, Hornsey. Enjoyed a successful practice and often painted members of the clergy.

COPE, Sir Arthur Stockdale KCVO RA RP 1857-1940
Born 2 November 1857, son of Charles West Cope RA. Studied at Carey's Art School and RA Schools from 1874. Became a prolific portrait painter, enjoying an extremely successful society practice. Exhibited at RA (276), RP (12) 1876-1935. Elected ARA 1899, RP 1900, RA 1910. Knighted 1917, KCVO 1927. Among his sitters were Kaiser Wilhelm II, Richard Redgrave RA, the Marquess of Hartington, General Lord Roberts, the Duke of Cambridge, the Archbishop of Canterbury, Lord Kitchener, Edward VII, George V, Edward VIII and Lord Knutsford. Collaborated with artist J.Charlton. Ran his own art school in South Kensington. Had many pupils including Vanessa Bell and Nina Hamnett. Died 5 July 1940. Worked in a grand imperial manner and was an accomplished draughtsman.
Represented: NPG London; Diocese of Llandaff; Grimsthorpe Castle.

COPE, Charles West RA 1811-1890
Born Leeds 28 July 1811, son of artist Charles Cope, a close friend of West and Turner. As a boy he was bullied at school resulting in a broken elbow that left his arm crooked for life. Studied at Sass's Academy 1827. Entered RA Schools 1828 (Silver Medal 1831). Went to Paris 1831/2, studying Venetian pictures in the Louvre, and travelled in Italy 1833-5. He had been a friend of the great patron John Sheepshanks from childhood, and was introduced by him to George Richmond and Richard Redgrave. Exhibited at RA (134), BI (14) 1833-82. Elected ARA 1843, RA 1848, founder of Etching Club. Painted a wide variety of subjects, including a number of portraits (particularly towards the end of his career). Represented in Centennial Exhibition of RA in Philadelphia 1876. Lived at Maidenhead from 1879 and retired 1883. Died Bournemouth 21 August 1890.
Represented: NPG London; BM; VAM; Leeds CAG;

CHARLES WEST COPE. Margaret Cope, the artist's daughter. Signed with initials and dated 1883. 10¾ x 8½ins (27.3 x 21.6cm)
Christie's

JOHN SINGLETON COPLEY. Colonel Baker. Signed and dated 1781. 30 x 25ins (76.2 x 63.5cm) *Christie's*

Ashmolean; Leicester AG; Castle Museum, Colchester. **Literature:** *Art Journal* 1890 p.320; C.H.Cope, *Reminiscences of C.W.C. RA,* 1891; DA.

COPEMAN, Constance Gertrude **1864-1953**
Born Liverpool, daughter of a solicitor and a favourite pupil of John Finnie. Exhibited at Liverpool Autumn Exhibitions and RA (6) 1885-1938. Also made toys with her friend Miss Paethorpe.
Represented: Walker AG, Liverpool; Liverpool City Libraries.

COPLAND, Miss L. **fl.1842**
Exhibited at RA (1) 1842 from Peckham Rye.

COPLEY, John Singleton RA **1737/8-1815**
Born Boston July 1737 or 1738 (conflicting sources). Son of Richard Copley from Limerick and Mary (née Singleton) from County Clare. His parents emigrated to Boston 1736, immediately after their marriage, where his father started a tobacco shop, but died the following year. Ten years later his mother married portrait painter Peter Pelham, under whom he studied. Copley developed a successful portrait practice in Boston and painted George Washington 1755. Left for Europe June 1774 and travelled via London and Paris to Rome, where he was encouraged by Gavin Hamilton to study Raphael and the antique. In October 1775 he settled in London, where he was encouraged by West and Reynolds. Exhibited portraits and histories at SA (9), RA (43), BI (8) 1766-1812. Elected FSA 1771, ARA 1776, RA 1779. Able to charge 100 guineas for a full-length 1783. Struck down by paralysis August 1815 and died 9 September. Buried Highgate Cemetery. Waterhouse describes him as 'the most

distinguished painter of the contemporary historical scene in English 18th century painting'. J.H.Bell was his pupil. His son became Lord Chancellor of England as Lord Lyndhurst. **Represented:** NPG London; SNPG; Tate; BM; VAM; Guildhall AG, London; HMQ; Fogg; NG Washington; Boston MFA; Yale; Los Angeles; Camperdown House, Dundee; Renishaw Hall. **Engraved by** F.Bartolozzi, J.M.Delatre, R.Dunkarton, E.Finden, A.Fogg, S.Freeman, R.Graves, J.Heath, B.Holl, A.Kessler, F.C.Nicholson, W.Ridley, W.Sharp, B.Smith, J.R.Smith, C.Townley, C.Turner, F.F.Walker, J.T.Wedgewood; T.Wright. **Literature:** DNB; M.B.Amory, *Domestic and Artistic Life of J.S.C.,* Boston 1884; A.Thorndike Perkins, *Sketch of the Life and List of Some of the Works of J.S.C.,* Boston 1873; J.Flexner, *J.S.C.,* 1948; J.D.Prown, *J.S.C.,* 2 vols 1966; DA.

COPNALL, Frank Thomas **1870-1949**
Born Ryde, Isle of Wight 27 April 1870. Settled in Liverpool. Took up portraiture as a career in 1897 and was a member of LA. Exhibited at RA (51), RSA, NPS 1905-45. Married artist Theresa Norah Butchart. Died Liverpool 13 March 1949. Capable of conveying considerable character and his best work is highly accomplished.
Represented: Walker AG, Liverpool; Southampton CAG; Royal College of Surgeons.

COPNALL, Mrs Theresa Norah (née Butchart) b.1882
Born Haughton-le-Skern 24 August 1882, daughter of Andrew Butchart, a director of a steel company. Studied in Brussels, Slade and Herkomer's School. Exhibited at RA (14) 1927-54. Married Frank Thomas Copnall.

COQUES, Gonzales **1614-1684**
Born Antwerp 8 December 1614. A celebrated Flemish painter. President of the Antwerp Guild of St Luke 1664;

worked for Charles I and may have lived in England for a time. Painted miniatures and small portraits and was influenced by Van Dyck. Died Antwerp 18 April 1684.
Represented: Wallace Collection; Rosenbach Library, Philadelphia; Malines Museum, Belgium.

CORBAUX, Miss Fanny RI RBA
(Maria Françoise Catherine Doetter) 1812-1883
Born Paris (according to 1851 census), probably daughter of author Francis Corbaux. In 1827, aged 15, she was forced to earn her living from art and that year obtained a large Silver Medal for a miniature exhibited at SA. The following year she won Silver Isis Medal and in 1830 Gold Medal. Mainly a miniature painter, but did produce some portraits in oils. Exhibited at SA, RA (86), BI (15), SBA (48), NWS 1828-54. Elected Honorary RBA 1830, RI 1839. Produced illustrations for Moore's *Pearls of the East,* 1837 and for *Cousin Natália's Tales,* 1841. Died Brighton 1 February 1883. The *Art Union,* 1839 writes: 'There are few who surpass her in elegant and delicate arrangement of a picture; and she has considerable skill in executing that which she conceives. She has a truly poetical mind and large powers of observation...'
Represented: BM. **Engraved by** H.Adlard, H.Cook, W.J.Edwards, R.J.Lane, Parry.

CORBET, Matthew Ridley ARA 1850-1902
Born South Willingham, Lincolnshire 20 May 1850, son of Rev Andrew Corbet. Educated at Cheltenham College, Slade under Davis Cooper and RA Schools from 1872. Visited Rome 1880-3 and studied under Giovanni Costa. Began as a portrait painter, but from c.1883 concentrated on landscapes. Exhibited at RA (38), SBA (2), GG, NWG 1875-1902. Elected ARA 1902. Married artist Edith (née Edinborough), widow of Arthur Marsh. Died of pneumonia at his residence in St John's Wood 25 June 1902.
Represented: Tate; VAM. **Literature:** *Art Journal* 1902 p.164; DNB.

CORBET, Philip fl.1823-1856
Exhibited at RA (31), BI (1) 1823-56 from London and Shrewsbury (from 1830). Among his sitters were Sir John Hanmer MP, Sir Henry Edwards and David Pugh MP of Llanerchydol.

CORBETT, John c.1777-1815
Son of Daniel Corbett, an engraver in Cork. Entered RA Schools 'Feb. 3rd 1798 aged 21' and studied under James Barry. Returned to Cork, where he had a successful practice painting portraits and miniatures. Died February 1815.
Represented: BM. **Engraved by** W.Ridley, C.Turner, J.Whessell.

CORBOULD, Alfred Hitchins fl.1842-1864
Exhibited at RA (19), RHA (5), BI (18), SBA (8) 1842-64 from London.

CORBOULD, Aster Richard Chilten 1812-1882
Born Easton, Suffolk son of Richard Thomas Corbould and Mary Chilten. Exhibited at RA (35), BI (32), RHA (8), SBA (60) 1841-80 from London. Among his patrons were the Earl and Countess of Rosshire. Also a lithographer.
Represented: Ipswich Town Hall.

CORBOULD, Edward Henry 1815-1905
Born London 5 December 1815. Exhibited at RA (17), BI (1), SBA (11), NWS 1835-80. Painted a portrait of Prince Albert. Appointed to teach Queen Victoria's children to paint in watercolour 1851 and executed their portraits. Died London 18 January 1905.
Engraved by B.Inwards, R.J.Lane. **Literature:** DA.

PHILIP CORBET. Mrs Thomas Carline (née Donaldson). Signed and inscribed on the reverse. Exhibited 1825. 20 x 16¾ins (50.8 x 42.6cm) *Christie's*

CORBOULD, Richard 1757-1831
Born London 18 April 1757. Entered RA Schools 21 March 1774 aged '17. 18th last April'. Exhibited at FS, RA (100), BI (27) 1777-1817 from London. Worked chiefly as an illustrator. Died Highgate 26 July 1831. Buried St Andrew's Church, Holborn. His sons Henry and George were also painters.
Represented: BM; VAM. **Engraved by** J.Baker, B.Granger, J.Hopwood, Kinnerley, T.Milton, A.W.Warren, C.Warren.

CORDEN, William 1797-1867
Born Ashbourne, Derbyshire 28 November 1797. Apprenticed at the Derby china works painting flowers and portraits. Set up as a portrait painter, but concentrated mostly on miniatures and enamels, and after receiving commissions from George IV and Queen Victoria settled at Old Windsor. Exhibited at RA (3) 1826-35. Died Nottingham 18 June 1867.
Engraved by W.J.Ward.

CORDER, Miss Rosa fl.1879-1882
Exhibited at RA (1), GG (1) 1879-82 from London.
Represented: Pusey House, Oxford. **Engraved by** R.Josey.

CORKRAN, Miss Henriette L. d.1911
Specialized in pastel portraits. Exhibited at RA (19) 1880-1903 from London. Died 17 March 1911.

CORMACK, Neil b.c.1793
Brother of Rev John Cormack, Minister of Stowe. Entered RA Schools 9 August 1816 aged 23. Exhibited at RA (5) 1814-16 from London. Applied to Court of Directors of East India Company 28 April 1818 to practice as a miniature painter, giving Earl of Fife and Charles Forbes MP as his

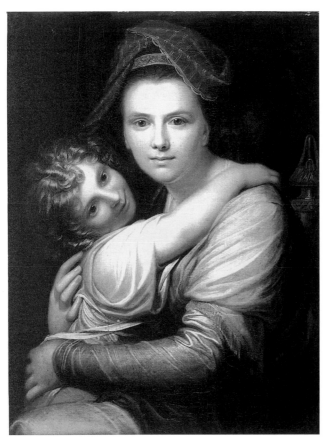

RICHARD COSWAY. A lady with a child. 26 x 19ins (66 x 48.2cm) *Christie's*

securities. Permission was granted and he sailed from Liverpool 27 June 1818, reaching Bombay 30 October 1818. In Madras 1823 and again c.1831-37, Bombay 1819-27.

CORNELISSEN, Miss Marie see LUCAS, Mrs Marie

CORNELISZ, Lucas **1493/5-1552**
Born Leyden, Holland, son and pupil of Cornelis Engelbrechtsz. Moved to England c.1527 with his wife and children. Reportedly a painter to Henry VIII and to have taught Holbein watercolour. Died Leyden.

CORNISH, John **fl.1750-1762**
Little known portrait painter. Worked for a time at Oxford. Painted a portrait of 'Charles Paxton' 1751.
Represented: NPG London. **Engraved by** T.Park, J.K.Sherwin.

CORTE, Cesare da **1550-soon after 1613**
A Genoese painter who came to England, where he is reported to have painted a portrait of 'Queen Elizabeth' and to have enjoyed great success. Put to death during the Inquisition.

CORVUS, Joannes **fl.1512-1545**
Reportedly born Jan Rave in Bruges, where he was a member of Painters' Guild 1512. Moved to England c.1518 when, like many of his fellow countrymen, he latinized his name. Painted portraits of 'Bishop Foxe, 1522' (Corpus Christi College, Oxford) and 'Mary Tudor' (Sudeley Castle), which were once signed on the frames 'Joannes Corvus Fladrus'. Also produced decorative paintings for the Crown 1527-31,

and frequently used a groundwork of gold.
Represented: NPG London. **Engraved by** J.Faber snr, G.Vertue.

CORWINE, Aaron Houghton **1802-1830**
Born near Maysville, Kentucky. Studied under T.Sully 1818-20, then set up a successful practice in Cincinnati. Moved to England 1829, where he painted his self portrait (Mason County Museum, Mayville, Kentucky). Died aged 28.
Literature: E.H.Dwight, *Antiques* June 1955 pp.502-4.

COSLETT, Roderick G. **b.c.1785**
Entered RA Schools 12 November 1802 aged 17 years. Exhibited portraits and miniatures at RA (39) 1808-27 from London.
Represented: Brighton AG.

COSSE, Lawrence Joseph **b.1759**
Entered RA Schools '3 December 1784, age 26, April 1784' (Silver Medal 1788). Exhibited portraits and miniatures at RA (93), SBA (7), BI (49) 1784-1837 from London.
Engraved by W.Bond, J.Collyer.

COSTA, John da see DA COSTA, John

COSTANTINI, Virgil (Virgillo) RI **b.1882**
Born Cefatj, Italy, son of an author. Studied at RA, in Italy and Paris. Based in Paris and exhibited there and in London, Venice, Rome and Pittsburgh. Elected RI 1923.

COSTELLO, Mrs Jensine **b.1886**
Born Norway 7 May 1886. Studied at Heatherley's. Exhibited at RP, ROI, Paris Salon and in the provinces from Exmouth.

COSWAY, Maria (née Hadfield) **c.1760-1838**
Born Maria Louisa Catherine Cecilia Hadfield at Florence, daughter of Charles and Isabella. Four previous children were murdered as babies by a deranged maid before the maid was caught with the baby Maria. Educated in a convent and was a devout Roman Catholic throughout her life. Studied in Florence under V.Cerroti and in Rome. Elected a member of the Florence Academy 1778. Came to London 1779, working most as a miniaturist. Married artist Richard Cosway 18 January 1781. Exhibited at RA (42) 1781-1801. She was a talented musician and the Cosways gave spectacular musical parties in the 1780s. Gave birth to Louisa Angelica 4 May 1790, but departed for Italy a few weeks later to recover from what was probably severe post-natal depression. Returned after four and a half years, but was devastated when only a year and a half later Louisa died 29 July 1796. Established a girls' convent school at Lodi, to which she retired after her husband's death. Made a Baroness by Francis I 1834. Died Lodi 5 January 1838. Her affair with Thomas Jefferson became the subject of the Merchant-Ivory film *Jefferson in Paris*.
Represented: Leeds CAG. **Engraved by** A.Cardon, V.Green, S.W.Reynolds, P.Tomkins, C.Watson. **Literature:** S.Lloyd, *Richard & Maria Cosway – Regency Artists of Taste and Fashion*, SNPG and NPG London exh. cat. 1995; DA.

COSWAY, Richard RA **c.1742-1821**
Baptized Okeford, Devon 5 November 1742, son of Richard Cosway and his wife Mary. Showed an early talent for art and moved to London 1754, probably spending a short time under Hudson. Studied at Shipley's Drawing School. Won his first premium from SA 1755. On leaving Shipley's he taught at Pars' Drawing School, painted ship signs and 'not always chaste' snuff-box lids. Entered RA Schools 1769. Exhibited at SA (13), FS (16), RA (46) 1755-1806. Elected ARA 1770, RA 1771. Appointed Principal Painter to HRH the Prince of Wales 1785 (who was a personal friend). Although he painted

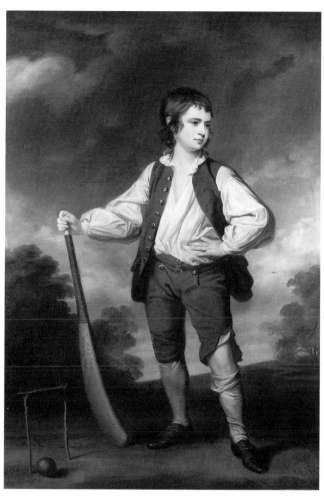

FRANCIS COTES. Lewis Cage. Signed, inscribed and dated 1768. 67 x 43ins (170.2 x 109.2cm) *Christie's*

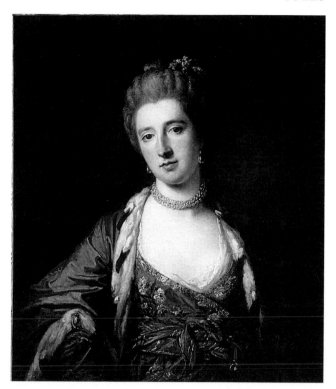

FRANCIS COTES. Elizabeth Burdett. 30 x 25ins (76.2 x 63.5 cm)
 Christie's

extensively in oils, he is chiefly remembered as an outstanding miniaturist, who Waterhouse describes as 'the smartest and one of the most elegant miniature painters England has produced'. Married Maria Hadfield 1781. Died Edgware 4 July 1821.
Represented: NPG London; BM; Ashmolean; Fitzwilliam; Exeter Museum; Powderham Castle; Wallace Collection; Blenheim; Longford; Metropolitan Museum of Art, New York. **Engraved by** J.S.Agar, W.Angus, W.W.Barney, F.Bartolozzi, W.Birch, W.Bond, M.A.Bourlier, M.Bovi, J.Brown, A.Cardon, T.Chambers, T.Cheesman, J.Clarke, J.Conde, J.Cook, H.R.Cook, T.A.Dean, R.Dagley, P.Dawe, F.Del Pedro, W.Dickinson, W.C.Edwards, W.Evans, J.Fittler, A.Freschi, G.Hadfield, J.E.Haid, J.Heath, W.Holl, J.Hopwood, J.Jehner, C.Josi, King, H.Kingsbury, R.J.Lane, W.Lane, W.Leney, G.Minasi, J.Murphy, G.Murray, W.Raddon, S.W.Reynolds, W.Ridley, P.Roberts, A.Roffe, Ruotte, I.Sailliar, J.Saunders, L.Schiavonetti, E.Scott, E.Scriven, W.Sharp, J.K.Sherwin, J.R.Smith, E.Stodart, G.T.Stubbs, R.Thew, C.Townley, A.Van Assen, C.Watson, C.White. **Literature:** G.C.Williamson, *R.C. RA and His Wife and Pupils*, 1897 and 1905; S.Lloyd, *Richard and Maria Cosway – Regency Artists of Taste*, SNPG and NPG London exh. cat. 1995; DA.

COTES, Francis RA 1726-1770
Born London 20 May 1726 (baptized 29 May 1726), son of Robert Cotes a pharmacist, and elder brother of miniaturist

Samuel Cotes. Apprenticed to George Knapton in the early 1740s, and began as a crayon portraitist (his earliest known pastel was produced in 1747, Leicester AG). An oil portrait dated 1753 is known, but oils before 1757 are rare. His work shows the influence of Liotard, Ramsay and Reynolds. He was highly accomplished and after 1764, could afford to employ Peter Toms (who he shared with Reynolds) to paint the draperies in many of the works. In 1765 he moved to a large house at 32 Cavendish Square (later occupied by Romney and Sir Martin Archer Shee), and became the most fashionable portraitist after Reynolds and Gainsborough, painting royal portraits by 1767. In 1768 he charged 25 guineas for a head in crayons; 20 guineas a head in oils, 40 guineas a half-length and 80 guineas a full-length. Exhibited at SA (50), RA (18) 1760-70. A founder RA. Wrote a short article on his technique (published in the *European Magazine* February 1797). In 1768 Cotes was extremely ill from 'the stone' and underwent an operation, which he managed to survive. Died London 19 July 1770. Among the possible causes of his death was listed 'accidental poisoning by soap'. Interred at Richmond, Surrey. Waterhouse describes him as 'the most accomplished British pastellist of the century'. Among his pupils were John Milbourn and John Russell RA, who cherished their friendship and claimed the only arguments they had arose over Cotes' frequent use of 'intemperate' language.
Represented: NPG London; NGI; Tate; SNPG; Yale; York AG; Stourhead NT; Inveraray Castle; Walker AG, Liverpool. **Engraved by** H.Adlard, F.Bartolozzi, J.Bengo, Blondel, M.A.Bourlier, R.Brookshaw, J.Cook, J.Finlayson, E.Fisher, M.Ford, S.Freeman, V.Green, J.Hall, R.Houston, E.Judkins, J.McArdell, W.H.Mote, T.Priscott, R.Purcell, W.Ridley, H.T.Ryall, W.W.Ryland, C.Spooner, J.Vendramini, J.Watson, J.T.Wedgwood, B.Wilson; J.Wilson. **Literature:** E.M.Johnson, *F.C.*, 1976; J.Russell, *Elements of Painting with Crayons*, 1772; DA.

COTMAN, Frederick George RI 1850-1920
Born Ipswich 14 August 1850, son of Henry Cotman and nephew of artist John Sell Cotman. Entered RA Schools 1868, where he won a Gold Medal for historical painting. His early watercolours were purchased by Leighton and Watts, and he did studio work for Leighton and H.T.Wells before starting on his own as a portrait and history painter. Exhibited at RA (49), SBA (9) RI 1871-1904. Elected RI 1882. Went to the Mediterranean with the Duke of Westminster, who had commissioned portraits from him, including a large group portrait of 'The Marchioness of Westminster, Lady Theodora Guest and Mr Guest Playing Dummy Whist'. Died 16 July 1920.
Represented: Town Hall, Ipswich; Castle Museum, Norwich; Ashmolean; Walker AG, Liverpool; Oldham AG.

COTTERELL, John fl.1851
Listed as a portraitist at 14 High Street, Worcester.

COTTON, Mrs Mariette (née Leslie) fl.1891-1927
Born New York. Studied in Paris under Carolus Duran and Henner. Exhibited at RA (6) 1891-1927 from London and Munich. Married Leslie Cotton.
Literature: Bénézit.

COUCH, Richard b.c.1823
Born Shooters Hill. Listed as a portrait painter aged 28 in 1851 census for Oxford Street, London. His wife Mary was born in Wales.

COUSEN (COUZENS), Charles c.1821-1889
Born Marylebone. Exhibited at SBA (1) 1848 from Norwood, London. Listed as a portrait painter aged 30 in 1851 census for Charles Street, London. Worked as an engraver for the *Art Journal*.

COUSINS, Charles fl.1877-1879
Exhibited at GG (5) 1877-9 from London.

COUTTS, Gordon fl.1917-1928
Born Glasgow. Exhibited at RA (5) 1917-28 from London. Taught at various art schools in Australia.
Represented: Sydney Museum.

COVELL fl.1646
Active in Bristol in 1646, when he painted 'Sir Thomas Fairfax' without sittings.
Literature: C.R.Markham, *A Life of the Great Lord Fairfax*, 1870 p.429.

COVELL, Miss S.E. fl.1810-1812
Exhibited at RA (1) 1810 from London.
Represented: NPG London.

COVENTRY, Charles Christopher fl. 1802-1811
Exhibited at RA (11) 1802-11 from London. Married Sarah Lawrence in Stepney 22 January 1803.
Engraved by J.Young.

COWIE, James RSA 1886-1956
Born Cuminestown, Aberdeenshire 16 May 1886. Exhibited at RA, RSA and elsewhere in Scotland. Based at Pollokshields in Glasgow. Died Netherton of Delgaty 18 April 1956.
Represented: Aberdeen AG; Glasgow AG; Paisley AG.
Literature: C. Oliver, *J.C.*, 1980; R. Calvoressi, *J.C.*, SNG 1979; McEwan.

COWIE, Robert fl.1878
Listed as a portraitist at 4 Airlee Terrace, Dundee.

COWPER, Douglas 1817-1839
Born Gibraltar 30 May 1817, son of a merchant. Brought up in Guernsey. Studied at Sass' Academy c.1834, where he became friendly with fellow pupil W.P.Frith (whose portrait he painted). Studied at RA Schools, winning medals in every class. Exhibited at RA (6), BI (3), SBA (8) 1837-9. A brilliant future was predicted for him, but he caught consumption. Returned to Guernsey, where he died 28 November 1839 aged 22. His work was admired by Sir Martin Archer Shee.
Literature: W.P.Frith, *My Autobiography and Reminiscences*, 1887; *Art Union* 1838 p.183.

COWPER, Frank Cadogen RA RWS RP 1877-1958
Born Wicken Rectory, Northamptonshire 16 October 1877. Educated at Cranleigh. Studied at St John's Wood School 1896, RA Schools 1897-1902 and with Edwin Abbey and J.S.Sargent. Exhibited at RA (135), RWS, RP and in Paris, Rome and Venice 1899-1957. Elected ARWS 1904, ARA 1907, RWS 1911/12, RP 1921, RA 1934. Painted a variety of subjects including portraits, and was influenced by the Pre-Raphaelites. Commissioned by Earl of Carlisle to paint six walls in the Houses of Parliament 1910. Worked in London, Guernsey and Fairford. Died Cirencester 17 November 1958.
Represented: Leeds CAG; Russell-Cotes AG, Bournemouth; Tate; Queensland AG.

COWPER, Colonel Thomas 1863-1927
Son of Thomas Christopher Cowper-Essex of Hawkshead. Educated at Harrow. Exhibited as 'Thomas Cowper' at RA (9), NWG, ROI, RP 1891-1906. Served in South African War 1901-2. Assumed the additional name of 'Essex' again 1903. From 1906-17 he was Lieutenant Colonel, 3rd Battalion, the Royal North Lancashire Regiment. In the 1st World War he was in command of 3rd (reserve) Battalion of the Regiment, retiring as honorary colonel 1917. Killed in a road accident in France.
Literature: Hall 1979.

COX, Alfred Wilson c.1820-c.1888
Born Nottingham. Exhibited at RA (7), SBA (2) 1868-86.
Represented: Castle Museum, Nottingham.

COX, Joseph 1757-c.1793
Entered RA Schools 1787. Exhibited at RA (4) 1793 from Knightsbridge. His profile of George III was engraved by J.K.Sherwin in *An Inventory of Cox's Museum* 1794.

CRABB, William 1811-1876
Born Laurencekirk. Assistant to Sir Francis Grant, painting draperies. Exhibited at RA (9), BI (4), SBA (9) 1848-63 from London. Among his sitters were Richard Monckton Milnes MP, and General Havelock (engraved in 1858 by Sinclair). His work was influenced by Raeburn. Went blind. Died Laurencekirk 20 July 1876.
Literature: McEwan.

CRAIG, Alexander d.1878
Spent his early years in Glasgow. Exhibited at RA (6), BI 1840-57. Among his sitters were Dr. David Livingstone, explorer of Central Africa, and the poet Thomas Campbell (Glasgow AG). Died Glasgow.
Engraved by A.Remanoczy.

CRAIG, Frank ROI 1874-1918
Born Abbey, Kent 27 February 1874. Educated at Merchant Taylor's School. Studied art at Lambeth, Cook's School, Fitzroy Street and RA Schools under E.A.Abbey. Exhibited at RA (49), SBA, NPS, Paris Salon 1892-1916 from Stoke Newington and Hampstead. Moved to The Tree Gables,

Hindhead 1903. Also worked as an illustrator for many leading magazines and illustrated Kipling's poems. Died Sintra, Portugal 9 July 1918. Painted in the manner of Abbey and F.C.Cowper.
Represented: NG Sydney; Tate; City Hall, Cardiff.

CRAIG, J.K. fl.1819-1821
Exhibited at RA (5) 1819-21 from London.

CRAIG, William Marshall fl.1787-1827
Believed to have been brother of James Craig, an Edinburgh architect. Worked in Liverpool 1787, Manchester 1788 and London from 1791. Exhibited portraits and miniatures at RA (127), OWS 1788-1827. Appointed painter in watercolour to the Queen and miniature painter to the Duke and Duchess of York. Taught Sarah Biffin.
Represented: VAM; BM. **Engraved by** J.Freeman, S.Freeman, J.Heath, J.Hopwood, J.Kennerley, H.Landseer, K.Mackenzie, C.Picart, J.Vendramini; T.Woolnoth.
Literature: McEwan.

CRAKE, Francis fl.1685
Provincial portrait painter. A head of a man aged 80 signed 'Fra.Crake fecit 1685' formerly belonged to Lord Zouche.

CRANCH, John 1751-1821
Born Kingsbridge, Devon 12 October 1751. An amateur painter of a variety of subjects including some portraits. He had a distinctive style. The young John Constable was impressed by his work. Exhibited at SA (1), BI (8) 1791-1808. Settled in Bath, where he died February 1821.
Represented: Tate.

CRANE, Thomas 1808-1859
Born Chester. Entered RA Schools 31 March 1825, aged 17, with the financial support of Edward Taylor. Returned to Chester, where he set up practice as a miniature painter. Moved to Liverpool, exhibiting at LA. Elected ALA 1835, LA 1838, Treasurer 1841. Also exhibited at RA (9), BI (3), RHA (12), SBA (3) 1842-58. Suffered ill health and settled in Torquay for twelve years. Moved to Bayswater 1857, where he died July 1859. Enjoyed a reputation for his portraits of children and ladies. Walter Crane was his son.
Represented: Walker AG, Liverpool. **Engraved by** T.O.Barlow. **Literature:** *Art Journal* 1859 p.360.

CRANE, Walter RWS 1845-1915
Born Liverpool 15 August 1845, son of artist Thomas Crane. Apprenticed in Torquay to the wood engraver W.J.Linton 1859. Studied at Heatherley's. Worked for the Dalziels from 1867. Known chiefly as an accomplished and important illustrator, but he also painted some portraits. Influenced by Burne-Jones and the Pre-Raphaelite Brotherhood, and was associated with William Morris and The Socialist League. Exhibited at RA (2), RHA (1), SBA (9), RWS, NWS, GG. Elected RI 1882-6, ARWS 1888, RWS 1899. Principal of RCA 1898-9. Died Horsham Cottage Hospital 14 or 15 March 1915.
Represented: BM; VAM; Tate; Ashmolean; Aberdeen AG; SNG; Birmingham CAG; Machester CAG; Dundee AG; Cecil Higgins AG, Bedford. **Literature:** P.G.Konody, *The Art of W.C.*, 1902; *W.C., An Artist's Reminiscences*, 1907; A.Crane, *My Grandfather, W.C.*, 1957; I.Spencer, *W.C.*, 1975; DA.

CRANKE, James snr 1707-1780
Born Urswick. Began as a decorative plasterer. By the 1740s he was working in London and had earned a position at the Old Academy of St Martin's Lane. Married the daughter of a prosperous family c.1744 and moved to Bloomsbury. Painted members of the Ryder family at Sandon 1745, charging 10 guineas for a half-length and 20 guineas for a full-length. In 1746 Vertue (iii p.134) saw a a man's head by Cranke 'painted strongly...and at least as well as anyone living'. Moved to Furness with his wife and children 1752 and by 1755 to Urswick, where he built a large new house. Here he had a successful portrait practice, painting north country landowners and their families. Died Urswick October 1780.
Represented: Yale; Barrow Museum & AG. **Engraved by** J.Faber jnr, J.McArdell. **Literature:** H.Gaythorpe, 'Two Old Masters – The Crankes of Urswick', *Cumberland and Westmorland Antiquarian and Archaeological Society's Transactions* Vol VI New series 1906; DA.

CRANKE, James jnr 1746-1826
Born Bloomsbury, son of artist James Cranke. When he was nine his family settled in Urswick, where he is believed to have attended the local grammar school. Studied at the galleries of Dresden and Antwerp. Entered RA Schools 1775 aged 27. Exhibited at RA (12) 1775-98 from London. By the turn of the century he had moved to Gainford, County Durham to look after the affairs of his clergyman brother John, who had suffered from fits after his appointment there in 1798. He continued to paint portraits and religious compositions. On his brother's death he returned to Urswick, living the rest of his life with his nephew at Hawkfield in the village. During the last years of his life he went blind.

CRAWFORD, Hugh Adam RSA 1898-1982
Born Busby, Lanarkshire 28 October 1898. Studied at Glasgow School of Art and in London. Exhibited at RSA. Elected ARSA 1938, RSA 1958.
Represented: SNPG; Glasgow AG; Paisley AG. **Literature:** C. Oliver, *C. and Company,* Glasgow exh. cat. 1978; McEwan.

CRAWFORD, Robert Cree RSW 1842-1924
Born Govanbank. Studied at Glasgow before moving to Canada. Returned to Scotland and earned a local reputation painting portraits. Exhibited at RA (15), RSA (27) 1871-98 from Glasgow. Elected RSW 1878.
Represented: Glasgow AG; Paisley AG. **Literature:** McEwan.

CRAWFORD, William ARSA 1825-1869
Born Ayr, son of a poet. Studied at Trustees' Academy, Edinburgh, under Sir William Allan. Won a travelling scholarship and spent several years in Rome. On his return he settled in Edinburgh, and taught drawing at Trustees' Academy until 1858. Enjoyed a successful portrait practice and his chalk drawings were particularly admired. Exhibited at RSA (195), RHA (9), RA (24) 1841-68. Elected ARSA 1860. Among his sitters were Lady Anne Duff, Sir George Macpherson Grant and 'Johnny, Son of Artist Thomas Faed RA'. Died Edinburgh 2 May 1869.
Engraved by F.Schenck. **Literature:** McEwan.

CREALOCK, Major John Mansfield RP 1871-1959
Born in Manchester and educated at Sandhurst. Served in the Boer War as a Lieutenant in the Imperial Yeomanry. Returned to Europe and studied art in Paris at the Académie Julian 1901-4. Exhibited at RA (8), RP 1908-30 from London. Elected RP 1917/18. Died 12 January 1959.

CREED, Mrs Elizabeth 1642-1728
Daughter of Sir Gilbert Pickering, 1st Bart. Married a country gentleman of Oundle, and on his death became an amateur painter of portraits and epitaphs. Died May 1728.
Literature: K.A.Esdaile, *Burlington Magazine* LXXVI; Clayton.

CREGAN, Martin PRHA 1788-1870
Born County Meath and brought up by foster parents. Became a servant of the Stewarts of Killymoon, County Tyrone. Entered Dublin Society Schools (winning medals

1806 and 1807). Moved to London and studied under Martin Archer Shee at the expense of the Stewarts. Exhibited at RHA (344), RA (37), BI (6) 1812-59. A friend of Constable, Hayter and Landseer. Married in London Jane, daughter of Henry Schwertzel 1816. They had 16 children. Worked in London until 1821/2, when he settled in Dublin, where he enjoyed a highly successful portrait practice. Elected founder RHA, President 1832-56. An accomplished portraitist and his best works have considerable character. Died Dublin 10 December 1870. Buried Mount Jerome.
Represented: NGI; Ulster Museum, Belfast. **Engraved by** S.Cousins, S.W.Reynolds snr & jnr, C.Turner, G.R.Ward.
Literature: Strickland; DA.

CREGEEN, Miss Bertha C. **fl.1893-1896**
Exhibited at RA (4) 1893-6 from Brockley.

CREGEEN, Miss Emily A. **fl.1892-1894**
Exhibited at RA (2) 1892-4 from Brockley.

CRESPIN, Felix **fl.1838**
Listed as a portrait painter at 73 North Street, Brighton.

CRESWELL, Miss Emily Grace **b.1889**
Born Ravenstone, Leicestershire 1 June 1889. Studied art at Leicester, Harrogate and Leamington Art Schools. Exhibited at RBSA and in Darlington from Leamington.

CRESWICK, H.G. **fl.1855**
Exhibited a portrait of a clergyman at RA (1) 1855.

CRICK, Montague **fl.1898-1904**
Exhibited at RA (3) 1898-1904 from Leicester and Norwich.

CRIDDLE, Mrs Mary Ann (née Alabaster) OWS
 1805-1880
Born Holywell, Flint, daughter of an amateur caricaturist. Educated in Colchester. Studied under Hayter 1824-6, winning several medals for drawing. Exhibited at RA (11), BI (25), SBA (14), OWS 1830-48. Elected OWS 1849. Married Harry Criddle c.1836. Several of her works were bought by the Baroness Burdett-Coutts. Went partially blind 1852, but recovered sufficiently to continue painting. Retired to Addlestone, near Chertsey 1861, where she died.

CRIGHTON, Hugh Ford **fl.1853-1882**
Exhibited at RA (1), SBA (1), RSA (28) from 1853-82 from London and Glasgow. Among his sitters was 'R.N.Philipps FSA'. Listed as a portraitist at 141 St Vincent Street, Glasgow 1878. Also worked in Edinburgh.

CRISP, Frank Edward Fitzjohn **d.1915**
Exhibited at RA (8) 1905-15 from London. Second Lieutenant in Grenadier Guards. Killed in action in France 5 January 1915.

CRISTALL, Joshua POWS **1767-1847**
Born Camborne, Cornwall (or according to other accounts 'from the shadow of Aldgate Pump, London'), son of Joseph Alexander Cristall, an Arbroath sea captain and merchant. Brought up in Rotherhithe and Blackheath and went to a school in Greenwich. His father found him various jobs in the China trade. Later worked as a copying clerk and as a printer at Old Ford. Determined to become an artist, he entered RA Schools. By 1795 he was trying to support himself entirely from painting. Exhibited at RA (3), BI (3), OWS 1803-44. Elected founder OWS 1804, POWS 1816, 1819 and from 1821-31. Married Mrs Cousins (Cozens), a wealthy French widow 1812, moving to Goodrich on the Wye 1823. Returned to London 1841, because of the death of his wife and failing health. In his last years he was an active member of the Sketching Club and

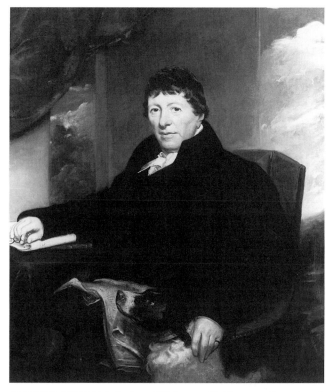

MARTIN CREGAN. Arthur Chichester McCartney. Signed and dated 1825. 50 x 40ins (127 x 101.6cm) *Christie's*

concentrated on portraiture. Died St John's Wood 18 October 1847 in his eightieth year. Buried beside his wife in Goodrich.
Represented: BM; VAM; Tate; Glasgow AG; Leeds CAG; Newport AG; Walsall AG; Ulster Museum; Gloucester CAG; Haworth AG, Accrington. **Engraved by** T.Trotter.
Literature: DNB; J.L.Roget, *History of the Old Water-colour Society,* 1891; *J.C.,* VAM exh. cat. 1975.

CRITZ, Emanuel de **1608-1665**
Baptized London 25 September 1608, son of John de Critz. Bought pictures and sculpture at the Commonwealth sale and tried unsuccessfully to become Serjeant-Painter in 1660. Painted a full-length of 'Sir John Maynard' 1657 in the commonwealth style of Robert Walker. Buried London 2 November 1665.
Represented: NPG London (works attributed to); Tate; Ashmolean.

CRITZ, John de (i) **c.1552/3-1642**
Born at Antwerp. Moved to England 1568, where he was apprenticed to Lucas de Heere. From 1582-8 he was much employed by Sir Francis Walsingham and sent abroad as a courier, especially to Paris. By 1598 he was considered one of the leading portrait artists in London. Received a grant of the reversion of the office of Serjeant-Painter in June 1603 and jointly held that office with Leonard Fryer from 1605, and with Robert Peake 1607-19. Painted royal portraits from 1606. Towards the end of his life he concentrated on heraldic and decorative painting. Buried London 14 March 1642 aged about 90.
Represented: NPG London; Dulwich AG. **Literature:** Walpole Society XLVII; DA.

CRITZ, John de (ii) **c.1593-c.1642**
Son of John de Critz. Sworn in as Serjeant-Painter 18 March 1641/2, but died at Oxford soon afterwards.
Literature: Walpole Society XLVII; DA.

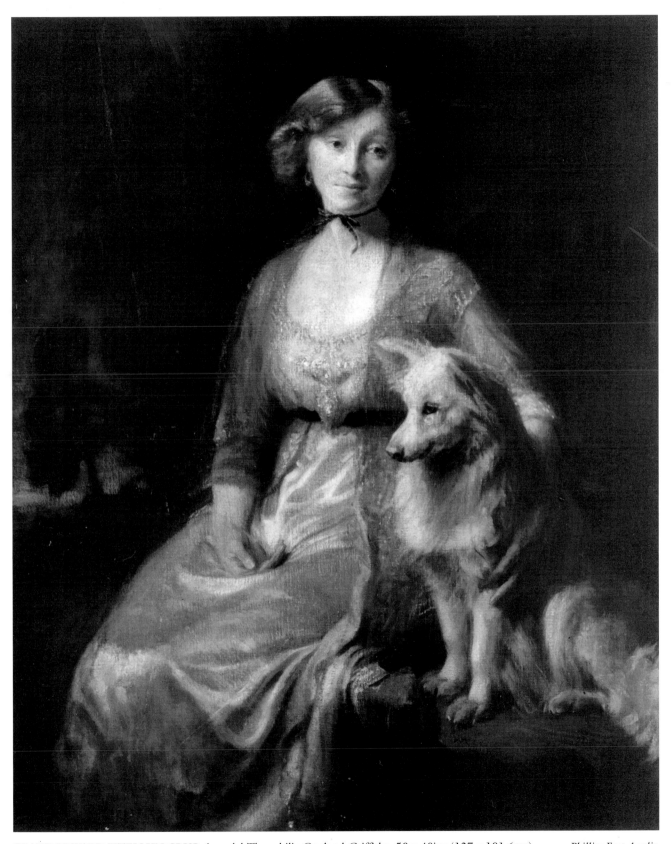

FRANK EDWARD FITZJOHN CRISP. Arundel Theophilia Copland-Griffiths. 50 x 40ins (127 x 101.6cm) *Phillips East Anglia*

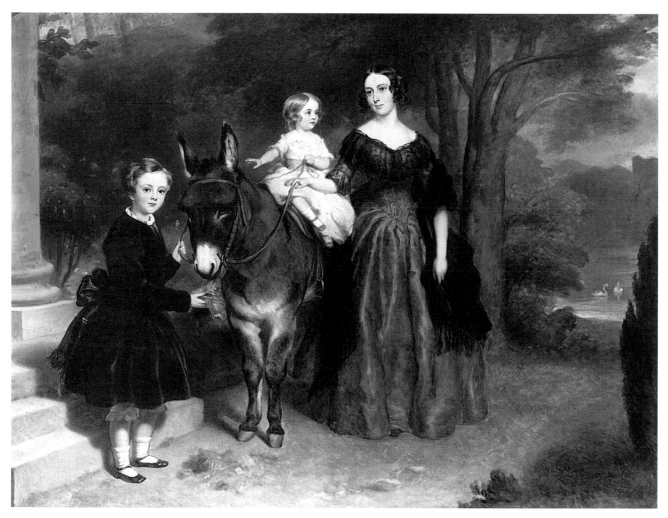

NICHOLAS JOSEPH CROWLEY. Mrs G. Shaw and children. Signed and inscribed on an old label on the reverse. Exhibited 1851. 34 x 44ins (86.4 x 111.8cm)
Phillips

CRITZ, Thomas de **1607-1653**
Baptized London 1 July 1607, son of John de Critz. Executed decorative and restoration work for the Crown 1629-37. Credited with painting outstanding portraits of Tradescant family (Ashmolean), which have been previously attributed to Emanuel de Critz. Buried London 22 October 1653.
Literature: Walpole Society XLVII; DA.

CROCHEZ, T. **fl.1850**
Exhibited at RA (1) 1850 from London.

CROKER, Miss Ely **fl. 1910-1917**
Exhibited at RHA (9) 1910-17 from Dublin.

CROKER (CROCKER), Joachim **d.1700**
Possibly a native of Germany. A prominent member of Corporation of Painter-Stayners and Cutlers in Dublin, the Guild of St Luke, and its Master 1699. Died Dublin January 1699/1700.

CROMBIE, Benjamin William **1803-1847**
Born Fountainbridge, Edinburgh 19 July 1803, son of a solicitor. Best known for his lithographic portraits and caricatures. Died Edinburgh.
Represented: SNPG. **Literature:** McEwan.

CROOK, James **1759-c.1781**
Entered RA Schools 1776 aged 17 (winning Silver Medals 1778 and 1779). Exhibited at RA (5) 1778-81 from Islington.

CROPLEY, Miss **fl.1789-1811**
An honorary exhibitor at RA (3) 1789-1811 from London.

CROSBY, William **1830-1910**
Born Sunderland, son of Stephen Crosby an inn keeper. Apprenticed aged 14 to a painter and glazier. Gave up to follow art and visited Antwerp for two or three years to copy old masters in the company of John Reay. On his return to Sunderland he established himself as one of the town's leading artists and mainly concentrated on portraiture. Exhibited at RA (8), SBA (5), in Newcastle 1859-73.
Represented: Sunderland AG. **Literature:** Hall 1982.

CROSS, John Baptist **fl.1855**
Listed as a portraitist at 6 Blackburne Terrace, Liverpool.

CROSSE, Edwin Reeve **fl.1888-1912**
Exhibited at RA (7) 1888-1912 from Leeds and Bushey, where he may have been at Herkomer's School of Art.

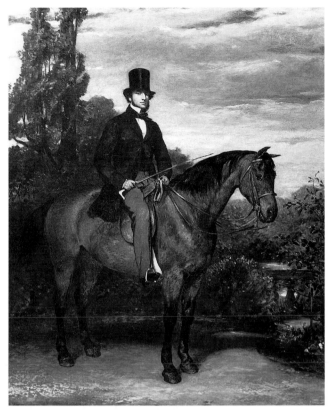

ROBERT CROZIER OF MANCHESTER. A gentleman on a hunter. Signed and dated 1858 and inscribed on a label on reverse. 21½ x 16½ins (54.6 x 41.9cm) *Christie's*

CROSSE, Richard 1742-1810
Born deaf and dumb in Knowle, Devon 24 April 1742, son of John and Mary Crosse. Settled in London c.1758/60, painting mainly miniatures, as well as some life-size portraits. Studied at Shipley's Drawing School and Duke of Richmond's Academy. Exhibited at SA, FS, RA (39) 1760-96. Appointed Enamel Painter to His Majesty 1788. Retired to Wells c.1798, but returned to Knowle, where he died. Held in great esteem by his contemporaries. A gifted artist.
Represented: SNPG; VAM. **Engraved by** V.Green, A.Smith, B.Smith, R.Thew. **Literature:** Long; Walpole Society XVII 1929 pp.61-94; DNB; Foskett.

CROSSLAND, John Michael 1800-1858
Exhibited at RA (5), SBA (1) 1832-45 from London.
Represented: NPG London.

CROSTHWAITE, Daniel fl.1832-1851
Born Ulverston. Practised as an artist at Cockermouth. Exhibited at RA (2), SBA (6), LA 1832-45. Awarded Isis Gold Medal for portraiture 1833. Recorded in Liverpool 1832-41. By 1851 he was living at Benson Street, Ulverston.
Represented: BM.

CROSTHWAITE, Samuel 1791-1868
Born Cockermouth, son of James Crosthwaite. Began work as a weaver. Exhibited at RA (2) 1823. Showed some 20 portraits and landscapes at Carlisle Academy 1823 from Kendal. His best known subject is William Wordsworth, whose portrait he painted no fewer than four times – the first in 1833, the last just before Wordsworth died. Died Kendal.
Represented: Dove Cottage, Grasmere; Keswick Museum; Whitehaven Museum; Rydal Mount, Ambleside. **Literature:** Hall 1979.

CROSTHWAITE, Thomas fl.1842
Born Cockermouth. Practised at Wigton, where his portraits were highly praised by the *Cumberland Pacquet* 14 June 1842.
Literature: Hall 1979 p.23.

CROUCH, W. fl.1774-1776
Exhibited at FS (4) 1774-6 from London.

CROUDACE, Mrs E.H (W.A.H?). fl.1852-1873
Exhibited at RA (1), SS (21) 1852-73 from London. Painted a number of Russian subjects.

CROWE, Eyre ARA 1824-1910
Born Sloane Street, Chelsea 3 October 1824, son of E.E.Crowe, historian and journalist. Studied under William Darley and in Paris under Paul Delaroche, with whom he went to Rome 1843. Entered RA Schools 1845, and worked at St Martin's Lane School. A life-long friend of Gérôme and secretary to Thackeray, who was his cousin, and went with him on a lecture tour of America 1852. Exhibited at RA (119), BI, SBA 1846-1908. Elected ARA 1876. Died London 12 December 1910.
Represented: NPG London; VAM. **Literature:** DA.

CROWE, Stephen b.1812
Born Kilkenny. Studied at Dublin Society Schools from 1825. Exhibited at RHA (104) 1826-48 from Dublin, where he had a highly successful practice painting mostly miniatures.

CROWE, Thomas fl.1847-1855
Exhibited at RHA (4), RA (5) 1847-55 from Dublin and Pimlico.

CROWHURST, George fl.1830s
Listed as a portrait painter at 29 King's Road, Brighton. Also produced profiles.
Represented: Brighton AG.

CROWLEY, Nicholas Joseph RHA 1819-1857
Born Dublin 6 December 1819, son of Peter Crowley a gentleman of property. Studied at Royal Dublin Society Schools. Exhibited from the age of 10 at RHA (89), RA (47), BI (17), SBA (1) 1829-58. Elected ARHA 1836, RHA 1837 (one of the youngest members ever to be elected). Worked in Dublin and Belfast, but from 1837 spent a considerable time in London, eventually being based at 13 Upper Fitzroy Street. Among his exhibited portraits were the 'Marquess of Normanby, late Lord Lieutenant of Ireland'; 'His Highness the Prince Napoleon Louis Bonaparte' and 'Her Excellency the Countess of Clarendon'. Painted a large number of Roman Catholic sitters. Died London 4 November 1857. His work has considerable charm, and many of his figures are painted in a thin elongated manner.
Represented: NGI. **Engraved by** C.Lewis, T.McLean, H.Robinson, Smith. **Literature:** DNB; Strickland; DA.

CROZIER, Robert, of Manchester 1815-1891
Exhibited at RA (5), RHA (3), BI (5), SBA (6) 1836-48. Also exhibited at RMI, where he was elected President. Father of artist George Crozier RCA.

CRUICKSHANK, Francis fl.1835-1855
Exhibited at RA (2), BI (1), SBA (18) 1835-55 from Edinburgh and London. Among his sitters were John Audubon, Viscountess Barrington and Colonel Sir George Hoste. Related to Frederick Cruickshank.

CRUICKSHANK, Frederick **1800-1868**
A native of Aberdeen. Lived for a time in Manchester. Studied under Andrew Robertson, a miniaturist. Worked in London and Scotland. Exhibited mainly miniatures at RA (149) 1822-60. Established a highly successful portrait practice and his portraits are often found in Scottish country houses. Among his pupils were Mrs F.Dixon and Margaret Gillies.
Represented: NPG London; VAM; NMM; Manchester CAG. **Literature:** McEwan.

CRUIKSHANK, Isaac **1756-c.1811**
Born Leith. Also an engraver. Exhibited at RA (3) 1789-92 from London. Died London. His portrait of William Pitt is in NPG London. George and Isaac Robert were his sons.
Engraved by G.Murray. **Literature:** McEwan; DA.

CRUIKSHANK, Isaac Robert **1789-1856**
Born Bloomsbury 27 September 1789, younger brother of George Cruikshank. Began his career as a midshipman in the East India Company, but then took up art. Exhibited at RA (8) 1811-17 from London. A close friend of Edmund Kean, of whom he made many studies. Illustrated a number of books. Concentrated on caricature. Died 13 March 1856.
Represented: NPG London. **Engraved by** J.Grant, B.Smith. **Literature:** DA; DNB.

CRUIKSHANK, William **1848-1922**
Born Broughton Ferry, Scotland 25 December 1848, grand nephew of George Cruikshank. Studied at RSA and RA Schools, and in Paris. His studies in Paris were interrupted by the Franco-Prussian War, and he settled in Canada 1871, opening a studio in Toronto. Taught at Central Ontario School of Art. Elected a member of Royal Canadian Academy of Arts 1894. Acquired a considerable reputation as a portrait painter. Died Kansas City 19 May 1922.
Represented: NG Ottawa. **Literature:** J.Mavor, 'W.C.', *Canadian Magazine* 1926.

CUBITT, Thomas **1757-c.1778**
Entered RA Schools 2 July 1773 aged '16. 31st March last'. Exhibited at RA (1), SA (2) 1775-8 from Marylebone.

CUBLEY, Samuel Horsley **fl.1835**
Listed as a teacher, portrait and landscape painter in Newark.

CUBLEY, William H. **1816-1896**
A drawing master in Newark, his best known pupil being Sir William Nicholson. Exhibited at RA (4), SBA (9) 1863-78. Painted mostly landscapes, but also accepted portrait commissions. Published *A System of Elementary Drawing*, 1876. Died Newark.
Represented: Castle Museum, Nottingham.

CUDLIP, S.B. **fl.1828-1833**
Exhibited at RA (7), BI (10), SBA (5) 1828-33 from London.
Engraved by W.Walker.

CUFAUDE, Francis **fl.1745-1749**
Worked in East Anglia. Portraits at Ipswich Museum are dated 1745 and 1749. Also recorded working as a painter at Denton, Norfolk.

CUITT, George **1743/5-1818**
Born Moulton, Yorkshire. Encouraged by Sir Lawrence Dundas, who sent him to Italy 1769-75. Exhibited landscapes and occasionally portraits at RA (14) 1776-1818. Settled in Richmond, Yorkshire c.1777, for health reasons. Died there 3 February 1818. His son George was also an artist.
Represented: BM; Leeds CAG; St Catherine's College, Cambridge; Newport AG.

CULLEN, John **1761-1825/30**
Son of E.Cullen, a Dublin box keeper at the Crow Street Theatre. Studied at Dublin Society Schools (prize winner 1775) and under H.D.Hamilton. Exhibited in Dublin 1800-17.

CUMING, J.B. **fl.1793-1812**
Exhibited portraits and then landscapes at RA (18) 1793-1812. His last exhibited portrait was 1798. A relative, Richard Cuming, aged 18, entered RA Schools 1794 from the same address in Walworth.

CUMING, William **PRHA** **1769-1852**
Entered Dublin Society's School 1785 (Silver Medallist 1790). Early established a successful portrait practice in Dublin. Exhibited at RHA (18) 1826-40. Elected a founder RHA 1823, PRHA 1829-32. Died Dublin 5 April 1852. Buried Mount Jerome.
Represented: NGI. **Engraved by** J.Heath, J.R.Smith, C.Turner, W.Ward. **Literature:** Strickland; DA.

CUMMINGS, Thomas **1804-1894**
Born Bath 26 August 1804, son of Charles and Rebecca Cummings. Moved as a baby to Bristol and then America. Encouraged by Augustus Earl and was placed in a drawing school run by J.R.Smith. Studied under John Inman from 1821 and after three years was taken into partnership. Married Jane Cook 1822 and had 14 children. Helped form NA, New York. Died Hackensack, New Jersey 4 September 1894.
Represented: Brooklyn Museum; Metropolitan Museum of Art, New York.

CUNDALL, Charles Ernest **RA RP RWS NEAC**
 1890-1971
Born Stretford, Lancashire 6 September 1890. Began designing pottery and stained glass for Pilkington. Studied at Slade, Manchester School of Art, RCA and in Paris. Exhibited at RA, NEAC. Elected NEAC 1924, RP 1933, ARWS 1935, ARA 1937, RWS 1941, RA 1944. Lived in Chelsea. Died 4 November 1971.
Represented: Tate; Southampton CAG.

CUNDELL, C.E. (or E.C.) **fl.1860-1869**
Exhibited at RA (3) 1860-9 from London. His portrait of artist 'John Phillip' is in Garrick Club, London.

CUNDELL, Nora Lucy **1889-1948**
Born London 20 May 1889, granddaughter of artist Henry Cundell. Studied at Blackheath Art School, then under Walter Sickert at Westminster Technical Institute (prize winner 1914). Exhibited at RA, RP, NEAC, SBA, Paris Salon. Resumed studying at Slade after the war 1919. Visited America several times. Published *Unsentimental Journey*, 1940. A friend of J.B.Priestley who described 'her unusual gift of sketch portraiture, at once rapid, graceful and truthful…'. Died London 3 August 1948.

CUNEO, Cyrus Cincinatto **ROI** **1879-1916**
Born San Francisco of Italian parents. Studied in Paris under Carlo Rossi and Whistler. Moved to England. Worked for *The Illustrated London News* and other magazines. Exhibited at RA (13), RHA (9) 1900-15 from London. Married artist Nell Marion Tenison, who acted as his assistant. Died of blood poisoning 23 July 1916 aged 37.

CUNLIFFE, David **fl.1826-1855**
Exhibited at RA (11), BI (3), SBA (7) 1826-55 from London and Portsmouth (by 1854). Also a gifted horse painter.
Represented: Somerset County Museum, Taunton.

CUNNINGHAM, Edward Francis c.1741-c.1795
Possibly born Kelso, of a Jacobean family. Taken to Italy by his father to escape persecution and trained at Parma, Rome and Naples. Worked Venice and Paris and was brought back to England by Lord Lyttelton. Enjoyed a successful portrait practice in oil and crayons. Exhibited at RA (14) 1770-81, usually under the pseudonym of 'Edward Francis Calza, called il Bolognese'. Among his sitters were Baron Diedeu, Danish Minister and Monseigneur Nolken, the Sardinian envoy. By 1784 he was court painter at Berlin. Reportedly died there 28 April 1795, although Redgrave says he died in poverty in London.
Engraved by D.Cunego, A.Gabrielli, W.Bromley.
Literature: McEwan.

CUNNINGHAM, H.F. b.1810
Born Middlesex. Listed in 1861 London census for 16b Cavendish Street as a widowed portrait painter.

CURNOCK, James 1812-1862
Son of Dennis Curnock, a boot and shoemaker. Educated Bristol Grammar School. Successful Bristol portrait painter, who also painted landscape and genre. Exhibited at RA (13), SBA (8) 1847-62, Royal West of England Academy (136), Bristol Society of Artists (18+). Died of the effects of tuberculosis at Walton in Gordano, Bristol on 29 May 1862 (not 1870) aged 49. Among his sitters were J.G.Shaw, Mayor of Bristol, the Marquess of Bute and the Dean of Bristol. His son James Jackson Curnock was also a painter.
Represented: Bristol AG. **Literature:** Geoffrey B. Curnock, unpublished research papers, Bristol AG 1995.

CURRAN, Amelia 1775-1847
Born Dublin, daughter of John Philpot Curran. Moved to Italy 1818, where she met the Shelleys in Rome and painted a portrait of one of their children. Died Rome.
Represented: NPG London. **Literature:** Strickland.

CURRIE, John S. **NEAC** c.1884-1914
Born Chesterton, Newcastle-under-Lyme. Studied at Newcastle and Hanley Schools of Art, where he won scholarships. Began as a ceramic artist, then taught life painting at Bristol. Entered Slade 1910 and friends with Augustus John and Mark Gertler. Left his wife 1911, and the following year was working at Newlyn. Exhibited at RA (1), RHA (3), NEAC from 1909. Elected NEAC 1914. Moved to Hampstead with his mistress Dolly Henry, and in a fit of jealousy shot her and himself. Died the following day 9 October 1914 in Chelsea Infirmary.
Represented: Tate.

CURRY, James fl.1730-1738
Worked in Dublin. Painted a portrait of William Stewart, second Viscount Mountjoy, as Grand Master of the Free Masons of Ireland 1738 (engraved by J.Faber 1741). Also restored pictures.

CURSITER, Stanley **CBE RSA RSW** 1897-1976
Born Kirkwall, Orkney Isles 29 April 1897. Apprenticed as a designer to a firm of printers. Studied at Edinburgh College of Art. Exhibited at RA (9), RSA (69), RSW, GI from Edinburgh and Stromness. Elected RSA 1937. Appointed His Majesty's Painter and Limner in Scotland 1948, CBE 1948. Married Phyllis Hourston. Keeper of National Galleries of Scotland 1924-30, Director 1930-48. Died Stromness 22 April 1976.
Represented: SNPG; Glasgow AG; Kirkcaldy AG; Paisley AG. **Literature:** McEwan.

CURTIS, Sarah 1676-1742/3
Studied under Mary Beale and set up a portrait practice 'seven years before Mrs Beale died' (Vertue, v, 14). First wife of Benjamin Hoadley, the Bishop of Winchester. After her marriage she retired and only painted relatives and family friends. Died 11 January 1742/3.
Represented: NPG London. **Literature:** Greer.

CURTOIS, Miss Mary Henrietta Dering 1854-1929
Born at Branston. Studied at Lincoln School of Art and Académie Julian, Paris. Exhibited at RA (6), NWG 1887-92 from Washingboro Manor, near Lincoln.

CUSTODIS, Hieronimo d.c.1593
A native of Antwerp. A member of the Dutch Reformed Church in London 1592, where his widow remarried 1593. Painted 'Elizabeth Bridges' 1589 (Woburn). The lettering on the signed portraits is rather distinctive and has led to a number of attributions.
Represented: Works attributed to him are in NPG London.

CUTHBERT, John Spreckley fl.1852-1877
Exhibited at RA (18), BI (2), SBA (2), GG 1852-65 from Pimlico, Munich and Chelsea. Working 1877.

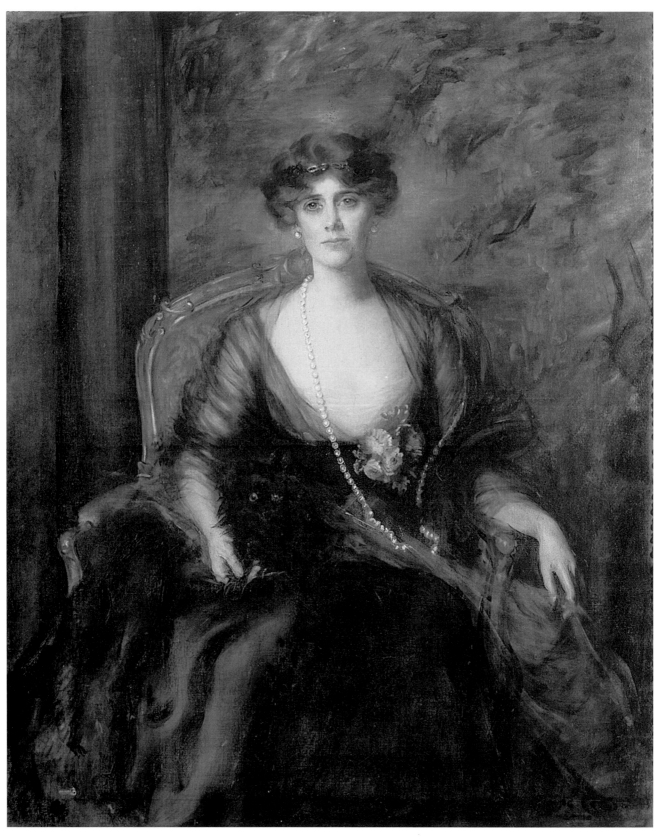

JOHN DA COSTA. Cornelia, Countess of Craven. Signed. 56 x 44ins (142.2 x 111.8cm) *Phillips*

D

DA COSTA, John ROI RP 1867-1931
Born Teignmouth 28 December 1867. Studied in
Southampton, Paris and with the Newlyn School. Settled in
London after his marriage to Elizabeth Glen Walker 1897.
His success at portraiture led him to visit America 1905,
where he received many commissions, returning there
regularly throughout his career. Exhibited at RA (30), RP,
ROI, GG, NWG, LA, RMI, Paris Salon 1890-1929, as well
as in Europe and America. A friend of Sargent, who
influenced his style. Through his friendship with Stanhope
Forbes his later portraits show an influence of the Newlyn
School. Died 26 May 1931.
Represented: Leeds CAG. **Literature:** *John Da Costa*,
Leighton House exh. cat. 1974.

DACRE, Isabel Susan 1844-1933
Born Leamington, but brought up in Manchester. Educated
in Paris 1858-68 and became a governess. Visited Italy 1869
and returned to Paris 1870, left again and returned, being
caught up in the Paris Commune. Trained at Manchester
School of Art 1871-4 and then travelled to Rome with her
artist friend Annie Louisa Swynnerton. Studied in Paris 1877-
80, London 1880-3 and Manchester again 1883-1904. A
suffragette. President of Manchester Society of Women
Painters from 1880. Settled in Blackheath 1904 with artist
Francis Dodd. Spent much time on the Continent.
Represented: Manchester CAG.

DADD, Richard 1817-1886
Born Chatham 1 August 1817, son of Robert Dadd, a
chemist. Studied at William Dadson's Academy. The family
moved to London 1834, where his father set up as a carver
and gilder leading to friendships with Stanfield and Roberts.
Entered RA Schools January 1837. Won a medal for the best
life drawing 1840. Member of The Clique. Exhibited at RA
(4), BI (5), SBA (16) 1837-42 from London. In 1842 he
toured Italy, Greece and the Middle East with his patron Sir
Thomas Phillips. Dadd began to feel that he was pursued by
devils in the guise of Sir Thomas and the Pope. Returned May
1843 and began producing drawings of friends with their
throats cut. On 28 August 1843 he murdered his father at
Cobham Park and fled to France, but was arrested two days
later after attacking a stranger. Extradited 1844 and admitted
to Bethlem Hospital, where he was encouraged to draw. Died
Broadmoor 8 January 1886 from consumption. Buried
Broadmoor.
Represented: NPG London; SNPG; Tate; BM; VAM;
Bethlem Hospital; Fitzwilliam; Newport AG; Laing AG,
Newcastle; Leeds CAG; Cecil Higgins AG, Bedford.
Literature: D.Greysmith, *R.D. – The Rock and Castle of
Seclusion*, 1973; P.Allderidge, *R.D.*, Tate exh. cat. 1974; DA.

D'AGAR (DE GARR), Charles 1669-1723
Born Paris, son of Jacob D'Agar. The family arrived in
London 1681. Apprenticed to Robert Robinson, a painter-
stainer. Travelled with his father to Copenhagen where he
stayed six years. Returned to London 1691, where he enjoyed
a successful portrait practice. His prices in 1707 were £7 for
a 30 x 25in., and £12 for a 50 x 40in. Committed suicide in
London, May 1723. A sensitive master, painting often in the
manner of Dahl. In some of his pictures he shows a fondness

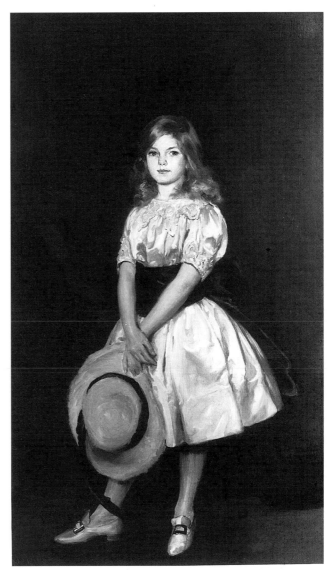

JOHN DA COSTA. Miss Vera Butler, daughter of Captain
Butler. Signed. 68 x 39ins (172.7 x 99.1cm)
Christopher Wood Gallery, London

for intricate backgrounds, but he rarely signed his works.
Represented: Ham House, VAM; Lamport Hall; Burghley
House; Drumlanrigg Castle. **Engraved by** Faithorne.
Literature: Huguenot Society XVIII 1911 p.127.

D'AGAR, Jacques (Jacob) 1642-1715
Born Paris February 1642. Believed to have been a pupil of
F.Voet in Paris. Agréé at the Académie 1675, but was
expelled for being a Protestant. Moved to London 1681,
with his wife and four children becoming denizens 14
October 1681. May have painted portraits in London.
Moved to Copenhagen c.1684, where he was Court painter
to Christian V and Ferdinand IV until his death. Died
Copenhagen 15 November 1715. Listed as 'Jacques' and
'Jacob'. His work has been confused with that of his son,
Charles. British works dated after 1685 are likely to be by
Charles. May also have had another son, as a portrait artist
named Jacopo D'Agar 'was much afflicted with gout and died
May 1753 aged 54'.
Represented: Uffizi Gallery, Florence. **Engraved by**
G.White.

DAGLEY, Richard c.1761-1841

An orphan educated at Christ's Hospital. Apprenticed to a jeweller, named Cousins (whose daughter he married) for whom he painted enamels. A friend of Henry Bone, the enamel painter. In Doncaster from 1797 and was recorded there as a drawing master 1805-15. Returned to London. Exhibited at RA (60), BI (3), SBA (3) 1785-1833, mostly from accommodation addresses. Among his sitters was 'Elizabeth Shaw who died at Tickhill, Yorkshire in her 117th year'.

DAHL, Michael snr c.1653-1743

Born Stockholm 29 September, the year being listed as 1653, 1656 and 1659 in varying sources. Studied under Ehrenstrahl in Stockholm and was well educated. Travelled to London 1682, where he met Kneller. 1684-9 he accompanied Henry Tilson to Paris, Venice and Rome (where they stayed for a year). Travelled back via Frankfurt and settled in London March 1689. By 1700 he was the most successful and prolific portrait painter in London after Kneller. Patronized by Prince George of Denmark and painted a number of portraits of members of the Court circle under Queen Anne, including the set of Admirals at Greenwich (c.1702-8). The Duke of Somerset was an enthusiastic patron during the 1690s, for whom he painted the 'Petworth Beauties'. In 1712 he charged £50 for a full-length royal portrait, and in 1724 30 guineas for a half-length. After 1714 he lost Court patronage but was popular with the nobility, the church and the law. Retired c.1740. Died London 'aged 90'

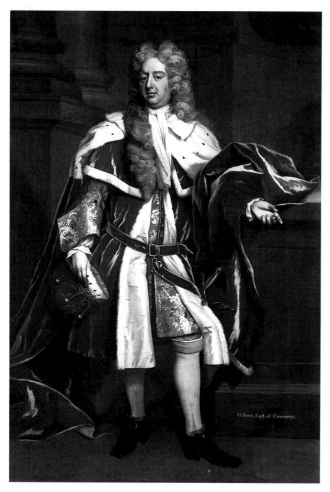

MICHAEL DAHL SNR. Gilbert, 4th Earl of Coventry in coronation robes. Signed. 96 x 58ins (243.8 x 147.3cm)

Christie's

(*Gentlemen's Magazine*). Buried St James's Church, Piccadilly. His death date is usually given as 20 October 1743, although this is unlikely as it was the date that his will was proved. His style can be very close to that of Kneller. Among his pupils were Richard Collins, M.Dahl jnr, James MacBurney and Hans Hysing. Christian Richter copied his works.

Represented: Petworth House, NT; NPG London; Tate; NMM; Blickling Hall, NT; Walker AG, Liverpool; Goodwood House; Stourhead, NT; National Museum, Stockholm. **Engraved by** W.P.Benoist, T.Blood, J.Brooks, T.Chambers, R.Cooper, J.Faber snr & jnr, W.Faithorne, W.T.Fry, S.Gribelin, Harding, W.Holl, T.Holloway, G.Lumley, B.Lens, Miller, Penny, S.F.Ravenet, B.Reading, J.Simon, J.Smith, J.Stow, J.Sympson, M.Tyson, G.Vertue, H.W.Watt, T.Wedgewood, G.White, R.Williams. **Literature:** W.Nisser, *M.D. and the Contemporary Swedish School of Painting in England*, 1927; DA.

DAHL, Michael jnr d.1741

Son, pupil and assistant of Michael Dahl. His father's will was dated 16 October 1735 bequeathed 'unto my son Michael Dahl all my Prints, Books and Drawings and all other things belonging to my business of painting', but Michael Dahl jnr died before his father. Buried St James's, Westminster 26 November 1741.

DAHT, Louis fl.1775

Provincial portrait painter working in Shetland Isles c.1775.

DALZIEL, Robert 1810-1842

Born Wooler, son of Alexander Dalziel. Studied in Edinburgh with John Thomson of Doddington. Worked in Glasgow and Edinburgh. Settled in London. Exhibited at BI (3), SBA (7), in Newcastle 1831-42. Portraits by him of his family appear in *The Brothers Dalziel*.

Literature: *The Brothers Dalziel*, 1901; S.Houfe, *The Dalziel Family – Engravers & Illustrators*, Sotheby's Belgravia Catalogue 16 May 1978; DNB Supplement 1912; Hall 1982.

DANCE, George RA c.1741-1825

Son of George Dance, architect of the Mansion House and brother of Nathaniel Dance. Followed in his father's footsteps as architect and city surveyor. Among his buildings were Newgate Prison 1770, Giltspur Street Prison and St Luke's Hospital. Exhibited at RA (24) 1770-1800. Elected a founder RA. Appointed RA Professor of Architecture 1798-1805, although he did not lecture. Produced many portraits in chalk as well as in the manner of Downman. Among his sitters were Sir Alan Gardner, Mr Boswell, Mr Northcote and William Dickson, Bishop of Down. Published *A Collection of Portraits Sketched from Life Since the Year 1793*, 1811. Resigned his office as city surveyor 1815. After a lingering illness died London 14 January 1825, the last survivor of the founder RAs. Buried St Paul's Cathedral.

Represented: NPG London; SNPG; BM; VAM; Ashmolean; Sir John Soane's Museum, London. **Engraved by** T.Blood, W.Daniell, J.Fittler, S.Harding, Hawksworth, C.Knight, W.Leney, J.Ogborne, J.Pass, S.W.Reynolds. **Literature:** *G.D. the Elder and the Younger*, Geffrye Museum exh. cat. 1978; DA.

DANCE (DANCE-HOLLAND), Sir Nathaniel RA 1735-1811

Born London 18 May 1735, son of George Dance, architect of Mansion House. Educated at Merchant Taylors' School 1743-8. Studied under F. Hayman for some years from c.1749. Worked in Rome 1754-65, where he painted a number of conversation pieces and accomplished portraits. From 1762 he became closely associated in business with P.Batoni, and learnt from him to paint in a lighter, less opaque palette. Met and fell in love with Angelica Kaufmann, but by their return to London in 1765 the romance had fizzled out.

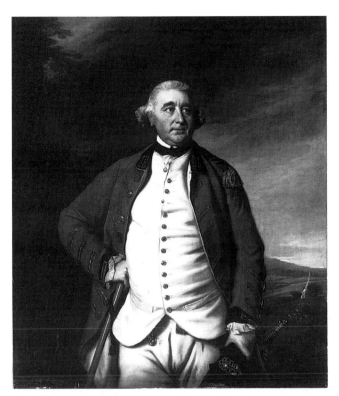

NATHANIEL DANCE. Henry Herbert, 10th Earl of Pembroke.
Signed. 56 x 47ins (142.3 x 119.4cm) *Sotheby's*

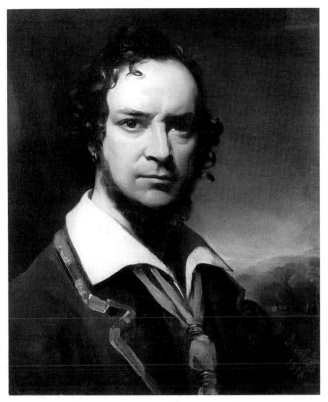

WILLIAM DANIELS. Self portrait. Signed and dated 1850. 23 x
19ins (58.4 x 48.2cm) *Phillips*

Exhibited at SA (5), FS (1), RA (22) 1761-1800. Elected a
founder RA. Enjoyed a successful portrait practice in London.
Seems to have inherited a fortune in the 1770s and gave up
professional portrait painting 1782. Remained a prominent
figure in the art world until 1790, when he resigned from RA
and married Mrs Dunner, an immensely rich widow. On 27
November 1800 he became Sir Nathaniel Dance-Holland,
Bart, MP for East Grinstead. In later life he and his brother
George produced a number of political caricatures. Died
Winchester 15 October 1811 aged 76. Left a fortune of
£200,000. Fond of using classical props suggesting the Grand
Tour, and used strong effects of light and shade.
Represented: NPG London; Tate; SNPG; HMQ; Upton
House, NT; Powis Castle, NT; NGI; Brighton AG; Guildhall
AG; Philadelphia Museum of Art; Uppark, NT; Yale; Knole,
NT. **Engraved by** H.Adlard, C.Armstrong, W.Arndt,
F.Bartolozzi, D.Beyer, M.Bovi, J.Chapman, J.Collyer,
H.R.Cook, T.Cook, H.Dawe, W.Dickinson, J.Dixon,
R.Dunkarton, R.Earlom, E.Fisher, V.Green, J.Hall, J.Heath,
T.Hollowey, R.Houston, J.S.Klauber, Mackenzie, H.Meyer,
W.Pether, S.W.Reynolds, E.Scriven, J.K.Sherwin, G.Stodart,
C.Townley, Thomson, T.Trotter, T.Watson, J.Watts,
W.Wilson. **Literature:** D.Goodreau, *N.D.*, Kenwood exh. cat.
1977; D.Goodreau, Ph.D thesis ULCA 1975; B.C.Skinner,
'Some Aspects of the Work of N.D. in Rome', *Burlington
Magazine* Vol 101. 768/79 September-October 1959 pp.346-
9; D.Goodreau, 'N.D.: An Unpublished Letter', *Burlington
Magazine* Vol.114, No.835 October 1972 pp.712-5; DA.

DANCKERT, Hugh **b.1826**
Son of a Cork wine merchant. Painted portraits and
miniatures in Cork.

DANDRIDGE, Bartholomew **1691-c.1755**
Baptized London 17 December 1691, son of a house painter.
Married Hannah Ashworth at Aldgate 2 April 1725.
Developed a successful portrait practice in London and took

over Kneller's old studio 1731. His career runs parallel with
Hogarth's. Waterhouse described him as 'a pioneer of the
rococo conversation piece'. Vertue considered him to be the
ablest and most original exponent of such pictures of his time.
Recorded in London 1754. Believed to have died in his prime.
Represented: Manchester CAG; NPG London; Leeds CAG;
Metropolitan Museum of Art, New York. **Engraved by**
J.Faber jnr, G. vr. Gucht, J.McArdell, J.S.Muller, T.Wright.
Literature: C.H.C.Baker, *Burlington Magazine* LXXII
March 1938 p.132; DA.

DANIEL, Henry Wilkinson **fl.1906-1957**
Began as a surveyor. Studied at Slade under Frederick Brown.
Exhibited at RA (7), RSA (30), Royal Scottish Society of
watercolours. Art master of Trinity College, Glenalmond and
Governor of Allen Fraser Art College, Arbroath. Retired to
Glenholm, Glenmore Road, Oban.

DANIELL, Frank Robinson **1866-1932**
Son of Shepherd Daniell. Exhibited at RA (18) 1889-1921 and
in the Salons of Paris, Berlin and Madrid from London and
Colchester. Among his sitters were many mayors and aldermen
of Colchester. Married Ethel Brignell. Died aged 66 in
Colchester on 11 March 1932 after suffering a heart attack.
Represented: Colchester Museums. **Literature:** *East Anglian
Daily Times* 12 March 1932, 16 March 1932, 18 March 1932.

DANIELS, William **1813-1880**
Born Liverpool 9 May 1813, son of a brickmaker and
victualler. Began work as an apprentice bricklayer, but
developed a talent for modelling portraits in clay. These were
admired by Alexander Mosses, who took him as a pupil at LA
Schools from 21 February 1827 to c.1831, and apprenticed
him to a wood engraver until c.1833. Practised painting at

night by candle light and attracted the patronage and encouragement of Sir Joshua Walmsley. Married Mary Owen of Liverpool 1839. Developed a successful portrait practice in Liverpool. Exhibited at RA (7), LA 1840-62. According to Marillier he acquired 'a taste for low life and convivial associations spoilt his chances and destroyed his excellent promise'. Died Everton, Liverpool 13 October 1880. Had a fondness for strong chiaroscuro effects and often portrayed his sitters with dark penetrating eyes. His work was variable, but he was capable of great heights. W.L.Windus was his pupil.
Represented: Walker AG, Liverpool; VAM. **Engraved by** R.W.Buss. **Literature:** H.C.Marillier, *The Liverpool School of Painters*, 1904.

DANLOUX, Henri-Pierre　　　　　　1753-1809
Born Paris 24 February 1753. A friend of Vien and accompanied him to Rome, where he remained until 1780. Went to Lyons, but fled to London January 1791 to escape the Revolution. Exhibited at RA (25) 1792-1800. Visited Scotland 1796, where he had some success, painting 'The Family of the 3rd Duke of Buccleuch' (1798). Among his sitters were Lord Malden and HRH Prince Augustus. His English Diary is a valuable resource about the French *émigré* world. Returned to Paris 1800, where he was less successful. Died Paris 3 January 1809.
Represented: NPG London; SNPG; Bowhill. **Engraved by** P.Audinet, J.R.Smith. **Literature:** R.Portalis, *Henri-Pierre Danloux et son journal durant l'émigration*, Paris, 1910; DA.

DARBY, George　　　　　　　　　fl.1822-1823
Listed as a 'Teacher and Portrait Painter at Bath'.

DARTINGUENAVE, Victor　　　　　　b.c.1813
Listed as 'born in Paris aged 38' in 1851 census. Exhibited at Paris Salon from 1838. Exhibited at RA (35), SBA (13) 1841-54 from London. Painted mainly miniatures, but also some portraits, mostly in watercolour. Among his sitters were General Charles Smith, Lieutenant-General Sir Howard Douglas GCB and the Earl of Arundel and Surrey.

DAUDET (DOWDETT), Samuel　　　　fl.1694-1727
Little known portrait painter. His documented works date 1694-1727.

DAVENPORT, Mr　　　　　　　　c.1642-1692
A pupil and copyist of Lely. Also associated with Greenhill. Died June 1692 when 'about the age of fifty'.
Literature: M.K.Talley, *Portrait Painting in England: Studies in Technical Literature before 1700*, 1981, p.312.

DAVEY, Miss Edith Mary　　　　　fl.1910-1950
Born Lincolnshire. Studied at Lincoln School of Art, RCA and under G.E.Moira. Exhibited at RA (21), RI, RMS, Paris Salon 1910-50 from Barnes.

DAVEY, Robert　　　　　　　　　　d.1793
Taught drawing at a school for young ladies in Queen's Square, London and succeeded G.Massiot as assistant drawing master at Woolwich 1780. Killed by robbers near Tottenham Court Road.

DAVID, Antonio　　　　　　　　　　b.1698
Born Venice. Portraits of Prince Charles Edward Stewart and Prince Henry Benedict Clement Stewart are in SNPG.
Engraved by P.I.Drevet.

DAVIDSON, Allan Douglas　ROI　　　b.1873
Born London 14 May 1873, son of artist Thomas Davidson. Studied at St John's Wood, RA Schools (Silver and Bronze Medals) and Académie Julian, Paris. Taught at Central School of Arts. Elected ROI 1921.

DAVIDSON, J.　　　　　　　　　　fl.1750s
Worked as a portrait painter in Edinburgh. Roubiliac modelled after a portrait by him the statue of President Duncan Forbes.

DAVIDSON, J.　　　　　　　　　　fl.1878
Listed as a portraitist at 2 West Lauriston Place, Edinburgh.

DAVIEL, Leon　　　　　　　　　　fl.1912-1928
Born Paris. Studied under Carolus-Duran. Exhibited at RA (9) 1912-28 from London.

DAVIES, Norman Prescott　FRS　　　1862-1915
Born Isleworth. Studied at RCA, City and Guilds Art School and Heatherley's. Exhibited at RA (11), SBA (13) 1880-94 from London and Isleworth. Died 15 June 1915.

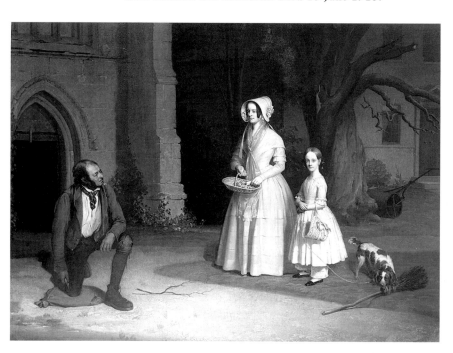

WILLIAM DANIELS Almsgiving – thought to be Lady Walmsley and her daughter. 29 x 36ins (73.7 x 91.5cm)
Phillips

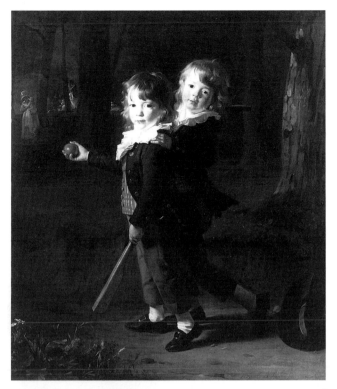

HENRI-PIERRE DANLOUX. The Masters Foster, sons of Constantia and Richard Foster. Signed and dated 1792. 45 x 37ins (114.3 x 94cm) *Christie's*

DAVIS, Charles 1741-1805
Worked in Bath where he produced pastel portraits. Thomas Beach was his tenant, and in 1798 Beach painted Davis's portrait.
Represented: Victoria AG, Bath.

DAVIS, Mrs Dorothy (née Booth) b.1882
Born Finchley 29 October 1882, daughter of Edwin Booth, coal merchant. Studied under E.Thornton Clarke ARA, Regent's Street Polytechnic, Camden School of Art and St Martin's School of Art. Lived in Chelsea and Maidenhead. Exhibited at RMS 1904-9.

DAVIS, Edward Thompson 1833-1867
Born Worcester. Studied at Birmingham School of Design under J.Kyd. Exhibited at RA (19) 1854-67 from Worcester. A close friend of the Rossettis. Died Rome 13 June 1867. Produced some outstanding portrait drawings.
Literature: *Country Life* 30 November 1989.

DAVIS, Edwin fl.1851-1856
Listed as a portraitist in Bristol.

DAVIS, James Morris fl.1810-1839
Exhibited portraits and miniatures at RA (63) 1810-39 from London. Among his exhibited portraits were those of Joshua Reynolds, J.Simpson and Louis-Philippe.

DAVIS, John Phillip 'Pope' RBA 1784-1862
Born Wales. Exhibited at RA (32), RHA (4), BI (17), SBA (53), NWS 1811-45. Elected RBA 1839. Married Mary Margaret Mostyn in London 13 May 1813. Travelled to Rome 1824, where he painted a large work of 'The Talbot Family Receiving the Benediction of the Pope' from which he got the nickname 'Pope Davis'. It measured 16 x 13ft. and contained the portraits of Cardinal Consalvi, Riaria Maestro di Camera,

Canova, Gibson, Riepenhausen and others. Published a number of books from 1843. A friend of B.R.Haydon, and like him became very critical of the RA. Died 28 September 1862. His middle name is given as both Phillip and Pain.
Represented: NPG London; Leeds CAG. **Engraved by** J.Cochran, W.C.Edwards, C.Fox, E.Girling, Mrs D.Turner.

DAVIS, John Scarlett 1804-1845
Born Leominster 1 September 1804, son of a Hereford shoemaker. Studied at RA Schools. Travelled widely on the Continent. Awarded a Silver Palette by SA 1816 and 1820. Exhibited at RA (7), BI (6) 1822-44. Worked in Paris 1831. Painted portraits and landscapes, but specialized in architectural subjects. His death has been mistakenly listed as 1844 and 1846. Wood writes: 'The brilliance of his watercolours is comparable to the work of Bonington'.
Represented: BM; VAM; Tate; Birmingham CAG; Leeds CAG; Ashmolean; Fitzwilliam; Hereford AG. **Engraved by** Mrs D.Turner. **Literature:** DNB.

DAVIS, Miss Kathleen fl.1892-1893
Exhibited at NWG 1892-3 from London.

DAVIS, Lucien RI b.1860
Born Liverpool 7 January 1860, son of artist William Davis. Studied at St Francis Xavier College, Liverpool and RA Schools, winning prizes. Exhibited at RA (7) 1905-8 and at RI, Liverpool and Glasgow. Elected RI 1894. Appointed art master of St Ignatius College, London. Worked on the staff of the *Illustrated London News*.

DAVIS, Noel Denholm 1876-1950
Studied at Nottingham school of Art and RA Schools. Exhibited at RA (13) 1899-1928. Worked for a time in London, but settled in Nottingham c.1928, where he had a successful practice working from a studio at York House, King Street. Lived with his wife, Judith, and daughter, Joan, in a bungalow with a large garden at Plumptree, near Nottingham. Good at most games, particularly tennis and badminton. Drove an Indian motorbike. Painted murals for the City Hall, Nottingham. Died 22 April 1950, when away from home.
Represented: Castle Museum, Nottingham.
(Illustration p.162)

DAVIS, Sarah Jane b.c.1824
Born Buckinghamshire, daughter of animal artist Richard Barret Davis. Listed as an 'Artist in Portraits' in 1851 census for 9 Bedford Place, London

DAVIS, Thomas Richard fl.1852
Listed as a portrait and animal painter, Friar Street, Oxford.

DAVIS, William 1812-1873
Born Dublin, son of an attorney. Studied in Dublin. Exhibited at RHA 1833-5. Moved to England by 1937 as a portrait painter. Attracted the attention of John Miller of Liverpool, who encouraged him to devote himself to landscape painting. His work was admired by Rossetti and F.Madox Brown, and through them showed at American Exhibition of British Art, New York (3) 1857. Believed to have moved to Liverpool by c.1842 and studied at LA schools from 1846. Exhibited at LA, RA (16), SBA (1) and Hogarth Club 1851-73. Elected ALA 1851, LA 1853, LA Professor of Painting 1851-72. Settled in London a few years before his death there on 22 April 1873.
Literature: *The Pre-Raphaelites*, Tate exh. cat. 1984.

DAVISON, Jeremiah c.1695-1745
Born London, of Scottish parents. Recorded c.1730, when he painted the Prince of Wales and did some copies after Van Dyck and Lely in the royal collection. Under the guidance of Joseph Van

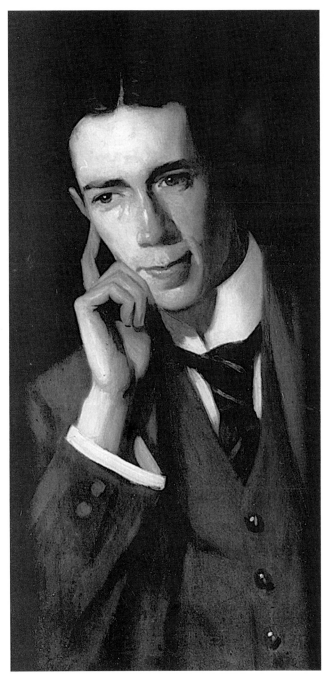

NOEL DENHOLM DAVIS. Thomas Furley Davis, the artist's brother. Signed. 26¼ x 11⅛ins (66.7 x 28.3cm) *Private collection*

Aken he acquired considerable dexterity in imitating the texture of satin. Painted a masonic portrait of the Duke of Atholl, and was brought to Scotland by him c.1736. There he had a successful practice c.1737-40, and was able to employ Van Aken for drapery. Moved back to London. Died Leicester Fields December 1745.
Represented: SNPG; NPG London; Atholl; Blair Castle; Dalmahoy House; Abercairney. **Engraved by** J.Faber jnr. **Literature:** McEwan.

DAVISON, John **b.c.1896**
Trained in art for five years at Hospital Field House, Arbroath before practising in Gateshead. Exhibited at Laing AG, Newcastle from 1918.

DAVISON, William **fl.1813-1843**
Exhibited at RA (22), BI (16), SBA (11) 1813-43 from London. Among his sitters were Sir J.G.Egerton Bart, MP and the Bishop of Calcutta.
Represented: NPG London.

DAVY, Robert **c.1735-1793**
Born Cullompton, Devon. Studied in Rome 1755-c.1760, and again 1765. Exhibited at SA (14), RA (21) 1762-82 and worked as a drawing master at Woolwich Academy. Knocked down within a few yards of his own door by three street robbers. Carried home speechless and died shortly afterwards on 28 September 1793.
Engraved by J.Arnold, S.E.Reid.

DAWE, George RA **1781-1829**
Born London 8 February 1781, son of mezzotint engraver Philip Dawe (an intimate friend of George Morland). Entered RA Schools 1794 (Gold Medallist). Exhibited at RA (47), BI (7) 1804-18. Elected ARA 1809, RA 1814. Had a studio in London and enjoyed a successful portrait practice. In June 1815 he briefly employed John Constable to paint in the background of his life-size portrait of Eliza O'Neil. Travelled in Europe after the Battle of Waterloo and was invited by the Emperor Alexander to paint a series of portraits in St Petersburg 1819-28 of all the superior officers who had been engaged in the war with Napoleon. During these nine years he painted nearly 400 portraits of Russian officers, besides three full-lengths, of Wellington, Kutusov, and Barclay de Jolly, and an equestrian portrait of the Emperor Alexander, 20ft. in height. This unique collection was placed in a gallery erected for it in the Winter Palace. Briefly returned to England 1828, then back to Russia later that year via Berlin (where he painted the King of Prussia and the Duke of Cumberland). Left Russia after ill health, returning to London August 1829. Died at the residence of his brother-in-law, engraver Thomas Wright, at Kentish Town 15 October 1829. Buried by the side of Fuseli in the crypt of St Paul's Cathedral. Made a large fortune by his visits to Russia (reportedly £100,000), but he lost much of it through money lending so that at the time of his death it was reduced to £25,000 – still a considerable sum. Among his sitters were S.T.Coleridge; HRH Princess Charlotte of Wales and Saxe Coburg; HRH Prince Leopold of Saxe Coburg and the Grand Duke Alexander and Grand Duchess Mary, children of their Imperial Majesties of Russia. Published *The Life of George Morland, With Remarks on His Works*, 1807. Extremely prolific, but his best works are of outstanding quality and can hang comfortably beside those of Lawrence.
Represented: NPG London; SNPG; Apsley House; HMQ; Brighton AG; Stratfield Saye; Hermitage, St Petersburg.
Engraved by H.Dawe, T.A.Dean, W.T.Fry, J.Godby, T.Hodgetts, G.Maile, S.W.Reynolds, W.Say, E.Scriven, J.Thomson, T.Woolnoth, T.Wright. **Literature:** DA.

DAWE, Henry Edward RBA **1790-1848**
Born Kentish Town 24 or 29 September 1790, son of engraver Philip Dawe, and brother of George Dawe RA. Studied at RA Schools. Exhibited at RA (1), BI (4), SBA (71) 1824-45 from London. Elected RBA 1830. Painted portraits of Sir E.Macgregor Bart; Count Woronzow; HRH the Duke of Cumberland and 'The Coronation of His Most Gracious Majesty George IV'. Also engraved a large number of portraits of Russian officers after the works of his brother and was one of the engravers employed by J.M.W.Turner on the *Liber Studiorum*. Died Windsor 28 December 1848.
Engraved by J.Cochran, H.Cook, E.Hacker, R.Page, J.Posselwhite. **Literature:** DNB.

DAWE, James Philip **fl.1820-1834**
Exhibited at RA (2), BI (1) 1820-8 from London. Recorded there as a portrait painter until 1834.

DAWE, Philip　　　　　　　　　　**fl.1750-1782**
Worked under Hogarth in the early 1750s. Listed as a 'History and Conversation Painter' at Mr. Brisbane's in Green Street, Leicester Square, London 1763. Studied under George Morland and produced prints after his work. Exhibited at FS (18) 1769-82. **Engraved by** A.Bannerman.

DAWSON, Lucy Elizabeth　　　　　　**1866-1958**
Educated at private schools. Married Cyril Dawson. Practised as a portrait painter at Whitehall, near Hitchen. Also produced sporting and animal paintings. Exhibited in America and London. Died near Hitchin 7 June 1958.

DAY, Barclay　　　　　　　　　　**fl.1873-1880**
Exhibited at RA (2), SBA (7) 1873-80 from London and Peckham Rye.

DAY, Charles William　　　　　　　**fl.1815-1859**
Worked in London, Florence and West Indies as a portrait and miniature painter. Awarded a prize by SA 1815. Exhibited at RA (14), SBA (2) 1821-59 from Deal and London. In 1852 he published *The Art of Miniature Painting* and *Five Years Residence in West Indies*.

DAY, G.F.　　　　　　　　　　　**fl.1850-1869**
Exhibited at RA (3), SBA (3) 1850-69 from Islington and Leicester.

DAY, Hamilton Smith　　　　　　　**fl.1837-1851**
Born Marylebone. Exhibited at RA (3), BI (1), SBA (4) 1837-49 from Camden Town. His age in 1851 census is listed unclearly as 63 or 68.

DAY, Hannah　　　　　　　　　　**fl.1849**
Exhibited at SBA (1) 1849 from Soho, London.

DAY, John George　　　　　　　　**1854-1931**
Specialized in etched portraits of remarkable sensitivity.
Represented: NPG London.

DAY, Thomas　　　　　　　　　**c.1732-c.1807**
Reportedly born in Devonshire. Listed as 'Master Day, pupil of Mr Dood' (D.Dodd) 1768. Also studied under O.Humphrey. Entered RA Schools 1770. Mainly a miniaturist, but did paint some portraits usually in crayons. Exhibited at FS (4), SA (8), RA (19) 1768-88. Often confused with the restorer and landscape painter Thomas Day.
Engraved by J.Jones.

DAY, William Cave　**RBA**　　　　**1862-1924**
Born Dewsbury. Studied in Paris under B.Constant and J.Lefebvre and at Herkomer's School. Took up art professionally 1890. Exhibited at RA (10), SBA 1890-1922. Elected RBA 1903. Lived in St Ives and Harrogate. Died April 1924.

DAYSBERD, Thomas　　　　　　　**b.c.1843**
Born Germany. Listed as a portrait and landscape artist aged 38 at 5/6 Albert Mansions, London in 1881 census.

DEACON, G.S.　　　　　　　　　**fl.1871-1879**
Painted 'Charles Ewens Deacon Esq, 32 years Town Clerk of Southampton' which was presented to the town 1871. Exhibited at RA (5), SBA (5) 1872-9. Worked in Antwerp, Southampton and London.

DEACON, James　　　　　　　　**c.1728-1750**
A miniature and portrait painter in colour and grey wash. Caught 'gaol fever' while attending the Old Bailey as a witness and died 21 May 1750.
Represented: BM.

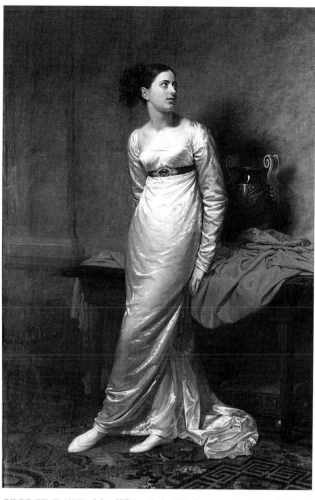

GEORGE DAWE. Mrs White (née Watford). Signed and dated 1809. 88½ x 54½ins (224.8 x 138.5cm)　　*Christie's*

DEAN, John　　　　　　　　　　**c.1750-1798**
Studied under Mr Green. Exhibited at SA, RA (6) 1773-91 from Soho. Advertised in *Calcutta Gazette* 13 October 1791: 'Miniature and Crayon painting by J.Dean, who begs to inform those ladies and gentlemen of Calcutta that wish to have their likenesses in either of those branches, that he has just arrived on the *Hunter*. Died London.

DEAN, John A.　　　　　　　　　**fl. 1855**
Listed as a portraitist at 80 Lower Cambridge Street, Manchester.

DEANE, Miss Emmeline　　　　　　**d.1944**
Portrait painter and miniaturist. Exhibited at RA (7) 1879-1903 from Bath, Box (Wiltshire) and London.
Represented: NPG London.

DEANES, Edward　　　　　　　　**fl.1860-1912**
Exhibited at RA (15), BI (8), SBA (17) 1860-1912 from London.

DEAR, Miss Mary Elizabeth　　　　　**b.1810**
Baptized St Pancras Old Church 30 December 1810, daughter of Jonas and Mary Dear. Exhibited at RA (7), SBA (5) 1848-67 from London and Rottingdean. Specialized in painting children.

DEARDEN, A. fl.1866-1873
Exhibited at RA (1), SBA (1) 1866-73 from Stroud and Womaston.

DE BREDA see BREDA, Carl Frederick von

DE CONING, Daniel 1660-c.1720
His portrait of 'King of Ockham' is in NPG London.

DEDREUX, Alfred 1810-1860
Born Paris 23 May 1810, son of architect Pierre-Anne Dedreux. His uncle was a friend of Gericault, and took him frequently to Gericault's studio. Studied with Leon Cogniet. Gained a reputation as a horse painter. Received medals from the Salons of 1834, 1844 and 1848; Cross of the Légion d'honneur 1857, commissions from Duc d'Orléans, Queen Victoria and Napoleon III. He was killed in Paris March 1860 in a dual provoked by an argument over the price of a painting.
Represented: Yale. **Literature:** DA.

DEEY, Rev William 1804-1874
Born Dublin. Went to England 1829. Exhibited at RHA (3), RA (21), BI (4), SBA (26) 1827-74 from London. Curate of St Thomas's Church, Southwark 1839-74. Died Bloomsbury 18 December 1874.
Engraved by J.Cochran.

DE FRETAY, Chevalier fl.1798
Exhibited at RA (1) 1798. No address was given.

DEFRIES, Miss Lily fl.1886-1915
Studied under Max Bohm. Exhibited at RA (4), GG (1) 1886-1915 from London and Orpington. Received honourable mention at Paris Salon 1900.

DE GLEHN, Captain Wilfred Gabriel RA RP NEAC
1870-1951
Born London 9 October 1870. Studied at Brighton College; Government Art Training School, South Kensington and École des Beaux Arts, Paris under E.Delaunay and G.Moreau. A close friend and pupil of Sargent, helping him to execute the Boston Public Library murals. Exhibited at RA (188), RP (53), NEAC, Paris Salon 1900-51 from London and Stratford Tony, near Salisbury. Elected NEAC 1900, ARA 1923, RA 1932. Married Jane Erin Emmet in New York 1904. Died Stratford Tony 10 May 1951. Fond of applying paint in thick impasto with high key colour.
Represented: NPG London.

DE GRONCKEL, Vital fl.1879
Exhibited at RA (2) 1879 from Bristol Hotel, London.

DE GROOT, J. fl.1735-1748
Listed as 'an eminent painter' in the *Universal Magazine* November 1748. Paid £3.4s.6d. each for a portrait of Dr Cleaver Morris and his wife 'in half bigness on copper'.
Engraved by J.Faber jnr.

DE HEERE, Lucas 1534-1584
Born Ghent, son of Jan De Heere, the leading sculptor in Ghent, and Anna de Smytere, a famous illustrator. Studied from an early age under Frans Floris and was renowned for his precocious skill. He and his father were employed in making decorations for the cathedral at Ghent 1559. Attracted the patronage of Philip II, but subsequently adopted the Reformed religion, and became a devoted follower of the Prince of Orange. Patronized by Adolph of Burgundy and set up a school of painting, which promised to carry on the Italianized traditions of Frans Floris. Poetry was as much studied as painting, and De Heere enjoyed, with his wife Eleonora Middelburg, a reputation as a literary talent. In August 1566 the iconoclastic outbreak took place and most of his work perished. About 1568 De Heere and others were banished and

his school broken up. He took refuge in London (probably arriving 1567) and may have been the teacher of some portraitists working in England. Produced *Beschrijving der Britsche Eilanden* (MS BM published 1937). Returned to Ghent after the Pacification of Ghent November 1576. Among his pupils was Carel van Mander. Died Ghent or Paris 29 August 1584. For some time supposed to be the painter of portraits signed 'H.E.' now attributed to Eworth. It is also stated that portraits by him are now among the many attributed to Holbein.
Represented: St Bavo, Ghent. **Literature:** DNB; F.A.Yates, *The Valois Tapestries*, 1959.

DE HEROYS, Boris b.1876
Born Russian Turkestan 22 March 1876, son of Vladmir de Heroys, General of the Russian Army. Studied at Imperial School of Arts in St Petersburg, Chelsea School of Art and Slade. Chief of staff for the 11th Army during the 1st World War. Moved to England as a refugee 1919. Exhibited at RP, NEAC 1921-8.

DE HOGHTON, Miss fl.1883-1887
Exhibited at GG (5) 1883-7 from London.

DE KOSTER, S. fl.1800-1801
Exhibited at RA (4) 1800-1 from George Street, Adelphi. Painted portraits of a number of employees of the Drury Lane Theatre.

DELACOUR, William d.1767
Probably born in France or London of French parents. Recorded as a theatrical scene painter and portraitist in London. Painted scenery for G.B.Pescetti's opera 'Busiri' 1740. During the 1740s published eight *Books of Ornament* of rococo motifs for the use of designers and craftsmen. By 1752 he is calling himself a 'portrait painter in oils and pastel' and was scene painting in Dublin 1753 and Edinburgh by 1757. Established himself in Edinburgh, where he became the first Director of the School of Design 1760. At Yester he produced large gouache wall paintings (1761). His self-portrait of 1765 sold at Christie's 6 July 1956 lot 14. Died Edinburgh 'of old age'.
Represented: SNPG. **Literature:** J.Fleming, 'Enigma of a Rococo Artist', *Country Life* 24 May 1962 pp.1224-6; D.F.Fraser-Harris, 'W.D.', Painter, Engraver and Teacher of Drawing', *The Scottish Bookman* Vol 1 No.5 1936; J.Simpson, 'Lord Alemoor's Villa at Hawkhill', *Bulletin of the Scottish Georgian Society* 1972 Vol 1 pp.2-9.

DE LACY, Charles John fl.1885-1930
Born Sunderland. Studied at Lambeth and South Kensington. Exhibited at RA (4), SBA (15) 1885-1918 from Camberwell, Streatham Common and Cheam. Special press artist to *Illustrated London News*. Artist to the Admiralty and Port of London Authority. Recorded in 1930.

DE LAFOLLIE, A. fl.1857-1862
Exhibited at RA (3) 1857-62 from London.

DE LA HITTE, Mlle fl.1847
Exhibited at RHA (7) 1847 from London.

DELANEY, William Vincent fl.1864-1873
Exhibited at RHA (7) 1864-73 from Dublin.

DELANOY, Abraham 1742-1795
Born New York City. The second American to go to London to study under West 1766-7. Returned to America and reverted to a more linear Dutch colonial style. Took to the life of an itinerant, painting in New York, Charleston, and in the West Indies (where he may have gone because of his health). Returned to New York by 1771, but he fell increasingly out of the mainstream, and turned to sign painting. Died in poverty of tuberculosis in Westchester, New York.
Represented: New York Historical Society.

DELANY, Mary (née Granville)　　　**1700-1788**
Born Coulston, Wiltshire 14 May 1700, eldest daughter
of Bernard Granville and granddaughter of Sir Bevil
Granville. Married Alexander Pendarves of Roscrow 1 March
1718 (he was 60, she 17). After his death in 1724/5
she married Dr Patrick Delany 9 June 1743. Knew Swift,
Pope and Fanny Burney. Reportedly taught by Bernard
Lens III and produced a number of portraits in oil and
crayon. Her own portrait was painted by Opie (Hampton
Court). Died London 15 April 1788. Buried St James's
Church vault.
Engraved by J.Brown.

DE LASZLO　　see **LÁSZLÓ, Philip Alexius de**

DEL HARDINGE, J.　　　**fl.1832**
Exhibited at RA (1) 1832 from 24 St Mary's Axe, London.

DELL, Henry L.　　　**fl.1894-1904**
Exhibited at RA (6) 1894-1904 from London and
Chithworth, near Petersfield.

DELLOW, Robert　　　**c.1696-1736**
Subscriber to Kneller Academy 1711, and followed in
Kneller's manner. Helped complete Kneller's unfinished
pictures. His name is often recorded as Dellon and he appears
in Oxford College accounts as Delleau. Waterhouse says that
his latest dated portrait was 'said to be in 1749', but he is
likely to be the Robert Dellow buried at St Botolph's,
Bishopsgate. May have had a son of the same name.
Represented: St John's College, Oxford.

DE LONGASTRE, L.　　　**c.1747-1798**
French émigré portrait painter. In Farington's *Diary* 10 May
1797 he is recorded as a gendarmerie colonel and about 50
years old. Exhibited at RA (20) 1790-8 from London. His
crayon portraits are extremely accomplished.
Represented: Bowhill.

DEMANARA, H.　　　**fl.1852**
Exhibited at RA (1) 1852 from 14 Berners Street, London.

DE MELE (MELLE), A.　　　**fl.1689**
A signed and dated portrait in the manner of Kneller sold at
Christie's 7 March 1952.

DE MELE (MEELE), Matthäus　　　**1664-c.1724**
Born at The Hague. Moved to London, where he worked as
a drapery painter for Lely. Returned to The Hague after
1680. Died 1714, 1724 or 1734 (varying accounts).

DE MELLE　　　**fl.1670-1680**
Had a portrait practice in Dublin 1670-80. Warden of Guild
of St Luke 1675.

DEMPSTER, Miss Margaret　　　**fl.1891-1893**
Exhibited at RA (1), SBA (1), GG (1) 1891-3 from
Edinburgh.

DENDY, William　　　**b.c.1811**
Probably the William Dendy baptized St Giles, Camberwell
29 July 1811. Produced miniatures and life-size chalk
drawings. Exhibited at RA (2), SBA (4) 1842-50 from
London. Confused with Walter C.Dendy and William
Denby.

DENMAN, John Flaxman　　　**b.c.1808**
Was awarded a premium at SA 1822. Entered RA Schools 31
March 1825 aged 17. Exhibited at RA (1), SBA (1) 1839
from London.

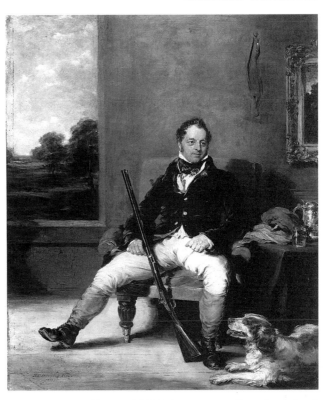

STEPHEN POYNTZ DENNING. A sportsman. Signed and dated
1832. On panel. 24 x 19½ins (61 x 49.5cm)　　*Christie's*

DENNING, Stephen Poyntz　　　**c.1795-1864**
Reportedly a beggar boy who studied under J.Wright. Exhibited
portraits and miniatures at RA (48), BI (2), SBA (2) 1814-52.
Appointed curator of Dulwich Gallery 1821. Also painted
copies. Among his sitters were W.Graves, John Burnet, George
Grote and 'Queen Victoria Painted as a Girl in 1823' (Dulwich
AG). Died at Dulwich College 10 June 1864, leaving effects of
under £1000 to his widow, Martha. His best work is full of life,
vitality and character, portrayed with fluid brushwork.
Represented: Dulwich AG; NPG London; SNPG; BM;
VAM; Wallace Collection; Fitzwilliam. **Engraved by**
W.Drummond, C.Fox, M.Gauci, R.Graves, H.Robinson.
Literature: *Art Journal* 1864 p.243; *Athenaeum* 1864.
Colour Plate 17

DENNIS, William T. (or S.)　　　**fl.1834-1847**
Exhibited at RA (6), SBA (7) 1834-47 from London.

DENT, William　　　**b.1816**
Born Cumberland. Moved to Dublin c.1840. Exhibited at
RHA (20) 1840-53 from Dublin.

DE NUNE, William　　　**c.1715-1750**
Signed the Charter of Edinburgh Academy of St Luke 1729.
Painted a portrait of Rev Archibald Gibson 1735. Usually
signed simply 'De Nune'. Died Dumfries June 1750. Probably
the person referred to in Douglas's *Baronage of Scotland*
under the entry of Denune of Catbole: 'William Denune esq,
a youth of great hopes and spirit, who died in the flower of his
age, unmarried'. A sale of his unclaimed portraits took place
in his studios at Dumfries in May 1751 and in Edinburgh in
December 1751 (Scottish Record Office, Edinburgh Register
of Testaments). Influenced by Ramsay. Fond of painting busts
and half-lengths in a sculpted oval.
Represented: SNG; SNPG; Marquess of Zetland.

DE PRADES, A. Frank **fl.1844-1883**
Exhibited at RA (4), BI (7), SBA (4) 1844-83 under the names
of A.F.De Prades and Frank De Prades from London. Sometimes
collaborated with E.J.Niemann. Painted full-length portraits of
Lord and Lady Cadogan (Denne Park, Northamptonshire).
Specialized in sporting and military subjects.

DERBY, Alfred Thomas **1821-1873**
Born London 21 January 1821, eldest son of artist William
Derby. Educated at Mr Wyand's School in Hampstead Road.
Studied at RA Schools. Awarded a premium at SA 1836. For a
few years he painted oil portraits and scenes from Scott's novels,
but his father's ill health made it necessary for him to help in the
production of watercolour copies after Landseer and others.
From that time onwards he concentrated on watercolour
portraits and figure subjects. Exhibited at RA (22), BI (8),
RHA (2), SBA (4) 1839-72. Died after a long illness in London
19 April 1873. Studio sale held Christie's 23 February 1873.
Represented: VAM; SNG. **Literature:** DNB.

DERBY, William **1786-1847**
Born Birmingham 10 January 1786. Studied under Joseph
Barber. Moved to London by 1808. Exhibited at RA (49), BI
(16), SBA (15) 1811-42 from London. Took over the
drawing for Lodge's *Portraits of Illustrious Personages of
Great Britain* from W.Hilton RA (completed 1834). Partially
paralysed 1838 and was then assisted by his son, Alfred
Thomas Derby. Among his sitters were the Earl of Egremont,
Lord de Clifford, the Earl of Derby and John Flaxman. Died
London 1 January 1847.
Represented: NPG London; SNPG; BM; VAM; Wallace
Collection; Greenwich. **Engraved by** J.Cochran, S.Freeman,
F.C.Lewis, Roberts, H.T.Ryall, J.Thomson, J.Wright.
Literature: DNB.

DERRICK, Thomas **1879-1954**
Born Bristol. Studied at RCA, where he taught decorative
painting. Also produced a number of portraits. Exhibited at
RA (6), NEAC and abroad from Berkshire. Married
Margaret, daughter of Sir George Clausen RA.

DE SALOMÉ, Antoine **fl.1848-1868**
Exhibited at RA (14), SBA (2) 1848-68 from London.
Among his sitters were Alderman Copeland MP, Lady
Georgiana Hamilton, HRH the Duke of Edinburgh and
Vice-Admiral Sir Sidney C.Dacres KCB.

DESANGES, Chevalier Louis William **1822-c.1887**
Born Bexley of a French family. Aged six travelled to Florence,
where he received his first drawing lessons. Returned to
England 1831. Sent to Hazlewood School, Birmingham, then
to Hall Place School, Bexley. Studied art under J.Stone and in
Lyons under Grobon. Visited Florence, Naples and Rome
before settling in London 1845. Painted historical subjects,
but concentrated on painting portraits, developing a
successful practice, mainly of ladies and children. Exhibited at
RA (49), RHA (2), BI (19), SBA (9) 1846-87. Among his
sitters were HRH the Princess of Wales; The Duchess of
Sutherland and HRH the Duke of Connaught KG. Painted
for the Studholme Chapter, Rose Croix. Travelled in India.
Also painted contemporary military scenes, including a series
of heroes for the 'Victoria Cross Gallery'.
Represented: National Army Museum, London. **Literature:**
Ottley; DA.

DES CLAYES, Miss Gertrude NPS **fl.1905-1960**
Born Aberdeen. Studied at RA Schools. Exhibited at RA (7),
NPS, Paris Salon and in Canada 1906-26 from London.
Painted the Duke and Duchess of Connaught and other
society figures. Her sisters, Alice and Bertha, were also artists.

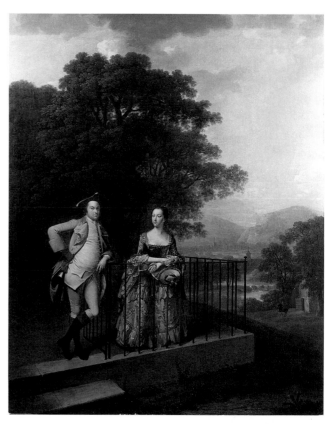

ARTHUR DEVIS. Edward Parker and his daughter Barbara.
Signed and dated 1757. 50 x 40ins (127 x 101.6cm) *Christie's*

DES GRANGES, David **1611-c.1671/2**
Baptized as a Huguenot in London 24 March 1611 or 24 May
1611 or 20 January 1613 (conflicting sources), son of Samson
Des Granges of Guernsey and his wife, Marie Bouvier. Became
a Roman Catholic and was associated for a time with French
Dominicans. Began as an engraver, but then worked mainly in
miniature, frequently signing 'D.D.G.', although there is some
evidence to suggest that he painted to the scale of life. The
Tate's remarkably fine portrait of 'The Saltonstall Family' is
traditionally attributed to this artist. Married a member of the
Hoskins clan and was said to have been a friend of Inigo Jones.
Employed by Charles I and Charles II, and was with the latter
in Scotland 1650-1, when he was appointed His Majesty's
Limner and may have followed him to The Hague. In 1671,
an old and ill man with failing sight, he petitioned the King for
payment of £72 for work done in Scotland. His death is
believed to have occurred in London soon after, for although
his claim was accepted no record of payment can be found.
Represented: NPG London; Ham House, VAM; Windsor
Castle; VAM; Rijksmuseum.

DESIGN, Dederick see DUSIGN, Dederick

DE SUCHEMONT, Mlle A.A. **fl.1816**
An honorary exhibitor at RA (2) 1816. No address was given.

DE THANNBERG, Count L. **fl.1850-1853**
Exhibited portraits, one a study of the 'Emperor Napoleon',
at RA (2) 1850-3 from London.

DE TOTT, Countess **fl.1801-1804**
Exhibited at RA (16) 1801-4 from London. Among her

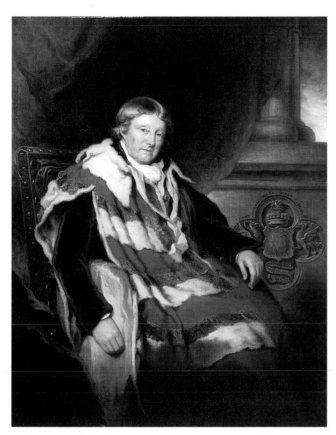

ARTHUR WILLIAM DEVIS. Viscount Curzon aged 89 in peer's robes. Inscribed and dated 13 February 1818. 56 x 44ins (142.2 x 111.8cm) *Christie's*

sitters were the Duchess de Guiche, Lady Crawford and Lady Susan Carpenter.

DEVER, Alfred　　　　　　　　　**fl.1859-1877**
Exhibited at RA (16), SBA (4) 1859-77 from London. Among his sitters was 'George Elliot Esq, MP for North Durham'.

DEVERIA, E.　　　　　　　　　　**fl.1851-1856**
Exhibited at RA (2) 1851-6 from Edinburgh and Pau, France. **Engraved by** E.Burton.

DEVILLALOBOS, A.　　　　　　　**fl.1838-1839**
Exhibited at RA (2) 1838-9 from London University.

DEVIS, Arthur　　　　　　　　　**1712-1787**
Born Preston 12 February 1712, son of a carpenter. Studied under P. Tillemans, and established a successful portrait practice by 1745. Became the leading exponent of small-scale conversation pieces, attracting the patronage of the newly enriched middle class. Exhibited at FS (26) 1761-80. President of FS at the time of the secession of those who formed the RA. In later years he experimented with painting on glass. His works are usually highly finished, with sitters adopting an exaggerated pose. They are extremely well painted and convey a naïve charm. His interiors have been regarded as faithful representations, but he frequently adopted an element of caprice and is likely to have consulted such volumes as *The Practice of Perspective: or, An Easy Method of Representing Natural Objects...*, 1726. The Palladian window in 'The Duet' (VAM) is almost certainly derived from one in a pattern book by B.Langley – *The City and Country Builder's and Workman's Treasury of Designs*, 1745. Also conformed to convention in poses in a pronounced way, for example it was customary for a gentleman of breeding to adopt a cross-legged posture when standing and he often makes great emphasis of this. It is likely that he consulted manuals of decorum such as F.Nivelon's *Rudiments of Genteel Behaviour*, 1737. Died Brighton 25 July 1787. Among his pupils were Thomas Maynard and George Senhouse. During his life he fathered no less than 22 children and of these Arthur William Devis and Thomas Anthony Devis were the most successful as painters.
Represented: NPG London; Harris AG, Preston; Tate; Leicester CAG; Yale. **Engraved by** J.Basire. **Literature:** S.H.Pavière, *The Devis Family of Painters*, 1950; E.D'Oench, Ph.D. thesis Yale 1979; E.D'Oench, *The Conversation Piece – A.D. and His Contemporaries*, Yale exh. cat. 1980; D.Sutton, 'Outside Edge', *Country Life* 10 July 1989 pp.78-81; DA; *Polite Society by A.D.*, NPG London exh. cat. 1984.
Colour Plate 1

DEVIS, Arthur William　　　　　**1762-1822**
Born London 10 August 1762, son of artist Arthur Devis. Entered RA Schools 1774. Exhibited at FS (10), RA (65), BI (13) 1775-1821. Went as a draughtsman on a voyage to East Indies 1782 in the *Antelope*, but the vessel was wrecked off the Pelew Islands and the crew was stranded for a year on an uninhabited island 1784. The crew became friendly with a neighbouring people, took part in the wars of the natives, built a vessel and sailed for Macao, but during the voyage Devis received two wounds from arrows shot from the coast, one in his body, the other on his cheek causing a permanent injury to his jaw. On arriving in Macao, the crew proceeded to Canton. After passing a year at Canton, Devis separated from the crew, proceeded to Bengal where he attracted the attention of Sir William Jones, Lord Cornwallis and General Harris. Successfully practised portrait and subject paintings in India 1785-95. On his return to England he mainly painted portraits and a few notable history subjects. In his later years he had financial problems and was helped by John Biddulph of Ledbury. Died of apoplexy in London 11 February 1822. Buried St Giles's churchyard.
Represented: Harris AG, Preston; BM; NPG London; SNPG; NMM. **Engraved by** W.W.Barney, F.Bartolozzi, J.Basire, J.Bromley, J.Burnet, A.Cardon, R.Cooper, R.Dunkarton, W.Evans, S.Freeman, J.Heath, T.Hodgetts, W.Holl, T.Lupton, H.Meyer, S.W.Reynolds, W.Say, E.Scriven, J.Skelton, B.Smith, J.R.Smith, C.S.Taylor, P.W.Tomkins, C.Turner. **Literature:** S.H.Pavière, *The Devis Family of Painters*, 1950; DA.

DEVIS, Thomas Anthony　　　　　**1757-1810**
Born London 15 September 1757, son of artist Arthur Devis. Entered RA Schools 1773. Exhibited at FS (19), SA (3), RA (4) 1775-88. Painted portraits and fancy pictures.
Literature: S.H.Pavière, *The Devis Family of Painters*, 1950.

DE WALTON, J.　　　　　　　　　**fl.1856**
Exhibited at RA (1) 1856 from 67 Berners Street, London.

DE WILDE, Samuel　　　　　　　**c.1748-1832**
Born Holland. Brought to England as an infant by his widowed mother. Baptized London 28 July 1751. Apprenticed to a joiner, but showed a talent for art. Entered RA Schools 9 November 1769 aged 28 (not consistent with reported birthdate of 1 July 1748). Produced a series of mezzotint portraits published under the pseudonym of 'Paul' from c.1770. Exhibited at SA (9), RA (68), BI (3) 1776-1821. Began a series of theatrical portraits for John Bell's *British Theatre*, 1790. From this time on the majority of his

work was carried out in soft pencil or crayon with light washes of watercolour. Mallalieu describes them as 'delicate and spirited'. Occasionally used a reed pen. Often signed with initials and dated. Died London 19 January 1832 aged 84. Buried in the burial ground adjoining Whitefield's Tabernacle in Tottenham Court Road.
Represented: NPG London; NGI; Garrick Club; BM; VAM; Ashmolean; Newport AG. **Literature:** DNB; I.Mayes, *The De Wildes*, Northampton exh. cat. 1971; DA.

DEXTER, Walter RBA **b.1876**
Born Wellingborough 12 June 1876, son of Walter Sothern Dexter. Studied at Birmingham School of Art. Exhibited at SBA, RA (7). Elected RBA 1904. Art master at Bolton School 1916-20.
Represented: Norwich AG.

DIAKOFF, Filetre **fl.1773**
Exhibited 'two portraits in oil' at RA (1) 1773. No address was given.

DIBDEN, Miss Marion A. **fl.1904**
Exhibited at RA (1) 1904 from Sutton, Surrey.

DICKENS, Kate see PERUGINI Mrs Kate

DICKINSON, John **1852-1885**
Born Merthyr Tydfil, son of an engineer. Aged 14 apprenticed to an engraver in Newcastle. Left to study at South Kensington 1870. Exhibited at RA (24), SBA (1), RSA and in Newcastle 1876-86 from London. Although based in London he returned each year to Newcastle to carry out portrait commissions. Among his sitters were Frederick Calvert QC, Captain Arthur Paget of the Scots Guards and Lady Colchester. Died of consumption aged 32.
Literature: Hall 1982.

DICKINSON, Miss Lilian **fl.1880-1883**
Exhibited at RA (4) 1880-3 from Shepherd's Bush and Hammersmith. Among her sitters was Dr Andrew Clark, Senior Physician to the London Hospital.
Engraved by C.H.Jeens.

DICKINSON (DICKENSON), Lowes Cato 1819-1908
Born Kilburn 27 November 1819, son of Joseph Dickinson, a lithographic publisher. With the encouragement of Sir R.M.Laffan he went to Italy 1850-3. On his return to England he took a studio in Langham Chambers, where Millais also had a studio, and was well acquainted with the Pre-Raphaelites. Exhibited oils and crayons at RA (110) 1848-91. Enjoyed a highly successful portrait practice painting the Victorian establishment. Among his sitters were Queen Victoria, HRH the Prince of Wales as Colonel of 10th Hussars, W.E.Gladstone, Richard Cobden, Quintin Hogg, John Bright, Earl of Auckland, Viscount Gough and General Gordon. Married Margaret Williams 15 October 1857, who as a reader discovered the genius of the Brontës. Dickinson was one of the growing band of Christian Socialists, and helped found the Working Men's College, where in the early days he taught drawing with Ruskin and Rossetti. Helped establish the Artists' Rifle Corps in 1860. Died Hanwell 15 December 1908. Buried Kensal Green Cemetery. Usually painted thinly with a fondness for strong lighting, and gained a reputation for posthumous portraits in crayons.
Represented: NPG London; BM; VAM; Government House, Madras; Fitzwilliam; Arundel Castle; Institute of Directors; Trinity College, Dublin. **Engraved by** John H. Baker, H.Cousins, S.Cousins. **Literature:** L.C.Dickinson, *Letters from Italy 1850-53*, 1914; W.M.Rossetti, *Some Reminiscences*, 1906 p.139; DNB.

DICKINSON, Thomas **b.1854**
Born Allendale. Studied art at Government School of Design, Newcastle. Although highly thought of, he decided against a career as a professional artist because of his frail health. Continued to paint portraits and landscapes as an amateur. Helped found Bewick Club and Pen & Palette Club in Newcastle.

DICKSEE, Sir Frank (Francis) Bernard PRA RI RP
1853-1928
Born London 27 November 1853, son and pupil of Thomas Francis Dicksee. Studied at RA Schools 1871-5 (Gold Medallist 1875), where he was influenced by Leighton and Millais. Began his career as an illustrator for *Cassell's Magazine*, *The Cornhill* and *The Graphic*, but soon enjoyed a successful practice as an elegant society portrait painter. Developed a confident painterly technique. Exhibited at RA (154), RHA (1), RP 1876-1929. His picture 'The House Builders' caused a sensation at RA 1880 and 'Harmony' was purchased by the Chantrey Bequest. Elected ARA 1881, RA 1891, PRA 1924 (aged 71), RP 1926. Knighted 1925, KCVO 1927. Trustee of BM and NPG London. Died London 17 October 1928. An outstandingly gifted draughtsman whose importance has been undervalued.
Represented: Denton House; BM; VAM; Newport AG; Southampton CAG; Bristol CAG; Tate; Merseyside County AGs; Glasgow AG; Manchester CAG; Leeds CAG; Royal Shakespeare Theatre, Stratford. **Literature:** E.R.Dibdin, *F.D.*, 1905; A.Kavanagh, 'A Post Pre-Raphaelite', *Country Life* 31 January 1985 pp.240-2; DA.

FRANK BERNARD DICKSEE. Beatrice Stuart. Signed and dated 1912. Pencil. 11 x 7½ins (28 x 19.1cm) *Maas Gallery, London*

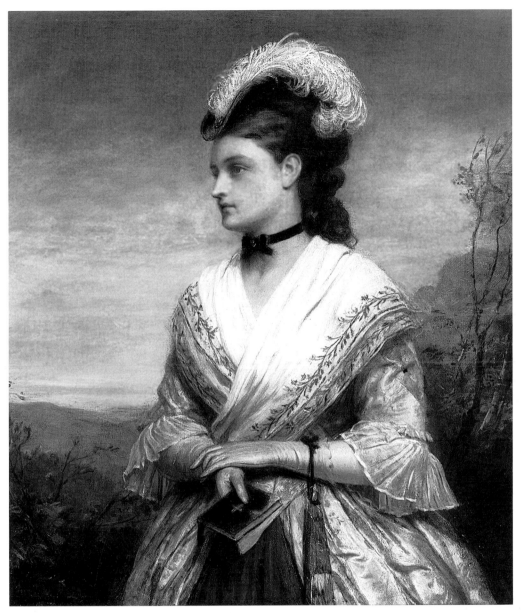

JOHN ROBERT DICKSEE. Returning from Church. Signed with monogram. 14 x 12ins (35.6 x 30.5cm)
Christopher Wood Gallery, London

DICKSEE, John Robert　　　　　　　**1817-1905**
Born St James's, London, brother of Thomas Francis Dicksee, and uncle of Sir Frank Dicksee PRA. Exhibited at RA (45), RHA (21), BI (6), SBA (13) 1850-1905 from London. Among his sitters were 'The Rt Hon Sir John Lawrence Bart GCB, Viceroy and Governor General of India. Painted for the new Institute of Delhi' and 'Sir R.Montgomery KCB, late Lieut.-Governor of the Punjab'.
Represented: Brighton AG; NGI.

DICKSEE, Thomas Francis　　　　　　**1819-1895**
Born St Pancras, London. Studied under portrait painter H.P.Briggs from 1838. Set up in London as a portrait painter. Exhibited at RA (66), BI (29), RHA (2), SBA (14) 1841-95. Among his sitters were William Allen FRS, FLS, Arthur Anderson Esq MP and B.M.Willcox MP. Father of artists Sir Frank, Herbert Thomas, and Margaret.
Represented: Brighton AG. **Engraved by** C.Baugniet, J.R. Dicksee, A.N.Sanders, W.Walker.

DICKSON, A.　　　　　　　　　　**fl.1690s**
His portrait of 'Lady Grace Gethin' (died 1697) was engraved by W.Faithorne in 1699 as the frontispiece to *Reliquiae Gethinianae*.

DICKSON, A.　　　　　　　　　　**fl.1850**
Exhibited at RA (1) 1850. No address given. May be the Anna Dickson who exhibited at SBA (1) 1864 from London.

DICKSON, Miss Frances　　　　　　**fl.1772**
Exhibited at SA (3) 1772. Probably the Miss Dixon who exhibited 'Portrait of a Boy' at SA 1771.

DICKSON, William Playfair　　　　**fl.1897-1902**
Exhibited at RA (5) 1897-1902 from London.

DIEPENBEECK, Abraham van　　　　**1596-1675**
Baptized Hertogenbosch 9 May 1596. Moved to Antwerp as a stained glass Master in 1623. Admitted Master as a painter

in 1638/9. Influenced by Rubens. Visited England c.1629. Painted a dozen life-size pictures of the Earl of Newcastle's manèged horses, as well as views and portraits. A number of these survive at Welbeck. Buried Antwerp 31 December 1675. **Engraved by** C.Caukercken, W.Hollar, L.Vorsterman jnr.

DIETZER, Augustus fl.1832-1834
Listed as a portrait painter in London 1832-4.

DIEZ (DIETZ), Samuel Friedrich 1803-1873
Born Neuhausen near Sonneberg 19 December 1803. Painted miniatures and portraits. Had a distinguished clientele in Germany, Russia 1840, France, England 1842 and Belgium 1851. Exhibited portraits of the royal family at RA (8) 1842. Produced a number of portraits in pencil, heightened with watercolour (published 300 of them as steel engravings). Died Meiningen 11 March 1873.
Represented: NPG London; SNPG; NG Berlin.

DIGHTON, Denis 1792-1827
Son of caricaturist Robert Dighton. Studied at RA Schools. Aged 19 received a commission, through the patronage of the Prince of Wales, in the 90th regiment, which he resigned in order to marry Phoebe Earl. Settled in London. Appointed military draughtsman to the Prince, who purchased a considerable number of his works. Exhibited at RA (17) 1811-25. Retired with his wife and son to Brittany, where he died 8 August 1827 aged 35. His wife was fruit and flower painter to the Queen. He used soft and delicate colouring and his drawing could be of an exceptionally high standard.
Represented: Canterbury Museums; VAM; SNPG; National Army Museum; Nottingham University. **Literature:** DA. Colour Plate 18

DIGHTON, Joshua 1831-1908
Baptized at St Michael's Worcester 9 October 1831, son of Richard Dighton snr and his wife Mary. Worked in Hammersmith, Merton and Wimbledon. Produced watercolour profile portraits on thin white card, often of sportsmen. Married Alice Eliza Slater 26 April 1868. Died in Union Infirmary, Kingston 19 May 1908 aged 77.
Represented: NPG. **Literature:** D. Patton, 'Richard and Joshua Dighton Discovered', *Antique Collector* March 1983 pp.86-9; DA.

DIGHTON, Richard snr c.1795-1880
Born London, son and pupil of Robert Dighton. Specialized in semi-caricature portraits in profile 1815-28, after which he produced mostly watercolour profile portraits in full-length or three-quarter length. Worked in Worcester c.1818-31, Cheltenham, Stoke then London. Died of an 'enlarged prostate and Bright's disease' at 3 Elm Grove, Hammersmith 13 April 1880 aged 84. Had a large family and his son Richard (b.1823) was also an artist.
Represented: BM; NPG London; SNPG; Ashmolean; NMM. **Literature:** D.Patton, 'Richard and Joshua Dighton Discovered', *Antique Collector* March 1983 pp.86-9; DA.

DIGHTON, Robert c.1752-1814
Entered RA Schools 24 February 1770. Exhibited at FS (14), RA (6) 1769-99 from London. Had a successful practice producing caricature portraits. In 1806 he was discovered to have stolen and sold a number of prints from BM, leaving copies in their place. Died London. Usually signed 'R.Dighton' in contrast to his son Richard who signed in full.
Represented: NPG London; SNPG; BM; VAM; Manchester CAG; Fitzwilliam; Ashmolean; Newport AG; Leeds CAG; SNG. **Literature:** D.Rose, *Life, Times and Recorded Works of R.D...*, 1981; Jeffrey Rose Collection, Sotheby's catalogue 23 February 1978; DA.

DILLON, C.G. fl.1808
His portrait of Sir George Don, Lieutenant-Governor of Jersey and Gibraltar was engraved by S.W.Reynolds and published in Jersey 1808.

DIXON, Alfred fl.1856
Listed as a portrait and landscape painter in Wolverhampton.

DIXON, E. fl.1835-1839
Exhibited at RA (6), BI (1), SBA (5) 1835-9 from London.
Represented: NMM. **Engraved by** R.Smith.

DIXON, Frederick Henry fl.1840
Listed as a miniature and portrait painter in London.

DIXON, John d.1721
Reportedly son or grandson of an artist working in Lely's studio. Produced pastel portraits and copies. Died Thwaite, Norfolk. Buried there 14 March 1721. The DNB confuses him with miniaturist Nicholas Dixon.

DIXON, John b.1869
Born Seaton Burn 8 January 1869. Studied at Newcastle, St John's Wood and RA Schools. Settled at Morpeth. Exhibited portraits and miniatures at Newcastle and RA (6) 1905-37.
Represented: Laing AG, Newcastle.

DIXON, Matthew fl.1671-1710
Studied under Lely. Painted portraits at Ecton c.1671-80. Paid in 1679 and 1680 at the rate of £8.10s. for a 50 x 40in. portrait (three-quarter length). Retired early (before 1691) to Suffolk. Buried Thwaite, Suffolk 2 November 1710. Confused by Vertue and Walpole with his son John Gostling Dixon (d.1720/1) who may not have been a painter.
Literature: M.Edmond, *Burlington Magazine* CXXV October 1983 p.612.

DIXON, William fl.1791-1818
Son of Thomas Dixon, a hosier of Cork Hill, Dublin. Worked in Dublin 1791-8, where he had a haberdashery business combined with that of a portrait and miniature painter.

DIXON, William d.c.1830
Published jointly with T.M.Richardson 1816, the first of a series of aquatint illustrations of Newcastle and Northumberland. Worked in London, Newcastle, Durham and Sunderland. Exhibited at RA, BI and in the North East.
Literature: Hall 1982.

DIXSEE, F.H. fl.1848
Exhibited a portrait of 'His Excellency Count de Gréci, Chamberlain of Honour to the Pope' at RA (1) 1848 from London.

DOANE, C. fl.1835-1851
Exhibited at RA (4), SBA (21) 1835-51 from London. Among his sitters were Miss Julia Bennett of the Theatre Royal, Haymarket and Sir Felix Booth Bart.
Engraved by T.Fairland.

DOBBIN, Miss Ethel F. fl.1910
Exhibited at RHA (2) 1910 from Bray, County Wicklow.

DOBSON, Cowan RBA RP 1893-1980
Born Bradford 26 August 1893, son of artist H.J.Dobson. Educated in Edinburgh. Exhibited at RA (13), SBA, RP (15) and in America and the Continent 1913-59 from Edinburgh, London and Glasgow. Elected RBA 1922, RP 1963. Painted HM King Haakon of Norway and HRH Prince Olaf. Painted with bravado and style. Died

COWAN DOBSON. Henry John Dobson. Signed and dated 1923. 54¼ x 36ins (137.8 x 91.7cm)
Richard Green Galleries, London

11 May 1980.
Represented: SNPG; Royal Glasgow Institute; Imperial War Museum.

DOBSON, Henry John RSW 1858-1928
Born Peeblesshire. Studied at School of Design and RSA. Exhibited at RA and in Scotland. Visited America and Canada 1911.
Represented: SNPG. **Literature:** McEwan.

DOBSON, John 1799-1867
Born Carlisle. Worked as a shoemaker, drawing master and portraitist. Studied at Carlisle Academy under M.E.Nutter. Exhibited at Carlisle Academy, Carlisle Athenaeum, and in Dumfries 1823-50.
Represented: Carlisle AG. **Literature:** Hall 1979.

DOBSON, William 1610/11-1646
Baptized St Andrew's Parish Church, Holborn 4 March 1610/11 (not 24 February), the son of William Dobson snr, a 'gentleman'. His father was 'a St Albans man' employed by Francis Bacon and assisted him in the decoration of his house on the estate at Gorhambury, near St Albans. According to John Aubrey he wasted a considerable fortune on high living. William Dobson probably had a classical education before being apprenticed to William Peake c.1625-32. Moved to St Martin's Lane, close to Daniel Mytens (who he may have observed at work) and to Francis Cleyn under whom he studied. At first struggled to become established, and was imprisoned (probably for debt), but was rescued by Mr Vaughan of the Exchequer Office. Copied Van Dyck, Titian and Tintoretto and developed a highly successful style. Described in Aubrey's *Lives* as 'the most excellent painter that England hath yet bred' and it is reported that his work attracted the attention of Van Dyck, who introduced him to the notice of the King. After Van Dyck's death in 1641 he filled the role of principal painter, although there is no evidence that this was an official appointment. Employed an assistant, Hesketh, by 1643. Dobson was a superb colourist, preferring coarse canvas and enjoying highly finished backgrounds, sometimes adorned with statues and reliefs. His name is forever associated with the Civil War, and his dramatically conceived compositions are solidly rendered in a rich range of Venetian hues (reds, blues and gold), which take their high key from the Royalists' crimson sashes. Often portrayed sitters with slightly bulging eyes, which helped convey a sympathetic character. Died in poverty in London aged 35. Buried St Martin's-in-the-Fields, London 28 October 1646.
Represented: NPG London; Tate; HMQ; NGI; Dunedin Public AG, New Zealand; Walker AG, Liverpool; University of Manchester; Birmingham CAG; NMM, Greenwich; Courtauld; SNPG; Yale; Chatsworth; Knowle; Alnwick. **Engraved by** A.Bannerman, J.Caldwall, C.Danckerts, W. Fairthorne, S.Freeman, Mackenzie, J.Posselwhite, G.Vertue, J.Watts, G.White, W.H.Worthington. **Literature:** M.Rogers, *W.D.,* NPG London exh. cat. 1983; W.Vaughan, *Endymion Porter & W.D.,* 1970; DA.
Colour Plate 19

DOBSON, William Charles Thomas RA RWS
** 1817-1898**
Born Hamburg 8 December 1817, son of John Dobson, a merchant. Educated in London. Studied under Edward Opie. Entered RA Schools 1836. Received free advice and encouragement from Eastlake, and through his influence gained a position at Government School of Design. Master of Society of Arts and School of Design in Birmingham 1843-5. Resigned to visit Italy. Spent several years in Germany. Influenced by the Nazarenes and devoted himself to painting biblical subjects. Returned to England 1860. Exhibited at RA

WILLIAM DOBSON. Sir Thomas Chicheley. 40 x 30ins (101.6 x 76.2cm) *Christie's*

(119), SBA (8), RHA (1), OWS 1842-94. Elected ARA 1860, AOWS 1870, RA 1871, OWS 1875. Towards the end of his life he lived at Petworth. Died Lodsworth, Sussex (not Ventnor as is often reported) 30 January 1898. Strongly objected to the use of bodycolour.
Represented: VAM.

DODD, Daniel fl.1761-c.1791
Exhibited at FS (79), SA (4) 1761-80 from London. Provided grey wash illustrations for the Bible, Harrison's series of *Novelists* and Raymond's *History of England.* John Smart (not the miniaturist) and Thomas Day were his pupils.
Represented: NPG London; BM. **Engraved by** A.Birrell, J.Collyer, T.Cook, J.Goldar, C.Grignion, G.Sibelius, B.Reading, Taylor, W.Walker.

DODD, Francis H. RA RWS NEAC RP 1874-1949
Born Holyhead 29 November 1874, son of Rev Benjamin Dodd, a Wesleyan minister and Jane (née Shaw). Educated at Garnet Hill School, Glasgow. Began working for National Telephone Company, then as a china decorator. Studied at Glasgow School of Art under A.Kay and F.H.Newbery, winning a travelling scholarship. Visited France, Italy and Spain. Received advice from Whistler. Worked in Manchester 1895, before settling in London from 1904. Exhibited at NEAC, RA (138), RWS 1904-39. Elected NEAC 1904, RP 1909, Official War Artist 1917-18, ARWS 1923, ARA 1927, RWS 1929, RA 1935. Died Blackheath 7 March 1949. Influenced by the Glasgow School.
Represented: NPG London; SNPG; Tate; Birmingham CAG; Fitzwilliam; Leeds CAG; Manchester CAG. **Literature:** *The Times* 10 March 1949; DNB; P.Davies, *A Northern School,* 1989; VAM MSS.

DODD, Joseph Josiah fl.1848
Listed as a portrait painter in Stretford, Manchester.

DODD, Miss M. fl.1830-1831
Exhibited portraits at RA (5), SBA (16) 1830-1 from Bristol.

DODD, Philip G. fl.1826-1836
Listed as a portrait painter at 11 Camomile Street, London. Exhibited portraits and miniatures at RA (45), SBA (16) 1826-36.

DODD, R. fl.1787-1789
Exhibited at RA (5) 1787-9 from London. Among his sitters were Sir Gilbert Elliot and Chinese artist Shee Shues Sham.

DODD, W. fl.1829-1840
Exhibited at RA (5), SBA (4) 1829-40 from London.

DOE, Enoch fl.1851
Listed as a portraitist at 93 High Street, Worcester.

DONALD-SMITH, Miss Helen fl.1883-1930
Born Scotland. Studied art in Kensington, Paris and at Herkomer's School in Bushey. Exhibited at Society of Lady Artists, RA (9), SBA, RI, ROI, GG, NWG 1883-1930 from London.
Represented: NPG London.

DONALDSON, John FSA 1737-1801
Born Edinburgh, son of a glover. Worked as a porcelain painter before coming to London 1762. Practised as a portrait and miniature painter. Exhibited at FS (8), SA (15), RA (4) 1761-91. Elected FSA 1771. Awarded premiums at SA 1764 and 1768. Died 11 October 1801. Buried Islington churchyard.
Represented: BM; SNPG; SNG. **Engraved by** J.Basire, C.Knight. **Literature:** Foskett; McEwan.

DONALDSON, John fl.1859-1860
Listed as a portraitist at 9 Trinity Crescent, Edinburgh.

DONDERS, Mrs fl.1890-1891
Exhibited at NWG (2) 1890-1 from Dorking, Surrey.

DONGWORTH, Miss Winifred Cecile 1893-1975
Born Richmond 6 August 1893. Studied at Brighton School of Art. Exhibited portraits and miniatures at RA (8), RMS and in the provinces 1914-30 from London.

DONKIN, Miss Alice E. fl.1871-1900
Exhibited at RA (13), SBA (2), NWS, GG, NWG 1871-1900 from Oxford and London. Married brother of Charles Dodgson (Lewis Carroll), and has made portraits based on photographs taken by Charles Dodgson.
Literature: M.N.Cohen, *Lewis Carroll and The Kitchens*, 1980.

DONNE, Walter, J. b.1867
Born Surrey. Studied in Paris at École des Beaux Arts under Bonnat. Exhibited at RA (44), SBA, NWS, NEAC, Paris Salon (medallist 1905) 1886-1923 from Scarborough and London. Principal of Grosvenor Life School. Painted in a strong impressionist style influenced by Clausen, Stott and the Newlyn School.
Literature: *Daily Telegraph* 25 October 1909.

DORIGNY, Sir Nicholas 1658-1746
Born Paris, son of painter and engraver Michael Dorigny and maternal grandson of Simon Vouet. After the death of his father he was brought up in law, which he followed until about 30 years of age. He was partially deaf and gave up the legal profession to take up painting and engraving. Studied under his brother Louis Dorigny in Rome. Selected to engrave Raphael's tapestries in the Vatican. On being told

ALICE E. DONKIN. Waiting – Xie Kitchen dressed as 'The Dane'. Signed with monogram and inscribed on the reverse. Exhibited 1874. 29 x 17ins (73.7 x 43.2cm) *Aldridges, Bath*

there were several of the original cartoons in England, and that Queen Anne was anxious that they should be engraved, he visited England 1711 and was given apartments in Hampton Court. At the suggestion of the Duke of Devonshire he was knighted June 1720. Painted some portraits in England before leaving for Paris. Died Paris 1 December 1746 aged 88.
Literature: DNB.

D'ORSAY, Count Alfred Guillaume Gabriel 1801-1852
Born Paris 4 September 1801, son of Albert, Count d'Orsay, a Napoleonic general. Reluctantly entered the army after the Restoration and was in England for the Coronation of George IV. In 1823 he was persuaded by the Earl and Countess of Blessington to resign his commission and to join them on a tour of Italy (where he painted a portrait of Byron). Briefly married the Blessingtons' daughter (she was barely 15), but they were almost immediately separated. Returned to England 1831 with the widowed Lady Blessington and with her established one of the most fashionable salons of the day, becoming a celebrated wit and dandy. Also an amateur artist and sculptor. Exhibited at RA (17), SBA (3) 1843-8. Later got into debt and was constantly pursued by bailiffs. The last

person to paint Wellington who is said to have exclaimed: 'At last I have been painted like a gentleman!'. Retired to Paris 1849, where he set up a studio and was appointed Director of Fine Arts by Louis Napoleon. Died Dieppe 4 August 1852. Napoleon III attended his funeral.
Represented: NPG London; SNPG; VAM; BM. **Engraved by** H.Lemon, C.E.Wagstaffe. **Literature:** DNB; *Art Journal* September 1852.

DOUGHTY, William **1757-1782**
Born York 1 August 1757, son of John Doughty, who ran a fishing tackle shop and his wife, Ann (née Kirkby). Encouraged by Canon Mason, who sent him to London. Entered RA Schools 1775 and studied under Reynolds until 1778. On leaving Reynolds he went to Ireland, with little success, despite being highly recommended, and so returned to London, where he produced mezzotints after Reynolds. Exhibited at RA (7) 1776-9. Married Margaret Joy 1780, a servant girl in Reynolds' house. With her set out for India, but was captured by French and Spanish patrols and was taken to Lisbon where he died 1782. Waterhouse describes him as: 'potentially the ablest of Reynolds' students and closest to Reynolds in style'.
Represented: NPG London; York CAG; NGI and VAM.
Literature: J.Ingamells, *Apollo* LXXX July 1964; DNB; DA.

DOUGLAS, Edwin **1848-1914**
Reportedly born Edinburgh. Studied at RSA School, living in Edinburgh until 1872, when he moved to London. Exhibited at RA (43) 1869-1900. Lived in Dorking, Guildford, Worthing and Findon, Sussex. Painted mostly sporting and animal subjects in the manner of Landseer.
Represented: Tate.

DOUGLAS, James **1753-1819**
Born London, son of John Douglas. Attended a military college in Flanders, but another account states that he was first employed by his brother abroad as an agent for business, and was left without resources due to some misconduct. Entered the Austrian army as a cadet, but exchanged to the British services. After leaving the army he took holy orders, eventually being appointed one of the chaplains to the Prince of Wales. Painted a number of portraits of his friends in oil and miniature. Died Preston, Sussex 5 November 1819.
Literature: DNB.

DOUGLAS, Sholto Johnstone **1871-1958**
Son of a Lockerbie landowner. Studied at the Slade under Tonks and Steer, in Paris at the Académie Julian and in Antwerp. Exhibited at RA (13) 1902-20 from London. Among his sitters were Sir Herbert Maxwell Bart MP and the Countess of Drogheda. Served as war artist in 1st World War. Died Near Mayfield, Sussex 10 March 1958. Left his widow, Elizabeth, £1,984.18s.3d.
Literature: McEwan.

DOUGLAS, Sir William Fettes PRSA **1822-1891**
Born Edinburgh 12 March 1822, son of James Douglas and Martha (née Fettes). Began his career in the Commercial Bank, but after ten years abandoned this for art. Spent a few months at Trustees' Academy under Sir William Allen 1847. His earliest works were mainly portraits, but he later concentrated on genre and landscape subjects. After visiting Italy 1857 he became a keen collector of antiquities, which he used as accessories in his pictures. Exhibited at RSA (260), RA (9) 1845-92. Elected ARSA 1851, RSA 1854, Curator of SNG 1877-82, PRSA 1882-91, Knighted 1882. Died in Newburgh, Fife 20 July 1891. Buried St Cyrus. Usually used the Douglas heart as his monogram, often in red.
Represented: NPG London; Tate; Aberdeen AG; VAM;

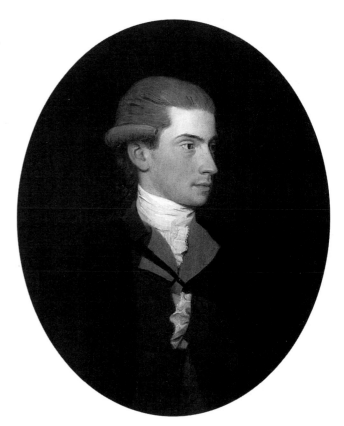

JOHN DOWNMAN. James Adair. Signed and dated 1778. Copper. 9 x 7½ins (22.9 x 19.1cm) *Christie's*

Ashmolean; Dundee AG; Glasgow AG; SNPG; SNG. **Engraved by** W.Walker. **Literature:** J.M.Gray, *Sir W.F.D., PRSA,* 1885; DNB; McEwan.

DOUTON, Miss Isabel F. **fl.1904-1914**
Exhibited portraits and miniatures at RA (18) 1904-14 from London.

DOWDNEY **fl.c.1760**
A portrait of 'Henry Banks' (d.1776) at Kingston Lacy is traditionally called Dowdney.

DOWIE, Sybil M. **fl. 1901**
Painted competent portraits of the daughters of Major S.E.Lamb, which she signed and dated.

DOWLEY, C. **fl.1833-1851**
Exhibited at RA (1), SBA (3) 1833-51 from Dulwich and Old Kent Road.

DOWLING, Robert Hawker **1827-1886**
Baptized Colchester 4 July 1827, youngest son of Rev Henry Dowling and Elizabeth (née Darke). Went to Australia aged seven with his parents. Educated at Launceston. Began as a saddler. Took lessons from Thomas Bock and Frederick Strange. Set up as a portrait and miniature painter August 1850. Returned to England 1857 and entered Leigh's Academy. Exhibited at RA (16), BI (5), SBA (24), RBSA 1859-84 from London. Painted the portraits of the Prince of Wales for the Tasmanian Government, HRH the Duke of Edinburgh, and the Arctic explorer Sir Francis McClintock. Went to Australia 1885, but returned to England 1886. Died 8 July 1886.
Represented: NG Victoria; NG Melbourne; Philadelphia

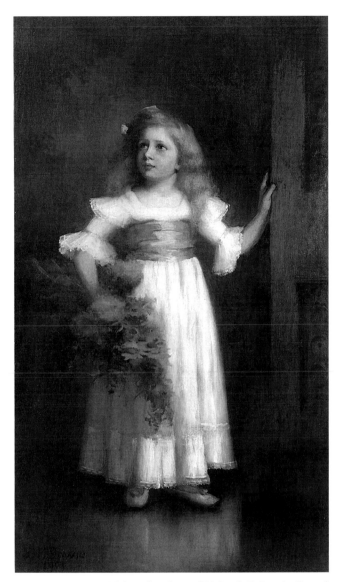

SYBIL M. DOWIE. Helen, daughter of Major S. E. Lamb. Signed and dated 1901. 58¼ x 32¼ins (148 x 81.9cm) *Phillips*

Museum of Art and Queen Victoria Museum and AG, Launceston. **Literature:** Australian DNB.

DOWNER, Nathan fl.1769-1774
Entered RA Schools 1769. Exhibited at RA (6) 1771-4.

DOWNES, Miss Annabel fl.1885-1890
Exhibited at RA (6), SBA (1), NWS, GG 1885-90 from Kensington. Worked in oil and pastel.

DOWNES, Bernard fl.1761-1775
Exhibited at SA (14), RA (11) 1761-75 from London. His work was admired by Walpole.

DOWNES, J.P. fl.1826-1827
Exhibited at RA (2) 1826-7 from London.

DOWNES, Thomas Price fl.1835-1887
Exhibited at RA (41) 1835-87 from London. Among his sitters were Lord Eustace Cecil, Lady K.Hamilton Russell, Lady Selina Bond and the Earl of Eldon.

DOWNING, Charles Palmer fl.1870-1898
Exhibited at RA (27) 1872-98 from London. Painted a number of military portraits including 'HRH The Duke of Connaught KG, KCB' (1898, for Royal Artillery Mess, Aldershot).

DOWNMAN, John ARA c.1750-1824
Possibly born near Raubon, son of Francis Downman, an attorney and his wife Charlotte (née Goodsend). Educated at Raubon. Said to have been sent to Chester and then to Liverpool to learn drawing. Became a pupil of Benjamin West 1768 and entered RA Schools 17 March 1769. Exhibited at FS (1), RA (148), BI (7) 1768-1819. Travelled on the Continent with Wright of Derby 1771, arriving in Rome March 1774 via Lyons, Nice, Turin, Verona, Venice and Florence. Returned to England 1775 and worked in Cambridge 1777-8; London again 1779-1804 then West Malling, Kent. Farington recorded in his *Diary* 24 July 1794 'Downman (whose beautiful little portraits now realize large sums in the sale rooms) called on me to solicit my vote to be an Associate. He told me he had heard I had mentioned his name for which he expressed his acknowledgements'. Elected ARA 1795. In Plymouth 1806 and married at Exeter, but left after his wife died 1808. Returned again to London, but made a tour of the Lake District 1812 and settled in Chester 1817. Died Wrexham 24 December 1824. Often painted portraits in light watercolour over black chalk or charcoal, and sometimes wrote comments on the sitters underneath his characteristic mounts. Waterhouse describes him with some justification as 'the prettiest and most elegant of portrait painters of his age in chalk and watercolours'. His oils are also remarkably subtle and sensitive, with soft, gentle colouring. Had a fondness for smallish portraits, portraying head and shoulders in an oval canvas (sometimes on copper).
Represented: NPG London; Tate; BM; VAM; Cecil Higgins AG, Bedford; Chatsworth; Wallace Collection; Fitzwilliam; Stourhead NT; Manchester CAG; NMM; Springfield Museum, Massachusetts. **Engraved by** F.Bartolozzi, J.Collyer, F.Deleu, W.T.Fry, J.Grozer, J.Jones, C.Picart, H.Robinson, R.Woodman. **Literature:** G.C.Williamson, *J.D.*, 1907; E.Croft-Murray, *British Museum Quarterly* XIV 1940 pp.60-6; DA.

DOWNS, Marion fl.1856
Three pastel portraits are in Southampton CAG.

DOYLE, Henry Edward RHA 1827-1892
Born Dublin, son of John Doyle. Trained in Dublin. Moved to London, where he worked as a draughtsman and wood engraver. Commissioner for Rome in the London International Exhibition 1862. Painted portraits (including John Ruskin) and religious murals (including in the chapel of the Dominican Convent at Cabra, near Dublin 1864). Exhibited at RHA (13), RA (1) 1870-84. Elected ARHA 1872, RHA 1874. Director of NGI for 23 years.
Represented: NGI; NPG London.

DOYLE, John (H.B.) 1797-1868
Born Dublin, son of a business man. Studied under G.Gabrielli, J.Comerford and at Dublin Society's School. Moved to London 1821, where he tried unsuccessfully to establish himself as a portrait painter. Exhibited at RA (6) 1825-35. His lithographs of prominent characters of the day became popular and he was employed as a cartoonist. Between 1829-40 he was the leading political cartoonist in London. His cartoons were admired by Thackeray, Macaulay, Wordsworth, Wilkie and Haydon. Most were signed 'H.B.' a signature contrived by a J.D. on top of a J.D., but preserving anonymity. Died 2 January 1868, aged 70 after some 17 years

175

of retirement. Sir Arthur Conan Doyle was his grandson.
Represented: BM; NGI. **Literature:** G.Everitt, *English Caricaturists*, 1886 pp.238-76; DA.

DOYLE, William fl.1877-1883
Listed as a portrait painter in Dublin.

DRAKE, John Poad 1794-1883
Baptized Stoke Damerel, Devonshire 20 July 1794, son of Thomas Drake and his wife Frances (née Poad). Studied under an architectural draughtsman. Apprenticed to a builder in Plymouth dockyard, but gave up to become a painter. Saw Napoleon on board the *Bellerophon* in Plymouth Sound, and produced a picture of the scene, which he carried to America. Commissioned by subscribers to paint a portrait of Justice Blowers to be hung in the court house, Halifax, Nova Scotia. Visited Montreal and New York. Also invented improvements in shipbuilding. Returned to England 1827. Patented his diagonal system and a screw trenail fastening 1837. Between 1829 and 1837 he was occupied with improvements for breech-loading guns and working heavy cannon. Died Fowey, Cornwall 26 February 1883.
Literature: DNB.

DRAKE, Nathan FSA 1726-1778
Baptized St Peter Eastgate, Lincoln 6 December 1726. Son of Samuel Drake, a canon at the cathedral, and his wife Elizabeth. Apprenticed as a cabinet maker to his brother at York, where he settled for the rest of his life, practising as an artist and teaching watercolour painting. Married Mary Carr 31 May 1763. Exhibited at SA (6) 1771-6. Elected FSA 1771. Died York 19 February 1778.
Represented: York AG. **Engraved by** V.Green, P.Rothwell, J.Stow. **Literature:** DA.

DRAPER, Herbert James 1863/4-1920
Born London. Studied at St John's Wood School, RA Schools from 1884 (awarded Gold Medal and Travelling Scholarship), Académie Julian, Paris and in Rome 1890-1. Settled in London 1891, painting subject pictures and portraits. Exhibited at RA (61), RHA (2), SBA and in Paris 1887-1920. His famous 'The Lament for Icarus' was brought by the Chantrey Bequest 1898. A highly accomplished painter, usually working in the manner of J.W.Waterhouse. Also produced mural decorations. Died 22 September 1920.
Represented: Tate; Walker AG, Liverpool; Manchester CAG; Leeds CAG; Preston AG; Nardford AG; Truro AG; Bradford AG.

DREW, J.P. fl.1835-1861
Exhibited at RA (18), BI (46), SBA (26) 1835-61. Worked in London. Moved to Streatley, Berkshire c.1847-55, then to Goring and Reading.

DREW, Miss Mary fl.1881-1901
Exhibited at RA (23), RHA (2), SBA (14) 1881-1901 from London and Seaford, Sussex.

DRUMMOND fl.1792
Exhibited at RA (2) 1792 from 24 Church Street, Soho.

DRUMMOND, Miss Eliza fl.1820-1843
Probably daughter of Samuel Drummond. Exhibited portraits and miniatures at RA (11), BI (2), SBA 1820-43 from London. Painted a number of paintings of figures from the theatrical world.

DRUMMOND, G. fl.1863
Exhibited a family group portrait at RA (1) 1863 from York.

DRUMMOND, H. fl.1831
Exhibited at RA (1) 1831 from London.
Engraved by H.R.Cook.

DRUMMOND, James RSA 1816-1877
Born Edinburgh. First worked as a draughtsman for Captain Brown, author of works on ornithology. Taught drawing briefly before entering Trustees' Academy under Sir William Allan. Exhibited scenes from Scottish history and portraits at RSA (126) 1835-77 from Edinburgh. Elected ARSA 1845, RSA 1852. Appointed Curator of SNG 1868. Died Edinburgh 13 August 1877.
Represented: VAM; Blackburn AG; SNG. **Engraved by** J.Posselwhite. **Literature:** *J.D. R.S.A,* Tolbooth Museum, Edinburgh 1977; McEwan.

DRUMMOND, Julian fl 1854-1892
Exhibited at RA (6), SBA (1) 1854-92. Worked in London and Oxford. May be Julian E.Drummond who exhibited coastal scenes at RA (4) 1896-1903 from Brighton.

DRUMMOND, Rose Emma fl.1815-1849
Probably a daughter of Samuel Drummond. Won a Silver Medal at SA 1823. Listed as a portrait painter at 3 Rathbone Place, London. Exhibited at RA (18), NWS 1815-35.
Represented: NPG London. **Engraved by** W.J.Alais, H.Cooper, J.Hopwood jnr, R.Page, J.Thomson, T.Woolnoth.

DRUMMOND, Samuel ARA 1765-1844
Born London 25 December 1765. Joined the navy aged 14, serving seven years (it was said he served in three engagements). Entered RA Schools 1791 (reportedly aged 21) and began producing portraits, first in crayons and later also in oils. Employed by the *European Magazine*. Exhibited at SA (8), RA (303), BI (84), SBA (9) 1790-1844. Elected ARA 1808, Curator of RA Painting School. Among his sitters were HRH the Duke of Sussex, Thomas Stothard, Sir Walter Scott and Edmund Kean as Richard III. Died London 6 August 1844. Among his pupils were George Henry Harlow and Thomas Musgrave Joy.
Represented: NPG London; SNPG; BM; Leeds CAG; NMM. **Engraved by** W.Barnard, J.Blood, T.Blood, W.Bromley, J.Carter, J.Chapman, H.R.Cook, I.Farn, J.Heath, J.Hopwood jnr, K.Mackenzie, H.Meyer, I.Purden, J.Rogers, W.Ridley, Ridley & Blood, Ridley & Holl, W.Say, E.Scriven, J.R.Smith, J.Stow, H.D.Thielcke, J.Thomson, W.Ward. **Literature:** DNB; Farington's *Diary*, 4 June 1804.

DRUMMOND, William fl.1830-1848
Exhibited at RA (2), BI (5), SBA (7) 1830-43 from London. Produced portraits for Heath's *Book of Beauty*. Painted portraits of Queen Victoria, Prince Albert and Thackeray.
Engraved by J.Cochran, W.H.Egleton, W.H.Mote, T.Wright.

DRURY, Richard b.c.1791
Entered RA Schools 31 October 1821 aged 30. Listed as a portrait painter in Manchester.

DU BOIS, Drahonet Alexander Jean fl.1832-1834
Exhibited portraits, including 'The Marchioness of Londonderry', at RA (2) 1832-4 from London.

DU BOIS, Simon 1632-1708
Baptized Antwerp 26 July 1632, younger brother of Edward Du Bois, with whom he is believed to have shared premises in London. Became a pupil of Berghan and Wouvermann 1652/3. Travelled to Italy, where he is recorded in Venice

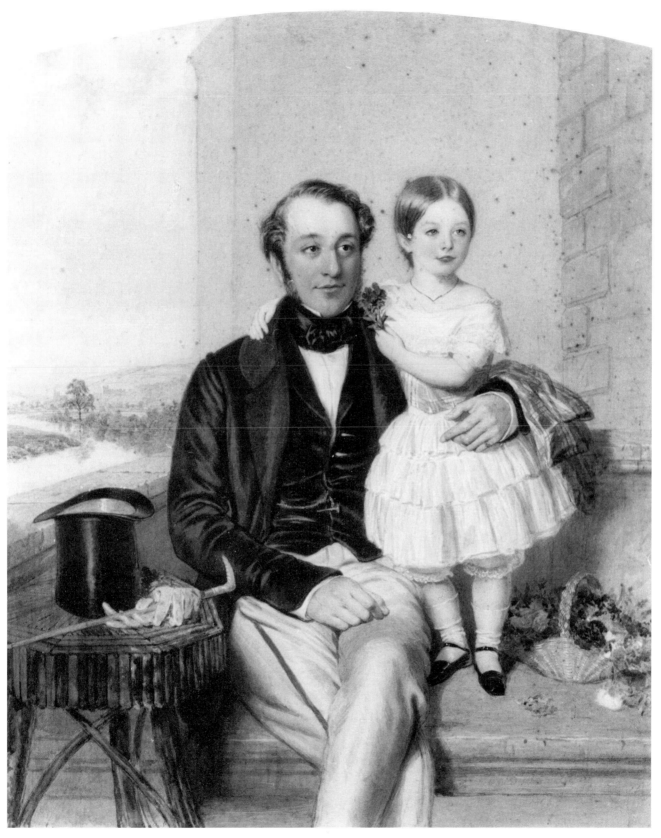

WILLIAM DRUMMOND. A gentleman and his daughter. Signed and dated 1848. Watercolour. 21 x 17ins (53.3 x 43.2cm)

David Lay, Penzance Auction House

1657. Paid in Rome for a portrait of 'Alexander VII' 1667. His earliest known English portrait is signed 'S du Bois fecit London 1681'. Also painted miniatures, battle scenes, landscapes and copies. Became a denizen 8 May 1697. Buried St Giles-in-the-Fields, London 26 May 1708.
Represented: Dulwich AG; Fitzwilliam. **Literature:** DA.

DU BOURG, M. fl.1786-1808
Exhibited at RA (3) 1786-1808 from London. Believed to have been a French émigré painter. Collaborated with John H.Clark.
Literature: Bénézit.

DUBUFE (DUBUFFE), Louis Edward 1820-1883
Exhibited at RA (8), BI (1) 1838-73 from Paris and London. Probably the Edouard-Louis Dubufe who was born Paris 1820, son and pupil of Claude-Marie Dubufe. Exhibited Paris Salon 1839-79. Died Paris or Versailles 11 August 1883.
Engraved by F.Joubert. **Literature:** Bénézit; DA.

DUBUISSON, Miss E. fl.1805-1840
Exhibited at RA (20), BI (2), SBA (3) 1805-40 from London.

DUCHÉ, Thomas Spence 1763-1790
Born Philadelphia. Studied in London under West after his loyalist father took him there 1777. Showed promise as a portraitist, but tuberculosis made him give up his practice 1789. Died London.
Represented: Trinity College, Hartford, Connecticut. **Literature:** *The American Pupils of Benjamin West,* NPG Washington exh. cat. 1980.

DUCREUX, Joseph 1735-1802
Born Nancy 26 June 1735. Only pupil of Quentin de La Tour. Appointed 'Premier Peintre' to Marie-Antoinette, but not a member of Académie, although he was an RA of Vienna. Visited London briefly, staying at 232 Piccadilly. Exhibited at RA (5) 1791 and at Paris Salon. Died Paris 24 July 1802.
Engraved by L.J.Cathelin. **Literature:** DA.

DUDLEY, Ambrose fl.1890-1919
Exhibited at RA (6) 1890-1919 from Notting Hill, London.

DUDMAN, R. fl.1797
Exhibited at RA (1) 1797 from the Strand, London. Advertised in *Morning Chronicle* 17 April 1797: 'Late of Strand, now of 17 Salisbury Street. Late pupil of Sir Joshua Reynolds'.

DUDMAN, William d.1803
Chichester portrait and miniature painter. A miniature was inscribed 'W.Dudman Pinxit. Ex Academia Regali Arliam. Londoni 1801'. Married Martha Brown (née Dally?), a widow, 1 October 1794 at St Andrews, Chichester. Thought to have committed suicide in Marylebone August 1803, by firing a pistol into his mouth. Some of his work was strongly influenced by Romney.
Represented: Bognor Old Town Hall. **Literature:** *The Times* 9 August 1803.

DUFF, George b.1881
Born Glasgow. Exhibited at RSA (6) and in the provinces from Glasgow.

DUFFIN, Paul d.1786
Son of a madhouse keeper at Chelsea. Became an itinerant portrait painter and later picture dealer/restorer. Redgrave

says he painted a number of portraits in the Canterbury area. Exhibited at SA, RA (1) 1772-5 from Holborn. His will was proved December 1786.

DUFOUR, William fl.1763-1770
Probably a pupil of Roux, the engraver. Exhibited at FS (3) 1765 from Rupert Street, Haymarket, London and a sculpture at RA (1) 1770.
Represented: VAM.

DUFRETAY, Le Chevalier 1771-1802
Possibly a French émigré portrait painter. Studied at RA Schools 1795 aged 24. Exhibited at RA (3) 1797-1802 from London.

DUGDALE, Thomas Cantrell RA ROI RP
 1880-1952
Born Blackburn 2 June 1880. Studied at Manchester School of Art, RCA, City & Guilds School Kennington, Académie Julian, Paris and Colarossi atelier. Married artist Amy K.Browning RP 1916. Exhibited at RA (154), RP (78), ROI 1901-53. Elected RP 1925, ARA 1936, RA 1943. Died London 13 November 1952.
Represented: SNPG; NPG London; Brighton AG; Tate; Southampton CAG.

DUGGAN, Peter Paul c.1810-1861
Born Ireland. Went at an early age to America, where he practised as a portraitist. Professor of Drawing in New York Academy, but resigned the post because of ill health. Visited England and afterwards Paris, where he died 15 October 1861.
Engraved by R.Grave.

DUGY, J. fl.1629
A female portrait signed 'J.Dugy pinxt.1629' is in NPG London.

DUKES, Charles fl.1834-1865
Exhibited at RA (35), BI (33) 1834-65 from London. A Charles Dukes exhibited at SBA (27) 1829-65 from London.

DU MONT, August Neven 1868-1909
Born Cologne. Studied at Düsseldorf Academy. Married Maria von Guilleaume, who came from a wealthy family of Westphalian industrialists. Moved to London April 1896. A close friend of John Lavery. Exhibited at International Society and RP (25).

DUNCAN, Thomas ARA RSA 1807-1845
Born Kinclaven, Perthshire 24 May 1807. Studied at Trustees' Academy in Edinburgh under Sir William Allan. Exhibited at RSA (100), RA (8), SBA (1) 1828-46. Elected RSA 1829, ARA 1843. Painted with great freedom and strong sense of colour. His promising career was cut short by a brain tumour and he died in Edinburgh 25 April 1845 aged 38. Buried in Edinburgh Cemetery at Warriston. After his death his self-portrait was purchased from the subscriptions of over 50 Scottish artists and presented to RSA. Ottley described his portraits as: 'faithfully and skilfully rendered. As a colourist, indeed he had few superiors'. The DNB writes 'His portraits are faithfully and skilfully rendered, and evince delicate feeling for female beauty and keen appreciation of Scottish character'. He was capable of handling complex compositions.
Represented: NPG London; SNPG; VAM; SNG. **Engraved by** E.Burton, J.Porter, J.Smyth. **Literature:** Maas; McEwan.

DUNKARTON, Robert c.1744-c.1810
Born London. Studied under Pether. Began as a crayon portraitist. Exhibited at SA (4), RA (9) 1768-79 from London. Won seven premiums for drawings at SA 1761-7. Became an accomplished mezzotint engraver and Waterhouse

states that his last dated prints were produced 1810. **Represented:** NPG. **Literature:** DNB.

DUNLAP, William **1766-1839**
Born Perth Amboy, New Jersey 17/18 February 1766. Produced a crayon portrait of George Washington as early as 1773. Studied under West in England 1784-7. Continued his portrait practice despite developing a career in the theatre and as a writer. Author of *History of the Rise and Progress of the Arts and Design in the United States*, 1834. Died New York 28 September 1839. Often painted on panel support. **Represented:** Chrysler Museum, Norfolk, Virginia; Brooklyn Museum. **Literature:** O.S.Coad, *W.D.*, 1917.

DUNN, Andrew **fl.1800-1820**
Studied at Dublin Society Schools under F.West. Worked in Waterford and Kilkenny before going to London. Returned to Ireland 1808, but moved to London the same year. Exhibited at RA (20), SA, Dublin 1809-19.

DUNN, Henry Treffry **1838-1899**
Born Truro. Studied at Heatherley's. Exhibited at SBA (1) 1867. Recommended as studio assistant to Rossetti by Walter Howel Deverell, a position he held for 20 years. After Rossetti's death Dunn fell into poverty and alcoholism, but he was rescued by the charitable Clara Watts-Dunton, who looked after him at The Pines in Putney, as she had done with Swinburne. **Represented:** NPG London. **Literature:** G.Pedrick, *Life with Rossetti*, 1964.

DUNN, John **fl.1801-1841**
Practised in Dublin 1801-10, and was recorded there 1841.

DUNN, Michael B. **fl.1819-1834**
Studied at Dublin Society Schools, where he won a prize 1819. Exhibited at RHA (8) 1826-34 from Dublin.

DUNTHORNE, James snr **1730-1815**
Apprenticed to Joshua Kirby 1745. Worked as a surveyor, portrait painter and miniaturist at Colchester. Married Elizabeth Hubbard at St James, Colchester 30 October 1752. Exhibited miniatures at RA (16) 1784-6. His son, James, was a caricaturist. Often confused with John Dunthorne of East Bergholt. **Literature:** W.Gurney Benham, *The Dunthornes of Colchester*, 1901.

DUNTHORNE, James jnr **c.1758-c.1793**
Born Colchester, son of artist James Dunthorne snr. Painted portraits, miniatures and caricatures and was known as 'The Colchester Hogarth'. Exhibited at RA (14) 1783-92. **Literature:** W.Gurney Benham, *The Dunthornes of Colchester*, 1901.

DU PAN, Barthélemy **1712-1763**
Born Geneva 18 August 1712. Studied in Paris and Rome. Moved to England by 1743. His major work in England was a large informal conversation piece of the 'Children of Frederick, Prince of Wales' (1746) which is at Windsor Castle. Briefly in Ireland 1750. Returned to Geneva by 1751, where he died 4 January 1763. Also worked on a small scale. **Literature:** *Burlington Magazine* LXXXVIII June 1946 p.152; DA.

DU PARC, Françoise (Marie-Thérèse) **1726-1778**
Exhibited crayon portraits at SA (3), FS (3) 1763-6 from London. **Literature:** DA.

DUPONT, Gainsborough **1754-1797**
Born 24 December 1754, nephew of Thomas Gainsborough, to

whom he was apprenticed in 1772. Entered RA Schools 1774/5. Articled aged 17 to Gainsborough and remained his only assistant, producing studio replicas and scraping mezzotints of portraits and fancy pictures. After Gainsborough's death he inherited his studio properties and lived for a time in Mrs Gainsborough's house. Exhibited at RA (26) 1790-5. Patronized by Pitt and the royal family, but was too shy and nervous to inherit Gainsborough's practice. From 1793 he did a number of portraits of actors for Thomas Harris, several of which are at the Garrick Club. Died after an illness of eight days at his house in Fitzroy Square, London 20 January 1797. Buried with his uncle at Kew. Worked closely in the style of his uncle, but tended to elongate the figures and nervously exaggerated the diagonal brush strokes of Gainsborough's technique. **Represented:** NPG London; Trinity House; Gainsborough House, Sudbury. **Engraved by** W.Bromley, W.Dickinson, V.Green, J.Jones, W.Ridley, C.Turner. **Literature:** DA.

DUPPA, Brian Edward **fl.1832-1853**
Exhibited portraits at RA (6), BI (1), SBA (7) 1832-53 from London. Painted John Landseer and Sir John Bowring. Engraved by E.Scriven in J.Saunders' *Political Reformers*, 1840.

DUPRA, Domenico **1689-1770**
Among his sitters were William Hay, John Irwin and 4th Duke of Perth. **Represented:** SNPG. **Engraved by** R.Houston.

DUPUIS, Philippe Felix **fl.1874-1882**
Exhibited at RA (3), SBA (2), GG 1874-82 from London. Painted a portrait of 'Sir Frederick Leighton PRA' (1881).

DURANT, John **b.1770**
Entered RA Schools 1791 aged 21. Awarded a Silver Medal 1793. Exhibited at RA (2) 1796-7.

DURDEN, James ROI **1878-1964**
Born Manchester. Studied at Manchester College of Art and RCA. Exhibited at RA (29), LA, ROI, RP, RI, Paris Salon (Silver Medal 1927) 1909-37 from London, Whitehaven and Keswick. Elected ROI 1926/7. Died Keswick. **Represented:** Keswick Museum. **Literature:** J.Walker Stephenson, 'J.D.', *The Studio* 1925. Colour Plate 20

DURHAM, Miss Mary Edith **1863-1944**
Educated at Bedford College. Studied at RA Schools. Exhibited at RA (3), RI, ROI from 1892 from London. Travelled widely and published several books about the Balkans. Died 15 November 1944.

DURRANI, B **fl.1880**
Exhibited at RA (1) 1880 from Streatham, London.

DURY, Antoine (Tony) **b.1819**
Born Lyons 22 March 1819. Studied at École des Beaux Arts, Lyons and in Paris. Exhibited in Paris 1844-78. Established in Warwick 1878. Worked in Liverpool 1879-86. Exhibited at Liverpool Autumn Exhibition. **Represented:** Walker AG, Liverpool.

DUSIGN (DESIGN), Dederick (Diederick) **1749-1770**
Baptized Bath 22 August 1749, son of Colonel Gerard Design and Anne (née Carmichael, daughter of the 2nd Earl of Hyndford). Entered RA Schools 1769 and studied under Reynolds. Visited Rome 1770, but died of consumption the same year, shortly after arriving there. **Literature:** Scottish Peerage; Will of Gerrad Design, Somerset 1786.

DUTERRAU, Benjamin **1767-1851**
Born London of French parents. Apprenticed to an engraver. Exhibited at RA (6), BI (3) 1817-23. Emigrated to Australia in the *Laing* and arrived in August 1832, where he set up a studio in Hobart Town. According to the *Hobart Town Courier* 29 November 1833, he was the first to portray aboriginals accurately, successfully revealing their temperaments as well as their appearance. Died 11 July 1851. **Represented:** Tasmanian Museum & AG; Dixson Gallery; Narryna Folk Museum, Hobart; National Library of Australia. **Literature:** Australian Dictionary of Biography.

DUTTON, John Frederick Harrison **fl.1893-1909**
Exhibited at RA (3), RCA 1893-1909 from Chester.

DUVAL, Charles Allen **1808-1872**
Born Ireland. Began as a sailor, before setting up as an artist in Liverpool. Settled in Manchester. Exhibited at RA (20), RHA (2) 1831-72. He did several large group portraits, one containing 100 portraits of leading Wesleyans in the U.K.; another of the chief members of the Anti-Corn Law League. His 'The Ruined Gamester' was engraved and became so popular that *Punch* produced a cartoon of it caricaturing Sir Robert Peel. Married Elizabeth Renney in both Liverpool 1833 and Manchester 1834 and had at least seven children. Died suddenly in Chorley 14 June 1872 aged 64. The DNB writes 'His portraits are good likenesses, and have considerable artistic merit, particularly his chalk studies of children . . . All his work was marked by great taste and beauty'. **Represented:** NPG London. **Engraved by** J.Thomson.

DUVAL, John **1816-1892**
Worked as a portrait painter in Ramsgate before settling in Ipswich c.1852. Exhibited at RA (17), SS (49) 1855-77.

DYCE, Sir William RA HRSA **1806-1864**
Born Aberdeen 19 September 1806, son of a doctor and lecturer in medicine. Educated at Marischal College, Aberdeen, receiving an MA aged 16. Studied art against his father's will, and Sir Thomas Lawrence was so impressed with his talent that he persuaded Dyce to take up art professionally. Briefly attended RSA and RA Schools, but went to Rome where he spent a considerable time studying the Roman and Tuscan Schools. By 1829 he was back in Scotland, establishing a practice as a portraitist in Aberdeen. He kept up his scientific interests and wrote a prize-winning essay on electro-magnetism 1830. Exhibited at RSA (58), RA (41), BI (4) 1827-65. Elected ARSA 1835, ARA 1844, RA 1848. Made several trips to Rome, where he was influenced by the Nazarenes and by Italian Renaissance painting. Moved to London 1837 to become Superintendent of new School of Design (resigning 1843). Successful in the fresco competition to decorate the New Palace of Westminster 1844 (completed 1851). Patronized by Prince Albert. One of the few artists to recognize immediately the potential of the Pre-Raphaelites. Persuaded Ruskin to look at them seriously for the first time. Died Streatham 15 February 1864. Studio sale held Christie's 5 May 1865. As a portraitist he was particularly successful and was praised for his depiction of children. **Represented:** NPG London; BM; SNPG; VAM; Tate; Aberdeen AG; Ashmolean; Southampton CAG; Birmingham CAG; Fitzwilliam; SNG. **Engraved by** T.Lupton, H.Robinson. **Literature:** M.Pointon, *W.D.*, 1979; *The Pre-Raphaelites*, Tate exh. cat 1984; McEwan; DA.

DYER, Wilson **fl.1855**
Listed as a portraitist at Newells Buildings, Market Street, Manchester.

DYKE, Richard William **fl.1787-1815**
Entered Dublin Society Schools 1787, winning medals 1788 and 1789. Worked in Belfast and charged one guinea for small portraits in watercolours or crayons. Returned to Dublin.

E

EADIE, Robert RSW **1877-1954**
Born Glasgow 16 March 1877, son of John Eadie, a tobacco maker. Educated Glasgow Board School. Studied at Andersonian College, Glasgow and in Munich and Paris. Served with Royal Engineers. Exhibited in London, Liverpool, Edinburgh, Glasgow and Paris. Elected RSW 1916. Painted a number of watercolour portraits.
Represented: Glasgow AG; Paisley AG. **Literature:** McEwan.

EALES, Miss M. **fl.1877**
Exhibited a portrait of 'Lady Magdalen Yorke, Youngest Daughter of the Earl of Hardwick' at RA (1) 1877 from London.

EARL(E), James **1761-1796**
Born Paxton, Massachusetts 1 May 1761, younger brother of Ralph Earl. Moved to England before 1787, following the band of loyalists, those former American colonists who after the Revolution fled to London. Probably a pupil of B.West. Entered RA Schools 24 March 1789. Exhibited at RA (17), SA (1) 1787-96 from London. Returned to America 1796 and was painting portraits at Charleston, South Carolina when he died of yellow fever 18 August 1796. His son, Augustus Earle, was also an artist.
Represented: Royal Ontario Museum, Toronto. **Literature:** R.G.Stewart, 'James Earl: American Painter of Loyalists and his Career in England', *The American Art Journal* XX no.4 1988.

EARL, Ralph **1751-1801**
Born Shrewsbury, Massachusetts 11 May 1751, son of Ralph and Phoebe Earl. Established as a portrait painter in New Haven by 1774. Married his cousin Sarah Gates of Worcester, but after the birth of their second child in 1777 the marriage broke up. He refused as a loyalist to join his father's regiment and was disinherited. He corresponded with the enemy, risking execution, and fled to England disguised as a captain's servant arriving April 1778. Studied unofficially under Benjamin West, but retained his primitive vision, painting portraits in London and in Norfolk, which Waterhouse describes as containing 'a certain innocent New England quality'. Exhibited at RA (4) 1783-5. Married Ann Whiteside of Norwich c.1784 and returned with her to America May 1785, where he had a successful practice in Connecticut. Imprisoned for debt in New York, after which he worked as an itinerant portrait painter. Died of 'intemperance' in Bolton, Connecticut 16 August 1801. His younger brother, James, was also a portrait artist.
Represented: NPG London; Yale; Metropolitan Museum of Art, New York; NG Washington; Lamport Hall, Northamptonshire; Toledo Museum. **Literature:** L.B.Goodrich, *R.E. Recorder of an Era*, New York 1967; M.Baigell, *Dictionary of American Art*, 1979; DA.

EARL, Ralph Eleaser Whiteside **c.1785-1838**
Born England, son of Ralph Earl by his second wife. Moved with his father to America when an infant. In England 1809-13 (Norwich), then France, and back to America 1815. Worked in Nashville 1817 and painted Andrew Jackson, marrying his niece. Painted many images of that President and became known as 'the King's Painter'.
Represented: National Museum of American Art, Smithsonian Institute; Chrysler Museum, Norfolk, Virginia.

EARL, Thomas **fl.1836-1885**
Exhibited at RA (49) 1840-80 from London.
Represented: NPG London.

EARL, William Eldon **b.1803**
Baptized Norwich 30 October 1803, son of William Eldon Earl. Listed as a portrait painter in Surrey Street, Norwich.

EARLE, Miss **fl.1821-1822**
Honorary exhibitor at RA (2) 1821-2.

EARLE, Augustus **1793-1838**
Born London 1 June 1793, son of American artist James Earl and his wife Caroline, and nephew of Ralph Earl. Studied at RA Schools, becoming friends with C.R.Leslie and Samuel Morse. Exhibited at RA (11) 1806-38. In 1815 he visited Sicily, Malta, Carthage, Ptolemais and Gibraltar before returning to England in 1817. Went to New York March 1818, Philadelphia, Rio 1820, Chile, Lima, India 1824, Sydney, Australia 1825 and New Zealand 1827. Returned to England 1830, and by the following year was in the employ of John Murray, 5th Duke of Atholl. On 28 October 1831 he joined HMS *Beagle* as artist and befriended Charles Darwin. His health deteriorated on the voyage and he left in August 1832, his place being taken by Conrad Martens. Returned to London, where he was listed as a portrait and landscape painter 1832-4. Died there of 'asthma and debility' 10 December 1838.
Represented: National Library of Australia. **Literature:** Australian Dictionary of Biography.

EARLE, Miss Kate **fl.1887-1903**
Exhibited at RA (5), SBA (6) 1887-1903 from Kensington and Holloway.

EARLES, Chester **b.1828**
Baptized Shoreditch 15 September 1828, son of William Earles and Elizabeth (née Chester). Exhibited at RA (56), BI (18), SBA (55) 1842-63 from London and Paris. Also painted literary subjects from Spenser, Shakespeare and Keats.

EARLOM, Richard **1742/3-1822**
Born London. Studied under Cipriani. Established a reputation as an important engraver. Exhibited at FS 1762-7. Died London 9 October 1822.
Represented: NPG London; Brighton AG. **Literature:** Bénézit; DA.

EARNSHAW, Mrs Mary Harriot **fl.1888-1900**
Exhibited at SBA (3), SM 1888-1900 from Newman Street, London.

EASTLAKE, Sir Charles Lock PRA **1793-1865**
Born Plymouth 17 November 1793, son of G.Eastlake, Solicitor to the Admiralty, and Judge Advocate at Plymouth. Educated at Charterhouse School under amateur artist Rev J.Bidlake. Studied art under Bidlake's former pupils Samuel Prout and B.R.Haydon. Entered RA Schools under Fuseli. Studied in Paris. Returned to Plymouth as a portrait painter. Painted a portrait of Napoleon, who was brought into port on the *Bellerophon*. The success of this picture provided funding to visit Rome and Greece 1816-30. During part of this time he was accompanied by Brockedon and Charles Barry. Exhibited at RA (51), BI (18) 1813-55. Elected ARA 1827, RA 1830, RA Librarian 1842-4, Secretary to Royal Commission for the Decoration of the Houses of Parliament, PRA from 1850, Director of NG London 1855-65. His official duties forced him to give up painting. Dubbed 'Archbishop Eastlake' he ranked sixth in Thackeray's Order of Merit (*Fraser's Magazine* 1838). Died Pisa 24 December

FRANK SAMUEL EASTMAN. Peter with his monkey. Signed and dated 1921. 54 x 31ins (137.1 x 78.7cm)
Christopher Wood Gallery, London

1865. Studio sale held Christie's 14 December 1868.
Represented: BM; VAM; Tate; Manchester CAG; Exeter Museum; Newport AG. **Engraved by** W.H.Mote, C.Turner, Mrs D.Turner. **Literature:** Lady Eastlake, *A Memoir of Sir C.L.E.*, 1869; C. Monkhouse, *Pictures by Sir C.L.E.*, 1875; D. Robertson, *Sir C.L.E. and the Victorian Art World*, 1978; VAM manuscripts.

EASTMAN, Frank Samuel 1878-1964
Born London 27 April 1878. Studied at Croydon School of Art and RA Schools. Exhibited at RA (35) 1902-49 from Sydenham, London and Leamington Spa. Died 12 October 1964. His wife Maud and daughter Edith were also artists.

EASTON, Reginald 1807-1893
Began as an engraver. Took up painting miniatures and portraits in watercolour. Became fashionable and was patronized by the royal family. Worked in London and Leamington 1845-62.
Represented: NPG London; HMQ.

EAVANS, John b.c.1816
Born Ireland. Listed as a portrait painter aged 45 in 1861 census for East Street, Southampton.

ECCARD(T), John Giles d.1779
Born Germany. Became an assistant of J.B.Van Loo, with whom he may have come to London 1737. Remained his assistant until Van Loo left England 1742. Then set up on his own with some success painting portraits in the Van Loo manner, but often on a small scale (15 x 12in.). Painted a series of 26 portraits for Horace Walpole 1746-54. Exhibited at SA (2) 1761 and 1768. Sold his studio and retired to Chelsea 1770. Will proved 20 Oct 1779. Left his son, Jacob, £2000 and his daughter the leasehold house.
Represented: NPG London. **Engraved by** J.Faber jun, J.Heath, J.McArdell, G.Vertue.

ECKSTEIN, John c.1770-c.1804
Born Strelitz, probably son of sculptor Johann Eckstein. Studied in London. Exhibited portraits, genre and works in coloured wax at RA (17) 1770-1802. Moved to Birmingham c.1792.
Represented: NPG London; VAM; BM. **Engraved by** J.Basire, A.Cardon, H.Cook, R.Laurie, S.W.Reynolds.

EDDIS, Eden Upton 1812-1901
Born London 9 May 1812, son of Eden Eddis (a clerk at Somerset House) and his wife Clementia (née Parker). Studied at Sass's Academy. Entered RA Schools 1828. Exhibited at RA (130), BI (16), RHA (1), SBA (10) 1834-83 from London and Shalford. A close friend of James Holland (with whom he sketched on the Continent) and George Richmond. Established a successful society practice. Among his sitters were Sir Francis Chantrey, the Duke of Bedford, Lord Macaulay, Lord Coleridge. Grew deaf and moved to Shalford, near Guildford, where he died 7 April 1901.
Represented: NPG London; NGI; Brighton AG; Lincoln's Inn; Middle Temple; Grimsthorpe Castle. **Engraved by** H.Adlard, J.Brown, J.Cook, S.Cousins, W.Drummond, M.Every & P.Gauci, W.Greatbach, F.Holl, F.Joubert, R.J.Lane, J.Posselwhite, W.Raddon, W.Read, J.S.Templeton, Miss Turner, C.Turner, J.A.Vintner, W.Walker, G.Zobel.
Literature: DNB.

EDDISON, Sam fl.1891-1892
Exhibited at RA (2) 1891-2 from 49 Cemetery Road, Leeds.

EDGAR, James P. 1819-1876
Exhibited at BI (1), SBA (1) 1864 from Liverpool.
Represented: SNPG. **Engraved by** E.Burton.

EDIS, Miss Mary (Lady T.P.Bennett) d.1976
Exhibited at RA (4) 1910-41 from London.
Represented: NPG London.

EDMONSTON, Samuel b.1825
Studied at RSA Schools under Sir W. Allan and Thomas Duncan. Exhibited at RSA (106), RA (2) 1845-87 from Edinburgh.
Represented: SNG. **Literature:** McEwan.

EDMONSTONE, Robert HRSA 1794-1834
Born Kelso. Apprenticed to a watchmaker. Worked in Edinburgh, where his drawings attracted much attention, including the patronage of Baron Hume. Settled in London 1819. Exhibited at RA (23), RSA (8) 1818-34. After attending Harlow's studio he visited Italy; a second visit

HENRY EDRIDGE. A gentleman. Pencil. Signed with initials. 9⅞ x 7½ins (25 x 19cm) *Private collection*

HENRY EDRIDGE. Mrs Crutchley, daughter of Lady Burrell. Signed and dated 1800. Pencil and grey and blue wash. 12 x 9ins (30.5 x 22.9cm) *Christie's*

1831-2. A severe attack of fever in Rome 1832 permanently injured his health and he returned to London, but found himself so weak he went back to Kelso, where he died 21 September 1834. His portraits were popular and he gained a reputation for his portrayal of children.
Literature: DNB; McEwan.

EDMUNDS, Keith Mckay fl.1910-1922
Exhibited at RA (5), ROI 1910-22 from London.

EDMUNDS, Miss Nellie M. Hepburn VPRMS
 d.1953
Daughter of Henry Chase Edmunds. Studied at Slade under Brown and at Westminster School of Art under M.Loudan. Exhibited mostly miniatures at RA (102), RI, RMS and widely abroad 1896-1952 from London and Bexhill. Elected VPRMS 1911. Died 14 February 1953.
Represented: VAM.

EDRIDGE, Henry ARA 1768-1821
Born Paddington 12 October 1768 (baptized St James's, Paddington 30 October 1768), son of Henry Edridge, a tradesman in St James's and his wife Sarah. Apprenticed under William Pether. Entered RA Schools 7 January 1784 'age 15 12 Oct. last', where he won the approval of Reynolds. Won Silver Medal 1786. Friends of Girtin and Hearne (with whom he made a number of sketching trips) and with Dr Monro, Sir George Beaumont and J.Farington. Exhibited portraits and miniatures at RA (202) 1786-1821. Elected ARA 1820. Had a highly successful society practice. Among his sitters were William Pether, Admiral Sir Richard King, Duchess of Hamilton, T.Hearne, T.Stothard, James Heath, W.Woollett, R.Corbould, B.Pouncy,

E.F.Burney, F.Bartolozzi, J.Nollekens, the Marquess of Lansdowne, William Pitt, Benjamin West, William Wordsworth and many members of the royal family. Visited France 1817 and 1819. Died London 23 April 1821. Buried Bushey churchyard. Produced a number of small full or three-quarter length drawings, with the sitter often formally posed against a landscape background. They are generally done with black lead pencil heightened by watercolour applied to the face and hands.
Represented: NPG London; BM; VAM; Leeds CAG; NMM; Manchester CAG; Liverpool Museum; SNG; Birmingham CAG; Ulster Museum. **Engraved by** G.Bartolozzi, E.Bocquet, A.Cardon, P.Condé, R.Cooper, T.Dickinson, W.Evans, S.Freeman, W.T.Fry, M.Gauci, Harding, J.Heath, P.Mansfield, T.Medland, H.Meyer, C.Picart, S.W.Reynolds, W.Ridley, Ridley & Blood, W.Say, L.Schiavonetti, E.Scriven, J.Stow, H.D.Thielcke, C.Turner, J.Vendramini, C.Wilkin, W.H.Worthington. **Literature:** S.Houfe, 'H.E.: A Neo-Classical Portraitist', *Antique Collector* August 1972, pp.211-16; DA.

EDRINGTON, Miss Amy fl.1898-1901
Exhibited at RA (2) 1898-1901 from 18 Dancer Road, Fulham.

EDWARDS, Miss Annie fl.1906-1920
Exhibited at RA (14) 1906-20 from Paris and Leamington.

EDWARDS, Miss E.E. fl.1868
Exhibited at RA (1) 1868 from London.

EDWARDS, Edward ARA 1738-1806
Born London 7 March 1738, son of a cabinet maker. He was physically weak as a child with distorted limbs, and remained

very small all his life. Began his career by providing designs for furniture makers, and studied painting at Duke of Richmond's Academy 1751. Shortly afterwards he opened his own evening drawing school, while still himself studying at St Martin's Lane Academy. Employed by Boydell to make drawings for engravers 1763, and the following year gained a premium from SA for the best historical picture in chiaroscuro. Entered RA Schools 30 January 1769. Exhibited at FS (1), SA (7), RA (104), BI (1) 1766-1806. Elected ARA 1773. Visited France and Italy 1775/6. Teacher of Perspective at RA 1788. Also practised decorative painting (being employed by Lord Bessborough to repair a ceiling by Thornhill) and scene painting. Produced a number of drawings for Horace Walpole. Best remembered for his *Anecdotes of Painters* which appeared posthumously 1808 and contains a short biography. Died London 10 December 1806. Generally signed with initials.
Represented: BM; VAM; Yale. **Engraved by** A.Cardon, J.Collyer, J.Goldar, J.Hall, B.Reading. **Literature:** DA.

EDWARDS, George fl.1843-1847
Exhibited at RHA (4) 1843-7 from Dublin.

EDWARDS, J.C. fl.1821
Exhibited at RA (1) 1821 from London.

EDWARDS, Miss Jennie M. fl.1912-1927
Exhibited at RA (8) 1912-27 from Wolverhampton and Brighton.

EDWARDS, John Kelt fl.1900-1910
Born Blaenau Ffestiniog. Studied art in Rome, Florence and in Paris under Bonnat. Painted Lloyd George as Chancellor of the Exchequer and a large number of Welsh sitters.

EDWARDS, Mabel (Mrs Rahbula) fl.1909-1956
Exhibited at RA (43) 1909-56 from London, Pinner, Ewell, Harrow-on-the-Hill and Cambridge.

EDWARDS, Samuel fl.1768-1771
Exhibited at SA (4) 1768-71 from Doctors' Commons.

EEDES, R. fl.1852
Exhibited at RA (1) 1852 from Warwick.

EGER, Adolph fl.1845
Listed as a miniature and portrait painter at 4 East Street, Brighton.

EGERTON, Hon Alice Mary c.1830-1868
Daughter of 1st Lord Egerton of Tatton. Exhibited at RA (1) 1859. Painted civil war subjects. Married R.Cholmondeley of Condover Hall, Shropshire 1867. Died the following year in childbirth.

EGERTON, John C. fl.1899
Exhibited at RA (1) 1899 from Bath.

EGLEY, William 1798-1870
Born Doncaster. Painted mainly miniatures, but sometimes on a larger scale. Worked in Doncaster, Nottingham and London and had an extremely successful practice. Exhibited at RA (169) 1824-69. His son, William Maw Egley, was also an artist.
Represented: NPG London. **Engraved by** J.Cochran, H.Cook, W.H.Mote. **Literature:** *Art Journal* July 1870.

EGLINTON, James T. fl.1847-1859
Exhibited at RA (2), SBA (2), BI (3) 1847-59 from Liverpool. Listed there as a portrait and animal painter.

EGLINTON (EGLINGTON), Samuel d.1860
Described as a portrait painter 'aged 64' in 1851 census at Aston, Warwickshire. Probably the Sam Eglinton who entered RA Schools 1809 'aged 24'. Worked in London, where his son was born. In Liverpool c.1818 and Islington 1821. Exhibited at LA, RA (2), BI (3) 1829-55. Elected ALA 1830, LA 1832, Secretary and Acting Treasurer 1834-41, Treasurer 1841-2, President 1842-5. Died Liverpool 20 April 1860 'aged 70'.
Represented: Walker AG, Liverpool.

EHRENSTRAHL, David Klocker c.1628-1698
Born Hamburg 27 April 1628 (DA) or 23 September 1629 (Waterhouse, Bénézit). Court painter in Stockholm from 1661. Waterhouse describes him as 'the dominant figure in Swedish painting'. Michael Dahl was his pupil. According to Vertue he visited England November 1660.
Literature: DA.

EKDAH, Edmund G. fl.1913-1921
Exhibited at RA (3) 1913-21 from London.

ELAND, John Shenton PS 1872-1933
Born Market Harborough 4 March 1872. Studied at RA Schools from 1893 and in Paris. Exhibited at RA (8), PS 1896-1911 from Stockwell and London. Painted many portraits in Britain and America. Among his sitters were Cardinal Gibbons, the Duke of Hamilton and Princess Victoria of Schleswig-Holstein. Died New York 7 January 1933.

ELEY, Miss Mary fl.1874-1897
Exhibited at RA (15), SBA (11) 1874-97 from London.

ELIZABETH, Princess 1770-1840
Born Buckingham House May 1770, daughter of George III. Married the Prince of Hesse-Homburg 1818. Died Frankfurt 10 January 1840.
Represented: HMQ.

ELLERBY, Thomas fl.1821-1857
Exhibited at RA (72), BI (31), SBA (5) 1821-57 from London. Among his sitters were John Gibson (painted in Rome), the Duke of Devonshire, and Thomas Creswick.
Engraved by S.Cousins, C.Turner, W.Ward.

ELLESON, G. fl.1857
Exhibited a portrait of an officer at RA (1) 1857.

ELLIOT, George fl.1856
Eccentric painter who spent many years in Bensham Asylum, Gateshead. Painted a number of regal portraits of himself as Emperor of the World. One was inscribed 'Dedicated to the World . . . George Elliot, Emperor of the World and True Live God, George the Fifth of Great Britain'.
Represented: Gateshead Central Library.

ELLIOTT, Charles Loring 1812-1868
Born Scipio, New York. Studied under Trumbull. Exhibited at RA (2) 1852 from 37 Milk Street, London. Reportedly painted more than 700 portraits of distinguished people. Died Albany.
Literature: DA.

ELLIOTT, Francis c.1667-after 1692
Employed by 2nd Duke of Newcastle 1690-1. Painted a variety of subjects including portraits.

ELLIOTT, Frank b.1858
Born London 2 February 1858, son of James Elliott, Civil Engineer. Educated at Victoria College, Jersey and Merchant Taylor's School. Studied at RCA and RA Schools. Exhibited at RA, Dudley Gallery.

ELLIOTT, John **b.1858**
Born 22 April 1858. Studied at BM, Académie Julian, Paris under Carolus-Duran and in Rome under J.Villegas. Painted portraits and worked as an architect. Visited Egypt, Greece and settled in America.
Represented: Metropolitan Museum of Art, New York.
Literature: Bénézit.

ELLIOTT, Miss Rebecca **fl.1840**
Listed as a portrait painter at 344 Strand, London.

ELLIOTT, Robinson **1814-1894**
Born South Shields, son of a prosperous hatter. Studied at Sass's Academy with fellow pupil Millais and on his return to the north-east he set up the first art school in South Shields. Exhibited at RA (11), BI (4), SBA (13), NWS, Carlisle Athenaeum and in Newcastle 1833-81. He was particularly good at portraying children. Also wrote poetry. Died South Shields.
Represented: South Shields Museum & AG; Sunderland AG.
Literature: Hall 1982.

ELLIS, Arthur **1856-1918**
Born Holloway 1 September 1856. After beginning in business, he studied at RA Schools 1882 and in Paris 1886. Exhibited at RA (23), RI, SBA (9+) 1874-1918 from London. Died 4 April 1918.

ELLIS, C. Wynn **d.1915**
Exhibited at RA (13), NWS 1882-1914 from London and Bishop's Stortford. Died January 1915.

ELLIS, Mrs Edith Kate Kingdon- **fl.1897-1925**
Exhibited at RA (5) 1897-1925 from Peterborough, Durham and Bedford. Among her sitters was the Dean of Peterborough.

ELLISON, Miss Edith **1863-1954**
Exhibited at RA (5), GG (2) 1884-8 from London and Windsor.
Represented: NPG London.

ELLYS, John (Jack) **1700/1-1757**
Born March 1700/1. Studied under Thornhill c.1716, Johann Rudolph Schmutz and with his friend Hogarth at Vanderbank Academy, St Martin's Lane c.1720. Eventually succeeded to Vanderbank's house and practice and with Hogarth succeeded to the directorship of the St Martin's Lane Academy, and maintained his connection with it for 30 years. Succeeded Mercier as 'Principal Painter to the Prince of Wales' October 1736. Advised Walpole on art and bought pictures for him. Walpole rewarded him with the Keepership of the Lions in the Tower. A member of the committee of artists, appointed 1755 to form a plan for constructing a royal academy but died London 14 September 1757, before he could see the result of his efforts. His style was strongly influenced by Kneller and he resented the departure from it inaugurated by Reynolds. Often signed 'Jack Ellys'.
Represented: Knole NT; Port Eliot. **Engraved by** J.Faber jnr, R.Grave, J.Sympson, J.Tinney, G.Vertue, G.White, R.Woodman. **Literature:** DNB.

ELMER, William **1762-c.1799**
Born 6 January 1762, son and follower of the still-life painter, Stephen Elmer. Entered RA Schools 1782. Exhibited at SA (19), RA (6) 1778-99. Concentrated on still-life, but also painted portraits. Worked in Ireland 1788-c.1796, but had returned to Farnham by 1797.

ELOUIS, Jean-Pierre-Henri **1755-1840**
Born Caën 20 January 1755. Studied under Restout, and moved to London, entering RA Schools 29 October 1784 aged '29, 20th Jany last' (Silver Medallist 1786). Exhibited portraits and miniatures at RA (8) 1785-7 from London. Moved to America c.1787, where he worked mainly in Baltimore and Philadelphia and painted miniatures of George and Martha Washington. Travelled with Humboldt c.1799-1804 to Mexico and South America and returned to France 1807, exhibiting at Paris Salon 1810-19. Became curator of Caën Museum from 1814. Died Caën 23 December 1840.

ELSTON, William **b.1895**
Born Southsea 20 May 1895, son of Joseph William Elston. Educated Holy Trinity Church School, Brompton. Studied at St Martin's School of Art. Exhibited at Whitechapel AG, RA and Memorial Hall, Bradford.

ELVERY, Miss Dorothy M. **fl.1904-1906**
Exhibited at RHA (3) 1904-6 from Dublin.

ELVERY, J. **fl.1762**
Exhibited at FS (3) 1762. No address given.

ELWELL, Frederick William **RA ROI RP** **1870-1958**
Born Beverley, Yorkshire 29 June 1870. Studied at Lincoln School of Art, Academy Schools, Antwerp and Académie Julian, Paris. Exhibited at RA (190), RHA (1), ROI, RP, Paris Salon 1895-1958. Elected RP 1931, ARA 1931, RA 1938. Lived most of his life in Beverley, Yorkshire, where he died 3 January 1958.
Represented: Tate.

ELWES, Colonel Simon **RA RP** **1902-1975**
Born Theddingworth, near Rugby 29 June 1902. Studied at Slade 1918-21 under Tonks and until 1926 in Paris. Exhibited at RA (102+), RP (30) from 1927. Elected RP 1933, ARA 1956, RA 1967. Served with 10th Hussars. Official war artist during 2nd World War on the Indian and South-East Asian Commands. Worked in London and New York. Died August 1975.
Represented: Imperial War Museum.

EMERSON, William **fl.1817-1843**
Exhibited at RA (28), BI (3) 1817-43 from London.

EMERY, John **fl.1835-1841**
Listed as a portrait painter in High Street, Shelton, Staffordshire. Also worked in Newcastle-under-Lyme. May be related to artist John Emery 1777-1822.
Engraved by S.W.Reynolds jnr.

EMMERSON, Henry Hetherington **1831-1895**
Born Chester-le-Street, County Durham. Studied at Government School of Design, Newcastle under William Bell Scott. Visited Paris for six months copying in the Louvre and then entered RA Schools. Exhibited at RA (54) and in Newcastle 1851-93. Elected first President of Bewick Club. Settled at Cullercoats 1865, where he died. Had a special gift for portraying children and also illustrated children's books.
Represented: York AG; Shipley AG, Gateshead; Laing AG, Newcastle. **Literature:** Hall 1982.

EMMERSON, Percy **fl.1884-1905**
Son of Henry Hetherington Emmerson. Exhibited at Bewick Club, Newcastle from 1884 until the outbreak of the Boer War, when he enlisted in the army and went to South Africa. It is believed he remained there after the war and became a member of the military police, painting portraits in his spare time, including Cecil Rhodes.
Literature: Hall 1982.

LYDIA FIELD EMMET. A boy. Signed. 62 x 42ins (157.5 x 106.7cm) *Christie's*

EMMET, Lydia Field **1866-1952**
Born New Rochelle, New York 23 January 1866, daughter of William Jenkins and Julia Colt (née Pierson) Emmet. Studied under Bourguereau and Fleury in Paris, and William Chase, Frederick Mac Monnies, H.Siddons Mowbray, Kenyon Cox and Robert Reid. Exhibited in America and won a number of prizes and medals. Elected ANA 1909, NA 1911. Died 16 August 1952. Her work could be highly accomplished.

EMSLIE, Alfred Edward ARWS RP **1848-1917**
Son of engraver John Emslie, and younger brother of John Phillipps Emslie. Studied at RA Schools and École des Beaux Arts, Paris. Exhibited at RA (59), SBA, RWS, GG, RP, Paris Salon from 1867 from London and Kent. Elected RP 1892. Produced drawings for *The Illustrated London News*. Also worked in Japan and New York. His wife, Rosalie, was a miniature painter. Towards the end of his life he turned increasingly to portrait painting.
Represented: NPG London.

ENCKE, Fedor **1851-1929**
Born Berlin 13 November 1851. Studied from 1869 at Berlin Academy, Weimar and in Paris 1879-83. Based in Berlin, but also worked in London and America. Among his sitters were T.Roosevelt and J.P.Morgan.
Represented: Brooklyn Museum.

ENDER, Eduard **1822-1883**
Born Rome 3 March 1822, son of Johann Ender. Studied at the Academy of Beaux-Arts, Vienna. Worked in Paris and London. Died London 28 December 1883.
Represented: Vienna Museum.

ENDERBY, Samuel G. **fl.1886-1908**
Exhibited at RA (14) 1886-1908 from London.

ENGELBACH, Mrs Florence A. (née Neumegen) ROI
1872-1951
Born Jerez de la Frontera, Spain 9 June 1872, of English parents. Studied at Westminster School of Art, Slade under Brown and in Paris. Exhibited at RA (6), RSA, ROI, SBA, Paris Salon, Laing AG from 1892. Awarded the Bronze Medal at Women's International Exhibition, London. Elected ROI and a member of National Society of Painters, Sculptors and Engravers. Following her marriage in 1902 she settled in Newcastle. After the 1st World War she moved to London, where she died 27 February 1951.
Literature: Hall 1982.

ENGLEFIELD, Arthur **b.1855**
Exhibited at RA (9) 1892-1904 from St Albans and Gloucester.

EPINETTE, Mlle **fl.1881**
Exhibited at RA (1) 1881 from 6 St James's Terrace, London. Probably Marie Epinette, who was born Rouen and exhibited at Paris Salon from 1875.

ERCOLE (ERCOLI), Alcide Carlo **fl.1857-1866**
Exhibited at RA (11) 1857-66 from London. Among his sitters was the Marchioness of Northampton.

ERICHSON, Miss Nelly **fl.1883-1897**
Exhibited at RA (16), SBA (3) 1883-97 from London.

ERRINGTON, Isabella Cecilia **1806-1890**
Born Tynemouth. Worked in South Shields. Exhibited in Newcastle, SBA, Carlisle Athenaeum from 1835. Became well known in South Shields for her portrait work. Died a spinster in North Shields aged 84.

ERWOOD, Miss Ada **fl.1903-1904**
Exhibited at RA (2) 1903-4 from London.

ESSEX, William B. **c.1823-1852**
Son of William Essex, 'Enamel Painter in Ordinary to Her Majesty and HRH Prince Albert'. Exhibited portraits and enamels at RA (10), BI (1), SBA (3) 1845-51 from London. Died Birmingham 19 January 1852.

ETTY, William RA **1787-1849**
Born York 10 March 1787, son of a baker and mill owner. After a strict Methodist schooling he worked as a printer's apprentice to Robert Pech in Hull 1798-1805, then moved to London. Entered RA Schools 1807 and studied under Lawrence 1808. Exhibited at RA (138), RSA (17), BI (77) 1811-50. Elected ARA 1824, RA 1828. His price for painting a full-length portrait in 1836 was £60. Devoted himself to painting the nude, which frequently shocked some Victorians. Retired back to York 1848, where he died 13 November 1849. Buried in the churchyard of St Olave's. Christie's sold his remaining sketches and studio drawings May 1850 for over £5000. Henry Baines was his pupil.
Represented: York CAG; BM; VAM; Tate; Southampton CAG; NGI; Birmingham CAG; Brighton AG; Leicester CAG; Leeds CAG; Manchester CAG; Cartwright Hall, Manchester. **Engraved by** S.Cousins, J.Thomson, C.W.Wass. **Literature:** VAM Manuscripts; A.Gilchrist, *Life of W.E.*, 2 vols 1844; W.C.Monkhouse, *Pictures by W.E.*, 1874; W.Gaunt, *E. and the Nude*, 1943; D.Farr, *W.E.*, 1958; B.J.Bailey, *W.E.'s Nudes*, 1974; *Art Journal* 1849; DNB; DA.

WILLIAM ETTY. Preparing for a fancy-dress ball – a portrait of Charlotte and Mary, daughters of Charles Williams Wynn of Llangedwyn. Painted in 1833. 60 x 51½ins (152.4 x 130.8cm) *Christie's*

EVANS, G.H. **fl.1840**
Exhibited at SBA (1) 1840 from London.

EVANS, George **fl.1764-1770**
Member of St Martin's Lane Academy. Exhibited at SA 1764. A house painter, who painted a number of portraits.

EVANS, George **fl.1842-1848**
Exhibited at RA (1) 1842 from 15 St Martin's Street, London. Listed as a portrait painter at Hulme, Manchester 1848. **Engraved by** C.Turner.

EVANS, Powys **b.1899**
Born London 2 February 1899, brother of artist Gwen Evans. Studied at Slade and under Sickert and Gosse. Exhibited at NEAC from London. Among his sitters were Sir Jacob Epstein, Walter Greaves, Henry Lamb and J.B.Priestley. Capable of penetrating portraits of considerable character. **Represented:** NPG London.

EVANS, Richard **1784-1871**
Born Birmingham or Hereford (conflicting sources). Entered RA Schools 1815. Began as a copyist of his friend Cox and then as a copyist of old masters in Rome. An assistant of T.Lawrence. Exhibited at RA (42), BI (6) 1816-56 from London. Among his sitters were the King of Haiti, the Turkish Ambassador, George Bradshaw. His portrait of Harriet Martineau (NPG London) received such 'brutal comment' by the notorious *Morning Chronicle* critic (Constable's enemy) that the critic was dismissed. His latter years were spent in Southampton, where he died November 1871 aged 87. **Represented:** NPG London; BM; VAM; Southampton CAG; NMM. **Engraved by** W.T.Fry, W.Holl, S.W.Reynolds, H.Robinson, W.Say. **Literature:** *Art Journal* March 1872.

EVANS, Wilfred Muir **fl.1888-1908**
Studied at Herkomer's School in Bushey, Hertfordshire. Exhibited at RA (7), NWG (1) 1888-1908 from Southwold and London.

EVANS, William **fl.1797-1809**
Exhibited at RA (19), BI (1) 1797-1808 from London.
(Waterhouse says he is probably not the same William Evans
who entered RA Schools as an engraver 1790, aged 18, and
who lapsed into neurasthenia soon after 1809.) Worked for
the Society of the Dilettanti, Boydell and others and took
pencil and wash portraits.
Represented: NPG London. **Engraved by** Chapon,
C.Picart.

EVATT, Miss **fl.1830**
Exhibited at RA (1) 1830 from East Hill, Wandsworth.

EVELYN, Miss Edith M. **fl.1886-1889**
Exhibited at RA (5) 1886-9 from London.

EVERETT, Miss Ethel F. **fl.1911-1936**
Born London, daughter of James Everett. Educated Mary
Datchelor School. Studied at RA Schools. Exhibited at RA
(8) 1911-36 from London, and illustrated children's books.

EVERITT, Walter **fl.1905-1911**
Exhibited portraits and miniatures at RA (15) 1905-11 from
Portman Square, London. Painted a number of distinguished
sitters.

EVERSON, Richard **fl.c.1805-1885**
Worked as a portrait painter in Kendal.
Represented: Kendal Town Hall.

EVES, Reginald Granville RA RP **1876-1941**
Born London 24 May 1876, son of William Henry Eves JP and
Anne (née Grenville). Educated at University College School.
Studied at Slade from 1891 under Legros, Brown and Tonks.
Encouraged by J.S.Sargent. Exhibited at RA (115), RP (128),
ROI, Paris Salon 1901-42 from London. Won a Silver Medal
1924 and Gold Medal 1926 at Paris Salon. Elected RP 1913,
ARA 1933, RA 1939. Established a highly successful London
portrait practice. Among his sitters were Thomas Hardy, Sir
Max Beerbohm, George VI and Queen Elizabeth. Died
Middleton-in-Teesdale 13 or 14 June 1941. Simon writes that
he 'is one of the most appealing British portraitists of his time'.
Represented: NPG London; SNPG; Tate; Arts Club,
London; London Museum; Leeds CAG; Brighton AG;
Middle Temple; Bowes Museum, Co. Durham. **Literature:**
The Times 16 June 1941; A.Bury, *The Art of R.G.E.*, 1940;
DNB.

EVOMS (EVANS), John **fl.1625**
Apprenticed to Cornelius Johnson in January 1625.

EWALD, Clara (née Philippson) **1859-1948**
Born Düsseldorf 22 October 1859. Studied under
Bouguereau. Exhibited in Berlin. Her portrait of Rupert
Brooke is in NPG London.

EWART, W. **fl.1846-1863**
Exhibited at RA (4), BI (5) 1846-63 from London.

EWORTH, Hans **fl.1540-1573**
Thought to have trained in Antwerp. Received as Master in
Antwerp Guild 1540 (as Jan Eeuwowts). Moved to England
c.1545 and was made a denizen (as John Euwouts) October
1550. His dated pictures range from 1549-70, and it is
generally accepted that he is the artist who signs his work
'H.E.'. His early portraits are in the style of Frans Floris, but
gradually as he became involved in Court patronage, his work

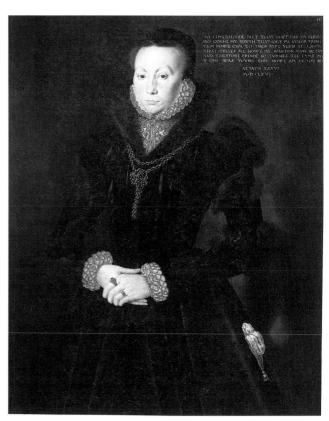

HANS EWORTH. Mrs Wakeman. Signed and dated 1566. 36 x
28ins (91.5 x 71.1cm) *Christopher Wood Gallery, London*

was influenced by Holbein and usually has a high enamel finish.
His later works anticipate the Elizabethan 'costume piece'.
Represented: Yale; SNPG; Tate; NPG London. **Engraved
by** W.H.Kearney. **Literature:** R.Strong, *H.E.*, Leicester AG
and NPG London exh. cat. 1965; DA.

EXSHAW, Charles **d.1771**
Born Dublin. Studied in France, Flanders and Italy from
1747-55, when he returned to Dublin and put up for sale a
large collection of old masters. Studied in Paris under Carle
Van Loo 1757. Made etchings after Rembrandt in
Amsterdam 1760. Painted history, landscape and portraits
and tried to start a drawing academy in London. Exhibited at
SA (2). Died London.
Represented: NGI. **Literature:** H.Potterton, *Connoisseur*,
CLXXXVII December 1974 pp.269-73.

EYCKE, John **fl.1624-after 1640**
Made a freeman of the Paynter-Stainers 1640. Followed in
the manner of Mytens.
Literature: J.W.Goodison, *Burlington Magazine*, LXXIII
September 1938 p.125.

EYDEN, Jeremias van der **fl.1658-1695**
A native of Brussels. Studied under Hanneman at The Hague
1658. Became assistant and drapery painter under Lely.
Appears in the 1675 and 1676 accounts of the Duke of
Rutland, and is responsible for the made up portraits of the
first eight Earls of Rutland at Belvoir Castle. Buried
Stapleford, Leicestershire 17 September 1695.

FABECK, La Baronne de fl.1834-1835
Exhibited portraits, including 'The Marquess of Stafford and the Lady Elizabeth Leveson Gower', at RA (2) 1834-5 from Regent's Park.

FAED, John RSA 1819-1902
Born Kirkcudbright, son of James Faed (a farmer, miller and engineer) and Mary (née McGeoch). Aged 11 began his career as a miniature painter in Galloway, but settled in Edinburgh c.1841. Exhibited at RA (40), SBA (3), RHA (1), RSA (234) 1841-95. Elected ARSA 1847, RSA 1851. Joined his brother, Thomas, in London 1862-80 and then retired back to Kirkcudbright, where he died 22 October 1902.
Represented: SNPG; Glasgow AG; Cartwright Hall, Bradford; Royal Shakespeare Theatre, Stratford. **Engraved by** E. Burton, James Faed (brother). **Literature:** M.McKerrow, *The Faeds – A Biography*, 1982; DA.

FAED, Thomas RA HRSA 1826-1900
Born 8 June 1826 Burley Mill, Kircudbright. Studied with his brother John in Edinburgh, and then under Sir William Allan and Thomas Duncan. Settled in London 1852. Exhibited at RA (98), RSA (73), SBA (1) 1844-93. Elected ARSA 1849, ARA 1861, HRSA 1862, RA 1864. Occasionally collaborated with J.F.Herring. Died St Johns Wood, London 17 August 1900. Studio sale held Christie's 16 February 1901.
Represented: VAM; BM; Tate; SNPG; Dundee AG; Glasgow AG; Brighton AG; Exeter Museum; Paisley AG; Haworth AG, Accrington. **Literature:** M.McKerrow, *The Faeds – A Biography*, 1982; DA.

FAGAN, Louis Alexander 1845-1903
Born Naples 7 February 1845. Worked in BM print room where he became Assistant Director of Prints. A diplomat, art critic and amateur painter. Exhibited at RA (4) 1877-87. Drew portraits, including those of Richard Cobden and Sir Charles Napier. Died Florence 5 or 8 January 1903.

FAGAN (FAGEN), Robert d.1816
Probably born Cork 5 March 1761 (although accounts give various dates), son of Michael Fagan. Entered RA Schools 21 June 1781 aged '20 years last 5th March'. Left England via Paris 1783 for Rome, where he settled. Visited Naples 1792/3, and was turned out of Rome by the French 1797, but returned 1800. Married a 15 year old Italian girl, Anna Maria Ferri 12 April 1790. In Italy he adopted a neo-classical portrait style, as well as painting histories. Carried out excavations and was described as the most successful excavator of the period there. Also dealt in old masters. Exhibited at RA (4) 1793-1816. Appointed Her Majesty's Consul General for Sicily and Malta 1809, residing in Palermo. Married a second time, again to an Italian. Committed suicide Rome 26 August 1816.
Represented: NGI. **Engraved by** C.H.Jeens, C.Turner. **Literature:** R.Trevelyan, *Apollo* XCVI October 1972, p.298; DNB; *Irish Portraits 1660-1860*, NGI exh. cat. 1969; DA. Colour Plate 21

FAGNANI, Giuseppe 1819-1873
Born Naples. Worked there 1840, Paris 1842-4, Spain 1846, Washington DC by 1849, New York 1852-7 then Europe, including England 1860-c.1865, finally settling in New York c.1865.
Represented: NPG London. **Literature:** E.E.Fagnani, *The Art and Life of a 19th Century Portrait Painter, Joseph Fagnani*, 1930.

FAHEY, Edward Henry RI 1844-1907
Born Brompton, son of artist James Fahey. Studied architecture at South Kensington and at RA Schools. Travelled to Italy 1866-9 and on his return re-entered RA Schools to study painting. Exhibited at NWS (127), RA (43), RHA (3), SBA (7) 1863-1904 from London. Elected ARI 1870, RI 1876. Died 13 March 1907.
Represented: VAM.

FAHEY, James RI NWS 1804-1885
Born Paddington 16 April 1804. Trained as an engraver under his uncle, John Swaine. Aged 19 studied painting in Munich under G.Scharf. Then in Paris 1825. Exhibited portraits and then mostly landscapes at NWS (485), RA (16), RHA (5), BI (3), SBA (5) 1825-62. Elected a founder NWS, Secretary NWS 1838-74. Drawing master at Merchant Taylors' School 1856. Died London 11 December 1885.
Represented: BM.

FAIJA, Guglielmo Francesco Ferdinando 1803-1873
Born Palermo, Sicily 21 March 1803. Studied under Comte at Naples and F.Millet in Paris. Exhibited in Paris, RA (17), SBA (1) 1831-48. Settled in London, marrying a local girl called Charlotte. Died London 2 April 1873.
Represented: HMQ (Windsor Castle).

FAIRBONE, John 1770-1798
Entered RA Schools 1790 aged 20. Exhibited at RA (18) 1794-8 from 20 New Street, Fetter Lane, London.

FAIRFAX, A. fl.1881
Exhibited at GG (1) 1881 from Manchester.

FAIRHAM, John fl.c.1740
Practised in London during the first half of 18th century. Many of his portraits were engraved.

FAIRHURST, Enoch RMS 1874-1945
Born Bolton 1 May 1874, son of William Fairhurst, a newspaper editor. Exhibited portraits and miniatures at RA (17), RSA, RWA, RMS 1918-43. Lived in Bolton. Elected RMS 1943. Died 31 October 1945.

FAIRLAND, Thomas 1804-1852
Studied at RA Schools under Fuseli, gaining a Silver Medal. Studied line engraving under Charles Warren, and was then attracted to lithography. After the decline in lithography due to foreign competition he devoted himself to portrait painting, and 'enjoyed the patronage of many eminent and illustrious personages, including royalty'. Died of consumption October 1852 in his forty-ninth year.
Literature: DNB.

FAITHORNE, William c.1616-1691
Born London. Studied under William Peake, John Payne and Sir Robert Peake. Joined the Royalist Army as 'painter to Prince Rupert', but was captured 1645 and banished to France, where he is thought to have studied with R.Nanteuil and P. de Champagne. Returned to England c.1650 (sharing a house with W.Hollar) and was freeman of the Goldsmiths' Company 1652. Became a leading printseller and engraver, but turned to making portraits in crayons c.1680, inventing a way of producing them on copper. Buried St Anne's Church, Blackfriars 13 May 1691 aged 'near 75' (according to

Buckeridge). Among his pupils were J.Fillian and Thomas Hill.
Represented: NPG London; BM; Ashmolean; Leeds CAG; Bodleian. **Engraved by** F.Bartolozzi, A.de Blois, M.Bovi, G.P.Cipriani, J.Collyer, Diodati, W.C.Edwards, W.Elder, W.M.Gardiner, R.Grave, W.Hibbart, W.Holl, J.S.Muller, J.Richardson, H.Robinson, J.Savage, R.Sawyer, G.F.Schmidt, C.Sharp, J.Simon, J.Sturt, Mrs D.Turner, G. & M. Van der Gucht, G.Vertue, C.E.Wagstaff, R.White, R.Woodman jnr. **Literature:** DNB; C.F.Bell and R.Poole, Walpole Society Vol XIV pp.49-55; Walpole Society Vol XLVII pp.131-2; Buckeridge; DA.

FALCONET, Pierre Etienne FSA **1741-1791**
Born Paris 8 October 1741, son of sculptor Etienne Maurice Falconet. Trained there and visited London 1765, where he is thought to have studied under Reynolds. Entered RA Schools 14 February 1769. At this time (1768/9) he produced portraits of 12 of the leading English artists of the day, drawn in profile in black lead, with a slight tint of colour on the cheeks, many of which were engraved by D.P.Pariset and B.Reading. Quickly absorbed the English style. Exhibited at SA (40), RA (4) 1767-73 from Great Ealing, Middlesex. Elected FSA 1771. Left England 1773 to join his father in St Petersburg and was back in Paris by 1778. Died Paris 25 June 1791.
Represented: SNPG. **Engraved by** J.F.Bause, Dixon, V.Green, Hibert, W.Maddocks, D.P.Pariset, V.M.Picot, B.Reading, G.Smith, J.Watson. **Literature:** DNB.

FALL, George **c.1848-1925**
Studied at York School of Drawing. Taught at Selby. Married an engraver's daughter 1875. Produced portraits and topographical scenes in York and County Durham.
Represented: York AG.

FALLON, W.A. **fl.1839-1840**
Exhibited at RA (2) 1839-40 from London.

FALVEY, Thomas **fl.1832**
Exhibited at RHA (2) 1832 from Cork.

FANNER, Henry George **b.1826**
Baptized St Pancras 5 February 1826, son of Henry Abbery Fanner and his wife, Charlotte. Exhibited at RA (24), SBA (16), RSA (7) 1854-88 from London. Painted a portrait of 'HI and RH the Duchess of Edinburgh'.
Represented: Glasgow AG. **Literature:** McEwan.

FANTIN-LATOUR, Henri **1836-1904**
Born Grenoble 14 January 1836, son of a well-known portrait painter. Mixed with the Impressionists and was admired by the Pre-Raphaelites. An important painter of still-life. Exhibited at Paris Salon, RA (82), SBA (3) 1861-1900 from London and Paris. Died Bure 25 August 1904.
Represented: Fitzwilliam; Birmingham CAG; Tate; Southampton AG; VAM; Louvre. **Literature:** Bénézit; DA.

FARINGTON, George FSA **1752-1788**
Baptized Leigh, Lancashire 10 November 1752, son of Rev William Farington and younger brother and pupil of Joseph Farington. Specialized in history painting and studied under West. Entered RA Schools 1770 (Silver Medallist 1771 and Gold Medallist 1780). Exhibited at SA (4), RA (4) 1771-82. Elected FSA 1771. Travelled to India 1782, where he worked mainly in Calcutta. Died at Moorshedabad, where he was engaged on a large painting of the durbar.

FARRER, Nicholas **1750-1805**
Born Sunderland. Studied under Robert Edge Pine and in the Schools of SA. Befriended by Reynolds and Northcote. His style was influenced by Reynolds. His main patron was the Duke of Richmond for whom he painted a number of portraits.

FARRER, Thomas **fl.1832-1834**
Listed as a portrait painter at 42 Robert Street, Hampstead Road, London.

FARRIER, Robert **1796-1879**
Born Chelsea. Based there all his life. Studied as an engraver, but took to miniature painting before entering RA Schools 15 January 1820. Exhibited at RA (35) 1818-59. Listed in the directories as a portrait painter, but also painted popular genre. Died Chelsea.
Represented: VAM. **Literature:** DNB.

FAULDER (FALDER), Joseph **1730-1816**
Born Cockermouth. Began as a sign painter. Took up engraving and portraiture. Regarded as 'the father of the Cockermouth School of Portrait Painting'. Also taught philosophy, mathematics and art. Among his pupils was Joseph Sutton.
Literature: Hall 1979.

FAULKNER, Benjamin Rawlinson **c.1787-1849**
Born Manchester (baptized 17 January 1787), son of William and Ann Faulkner and brother of miniaturist Joshua Wilson Faulkner. Began work for a large merchant company in Gibraltar, but caught the plague and returned to England c.1813. He unexpectedly recovered and during his convalescence studied art by drawing in chalk from the antique. Took up portraiture in Manchester and then London, with considerable success. Exhibited at RA (64), BI (8) RMI, LA, SBA (27) 1821-59. Died London 29 October 1849. His son, Robert, was also a portrait painter.
Represented: SNPG; NPG London; Royal Society, London. **Engraved by** C.Heath, R.J.Lane, F.C.Lewis, W.H.Mote, S.W.Reynolds snr & jnr, H.Robinson, W.Say, Miss Turner. **Literature:** *Art Journal* 1850 p.94.

FAULKNER, Joshua Wilson LA **fl.1809-1820**
Born Manchester. Exhibited portraits and miniatures at RA (20), LA 1809-20 from Manchester and London. Elected LA.
Represented: BM. **Engraved by** S.Freeman.

FAULKNER, Miss Mary **fl.1838-1842**
Exhibited at RA (5) 1838-42 from London. Probably daughter of Benjamin Rawlinson Faulkner.

FAULKNER, Robert **b.1829**
Baptized Holborn 21 June 1829, son of Benjamin Rawlinson Faulkner and Sarah. Exhibited at RA (1), SBA (6) 1847-62 from London.
Represented: NPG London.

FAWKES, Colonel Lionel Grimston **1849-1931**
JP for Hampshire and an amateur portrait painter. Born 2 May 1849, son of Major Richard Fawkes and Fanny (née Paris). Commissioned in Royal Artillery 1 December 1870, Professor of Royal Military Academy 1895. Retired 1903. Died Culzean, Canada 24 August 1931.
Represented: NPG London.

FAWKES, Miss Madeleine C. **fl.1909-1931**
Born Leighton Buzzard. Studied in Newlyn under Stanhope Forbes, and in Paris. Exhibited at RA (10), NPS 1909-31 from London.

FAWSSETT, Mrs Gertrude Alice (née Sadler) **b.1891**
Born London 5 October 1891, daughter of Thomas Sadler, a

barrister. Educated at Hillcote, Eastbourne. Studied under Miss Thomason. Exhibited at Welsh Academy. Married Dr R.Shirley Fawssett.

FAYRAM, John **d.1744**
Studied at Kneller's Academy 1713. His dated portraits range from 1727 to 1743 and owe a debt to Enoch Seeman. Patronized by 1st Earl of Bristol (dated Hervey portraits 1734-9) and worked in East Anglia and Bath and possibly the Midlands and the north. Also painted and etched landscape views around London. The *Daily Advertiser* 24 December 1744 refers to John Fayram, limner, St James's 'lately deceased'.
Represented: Raby Castle; Marquess of Bristol, Ickworth.

FEARNLEY, Charles Newstead **fl.1841**
Listed as a portrait painter in York.

FEILLET, Mlle Hélène **fl.1836-1854**
Born Bayonne. Exhibited at Paris Salon 1836-48. Exhibited at RA (3) 1853-4 from Bayonne and Camberwell.

FEKE, Robert **c.1707-1752**
Born Oyster Bay, New York. A mariner, who is said to have travelled to England and the Continent. Worked in Boston 1741. Made Newport RI his base 1742, although he is recorded in Boston 1748, and Philadelphia 1746 and 1750. Left Newport on a voyage 1751, and is probably the Robert Feak buried at Barbados 1752. Simon describes him as 'the most important American born painter before Copley'. Used a range of poses and devices taken from British portrait prints.
Represented: Boston MFA; Metropolitan Museum, New York; Peabody Museum, Salem, Massachusetts; Bowdoin College, Maine. **Literature:** H.W.Foote, *R.F. – Colonial Portrait Painter*, Cambridge MA 1930; R.P.Mooz, *The Art of R.F.*, University of Pennsylvania PhD 1970.

FELL, C. **fl.1872**
Exhibited at RA (1) 1872 from Clappersgate, Ambleside.

FELLOWES, James **fl.1719-1751**
Provincial portrait painter working in the style of Enoch Seeman. Active in Cheshire and the north-west. His latest known dated portraits were painted 1751. Usually signed and dated on the back, which of course would be obscured by re-lining.
Represented: Manchester CAG; Portsmouth Museum; BM. **Engraved by** Vertue.

FENNER, Mr **fl.1616**
Painted a full-length portrait of James I for Guildhall, Bury St Edmunds, for which he was paid £40 by the Trustees.

FERGUSON, Mrs A. **fl.1881**
Exhibited at GG 1881 from Kirkcaldy. Elected a member of Society of Lady Artists. Possibly the Mrs Ferguson of Raith who painted a watercolour portrait of Lady Stirling-Maxwell (SNPG).

FERGUSON, James **1710-1776**
Born near Keith, Banffshire 25 April 1710. Began as a farm labourer, then developed a talent for astronomy. Encouraged by Sir James Dunbar he studied in Edinburgh. Moved to London in the early 1740s producing small portraits and miniatures, often in ink. Among his sitters were Richard Bulstrode and the Duke and Duchess of Perth.
Represented: SNPG; VAM. **Literature:** McEwan.

FERGUSON, Richard **fl.1879**
Signed and dated a portrait of artist John Woodcock Graves, which was recorded in Carlisle.

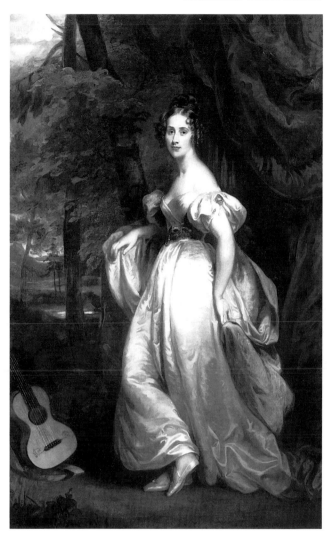

BENJAMIN RAWLINSON FAULKNER. Louisa, Countess of Kintore. Exhibited 1835. 84½ x 58ins (214.6 x 147.3cm)
Christie's

FERGUSSON, John R. **fl.1871-1896**
Exhibited at RSA (2). Listed as a portraitist at Castle Street, Dumfries. J.G.M.Arnott was his pupil.

FERNELEY, John E. snr **1782-1860**
Born Thrussington, Leicestershire 18 May 1782, son of a wheelwright. Worked for his father until he was 21, painting in his spare time. Encouraged by the 5th Duke of Rutland and other local patrons, and was sent to London to study under Ben Marshall for three years. Exhibited at RA (22), BI (4), SBA (12) 1806-53. Worked in Dover and Ireland, before settling at Melton Mowbray. Painted mostly sporting pictures, but also the occasional portrait and equestrian portrait including 'F.Grant ARA on His Favourite Hunter'. Died 3 June 1860. Buried Thrussington. Had four sons, including the artists John jnr and Claude Lorraine Ferneley. His work was admired by Alfred Munnings PRA.
Represented: Tate. **Engraved by** C.Turner. **Literature:** G.Paget, *The Melton Mowbray of J.F.*, 1931; S.Walker, 'J.F. and his Sporting World', British Sporting Art Trust essay No.24 Autumn 1991; DA.
(Illustration p.193)

SAMUEL LUKE FILDES. A lady. Signed, dedicated to F. E. Thompson and dated 1895. 14½ x 10ins (36.8 x 25.4cm)
Christie's

FERNELL, John fl.1824-1839
Listed as a portrait and miniature painter in Liverpool.

FERRERS, Benjamin d.1732
Deaf and dumb. Most of his portraits date after 1700. Subscribed to Kneller's Academy 1711.
Represented: NPG London; Bodleian Library; Newbattle Abbey. **Engraved by** J.Rogers, W.Sherwin, T.Trotter, M.Van Der Gucht.

FERRIÈRE, François 1752-1839
Born Geneva 11 July 1752. Studied in Paris 1772. Moved to England 1793. Exhibited miniatures and portraits at RA (63), BI (3) 1793-1822. Patronized by the royal family. Went to St Petersburg 1804 and Moscow c.1810. Lost his fortune in the French invasion 1812 and returned to St Petersburg, where he was made a member of the Academy 1813. Returned to England 1817 and from 1819 described himself as 'Portrait Painter to Her Imperial Majesty the Dowager Empress of all the Russians, and to the Grand Dukes Nicholas and Michael, Professor of the Academy of Painting at Geneva and Associate to that of St Petersburg'. Returned to Geneva 1822 and worked there until 1835. Retired to Morges, where he died 25 December 1839. His son Louis Ami Ferrière was also an artist.
Represented: SNPG; VAM; Musée Rath, Geneva.

FFITCH, G.S. fl.1839-1847
Exhibited at RA (8), BI (3), SBA (4) 1839-47 from London and Maidenhead.

FIELD, John M. 1771-1841
Portrait, landscape and silhouette artist, who often painted on to plaster of Paris. Exhibited at RA (43), SBA (3) 1800-36 from London, including a portrait of the eminent silhouette artist John Miers, under whom he may have studied. By 1830 he was Profilist to Her Majesty and HRH the Princess Augusta. Died Molesey.
Represented: NPG London; BM.

FIELD, Mrs Mary F. fl.1906-1918
Exhibited at RA (4) 1906-18 from Hampstead and Woking.

FIELD, Robert 1769-1819
Born Gloucester. Entered RA Schools 19 November 1790 aged 21 as an engraver. Painted miniatures and oil portraits, some on copper. Worked in New York 1794, Philadelphia 1795 and drew portraits of George Washington and his wife. Then visited Boston, Baltimore, Halifax, Ontario and Nova Scotia (where he sent a picture to RA (1) 1810). Recorded in Jamaica 1816, where he died of yellow fever 9 August 1819. Described as a handsome man, fond of music, a good conversationalist, a sturdy loyalist and a member of the Church of England.
Represented: NPG London; SNPG; Metropolitan Museum, New York; NG Canada. **Literature:** H.Piers, *R.F.*, 1927; DA.

FIELD, Walter AOWS 1837-1901
Born Hampstead, son of artist E.W.Field. Educated at University College School. Studied under J.R.Herbert and John Pye. Entered RA Schools. Exhibited at RA (42), NWS 1856-99. Elected AOWS 1880. Died Hampstead.
Represented: VAM.

FIELDING, Nathan Theodore 1747-c.1814
Born Sowerby, near Halifax. At first painted highly detailed 'porcelainy' portraits which earned him the title of 'the English Denner'. Settled in London 1788. Exhibited at SA (4), FS (1), BI (3) 1791-1814. By 1800 he was living in Keswick, and worked in Liverpool 1807-9. Gradually concentrated on landscape painting. At least four of his sons were also painters, the most notable being Copley Fielding.
Represented: VAM.

FIELDING, Thales Henry Adolphus AOWS
 1793-1837
Born London or Sowerby (conflicting sources), son of N.T.Fielding. Worked in London and Paris, shared a house with Delacroix (of whom he painted a portrait) and was for a number of years teacher of drawing at Royal Military Academy, Woolwich. Exhibited at RA, OWS from 1810, but his work is confused with that of his elder brother Theodore Henry Adolphus Fielding. Died London.
Represented: BM; VAM; Gloucester CAG.

FIGGIS, Miss Kathleen E. d.1960
Exhibited at RA (24) 1904-60 from London.

FILDES, Sir Samuel Luke KCVO RA 1843-1927
Born Liverpool 18 October 1843. Studied at a local Mechanics' Institute. After three years at Warrington School of Art, he moved to London 1863 to study at South Kensington Schools. Then worked for *The Graphic* and other magazines. On the recommendation of J.E.Millais he was commissioned by Dickens to illustrate *Edwin Drood*. Turned from illustration to painting 1870. Although he enjoyed considerable success as a genre painter, his reputation as a portrait painter was outstanding. Painted a portrait of the Princess of Wales 1894, which led to several royal commissions including state portraits of Edward VII 1902, and George V 1912. Exhibited at RA (76) 1868-1906. Elected

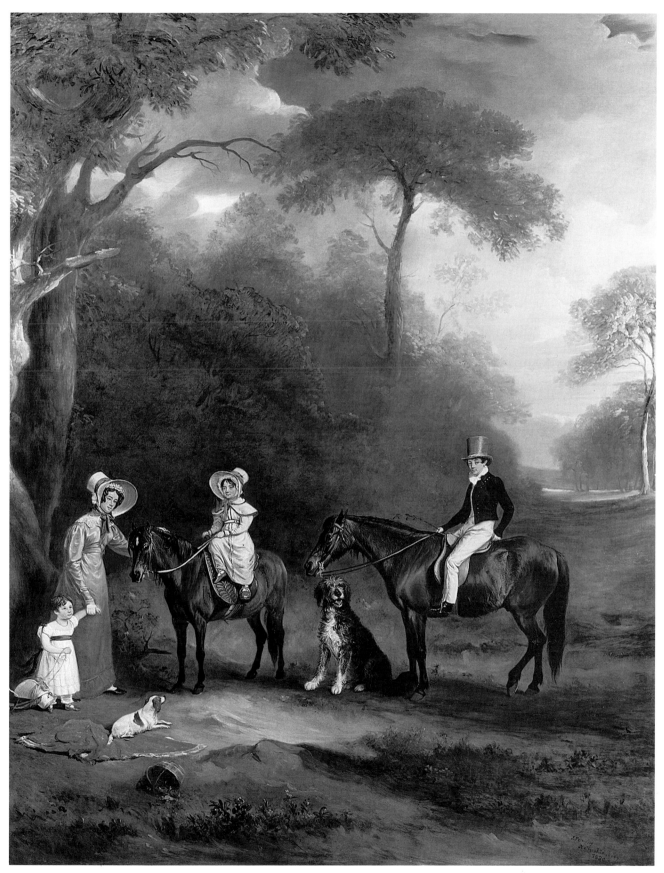

JOHN E. FERNELEY SNR. The Ferneley Children. Signed and dated 'Melton Mowbray 1830'. 56½ x 43ins (143.5 x 109.2cm)
Richard Green Galleries, London

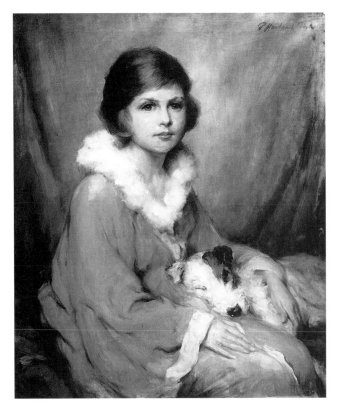

PERCY HARLAND FISHER. Best of friends. Signed. 30 x 25ins (76.2 x 63.5cm) *Christie's*

ARA 1879, RA 1887, Knighted 1906, KCVO 1918. Married artist Fanny Woods. Died Kensington 27 February 1927. Studio sale held Christie's 24 June 1927.
Represented: NPG London; VAM; Tate; Brighton AG; Glasgow AG; HMQ (Osborne House); St Bartholomew's Hospital, London. **Engraved by** J.B.Pratt. **Literature:** D.C.Thompson, *L.F. RA*, 1895; L.V.Fildes, *L.F. RA – A Victorian Painter*, 1968; DA.

FILLANS, G. fl.1838-1840
Exhibited at RA (2), BI (2) 1838-40 from London.

FINCH, Christopher fl.1764-1766
Exhibited at FS (2) 1764-6 from Snow Hill, London.

FINDLATER, William fl.1800-1821
Exhibited at RA (25), BI (8) 1800-21 from London.

FINLINSON, Miss Edith M. fl.1897-1909
Studied at Wimbledon Art College. Exhibited at RA (4) 1897-1909 from South Godstone, Surrey.

FINN, Leopold John b.1891
Born St John's Wood 3 October 1891, son of artist H.J.Finn. Exhibited portraits at ROI and lived in London.

FINNEMORE, Joseph RBA RI 1860-1939
Born Birmingham 8 January 1860. Studied at Birmingham School of Art and in Antwerp under Verlat. Settled in London 1881. Exhibited at RA (13), RHA (1), SBA, RBSA, NWS 1891-1922. Painted portraits of the royal family. Also worked for *The Graphic, Black and White* and *The Sphere*. Elected RBA 1893, RI 1898. Travelled to Malta, Greece, Turkey and Russia. Died 18 December 1939.

FINNEY, Samuel 1718/19-1798
Born Wilmslow 13 February 1718/19, son of Samuel Finney and Esther (née Davenport). Studied law in London. Exhibited at FS, SA 1761-6. Early in his career he produced a number of portraits in Indian ink, but later produced large portraits and miniatures on ivory. Appointed enamel painter to Queen Charlotte 31 December 1763, which led to a highly distinguished practice. Retired to Fulham 1769 and became a JP. Buried at Wilmslow.

FIRMIN, D. fl.17th century
A number of his works were engraved by J.Faber jnr, G.King, C.Knight, P.Pelham and I.Taylor.

FISCHER, Johann Georg Paul 1786-1875
Born Hanover 16 September 1786, son of an engraver. Studied under H.Ramberg. Moved to England 1810, working mostly in London and Cheltenham. Exhibited at RA (80), SBA (17) 1817-52. Painted portraits of Queen Charlotte, Queen Victoria and other members of the royal family. Possibly visited India c.1848. Died London 12 December 1875.
Represented: HMQ (Windsor Castle); BM.

FISCHER, Leopold b.c.1813
Born Vienna, where his father was a painter in a porcelain factory. Studied at Vienna Academy c.1828. Exhibited there 1832-47. Visited Italy and moved to London, where he exhibited at RA (5) 1854. Exhibited Oesterreichischer Kunstverein 1850-64.

FISHER, Miss Beatrice fl.1889-1891
Exhibited at SBA (6), RHA (1) 1890-1 from London.

FISHER, E.J. fl.1836-1853
Exhibited at RA (6), BI (1), SBA (7) 1836-53 from 36 Leadenhall Street, London. Painted the portrait of 'John Kinnersley Hooper, Lord Mayor of London'.

FISHER, Matthew 1828-c.1889
Born Dalston Forge, near Carlisle. Practised portraiture in Carlisle, where he married 1858. Later turned to photography opening a studio 1861. Moved to Gateshead after 1867, where he died.

FISHER, Percy Harland 1867-1944
Born Dulwich 3 August 1867, son of Samuel Fisher. Educated at Dulwich College. Exhibited at RA (19), RHA (2), ROI, RI, PS and in the provinces 1891-1930 from London and Camberley. On his return from living 20 years in Italy and the Continent, he settled in Camberley. A reserved figure who preferred a quiet life. Died Camberley 12 May 1944.
Literature: *An Edwardian Rediscovered*, David Messum exh. cat. 1991.

FISHER, Robert fl.1655
Painted a portrait of John Wilson, Professor of Music at Oxford (Examination Schools, Oxford).

FISHER, Samuel Melton RA PS RWA RP ROI
1856-1939
Born London 2 January 1856 (not 1859/60). Educated at Dulwich College, then France, Lambeth School of Art, RA Schools 1876-81 (Gold Medallist and travelling scholarship) and finally a pupil of Bonnaffé in Paris. Spent ten years in Italy. Exhibited portraits and Italian genre at RA (195), SBA, RHA (2), GG, RP, ROI 1878-1940 from London and Venice. Elected RP 1900, ARA 1917, RA 1924, ROI 1924. Painted portraits of Mrs Val Prinsep, Sir Oswald Mosley and his daughters. Died

Camberley 5 September 1939. His son Stafani Melton Fisher was also a portrait artist.
Represented: NPG London; Tate; Walker AG, Liverpool; NG, Sydney.

FISHER, William 1817-1895
Irish painter who settled in London. Exhibited at RA (48), RHA (15), BI (29) 1840-84. Painted portraits of Duke of Cambridge and Robert Browning.
Represented: NPG London. **Engraved by** W.H.Egleton.

FISK, William 1796-1872
Born Thorpe-le-Soken, Essex, son of a yeoman farmer. His inclination towards art was discouraged by his father, who placed him in a mercantile house in London, where he remained working for ten years, although he practised art as an amateur. Married c.1826, and after the birth of his eldest son turned professional. Exhibited at RA (25), RHA (4), BI (17), RMI, SBA (44) 1818-48 from London. Among his sitters was W.R.Bigg RA. Died Danbury, Essex 8 November 1872. His son, William Henry Fisk, was also a painter.
Engraved by W.Barnard, S.Freeman, J.Scott.

FITHIAN, Miss Edith fl.1894
Studied at Herkomer's School. Exhibited at RA (1) 1894 from Bushey.

FITZGERALD, Miss Dorothy fl.1905-1930
Exhibited at RHA (16), RA (1) 1905-30 from Dublin and London.

FITZGERALD, Edward 1809-1883
Made a portrait drawing of Tennyson.

FITZGERALD, John A. 1832-1906
Baptized John Anston Fitzgerald in Lambeth 5 February 1832, son of William and Mary Fitzgerald. Member of the Maddox Street Sketching Club. Exhibited at RA (33), BI (27), RHA (6), SBA (61) 1845-1902. Known chiefly for his magnificent fairy paintings. Died Kensington 11 March 1906. His middle name is given as Austen, Aster and Anster.
Represented: Guildhall, London; Walker AG, Liverpool.

FLACK, Charles fl.1890-1892
Studied at Herkomer's School, Bushey. Exhibited at RA (3), SBA (1) 1890-2 from Bushey and Surbiton.

FLAGG, James Montgomery 1877-1960
Born New York 18 June 1877. Studied in New York, England and Paris. A member of a number of art societies in America.
Represented: NPG London.

FLATMAN, Thomas 1635-1688
Born London, son of a Clerk in Chancery. Educated at Winchester and New College, Oxford, where he was elected a Fellow 1656. Admitted to the Inner Temple 31 May 1655 and called to the bar 11 May 1662. On 11 December 1666 the King requested the University of Cambridge to admit him as MA. Elected FRS 1668. Moved in Anglican and aesthetic circles, which included Charles and Mary Beale. Took up miniature painting by 1661, but also painted to the scale of life. Married a wealthy girl 26 November 1672. Died London 8 December 1688. Waterhouse describes him as 'the most distinguished miniaturist of his generation'. Among his pupils were Charles and Bartolomew Beale. His signature varied from 'T.F.' in monogram to 'T.F.' in separate letters.
Represented: NPG London; Fitzwilliam; VAM; HMQ; Wallace Collection; Knowle, NT. **Literature:** DA.

FLEETWOOD-WALKER, Bernard
RA, RWS RP ROI NEAC 1893-1965
Born Birmingham. Studied art there and in London and Paris. Exhibited at RA (147), NEAC, RWS, RP, ROI, Paris Salon (where he won a Silver Medal). Elected ARBSA 1824, ROI 1932, ARWS 1940, RP 1945, RWS 1946, ARA 1946, NEAC 1950, RA 1956. Died 30 January 1965 aged 71.

FLESSIERS (FLESSHIERS), Willem fl.1627-1666
Son of artist Balthasar Flessier. His sister married the sea painter Jan Porcellis. Moved to England and stayed in Bristol.
Represented: Bristol AG.

FLETCHER, Miss Annie G. (Mrs E.J.Houle)
fl.1895-1937
Exhibited portraits and miniatures at RA (31) 1895-1937 from London.

FLETCHER, Frank Morley 1866-1949
Born Whiston, Lancashire, son of Alfred Evans Fletcher and Sarah (née Morley). Studied at Atelier Cormon, Paris. Exhibited at RA (2), Paris Salon from 1892. Also a graphic artist and Director of Edinburgh College of Art 1908-23. Settled in California 1923, where he died 2 November 1949.
Literature: McEwan.

FLEUSS, Henry J. fl.1847-1874
Exhibited at RA (8) 1847-74 from Marlborough, Wiltshire, and London.

FLICKE, Gerlach d.1557/8
A native of Germany. Owned property at Osnabrück and moved to England c.1545. Became involved in religious politics and was imprisoned (apparently under sentence of death). Died London. His will was proved in London by his wife 11 February 1557/8. His work is of a high quality.
Represented: NPG London.

FLINTOFF, Thomas 1809-1891
Born Newcastle. Worked there as an artist and dancing teacher until c.1850, when he emigrated to Texas, where he painted portraits of leading members of the State Legislature, and dealers in cattle and slaves. Worked in Mexico, then Ballarat, near Melbourne by 1856, where he continued to paint portraits and attracted an impressive clientele. Settled in Melbourne 1872. Died there aged 82, during an influenza epidemic by swallowing a glass of ammonia in mistake for a tonic.
Represented: State Library, Victoria; Melbourne.
Literature: Hall 1982.

FLOR, Ferdinand 1793-1881
Born Hamburg 22 January 1793. Studied at Eutin, Dresden and Munich. Travelled to Italy 1819 and visited England and Paris. His portrait of Queen Adelaide was in the collection of the Earl of Shrewsbury. Died Rome 5 April 1881.
Represented: Copenhagen Museum; Hamburg Museum.

FLOWER, Clement fl.1899-1908
Exhibited at RA (4) 1899-1908 from Herkomer's School in Bushey.

FLOWER, Marmaduke C. William d.1910
Assistant to Herkomer at Bushey. Exhibited at RA (24) 1878-1904 from Leeds and Bushey. Died 1 October 1910.
Represented: Leeds CAG.

FLOWER, Noel fl.1898-1909
Exhibited at RA (8) 1898-1909 from Kensington, London.

FLOYD, Harry fl.1884-1917
Exhibited at RA (4) 1884-1917 from Eastbourne and London.

FOGGO, George 1793-1869
Born London 14 April 1793, younger brother of James Foggo, with whom he collaborated. Studied under his brother and Jean Baptiste Regnault. Exhibited at RA (6 on his own, 1 with James), BI (8 on his own, 5 with James), SBA (22 on his own, 14 with James) 1816-64 from London. Also a lithographer. With his brother he founded a society for obtaining free access to our museums, of which the Duke of Sussex was President. Died London 26 September 1869.
Literature: DA.

FOGGO, James 1789-1860
Born London 11 June 1789, son of a watchmaker, and elder brother of George Foggo with whom he collaborated. Studied at the Imperial Academy, Paris under Jean Baptiste Regnault. Exhibited at RA (4 on his own, 1 with George), BI (3 on his own, 5 with George), SBA (7 on his own, 14 with George) 1816-58 from London. Died London 14 September 1860. Buried in Highgate Cemetery. His work was admired by Lawrence, Fuseli, Hilton, Flaxman and others.
Literature: Ottley; DNB; DA.

FOLDSTONE (FOLDSONE), John d.1784
Exhibited at SA (5), RA (18) 1769-83 from Oxford Market and London. Painted a number of conversation pieces and specialized in small portraits which he completed in a day at the sitter's home. Also painted to the scale of life. Some of his work shows the influence of Reynolds and Romney. Died London. His daughter was miniaturist, Mrs Anne Mee.
Represented: Stourhead, NT; Grimsthorpe Castle.
Engraved by R.Laurie.

FOLEY, Charles Vanderleur fl.1846-63
Exhibited at RHA (21), RA (2) 1846-63 from Dublin and London.

FOLINGSBY, George Frederick 1828-1891
Born County Wicklow, Ireland 23 August 1828. Travelled to New York aged 18, and attended NA and illustrating for *Harper's Magazine* and the *Illustrated Magazine of Art*. Studied drawing at Munich Academy 1852-54 and under T.Couture in Paris. Returned to Munich, where he worked under Karl von Piloty for five years. Established himself as a portrait and history painter in Munich and exhibited internationally, including in London. Settled in Melbourne by 1880, where he painted portraits and was an examiner of art teachers. In September 1882 he became Director of Melbourne NG and Master of the School of Art, completely reorganizing teaching methods. Died 4 January 1891. Buried in the Church of England section of Kew Cemetery, Melbourne.
Represented: La Trobe Library, Melbourne; The Mitchell Library, Sydney; NG, Victoria. **Literature:** Australian Dictionary of Biography.

FOLKARD, Miss Julia Bracewell 1849-1933
Born Kensington 5 August 1849, daughter of Henry Folkard MRCP MRCS. Educated Bayswater. Studied at South Kensington and RA Schools (Silver Medallist). Exhibited at RA (29), RHA (2), SBA 1873-1917 from London. Member of Society of Lady Artists. Died 29 December 1933.
Represented: NPG; Ipswich Borough Council.

FONTANELLI, Carlo b.c.1755
Entered RA Schools 1776 aged 21. Exhibited at FS (1), RA (1) 1779-80, while lodging with Zucchi.

FOOTNER, Miss Frances Amicia de Biden d.1961
Daughter of Harry Footner, a civil engineer. Studied in Liverpool, abroad and at RA Schools. Exhibited at RA (7) 1902-20 from Chester, London and Bath. Died 19 October 1961.
Represented: Somerville College, Oxford; Berkhamsted Grammar School; Royal Holloway College.

FORBES, Anne 1745-1834
Born Edinburgh, granddaughter of William Aikman. Travelled to Rome 1767-70, where she studied under Gavin Hamilton and copied old masters. She was briefly in London, exhibiting at RA (4) 1772. Returned to Scotland, where she was able to attract more patrons. Worked mostly in crayon, although sometimes in oil. Died Edinburgh.
Represented: SNG; SNPG; Duke of Hamilton Collection.
Engraved by J.R.Smith. **Literature:** McEwan.

FORBES, Charles Stuart 1856-1926
Born Geneva of American parents. Worked in Paris. His portrait of Robert Browning is in the collection of the Contessa Rucellai, Florence.

FORBES, Colin fl.1906
Painted portraits of Queen Alexandra and Edward VII for the Canadian House of Parliament. These were exhibited by command of the King at RA 1906 from 37 Queen's Gate Gardens, London.

FORBES, Elizabeth Adela Stanhope (née Armstrong)
ARWS NEAC 1859-1912
Born Ottawa. Visited England as a young girl and stayed in Chelsea, next door to Rossetti. Returned to Canada. Visited America c.1877 and joined the Art Students' League in New York. Moved to Munich, then Brittany. Exhibited RI and RA. Settled in Newlyn 1885. Married Stanhope Forbes 1889. Founded with him the Newlyn School. A great believer in the principles of *plein-air* painting. Died Newlyn.
Literature: L.Birch, *Stanhope A.Forbes and E.S.F.*, 1906; DA.
Colour Plate 22

FORBES, James 1797-1881
Born Lonmay, Aberdeenshire. Largely self taught. Practised as a portrait painter in London, Peterhead and Aberdeen. Emigrated to Chicago in the mid-1850s. Died Plainwell, USA. John Phillip was a pupil.
Literature: McEwan.

FORBES, Kenneth K. b.1892
Canadian portraitist. Exhibited at RA (14) 1913-38 from London and Toronto.

FORBES, Stanhope Alexander RA 1857-1947
Born Dublin 18 November 1857, son of William Forbes the manager of Midland Great Western Railway of Ireland. Educated at Dulwich. Studied at Lambeth School of Art, RA Schools 1874-8, and for two years in Paris under Bonnat. Influenced by Bastien-Lepage. Painted in Brittany with La Thangue 1880. Settled in Cornwall 1884. Married artist Elizabeth Armstrong 1889. With her he founded the Newlyn School 1899. Exhibited at RA (246), RHA (4), SBA, NEAC 1878-1945. Elected ARA 1892, RA 1910. Died Newlyn 2 March 1947.
Represented: Tate; NGI. **Literature:** L.Birch, *S.A.F. and Elizabeth S.Forbes*, 1906; C.L.Hind, 'The Art of S.F.', *Art Journal* Christmas Number 1911; DA.

FORD, Charles 1801-1870
Born Bath. Exhibited miniatures and portraits at RA (21) 1830-56. Reportedly a pupil and friend of Lawrence.
Represented: Holburne Museum, Bath; Victoria AG, Bath; BM. **Engraved by** J.Thomson.

FORD, Miss Harriet Mary fl.1890-1929
Born Brockville, Ontario, daughter of barrister David B.O.Ford. Educated at Bishop Stracans School, Toronto. Studied in Paris under Merson, in Italy, Ontario School of Art and St John's Wood School. Exhibited at Paris Salon, ROI, RHA (2), SBA (1), Canadian Academy from St Ives and San Gimignano, Italy.

FORD, Henry Justice 1860-1941
Son of W.A.Ford, a solicitor. Studied at Slade and Bushey. Exhibited at RA (32), RI, NWG 1892-1930 from London. Died 25 November 1941.

FORD, J.A. fl.1893
Exhibited at RA (1) 1893 from Edinburgh.

FORD, Wolfram Onslow b.c.1880
Born London, son of sculptor Edward Onslow Ford. Studied at RA schools. Exhibited at RA (24) 1897-1916 from London. Painted a portrait of Whistler. Enlisted during the 1st World War and was 2nd Lieutenant in the Oxford and Bucks Light Infantry.

FORDE, James fl.1846
Exhibited at RHA (2) 1846 from Dublin.

FORMER, J.W. fl.1819
Exhibited at RA (1) 1819 from Beech Street, Barbican.

FORREST, Charles fl.1765-1780
Studied at Dublin's Society School 1765. Exhibited in Dublin 1771-80 (winning premium 1772). Also exhibited at SA (7) 1776 from London. His portraits are usually in crayon or miniature.
Represented: RIA. **Literature:** E.A.McGuire, *Connoisseur* CIII January 1939 p.14.

FORSTER, Charles fl.1828-1847
Exhibited at RA (8) 1828-47 from London. Among his sitters were Mr Anderson of the Theatre Royal and Samuel Prout FSA. His son Charles jnr was also an artist.

FORSTER, George fl.1832-1834
Listed as a portrait painter at 6 Gray's Inn Terrace, London.

FORSTER, John Wycliffe Lowes b.1850
Born Norval, Ontario 31 December 1850, son of Thomas Forster JP. Studied at Académie Julian, Paris. Exhibited at Paris Salon, Toronto, Montreal, Chicago, Detroit, St Louis, London, Manchester, Liverpool and Halifax.
Represented: Parliaments of Ottawa and Ontario.

FORSTER, Joseph Wilson fl.1889-1915
Exhibited at RA (10) 1889-1915 from London. Painted the portraits of Rev Charles Voysey and 'J.Gilbert Baker, Keeper of the Herbarium, Kew Gardens'.
Represented: Government House, Toronto.

FORTUNE, W.P. fl.1842
Exhibited at RHA (2) 1842 from Wexford.

FOSTER, Arthur J. fl.1885-1904
Exhibited at RA (14), RHA (1) 1885-1904 from London.

FOSTER, Thomas c.1797-1826
Born Ireland. Moved to England, aged about 15. Entered RA Schools. Exhibited at RA (18), BI (5) 1818-26 from London. Copied several of Lawrence's portraits. Committed suicide in March 1826 in his twenty-ninth year. Left a note saying that his friends had deserted him, that he knew no cause, and that he was tired of life.
Engraved by S.W.Reynolds. **Literature:** Redgrave.

FOSTER, Thomas A. d.c.1826
Elected ARHA 1825. Exhibited posthumously at RHA (4) 1826. Possibly the same man as above.
Engraved by S.W.Reynolds.

FOSTER, William d.1812
Exhibited portraits and miniatures at SA (8), RA (18), BI (4) 1772-1812 from London. Produced a number of studies of actresses in pencil and watercolour.
Represented: BM. **Engraved by** H.R.Cook.

FOSTER, William fl.1852-1856
Exhibited at RHA (3) 1852-6 from Dublin.

FOUNTAIN(E), George fl.1698-1747
Court painter of Huguenot origin. Probably a court painter at Hanover 1723, and was paid his expenses for transferring from London 1730.

FOWLER, Trevor Thomas fl.1829-1850
Worked for a short time in London, but moved to Dublin. Exhibited at RHA (45), RA (1), SBA (1) 1829-50. Practising in New York by 1837 and in 1840 painted the American statesman Henry Clay and President Benjamin Harrison. Moved to New Orleans, then Paris 1843, in Dublin again 1844, before returning to New Orleans and Cincinnati until 1853. Settled in Germantown, Pennsylvania 1854-69, exhibiting at Pennsylvania Academy of the Fine Arts.

FOWLER, William 1796-1880
Exhibited at RA (23), BI (72), RSA (5), SBA (74) 1825-67. Based in London, but travelled widely on sketching tours including Rome and the Continent. Among his sitters were Queen Victoria and Sir John Conroy.
Engraved by B.P.Gibbon, C.Turner, W.J.Ward.

FOX, A.Shirley see SHIRLEY FOX, Mrs Ada R.

FOX, Augustus Henry fl.1841-1855
Listed as a 'Teacher and Portrait Painter' in Stockport, Cheshire. Exhibited at RA (3), SBA (1) 1841-9 from London and Stockport.

FOX, Charles 1794-1849
Born Cossey Hall 17 March 1794. Studied under engraver John Burnet. Exhibited at RA (4) 1836-7. Specialized in miniatures and small watercolour portraits. Also painted exotic Oriental portraits. Died Leyton 28 February 1849.
Represented: NPG London; NGI; VAM. **Engraved by** W.C.Edwards.

FOX, E. Phillips d.1915
Exhibited at RA (24) 1903-12 from London and Paris. Died 8 October 1915.

FOX, Miss Eliza see BRIDELL, Mrs Eliza Florence

FOX, James fl.1841
Listed as a portrait painter in Glasshouse Street, Nottingham.

FOX, John Shirley see SHIRLEY FOX, John

FOY, William c.1789-c.1862
Reportedly born Londonderry 1791. Exhibited at RA (14), RHA (72), BI (10), SBA (7) 1828-61 from Dublin, London and Derry. Probably the William Foy who entered RA Schools 12 November 1814 aged 25.
Engraved by G.Foggo.

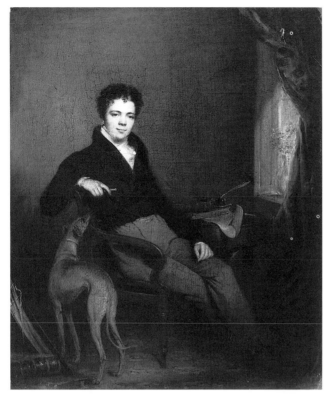

WILLIAM FREDERICK. A gentleman. Panel. 17 x 13½ins (43.2 x 34.3cm) *Christie's*

FRADELLE, Henry Joseph **1778-1865**
Born Lille. Studied in Paris until 1808 and then Italy. Settled in London 1816. Exhibited at RA (11), BI (36), SBA (2) 1817-55. Died London 14 March 1865.
Literature: DNB.

FRAMPTON, George Vernon Meredith RA
 1894-1984
Born London 17 March 1894, son of sculptor Sir George Frampton RA. Studied at RA Schools. Exhibited at RA (33) 1920-45 from London and Wiltshire. Elected ARA 1934, RA 1942. Died 16 September 1984.
Represented: SNPG; Tate; NPG London.

FRANKLYN, George **fl.1825-1847**
Exhibited at RA (9), BI (8), SBA (3) 1825-47 from London.

FRANKLYN, John **b.c.1800**
Exhibited at RA (9), BI (10), SBA (9) 1830-68 from London.
Represented: VAM.

FRANQUINET, William-Hendrick **1785-1854**
Born Maastricht 25 December 1785. Studied under Herreyns. Exhibited at RA (1), BI (7), SBA (10) 1831-6 from London. Collaborated with J.Chabert. Died New York 12 December 1854.

FRASER, Patrick Allan HRSA **1813-1890**
Apprenticed to a housepainter before studying under Scott Lauder. Exhibited at RSA (32), RA (4) 1852-80 from Arbroath. Elected honorary RSA 1871. Among his sitters were the artists W.Calder Marshall, John Phillip and John Hutchinson. Bequeathed his house and art collection at Hospitalfield, Arbroath for the purposes of a School of Art.
Literature: McEwan.

FRASER, Thomas **d.1851**
Exhibited at RSA (18) 1825-53. Died Edinburgh.
Represented: SNPG.

FRASER, William **fl.1806-1811**
Exhibited at RA (7), BI (1) 1806-11 from London.

FRAZER, Hugh RHA **1826-1861**
Exhibited at RHA (117) 1826-61 from Dublin, Dromore and Belfast.

FRAZER, Oliver **1808-1864**
Born Fayette County, Kentucky. Studied in Lexington under Jouett, and in Philadelphia under Sully. Travelled with Healey in Europe 1834 and studied in Paris, Berlin, Florence and London, returning to Lexington 1838.
Represented: J.B.Speed Art Museum, Louisville, Kentucky.

FREDERICK, William **b.c.1796**
Entered RA Schools 5 November 1818 aged 22. Listed as a portrait painter in Manchester 1825 and at Leeds from 1828. Described as a 'chaste sweet painter of portraits, dead game and small moonlights'.
Represented: Leeds CAG. **Engraved by** B.H.Allen.

FREEMAN, Lieutenant **fl.1783**
An honorary exhibitor of a portrait of the Duchess of Devonshire at RA 1783.

FREEMAN, Flower jnr **fl.1775-1776**
An honorary exhibitor at FS (3) 1775-6.

FREEMAN, Joseph **fl.1778-1799**
Surveyor and land agent in Cambridge. Reportedly self-taught. Exhibited at SA (1), FS (2) 1775-6, working in oil and crayon. Much employed by Cambridge colleges copying and restoring portraits. Also copied many portraits for the Palace at Ely.

FREEMAN, Miss Mary Winifride **fl.1886-1927**
Exhibited at NWS, RA (7), NWG 1886-1927 from London, Newlyn and Bushey.

FREEMAN, Thomas **1757-1780**
Reportedly born 15 October 1757. Entered RA Schools 1776. Exhibited at RA (1) 1780 from Windsor.

FREESE, N. **fl.1794-1814**
Exhibited at RA (14) 1794-1814 from the Strand, London. Joined Artist's Volunteer Corps 1803.
Represented: Fitzwilliam.

FREEZOR, George Augustus **fl.1861-1869**
Exhibited at RA (5), BI (1), SBA (1) 1861-9. Painted portraits in the Keepsake tradition. His wife was also a painter. His surname has been spelt Freezer and Frezzar.
Represented: Graves AG, Sheffield.

FRIER, Walter **fl.1705-1731**
Itinerant portrait painter working mainly in the north country. Paid £6.9s. for 'dressing pictures and drawing the King's picture'. Signed with the monogram 'WF'.
Represented: SNPG; Prestonfield. **Literature:** McEwan.

FRIPP, George Arthur **1813-1896**
Born Bristol, son of Rev. S.C.Fripp who married a daughter of Nicholas Pocock. Studied under J.B.Pyne and influenced by Samuel Jackson. Began painting portraits in oil in Bristol, but after visiting Italy 1834 with W.J.Müller, he concentrated on landscapes and topographical views. Exhibited at RA (4), BI (7), OWS (nearly 600) and in Bristol. In 1860 Queen Victoria

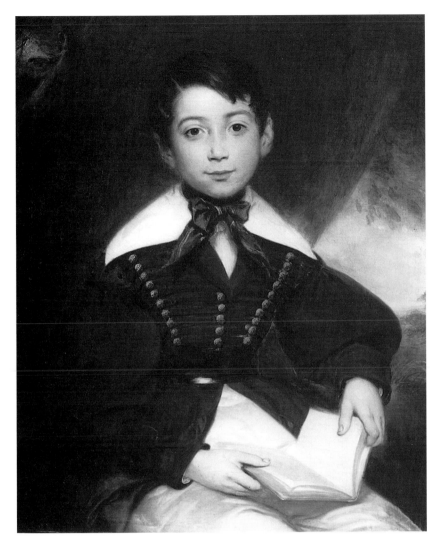

WILLIAM EDWARD FROST. A boy. Signed and dated 1840. 28¼ x 22½ins (71.8 x 57.2cm) *Christie's*

commanded him to stay at Balmoral, while he completed a series of drawings of the neighbourhood for the royal collection. Died after a long illness in London 17 October 1896. Buried Highgate Cemetery.
Literature: DNB.

FRISWELL, Mrs Emma fl.1852-1862
Married James Friswell. Exhibited at RA (3), BI (4), SBA (7) 1852-62 from London.

FRITH, John fl.1819-1834
Exhibited at RA (2) 1819 from Croydon. Listed as a portrait and miniature painter at 7 Cornhill, London 1832-4.

FRITH, William Powell RA 1819-1909
Born Studley, near Ripon 9 January 1819. Educated at Knaresborough and St Margaret's Dover. Studied at Saas's Academy 1835 and RA Schools 1837. Exhibited at RA (146), BI (13), RHA (3), SBA (13) 1838-1906. Elected ARA 1845, RA 1853. Member of St John's Wood Clique along with Richard Dadd, A.L.Egg, H.N.O'Neil and John Phillip. A visit to Ramsgate 1851 gave him the idea for his first 'panorama' of modern day Victorian life, and 'Ramsgate Sands' was exhibited at RA 1854. It was an enormous success and was purchased by Queen Victoria. Encouraged by this he painted 'Derby Day' 1858, 'The Railway Station' 1862, and 'Private View at the Royal Academy' 1883. Among his exhibited

portraits were Thomas Creswick RA and his friend Charles Dickens. Studio sale held Christie's 14 June 1884. Died London 2 November 1909.
Represented: NPG London; Aberdeen AG; HMQ; VAM; Birmingham CAG; Tate. **Engraved by** W.H.Simmons, J.Smyth. **Literature:** VAM MSS; W.P.Frith, *My Autobiography and Reminiscences,* 1888; *The Times* 4 November 1909; DA.

FROST, William Edward RA 1810-1877
Born Wandsworth September 1810. Studied under Etty, Sass's Academy and at BM. Entered RA Schools 1829. Set up as a portraitist with considerable success. Exhibited at RA (78), BI (33), SBA (2) 1836-78 from London. Awarded Gold Medal of the Academy 1839 for a mythological subject. Won £200 prize in the Houses of Parliament competition. These successes led him to leave portraiture for subject painting. Elected ARA 1846, RA 1870. Died London 4 June 1877. Studio sale held Christie's 14 March 1878. Ottley reported that he painted upwards of 300 portraits in 14 years, few of which were exhibited.
Represented: NPG London; VAM; BM; Tate; Ashmolean; Fitzwilliam. **Engraved by** C.Turner. **Literature:** DA.

FRY, J. fl.1720-1732
His portrait of 'Mathias Earbery' was engraved 1720. A portrait of 'John Balderston' at Emmanuel College, Cambridge copied after a Loggan miniature of 1684 is signed 'I.Fry pinx.1732'.

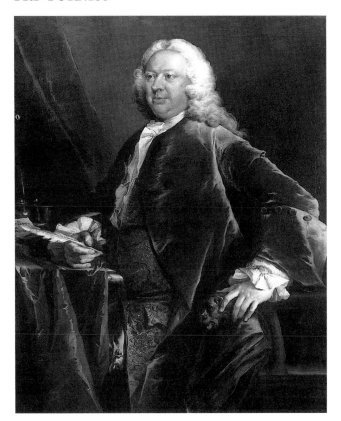

THOMAS FRYE. Mr Crispe of Quex Park. Signed and dated 1746. 50 x 40ins (127 x 101.6cm) *Christie's*

FRY, M.W. **1825**
Listed as a portrait, miniature and transparency painter in Manchester..

FRY, Roger NEAC **1866-1934**
Born Highgate 14 December 1866, son of Rt Hon Sir Edward Fry. Educated at Clifton College and King's College, Cambridge. Studied art under Francis Bate and at Académie Julian, Paris. Returned to London 1893 and worked under Sickert. Elected NEAC 1893. Founded the Omega Workshop and was influential as an art critic. Died London 9 September 1934.
Represented: NPG London; Southampton AG.

FRY, William Arthur **b.1865**
Born Otley, Yorkshire 25 September 1865, son of William Fry, a librarian. Educated at Salt Schools, Shipley. Settled at Holywood, County Down in Northern Ireland. Exhibited at RHA (11) 1904-31.

FRYE, Thomas **c.1710-1762**
Born in or near Dublin. His earliest known works are crayon portraits of 1734 in the style of Rosalba Carriera. Moved to England by 1735, and was painting miniatures and oil portraits in the later 1730s. Studied under John Brooks of Battersea enamel factory. His full-length portrait of 'Frederick, Prince of Wales in Garter Robes' (1736) was commissioned by the Saddlers' Company and was reproduced in mezzotint by himself 1741. Helped found Bow porcelain factory 1744 and acted as manager until 1759 when illness forced him to retire, although he continued to paint portraits. Worked in Wales 1760, where he regained his strength. Exhibited at SA (6) 1760-1. Embarked on two series of mezzotint heads 1760-1, and their marked chiaroscuro may have influenced Wright of Derby. Died of consumption London 2/3 April 1762.

William Pether was his pupil. His work was influenced by J.B.Van Loo and W.Hogarth, and he painted Hogarth's friend Richard Leveridge. Waterhouse 1981 describes him as 'one of the most original and least standardized portrait painters of his generation'. Showed remarkable confidence in the handling of architectural background. His mature work demonstrates a keener interest in light-and-shade modelling.
Represented: NPG London; VAM; Royal College of Physicians; NGI; HMQ; Warwick Courthouse. **Engraved by** W.Bromley, D.Dodd, J.Faber jnr, R.Houston, Macarrol, Nusbiegel, B.Reading, J.Watson. **Literature:** G.Wills, 'A Forgotten Artist', *Country Life* 13 January 1955 pp.96-7; M.Wynn, *Burlington Magazine* CXXIV October 1982 pp.624-8, CXIV February 1972, pp.79-84; DA.

FUGE, William Haydon **fl.1849-1866**
Exhibited at RA (6), BI (1), SBA (3) 1849-66 from Bocking, Essex. Married Isabella Maria Gunning at St John the Evangelist, Notting Hill 4 September 1855.

FULCHER, Miss Norah **fl.1898-1913**
Exhibited at RA (3) 1898-1913 from Notting Hill.

FULLER, Isaac **1606-1672**
Worked in Oxford 1644. A Royalist during the Civil War. Visited Paris c.1645-50, where he studied under François Perrier and learned engraving. Returned to England by 1650, and published a drawing book, with etched plates, 1654. Painted a number of large scale histories and enjoyed a good reputation for them. After the Restoration he went to Oxford, where he painted 'The Last Judgement' at Magdalen (destroyed). His son, Isaac Fuller ii, was also a painter.
Represented: NPG London; Dulwich Picture Gallery; Examination Schools, Oxford; Bodleian Library. **Engraved by** T.Chambers. **Literature:** E.Croft-Murray, *I.F.'s Paintings of Charles II's Escape From The Battle of Worcester*, 1971. Colour Plate 23

FULLER, Leonard John ROI **1891-1973**
Born Dulwich 11 October 1891. Studied at Dulwich College, Clapham School of Art and RA Schools. Won a BI scholarship 1913. Exhibited at RA (31), RP, ROI, RSA 1919-50. Taught at St John's Wood School of Art. Principal of St Ives School of Painting from 1938. Died 24 July 1973.

FULTON, Robert **1765-1815**
Born Little Britain, Pennsylvania 14 November 1765. Practised in Philadelphia as a portrait and miniature painter before coming to England 1786. Studied with West and possibly RA Schools 1788. Exhibited at SA (4), RA (3) 1791-93. After 1793 he was attracted to engineering (canals, submarines and steamboats). Visited France from c.1796 to 1803, and returned briefly to London before going back to America 1806. There he developed with Livingston the first commercially successful steamboat. Died New York City 23/24 February 1815.
Represented: Rockwood Museum, Wilmington; Nelson Atkins Art Museum, Kansas City; Historical Society of Pennsylvania.

FURLY, Miss **fl.1783**
Exhibited a portrait of a lady at FS 1783.

FURNISS, Harry **1854-1925**
Born Wexford, son of a civil engineer. Educated in Dublin and attended RHA Life School. Moved to London aged 19, and began to draw for *Punch* 1880-94 as well as other magazines and books. Exhibited at RA (6), RHA (1), SBA (1) 1880-9 from Regent's Park. Died Hastings.
Represented: NPG London; VAM card cat. (list of illustrated works); Birmingham CAG. **Engraved by** Swain.

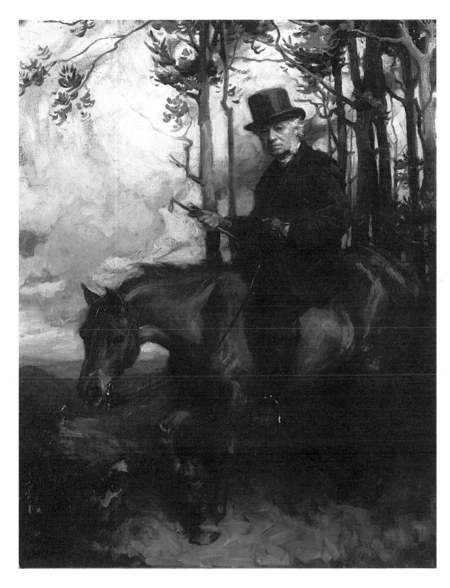

CHARLES WELLINGTON FURSE. The artist's father – Archdeacon Charles Wellington Furse in 1899. 35 x 27ins (89 x 68.6cm)

Private collection. Derek Bird, Family Copies London

FURSE, Charles Wellington ARA NEAC RP
1868-1904

Born Staines, Middlesex 13 January 1868, son of Charles Wellington Furse, Archdeacon of Westminster, and Jane Diane Monsell. Through his father he was related to Joshua Reynolds. Studied at Slade under Legros from 1884; Académie Julian, Paris and Westminster School of Art under Fred Brown. Exhibited at RA (26), SBA, NEAC, RP (4), NWG 1885-1905 from London. Elected RP 1891, NEAC 1892, ARA 1904. Married Katherine Symonds at St Margaret's, Westminster, 16 October 1900. Died of tuberculosis at Camberley 15 October 1904 aged 36. Buried at Frimley churchyard. A number of his portraits were left unfinished at his death. Influenced by Whistler and by his friend J.S.Sargent. Known as one of 'The Slashing School'. Took delight in the exciting effects of brushwork and creamy flesh tones. An outstandingly gifted draughtsman. His heads are well modelled with considerable character.
Represented: NPG London; NGI; Tate; Eton College; Trinity College, Cambridge; Walker AG, Liverpool; Cordwainers Company. **Literature:** Maas; *Illustrated Memoir of C.W.F. ARA – with a Chronological List of Works,* Burlington Fine Arts Club 1908; Sir W.Rothestein, *Men and Memories,* 1931 Vol. 1 p.173; Dame K.Furse, *Hearts and Pomegranates – The Story of Forty-Five Years*

1875-1920, 1940; DA.
Colour Plate 24

FURSE, Thomas fl.c.1840
His portrait of Cardinal Wiseman is in the English College at Rome.

FUSSELL, Joseph 1818-1912
Born Birmingham. Studied at RA Schools. Listed as a landscape and portrait painter at 57 Penton Street, London. Taught at Nottingham School of Art. Died Point Loma, California 6 May 1912.
Represented: Nottingham AG.

FYFE, William Baxter Collier c.1836-1882
Born Dundee. Brought up in Carnoustie. Studied at RSA Schools (winning prizes for crayon portraits) and in Paris 1857-8. Exhibited at RSA, RA (26), BI (2), SBA (4) 1861-82. Visited France, Italy and Belgium, before settling in London 1863. Spent many of his summers in Scotland. Among his sitters were John Faed RSA, Earl and Countess of Dufferin, Lord Houghton, Sir David and Lady Baxter. Died suddenly in St John's Wood 15 September 1882 in his forty-seventh year. Buried Willesden Cemetery.
Literature: DNB; McEwan.

WILLIAM HIPPON GADSBY. May and Violet Craik. Signed and dated 1883. 36 x 28ins (91.5 x 71.1cm)

G

GABAIN, Miss Ethel Leontine (Mrs Copley) RBA ROI
1883-1950
Born Le Havre. Studied at Slade, Central School of Arts and
Crafts and in Paris. Exhibited at RA (52), ROI, SBA 1908-49
from Paris, Bushey and London. Elected RBA 1932/3, ROI
1933. Married artist John Copley 1913. Awarded De Laslo
Silver Medal 1933 for her portrait of Dame Flora Robson
(Manchester CAG). Official war artist 1940. Died London
30 January 1950. Influenced by Manet.
Represented: BM; VAM; NG Ottawa; Bradford AG; Public
Library, Boston; Glasgow AG; Uffizi Gallery, Florence.
Literature: McEwan.

GADSBY, William Hippon RBA 1844-1924
Born Derby, son of a solicitor, in whose office he worked for
two years. Studied at Heatherley's and for nine years at RA
Schools, where he was influenced by Millais. Travelled on the
Continent visiting Rome and Venice 1870. Exhibited at RA
(5), BI, SBA (74) 1869-94 from London. Elected RBA 1876,
and at the time of his death was the society's oldest member.
Commissioned to copy a portrait of Queen Victoria at
Buckingham Palace 1896. Specialized in portraits and genre
paintings of children. Painted a watercolour of a child's head
for the Queen's Dolls' House 1922. Rarely signed his pictures.
Represented: Derby AG.

GAGNIER, Mrs John fl.c.1720-after 1725
Wife of John Gagnier, Professor of Arabic. Worked as a
professional portrait painter in Oxford.

GAINSBOROUGH, Thomas 1727-1788
Baptized Sudbury 14 May 1727, son of John Gainsborough,
a cloth merchant. Educated at Sudbury Grammar School.
Studied in London 1740-8, mainly at St Martin's Academy
under Gravelot and Hayman. Enjoyed landscape painting,
and was influenced by the Dutch 17th century painters,
particularly Wynants and Ruisdael. His love of landscape is
often shown in the background of his portraits, such as 'Mr
and Mrs Andrews' (NG London). Returned to Sudbury
1748, but soon moved to Ipswich where he married. Went to
Bath 1759, where he had a fashionable portrait practice.
There his style was greatly influenced by Van Dyck, whose
work he saw in west country houses. Settled in London 1774,
where he further developed his personal style, working with
light and rapid brush strokes and experimenting with a
palette of delicate and evanescent colours. Became a favourite
painter with the royal family. Exhibited at SA (19), FS (3), RA
(96) 1761-83. Elected founder RA 1768. Towards the end of
his career he decided that the RA's hanging of pictures did
not suit his style and exhibited directly from his studio.
Generally considered second only to Reynolds, although the
royal family employed him in preference from 1776. From
1772 he was assisted in his studio by his nephew,
Gainsborough Dupont. Died of cancer in London 2 August
1788. Buried at Kew. Usually used fine-woven canvas, primed
with light grey or yellow paint so that he started his portrait
on a smooth surface. He allowed this ground to be seen
through his surface paints. He was able to paint with brushes
up to several feet long and his studio had 'scarcely any light'.
His art varies in quality, but his best works show him to be a
great genius. Enormously important and influential as a

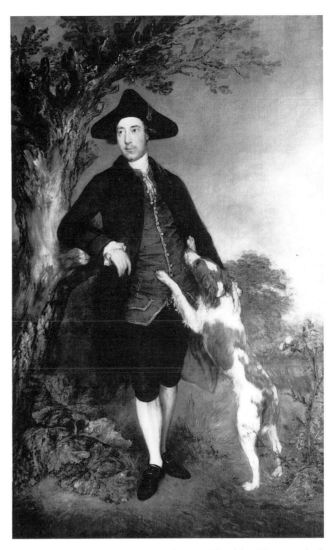

THOMAS GAINSBOROUGH. George Venables Vernon, 2nd
Lord Vernon. 97 x 59ins (246.4 x 149.9cm) *Southampton CAG*

landscape painter. Frederick Percy Graves fl.1858-72 made a
number of copies of his work.
Represented: NPG London; Tate; NG London; SNG; SNPG;
HMQ; NGI; BM; VAM; Iveagh Bequest, Kenwood House;
Gainsborough House, Sudbury; Manchester CAG; Houghton
Hall; Leeds CAG; Walker AG, Liverpool; Dulwich AG;
Christie's; Wakefield AG; Wallace Collection; Canterbury
Museums; NG Washington; Ashmolean; Southampton CAG;
Philadelphia Museum of Art; North Carolina Museum of Art.
Engraved by T.Appleton, T.L.Atkinson, P.Audinet,
T.O.Barlow, W.W.Barney, F.Bartolozzi, J.Basire, E.Bell,
H.Birche, E.Bocquet, M.Bourlier, A.Cardon, C.Carter,
J.Chapman, G.Clint, J.Colyer, H.R.Cook, J.Dean,
W.Dickinson, J.Dixon, G.Dupont, S.Einslie, W.Evans,
G.H.Every, L.Flameng, S.Freeman, W.T.Fry, T.Gaugain,
R.Graves, W.Greatbach, V.Green, E.Gullard, J.Hall, J.Heath,
W.Holl, J.Hopwood, J.Jones, R.Josey, J.Keating, Kennerley,
R.J.Lane, V.Lhuillier, J.McArdell, P.Mazell, H.Meyer,
J.Miller, E.Morton, Murray, P.Naumann, R.B.Parkes,
Pontenier, J.B.Pratt, P.Rajon, S.W.Reynolds, W.Ridley,
Rotwell, G.Sanders, A.N.Sanders, J.Scott, W.Sharp, C. &
J.K.Sherwin, W.H.Simmons, J.R.Smith, J.Spilsbury, E.Stamp,
R.Stanier, A.Tardieu, C.Tomkins, T.Trotter, C.Waltner,
C.Watson, J.Watson, W.Ward, J.Whessell, J.Young. **Literature:**

E.Waterhouse, *G.*, 1966; J.Hayes, *The Drawings of T.G.*, 2 vols 1970; M.Woodall, *T.G.: His Life and Work*, 1949; J.Hayes, *G. as Printmaker*, 1971; G.W.Fulcher, *Life of T.G.*, 1856; W.T.Whitley, *T.G.*, 1915; W.Armstrong, *T.G.*, 1894; J.Hayes, *G.*, 1975; J.Hayes, Tate exh. cat. 1980; J.Lindsay, *T.G.: His Life and Art*, 1981; M.Cormack, *The Paintings of T.G.*, 1992; DA. Colour Plate 26

GAINSFORD, F.G. fl.1805-1816
Exhibited at RA (6) 1805-16 from London.
Represented: NPG London. **Engraved by** Alais, M.Haughton.

GAIR, Gillies fl.1872-1874
Exhibited at RA (3), SBA (1) 1872-4 from London.

GALE, Benjamin 1741-1832
Born Aislaby, Yorkshire. Worked as a portraitist and landscape painter in Hull c.1775-1803. A friend of J.C.Ibbetson, who helped him gain commissions. Became resident drawing master at Scawby Hall, Lincolnshire 1803, home of Nelthorpe family.
Represented: Wilberforce House, Hull.

GALE, William 1823-1909
Studied at RA Schools. Influenced, in his early period, by the Pre-Raphaelites. Exhibited at RA (101), RHA (5), BI (42), SBA (32) 1844-93 from London. Travelled to Italy 1851, Syria 1862, Palestine 1867 and Algeria 1876-7.
Represented: Tate; Glasgow AG.

GALES, Henry fl.1868
Painted a group portrait of the 'Cabinet of the Earl of Derby'. It was lent by the Baroness Kinloss to The Victorian Era Exhibition 1897 and is now in NPG London.
Engraved by J.Scott.

GALLAIT, Louis HFRA HRA 1810-1887
Born Tournai 10 March 1810. Studied under Hennequin and in Paris under Delaroche. Exhibited at RA (3) 1872 from 51 Bedford Square, London. Died Schaerbeck, Brussels 20 November 1887.
Literature: Bénézit.

GALLIMORE, Samuel 1835-1893
Baptized Newcastle under Lyme 3 May 1835, son of John, a carpenter, and Hannah. Exhibited at RA (5), BI, SBA (1), NWS (1) 1861-93 from Pimlico, Newcastle, Staffordshire and Huddersfield. Painted a portrait of Rt Hon W.E.Gladstone MP 1881. Died St John's Wood 20 July 1893 aged 58.

GALLON, Robert Samuel Ennis fl.1830-1868
Exhibited portraits, genre and lithographs at RA (28), BI (8), SBA (19) 1830-68 from London. Among his sitters were 'Edward Hart, a Pensioner in Greenwich Hospital, aged 94, One of Captain Cook's Crew' (1839) and opera singer 'Marietta Alboni'. His son was the landscape painter Robert Gallon.

GALLOWAY, S. jnr fl.1832-1834
Son of artist Samuel Galloway. Exhibited at SBA (5) 1832-34 from London.

GALLOWAY, Vincent b.1894
Born Hull 30 January 1894. Studied at Hull College of Art, in London and in Holland. Exhibited at RP. Curator of Ferens AG, Hull.

GALPIN, William Dixon fl.1883-1887
Exhibited at RA (3), SBA (1) 1883-7 from Roehampton.

GAMBARDELLA, Spiridione fl.1842-1868
Born Naples. Escaped as a political refugee to Boston,

Massachusetts 1834-40. Travelled to France. Moved to London 1841, where he was introduced by Emerson to Thomas Carlyle (whom he painted). Patronized by 2nd Duke of Wellington. Exhibited at RA (4), BI (8), LA 1842-52. Worked in Liverpool 1844-5 painting portraits mostly of merchants. Returned to London until 1852 or later. Then moved to Italy, where he died. Fond of strong lighting effects and used a wide range of settings with considerable accomplishment. Had a natural gift for character and drapery. His daughter, Julia, was also an artist.
Represented: University of London; Walker AG, Liverpool; Stratford Saye; Apsley House. **Engraved by** Maclure & Co.

GANDY, Mrs Ada fl.1898
Exhibited at RA (1) 1898 from Brixton. Married to artist Walton Gandy.

GANDY, James 1619-1689
Born Exeter. Said to have been a pupil of Van Dyck. In 1661 he was taken to Ireland in the service of the Viceroy, the 1st Duke of Ormonde. Developed a highly successful practice in Ireland painting 'noblemen and persons of fortune'. Died Ireland 1689, aged 70. His son was artist William Gandy. Redgrave says that Reynolds, at the commencement of his career, was impressed with Gandy's work.
Represented: Guildhall, Exeter. **Engraved by** R.Grave, A.Wivell. **Literature:** *The Gentleman's and Connoisseur's Dictionary of Painters . . . 1250-1767*, 1770; Strickland.

GANDY, Thomas fl.1831-1859
Exhibited at RA (7), SBA (1) 1831-59 from London. Listed in the directories there as a portrait painter. Among his sitters were Captain Sir Thomas Hastings RN, the Dean of Exeter, and Admiral Sir Edward Chetham Strode KCB.

GANDY, William c.1655-1729
Registered as son of artist James Gandy, although in later life he told people that he was the natural son of his father's patron, the Duke of Ormonde. Probably practised in Ireland. Studied under Gaspard Smitz and is recorded as an apprentice of Thomas Gandy, Upper Warden of Painter-Stainers' Company. Settled in England c.1700 and practised as an itinerant portrait painter, mainly in Exeter and Plymouth. His known work dates after 1700, and is usually of an extremely high standard with hands well drawn. His paintings were admired by Sir Godfrey Kneller, and he is traditionally said to have influenced Reynolds, especially in the texture of paint. Reynolds and Northcote are both reported to have borrowed his pictures to make studies. His compositions can be original, and he often represents the sitter 'tightly' within the framework of the canvas. Died Exeter. Buried St Paul's Church 14 July 1729.
Represented: Albert Memorial Museum, Exeter; Devon & County Hospital, Exeter; Earl of Iddesleigh. **Engraved by** G.Vertue; M. Van Der Gucht. **Literature:** DNB.

GARBRAND, Caleb John 1748-1794
Born London, of a Jamaican family. Entered RA Schools 1771. Exhibited at FS (10), SA (6), RA (8) 1771-80 from London. Working in India by 1783, but gave up painting for trade. Died Chittagong 10 March 1794.

GARBUT, Joseph ('Putty') fl.1870-1900
Worked as a glazier in South Shields, County Durham. Painted a variety of subjects including portraits.
Represented: South Shields Museum.

GARDELLE, Theodore 1722-1761
Born Geneva 30 November 1722, son of Giovino Gardelle of Ravenna. Educated at Turretine's Charity School. Apprenticed to M.Bousquet, a limner and printseller. Ran away to Paris aged 16, returned home but studied in Paris 1744-50. Returned to

Geneva, but left because of his moral conduct 1756, taking with him a woman he passed off as his wife. He parted company with her in Paris, and then went to Brussels and eventually England 1760. Set up as a miniature and portrait painter and lodged with Mrs Anne King, whose throat he cut with a penknife on 19 February 1761. Having concealed the body he was unable to dispose of it for some days, but eventually cut it up and dispersed it under 'very revolting circumstances', burning much of it. Arrested 27 February and made an unsuccessful attempt at suicide with laudanum. Executed 4 April 1761 and his body hung in chains on Hounslow Heath. An engraving of Gardelle on his way to execution is in NPG London.
Literature: DNB.

GARDEN, J. fl.1834
Exhibited at RA (2) 1834 from 5 Carburton Street, London.

GARDINER, Alfred Clive d.1960
Exhibited at RA (9) 1915-52 from London. Died St Stephen's Hospital, Chelsea 15 May 1960.

GARDINER, Christopher fl.1672-1683
Native of Bristol. Worked in Salisbury, where he became a freeman 1672. Still living there 1683. His portrait of 'Sir Robert Hyde' belongs to Salisbury Corporation.
Literature: C.Haskins, *The Salisbury Corporation Pictures and Plate*, 1910 pp.15, 153.

GARDINER, John H. fl.1918-1925
Exhibited at RA (5) 1918-25 from London, Clacton and Worthing.

GARDINER, William Nelson 1766-1814
Born Dublin 11 June 1766, son of John Gardiner 'crier and factotum' to William Scott, Justice of the King's Bench. Studied at Dublin Society Schools 1781-4 (winning a Silver Medal). Moved to London as an engraver, became bored and tried his hand at times as a silhouette painter, a portraitist, actor and scene painter. Returned to Dublin where he got into debt, so came back to England and tried unsuccessfully for a Cambridge fellowship. Exhibited at RA (11) 1787-93. Opened a bookshop in Pall Mall 1801, but became ill and finally committed suicide 8 May 1814.
Represented: NPG London; BM; VAM. **Engraved by** W.Evans, J.Nixon, C.Picart.

GARDNER, Daniel 1750-1805
Born Kendal. Attended town's grammar school, where he was a fellow pupil with G.Romney. Left for London c.1767/8, where he is believed to have worked with Romney. Entered RA Schools 17 March 1770 (Silver Medallist 1771), where he received tuition from Zoffany, Dance and Bartolozzi. Exhibited at RA (1), before briefly assisting in Reynolds' studio c.1773. Established a fashionable practice. Specialized in small-scale portraits in crayons or gouache, often borrowing Reynolds' poses. His oils date from c.1779 and are rare. A friend of Constable. Some of his oil portraits have been attributed to that artist. Married Nancy Howard c.1776/7. A son, George, was born 1778. His wife and second son died shortly after the birth, and he never fully recovered from the shock, sending his son George to be looked after by a friend in Kendal. Died from a liver complaint in London 8 July 1805 aged 55. Redgrave writes: 'He had a nice perception of beauty and character, and composed with elegance'.
Represented: Abbot Hall AG, Kendal; NPG London; Tate; Montacute House, NT; Yale. **Engraved by** J.Caldwall, W.Dickinson, W.Doughty, W.C.Edwards, V.Green, J.Heath, J.Jones, R.Josey, T.Watson. **Literature:** G.C.Williamson, *D.G.*, 1921; D.G. Kenwood House exh. cat. 1972; DA.
Colour Plate 25

GARLAND, Charles Trevor fl.1874-1907
Exhibited at RA (27), BI (19), SBA (18) 1874-1901 from London and Paris. By 1892 he had moved to Chyoone Grove, Paul, Penzance. Painted a number of portraits of children with their pets. Recorded in Colchester 1907.

GARLAND, Theodore fl.1852-1853
Listed as a portrait painter in Exeter.

GARLAND, William d.1882
Exhibited at RA (4), SBA (10) 1857-75 from Winchester. Died 30 August 1882.

GARNERY, Priori fl.1785-1795
Exhibited at RA (3) 1785 from London. His portrait of 'Miss Simonet, the First Female Balloonist' was reproduced in mezzotint by Pergolesi 1795.

GARNETT, Miss Ruth fl.1893-1908
Exhibited at RA (10) 1893-1908 from London. Among her sitters were Sir Robert Head, Bart, and Gwendolen, daughter of the Late Captain G.Sutherland Morris.

GARRAND, Jean Baptiste d.1780
His portrait of John Turberville Needham is in NPG London.

GARRARD, George ARA 1760-1826
Born 31 May 1760 (baptized 24 June 1760), son of Robert Hazlewood Garrard and Miriam. Studied under Sawrey Gilpin (whose daughter he married). Entered RA Schools 1778. First specialized in animal paintings, occasionally accompanied by the owner. Started to produce a number of sculptured busts c.1795, and from 1813 occasionally exhibited portraits, for which he showed a talent. Exhibited at RA (216), BI (14), SBA (9) 1783-1826. Elected ARA 1800. Among his sitters were Colonel Beaumont, MP for Northumberland, and Sir A.Corbet, Bart. Died Brompton 8 October 1826.
Represented: BM; SNPG. **Engraved by** J.C.Stadler & T.Morris. **Literature:** DA.

GARRARD, Marc see GHEERAERTS, Marcus

GARRATT, Arthur Paine b.1873
Born London 17 July 1873. Exhibited at RA (13), RP, NPS and Paris Salon 1908-19. Also painted churches in London, Oxford, Eton and Harrow.

GARRAWAY, George Hervey b.1846-after 1929
Born in Dominica, West Indies 2 October 1846. Studied at Heatherley's and at École des Beaux Arts. Exhibited at RA (4), SBA, RI, LA from 1870 from London, Liverpool and Florence.
Represented: Walker AG, Liverpool.

GARRISON, J. fl.1706-1713
Painted portraits probably in the Wigan area, where his portrait of the Bradshaigh family was formerly at Haigh Hall. Jacob and John Garrison were witnesses to the will of the painter W.W.Claret in 1706.

GARVIE, Thomas Bowman 1859-1944
Born Morpeth 6 February 1859. Studied at local Mechanics' Institute, Calderon's School, RA Schools and Académie Julian, Paris under Fleury and Bouguereau. Visited Italy and worked in Morpeth before settling in Rothbury, Northumberland c.1894. Exhibited at Bewick Club, Newcastle, RA (13), RSA, Glasgow Institute of Fine Arts, Laing AG, Walker AG, SBA 1884-1944. One of Northumbria's most successful portrait painters. Died Forest Hall, Newcastle.
Represented: Laing AG, Newcastle; Cragside, NT; Sunderland AG. **Literature:** Hall 1982.

GASCARS, Henri c.1635-1701
Born Paris. Studied in Rome 1659. Agréé at Paris Academy 1671. Left for England 6 March 1672, where he was patronized by the Duchess of Portsmouth. Painted portraits for the court circle, some of which were reproduced in mezzotint. Left England c.1677 and the following year painted the signing of the peace treaty at Nijmegen. Received in the French Academy 1680. Travelled to Modena 1681, Venice 1686, Poland 1691 and eventually to Rome, where he died 18 January 1701.
Represented: Goodwood; NMM. **Engraved by** E.Baudet, P.Vanderbank. **Literature:** DA.

GASH, Walter Bonner 1869-1928
Born Lincoln 2 February 1869. Studied at Lincoln School of Art and Académie des Beaux Arts, Anvers. Exhibited at RA (5), Paris Salon 1918-28. Taught art at Kettering Grammar School.

GASKIN, Arthur Joseph ARE RBSA 1862-1928
Born Birmingham March 1862, son of Henry and Harriet Gaskin. Educated Wolverhampton Grammar School. Studied at London School of Arts and Crafts, and Birmingham School of Art. Taught tempera painting by J.E.Southall, with whom he visited Italy 1897. Exhibited at RA (3), SBA (8), RBSA (170) from Birmingham, Warwickshire and Chipping Campden. Elected RBSA 1903, ARE 1927. Also illustrated *Shepherd's Calendar* published by William Morris, Kelmscott Press 1897. Died Egbaston, Birmingham 4 June 1928.
Represented: Birmingham CAG.

GASPARS, John Baptist fl.1641-1692
Reportedly born Antwerp. Believed to have studied under Willeboerts and Bossaert. Master at Antwerp 1641/2 (as Jan Baptist Jaspers). Moved to England by 1650, when he was a buyer at the Commonwealth sale. Entered the service of General Lambert, whom he taught to paint. Leading assistant in Lely's studio from c.1660, but also worked for Riley and Kneller. Sometimes produced work on his own using 'postures' borrowed from Lely, Riley and Kneller.
Represented: Lamport Hall; Blickling, NT.

GAST, Frank fl.1891-1892
Exhibited at RA (2), SBA (3) 1891-2 from Haverstock Hill, London.

GAUCI, G. fl.1810-1823
Exhibited at RA (9) 1810-23 from London. Painted a portrait of 'His Excellency the Persian Ambassador'.

GAUGAIN, Philip Augustus 1791-1865
Born London 17 May 1791 (baptized 12 June 1791), son of Thomas and Maria Gaugain. Exhibited at RA (12), BI (8), SBA (1) 1808-47 from London and Southampton. Exhibited at Henry Buchan's Picture Gallery, High Street, Southampton. A freemason at Royal Gloucestershire Lodge (No.212). His portraits of local freemasons James Barlow Hoy and Mr Rudd were reproduced as lithographs 1830. Also painted a portrait of Charles E. Deacon for Masonic Hall, Southampton, reviewed by the *Hampshire Advertiser* (November/December 1829): 'The likeness is most admirable, and we have never, in fact, seen a more successful portrait'. Returned to London c.1838, with his wife Anne (also an artist). Died Newington Butts, Surrey 3 January 1865.
Literature: *Hampshire Chronicle* 22 February 1830.

GAUGAIN, Thomas c.1756-c.1805
Born Abbeville, France 24 March 1756 (not 1748 Bénézit). Entered RA Schools 1771. Exhibited at RA (7) 1778-82 from Soho. Married Marianne Ame LeCointe in Soho 17 June 1787. Also a copyist and engraver. Died London.
Literature: DA.

GAULD, John Richardson ARCA c.1886-1962
Born Gateshead. Studied at RCA. Exhibited in Newcastle and at RA (4) 1905-37. Appointed Chief Assistant at Huddersfield School of Art. Based in the Midlands.
Represented: BM; VAM; Bolton AG; Darlington AG; Laing AG, Newcastle; Rochdale AG; Salford AG. **Literature:** Hall 1982.

GAUNT, Thomas Edward fl.1876-1892
Exhibited at RA (3), SBA (11) 1876-84 from The Elms, Philip Lane, Tottenham.
Represented: NPG London. **Engraved by** T.L.Atkinson.

GAUPP, Gustav Adolf b.1844
Born Markgröningen 19 September 1844. Studied in Stuttgart and Munich. Exhibited in Berlin and Munich 1876-90 and at RA (1) 1884 from London.
Represented: Strasbourg Museum; Stuttgart Museum.

GAVEN, George fl.1750-1775
Studied at Dublin Society's Schools under Robert West, winning prizes 1756 and 1760. Set up a practice in Dublin producing crayon portraits. Exhibited at Society of Artists, Dublin 1771-5. Could paint to a high standard.
Represented: NGI. **Engraved by** J.Gainer. **Literature:** Strickland.

GAVIN, Malcolm ARSA RP 1874-1956
Born 13 October 1874, son of Alexander Gavin. Studied in Edinburgh, at South Kensington and at RA Schools. Exhibited at RSA (42), RP, GI and in Liverpool from Edinburgh and London. Elected RP 1919, ARSA 1930. Died London 4 April 1956.
Literature: McEwan.

GAVIN, Robert RSA 1827-1883
Born Leith. Exhibited at RSA (137), RA (5) 1846-82 from Edinburgh and Morocco. Elected ARSA 1854, RSA 1879. Died Newhaven, near Edinburgh 6 October 1883.
Literature: McEwan.

GAWDY, Sir John, Bart 1639-1708/9
Born 25 September 1639. Succeeded to baronetcy 1669. Died January 1708/9. Believed to have been a deaf mute, but there may be confusion with his younger brother, Framlingham, who studied painting under John Freeman with help from Lely.

GAWTHORN, Henry George d.1941
Born Northampton. Studied at Regent Street Polytechnic and at Heatherley's. Began as an architect, but concentrated on art. Exhibited at RA (7) 1917-41 from London. Died 11 September 1941.

GAYLEARD, Miss Sophia fl.1839-1846
Exhibited miniatures and portraits at RA (10), SBA (1) 1839-46 from 56 Beaumont Street, London.

GAYTON, Miss Anna M. fl.1888-1899
Exhibited portraits and sculpture at RA (9), SBA (2) 1888-99 from Much Hadham, Hertfordshire.

GAYWOOD, Richard fl.c.1650-1680
Studied under Hollar. Worked as engraver, etcher and draughtsman of portraits.
Represented: BM.

GEAR(E), John William b.1800
Born Portsmouth, son of J.Gear, marine painter to Duke of Sussex. Exhibited portraits and miniatures at RA (29), SBA (9) 1821-52 from London. Married Elizabeth Grisdale at St

ANDREW GEDDES. The six daughters of George Arbuthnot of Elderslie, Surrey, in Charles I costumes. Signed and dated 1839. 71½ x 94ins (181.6 x 238.8cm)
Christie's

Martin-in-the-Fields 19 February 1827. Painted many portraits of theatre and opera stars.
Represented: BM. **Engraved** a number of his own works.

GEDDES, Andrew ARA 1783-1844
Born Edinburgh 5 April 1783, son of David Geddes, an auditor of excise and art collector. Educated at Edinburgh High School and University. Encouraged by Wilkie. Entered RA Schools 1807. Set up as a portrait painter in Edinburgh from 1810. Visited Paris 1814 and Flanders with engraver John Burnet. Married daughter of miniaturist N.Plymer 1827. The couple travelled to Rome 1828, returning via Germany and France to London early 1831, where they were mainly based (although in Holland 1839). Exhibited at RA (100), BI (28) 1806-45. Elected ARA 1832. Among his sitters were Sir W.Allan PRSA, David Wilkie RA, Viscount Duncan, HRH the Duke of York, John Sheepshanks, John Gibson RA and Camullini, President of Academy of St Luke, Rome and Principal Historical Painter to His Holiness the Pope. Formed a collection of old masters and was influenced by Rubens and Rembrandt. Wilkie said of him: '. . . his works are so far above what is called the fashion, and in this style of art, it is my decided opinion he has more taste than any artist in Britain.' Died of consumption in London 5 May 1844. Studio sale held Christie's 8-12 April 1845. The *Art Union* wrote: 'His small full-length portraits were beautifully executed and his landscapes were remarkable for their truth and purity of feeling'.
Represented: SNPG; SNG; NPG London; VAM; BM; Walker AG, Liverpool. **Engraved by** S.Bellin, T.Hodgetts,

R.Rhodes, J.Stewart, C.Turner, W.Ward. **Literature:** Mrs Geddes, *Memoir of the late A.G.*, 1844; *Art Union* 1844 pp.148, 291; *G.*, Edinburgh exh. cat. 1921; McEwan; DA.

GEE, David 1793-1872
Son of a Coventry watchmaker who spent most of his life in the city. Educated at Green Gift School and sold his first painting, 'The Death of Nelson', when only 13. Possibly received artistic training from topographical artists Edward Rudge and Rev William Bree, and from seeing works at Coombe Abbey, Packington House and Warwick Castle. Died Coventry 9 January 1872 (not 1871). His portraits are painted in a provincial style with considerable charm. Many of his works are characterized by over-large noses.
Represented: Herbert AG, Coventry, where his own list of works is held.

GEE, Miss Lucy (Mrs H.Coxeter) fl.1897-1930
Exhibited at RA (6) 1897-1919 from Bletchley and London.
Represented: NPG London.

GEENS, J.J. fl.1828
Exhibited at RA (3) 1828 from 7 Mecklenburg Street, London. Member of Amsterdam RA.

GEEST, Julius Franciscus de fl.1656-1699
Studied under Erasmus Quellinus. Master at Antwerp 1656/7. Worked mainly at Leeuwarden, but may have visited

BENEDETTO GENNARI. James II. 78¾ x 50ins (200 x 127cm)
Christie's

Scotland. Painted a group portrait of 'The Family of the 5th Lord Blantyre' (Duke of Hamilton, Lennoxlove) which is signed 'J.de Geest 1698'. Died 25 May 1699.

GELDORP, George　　　　　　　　　　　**c.1595-1665**
Born Cologne, son of an artist. Master at Antwerp 1610. Left Antwerp for England 1665. Involved in Van Dyck's coming to England, and later specialized in copies of Van Dyck. About 1638-40 he was associated with Van Dyck in picture dealing, and later with Gerbier and Lely during the Commonwealth. After the Restoration he became Keeper of the King's Pictures. Believed to have been employed in diplomatic political negotiations under artistic cover.
Represented: Hatfield House; Hardwick Hall, NT; Leeds CAG (Temple Newsam House). **Engraved by** R.Vaughan, R.van Voerst.

GEMELL　　　　　　　　　　　　　　　**fl.1723**
Painted a portrait of 'Robert Johnson of Hilton' 1723.

GENNARI, Benedetto　　　　　　　　　**1633-1715**
Born Cento 19 October 1633, nephew of artist Guercino. Studied under his uncle, and painted in his style. Worked in Emilia and Paris. Arrived in London 24 September 1674, where he was employed by Charles II. Painted erotic mythological subjects for the dining room at Windsor and altar pieces for the Queen's Catholic chapels. Also painted portraits and kept records of his English commissions (unpublished MSS Bologna, Archiginnasio MS B344). Followed James II to St Germain 1688, where he continued in royal service up to April 1692, when he returned to Bologna. Died Bologna 9 December 1715.
Represented: Kingston Lacy, NT. **Engraved by** P.Drevet. **Literature:** D.C. Miller, 'B.G.'s Career at the Court of Charles II and James II', *Apollo* January 1983; P. Bagni, *B.G. e la Bottega del Guercino,* 1986.

GENT, P.　　　　　　　　　　　　　　**fl.c.1670**
An accomplished little known portrait artist. His portrait of Herbert Croft, Bishop of Hereford is at Croft Castle.

GENT, Mrs S.S. (née Daniell)　　　　　**fl.1826-1845**
Possibly daughter of William Daniell RA. Exhibited miniatures and portraits at RA (45), BI (1) 1826-45 from London. **Engraved by** J.Cochran.

GENTILESCHI, Artemisia　　　　　　　**1593-c.1652**
Born Rome, daughter of Orazio Gentileschi. Studied under her father. Worked under Guido Reni, studying the style of Domenichino. Accompanied her father to England 1626, and painted several pictures for Charles I and portraits for the court circle. Returned to Italy before 1630, residing principally in Naples. A renowned beauty, and famous for her portraits and amours. Eventually married Piero Antonio Schiattesi. Died in Naples.
Represented: Hampton Court. **Literature:** DNB; Clayton.

GENTILESCHI, Orazio (Horatio)　　　　**1563-1639**
Born Pisa. Studied in Rome. Employed by Pope Clement VIII on paintings in the Vatican and enjoyed considerable success. Invited to the Court of Carlo Emmanuele I of Savoy at Turin and from there travelled to Paris. Attracted the attention of George Villiers, Duke of Buckingham and moved to England 1626. His work was admired by Van Dyck, who drew his portrait. Charles I treated him with great honour, furnishing a house for him at great cost and gave him an annuity of £100. Remained in England until his death. Buried in the chapel at Somerset House. Died London 7 February 1639.
Literature: DNB; DA.

GEORGE, J.　　　　　　　　　　　　　**fl.1828-1838**
Exhibited at RA (4), SBA (7) 1828-38 from London.

GEORGE, John　　　　　　　　　　　　**fl.1763-1771**
Exhibited at FS (14) 1763-71 from London.

GEORGE, Thomas　　　　　　　　　　　**c.1790-c.1840**
Reportedly born at Fishguard. Exhibited at RA (5), BI (1) 1829-38 from London. Died Madeira.
Represented: VAM; BM; National Museum of Wales.

GERBIER, Sir Balthasar　　　　　　　**1591/2-c.1663**
Born Middelburg, The Netherlands 23 February 1591/2, son of Anthony and Radigonde Gerbier, Protestant refugees from France. Studied in Germany. Moved to England 1616 with Dutch Ambassador. Became art adviser to the Duke of Buckingham, for whom he acted as architect, decorator, miniaturist and portraitist. Remained in his employ until Buckingham's murder 1628. Naturalized 1629. Entered service of Charles I, working on diplomatic missions under the cover of artistic matters. Rubens stayed in his house 1629. Gerbier travelled to Brussels 1631-40, where he betrayed the confidence of the King to the Regent of The Netherlands. Knighted 2 October 1638 at Hampton Court. Visited Paris 1643-9, where he was an active pamphleteer. Started a general academy in Bethnal Green, London 1649, and many of his lectures and pamphlets were published. The academy did not

MARCUS GHEERAERTS (ii). Anne of Denmark. 88 x 53ins
(223.6 x 134.6cm) *Christie's*

last and he then went to Holland 1652, but returned again to
London 1661. Employed building a house for Lord Craven at
Hamstead Marshall, Berkshire where he died.
Represented: VAM; BM; Pepysian Library, Magdalene
College, Cambridge; Her Majesty the Queen of The
Netherlands. **Literature:** H.R.Williamson, *Four Stuart
Portraits,* 1949 pp.26-60; Long; DNB.

GERE, Charles March RA NEAC RWS 1869-1957
Born Gloucester 5 June 1869, son of Edward W.Gere.
Studied and taught at Birmingham School of Art. Worked as
an illustrator for William Morris's Kelmscott Press. Exhibited
at RA (132), NWG (6), RHA (1), RWS, RBSA 1890-1958
from Leamington and Painswick. Elected, NEAC 1911, RWS
1926, ARA 1934, RA 1939. Died Gloucester 3 August 1957.
Represented: Tate; Cartwright Hall, Bradford.

GERTLER, Mark NEAC 1892-1939
Born Spitalfields, London 9 December 1892, son of Louis
Gertler. Studied at Slade, winning Slade Scholarship 1911, BI
Scholarship 1912. Exhibited at NEAC (21) 1911-16. Elected
NEAC 1912. Committed suicide in Highgate 23 June 1939.
Roger Fry praised his 'persevering courage that impels him to
squeeze the last drop of significance from his subject'.
Represented: VAM; Manchester CAG; NPG London; Belfast
AG; Brighton AG; Leeds CAG; Bradford AG; Tate. **Literature:**

ROBERT GIBB. The artist's wife. Signed and dated 1893. 50 x
37ins (127 x 94cm) *Christopher Wood Gallery, London*

J.Woodeson, *M.G.,* 1972; N.Carrington (ed.), *M.G. – Selected
Letters,* 1965; *Country Life* 30 January 1992; M.G. Camden
Arts Centre & Leeds CAG exh. cat. 1992; DA.

GHEERAERTS, Marcus (ii) 1561-1635/6
Born Bruges, son of artist Marcus Gheeraerts (i), with whom he
moved to England 1568 to flee from religious persecution.
Attracted the patronage of Sir Henry Lee of Ditchley (who was
witness at the baptism of one of his children). Painted several
portraits of Elizabeth I. One of the leading and most fashionable
portrait painters of his age, until the arrival of Mytens and Van
Somer. Married Magdalena de Critz at Dutch Church, Austin
Friars 19 May 1590. She was half-sister of miniaturist Isaac
Oliver and a relative of John de Critz. There seem to be strong
links between these studios. After the death of Queen Elizabeth
he continued as court painter to James I and Queen Anne. Died
London 19 January 1635/6. Mentioned by Francis Meres in
Wit's Commonwealth (1598), as among the notable painters in
England. His highly finished portraits are of an extremely high
standard. Redgrave writes that his works 'are painted with a
neat, facile pencil – the draperies formal, and enriched with
carefully finished jewels and ornaments. His drawing is good, his
flesh-tints thin and silvery, but pleasing in colour'.
Represented: NPG London; SNPG; HMQ; Penshurst Place,
NT; BAC Yale. **Engraved by** J.S.Agar, J.Basire, S.& W.Freeman,
W.Holl, J.Houbraken, S.F.Ravenet, E.Scriven, A.Smith,
G.Vertue, R.White. **Literature:** DNB; Walpole Society Vol
XLVII 1980 pp.134-9; *Burlington Magazine,* CV April 1963; DA.

GIANELLI, Giovanni Domenico 1775-1820
Born Copenhagen 27 April 1775. Exhibited a portrait of
George III on horseback at SA 1777. Died London.
Represented: NPG London.

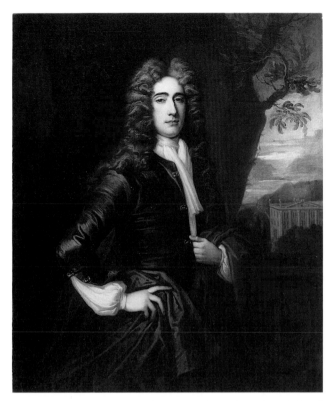

THOMAS GIBSON. A gentleman aged 37. Signed and dated 1710. 50 x 40ins (127 x 101.6cm) *Christie's*

GIBB, Robert RSA **1845-1932**
Born Laurieston 28 October 1845, son of David Gibb and Christine (née Morrison). Trained as a lithographer. Studied at RSA Schools. Became a military painter. King's Limner for Scotland 1908-32. Exhibited at RSA (119), RA (5) 1867-1916 from Edinburgh. Elected ARSA 1878, RSA 1882. Keeper of SNG 1895-1907. Died Edinburgh 11 February 1932. Sometimes confused with Robert Gibb RSA 1801-1837.
Literature: McEwan.

GIBBON, G. **fl.1818-1821**
Exhibited at RA (2) 1818-21 from London.

GIBBS, H.F. **fl.1833**
Exhibited at RA (1) 1833 from 59 Museum Street, Bloomsbury.

GIBBS, Henry **fl.1865-1907**
Exhibited at RA (31), SBA (5+) 1876-1907 from London and Crawley. Among his sitters was F.R.Pickersgill RA.

GIBBS, Percy William **fl.1894-1937**
Studied at RA Schools, where he won the Creswick Prize 1894/5. Exhibited at RA (36) 1894-1937 from London and East Molesey.
Colour Plate 27

GIBBS, R. **fl.1810**
Worked as a portrait painter in Cork.

GIBBS, Richard **fl.1845-1848**
Listed as a portrait painter in the Manchester area.

GIBBS, Snow **b.1882**
Studied at Central School of Arts and Crafts, New York School of Art and École des Beaux Arts, Paris. Exhibited at RI, ROI, PS, Paris Salon. Lived in Leigh-on-Sea, Essex.

GIBBS, Thomas Binney **b.1870**
Born Darlington 27 May 1870. Studied at Liverpool School of Art. Worked in Manchester and then London. Exhibited at RA (17), ROI, Paris Salon and International Society of Sculptors, Painters and Engravers 1901-38. Settled in Perthshire.

GIBERNE, Miss Maria R. **fl.1832-1851**
Painted portraits of Cardinals Newman and Wiseman. **Engraved by** J.A.Vinter.

GIBLET, J. **fl.1846**
Exhibited at RA (1) 1846 from Barnsbury Villa, London.

GIBSON, David Cooke **1827-1856**
Born Edinburgh 4 March 1827, son of a portrait painter (who died early of consumption). Educated at Edinburgh High School. Studied at Trustees' Academy under Sir William Allan, Charles Heath Wilson and Thomas Duncan. Aged 17 he devoted himself to portraiture to support his mother and sister, but both had died by December 1845. Travelled to Belgium and Paris, and settled in London April 1852. Exhibited at RA (5) 1855-7. Wrote humorous verses. Contracted consumption and was advised to go abroad for his health, passing the winter of 1855-6 at Malaga. Died 5 October 1856. His work was admired by E.Landseer, T.Creswick and J.Phillip.
Represented: SNPG. **Literature:** W.MacDuff, *The Struggles of a Young Artist: Being a Memoir of D.C.G. by a Brother Artist,* 1858; DNB; McEwan.

GIBSON, Edward **1668-1701**
Possibly son, or nephew, of artist Richard Gibson, whom he studied under. Buried at Richmond, Surrey 1701 aged 33. His self portrait in chalks 1690 is in NPG London.

GIBSON, J.D. **fl.1827**
Exhibited at RA (2) 1827 from 31 Cromer Street.

GIBSON, John **d.1852**
Born and worked in Glasgow. Exhibited at West of Scotland Academy. On 7 October 1852, while on the hanging committee of the academy, he fell down the stairs and died the following night at 'an advanced age'.
Represented: SNPG. **Literature:** DNB.

GIBSON, Joseph Vernet **fl.1861-1888**
Exhibited at RA (6), RHA (2), BI (1), SBA (1) from London and Manchester. Also recorded as Joseph Vincent.

GIBSON, Thomas **c.1680-1751**
From 1711 he was an active director of Kneller's Academy (in whose manner he painted). Established a successful portrait practice in London, charging 12 guineas for a half-length (1728). Highmore said that Sir James Thornhill sometimes employed him to sketch figures in difficult action. Painted a portrait of his pupil George Vertue 1723. Fell seriously ill c.1729 and left London. Returned c.1732, after a stay in Oxford had restored his health. His last recorded works were of the Princess of Wales and her children (1742). Died London 28 April 1751 aged about 71.
Represented: Society of Antiquaries; NPG London; Bodleian Library; NMM; Magdalen College, Oxford. **Engraved by** J.Baker, A.Birrell, G.Bockman, G.Dawe, J.Faber, T.Holloway, J.Houbraken, A.Johnson, Page, P.Pelham, B.Reading, Rivers, P.Schenck, J.Simon, J.Smith, J.Thomson, M.vr.Gucht, G.Vertue, G.White. **Literature:** DNB; DA.

GIBSON, Thomas **1810-1843**
Born North Shields, son of James Gibson. Exhibited in Newcastle, Carlisle and SBA (4) 1833-41. Moved to London 1841, but visited Carlisle, where he enjoyed a successful reputation as a portrait painter. Died London.

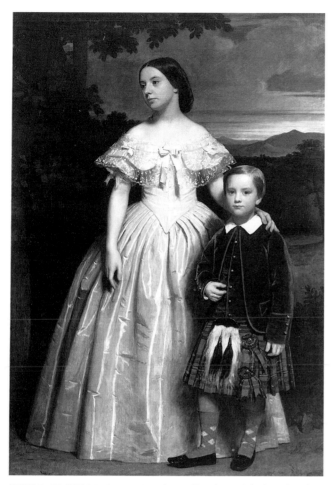

JOHN GRAHAM GILBERT. Anne Barclay with her brother Robin. Signed and dated 1858. 76 x 50ins (193.1 x 127cm)
Christie's

JOSIAH GILBERT. Three girls. Signed and dated 1860. Pastels. 24½ x 19ins (62.2 x 48.2cm) *Christopher Wood Gallery, London*

GIBSON, William c.1644-1703
Nephew and pupil of dwarf miniaturist R.Gibson. Studied under Lely, and purchased part of Lely's collection after his death. Employed by Henry Cavendish, Earl of Ogle, son of 2nd Duke of Newcastle. Reportedly buried Richmond 1702 aged 58, although records show he was buried St Giles-in-the-Fields, Richmond 11 December 1703. The *Daily Courant* 13 March 1704 announced the 'Sale of drawings & prints of William Gibson, Limner, lately deceased, at the lowermost Great House, in the Arched Row, over against the end of Portugal Row, in Lincoln's Inn Fields'.

GIFFORD, E.A. fl.1833-1876
An architect and amateur painter. Exhibited at RA (14), BI (6), SBA (16) 1833-76 from Fulham, Pimlico and Battersea. Retired by 1870 to Sycamore Cottage, Lansdown, Bath.

GILBERT, Albert Thomas Jarvis ROI d.1927
Born London. Exhibited at RA (11), ROI, Langham Sketching Club 1907-27. Elected ROI 1909. Died 14 June 1927.

GILBERT, Sir John RA PRWS 1817-1897
Born Blackheath 21 July 1817. Gave up his career as an estate agent 1836 to take up painting, receiving guidance from G.Lance. Illustrated about 150 books and contributed nearly 30,000 drawings for *The Illustrated London News*. After 1851 he devoted himself to watercolours and mainly painted historical genre, although he did produce some portraits. Exhibited at RA (55), BI (40), SBA (23) 1836-97. Elected AOWS 1852, OWS 1854, POWS 1871, knighted 1871, ARA 1872, RA 1876. Died 5 October 1897.
Represented: NPG London; BM; VAM; Tate; Ashmolean; SNG; Manchester CAG; Newport AG; Towneley Hall, Burnley; Haworth AG, Accrington. **Engraved** by J.Faed, W.Walker. **Literature:** R.Davies, 'Sir J.G.', OWS Vol X; R.Ormond, *Country Life* 18-25 August 1966.

GILBERT, John Graham RSA 1794-1866
Born John Graham in Glasgow. Entered RA Schools 1818 (Silver Medal 1819 and Gold Medal 1821). Travelled in Italy for two years where he met John Gibson RA and acquired a taste for collecting Italian old masters. Settled in Edinburgh, where he was based. Married an heiress, Miss Gilbert of Yorkhill, 1834 and moved to Glasgow, changing his name to John Graham Gilbert. However, he is recorded as having signed works 'John Graham' until 1841. Exhibited at RSA (186), RA (18), BI (25) 1812-67. Elected RSA 1829, President of West of Scotland Academy, founder member of Glasgow Institute. Among his sitters were John Gibson RA, the Duke of Montrose and the Marquess of Graham and Sir John Watson Gordon RA, PRSA. Formed a large old master collection, now in Glasgow AG. Died Yorkhill-on-Clyde 4 June 1866. His style follows in the tradition of Raeburn.
Represented: NPG London; SNPG; Glasgow AG; Mount Stuart. **Engraved** by R.C.Bell, E.Burton, J.Horsburgh. **Literature:** DNB; McEwan; DA.

GILBERT, Josiah 1814-1892
Born Rotherham, son of Rev Joseph Gilbert. Studied at RA Schools and Sass's School. Became a portrait painter mostly

in pastel and watercolour. Exhibited at RA (35), BI (1), SBA (15) 1837-65 from Marden Ash, near Ongar and in London. Among his sitters were Lord Worsley, the Marquess of Downshire, Lord Edward Hill MP and Lady Pilkington and her son. Gained a reputation for painting children's portraits. Died Marden Ash 15 August 1892. Left his widow, Mary, £12,994.17s.10d.
Represented: NPG London; Castle Museum, Nottingham.

GILBERT, Varnee **fl.1888**
Exhibited at SBA (1) 1888 from London.

GILBERT, William H. **fl.1888/9**
Exhibited at SBA (1) 1888/9 from London.
Represented: Lancaster AG.

GILCHRIST, Mrs **fl.1774-1775**
Exhibited at SA (5) 1774-5 from London and Surrey.

GILDAVIE, James **fl.1846-1868**
Worked as a portrait painter in Edinburgh before moving to London. Listed as a portrait painter in Birmingham, Wolverhampton and Hanley. Exhibited RA (1), RSA (7) 1846-56.

GILES, B. **fl.1828**
His portrait of John Meffen, minister at Great Yarmouth, was published by Wightman & Cramp 1828 (BM).

GILES, John Alfred **fl.1849-1862**
Exhibited at RA (5) 1849-62 from London. Painted in a charmingly naïve style and could achieve a very high quality. His sitters often have a china doll-like appearance.

GILES, Peter **fl.1810-1825**
Worked in Glasgow, before settling in Belfast c.1810. Also taught drawing and painting in Shaw's Academy.

GILES, Robert Humphrey **fl.1826-1877**
Exhibited portraits and miniatures at RA (48), SBA (20) 1826-77 from Gravesend, London and Plymouth. Headmaster of St George's Church of England Secondary School, Gravesend 1825-30.

GILFILLAN, John Alexander **1793-1866**
Born Jersey. Taught at Glasgow School of Art. Moved to Australia and worked at Sydney, Adelaide and Melbourne. Died Melbourne.
Represented: SNPG; VAM; Glasgow AG.

GILL, Charles **1742-c.1828**
Born Bath, son of a leading pastry cook. Entered RA Schools 1769. Pupil of Reynolds 1771-4 before setting up practice in Bath. Moved to London by 1781. Exhibited at RA (14) 1772-1819. Became crippled and received charity from RA 1796-1828.
Represented: Tate.

GILL, E.W. **fl.1843-1868**
Exhibited still-life at RA (11), SBA (1) 1843-68 from Hereford and Hoxton.
Represented: NPG London.

GILL, R. **fl.1807-1825**
Exhibited at RA (3) 1807-25 from London.

GILL, Samuel Thomas **1818-1880**
Born Perriton, near Minehead 21 May 1818, son of Rev Samuel Gill. Educated at Plymouth and at Dr Seabrook's Academy. Started work in the Hubbard Profile Gallery,

producing silhouettes. Reached South Australia December 1839 with his parents. Established a studio in Adelaide, which was open from 'eleven to dusk'. Went on J.A.Horrocks' expedition, which ended when Horrocks died from a gun accident. He raffled drawings of the expedition 1846/7. Published a number of lithographs. Collapsed and died Melbourne 27 October 1880.
Represented: National Library, Canberra; NG Victoria; New South Wales AG. **Literature:** Australian Dictionary of Biography; DA.

GILL, William RBA **fl.1826-1869**
Exhibited at RA (18), BI (22), SBA (46) 1826-69 from London, Warwick and Leamington. Elected RBA 1848.

GILLARD, William **b.c.1812**
Born in England. Exhibited at RHA (72), RA (1) 1831-76 from Bristol, Dublin, Chester, Belfast and Liverpool.
Literature: Strickland.

GILLIES, Miss Margaret OWS **1803-1887**
Born London 7 August 1803, daughter of William Gillies a Scottish merchant. After the early death of her mother she was brought up by her uncle, Lord Adam Gillies, an Edinburgh judge. There she met Sir Walter Scott, Jeffrey and Lord Eldon. Moved to London when she was about 18, where she studied miniature painting under F.Cruickshank. Before she was 24 she was commissioned to paint a miniature of Wordsworth. Also painted Charles Dickens. Exhibited at RA (101), RSA (14), BI (2), SBA (8), OWS (254) 1832-61. Elected OWS 1852. Went briefly to Paris 1851, where she studied under Hendrick and Ary Scheffer. On her return she concentrated on watercolours. Died from pleurisy near Edenbridge 20 July 1887. Sometimes signed with her initials 'M.G.'. The *Art Union* 1839 commented: 'This lady will hold place among the most successful exhibitors in the gallery. Her touch is free and firm, she designs with masculine boldness and finishes with feminine delicacy. She knows her art well and though she draws upon imagination she does not sacrifice truth'.
Represented: NPG London; BM; VAM. **Engraved by** J.C.Armytage, Finden, A. Heath, F.A. Heath. F. Holl. **Literature:** *The Times* 26 July 1887; DNB.

GILMAN, Harold John Wilde **1876-1919**
Born Rode, Somerset 11 February 1876, son of a clergyman. Studied at Hastings Art School 1896 and Slade from 1897. Joined Sickert's circle in Fitzroy Street. Painted some sensitive portraits in the British Post-Impressionist style, of which he was a leading and influential exponent. A founder member of Camden Group 1911. After teaching at Westminster School of Art he founded a school with his friend Ginner. Died London 12 February 1919.
Represented: Tate; Southampton CAG; Brighton AG; Leeds CAG; Manchester CAG. **Literature:** W.Lewis & L.F.Fergusson, *H.G.*, 1919; *H.G. – English Post-Impressionist*, Colchester, Oxford, Sheffield exh. cat. 1969; *H.G.*, Arts Council exh. cat. 1981; DA.

GILROY, John Thomas Young ARCA FRSA **b.1898**
Born Newcastle, son of J.W.Gilroy. Attended Armstrong College and after serving in the 1st World War won a scholarship to RCA. Settled in London as a portrait painter and commercial artist. Taught at Camberwell School of Art. Exhibited at RA (23), RP, NEAC, Laing AG, Fine Art Society (over 100 works) 1930-53. Painted portraits of the royal family. Created the famous series of Guinness posters published 1925-60.
Represented: NPG London; Belfast AG; Laing AG, Newcastle; Leeds CAG; Walker AG, Liverpool.

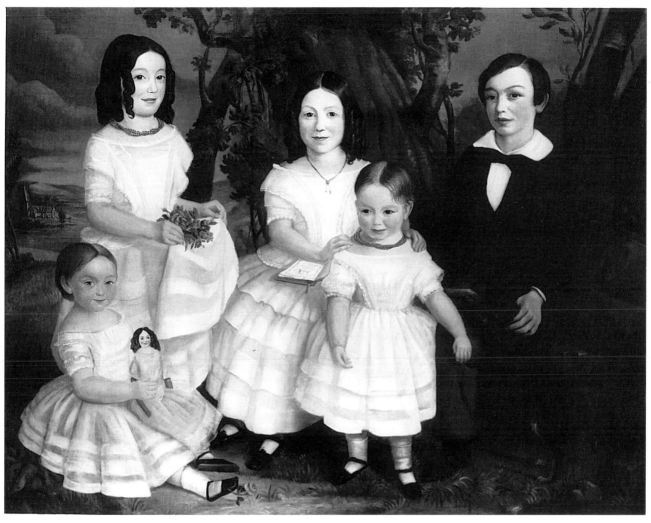

JOHN ALFRED GILES. A family group. Signed. 45¼ x 57ins (114.9 x 144.8cm)

Sotheby's

GILROY, John William **1868-1944**
Born Newcastle. Exhibited there at Bewick Club and in provincial exhibitions. Painted a number of marine works, but also portraits. Practised in Newcastle until the early 1920s, when he moved to Whitley Bay.
Represented: Laing AG, Newcastle; Shipley AG, Gateshead.

GINNETT, Louis **ROI** **1875-1946**
Educated at Brighton Grammar School. Studied art in Paris and London. Exhibited at RA (31), ROI 1907-41 from London and Ditchling, Sussex. Died 12 August 1946.
Represented: NPG London; Brighton AG.

GIRARDOT, Ernest Gustave **RBA** **fl.1860-1893**
Exhibited at RA (18), BI (11), SBA (76) 1860-93 from London. Elected RBA 1874. Painted portraits of the poet Alfred Tennyson, the Hon. Mrs James Williamson, Her Excellency the Lady Lytton and L.D.Powles Esq of the Inner Temple; Stipendiary and Circuit Magistrate, Bahama Islands.

GIULIANI, Don Andrea **fl.1853**
Born Livourne. Exhibited portraits of 'HRH the Duke of Montpensier in the uniform of Cavalier Maestrante of Grenada' and 'HRH the Duchess of Montpensier, Infanta of Spain' at RA (2) 1853 from London. Director of Academy of Fine Arts, Grenada and Painter in Ordinary to HIM the Emperor of Brazil.

GLADSTONE, Thomas **1803-1832**
Scottish portrait painter. Nephew of Robert Gladstone of Capenoch.
Represented: SNPG. **Literature:** McEwan.

GLASGOW, Alexander **fl.1859-1884**
Exhibited at RA (15), BI (6), SBA (16) 1859-84 from London. Among his sitters were the Hon. Robert Curzon and Son; Viscount Sydney GCB, Charles Dickens and Admiral Sir Walter J.Tarleton KCB.

GLASS, James William jnr **1825-1857**
Born Cadiz, son of the British Consul there. Became a pupil of Huntington in New York 1845. Visited London 1847. Duke of Wellington sat for him July 1852. His 'Last Return from Duty' (an equestrian portrait of the Duke of Wellington) brought him considerable attention. It was bought by Lord Ellesmere and a duplicate was ordered by Queen Victoria. Exhibited at RA (8), RHA (4), BI (16), SBA (5) 1848-55 (Graves 1969 and 1970 muddles him with John H.Glass). Returned to America 1856. Committed suicide in New York City.
Represented: HMQ.

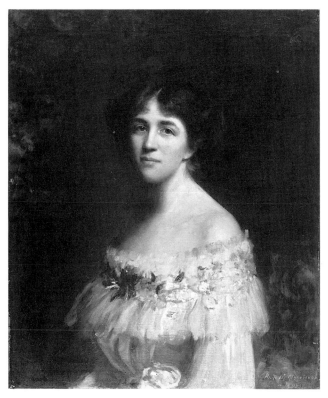

HUGH DE TWENEBROKES GLAZEBROOK. A lady. Signed and dated 1903. 34¾ x 28¾ins (88.3 x 73cm) *Christie's*

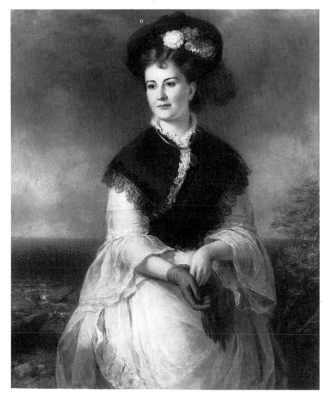

SAMUEL BERRY GODBOLD. Miss Clare Galwey. Signed with initials. 50 x 45ins (127 x 114.3cm) *Christie's*

GLASSON, Lancelot Miles **b.1894**
Born Twickenham, son of Lancelot T.Glasson, a barrister. Educated Marlborough School. Studied at RA Schools. Exhibited at RA (13) 1928-49 from London.

GLAZEBROOK, Hugh de Twenebrokes RP
1855-1937
Born Hampstead March 1855. Educated at Dulwich College. Studied at South Kensington under Poynter, and in Paris under Bonnat. Exhibited at RA (56), RHA (10), RP, NWG, GG (4) 1885-1924 from London. Elected RP 1891. Visited Toronto, Italy, Spain, Germany, Austria, Holland and Belgium. Died Alassio 6 May 1937.
Represented: NPG London; Stratford-on-Avon AG; NG of Canada, Ottawa.

GLEW, Edward Lees **1817-1870**
Born Dublin 3 March 1817, son of Thomas Faulkner Glew and his wife Suzanne Purcell. Educated at Trinty College, but left without taking his degree. Exhibited at RHA (6) 1849 from Dublin. Moved to England and settled at Walsall. Published *A History of Walsall* (1852). Started a newspaper in Birmingham. Went to America and practised as a painter in New York, Philadelphia and Trenton. Died Newark, New Jersey 9 October 1870. **Represented:** NGI. **Literature:** Strickland.

GLIDDON, Ann **fl.1840**
Her portrait drawing of George Henry Lewes is in NPG London.

GOBLET, Henry F. **fl.1822-1836**
Believed to be son of sculptor Lewis Alexander Goblet. Exhibited at RA (9), BI (1), SBA (5) 1822-36 from London. Among his sitters was Lord Cranstown.

GODBOLD, Samuel Berry **c.1823-1884**
Born London, son of George Berry Godbold, Clerk in Holy Orders. Exhibited at RA (67), RHA (21), BI (13), SBA (45) 1842-80 from Dublin and London. Married Henrietta Charlton Orton 19 February 1853 at All Souls, Langham Place. Among his sitters were Dr Inglis of the 10th Regiment and Prince Gholam Mohumed, son of the late Tippo Sultan. Collaborated with R.Ansdell. Died at Bethlehem Lunatic Hospital in June 1884. His watercolour portraits were influenced by George Richmond.

GODDARD, James **b.1756**
Born 23 January 1756. Entered RA Schools 18 December 1771 'aged 15.23 Jan last'. Exhibited at FS (10) 1782-3 from London. **Engraved by** B.Reading.

GODELET, F. **fl.1818-1826**
Exhibited at RA (2) 1818-19 from London. Recorded there 1826.

GOETZE, Sigismund Christian Hubert **1866-1939**
Born London 24 October 1866, son of James Henry Goetze. Studied at Slade and RA Schools. Exhibited at RA (39), GG, Paris Salon 1888-1939 from London. Also painted murals at the Foreign Office. Died 24 October 1939. Left his widow £117,814.11s.10d.
Literature: S.Goetze, *Mural Decorations at the Foreign Office, Descriptive Account by the Artist*, 1921.

GOFFEY, Harry **1871-1952**
Born Liverpool 31 May 1871. Studied at Liverpool School of Art and under Herkomer at Bushey. Exhibited at RA (12) 1906-47 from Berkhamsted, Hertfordshire. Died at Napsbury Hospital, St Albans 1 January 1952 (not 1951).

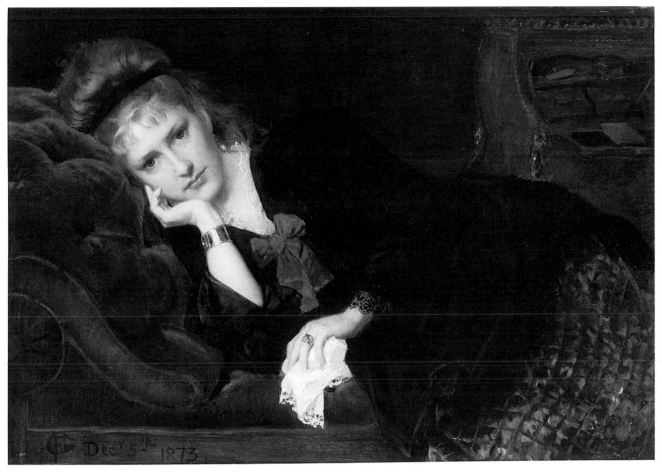

FREDERICK GOODALL. Alice, the artist's wife. Signed with monogram and dated 5 December 1873. 14¾ x 21ins (37.5 x 53.3cm)
Christopher Wood Gallery, London

GOGIN, Charles **1844-1931**
Born London. Studied under J.P.Laurens. Exhibited at RA (14), RHA (4), SBA (3) 1874-94 from London and Shoreham. Died Redhill 23 January 1931.
Represented: NPG London; Glasgow AG; Brighton AG; Cartwright Hall, Bradford; Hove Library.

GOHLI **fl.1773**
Exhibited half-length portraits of the Prince and Princess of Brunswick at SA (2) 1773. May have been Johann Gottfried Göhle, who worked in Bunzlau.

GOLD, F. **fl.1819-1820**
Exhibited a landscape and a portrait of 'Sir W.W.Doveton' at RA (2) 1819-20 from 3 College Green, Bristol.

GOLDBECK, Walter Dean **1882-1925**
Born St Louis. Studied in Berlin, London, Chicago and Paris. Established a successful international socialite practice. Among his sitters were Count John McCormack and Paderewski.
Represented: Dartington Hall.

GOMERSALL, Thomas **fl.1670-1683**
Believed to be from Chester. Married at Wrexham 1670 and then moved to Shrewsbury. Painted a portrait at Chirk 1683.
Literature: W.M.Myddleton (ed.), *Chirk Castle Accounts,* 1931 p.158.

GOOCH, James **fl.1825-1837**
Exhibited at SBA (6), BI (6) 1825-37 from Norwich and London. Related to artists Thomas and John Gooch.

GOOD, Thomas Sword **HRSA** **1789-1872**
Born Berwick-upon-Tweed 4 December 1789. Began as a house painter, taking portraits in his spare time. Studied under Wilkie. Exhibited at RSA (17), RA (19), BI (43), SBA (2) and in Carlisle and Newcastle 1815-50. Elected HRSA. Among his sitters was Thomas Bewick. Married a wealthy woman 1839, and reduced his output. Died at his home in Quay Walls, Berwick-upon-Tweed 15 April 1872 aged 82.
Represented: NG London; NPG London; NGI; Fitzwilliam; SNPG; VAM; Tate; Grays AG, Hartlepool; Laing AG.
Literature: *Country Life* 23 January 1948; Hall 1982.

GOODALL, Frederick **RA** **1822-1904**
Born London 17 September 1822, son of engraver Edward Goodall. Aged 14 won a Silver Medal at SA 1837. Toured Ireland with artist F.W.Topham 1843. Began painting genre subjects in the Wilkie tradition, but later specialized in Egyptian scenes and biblical genre, at which he excelled. Exhibited at RA (165), BI (33), RHA (1), SBA (6) 1838-1902. Elected ARA 1852, RA 1863. Exhibited his first portrait at RA 1872, when he showed 'The Rt Hon Sir John McNeill GCB'. However, it was not until 1888 that he exhibited his next portrait, this time the sitter was Lady

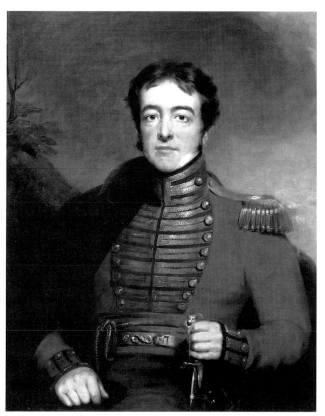

JOHN WATSON GORDON. Major Archibald Oliver of Oberton Bush. Signed and dated 1826. 35 x 28ins (88.9 x 71.1cm)
Christie's

Grantley, but from this time portraits were regularly among his exhibits including those of Sir Moses Montefiore Bart, Sir Oscar Clayton CMG and Lady Dorothy Nevill. At the height of his career he was earning over £10,000 a year, but he was not good with money and in 1902 was declared bankrupt. Died London 28 July 1904 leaving effects of £120. Two of his sons, Frederick Trevelyan Goodall and Herbert H.Goodall, were painters.
Represented: NPG London; BM; VAM; Tate; Brighton AG; Manchester CAG; Sydney AG. **Literature:** *Art Journal* 1850 p.213, 1855 pp.109-12; DA.

GOODALL, Frederick Trevelyan c.1848-1871
Son of Frederick Goodall RA. Studied at RA Schools. Exhibited at RA (17) 1868-71 London, winning Gold Medal 1869. Visited Italy, where he was killed in an accident at Capri 11 April 1871, aged 23.
Represented: VAM. **Literature:** DNB; Redgrave.

GOODALL, John Edward fl.1877-1911
Exhibited at RA (10) 1877-1911 from London.
Represented: NPG London.

GOODALL, Walter RWS 1830-1889
Born London 6 November 1830, son of Edward Goodall. Studied at Government School of Design and RA Schools. Also attended Clipstone Street 'Academy' (later the Langham Sketching Society). Exhibited at RA (3), OWS (156), RMI from London. Elected AOWS 1853, OWS 1861. Spent winter of 1868-69 in Rome and also visited Venice. Became partially paralysed 1875 and eventually totally helpless. Died Clapham, Bedfordshire 14 May 1889.
Literature: DNB.

GOODCHILD, Miss Emily fl.1890-1897
Exhibited at RA (5) 1890-7 from Hampstead.

GOODEN, Master H. fl.1774
Exhibited at FS (1) 1774 from Tottenham Court Road, London.

GOODERSON, Thomas Youngerman fl.1846-1860
Exhibited at RA (21), BI (14), SBA (24) 1846-59 from London.
Represented: NPG London.

GOODMAN, Mrs Julia see SALAMAN, Miss Julia

GOODMAN, Walter b.1838
Born London 11 May 1838. Spent time working in Europe. Exhibited RA (3), RSA (4), BI (2), SBA (1) 1859-90 from London and Brighton. Among his sitters were 'His Excellency Kuo-Ta-Jen, the Chinese Minister at the Court of St. James' and author Wilkie Collins.

GOODRICH, Jerome c.1803-1874
Son of Robert Franklin Goodrich, a clerk. Exhibited at RA (3), BI (6), SBA (3) 1829-59 from London and Rotherham. Worked in Worthing and Brighton. Married Emily Day, daughter of a wine merchant at St Olave Hart, London 27 December 1845. Died Bishop's Stortford 14 February 1874. His son, Jerome, was also an artist.

GOODWIN, James b.c.1827
Born Kensington. Listed as a portrait painter in 1861 census for Brompton. Then a widower aged 34, with two daughters.

GORDIGIANI, Michele 1830-1909
Born Florence. Exhibited at RA (3) 1867-86 Florence and London. Died 7 September 1909.
Represented: NPG London.

GORDON, G. fl.1821-1840
Exhibited at RA (2) 1821-40 from London. May be G.C.Gordon, who exhibited topographical views at SBA (4) 1856-8 from Camden Town.

GORDON, Sir John Watson RA PRSA 1788-1864
Born John Watson in Edinburgh, son of Captain J.Watson RN. Brought up in Stockbridge. Studied at Trustees' Academy under Graham and in the studio of his uncle George Watson PRSA. Began painting genre and history subjects, but concentrated on portrait painting by 1821. Added the name Gordon 1826, to distinguish himself from his uncle and two cousins also practising in Edinburgh. A close friend of Raeburn, who influenced his style. Also influenced by Lawrence and Velázquez. After Raeburn's death 1823, he became the leading Scottish portrait painter. Exhibited at RA (124), SBA (1), BI (3), RSA (294) 1809-65. Elected RSA 1829; ARA 1841; RA 1851; PRSA, knighted and Limner to the Queen in Scotland 1850. Among his sitters were Sir Walter Scott, the Duke of Buccleuch, Thomas de Quincy, John F.Lewis, David Roberts, Francis Grant, David Cox and HRH the Prince of Wales. Died of a stroke in Edinburgh 1 June 1864. Caw described his style as 'simple, sincere, and, at its best, gravely beautiful'. Capable of producing unusual compositions. His paint is often applied with the richness of a true master. Usually drew studies of his subjects' heads and hands in pencil before painting. His method of laying colour was to lay down the various pigments side by side like a mosaic, not on to twill canvas but on to the smoother, less absorbent surface of Scotch sheeting. Unlike Raeburn he did not blend his separate tints to achieve an overall warmth of tonality.
Represented: NPG London; Tate; SNPG; Walker AG, Liverpool; Royal Company of Archers, Edinburgh;

Philadelphia Museum of Art. **Engraved by** E.Burton, S.Cousins, H.Dawe, T.Fairland, S.Freeman, T.Hodgetts, R.J.Lane, T.Lupton, J.B.Shaw, J.Sinclair, J.T.Smyth, J.Stephenson, J.Stewart, G.Stodart, J.A.Vinter, W.Walker, G.Zobel. **Literature:** DNB; McEwan; DA.

GORDON, Miss Nora Mary fl. 1916-1937
Studied at St John's Wood. Exhibited at RA (5), RSA from Alton, Hampshire.

GOSSE, William fl.1814-1839
Exhibited at RA (2) 1814 and 1839 from London. Among his sitters was Thomas Bell FRS, Professor of Zoology in King's College.
Represented: NPG London.

GOTCH, Thomas Cooper RBA RI RP 1854-1931
Born Kettering 10 December 1854, son of Thomas Henry Gotch and Mary Ann (née Gale). Studied at Heatherley's; École des Beaux Arts, Antwerp; Slade and in Paris under J.P.Laurens. Married Caroline Yates. Travelled to Australia 1883. Returned to London, but settled in Newlyn 1887 (he had first visited in 1879). Visited Italy 1891, and developed a more symbolic style. Exhibited at RA (69), SBA (22+), RHA (8), OWS, NWS, GG, NWG, RP, Munich, Paris, Chicago 1880-1931. Founder NEAC, RBA 1885, RI 1912, Founder of RBC 1887 and President 1913-28. Elected RP 1913. Moved to Shottermill, Surrey. Settled in Newlyn. Died Newlyn 1 May 1931. A retrospective exhibition held at Laing AG, Newcastle 1910. His wife was also an artist.
Represented: Tate; BM; Alfred East AG, Kettering; Bristol AG; Harris Museum and AG, Preston; Walker AG, Liverpool.
Literature: VAM archives; Philip Saunders, *A Catalogue Raisonné of the works of T.C.G.*, in preparation.

GOTZENBERG, F. fl.1855-1857
Exhibited at RA (2), BI (2), SBA (1) 1855-7 from London. Also worked in Oxford. The initial of his first name has also been recorded as P and J.

GOUGE, Edward fl.1690-1735
Studied under Riley. Matriculated at Padua University 1705. Painted portraits and copies in Rome 1707. Director at Kneller's Academy 1711. Buried London 28 August 1735.
Represented: Dyrham Park NT. **Engraved by** C.Grignion, G.Vertue, G.White. **Literature:** Egmont, Diary 1 September 1735, in Historical MSS Commission, 3 vols, 1920-3; B.Ford, NT Yearbook 1975/6. pp.24.

GOULD, T.Butler fl.1914-1919
Exhibited at RA (4) 1914-19 from Southport.

GOUPY, Louis c.1670-1747
Born France. Subscriber to Kneller's Academy, London 1711. Accompanied Lord Burlington to Italy 1719. Studied under L.Chéron 1720. His early portraits tended to be in oil, but he later concentrated on working in crayons or gouache. Ended as a fashionable teacher of crayon and watercolour painting. Died London 2 December 1747. A work attributed to him is in NPG London.
Engraved by G.White.

GOURSAT, Georges 1863-1934
Born Périgueux, Dordogne 23 November 1863. Frequently visited England between 1905-10, when he sketched the celebrities of Newmarket and Cowes and left 'indelible images of Edward VII'. Painted a watercolour portrait of Sir Edwin Landseer. Died Paris.

GOVETT, W.R. fl.1846
Made a portrait drawing of Sir William Molesworth.

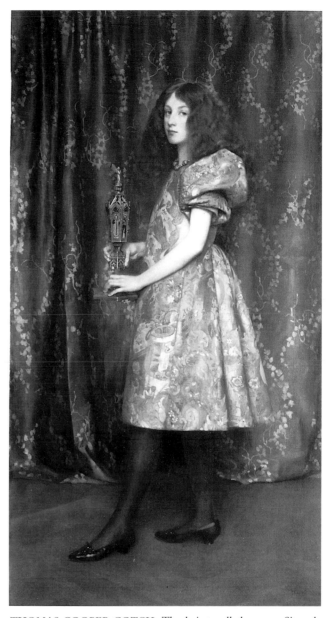

THOMAS COOPER GOTCH. The heir to all the ages. Signed. Exhibited 1897. 59¼ x 31ins (150.5 x 78.7cm)
Christopher Wood Gallery, London

GOW, Andrew Carrick RA RI 1848-1920
Born London 15 June 1848, son of artist James Gow. Studied at Heatherley's. Exhibited at RA (95), SBA (3), NWS (48), GG (1) 1866-1919. Elected ANWS 1868, NWS 1870, ARA 1881, RA 1891, Keeper 1911. Died London 1 February 1920. His work was admired by Ruskin. His portrait of 'Queen Victoria at St Paul's Cathedral on Diamond Jubilee Day' is in Guildhall AG, London.
Represented: VAM; Tate; Manchester CAG.

GOW, Charles fl.1834-1872
Exhibited at RA (7), SBA (1), RSA (3) 1834-72 from London.
Represented: NPG London.

GOWDY, William 1827-1877
Little known portrait painter who worked in Newcastle.

GOWER, George c.1540-1596
Member of the Gower family of Stettenham, Yorkshire. Established as a portraitist in London by 1573. Serjeant-Painter to the Queen 1581-96. Painted decorations for Whitehall, Greenwich, Hampton Court and Richmond. Buried London 30 August 1596.
Represented: NPG London; NGI; Tate. **Literature:** J.W.Goodison, *Burlington Magazine* XC September 1948 p.261; Walpole Society XLVII.

GOWERS, David fl.1799-1808
Exhibited at RA (4) 1799-1808 from London.
Engraved by W.T.Annis, W.Barnard.

GOWY, J. fl.c.1632-c.1661
Believed to have been Jacomo Pedro Gouwi who was a pupil at Antwerp in 1632/3. Became a Master there 1636/7 as Jacques Peeter Gouwi. His full-length portrait of a man was formerly at Wilton.
Represented: Christ Church, Oxford.

GRACE, Alfred Fitzwalter RBA 1844-1903
Born Dulwich. Studied art at Heatherley's and at RA Schools, where he won the Turner Gold Medal. Painted landscapes, portraits and miniatures. Exhibited at RA (57), BI (6), SBA (81), NWS (10), GG (5), NWG (3) 1865-1904. Elected RBA 1875. A friend of J.M.Whistler. Lived in London. Moved to Amberley, Sussex by 1872, where he remained until 1888. Then moved to Steyning, with his wife, who was an enamel painter. Died Steyning 10 November 1903.
Represented: VAM; Brighton AG.

GRACE, Miss Harriette Edith fl.1878-1900
Exhibited at RA (11), SBA (16) 1878-1900 from Brighton.
Represented: Brighton AG.

GRACE, Mrs Mary (née Hodgkins) fl.1749-c.1786
Daughter of a shoemaker. Set up as a portrait painter at Throgmorton Street, London. Exhibited at SA (15) 1762-69. Elected honorary FSA. Retired to Homerton, where she built a gallery to exhibit her pictures. Died Homerton c.1786.
Engraved: J.Faber jnr. **Literature:** DNB.

GRAEFLE, Albert 1807-1889
Exhibited at RA (1) 1851. Painted a portrait of Queen Victoria as a widow 1864. Lived in Paris.
Engraved by W.Holl, R.J.Lane, J.A.Vinter.

GRAHAM, C. fl.1834-1850
Exhibited at RA (2), SBA (5) 1841-50 from London. Visited St Petersburg c.1844. Possibly Miss C.Graham who exhibited at RA (1) 1868.

GRAHAM, Mrs E.C. fl.1850-1851
Exhibited at RHA (3) 1850-1 from Dublin.

GRAHAM, John 1755-1817
Born Edinburgh 17 March 1755. Trained as a coach painter. Entered RA Schools 1783. Exhibited at FS (3), SA (2), RA (35) 1780-97 from London. Returned to Edinburgh 1798 and taught first at Drawing Academy, then at Trustees' Academy (with which it was united in 1800). An important teacher. Among his pupils were Sir David Wilkie, Sir J. Watson Gordon and Sir William Allan. Died Edinburgh November 1817. A highly competent portraitist (although his works are relatively rare) who employed a rich use of colour. Sometimes confused with John Graham Gilbert, who signed 'John Graham' until 1841.
Represented: Stationers' Hall; VAM. **Engraved by** J.Caldwall, J.Cochran, M.Gauci, T.Hodgetts & Son, W.Leney, W.Skelton, W.J.Ward, Wilson. **Literature:** McEwan.

GRAHAM, Thomas Alexander Ferguson HRSA 1840-1906
Born Kirkwall. Studied with Orchardson, Pettie, Chalmers and McTaggart at Trustees' Academy (entered 1855) under R.S.Lauder. Exhibited at RSA from 1859, but settled in London 1863 with Orchardson and Pettie. He was influenced by the Pre-Raphaelites. Travelled to Paris 1860 with McTaggart and Pettie. Visited Brittany 1862, Venice by 1864, Morocco 1885. Exhibited at RA (41), RSA (66), BI (1), SBA (2) 1859-1906. Elected HRSA 1883. Died Edinburgh 24 December 1906. His work was admired by John Singer Sargent.
Represented: VAM. **Literature:** McEwan.

GRAHAM GILBERT, John see GILBERT, John Graham

GRANBY, Marchioness of
see RUTLAND, Marion, Duchess of

GRANT, Miss Alice fl.1879-1907
Exhibited at RA (32), RHA (2), SBA (6+) 1879-1907 from London. Member of Society of Lady Artists. The majority of her sitters were from military families.

GRANT, Charles fl.1825-1845
Exhibited at RA (15), BI (1) 1825-39 from London. Believed to have moved to India, where he published books of portraits until 1845.
Represented: BM.

GRANT, Coleworthy 1813-1880
An artist and journalist who painted portraits and topographical views. Went to India 1832. Appointed drawing master at Engineering College at Howrah and later at Presidency College, Sibpur. Visited Rangoon 1846. Official artist to the embassy of the King of Ava 1855. During the Indian Mutiny he was the correspondent for the *Durham Advertiser*. Settled at Malnath by 1857.
Represented: India Office Library. **Literature:** P.C.Mittra, *Life of C.G.,* 1881.

GRANT, Sir Francis PRA 1803-1878
Born Kilgraston, Perthshire 18 January 1803, fourth son of Francis Grant, the Laird of Ligraston and brother of Lieutenant General Sir J.Hope Grant. Educated at Harrow School. Originally intended for the bar, but began painting as an amateur, becoming professional from 1831. Spent some time in the studios of Edinburgh artists, among them Alexander Nasmyth, William Allan and John Watson Gordon. In Leicestershire he became a good friend of John Ferneley, from whom he may have received lessons (they later collaborated). In 1834 'The Melton Breakfast' helped establish Grant's success in England. Enjoyed a distinguished reputation for equestrian portraits, and in 1840 the success of his portrait of 'Queen Victoria and Melbourne Riding in Windsor Park' ensured that he was the most fashionable portrait painter of the day. His social position improved with his marriage to the niece of the Duke of Rutland, and opened further channels of patronage to him. Exhibited at RA (253), RSA (53), RHA (1), BI (7), SBA (9) 1829-79. Elected ARA 1842, RA 1851, PRA and knighted 1866. Among his sitters were Count D'Orsay, Queen Victoria, Prince Albert, the Countess of Zetland, the Duke of Devonshire, Benjamin Disraeli MP, Palmerston, and Sir Edwin Landseer. His sitter's list 1828-78 is in NPG London. Died suddenly of heart disease at his residence in Melton Mowbray 5 October 1878. Studio sale held Christie's 28 March 1879. His best works are of a breathtaking quality, employing an exquisite use of colour and sensitive highlights. Collaborated with Edwin Landseer and employed G.F.Clarke to make copies of his pictures for engravers. William Crabb was a studio assistant painting draperies. Lord Willoughby de Broke wrote of Grant:

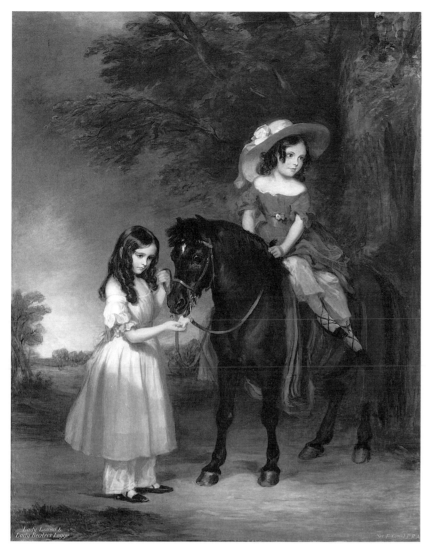

FRANCIS GRANT. Lady Louisa and Lady Beatrix Legge with their pony. Signed and inscribed. 90 x 66ins (228.6 x 167.7cm)
Richard Green Galleries, London

'... he knew how a well-bred man ought to sit on a well-bred horse, and he put him there, as few artists ever could'.
Represented: NPG London; NGI; Walker AG, Liverpool; Perth Museum; SNPG; HMQ; University of Edinburgh. **Engraved by** H.Adlard, T.L.Atkinson, J.C. & F.Bromley, J.Burnet, H. & S.Cousins, H.Davis, A.Duncan, J.Faed, W.Humphreys, J.R.Jackson, C.H.Jeens, R.Josey, R.J.Lane, C.G.Lewis, F.C.Lewis, W.H.Mote, S.W.Reynolds jnr, H.Robinson, G.Saunders, A. & J.Scott, F.Stacpoole, Taylor & Co, J.Thomson, W.Walker, G.R. & W.J. Ward, G.Zobel. **Literature:** J.Steegman, 'Sir F.G. PRA', *Apollo* June 1964 pp.279-85; C.Wills, 'Sir F.G's Sporting Pictures', *Country Life* 31 October 1991 pp.58-61. Colour Plate 28

GRANT, Henry fl.1868-1888
Exhibited at RA (3), SBA (6) 1872-88 from London. *Painted to a high standard in the manner of Sir Francis Grant.*
Represented: Stourhead, NT.

GRANT, James Ardern RP 1885-1973
Born Liverpool. Studied at Liverpool School of Art (where he subsequently taught) and at Académie Julian, Paris. Exhibited at RA (42), RP, RE, NEAC, LA 1913-53. Moved permanently to London after his marriage in 1913. Vice-Principal of the Central School of Arts and Crafts.
Represented: NPG London; Walker AG, Liverpool.

GRASSIE, John fl.1776-1781
Exhibited at RA (2) 1776-81. No address given.

GRATIA, Charles Louis 1815-1911
Born Rambervilliers 25 November 1815. Studied under H.Descaisne. Moved to England 1848-64. Exhibited at RA (6) 1851-64 from London. Returned to France. Died Mount Lignon August 1911. *Gained a reputation for his pastel portraits.*

GRATTAN, George 1787-1819
Born Dublin. Studied at Dublin Society Schools, winning medals. Exhibited in Dublin 1801-13. His work attracted the attention of the Earl of Hardwicke, for whom he painted portraits and made views in crayon. Occasionally visited London. Exhibited at RA (3), BI (2). Because of failing health he moved to Cullenswood, where he died 18 June 1819. Buried at the old churchyard, Glasnevin.
Represented: VAM.

GRAVES, Mr fl.1689-1692
Recorded as coming from London and working in East Claydon 30 April 1689. Painted portraits of Mrs Thomas Worsley, and of her three children (Hovingham). *His work can have considerable provincial charm.*

GRAVES, Hon Henry Richard 1818-1882
Born 9 October 1818, son of Thomas North, 2nd Baron

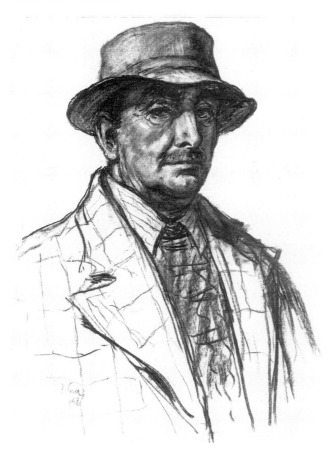

GRAY, JOSEPH. Self-portrait. Charcoal. 31 x 22⅞ins (79 x 58cm)
Private collection

Graves and his wife Lady Mary Paget, sister of 1st Marquess of Anglesey. Exhibited at RA (71) 1846-81. Established a high society practice. Among his sitters were Lady Dorothy Nevill, General Sir George Brown GCB, Sir Henry Keppel RN, Lord and Lady Lennox, Marchioness of Bristol, the Duke of Richmond and Countess Beauchamp. Painted by command many members of the royal family including Princess Louise and Princess Beatrice. Died 28/29 April 1882.
Engraved by G.Sanders.

GRAVES, John Woodcock　　　　　　**1795-1886**
Born Cumbria. Produced naïve portraits, ballads, writings and mechanical inventions. He was author of 'D'ye ken John Peel?'. Painted a number of portraits of the huntsman while in Tasmania c.1865 (he emigrated there 32 years earlier). Five unfinished portraits of John Peel were produced and stolen by natives before he finally completed one. This he sent to a Cumbrian publisher 1867. In 1904 it was bought and used for the bottle label design of the 'John Peel' brand of whisky. Died Hobart, Tasmania.
Literature: Hall 1979.

GRAVES, Robert　ARA　　　　　　　**1798-1873**
Born London 7 May 1798. Exhibited portraits and engravings at RA (25), SBA (13) 1824-73 from London. Elected ARA 1873. Died 28 February 1873.
Literature: DA.

GRAY, Mrs　　　　　　　　**fl.1844-1857**
Exhibited at RA (3) 1844-57 from London.

GRAY, Miss Alice　　　　　　**fl.1891-1892**
Exhibited at RA (2), SBA (1) 1891-2 from Edinburgh.

GRAY, Douglas Stannus　ROI RP　　　**1890-1959**
Born London 4 June 1890, son of Robert Stannus Gray and Emily (née Galer). Studied at Croydon School of Art and RA Schools, winning the Landseer and BI scholarships. Served with 2nd and 3rd London Regiments in 1st World War. Exhibited at RA (51), ROI, RP (9) 1920-58 from Clapham and Southwick. Elected RP 1933. Taught briefly at Brighton Art College 1947. Died Chichester 2 November 1959. Follower of Sargent's *alla prima* manner.
Represented: Tate.

GRAY, George　　　　　　　　**1758-1819**
Born Newcastle, son of a bookbinder. Educated at Newcastle Grammar School. Apprenticed to 'an eminent fruit painter' called Jones. Went with his master to York. Returned to Newcastle, where he painted still-life and portraits in oil and crayon. Exhibited at RA (1) 1811. Sailed from Whitehaven on a 'botanizing expedition' 1787. Then engaged on an expedition to Poland, but returned to Newcastle where he opened an unsuccessful shop in Dean Street as a 'portrait, fruit, house and sign painter'. A close friend of Thomas Bewick. Died at his home in Pudding Chare, Newcastle.
Represented: Laing AG, Newcastle; Shipley AG, Gateshead.
Literature: Hall 1982.

GRAY, John　　　　　　　　**fl.1885-1922**
Exhibited at RA (24), SBA (10) 1885-1922 from Bedford Park, London, Thursley near Godalming, Maiden Newton Blandford, Dorset and Saxmundham, Suffolk.

GRAY, Joseph　　　　　　　　**1890-1963**
Born South Shields, son of a sea captain. Trained as a sea-going engineer before attending South Shields Art School under John Heys. Began as an illustrator with the *Dundee Courier*, remaining with the paper until the outbreak of the 1st World War, when he enlisted in the Black Watch Regiment. Invalided out and found work illustrating for *The Graphic*. Began portrait painting with success and took over J.S.Sargent's studio in Chelsea. Enlisted again in the 2nd World War, when he was attached to the Camouflage Department of the War Office. After the war he worked in Marlow, Norfolk, Bath, Deal, Suffolk, Dorset and for some years at Broughton Ferry. Exhibited in Scotland, London, Europe and America.
Represented: BM; VAM; Imperial War Museum; Dundee AG; South Shields Museum & AG. **Literature:** Hall 1982.

GRAY, Miss Millicent Etheldreda　　　**b.1873**
Born London 12 September 1873. Studied at Cope and Nicol School and at RA Schools. Exhibited at RA (29), RP 1899-1938 from London. Among her sitters were Colonel H.W.Gray VD, 2nd South Middlesex VRC and Colonel Sir Howard Vincent KCMG MP.
Literature: *The Gentlewoman* 17 June 1911.

GREATA, Mme　　　　　　　**fl.1858-1860**
Exhibited at SBA (5) 1858-60 from London.

GREEN, Benjamin Richard　　　**1807/8-1876**
Born London, son of artist James Green and his wife Mary. Entered RA Schools 15 December 1826 aged 19. Won premiums at SA 1824-7. Exhibited at RA (40), SBA (36), NWS 1832-76. Elected NWS 1834. Published books on perspective and lectured on the subject. Worked in Inverness 1840. Died London 5 October 1876.

GREEN, E.F.　　　　　　　　**fl.1824-1851**
Exhibited at RA (14), BI (22), SBA (20) 1824-51 from London, Malta and Bombay. Among his sitters were Admiral the Hon Sir Robert Stopford GCB GCMG, Commander-in-Chief of Her Majesty's Forces in the Mediterranean, and Dr James Burnes FRS.

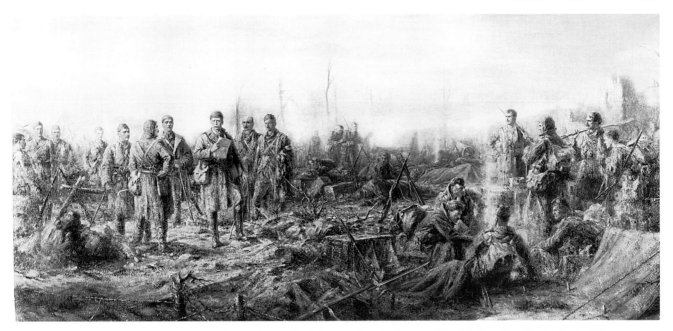

JOSEPH GRAY. After Neuve Chapelle (10th March, 1915) with portraits of Officers of the 4th Battalion Black Watch. Oil on canvas. 45 x 94½ins (114.3 x 240cm). Inscribed 'Joseph Gray, 1921' *Dundee Art Galleries and Museums*

GREEN, George Pycock Everett **d.1893**
Exhibited at RA (20), BI (10), SBA (12) 1841-73 from London. Among his portraits were HRH the Duke of Cambridge and G.W.Martin, founder and conductor of National Choral Society. **Represented:** NPG London. **Engraved by** J.Cook.

GREEN, James **1771-1834**
Born Leytonstone 13 March 1771, son of a builder. Apprenticed in London to Thomas Martyn, a natural history draughtsman. Entered RA Schools 18 February 1791. Encouraged by Reynolds, copying many of his pictures. Exhibited portraits and miniatures at RA (167), BI (30), SBA (9) 1793-1834. Married miniaturist Mary, daughter of engraver William Byrne 1805. Died Bath 27 March 1834. Buried Wolcot Church. His best pictures are of a remarkably high standard. **Represented:** NPG London; Salford Museum; BM; Royal College of Surgeons. **Engraved by** R.Cooper, M.Gauci, W.Say, E.Scriven, C.S.Taylor, J.Ward. **Literature:** DNB; *Arnold's Magazine of Fine Arts,* May 1834.

GREEN(E), John of Oxford **fl.1746-1768**
A member of a family of painters working in Oxford. J.Green signed and dated a group portrait of 'A Fencing Lesson' 1746, and was painting copies of portraits 1768. May also be 'Green junior' who copied a portrait of 'Thomas White' for Bodleian 1750. **Literature:** J.Sparrow, *Burlington Magazine* CII October 1960 p.452.

GREEN, Mrs R. **fl.1845-1850**
Exhibited portraits of children at RA (2), SBA (1) 1845-50 from Eltham and London. **Engraved by** J.Thomson.

GREENBURY, Richard **b.c.1599**
In the employment of the Crown by 1623 and called 'Painter to the Queen' 1631. Worked in Oxford 1626-36. A Roman Catholic. Invented a technique for painting cloth. Last documented as painting a group portrait of an anatomy lecture for the Barber-Surgeons. **Represented:** New College, Oxford; Magdalen College, Oxford; Syon House. **Literature:** DNB.

GREENHILL, John **1642-1676**
Born near Frome, son of John Greenhill, registrar of the diocese of Salisbury, and Penelope (née Champneys). From a 'good' family. Had some local training before settling in London by October 1662, where he became a pupil of Lely. Specialized in crayon portraits of actors in character parts 1663-4. Before 1673 his style was influenced by Lely, although towards the end of his career it was closer to Riley. Sometimes signed 'J.G.' or 'John Greenhill fecit'. Enjoyed riotous living in the company of actors (Mrs Aphra Behn became infatuated with him). Died at an early age after falling into a gutter in a state of intoxication. Left a widow and family to whom Lely gave an annuity. Buried London 19 May 1676. **Represented:** Dulwich AG; NPG London; BM; VAM. **Engraved by** A.Bannerman, A.Binneman, A.Blooteling, G.T.Doo, R.Dunkarton, P.van Gunst, F.Place, W.Faithorne, E.Lutrell, W.H.Worthington. **Literature:** S.Whittingham, 'J.G. 1642-1676: Sir Peter Lely's most excellent pupil', *The Hatcher Review* II Autumn 1980; DA.

GREENLEES, Robert M. **RSW** **1820-1904**
Head of Glasgow School of Art. Exhibited a variety of subjects, including a portrait of the Governor of Barataria, at RA (4), RSA (52), RSW (24), RHA (5) 1873-77 from Glasgow. **Literature:** McEwan.

GREENLEES, William **fl.1847-1850**
Edinburgh portrait painter of conversation pieces in oil. Exhibited RSA (9). **Represented:** SNPG.

GREENWOOD, John **FSA** **1727-1792**
Born Boston, Massachusetts 7 December 1727. Apprenticed as an engraver to Thomas Johnston, a chart maker and armorial artist. Practised as a portraitist in Boston from 1745, and was working there when Copley was beginning, becoming his friend and patron. Left Boston for Surinam, where he painted portraits 1752-7. From there he went to Amsterdam, where he trained as a mezzotinter and dealt in pictures. Visited Paris 1763 and settled in London. Exhibited in oil and crayon at SA (12) 1764-76. Elected FSA 1769, Director 1775. From c.1773 he acted mainly as a dealer and auctioneer. Died Margate 16 September 1792. **Represented:** Boston MFA; BM.

GREGG, Thomas Henry **b.1801**
Entered RA Schools 31 October 1821 aged 20 years. Exhibited at RA (17), BI (3), SBA (6) 1824-72 from Cambridge and London. Listed as a portrait and miniature painter.

GREGORY, Charles **fl.1844-1848**
Listed as a portrait painter in Landport, Hampshire and Cowes, Isle of Wight. Also painted marine subjects.

GREGORY, Miss Edith M. **fl.1888-1897**
Exhibited at RA (3) 1888-97 from London.

GREGORY, Edward John **RA PRI** **1850-1909**
Born Southampton 19 April 1850, son of Edward Gregory of the P & O Steamship Company, where he began in the drawing office. Showed a talent for art, and after meeting Herkomer moved to London 1869. Studied at RCA and RA Schools. Worked on decorations for the VAM 1871-5. Illustrated for *The Graphic*. Exhibited at RA (34), NWS (55), GG (14), RI 1871-1908. Elected ARI 1871, RI 1876, ARA 1883, RA 1898, PRI 1898-1909. Travelled on the Continent and in Italy 1882. Died Great Marlow 22 June 1909. Had a 'hopelessly disconcerting' stutter. His portraits are usually sensitively painted to an extremely high standard, and he has been considerably underrated.
Represented: NPG London; SNPG; Tate; BM; Manchester CAG, Lady Lever AG, Port Sunlight; Canterbury Museums; archives in VAM. **Literature:** *Magazine of Art* 1884 pp.353-9; Maas.

GREGORY, George **fl.1832-1834**
Listed as a 'Teacher, Portrait and Landscape Painter' in Lewisham.

GREIFFENHAGEN, Maurice William **RP RA**
 1862-1931
Born London 15 December 1862. Entered RA Schools 1878 (winning prizes). Exhibited at RA (104), RHA (2), SBA, RP 1884-1932 as well as in Munich, Venice and Pittsburgh. Elected RP 1909, ARA 1916, RA 1922. Gained a reputation for painting portraits of society ladies, but was equally good with men. Also a prolific illustrator, working for *The Lady's Pictorial*, *The Daily Chronicle* and the novels of Ryder Haggard (whose portrait he exhibited at RA 1897). After c.1900 he concentrated on portrait painting. Headed the Life Department at Glasgow School of Art 1906. Died London 26 December 1931.
Represented: NPG London; SNPG; Tate; Leeds CAG; Eton College; VAM card index.

GREIG, John Russell **b.1870**
Studied at Gray's School of Art, Aberdeen and at RSA, Edinburgh. Returned to Gray's School as a teacher. Exhibited at RA (2), RSA.

GREVENBROEK, Martinus van **1646-after 1670**
Recorded at The Hague 1670 aged 24. Painted copies for the Earl of Northampton 1665-6.

GREY, Charles **RHA** **1808-1892**
Born Greenock. Settled in Dublin as a young man, where he worked as a portrait painter. Exhibited at RHA (121) 1837-93. Elected ARHA 1838, RHA 1845.
Represented: NGI; Ulster Museum; SNPG. **Engraved by** J.Kirkwood, J.Lockwood. **Literature:** Strickland; McEwan.

GREY, Miss Edith F. **c.1865-c.1914**
Born Tyneside. Studied at Newcastle School of Art. Had a studio in Newcastle. Exhibited at RA (16), NWS (3), SBA, RMS and in Newcastle 1891-1911. Died Newcastle.
Literature: Hall 1982.

GREY, Mrs Jane Willis **fl.1882-1896**
Exhibited at RA (5), SBA (19) 1882-96 from London and Haywards Heath.

GRIBBLE, Bernard Finegan **RBC** **1873-1962**
Born South Kensington 10 May 1873, son of Herbert Gribble, the architect of Brompton Oratory. After an education in Bruges he trained as an architect and at South Kensington Schools. Painted mainly shipping subjects, but some portraits. Exhibited at RA (67), RI, RHA (9), Paris Salon and in the provinces 1891-1941. Illustrated works of several authors, including Conan Doyle. Lived in London and Parkstone, Dorset. Died 21 February 1962.
Represented: Bristol AG; Plymouth AG; Preston Museum & AG.

GRIBBLE, W. **fl.1830**
Exhibited at RA (1) 1830 from 7 Newman Street, London.

GRIER, Sir Edmund Wyly **1862-1957**
Born Melbourne, Australia 26 November 1862. Moved to Canada 1876. Studied at Slade under Legros, at Académie Julian, Paris under Bouguereau and Fleury, and in Rome at Scuola Libera. Exhibited at RA (6), SBA (2) 1886-95 from London and St Ives. Returned to Canada 1891, where he set up a highly successful portrait practice in Toronto. Knighted 1935. Died Toronto 7 December 1957. His brother Louis Munro Grier was also an artist.
Represented: NG Ottawa.

GRIEVE, Alexander **1864-1933**
Born Dundee. Studied at Académie Colarossi in Paris. Exhibited at RA (1), RSA (15), SSA, Paris Salon. Lived in London and Tayport, Fifeshire. Died Dundee.
Represented: Dundee AG; Paisley AG. **Literature:** McEwan.

GRIFFEN, Anna **fl.1888-1891**
Exhibited at SBA (3) 1890/1 from Glebe Place, Chelsea.

GRIFFIN, William **b.c.1751**
Entered RA Schools 8 April 1772 'aged 21 next August' (Silver Medallist). Exhibited crayon portraits and miniatures at SA (5), RA (4) 1772-6 from London. Recorded in Birmingham May 1778.

GRIFFITHS, Miss Gwenny **WIAC** **b.1867**
Born Swansea 25 June 1867. Studied at Slade and Académie Julian, Paris. Exhibited at RA (1), RP and SBA (1) from 1892 from Druslyn, Swansea and London.

GRIFFITHS, Moses **1747-1819**
Born Caernarvonshire 25 March 1747 (not 6 April 1749 as sometimes stated) of humble parents. Educated at Free School of Bottwnog. Painted and engraved some 700 subjects for Thomas Pennant, some of which have been reassembled at Nantlys. Died 11 November 1819.
Represented: VAM; Brighton AG. **Literature:** *Walker's Monthly* August and September 1938 and January 1939; *Country Life* 16 September 1982; *M.G.: Artist and Illustrator in the service of Thomas Pennant*, Welsh Arts Council, exh. cat. 1979.

GRIGNION, Charles **1752-1804**
Born London, son of engraver Charles Grignion. Studied under Cipriani. Entered RA Schools 1769 aged 17 (Gold Medallist 1776). Exhibited at RA (19) 1761-84. Awarded an RA travelling scholarship to Rome 1782, where he was influenced by Angelica Kauffmann and Wilhelm Tischbein. Developed a very linear and precise style. Left Rome because of the Napoleonic invasion. Retired to Leghorn, where he died 4 November 1804. Produced a number of oval portraits 20 x 16in. (58 x 42cm), but was equally comfortable on a larger scale.
Represented: NPG London; NMM; Powis Castle, NT. **Engraved by** W.T.Fry, T.Holloway, J.Hopwood, J.Murphy, W.Pether, J.Young. **Literature:** DA.

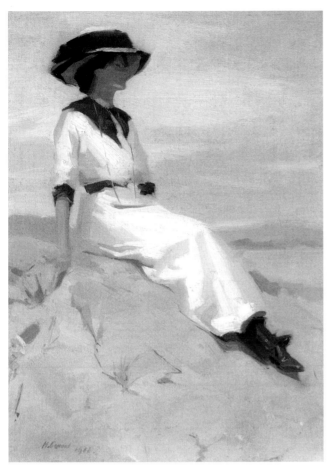

HERBERT JAMES GUNN. Jeannie (the artist's sister) on the rocks. Signed and dated 1912. Panel. 14 x 10ins (35.5 x 25.5cm)
David Messum Fine Art

GRIMM, Stanley A. RP ROI **1891-1966**
Born London 2 June 1891. Studied at Riga Arts School 1910-13, Russia and Munich 1913-14. Became a prisoner of war in Germany during the 1st World War. Exhibited at RA (27), RHA (3), RP, ROI from London. Died 17 February 1966.

GRIMMOND, William **fl.1878**
Listed as a portraitist at 209 St Vincent Street, Glasgow.

GRIMSTON(E), Edward **fl.1837-1879**
Exhibited at RA (15), SBA (13), BI (3) 1837-79 from London, including a portrait of Dr Livingstone.
Represented: SNPG.

GRISÉE, Louis Joseph **b.1822**
Born St Cyr-l'École 23 February 1822. Studied under P.Delaroche. Entered École des Beaux Arts, Paris 19 September 1842. Exhibited at Salon 1844-67. Reportedly worked in London.

GRISONI, Giuseppe **1699-1769**
Born Mons 24 October 1699. Studied in Florence under Tommasco Redi. Met John Talman in Rome, who encouraged him to move to England c.1720. Painted a ceiling at Canons (now destroyed) and a number of portraits. Returned to Italy 1728, accompanied by his pupil William Hoare, and painted several altar pieces in Florence.
Represented: NPG London; Garrick Club, London; Fitzwilliam.
Engraved by J.H.Robinson, J.Simon. **Literature:** DA.

GRISPINI, Filippo **fl.1863**
Exhibited at RA (2) 1863 from 51 Pall Mall, London.

GRITTON, T. **fl.1807-1817**
Exhibited at RA (3) 1807-17 from London.

GROOMBRIDGE (GROOMRICH), William
1748-1811
Born Goudhurst or Tonbridge. Worked in Tonbridge, London, Bromley, and Canterbury. Exhibited at FS, SA, RA (28) 1773-90. Fell into debt and went to Paris to escape creditors. Spent a time in debtors' prison before petitioning for his release. Then went to Philadelphia, where his wife, Catherine, conducted a school for girls. Died Baltimore 24 May 1811.
Literature: *London Gazette* 10 October 1778.

GROSSMITH, Walter Weedon **1854-1919**
Educated at Simpson's School, Hampstead. Studied at Slade and RA Schools. Exhibited at RA (11), RHA (9), SBA (13+) 1872-1919 from London. He and his brother George pursued successful theatrical careers. In 1852 they began to publish *Diary of a Nobody* in *Punch*, with text by both brothers and illustrations by Walter Weedon. It has remained constantly popular. Died 14 June 1919.
Represented: VAM. **Literature:** W. Grossmith, *From Studio to Stage*, 1912; *Oxford Companion to English Literature*, 1985; S. Houfe, *The Dictionary of 19th Century British Book Illustrators*, 1996.

GUBBINS, John **fl.c.1819**
Born Limerick. Practised as a portrait painter in Limerick, Dublin and Belfast. Copied 'Woman Taken in Adultery' by Rubens for the Dominican Convent, Limerick. Exhibited at Dublin Society (9) 1819.
Engraved by H.Brocas; B.O'Reilly. **Literature:** Strickland.

GUEST, George **fl.1806-1831**
Honorary exhibitor at RA (15), BI (3), SBA (3) 1806-31 from London.

GUEST, H. **fl.1843-1853**
Exhibited at RA (3) 1843-53 from London. Possibly Henry Guest who won a premium at SA 1826.

GUEST, Thomas Douglas **b.1781**
Entered RA Schools 31 March 1802 aged 21 (Gold Medallist 1805). Exhibited at RA (15), BI (32), SBA (5) 1803-39 from London. Among his sitters was J.Wilton RA, Keeper of RA. His large painting of 'The Battle of Waterloo' (3ft. 4in. x 4ft. 9in BI 1816) prompted him to submit the longest catalogue description in the history of the BI. Published *An inquiry into the Causes of the Decline of Historical Painting*, 1829.
Represented: BM. **Literature:** DA.

GUILLEMARD, Miss Mary F. **fl.1882-1884**
Exhibited at RA (1), SBA (1) 1882-4 from Cambridge.

GUILLOD, Thomas Walker **fl.1839-1860**
Exhibited at RA (10), BI (6), SBA (16) 1839-60 from London.

GUINNESS, Miss Elizabeth S. **fl.1874-1889**
Exhibited at RA (8), RHA (8), SBA (10) 1874-89 from London.

GULLAND, Miss Elizabeth **c.1860-1934**
Born Edinburgh. Studied there and at Bushey under Herkomer. Engraved Herkomer's portrait of William Brooke. Exhibited at RA (17), RSA (20) 1887-1910. Died Bushey 6 November 1934.
Literature: McEwan.

GULLICK, Thomas J. **b.c.1829**
Born Middlesex. Listed as an artist in portraits aged 32 in 1861 census for Berners Street, London.

GUNN, Sir Herbert James RA PRP NS 1893-1964
Born Glasgow 30 June 1893, son of Richard Gunn (a prosperous draper) and Thomasina Munro. Studied at Glasgow School of Art, Edinburgh College of Art and Académie Julian, Paris under J.P.Laurens. Exhibited at RA (139), RSA, RP, Royal Glasgow Institute of Fine Arts, Paris Salon (Gold Medal 1939) 1923-65. Elected RP 1945, PRP 1953, ARA 1953, RA 1961. Among his sitters were Hilaire Belloc, G.K.Chesterton, George VI and Elizabeth II. Served in 1st World War, enlisted in Artists' Rifles, and commissioned in 10th Scottish Rifles. Married Pauline Miller (d.1950) 1929 and settled in Hampstead. Died Hampstead 30 December 1964. His best work is outstanding and he was one of the most accomplished portrait painters of the 20th century.
Represented: NPG London; SNPG; HMQ; Royal Engineers Corps London; AGs Glasgow, Preston, Rochdale, Dundee and Bradford. **Literature:** *J.G.*, SNPG exh. cat. 1994. (Illustration p.223)

GUNNING, Robert Bell c.1830-1907
Born Dumfries. Moved to Whitehaven, where he taught art for more than 40 years and painted portraits and landscapes. Died at Dumfries. Interred at Whitehaven.
Represented: Whitehaven Museum.

GURENSTONE, T. fl.1853
Exhibited at SBA (2) 1853 from Kensington.

GUSH, Frederick fl.1847-1866
Exhibited at RA (9), BI (1), SBA (6) 1847-66 from London.

GUSH, William fl.1832-1874
Won several awards at SA 1832-5. Exhibited at RA (53), BI (4), SBA (2) 1833-74 from London. Worked in Rome 1845. Painted in the manner of Baxter, Buckner and the 'Keepsake Tradition'. Among his sitters were the Duke of Beaufort, the Bishop of Gloucester and Bristol, and the Earl of Oxford. Many of his portraits were reproduced in *The Methodist Magazine*.
Represented: NPG London; Nottingham Museum AG. **Engraved by** F.Bacon, J.Cochran, T.A.Dean, T.W.Hunt, J.Thomson, G.Zobel.

GUTHRIE, Miss Eliza b.c.1829
Born Paddington, daughter of Alexander Guthrie, a Liverpool tailor, who moved to London and employed 20 men. Exhibited at SBA (2) 1849-55 from 54 New Bond Street, London. Her sister, Margaret, was also a portraitist.

**GUTHRIE, Sir James PRSA HRA RSW RP
1859-1930**
Born Greenock 10 June 1859, son of Rev John Guthrie. Began his career in law, but gave up for painting 1877. Studied in London 1879 under the guidance of J.Pettie and was also friendly with other Scottish painters there. Visited Paris 1882 and was influenced by *plein-air* painters. Returned to Scotland and was a leading figure of the Glasgow School. Also kept a house in London 1879-1901. Took up portrait painting 1885 and established a highly successful society portrait practice. Exhibited at RSA (72), RHA (2), ROI, RA (6), RP (16) from 1887. Elected RP 1893, President of Glasgow Art Club 1896-8, ARSA 1888, RSA 1892, NEAC, RSW, PRSA 1902-19, knighted 1903, HRA 1911. Travelled widely, including West Indies, Spain, France and Italy. Died Rhu, Dumbartonshire 6 September 1930.
Represented: NPG London; SNPG; Glasgow AG; NGS. **Literature:** J.L.Caw, *Sir J.G. PRSA*, 1932; R.Billcliffe, *G. and the Scottish Realists*, Fine Art Society, exh. cat. 1982; M.Hogg, *J.G.*, Leicester Polytechnic Thesis 1987; McEwan; DA.

GUTHRIE, Margaret b.c.1826
Born St James's, Westminster, daughter of Alexander Guthrie and his wife Kitty. Listed as a portrait painter in 1851 census.

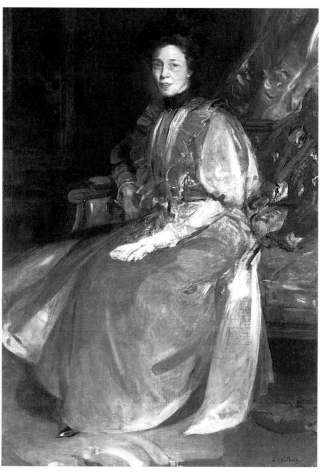

JAMES GUTHRIE. Mrs Edward Martin, sister of Robert Alexander RSA. Signed and dated 1885. 72 x 44ins (182.9 x 111.8cm) *Christie's*

Her sister Eliza was also a portraitist.

GUTTENBRUNN, Ludwig fl.1770-1813
Born Krems, near Vienna. 'Painter to the Archduke of Austria' 1782. Exhibited at RA (17) 1790-5. Court painter in St Petersburg 1795-c.1805. Elected a member of Academy of Florence. Last recorded in Rome 1813. His self-portrait was given to the Uffizi. Among his sitters were Princess Lignouzky of Vienna, and Countess Thunn of Vienna.

GUY, Seymour Joseph NA 1824-1910
Born Greenwich. Trained in London. Moved to America by 1854. Worked in New York City, where he gained a reputation for children's portraits. Exhibited at NA, New York. Elected NA 1865.
Represented: Brooklyn Museum; Yale.

GUYNIER, Claudius fl.1716-1729
Reportedly born at Grenoble. Worked in England 1716, when he was employed by Lord Harley to paint portraits of his daughter and the Master of Christ's College (for £3.4s.6d). His daughter married artist G.M.Moser.

GWATKIN, Joshua Reynolds fl.1832-1851
Exhibited at RA (6), BI (1), SBA (5) 1832-51 from London. Painted a portrait of A.Garden MD, physician at Calcutta.
Engraved by P.Gauci.

GYNGELL, Edmund fl.1893

H

HAAG, Carl RWS RBA 1820-1915
Born Erlangen, Bavaria 20 April 1820, son of Christopher Wilhelm Haag. Studied under Albert Reindel in Nuremberg and under Cornelius in Munich. Worked in Brussels as a miniature painter. Moved to England 1847, spent the winter in Rome and returned the following year entering RA Schools. Nearly lost his right hand in an accidental explosion December 1848, but it was saved by the surgeon Sir P.Hewitt who became his friend and patron. Travelled widely in the Middle East, often in the company of Frederick Goodall RA. Exhibited at RA (11), SBA (3), RHA (2), OWS 1849-89 from London. Elected AOWS 1850, OWS 1853, RBA 1882. His eastern subjects were extremely popular. Received a commission from the Queen. Appointed Court Painter to Duke of Saxe Cobourg. Died Oberwesel 17 or 24 January 1915. Ottley praised his work for its 'remarkable breadth and power of treatment, for rich contrasts of light and shade, and for an immense executive skill, and untiring painstaking in the most minute details'.
Represented: BM; VAM; Leeds CAG; Blackburn AG; Ulster Museum. **Literature:** *Magazine of Art* 1889; *Art Journal* 1883; DA.

HACKER, Arthur RA RP 1858-1919
Born London 25 September 1858, son of Edward Hacker, a line engraver. Studied at RA Schools 1876-80 and with Bonnat in Paris 1880-1. Exhibited at RA (156), RHA (8), BI, SBA, GG, NWG, RP 1878-1920. Elected RP 1891, ARA 1894, RA 1910, RI 1918. Travelled widely in North Africa, Spain and Italy often with his friend Soloman. Became an extremely popular society portrait painter. His use of original composition and evocative light effects placed him in the top rank. Died London 11 or 12 November 1919.
Represented: Tate; NMM; Royal Shakespeare Gallery; Brighton AG; Leeds CAG; London Museum; Cambridge University.
Colour Plate 29

HADDON, Arthur Trevor RBA 1864-1941
Studied at Slade under Legros from 1883, Madrid and under Herkomer 1888-90. Exhibited at RA (18), RHA (2), SBA, RI 1883-1922. Elected RBA 1896. Lived in Rome 1896-7. Visited Venezuela 1921 and Canada. Worked in London and Cambridge. Died 13 December 1941 aged 77.

HADDON, David W. fl.1884-1910
Exhibited at RBSA (62) 1884-1910. Worked in Birmingham.

HADEN fl.1774
Studied under Thornton. Exhibited black lead portraits at SA (2) 1774 from London.

HAGARTY, James jnr fl.1772-1783
Son of Irish artist James Hagarty. Exhibited at FS (29) 1772-83 from London.

HAGARTY, Parker ARCA 1859-1934
Born Canada 27 September 1859, son of Alfred John Hagarty. Studied at Liverpool School of Art and Académie Julian, Paris under Bougeureau and Boulanger. Exhibited at

RA (26), RI, SBA 1884-1916 from Liverpool and Cardiff. Elected RCA 1900. Founder member of South Wales Art Society. Died June 1934.

HAGGIS, John Alfred b.1897
Born London 23 April 1897. Studied in Australia and at RCA under Osborne. Exhibited at RA (8), ROI, RP, NEAC, RSA.

HÄHNISCH, Anton 1817-1897
Born Vienna 28 October 1817. Studied at Vienna Academy. Went to Berlin 1847 and then Frankfurt, Paris, London 1850-62 and Edinburgh, returning to Berlin 1869. Visited Rome 1872-3 and from there to Karlsruhe. Exhibited in Vienna 1836-47, RA (18), RSA (10). Extremely successful, enjoying a distinguished clientele, including HRH Prince Frederick of Prussia, HRH the Princess Royal of Prussia and Lady Mary Victoria Hamilton. Died Karlsruhe.
Represented: BM; Karlsruhe AG. **Literature:** McEwan.

HAIGH-WOOD, Charles ARE 1856-1927
Born Bury 9 May 1856. Studied at RA Schools. Exhibited at RA (42), RI, RE, SBA 1879-1916 from London. Elected ARE 1917.

HAILE, Richard Neville 1895-1968
Born London 14 November 1895. Studied at Chelsea Polytechnic and at Regent Street Polytechnic. Exhibited at RA (1), PS, Paris Salon from Bognor Regis. Served in Royal Flying Corps. Also worked as a portrait photographer. President of Royal Photographic Society. Died Bognor Regis 20 February 1968.
Literature: *Bognor Regis Post* 24 February 1968.

HAILES, D. fl.1771
Honorary exhibitor of a crayon portrait at SA 1771.

HAINES, William 1778-1848
Born Bedhampton, Hampshire 21 June 1778, but was taken in infancy to Chichester. Educated at Midhurst Grammar School. Studied under the engraver Thew at Northaw. Worked with Scriven and others on the Boydell-Shakespeare plates. Travelled to the Cape 1800, Philadelphia, and returned to England c.1805, where he painted miniatures and watercolour portraits. Exhibited at RA (57), BI (19), OWS, SBA (7) 1808-40 from London. Among his sitters were Sir T. Gage, Bart, Lord Strangford, Sir William Parry and the 5th Earl of Stanhope. Retired on receiving an inheritance 1840. Died East Brixton 24 July 1848.
Engraved by H.R.Cook, S.W.Reynolds, C.Turner.

HAINSSELIN, Henry fl.1843-1853
Reportedly born in Devonport. Exhibited at RA (20), BI 1843-53 from Devonport and London. Among his exhibited portraits were 'E.Hulme MD, Barnfield Lodge, Exeter' and 'An Old Sailor Aged 90, Supposed to be the Only Survivor of Keppel's Action'.

HAKEWILL, John 1742-1791
Born London 27 February 1742. Studied under Wale, Duke of Richmond's Academy and RA Schools 1769. Won many prizes for drawing and a Silver Palette for landscape from SA 1772. Exhibited at SA (9) 1765-73, but specialized in decorative painting. Died London 21 September 1791.

HAKEWILL, Mrs Maria Catherine (née Browne) d.1842
Exhibited at RA (37), BI (45), SBA (15) 1808-38 from London. Married architect and artist James Hakewill 1807. Visited Italy. Her son Frederick Charles Hakewill also painted portraits. Died Calais.

HALE, John Howard RBA 1863-1955
Born Farnham, Surrey 16 June 1863. Studied at Farnham Grammar School, RCA and Westminster School of Art. A teacher and Director of Blackheath School of Arts and Crafts 1887-1928. Exhibited at RA (3), SBA, RHA (1), ROI, Paris Salon from 1902. Elected RBA 1920. Died 15 April 1955.

HALFORD, Miss Constance (Mrs Cecil Rea)
** fl.1892-1935**
Exhibited at RA (27), SBA 1892-1935 from London.

HALFPENNY, Joseph S. see ALPENNY, Joseph Samuel

HALHED, Miss Harriet ASWA 1850-1933
Born Australia. Moved to England aged six. Studied at T.S.Cooper Gallery of Art in Canterbury, RCA and in Paris with Louis Deschamps. Lived and worked for a time in Sevenoaks. Exhibited at RA (12), SBA (4), SWA and in Paris 1890-1932. Elected ASWA 1896. Died Hampstead 5 February 1933.
Represented: Canterbury Museums.

HALL, Charles c.1720-1783
Worked as an engraver and portrait painter. Painted 'Elizabeth, Countess of Aylesford' at Packington. Died London.

HALL, Fanny R. fl.1830-1837
Exhibited at RA (3), BI (10), SBA (3) 1830-7 from London.

HALL, Frederick RBC 1860-1948
Born Stillington, Yorkshire 6 February 1860, son of a Yorkshire doctor. Studied at Lincoln School of Art and at Antwerp under C.Verlat. From 1883-98 he was a member of Newlyn School with Stanhope Forbes and Walter Bramley. Exhibited at RA (69), SBA, RHA (1), GG, NWG 1883-1937. Worked from Wragby, Newlyn, Liverpool 1897, Dorking and Newbury from 1911. Gave up painting during mid-1930s due to failing eyesight. Died Newbury.
Represented: Southampton CAG; Leeds CAG. **Literature:** *Painting in Newlyn 1880-1930*, Barbican AG exh. cat. 1985 pp.72-3.

HALL, Harry c.1813/14-1882
Born Cambridge. Exhibited first portraits and then sporting paintings at RA (8), BI (17), SBA (26) 1838-75 from St John's Wood and Newmarket. Died Newmarket 22 April 1882.
Represented: Tate. **Engraved by** J.B.Hunt, F.C.Lewis.

HALL, Henry Bryan snr 1808-1884
Born London 11 March (or May) 1808. Studied engraving under B.Smith, H.Meyer and Ryall in London. Settled in New York 1850, where he established a successful engraving and publishing business. Exhibited at NA 1862-75. Died Morrisania, New York 25 April 1884.

HALL, James 1797-1854
Youngest son of geologist Sir James Hall of Dunglass. Studied for the legal profession. Studied at RA Schools and was friends with Wilkie, J.W.Gordon, Collins and Allan. Exhibited at RA (8), BI (7) 1835-54 from 40 Brewer Street, London. Among his sitters was Sir Walter Scott and the Duke of Wellington, although he only practised art as an amateur. Died, unmarried, at Ashiesteel 26 October 1854.
Represented: SNPG. **Literature:** DNB.

HALL, Lindsay Bernard NEAC 1859-1935
Born 28 December 1859, son of Lindsay Hall of Liverpool. Studied at Cheltenham College, South Kensington, Antwerp and Munich. Exhibited at RA (8), NEAC, SBA 1882-1923 from London. Founder NEAC. Settled in Australia, where he became Director of NG Victoria. Died 14 February 1935.

HALL, Sydney Prior 1842-1922
Born Newmarket 18 October 1842, son of artist Harry Hall. Studied at Merchant Taylors' School, Pembroke College Oxford, under A.Hughes and at RA Schools. Illustrated for *The Graphic*. Exhibited at RA (33), RI, RHA (6), GG (14) 1875-1920. Painted a number of portraits of the royal family including 'The Marriage of HRH the Duke of Connaught KG'. Accompanied the Prince of Wales on his visit to India, and many of his India sketches are at Osborne House, Isle of Wight. Among his sitters were the Archbishop of Canterbury, 'Mr Gladstone Playing His Evening Game of Backgammon with His Son, the Rev Stephen Gladstone at the Rectory, Harwarden' and 'James Balfour and Joseph Chamberlain'. Awarded MVO 1901. Died London 15 December 1922. A gifted draughtsman able to capture natural attitudes and postures with great skill.
Represented: NPG London; NGI; SNPG; VAM card cat.

HALLÉ, Charles Edward 1846-1919
Born Paris, son of musician Sir Charles Hallé. Studied in Paris under Baron Marochetti and Mottez. Came to England 1848. Exhibited at RA (28), RHA (1) 1866-82. Friends with Burne-Jones, Watts, R. Doyle, Herkomer and Alma-Tadema. Helped found GG 1876. Died London 31 January 1919. Gained a reputation for portraits of beautiful women and children.
Represented: Sheffield AG. **Literature:** Hallé, *Notes from a Painter's Life*, 1908.

HALLÉ, Miss Elinor fl.1881-1914
Exhibited at RA (5) 1886-1914 from London. Produced sculpture and painted portraits. Among her sitters was Cardinal Newman.
Represented: HMQ.

HALLÉ, Samuel Baruch 1824-1889
Born Frankfurt-on-Main 27 February 1824. Studied art there. Exhibited at RA (22), BI (32), SBA (15), 1847-68 from Frankfurt and London. Exhibited Paris Salon 1878-1882. Naturalized Frenchman. Died Paris.

HALLIDAY, Edward Irvine PRBA PRP b.1902
Born Liverpool 7 October 1902. Studied at Liverpool School of Art 1921-3 and Académie Colarossi, Paris 1923, RCA 1923-5 and British School, Rome 1926-9. Exhibited at RA (58), SBA, RP, Paris Salon from 1929. Elected RBA 1942, RP 1952, PRBA 1956, PRP 1970.
Literature: S.Cross (ed), *Artists at Work*, 1933.

HALLS, John James 1776-1853
Reportedly born Colchester, son of James Halls and Amelia Garnett, daughter of the Bishop of Clogher. Studied at RA Schools 1797. Settled in London where he was a friend and pupil of Hoppner. Went to Paris in 1802 with Fuseli. Exhibited at RA (108), BI (17) 1791-1828. Established a successful society portrait practice. Among his sitters were Lord Lovaine, Edmund Kean and HRH the Duchess of Gloucester. Married 2 December 1819 Maria Ann Sellon. Wrote a biography of his friend Henry Salt. Died Hampstead 22 July 1853 aged 77 (not 1834). His son was also called John James.
Represented: Colchester Museums; VAM, NPG London; NMM. **Engraved by** T.Blood, W.T.Fry, M.Gauci, J.Godby, R.Page, S.W.Reynolds, W.Skelton, C.Turner. **Literature:** H.W.Lewer, 'J.J.H. Portrait Painter and Biographer', *Essex Review* Vol.XXV July 1916 pp.99-108

HAMBURGER, Johann Conrad 1809-c.1870
Born Frankfurt-on-Main 3 March 1809. Studied there. Worked in London 1830-6. Exhibited at RA (8). Appointed Portrait Painter in Watercolours to William IV 1834. Went to Amsterdam 1836 and exhibited there until 1861. Died Amsterdam.

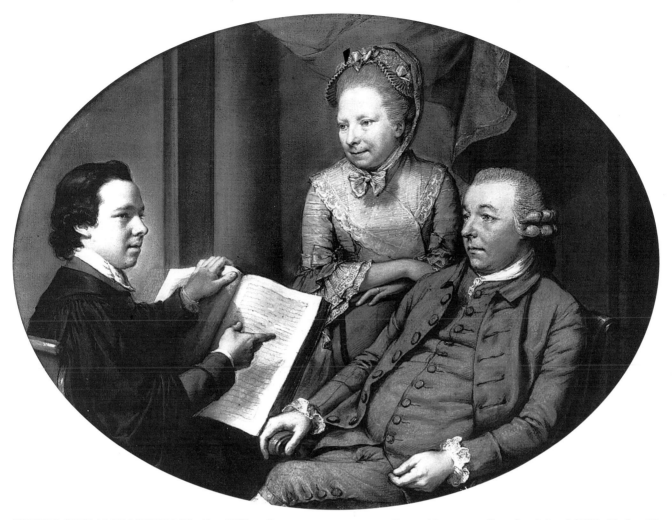

HUGH DOUGLAS HAMILTON. The Rev William Rose as a young man reading to his parents. Signed and dated 1775. Chalks. 15 x 19ins (38.1 x 48.2cm)

Christie's

HAMERTON, Robert Jacob RBA b.1811
Baptized St Pancras 25 December 1811, son of Robert and Betsy Hamerton. Showed a precocious talent and, aged 14, taught drawing at a school in Longford. Worked as a lithographer for Hullmandel in London. Exhibited at RA (7), BI (11), RHA (2), SBA (48) 1831-58. Elected RBA 1843. Illustrated for *Punch* until 1848.
Represented: BM. **Engraved by** J.R.Dicksee.

HAMILTON, Miss Augusta D. fl.1896
Exhibited at the RA (1) 1896 from 86 West Cromwell Road, London.

HAMILTON, Eva Henrietta fl.1904-1946
Exhibited at RHA (121) 1904-46 from Dublin.

HAMILTON, Gavin 1723-1798
Born Murdieston House, Lanarkshire. Educated at Glasgow University 1738-42. Travelled to Rome and became a pupil of Agostino Masucci until 1748. From 1752 to 1756 he had a successful portrait practice in London, but returned to Rome 1756 determined to paint histories on the scale of life. Exhibited at SA (4), FS (1), RA (5) 1760-88 and painted a series of six poetic scenes from *The Iliad* 1760-75. One of the founders of neo-classical history painting and helped encourage a taste for the neo-classic. His magnificent painted ceiling survives at the Villa Borghese, Rome. Died Rome 4 January 1798. Anne Forbes was his pupil.
Represented: SNPG; Tate; Holyrood House; University of Glasgow; Villa Borghese, Rome; Museo di Roma; Lennoxlove. **Engraved by** J.Faber jnr, R.Houston, W.Lizars. **Literature:** D.Irwin, *Art Bulletin* XLIV, 1962; DNB; McEwan.

HAMILTON, Gawen c.1697-1737
Born near Hamilton, Scotland. Studied under a bird painter named Wilson. Practised in London from c.1730. Specialized in conversation pieces and small full-lengths. Thought by some contemporaries to be superior to Hogarth. Died London 28 October 1737.
Represented: NPG London; Tate; NG Canada. **Literature:** DA.

HAMILTON, Harriott (Mrs Way) c.1769-after 1828
Born London, daughter of Hugh Douglas Hamilton. Married John Way 1817. Exhibited in Dublin 1826-7 as Mrs Way.
Engraved by H.Meyer, C.Turner.

HAMILTON, Hugh Douglas c.1736/9-1808
Born Dublin c.1736 or c.1739, son of a wigmaker. Studied there under James Mannin and at Dublin Society's Schools under Robert West 1750-6 (winning prizes). Set up on his own and specialized in small oval crayons. Moved to London c.1764, where he was extremely successful. Charged 9 guineas for a small

FLORENCE HANNAM. Mrs Windsor. Signed and dated 1892.
24 x 20ins (61 x 50.8cm) *Phillips*

oval, but also occasionally painted full-lengths and conversation pieces. Exhibited at FS (4), SA (43), RA (3) 1764-91. Won prizes for history painting from SA 1764 and 1765 or 1769. Travelled to Italy 1778, where he visited Rome and Florence, painting British visitors. Friends with Flaxman and Canova, and was encouraged to use neo-classical settings. He continued this style after returning to Dublin 1791, and was so successful that towards the end of his life he was able to charge 120 guineas for a full-length. Retired 1804. Died Dublin 10 February 1808. Produced a number of drawings on flesh-coloured paper with black and white chalk and a sparing use of crayon. These were admired by Walpole. His work, although varied, can be outstanding and he has been greatly underrated. Alexander Pope was his pupil. Horace Hone produced work in his manner.
Represented: NPG London; SNPG; NGI; Castle Museum, Nottingham; Uffizi Gallery, Florence; Ulster Museum; Ickworth, NT. **Engraved by** W.Barnard, F.Bartolozzi, S.Bellin, D.Berger, F.Cecchini, J.Collyer, T.A.Dean, R.Earlom, R.Golding, W.Greatbach, V.Green, E.B.Gulston, J.Heath, R.Houston, S.Ireland, R.Laurie, J.R.Smith, G.T.Stubbs, J.Strutt, J.Thomson, W.Ward, J.Watson. **Literature:** DNB; F.Cullen, 'The Oil Paintings of H.D.H.', Walpole Society, L, 1984, pp.165-208.

HAMILTON, James ARSA 1853-1894
Born Kilsyth. Studied at RSA Schools from 1874. Exhibited at RSA (93), RA (1) 1875-95 from Edinburgh. Elected ARSA 1886. Died Edinburgh 29 December 1894.
Represented: Glasgow AG. **Literature:** McEwan.

HAMILTON, John McLure RP PS 1853-1936
Born Philadelphia 31 January 1853. Studied at Pennsylvania Academy, in Antwerp and Paris under Gérôme. Settled in London 1878. Exhibited at RA (8), RHA (2), Paris Salon 1880-1906. Among his sitters were the Rt. Hon. W.E.Gladstone MP and E.Onslow Ford ARA. Published *Men*

I Have Painted, 1921. Died 10 September 1936.
Represented: NPG London; Glasgow AG. **Engraved by** P.Naumann.

HAMILTON, William RA c.1750/1-1801
Born Chelsea, son of a Scottish assistant to Robert Adam. At an early age he was sent to Rome where he studied as an architectural draughtsman under Zucchi. Returned and entered RA Schools 1769. Exhibited at RA (82) 1774-1801. Elected ARA 1784, RA 1789. Painted a number of theatre portraits, including Mrs Siddons. Also produced histories and narrative scenes. Worked for Boydell's Shakespeare Gallery. Collaborated with Fuseli in illustrating Thompson's 'Seasons', and Gray. Died of fever London 2 December 1801. Buried St Anne's Church, Soho.
Represented: NPG London; SNPG; HMQ; BM; VAM; Fitzwilliam; Leicester AG; Kedleston Hall; Cecil Higgins AG, Bedford. **Engraved by** F.Bartolozzi, J.Caldwall, J.Fittler, J.Heath, P.W.Tomkins. **Literature:** McEwan; DA.

HAMMOND, Miss Gertrude E. Demain RI
1862-1952
Born Brixton. Entered Lambeth Art School 1879 and RA Schools 1885 (winning prizes). Exhibited at RA (22), RHA (1), SBA, RI, Paris Exhibition (Bronze Medallist) 1886-1940 from Clapham, West Kensington, Stow-on-the-Wold and Worthing. Elected RI 1896. Illustrated editions of Shakespeare. Died 21 July 1952.
Represented: Shipley AG, Gateshead; Sydney AG.

HAMNETT, Nina 1890-1956
Born Tenby 14 February 1890. Educated in Bath. Studied at Pelham Art School under A.Cope and at London School of Art under Swan, Lambert and Nicholson. Exhibited at NEAC and in France. Worked in the Omega Workshop and in Paris. Taught at Westminster Technical Institute 1917-18. Died London 16 December 1956.
Represented: NPG London; Southampton CAG. **Literature:** DA.

HANCOCK, Charles 1795-1868
Exhibited at RA (22), BI (55), SBA (46), NWS 1819-67 from Marlborough, Reading, London and Stoke Newington. Worked as a drawing master and advertised his own brand of 'scentless' colours. Probably the portrait and miniature painter 'Mr Hancock' listed at Bristol 1840.
Represented: Tate. **Engraved by** W.Giller, W.Roffe.

HANCOCK, Robert 1731-1817
Baptized Badsey 7 April 1731. Associated with the Worcester porcelain factory. Exhibited at RA (2) 1802 from London. Among his sitters were Samuel Taylor Coleridge, Charles Lamb and William Wordsworth. Moved to Bristol late in his life. His son, Robert 1774/5-1844, was also an artist.
Represented: NPG London. **Engraved by** J.Heath, H.Robinson, R.Woodman. **Literature:** DA.

HANCOCK, Samuel Harry d.1932
Painted landscapes and portraits and lived in Ilford. Founder and first President of Ilford Art Society. Exhibited at RA (5) 1910-24.

HAND, John E. fl.1846-1850
Listed as a portrait painter in Birmingham. Exhibited at RBSA (1) 1846.

HANDLEY, John W.H. fl.1827-1846
Exhibited at RA (11), SBA (2) 1827-46 from London.

HANDLEY, Thomas fl.1855
Listed as a portrait and miniature painter at Stock Exchange Buildings, Ducie Street, Manchester.

GEORGE HARCOURT. The donkey ride – the artist's daughters, Anne, Aletha and Mary. Signed and dated 1906. 57 x 100½ins (144.8 x 255.3cm)
Owen Edgar Gallery, London

HANDLEY-READ, Edward Harry MBE RBA
1869-1935
Born London. Studied at Westminster School of Art under Brown and at RA Schools, where he won the Creswick Prize. Painted in France and the Low Countries, but was based at Storrington, Sussex. Exhibited at RA (10), RI, SBA 1910-25. Instructor on camouflage to Machine Gun Corps and invented a set of coloured diagrams for machine gun teaching. Died 6 December 1935 aged 66.

HANDY, John **fl.1787-1791**
Exhibited at SA (2), RA (1) 1787-91 from London.

HANKEY, William Lee **1869-1952**
Born Chester 28 March 1869. Educated at King Edwards School, Chester. Exhibited at RA (81), RHA (2), SBA 1893-1952 from London, Gidea Park and France. On active service in Flanders with the Artists' Rifles 1915. Promoted to Captain November 1917. His work was sensitively painted and of the highest quality and he was a leading light of the Newlyn School. His first wife, Mabel Emily (née Hobson), was a miniature painter, but the marriage was not a success and they divorced 1917, in which year he married Mary Edith Garner. Died St Stephens Hospital, Chelsea 10 February 1952.
Represented: VAM; Dundee CAG; Glasgow AG; Brighton AG; Manchester CAG; Newport AG, Ulster Museum; Grosvenor Museum, Chester.

HANLEY, Edgar **fl.1878-1883**
Exhibited at RA (22), SBA (5) 1878-83 from London. Among his sitters was 'The Rt Hon G. Osborne Morgan QC MP, Her Majesty's Advocate-General'.

HANNAH, Robert **1812-1909**
Born Creetown, Kirkcudbright. Exhibited at RA (22), RHA (1), BI (1) SBA (2), in Liverpool and Rome 1842-70. Among his sitters was J.C.Hook RA. Two works by him were in the collection of Charles Dickens. Died Kensington 5 April 1909.
Represented: VAM; Glasgow AG; Castle Douglas AG.
Literature: McEwan.

HANNAM, Florence **fl.1890-1898**
Miniature and portrait painter. Exhibited at RA (5) 1890-8 from London.

HANNEMAN, Adriaen **c.1604-1671**
Born at The Hague. A pupil there under Anthonie van Ravesteyn 1619. Moved to London 1626, where he married. May have been assistant to Van Dyck in London from 1632, who influenced his work. Painted a portrait of 'Cornelius Jonson, His Wife and Son' (Rijksmuseum, Enschede). Returned to The Hague c.1638 and was a prominent member of the Painters' Guild there from 1640. During the Commonwealth he painted many of the English Court in exile there. His son William was an esteemed portrait painter in the reign of Charles I, but died young. Buried at The Hague 11 July 1671.
Represented: SNPG. **Engraved by** R.Cooper, H.Danckerts, W.Faithorne jnr, R.Gaywood, G.Vertue. **Literature:** M.R.Toynbee, *Burlington Magazine* XCII March 1950 pp.73-80; O. ter Kuile, *AH.*, 1976; DNB; DA.

HANSEN-BAY, Mrs Celia **b.1875**
Born London. Studied at RCA. Lived in Derbyshire. Painted portraits and landscapes in oil and watercolour.

HANSON, J. **fl.1853-1856**
Exhibited at SBA (2) 1853-6 from London.

HARCOURT, George RA PRP **1868-1947**
Born Dumbartonshire, Scotland 11 October 1868. Studied art in Dumbarton, and there decorated the first-class saloons of the Union Steamship Company's New Zealand liners for

GEORGE HARCOURT. At the harpsichord: my children. Signed and dated 1907. 110½ x 76½ins (280.7 x 194.3cm) *Christie's*

the Denny Brothers. Studied under Herkomer at Bushey from 1889 and became his assistant. Exhibited at RA (140), RSA (6), Paris Salon 1893-1948. Elected RP 1912, ARA 1919, RA 1926. Awarded a Gold Medal at Paris Salon 1923. His portrait of Michael Faraday is in the Institution of Electrical Engineers. Married artist Mary Lascelles Leesmith 1919. Died Bushey 30 September 1947. A talented and perceptive portraitist.
Represented: NPG London; Lady Lever AG; Southampton CAG; Sydney AG. **Literature:** M.H.Spielmann, 'Our Rising Artists – Mr. G.H.', *Magazine of Art* November 1896-April 1897 pp.233-9; McEwan.

HARDIE, Charles Martin RSA JP 1858-1916
Born East Linton 16 March 1858. Studied at Edinburgh School of Design from 1875, then RSA Schools, winning prizes 1878, 1880. Exhibited at RA (12), RSA (171), RHA (2), NWS 1877-1916 from Edinburgh. Elected ARSA 1886, RSA 1895. Died Edinburgh 1 or 3 September 1916.
Represented: SNPG.

HARDING, Charles fl.1822-1847
Exhibited at RA (11), BI (3), SBA (5) 1822-47 from London. Among his sitters were the Duke of Norfolk, the Duke of Hamilton and Brandon, the Duke of Sussex and the Hon Daniel Webster of the United States Senate.

HARDING, Chester 1792-1866
Born Conway, New Hampshire 1 September 1792. A house and sign painter in Pittsburgh 1817, but then specialized in portraiture. Studied briefly at Pennsylvania Academy of the Fine Arts and then worked in America as an itinerant portrait painter. Went to Boston to see Stuart 1822. In England 1823-6, where he was influenced by Lawrence's use of rich colour. Visited England again briefly 1846. Died Boston 10 April 1866.
Represented: Boston MFA; Metropolitan Museum, New York. **Engraved by** C.Turner. **Literature:** C.Harding, *My Egotistigraphy,* 1866; C.H., Connecticut Valley History Museum, Springfield, Massachusetts exh. cat. 1952; DA.

HARDING, Edward J. 1804-1870
Born Cork 1 March 1804. Painted portraits and miniatures in oil, watercolour and ink. Died 19 August 1870.

HARDING, Emily J. (Mrs Andrews) fl.1877-1898
Exhibited miniatures at RA (3) 1877-98 from London. Capable of extremely sensitive and penetrating portraits. Married artist Edward. W. Andrews.
Represented: NPG London.

HARDING, George Perfect 1781-1853
Son of artist Sylvester Harding. Specialized in miniatures and portrait copies. Exhibited at RA (20), SBA (2) 1802-40. Published a series of portraits of the Deans of Westminster 1822-3. Later worked on a series of the Princes of Wales. Involved in the Granger Society 1840-3, which intended to publish previously unengraved historical portraits. After the society's collapse he published 15 on his own account. Elected FSA 1839-47, then resigned. Died Lambeth 23 December 1853.
Represented: NPG London; SNPG; BM; National Museum of Wales. **Engraved by** J.Brown, T.A.Dean, S.J.Ferris. **Literature:** Ottley; DNB.

HARDING, Miss Mary E. fl.1880-1916
Exhibited at RA (30), SBA 1880-1916 from London and Exeter.

HARDING, O. fl.1796
Exhibited at RA (1) 1796 from 91 White Lion Street, Islington.

HARDING, Sylvester 1745-1809
Born Newcastle-under-Lyme 25 July 1745 (or 5 August 1751 according to RA Schools). Placed as a child in the charge of his uncle in London. Ran away, aged 14, to join a company of strolling actors, but returned to London 1775 setting up as a miniature painter. Entered RA Schools 25 November 1776 aged '25 5th August last'. Exhibited at FS, RA (22) 1776-1802. Began a book and printseller's shop with his brother, Edward, in Fleet Street and then Pall Mall. Compiled with his brother an anthology of historical portraits, *Biographical Mirror,* 1792-8. Died London 12 August 1809.
Represented: NPG London; BM; Wallace Collection; NGI. **Engraved by** J.Baldrey, A.Birrell, H.R.Cook, W.N.Gardiner, E.Harding jnr, J.Hopwood, W.Humphrey, C.Knight, J.Jones, Legoux, J.Ogborne, Ridley, Holl & Blood, J.Parker, T.Nugent. **Literature:** DNB.

HARDMAN, Mrs Emma Louise fl.1888-1918
Exhibited at RA (8), SBA, NWS, Paris Salon 1906-18 from Northaw, Hertfordshire. Married to artist Thomas Hardman.

HARDMAN, Mrs Minnie J. fl.1900-1930
Exhibited at RA (6), SM 1900-30 from Northaw, Hertfordshire.

HARDWICK fl.1773
Exhibited a crayon portrait at FS 1773 from 'The Tower'.

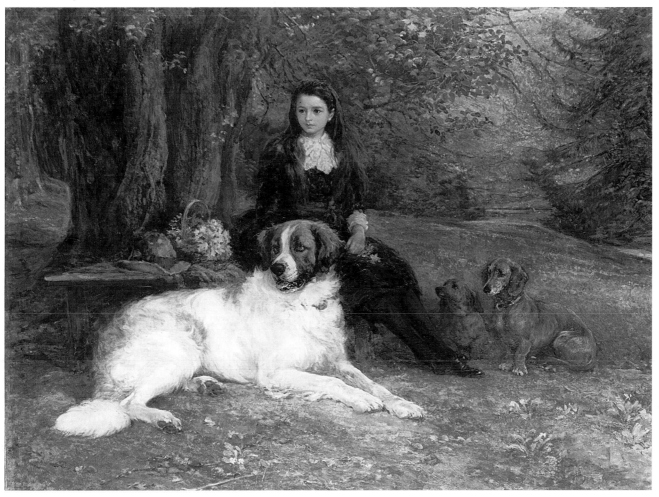

HEYWOOD HARDY. Agnes Fanny Marland Denny at Chiddingstone Castle, Kent. Signed and dated 1889. 30 x 38ins (76.2 x 96.5cm)
Sotheby's Sussex

HARDWICK, Charles fl.1848
Listed as a portrait painter at Preston.

HARDY, F. fl.1790
Exhibited at FS (4) 1790 from London.

HARDY, Mrs Florence Deric (née Small) PS
fl.1889-1931
Born Nottingham, daughter of William Small. Educated in London. Studied art in Geneva, Berlin and Paris. Exhibited at PS, RA (3), NWG, GG, Paris Salon (Bronze Medallist) 1889-1931. Married Charles Frederic (Deric) Hardy 1893.

HARDY, Heywood RP ARWS RE ROI 1842-1933
Born Chichester 25 November 1842, youngest of six children of artist James Hardy snr and Elizabeth (née Vinson). The family moved to Bath, and the quarrelsome nature of his father led to his leaving home aged 17. After a short time in 7th Somerset Volunteers, he borrowed money from his brother, James, and entered the Beaux Arts in Paris 1864. Before the outbreak of war with Prussia he left Paris for Antwerp where he studied the old masters. Returned to England before 1868, and was often invited to country estates to paint portraits, sporting pictures and animal studies. Among his distinguished patrons were Colonel Wyndham Murray, the Marquess of Zetland and the Sitwells of Renishaw. Although an outstanding portrait artist, he made

his reputation painting period genre. Exhibited at RA (46), BI (9), SBA (17+), OWS, RP 1861-1919. Elected RP 1891. Illustrated for magazines such as *The Graphic* and *Illustrated London News*. On 30 June 1868 he married Mary, youngest daughter of Admiral F.W.Beechey, and granddaughter of Sir William. They had four daughters (Mabel married the brother of Somerset Maugham), but eventually separated. Shared a studio in St John's Wood with Briton Riviere, and was a friend of J.S.Sargent, Whistler and their circle. Moved to West Sussex 1909, where he lived at the Rosery, East Preston. At the age of 73 he painted the first of a series of eight biblical scenes for the chancel of Clymping Church, which caused considerable controversy as they depicted Christ walking in the Downs of Sussex among modern figures, said to be portraits of the residents of the village. Died Epsom 20 January 1933 aged 90, while staying with his daughter. His ashes were buried at Clymping Church.
Literature: B.Stewart & M.Cutten, *Antique Collector* 1986; Stewart & Cutten.

HARDY, James snr 1801-1879
Born Hounslow, Middlesex, son of William Hardy and Jane (née Chapman). Originally his taste was for music and he became chief trumpeter to George IV. Then worked as a portrait and landscape painter in Manchester 1825, London 1832, Brighton 1833-4, Lewes 1836, Chichester 1837-45 and Bath 1846-79. Produced work of an extremely high

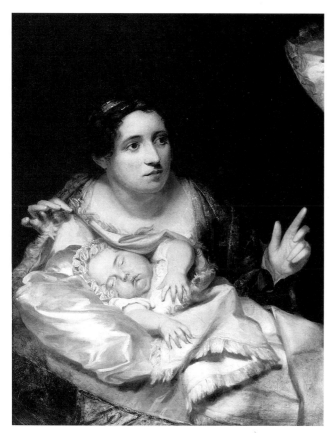

GEORGE HENRY HARLOW. A mother and sleeping child. Signed. 37 x 29ins (94 x 73.7cm) *Phillips*

standard. Patronized by the Duke of Richmond and the gentry. Exhibited at RA (10), SBA (10) 1832-57. In his later years he developed a religious mania, and lost the patronage by obtruding his views in an irritating manner upon his patrons in private, and upon the public in general, by proclaiming at street corners whenever the opportunity occurred. Died Bath 7 January 1879. His sons, David, James and Heywood were all successful painters.
Literature: Stewart & Cutten.

HARDY, James jnr RI 1833-1889
Born Brighton 16 January 1833, son of James Hardy snr and brother of Heywood Hardy. Worked in Bath as a portrait painter. Moved to Bristol 1859, London 1871. Exhibited at RA (9), BI (8), ROI 1862-88. Died Virginia Water, Surrey 24 July 1889.
Represented: Brighton AG.

HARDY, Miss Nina (Charlotte Nina Elizabeth) b.1869
Born Goring, Oxfordshire 9 June 1869 (baptized 4 July 1869), daughter of Heywood Hardy and Mary. Exhibited at RA (15), NWG, GG 1891-1919 from London and Windsor. Married Edward John Curtis, Company Director.

HARDY, Thomas 1757-after 1804
Born June 1757. Entered RA Schools 1778. Exhibited at SA, RA (31) 1778-98. Also a mezzotint engraver. His last known print was published 1804.
Represented: NPG London; Hatchlands, NT. **Engraved by** Cooke, J.Jones, W.Nutter, B.Smith.

HARDY, W. fl.1785-1803
Exhibited at RA (4) 1785-1803 from London.

HARE, Julius RCA 1859-1932
Born Dublin 23 January 1859, son of Mathias Hare LL.D. Educated at Loughborough Grammar School. Studied under Adolf Yvon in Paris, South Kensington Schools and Heatherley's. Exhibited at RHA (2), RA (2), SBA (1) 1886-9 from Fulham and Conway, North Wales. Died 12 March 1932.

HARE, St George RI ROI 1857-1933
Born Limerick 5 July 1857, son of George Frederick Hare, an Englishman. Studied there under N.A.Brophy. Moved to London 1875. Entered School of Art, South Kensington. Exhibited at RHA (27), RA (32), SBA, RI, ROI, DG 1881-1923. Elected RI 1892. Died London 30 January 1933.
Represented: NGI; Stourhead, NT. **Literature:** *Art Journal* 1908 pp.345-9.

HARGRAVE, J. fl.1693-1719
Painted a number of portraits in the manner of Kneller. May be the Mr Hargrave who provided Vertue with information 1719.
Engraved by W.Elder.

HARGREAVES, George RBA 1797-1870
Son of artist Thomas Hargreaves. Exhibited at RA (3), SBA (6) 1818-28 from London. Founder RBA. Settled in Liverpool 1824. Elected ALA 1822, LA 1823-31.
Engraved by W.T.Fry.

HARGREAVES, Thomas RBA 1774-1847
Born Liverpool 16 March 1774 (baptized 7 April), son of Henry Hargreaves, a woollen draper. Entered RA Schools 29 March 1790. An articled assistant under Lawrence from 10 May 1793, until he returned to Liverpool 6 August 1795 as 'a portrait painter in oil and miniature'. In London again 1797, when it is believed he was helping Lawrence, but had returned to Liverpool by 1803, where he established a successful practice and helped with his father's business. Exhibited at RA (9), SBA (8) 1798-1831. Elected founder LA 1810, founder SBA 1824. According to a reviewer of 1827 his 'chief sittings are short, and in them he contents himself with pencil sketches, from which he works up, at his leisure, those beautiful heads which have long been the admiration of the public'. Married Sarah Shaw and had several children, of whom three sons were certainly artists, probably helping in 'a family business'. Worked for a brief time in Manchester and gradually concentrated on miniatures because of delicate health. Died Liverpool Tuesday 5 January 1847 (not 23 December 1846 as often stated).
Represented: Walker AG, Liverpool; VAM; Liverpool Record Office; Athenaeum Library, Liverpool. **Engraved by** J.Cochran, W.T.Fry, R.Grave, E.Smith.

HARLAND, T.W. fl.1832-1854
Exhibited at RA (17) 1832-54 from London. Among his sitters were Charles Barry and Mr Holl of the Haymarket Theatre. Possibly Thomas Wilkinson Harland who married Ann Furser 30 November 1817.
Represented: NPG London. **Engraved by** F.Holl.

HARLAND FISHER, Percy see FISHER, Percy Harland

HARLING, William Owen fl.1849-1879
Exhibited at RA (27), BI (4), SBA (2) 1849-79 from Chester, London and Nice.

HARLOW, George Henry 1787-1819
Born St James's Street, London 10 June 1787, five months after the death of his father, a china merchant. Educated at Dr Barrow's, Mr Roy's in Burlington Street and Westminster School. Studied under Hendrick Frans de Cort and Samuel Drummond before entering Lawrence's studio aged 15, where he was much influenced by Lawrence's style and use of

colour. Remained with Lawrence about 18 months, but a difference over the authorship of a work (Harlow reportedly informing one of Lawrence's clients that a painting was primarily by his hand) led them to fall out. Harlow rendered reconciliation impossible by painting a caricature inn sign at Epsom in Lawrence's style and affixing Lawrence's initials to it. Despite their differences Lawrence, with some justification, considered him the most promising 'of all our painters' and he was also admired and encouraged by Fuseli. Exhibited at RA (45), BI (5) 1804-18 from London. Among his sitters were HRH the Prince of Wales, HRH the Duke of Sussex, Benjamin West PRA, James Northcote RA, Sir William Beechey RA and Henry Fuseli RA. He had an extravagant taste in clothes, which led his friends to nickname him 'Clarissa Harlow'. Visited Rome 1818, where he was befriended by Canova, who admired his work and obtained for him an introduction to meet the Pope. Elected an Academician of Merit in the Accademia di San Luca, and invited to deposit his portrait in the Gallery of Self Portraits at the Uffizi. Returned to London 13 January 1819. Died 4 February aged 32 from an infection of the throat (recorded as mumps). Buried under the altar of St James's, Piccadilly. Studio sale held Foster's, London 21 June 1819 and 3 June 1820. Robert Edmonstone was his pupil.
Represented: NPG London; BM; VAM; NGI; Ashmolean; Birmingham CAG; Walker AG, Liverpool; Garrick Club; Accademia di San Luca, Rome; Philadelphia MA; Yale; Metropolitan Museum, New York. **Engraved by** T.Blood, W.O.Burgess, A.Cardon, L.Chapon, G.Clint, H.D.Cook, H. & R.Cooper, T.A.Dean, T.Fairland, E.Finden, J.Fittler, S.Freeman, J.Godby, W.Greatbach, Guillaume, B.Holl, J.Hollis, C.H.Jeens, J.Jenkins, R.J.Lane, F.C.Lewis, H.Meyer, W.H.Mote, P.Nocchi, R.Page, I.J.Penstone, S.W.Reynolds, H.Robinson, J.Roffe, J.Rogers, C.Rolls, F.R. & W.Say, E.Scriven, R.T.Stothard, J.Thomson, C.Turner, Mrs D.Turner, W. van Senus, W.Ward, C.Warren, T.Woolnoth, W.Worthington, A.Wivell. **Literature:** DNB; Annals of the Fine Arts, Vol 4 no.12 1820 pp.158-9, Vol 13 1820 p.339; DA.

HARMAR, Fairlie (Viscountess Harberton) NEAC
1876-1945
Born Weymouth, daughter of Colonel Charles D'Oyly Harmar. Studied at Slade. Exhibited at RA (31), NEAC (26) 1906-44. Elected NEAC 1917. Married 7th Viscount Haberton 1 March 1932. Died 13 January 1945.
Represented: Walker AG, Liverpool; Wolverhampton AG; Harrogate AG; Bradford AG; Newport AG; Belfast AG; Manchester CAG; Birmingham CAG.

HARPER, Edward S. RBSA 1878-1951
Born 11 June 1878. Educated in Birmingham. Exhibited at RA (22), NWS 1885-1927 from Birmingham. Art master at Wolverhampton Grammar School until 1942. Died 5 April 1951.

HARPER, John fl.1814-1824
Exhibited at RA (11), BI (4) 1814-24 from Wednesbury and Brighton. Brighton AG gives his dates as 1809-42, but the birthdate seems unlikely.
Represented: Brighton AG.

HARPER, Thomas fl.1817-1843
Exhibited portraits and miniatures at RA (19) 1817-43 from London.
Represented: VAM.

HARRIS, Master Charles fl.1780
Honorary exhibitor of a crayon portrait at SA 1780.

HARRIS, Edwin RBSA 1855-1906
Born Ladywood, Birmingham. Educated Old Edgbaston School, where he became a friend of W.A.Breakspeare. Entered

GEORGE HENRY HARLOW. James Northcote RA. 21 x 17ins (53.3 x 43.2cm) *Christie's*

Birmingham School of Art, aged 14. Became assistant master for two years. Studied at Verlat's Academy, Antwerp from 1880. Exhibited at RA (13), SBA (1), RBSA 1877-1904. Elected ARBSA 1881, RBSA 1888. Worked in Birmingham, Newlyn from 1883, Eversham, Cardiff, Newport and Bristol. Died Birmingham. His work could reach a very high standard.

HARRIS, George fl.1858-1881
Exhibited at RA (6), SBA (3) 1858-81 from London. Sometimes confused with still-life painter George Walter Harris.

HARRIS, George Frederick d.1926
Worked as a portrait painter in Merthyr Tydfil. Emigrated to Australia, where he died of influenza 1926. Grandfather of TV entertainer Rolf Harris.
Represented: Cyfartha Castle.

HARRIS, James Cobham fl.1852-1853
Listed as a portrait painter in Plymouth. May be the James C.Harris who exhibited at ROI and worked as a watercolour artist in Nice.

HARRIS, John jnr c.1791-1873
Son of artist John Harris. Entered RA Schools 10 January 1812 aged 20. Exhibited portraits, figurative subjects and lithographs at RA (15), BI (4), SBA (4) 1822-51 from London. A freemason. Among his exhibited portraits was 'HRH the Duke of Sussex, M.W. Grand Master of the United Free and Accepted Masons of England'. Recorded in Liverpool 1860-1. Died 28 December 1873.
Represented: NPG London; Walker AG, Liverpool. **Engraved by** J.Kennerley.

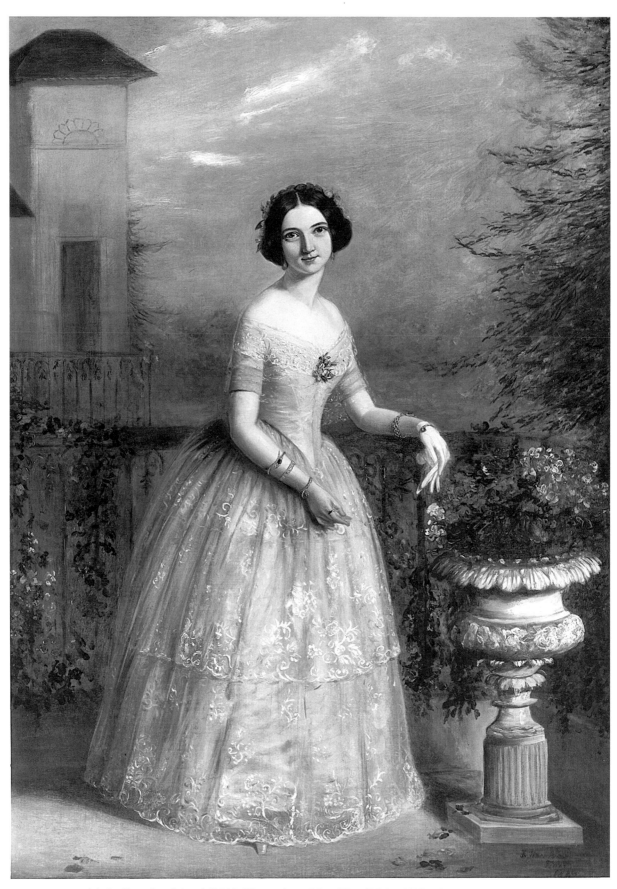

J. HARRISON. A lady. Signed and dated ?1849. Watercolour. 10 x 6¾ins (25.4 x 17.2cm) *Christopher Wood Gallery, London*

HARRIS, John b.c.1823
Born St Pancras. Listed as a portrait painter in 1851 census for London aged 28.

HARRIS-BROWN, H. see BROWN, Henry Harris

HARRISON, Cecilia fl. 1897
Her portrait of George Macdonald is in SNPG.

HARRISON, Darent fl.1897-1900
Exhibited at RA (4) 1897-1900 from West Kensington, London.

HARRISON, Gerald E. fl.1890-1921
Exhibited at RA (13), RHA (3), SBA 1890-1921 from Brighton, London and East Grinstead.

HARRISON, J. fl.1845-1865
Exhibited at RA (28) 1846-65 from York and London. Practised as a miniature and portrait painter and reportedly used York as a base for his travels to the northern provinces. Had a distinguished clientele.
Engraved by F.Holl.

HARRISON, J.B. fl.1867-1872
Exhibited at RA (4) 1867-72 from London. Among his sitters were the Bishop of Hereford and Dr David Livingstone.

HARRISON, John jnr fl.1801-1852
Exhibited at RA, BI and SBA 1801-34 from London. Dropped the jnr by 1811. Inextricably confused in the RA catalogues with James Harrison.
Engraved by W.Say.

HARRISON, Lawrence Alexander NPS c.1867-1937
London portrait painter who rarely exhibited his work in public. Died 17 March 1937 aged 70.

HARRISON, Miss Sarah Cecilia 1863-1941
Born County Down, Ireland 21 June 1863. Studied at Slade under Legros. Exhibited at RA (12), RHA (60), NEAC, NWG (1) 1889-1933 from London and Dublin.
Represented: NGI.

HARRISON, William A.D. fl.1896
Exhibited at RA (2) 1896 from London.

HART, James Turpin 1835-1899
Baptized Radford, Nottinghamshire 29 March 1835, son of Edmund Richardson Hart, a cordwainer and his wife Jane née Turpin. Studied there at School of Design and at RA Schools 1860-7 (Silver Medallist and life studentship). Exhibited at RA (4), BI (12) 1856-66. Returned to Nottingham, where he built up a portrait practice and taught at the School of Art. Died Nottingham December 1899 aged 64. His death has been given incorrectly as 1898 and 1907. Painted with meticulous detail and bright colours.
Represented: Nottingham Castle Museum.

HART, Solomon Alexander RA 1806-1881
Born Plymouth April 1806, son of Samuel Hart, a Jewish goldsmith, engraver and Professor of the Hebrew Language, who had studied under Northcote 1785. Accompanied his father to London 1820, where he was apprenticed to S.Warren, a line engraver. Entered RA Schools 15 August 1823. Began his career as a miniaturist, later producing work on the scale of life. Exhibited at RA (122), BI (25), RHA (3), NWS, SBA (34) 1826-81. Elected ARA 1835, RA 1840. Visited Italy 1841-2. Succeeded C.R. Leslie as Professor of Painting at RA Schools 1854-63, and librarian 1864-81. Died London 11 June 1881. Studio sales held Christie's 29 July and 2 August 1881.
Represented: BM; Tate; VAM. **Literature:** *Art Journal* 1881 p.223; A.Brodie, *Reminiscences of S.A.H. RA,* 1882; DNB.

HARTLEY, Alfred RBA RE 1855-1933
Born Stocken Pelham, Hertfordshire 15 July 1855, son of Rev Charles Hartley. Studied under Sir Frank Short and C.J.Watson; South Kensington Schools and Brown's class at Westminster School of Art. Exhibited at RA (65), SBA (20+), RHA (6), NWS, GG, NWG, RE 1885-1931 from London, Dorset and Cornwall. Elected RBA 1891. Had a highly successful portrait practice. Among his sitters were Lord Randolph Churchill, Lord Russell and the Prime Minister. Also an engraver in line and aquatint. Died 27 October 1933.

HARTLEY, Herbert Johnson fl.1911
Painted portraits and animals.

HARTLEY, Miss M. fl.1764
Amateur portrait painter. Painted Buxton, the arithmetician.

HARTLEY, Thomas fl.1820-1860
Exhibited at RA (12), BI, SBA (38), OWS 1821-59 from London.
Engraved by C.Turner 1836.

HARTMANN, Karl 1818-1857
Exhibited at RA (7), BI (1), SBA (18) 1850-7 from London. Two watercolour portraits of Jane Carlyle by him are in Carlyle's House, London.

HARTNELL, Nathaniel fl.1831-1864
Exhibited at RA (10), BI (6), SBA (10) 1831-64 from London. Listed as a portrait painter in the directories.

HARVEY, Douglas fl.1861-1878
Exhibited at RSA (14). Listed as a portraitist at 3 Cromwell Place, Ayr.

HARVEY, George ANA c.1800-1878
Born Tottenham. Moved to America aged 20. Spent several years in Ohio, Michigan and Upper Canada, before establishing himself as an artist. Settled in Brooklyn by 1828. Elected ANA 1828. Moved to Boston 1829 and studied art in England shortly after. Exhibited at RA (8) 1832-49 from Fitzroy Square, London. Made regular trips to North America, Florida and Bermuda. The landscape painter George Harvey was his nephew and pupil.

HARVEY, Sir George PRSA 1806-1876
Born St Ninians, Fifeshire February 1806, son of a watchmaker. Apprenticed to a bookseller in Stirling. Studied under Sir William Allan at Trustees' Academy, Edinburgh 1823-5. Exhibited at RSA (125), RA (15), BI (1), SBA (2) 1826-75 from Edinburgh. Elected a founder ARSA 1826, RSA 1829, PRSA 1864. Died Edinburgh 22 January 1876.
Represented: SNPG; Glasgow AG. **Literature:** A.L.Simpson, *Harvey's Celebrated Paintings,* 1870; McEwan; DA.

HARVEY, Harold C. 1874-1941
Born Penzance, son of Francis McFarland Harvey. Studied under Norman Garstin and at Académie Julian, Paris under B.Constant and J.P.Laurens. Exhibited at RA (63), RHA (18) 1898-1941. Settled in Newlyn. Died Newlyn 19 May 1941. Described by *The Studio* as one of the 'truest and sincerest of British Painters'.
Represented: AGs of Cardiff, Swansea, Oldham, Hartlepool, South Shields, Truro, Northampton, Leamington Spa and Brighton.
Colour Plate 30

HARVEY, J.S. fl.c.1760
Signed a portrait of 'Benjamin Way of Denham Place'.

HARVEY, John Rathbone RBSA d.1933
Studied at Slade. Worked in Birmingham. Exhibited at RA (1), RBSA from 1887. Elected ARBSA 1902, RBSA 1917.

HARVEY, Robert fl.1851-1871
His portrait of Robert Cook is in SNPG.

HARVIE, R. fl.1751-1763
Painted portraits of Scottish border families. His dated works range from 1751-63. Among his sitters was Elizabeth (Dalrymple) wife of William Duff.
Represented: Mellerstain (Lord Haddington).

HARWOOD, John James c.1816-1872
Born Clonmell, son of a house painter, reportedly in 1816, although the 1871 census for London lists his age as 50. Believed to have studied in Italy. Worked in Clonmell 1836, London 1839 and Bath 1841-4. Settled in London. Exhibited at RA (51), BI (18), SBA (15), RHA (29) 1836-71.
Represented: NGI.

HARWOOD, Robert 1830-after 1880
Born Clonmell, younger brother of J.J.Harwood. Settled in London. Exhibited at RA (11), BI (7), SBA (19), RHA (2) 1855-80.

HASKOLL, Theodore F. fl.1883
Listed as a portraitist at 2 Phillipsburgh Avenue, Drumcondra, Dublin.

HASLEM, John 1808-1884
Born Carrington, near Manchester February 1808. Studied under George Hancock. Aged 14 entered as a painter the Derby Porcelain Works of his uncle James Thomason. Attracted the attention of the Duke of Sussex, who sent him to London for further study under E.T.Parris 1835. Returned to Derby 1857. Produced portraits in enamel, oil and watercolour. Exhibited at RA (37), SBA (14) 1836-65. Painted enamel portraits for the royal family and published works on Derby china. Died Derby.
Represented: NPG London; Ashmolean; Derby AG.
Literature: DNB.

HASSAM, Alfred fl.1870-1897
Painted portraits and travelled to the Near East. Also wrote *Arabic Self-Taught*, 1897.

HASSELL, William fl.1770
Worked as a portrait and miniature painter. Sat to Kneller for his own likeness. George Lambert was his pupil.
Engraved by J.Smith, P.Vanderbank. **Literature:** Redgrave.

HASSELLS, Warner fl.1680-1710
A native of Germany. Worked in London. George Lambert was said to have been his pupil. Painted in the manner of Kneller.
Represented: VAM. **Engraved by** C.L.Fels, J.Smith, P.Vanderbank, J.Witt. **Literature:** DNB.

HASTINGS, Edward (Edmund) 1781-1861
Born Alnwick. Educated at Bamburgh. Studied art under the patronage of the Archdeacon of Northumberland, R.G.Bouyer. Exhibited at RA (47), BI (11), SBA (9), OWS and in Newcastle 1804-27. Based in London and Durham (where he married c.1805). Worked much in the north-east. Died Durham. Sometimes recorded as Edmund Hastings.
Represented: Laing AG; Old Town Hall, Durham.
Engraved by J.Collyer, L.Corbaux, C.Turner, T.Woolnoth.
Literature: Hall 1982.

HASTINGS, Miss Kate Gardiner fl.1885-1888
Exhibited at RA (4), GG, NWG 1885-8 from London.

HASTINGS, William A. fl.1830-1831
Exhibited at RA (3), SBA (3) 1830-1 from Bedford Square.

HATTON, Brian 1887-1916
Born Hereford. Aged 12 had already attracted the attention of Princess Louise and G.F.Watts. Sent for a year to Oxford and a period at George Harcourt's Painting School, Arbroath. Learnt modelling under Professor Lanteri. Studied in Egypt 1908-9. Entered Académie Julian, Paris 1910. Set up practice in London 1912 and began to receive important commissions. Exhibited at RA (1) 1914. Joined up for the war in 1916 and was killed at Oghratina, Egypt the same year.
Represented: BM; Brian Hatton Gallery, Churchill Museum, Hereford. **Literature:** C.Davies, *B.H. A Biography of the Artist*, 1978.

HATTON, Edward b.c.1827
Born Westminster. Aged 34 in 1861 census. Exhibited at SBA (1) 1850 from Fitzroy Square, London.

HATTON, Miss Helen Howard (Mrs Margetson) b.1860
Born Bristol. Exhibited at RA (9), RHA (1), SBA (6) 1879-1904 from London. Married artist William Henry Margetson c.1894/5.

HATTON, Richard George ARCA 1865-1926
Born Birmingham, son of George and Ellen Hatton. Studied at the School of Art there. Painted portraits, genre and landscape. Appointed assistant art master at Armstrong College in Newcastle 1890, Head 1895 and Director of King Edward VII School of Art, Newcastle 1912 (Professor of Fine Art 1917). The Hatton Gallery, Newcastle University was named after him. Published a number of art books 1901-25. Died Newcastle 19 February 1926.
Represented: Laing AG.

HAUCK, John Maurice fl.1759
Worked as a portrait painter in York.
Represented: York AG.

HAUCK, Philip Elias fl.1761-1777
Listed as a portrait painter. Exhibited at SA (6), FS (1) 1761-77 from London.

HAUGH, George 1756-1827
Baptized Carlisle 12 March 1756. Studied under Captain J.B.Gilpin. Entered RA Schools 1772. Settled in Doncaster c.1780. Exhibited at RA (3), BI (9), Carlisle Academy (14) 1777-1826. Died Doncaster 27 May 1827.
Represented: VAM.

HAUGHTON, Moses snr 1734-1804
Born Wednesbury. Trained as a Birmingham enameller at Mr Holden's manufactory. Settled in Birmingham and gained a reputation for still-life. Exhibited at RA (4) 1788-92. Died Ashted, near Birmingham 23/24 December 1804 aged 70. A monument was erected to his memory in St Philip's Church, Birmingham. His work is confused with that of his nephew, Moses Haughton jnr. His son Matthew was an engraver.
Literature: DNB.

HAUGHTON, Moses jnr c.1774-c.1848
Born Wednesbury, nephew of Moses Haughton snr. Moved to London. Studied under George Stubbs. Entered RA Schools 12 October 1795 aged 21. Set up as a portrait and

miniature painter. A friend of Fuseli, whose work he engraved. Exhibited at RA (91) 1800-48.
Represented: BM; Walker AG, Liverpool. **Literature:** DNB; Farington's *Diary* 27 February 1802.

HAVELL, Edmund jnr 1819-1894
Born Reading, son of artist Edmund Havell. Exhibited at RA (80), BI (16), SBA (11) 1835-95 from Reading, London and Bristol. Visited America and exhibited in Philadelphia. Succeeded his father as a drawing master at Reading. Collaborated with artist William H.Hopkins.
Literature: WH., Reading Museum exh. cat. 1970.

HAVELL, George fl.1826-1833
Exhibited at RA (4), BI (1), SBA (5) 1826-33 from Reading, London and Oxford. Married miniaturist Marianne A.Hale c.1825.

HAVELL, Miss H. Christabelle fl.1904
Exhibited at RA (1) 1904 from 7 Dilke Street, Chelsea.

HAVERTY, Joseph Patrick RHA 1794-1864
Born Galway. Exhibited at RHA (88), RA (17), SBA (8) 1826-66 from London and Dublin. Elected founder ARHA 1824, RHA 1829. Worked in Galway, Rostrevor, Limerick, London and Dublin. Painted 'His Eminence Cardinal Wiseman'. Died Dublin or Galway (conflicting sources) 27 July 1864.
Represented: NGI. **Literature:** DNB.

HAVERTY, Thomas fl.1846-1858
Exhibited at RHA (21) 1846-58 from Dublin and London.

HAVILAND, Francis O.A. d.1912
Exhibited portraits and miniatures at RA (18) 1894-1910 from London. Died March 1912.

HAVILAND, Harriet M. fl.1863-1865
Her portrait of historian Alexander William Kingslake is in NPG London.

HAVILL, Frederick d.1884
Exhibited at RA (11), SBA (4) 1849-74 from Cheltenham and Manchester. His portrait of David Livingstone is in NPG London.

HAWES fl.1786
Painted a portrait of 'The Rev. Edmund Cartwright and His Five Children' in Doncaster 1786.

HAWKER, Thomas c.1641-1722
Believed to have been assistant to Lely at the the time of his death (1680) and took the lease on Lely's house for some years in the 1680s, but defaulted and moved to Covent Garden 1700. Painted competently in the manner of Lely and charged, in 1683, £15 for a 50 x 40in. Moved to Windsor by 1716, where he died (a 'poor Knight') 1722, aged over 80. Paintings attributed to him are in NPG London and Duke of Grafton collection.
Engraved by Beckett, C.N.Schurtz; R.Tompson. **Literature:** *Diaries of Sir Edward Dering*, 1976 p.5; DNB.

HAWKINS, Benjamin Waterhouse fl.1832-1849
Exhibited at RA (4), BI (4) and SBA (16) 1832-49 from Hyde Park. Also an illustrator, lithographer and sculptor.

HAWKINS, Henry RBA c.1796-1881
Entered RA Schools 31 October 1821 aged 25. Exhibited at RA (8), BI (2), SBA (193) 1822-81 from London, Leamington and Nottingham. Elected founder RBA 1824.

HAWKINS, Miss Jane fl.1871-1879
Exhibited at RA (1), SBA (9) 1871-9 from Chelsea.

HAWKINS, Mrs Louisa (W.H.) fl.1839-1868
Exhibited at RA (20), SBA (10) 1839-68 from London.
Engraved by W.H.Mote.

HAWKSETT, Samuel 1776-1851
A native of Belfast, where he was a leading portrait painter. Exhibited at RHA (13), Association of Artists, Belfast 1826-33.
Engraved by Adcock, T.Lupton.

HAWKSLEY, Miss Dorothy Webster RI 1884-1970
Studied at RA Schools under Clausen, Soloman and Dicksee, where she won a Silver Medal and Landseer Scholarship. Exhibited at RA (66), RI, Paris Salon (Silver Medallist 1931) 1909-64 from London. Died 1 July 1970.
Represented: Brighton AG.

HAWORTH, Miss E.F. fl.1844-1845
Honorary exhibitor at RA (2) 1844-5. Among her sitters was 'Miss Lowe, Daughter of the Dean of Exeter'.

HAY, Andrew fl.1710-1754
Born in Fife. Trained as a portraitist under Medina. By the 1720s he had given up painting professionally and concentrated on picture dealing, often travelling to Italy.
Literature: DA.

HAY, John fl. 1768-1776
Studied under R.Cosway. Entered RA Schools 1769. Concentrated on miniatures, but also painted life-size portraits. Exhibited at SA, FS and RA (4) 1768-76 from Leicester Square.
Engraved by J.Collyer, W.Hirst.

HAY, John Arthur Machray RP 1887-1960
Born Aberdeen, son of James Hay. Studied at Alan Fraser Art College. Exhibited at RP. Elected RP 1928. Member of London Portrait Society. Died London 24 November 1960.
Literature: McEwan.

HAY, Miss Mary fl.1797-1809
Exhibited at RA (3) 1807-9 from 45 Chandos Street, London.

HAY, Peter Alexander RI RSW RBC 1866-1952
Born Edinburgh, son of Peter Hay. Studied at RSA Schools, Académie Julian, Paris and in Antwerp. Exhibited at RHA (4), RA (64), SBA, ROI, NWG, Paris Salon and in Scotland 1892-1941 from Edinburgh and London. Died 13 March 1952.
Literature: McEwan.

HAY, W. fl.1776-1797
Exhibited at RA (18) 1776-97. Worked in London, Plymouth, Gloucestershire and Bath.
Engraved by J.Chapman.

HAY, William M. fl.1852-1881
Exhibited at RA (18), BI (13), SBA (39) 1852-81 from London. Among his sitters were Lady Morshead and 'David Holland Erskine Esq, Her Majesty's Consul at Madeira'.

HAYDON, Benjamin Robert 1786-1846
Born Plymouth 25 or 26 January 1786, son of a printer and publisher. Encouraged by J.Bidlake of Plymouth Grammar School (where he was a school friend of S.Prout) and by a Neapolitan bookbinder named Fenzi, who was employed by his father. Spent six months with an accountant, before being apprenticed to his father. Moved to London. Encouraged by

Prince Hoare, Northcote, Fuseli, Opie and Smirke. Studied at RA Schools, where he was friends with Wilkie and Jackson. Exhibited at RA (11), BI (16), SBA (28), OWS 1807-45. Could be quarrelsome, and produced some pamphlets with scathing attacks on the Academy. Obsessed by the idea of elevating historical painting in England. Disappointed in the Westminster Hall competitions, and as a result, arranged an exhibition of his work at the Egyptian Hall, Piccadilly 1846. This was very poorly attended, and Haydon's annoyance was intensified by the fact that a dwarf ('Tom Thumb') appearing nearby attracted huge crowds. His high aims prevailed over economic considerations and he was briefly imprisoned for debt. Depression set in, and on 22 June 1846 he committed suicide in London by both shooting himself and cutting his throat. The quality of his work varies considerably, but he was capable of penetrating and accomplished portraits. Among his pupils were Sir C.L.Eastlake, W.Bewick, W.Harvey, G.Lance, F.Y.Hurlstone, Emma Derby, and Charles, Edwin and Thomas Landseer.
Represented: NPG London; VAM; Tate; Stratford Saye; BM; Ashmolean; Manchester CAG. **Engraved by** J.C.Bromley, H.Cook, C.H.Jeens, T.Landseer, T.Lupton, Roffe, J.Thomson, G.R.Ward. **Literature:** *Art Union* 1846 p.235; T.Taylor, *Life and Art of B.R.H*, 1853; F.W.Haydon (ed), *Correspondence and Table Talk of B.R.H.*, 1876; E.George, *The Life and Death of B.R.H.*, 1948, 2nd edition with additions by D.George, 1967; C.Olney, *B.R.H. – Historical Painter*, 1952; DNB; DA.

HAYES, Claude RI ROI 1852-1922
Born Dublin, son of Edwin Hayes RHA and Ellen (née Brisco). Ran away to sea, serving on *The Golden Fleece* which was being used in the Abyssinian Expedition 1867-8. Spent a year in America before studying at Heatherley's School for three years. Then at RA Schools and at Antwerp under Verlat. First practised as a portrait painter, but soon abandoned this for landscape painting. Exhibited at RHA (21), RA (82), SBA (41+), NWS, GG, NWG 1874-1919 from London, Godalming, Addlestone, Shalford and Guildford. Elected RI 1886. Married sister of William Charles Estall. Died Brockenhurst, Hampshire 25 January 1922.
Represented: VAM; Brighton AG; Leeds CAG; Wakefield AG; Newport AG; Towner AG, Eastbourne.

HAYES, Edward RHA 1797-1864
Born County Tipperary. Studied under J.S.Alpenny and Dublin Society Schools. Began as a miniaturist and teacher of drawing, working in Clonmel, Kilkenny and Waterford. Set up practice in Dublin 1831, painting miniatures and watercolour portraits. Exhibited at RHA (115) 1830-64. Elected ARHA 1856, RHA 1861. Died Dublin 21 May 1864. His son Michael Angelo Hayes was also an artist.
Represented: NGI. **Engraved by** C.Hutchins.

HAYES, George c.1823-1895
Listed as a portrait painter at Ardwick, Manchester. Member of Royal Cambrian Academy. Exhibited at RA (3) 1855-75. Died Gorphwysfa Gyffin, near Conway 28 April 1895. Left effects of £20 to Jane Ellen Hayes.

HAYES, John 1786-1866
Born Middlesex. Exhibited at RA (77), BI (9), SBA (1) 1814-57 from London. Specialized in portraits of military and naval officers. Had a highly successful practice.
Represented: NPG London. **Engraved by** F.C.Lewis, J.H.Lynch, J.Thomson, C.Turner, W.Walker.

HAYES, John W. fl.1861
Born near St Paul's, London. Listed as a portrait painter aged 40 in 1861 London census. He was married with five children.

HAYES, Michael Angelo RHA 1820-1877
Born Waterford 25 July 1820, son of Edward Hayes. Exhibited at RHA (50), NWS 1837-76. Elected RHA 1854, Secretary 1856. Died after accidentally falling into the water tank at the top of his house in Dublin 31 December 1877.
Literature: DNB; DA.

HAYES, William fl.1845
Listed as a portraitist at 65 King Street, Manchester.

HAYLLAR, James RBA 1829-1920
Born Chichester 3 January 1829 (baptized 13 February in the parish of St Pancras) son of a coal merchant, farmer and miller. Educated at Midhurst Grammar School. Studied in Chichester under marine artists William and John Cantiloe Joy. Reluctantly allowed by his father to enrol in F.S.Cary's Art School, Bloomsbury. From 1849 he worked for two years as a portrait painter, principally in crayons before he travelled to Rome with John Cavell 1851. Returned to England October 1853 and again took portraits, mostly of small heads in oils after the fashion of the sketches he made in Italy. On 8 March 1855 he married Cavell's sister, Ellen, after a long engagement. At this time he was enjoying some success as a portrait painter. Among his patrons were Sir Watkin Williams-Wynn, the Duke and Duchess of St Albans and the Barclays. Then concentrated on delightfully intricate domestic genre scenes, at which he excelled. Exhibited at RA (62), BI (23), RHA (14), SBA (213) 1851-98. Elected RBA 1876. Had a family of nine children, and four of his daughters were talented artists. Settled at Castle Priory, Wallingford, but after the death of his wife in 1899 he moved to Bournemouth. Died there 9 March 1920 aged 91. Left £22,857.4s.7d.
Represented: NPG London; VAM; Southampton CAG; Forbes Magazine Collection. **Literature:** C.Wood, 'The Artistic Family Hayllar', *Connoisseur* May and June 1972; Stewart & Cutten.

HAYLS, John c.1600-1679
Born England. Studied under Miereveldt. Painted portraits in Rome 1651 and London 1658. Died Bloomsbury. Buried St Martin's Church 27 November 1679. Worked in manner of Van Dyck.
Represented: BM; NPG London. **Engraved by** T.Thomson. **Literature:** DA.

HAYMAN, Francis RA c.1708-1776
Born Devon. Apprenticed to Robert Brown 1718. Painted scenery at Drury Lane as well as portraits, genre and historical subjects. Taught with Gravelot at St Martin's Lane Academy and painted a number of pavilion decorations for Jonathan Tyers. Had a successful practice producing conversation pieces, theatrical portraits and small full-lengths during the 1740s and 1750s, although he also painted on the scale of life. Helped in foundation of SA 1760. PSA 1766-8. Exhibited at SA (12), RA (6) 1760-72. Elected a founder RA, RA Librarian 1771. Died London 2 February 1776. Among his pupils were Nathaniel Dance RA, L.F.Abbott, John Taylor, Thomas Gainsborough RA and William Jefferys.
Represented: VAM; NPG London; Tate; Southampton CAG; NGI; Yale. **Engraved by** H.R.Cook, J.Faber jnr, C.Grignion, J.McArdell, J.Miller, S.F.Ravenet, B.Reading. **Literature:** Gowing, *Burlington Magazine* XCV January 1953; H., Kenwood exh. cat 1960; D.Lambert Courtauld MA Thesis 1973; B.Allen, *F.H. and the English Rococo*, Courtauld Ph.D 1984; B.Allen, *F.H.*, 1987.

HAYMAN, N. fl.c.1580
Redgraves records a portrait artist of this name, who painted Tallis, the musician. It was engraved.

HAYNES, Edward Travanyon fl.1867-1885
Exhibited at RA (20), BI (1), SBA (2) 1867-85 from London.
Represented: Greenwich Naval College.

FRANCIS HAYMAN. Jonathan Tyers and family. Signed and dated 1740. 30 x 40ins (76.2 x 101.6cm) *Christie's*

JAMES HAYLLAR. Going to the drawing room. Signed and dated 1863. Inscribed on the reverse. 25 x 30ins (63.5 x 76.2cm) *Christie's*

GEORGE HAYTER. Sir H. G. Grey, Rt Hon Viscount Howick. Signed and dated 1835. Board. 14 x 11ins (35.6 x 28cm)
Christie's

GEORGE HAYTER. Viscount Mahon. Signed and dated 1834. Board. 13¾ x 12ins (34.9 x 30.5cm) *Christie's*

HAYTER, Angelo Cohen **fl.1848-1852**
Exhibited at RA (5), BI (4) 1848-52 from London.

HAYTER, Charles **1761-1835**
Born Twickenham 24 February 1761. Entered RA Schools 30 January 1786. Exhibited miniatures and crayon portraits at RA (113), SBA (12) 1786-1832 from London and Winchester. Appointed teacher of perspective to Princess Charlotte. Died London 1 December 1835. Father of Sir George Hayter.
Represented: VAM. **Engraved by** P.Audinet, T.Blood, T.Burke, G.Cook, J.Goldar, W.Read, J.Saunders, C.Townley, J.Wright.

HAYTER, Sir George **1792-1871**
Born London 17 December 1792, son of artist Charles Hayter and Martha (née Stevenson). Studied at RA Schools, where he won two medals. Is said to have gone to sea as a midshipman in the Royal Navy 1808. Won a 200 guineas premium at BI 1815. Appointed miniature painter to Princess Charlotte and the Prince of Saxe-Coburg 1815. Visited Italy and Paris 1815-18 and 1826-31. Elected a member of the Academies of Rome, Parma, Florence, Bologna and Venice. On the accession of Queen Victoria in 1837 he was appointed her Portrait and History Painter. Painted a large picture of her Coronation, as well as her State portrait. Established a highly successful society portrait practice. Appointed Principal Painter in Ordinary to the Queen 1841. Knighted 1842. Exhibited at RA (48), BI (40) 1809-38 and his last exhibited works were portraits of Queen Victoria and Lord Melbourne. A transcript of his diaries 1838-49 is in NPG London. Died London 18 January 1871. Buried St Marylebone Cemetery, Finchley. Studio sale held Christie's 19 April 1971. Best remembered for his large portrait groups. The miniaturist, Henry Collen, was his pupil.
Represented: NPG London; SNPG; NGI; BM; VAM; Stratford Saye; Althorp; HMQ; Government House, Madras; Chatsworth. **Engraved by** T.L.Atkinson, H.J.Backer, H.Berthoud, J.C.Bromley, J.Chapman, J.Cochran, H.Collen, J.W.Cook, J.E.Coombs, H.Cousins, T.A.Dean, W.H.Egleton, F.Elias, W.Greatbach, Hawkins, T.Hodgetts, B.Holl, W.Holl, T.Landseer, R.J.Lane, F.C.Lewis, W.H.Mote, J.G.Murray, J.Porter, J.Posselwhite, S.W.Reynolds snr & jnr, C.Roberts, H. & J.H.Robinson, H.T.Ryall, J.Scott, E.Scriven, W.Sharp, C.Turner, C.E.Wagstaff, H.Wilson. **Literature:** *Art Journal* 1871 p.79; Sir G.H., *A Descriptive Catalogue of the Picture of the Interior of the British House of Commons in 1833,* 1844; DNB; DA.

HAYTER, John **1800-c.1891/5**
Born London, son of artist Charles Hayter and younger brother of Sir George. Entered RA Schools 24 November 1815 aged 15. Established a highly successful society portrait practice. Exhibited at RA (126), BI (26), SBA (29) 1815-79 from London. Died 1891 or 1895 (conflicting sources). His portrait sketches were highly popular.
Represented: NPG London; VAM. **Engraved by** H.Austen, J.Brown, J.Cochran, W.J.Edwards, W.H.Egleton, B.Eyles, E.Finden, H.Hall, W.& F.Holl, T.W.Knight, R.J.Lane, H.Meyer, W.H.Mote, J.J.Penstone, H.Robinson, W.Sharp, J.S.Templeton, C.E.Wagstaff, R.Young.

HAYTLEY, Edward **fl.1740-1761**
Recorded producing flower drawings for Elizabeth Robinson (later Mrs Montague) 1740 and painted her portrait with her family at Sandleford Priory 1744. Knew Devis and shared a number of patrons with him in the Wigan and Preston area. Presented two circular landscape views to Foundling Hospital 1746. Exhibited at SA (5) 1760-1.
Represented: Metropolitan Borough of Wigan. **Engraved by** J.Faber jnr, C.Spooner. **Literature:** DNB.

HAYWARD, Alfred Frederick William ROI
1856-1939
Born Pope Hope, Ontario, Canada 20 June 1856. Moved to England 1875, where he studied at West London Art Schools and RA Schools. Exhibited at RA (65), RHA (2), RSA, ROI, Paris Salon 1880-1935 from London, Maida Vale, Winchester, Northwood and St Ives, Huntingdonshire. Married artist Edith Burrows by 1901.

HAYWARD, Alfred Robert ARWS RP NEAC
1875-1971
Born London 21 February 1875. Studied at RCA and Slade 1891-7 under Brown, Tonks and Steer. Exhibited at RA (39), RP, RHA (36), NEAC, Paris Salon 1907-65. Elected NEAC 1910, RP 1929. Official war artist 1918-19. Died 2 January 1971.
Represented: Brighton AG; Johannesburg AG; Imperial War Museum; Southampton CAG; National Museum of Wales; Tate; Whitworth AG, Manchester.

HAYWARD, Jane Mary 1825-1894
Exhibited at RA (11), BI (1) 1852-4 from London.
Represented: NPG London.

HAYWOOD, George fl.1904
Exhibited at RA (1) 1904 from the RCA.

HAZARD, William fl.1840
Listed as a portrait painter and 'Teacher of Drawing' in Bristol.

HAZLITT, John 1767-1837
Baptized at Marshfield, Gloucestershire 6 July 1767, son of a Unitarian minister and brother of essayist William Hazlitt. Practised as a miniaturist in America until 1787, when the family returned to England. Exhibited mostly miniatures, but also life-size portraits at RA (79), BI (7) 1788-1819. Moved to Stockport 1832, where he died 16 May 1837.
Represented: NPG London; Maidstone Museum. **Engraved by** H.Meyer, W.Nutter, C.Turner.

HAZLITT, William 1778-1830
Born Maidstone 10 April 1778, son of a Unitarian minister and brother of John Hazlitt. Went with his brother to America 1783-6. Studied at the Unitarian College, Hackney and under his brother. Met Coleridge and took up writing. Visited Paris 1802-3. Exhibited at RA (2) 1802-5. Died London 18 September 1830.
Represented: NPG London; BM. **Engraved by** T.S.Engleheart, J.Holmes. **Literature:** DA.

HEAD, Guy 1762-1800
Born Carlisle 4 June 1762, son of a butcher. Studied under Captain J.B.Gilpin. Entered RA Schools 1778, where his work was admired by Reynolds. Exhibited mainly histories, but also portraits including 'HRH Prince Augustus Frederick' at FS (3), SA (3), RA (7) 1779-1800. His sitters included John Flaxman, Horatio Nelson and the Duke of Sussex. Married artist Jane Lewthwaite. Travelled on the Continent after 1781. Member of Florence Academy 1787. Settled in Rome by 1790. Elected a member of Accademia di San Luca 1792. At the time of the French invasion he took refuge on Nelson's ship at Naples and travelled round Sicily with Charles Lock 1799. Died London 16 December 1800, shortly after returning.
Represented: NPG London; VAM. **Engraved by** B.Reading. **Literature:** Hall 1979; DA.

HEALEY, George Peter Alexander 1808-1894
Born Boston 15 July 1808. Reportedly self-taught. Encouraged by Sully. Working in Boston 1831. Studied in Paris 1834 under Baron Gros and met Couture. Married in London 1839. Had some success in Europe. Exhibited at RA (32) 1838-83. Returned to America 1842 and was commissioned by Louis-Phillipe to paint the portraits of prominent Americans. Worked in both Paris and America 1848-55; Chicago 1855-66, then Paris again, Rome and finally settled in Chicago 1892. Among his sitters were Joseph Hume, Lord Ashburton, His Excellency the American Minister and Count Ferdinand de Lesseps. Died Chicago 24 June 1894.
Represented: Boston MFA; NG Washington; Smithsonian Institute; Santa Barbara Museum of Art; Union League Club, Chicago. **Engraved by** W.Holl. **Literature:** M.de Mare, *G.P.A.H.: American Artist,* 1954; Bénézit; DA.

HEALY (HAYLEY), Robert c.1743-1771
Studied at Dublin Society Schools under R.West. Produced small full-length and bust portraits. A friend of the actor John O'Keefe, who wrote in *Recollections* that Healy excelled at 'drawing in chalks, portraits, etc, but his chief forte was horses which he delineated so admirably that he got plenty of employment from those who had favourite hunters, mares or ladies' palfreys'. Pasquin writes that his works are 'proverbial for their exquisite softness. They look like fine proof prints of the most capital mezzotinto engravings'. Also decorated Moira House. Died July 1771 from a cold caught while sketching at Lord Mornington's park at Dangan.
Represented: NGI. **Literature:** DA.

HEAPE, George fl.1809-1815
Listed as a portrait and miniature painter in Birmingham.
Engraved by F.Egington.

HEAPHY, Thomas PSBA 1775-1835
Born London 29 December 1775, son of John Gerrard Heaphy, a merchant. Apprenticed to a dyer and articled to engraver R.M.Meadows. Studied under John Boyne at Bloomsbury Drawing School. Established an extremely successful practice as a miniature painter and watercolour portraitist. Appointed portraitist to the Princess of Wales, Princess Charlotte and Prince Leopold. On the invitation of the Duke of Wellington, he took portraits of officers in the British Camp in the Peninsula until the end of the war. Exhibited at RA (53), SBA (14), OWS, NWS 1797-1836. First President of SBA. Visited Italy 1831-2. Died London 23 October 1835. Whitley states that he charged 12 to 15 guineas for oil portraits, 12 to 40 guineas for watercolours and 10 to 50 guineas for miniatures. His charge for teaching was 1 guinea per hour or 2 guineas for three hours.
Represented: VAM; SNPG; NPG London. **Engraved by** C.Armstrong, A.Smith, Mrs D.Turner. **Literature:** W.T.Whittley, *T.H. First President of the Society of British Artists,* 1933; DNB; DA.

HEAPHY, Thomas Frank RBA 1813-1873
Born St John's Wood 2 April 1813, son of artist Thomas Heaphy and his first wife Mary (née Stevenson). Visited Italy 1831 with his father and began as a watercolour portraitist and soon built up a successful practice. During the early period he assumed the additional name of Frank, to distinguish his work from that of his father, but dropped it before 1850. Exhibited at RA (51), RHA (8), BI (8), SBA (68) 1831-73. Elected RBA 1867. Spent many years researching a learned article for the *Art Journal* 1861 on 'The Likeness of Christ'. Also painted altarpieces in Malta and Toronto. Died London 7 August 1873.
Represented: NPG London; VAM; SNPG; BM. **Engraved by** H.Meyer. **Literature:** *Art Journal* 1873 p.308; DNB; DA.

HEARD, Isaac d.1859
Born Whitehaven. Exhibited at Whitehaven Exhibition 1826. Also worked in London and Liverpool.

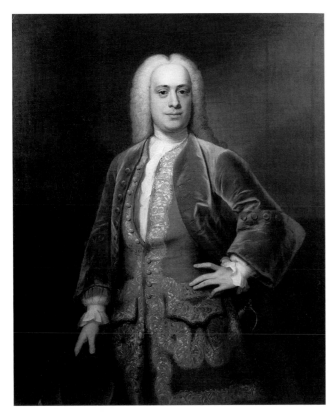

DIETRICH HEINS. Thomas Wright of Wighton, Norfolk. Signed. 50 x 40ins (127 x 101.6cm) *Christie's*

HEARN, George R.M. fl.1900-1902
Exhibited at RHA (2) 1900-2 from London.

HEARNE, Richard A. fl.1846
Exhibited at RHA (2) 1846. No address given.

HEATH, Miss C. fl.1802-1806
Daughter of engraver James Heath ARA. Exhibited at RA (4) 1802-6 from London.

HEATH, Charles RBA 1785-1848
Illegitimate son and pupil of engraver James Heath ARA. Enjoyed a reputation for his book engravings. Exhibited at RA (11), SBA (30) 1801-25 from London. Elected RBA 1824. Died London 18 November 1848 in his sixty-fourth year.
Literature: J. Heath, *The Heath Family of Engravers*, 1993.

HEATH, Dudley fl.1892-1922
Exhibited at RA (12), SBA 1892-1922 from London.

HEATH, Henry b.1830
Born St Pancras. Listed as a London portrait artist in 1851 census.

HEATH, Miss Margaret A. fl.1886-c.1920
Exhibited at RA (12), NWS 1889-1900 from London.

HEATH, Thomas Hastead fl.1901-1905
Exhibited at RA (3) 1901-5 from Cardiff.

HEATH, William 1795-1840
A portrait, genre, military painter and engraver and illustrator. Reputedly an 'ex-captain of dragoons'. Worked as an illustrator under the pseudonym of 'Paul Pry'. Died Hampstead 7 April 1840.
Represented: BM; VAM; SNG. **Literature:** DA.

HEATON, Edward fl.1825-1838
A portrait painter and copyist.
Represented: NPG London; VAM.

HEDLEY, Percival 1870-1932
Exhibited at RHA (2) 1907 from St John's Wood. Also sculpted portraits.
Represented: NPG London.

HEEMSKERCK, Egbert van c.1634-1704
Born Haarlem. Said to have spent most of his life in London working for the Earl of Rochester. Known to have worked for a short time in Oxford. Died London, leaving a son of the same name. Often signed works 'H.K.' in monogram or 'E.H.Kerk'. Vincent Bourne wrote poems on two of his pictures.
Represented: BM. **Engraved by** R.Earlom, J.Oliver, F.Place and J.Smith. **Literature:** DNB; DA.

HEES, F. van fl.1655-1656
Painted a pair of portraits of John Millington of Wandsworth and his wife which he signed 'F.v.hees F/A 1655'. May have painted in England.

HEIGHWAY, Richard fl.1787-1793
Exhibited at RA (5) 1787-93 from London, Lichfield and Shrewsbury.
Represented: VAM.

HEINS, Dietrich (John Theodore snr) 1697-1756
Born Dietrich Heins in Germany. Settled in Norwich c.1720. Commissioned to paint a civic portrait for St Andrew's Hall 1732. Also painted candle-light scenes and scraped mezzotints. Died Norwich. Will proved 30 August 1756 by his widow, Abigail. In the 1720s he signed 'D.Heins' and later usually 'Heins pinxit'.
Represented: Castle Museum, Norwich; BM; Felbrigg, NT; Cambridge University. **Engraved by** T.Cook, J.M.Delattre, C.H.Hodges, P.S.Lamborn, W.Ridley, W.Robins, Rothwell, G.Vertue.

HEINS, John Theodore jnr c.1732-1771
Born Norwich, son of artist John Theodore Heins. Apprenticed to a snuff manufacturer before practising as a topographical etcher, portraitist and miniaturist. Settled in London in the 1760s. Exhibited at FS (1), SA (3) 1767-70. Died Chelsea 11 May 1771.
Literature: DNB; *Evening Post* 11 May 1771.

HELLEU, Paul César 1859-1927
Born Vannes, Brittany 17 December 1859, son of Pierre-César Helleu and Marie-Esther (née Guyot). Studied under Gérôme at Écoles des Beaux Arts, where he became friends with J.S.Sargent, sharing a studio. He embraced Impressionism and became friends with Monet, Degas, Rodin, Forain and Renoir. Began dry-point etching 1885, Tissot reputedly giving him his own diamond point and Sickert assisting with the production of his first plate. He found this medium suited to his flamboyant style, often making only one or two copies of each edition. Married Alice Louis-Guerin 29 July 1886. Frequently travelled with Sargent and visited Sargent's home in Worcestershire 1889. Visited England frequently, as well as America. Died Paris 23 March 1927. Degas described him as 'Le Watteau de Vapeur'.
Represented: Brooklyn Museum; Musée Bonnat.
Literature: F.Wedmore, 'M.H.'s Dry-Points', *Magazine of Art* 1895 pp.252-4; E.Arnold, *A Gallery of Portraits by P.H.*, 1907; R.de Montesquiou, *P.H. Peintre et Graveur*, 1913; Richard Green exh. cat. 1991; DA.
Colour Plate 31

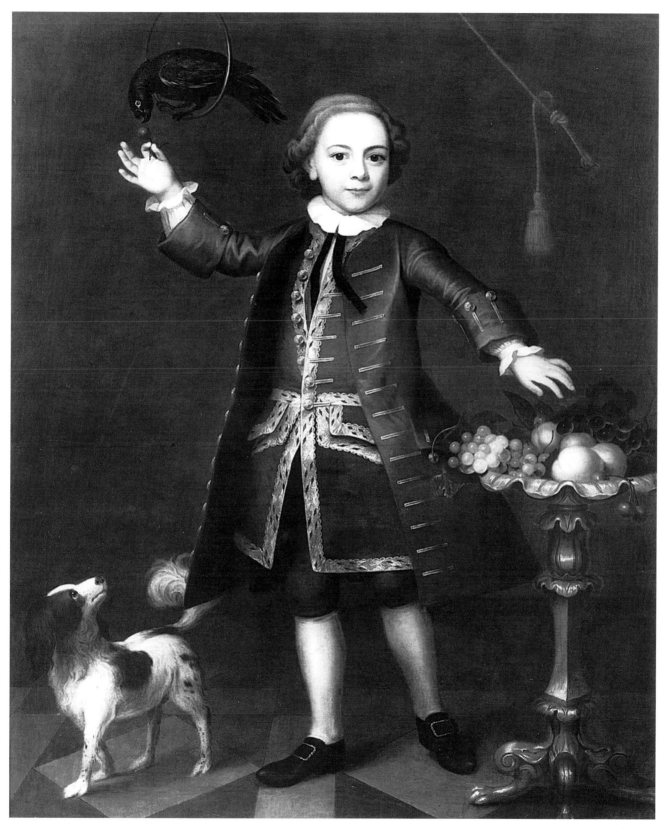

DIETRICH HEINS. A boy feeding a parrot. Signed and dated 1741. 50 x 40ins (127 x 101.6cm) *Christie's*

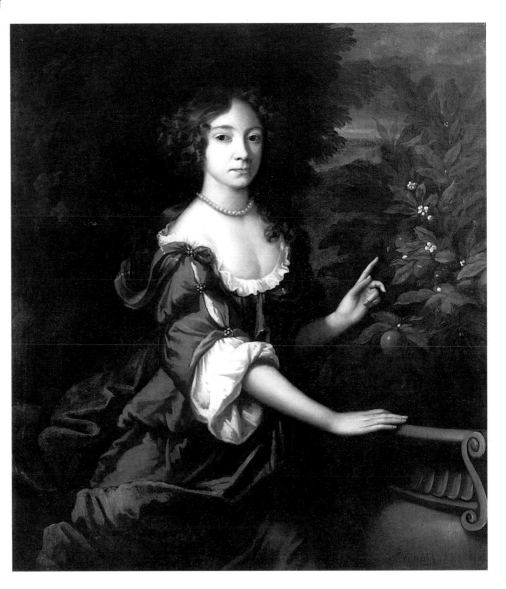

ADRIAEN DE HENNIN. Princess Mary Stuart, wife of William of Orange. Signed and dated 1677. 44½ x 37½ins (113 x 95.2 cm) *Christie's*

HELLIAR, John fl.1696-1734
Commissioned in 1696/7 by the Corporation of Plymouth to paint a full-length portrait of 'William III' and was paid a total of £14 (which included the frame and restoration of other works). May have been Mayor of Plymouth 1733/4.

HEMING, Miss fl.1821
Exhibited at RA (1) in 1821 from London. Possibly the Miss Serena Hemming who exhibited SBA (2) 1851-3 from St Martin's Lane, London.

HEMSLEY, William VP RBA 1819-1906
Born London, son of William Whitfield Hemsley, an architect and surveyor. Educated in Brighton. Painted portraits from the age of 13. Began work as a drawing clerk for John Crak in London, and practised art in his spare time before making it his career. Exhibited at RA (20), BI (28), SBA (161) 1848-94 from London. Elected RBA 1859, later Vice-President. Died 24 December 1906.
Represented: Ashmolean.

HENDERSON, Andrew 1783-1835
Born Cleish, near Kinross, son of the gardener to Lord-Chief-Commissioner William Adam. Apprenticed as a gardener to his brother, Thomas, and was employed by the Earl of Kinnoull and the Earl of Hopetoun. Weak health led him to work for a manufacturer in Paisley, before studying at RA Schools 1809-12. Returned to Glasgow 1813 and set up as a portrait painter. Exhibited at RSA from 1828. Died of apoplexy in Glasgow 9 April 1835.
Represented: SNPG. **Literature:** DNB; *The Laird of Logan, Anecdotes and Tales Illustrative of the Wit and Humour of Scotland*, 1841; McEwan.

HENDERSON, Cornelius 1799-1852
Born Lancaster 9 October 1799, son of John Henderson, a shoemaker and amateur painter. Trained as an artist and painted portraits in Lancaster working in Liverpool c.1826. Attracted patronage of Joseph Williamson, who built him a house and left him an annuity. Exhibited at LA 1834. Copied Phillips' Duke of York and Lawrence's George III, which he presented to Lancaster. Died Edge Hill 20 December 1852.
Represented: Walker AG, Liverpool.

HENDERSON, Keith (Alan) OBE RP RSW RWS ROI
1883-1982
Born 17 April 1883. Educated at Marlborough. Studied at Slade and in Paris. Exhibited at RA (32), RSA (35), RSW

ARCHIBALD SAMUEL HENNING. The Judge and Jury Society in the Cider Cellar. Signed and dated 1843. 42 x 61ins (106.7 x 154.9cm)

Christie's

(18), RWS, ROI (20) 1905-54 from London, Burleigh and Inverness-shire. Elected RP 1912, RWS 1937. Author and illustrator of several books.
Represented: Kirkcaldy AG; Glasgow AG; Manchester CAG; Preston AG; Birmingham AG; Worthing AG; Newport AG; Leamington AG; Edinburgh AG. **Literature:** McEwan.

HENDERSON, W.S.P. **fl.1836-1874**
Exhibited at RA (30), BI (64), SBA (55) 1836-74 from London, Henley and Guildford.

HENLEY, J. **fl.1836-1843**
Exhibited at RA (1), BI (1), SBA (2) 1836-43 from London.

HENNIN (HENNY), Adriaen de **fl.1665-1710**
Recorded in The Hague Guild 1665. Believed to have been a pupil of Berghem. Spent two years in Paris and probably settled in England c.1676, when he was associated with the Beales. Mainly painted classical landscapes, but occasionally portraits. Walpole said he died in England 1710.
Represented: Callaly Castle.

HENNING, Archibald Samuel **d.1864**
Son of John Henning. Exhibited at RA (1), SBA (21), BI (3) 1825-34 from London. Painted 'The Judge and Jury Society in the Cider Cellar' 1843, which was a large group portrait of the members who re-enacted famous murder trials. Designed *Punch*'s first wrapper. Married sister of artist Kenny Meadows.

HENNING, John RBA HRSA **1771-1851**
Born Paisley 2 May 1771, son of Samuel Henning, a

carpenter and builder. Drew plans and elevations, and set up as a modeller of wax portraits in Glasgow, where he attracted the patronage of the Duke of Hamilton. Moved to Edinburgh, where he studied at Trustees' Academy and made portraits, busts and enamel and wax portraits. Moved to London 1811 and worked for Wedgwood. Attracted royal patronage. Exhibited at RA (9), BI (2), SBA (34), RSA (90) 1816-29. Founder RBA 1824. Died London 8 April 1851. His son John Henning jnr was also a sculptor.
Represented: NPG London; SNPG. **Engraved by** A.Freebairn, H.Thomson. **Literature:** Gunnis; McEwan.

HENRY, George RSA RA RP **1858-1943**
Born Ayrshire 14 March 1858. Studied at Glasgow School of Art and in Paris. A friend of Guthrie. Travelled to Japan with E.A.Hornel 1893-4 (with whom he shared a studio). Moved to London 1901, where he had a successful society portrait practice. Exhibited at RA (133), RSA (28), SBA, NEAC, RP 1887-1944. Elected NEAC 1887, ARSA 1892, RP 1900, RSA 1902, ARA 1907, RA 1920. Died London 23 December 1943.
Represented: Walker AG, Liverpool; Glasgow AG; Aberdeen AG; Paisley AG; Manchester CAG; Newcastle AG; Worthing AG. **Literature:** McEwan.

HENRY, Paul RHA **1876-1958**
Born Belfast 11 April 1876. Studied at Belfast School of Art and in Paris under Whistler and J.P.Laurens. Lived in County Wicklow. Exhibited at RHA (34), RA (2), Paris Salon, Canada, America and Australia 1910-59. Died County Wicklow 24 August 1958.
Literature: P.H., *An Irish Portrait – The Autobiography of P.H. RHA*, 1951; DA.

ROBERT HERDMAN. A girl. Signed and dated 1853. 21 x 16½ins (53.3 x 41.9cm) *Christie's*

HENSHALL, Henry George **fl.1862-1864**
Listed as a portraitist in Wolverhampton and Hanley.

HENSHALL, John Henry RWS **1856-1928**
Born Manchester 11 April 1856. Studied in Manchester, RCA and RA Schools. Exhibited at RA (68), SBA (9), RWS 1878-1927 from London, Southport, Chichester and Pinner. Elected member of Manchester Academy of Fine Arts 1901, ARWS 1883, RWS 1897. Bronze medallist in Paris 1900. Died Bosham 18 November 1928. Left effects resworn of £6,209.18s.1d.
Represented: VAM; Leeds CAG; Cardiff AG.

HENSHAW, William **b.1753**
Born 22 September 1753. Entered RA Schools 1773. Studied under Bartolozzi. Exhibited at RA (2) 1775.

HENSON see HEWSON, Stephen

HENWOOD, Thomas **fl.1832-1834**
Listed as a 'Teacher, Portrait and Landscape Painter' in Lewes.

HERBERT, Frank **fl.1857-1866**
Exhibited at RA (1), BI 1857-66 from London.

HERBERT, J.Dowling **c.1762-1837**
Born Dublin. Exhibited at RHA (5) 1835-6 from Dublin. Died Jersey.
Represented: Dublin Museum.

HERBERT, John Rogers RA HRI **1810-1890**
Born Maldon, Essex 23 January 1810, son of a controller of customs. Studied at RA Schools 1826-8. Visited Italy. A

HUBERT VON HERKOMER. A lady. Signed with initials and dated 1877. 23 x 15¼ins (58.4 x 38.7cm) *Christie's*

friend of Pugin. Converted to Catholicism c.1840, producing a large number of biblical scenes, influenced by Dyce and the Nazarines. Exhibited at RA (102), BI (26), RHA (1), SBA (7), LA 1830-89. Elected ARA 1841, RA 1846. One of the first masters at the Government School of Design, Somerset House. Elected a Foreign Member of Academy of Fine Arts Institute of France 1869. Among his sitters were A.W.Pugin and the Rt Hon W.E.Gladstone MP. Died Kilburn 17 March 1890. Three sons were also painters.
Represented: BM; VAM; Tate; Guildhall AG, London. **Engraved by** J.C.Bromley, S.Bellin, R.J.Lane, G.T.Payne, J.Outrim, S.W.Reynolds, C.Rolls, G.R.Ward. **Literature:** DNB; DA.

HERBERT, Wilfred Vincent **fl.1863-1891**
Born London, son of artist J.R.Herbert RA. Exhibited at RA (27) 1863-91 from London.
Represented: VAM; BM.

HERDMAN, Miss Maud **fl.1891-1897**
Exhibited at RA (6), RHA (6) 1891-7 from County Tyrone, Ireland.

HERDMAN, Robert RSA RSW **1829-1888**
Born Rattray, Perthshire 17 September 1829, son of Rev William

JOHN ROGERS HERBERT. A lady and her family, possibly Elizabeth Diana Davidson (née Macdonald). Signed and dated 1831. 80 x 104 ins (203.2 x 264.2cm)
Christie's

Herdman a parish minister. Educated in theology at St Andrew's University, and was outstanding in Greek. Entered Trustees' Academy 1847 under John Ballantyne and Scott Lauder (winning prizes 1848, 1850-2, 1854). Visited Italy 1855-6. Exhibited at RSA (219), RA (38), RHA (2), BI (2) 1850-88. Elected ARSA 1858, RSA 1863. Visited Italy again 1868-7. Among his sitters were General Sir John Campbell CB KCSI, Sir George Harvey PRSA, Sir Noel Paton RSA and Thomas Carlyle. Died suddenly in Edinburgh 10 January 1888. His portraits are 'distinguished by much grace, refinement and sweetness of colouring'. A large collection of artists' portraits by him is in Aberdeen AG.
Represented: NPG London; SNPG; Glasgow AG; Paisley AG; Perth AG. **Engraved by** R.Anderson, F.Holl. **Literature:** DNB; McEwan; DA.

HERDMAN, Robert Duddingstone ARSA
 1863-1922
Son of artist Robert Herdman. Studied at RSA Schools and travelled in France, Spain and Holland. Based in Edinburgh. Exhibited at RSA (101), RA (10), in Paris, Munich and Vienna 1886-1916. Elected ARSA 1908. Died Edinburgh 9 June 1922 (not January).
Represented: SNPG. **Literature:** McEwan.

HERFORD, Miss A. Laura fl.1861-1868
Exhibited at RA (6), BI (1), SBA (6) 1861-8 from London.

HERKOMER, Herman Gustave ROI RP b.1863
Born Cleveland, Ohio, son of Hans Herkomer and cousin of Hubert Von Herkomer. Moved to England 1881. Studied under Hubert Von Herkomer at Bushey. Exhibited at RA (22), RHA (1), SBA (5), RP 1886-1907. Elected RP 1891. Among his sitters was the Duke of Cambridge.
Represented: Leeds CAG.

HERKOMER, Sir Hubert Von RA RWS CVO
 1849-1914
Born Waal, Bavaria 26 May 1849, son of Lorenz Herkomer, a wood carver who settled in Southampton 1857. Entered South Kensington Schools 1866, where he studied under Fildes and was also influenced by Walker. Worked for *The Graphic* from 1869. Exhibited at RA (212), SBA, RHA (3), RP (23), RWS, RI, GG, NWG 1868-1914. Elected RI 1871, ARA 1879, RA 1890, ARWS 1893, RWS 1894, CVO 1890, knighted 1907. Raised to noble rank by the Emperor of Germany 1899 and afterwards assumed the prefix of Von. Chiefly remembered for his outstanding social genre paintings, but he also established a highly successful society portrait practice. Among his sitters were Wagner, Ruskin, Lord Kelvin and Lord Kitchener. Also capable of producing large group portraits. He composed music, wrote operas, acted and designed stage scenery and sets for the cinema. Founded the influential School of Art at Bushey 1883 and directed it until 1904. Also Slade Professor

KARL ANTON HICKEL. Edward Pease of Darlington MP. Signed and dated 1793. 22 x 18ins (55.9 x 45.7cm) *Christie's*

of Fine Arts at Oxford 1885-94. Died Budleigh Salterton 31 March 1914. His fluent, confident command of paint ensured that he could produce a penetrating likeness at speed. George Harcourt was his assistant.
Represented: NPG London; SNPG; Southampton CAG; Lady Lever AG; RA; BM; Leeds CAG; Ulster Museum; Bristol AG; HMQ; Tate; Lambeth Palace, Manchester CAG; Watford Museum; Walker AG, Liverpool. **Engraved by** T.H.Crawford, W.B.Gardner, E.Gulland, F.Sternberg, A.Uhirich. **Literature:** H.H., *Autobiography,* 1890; L.Pietsch, *H.,* 1901; A.L.Baldry, *H.H. RA, A Study and a Biography,* 1902; H.H., *My School and My Gospel,* 1908; H.H., *The Herkomers,* 2 vols 1910-11; J.S.Mills, *Life and Letters of Sir H.H., A Study in Struggle and Success,* 1923; P.Faraday, 'H.V.H.', *Country Life* 25 January and 1 February 1973; G.Longman, *The Beginning of The Herkomer Art School,* 1983; G.Longman, *H. as a Painter in Enamels,* 1988; DA.

HERMANN, H. fl.1858-1859
Exhibited at RA (5) 1858-9 from 35 London Street, London.

HERRICK, William Salter fl.1852-1880
Exhibited at RA (33), BI (7) 1852-80 from London.

HERVÉ, Alfred fl.1841-1893
Exhibited at RA (3) 1841-3 from 145 Strand, London.

HERVIEU (HERVIER), August Jean fl.1819-1858
Exhibited at RA (31), BI (3), SBA (13) 1819-58 from London. Member of Society of Fine Arts at Lille. Worked in London and Vienna.
Represented: NPG London.

HESELTINE, William fl.1799-1805
Exhibited at RA (7) 1799-1805 from London. Entered RA Schools 21 June 1800.

HESKETH, Jerome fl.1643
A professed priest at Douai and assistant to Dobson at Oxford 1643. Also made topographical drawings for Aubrey. Later went to Lancashire. Possibly the portraitist who signs 'J.H.'.
Literature: M.R.Toynbee, *Country Life* 13 May 1954 p.1503.

HESKETT fl.1621
Paid £10 for 'mending my Lord's closet, gilding a bedstead, drawing Mrs. Elizabeth and Mrs. Marye's pictures and Mr.Thomas' on 10 June 1621 according to Lord William Howard's accounts for Naworth Castle.

HEWETT, G. fl.1825-1828
Exhibited at SBA (3) 1825-8 from London.

HEWLETT, Arthur L. fl.1889-1914
Exhibited portraits and engravings at RA (5) 1889-1914 from Bushey (where he was probably at Herkomer's School) and Manchester.

HEWLETT, James 1789-1836
An honorary exhibitor at RA (15) 1799-1807 from Bath. Died Isleworth.

HEWSON, Miss fl.1789
Honorary exhibitor at RA (1) 1789.

HEWSON, Stephen fl.1775-1812
Exhibited at FS (16), SA (15), RA (49) 1775-1805 from London and Birmingham. Worked in Cheltenham 1786, where he painted two landscapes for Simeon Moreau's 'A Tour of Cheltenham Spa'. Recorded visiting York 1788, 1790

STEPHEN HEWSON. Alderman James Simmons, Mayor of Canterbury. Signed and dated 1806. 50 x 40ins (127 x 101.6cm)
Canterbury Museum

THOMAS HICKEY. The christening party. Signed with initials. 77 x 99ins (195.6 x 251.5cm) *Christie's*

and 1791. Advertised as a portrait and miniature painter and described himself as 'well known in York' (*York Courant* 2 November 1790). Also taught. Listed at 87 Titchfield Street, Portland Place, London 1808 and painted 'Mr John Baxter of the City of Chichester' 1812 (engraving published 1828). Painted in a provincial style, but often with considerable charm. His signature has often been misread as Henson. Probably the Stephen Hewson who married Jane Hodgeson at St Marylebone 31 January 1771.
Represented: Canterbury Museums; BM; York AG; Garrick Club, London; Trinity College, Oxford; Sussex Archaeological Collection, Lewes. **Engraved by** J.Jones, R.Penrose.

HIBBARD, William fl.c.1750
Worked in Bath. There are several heads etched by him in the manner of Worledge and he produced a very fine head of Lawrence Delvaux.
Literature: Redgrave.

HICKEL, Karl Anton 1745-1798
Born Czechoslovakia. Trained in Vienna. Worked in France, but left during the Revolution for London, where he exhibited at SA (3), RA (15) 1792-6. Appointed 'Painter to the Emperor of Germany' 1793 and the same year began 'William Pitt Addressing The House of Commons'. Died Hamburg 30 October 1798. Specialized in small oval

portraits of heads, and reached a high level of competence.
Represented: NPG London; HMQ; Vienna AG. **Engraved by** W.Ridley. **Literature:** Farington *Diary* 25 July 1794.

HICKEY, Rev Father Ephrem 1872-1955
Born George Kilmacow, County Limerick 1 November 1872. Received into the English Province of the Friars Minor at their Novitiate at Killarney. Secularized 17 April 1918, joining the Northampton Diocese. An amateur painter who exhibited at RHA (6) 1912-14 from the Franciscan Friary, Forest Gate. Died Corby 28 February 1955 (not 1958).

HICKEY, Thomas 1741-1824
Born Dublin May 1741, second son of Noah Hickey. Studied under West at Dublin Society Schools 1753-6, winning prizes. Travelled to Italy c.1760-6. Returned to Dublin 1767 where he exhibited 1768-70. Moved to London and entered RA Schools 1771. Exhibited at RA (16) 1772-92. His small half-length portrait of HRH the Duke of Cumberland was admired by Walpole. Worked in Bath by 1778. Embarked for India 1780, but the vessel was captured by the French *en route* and he was released at Cadiz. Proceeded by land to Lisbon, where he worked successfully 1782-4. Then continued to India on a first visit, arriving in Bengal March 1784, where he took a large, handsome house in the most fashionable part of Calcutta. Published *History of Ancient*

Painting and Sculpture, 1788. Returned to England June 1791. Portrait painter to Lord Macartney's expedition to China 1792-4. Probably in Dublin 1796. Returned to India 1798, where he had a successful portrait practice until his death. Buried Madras 20 May 1824.
Represented: NGI; Tate; BM; Government House, Madras; Stratford Saye; Guildhall, Bath. **Engraved by** A.Cardon, J.Collyer, R.de Launay, J.Hall, C.Knight, W.Say, L.Schiavonetti, J.Watson. **Literature:** Sir H.E.A.Cotton, *T.H. – Portrait Painter*, 1924; G.Breeze, Birmingham University MA thesis 1973; *Madras Government Gazette* 17 June 1824.

HICKS, George Elgar RBA 1824-1914
Born Lymington 13 March 1824. Trained to be a doctor at University College, London 1840-2. Then took up a career in art studying at Bloomsbury School of Art. Entered RA Schools 1844. Exhibited Frith-like contemporary subjects, genre and portraits at RA (117), BI (12), SBA (32+), GG 1848-1905. Elected RBA 1889. Worked in London until 1890, when he moved to Colchester and finally to Odiham, Hampshire. Died Odiham 4 July 1914. His work was extremely well painted, and his portraiture was much in demand.
Represented: Geffrye Museum, London; VAM; Tate; Southampton CAG. **Literature:** R.Alwood, *G.E.H, Painter of Victorian Life,* Geffrye Museum exh. cat. 1982; DA.

HICKS, Thomas NA 1823-1890
Born Newtown, Pennsylvania, cousin and pupil of Edward Hicks. Entered Pennsylvania Academy of the Fine Arts 1837, then at NA, New York. Elected ANA 1841. From 1845 he travelled in Europe including London, Florence and Rome. Spent a brief spell in the Paris studio of Couture. Returned to New York 1849. Elected NA 1851. Painted his first oil portrait of Lincoln 1860. Died Trenton Falls, New York.
Represented: Brooklyn Museum; New York Historical Society; North Carolina Museum; Museum of the City, New York.

HIGGIN, W. fl.1786
Exhibited at RA (1) 1786 from 11 Holborn Bars, London. May be the W.Higgins who exhibited at RA (1) 1811 from 71 Newman Street.

HIGGINBOTTOM, William Hugh b.1881
Born Newcastle, son of Albert H.Higginbottom, a wine and spirit merchant. Studied at RA Schools and Académie Julian, Paris. Exhibited at RA (2) and northern provinces 1908-36. Lived in Chiswick for much of his later life.

HIGGINS, Miss Elsie fl.1899-1916
Exhibited at RA (11) 1899-1916 from Rye, Salford and Bushey. Probably attended Herkomer's School of Art.

HIGGINS, Mrs Kate see OLVER, Kate Elizabeth

HIGGINS, Reginald Edward RBA ROI 1877-1933
Born London 31 March 1877, son of Thomas and Helen Higgins. Studied at St John's Wood Art School, BM and RA Schools. Exhibited at RA (8), SBA 1900-13 from London. Elected RBA 1914, ROI 1923. Died 11 February 1933.

HIGGINTON, Miss Fay b.1899
Born London. Studied at Goldsmiths. Exhibited at RA (33), RI, Paris Salon 1923-60.

HIGHMORE, Anthony 1718-1799
Born London, only son and pupil of artist Joseph Highmore. Married early in life Anna-Maria (d. Wincheap, Canterbury 13 October 1794), daughter of Rev Seth Ellis rector of Brampton, Derbyshire. Worked with his father until his father retired to Canterbury 1761. It is widely reported that he

GEORGE ELGAR HICKS. Children of Sir H. Hussey Vivian Bart, MP. Signed and dated 1883. 76 x 58ins (193.1 x 147.3cm)
Christie's

retired with his father to Canterbury, but this is incorrect as he is listed as a portrait painter and drawing master at Ingram's Court, Fenchurch Street, London 1763. May have settled in Canterbury as early as 1775 or mid-1780s. Also painted topographical views, some of which were engraved by John Tinney c.1740. Towards the end of his life he went deaf, and became increasingly engrossed in theological writing, which he never published. Died Wincheap, Canterbury October 1799 on the completion of his eighty-first year.
Represented: Fitzwilliam; Melbourne AG; Yale. **Engraved by** J.Tinney, G.Vertue. **Literature:** *Gentleman's Magazine* 1799.

HIGHMORE, Joseph c.1692-1780
Reportedly born London 13 June 1692 (Mild believes 1693 more probable), son of Edward Highmore (a woodmonger and retailer of firewood and coal) and Maria, daughter of Samuel Tull. Educated at Merchant Taylors' School. His father went bankrupt 1706. Studied to become a lawyer, but gave up for art. Observed the landscape painter Nicholas or Hendrick Van der Straeten at work. Subscribed to St Martin's Lane Academy at its opening 1720, paying the fee of 2 guineas. Set up a highly successful portrait practice 1715, and continued to study for ten years in Kneller's Academy. Lived for most of his career at Lincoln's Inn Field (four doors from Jonathan Richardson and close to Sir Godfrey Kneller). Married Susanna Hiller from Surrey at Little Bookham Parish Church 28 May 1716. They had a son and a daughter. Among the most accomplished portrait painters of his age, and his development runs parallel with that of Hogarth. Joined the Freemasons, his lodge (Thornhill was master) meeting at The Swan, East Street, Greenwich. Elected Junior Grandwarden 27 December 1727. Painted 'Hagar and

JOSEPH HIGHMORE. A gentleman. Signed and dated 1734. 30 x 25ins (76.2 x 63.5cm) *Christie's*

Ishmael' as a gift for the Foundling Hospital 1746. Produced a series of illustrations for his friend Samuel Richardson's *Pamela* (engraved 1745). Exhibited at SA (3), FS (2) 1760-1. His wife died 18 November 1750. Moved to Canterbury 1761, where he lived in Green Court with his daughter and son-in-law John Duncomb. From Canterbury he proof-read and published *The Practice of Perspective*. A friend of Francis Grose. Died Canterbury 3 March 1780 aged 87. Buried in sheep's wool (to comply with a 17th century statute to encourage the wool trade) in the fifth bay of the south aisle of Canterbury Cathedral. George Vertue listed Highmore among nine portrait painters who were 'to be distinguished in the first class – of those who make the best figure'. Simon writes ' . . . he helped to reveal a new vocabulary for British portraiture, and was capable of painting with the greatest refinement'.
Represented: NPG London; Tate; Yale; Stationers' Hall, London; Wolverhampton AG; Fitzwilliam; Manchester CAG; NG Victoria, Melbourne; Leeds CAG; Walker AG, Liverpool; Henry Huntington Library & AG, California; Detroit Institute of Art; National Archives of Canada; Historical Society of Pennsylvania, Philadelphia; NG Washington; Coram Foundation, London. **Engraved by** P.Audinet, T.Cook, W.C.Edwards, J.Faber jnr, R.Graves, C.Grignion, J.Hopwood, R.Houston, J.McArdell, A.Miller, N.Schiavonetti, J.Smith, W.J.Taylor, J.Tinney, G.Van Der Gucht, G.Vertue, C.Watson, R.Woodman. **Literature:** *Gentleman's Magazine* 1780 pp.176-9; A.Shepherd Lewis Ph.D thesis Harvard 1976; *Paintings by J.H.,* Kenwood House exh. cat. 1963; W. Mild, *J.H. of Holborn Road*, 1990; C.R.Beard, 'Highmore's Scrapbook', *Connoisseur* 93 1934 p.294, 94 July 1934 pp.9-15; DA.

HILL, Arthur RBA **b.c.1829**
Reportedly born Nottingham. Exhibited at RA (26), BI (2), SBA (28) 1858-93 from London and Nottingham. Elected RBA 1881. Also painted female classical figures in the manner of Alma-Tadema.

HILL, Charles **1824-1916**
Born Coventry. Studied engraving at Newcastle and London, and under S.W.Reynolds jnr. Moved to Adelaide 1854, where he conducted his own art school. Appointed art master of South Australian School of Design on its foundation in 1861. The same year he completed 'The Proclamation', containing 79 portraits for which he obtained sittings.
Represented: NG of South Australia. **Literature:** R.G.Appleyard, *Bulletin of NG of South Australia,* January 1967.

HILL, David Octavius RSA **1802-1870**
Born Perth. Studied under Andrew Wilson at Edinburgh School of Art. Secretary of Society of Artists in Edinburgh for eight years before it became RSA 1838, and continued to occupy the post until his death. Published *The Land of Burns,* 1841, a series of 60 engraved illustrations, which became popular. Began a large group portrait 'The Signing of the Deed of Demission' 1843, to commemorate the first general assembly of the new congregation of ministers who had withdrawn from the established Presbyterian Church of Scotland (now in Free Church Assembly Hall, Edinburgh). It contained no less than 474 likenesses and together with Robert Adamson (whom he partnered in a photographic business) they began to take calotype photographs of each person to appear in the painting, which was not completed until 1865. Exhibited mostly landscapes at RSA (307), RHA (12), RA (4), BI (1), SBA (2) 1821-70. Also helped found SNG. Married sculptress Amelia R.Paton. Died Edinburgh 17 May 1870. Buried Dean Cemetery.
Represented: NPG London; SNPG; SNG; Williamson AG, Birkenhead. **Engraved by** T.O.Barlow. **Literature:** DNB; *Printed Light*, SNPG exh. cat. 1986.

HILL, Miss Ellen G. **fl.1864-1893**
Exhibited at RA (12), BI (1), SBA (1) 1864-93 from Hampstead.

HILL, James **fl.1827-1838**
Exhibited at RBSA (3) 1827-38 from Birmingham.

HILL, James John RBA **1811-1882**
Born Birmingham. Studied under J.V.Barber. Moved to London 1839. Exhibited at RA (10), BI (5), RHA (1), SBA (121) 1842-81. Elected RBA 1842. Patronized by Lady Burdett-Coutts, for whom he produced a number of portraits and animal studies. Made frequent trips to Ireland. Worked for *The Illustrated London News*. Sometimes collaborated with Henry Bright. Died of bronchitis at Highgate 27 January 1882.
Literature: DNB.

HILL, Robert **fl.1750**
Signed and dated 1750 a portrait of a lady in a feigned oval (Sotheby's 3 June 1964 lot 107).

HILL, Samuel **fl.c.1756-c.1770**
Itinerant Irish painter of crayon portraits.

HILL, Thomas **c.1661-c.1734**
Taught drawing by the engraver W.Faithorne and painting by Dirke Freres c.1678/9. Most of his known works date from after 1695. Appears to have worked in London, Wells and Melbury. Retired from painting 1725, selling the contents of

his studio. Believed to have died at Mitcham. Waterhouse writes: 'His portraits have distinction and refinement and are nearer to Dahl than Kneller'.
Represented: NPG London; Melbury House; Bishop's Palace, Hereford; Society of Antiquaries, London. **Engraved by** R.Graves, G.Vertue, W.Skelton, J.Smith, A.Wivell. **Literature:** DNB.

HILL, Thomas **1852-1926**
Exhibited at RA (23), RHA (4), SBA 1871-1922 from London, Wednesfield, Wolverhampton, Radford and Birmingham. Died 3 September 1926 aged 74.
Engraved by R.Williams.

HILLIARD, C.C. **fl.1829**
Exhibited at RHA (3) from Dublin.

HILLIARD, Nicholas **1547-1618/19**
Born Exeter, son of Richard Hilliard, a goldsmith and his wife, Laurence (née Wall). Apprenticed to goldsmith and jeweller Robert Brandon. Freeman of Goldsmiths' Company 1569. Appointed Limner and Goldsmith to Elizabeth I, a position he held under James I. Became one of the most important miniaturists, but also painted occasionally at life size. Went to Paris 1576-c.1578, but mostly worked in London. Died aged 72. Buried St Martin-in-the-Fields 7 January 1618/19.
Represented: Hatfield House; NPG London; HMQ; VAM. **Engraved by** J.Bouvier, J.Brown, T.Chambers, F.Delaram, R.Earlom, W.C.Edwards, W.T.Fry, W.T.Mote, J.Stow, S.Williams. **Literature:** *N.H. and Isaac Oliver*, VAM exh. cat. 1947; M.Edmond, *H. and Isaac Oliver*, 1983; E.Auerbach, *N.H.*, 1961; DA.

HILLIER, Miss Harriet C. **fl.1850-1857**
Exhibited at SBA (4) 1850-7 from London.

HILTON, William **c.1750-1822**
Born Newark. Began as a scene painter. Exhibited at SA (3), RA (1) 1777-83 from 399 Strand. Worked as a portrait painter in Nottingham 1783, Lincoln 1786 and Norwich after 1800. His son was historical painter William Hilton RA 1786-1839.
Engraved by W.C.Edwards, T.Medland, W.Sharp, C.W.Waas.

HINCHLEY, Mrs Edith Mary (née Mason) **RMS SWA**
 b.1870
Studied at RCA until 1895. Exhibited at RA (22), RMS, Paris Salon 1906-28. Lived in London.

HINCHLIFFE, Richard George **PRCA** **1868-1942**
Born Manchester 15 July 1868, son of George and Louisa Hinchliffe. Studied at Liverpool School of Art, Slade, Académie Julian and Munich. Lived in Liverpool. Exhibited at RA (6), LA 1902-28. Elected PLA. Died 7 January 1942.
Represented: Walker AG, Liverpool.

HINCKS, William **1752-c.1797**
Born Waterford. Apprenticed to a blacksmith. Exhibited at Dublin 1773-80. Moved to London 1780 and entered RA Schools aged 28. Exhibited at FS (1), RA (18) 1781-97. Among his sitters was HRH the Princess of Wales.

HINDE, Joseph **fl.1747-1762**
Reportedly born Whitehaven, nephew of Matthias Read. Became a portraitist and copyist.

HINDLEY, Thomas **fl.1845**
Listed as a portraitist at 10 Thomas Street, Ardwick.

HINDSON, R.G. **fl.1825-1850**
Worked as a portrait and genre painter in Penrith. Exhibited at Carlisle Academy and Carlisle Athenaeum 1825-50.

HIPKINS, Miss Edith **d.c.1940**
Exhibited at RA (6), SBA (7+) 1883-1911 from Kensington.
Represented: NPG London.

HIRD, Robert **fl.1790s**
Believed to have been a native of Cockermouth, where he was one of six apprentices to Joseph Sutton.

HIRSCHMANN, Johann Leonhard **1672-1750**
Born Nürnberg 1 November 1672. Possibly a pupil of Kneller in London c.1704. Returned to Germany 1706. Died Nürnberg 13 November 1750.

HIRST, Joseph **fl.1841**
Listed as a teacher and portrait painter in Huddersfield.

HITCHCOCK, H. **fl.1800**
Canterbury portrait painter. Painted a portrait of John Nicholas Tom.

HITCHCOCK, J. **fl.1790-1793**
Exhibited at RA (4) 1790-3 from 234 Strand.

HITCHENS, Alfred **b.1861**
Born Peckham Rye, London 27 November 1861. Studied at South Kensington, Académie Julian, Paris and in Rome. Exhibited at RA (17), ROI, GG 1889-1919 from London and Surrey.

HOADLY, Sarah (née Curtis) **1676-1743**
Studied under Mary Beale. Wife of Dr Benjamin Hoadly, Bishop of Winchester and an accomplished amateur portraitist.
Represented: NPG London.

HOARE, Mary **1744-1820**
Eldest daughter of artist William Hoare. Painted crayon portraits and histories in the style of her father. Won Gold Palette for drawing by a young person under 16 at SA 1760. Exhibited at FS (4), SA (1) 1761-4. Married Henry Hoare of Beckenham (not Stourhead) 1765. In London she was a friend and neighbour of the Garricks. After the death of her husband, she lived with her sister Anne. They share a monument in Chislehurst Churchyard.
Represented: Stourhead, NT. **Literature:** E.Newby, *William Hoare of Bath*, Victoria AG exh. cat., Bath 1990.

HOARE, Prince **1755-1834**
Baptized Bath 9 October 1755, son and pupil of William Hoare. Educated at King Edward's School, Bath. Won a premium for a flower painting at SA 1772. Entered RA Schools 1773. Travelled to Rome via Florence 1776, studying under Mengs and becoming friendly with Fuseli. Returned to England with Northcote via Florence, Venice, Germany and Belgium 1779-80. Exhibited at FS (1), RA (13) 1781-5, when he gave up painting professionally and travelled for his health. Returned to London c.1788 and wrote musical farces and a number of books on fine art. Succeeded Boswell as Secretary for Foreign Correspondent to RA 1799. An honorary exhibitor of a portrait of Northcote 1815. Died as the result of a carriage accident in Brighton 22 December 1834.
Represented: Stourhead, NT; Lady Lever AG; BM; VAM; Coram Foundation, London. **Engraved by** J.De Claussin, C.Lasinio, Page, S.W.Reynolds. **Literature:** N.Presley, *The Fuseli Circle in Rome*, BAC Yale exh. cat. 1979, pp.96-8; DNB; E.Newby, *W.Hoare of Bath*, Victoria AG exh.cat., Bath 1990; DA.

WILLIAM HOARE OF BATH. A lady. 23⅜ x 17⅜ins (59.4 x 44.2cm). Pastel *Black Horse Agencies, Geering & Colyer*

WILLIAM HOARE OF BATH. A young girl. Signed. 35 x 27½ins (88.9 x 69.9cm) *Richard Green Galleries, London*

HOARE, William, of Bath RA 1707-1792
Born near Eye, Suffolk. Reportedly educated in Faringdon, Berkshire. Excelled at art and his father sent him to London, probably in the early 1720s. Studied under Grisoni, whom he accompanied to Italy 1728, where he shared lodgings at 53 via Gregoriana (Palazzo Zuccaro) with Angillis, a painter, and Delvaux and Scheemakers, both sculptors. Studied in Rome under Francesco Fernandi, called Imperiali, (who taught Ramsay and Batoni). Also influenced by the work of the Venetian pastellist Rosalba Carriera. Returned to England by 1739, settling in Bath, where he established a highly successful practice painting portraits in crayons and oils. Became the favourite portraitist of the Duke of Newcastle and his family. Married Elizabeth Barker, a London merchant's daughter c.1743. Went to London 1752 to paint several portraits for the Pelham family, returning to Bath, where Vertue noted that he 'lived in handsome, genteel manner'. Among his assistants were Henry Leake and John Taylor. Exhibited at SA (2), RA (22) 1761-79. Elected RA 1769, soon after its foundation. He was a frequent visitor to Stourhead, and Henry Hoare was among his most enthusiastic patrons. Throughout the 1760s and 1770s Hoare's portraits developed a softer, more natural style. The sitters are less likely to be posed, and instead appear to be interrupted at their daily tasks. Under Gainsborough's influence the brushwork becomes more feathery. The colour schemes of his pastel style are simplified and muted. Died Bath December 1792 'aged 84'. Like many crayon portraitists of his time, most of his pastels were produced in narrow proportions for the practical reason that standard glass usually came like that. His portraits are of the highest calibre and the sitters are sensitively portrayed.
Represented: Stourhead, NT; NPG London; VAM; Plas Newydd, NT; Rhode Island School of Design. **Engraved by**

F.G.Aliamet, P.Audinet, B. de Bakker, G.Bickham, W.Bond, J.Brooks, T.Chambers, P.Condé, J.Dixon, W.Evans, J.Faber jnr, E.Fisher, M.Ford, J.Hall, W.Holl, C.H.Hodges, R.Houston, M.Jackson, J.June, J.McArdell, A.Miller, J.Neagle, J.E.Nilson, R.Purcell, S.F.Ravenet, W.Ridley, J.Simon, R.Sisson, A.Smith, C.Spooner, Taylor, J.Thomson, C.Towneley, A.Walker, C. & J.Watson. **Literature:** E.Newby, *W.H. of Bath*, Victoria AG exh. cat., Bath 1990; *Apollo* XXXI February 1940 pp.39-43, XCVIII November 1973 p.375; DNB; DA.

HOBDAY, William Armfield 1771-1831
Born Birmingham, son of a manufacturer. Apprenticed to an engraver named Barney. Entered RA Schools 19 November 1790 aged 18. Established himself as a fashionable miniature and watercolour portraitist. Exhibited at RA (70), BI (2) 1794-1830. Worked in London and Bath, but moved to Bristol 1804, where he made a fortune painting portraits of officers embarking for the Peninsular War. Returned to London 1817, and his extravagant lifestyle, together with a panoramic exhibition speculation, led to his bankruptcy 1829. Died London 17 February 1831.
Represented: BM; VAM; Leicester CAG. **Engraved by** W.Bond, H.Cook, W.Sharp. **Literature:** DNB.

HOBSON, Henry Edrington 1820-1870
Baptized St Pancras Old Church, London 8 November 1820, son of engraver and landscape painter Henry Hobson. Exhibited at RA (1), BI (2) 1857-66 from Bath.
Represented: VAM.

HOBSON, Victor 1865-1889
Born Darlington. Studied there at Mechanics Institution under S.A.Elton and at South Kensington and RA Schools, winning

WILLIAM HOGARTH. Thomas Cooke of Ty-Cooke, Mamhilad, Monmouthshire. 30 x 25ins (76.2 x 63.5cm)
Christie's

medals. Lived in Darlington, County Durham and painted portraits and landscapes in the area. Died at Lugana, Tenerife. His best portraits are sensitively painted and highly sympathetic. **Represented:** Bowes Museum, Barnard Castle; Darlington AG. **Literature:** Hall 1982.

HODGE, Francis Edwin RI RP RBA ROI RWA
1883-1949
Born South Devon. Studied at Westminster School of Art, Slade, under Brangwyn, John and Orpen, and in Paris. Exhibited at RA (41), NEAC, RP, SBA, ROI, Paris Salon (Silver Medal) 1908-49. Died 6 February 1949.

HODGES, Charles Howard 1764-1837
Born London 23 July 1764. Probably a pupil of John Raphael Smith. Entered RA Schools as an engraver 1782 (Silver Medal 1784). Exhibited at SA (1) 1783. Settled in Holland 1788, where he lived in Amsterdam and The Hague until his death. Established a successful portrait practice there, and also scraped mezzotints of British sitters after Reynolds and company. Died Amsterdam 24 July 1837. S.W.Reynolds was his pupil.
Represented: Rijksmuseum, Amsterdam. **Engraved by** E.Bell. **Literature:** DNB; DA.

HODGES, J. Sydney Willis 1829-1900
Born Worthing. Established a successful society portrait practice. Exhibited at RA (35), BI (8) 1854-93 from Liverpool, London and Torquay. Some of his portraits were reproduced as engravings.

HODGES, T. or J. fl.1666-1688
Painted a portrait of 'Sir Edward Stanley, 3rd Bart' at Knowsley. A Hodges is listed as 'a good painter by the life' in Randle Holme's *Academy of Armory*, 1688.

HODGES, William fl.1824-1827
Exhibited at RA (1) 1824 from 34 Foley Street, London. Listed as a portrait painter there 1827.

HODGETTS, Thomas fl.1801-1846
Exhibited at RA (10), BI (2), SBA (11) 1801-46 from London. Also a well-known mezzotint engraver.

HODGKINS, Frances Mary 1869-1947
Born Dunedin 28 April 1869, daughter of William Matthew Hodgkins and Rachel (née Parker). Studied at Dunedin School of Art. Began exhibiting in New Zealand from 1890. Travelled in England, France, Italy, Morocco, Belgium and The Netherlands 1901-3. In England again 1906-7 and Paris 1908-12 (teaching at Académie Colarossi). Returned to Australia and New Zealand 1912-13, Italy and France 1913-14, St Ives 1914-20, and alternated between France and England from 1921. Died 13 May 1947.
Represented: Tate. **Literature:** E.H.McCormick, *Portrait of F.H.,* 1981; DA.

HODGSON, John Evan RA HFRE 1831-1895
Born Camberwell 1 March 1831, son of a Russia merchant. Spent his early youth in Russia. Educated at Rugby School. Began work at his father's counting house in St Petersburg but, after studying old masters at the Hermitage, he abandoned his career for art. Entered RA Schools 1855. Member of St John's Wood Clique. Exhibited at RA (90), BI (4), SBA (1) 1856-93 from London. Elected ARA 1873, RA 1879, RA Librarian 1882-95. Professor of Painting at RA 1882-95. Retired to Amersham. Wrote with Fred A.Eaton *The Royal Academy and its Members 1768-1830*, 1905. Died near Amersham 19 June 1895.
Literature: *Art Journal* 1895 p.256; B.Hillier, 'The St John's Wood Clique', *Apollo* June 1964; DNB.

HOG, James b.1761
Born 28 January 1761. Aged 12 exhibited crayon portraits at FS (2) 1773. Studied under Caldwell, an engraver. Entered RA Schools as an engraver 1780.

HOGARTH, William 1697-1764
Born Bartholomew Close, London 10 November 1697, son of a Latin scholar and author from the North Country. His father's attempt to run a coffee house ended in financial ruin and he was imprisoned for debt in Fleet Prison. His mother took to selling home-made 'tonics'. Apprenticed to Ellis Gamble, a silversmith 1714, who taught him ornamental engraving. Produced satirical prints and set up by 1820 as independent engraver. Believed also to have worked as a sign and scene painter. Studied painting at the same time at the new St Martin's Academy 1720, run by Louis Chéron and John Vanderbank, where his fellow pupils were Joseph Highmore, Arthur Pond and William Kent. Later attended the private art school in Covent Garden, founded by a man whom he idolized, Sir James Thornhill. Eloped with Thornhill's daughter, Jane 1729. His important paintings begin c.1728/9 with versions of 'The Beggars Opera'. From this time until the mid-1730s he specialized in small-scale conversation pieces and single portraits on the same scale. Adapted continental late-Baroque and Rococo forms to provide a very new type of British portraiture. In the early 1730s he began on his first series of modern moral subjects, of which 'The Harlot's Progress' was engraved 1732 and became popular with the middle classes. Secured the passing of a copyright act before his next series, 'The Rake's Progress', was engraved 1735. On Thornhill's death in 1734 he inherited the equipment of the first Academy and established the influential St Martin's Lane Academy. In 1735/6 he painted two large histories for St Bartholomew's

WILLIAM HOGARTH. The Edwards Hamilton family. 27 x 33¾ins (68.6 x 85.7cm) *Christie's*

Hospital, but these did not lead to commissions and Hogarth concentrated for a period painting portraits on the scale of life. His finest portraits usually date from the 1740s and his portrait of Captain Coram (1740), presented to the Foundling Hospital, provided an important landmark in the development of British portraiture. It helped encourage the production of important middle class portraits in the manner usually preserved for State portraits (although without the formality). In 1743 he visited Paris and from 1743 to 1745 he painted the 'Marriage à la Mode' series (NG London). Wrote *The Analysis of Beauty* (1748-53), which encouraged a great interest in aesthetics, resulting in the writings of Burke on the sublime and the beautiful, and Gilpin and Price on the Picturesque. Collectively, these changed the course of British art. His last moral series, 'The Election', was begun 1754. Appointed Sergeant Painter to George II 1757. Exhibited at SA (5) 1761. Died London 26 October 1764. Buried Chiswick churchyard. Philip Dawe was for a while his assistant.
Represented: Tate; NG London; NPG London; NGI; Sir John Soane's Museum, London; Yale; Walker AG, Liverpool; Dulwich AG; Brighton AG; Thomas Coram Foundation for Children; Fitzwilliam; Philadelphia MA. **Engraved by** F.G.Aliamet, C.Apostool, P.Audinet, A.Bannerman, Barlow, B.Baron, J.Basire, W.Blake, H.Bourne, T.Chambers, J.Chapman, G. & T.Cook, S.Cousins, G.Cruikshank, R.Dodd, J.Faber jnr, A.Fogg, M.Ford, M.Gauci,

B.P.Gibbons, C.Hall, J.Haynes, W.Holl, J.Hopwood, S.Ireland, Jackson, M.Knight, R.Livesay, J.McArdell, W.Maddocks, T.Major, A.Miller, J.Mills, J.Mollison, J.Moore, C.Mosley, W.Nutter, E.Portbury, H.Robinson, A.Romanet, F.Ross, T.Ryder, E.Scriven, W.P.Sherlock, B.Smith, C.Spooner, Sykes, I.Taylor, C.Townley, Wachmann, W.H.Worthington, J.Young. **Literature:** R.Paulson, *H.*, 2 vols 1971; R.B.Beckett, *H.*, 1949; L.Gowing and R.Paulson, *H.*, Tate Gallery exh. cat. 1971/2; G.A.Sala, *W.H.– Painter, Engraver and Philosopher. Essays on the Man, the Work and the Time*, 1970; J.Burke & C.Caldwell, *H. – The Complete Engravings*, 1968; D.Jarret, *The Ingenious Mr H.*, 1976; DA.

HOGG, Arthur H. **d.1949**
Born Kendal. Studied at South Kensington and in Paris. Exhibited at RA (9), London Salon 1913-29 from London. Died 11 August 1949 at Woolwich Memorial Hospital, Shooter's Hill, London. Left effects of £420.13s.10d.

HOGG, J. **fl.1841-1844**
Exhibited at SBA (3) 1841-4 from London.

HOLBEIN, Hans, the younger **1497/8-1543**
Born Augsburg, son and pupil of distinguished painter Hans Holbein the elder. Began as a German late-Gothic religious painter, but refined his style under the influence of Erasmus and Froben in 1515. By 1520 he had absorbed the influences

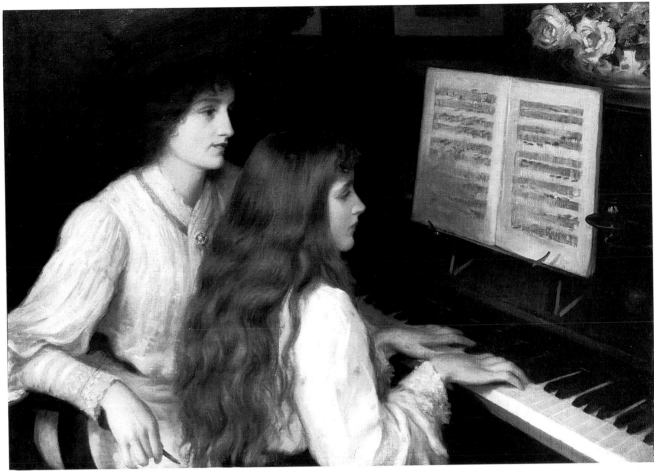

THOMAS W. HOLGATE. The music lesson. Signed. 22 x 30ins (55.9 x 76.2cm) *Christopher Wood Gallery, London*

of Italian high Renaissance. First visited England via Antwerp 1526-8 because of religious troubles in Basel, and painted portraits of Sir Thomas More and his humanist friends. Returned to Basel 1528, but finally settled in London 1532. First recorded in the service of Henry VIII 1536, who employed him as a portraitist. Also painted miniatures, and worked as a book illustrator and jewellery designer. Went to Brussels 1538 to paint the portrait of Christina, Duchess of Milan. Died 1543 aged 45 in the plague. His will was proved London 29 November 1543. He was a great master and was often copied. His style was highly linear, and he was fond of embellishing his portraits with symbolic objects. Capable of portraying considerable character and sensitivity.
Represented: NG London; HMQ; VAM; Louvre; National Museum, Munich; Frick Collection, New York. **Engraved by** A.Alfieri, P.Audinet, B.Baron, F.Bartolozzi, N.Billy, E.Bocquet, W.Bond, M.Bourlier, M.A.Bourlier, E.Buchel, M.Burghers, A.Cardon, G.B.Cecchi, F & T.Cheesman, Cochin, J.W. & T.Cook, R.Cooper, R.Dalton, T.A.Dean, E. De Boulonois, W.C.Edwards, G.S.Facius, J.Fillian, S.Freeman, R.Gaywood, R.Graves, C.Grignion, P.v.Gunst, E., G. P. & S. Harding, Hargrave, W. Holl, W. Hollar, J.Houbraken, R.Hubner, C.Knight, C.Lasinio, F.C.Lewis, E.Lievre, C. de Mechel, H.Meyer, S. & J.Minasi, W.Nicholls, J.Ogborne, F.Patton, Phillibrown, C. & L.Picart, N.Pitau jnr, W.Poole, L.Poratzky, R.Purcell, S.W.Reynolds, H.Robinson, E.Rooker, H.T.Ryall, Scheneker, L.Schiavonetti, E.Scriven, G.Sensi, P.Simms, W.Sherlock, A.Stock, I.Taylor, J.Thomson, P.W.Tomkins, C. & H.S.Turner, Miss Turner, M.Tyson, C.Vermeulen, G.Vertue, L.Vorsterman, F.Weber, R. &

W.J.White, R.Woodman. **Literature:** A.B.Chamberlain, *H.H. the Younger*, 1913; P.Ganz, *H.*, 1956; R.Strong, *H. and Henry VIII*, 1967; J.Rowlands, *H.*, 1985; W.Gaunt, *Court Painting in England*, 1980; J.Rowlands, *H. – The Paintings of H.H. the Younger*, 1985; DA.
Colour Plate 32

HOLD, Abel 1815-1891
Born Alverthorpe, near Wakefield. Apprenticed to a house painter in Wakefield. Established a reputation as a portrait painter. Moved to Barnsley, settling eventually at Cawthorne. Exhibited at RA (16), SBA (1) 1849-71.
Represented: Cooper AG, Barnsley.

HOLDEN, Professor Albert William 1848-1932
Studied at RA Schools. Exhibited at RA (7), SBA (11+) 1881-1917 from Hampstead, Chiswick and Bedford Park.
Represented: NG Sydney.

HOLDEN, Miss Louisa Jane fl.1830-1843
Awarded premiums at SA 1830 and 1832. Exhibited at RA (6) 1840-3 from London.

HOLDEN, S. fl.1845-1847
Exhibited at RA (4) 1845-7 from Greenwich.

HOLDERNESSE d.1640
Worked as a portrait painter. Little is known of his life, but he is listed in Sir William Musgrave's *An Obituary of the Nobility, Gentry, etc...*, 1882.

HOLE, William Brassey RSA RSW RE 1846-1917
Born Salisbury 7 November 1846. Studied at RA Schools.
Exhibited at RSA (157), RHA (1), RA (14) 1866-1916 from
Edinburgh. Elected ARSA 1878, RSA 1889. Died Edinburgh
22 October 1917.
Represented: SNPG; Glasgow AG. **Literature:** McEwan.

HOLGATE, Thomas W. fl.1899-1910
Exhibited at RA (5) 1899-1910 from London.

HOLIDAY, Henry James 1839-1927
Born London 17 June 1839, son of G.H.Holiday a teacher of
the classics and mathematics. Studied at Leigh's Academy and
RA Schools 1854. Kindly received by Millais, Rossetti and
Holman Hunt. In 1861, under the influence of Burne-Jones,
he began to design stained glass for Powell & Sons. Founded
his own glassworks in Hampstead 1890, where he also
produced mosaics, enamels and sacerdotal objects. Exhibited
at RA (40), RHA (1), SBA (4), GG 1858-1902. Illustrated
Lewis Carroll's *The Hunting of the Snark*. Died London 15
April 1927.
Represented: Walker AG, Liverpool; BM. **Literature:**
H.Holiday, *Reminiscences of My Life*, 1914; DA.

**HOLL, Francis Montague 'Frank' RA ARWS
1845-1888**
Born London 4 July 1845, son of engraver Francis Holl.
Entered RA Schools 1861, Gold Medallist 1863. Awarded
the Travelling Prize and visited Italy 1868-9. Queen Victoria
purchased his 'No Tidings from the Sea' 1870. Exhibited at
RA (87), BI (2), RHA (3), SBA (5), OWS, NWG 1864-88.
Elected ARA 1878, RA 1883. Married Annie Laura,
daughter of artist C.Davidson. Known for his social realism,
but in 1877 he began to paint portraits and soon developed
one of the most successful society portrait practices of his
period, being the main rival to Millais and Watts. His portraits
are painted in strong black and brown tones, with dramatic
chiaroscuro influenced by Dutch 17th century art. Among
his sitters were Samuel Cousins RA, Sir John E. Millais RA,
John Bright MP, W.E.Gladstone MP, W.S.Gilbert, HRH
Duke of Cambridge and HRH Prince of Wales. Fell ill on a
visit to Spain and died Madrid 31 July 1888. Buried Highgate
Cemetery.
Represented: NPG London; Tate; VAM; Southampton CAG;
NGI; SNG; BM; Brighton AG; Leeds CAG; Bristol CAG;
Royal Holloway College; Dundee AG; Canterbury Museums.
Engraved by P.Naumann, G.Robinson, C.Tomkins,
D.A.Veresmith, C.Waltner, S.Wehrschmidt. **Literature:**
A.M.Reynolds, *The Life and Works of F.H.*, 1912; Maas; DA.

HOLLAND, Miss Asa R. (Mrs Sachs) fl.1888-1908
Exhibited at RA (7), SBA (5) 1888-1908 from London.
Married Edwin Sachs c.1898-1900.

HOLLAND, John fl.1764-1767
Exhibited at SA (3) 1764-7 from London. May have been the
copyist John Holland of Ford Hall, Derbyshire who was a
friend and executor to Wright of Derby.

HOLLAND, Nathaniel Dance- see DANCE, Sir Nathaniel

HOLLAND, Peter 1757-1812
Born 1 March 1757. Entered RA Schools 8 October 1779,
winning Silver Medal 1781. Exhibited at RA (7) 1781-93
from 'Mr S.Finney's, 56 Frith Street, Soho' and in Liverpool.
First VP of LA 1810.

HOLLINGDALE, Richard fl.1850-1899
Exhibited at RA (26), BI (6), SBA (11) 1850-99 from Stroud
and London.

FRANCIS MONTAGUE 'FRANK' HOLL. William Oxenden
Hammond. Signed, dated 1883 and inscribed 'W. Oxenden
Hammond nat:1817'. 28 x 23½ins (71.1 x 59.7cm)
Canterbury Museums

HOLLINS, John ARA 1798-1855
Born Birmingham 1 June 1798, son of William Hollins, a
glass painter and architect. Settled in London 1822.
Exhibited at RA (101), BI (35), SBA (6) 1819-55. Elected
ARA 1842. Travelled in Italy 1825-7. On his return to
London resumed his practice as a portrait painter.
Collaborated with artist F.R.Lee. Died unmarried at his
residence in Berner's Street, London 7 March 1855. Often
painted with freedom and vigour.
Represented: NPG London; VAM; Fitzwilliam; Castle
Museum, Nottingham; Corsham Court. **Engraved by**
H.Droehmer, W.O.Geller, S.W.Reynolds, C.Turner.
Literature: *Art Journal* 1855.

HOLLOGAN, Master J. fl.1790
An honorary exhibitor of chalk portraits at SA (2) 1790.

HOLLOWAY, George 1820-1843
Son of George Holloway, a shipbuilder. Showed a precocious
talent and studied under G.Patten RA. Exhibited at RA (1),
SBA (4) 1842-3 from London. Died Christchurch 12 July
1843 aged 23.
Literature: *Art Union* 1843 p.244.

HOLLOWAY, L. fl.1857-1865
Exhibited at RA (8), BI (1), SBA (2) 1857-61 from London
and Southampton.

HOLLOWAY, Thomas 1749-1827
Born London 29 July 1749. Entered RA Schools 1773 as an
engraver. Exhibited gem engravings and portraits in crayon and
wax at SA (10), RA (19) 1777-92 from London and Hoxton.
Engraved by H.Adlard, W.Holl.

HOLME, William **fl.1833-1849**
Exhibited at RA (2), BI (3), SBA (5) 1833-49 from London.

HOLMES, Mrs Dalkeith **fl.1837**
Exhibited at RHA (5) 1837. No address given.

HOLMES, Edward RBA **fl.1841-1891**
Exhibited at RA (20), BI (11), SBA (169) 1841-91 from Chelsea. Elected RBA 1889.

HOLMES, H. **fl.1840-1852**
Exhibited at RA (1), BI (2), SBA (9) 1840-52 from London.

HOLMES, James PRBA **1777-1860**
Born Burslem, son of a dealer in precious stones. Apprenticed to engraver R.M.Meadows, but then painted watercolours and oils. Entered RA Schools 19 March 1796. Exhibited at RA (18), BI (3), OWS, NWS 1798-1849 from London. Founder member SBA 1827, PRBA 1829, resigned 1850. Among his sitters were Lord Byron, William IV, the Countess of Jersey and HRH Princess Amelia. His musical talents gained him the friendship of George IV, earning him the title of 'the King's hobby' in Court circles. His 'Michaelmas Dinner' of 1817 was purchased by the King. Also a popular teacher, and Gilchrist recorded that William Blake was indebted to him. Died in his sleep in London 24 February 1860. Byron wrote that Holmes' portrait of him was 'the very best of me'.
Represented: NPG London; Leeds CAG. **Engraved by** W.H.C.Edwards, W. & E.Finden, P.Gauci, W.Giller, R.Graves, Mrs Hamilton, C.Heath, W.Hollis, P.Lightfoot, H.Mayer, W.H.Mote, E.J.Portbury, H.C.Shenton, J.Thomas. **Literature:** A.Gilchrist, *Life of William Blake*, I 1863 p.247; A.T.Storey, *J.H. and John Varley*, 1894.

HOLMES, James jnr **fl.1836-1859**
Presumably son of artist James Holmes. Exhibited at RA (3), BI (1), SBA (20) 1838-59 from London.

HOLROYD, Sir Charles **1861-1917**
Born Leeds 9 April 1861. Exhibited at RA (17) 1885-1917 from London, Chertsey and Weybridge. First Keeper of Tate and Director of NG London. Among his sitters was Baron Ampthill. Died 17 November 1917.
Represented: Tate. **Engraved by** R.C.Clouston, R.Cooper.

HOLROYD, Lady **d.1924**
(Miss Fannie Fetherstonehaugh Macpherson)
Wife of Sir Charles Holroyd, first keeper of Tate and Director of NG London. Exhibited at RA (2), NWG 1892-1909 from Hyde Park. Died 17 April 1924.
Represented: NPG London.

HOLWELL, W. **fl.1786-1790**
Honorary exhibitor at RA (1), SA (2) 1786-1790.

HOLYOAKE, Rowland **fl.1880-1907**
Son of artist William Holyoake. Exhibited at RA (23), SBA (59), RHA (1), NWS, GG 1880-1907 from London.

HOMAN, Miss Gertrude **fl.1886-1905**
Exhibited at RA (17), SBA (8) 1886-1905 from Regent's Park.

HOME, Robert **1752-1834**
Born Hull 6 August 1752 son of army surgeon Robert Boyne Home and his wife Mary née Hutchinson. His parents wanted him to become a doctor but he ran away aged 12, becoming a stowaway on board a whaler bound for Newfoundland. Returned to his family in London December

ROBERT HOME. Crown Prince Nazir-ud-din. 36 x 27ins (91.5 x 68.6cm) *Christie's*

1767. Developed an aptitude for drawing and assisted his brother-in-law, Dr John Hunter with anatomical diagrams. Received some lessons from Angelica Kauffmann. Entered RA Schools 1769. Exhibited at RA (23) 1770-1813. Studied in Rome 1773-8, before working in Dublin by 1779. Moved to London by 1789, before going to India 1790, where he had highly successful portrait practices in Madras, Calcutta and Lucknow. His sitters' list 1795-1814 is in NPG London. Appointed Secretary to Asiatic Society 1802, whose rooms he decorated with portraits. Appointed Court Painter to the King of Oudh 1814. Retired, extremely wealthy, to Cawnpore 1825, where he died 12 September 1834. Keenan was his pupil and probably came to London with him 1789. Often painted thinly in a restrained manner and sometimes signed with the monogram 'R.H.'.
Represented: NPG London; National Army Museum; VAM; NGI; SNG; SNPG; HMQ; Oriental Club, London; Royal College of Surgeons; Government House, Madras; Apsley House; Asiatic Society, Calcutta. **Engraved by** J.C.Bock, J.C.Easling, A.Easto, J.Heath, J.Jenkins, J.Jones, P.Lightfoot, Tassaert, C.Turner, D.Weiss, T.Williamson, W.H.Worthington. **Literature:** Sir H.E.A.Cotton, *R.H.*, 1928; Foskett; Walpole Society Vol XIX pp.42-9.

HOME, Robert **b.1865**
Born Edinburgh 29 January 1865. Settled in Fife. Exhibited at RA (2), RSA, SSA.
Represented: Royal Hospital, Chelsea.

HONE, Horace ARA **1754-1825**
Born London 11 February 1754, son and pupil of artist Nathaniel Hone. Entered RA Schools 19 October 1770 when his age was noted as '17 Feb 11th next'. Exhibited portraits in oil, miniature and enamel at RA (64) 1772-1822 from London. Elected ARA 1779. Moved to Ireland 1782

NATHANIEL HONE. The green boy. Signed and dated 1782.
25 x 20ins (63.5 x 50.8cm) *Henry Wyndham Fine Art*

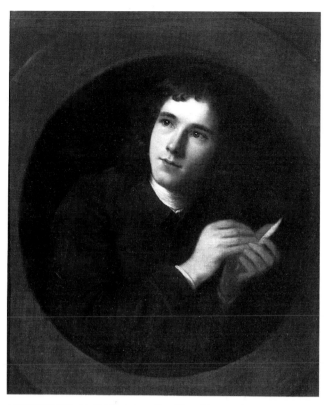

NATHANIEL HONE. John Camillus Hone, the artist's son.
Signed and dated 1775. 30 x 25ins (76.2 x 63.5cm) *Christie's*

and had a successful practice in Dublin. Appointed miniature painter to the Prince of Wales 1795, and retained the position when he became king. Returned to London 1804 and worked in Bath the same year. Suffered from mental ill health from 1807. Died London 24 May 1825 in his seventy-sixth year. Buried St George's, Bayswater Road, London.
Represented: NPG London; SNPG; VAM; NGI; Fitzwilliam; BM. **Engraved by** F.Bartolozzi, J.Heath, T.Nugent, G.F.Phillips, R.Pollard, L.Schiavonetti, B.Smith. **Literature:** Strickland.

HONE, John Camillus 1759-1836
Born London, son and pupil of Nathaniel Hone. Exhibited at FS (11), RA (6) 1775-82 from London. In the early 1780s he travelled to Calcutta. Returned to Dublin c.1790, where he was appointed Engraver of Dies in the Stamp Office. Died Dublin 23 May 1836.

HONE, Nathaniel RA 1718-1784
Born Dublin 24 April 1718, son of Nathaniel Hone, a merchant of Presbyterian Dutch descent and his wife Rebecca (née Brindley). Believed to have started as an itinerant portrait painter and may have had lessons from Robert West. Married a wealthy wife, Mary Earle, at York Minster February 1742, which enabled him to settle in London, where he had a successful practice painting mainly miniatures and enamels. Reportedly travelled to Italy 1750-2, but Hilary Pyle convincingly argues (from a study of his diaries) that this is unlikely, and that it was more probable that the Hone reported in Italy (and caricatured by Reynolds) was his brother, Samuel. Visited the Princess of Wales at Kew to paint portraits and advise her about her collection. Visited Paris August 1753. Assisted in the formation of Incorporated Society of Artists, becoming one of its first directors 1766. Exhibited at SA (28)

1760-8. In 1763 he was still listed as a 'Portrait Painter in Enamel, watercolours &c.', but from 1760 he had given up his 'leisure hours from that time to painting in oil' for which he gained a reputation. Elected a founder RA. Exhibited at RA (69) 1769-84. In 1774 he attacked Reynolds directly by proposing Gainsborough for the presidentship of RA. His feud with Reynolds and the rejection from RA of Hone's picture 'The Conjuror' (said to be an obvious attack on Reynolds and containing a nude model of Angelica Kauffmann) led him to put on the first 'retrospective one-man show' in the history of British painting. Died 44 Rathbone Place, London 14 August 1784. Buried at Hendon. He usually signed his works 'NH'. His portraits can be delightful and of an outstanding quality. Often portrayed his sitters with dark almond-shaped eyes, which gives the subject the impression of being in deep thought. He was capable of original and exciting compositions. John Plott was his assistant and his sons Horace and John Camillus were also artists.
Represented: NGI; NPG London; Tate; Dublin; Kedleston Hall; RA; Fitzwilliam; Leeds CAG; Manchester CAG; BM (diaries). **Engraved by** W.Baillie, F.Bartolozzi, Bland, G. & J.Cook, W.Dickinson, J.Finlayson, R.Grave, J.Greenwood, E.Harding, W.Humphreys, J.McArdell, V.Picot, R.Purcell, W.Ridley, J.R.Smith, J.Watson. **Literature:** DNB; John Newman, *Reynolds and H. – The Conjuror Unmasked*, RA exh. cat. 1986.

HONTHORST, Gerrit van 1590-1656
Born Utrecht 4 or 14 November 1590. Studied there under Abraham Bloemaert 1620. Worked in Italy (where he was known as Gherardo delle Notti) and painted altarpieces and history pictures. Returned to Holland, where he enjoyed considerable success as one of the leading painters of the Utrecht Caravaggesque School. Visited England briefly from

April to December 1628 on the invitation of the Duke of Buckingham (who was murdered in August that year). Returned to Holland with introductions from Charles I to his sister, the Queen of Bohemia, at The Hague, for whom he painted a great many portraits. From 1637 to 1652 he was based at The Hague and was Official Painter to Frederick Henry, Prince of Orange. Returned to Utrecht 1652, as an internationally famous portrait painter. Died Utrecht 27 April 1656. **Represented:** Dulwich AG; NPG London. **Engraved by** P.Audinet, J.Brouwer, R.Cooper, T.A.Dean, W.Evans, J.Faed, W.Freeman, W.Greatbach, J.Holmes, H.Robinson, C.Sherwin, J.Suyderhoef, P.Van Gunst, R.Van Voerst, G.Vertue, C.Visscher. **Literature:** J.R.Judson, *G.v.H.,* The Hague 1959; C.White, *The Dutch Pictures in the Collection of H.M. the Queen,* 1982; DA.

HOOD, Hon Albert 1841-1921
Born 26 August 1841, son of 3rd Viscount Hood. Exhibited at RA (2), SBA (2) 1874-8 from London. Died 21 December 1921. **Literature:** Burke's Peerage 1970.

HOOD, George Percy Jacomb-
see JACOMB-HOOD, George Percy

HOOGSTRAETEN, Samuel van 1627-1678
Born Dordrecht 2 August 1627. Studied under Rembrandt in Amsterdam during the 1640s, but was back in Dordrecht by 1648. In the early 1650s he travelled to Vienna and Rome. Married at Dordrecht 1648. Worked in England 1662-7, mainly on portraits and interior perspective arrangements. In the Guild at The Hague 1668, where he painted genre scenes in the manner of Pieter de Hooch. By 1673 he was back at Dordrecht, where he published a book on painting 1678. Died Dordrecht 19 October 1678. Signed in monogram 'S.vH.'. **Represented:** Dyrham Park, NT.

HOOK, Allan J. b.1853
Exhibited at RA (28) 1876-96 from Farnham and London. His brother, Bryan, was also a painter.

HOOK, James Clarke RA HFRE 1819-1907
Born Clerkenwell 21 November 1819, son of James Hook, judge in Sierra Leone, and Eliza (née Clarke). Studied under portrait painter John Jackson. Entered RA Schools 1836 (Gold Medallist). Painted portraits early in his career but then specialized, with considerable success, in coastal scenes, seascapes and historical genre. Won Gold Medal in Houses of Parliament Competition 1844 and in 1845 won a three year travelling prize, which he spent in France and Italy. Exhibited at RA (192), BI (8), SBA (1), Paris Salon 1839-1902. Elected ARA 1850, RA 1860. Died Churt, Surrey 14 April 1907. **Represented:** Tate. **Literature:** F.G.Stephens, *J.C.H. His Life and Work,* 1890.

HOOKE, Richard 1823-1887
Exhibited at RHA (19), RA (1) 1850-81. Established a successful practice in Belfast, although also worked for periods in Dublin and Manchester.

HOOPER, Miss Margaret L. fl.1884-1887
Exhibited at RA (4) 1884-7 from 2 Pembroke Gardens, London.

HOPE, Lancelot fl.1815-1822
Worked in Liverpool 1822, and painted portraits and miniatures 'at private houses without extra charge'.

HOPE, Mrs Laura Elizabeth Rachel d.1929
Born London, daughter of Sir Thomas Troubridge, Bart. Worked as an illustrator and painted many watercolour

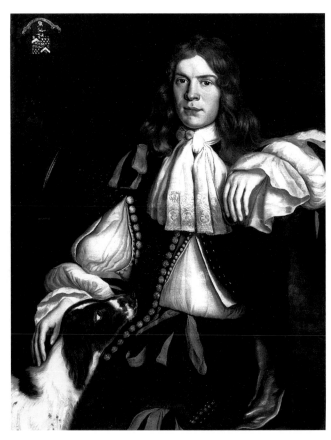

SAMUEL VAN HOOGSTRAETEN. Thomas Godfrey of Burton Aleph. Signed with initials and dated 1663. 41¾ x 31⅜ins (106.1 x 80.6cm) *Christie's*

portraits of children and fairies. Produced portraits of the royal family. Married Adrian C.F.Hope 1888. Died 15 March 1929.

HOPE, Robert RSA 1869-1936
Born Edinburgh. Began as a lithographic draughtsman. Studied at Edinburgh School of Art and Design (Gold Medallist) and RSA Life School. Exhibited at RSA (76), RA (1), NWG, DG, SSA, GI 1891-1916 from Edinburgh. Elected ARSA 1911, RSA 1925. Died Edinburgh 10 May 1936. **Represented:** Glasgow AG; Kirkcaldy AG; Paisley AG. **Literature:** McEwan.

HOPKINS, Arthur RWS RBC 1848-1930
Born London 30 December 1848, brother of poet Gerald Manley Hopkins. Studied at Lancing College and RA Schools. Exhibited at RA (37), SBA, RWS (106) 1872-1925 from London. Elected AOWS 1877, RWS 1896. Died 16 September 1930.

HOPKINS, J. fl.1791-1809
Exhibited portraits and miniatures in Dublin and RA (22) 1791-1809 from London. **Engraved by** J.Singleton, J.Young.

HOPKINS, W. fl.1790-1811
Possibly a pupil of Beechey, whose work he copied. Exhibited at RA (13) 1803-11 from Windsor Castle.

HOPLEY, Charles fl.1869
Exhibited a pastel portrait of 'Sir Richard Owen' 1869 (Royal College of Surgeons).

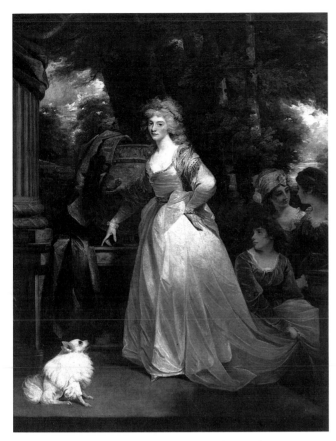

JOHN HOPPNER. HRH Frederica Charlotte Ulrica, Princess Royal of Prussia and Duchess of York. Exhibited 1792. 107 x 83ins (271.8 x 210.8cm) *Christie's*

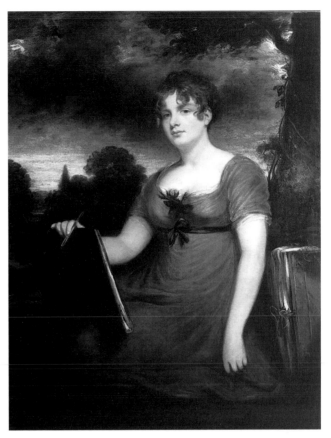

JOHN HOPPNER. Lady Arundel of Wardour. 50 x 40ins (127 x 101.6cm) *Christie's*

HOPLEY, Edward William John **1816-1869**
Born Whitstable. Originally studied medicine. Turned to art and enjoyed popularity as a genre and portrait painter. Exhibited at RA (15), BI (26), SBA (7) 1844-69 from London. Also invented a trigonometrical system of facial measurement for the use of artists. Died London 30 April 1869.

HOPPER, Joe **fl.1856**
Painted charmingly naïve portraits of children. Presumably an itinerant portrait painter. Worked at Petworth 1856.

HOPPNER, John RA **1758-1810**
Born Whitechapel, London 25 April 1758, 'son' of a German surgeon. His mother was a German attendant or lady-in-waiting at the palace, and it was rumoured that he was the natural son of the future George III. As the boy grew older, he was brought up in the palace to be a chorister in the Chapel Royal. Walton, the King's librarian, was given charge of Hoppner's education, and the King visited the library constantly to note his progress. George III made him a small allowance to enable him to become a painter. Entered RA Schools 6 March 1775, (the same day as Gainsborough Dupont). Won Silver Medal for drawing from life 1778, Gold Medal 1782. Became a friend of Gainsborough. Exhibited at RA (168) 1780-1809. Elected ARA 1793, RA 1795. On 8 July 1782 he married Phoebe Wright, daughter of Patience Wright, an American modeller in wax and ardent patriot in the American cause. She is credited with having acted as a spy in London for the benefit of Benjamin Franklin, then the American Ambassador in Paris. He consequently lost the patronage of George III, under pressure from Benjamin West, although he managed to retain the patronage of Queen Charlotte at Windsor. He enjoyed a highly successful portrait practice and his portraits of HRH Princess Sophia, HRH Princess Amelia and HRH Princess Maria (exhibited RA 1785) led to his appointment as 'Portrait Painter to the Prince of Wales' 1789. Influenced by Reynolds and Romney. With Lawrence (seven years his junior) divided the favours of high society. Visited Paris 1802 in the company of Turner and Henry Fuseli. Collaborated with S. Gilpin. Died London 23 January 1810. Buried in St James's Chapel Cemetery, Hampstead Road, London. His art varies considerably in quality, but the finest examples are outstanding achievements in British portraiture. His colours, like those of Reynolds, were rich, creamy and mellow. His sons, William Lascelles Hoppner (who finished a number of his works after his death), and Richard Belgrave Hoppner were also artists. Among his pupils and assistants were J.J.Masquerier, Henry Salt, John James Halls, Augustus Wall Callcott and R.R.Reinagle.
Represented: NPG London; NGI; Tate; SNPG; Wallace Collection; Government House, Madras; BM; VAM; Brighton AG; Metropolitan Museum, New York; Detroit Institute; HMQ; The Hermitage, St Petersburg. **Engraved by** J.S.Agar, J.Andrews, W.W.Barney, F.Bartolozzi, T.Blood, T.Bragg, T.Burke, J.W.Chapman, G.Clint, J.Cochran, R.S.Clouston, H.D.Cook, H.R.Cook, R.Cooper, R.H.Cromek, J. & T.A.Dean, W.Dickinson, W.C.Edwards, S.Einslie, G.S.Facius, E. & W.Finden, J.Fittler, S.Freeman, W.T.Fry, R.Grave, W.Greatbach, J.Heath, N.Hirst, E. & C.H.Hodges, W.Holl, J.Hopwood, J.Jones, J.Kingsbury, C.Knight, H.Landseer, D.Lucas, L.Massard, J. & H.Meyer, T.Nugent, T.Park, R.Page & Son, J.Posselwhite, J.B.Pratt, S.W.Reynolds, W.Ridley, H.Robinson, W.Say, E.Scriven, W.Sharp, J.R.Smith, R.W.Sievier, J.Stow, J.Thomson, C.Townley, C.Turner,

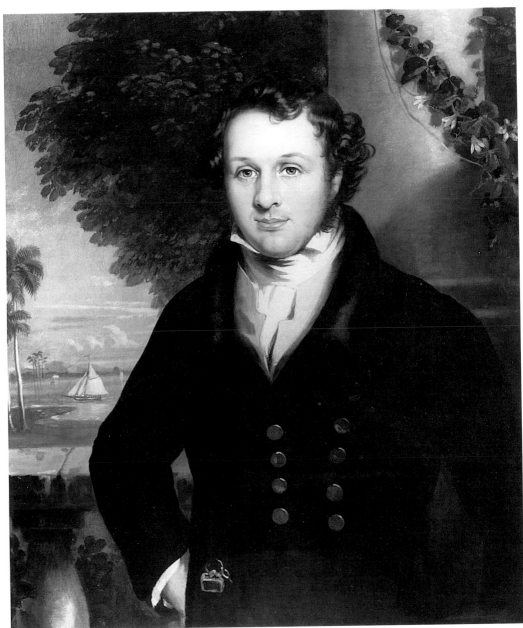

WILLIAM HOWELL. Edward Griffiths. Signed and dated 1821. Inscribed on relining on the reverse 'Madras October 5 1821'. 32 x 26ins (81.3 x 66cm)
Christie's

HOWELL, William fl.1821
Painted portraits in Madras 1821.

HOWES, John fl.1770-1795
Entered RA Schools 8 June 1770 (Silver Medallist 1772). Exhibited at RA (32) 1772-93 from London. Mainly a miniaturist and enamel painter, but also produced portraits on the scale of life.

HOWEY, John William 1873-1938
Born West Hartlepool. Painted a variety of subjects including portraits.
Represented: Grays AG, West Hartlepool.

HOWIE, James fl.1859-1860
Listed as a portraitist in 45 Princes Street, Edinburgh.

HOWIS, William fl.1828-1863
Exhibited at RHA (110) 1828-63 from Dublin.

HOWSE, F. fl.1846-1849
Exhibited at RA (4) 1846-9 from London.

HOYALL, Philip b.1816
Born Breslau. Studied at Düsseldorf Academy 1834-9 under W. von Schadow. Exhibited at Berlin Academy 1836-46, but by 1855 was working in Manchester. Moved to London by 1864, where he exhibited at RA (10), RHA (28), BI (6), SBA (28) 1863-75.

HUBBARD (HUBBERT) fl.1583-1586
Painted a portrait of 'The Earl of Northumberland' 1586 for £12. Portraits by him are recorded in the Lumley Inventory 1590.

HUBBARD, B. fl.1839-1864
Exhibited at RA (7) 1839-64 from, or near, Louth, Lincolnshire.

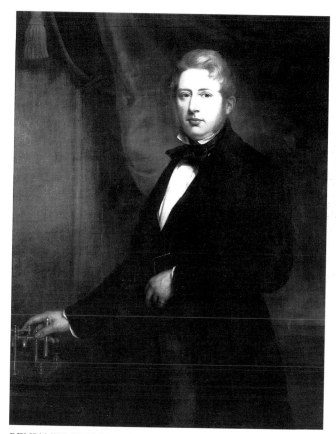

BENJAMIN HUDSON. Sir William Brooke O'Shaughnessy FRS with his telegraph machine. Signed. 50 x 40ins (127 x 101.6cm)
Christie's

HUBBARD, William James 1807-1862
Born Whitchurch. Began producing silhouettes as an 'infant phenomenon'. Travelled with his manager to New York 1824 and started painting in Boston, possibly encouraged by Gilbert Stuart. Returned to England 1826-8, but settled in America working in Philadelphia, Baltimore and Gloucester County. Fond of painting small full-lengths, with the sitter taking up only a small proportion of the pictorial space and well lit against a contrasting background. Often painted on panel, 6 x 5in. for busts and 20 x 14in. for full-lengths.
Represented: Baltimore Museum.

HUBRICHS, Miss fl.1769
Exhibited a crayon portrait at SA 1769 from London.

HUDDESFORD, Rev George 1749-1809
Born Oxford October 1749 (baptized St Mary Magdalen, Oxford 7 December 1749), son of George Huddesford, President of Trinity College, Oxford. Educated at Winchester College 1764 and matriculated at Trinity College, Oxford 1768. Entered RA Schools 1775 and studied under Reynolds. Honorary exhibitor at RA (2) 1786-7. Graduated BA, Oxford 1779, MA 1780. Was ordained and abandoned painting professionally, although continued as an amateur. Also a satirical poet of some reputation. Died London. A still-life was exhibited posthumously in his honour at BI 1810.
Literature: DNB.

HUDSON, Benjamin fl.1852-1853
Exhibited at RA (4), SBA (2) 1852-3 from Newman Street, London. Among his sitters were 'Sir Fitzroy Kelly – HM Solicitor General'.
Engraved by T.W.Hunt.

HUDSON, Henry John RP fl.1881-1912
Exhibited at RA (34), SBA, RP 1881-1910 from London. Elected RP 1891.
Represented: NPG London.

HUDSON, Paul Greville 1876-1960
Born London of Anglo-French extraction. Studied at the London College of Art. Exhibited from the age of 18 at RA, RSA and London Salon. Began by illustrating for the newspapers before designing decorations for boxes. Travelled widely abroad and settled in Scotland 1939. Could be both accomplished and original.
Represented: Carlisle AG; Carlisle Library; Wilton House Museum, Hawick.

HUDSON, Robert fl.1818-1829
Exhibited at RA (5), BI (2), SBA (2) 1818-29 from London. Probably the Robert Hudson listed as a portrait painter in Pontefract 1841.

HUDSON, Thomas 1701-1779
Born Devon. Studied under J.Richardson (whose daughter he ran away with and married 1725). Practised in the west country as well as London 1730-40. Influenced by Van Loo, whom he succeeded. With Ramsay, he became the most fashionable painter in London, and both painters employed Joseph and Alexander Van Aken to paint their draperies. He admired Rembrandt, and some of his portraits adopt a strong chiaroscuro. Gave a portrait of 'Theodore Jacobsen' to the Foundling Hospital 1746. Visited France and the Low Countries 1748 (accompanied by Hogarth, Hayman and others). Made a brief visit to Italy with Roubiliac 1752. Exhibited at SA (9), FS (1) 1761-79. In later life he made a second marriage with Mrs Fiennes, a widow with a good fortune. Died Twickenham 26 January 1779. Among his

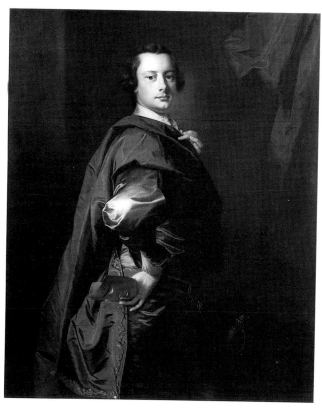

THOMAS HUDSON. George Hunt. Signed, inscribed and dated 1750. 50 x 40ins (127 x 101.6cm)
Christie's

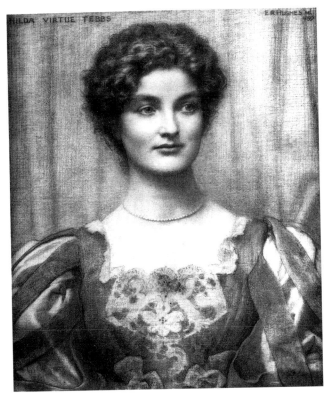

EDWARD ROBERT HUGHES. Hilda Virtue Tebbs. Signed, inscribed and dated 1877. Red chalks. 24 x 20ins (61 x 50.8cm)
Christie's

pupils and assistants were Joshua Reynolds (1740-3), John Astley, J.Dixon, Richard Cosway, P.J.Tassaert, Wright of Derby, Rev Matthew William Peters, Edward Penny, Thomas Jenkins, J.H.Mortimer and probably Benjamin Wilson. His best work has great charm and feeling.
Represented: NPG London; NGI; Tate; Bodleian Library; Dulwich AG; Goldsmiths' Company; Blenheim Palace; Yale. **Engraved by** W.P.Benoist, C.Bestland, W.Bond, W.Bromley, J.Collyer, H.R.Cook, P.Dawe, J.Dixon, J.Faber jnr, E.Fisher, M.Ford, S.Freeman, R.Graves, W.Greatbach, A.v.Haecken, Harding, J.Hopwood, R.Houston, Hulett, J.McArdell, J.Marchant, J.S.Muller, Proud, R.Purcell, T.Ryley, W.W.Ryland, A.Sartain, A.Smith, C.Spooner, R.Taylor & Co, J.Thomson, S.Walch, J.Watson, G.White. **Literature:** E.Miles and J.Simon, *T.H.*, Kenwood exh. cat. 1979; DNB; DA. Colour Plate 33

HUDSON, William NWS 1782-1847
Began as a flower painter but then concentrated on miniatures and watercolour portraits, enjoying a successful practice. Exhibited at RA (148), NWS 1803-46 from Croydon and London.

HÜET-VILLIERS see VILLIERS, François Hüet

HUGGINS, William 1820-1884
Born Liverpool 13 May 1820. Studied at Mechanics Institute and Liverpool Academy Schools. Exhibited at LA, RA (31), SBA (1) 1835-78. Elected ALA 1847, LA 1850. Early works included many chalk portraits, but he later gained a reputation as an animal painter. Died Christleton, near Chester 25 February 1884. His gravestone there describes him as 'a just and compassionate man, who would neither tread on a worm nor cringe to an emperor'.
Represented: Tate; Walker AG, Liverpool.

HUGHES, Arthur 1832-1915
Born London 27 January 1832. Studied under Alfred Stephens. Entered RA Schools 1847. Exhibited at RA (67), RHA (2), GG, NWG 1849-1911. Converted to Pre-Raphaelitism c.1850 and met Holman Hunt, Rossetti, Madox Brown and later Millais. Produced a number of outstanding works. Also an illustrator. Died London 22 December 1915. Studio sale held Christie's 21 November 1921.
Represented: NPG London; Tate; BM; Ashmolean; Birmingham CAG; Manchester CAG. **Literature:** Leonard Roberts, *A.H. His Life and Works: A Catalogue Raisonné*, in preparation.

HUGHES, Edward 1832-1908
Born London, son of artist George Hughes. Enjoyed a successful society portrait practice. Exhibited at RA (36), BI (14), SBA (11), GG 1847-84 from London. Died London May 1908.
Represented: Alton Towers; Grimsthorpe Castle; Holkham; Royal College of Surgeons.

HUGHES, Edward Robert VPRWS 1851-1914
Born London 5 November 1851, nephew and pupil of Arthur Hughes. Studied at RA Schools and under Holman Hunt. Exhibited at RA (21), BI, RWS, GG 1870-1911 from London. Elected ARWS 1891, RWS 1895, VPRWS 1901-3. Also exhibited at international exhibitions in Venice, Munich and Düsseldorf. Died St Albans 23 April 1914.
Represented: NPG London; Maidstone Museum; Ashmolean; Sydney AG; Melbourne AG.

HUGHES, George fl.1813-1858
Exhibited at RA (67), BI (10), SBA (4) 1813-58 from London. Among his sitters was actress Miss Ellen Tree. Practised as a portrait and miniature painter.
Engraved by J.Rogers.

HUGHES, Hugh 1790-1863
Born Pwllygwichiaid. Worked as a wood engraver, portrait painter and satirical cartoonist. Listed as a portrait painter in London 1832-4. Died Great Malvern 11 March 1863.

HUGHES, John fl.1819-1838
Exhibited at RA (5), BI (7), SBA (7) 1819-36 from London.

HUGHES, Leonard RCA fl.1889-c.1930
Exhibited at RA (2) 1889-94 from Holywell, Flintshire.

HUGHES, Mrs Philippa Swinnerton 1824-1917
Portraits of her father, Robert Lucas de Pearsall are in the Benedict Abbey of Einsiedeln, Switzerland and NPG London.

HUGHES, Talbot ROI 1869-1942
Born Chelsea, son of still-life painter William Hughes. Exhibited at RA (16), ROI, RHA (1), PS 1905-19 from London and Osmington, near Weymouth. Died 6 February 1942.

HUGHES, Thomas John fl.1851-1889
Exhibited at RA (8), BI (1), SBA (10) 1851-89 from London.
Engraved by J.B.Hunt.

HUGUIER, James Gabriel fl.1772
Exhibited crayon portraits at SA (4) 1772 from London.

HULME, Jesse fl.1830-1842
Listed as a portrait painter in Burslem and Shelton, Staffordshire.

HUMBLE, Mrs Catharine (née de Keyser) d.1724
Probably daughter of Willem de Keyser. Painted miniatures and small oil portraits, often on copper.

HUMBLE, Stephen jnr **1812-1858**

Born Newcastle, son of artist Stephen Humble. Began, like his father, as a brick maker and while working on the property of John Balmbra was commissioned to paint his portrait. The success of this led to further commissions and a successful practice in the town. Exhibited in Newcastle, where he died at the 'height of his powers' aged 46.
Literature: Hall 1982.

HUME, J.Henry **1858-1881**

Exhibited at RA (11), SBA (11) 1875-81 from London, Midhurst and Petersfield. Died aged 23. The *Art Journal* commented 'a young artist of promise – though chiefly a landscape painter, he had late turned his studies with success to figure and portrait painting, showing a rich and refined feeling for colour'.
Literature: *Art Journal* 1881 p.192.

HUMPHREYS, Robert **fl.1830-1833**

Exhibited at RHA (5) 1830-3 from Dublin.

HUMPHRIES, Catherine **fl.c.1730s**

Painted a portrait of the 'Rev Nathan Wrighte'.

HUMPHRY, Ozias RA **1742-1810**

Born Honiton, Devonshire 8 September 1742, son of George Humphry, a peruke maker and mercer, and his wife, Elizabeth. Educated by Samuel Bamfield and at the Grammar School under Rev Richard Lewis. Studied at Shipley's Academy 1757, Duke of Richmond's Academy and under Samuel Collins at Bath 1760-2. On Collins' removal to London to avoid creditors Humphry succeeded to his practice. Became acquainted with Gainsborough in Bath. Settled in London 1763 with the encouragement of Reynolds, where he painted portraits in oil, crayon and miniature. His work was admired by Walpole and he exhibited at SA (12), RA (48) 1765-97. Elected FSA 1773, ARA 1779, RA 1791. He fell from a horse 1771. This damaged his eyesight and he concentrated on oils. Travelled with Romney (who influenced him) to Rome 1773 and remained there until 1777. Left for India 25 January 1785, and met there with considerable success. Ill-health forced his return again to London, where he was appointed Portrait Painter in Crayons to the King. In 1797 his eyesight deteriorated badly leading to blindness. Died London 9 March 1810. Buried St James's Chapel, Tottenham. Although he remained unmarried he had a son by Dolly Wickers, called William Upcott. Humphry sometimes signed with an 'H' within an 'O'. Among his pupils and followers were William Singleton, Richard Collins, Thomas Day and H.Spicer Bone. Painted a portrait of George Stubbs.
Represented: NPG London; BM; Tate; VAM; Walker AG, Liverpool; Bodleian; Berkeley Castle; Knole, NT. **Engraved** by C.Bestland, T.Blood, R.Cooper, E.Finden, W.Greatbach, C.Knight, T.Ryder, J.Singleton, E.Train, Mrs D.Turner.
Literature: G.C.Williamson, *O.H.*, 1918; *Gentleman's Magazine* 1810; DNB; DA.

HÜNNEMANN, Christopher William **1755-1793**

Born May 1755, son of a Court Physician at Hanover. Entered RA Schools 6 December 1773, when his age was noted as '18 last May'. Silver Medallist 1776. Recommended to the King as a first-rate copyist, and his copies of Gainsborough's royal portraits are in Audley End and Hartlebury Castle. Also practised as a portrait and miniature painter. Exhibited at RA (24) 1776-93 from London. Died London 21 or 23 November 1793.

HUNT, Arthur Acland **fl.1863-1902**

Exhibited at RA (19), BI (4), SBA (22), NWS 1863-1902 from London.

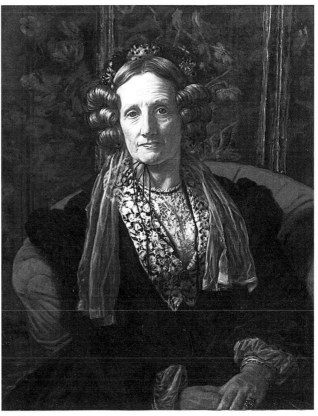

WILLIAM HOLMAN HUNT. Mrs George Waugh (née Mary Walker). Signed twice with monograms and dated 1868. 24 x 26ins (61 x 66cm) *Christie's*

HUNT, Gerard Leigh **d.1945**

Exhibited at RA (11) 1894-1918 from London. Died 7 January 1945.

HUNT, Herbert S. **fl.1893**

Exhibited at SBA (1) 1893/4. Lived in London and Concarneau, Brittany.

HUNT, Richard **fl.1642**

Signed and dated 1642 a portrait of a man. It was painted in the manner of Cornelius Johnson.

HUNT, Robert **c.1775-c.1848**

Born Philadelphia, son of Isaac Hunt and Mary (née Shelwell). Exhibited at RA (13) 1802-42 from London.

HUNT, T. Greenwood **fl.1873-1878**

Exhibited at RA (3) 1875-8 from London and Chelmsford.

HUNT, William **fl.1845-1846**

Listed as a portrait and miniature painter in Brighton.

HUNT, William Henry Thurlow **b.1862**

Baptized St Pancras 29 July 1862, son of William Henry Brooks Hunt. Exhibited at RA (4) 1883-5 from 160 Camden Road.

HUNT, William Holman ARSA RWS OM
 1827-1910

Born London 2 April 1827, son of William Hunt, a warehouse manager and Sarah (née Hobman). Worked as an office clerk for an estate agent 1839. Against his family's wishes began a career in art. Studied under portrait painter, Henry Rogers. Entered RA Schools 1844. Met Millais who became his close friend, and

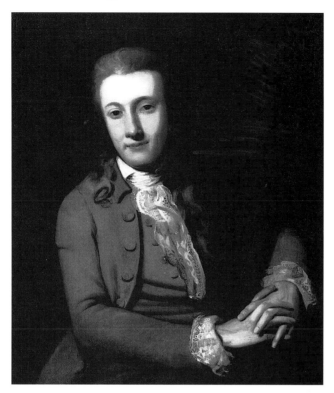

ROBERT HUNTER. A gentleman. Signed. 30 x 25ins (76.2 x 63.5cm) *Philip Mould/Historical Portraits Ltd*

through him Rossetti and Ford Madox Brown. A founder member of Pre-Raphaelite Brotherhood 1848. He went on to produce a number of major works including 'The Hireling Shepherd', 'The Light of the World', 'The Awakening Conscience' and 'The Scapegoat'. Exhibited mostly religious works and the occasional portrait at RMI, RA (25), BI (1), RHA (4), OWS, GG, NWG 1845-1903. Elected OWS 1869. Died London 7 September 1910. Interred in St Paul's Cathedral.
Represented: NPG London; BM; VAM; Tate; Southampton CAG; Ashmolean; Coventry AG; Birmingham CAG; Walker AG, Liverpool; Manchester CAG. **Engraved by** Jonnard. **Literature:** *A Memoir of W.H.H.'s Life,* 1860; F.W.Farrar, *W.H.H.,* 1893; A.C.Gissing, *W.H.H.,* 1936; D.Holman Hunt, *My Grandfather, His Wives and Loves,* 1969; *W.H.H.,* Wolverhampton AG exh. cat. 1981; *W.H.H.* VAM exh. cat. 1969; D.H.Hunt, *My Grandmothers and I, 1961;* J.Maas, *H.H. & The Light of the World,* 1984; DA.

HUNTER, Miss Ada **fl.1886-1898**
Exhibited at RA (9), NWS 1886-98 from London.

HUNTER, James **fl.1814-1820**
Worked in Wakefield as a portrait painter and taught figure drawing. Thomas Hartley Cromek was his pupil.
Engraved by J.Godby.

HUNTER, John Kelso **1802-1873**
Born Dunkeith, Ayrshire 15 December 1802. Employed as a herd boy. Apprenticed to a shoemaker. Set up as a cobbler in Kilmarnock. Taught himself portrait painting. Moved to Glasgow, where he practised as both a cobbler and portraitist. Exhibited at RA (1), RSA (5) 1847-72. Published his first book *The Retrospective of an Artist's Life* 1868. His *Life Studies of Character* 1870 throws much light on the works of Burns. Died Pollokshields 3 February 1873.
Literature: DNB; McEwan.

HUNTER, John Young RBA **1874-1955**
Born Glasgow 29 October 1874, son of artist Colin Hunter ARA. Educated at Clifton College and University of London. Studied at RA Schools (winning Silver Medals). Exhibited at RA (42), SBA, RP and in America 1895-1938. Elected RBA 1914. Died Taos, New Mexico 9 August 1955. His wife, Mary, was also a painter.
Represented: Tate; Liverpool AG. **Literature:** McEwan.

HUNTER, Mary Anne (Mrs Trotter)
 c.1752-after 1777
Daughter of artist Robert Hunter. Painted portraits and historical subjects. Married artist John Trotter 1774.

HUNTER, Mrs Mary Ethel **1878-1936**
Born Yorkshire. Studied at Newlyn. Exhibited at RA (19) 1900-37. Married artist John Young Hunter.

HUNTER, Mrs Mary Young **fl.1900-1914**
Exhibited at RA (22) 1900-14 from Gloucester, Suffolk and London.

HUNTER, Robert **c.1715/20-1803**
Born Ulster. Studied under Thomas Pope the elder. Established a considerable practice in Dublin, modelling his tone and colouring on the old masters. Helped found Dublin Society of Artists. Won a premium at Dublin Society 1763. For 30 years he was the 'most important painter of the Irish establishment'. Taylor writes that he had 'collected many old pictures' and that 'he was a mild, amiable man, liberal in communicating what he knew, and generous in estimating the works of his brother artists'. Painted a number of small full-lengths, some of which have been catalogued as by Devis. His last works show the influence of Reynolds.
Represented: NGI. **Engraved by** W.Dickinson, J.Dixon, E.Fisher, S.Harding, R.Purcell, J.Watson. **Literature:** DNB; W.B.S.Taylor, *The Origin, Progress and Present Condition of the Fine Arts in Great Britain and Ireland,* 1841 II pp.283-4; DA.

HUNTER, William **fl.c.1780**
Worked as a portrait painter in London. Also painted histories.

HUNTINGTON, Daniel NA **1816-1906**
Born New York 14 October 1816. Met Elliott, who encouraged him to take up portraiture. Studied in New York under Morse and Inman. In 1839 travelled to Rome, Florence and Paris. Worked in England 1851-8. Exhibited at RA (6) 1852-9 from New York and London. Elected ANA 1839, NA 1840. Made his last visit to Europe 1882. Among his sitters were Sir Charles Eastlake PRA and The Archbishop of Canterbury. Died New York 18 April 1906.
Represented: Yale.

HUNTLEY, Miss Georgina **fl.1816-1825**
Exhibited at RA (7) 1816-25 from London. Won a Silver Medal at SA 1820.

HUNTLY, Miss Nancy Weir (Mrs Sheppard) **b.1890**
Born Nusseerabad, India 9 March 1890. Studied at Düsseldorf and RA Schools. Exhibited at RA (12), ROI, RP, PS, Paris Salon 1913-33. Signed her work 'Huntly' and occasionally 'N.Sheppard'.

HUQUIER (HEQUIER), Jacques Gabriel 1725-1805
Born Paris, son of painter and engraver Gabriel Huquier. Settled in England c.1770. Exhibited at SA, RA (8) 1771-86. Worked in Shrewsbury 1776, Cambridge 1783. It is likely he earned his living as an itinerant pencil and crayon portraitist, although he was also an engraver and printseller. Died Shrewsbury 7 June 1805.
Represented: BM. **Engraved by** T.Burke.

HURLESTON (HURLSTONE), Richard d.c.1780
Won premiums for drawing at SA 1763-4. Entered RA Schools 1769. Studied under Wright, whom he accompanied to Rome 1774-80. Exhibited at RA (8) 1771-3. Killed by lightning while riding his horse on Salisbury Plain c.1780. **Engraved by** Dean, W.Pether. **Literature:** DNB.

HURLSTONE, F.B. jnr fl.1857-1869
Exhibited at RA (1), SBA (9) 1857-69 from London.

HURLSTONE, Frederick Yeates RBA 1800-1869
Born London 15 February 1800 (baptized 6 January 1801), son of Thomas Hurlstone, a newspaper proprietor and Elizabeth (née Willet). Entered RA Schools 1820 (Gold Medallist 1823). Studied under Beechey, Lawrence and Haydon. Exhibited at RA (37), BI (19), SBA (326) 1821-69. Elected RBA 1831, President 1835-69. Awarded a Gold Medal at Paris Exhibition 1855. Travelled frequently including Spain, Morocco and Italy. Enjoyed a highly successful portrait practice. Married artist Jane Coral. Died London 10 June 1869.
Represented: BM; Inveraray Castle. **Engraved by** J.Cross, N.Hanhart, J.Linnell, W.Walker. **Literature:** *Art Journal* 1869 p.216; DA.

HURLSTONE, Mrs Jane (née Coral) d.1858
Exhibited at RA (6), SBA (23) 1846-56. Married Frederick Yeates Hurlstone.

HURRY, Miss Agnes fl.1901-1936
Exhibited at RA (26) 1901-36 from 30 Fulham Road, London.

HURST, Hal (Henry William Lowe) RI RBA HRMS 1865-1938
Born London 26 August 1865, son of Henry Hurst, the African traveller. Studied at Académie Julian, Paris and RA Schools. Exhibited at RA (19), SBA, RI 1896-1919 from London. Also worked as illustrator in America. Died 23 December 1938.

HURTER, Charles Ralph (or Rudolph) b.1768
Probably born Berne 25 March 1768, son and pupil of J.H.Hurter. Entered RA Schools 29 March 1781 'age 13 25th March Inst.'. Awarded a Silver Medallion by SA for drawing portraits 1782. Accompanied his father to Karlsruhe 1786. Exhibited at RA (2) 1787-9.

HURTER, Johann Heinrich 1734-1799
Born Schaffhausen 9 September 1734. Worked in Berne 1768-70, Versailles and The Hague 1772, where he became a member of the Painters' Guild. Settled in London c.1777 and specialized in enamel miniatures and occasionally crayon portraits. Exhibited at RA (4) 1779-81. Between 1785-7 he travelled to Schaffhausen, Karlsruhe, The Hague and Paris, returning to London, where he founded a factory for mathematical and other instruments. Died in Düsseldorf 2 September 1799.

HUSKINSON (HUSKISSON), Henry b.1793
Baptized Langar, near Nottingham 25 June 1793, son of Henry Huskinson and Sarah (née Goodacre). His mother was buried 3 September 1804, his father 20 December 1810. Listed in Pigot's directory as a portrait painter 1830-1 in Nottingham, and exhibited at RA (1) in 1832 from there. He is recorded at Park Street, Nottingham in 1841. He appears to be related to (and confused with) the fairy painter R. Huskisson and the genre painter L. Huskisson.
Represented: Nottingham AG. **Literature:** H.C. Hall, *Artists of Nottinghamshire*, 1953.

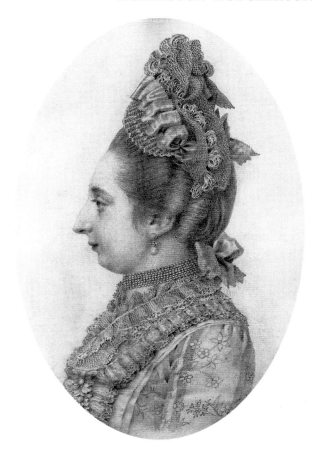

GILES HUSSEY. Juliana, Mrs Edward Weld. Pencil. 11½ x 8ins (29.2 x 20.3cm) *Sotheby's*

HUSON, W. fl.1783
Honorary exhibitor of a portrait of a lady at RA 1783.

HUSSEY, Giles 1710-1788
Born Marnhull, Dorset 10 December (Waterhouse) or 10 February (Redgrave) 1710, of a Roman Catholic family. Studied briefly under Richardson, and then Damini, with whom he travelled to Italy 1737, where he won prizes at Bologna. Specialized in neat pen portraits, of which the largest collection is at Ugbrooke. Returned to London, where he produced profile portraits and histories. Retired to the country 1768 and took to theorizing. Died Beeston, Dorset June 1788. Redgrave writes: 'His portraits are simple and characteristic, and have much elegance'. West possessed some of his chalk portraits, which he declared had never been surpassed.
Represented: Syon House. **Engraved by** J.Mitan. **Literature:** *Connoisseur* LXV March 1923 pp.136-9; Redgrave; *Nichols's Literary Anecdotes* Vol 8; Sotheby's catalogue 12 March 1987.

HUSSEY, Philip 1713-1783
Born Cloyne, County Cork. Began as a seaman and was five times shipwrecked. Commenced art by drawing figureheads, before establishing a portrait practice in Dublin. Also a botanist, florist and musician. Died Dublin June 1783.
Represented: NGI. **Literature:** Pasquin; DA.

HUSTON, William fl.1827-1830
Exhibited at RHA (10) 1827-30 from Dublin.

HUTCHINSON, A. jnr fl.1832
Exhibited at RA (1) 1832.

HUTCHINSON, M. fl.1828-1831
Exhibited at RA (4) 1828-31 from 2 Baches Row, Hoxton.

HUTCHISON, Robert Gemmell RSA RSW
 1855-1936
Born Edinburgh, son of George Hutchison. Began his career
as a seal engraver. Studied at Board of Manufacturers School
of Art, Edinburgh. Exhibited at RSA, RA (58), NWG, Paris
Salon (Gold Medallist) 1879-1934. Elected RSW 1895,
ARSA 1901, RSA 1911. Died 23 August 1936. Influenced by
Joseph Israels.
Represented: Oldham AG; Walker AG, Liverpool; Glasgow
AG; Paisley AG; Toronto AG. **Engraved by** J.Collyer.
Literature: *R.G.H.* Fine Art Society exh. cat. n.d.

HUTCHISON, Sir William Oliphant PRSA VP RP
 1889-1970
Born Kirkcaldy 2 July 1889. Educated at Rugby, Edinburgh
College of Art 1909-12 and in Paris. Exhibited at RA (53),
RSA, NEAC, Paris Salon 1905-70. Elected ARSA 1937, RSA
1943, RP 1948, PRSA 1950, VPRP 1960, knighted 1953.
Lived in London and Edinburgh. Died 5 February 1970.
Represented: NPG London; SNPG.

HUTCHISSON (HUTCHISON, HUTCHINSON), Joseph
 1747-1830
Born Dublin, son of a currier. Entered Dublin Society
Schools 1764. Apprenticed to G.Carncross, an heraldic
painter. Went to London c.1790, where he worked as a
portrait and animal painter, and later as a miniaturist.
Exhibited at RA (33) 1791-1819. Also worked in Bath from
c.1795. Died Bath 1 September 1830 after a lingering illness.
Represented: Victoria AG, Bath. **Engraved by** R.Hancock.
Literature: *Bath Chronicle* 28 August 1817, 2 September
1830; Foskett.

HUYSMANS, Jacob c.1630-1696
Reportedly born Antwerp, where he studied under Frans
Wouters 1649-50. Moved to England soon after the
Restoration. Settled in London by 1662, where he took a
studio in Westminster. By August 1664 he was considered to
rival Lely (Pepys considered him better) and he was patronized
by Queen Catherine of Braganza and her Court circle. He
used a rich palette and often embellished his compositions
with continental Baroque conventions such as lambs, cupids,
etc. Painted the altarpiece (now lost) for the Queen's Chapel
and mythological subjects. Died London. Buried St James's
Church, Piccadilly. Redgrave writes: 'His heads are well drawn
and coloured, the character and expression good'.
Represented: NPG London; HMQ; Tate; Melbourne Hall;
Walker AG, Liverpool. **Engraved by** P.Audinet, A.de Jode,
G.Maile, E.Pinkerton, H.Robinson, C.Rolls, J.Scott,
W.Sherlock, W.Sherwin, P.Van Somer, R.Tompson,
W.Vincent. **Literature:** DNB; DA.

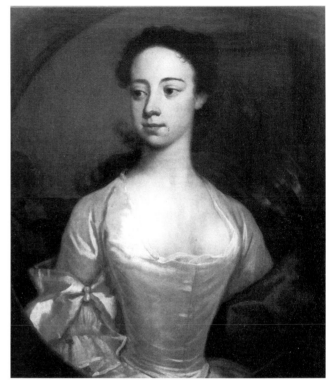

HANS HYSING. A lady. Signed and dated 1741. 30 x 25ins
(76.2 x 63.5cm) *Sotheby's*

HYDE, Frank fl.1872-1916
Exhibited at RA (8), SBA 1872-1916 from London,
Southsea and Maidstone.

HYSING (HUYSSING), Hans 1678-1753
Born Stockholm. Apprenticed there as a goldsmith 1691-4
and then to artist David Krafft. Settled in London 1700,
where he studied under Dahl for many years. Set up his own
practice by 1715. Among his sitters were the royal princesses
and Sir Robert Walpole. Alan Ramsay was for a brief time his
pupil (1734). Died London.
Represented: Stourhead NT; King's College, Cambridge;
SNG. **Engraved by** T.Burford, Clark, C.Du Bose,
J.Bretherton, J.Faber jnr, J.S.Muller, P.Pelham, J.C.Philips,
S.F.Ravenet, H.Robinson, J.Simon, J.Tookey, G.Vertue,
G.Whites, W.H.Worthington. **Literature:** W.Nisser, *Michael
Dahl and the Contemporary Swedish School of Painting (in
England)*, 1927 pp.97-105; DNB; DA.

I

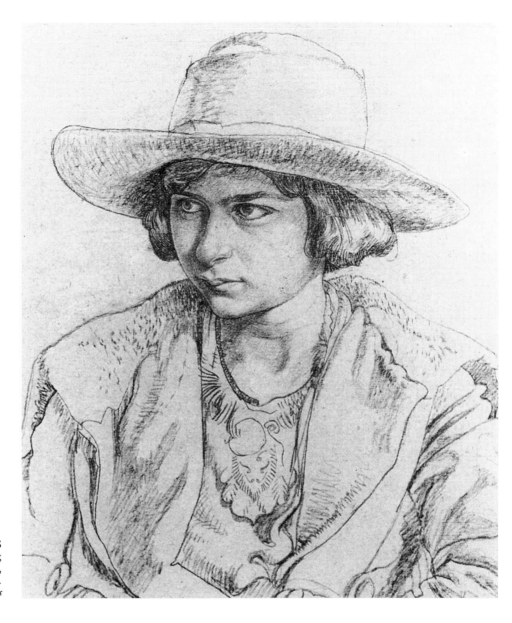

RUDOLPH ERNEST CHARLES IHLEE. Portrait of a young woman. Signed and dated '19, pencil on paper. 11¾ x 9¾ins. (30 x 25cm) *Phillips*

I'ANSON, F. fl.1833-1837
Exhibited at RA (2) and SBA (3) 1833-7 from London.

ICHENHAUSER, Mrs Natalie fl.1889-1894
Exhibited at RA (1) in 1894 from London.

IHLEE, Rudolph Ernest Charles 1883-1968
Born Wimbledon March 1883, probably the son of Henry Ferdinand Ihlee. Exhibited at NEAC, RBA and Salon des Indépendants, Paris from 1910. A gifted draughtsman. Lived in London and later at the Yews, West Deeping with his wife Isabelle. Died 25 September 1968 leaving £154,078.

ILLIDGE, Thomas Henry 1799-1851
Born Warwick, Birmingham 26 September 1799. Studied under Mather Brown and William Bradley. Based in Manchester 1825-31, Yorkshire 1833, Blackburn, London and Liverpool. Exhibited at RA (14), SBA (5), LA, RMI 1826-51. Among his sitters were Benjamin Robert Haydon, Sir William Charles Ross RA, Colonel the Hon Sir Edward Cust, His Grace the Duke of Manchester and author James Montgomery. Commissioned to paint portraits for Town Hall, Birkenhead and for Royal Free Hospital. On the death of H.P.Briggs he purchased the lease of his house in Berkeley Square, where he had an extremely successful practice. Afforded three servants and a lady's maid. Died unexpectedly of fever in London 13 May 1851.
Represented: Walker AG, Liverpool. **Engraved by** W.Say, J.Smyth, C.Turner, G.R.Ward, C.E.Wagstaff. **Literature:** DNB; *Art Journal* 1851 p.182.

IMMANUEL, M. fl.1783-1798
Practised as a portrait painter and teacher of drawing in Norwich and Yarmouth. Exhibited at FS (1) 1783.

IMPERITORI, Mrs fl.1832-1834
Listed as a portrait painter at 59 Lower Brook Street, London.

INGHAM, Charles Cromwell NA 1796-1863
Born Dublin. Entered Dublin Society Schools 1809, winning prizes 1810 and 1811. Studied for four years under William Cumming. Settled in New York 1816, where he set up as a portrait and miniature painter. Exhibited at RHA (2) 1828-42. Elected a founder NA 1826 and Vice-President. Died New York 10 December 1863. Usually painted with a

porcelain-like smoothness, a style achieved through laborious glazing rather than direct painting.
Literature: DA.

INGLES, David N. ARHA fl.1913-1932
Exhibited at RHA (25), RSA (4) 1917-32 from Dublin and London. Elected ARHA 1919.
Represented: NPG London.

INGLIS, Miss Jean Winifred NS 1884-1959
Born Kensington 12 March 1884. Studied at Slade. Exhibited at RA (8), RP, NEAC, Paris Salon from London and Stroud. Died 8 December 1959.

INMAN, Henry NA 1801-1846
Born Utica, New York 28 October 1801, son of English parents. Apprenticed to J.W.Jarvis in New York City 1814-22. Worked in Boston for a short time before settling in New York 1824, where he became a founder NA and a leading portraitist. Moved to London 1830 and exhibited 'William Charles Macready as William Tell' (Metropolitan Museum, New York) at SBA (1). The following year he was in Philadelphia as a partner of Colonel Childs in lithography, and with him was involved in Pennsylvania Academy of Fine Arts. Returned to New York 1834, but visited England again 1843-5, painting portraits of Wordsworth and Macaulay. Returned again to New York, where he died 17 January 1846. Among his pupils were Charles Wesley Jarvis and Thomas S.Cummings. His portrait style is fluid and accomplished.
Represented: Boston MFA; Historical Society, New York City. **Literature:** DA.

INNES, Henry P. fl.1897-1899
Exhibited at RA (2) 1897-9 from London.

INNES, Robert fl.1843-1868
Exhibited at RHA (7), RSA (67) 1843-68 from Edinburgh and Dublin.
Represented: SNPG. **Literature:** McEwan.

INSKIPP, James 1790-1868
Originally employed in the commissariat service, from which he retired with a pension. Took up painting as a profession 1820, producing landscapes, genre and portraits. Between 1833-6 he drew a number of illustrations for Izaak Walton's *Compleat Angler* and published *Studies of Heads from Nature*, 1838. Exhibited at RA (24), BI (83), RHA (17), SBA (56) 1816-64. From 1846 he lived at Godalming, where he died 15 March 1868.
Engraved by H.Robinson.

I'ONS, Frederick Timpson 1802-1887
Born Islington 15 November 1802, son of John I'Ons, a keeper of a riding school. Educated at Edward Flower's Academy in Islington and then at a boarding school. Taught drawing, painting, handwriting and commercial subjects at his own school in Marylebone, but later converted the school into a studio. Married Ann Frazer 1827. Her bad health prompted them to emigrate to the Cape 1834. Received many commissions from officers, but struggled to earn a living. Died Grahamstown 18 December 1887. One of the most prolific artists in South Africa during the 19th century. The quality of his art varied considerably.
Represented: Africana Museum, Johannesburg; Rhodes University Library, Grahamstown; Albany Museum, Grahamstown. **Literature:** Dictionary of South African Biography.

IRVINE, James b.1757
Born 18 March 1757. Studied at RA Schools. Worked in Rome 1786, where he was a pupil of Gavin Hamilton. Recorded buying old masters for Buchanan and others in Rome 1803. Exhibited from there at RSA (2) 1826-8. Recorded alive in September 1830. Often confused with John Irvine 1805-88.
Literature: McEwan.

IRVINE, James 1833-1899
Born and educated at Menmuir, Forfarshire. Studied art in Brechin under Colvin Smith, and at Edinburgh Academy. Employed by Mr Carnegy-Arbuthnott of Balnamoon to paint portraits of the old retainers on his estate. Practised for some years as a portrait painter in Arbroath, before moving to Montrose. After a slow start he became recognised as one of the best portrait artists in Scotland and enjoyed a highly successful practice. A close friend of George Paul Chalmers. Exhibited at RA (2) 1882-4. Died of congestion of the lungs in Montrose 17 March 1899.
Represented: SNPG. **Literature:** DNB; McEwan; DA.

IRVINE, John ARSA 1805-1888
Born Lerwick. A precocious talent exhibiting from the age of nine. Exhibited at RSA (127), RA (25), BI (2), SBA (2) 1814-62 from Edinburgh and London. Many of his sitters were from the medical profession, church or army. Worked in Melbourne, New South Wales 1859. Died Dunedin, New Zealand.
Represented: SNPG; Dunedin AG. **Literature:** McEwan.

IRVING, William fl.1818-1824
Believed to have been born at Longtown. Exhibited at Carlisle Academy (4) 1824 from Longtown and London.
Represented: Carlisle AG.

IRVING, William 1866-1943
Born Ainstable, son of a farmer. Moved as a child to Newcastle-upon-Tyne. Studied at Newcastle School of Art under William Cosens Way and at Académie Julian, Paris (c.1905-8). Worked as an illustrator on the *Newcastle Chronicle*, while building up a successful reputation as a portrait painter. Exhibited at Bewick Club, Newcastle and RA (3) 1898-1906. Died Newcastle 4 June 1943.
Represented: Carlisle AG; Laing AG, Newcastle. **Literature:** Hall 1979.

IRWIN, Miss Madelaine fl.1888-1906
Exhibited at RA (11), RHA (1), SBA 1888-1906 from Colchester.

ISAACS, Miss Martha fl.1771-1779
Studied under 'Mr Burgess'. Exhibited at FS (12) 1771-4. Travelled as a miniaturist to India 1778, where she married Alexander Higginson (a member of Indian Board of Trade) 1779. In order to marry him she renounced her Jewish faith.

ISHIBASHI, Kazunori RP ROI 1879-1928
Born Matsue, Japan 4 June 1879. Studied at RA Schools 1905-10. Exhibited at RA (15), ROI, RP 1908-27. Elected a member of Imperial Art Society of Japan. Died Tokyo 2 May 1928.

IVEY, Miss Marion Teresa fl.1884-1888
Exhibited at RA (2), SBA, NWS from 1884 from the Tower of London.

J

JACK, Richard RA RP **1866-1952**
Born Sunderland 15 February 1866. Studied at York School of
Art, South Kensington (where he won a Gold Medal and
travelling scholarship), Académie Julian, Paris and Atelier
Colarossi. Settled in London by 1895. Exhibited at RA (158),
RSA, RI, RP (43) 1893-1951. Elected RP 1900, ARA 1914,
RI 1917, RA 1920. Awarded Silver Medal for portraiture at
Paris International Exhibition 1900. Painted an
uncommissioned portrait of George V (who turned up for
sittings after it was begun), which led to portraits of the Queen
and Princess Elizabeth. Visited Canada 1930 and decided to
emigrate to Montreal 1932, where he died 29 June 1952.
Represented: Royal College of Surgeons; Tate; Gray AG,
Hartlepool; VAM; Leeds General Infirmary; HMQ; Laing
AG, Newcastle; Sunderland AG; Shipley AG. **Literature:**
Magazine of Art 1904 pp.105-11; Hall 1982.

JACKSON, Francis Ernest ARA **c.1872-1945**
Born Huddersfield, Yorkshire 15 August 1872 or 1873. Studied
at Académie Julian, Paris and at École des Beaux Arts. Taught at
Central School, RA Schools and Byam Shaw School. Also litho-
grapher and designed posters for the London Underground. Exhi-

JOHN JACKSON. Charles, 2nd Earl Grey, Viscount Howick and
Baron Grey in peer's robes. 30 x 25ins (76.2 x 63.5cm) *Christie's*

bited at RA (38), RHA (8) 1907-45. Elected ARA 1944. Died
Oxford 11 March 1945, following a road accident.
Represented: Tate. **Literature:** *Notes from the Sketch Books of
F.E.J.*, Oxford 1947; *F.E.J.*, Byam Shaw School exh. cat. 1955.

JACKSON, Gerald G. **fl.1907-1936**
Exhibited at RA (9) 1907-36 from London, Bucking-
hamshire and Suffolk.

JACKSON, Gilbert **fl.1621-1640**
Itinerant portrait painter who seems to have worked in North
Wales in the 1630s. Had an academic clientele at Oxford and
Cambridge. His signed and dated works range 1622-40, and he
often signs 'Gil.Jack' or 'G.J'. Made Freeman of the Painter-
Stainers Company, London, 1640. His work tends to be highly
finished, with an eye for detail and although it follows in the
manner of Cornelius Johnson it retains a charmingly naïve
quality. Among his sitters were Bishop Williams (1625 St John's
College, Cambridge) and Master William Hickman (1634).
Represented: NPG London. **Literature:** A.J.Finberg,
Walpole Society X; Mrs R.L. Poole, *Catalogue of Portraits in
the Possession of the University Colleges, City and County of
Oxford*, Vol II, xxv, xxvi, 1925; DA.

JACKSON, Miss H.A.E.
see BROWNING, Mrs Harriet A.E.

JACKSON, Herbert P.M. **fl.1895-1901**
Exhibited at RA (3) 1895-1901 from Earl's Court, London.

JACKSON, J.W. **fl.1831-1832**
Exhibited at RA (2) 1831-2 from London.

JACKSON, John RA **1778-1831**
Born Lastingham, Yorkshire 31 May 1778, son of a tailor.
Started in his father's career, but showed a talent for art and his
earliest portraits were in pencil, weakly tinted in watercolour.
Attracted the patronage of Lord Mulgrave at Whitby, who

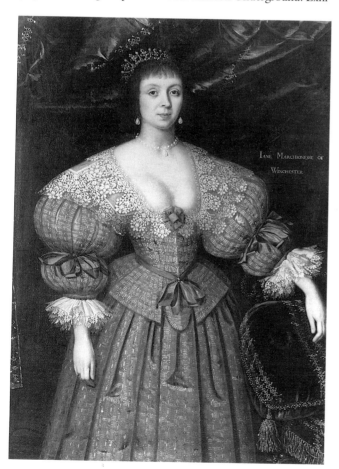

GILBERT JACKSON. Jane, Marchioness of Winchester. Signed
and dated ?1627. 52 x 36ins (132.1 x 91.5cm) *Christie's*

introduced him to the Earl of Carlisle and Sir George Beaumont. The latter sent him to RA Schools 9 March 1805, where he became a close friend of Wilkie and Haydon. Also made copies at BM. Exhibited at RA (156), BI (20) 1804-30. Elected ARA 1815, RA 1817. A follower of Wesley, who was the subject of one his first portraits. After the death of his first wife he married Matilda, daughter of James Ward, 1818. She was much younger than him and he had a daughter older than his new wife. Visited The Netherlands with General Phipps 1816. Travelled through Switzerland to Rome with Sir Francis Chantrey 1819. There his portrait of Canova 'astonished' the Italians with its high quality, and he was elected a member of Roman Academy of St Luke. Established a successful practice, although in the shadow of Lawrence. Among his sitters were the Archbishop of York, Thomas Stothard RA, James Ward RA, Richard Westmacott RA, Martin Archer Shee RA, George Dance RA, HRH the Duke of York and Francis Chantrey RA. Died at his house in St John's Wood 1 June 1831. Among his pupils were James Clarke Hook and Marshall Claxton. His style shows the influence of Raeburn and Lawrence. At his best he produced paintings of the highest order, and he has been considerably underrated. Sir Thomas Lawrence said of his portrait of Flaxman at the Academy dinner of 1827 that it was 'a grand achievement of the English School, and a picture which Vandyck might have felt proud to be the author'.
Represented: NPG London; SNPG; BM; Tate; VAM; RA; NGI; NMM; Newport AG; Portsmouth Museum; Yale; Canterbury Museums. **Engraved by** H.Adlard, J.Basire, W.Bond, Branwhite and Meyer, W.Brett, T.Cheeseman, J.Cochran, J.Collyer, R.Cooper, S.Cousins, F.Croll, R. & T.A.Dean, G.T.Doo, W.Drummond, W.C.Edwards, W.T.Fry, R.Graves, W.Greatbach, C.Heath, R.Hicks, W.Holl, C.H.Jeens, J.Jenkins, R.J.Lane, F.C.Lewis, T.Lupton, H.Meyer, R.Page, Pannier, C.Penny, C.Picart, R. & J.Posselwhite, S.W.Reynolds snr & jnr, W.Ridley, H.Robinson, R.Roffe, W.Say, E.Scriven, W.Sharp, R.W.Sievier, W.Skelton, G.Stodart, J.Stow, J.Thomas, J.Thomson, C.Turner, W.Walker, W.Ward snr & jnr, E.R.Whitfield, R.Woodman, J.Woolnoth, J.Wright. **Literature:** DNB; O.Beckett, *The Life and Work of James Ward RA*, 1995; DA.
Colour Plate 34

JACKSON, Mason　　　　　　　　　　　**1819-1903**
Born Ovingham, Northumberland, brother and pupil of John Jackson. Exhibited at RA (2) 1858-9 from London. Died London 29 December 1903.

JACKSON, Mulgrave Phipps B.　　**fl.1852-1857**
Exhibited at RA (3), BI (2), SBA (5) 1852-4 from London. Listed as a portrait painter in Ealing.

JACKSON, William　　　　　　　　　　**1730-1803**
Born Exeter. Exhibited at Liverpool SA 1774 and at Society for Promoting Painting and Design, Liverpool 1784 and 1787. Died 12 July 1803.

JACOB, Julius (Isaak)　　　　　　　**1811-1882**
Born Berlin 25 April 1811. Studied in Berlin, Düsseldorf and in Paris under Delaroche. Exhibited at Paris Salon 1838-44. Member of Royal Society of Fine Arts in Paris. Exhibited at RA (16) 1845-54 from London and Berlin. Specialized in painting the portraits of children, often with animals. Also painted histories and genre. Died Berlin 20 October 1882. A son, Julius, was also a painter.
Literature: Bénézit.

JACOBSON, J.　　　　　　　　　　**fl.1659-1699**
Painted a portrait of 'Thomas Ferris' 1699 (now lost; a copy is in Trinity House, Hull) and an unidentified portrait was recorded as being signed and dated 1659.

JACOMB-HOOD, George Percy　MVO RBA ROI RE RP
1857-1929
Born Redhill, son of an engineer and director of the London, Brighton and South Coast Railway. Educated at Tonbridge school and won a scholarship to Slade (where he won prizes). Studied under J.P.Laurens in Paris. A close friend of H.S.Tuke. Exhibited paintings and bronzes at RA (58), RHA (2), ROI, SBA, GG, NWG, RP and Paris Salon 1877-1929. Elected a founder NEAC, RBA 1884, RP 1891, ROI, Vice-President of Royal British Colonial Society of Artists. Served on Council of Royal Society of Painters-Etchers. Illustrated for *The Graphic*, who sent him to Greece 1896; to Delhi for the Durbar 1902; on the Indian Tour of the Prince and Princess of Wales 1905; and on George V's tour of India 1911, when he was a member of the personal staff. Awarded MVO 1912. Died at Villa Costa Bella, Alassio, Italy 11 December 1929.
Represented: Trinity College, Oxford; NPG London; Manchester CAG. **Engraved by** F.Short. **Literature:** *Memorial Exhibition of the Works by the late G.P.J.-H.*, Walker AG exh. cat. 1934; G.P.Jacomb-Hood, *With Brush and Pencil*, 1925.

JAGGER, David　RP ROI　　　　　　　**d.1958**
Exhibited at RA (59), RP (15), SBA, ROI and in Liverpool 1917-58 from London. Died 26 January 1958. Capable of sensitive portraits. His later work was sometimes influenced by the chiaroscuro of studio portrait photography.
Represented: Nottingham Castle Museum & AG.

JAMES, E.　　　　　　　　　　　　　　**fl.1825**
Exhibited at RA (2) in 1825 from London.

JAMES, Miss Edith Augusta　　　　　**1857-1898**
Born Eton, Berkshire 24 January 1857. Studied in Paris under Chaplin. Exhibited at RA (4), SBA (2) 1886-96 from London, Paris and Tunbridge Wells. Died Tunbridge Wells 31 December 1898.
Represented: VAM.

JAMES, George　ARA　　　　　　　　　**d.1795**
Born London, son of a well-to-do bookseller. Apprenticed to Arthur Pond 1749 and went early in his career to Italy. Visited Naples 1755 and Rome until 1760, when he returned to London, with Biagio Rebecca as his assistant. They soon quarrelled and parted company. Exhibited at FS (5), SA (11), RA (16) 1762-90 from Dean Street, Soho. Elected ARA 1770. Moved to Bath c.1780, where he continued to paint portraits. Inherited property from his grandfather (who built Meard's Court in Dean Street), married a rich lady and soon gave up painting. Towards the end of his life he retired to Boulogne where he was a victim of the Revolution and died in prison early in 1795.
Engraved by J.Watson. **Literature:** Walpole Society XXXVI 41 n4.

JAMES, Miss M.E.　　　　　　　　　　**fl.1804**
Exhibited at RA (1) in 1804 from London.

JAMES, Robert　　　　　　　　　　　**1806-1853**
Born Nottingham. Apprenticed to a house painter before setting up as a portrait painter. Exhibited at RA (4) 1841-51 from Nottingham.
Represented: Castle Museum, Nottingham.

JAMESON, Cecil Stuart　RP　　　　　　**b.1883**
Educated in New Zealand. Moved to London aged 20, studying at Lambeth, Kensington and RA Schools. Exhibited at RA (6), RSA (1), RHA (1), RP, Paris Salon 1922-37 from London.
Represented: NPG London.

JAMESON, G. fl.1734
Signed and dated a portrait of 'Michael Hubert' 1734, painted in the manner of J.Highmore.

JAMESON, Middleton 1851-1919
Brother of Dr Jameson of Jameson Raid. Worked in Paris in the 1880s with Arthur Melville. Exhibited at RA (10), RSA (4) 1906-19 from London. Died April 1919.

JAMESONE, George c.1587-1644
Reportedly born Aberdeen 8 February 1587, son of Andrew Mason, a prosperous mason and his wife Marjory. Apprenticed to artist John Anderson in Edinburgh 27 May 1612. Reportedly studied in Antwerp 'under Rubens alongside of Vandyck'. Practising as a portrait painter in Aberdeen by 1620, when he painted his earliest known portrait 'Sir Paul Menzies' (Marischal College, Aberdeen). Married Isabel Toche 12 November 1624. Visited Italy in the company of Sir Colin Campbell of Glenorchy. Established a considerably successful practice working in Aberdeen and Edinburgh. Enjoyed royal patronage and painted the most celebrated Scotsmen of the time. Considered to be founder of the native Scottish School of Portraiture. Charged 20 merks for a bust-sized portrait, and with gold frame £20. Took John Michael Wright as a pupil at Edinburgh 1633/4. Died Aberdeen late 1644. Buried in churchyard of Greyfriars, Edinburgh. Influenced by Rubens, and usually painted thinly, with great delicacy.
Represented: SNPG; Craigievar Castle; Crathes Castle; Fyvie Castle; NGI. **Engraved by** R.C.Bell, R.Cooper, S.Freeman, E.Harding, T.Trotter, A.W.Warren. **Literature:** D.Thomson, *The Life and Art of G.J.*, 1974; DNB; McEwan; DA.

JAMIESON, Alexander ROI 1873-1937
Born Glasgow 23 September 1873. Studied at Haldane Academy, Glasgow. Won a scholarship to study in Paris 1898. Visited Spain 1911 and served in France during 1st World War. Exhibited at RA (14), RSA (15), ROI 1906-37. Elected ROI 1927. Married Biddy Macdonald and lived at Weston-Turville, Aylesbury. Died London 2 May 1937.
Represented: VAM; Brighton AG. **Literature:** *A.J. and his Wife Biddy Macdonald*, Hazlitt Gallery exh. cat., 1970; McEwan.

JANSEN, Fritz fl.1883-1885
Exhibited at RA (1), NWS 1883-85 from London.

JANSSEN (JANSEN), Theodore see JENSEN, Theodor

JAQUES, Miss Lilian fl.1904
Exhibited at RA (1) in 1904 from 70 Francis Street, Leeds.

JARRET(T), G. fl.1827-1829
Exhibited at RA (1), SBA (1) 1827-9 from London.

JARVIS, John Wesley 1780-c.1840
Born South Shields, a nephew of evangelist John Wesley. Aged five emigrated to Philadelphia. Apprenticed to engraver Edward Savage, with whom he moved to New York 1801. Went into partnership with Joseph Wood 1802, a specialist in small, cabinet-size portraits. Tried portraiture with considerable success, and made several visits to the South of USA with his pupil, Henry Inman, who was said, on one occasion, to have finished off six portraits in a week. Jarvis painted a series of full-length portraits of American military and naval heroes. Towards the end of his life he met with hard times, due largely to his 'extravagant, irascible, and unpredictable' nature. Died 12 January 1840 or 14 January 1839 (conflicting sources). John Quidor was also a pupil.
Represented: New York Historical Society. **Literature:** *A History of the Rise and Progress of the Arts of Design in the United States,* 1834; Harold E.Dickson, *J.W.J.,* 1949; Hall 1982; DA.

GEORGE JAMESONE. Lady Anne Erskine and children. Signed and dated 1626. 85 x 51ins (215.9 x 129.5cm) *Christie's*

JEAN, Philip 1755-1802
Baptized St Ouen's Church, Jersey 30 November 1755, son of Nicholas Jean jnr and Marie (née Grandin). Money's diary 1798 describes him as 'a self-taught genius, originally a barber here [Jersey]'. Served in the navy before practising mainly as a miniaturist, although he did paint a number of life-size portraits. Established himself in London by 1784. Exhibited at RA (47) 1787-1802. Painted a number of sitters from the royal family and their immediate circle, as well as Paul Sandby, John Richards, Francis Newton and Benjamin West. Influenced by Hoppner, Reynolds, Gainsborough and Cosway. Died in Captain Hodges' house (where he was painting his portrait), Hempstead, Kent 12 September 1802 aged 47.
Represented: S.Jersey AG; NPG London; VAM. **Engraved by** J.Collyer, W.Ridley, J.Thomson, J.Vendramini. **Literature:** DNB; G.R.Balleine, *A Biographical Dictionary of Jersey.*

JEFFERSON, John fl.1811-1825
Recorded working in Newcastle 1811, and was practising in North Shields 1818, when the birth of his son was documented on 17 January. By 1822 he was residing in Sunderland. Exhibited at Northumberland Institution for Promotion of Fine Arts, Newcastle.
Represented: Sunderland AG.

JEFFERYS, William **d.1805**
Born Maidstone. Studied under Hayman. Exhibited at FS (8) 1766-75. Died Maidstone. His son, James Jefferys 1757-84, was also an artist.
Literature: T.Clifford and S.Legouix, *Burlington Magazine* CXVIII March 1976 pp.148-57.

JEMELY, James **fl.1723**
Scottish portrait painter working in the style of Medina. Received £10 for a 30 x 25in. portrait in 1723. May be the artist known as Gemell.
Literature: B.Balfour-Meville, *The Balfours of Pilrig*, 1907 p.71.

JENKINS, Miss Blanche **fl.1872-1915**
Exhibited at RA (49), SBA (18+) 1872-1915 from London. Member of Society of Lady Artists. Among her sitters were Hon Mrs Henry Howard, Captain A.G.Corbett, and Mrs W.L.Wyllie.

JENKINS, Thomas **1722-1798**
Born Sidbury, Devon. Studied in London under Thomas Hudson. Listed as an 'eminent painter' in the *Universal Magazine*. Visited Rome by 1753, living in the same house as Richard Wilson. Among his sitters were Lord Dartmouth and distinguished musician Francesco Geminiani. An honorary Accademico di San Luca in Rome 1761, but shortly afterwards ceased to practise as a painter, becoming the principal English banker in Rome and a dealer in pictures and antiquities. Remained in Rome until the occupation of the French, when he lost all his property and escaped to England, but died on arrival.
Engraved by N.Mosman. **Literature:** B.Ford, *Apollo* VCIX June 1974 pp.416-25; DNB.

JENNER (JEHNER), Isaac **1750-c.1806**
Born Westminster, son of a German gunsmith. Had an accident aged nine, which left him a deformed dwarf for life. Apprenticed to an engraver c.1770, then under William Pether. Settled in Exeter c.1780, making engravings and painting portraits. A freemason. Published a small sketch of his career under the title *Fortune's Football* 1806.
Literature: DNB.

JENNINGS, Reginald George **1872-1930**
Born Wandsworth. Studied at Westminster School of Art. Exhibited at RA (3), RI 1911-13. Lived in London and Siena. Died Banstead Mental Hospital, Sutton 1 October 1930. Represented SNPG.

JENNINGS, Samuel **fl.1789-1834**
Entered RA Schools 1790. Exhibited at RA (35), BI (14) 1789-1834 from London.

JENOUR, Charles **d.1851**
Exhibited at RA (8) 1825-32 from London. Listed in directories as a portrait painter there in 1834. His obituary in *Carlisle Journal* 11 April 1851 commented that he was 'well and favourably known in Whitehaven'.
Represented: Carlisle AG; Whitehaven Museum. **Engraved by** C.Turner.

JENSEN, Christian Albrecht **1792-1870**
Born Bredsted 27 June 1792. Studied at Copenhagen. Visited Rome and Venice 1818. Exhibited at RA (8) 1837-8 from Copenhagen. Among his sitters were HRH Prince Christian Frederick of Denmark, and Prince Ernest of Hesse Philipsthal. His portrait of 'Sir John Herschel' is in Royal Society, London. Died Copenhagen 13 July 1870.
Literature: DA.

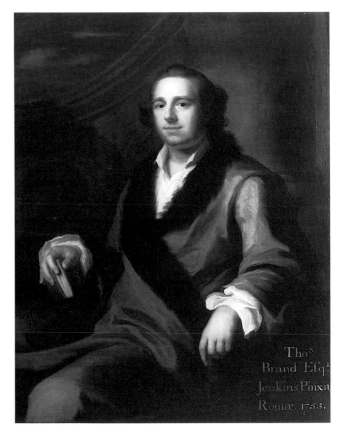

THOMAS JENKINS. Thomas Brand. Signed and dated 1753. 45 x 36ins (114.3 x 91.5cm) *Christie's*

JENSEN, Theodor **1816-1894**
Born 21 June 1816. Studied at Düsseldorf Academy. Exhibited at RA (5), BI (7), SBA (2) 1854-64 from London. Among his exhibited portraits were 'HRH the Prince of Wales Represented in the Robes of the Star of India' and 'HRH the Princess of Wales in State Robes'. Also an engraver. Died Düsseldorf 21 June 1894.

JERICHAU-BAUMANN, Mrs Elizabeth Maria Anne (née Bauman) **1819-1881**
Born Warsaw 27 November 1819. Married a Russian officer. When the marriage failed she turned to art, studying under Prof Strelke and Prof C.John. Having studied seven years at Düsseldorf she went to Rome, where she married the eminent Danish sculptor Jerichau. A friend of Hans Christian Anderson, who attended her marriage and wrote her a poem for the occasion. Exhibited at RA (22) 1859-69 from London. Member of the Royal Academy of Fine Arts, Copenhagen. She 'had the honour to paint pictures and portraits for nearly every sovereign in Europe'. Visited Constantinople 1869 and 1874. T.Gautier declared once that there were only three women in Europe 'qui peignent', Rosa Bonheur, Henrietta Brown and Elizabeth Jerichau. Died Copenhagen 11 July 1881.
Literature: Clayton.

JÉROME, Miss Ambrosini **fl.1840-1871**
Exhibited at RA (17), BI (23), SBA (35) 1840-71. Originally lived near Colnbrook, but moved to London 1841 residing first in Bloomsbury and then in Camden Town. Appointed portrait painter to HRH the Duchess of Kent 1843.

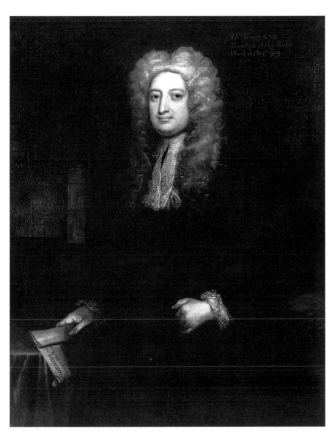

CHARLES JERVAS. Sir William Fortesque. Signed, inscribed and dated 1731. 50 x 40ins (127 x 101.6cm) *Christie's*

JERVAS, Charles c.1675-1739

Born Ireland (probably Dublin as he was described as 'Charles Jervas of the city of Dublin, gent' in 1697-8). Received a good education before assisting in Kneller's studio 1694-5. Attracted the patronage of Norris, Keeper of Paintings to William III and made various copies of pictures (including Raphael cartoons) at Hampton Court by 1695. Visited Paris by 1699, and had settled in Rome (known as Carlo Jervasi) by the end of 1703, where he studied the old masters, making many copies. Remained there until 1708, and had settled in London by 1709. Became extremely fashionable, partly due to his friendship with Pope (whom he taught to paint), Steele, Swift and others in the literary world. Pope wrote an adulatory poem to Jervas, which was published in Dryden's translation of Du Fresnoy's *Art of Painting* edited by Richard Graham 1716:

> Beauty, frail flow'r that every season fears,
> Blooms in thy colours for a thousand years.
> Thus Churchill's race shall other hearts surprise
> And other Beauties envy Wortley's eyes.
> Each pleasing Blount shall endless smile bestow,
> And soft Belinda's blush for ever glow.

Painted a number of ladies as shepherdesses or country girls (*Tatler* 4, April 1709), had a number of standard poses, which he was fond of repeating and refined his drapery style by copying Van Dyck. Succeeded (in preference to Dahl) Kneller as Principal Painter to the King October 1723 and held the post under George I and II. Married Penelope Hume 1727, a rich widow (said to be worth £20,000). Remained based in London until his death, although he made a number of lengthy visits to Ireland and may have travelled

to Jamaica and Italy (for relief from asthma). Died London 2 November 1739. His collection sold March 1740 (516 lots). He does not appear to sign his paintings and there are many doubtful attributions. There are numerous stories about his 'vanity' and the liberties he took with fashionable sitters. Reported as having remarked to the Duchess of Bridgwater that she did not have a handsome ear and when she asked him his opinion of what was a handsome ear, he showed her one of his own. Also translated a popular edition of *Don Quixote*, posthumously published 1742.
Represented: NPG London; NGI; Dulwich AG; Leeds CAG; Bodleian Library; London University; Boughton House. **Engraved by** J.Brooks, J.Caldwall, J.Faber jnr, Geremia, E.Harding, A.Miller, J.H.Robinson, J.Simon, J.Thomson, G.Vertue. **Literature:** DNB; P.Quinnell, *Alexander Pope*, 1968 p.129; J.Aston, *Social Life in the Reign of Queen Anne*, 1929; *Irish Portraits 1660-1860*, NGI cat.1969.

JERVIS, John fl.1765

Signed and dated a provincial portrait of a lady 1765.

JESSOP, Samuel fl.1845-1850

Exhibited at RHA (7) 1845-50 from Enniscorthy and Dublin.

JEWEL fl.1793

Exhibited at RA (1) 1793. No address was given.

JEWETT, William S. ANA 1812-1873

Born South Dover, New York. Based in New York 1833-49. Elected ANA 1845. Left for San Francisco 1849, where he worked 1850-69. Also had a studio in Sacramento 1850-5 and was reputedly the first professional portraitist in California. Returned to New York 1869. Recorded in England 1873, just before his death. Reportedly died Bayonne, New Jersey.
Represented: De Young Museum, San Francisco; Bowers Memorial Museum, Santa Ana; National Academy of Design, New York; Sutter's Fort, Sacramento. **Literature:** H.C.Nelson, *Antiques,* November 1942 pp.251-3.

JOBLING, Mrs Isabella (née Thompson) d.1926

Exhibited at RA (8) 1892-1912 from Newcastle and Whitley Bay. Married Newcastle artist Robert Jobling between 1893-7. Died Newcastle 8 October 1926.

JOCELYN, Nathaniel 1796-1881

Born New Haven 31 January 1796, son of Samuel Jocelin, a clockmaker and engraver. Began as a clockmaker, then studied engraving under George Munger c.1813. Associated with the Hartford Graphic & Bank Note Engraving Company. Went into partnership with his brother S.S.Jocelyn 1843. Was in Savannah 1820-2 and on his return to New Haven established himself as a portrait painter. Exhibited at NA. Elected NA 1846. Visited England and France 1829. Had a studio in New York 1843-7. After a fire in 1849 he gave up painting and took up bank note engraving, founding the National Bank Note Company, from which he retired 1864. Died New Haven 13 January 1881.
Literature: DA.

JOEL, Grace 1865-1944

Born Dunedin, New Zealand. Studied at Melbourne NG School and Académie Julian, Paris, under Baschet and Schominier. Died London.
Represented: New South Wales AG.

JOHN, Master fl.1544-1545

His outstanding portrait of Mary I is in NPG London.

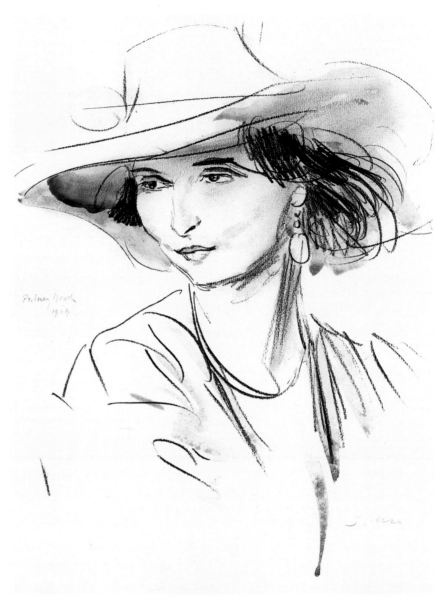

AUGUSTUS EDWIN JOHN. Dorelia.
Signed and inscribed 'Putney Heath
1909'. Watercolour and black chalk. 10 x
14ins (25.4 x 35.6cm)
John Mitchell & Son, London

JOHN, Augustus Edwin OM RA PRP 1878-1961
Born Tenby, Wales 4 January 1878. Studied at Slade 1894-8
under Brown, Tonks and Steer, where he developed a
spontaneous and seemingly effortless style of drawing that won
him immediate recognition. It is reported that his impact on the
Slade resulted from a radical change of personality which followed
a bathing accident in the summer of 1897, when he hit his head
on a rock. Exhibited at RA (82), RHA (10), RP (14), NEAC
1899-1962. Elected ARA 1921, RA 1928 (resigned 1938, re-
elected 1940), Professor of Painting at Liverpool University
1901-4, PRP 1948-53, OM 1942. Applied for military service
1916 and was rejected. Died Fordingbridge 31 October 1961.
Widely regarded as one of the leading painters of his day.
Represented: Tate; Southampton CAG; NPG London; NGI;
SNPG; Manchester CAG; Ontario AG; Glasgow AG; Brighton
AG; Aberdeen AG; Leeds CAG; National Museum of Wales.
Literature: A.Bertram, *A.J.,* 1923; M.Easton & M.Holroyd,
The Art of A.J., 1974; J.Rothenstein, *A.J.,* 1945; *A.J.,* RA exh.
cat. 1954; A.John, *Chiaroscuro – Fragments of Autobiography:
First series,* 1952; A.John, *Finishing Touches,* 1966; L.Browse
(ed), *A.J. – Drawings,* 1945; *AJ: Studies for Composition:
Centenary Exhibition,* National Museum of Wales exh. cat.
1978; M.Holroyd, *A.J. A Biography,* 1974; DA.

JOHN, Gwendolen Mary 1876-1939
Born Haverfordwest, Pembrokeshire, the gifted sister of
Augustus John. Studied at Slade and Whistler's School in
Paris. Settled in Paris, exhibiting at NEAC from 1900 and in
France. Painted mostly small, intimate and highly sensitive
portraits of outstanding quality. Died Dieppe.
Represented: NPG London; Tate; Southampton CAG; Leeds
CAG. **Literature:** *G.J.: Retrospective Exhibition,* Arts Council
1968; A.D.Jenkins, *G.J. – At the National Museum of Wales,*
1976; M.Taubman, *G.J.,* 1985; C.Langdale, *G.J.,* 1987;
S.Chitty, *G.J.,* 1981; DA.
Colour Plate 35

JOHNS, J. W. fl.1854
Exhibited at RA (1) in 1854 from London. May be architect
J.W.Johns who exhibited a design for a botanical institution
at RA (1) 1835 from 14 Cunningham Place.

JOHNSON, Benjamin fl.1830-1883
Listed as a portrait painter at 33 Upper Bath Row, Birmingham.

JOHNSON, Mrs Bertha J. fl.1878-1882
Exhibited at RA (3) 1878-82 from Oxford. Married Rev
A.H.Johnson.

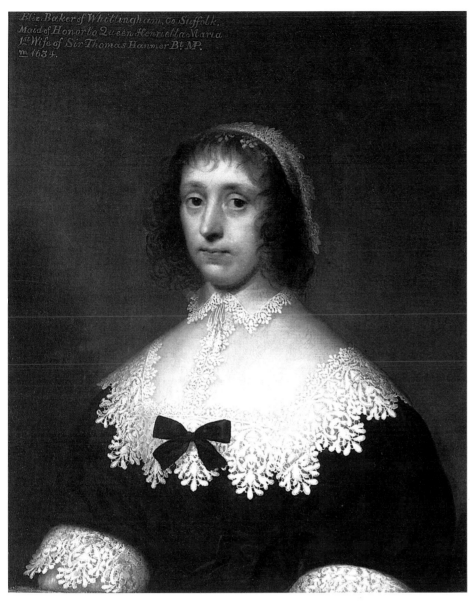

Eliz. Baker of Whittingham, co. Suffolk,
Maid of Honor to Queen Henrietta Maria
1st Wife of Sir Thomas Hanmer Bt. MP.
m. 1634.

CORNELIUS JOHNSON (i). Elizabeth Baker of Whittingham, Suffolk. Signed and dated 1634. 30 x 25ins (76.2 x 63.5cm) *Christie's*

JOHNSON (JONSON, JANSEN), Cornelius (i)
1593-1661

Baptized Cornelis Jansz at the Dutch Church, London 14 October 1593, son of Cornelis and Johanna Jansz. His family were originally from Cologne (their original name seems to have been Van Ceulen), and his parents had been refugees from Antwerp. Believed to have trained in Holland. Returned to London c.1618, and for the next 20 years became the fashionable depicter of court nobility and gentry in England. The earliest known signed portrait is dated 1617, and there are a number of signed (usually with the initials 'C.J.') and dated portraits from 1618-43. Married Elizabeth Beke of Colchester at the Dutch Church, Austin Friars 16 July 1622. Lived in Blackfriars for some years, but in 1636 also resided with or near Sir Arnold Braems at Bridge, near Canterbury. Painted to a smooth, glossy finish and at first favoured panel, but later canvas. Often placed 'heads' in a feigned oval. After Van Dyck's arrival his compositions became more sophisticated. Waterhouse writes 'His portraits are very sensitive to character and are beautifully drawn and meticulously painted'. In January 1625 he took on John Evoms (Evans) as an apprentice to help him keep up with the demand for his work. Theodore Russel was also a pupil. Johnson was sworn as the King's Painter 1632. His wife's fears of the Civil War caused him to retire to Holland in October 1643 and it was recorded in the journals of the House of Commons that 'Cornelius Johnson, Picture Drawer, shall have Mr Speaker's Warrant to pass beyond the seas with Emanuel Pass and George Hawkins and to carry with him such pictures and colours, bedding, household stuff, pewter and brass as belonged to himself'. Visited Middelburg 1644, Amsterdam 1646 and Utrecht 1652. Reportedly ruined by the extravagance of his second wife and to have died a poor man in Utrecht 5 August 1661. **Represented:** NPG London; NGI; Tate; Yale; Dulwich AG; Canterbury Museums; Holburne Museum, Bath. **Engraved by** F.Bartolozzi, W.P.Benoist, A.Birrell, L.P.Boitard, J.Brown, W.Bromley, T.Cheeseman, G.B.Cipriani, R.Cooper, S.De Passe, T.A.Dean, R.Dunkarton, J.Finlayson, J.Fittler, W.N.Gardiner, G.Glover, J.Godefroy, J.Hall, Harding, E. & W.Holl, W.Hollar, J.Houbraken, C.H.Jeens, J.McArdell, C.Picart, G.Powle, E.Radclyffe, W.Raddon, Rodttermondt, J.Rogers, E.Scriven, J.Stow, J.Thomson, Tiebout, C.Turner, G.Vertue, A.Walker, R.White, W.H.Worthington. **Literature:** A.J.Finberg, Walpole Society X 1922; DA.

JOHNSON (JONSON), Cornelius (ii) 1634-after 1700
Baptized St Anne's, Blackfriars 15 August 1634, son of eminent portrait artist Cornelius Johnson i and Elizabeth (née Beke) of Colchester. Accompanied his father to Holland 1643. Recorded in Utrecht 1700. It is not known if he ever painted in England.

JOHNSON, Cyrus RI ROI 1848-1925
Born 1 January 1848. Studied under W.W.Ouless. Exhibited portraits and miniatures at RA (49), RHA (4), ROI 1877-1917 from London. Died 27 February 1925.

JOHNSON, Ernest Borough RI RP RBA ROI 1867-1949
Born Shifnal, Salop 9 December 1867, son of Dr C.H.Johnson JP. Studied at Slade under Legros and at Herkomer's School, Bushey. Exhibited at RA (52), RP, SBA, ROI Paris Salon (winning Silver Medals for portraits) and various international exhibitions 1887-1945. Became Professor of Fine Arts at Bedford College. Married artist Ester George and lived in Chelsea and St John's Wood. Wrote a number of books on art. Died London 30 July 1949.
Represented: NPG London; NG, Melbourne; Aberdeen AG; Nottingham AG; VAM; Brighton AG; Guildhall AG, London; BM; Wolverhampton AG. **Literature:** Who Was Who 1941.

JOHNSON, Mrs Ester Borough (née George) d.1945
Born Ester George at Sutton Maddock, Shropshire. Studied at Birmingham and Chelsea Schools of Art and at Herkomer's School. Exhibited at RA (31), RI, ROI, RP, PS 1903-49 from London.
Represented: Brighton AG.

JOHNSON, Henry fl.1824-1847
Exhibited at RA (12), BI (9), SBA (12) 1824-47 from London. Among his sitters was John Fernley. Also an illustrator.
Represented: NPG London.

JOHNSON, Robert 1770-1796
Born Shotley, son of a carpenter. Studied under Bewick in Newcastle. Painted portraits in miniature and watercolours. Died Kenmore, Perthshire 26 October 1796. Buried Ovingham.

JOHNSON, William fl.1832-1841
Listed as a portrait painter in Nottingham.

JOHNSTON, Alexander 1815-1891
Born Edinburgh, son of an architect and began his career, aged 15, with a seal engraver. Studied at Trustees' Academy 1831-4. Practised as a portrait painter before coming to London with an introduction from David Wilkie. Entered RA Schools under W.Hilton 1836. Exhibited at RA (77), RSA (8), RHA (5), BI (49), SBA (16) 1833-86. Died Hampstead 2 February 1891.
Represented: Tate; SNPG; Sheffield AG; Sunderland AG. **Engraved by** T.L.Atkinson, F.Bromley, C.H.Jeens, C.Lightfoot. **Literature:** DNB; McEwan.

JOHNSTON, Mrs Mary Ann (née Wheeler) fl.1834-1847
Daughter of T.Wheeler. Exhibited at RA (5) from Peckham 1834-47. Married David Johnston c.1836.

JOHNSTONE, Mrs Couzens fl.1835-1859
Exhibited at RA (14) 1835-59 from London.

JOHNSTONE, George Whitton RSA RSW 1849-1901
Born Glamis, Forfarshire 3 May 1849. Moved to Edinburgh as a cabinet maker. Studied at RSA Life School. During this period painted genre and portraits, but gradually concentrated on landscapes. Exhibited at RSA (153), RA (7) 1872-1901. Elected ARSA 1883, RSA 1895, RSW. Died Edinburgh 22 October 1901.
Represented: VAM; Munich AG. **Literature:** *Art Journal* 1899 pp.146-9; McEwan.

JOHNSTONE, William Borthwick RSA 1804-1868
Born Edinburgh 21 July 1804, son of a lawyer. Studied law in Edinburgh, before taking up painting. Had lessons in miniature painting from R.Thorburn in London. Studied at Trustees' Academy 1840-2. Went to Italy 1842-4. Exhibited at RSA (97), RHA (2) 1836-68 from Edinburgh and Rome. Elected ARSA 1840, RSA 1848, Treasurer 1850-68, Interim Librarian 1853-7. Died Edinburgh 5 June 1868.
Represented: SNG; VAM. **Literature:** McEwan.

JONAS, Harry Maude 1893-1990
Son of a potato merchant. Studied at St Paul's and St John's Wood Schools. Worked briefly as a silent screen actor, and after the 1st World War used a legacy of £5,000 to set up as a painter. Shared a studio with John Armstrong, and then moved to a studio of his own in Maple Street, Fitzrovia, which had once belonged to Thackeray. Friends with Sickert, Utrillo and Augustus John. Died March 1990. Tended to work slowly, making many revisions and alterations.
Represented: Tate; NPG London. **Literature:** *Daily Telegraph* 13 March 1990.

JONES, B. fl.1774
Exhibited at FS (4) in 1774 from London. Studied under Thomas Pether, a wax modeller. Possibly worked in Bath and Manchester.

JONES, Mrs D. (Viola) fl.1893
Exhibited at RA (1) in 1893 from London.

JONES, Miss E. fl.1833-1834
Exhibited at RA (1), SBA (1) 1833-4 from Shrewsbury.

JONES, Eliza fl.1815-1852
Won a premium at SA 1807. Exhibited miniatures and small portraits at RA (98), BI (35), OWS 1815-52. Her sitters included Queen Victoria, Sir Francis Chantrey and Lady Caroline Lamb.
Engraved by H.Meyer, C.Picart.

JONES, Miss Emma E.
see SOYER, Mrs Elizabeth Emma

JONES, George RA 1786-1869
Born London 6 January 1786, son of mezzotint engraver John Jones. Entered RA Schools 1801, but interrupted his studies by serving in the Peninsular War. Formed part of the army of occupation in Paris after Waterloo 1815. When he resumed his career, he concentrated on military subjects, for which he was awarded premiums at BI 1820 and 1822. Exhibited at RA (221), BI (141), OWS 1803-70. Elected ARA 1822, RA 1824, Librarian 1834-40, Keeper 1840-50, acting President 1845-50. A close friend and executor of Chantrey and Turner. Published *Recollections of Sir Francis Chantrey*, 1849. Also chief adviser to Robert Vernon in the formation of his collection. Prided himself on his resemblance to the Duke of Wellington, for whom he was once mistaken. The story, when repeated to the Duke, drew from him the remark that he had never been mistaken for Mr Jones. Died London 19 September 1869. Collaborated with Henry Collen.
Represented: BM; VAM; NPG London; Fitzwilliam; Tate; Newport AG. **Literature:** DNB; *Art Journal* 1869 p.336 obit.

JONES, H.Thaddeus see THADDEUS, Henry Jones

JONES, J.S. fl.1710
Signed and dated a portrait of 'Mrs Francis Stephens' 1710.
Literature: Somerset and Dorset Notes and Queries XIV 1915 p.79.

JONES, Marion Clayton (Mrs Alexander) b.1872
Born Bendigo, Victoria, Australia 23 November 1872. Studied at NG Melbourne. Exhibited at RA (14), RSA, ROI, SM, Paris Salon 1908-29 from London and Exeter.

JONES, R. fl.1818-1820
Exhibited at RA (11) 1818-20 from Reading and London.

JONES, R. c.1839
His portrait of comedian Charles James Matthews was reproduced in Charles Dickens' *Charles James Matthews*, 1879.

JONES, R.M. fl.1833
Exhibited at RA (1) in 1833 from London.

JONES, R.P. fl.1781-1786
An honorary exhibitor at RA (4) 1781-6 from Custom House.

JONES, Richard fl.1780-1812
Honorary exhibitor at RA (7), BI (1) 1780-1812 from London.
Represented: VAM.

JONES, Mrs S. fl.1806-1812
Exhibited at RA (19) 1806-12 from London. May be the Sophia Jones whose portrait of George Morland is in NPG London.

JONES, T. fl.1628
Painted a portrait of a young lady signed and dated 'T.Jones/fecit 1628' in the manner of Gilbert Jackson.

JONES, Sir Thomas Alfred PRHA 1823-1893
Born Dublin. Studied at Royal Dublin Society Schools and RHA. Then went to Trinity College 1842, but left before completing his degree. Travelled in Europe 1846-9. Returned to Dublin, where he practised as a portrait painter. After the death of Catterton Smith he was considered the leading portrait artist in Ireland. Exhibited at RHA (249), RA (5) 1841-93. Elected RHA 1861, President 1869 (a position he held until his death), knighted 1880. Died Dublin 10 May 1893.
Represented: NGI; Belfast City Hall.

JONES, Thomas William fl.1832-1850
Exhibited at RA (9), BI (5), SBA (1) 1832-50 from London. Listed in Islington as a portrait painter.

JONES, William fl.1726
Provincial portrait painter. Usually signed on the back 'Guliel S.Jones'. Painted a number of portraits of the Neale family of Corsham.
Literature: C.H.Collins Baker, *Connoisseur* LXVIII January 1924 pp.13-14.

JONES, William d.1747
Irish painter of a variety of subjects including portraits, some of which were engraved.

JONES, William fl.1818-1853
Exhibited at RA (11), BI (1), SBA (2) 1818-53 from London, Beaumaris and Chester. Among his sitters were the Bishop of London (Bloomfield) and Earl Grosvenor. An engraving after his work was published by E.Parry, Chester 1841.
Literature: T.M.Rees, *Welsh Painters*, 1912.

JOPLING, Joseph Middleton RI 1831-1884
Born London, son of a clerk in the Horse Guards. Worked for a number of years as a clerk in the War Office, but showed a talent for art which he took up professionally. Exhibited at RA (30), SBA (21), NWS (126), RHA (6), GG 1848-72. Elected RI 1859, but resigned 1876. Director of Fine Art Section of Philadelphia International Exhibition and was active in 3rd Middlesex Volunteers, winning the Queen's Prize for rifle shooting at Wimbledon 1861. Officially commissioned to make drawings of the Queen inspecting the Troops. Many of his sitters were from military backgrounds. A close friend of Millais. Married artist, and widow, Louise Romer (née Goode) 1874. Died Chelsea December 1884. Studio sale held Christie's 12 February 1885.
Represented: NPG London; BM; VAM; Williamson AG, Birkenhead.

JOPLING, Mrs Louise RP PS 1843-1933
(Mrs Frank Romer, née Goode)
Born Louise Goode in Manchester 16 November 1843, daughter of T.S.Goode, railway contractor. Aged 17 married Frank Romer, who in 1865 was appointed private secretary to Baron Rothschild in Paris. The Baroness encouraged her talent and arranged for her to take lessons with M.Charles Chaplin 1867-8. Her husband lost his appointment and died 1873. Married artist Joseph Middleton Jopling 1874. Exhibited at RA (70), SBA (24), RHA (9), NWS, GG, Paris Salon 1870-1916. The first woman to be elected RP. After the death of J.M.Jopling in 1884 she married George William Rowe, a lawyer. Died 19 November 1933.
Represented: NPG London. **Literature:** Clayton; Mrs Jopling, *Twenty Years of My Life*, 1925; *Windsor Magazine* Vol 24 June-November 1906.

JOSEPH, George Francis ARA 1764-1846
Born Dublin 25 November 1764. Entered RA Schools 3 December 1784. Exhibited at RA (146), RHA (2), BI (14) 1788-1846. Elected ARA 1813. Won a Gold Medal at RA for a scene from *Coriolanus*, 1792. Awarded a 100 guineas premium by BI 1812. Among his sitters were Admiral Sir Richard King, Mrs Siddons, and HRH the Duke of Gloucester. Also painted fancy pictures and illustrated books. Based in Cambridge from 1837, where he died. Buried St Michael's Churchyard.
Represented: NPG London; NGI; VAM; BM; Doddington Hall. **Engraved by** W.Bond, R.J.Lane, Mackenzie, W.Sharp, J.Thomson. **Literature:** DNB.

JOSEPH, Mrs Lily Delissa (née Soloman) 1864-1940
Born Bermondsey 24 June 1864, sister of Soloman J. Soloman. Studied at RCA and Ridley Art School. Exhibited at RA (25) 1904-38 from London. Married architect Delissa Joseph. Died London 27 July 1940.
Represented: Tate.

JOUFFROY, Pierre fl.1742-1767
Reportedly born in Nancy. Appointed Court Painter to Stanislas Leczynski, King of Poland, 1742. In England 1765-7. Exhibited at SA, FS.

JOWSEY, John Wilson 1884-1963
Born Ashington, son of a shipwright. Studied art in Edinburgh, Paris and Newlyn. Shortly before the 1st World War he opened a studio in Newcastle, where he painted portraits of leading Tyneside shipowners. Moved to London 1928, where he practised as a portrait painter until his death. Among his sitters were Lord Kerkley and Winston Churchill. Exhibited at SBA, Laing AG, Royal Cambrian Academy; RP and Paris Salon. Died London.
Literature: Hall 1982.

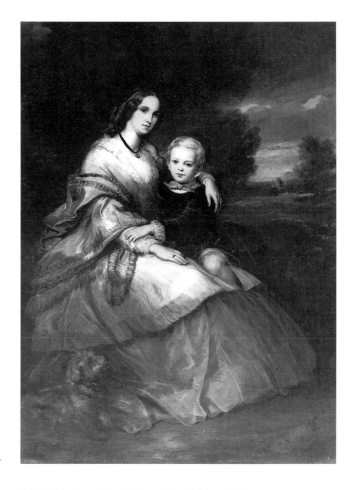

THOMAS MUSGROVE JOY. Mrs Farrell Watson and son. Signed and dated 1857. 75 x 53ins (190.5 x 134.6cm) *Christie's*

JOY, Arthur fl.1830-1852
Exhibited at RHA (25) from Dublin.

JOY, Miss Caroline b.1817
Born Holborn. Exhibited at RA (2) 1845-55 from London. Listed at Technical Ladies School aged 44 in 1861 census.

JOY, George William 1844-1925
Born Dublin 7 July 1844, son of W.Bruce Joy MD. Educated at Jefferys School, Woolwich. Studied at South Kensington and RA Schools. Visited Paris 1868, where he studied under Bonnat and Charles Jalabert, who had been a pupil of Delaroche. Exhibited at RA (48), RHA (11), SBA 1872-1914. Painted a portrait of 'HRH The Princess Alice of Albany' by command of HM the Queen, 1866. Best known for 'The Bayswater Omnibus' (London Museum). Served 21 years in Artists' Corps. Died Purbrook, Hampshire 28 October 1925. A fine shot, representing Ireland in the sport. **Represented:** Russell-Cotes AG, Bournemouth; Oldham AG; Leeds CAG. **Literature:** *Art Journal* 1900 pp.17-23; G.W.Joy, *The Work of G.W.J.*

JOY, Thomas Musgrove 1812-1866
Born Boughton Monchelsea, Kent, 9 July 1812, son of Thomas Joy, a landed proprietor. Studied under Samuel Drummond ARA. Exhibited society portraits at RA (67), BI (82), SBA (50), RHA (8), NWS 1831-67 from London. Exhibited from Boughton Hall, Maidstone 1832. Patronized by Lord Panmure, who placed John Philip with him as a pupil. Commissioned by Queen Victoria to paint portraits of the Prince and Princess of Wales, 1841. Painted 'The Meeting of the Subscribers to Tattersall's Before the Races', 1864, which contained portraits of the most noted patrons of the Turf. Died of bronchitis in London 7 April 1866. Studio sale held Christie's 18 June 1866. **Represented:** VAM; SNPG. **Engraved by** W.Carlos, H.Cousins, R.J.Lane, G.Zobel. **Literature:** DNB; *Art Journal* 1866 p.240; DA.

JUDLIN, Alexis b.1746
Born Thann. Entered RA Schools 22 October 1773 aged 27. Exhibited at RA (7) 1773-6 from London and at Paris Salon 1791 and 1793. Believed to have worked in several courts in Europe and received a pension from George III. **Represented:** VAM.

JULIAN, Ernest Roderick Eluse b.1872
Born London. Studied at Central School of Arts and Crafts, in William Morris Studios and at RCA. Lived in Bournemouth. Exhibited at SBA.

JUNGMAN, Nico W. RBA 1872-1935
Born Amsterdam, where he studied art. Moved to London in the 1890s, becoming a British subject. Also an illustrator. Exhibited at RA (1), RHA (4) 1897-1909. **Represented:** Tate. **Literature:** *Magazine of Art* 1902 pp.301-5.

JUNOR, David 1773-1835
Drawing Master at Perth Academy 1798. Retired 1830, but continued to paint. Died Perth 14 October 1835. D.O.Hill was his pupil. **Represented:** Perth AG. **Literature:** McEwan.

JUSTYNE, Percy William 1812-1883
Born Rochester. Exhibited at RA (1), SBA (2) 1837-8 from London. Worked in Granada 1841-8. Also an illustrator. Some of his portraits were reproduced as engravings. Died 6 June 1883.

K

KACHLER, T.T. fl.1775
Exhibited at RA (1) 1775 from Lincoln's Inn Fields.

KAUFFMANN, Angelica RA 1741-1807
Born Coire, Switzerland 30 October 1741, daughter of artist
Joseph Johann Kauffmann. The family travelled widely in
Italy. Studied art and music in Milan, Florence 1762 and
Rome 1763. Visited England c.1766-81. Married 20
November 1767 in St James's Church, Piccadilly, a man who
called himself Count Frederick de Horn. The man used
several false names, and seems to have been a valet or a
courier. His deception was discovered, and he was bribed to
leave England. A Deed of Separation was secured from the
Pope, and the man's death eventually freed her. Elected
founder RA 1768. Exhibited at SA (3), FS (5), RA (79)
1765-97. Received commissions for portraits from the royal
family, including Queen Charlotte and Christian III of
Denmark. Much admired for her portraits, neo-classical
histories and poetical subjects. Also produced decorative
paintings for Robert Adam. Continued to paint portraits,
often on a conversational scale. Had considerable charm and
was romantically associated at different times with
Winckelmann, Fuseli, Dance, Reynolds, Goethe and Canova.
Married Antonio Zucchi 1781 and left England for Venice.
Settled in Rome, where she died 5 November 1807. Kept an
incomplete list of her works (see Manners & Williamson).
Painted mainly in oil, but also in pastel. Her best work shows
her to be an outstanding talent. Robert Home was said to
have been her pupil.
Represented: NPG London; BM; VAM; Tate; Fitzwilliam;
SNG; NGI; Stourhead, NT; Brighton AG; Saltram, NT;
Althorp; Nostell Priory, NT; SNPG; Holborne Museum,
Bath. **Engraved by** P.Audouin, Bartolozzi, T.Burke,
T.Cheeseman, R.Cooper, S.Freeman, F.Haward, R.Morghen,
W.Ridley, T.Ryder, A.Testa, J.Spilsbury, J.Watson. **Literature:**
G.G.Rossi, *A.K.*, 1810; Lady V.Manners & G.C.Williamson,
A.K., 1924; F.Gerard, *A.K. – A Biography*, 1893; D.M.Mayer,
A.K., 1972; A.Hardcup, *Angelica – The Portrait of an 18th
Century Artist*, 1954; DNB; Kenwood House exh. cat. 1955;
W. Roworth (ed), *A.K. – A Continental Artist in Georgian
England*, Brighton AG exh. cat. 1992; Greer; DA.

KAUFFMANN, Joseph Johann 1707-1782
Born Schwarzenburg 27 February 1707. Father of Angelica
Kauffmann, with whom he came to London c.1766.
Exhibited at RA (11) 1771-9 from London. Left for Venice
1781 and died there 11 January 1782.

KAULBACH, E. fl.1853-1857
Exhibited at RA (4) 1853-7 from London.

KAY, John 1742-1826
Born near Dalkeith April 1742, son of a stonemason. When
he was eight his father died and he moved to Leith.
Apprenticed to a Dalkeith barber for six years. Set up as a
barber on his own in Edinburgh and painted miniatures in
his spare time. In 1782 he received an annuity of £20 and
devoted his time to miniatures, etched portraits and
sketches. Exhibited at Edinburgh Association of Artists
1811-16 and at Institute for the Encouragement of Arts
1822. Died Edinburgh 21 February 1826. Buried

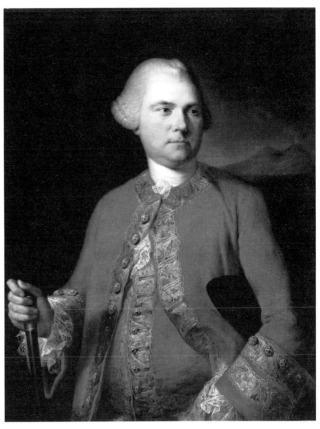

ANGELICA KAUFFMANN. Brownlow, 8th Earl of Exeter,
Vesuvius beyond. Signed, inscribed and dated 1764. 40 x 30ins
(101.6 x 76.2cm) *Christie's*

Greyfriars' Churchyard.
Represented: SNPG; Glasgow AG. **Engraved by** Consitt,
Goodwill. **Literature:** H. & M.Evans, *J.K. of Edinburgh,
Barber, Miniaturist and Social Commentator*, 1973; McEwan.

KEAN, Michael 1761-1823
Born Dublin 16 October 1761. Studied at Dublin School
1771 (Silver Medallist) and under sculptor Edward Smith.
Moved to London and entered RA Schools 29 October
1784. Exhibited at RA (10) 1786-90 from London, when he
gave up painting to become a partner in a Derby china
factory. Sold the factory to Robert Bloor 1811. Retired to
London, where he died November 1823.
Represented: VAM. **Engraved by** T.Nugent.

KEARNEY, William Henry NWS 1800-1858
Exhibited at RA (9), SBA (6), NWS (170) 1823-58 from
Bermondsey. Founder NWS and later Vice-President. Used
watercolour in an 18th century manner, scorning the use of
body colour. Died London 25 June 1858. Studio sale held
Christie's 30 March 1859. His widow was left in poverty.
Represented: BM; VAM; Guildford Museum. **Literature:**
Art Journal 1858 p.253.

KEARSLEY, Miss Harriet d.1881
Exhibited at RA (44), BI and SBA (24) 1824-58 from
London. Died London 22 January 1881.
Represented: VAM.

KEARSLEY, Thomas 1773-c.1801
Entered RA Schools 1790. Exhibited at RA (35) 1792-1801
from London. Among his sitters was artist George Chinnery.
Engraved by R.H.Laurie, B.Smith.

KEATING, George 1762-1842
Born Ireland. Worked in Ireland and London. Exhibited heads in chalks at FS (3) 1775-6. Studied under W.Dickinson. Concentrated on engraving and produced work after Reynolds, Gainsborough and Morland. Died London 3 February 1842.

KEATING, John (Sean) PRHA 1889-1977
Born Limerick 29 September 1889. Studied at Dublin Metropolitan School of Art. Worked with Orpen until 1916. Exhibited at RHA (299), RSA, RA (28) 1915-78 from Dublin. Elected ARHA 1919, RHA 1923, PRHA 1949-62, Honorary RA 1950. Died Dublin 21 December 1977.
Represented: NGI. **Literature:** DA.

KEBBELL, William Francis Vere PS d.1963
Studied at Byam Shaw and Vicat Cole Schools of Art. Exhibited at RA (11), RP, ROI 1915-45 from London. Died Ealing, London 29 March 1963. Left £16,721.18s.10d.

KECK, Miss Susan 1746-1835
Daughter of Anthony Tracey Keck of Great Tew. An honorary exhibitor of crayon portraits of the Duke of Hamilton and his wife at RA (2) 1769-71. Maid of Honour to Princess Dowager and to Princess of Wales. Married Francis Charteris (de jure Lord Elcho) 18 July 1771. Died 25 February 1835.

KEEBLE (or KEABLE), William c.1714-1774
Possibly born East Anglia. A member of St Martin's Lane Academy, 1754. Produced a number of charming, small full-lengths in the manner of Hayman and Devis, although also painted large scale. By 1761 he was in Naples (where he was known as Ghibel), and painted a portrait of Castruccio Bonamici. Settled in Bologna 1765 in the house of Domenico Gandolphi, becoming Accademico della Clementina 1770. Buried Bologna 12 January 1774. Sometimes signed his work 'W.Keable'.
Represented: Yale; Hatfield House. **Literature:** A.W.Rutlidge, *Connoisseur*, CXLI May 1958 p.267.

KEELING, Michael 1750-1820
Baptized Stafford 16 November 1750, son of John Keeling and Elizabeth. Working in Stafford by 1774. Studied at RA Schools 1782-1809. Exhibited at RA (8) 1782-1809 from Marylebone. His style later became influenced by Raeburn, becoming more fluent and free. Redgrave says his works were 'well esteemed in Staffordshire'. Died near Stone, Staffordshire.
Represented: Brodie Castle. **Engraved by** H.R.Cook, T.Lupton.

KEELING, William Knight RI 1807-1886
Born Manchester. Apprenticed there to a wood engraver. Moved to London and studied under W.Bradley. Returned to Manchester c.1835, where he taught drawing and had a portrait practice. Also painted genre. Exhibited at RA (1), BI (1), RI (60), RMI. Elected ARI 1840, RI 1841. Helped establish RMI, President 1864-77. Died Barton-upon-Irwell 21 February 1886.
Represented: VAM.

KEENAN, John b.c.1785
Irish painter. Studied under Robert Home in Dublin. Practised as an itinerant portrait painter based in London from 1790, Bath from 1792 and Windsor from 1803. Exhibited at RA (61), BI (1) 1791-1815. Portrait Painter to Queen Charlotte by 1809. Returned to Dublin 1817, where his last exhibited picture was shown 1919.
Engraved by W.Barnard, J.Chapman, J.Cochran, S.Freeman, E.Scott, C.Turner, J.H.Wallis, J.Young.

KEENS, Henry fl.1826-1827
Listed as a portrait painter at 17 Frith Street, Soho.

KEITH, Alexander fl.1836-1874
Edinburgh painter. Exhibited at RA (2), RSA (9), BI (2), SBA (2) 1836-74 from London and Edinburgh.
Literature: McEwan.

KELLY, Anna Elizabeth 1825-1890
Born St Gall 10 April 1825. Also an engraver and painter of landscapes. Died St Gall 1 May 1890.
Represented: St Gall Museum; SNPG.

KELLY, Sir Gerald Festus RP KCVO PRA RHA RSA
1879-1972
Born London 9 April 1879. Educated at Eton and Trinity Hall, Cambridge. Studied art in Paris, where he lived for many years and became friends with Degas, Renoir, Monet, Rodin and Cézanne. Exhibited at RA (294), RHA (206), RP (18), RHA 1905-70 from London. Elected ARHA 1908, NPS 1910, RHA 1914, ARA 1922, RP 1928, RA 1930, PRA 1949-54, knighted 1945, KCVO 1955. Painted State portraits of the King and Queen 1945 and established an extremely successful society practice, acquiring an international reputation. Visited Spain, Burma, America and South Africa. Died London 5 January 1972.
Represented: NPG London; NGI; Tate; Royal College of Music. **Literature:** D.Hudson, *For The Love of Painting – The Life of Sir G.K. KCVO PRA,* 1975.
Colour Plate 38

KELLY, Robert George 1822-1910
Born Dublin 22 January 1822. Exhibited at RA (5), RSA (6), RHA (58), BI (3), SBA (6) 1842-99. Died Chester 9 May 1910. His son, Robert George Kelly, was also an artist.
Literature: McEwan.

KEMAN, Georges Antoine 1765-1830
Born Sélestat 7 August 1765. Studied in France under Jean-Michel and Jean Pierre Diebolt. Entered RA Schools 22 March 1793. Exhibited portraits and miniatures at RA (25) 1793-1807 from London. By 1805 he was Miniature Painter to HRH the Duke of Cumberland. Worked in Bristol 1769-1807. Left England 1816. Died Sélestat.
Represented: VAM.

KEMP, John fl.1868-1876
Studied at Cork School of Art. Taught at Gloucester School of Art. Exhibited at SBA (4) 1871-6. Believed to have emigrated to Australia c.1877.
Represented: VAM.

KEMP-WELCH, Miss Edith M. fl.1898-1940
Exhibited at RA (29) 1898-1940 from Bushey, where her sister Lucy Elzabeth Kemp-Welch took over Herkomer's School 1905.

KENDALL, Richard fl.1851
Recorded as a portrait painter at Ambleside.

KENDALL, Robert fl.1852-1853
Listed as a portrait painter in Gloucester.

KENNEDY, Charles Napier ARHA 1852-1898
Born London February 1852, son of Lt-Colonel John Pitt Kennedy. Studied at Slade, in Paris and University College under E.J.Poynter, who had a great influence on his work. Exhibited at RA (27), SBA (14), RHA (10), GG, ROI, NWG, RHA 1872-97 from London and St Ives. Elected ARHA 1896. Married artist Lucy Marwood. Died St Ives, Cornwall 17 January 1898.
Represented: NGI; Leeds CAG; Sheffield AG; Walker AG, Liverpool; Manchester CAG. **Literature:** Strickland.

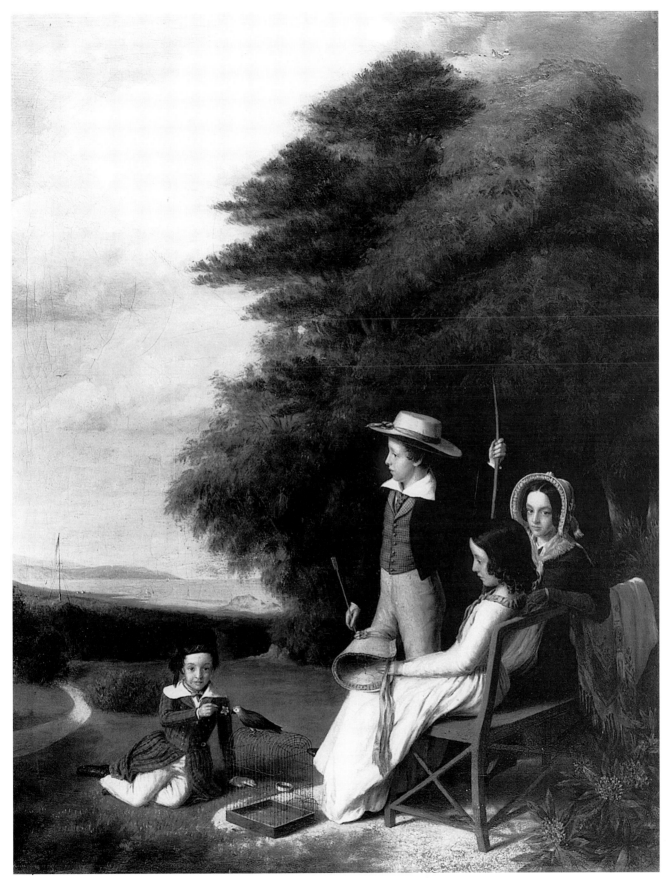

ROBERT GEORGE KELLY. Children. Signed and dated 1846. 36 x 28ins (91.5 x 71.1cm)

Christie's

KENNEDY, John fl.1823-1852
Exhibited a portrait of W.Pitt at RA in 1823 from London. Worked in Oxford 1852, where he was listed as a portrait and historical painter.
Engraved by J.Cochran.

KENNEDY, William Denholm 1813-1865
Born Dumfries 16 June 1813. Studied in Edinburgh. Moved to London and entered RA Schools 1833. A friend of William Etty, who influenced his work. Painted a variety of subjects, including portraits. Designed stained glass for Thomas Willemont. Exhibited at RA (52), BI (22), RHA (1), RSA (12), SBA (16) 1833-65. Won a Gold Medal for historical painting 1835. Visited Rome 1840-2. Died London 2 June 1865. Studio sale held Christie's 10 and 11 July 1865.
Represented: BM; NGI. **Literature:** McEwan.

KENNEY, Miss M.T. fl.1837-1840
Exhibited at RA (2), SBA (1) 1837-40 from London. Painted 'Miss Ellen Tree as Ginevra in The Legend of Florence'.

KENNINGTON, Eric Henri RA 1888-1960
Born Chelsea 12 March 1888, son of artist T.B.Kennington. Studied at Lambeth School of Art and City and Guilds School. Visited Russia and painted commissions in St Petersburg. Exhibited at RA (51), Leicester Galleries 1908-61 from Ipsden, Oxfordshire. Elected ARA 1951, RA 1959. Served in France in 13th London Regiment 1914-15. Invalided home June 1915. Appointed official war artist 1916-19 and 1940-3, when he painted portraits of sailors and airmen. A close friend of T.E.Lawrence, he was art editor to the *Seven Pillars of Wisdom*, 1926. Died Reading 13 April 1960. Buried Checkendon.
Represented: NPG London; Tate; Aberdeen AG; Imperial War Museum; Birmingham CAG; Musée de Luxembourg, Paris. **Literature:** DNB.

KENNINGTON, Thomas Benjamin RBA NEAC RP
 1856-1916
Born Great Grimsby 7 April 1856. Studied at Liverpool School of Art, South Kensington (Gold Medallist) and Académie Julian, Paris. Exhibited at RA (72), SBA (16), NWS, RHA (1), GG, NEAC, RP, Paris (Bronze Medallist) and Rome 1880-1916 from London. Elected RBA 1888, RP 1891, ROI. Died London 10 December 1916. Left £9731.19s.
Represented: Tate; Manchester CAG.

KENNY, Nicholas c.1807-c.1856
Born Kilkenny. Painted 'The Irish House of Commons on 16 April 1782, when Grattan Moved the Declaration of Irish Rights' commissioned by Henry Grattan jnr and completed 1844. It measured approximately 9 x 7ft. and contained 149 portraits of members and 98 portraits of visitors in the gallery.
Engraved by F.C.Lewis. **Literature:** Strickland.

KENT, Miss Ethel A. fl.1896
Exhibited at RA (1) 1896 from Cliftonville, Margate.

KENT, William 1685-1748
Born Bridlington, son of William Kent. Studied in Rome under Benedetto Luti. Won a prize for painting from Accademia di San Luca 1713. Attracted the patronage of Lord Burlington and the Dukes of Grafton and of Newcastle. Appointed master carpenter, architect, keeper of pictures and, upon the death of Jarvis in 1719, Principal Painter of History and Portrait to the King. Designed gardens at Stowe and Rousham. Died after an attack of inflammation of the bowels at Burlington House, London 12 April 1748 (not 1758). Buried in Lord Burlington's vault at Chiswick.
Literature: E.Croft-Murray, *Decorative Painting in England*, II, 1970; DA.

KENWORTHY, John Dalzell ARCA 1858-1954
Born Whitehaven 5 November 1858. Exhibited at RA (1), Royal Cambrian Academy, Carlisle AG and in Liverpool. Elected Associate of Royal Cambrian Academy 1914. Lived at St Bee's, Cumberland. Also worked in France and Scotland. Died Whitehaven 4 March 1954.
Represented: Whitehaven Museum.

KERR, Charles Henry Malcolm RBA 1858-1907
Born London 22 January 1858. Educated at Corpus Christi College, Oxford. Studied at RA Schools and Académie Julian, Paris. Exhibited at RA (28), SBA (13) 1884-1905 from London. Elected RBA 1890. Died London 7 or 27 December 1907.
Represented: Tate; Leeds CAG.

KERR, Henry Wright RSA RSW 1857-1936
Born Edinburgh. Studied at RSA Schools and in Dundee. Worked in Scotland and Holland. Exhibited at RA (8), RSA (104) 1882-1922. Elected ARSA 1893, RSA 1909. Died Dundee 17 February 1936.
Represented: Dundee CAG; SNPG; SNG; Kirkcaldy AG. **Literature:** McEwan.

KERRICH, Rev Thomas 1748-1828
Born 4 February 1748, son of a clergyman. Educated at Magdalene College, Cambridge. Travelled on the Continent after 1771 and received a medal from Antwerp Academy 1776. Became librarian to Cambridge University 1797. Died Cambridge 10 May 1828.
Represented: BM. **Engraved by** Facius, C.Turner.

KERR-LAWSON, James 1865-1939
Born Anstruther, Fifeshire 2 October 1865. Studied in Rome and Paris with Lefebvre and Boulanger. Exhibited at SBA (1) 1890. Lived in Canada, Italy and London. Also a lithographer and mural decorator. Died London 1 May 1939.
Represented: NPG London; SNPG; Walker AG, Liverpool; Glasgow AG. **Literature:** McEwan.

KERSEBOOM (CASAUBON), Frederick 1632-1693
Born Solingen, Rhineland. Thought to have studied under Charles Le Brun in Paris. Spent 14 years in Rome, where he studied for two years under Poussin. Came to England, probably in the early 1680s, where he painted history subjects and portraits. Buried St Paul's, Covent Garden as Frederick Casaubon 30 March 1693. His work reached a remarkably high standard and shows considerable sensitivity. His nephew, Johann Kerseboom, was also a painter.
Represented: Stoneleigh; Paul Mellon Centre. **Literature:** *Country Life* 19 February 1970, p.436; DA.

KERSEBOOM, Johann d.1708
Nephew of Frederick Kerseboom, whom he probably accompanied to England in the 1680s. Enjoyed a successful portrait painting practice, often using poses derived from Lely and Kneller. Charged in 1694 £16.10s for a 50 x 40in. with frame. Buried London 26 October 1708.
Represented: NPG London. **Engraved by** P.Coombes, W.Faithorne jnr, J.Smith. **Literature:** DA.

KETEL, Cornelis 1548-1616
Born Gouda 15 or 18 March 1548, illegitimate son of Govert Jansz van Proyen and Elizabeth, daughter of Jacob Ketel. Began as a glass painter and went to Delft 1565 to study under Anthonie Blocklandt. Then worked briefly at Fontainebleau and Paris, before visiting England 1573-81. Enjoyed success as a portrait painter and was patronized by Sir Christopher Hatton. Reputed to have painted a portrait of Queen Elizabeth. Returned to Holland 1581. Settled in

Amsterdam, where he became the leading portrait painter. Buried Amsterdam 8 August 1616. Sometimes signed his work 'C.K.' in monogram. Pieter Isaacsz was his pupil. **Represented:** Arundel Castle; Leeds CAG; Longleat; Rijksmuseum; Bodleian Library, Oxford. **Engraved by** H.Bary, T.Chambers, R.Cooper, J.Jenkins, W.H.Mote, E.Scriven. **Literature:** DNB.

KETTLE, Tilly **1734/5-1786**
Born London 31 January 1734/5, son of Henry Kettle, a house painter. Studied at Shipley's, St Martin's Lane and 3rd Duke of Richmond Academies. Working professionally by 1760, and his portraits owe a debt to Reynolds. Exhibited at FS (1), SA (28), RA (11) 1761-83. About 1762-64 he was greatly encouraged by Sir Richard Kaye, who gave him introductions to many clients in the Midlands. Established a successful practice in London 1764-9. Then left for India 1769-76, where he met with success painting nabobs and native princes and acquired a considerable fortune. Returned to England, marrying the younger daughter of James Paine snr, the architect. His practice declined 1776-83 and he fell into financial difficulties, becoming bankrupt. Briefly visited Dublin and Brussels. Died near Aleppo, while returning to India to recoup his fortune. A remarkably competent and sympathetic painter, his pictures often have a delightfully naïve charm. Fond of placing his sitters with the light on a level with the face. **Represented:** NPG London; VAM; Tate; NGI; Yale; Government House, Madras. **Engraved by** W.Angus, A.Cardon, W.Dickinson, R.Dunkarton, R.Earlom, V.Green, S.Okey, H.Robinson, W.P.Sherlock, J.Watson. **Literature:** DNB; J.D.Milner, Walpole Society XV 1926-7, pp.78-97.

KEYL, Friedrich Wilhelm **1823-1871**
Born Frankfurt 17 August 1823. Studied under E.Verboeckhoven in Brussels. Moved to London 1845 to study under E.Landseer, who introduced him to the royal family, for whom he painted many animal pictures. Exhibited at RA (42), RHA (1), BI (34) 1847-72 from St John's Wood. Died London St John's Wood 5 December 1871. Buried Kensal Green Cemetery. Although principally an animal painter, Keyl often included portraits of 'owners' in his work. These, at worst, can be wooden, but at best are delightful. **Represented:** BM.
Colour Plate 36

KEYMOUR (KEYMER), Matthew H. **b.1754**
Baptized Norwich 7 May 1754, son of Matthew and Mary, a Quaker family. Exhibited at RA (3) in 1787 from London. Worked in Norwich 1787, but settled in Yarmouth, where he presented the Town Hall with a portrait of Nelson 1805. **Represented:** VAM.

KEYSER, Willem de **c.1647-1692**
Born Antwerp. Moved to England c.1687, where he met with considerable success. His practice deteriorated after the 1688 Revolution. Conducted experiments to find the philosopher's stone. Died London. His daughter painted small portraits and died in England 1724.

KIDD, Joseph Bartholomew **1808-1889**
Born Edinburgh. Studied under Thomson of Duddingston. Elected a founder ARSA, RSA 1829. Exhibited at BI (1), RSA (75) from 1827. Resigned from RSA 1836 and moved to London, where he became a drawing master at Greenwich. Died Greenwich 7 May 1889.
Literature: McEwan.

KIDD, William **RSA** **1790/6-1863**
Studied under animal painter, J.Howe. Moved to London from Scotland. Exhibited at RSA (42), RA (33), RHA (12),

TILLY KETTLE. A gentleman. Signed and dated 1773. 50 x 40ins (127 x 101.6cm) *Christie's*

BI (68), SBA (87) 1809-56. Elected honorary RSA 1829. Painted mainly Scottish genre in the manner of Wilkie, but also some portraits. He was not good with money and lived in continual poverty. Towards the end of his life he was supported by an Academy pension and the charity of his friends. Died London 24 December 1863.
Represented: Cape Town AG. **Literature:** McEwan.

KIDSON, H.E. **fl.1887-1888**
Painted portraits and landscapes. Exhibited at LA. Lived in Liverpool.
Represented: Walker AG, Liverpool.

KILLIGREW, Anne **1660-1685**
Born London, daughter of the Chaplain to the Duke of York (later James II). Became Maid of Honour to his second Duchess, and was an amateur poet and painter of histories and portraits. Her self-portrait was engraved in mezzotint by I.Beckett. Died in her twenty-sixth year of smallpox in her father's rooms in the cloisters of Westminster Abbey. Buried 15 June 1685 in the chancel of St John the Baptist's Chapel in the Savoy. Dryden wrote an ode to her memory. **Engraved by** I.Beckett, A.Blooteling, T.Chambers. **Literature:** DNB; *Burlington Magazine* XXVIII, December 1915, p.112; DA.

KILLINGBECK, Benjamin **fl.1763-1789**
Thought to be of Yorkshire origin. Exhibited at FS (29), SA (12), RA (11) 1776-89 from London. Established a highly successful practice in horse painting, but also produced some portraits.

KINDON, Miss Mary Evelina **fl.1874-1919**
Studied under Herkomer. Exhibited at RA (19), RHA (1), SBA, NWS and in Paris 1879-1918 from Chelsea, Croydon, Chalk Hill, Bushey and Watford. Fond of painting children.

KING, Miss Agnes Gardner fl.1882-1907
Mostly painted miniatures. Exhibited at RA (8), NWS, SBA (10) 1882-1902 from St John's Wood and Newbury.
Represented: NPG London.

KING, D. fl.1680
Little known painter of portraits. Painted a portrait of 'John Lavie, a French Protestant', 1680. His style owes a debt to Riley.

KING, Edward R. fl.1884-1924
Exhibited at RA (51), SBA 1884-1924 from Fulham, Petersfield, St Ives and Parkstone.

KING, Elizabeth (née Thomson) 1848-1914
Exhibited at RA (3), SBA (4), NWS 1880-1901 London and Newbury.
Represented: NPG London; SNPG.

KING, Miss Ethel Slade fl.1884-1896
Exhibited at RA (24) 1884-96 from London.

KING, Gunning see KING, William Gunning

KING, John, of Dartmouth 1788-1847
Born Dartmouth. Moved to London 1820 and entered RA Schools. Exhibited at RA (29), BI (36), SBA (13) 1814-47. Painted portraits in London and Bristol, as well as biblical subjects and Shakespearian themes. Among his sitters were his friend Francis Danby RA (Bristol CAG) and James Northcote RA. Died Dartmouth.
Represented: NPG London.

KING, John William b.c.1811
Born Ireland. Exhibited at RHA (5), RA (10), BI (6), RHA (9), SBA (6) 1835-53 from Dublin and London. Aged 40 in 1851 census for London, and was married to Marianne, with two daughters. Fond of painting children.

KING, Margaret fl.1779-1787
A pupil of Knapton. Exhibited crayon portraits at RA (16) 1779-87 from London. Some of her portraits are reproduced as mezzotints.

KING, Samuel fl.1693-1695
Practised in the Midlands 1693-5. Sometimes signed his works 'Sam: King Pinxt'. A number of pictures were formerly at Bessels Leigh.
Represented: Stoneleigh. **Literature:** C.H.Collins Baker, *Lely and the Stuart Portrait Painters,* 2 vols, 1912.

KING, Thomas fl.1735-c.1769
Studied under George Knapton 1735. Became assistant to Pond 1744-8. Specialized in draperies, and reluctantly painted portraits, mostly in the later part of his life. Died London. Buried St Marylebone churchyard. His individual works are rare.
Engraved by R.Houston, J.McArdell, P.J.Tassaert.

KING, William Gunning NEAC 1859-1940
Born London. Studied at South Kensington and RA Schools, winning a Silver Medal. Worked for *Punch*. Exhibited at RA, RP, SBA from 1878. Awarded a Gold Medal at International Exhibition, Crystal Palace 1899. Died South Harting, near Petersfield 10 October 1940 aged 84. Left effects of £6083.1s.8d.
Represented: York CAG; Prince of Wales Museum, Bombay.

KINKEAD, Miss Alice S. fl.1897-1920
Exhibited at RHA (7), RA (1) 1897-1920 from Galway and London.

KIRCHHOFFER, Henry RHA 1781-1860
Son of Francis Kirchhoffer, a cabinet maker working in Dublin and his wife Sarah (née Brooke). Entered Dublin Society Schools 1797. Exhibited in Dublin from 1801. Practised as a miniature painter in Cork. Returned to Dublin 1816, but moved to London 1835. Exhibited at RHA (60), RA (10), BI (1), SBA (3) 1826-43 from Dublin, London, Holyhead and Brighton. Elected founder ARHA, RHA 1826. Died London 20 March 1860.
Represented: VAM; NGI.

KIRCHMAYR, Cherubino b.1848
Born Venedig. Exhibited at RA (6) 1886-1900 from Kensington and Bedford Park.

KIRK (KYRKE), Samuel fl.1594-1655
Painted a full-length of 'Sir Christopher Hoddeson' (Stoneleigh) 1594, and a posthumous three-quarter length version in 1632 (Christie's 2 November 1984, lot 58). Painted a ceiling at Staunton Harold Church, Leicestershire with Zachary Kirk. Worked at Lichfield.
Represented: Lichfield Museum.

KIRKBY, Thomas 1775-c.1847
Entered RA Schools 1795. Exhibited at RA (43), BI (12) 1796-1847 from Litchfield and London. Painted a number of 'leaving' portraits for Eton, Oxford University and colleges.
Represented: Wadham College, Oxford; Eton. **Engraved by** E.Dent, A.Hoffay, W.Holl, T.Lupton, T.Maddocks, S.W.Reynolds, W.Say, C.Turner, W.Ward.

KIRKPATRICK, James fl.1820-1845
Practised in Carlisle. A friend of Samuel Bough. Left Carlisle 1845, because 'he found difficulty finding work as a portrait painter' and moved to Newcastle-upon-Tyne, where he was introduced to John Wilson Carmichael.
Represented: Carlisle AG.

KIRKPATRICK, Richard fl.1812-1817
Exhibited at RA (6), BI (1) 1812-17 from London.

KIRKUP, Seymour Stocker 1788-1880
Born London, son of a London diamond merchant. Entered RA Schools 1809 and became a friend of Blake and Haydon. Visited Italy 1816 for health reasons, settling in Rome and Florence, where he made portrait drawings of John Gibson and Joseph Severn. Exhibited at RA (2) 1833-6 from Florence and was present at the funerals of Keats and Shelley. Helped discover Giotto's missing portrait of Dante 1840, for which he was later made a cavaliere of the Order of San Maurizio e Lazzaro. Owing to a misunderstanding he referred to himself as 'Baron' thereafter. Moved to Leghorn 1872, and married a 22 year old Italian girl 1875 (he was then aged 87). Died Leghorn 3 January 1880. Buried in British Cemetery there. His chalk and watercolour portraits mostly show the influence of Lawrence.
Represented: SNPG; Ashmolean.

KISTE, Adolph 1812-1846
Born Hamburg 2 August 1812. Worked in Paris and Scandinavia. Exhibited pastel portraits at SBA (3) 1840 from London. Died London.

KITCH, George fl.1852-1871
Listed as a portrait painter at 2 Thomas Street, Bath. By 1870 he was working as a portraitist and photographer at 2 Lyncombe Place, Bath.

KITCHINGMAN, John c.1740-1781
Studied at Shipley's and won a number of premiums for drawings at SA 1762-70. Entered RA Schools 4 April 1769

GEORGE KNAPTON. A lady. Signed and dated 1749. 30 x 25ins (76.2 x 63.5cm) *Christie's*

GODFREY KNELLER. Don Hosé Carreras y Coligo. 30 x 25ins (76.2 x 63.5cm) *Philip Mould/Historical Portraits Ltd*

(Silver Medallist) and won a premium at SA. Exhibited at SA, FS, RA (26) 1766-81 from 'Mr Francis's, King Street, Covent Garden'. Fond of boating, and won the Duke of Cumberland's cup in the annual sailing match on the Thames. Married young, but separated from his wife and lived an intemperate life. Died in great pain, during the amputation of his leg, at Covent Garden 28 December 1781. **Represented:** VAM. **Engraved by** B.T.Pouncy, H.Kingsbury, J.Newton. **Literature:** DNB.

KNAPTON, George 1698-1778
Born London, son of James Knapton. Apprenticed to Richardson 1715-22. Listed as a subscriber to St Martin's Lane Academy. Travelled to Italy 1725-32. On his return, he was one of the first fashionable portrait artists in crayons, and was important in the establishing of the medium in England. A foundation member and official painter to Dilettanti Society 1736-63, and painted 23 portraits of members (mostly in fancy dress). Succeeded Stephen Slaughter as Surveyor and Keeper of the King's Pictures 1765. Died Kensington December 1778. His portraits can be remarkably accomplished, with a high standard of draughtsmanship and original use of composition. Francis Cotes was his pupil. **Represented:** Chatsworth; NPG London; Dulwich AG; Society of Dilettanti, London; Metropolitan Museum, New York; HMQ. **Engraved by** J.Collyer, J.Faber jnr, E.Harding, J.McArdell, B.Picart, S.F.Ravenet, Taylor. **Literature:** DNB; G.Macmillan, *The Society of Dilettanti: Its Regalia & Pictures*, 1932; DA.

KNELLER, Sir Godfrey c.1646-1723
Born Gottfried Kniller in Lubeck, Germany, probably on 8 August 1646, third son of the portraitist and chief surveyor of the city, Zacharius Kniller and his wife, Luci (née Beuten). Intended for a military career and was sent to Leyden to study mathematics and fortification. Studied with his father's

blessing under Ferdinand Bol and Rembrandt in the early 1660s. His first known dated portrait was painted 1666. Visited Italy (Rome and Venice) 1672-5. There he studied from the antique and the paintings of Raphael, Carracci, Titian and Tintoretto. Worked in the studios of Carlo Maratti and Bernini. Then Nuremberg 1674 and Hamburg before settling in London 1676, where he first stayed with Hamburg born merchant John Banckes. By 1679 was patronized by the King and was sent by Charles to France 1684/5 to draw the portrait of Louis XIV. Jointly appointed with Riley the Principal Painter to William and Mary 1688. On Riley's death in 1691 he continued alone and retained that office until his death. Accompanied William III, his greatest patron, to the Low Countries 1697, commissioning from him a portrait of the Elector of Bavaria, with whom William was seeking an alliance. His style changed after this visit, and his creamy colours were laid on with more dash and with a lighter, almost Rococo touch. Knighted 1692 and made a baronet 1715. Maintained a busy studio, which was for a time presided over by Edward Byng, producing a great many copies of his commissioned portraits. Kneller created the influential kit-cat format (36 x 28in.) showing one hand, for his portraits of members of the Kit-Cat Club (the leaders of the Whig establishment). In 1709 Christopher Wren designed a country house for him, Whitton, near Hounslow, Middlesex. First governor of the first 'Academy' in London 1711-18, when he was succeeded by Thornhill. Kneller dominated portraiture, and remained the most distinguished and successful portrait painter in England until his death in London 19 October 1723. Vertue said of him: 'He has been the Morning star for all other Portrait Painters in his Time to follow'. He was Court Painter during five reigns. He worked rapidly and his best portraits show considerable sensitivity and understanding of character. Such was the demand that his studio produced work of widely varying quality, making connoisseurship

HAROLD KNIGHT. Lady Munnings. Signed. Canvas on millboard. 59 x 47½ins (149.9 x 120.7cm)

Christopher Wood Gallery, London

extremely difficult. Horace Walpole's verdict on Kneller was that 'where he offered one picture to fame he sacrificed twenty to lucre'. To judge him fairly, the 6,000+ portraits attributed to him, or his studio, should be reduced to a much smaller number that represent him at his personal best. Waterhouse justifiably describes him as 'the great master of the English baroque portrait'. Among his pupils and assistants were John James Bakker, Edward and Robert Byng, Joseph Highmore, Marcellus Laroon (drapery), John Pieters (drapery), Jean Baptist Gaspar (poses), Fancatti (copyist), George Marshall, Rudolf Schmuz, James Worsdale, Charles Jervas, Jean Baptiste Monnoyer (flowers), Henry Vergazon (architecture and landscapes), Jacob Van der Roer, John Zachary Kneller (copyist), Hamlet Winstanley and possibly J.L.Hirschmann, Henry Tilson and Warner Hassells. Often signed and dated his pictures, sometimes with a monogram 'GK'.

Represented: NPG London; VAM; HMQ; Tate; NGI; Yale; NG Canada; SNPG; Hampton Court; Dulwich AG; Philadelphia Museum of Art; NMM; many country houses. **Engraved by** H.Adlard, F.Anderson, P.Audinet, Aveline, J.Baker, A.Bannerman, B.Baron, F.Bartolozzi, J.Basire, I.Beckett, A.Bell, A. & W.P.Benoist, D.Berger, G.Bickham, A.Birrell, M.Bisi, M.Bodenehr, W.Bond, S.Boyce, T.Bragg, W.Bromley, J.Brooks, J.Brown, J.Caldwall, A.Cardon, T.Chambers, J.Chapman, T.Cheeseman, J.Chereau, N.Chevalier, G.B.Cipriani, R.Clamp, J.Clark, J.Cochran, J.Collyer, H.R.Cook, T.Cook, I. & R.Cooper, J.Corner, R.Cromek, J.M.Dellattre, Dequevauviller, P.Drevet, G.Duchange, L.Du Guernier, Durant, G.Edelinck, W.C.Edwards, W.Emmett, J. & C.Esplens, W.Evans, J.Faber jnr, W.Faithorne, E.Ficquet, W.Finden, J.Fittler, H.Fletcher, M.Ford, P.Foudrinier, J.C.Francois, S.Freeman, W.T.Fry, R.Gaillard, S.Gantrel, W.N.Gardiner, M.Gauci, J.Goldar, W.Grainger, J.B.Grateloup, R.Graves, C.Gregori, J.Griffier, C.Grignion, J.Hall, J.Heath, E.C.Heiss, W.Holl, T.Holloway, J. & W.Hopwood, J.Houbraken, J.Hulett, C.H.Jeens, C.Knight, F.Kyte, P.A. Le Beau, J.C.Le Blon, D.Lemkins, B.Lens, D.Loggan, J.McArdell, A.Miller, W.H.Mote, J.S.Muller, G.Noble, J.Oliver, N. & R.Parr, P.Pelham, B.Picart, J.Posselwhite, R.Purcell, S.F.Ravenet, R.Rhodes, W.Ridley, Rivers, H.Roberts, J. & H.Robinson, E.Rooker, P.Rothwell, T.Ryder, W.Ryland, F.Sansom, P.Schenck, L. & N.Schiavonetti, C.N.Schurtz, E.Scriven, J.G.Seiller, W.Sharp, R.Sheppard, C.W.Sherborn, K.K. & W.Sherwin, J.Simon, A & J.Smith, D.Sornique, Strange, J.Sturt, P.Tanje, A.Tardieu, S.Taylor, P.Tempest, J.Thomassin, J. & R.Thomson, Thornwaite, T.Trotter, A.Trouvain, G.Valck, P.Vanderbank, M.Vander Gucht, P.Van Gunst, P. Van Somer, G.Vertue, C.E.Wagstaff, A.W.Warren, C.Watson, J.Whessell, G. & R.White, J.G.Wille, R.Williams, A.Wivell, A.M.Wolfgang, Woodman jnr, W.H.Worthington. **Literature:** DNB; J.Douglas Stewart, *Sir G.K. and the English Baroque Portrait,* 1983; J. Douglas Stewart, *K.;* NPG exh. cat. 1971; Lord Killanin, *Sir G.K. and his Times,* 1948; DA.

KNELLER, John Zachary 1642-1702
Born Lübeck 15 December 1642 or 6 October 1644 (conflicting sources), elder brother of Sir Godfrey Kneller. Accompanied his brother to Italy 1672 and England 1676. Painted portraits, still-life, and miniatures including copies of his brother's portraits. Buried St Paul's, Covent Garden 31 August 1702.

KNIGHT, Miss Ada fl.1893-1928
Exhibited at RA (42) 1893-1928 from Gloucester and Bournemouth.

KNIGHT, Harold RA ROI RP 1874-1961
Born Nottingham 27 November 1874. Studied at Nottingham School of Art, where he met his wife, Laura. Also studied at RCA and in Paris under J.P.Laurens and B.Constant, where he was influenced by Impressionism. Travelled to Holland 1905 and was influenced by 17th century Dutch and Flemish art. Exhibited at RA (185), RP

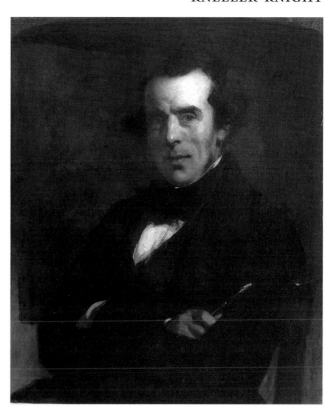

JOHN PRESCOTT KNIGHT. Thomas Sidney Cooper. Exhibited 1850. Signed. 30 x 25ins (76.2 x 63.5cm) *Canterbury Museums*

(11), RHA (4) 1896-1962 from Yorkshire, Holland, Cornwall, London and Herefordshire. Elected ARA 1928, RA 1937. His palette brightened while at Newlyn 1907 and he was later in great demand for official portraits. Died Collwall, near Malvern, 3 October 1961. With his wife, Dame Laura Knight, the couple were an impressive and powerful force in 20th century British art.
Represented: Tate; NPG London; Leeds CAG; Nottingham Castle Museum; Cape Town AG.
Colour Plate 39

KNIGHT, John Baverstock 1785-1859
Born Langton Rectory, near Blandford 3 May 1785, son of a militia Captain. Educated at Child Okeford, worked as a land surveyor, but took up painting. Exhibited at RA (4) 1818-19 from Piddlehinton. Died Broadway, Dorset 14 May 1859.
Represented: Tate. **Engraved by** H.Dawe.

KNIGHT, John Prescott RA 1803-1881
Born Stafford 9 March 1803, son of Edward Knight, celebrated actor and comedian. Moved to London as a boy, and worked as a junior clerk in a West India merchant's office, but took up art when the firm went bankrupt. Made copies after West's illustrations in the Bible and studied drawing at Sass's Academy and colour under George Clint. Entered RA Schools 1823. Exhibited at RA (227), BI (22), SBA (26) 1824-78. Elected ARA 1836, RA 1844, RA Council member, Professor of Perspective 1839-60, Secretary 1847. Established a successful practice and painted portraits of Sir Walter Scott, John Bright MP, T.S.Cooper ARA, Charles Barry RA and Sir Charles L. Eastlake PRA. Among his pupils was Thomas Brigstocke. Died London 26 March 1881. Buried Kensal Green Cemetery. Studio sale held Christie's 2 July 1881. Sandby in *The History of the Royal Academy* describes his portraits as painted 'with a vigorous hand, a broad touch, good effects of colour, and all the

expression necessary to distinguish them as striking portraits'. His wife, Clarissa Isabella Hayne, was also a painter.
Represented: Tate; Canterbury Museums; BM; NPG London; SNPG; Leicester AG; Salford AG; Stourhead NT; St Bartholomew's Hospital, London; VAM. **Engraved by** S.Bellin, F.Bromley, S.Cousins, G.T.Doo, J.Jackson, C.G.Lewis, T.Lupton, J.H.Lynch, S.W.Reynolds jnr, H.T.Ryall. **Literature:** H.Dyson, 'J.P.K. RA', *Stafford Historical and Civic Society*, 1971; DNB; Ottley; Maas. Colour Plate 37

KNIGHT, Dame Laura (née Johnson) DBE RA RWS
1877-1970
Born Long Eaton, Derbyshire 4 August 1877. Educated in Nottingham and St Quentin, France. Studied at Nottingham School of Art under Wilson Foster, and RCA. Married Harold Knight 1903. Exhibited at RA (284), RHA (8), RP 1903-70. Elected ARA 1927, DBE 1929, RA 1936, RP 1960. Published autobiography *Oil Paint and Grease Paint*, 1936. Died St John's Wood 7 July 1970. Studio sale held Sotheby's 26 November 1970 and 22 July 1971. A talented and outstanding draughtswoman with a gifted and original use of line.
Represented: NPG London; Imperial War Museum; Brighton AG; Canterbury Museums; Tate. **Literature:** C.Fox, *Dame L.K.*, 1988; L.Knight, A *Proper Circus Omie*, 1962; L.Knight, *The Magic of Line* (autobiography), 1965; M.Salaman, *L.K.*, 1932; J.Dunbar, *L.K.*, 1975; F.Bolling & V.E.Withington, *The Graphic Work of L.K.*, 1993; DA.
Colour Plate 40

KNIGHT, Mary Ann 1776-1851
Born London 7 September 1776, daughter of John Knight, a merchant, and his wife (née Woodcock). Studied under Andrew Plimer, who married her sister, Joanna. Exhibited at RA (30), OWS 1803-36. Had a successful practice painting mainly miniatures, watercolour portraits and, occasionally, oils. A competent draughtswoman.
Represented: SNPG. **Literature:** G.C.Williamson, *Andrew and Nathaniel Plimer*, 1903.

KNIGHT, William George d.1938
Studied at RCA and in Paris. Exhibited at RA (4) 1896-1924 from the School of Art, Weston-Super-Mare, Somerset. Died 26 March 1938.

KNIGHT, William Henry 1823-1863
Born Newbury 26 September 1823, son of John Knight, a schoolmaster. Started his career as a solicitor, but gave up to become a painter, training at RA Schools. Began as a portrait painter, but later specialized in genre scenes. Exhibited at RA (29), BI (17), SBA (8) 1844-63 from Newbury, London, and Chertsey. Died London 31 July 1863.
Literature: DNB.

KNIGHT, William Henry b.1859
Born Birmingham 10 July 1859. Studied at Birmingham Municipal School of Art, RCA and in Paris and Italy. Head of Northampton School of Art and later Principal of Penzance School of Art.

KNOTT, Tavernor fl.1846-1858
His portrait of Norman Macleod is in SNPG.

KNOWLES, Marshal 1783-1825
Listed as a portrait painter at 10 Meal Street, Manchester. Married Ann Ward at Manchester Cathedral on 3 March 1783.

KNOX, John 1778-1845
Reportedly studied under Alexander Nasmyth. Exhibited at RA (5), SBA (3), BI (6), RMI (20) and also in Glasgow

1829-34. Worked as a portrait and landscape painter in London 1829-36. Returned to Glasgow until 1840. Finally settled in Keswick. Specialized in landscapes of outstanding quality. Died Keswick 5 January 1845. Buried Crosthwaite Church, near the poet Robert Southey. Seldom signed. H.McCulloch and Sir D.Macnee were his pupils.
Literature: Glasgow AG exh. cat. 1974.

KNYFF, Leonard (Leendert) 1650-c.1721/2
Born Haarlem 10 August 1650, younger brother of painter Jacob Knyff. A prolific landscape painter, and a picture dealer and auctioneer. Also painted some portraits, including the 3rd Viscount Irwin (Temple Newsam House, Leeds). Died London. His work often shows the influence of Francis Barlow.
Literature: DA.

KOBERWEIN, George 1820-1876
Born Vienna. Settled in London, exhibiting at RA (32), BI (1), SBA (2) 1859-76. Painted a number of portraits of the royal family by command of Queen Victoria as well as a portrait of P.H.Calderon RA. His daughters Georgina and Rosa were also artists.
Represented: NPG London.

KOBERWEIN, Georgina F. see TERRELL, Mrs G.F.

KOBERWEIN, Rosa fl.1876-1885
Daughter of George Koberwein. Exhibited at RA (10), SBA (1), NWS, GG 1876-82 from London and Downton, near Salisbury.

KOE, Laurence (Lawrence) E. 1868-1913
Born London. Exhibited at RA (22), SBA, NWS 1888-1908 from Brighton and London. Also exhibited in Paris, receiving honourable mention 1904 and a medal 1905. Died 8 January 1913.
Represented: Brighton AG.

KOENIG, S. fl.1818
Exhibited at RA (2) 1818 from 6 Oxford Market, London.

KORTRIGHT, Henry Somers RBA 1870-1942
Born Southampton 6 July 1870, son of Captain John S. Kortwright of the Indian Navy, and his wife Matilda. Studied at Lambeth School of Art and under Herkomer. Exhibited at RA (20), RBA, Paris Salon 1899-1920 from London and Bexhill, Sussex. Died Bexhill 25 April 1942.

KOZANECKI, Louis fl.1838-1848
Exhibited at RA (3), RHA (4) 1838-48 from Islington, Dublin and Douglas, Isle of Man.

KRAFTMEIER, Miss Maria fl.1899-1901
Exhibited at RA (3), RHA (2) 1899-1901 from London.

KRAMER, J.H. fl.1765-1775
Exhibited at SA (3), FS (4), RA (2) 1765-75 from London.

KRAMER, Jacob 1892-1962
Born in the Ukraine, son of a painter. Settled with his parents in Leeds 1900. Studied in Leeds and at Slade. Exhibited at NEAC.
Represented: Leeds CAG.

KYTE, Francis fl.1710-1745
Believed to have studied under Edward Cooper, for whom he worked as mezzotint engraver. Convicted of forging a banknote 1725 and was sentenced to the pillory. Devoted his life to portrait painting. Possibly changed his name to Milvus. Sometimes painted portraits in feigned ovals and could reach a very high standard.
Represented: NPG London. **Engraved by** W.Angus, J.Faber jnr, F.C.Lewis, G.F.Schmidt, T.Worlidge. **Literature:** DNB; DA.

L

LACON, J. d.c.1757
Worked in Bath, painting miniatures and watercolour portraits. Owned a popular puppet show in Bath.
Represented: VAM.

LACRETELLE, Jean Edouard 1817-1900
Born Forbach 4 June 1817. Exhibited at RA (25), RHA (2), SBA (1), Paris Salon 1841-91 from London and Paris. Painted a portrait of Jean-Jacques Rousseau. Died Paris. Some of his portraits were reproduced as engravings.

LADBROOKE, Robert 1770-1842
Born Norwich. Apprenticed to an artist and printer called White. Worked as a journeyman printer and while so engaged met his future brother-in-law John Crome, with whom he shared a studio and founded Norwich Society of Artists 1803. Fell out with Crome 1816 and formed a rival society. Exhibited at RA (5), BI (8) 1804-22 from Norwich. Painted mainly landscapes but also occasionally portraits. Died Norwich 11 October 1842.
Represented: BM; Tate; Castle Museum, Norwich.
Literature: W.F.Dickes, *The Norwich School*, 1905; Day II; DA.

LADD, Ann c.1746-1770
Painted portraits and still-life. Died, unmarried, of smallpox in London 3 February 1770 aged 24.

LA FOLLIE, Yves Adolphe Marie de 1830-1896
Born Guingamp, Côtes-du-Nord 27 November 1830. Exhibited at RA (4), Paris Salon 1857-80 from London.

LAGUERRE, Louis 1663-1721
Born Versailles. Brought up as a Jesuit. Studied at French Academy under Charles Le Brun. Moved to England c.1684 as an assistant to Verrio. Working on his own by 1687. A highly accomplished Baroque history painter on ceilings and walls. His chief surviving decorative works are at Sudbury Hall, Chatsworth, Burghley, Marlborough House, Petworth and Blenheim. Occasionally painted easel histories and portraits. Among his sitters was 1st Earl of Cadogan. Died London 20 April 1721.
Represented: VAM; Yale. **Engraved by** J.Simon. **Literature:** DA.

LAIDLER, Miss fl.1838
Painted a portrait of 'Miss Grace Darling' 1838.

LAING, Frank ARE 1862-1907
Born Dundee. Studied in Edinburgh and in Paris under J.P.Laurens. Spent some time in Paris. Exhibited at Paris Salon, RA (3), RSA (6). Elected ARE 1892. His etchings were admired by Whistler.
Represented: Dundee AG; Victoria AG, Australia.
Literature: McEwan.

LAING, Miss Georgiana fl.1898-1910
Exhibited at RA (3), SM 1898-1910 from Liverpool.

LAKE, Charles fl.1852-1853
Listed as a portrait painter in East Street, Taunton, Devon.

LAKE, Frederick fl.1834-1853
Exhibited at RA (1) 1834 from East Street, Taunton. Recorded there 1853.
Engraved by W.Say.

LAMB, Henry Taylor RA 1883-1960
Born Adelaide, South Australia, 21 June 1883, son of Sir Horace Lamb. Brought up in Manchester. Began in medicine, before studying art under John, Orpen and in Paris under J.E.Blanche 1907-8. Member of Camden Town Group 1911-12. Worked in Ireland 1912-13. Official War Artist 1916-18 and again 1939-45. Exhibited at RA (131), NEAC 1909-61. Elected ARA 1940, RA 1949. Died Salisbury 8 October 1960.
Represented: NPG London; Tate; Imperial War Museum; Manchester CAG; Guildhall Museum, Poole; AGs of Southampton, Brighton, Belfast, Sheffield, Rochdale, Aberdeen. **Literature:** DNB; *The Times* 10 October 1960; K.Clements, *H.L., The Artist and his Friends*, 1985.

LAMB, J. fl.1890s
Worked as a portraitist in Edinburgh.

LAMBERT, E.F. fl.1823-1846
Exhibited at RA (15), SBA (7) 1823-46 from London. Some of his portraits were reproduced as engravings.

LAMBERT, George Washington ARA 1873-1930
Born 13 September 1873 St Petersburg, of an American father and English mother. Visited England 1878, then Sydney where he studied under J.R.Ashton. Went to Paris on a scholarship. Taught at London School of Art 1910. Exhibited at RA (28), ROI (1), RSA (5), NEAC (12), RHA (5) 1904-31 from London. Elected ARA 1922. When painting the portraits of the children of art dealer C.Thompson, he did somersaults in the garden to amuse them. Returned to Australia c.1928. Died Cobbity, New South Wales, 28 May 1930.
Represented: NPG London; Brighton AG. **Literature:** A.Motion, *The Lamberts*, 1986; B.Falk, *Five Years Dead*, 1938; A.Lambert, *Thirty Years of an Artist's Life – The Career of G.W.L. ARA*, 1938; DA.

LAMBERT, James snr 1725-1788
Baptized Willingdon 29 December 1725, son of James Lambert, flaxdresser of Lewes, and Susannah (née Bray). Practised as a portrait and landscape painter in Lewes. Married Mary Winton at Stopham 29 April 1760. Died 7 December 1788 after a long illness. Buried St John-sub-Castro, Lewes.
Represented: Sussex Archaeological Society. **Literature:** W.H.Challen, 'Baldy's Garden, the Painters' Lambert and other Sussex Families', *Sussex Archaeological Collection* Vol 90.

LAMBERT, John c.1640-1701
Born Yorkshire, son of Parliamentary General, John Lambert. Described by Thoresby as a 'great scholar and virtuoso and most exact limner'. Died Yorkshire 14 March 1701. Signed some portraits 'I.L.'
Engraved by J.Smith. **Literature:** Thoresby, *Diary*, 1830 ed, I p.131.

LAMQUA fl.1835-1845
Exhibited at RA (2) 1835-45 from Canton. Painted in Anglo-Chinese style.

LANCASTER, William Charles b.1800
Baptized St Pancras 21 November 1800, son of Richard Hume Lancaster and his wife, Elizabeth. Exhibited at RA (2) 1830-1 from London. Listed as a portraitist in London 1834.

LANCE, George **1802-1864**
Born Little Easton, near Colchester 24 March 1802, son of an Adjutant in the Essex Yeomanry. Studied under B.R.Haydon. Entered RA Schools 15 January 1820. Painted a number of competent portraits, before gaining a national reputation as a still-life painter. Sir George Beaumont bought his first still-life, which followed with commissions from the Earl of Shaftesbury and Duke of Bedford. Exhibited at RA (38), BI (135), SS (47), NWS, LA 1824-64 from London. His favourite pupil and imitator was William Duffield. Died near Birkenhead 18 June 1864. Studio sale held Christie's 27 May 1873.
Represented: NPG London; Tate; Leeds CAG; VAM. **Engraved by** S.Bellin, A.Roffe, J.Scott, W.Sharp. **Literature:** Ottley; DA.

LANDAU, Dorothy Natalie Sophia (Mrs Da Fano) **ROI**
 d.1941
Exhibited at RA (9), ROI, SBA 1909-30 from London. Died 16 November 1941. Usually signed in her maiden name.

LANDER, John St Helier **ROI** **1869-1944**
Reportedly born Jersey 19 October 1869 (although 1851 census lists his birthplace as High Littleton, Somerset). Studied at Frank Calderon's School of Animal Painting, RA Schools and Académie Julian, Paris. Exhibited at RA (30), ROI, RP, Paris Salon (Silver Medal 1923) 1895-1928 from Jersey and London. Built up a successful practice, and liked to stress the air of aristocratic 'good breeding' in his portraits. Died 12 February 1944.
Represented: Manchester CAG; Leeds CAG.

LANDSDOWN, Henry V. **fl.1852-1853**
Listed as a portrait painter at 20 Great Stanhope Street, Bath.

LANDSEER, Charles **RA** **1799-1879**
Born London 12 August 1799, son of engraver John Landseer ARA and elder brother of Sir Edwin. Studied under B.R.Haydon. Entered RA Schools 1816. Exhibited at RA (73), BI (26), SBA (12) 1822-79. Elected ARA 1837, RA 1845, Keeper 1851-73. The *Art Journal* commented that his works are 'distinguished by careful execution'. Died London 22 July 1879. Studio sale held Christie's 14 April 1880.
Represented: NPG London; Tate; BM; VAM; Ashmolean. **Engraved by** W.Drummond, R.J.Lane, C.Lewis. **Literature:** *Art Journal* 1879 p.217; DNB; DA.

LANDSEER, Sir Edwin Henry **RA** **1802-1873**
Born London 7 March 1802, son of engraver, John Landseer. Entered RA Schools aged 14. Encouraged by B.R.Haydon. An outstanding animal painter. Studied dissection and anatomy to perfect his knowledge of animals. Exhibited at RA (177), RSA (19), BI (94), SBA (4), RHA (1), OWS 1815-73. Elected ARA 1826, RA 1831. Knighted 1850. His work was greatly admired by Queen Victoria, who bought and commissioned a large number of paintings. The most popular artist of his generation. Commissioned to model the large bronze lions in Trafalgar Square and in 1865 was offered the Presidency of RA but declined. Died St John's Wood, London 1 October 1873. Buried with public honours in St Paul's Cathedral. Studio sale held Christie's 8 May 1874. He worked quickly and confidently, with masterly brushwork. Although his reputation is as a great animal painter, his portraits are also of the highest order and show him to be a true master. Henry Baines was a pupil.
Represented: NPG London; BM; VAM; Tate; Fitzwilliam; Wallace Collection; Maidstone Museum; SNPG; SNG; NGI; Southampton CAG; HMQ; Nottingham University. **Engraved by** T.L.Atkinson, E.Burton, H.Cooper, S.Cousins, E.Desmaisons, A.Duncan, F.Hanfstaengl, C.Heath, F.Holl, S.G.Hunt, J.W & R.Josey, T.Landseer, R.J.Lane, F.C.Lewis, R.Piercy, J.B.Pratt, H & J.H.Robinson, W.Roffe, C.Rolls,

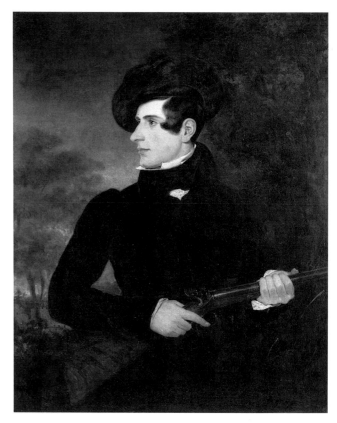

GEORGE LANCE. William Carling, son of William Carling of Preston Castle, Hitchin, Herts. Signed and dated 1832. 45 x 36ins (114.3 x 91.5cm) *Phillips*

Lady E.Russell, H.T.Ryall, J.Scott, W.H.Simmons, J.Stephenson, J.Thomson, E.J.Willmore. **Literature:** *Art Journal* 1873 p.326; C.Lennie, *L., the Victorian Paragon*, 1976; DNB; F.Stephens, *Sir E.L.*, 1881; R.Ormond, *Sir E.L.*, Tate exh. cat. 1981; Maas; DA.

LANDSEER, George **c.1834-1878**
Son of engraver Thomas Landseer and nephew of Sir Edwin. Exhibited at RA (21), BI (12), RHA (1), SBA (1) 1849-58 from London. Travelled to India, where he painted portraits and watercolour views. Returned to England 1870. Died London 10 March 1878.
Represented: VAM. **Literature:** *Art Journal* 1878.

LANDSEER, Miss Jessica **1810-1880**
Born 29 January 1810, precocious daughter of John Landseer and sister of Sir Edwin, for whom she kept house. Exhibited at RA (10), BI (7), SBA (6), OWS 1816-66. Died Folkestone 29 August 1880.
Represented: SNPG; VAM.

LANE, Anne Louisa **fl.1769-1782**
Miniaturist. Occasionally painted portraits in oil. Honorary exhibitor at SA (9), RA (3) 1769-82 from London.

LANE, John Bryant **1788-1868**
Born Helston, Cornwall, son of Samuel Lane, a chemist and exciseman, and Margaret (née Baldwin). Educated at Truro. Aged 14 his taste for art attracted the patronage of Lord de Dunstanville who sent him to Rome 1817, where he remained for 10 years. His 'The Vision of Joseph' caused offence and he and his picture were expelled from the papal dominions. Exhibited

EDWIN HENRY LANDSEER. Two gentlemen out shooting. 20½ x 19½ins (52.1 x 49.5cm) *Christie's*

at SA (Gold Medallist), RA (16), BI (3), SBA (3) 1808-34 from London. Died unmarried London 4 April 1868. **Literature:** DNB.

LANE, Richard James ARA **1800-1872**
Born Berkeley Castle 16 February 1800, son of Rev Theophilus Lane, and great-nephew of Thomas Gainsborough. Apprenticed to engraver Charles Heath. Painted the well-known portrait of Princess Victoria aged 10 1829 (Dulwich AG). Exhibited lithographs and portraits at RA (66), SBA (16) 1824-72. Elected ARA 1827, Lithographer to the Queen 1837. Produced portraits in pencil or chalk of the Queen and most of the royal family at various ages. Six volumes of his lithographs 1825-50 are in NPG London. Died Kensington 21 November 1872.
Represented: NPG London; BM. **Engraved by** J.Cook, W.G.Jackson, E.Morton, H.Robinson, J.Thomson, engraved many of his works himself. **Literature:** DNB.

LANE, Samuel **1780-1859**
Born King's Lynn 26 July 1780. After a childhood accident was left deaf and partially dumb. Studied under Joseph Farington and later under Sir Thomas Lawrence, who employed him as one of his chief assistants. A friend of John Constable. Exhibited at RA (218), BI (1), SBA (4) 1804-57 from London. Established a highly successful portrait practice. Among his sitters were Lord George Bentinck, Admiral Lord Saumarez and Captain Murray. Moved to Ipswich 1853, where he died 29 July 1859. He was capable of conveying considerable character.
Represented: NPG London; VAM; Dulwich AG; United Services Club; SNPG; Royal College of Physicians; Tate; Town Hall, King's Lynn. **Engraved by** G.Adcock, S.Bellin, S.Bull, J.Cochran, H.Dawe, J.Harvey, T.Hodgetts, R.J.Lane, S.W.Reynolds, W.Say, C.Turner, Mrs D.Turner, W.Ward, C.W.Wass, J.Young. **Literature:** DNB.

LANE, Miss Sarah H. **fl.1843-1872**
Exhibited at RA (4), BI (4), SBA (5) 1843-72 from Brighton and London.

LANE, Theodore **1800-1828**
Born Isleworth, son of a drawing master from Worcester. He was left-handed. Apprenticed to artist J.C.Barrow. Exhibited at RA (7), BI (7), SBA (3) 1816-30 from London. Gained a reputation for watercolour portraits and miniatures. Took up oil painting 1825, with encouragement from A.Fraser RSA. Died 21 May 1828, falling through a skylight in his house in the Gray's Inn Road. Buried St Pancras Church.
Represented: BM; Tate. **Engraved by** H.Beckwith, R.Graves. **Literature:** DNB.

LANE, William **c.1747-1819**
Began as a gem cutter, but also painted portraits. Exhibited gems and portraits at RA (62), BI (1) 1778-1815 from London. Established a successful practice. Among his sitters was 'Mrs Siddons'. Died Hammersmith 4 January 1819 in his seventy-third year.
Represented: NGI; BM. **Engraved by** H.R.Cook, W.Evans, C.Picart, W.Ridley, W.Skelton.

LANG, Thomas **fl.1848-1855**
Listed as a portrait painter in Manchester.

LANGLEY, C.D. **fl.1841**
His portrait of Richard Mountford was engraved by S.W.Reynolds and published 1841. Two charming portraits were sold at Christie's 7 November 1969.

LANGLEY, Walter RI **1852-1922**
Born Birmingham 8 June 1852. Aged 15 apprenticed to a Birmingham lithographer, later becoming partner in the business. Studied at South Kensington Art School 1873-5. Returned to Birmingham, but settled in Newlyn 1882,

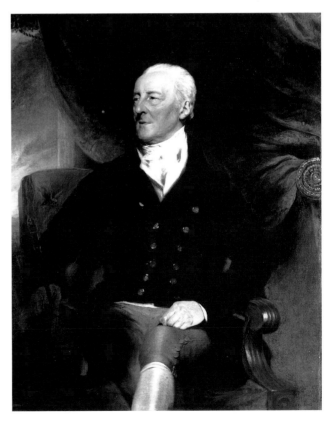

SAMUEL LANE. John Weyland of Nuneaton and Woodrising. Engraved 1816. 50 x 40ins (127 x 101.6cm) *Christie's*

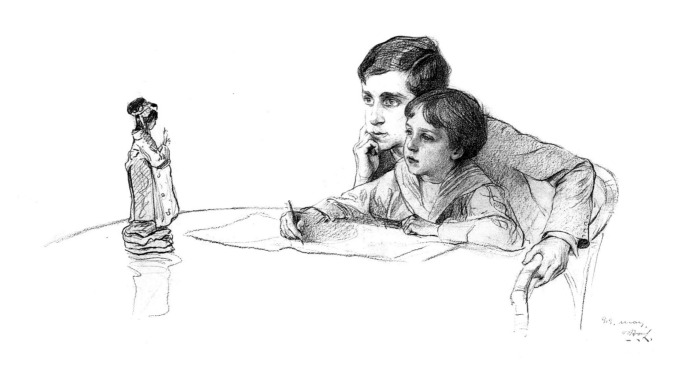

PHILIP ALEXIUS DE LÁSZLÓ. The artist's sons, Henry and John. Signed and dated May 1919. Black chalk. 14¼ x 21⅛ins (36.2 x 54cm)
Christopher Wood Gallery, London

becoming part of Newlyn School with Stanhope Forbes and Frank Bramley. Exhibited at RA (13), SBA (3), RHA (1), NWS 1880-1919. Elected RI 1883. The artist Henry Scott Tuke described him as 'the strongest watercolour man in England'. Died Penzance 21 March 1922. His sitters are portrayed with great sensitivity.
Represented: Leicester AG; Birmingham CAG. **Literature:** DA.

LANGLOIS, Camille jnr **b.c.1812**
Born Paris, son of French portraitist Claude Bernard Camille Langlois de Sens. Aged 39 in 1851 census. Awarded a prize at SA 1836 for a miniature. Exhibited at RA (10), SBA (5) 1833-49 from London. Probably the C.Langlois who was listed as a portrait painter and photographer in Brighton 1869.

LANGLOIS DE SENS, Claude Bernard Camille
1786-c.1860
Born Sens 24 October 1786, son of portrait painter Claude Louis Langlois of Sezanne (1757-1845). Exhibited at Paris Salon 1806-36. Exhibited also at RA (11) 1831-41 from London according to Graves, but Foskett records an RA exhibit 1849 from Duveen's catalogues. Died Brighton.
Represented: VAM.

LANSCROON, Gerard **c.1655-1737**
Son of a sculptor from Malines, with whom he moved to England 1677. Worked as assistant to Verrio 1678, and on his own by 1690. Painted mostly histories. A ceiling by him at

Melbury was painted from the 1690s. Occasionally painted portraits, which suggest some Italian influence. Died London. Buried 26 August 1737.
Literature: DA.

LAPORTE, George Henry **1799-1873**
Born Hanover, son of artist John Laporte. Animal painter to HRH the Duke of Cumberland and to the King of Hanover. Also produced portraits, usually accompanied with favourite animals. Exhibited at RA (9), BI (21), SBA (18), NWS 1821-50. Died London 23 October 1873.
Represented: Tate. **Engraved by** J. Harris. **Literature:** DNB.

LAPORTE, Miss Mary Ann **b.c.1795**
Daughter of artist John Laporte, and sister of George Henry Laporte. Exhibited at RA (4), BI (3), NWS 1813-45 from 21 Winchester Road, London. Elected NWS 1835, but retired 1846 because of illness.

LARGILLIÈRRE, Nicolas de **1656-1746**
Baptized Paris 10 October 1656, from a prosperous family of hat makers. Trained in Antwerp as a still-life painter under Antonie Goubaud. Master in the Guild of Antwerp c.1672-4. Visited England c.1674-80, and entered the studio of Sir Peter Lely where he painted drapery and still-life to a high standard and assisted Verrio 1679. Decided to become a portrait painter on his return to Paris in 1682. Visited

London briefly 1686 to paint portraits of James II and his Queen. His successful career as a court portraitist was in Paris, where he was *agréé* at the Académie. Died Paris 20 March 1746. With his friend and rival Hyacinth Rigaud he evolved the *portrait d'apparat* – the official portrait designed to glorify noblemen, *grand bourgeois,* and professional men.
Represented: NPG London; NGI; SNPG; Louvre. **Engraved by** P. Drevet, G.Edelinck, S.Gantrel, J.Smith, P.v.Schuppen, C.Vermeulen. **Literature:** M.N.Rosenfield, *L.,* Montreal MFA exh. cat. 1981; Dr D Breme, forthcoming catalogue raisonnée; DA.
Colour Plate 41

LARKIN, William d.1619
Probably son of William Larkin, a Freeman of Company of Bakers and later host of a large London inn called The Rose. Believed to be a native of London. Had a highly successful portrait practice. His work was remarkably accomplished, although a number of portraits painted in his manner have been attributed to him. Died comparatively young in London 1619 between 10 April, when his will was made, and 14 May when it was proved. Survived by his wife Mary and one child.
Represented: Ranger's House, Blackheath; Longleat.
Literature: Walpole Society Vol XLVII 1980 pp.127-9; DA.

LAROON (LAURON), Marcellus, the elder
c.1648/9-1701/2
Born The Hague c.1648-9, son of landscape painter Marcel Lauron, with whom he came to England in the 1660s. Admitted a Painter-Stainer in London 1674. Painted portraits to a high standard. Worked mainly as an engraver and assistant and drapery painter to Kneller. Married Elizabeth, daughter of Jeremiah Keene, a wealthy builder of Little Sutton, near Chiswick. Died of consumption at Richmond 11 March 1701/2. Buried Richmond. His collection of pictures sold 24 February 1725. De Piles says of him, 'He painted well, both in great and little, and was an exact draughtsman; but he was chiefly famous for drapery, wherein he exceeded most of his contemporaries'. His son, Marcellus Laroon the younger, was also a painter.
Represented: Christ's Hospital, Horsham; BM. **Engraved by** I.Beckett, P.Tempest, R.Williams, John Smith. **Literature:** R.De Piles, *The Art of Painting,* 1744; R.Raines, *M.L.,* 1966; R.Raines, *M.L.* Tate exh. cat. 1967; DNB; Foskett.

LAROON, Marcellus, the younger 1679-1772
Born Chiswick 2 April 1679, son and pupil of Marcellus Laroon (Lauron). Studied at Kneller's Academy c.1712, and was an assistant of Kneller for a time. Said to have become an actor and singer on the stage at Drury Lane Theatre after family differences, followed by an army career until he retired as Captain 1732. Painted mainly Rococo conversations, fancy pictures and stage scenes, but occasionally portraits. Seems to have settled in Oxford in the 1750s. Died Oxford 1 June 1772. Buried in St Mary Magdalene's Church. A friend and follower of Hogarth.
Represented: Yale; BM. **Engraved by** B.Green, J.Savage, W.J.Taylor. **Literature:** R.Raines, *M.L.,* 1966; DNB.

LASCH, Professor Karl Johann 1822-1888
Born Leipzig 1 July 1822. Studied under Beudemann at Dresden, and Schnorr and Kaultach at Munich. Exhibited at RA (1) 1879 from 112 Queen's Gate, London. Died Moscow 28 August 1888.
Represented: Düsseldorf Museum.

LASSOUQUERE, T.R. fl.1847
Exhibited at RA (2) 1847 from 9 Somerset Street, London.

LÁSZLÓ, Philip Alexius de PRBA RP NPS
1869-1937
Born Budapest, son of a businessman. Apprenticed to a scene

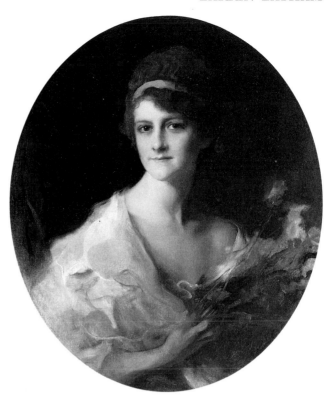

PHILIP ALEXIUS DE LÁSZLÓ. Hilda Luny Turner. Signed and dated 1919. 29½ x 24ins (74.9 x 61cm)
Christopher Wood Gallery, London

painter 1880, but left after a few months. Studied at National Academy of Arts, Budapest, Académie Julian, Paris and Royal Bavarian Academy of Arts, Munich. His first royal commission, in 1894, was to paint Prince Ferdinand and Princess Marie-Louise of Bulgaria in their Ruritanian castle at Sofia. Established a highly fashionable practice in the Austro-Hungarian Empire. In 1900 married Lucy, a member of the Guinness family. Painted often in England and Ireland. Lived in London 1907 and America 1908, painting Roosevelt. Exhibited at RA (4), RHA (13), RSA (18), SBA (38), NPS, RP (14), Paris Salon. Elected NPS 1911, RP 1912/3, PRBA 1930. Regarded as Sargent's natural successor. Became a naturalized British subject 1914, but was interned 1917-18. His portrait of Benito Mussolini won him the Grand Cross of the Crown of Italy. By the end of his life he had been awarded 22 orders and 17 medals. Died London 22 November 1937.
Represented: NPG London; SNPG; Clandon Park NT; Philadelphia MA; Tate; Imperial War Museum. **Literature:** *P.A. de L.: Portraits – The Artist's Record of his Works,* 2 vols sold Michael Bennett Art Catalogues, Carlisle 35 no 136; O.Rutter, *Portrait of a Painter: The Authorized Life of P.L.,* 1939; D.Clifford, *The Paintings of P.L.,* 1969; DA.

LATHAM, James 1696-1747
Born in County Tipperary. Educated in Antwerp. Master in the Antwerp Guild 1724/5. Settled in Dublin, where he established a successful practice, being named the Irish Van Dyck. Possibly visited London in the early 1740s. Died Dublin 26 January 1747. Appears to have been influenced by Hermann Van Der Myn and Joseph Highmore. His paintings could reach a very high standard, but varied in quality.
Represented: Trinity College, Dublin; NGI; Tate. **Engraved by** J.Brooks, J.Faber jnr, A.Miller. **Literature:** *Irish Portraits 1660-1860,* NGI exh.cat. 1969; DA.

LATILLA, Eugenio Honorus Nichola RBA
1800-1859
Born Italy, son of an Italian, living in England. Exhibited at
RA (5), BI and SBA (68) 1829-58. Elected RBA 1838.
Worked in London 1828-42, Rome 1842, Florence 1847-8,
London 1849 and then in America, where he died at
Chapaqua, New York. Among his exhibited portraits were
Queen Victoria, D.Harvey and D.O'Connell.
Engraved by B.Holl, S.Shade.

LA TOUR, Maurice Quentin de 1704-1788
Born St Quentin 5 September 1704. The leading French
crayon portraitist of his day. Elected *agrée* at the French
Academy 1737. Practised successfully in London 1725-7,
under the patronage of Robert Walpole. Married Harriett
Goodwin at Marylebone 8 November 1731. Recorded in
London 1751. Died Paris 16/17 February 1788.
Literature: A.Besnard & G.Wildenstein, *La Tour*, 1928; DA.

LAUDER, James Eckford L. RSA 1811-1869
Born Silvermills, Edinburgh, brother and pupil of Robert
Scott Lauder. Studied at Trustees' Academy. Exhibited at
RSA (171), RHA (8), RA (6), BI (7), SBA (1) 1833-69.
Elected ARSA 1839, RSA 1846. Visited Rome c.1837-8.
Died Edinburgh 27 March 1869.
Represented: SNPG; Walker AG, Liverpool. **Literature:** *Art
Journal* 1869 p.157; McEwan; DA.

LAUDER, James Thompson fl.1830-1850
Portrait painter and father of Charles James Lauder RSW.
Worked in Glasgow.

LAUDER, Robert Scott RSA 1803-1869
Born Silvermills, near Edinburgh 25 June 1803. Received
advice from David Roberts before studying at Trustees'
Academy from 1817, first under Andrew Wilson and then Sir
William Allan. Worked in London 1822-3, Edinburgh 1827/8.
Elected RSA 1829. In 1833 he travelled on the Continent for
five years, mainly in Rome, but also Florence, Venice and
Munich, where he painted portraits before returning to
London 1838. Exhibited at RSA (153), RA (25), RHA (3), BI
(11) 1826-69. Appointed Master of Trustees' Academy 1852
and became a popular and highly successful teacher. Married
the daughter of Rev John Thompson of Duddingston. Suffered
a paralytic stroke 1861. Died Edinburgh 21 April 1869.
Represented: NPG London; SNPG; SNG; RSA; Glasgow
AG. **Engraved by** G.B.Shaw. **Literature:** *Art Journal* 1869
p.176; Ottley; McEwan; DA.

LAUGÉE, François Désiré 1823-1896
Born Maromme 25 January 1823. Portrait and history
painter. Exhibited at Paris 1845-80, winning honours. Also at
RA (15) 1871-4 from London. Died Paris 24 January 1896.
Literature: Bénézit.

LAURENCE, Samuel 1812-1884
Born Guildford. Exhibited at RA (91), BI, SBA (14) 1834-82.
Travelled to America 1854 on Thackeray's advice. Based in
New York until 1861, when he returned to England. Also
visited Italy. Among his sitters were Charles Dickens, Thomas
Carlyle, W.M.Thackeray and Robert Browning. Died London
28 February 1884. A skilful and sensitive draughtsman.
Anthony Frederick Augustus Sandys was a pupil.
Represented: NPG London; NMM; Hovingham Hall.
Engraved by J.C.Armytage, L.Dickinson, F.Holl, C.H.Jeens,
J.H.Lynch, E.Morton, G.T.Payne, L.Rousseau, W.Walker.
Colour Plate 42

LAVERY, Sir John RSA RA RHA PRP 1856-1941
Born Belfast 16 or 20 March 1856. Studied at Haldane Academy,

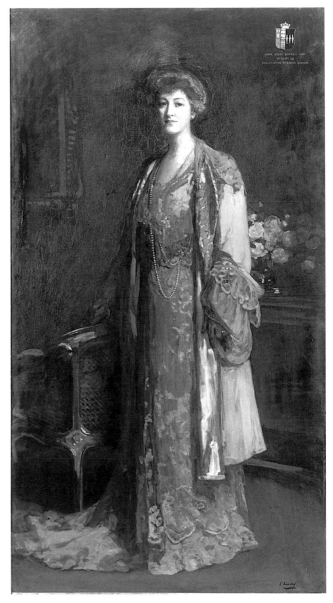

JOHN LAVERY. Anne Selby Burrell Ord, 5th Lady Gwydyr.
Signed and dated 1903. 78 x 42ins (198.2 x 106.7cm)
Sotheby's

Glasgow, Heatherley's and Académie Julian, Paris (under
Bouguereau). Returned to Glasgow 1881, where he was a friend
of James Guthrie and other members of the Glasgow School, as
well as James McNeill Whistler (who was an influence). Painted
the official picture of the Queen's State Visit to Glasgow 1888.
Became a highly fashionable portrait painter. Exhibited at RA
(168), RHA (63), SBA, GG, NEAC, RP (140), RSA, Paris
Salon 1882-1941 as well as many European Academies. Elected
ARSA 1892, RSA 1896, ARA 1911, RA 1921, knighted 1918,
PRP 1931, Vice-President of International Society of Sculptors,
Painters and Gravers. Had a studio in Tangiers, which he used
in winter. Died Kilmaganny, County Kilkenny 10 January 1941.
Buried Putney Vale Cemetery. Developed a confident, fluid and
broad style with a masterly touch.
Represented: NGI; NPG London; Tate; SNPG; VAM;
Burrell Collection, Glasgow; Brighton AG; Southampton
CAG; HMQ; Leeds CAG; Ulster Museum, Belfast.
Engraved by N.Hirst. **Literature:** W.S.Sparrow, *J.L. and his*

Work, 1911; *J.L., The Life of a Painter*, 1940; *British Artists at the Front. Part II: Sir J.L.*, 1918; D.Scrutton, *J.L. – The Early Career*, St Andrews exh. cat. 1983; K.McConkey, *Sir J.L. RA 1856-1941*, Ulster Museum exh. cat. 1984-5; DA; K.McConkey, *Sir J.L.*, 1993.

LAW, Andrew **1873-1967**
Born Kilmaurs, Ayrshire. Educated at Kilmarnock. Studied at Glasgow School of Art 1890-6 under F.H.Newbury and in Paris. Exhibited at RSA (40), GI, Paris Salon. Member of Glasgow Art Club. Worked at Glasgow Art School.
Represented: Glasgow AG. **Literature:** McEwan.

LAWLOR, Uniacke James **fl.1854-1876**
Exhibited at RA (2), BI (1), SBA (1) 1854-6 from London.

LAWRANCE, Alfred Kingsley RA RP 1893-1975
Born Southover, Lewes 4 October 1893. Studied at King Edward VII School of Art, Newcastle under R.G.Hatton, RCA under Rothenstein and British School at Rome. Exhibited at RA (47), RP 1929-70 from London. Elected ARA 1930, RA 1938, RP 1947. Died 5 April 1975.
Represented: SNPG.

LAWRANSON, Thomas FSA fl.1733-1786
Believed to be of Irish origin. Dated works exist from 1737. Listed as a portrait painter in Bloomsbury. Exhibited portraits and miniatures at SA (27) 1762-77. Elected FSA 1771. Painted dramatist John O'Keefe. His son William, was also a portraitist.
Represented: NPG London; BM. **Engraved by** Blackberd, T.Bragg, J.Corner, J.Dixon.

LAWRANSON, William L. FSA fl.1760-c.1783
Son of portrait painter, Thomas Lawranson. Won premiums for drawings at SA in seven successive years 1760-6. Entered

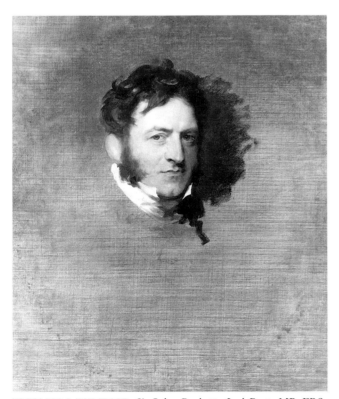

THOMAS LAWRENCE. Sir John Beckett, 2nd Bart, MP, FRS. 36 x 28ins (91.5 x 71.1cm) *Christie's*

RA Schools 1769. Exhibited at SA (26), FS (4), RA (8) 1760-80 from London. Elected FSA 1771.
Engraved by R.Dunkarton, W.Evans, J.Jones, W.Pether.

LAWRENCE, George **c.1758-1802**
Studied at Dublin Society Schools 1771 and worked under F.R.West and J.Mannin. Exhibited at Dublin Society of Artists from 1774. Produced a number of crayon portraits 9 x 7in. oval. In 1788 his label read 'Likenesses engaged; In Crayons and in Miniature at one guinea each. The same size of the Crayons in Oil at one guinea and a Half'. Later charged two guineas each.
Represented: National Museum of Ireland. **Literature:** E.McGuire, *Connoisseur* Vol XCVII pp.206-9.

LAWRENCE, J. **fl.1842**
Exhibited watercolour portraits at SBA (2) 1842.

LAWRENCE, John **fl.1771-1793**
A native of Dublin, brother of George Lawrence. Studied at Dublin Society's School. Painted miniatures and small portraits in London.

LAWRENCE. Mrs Marguerite E. **fl.1903-1919**
Exhibited at RA (2), RHA (2) 1903-5 from West Kensington and Winslow, Buckinghamshire. Capable of great sensitivity.

LAWRENCE, Sir Thomas PRA 1769-1830
Born Bristol 13 April 1769, a younger child in a family of 16 children of whom only five survived. An infant prodigy, taking pencil likenesses from the age of five in his father's inn at Devizes. The family settled in Bath by 1780 and Lawrence began making crayon portraits, with advice from William Hoare. They are almost always oval, and mostly 12 x 10in (30.5 x 25.4cm) and inscribed on the back 'Be pleased to keep from the damp and the sun'. Moved to London 1787, when he attended RA Schools for a few months. Exhibited at RA (311), RHA (8), BI (3) 1787-1830. Elected ARA 1791, Painter in Ordinary to the King in succession to Reynolds 1792, RA 1794 (at the earliest permitted age), knighted in April 1815 and succeeded West as PRA 1820. Showed his first oil portrait 1788, his first full-length in 1789 and caused a sensation in 1790 (the last year in which Reynolds exhibited) with full-lengths of 'Queen Charlotte' (NG London) and 'Miss Farren' (New York) painted in his new romantic style. Between 1797 and 1807 his personal life was in chaos, and the quality of his work could not be depended upon. He at first fell in love with Sarah Siddons' daughter, Sally, and then her second daughter Maria. While Maria was dying of consumption in 1798, she extracted a promise from Sally that she would not marry Lawrence. Sally also contracted consumption dying 1803. The trauma drained Lawrence and, with the addition of enormous financial problems, he undertook too many commissions and left too much to his assistants. By 1807 his financial affairs had been put into better order, and after the death of Hoppner in 1810 he had little competition and was able to charge 400 guineas for a full-length (which later rose to over 1000 guineas). He was commissioned by the Prince Regent to paint the key figures who helped to defeat Napoleon, which became the great series of portraits (1814-20) in the Waterloo Chamber at Windsor. These helped establish his rightful position as first painter in Europe, which he retained until his sudden death in London on 7 January 1830 at the age of 60. His body lay in state at the RA, and his funeral at St Paul's Cathedral was a national event, with 64 carriages in attendance. He was a man of great taste, and his collection of old master drawings was one of the finest ever made. Sadly, the opportunity to acquire it for the nation was not taken and the collection was broken up. He took his first apprentice-assistant, Thomas

Hargreaves of Liverpool, in 1793 and from this date was never without apprentices, assistants and paying pupils. They included George Henry Harlow (1802-4), Samuel Lane (from 1800), F.C.Lewis, Henry Wyatt, J.F.Lewis, Friedrich Von Amerling, F.Y.Hurlstone, Frank Howard, William M. Bennett, W.Robinson, R.Rothwell, F.S.Cary, G.Sheffield, William Etty (from 1807), John Simpson, George Raphael Ward (employed for a time to make copies), Richard Evans, F.T.Lines, William Evans, and possibly Margaret Carpenter, Thomas Sully and Henry William Pickersgill. Throughout his career the performances emanating from his studio were uneven. Lawrence's best works, however, show an outstanding and breathtaking genius and are among the highest achievements in Western art. His 'heads' contain remarkable life, vitality and character. His fluid, brilliant brushwork was much imitated.

Represented: NPG London; HMQ; VAM; SNG; NGI; SNPG; Aberdeen AG; Dulwich AG; Brighton AG; Tate; Wallace Collection; Metropolitan Museum of Art, New York; NG Washington; Whitworth AG, Manchester; Fyvie Castle, NT; Cleveland Museum of Art, Ohio; Birmingham CAG; Huntington AG, San Marino; Louvre; RA; Guildhall AG; Haddo House, NT; Southampton CAG; Yale; Chicago Art Institute; Harewood; Philadelphia MA; Sir John Soane's Museum; Frick Collection, New York. **Engraved by** Adam, G.Adcock, J.Alais, C.Armstrong, J.C.Armytage, R.Artlett, F.Bartolozzi, G.Baxter, W.Blake, T.Blood, W.Bond, M.A.Bourlier, W.Brett, J. & W.Bromley, J.Bull, W.O.Burgess, J.Burnet, T.L.Busby, A.Cardon, T.Cheeseman, G.Clint, J.Cochran, P.Conde, H.R. & J.W.Cook, J.E.Coombs, M.Cormack, H. & S.Cousins, W.Daniell, J.S.Davis, H.Dawe, T.A. Dean, E. Desmaisons, W. Dickinson, G.T. Doo, W. Drummond, L. Dujardin, W. Edwards, J. Egan, T.S.Engleheart, W.Ensom, T.Evans, G.S.Facius, E. & W.Finden, C.Fox, S.Freeman, W.T.Fry, T.Garner, M.Gauci, E.Gaujean, Gigoux, W.Giller, J.Godby, R.Golding, R.Graves, W.Greatbach, H.Grevedon, J.Grozer, E.B.Gulston, H.B.Hall, E.Harding, C. & J.Heath, N.Hirst, T.Hodgetts, B., F. & W.Holl, T.Holloway, J.Hopwood, W.Humphrys, T.Illman, J.R.Jackson, C.H.Jeens, E.Jowett, C.Knight, R.J.Lane, J.W.Latham, F.C.Lewis, W.J.Linton, J.B.Longacre, G.Longhi, D.Lucas, T.Lupton, J.H.Lynch, E.McInnes, C.Marr, Maurin, R.M.Meadows, H.Meyer, F.Moller, J.Morrison, W.H.Mote, R.Newton, W.Nicholls, J.Outrim, G.Parker, T.H.Parry, G.H.Phillips, C.Picart, J.B.Pratt, S.W.Reynolds, W.Ridley, H. & J.H.Robinson, J.Roffe, C.Rolls, H.T.Ryall, T.Ryder, W.Say, E.Scott, E.Scriven, W.Sharp, W.Skelton, E & J.R.Smith, R.Smythe, Swebach, W.D.Taylor, P.Thomas, J.Thomson, T.Trotter, C.Turner, C.W.Waas, C.E.Wagstaffe, J.G.Walker, W.Walker, H.Wallis, C.Waltner, J., G.R. & W.J.Ward, C.Watson, J.H.Watt, J.T.Wedgewood, E.Wehrschmidt, Westermayr, W.J.White, C.Wilkin, R.Woodman, T.Woolnoth, J. & W.H.Worthington, T.Wright, J.Young. **Literature:** K.Garlick, *L.*, 1954; Walpole Society XXXIX 1964; K.Garlick, *Sir T.L. – A Complete Catalogue of the Oil Paintings*, 1989; O.G.Knapp, *An Artist's Love Story*, 1904; D.Goldring, *Regency Portrait Painter*, 1951; D.E.Williams, *The Life and Correspondence of Sir T.L.*, 1831; M.Levy, *Sir T.L.*, NPG 1979.
Colour Plate 43

LAWRENCE, William fl.1743
Practised in Dublin.
Engraved by A.Miller.

LAWRENSON see LAWRANSON

LAWRIE, Robert fl.1775
Exhibited watercolour portraits at SA (3) 1775 from Fleet Street, London.

LAWSON, Francis Wilfred 1842-1935
Born Shropshire, of Scottish parents and elder brother of artist Cecil Gordon Lawson. Began as a designer for periodicals, including *The Graphic*. Exhibited at RA (14), SBA (4), GG, DG 1867-84.
Represented: NPG London; Walker AG, Liverpool.

LAWSON, Miss M.Stace fl.1831-1840
Exhibited at SBA (5) 1831-40 from Bexleyheath, Kent. Won a Silver Medal from SA 1832 for a miniature copy.

LAWSON, William b.c.1813
Born Dundee and aged 48 in 1861 census. Moved to London c.1861. Reportedly exhibited at RA (6), SBA (12) 1819-64 from Edinburgh, London and Bristol. He is either confused with another William Lawson, or exhibited from the age of six (which is not impossible). Married Miss Elizabeth Stone, and their sons, Francis Wilfred and Cecil Gordon were artists.

LEA, Anna M. (Mrs Merritt) fl.1871-1901
Exhibited at RA (41) 1871-6 from London. Married Henry Merritt c.1876-8. Lived in Chelsea and Andover.
Represented: Tate.

LEAHY, Edward Daniel 1797-1875
Born London, son of David Leahy. Studied at Dublin Society's School (winning prizes) and worked and exhibited in Dublin 1815-27. Settled in London and established a successful portrait practice. Exhibited at RA (34), BI (25), RHA (8), SBA (1) 1820-53. Among his sitters were the Duke of Sussex and the Marquess of Bristol. Lived in Italy 1837-45, and while in Rome painted a portrait of John Gibson RA. Died Brighton 9 February 1875.
Represented: NPG London. **Engraved by** J.Goodyear.
Literature: Strickland.

LEAKE, Henry L. fl.1764-1766
Son of a Bath bookseller. Studied under William Hoare. Won a premium at SA for drawing 1760. Exhibited at SA (3) 1765-6 from London. Thought to have travelled to India and died there early.

LEAKE, S. fl.1826-1827
Exhibited at RA (3), SBA (3) 1826-7 from London.

LEAKEY, James 1775-1865
Born Exeter 20 September 1775, son of a wool stapler of Bradford, reportedly of Irish descent. Exhibited at RA (12) 1821-46 from London and Exeter. Married Eliza Hubbard Woolmer 1815, and had 11 or 12 children. While in London he knew Constable, Lawrence and Wilkie, and Lawrence once introduced him as the 'English Wouvermans'. Painted Farington in miniature and Bishop Fisher in oils. A deeply religious man who reportedly gave up the 'brush for the pulpit'. For a time he lived next door to John Raphael Smith. Mrs Frankau in *John Raphael Smith*, 1902 wrote that Smith was known as 'Old Vice' and Leakey as 'Young Virtue'. Died Exeter 16 February 1865.
Represented: NPG London; BM. **Engraved by** S.Cousins.
Literature: *Art Journal* 1865 p.125; *Exeter Gazette* 16 February 1865.

LEAR, Charles Hutton 1818-1903
Son of prosperous parents. Studied under Sass and at RA Schools 1839-46. Exhibited at RA (10), BI (3), SBA (4) 1842-52 from London. Made a number of sketch portraits of fellow artists, which are now in NPG London. After 1852 he gave up painting professionally. Died 12 September 1903, leaving an estate of over £160,000.
Literature: R.Ormond, 'Victorian Student's Secret Portraits', *Country Life* 1967 pp.288-9.

LEBOUR, Alexandre b.c.1811
Born Paris. Exhibited at Paris Salon, RA (9), BI (1), SBA (11) 1833-66 from London. Aged 50 in 1861 census.

LEBRUN, Louise E. Vigée
 see VIGÉE-LEBRUN, Marie Louise Elizabeth

LECKY, Andrew Alexander fl.1833-1834
Born Dublin, son of Mrs Emilia Lecky. Exhibited at RHA (3) 1833-4 from Dublin.

LECKY, Mrs Emilia b.c.1788
Wife of William Alexander Lecky. Born Dublin. Exhibited at RHA (18) 1826-42 from Dublin. Recorded in Dublin 1844. Her son was Andrew Alexander Lecky.

LE CLEAR, Thomas NA 1818-1882
Born Oswego, New York 11 March 1818. Mostly self-taught. Worked as a portraitist in London. Settled in New York 1839, where he had some training from Inman. Worked in Buffalo 1844 returning to New York City 1860. Exhibited at NA. Elected NA 1863. Also exhibited at RA (2) 1873. Died Rutherford Park 26 November 1882.
Represented: Maryland Historical Society; Corcoran Gallery, New York City.

LECLERC, David 1679/80-1738
Born Berne, son of medallist Gabriel Le Clerc of Rouen. Studied under Joseph Werner in Berne. Went to Frankfurt 1698, where he obtained a bursary from Landgrave Karl von Hessen-Cassel which enabled him to travel to Paris and London. Worked for the Landgrave for 31 years. Visited in London 1715-17. Died Frankfurt-on-Main.
Represented: Landesmuseum, Cassel.

LEDERER, John A.F. 1830-1910
Born Frankfurt-on-Main. Trained at Frankfurt, Antwerp, Brussels. Worked in Paris before moving to London 1859. Settled in Liverpool by 1864, where he died 1 June 1910.
Represented: Walker AG, Liverpool.

LEDIARD, H. fl.1850
Exhibited at RA (1) 1850 from 73 St Margaret Street, London.

LEE, Anthony d.1767
Pasquin states that he was one of the earliest portraitists in Ireland, practising from 1724. Worked in Dublin, where he enjoyed a successful practice. Married Martha Mahon February 1733/4. Died Dublin June 1767. Buried Kilcroney. His work was influenced by Stephen Slaughter.
Represented: NGI. **Engraved by** J.Brooks, R.Grave, A.Miller. **Literature:** Strickland.

LEE, Arthur fl.1878
Listed as a portraitist at 38 Barrack Street, Dundee.

LEE, B.D. fl.1819-1821
Exhibited at RA (2) 1819-21 from South Street, Chichester.

LEE, John c.1869-after 1934
Studied at School of Art, Darlington under S.A.Elton. Working in London by 1889. Exhibited at RA (1), SBA, RI. Settled in Middleton-in-Teesdale by 1900.
Represented: Darlington AG; Bowes Museum, Barnard Castle.

LEE, May B. see STOTT, Lady May Bridges

LEECH, William John ROI RHA 1881-1968
Born Dublin 10 April 1881. Studied at RHA Schools, Metropolitan School of Art Dublin and at the Académie Julian, Paris. Exhibited at RHA (305), ROI 1899-1967 from Dublin and Clandon. Elected ARHA 1907, RHA 1910. Died 16 July 1968.
Represented: NGI. **Literature:** DA.

LEE-HANKEY, William see HANKEY, William Lee

LEEMPUT, Remee (Remigius) van 1607-1675
Baptized Antwerp 19 December 1607. Master in Antwerp 1628. Moved to England by 1635, possibly as an assistant to Van Dyck. An accomplished professional copyist, mainly of Van Dyck and Lely, but occasionally painted portraits on his own. Visited Rome 1651. Buried London 9 November 1675.
Represented: Lennoxlove. **Literature:** DA.

LEES, Charles RSA 1800-1880
Born Cupar, Fifeshire. Studied under Raeburn, in whose manner he painted. After a six months' visit to Rome he returned to Fifeshire, where he painted portraits, landscapes and genre. Exhibited at RSA (217), RA (6), RHA (7), BI (5), SBA (1) 1822-80 from Edinburgh. Elected RSA 1829, Treasurer 1868-80. Died Edinburgh 28 February 1880.
Represented: SNPG. **Engraved by** C.Warren. **Literature:** *Art Journal* 1880 p.172; McEwan.

LEES, Henry fl.1832-1848
Listed as a portrait painter, carver and gilder in Nottingham.

LEES, Miss Marion fl.1894
Exhibited at RA (1) 1894 from Abbey Road, London.

LEESMITH, Miss Mary Lascelles fl.1893-1897
Studied at Herkomer's School of Art, Bushey. Exhibited at RA (3) 1893-7. Married artist George Harcourt 1919.

LEFEBVRE, Rolland c.1608-1677
Reportedly born Bagneux. Known as Lefebvre de Venise. Member of Academy of St Luke, Rome 1636 and was there again 1639. Elected Associate at French Academy 1662 and member 1665. In England from 1676 until his death in London 1677, aged 69.
Represented: Sheffield Museum.

LEFEVRE, Claude 1632-1675
Born Fontainebleau 12 or 17 September 1632. Influenced by Le Sueur and Le Brun. Worked in Paris and for some years in England. A Professor of Académie Royale. Died Paris 25 April 1675.
Literature: DA.

LEGROS, Professor Alphonse RE 1837-1911
Born Dijon, France 8 May 1837, son of Lucien Auguste Legros, an accountant, and Anne (née Victoire). Apprenticed to Maître Nicolardo 1848, a builder and decorator. Moved to Paris 1851, where he worked as a scene painter under Cambon. Studied at École des Beaux-Arts and under Lecoq de Boisbaudran and Belloc. Exhibited at the Salon from 1857, where a profile portrait attracted Champfleury's attention and led to his association with the 'Realists'. He appears in Fantin-LaTour's 'Hommage à Delacroix'. His work was admired by Baudelaire. Encouraged by Whistler to come to London 1863, being welcomed by Rossetti and Watts. A few years later he was appointed Teacher of Etching at South Kensington School of Art, and Professor of Fine Art at Slade 1876-92. Among his pupils were Henry Tuke, Thomas Gotch, Charles Furse, and William Strang. Exhibited at RA (37), GG, NWG 1864-82. Founder member of Royal Society of Painter Etchers and Engravers. Died Watford 7/8 December 1911. Buried Hammersmith Cemetery.
Represented: NPG London; SNPG; BM; Walker AG, Liverpool; Tate; Fitzwilliam; Southampton CAG; Peel Park Museum, Salford; VAM; bronze head of Legros by Rodin in Manchester CAG. **Literature:** M.Salaman, *A.L.*, 1926; DNB; DA.

LE HARDY, Thomas **b.1771**
Baptized St Saviour's Church, Jersey 20 June 1771, son of miniaturist Thomas Le Hardy and François (née Dumaresq). Encouraged by miniaturist Philippe Jean. Visited London. Exhibited at RA (21), SA (4) 1793-1807.
Represented: NPG London; VAM; S.Jersey AG. **Literature:** G.R.Balleine, *A Biographical Dictionary of Jersey*.

LEHMANN, Henrich **1814-1882**
Born Kiel 14 April 1814. Exhibited at RA (4) 1863-6 from London and Paris. Died Paris 30 March 1882.

LEHMANN, Rudolph **1819-1905**
Born Wilhelm August Rudolf Lehmann in Ottensen, Hamburg 19 August 1819, son of artist Leo Lehmann. Visited Paris 1837, where he studied under his brother Heinrich a pupil of Ingres. Exhibited at Paris Salon (Gold Medallist). From Paris he went to Munich, studying under Kaulbach and Cornelius. Joined his brother in Rome 1838. First visited London 1850. Stayed in Italy 1856-66. Married Amelia Chambers in Rome 1861. Settled in London 1866. Exhibited at RA (113), RHA (1), GG, NWG 1851-1905. Among his sitters were Lord Revelstoke, Earl Beauchamp, Robert Browning and Miss Emily Davies (Girton College, Cambridge). Moved to Bournemede, Bushey 1904, where he died 27 October 1905. Buried Highgate Cemetery. Often signed with a monogram and date and favoured a smooth and painstaking finish, which he achieved with great accomplishment.
Represented: NPG London; Uffizi Gallery, Florence; BM; Royal College of Surgeons; Baylor University, Texas. **Engraved by** T.O.Barlow, R.J.Lane, Toubert, W.Walker. **Literature:** R.Lehmann, *An Artist's Reminiscences*, 1894; R.Lehmann, *Memories of Half a Century*, 1908; DNB.

LEIGH, James Matthews **1808-1860**
Baptized St Martin's-in-the-Fields, Westminster 14 April 1814, son of publisher and bookseller Samuel Leigh. Studied under William Etty 1828. Exhibited at RA (25), BI (23), SBA (29) 1825-49. Also a writer and published the historical play *Cromwell*. Started a well-known painting school in Newman Street, which rivalled that run by Henry Sass (whose portrait he painted). After his death in London a sale of his remaining works was held at Christie's 25 June 1860. John Bagnold Burgess was his pupil.
Literature: *Art Journal* 1860 p.200.

LEIGH, T. **fl.1634-1656**
Worked in the manner of a provincial Cornelius Jonson. Signed and dated portraits in North Wales 1643.
Represented: National Museum of Wales; Gwysaney Hall, Mold.

LEIGHTON, Charles Blair **1823-1855**
Born 6 March 1823. Studied at RA Schools. Exhibited at RA (13), BI (3) SBA (1) 1843-55. Also a lithographer of note. Died 6 or 12 February 1855. His son was artist Edmund Blair Leighton.
Represented: NPG London.

LEIGHTON, Lord Frederic PRA RWS HRCA HRSW
(Baron Leighton of Stretton) **1830-1896**
Born Scarborough 3 December 1830, son of Frederic Septimus Leighton, a prosperous doctor. His father gave up his practice to cultivate musical and artistic tastes and, for the sake of his wife's health, to travel on the Continent. The young Frederic Leighton learnt fluent German, French, Italian and (later) Spanish. By the age of 11 he had taken drawing lessons from Francesco Meli in Rome 1841 and under various masters in London, Dresden, Berlin, Frankfurt and Florence. Spent a year studying in Brussels 1848, and was in Paris 1849. Thereafter he returned to Frankfurt, where he studied for three years under the German Nazarene painter Johann Eduard Steinle. In Rome he was helped and advised by Richard Buckner and, from there, exhibited his first picture at RA 1855. Entitled 'Cimabue's Celebrated Madonna Carried in Procession through the Streets of Florence', it justifiably caused a sensation at the RA, and was bought by Queen Victoria for £600, launching him on a long and highly successful career. Exhibited at RA (165), RSA (5), SBA (61), RHA (11), OWS, GG and in France and Italy 1855-96. Elected ARA 1864, RA 1868, RBA 1870, PRA 1878. Knighted 1878, baronet 1886. In 1896, just a few days before his death, became the only artist to be raised to the peerage. Died London 25 January 1896. Studio sale held Christie's 11 and 13 July 1896. His house in Holland Park was, in its heyday, a spectacle of splendour, and is now a charming museum. Although he is remembered for his delightful depiction of Hellenistic subjects, he was a portrait painter of the very highest order. Among his studio assistants, pupils and followers were F.G.Cotman, J.H.Walker, E.J.Poynter, C.E.Perugini.
Represented: NPG London; Uffizi Gallery, Florence; BM; VAM; Ashmolean; Fitzwilliam; Reading AG; Manchester CAG; HMQ; Birmingham CAG; Yale; Tate; Lady Lever AG, Port Sunlight; Philadelphia MA; Leeds CAG; Kimbell Art Museum, Fort Worth, Texas; Stourhead, NT. **Engraved by** G.Zobel. **Literature:** Lord Leighton, *Addresses Delivered to the Students of the RA,* 1896; Mrs A.Lang, *Sir F.L. Life and Works,* 1884; J.Ward, *Lord L. Some Reminiscences and an Explanation of the Methods in which the South Kensington Frescoes were Painted,* nd; E.Rhys, *Sir F.L.,* 1895 and 1900; G.C.Williamson, *F., Lord L.,* 1902; A.Corkran, *L.,* 1904; Mrs R.Barrington, *The Life and Works of F.L.,* 1906; E.Staley, *Lord L.,* 1906; A.L.Baldry, *L.,* 1908; R & L. Ormond, *Lord L.,* 1975; C.Newall, *The Art of L.L.,* 1990; RA exh. cat. 1996; DA. Colour Plate 45

LEIGNES, John Charles **b.1763**
Baptized St Martin's-in-the-Fields 20 March 1763, son of Charles Peter Leignes and Louisa (née Belliard). An honorary exhibitor (from the age of 12) at SA (2), FS (4) 1776-80 from London.

LEIGNES, Miss Magdalen Louisa **b.1762**
Sister of John Charles Leignes. Honorary exhibitor (from the age of 12) at SA (2), FS (14) 1774-80 from London.

LEIVERS, William **fl.1776-1779**
Painted a portrait of 'John Cleaver', the Duke of Portland's agent, in 1776. Honorary exhibitor of animal subjects at RA (3) 1779. Probably worked in Nottinghamshire.

LE JEUNE, A. **fl.1825**
Exhibited at RA (1) 1825 from 45 Goodge Street, London.

LELY, John **fl.1737**
Grandson of Sir Peter Lely. A poem praising his paintings was published in *The Gentleman's Magazine* March 1737.

LELY, Sir Peter **1618-1680**
Born Pieter van der Faes at Soest, Westphalia 14 September 1618, son of a Dutch army captain stationed there. By 1637 he was using the name of Lely when he registered in the Haarlem Guild as a pupil of Frans Pietersz de Grebber. Reportedly adopted the surname Lely from the nickname given to his father who was born in a scent shop, The House of Lily, in The Hague. Moved to England c.1643 and first painted pastoral scenes before concentrating on portraiture. By 1647, when he became Painter-Stainer, he was employed by the Duke of Northumberland (who had the royal children

FREDERIC LEIGHTON. Memories – Edith Pullen. Exhibited 1883. 30 x 25ins (76.2 x 63.5cm) *Christie's*

PETER LELY. A lady of the Popham family. 30 x 25ins (76.2 x 63.5cm) *Philip Mould/Historical Portraits Ltd*

in his charge) to paint the imprisoned royal family (Syon House and Petworth). Studied his patron's important art collection, and based his portrait style on Van Dyck and Dobson. By the end of the Commonwealth, Lely had deservedly become the leading portraitist of his day. He painted Cromwell (Birmingham), but also skilfully retained the patronage of noble families prominent in the Restoration. Appointed Principal Painter to the King 1661. Naturalized 1662. His prices in the early 1650s were £5 for a head and £10 for a half-length; by 1660 these had risen to £15 and £25; and by 1671 £20 and £30 and £60 for a full-length. Became so successful that he had a factory of assistants churning out portraits and replicas of varying quality in a variety of lively stock poses (numbered for the convenience of his assistants). Work produced mainly by Lely's hand is always of an exceptionally high quality, in richness of colour, standard of draughtsmanship and portrayal of character. By the end of his life he had assembled an important collection of art, including more than 25 of Van Dyck's major English works. Knighted 1680. Died London 30 November 1680. Among his assistants, pupils and followers were John Baptist Gaspars, Willem Wissing, Matthew Dixon, Henry Tilson, Thomas Hawker (draperies), Joseph Buckshorn (draperies), John Greenhill, Frederic Sonnius, Jeremiah Van der Eyden, William Gibson, Prosper Henry Lankrink (backgrounds, flowers and ornaments) and Nicholas de Largillièrre (draperies and still-life).
Represented: Tate; NPG London; SNPG; NGI; Ham House; VAM; Syon House; Petworth House, NT; Birmingham CAG; NMM; Manchester CAG; Philadelphia MA; Audley End; Dulwich AG; Kimbell Art Museum, Fort Worth; J.Paul Getty Museum. **Engraved by** H.Adlard, J.S.Agar, F.Anderson, P.Audinet, A.Bannerman, F.Bartolozzi, F.Basan, I.Beckett, S.Bellin, A.Blooteling, E.Bocquet, P.Bouttats, T.Bragg, A.Browne, M.Burhers, R.Clamp, J.E.Clutterbuck, J.Cochran, R.Cooper, J.Corner, D.Coster, Damman, T.A. Dean, A. De

Blois, A. De Jode, E. Desrochers, R.Dunkarton, R.Earlom, W.Edwards, J.Enghels, B.Eredi, J.Faber jnr, F.W.Fairholt, W.Faithorne snr & jnr, E.Ficquet, W.Finden, S.Freeman, W.T.Fry, W.N.Gardiner, Godfrey, F.Goldar, V.Green, J.Griffer, C.Grignion, E.Harding, B & W.Holl, T.Holloway, J.Houbracken, E.Le Davis, D.Loggan, P.Lombart, J.Loyd, E.Luttrell, J.McArdell, G.Maile, W.Marshall, P.A.Massard, H.Meyer, A.Miller, A.Mongin, W.H.Mote, J.Nixon, J.Ogborne, R.Page, B. & C.Picart, M.Pitteri, G.Powle, R.Purcell, H.H.Quiter, W.Raddon, S.F.Ravenet, B.Reading, W.W.Ryland, P.Schenck, Schiavonetti, E.Scriven, T.S.Seed, C.Simonneau, A. & J.Smith, P.Stephani, J.Swaine, J.Thomson, P.W.Tomkins, R.Tompson, C.Townley, T.Trotter, C.Turner, J.Vander Vaart, G.Valck, P.Vanderbank, P. Van Bleeck, P. Van Somer, J.Verkolje, G.Vertue, A.Warren, J. & T.Watson, R.White, R.Williams, T.Worlidge, T.Wright, N.Yeates, J.Young. **Literature:** C.H.Collins Baker, *L. and the Stuart Portrait Painters...*, 1912; C.H.Collins Baker, *L. and Kneller*, 1922; R.B.Beckett, *L.*, 1951; O.Millar, *L.* NPG exh. cat. 1978; *Burlington Magazine* LXXXIII August 1943 p.185; executors' account book British Museum MS Add. 16,174; DA.
Colour Plate 44

LENS, Andrew Benjamin c.1713-c.1780
Son and pupil of Bernard Lens III. Painted portraits and miniatures. Exhibited at FS, SA 1764-79. Sometimes confused with Andries Lens 1739-1822, director of Antwerp Academy.
Represented: VAM; BM; Usher Museum, Lincoln.
Literature: Foskett.

LENS, Bernard (i) c.1630-1707/8
Is credited with a portrait of 'Archbishop Sancroft' at Emmanuel College, Cambridge (1650). Chiefly known as an enamel painter. Vertue records that he wrote a large book in

English on 'scriptural matters'. Died London 5 January 1707/8 aged 77. Buried St Bride's Church, Fleet Street, London.
Engraved by L.P.Boitard, J.Sturt. **Literature:** Foskett.

LENS, Peter Paul c.1714-c.1750
Son of miniaturist Bernard Lens iii. Apprenticed to his father 23 July 1729. Painted portraits and miniatures. A leading member of the Club in Ireland known as The Blasters, and professed himself a votary of the devil. After the Irish House of Lords took up the matter in March 1738, he fled to England.
Represented: VAM. **Literature:** Foskett.

LENTALL (LENTHALL) fl.1693-1702
Enjoyed some success in London as a portrait painter. Considered for a portrait of Queen Anne for the Guildhall 1702. Listed in the Claydon inventory 1740 as painting portraits of the second and third wives of 1st Lord Fermanagh.
Literature: *Burlington Magazine* CVI July 1964 p.308.

LEPAGE, Jules Bastien 1848-1884
Born Damvillers 1 November 1848, son of a wealthy farmer. Exhibited at Paris Salon from 1870. Visited Rome. Exhibited at RA (4) 1878-80 from Paris and a hotel in Ryder Street, London. Painted portraits of Sir Henry Irving, Sarah Bernhardt and Edward VII. Died Paris 10 December 1884. His influence was great, with painters of all nationalities imitating his naturalistic style.
Represented: NPG London; NGI; Louvre. **Literature:** A.Theuriet, *J.B.L and his Art – A Memoir*, 1892; J.Cartwright, *J.B.L.*, 1894; W.S.Feldman, *J.B.L – His Life and Work*, unpublished Ph.D. thesis, New York University 1973; Bénézit; K.McConkey, *Art History*, Vol I no.3 p.371-82.

LE ROHO, Henry Louis fl.1842-1852
Son of Xvon Le Roho. Worked as a portraitist in Paris. Exhibited at RA (6), SBA (1) 1842-6 from Clapham.

LESAC fl.1730
Studied at French Academy. A 'famous face-painter from Paris' who visited Dublin 1730.
Literature: Strickland.

LESCHALLAS, J. fl.1791-1823
Exhibited at RA (22), BI (3) 1791-1823 from London.

LESLIE, Charles Robert RA 1774-1859
Born Clerkenwell 19 October 1774, son of a watchmaker. Brought up in Philadelphia, where he studied under G.Sully. Apprenticed to a New York bookseller. Returned to England 1811, when he studied art in London under West and Allston, sharing rooms with Morse. Entered RA Schools 23 March 1813. Exhibited at RA (78), BI (11) 1813-59. Elected ARA 1821, RA 1826. RA Professor of Painting 1847-52. Visited Italy with C.W.Peale, but was mostly based in London, except for a few months in America 1833 to take up a post at the US Military Academy. Published autobiographical memoirs and biographies of Constable and Turner. A friend of Dickens, whose portrait he painted. Died St John's Wood 5 May 1859 in his sixty-fifth year.
Represented: NPG London; BM; Tate; VAM; Derby AG; Castle Museum, Nottingham; Hove Library; Williamson AG, Birkenhead. **Engraved by** T.Blood, J.W.Cook, S.Cousins, M.Danforth, P.Gauci, J.Hopwood, R.J.Lane, C.G.Lewis, D.Lucas, T.H.Maguire, H.Meyer, S.W.Reynolds jnr, H.Robinson, H.T.Ryall, Mrs D.Turner. **Literature:** J.Dafforne, *Pictures by C.R.L.*, 1875; J.Constable, *The Letters of J.C. and C.R.L*, 1931; Ottley; C.R.Leslie (ed), T.Taylor, *Autobiographical Recollections*, 1860.

LESLIE, George Dunlop RA 1835-1921
Born London 2 July 1835, son of C.R.Leslie. Entered RA Schools 1854. Exhibited at RA (113), BI (12), SBA (2), GG, NWG 1857-1921. Elected ARA 1868, RA 1876. For a time he lived in St John's Wood and was a member of The Clique. Moved to Wallingford on Thames 1884, where he lived on the riverside, next door to James Hayllar. Published *Riverside Letters*, 1896. His last years were spent at Lindfield, near Haywards Heath, where he died 21 February 1921.
Represented: Aberdeen AG; Tate; Brighton AG. **Literature:** B.Hillier, 'The St. John's Wood Clique', *Apollo* June 1964.

LESLIE, Sir John 1822-1916
Born London 16 December 1822. An amateur painter. Educated at Christ Church, Oxford. Served as Captain in the Life Guards. Visited Rome. Was a close friend of Richard Buckner, Herbert L.Wilson and Frederic Leighton. Studied under K.F.Sohn in Düsseldorf. Exhibited at RA (15), BI (2), SBA (1), GG 1853-67. Created baronet 1876. Lived at County Monaghan and was MP for the county. Died London 23/24 January 1916.
Represented: County Museum, Armagh. **Literature:** *American Art News* XIV 1916 No.17 p.4; *The Times* 28 January 1896.

LESLIE, Peter fl.1826-1827
Listed as a portrait painter at 14 London Street, Fenchurch Street, London.

LESLIE, Peter 1877-1953
Born London 3 June 1877, son of G.D.Leslie. Studied at Herkomer's School in Bushey. Exhibited at RA (43) 1899-1919. Lived at Riverside, Wallingford, Lindfield and in Bushey. Died 2 July 1953.

LESLIE, Robert Charles fl.1843-1887
Eldest son of artist George Dunlop Leslie RA. Specialized in marine subjects and for many years had a studio in Southampton, but he also painted genre and portraits. Exhibited at RA (38), BI (5), SBA (2), DG 1843-87. Author of several works on nautical subjects.

LESSORE, Jules RBA RI 1849-1892
Born Paris, son and pupil of lithographer, engraver and painter, Emile Aubert Lessore. Studied under F.J.Barrias. Worked mainly in England. Exhibited at RA (9), SBA (21), NWS, GG, Paris Salon 1864-92. Elected RI 1888.
Represented: VAM; Glasgow AG.

L'ESTRANGE Henry 1815-1862
Born Norfolk 25 January 1815. Portrait and miniature painter who worked in Halifax, Nova Scotia 1832-4. Died London 27 July 1862.
Literature: Burke's Peerage.

LETHBRIDGE, Walter Stephen 1772-c.1831
Baptized Charlton, Devon 13 October 1772, son of a farmer. Apprenticed to a house painter and assisted a travelling artist. Exhibited mostly miniatures at RA (43), SBA (4) 1801-29 from London. *The Kentish Gazette* 27 August 1805 reported 'Likenesses painted in miniature. Mr Lethbridge is just arrived in Canterbury. Price 3 guineas and upwards'. Retired to Plymouth 1831, where he is said to have died.
Represented: NPG London; BM; VAM. **Engraved by** H.R.Cook, R.Cooper, E.Scriven.

LEVESON, Miss Dorothy fl.1896
Exhibited at RA (5) 1896 from Cluny, Anerley, London.

LEVESON, Miss Mary E. fl.1899
Exhibited a presentation portrait of 'Admiral Sir Michael Culme Seymour, Bart KCB' at RA 1899 from Westminster.

LEVIN, Phoebus RBA fl.1836-1879
Born Berlin. Studied Berlin 1836-44 and exhibited there until 1868. Travelled to Rome 1845-7. Worked in London 1855-78. Exhibited at RA (11), BI (4), RHA (2), SBA (63). Elected RBA 1862.
Represented: London Museum.

LEWIS, Alfred Neville RP NEAC 1895-1972
Born Cape Town 8 October 1895. Educated in South Africa. Studied at Slade. Served in 1st World War in France, Italy and Belgium. Exhibited at NEAC, RP. Elected NEAC 1920, RP 1936. Painted portraits in South Africa, Spain and America. Died 26 June 1972.
Represented: Tate.

LEWIS, Arthur James 1824-1901
Exhibited at RA (38), BI (2), GG, NWG 1848-85 from London. Died London 24 November 1901.

LEWIS, C.H. fl.1841-1843
Exhibited at SBA (3) 1841-3 from Kensington.

LEWIS, Edward Goodwin fl.1860-72
Listed as a portrait painter at 79 Lord Street, Liverpool.
Represented: NPG London.

LEWIS, Frederick Christian jnr 1813-1875
Youngest son of artist and engraver Frederick Christian Lewis. Studied under Lawrence. Visited Persia 1836-8. Then India c.1840, where he remained for many years gaining the nickname Indian Lewis.
Represented: Government House, Madras. **Engraved by** F.C.Lewis snr. **Literature:** E.Cotton, 'F.C.L. – A Victorian Artist in the East', *Bengal Past and Present* XLIV 1932.

LEWIS, George Robert 1782-1871
Born London, younger brother of artist and engraver F.C.Lewis. Studied under Fuseli at RA Schools. Exhibited at RA (45), BI (17), SBA (20), NWS 1817-59 from London and Croydon. Also illustrated, engraved and published a number of books. Died Hampstead.
Represented: BM; Tate; Leeds CAG. **Engraved by** F.C.Lewis, J.Posselwhite.

LEWIS, John fl.1739-1757
Believed to have been Lord Egmont's tenant in London 1739-45. Worked as a 'good scene and portrait painter then in Dublin'. In Dublin 1750-7, where he painted Peg Woffington and Thomas Sheridan (1753). May be the John Lewis who exhibited at SA (11) 1762-76. Elected FSA 1768, Director 1775.
Represented: NPG London; NGI. **Engraved by** M.Jackson.

LEWIS, John Frederick RA POWS 1805-1876
Born London 14 July 1805, son of Frederick Christian Lewis snr. As a boy he studied animals with E.Landseer and also worked with T.Lawrence. Employed by George IV 1824 to paint sporting subjects at Windsor. Exhibited at RA (82), BI (25), OWS (100) 1820-77. Elected AOWS 1827, OWS 1829, POWS 1855, ARA 1859, RA 1865. Visited Switzerland and Italy 1827, Spain 1832-4, Paris 1837, Rome 1838-40 then Greece and Middle East, Cairo 1841-51. In 1850 his watercolour 'The Harem' created a sensation and Ruskin described it as 'faultlessly marvellous'. Died Walton-on-Thames 15 August 1876. Studio sale held Christie's 4 May 1877. Known chiefly for his meticulously detailed and richly coloured portrayals of eastern subjects, but his rare portraits are equally accomplished.
Represented: NPG London; VAM; Birmingham CAG; Tate; Leeds CAG; Ashmolean. **Engraved by** F.C.Lewis. **Literature:** R.Davies, 'J.F.L.', OWS III 1926; H.Stokes,

'J.F.L.', *Walker's Quarterly* XXVIII 1929; Major General M.Lewis, *J.F.L.*, 1977; DA.

LEWIS, John Hardwicke c.1840-1927
Born Hyderabad in 1840 or 1842, son and pupil of F.C.Lewis. Studied under Couture in Paris. From 1875-85 worked in California and London, drawing for newspapers. Exhibited at RHA (5) 1883-5. Then settled in Switzerland, where he illustrated a number of books. Died Veytaux, near Chillon.
Represented: VAM; Worcester CAG. **Engraved by** C.G.Lewis.

LEWIS, Percy Wyndham 1882-1957
Born Amherst, Nova Scotia 18 November 1882. Educated at Rugby. Studied at Slade 1898-1901. Member of Camden Town Group. Founded the Vorticists 1914 and edited *Blast*. Also wrote novels. Lost his sight 1951. Died London 7 March 1957.
Represented: NPG London; Tate; Brighton AG; Leeds CAG; Southampton AG; Manchester CAG. **Literature:** DA.

LEWIS, Thomas b.c.1806
Born Glasgow. Listed as aged 35 in 1841 census and aged 40 in 1851 census. Exhibited at RA (8), BI (1), SBA (14) 1835-49 from London. Painted a portrait of poet Thomas Hood. Recorded working 1852.
Engraved by R.J.Lane.

LEWTHWAITE, John fl.c.1830-1866
Born Cockermouth. Studied under Joseph Sutton. Exhibited at Mechanics Institution 1866.

LEYDE, Otto Theodore RSA RSW 1835-1897
Born Wehlau. Moved to Edinburgh in his youth. Exhibited a large number of works at RSA, RHA (1), RA (3) 1858-97. Elected ARSA 1870, RSA 1880, RSA Librarian 1886-96. Also an engraver. Died Edinburgh 11 January 1897.
Literature: *Art Journal* 1897 p.iv; McEwan.

LIDDELL, Miss Violet fl.1887
Exhibited a portrait at GG 1887.

LIEVENS, Jan 1607-1674
Born Leiden 24 October 1607. Associated in his early years with Rembrandt. Visited England 1632-5, where he is said to have painted portraits of the royal family. In Antwerp 1635-44. Moved to Amsterdam, where he died 4 June 1674.
Represented: SNPG; Brighton AG. **Literature:** H.Schneider, *J.L.*, 1932.

LILEY, William ARCA 1894-1958
Born Sunderland. Studied at Bede Collegiate School and Sunderland School of Art, where he was an outstanding pupil. Later attended RCA and Central School of Arts and Crafts, London before teaching art at Sunderland School of Art. Head of a school of art at Ashton-under-Lyne, remaining there until his retirement. Died Bollington, Cheshire.
Literature: Hall 1982.

LILLEY (LILLY), Edmund d.1716
Listed 1702 as one of the candidates to paint Queen Anne for the Guildhall, but failed to get the commission, although he did produce a number of portraits of her. Buried Richmond 23 May 1716.
Represented: Blenheim Palace; Royal College of Physicians; Lord Clarendon collection. **Engraved by** W.Faithorne jnr, J.Simon.

LILLEY, H. fl.1843
Exhibited a portrait of 'Mrs Romeo Coates' at RA 1843.

LILLEY (LILLY), John fl.1832-1853
Exhibited at RA (12), RHA (1), BI (3), SBA (15) 1832-46 from London. Painted 'The Duke of Wellington as Lord Warden of the Cinque Ports' for the Corporation of Dover (1837). Married Mary Ann Bulger in Bolton 1853.
Represented: India Office, London. **Engraved by** J.Scott.

LINDO, Francis (Joseph Beschey) 1714-c.1767
Reportedly born Isleworth or Antwerp. Painted portraits in oils and crayons in Lowland Scotland and in Aberdeenshire 1760-2, including busts and small full-lengths. His portraits can have considerable charm.
Represented: Esslemont; Traquair House. **Literature:** McEwan.

LINDSAY, Sir Coutts, Bart **RI** 1824-1913
Born Balcarres, Fife 2 February 1824, son of Lieut-Gen James Lindsay and Anne, daughter of Sir Coutts Trotter. Exhibited at RA (10), NWS, GG 1862-90 from London. Elected RI 1879. Painted the ceiling at Dorchester House. Helped found GG 1877 with his wife, Blanche Fitzroy. Their separation led to its closing 1890 and the founding of NWG. Died London 7 May 1913.
Literature: V.Surtees, *C.L. 1824-1913*, 1993; P.Mould, *Sleepers – In Search of Old Masters*, 1995, pp.195-205; DA.

LINDSAY, Miss Violet
see RUTLAND, Marion Margaret Violet, Duchess of

LINDSEY, S.Arthur **PRMS** fl.1902-1943
Exhibited at RA (34), RMS 1902-43 from Southbourne, Bournemouth and London.

LINEN, George 1802-1888
Born Greenlaw, Scotland. Studied at RSA. Worked as an itinerant portrait painter. Moved to USA 1834 with his brother, John. Died in America.
Represented: Maryland Historical Society.

LINEN, John c.1800-c.1860
Possibly born Greenlaw, Scotland. Moved to America with his brother George. Worked as a portraitist in New York.

LINGARD, Miss fl.1832-1834
Exhibited at SBA (3), BI (2) 1832-4 from London.

LINNELL, John 1792-1882
Born Bloomsbury June 1792, son of James Linnell, a carver and gilder. Studied with W.Hunt and Mulready under John Varley 1804, and under James Holmes. Entered, under the patronage of Benjamin West, RA Schools 28 November 1805 (Medallist 1807 and 1810). In 1812, aged 20, Linnell was converted and carried fundamentalist convictions to the extreme of refusing to be married in a church, always working on the sabbath, and later briefly joining the Plymouth Brethren. Married Mary Palmer 1817 and concentrated on portraiture until c.1847, when he gained a reputation for his spiritual landscapes. Exhibited at RA (177), RSA (36), BI (91), OWS (52) 1807-81 from Hampstead and Redhill. Elected OWS 1810-20, when he resigned to concentrate on landscape painting in oil. A friend and patron of William Blake and father-in-law to Samuel Palmer. Among his sitters were A.W.Callcott RA, William Mulready RA, T.R.Malthus, Thomas Phillips RA, Sir Robert Peel, Dr Crotch and Thomas Carlyle. Died Redhill 20 January 1882. Buried at Reigate. Story estimated Linnell's fortune after his death to be around £200,000. Three of his sons were painters.
Represented: NPG London; SNPG; BM; VAM; NGI; Tate; Brighton AG; Ashmolean; Fitzwilliam; Leeds CAG; Newport AG; Walsall AG; Ulster Museum; Southampton CAG;

FRANCIS LINDO. Lady Anne Patterson. Signed and dated 1761. Panel. 8 x 6⅜ins (20.3 x 16.2cm) *Christie's*

Cartwright Hall, Bradford. **Engraved by** J.Cochran, S.Freeman, W.T.Fry, M.Gauci, J.Guillaume, C.H.Jeens, H.Robinson, J.Scott, J.Thomson, C.W.Wass. **Literature:** A.T.Story, *The Life of J.L.*, 1892; Evan R.Firestone, *J.L.*, Ph.D dissertation, University of Wisconsin; K.Crouan, *J.L.: A Centennial Exhibition*, Fitzwilliam exh. cat. 1982/83; DA.

LINTON, J. fl.1680-1693
A committee member of Painter-Stainers 1680. Painted portraits of at least two Lord Mayors of London.
Engraved by R.White.

LINTON, Sir James Dromgole **PRI HRSW**
 1840-1916
Born London 26 December 1840, son of James Linton and Jane (née Scott). Studied at J.M.Leigh's Art School. Began his career as an illustrator for *The Graphic*. Exhibited at RA (22), SBA (4), NWS (104), RHA (1), GG, NWG, DG 1863-1916. Elected ANWS 1867, RI 1870, PRI 1884-98, 1909-16. Knighted 1885 (in which year he painted by royal command 'The Marriage of HRH the Duke of Albany KG'). Died London 3 October 1916. Studio sale held Christie's 19 January 1917.
Represented: VAM; Ashmolean; Cartwright Hall, Bradford; Dundee CAG.

LINTOTT, Edward Barnard **NPS** 1875-1951
Born London 11 December 1875. Studied at Académie Julian, Paris and École des Beaux Arts with brilliant academic success. In 1915 he was acting librarian at RA and art editor of the woman's supplement of *The Times*. Worked as an examiner for the Board of Education. Travelled to Russia and

JOHN LINNELL. John Chin. Signed and dated 1816. Panel. 11¾ x 8¾ins (29.8 x 22.2cm) *Christie's*

America. Exhibited at RA (21), RP, NPS, NEAC 1916-35. Died March 1951.
Represented: VAM.

LINTOTT, Henry John RSA **1877-1965**
Born 25 December 1877. Studied at Brighton, South Kensington, Paris and Italy. Exhibited at RSA, RA (12) 1905-33 from Edinburgh.

LION, Mrs Flora ROI RP NPS **1876-1958**
Born Flora Lion 3 December 1876. Studied at St John's Wood School 1894, RA Schools 1895-9 and Académie Julian, Paris under J.P.Laurens. Exhibited at RA (69), NPS, RP (83), ROI 1907-57. Elected ROI 1909, NPS 1910, RP 1911. Married 1915, her husband adopting her name. Died London 15 May 1958.
Represented: NPG London; Tate; SNPG.

LION, Pierre-Joseph **1729-1809**
Born Dinant 7 May 1729. Studied under Vien. Court painter at Vienna 1760. Visited London briefly 1770-1. Patronized by the Duke of Newcastle. Exhibited at SA (3) 1771. Returned to Dinant, gave up painting 1790. Died Dinant 1 September 1809. A fluent draughtsman, capable of catching considerable personality in his sitters.
Engraved by F.E.Adams, J.Watson.

LIOTARD, Jean-Etienne (John Stephen) **1702-1789**
Born Geneva 22 December 1702, son of Antoine Liotard, a French Protestant jeweller and twin brother of engraver Michel Liotard. Studied in Geneva under Daniel Gardelle and from 1725 under J.B.Massé in Paris, where he remained until 1736. Then travelled extensively in Naples, Rome, Constantinople 1738-43 (where he grew a beard and wore Turkish dress) and Vienna. His visits to England were between 1753 and 1755, when he painted all the children of the Prince of Wales (Windsor Castle). Left for Holland 1755, where he married 1756. To London again 1772. Exhibited at RA (3) 1773-4. Patronized by Sir William Ponsonby (later Earl of Bessborough), with whom he travelled. Died Geneva 12 June 1789. Although he also painted in oil and miniature he was the leading international pastel portraitist of his time and had a formulative influence on Francis Cotes.
Represented: Musée d'Art et d'Histoire, Geneva; VAM; Rijksmuseum; Hofbibliothek, Vienna; Castle Museum, Nottingham; Earl of Bessborough collection. **Engraved by** W.C.Edwards, J.Holland, R.Houston, C.Lasinio, J.McArdell, R.Purcell, J.C.Reinsperger, J.R.Smith, C.Spooner.
Literature: F. Fosca, *L.,* 1928, 1956; R. Loch & M.Röthlisberger, *L'opera completa di L.,* Milan 1978; DA; *Country Life* 6 June 1985.

LITCHFIELD, Miss Dorothy Fraser RP
fl.1917-1920
Exhibited at RA (4), RP 1917-19 from Kensington. Elected RP 1920.

LITTLE, George Leon **1862-1941**
Born London, son of Thomas Little. Exhibited at RA (2), SBA (7) 1884-1902 from Reigate and London. Among his sitters was H.Rider Haggard (NPG London). Died 13 May 1941.

LITTLER, William Farran **fl.1887-1892**
Exhibited at RA (1) 1892 from 36 Claverton Street, London.

LIVENS, Horace Mann **1862-1936**
Born Croydon, son of a colonial broker. Worked with his father in the city. Studied under Walter Wallis at Croydon School of Art. Then moved to Belgium, where he attended Antwerp Academy and joined the studio of Charles Verlat. Became friends with Vincent Van Gogh, on whose suggestion he went to France. Exhibited at RA, NEAC 1890-1904. Died London.
Represented: Tate; Toronto AG; Ottawa AG.

LIVERATI, C.E. **fl.1827-1828**
Exhibited at RA (3), SBA (1) 1827-8 from London.

LIVERSEEGE, Henry **1803-1832**
Born Manchester 4 September 1803. Moved to London 1827 to study at BM and BI. Failed to gain admission to RA Schools and returned to Manchester 1828. Exhibited at RA (5), BI (5), SBA (8) 1828-33. Collaborated with Alfred Vickers. Died Manchester 13 January 1832.
Represented: BM; VAM; Manchester CAG. **Literature:** C.Swaine, *Memoirs and Engravings from the Works of H.L.,* 1835; G.Richardson, *The Works of H.L.,* 1875; DA.

LIVESAY, Richard **1753-1826**
Born 8 December 1753. Entered RA Schools 21 March 1774 as a draughtsman. Lived in the house of Hogarth's widow 1777-85 and produced copies and engravings after Hogarth. Later became pupil and assistant to Benjamin West, for whom he painted copies at Windsor, where he moved 1790. Taught drawing to children of the royal family 1790-3. Exhibited at RA (69) 1776-1821. From 1796 he was drawing master at Royal Naval College, Portsea and painted and engraved marine subjects. Died Southsea 1826 (not 1823).
Represented: NPG London; Eton collection; NGI.
Engraved by F.Bartolozzi, J.Collyer, S.Freeman, R.Godfrey, J.Murphy, W.Ridley. **Literature:** *Bath Chronicle* 6 December 1826.

LIVINGSTON, John fl.1827-1834
Exhibited at RHA (52) 1827-34 from Dublin, where he had a highly successful portrait practice.

LIZARS, William Home **HRSA** **1788-1859**
Born Edinburgh, son and pupil of Daniel Lizars. Engraver and painter. Exhibited at RSA (24) 1808-30 from Edinburgh. Elected Associate Engraver 1826, Honorary RSA 1834. Died Jedburgh 30 March 1859.
Represented: SNPG; SNG. **Literature:** Bénézit; McEwan.

LLEWELLYN, Sir William (Samuel Henry William)
PRA RBA RI RP **1858-1941**
Born Cirencester 1 December 1858. Studied at South Kensington under Poynter, and in Paris under Cormon, Lefebvre and G.Ferrier. Exhibited at RA (188), SBA, NWS, GG, NEAC, NWG, RP 1884-1941. Elected NEAC 1887, RBA, RI, RP 1891, ARA 1912, RA 1920, PRA 1928-38, KCVO 1918, GCVO 1931. Painted many portraits of royalty and in 1910 painted the State portrait of Queen Mary. Married miniaturist Marion Meates. Died London 28 January 1941.
Literature: M.H.Dixon, 'The Portraits of Mr W.Llewellyn', *The Lady's Realm* 1906.

LLOYD, Mrs see MOSER, Miss Mary

LLOYD, Miss Ethel A. fl.1893-1899
Exhibited at RA (7) 1893-9 from Chelsea and Bonchurch, Isle of Wight.

LLOYD, James fl.1848
Listed as a portrait painter in Manchester.

LOCK, Beatrice (Mrs Fripp) 1880-1913
Exhibited at RA (5) 1906-12 from London.
Represented: NPG London.

LOCK, Frederick William b.c.1825
Born London and aged 56 in 1881 census. Exhibited at RA (2), SBA (6) 1845-71 from London. Among his sitters was 'Sir James Outram'. His portrait of Queen Victoria and Prince Albert was engraved (BM).

LOCKEY (LOCKY), Nicholas fl.1593-1624
Apprenticed to his brother Rowland 1600. Recorded working 1624.
Engraved by S. de Passe. **Literature:** O.Kurz, *Burlington Magazine* XCIX January 1957 p.15.

LOCKEY (LOCKY), Rowland c.1565-1616
Apprenticed to N.Hilliard 1581 for eight years. Painted miniatures and portraits on the scale of life. Produced a number of portraits for Hardwick 1608/10. He made his wife, Martha, executrix to his will and left 20s. to his apprentice John Langton and all his Italian prints and plasters to his brother Nicholas. Buried London 26 March 1616.
Represented: NPG London; St. John's College, Cambridge.
Literature: R.Strong, *Artists of the Tudor Court*, 1983 p.159; O.Kurz, *Burlington Magazine* XCIX January 1957 p.13; E.Auerbach, *Nicholas Hilliard*, 1961 pp.254-62; DA.

LOCKHART, William Ewart **RSA ARWS RSW RP**
 1846-1900
Born Eglesfield, Annan, Dumfriesshire, son of a farmer. Studied from the age of 15 at Trustees' Academy under J.B.MacDonald RSA (whose niece, Mary Will, he married 1868). Visited Australia 1863 due to bad health; on his return he settled in Edinburgh. Visited Spain 1867 and began painting Spanish genre in the manner of John Phillip. Exhibited at RSA (135),

RA (29), RHA (4), OWS, GG, RP 1861-99. Elected ARSA 1871, RSA 1878, RP 1897. Commissioned by Queen Victoria 1887 to record 'The Jubilee Ceremony at Westminster Abbey' (Windsor Castle). After this remained in London and concentrated on portraiture. Died London 9 February 1900. Painted with considerable bravura and much brilliance of colour.
Represented: Dundee AG; Aberdeen AG; Glasgow AG; Paisley AG, Walker AG, Liverpool; SNG. **Literature:** DNB; McEwan.

LOCKWOOD, (Robert) Wilton **NA** **c.1861-1914**
Born Witton, Connecticut in 1861 or 12 September 1862. Trained as a glass designer in New York City under La Farge; Art Students' League and in Paris under Benjamin Constant 1886. Worked as a portraitist in New York, then in London 1892 (where he married), Munich and Paris. Returned to America 1896, where he lived in Boston (although he also worked in New York). Elected ANA 1902, NA 1912. Died in Brooklyn, Massachusetts 20 March 1914.
Represented: Boston MFA.

LODDER, William Phillip James fl.1783-1805
Studied under De Loutherbourg. Exhibited at FS (1) 1783 and RA (14) 1801-4 from London. Married Mary Shoolbred 6 May 1805. Among his sitters were Sir Walter Stirling Bart, De Loutherbourg and HRH Prince William of Gloucester.
Engraved by T.Blood, A.Cardon, H.R.Cook, A.Easto.

LOEVIN, Martin Julius fl.1845
Exhibited at RHA (2) 1845 from Dublin.

LOGGAN, David 1634-1692
Born Danzig of Scottish descent. Baptized 27 August 1634. Studied under engraver W.Hondius, and under Crispin van der Pass in Amsterdam where he remained for seven years. Employed by the King's printers to engrave the title page of the Book of Common Prayer. Returned to London 15 June 1663. During the plague he left and had settled at Nuffield, near Oxford, by 1665. Appointed Public Sculptor to the Unversity 1669, with a stipend of 20s. per annum. Matriculated 1672. Naturalized 1675. Returned to London by 1676. Engraver to Cambridge University 1690. A fine plumbago portraitist on vellum. Among his pupils were Edward le Davis, Robert Shepherd, Robert White and Michael Vander Gucht. Buried St Martin's-in-the-Fields 1 August 1692.
Represented: NPG London; BM; VAM. **Engraved by** M.Burghers, G.B.Cipriani, R.Clamp, R.Dunkarton, R.Earlom, W.Elder, R.Graves, C.Grignion, D.Loggan, R.Page, B.Reading, C.Turner, M.Vander Gucht, G.Vertue, A.Walker, R.White. **Literature:** DNB; Walpole Society Vol XIV pp.55-64; DA.

LOGSDAIL, William **RP NEAC** **1859-1944**
Born Lincoln 25 May 1859. Studied at Lincoln Art School under E.R.Taylor and in Antwerp under Verlat, with his friend Frank Bramley. Exhibited at RA (96), SBA, GG, NEAC, NWG, RP 1877-1926 from Lincoln, Venice, London and Oxford. Elected RP 1913. Died Oxford 3 September 1944. A skilful and sensitive artist.
Represented: Tate; Walker AG, Liverpool.

LOMAS, William jnr fl.1877-1890
Exhibited at RA (7), RHA (6), SBA (1) 1877-89 from Brussels and London.

LONDON, Thomas fl.1856
Listed as a portraitist at 11 Miles Buildings, George Street, Bath.

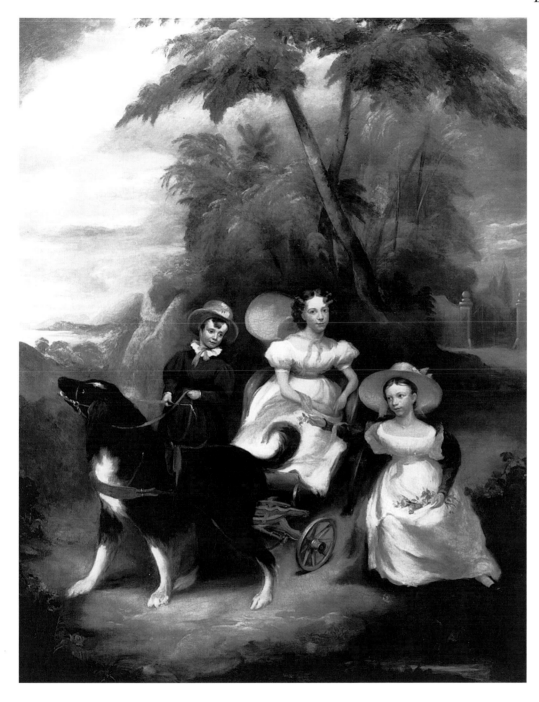

JOHN LIVINGSTON. Three children, thought to be the McGillycuddy family. Signed and dated 1832. 44½ x 36ins (113 x 91.5cm) *Christie's*

LONG, Edwin RA 1829-1891
Born Bath 12 July 1829. Studied under John Phillip. Began by painting portraits and Spanish subjects, but later was known for his large biblical and historical subjects, often set in Egypt. Exhibited at RA (93), BI (13), RHA (1), SBA (4) 1855-91. Elected ARA 1876, RA 1881. In 1875 his 'Babylonian Marriage Market' created a sensation at RA and sold for an amazing 7,000 guineas. Among his sitters were Henry Irving, Samuel Cousins RA and Lord Randolph Churchill. Died Hampstead 15 May 1891.
Represented: NPG London; VAM; Russell-Cotes Museum, Bournemouth; Guildhall AG, London. **Engraved by** S.Cousins. **Literature:** *Art Journal* 1891 p.222; R.Quick, *The Life and Works of E.L.,* 1931; DA.

LONG, Richard Joseph fl.1914
Exhibited at RHA (2) 1914 from Galway.

LONG, William fl.1821-1855
Exhibited at RA (33), BI (13), SBA (19) 1821-55 from London.

LONGSTAFF, Sir John RP 1862-1941
Born Clunes, Victoria 10 March 1862, son of Ralph and Jessie Longstaff. Studied at Melbourne NG Art Schools under G.F.Folingsby and in Paris under Cormon. Exhibited at Paris Salon, RP and RA (30) 1891-1920 from East Melbourne and London. Elected RP 1915. Knighted 1928. Died 1 October 1941.
Represented: NPG London. **Literature:** N.Murdoch, *Portrait in Youth of Sir J.L.,* 1948.

LONSDALE, James RBA **1777-1839**
Born Lancaster 16 May 1777. Encouraged by an architect named Threlfall, and the Duke of Hamilton, then Lord Archibald who invited him to Ashton Hall. Studied under Romney in London, and was one of his favourite pupils, accompanying Romney abroad as both companion and pupil. Entered RA Schools 23 October 1801. Exhibited at RA (137), BI (7), SBA (88), LA 1802-38 from London. Married a lady from Lancaster by the name of Thornton, who resided at Southgate. Established a highly successful practice and on the death of Opie was rich enough to purchase his studio in Berners Street, where he resided the rest of his life. Among his sitters were the Duke of Hamilton, the Marquess of Downshire, the Duke of Norfolk, HIH the Grand Duke Nicholas, HRH the Duke of Sussex, the Duke of Argyll, the Duke of Somerset, J.Nollekens RA, HIH the Archduke Maximilian and HRH Prince Leopold of Saxe-Coburg. Appointed portrait painter to Queen Caroline. Died London 17 January 1839. He had three sons, one a portrait painter, one a barrister and the other a surgeon. Said to have been highly esteemed and extremely witty.
Represented: NPG London; VAM; Walker AG, Liverpool. **Engraved by** G.Adcock, A.Cardon, G.Clint, H.Cook, H.Cousins, S.Freeman, T.Hodgetts, J.Jenkins, R.J.Lane, T.Lupton, J.Porter, S.W.Reynolds, E.Scriven, W.Skelton, J.Thomson, C.Turner, C.Warren, W.H.Worthington. **Literature:** *Art Union* 1839 p22.

LONSDALE, Richard Threlfall **b.1813**
Baptized London 17 December 1813, son of portrait painter James Lonsdale and his wife Jane. Exhibited at RA (16), BI (13), SBA (29) 1826-49 from London.
Engraved by D.Lucas.

LORIMER, John Henry RSA RSW RP RWS
 1856-1936
Born Edinburgh 12 August 1856, son of Professor James Lorimer LLD. Studied at RSA under McTaggart and Chalmers, and in Paris under Carolus Duran 1884. Exhibited at RSA (121), RHA (2), RA (45), RP, Paris Salon (medallist 1890, 1896) 1873-1916. Elected ARSA 1882, RP 1892, RSA 1900, Correspondant de L'Institut de France 1903, ARWS 1908, RWS 1932. Died Pittenweem 4 November 1936. His portraits were usually highly finished with exquisite colour and luminosity. His work was admired by Leighton and Millais.
Represented: SNPG; Tate; Government House, Madras; Philadelphia AG; Royal & Ancient Golf Club, St Andrews. **Literature:** *Art Journal* 1895 pp.321-4; McEwan.

LOUD, Arthur Bertram RCA **1863-1931**
Born Arthur Bertram Jones in Peckham 17 May 1863, son of artist Charles Jones. Studied at RA Schools 1880 and at Académie Julian, Paris. Exhibited at RA (3) 1884-7. Elected RCA 1890. Changed his name officially 1908 although he had been using Loud prior to this date. Died 23 October 1931.

LOUDAN, William Mouat NPS RP **c.1868-1925**
Born London (Bénézit says 1860, Wood 1868), of Scottish parents. Educated at Dulwich College. Studied at RA Schools (winning a Gold Medal and travelling scholarship) and under Bouguereau in Paris. Exhibited at RA (68), RHA (1), SBA, GG, NPS, NWG, RP 1880-1925. Member of Art Workers' Guild and NPS. Elected RP 1891. Died 26 December 1925.
Represented: Birmingham CAG; Leeds CAG; VAM; Walker AG, Liverpool.

LOUREIRO, Artur José **1853-1932**
Born Oporto, Portugal 11 February 1853. Studied there at Fine Art Academy and at Académie des Beaux Arts under A.Cabanel. Briefly visited London but in 1884 had to seek a warmer climate for his health and moved to Melbourne.
Literature: *Australian Dictionary of Biography*.

LOVE, Horatio Beevor **1800-1838**
Born Norwich. Exhibited there and at SBA. Listed as a portrait painter at Pottersgate, Norwich. Among his sitters were John Sell Cotman and James Stark.
Represented: NPG London; VAM; BM; Castle Museum, Norwich.

LOVEJOY, R.W. **fl.c.1680**
Painted an accomplished portrait of 'Mary, Duchess of Norfolk' c.1680 in the manner of Riley. He signed it on the reverse.

LOVELL, Robert S. **fl.1889-1890**
Exhibited at RA (2) 1889-90 from Bayswater, London.

LOVER, Samuel RHA **1797-1868**
Born Dublin 24 February 1797, son of S.Lover, a lottery office keeper and money changer. Worked in his father's office from the age of 13 until 17. Fell out with his father, left home and took up art, teaching drawing and studying at the same time. Encouraged by J.Comerford and moved to London 1834. Exhibited mostly miniatures at RA (58), RHA (119) 1832-62 from London, Dublin and Sevenoaks. Elected ARHA 1828, RHA 1829. Visited America 1846-8 and retired to Jersey c.1864, where he died 6 July 1868. Buried Kensal Green Cemetery 6 or 15 July 1868.
Represented: NPG London; NGI. **Engraved by** W.Greatbach. **Literature:** Foskett.

LOVERIDGE, John **fl.1855**
Listed as a portraitist at 17 Great Orford, Liverpool.

LOVERING, Miss Ida **fl.1881-1914**
Niece of artists Alfred and Henry Tidey. Exhibited at RA (14), SBA (3), NWS 1881-1914 from London. Member of Society of Lady Painters.

LOWE, Mauritius **1746-1793**
Reportedly an illegitimate son of 2nd Lord Southwell, who made him an allowance. A friend of Dr Johnson. Studied under G.B.Cipriani. Entered RA Schools 9 August 1769, where he was awarded a Gold Medal for 'Time Discovering Truth'. Awarded the first RA travelling scholarship and visited Rome 1771. The following year his scholarship was discontinued due to his 'indolence'. Married a servant girl by whom he had a number of children. Exhibited at SA, RA (12) 1766-86. Died in squalor in London 1 September 1793.
Represented: VAM. **Literature:** Ottley.

LÖWENTHAL, Emil **1835-1896**
Born Jarocin, son of Steffeck Lowenthal. Exhibited at RA (6), RHA (1) 1865-83 from Rome. Among his sitters were John Gibson. Died Ems.
Represented: Pitti Palace, Florence; Academy Saint-Luc, Rome.

LOWRY, Matilda (Mrs Heming) **fl.1804-1855**
Daughter of Wilson Lowry, the engraver. Won a Gold Medal at SA 1804. Exhibited at RA (4) 1808-55 from London.
Represented: BM; VAM.

LOWRY, Strickland **1737-c.1785**
Born Whitehaven. Practised there and in the Midlands as a portrait painter. Worked in Dublin c.1768 and Northern Ireland for several years. Then practised in Worcestershire, Shropshire and Staffordshire. Produced engravings for *The History and Antiquities of Shrewsbury*, 1779. Believed to have died Worcester. His style resembles that of Joseph Wilson, and his son was christened Wilson Lowry.
Represented: Ulster Museum.

LOWTHER, Phineas fl.1830-1831
Listed as a portrait painter in Hull.

LOWTHER, T. fl.c.1800
A primitive portrait painter working in Carlisle c.1800.
Represented: Carlisle AG.

LUCAS, John 1807-1874
Born London 4 July 1807, son of William Lucas. Apprenticed to mezzotint engraver S.W.Reynolds 1821. Accompanied his master to Paris, and was encouraged in his natural aptitude for painting. On his return to London he built up a highly successful society portrait practice. Exhibited at RA (95), BI (13), SBA (7) 1828-74. Among his sitters were the Prince Consort (whom he painted four times), Queen Adelaide, the Duke of Wellington, the Earl of Egremont, Joseph Hume, George and Robert Stephenson and Gladstone. Became exhausted from completed commissions and for health reasons moved to St John's Wood, where he built a house and studio next door to Edwin Landseer. Died 30 April 1874, three days after the effects of a minor operation, incompetently performed by a doctor recommended by a friend. Studio sale held Christie's 25 February 1875. His style is similar to that of Richard Buckner, whom he knew, but the brushwork is usually more reserved and deliberate. A list of sitters is in his biography by his son Arthur. His son, John Templeton Lucas, was also an artist and another son, William, is recorded producing replicas 1861.
Represented: NPG London; Hatfield House; HMQ; NGI; Chatsworth; Petworth House, NT; Chesterfield Town Hall. **Engraved by** T.O.Barlow, S.Bellin, J.Bromley, W.O.Burgess, J.J.Chant, J.Cochran, H. Cook, H. & S.Cousins, J.F.Dicksee, S.Freeman, M.Gauci, L.Haghe, T.Hunn, W.T.Knight, G.T.Payne, S.W.Reynolds jnr, E.Scriven, Miss Turner, W.J.Ward, G.Zobel. **Literature:** *Art Journal* 1874 p.212; A.Lucas, *J.L. Portrait Painter,* 1910.
Colour Plate 46

LUCAS, John Seymour **RA RI NWS** 1849-1923
Born London 21 December 1849, son of Henry Lucas and nephew of John Lucas. Worked for a monumental sculptor and was apprenticed to Gerald Robinson, a wood carver. Studied at St Martin's School of Art, RA Schools from 1871 and under J.Lucas. Exhibited at RA (214), SBA (17), NWS 1871-1923 from London. Elected ANWS 1876, NWS 1877, ARA 1886, RA 1898, RI 1877. Married artist Marie Elizabeth Cornelissen 1877. Died Southwold 8 May 1923.
Represented: NPG London; VAM (including manuscripts); Birmingham CAG; Southampton CAG; Tate; BM.

LUCAS, Mrs Marie Elizabeth Seymour (née Cornelissen) 1855-1921
Born Paris 23 April 1855. Studied Paris, at RA Schools and in Germany. Exhibited at RA (45), SBA, NWS 1877-1913. Illustrated children's books. Married artist, John Seymour Lucas, 1877. Died 25 November 1921.
Literature: *Connoisseur* Vol 66 1923 p.114.

LUCAS, Miss May Lancaster fl.1888-1910
Exhibited at RA (9), Paris Salon 1888-1910 from London.

LUCAS, Ralph W. 1796-1874
Exhibited at RA (45), BI (12), SBA (19), NWS 1821-52 from Woolwich, Greenwich and Blackheath.

LUCAS, William b.1762
Studied under William Burgess. Exhibited crayon portraits from the age of 10 at FS (2) 1772-80.

LUCAS, William c.1840-1895
Born London, nephew of John Lucas, and brother of

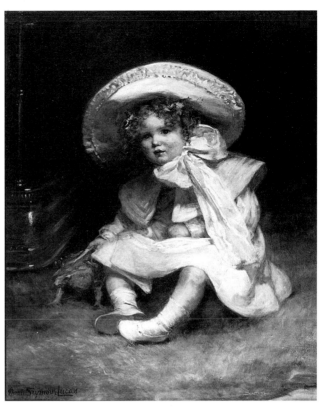

MARIE ELIZABETH SEYMOUR LUCAS. Muriel, daughter of Sir Charles Swinfen Eady, QC. Exhibited 1909. Signed. 37 x 31ins (94 x 78.7cm) *Christie's*

J.S.Lucas. Exhibited at RA (15), BI (2), SBA (12), NWS (100) 1856-80. Elected ANWS, but resigned 1882 when it moved to the Piccadilly Institute. Died London 27 April 1895.
Literature: *Art Journal* 1895 p.191.

LUCY, Charles 1692-c.1736
Born London. Travelled to Florence 1705, where he studied with Pietro Dandini, and eight years with Cignani at Forli. Then practised portraiture in Bologna. His portraits of the singers Farinelli and Gizziello were reproduced in mezzotint by Alexander van Haecken in 1735/6.

LUCY, Charles 1814-1873
Born Hereford. Studied at École des Beaux Arts under Paul Delaroche, and at RA Schools. Lived for about 16 years at Barbizon, where he painted historical subjects. Exhibited at RA (42), BI (14), SBA (9), RHA (7), NWS 1838-73 from London. Won prizes in Westminster Hall competitions in 1844, 1845 and 1847. Commissioned to paint a series of portraits of eminent men including Oliver Cromwell, Nelson, Bright, Cobden and Gladstone (VAM). Died Notting Hill 19 May 1873. Studio sale held Christie's 4 and 5 March 1875.
Literature: *Art Journal* 1873 p.208; DA.

LÜDERS, David c.1710-1759
Born Hamburg. Visited England c.1748-55. Painted 'George III as Prince of Wales' which was reproduced in mezzotint by McArdell 1753. Died Moscow.
Represented: Penshurst.

LUDLOW, Henry Stephen 'Hal' b.1861
Born Newport, Monmouthshire 15 January 1861. Studied at Heatherley's. Exhibited at RA (13), RI 1908-28 from London. Also worked for *The Illustrated London News* and *The Sketch*.

LUDOVICI, Albert **1820-1894**
Exhibited at RA (25) 1848-89 from London.
Represented: NPG.

LUMLEY, Captain Augustus Savile **fl.1855-1881**
Enlisted in 2nd Regiment of Life Guards 23 November 1849.
Lieutenant 25 November 1853, Captain 27 November 1857.
Exhibited genre and portraits (including HRH the Prince of
Wales) at RA (8), BI (7), RHA (2), SBA (7) 1855-81 from
London.

LUMLEY, George **fl.c.1700-1716**
Practised in Yorkshire as an amateur portrait painter in
crayons. A kinsman of Ralph Thoresby, who sat to him for his
portrait in crayons 1710.

LUMSDEN, Ernest Stephen RSA RE **1883-1948**
Born London 22 December 1883. Intended to join the Navy,
but was forced to leave through ill health. Studied art at
Reading under Morley-Fletcher and in Paris. Exhibited at
RSA, RA (2), RE. Died 29 September 1948.
Represented: SNPG.

LUND, Niels Moeller RBA ROI ARE **1863-1916**
Born Faaborg, Denmark 30 November 1863. Moved with his
parents to Newcastle at the age of four. Studied at Newcastle
School of Art, St John's Wood, RA Schools and Académie
Julian, Paris. Exhibited at RA (43), RSA, RHA (1), RI, Paris
Salon (Gold Medallist) and in Northumbria 1887-1916 from
London. Elected RBA 1896, RI 1897. Died London 28
February 1916.
Represented: Laing AG, Newcastle; Shipley AG, Gateshead.
Literature: Hall 1982.

LUNDGREN, Egron Sellif OWS **1815-1875**
Born Stockholm. Studied in Paris for four years. Went to Italy
1841, where he remained for eight years. Served under
Garibaldi at the siege of Rome 1849. Then lived in Spain for
10 years. Met F.W.Topham and J.Phillip in Seville c.1852 and
they persuaded him to move to London 1853. Then went to
India, where he was on Lord Clyde's staff during the
campaigns in 1857. Visited England again and undertook
several commissions for the Queen. Continued to travel
widely, and his last years were divided between London and
Stockholm. Died Stockholm. His portrait drawings followed
in the manner of A.E.Chalon.
Represented: BM; VAM; Maidstone Museum; Fitzwilliam.

LUNTLEY, James **fl.1851-1858**
Exhibited at RA (6), BI (1) 1851-8 from London.

LUSH, John **1808-1884**
Baptized Frome 27 August 1808. Worked in Chichester during
the 1830s. Later emigrated to South Australia and died there
13 March 1884. His diary is in West Sussex Record Office.

LUTTICHUYS, Simon **1610-c.1662/3**
Baptized London 6 March 1610 of a Dutch family. Appears
to have worked as a portraitist and still-life painter in England
and is possibly the 'Simon Littlehouse' who was paid in
January 1637/8 for a full-length portrait of 'Bishop Thomas
Morton' at St John's College, Cambridge. Died Amsterdam
c.1662/3.
Literature: W.R.Valentiner, *The Art Quarterly* I 1938 p.151.

LUTTRELL (LUTTERELL), Edward c.1650-c.1724
Reportedly born Dublin, but moved early to London.
Believed to have studied law at New Inn, before taking up art

professionally. Studied crayons under Ashfield. His first works
appear to begin in the early 1680s and he invented a
technique of using pastel on a prepared copper plate.
Produced pastel copies after Rembrandt in this manner, as
well as small portraits at which he later became accomplished.
One of the first native practitioners of mezzotint. Is known to
have signed in monogram 'E.L.' or in a flamboyant
copperplate scroll. Wrote a *Technical Treatise* 1683 (BAC Yale
MS).
Represented: NPG London; NGI; Bodleian; VAM.
Engraved by Vanderbank, Vander Gucht, R.Williams.
Literature: P.J.Noon, *English Portrait Drawings and
Miniatures*, 1979 p.11; Walpole Society V 1915-17 pp.1-18.

LUTYENS, Charles Augustus Henry **1829-1915**
Exhibited at RA (45), BI (11), SBA, GG 1860-1903 from
Lutzen and London. Died Thursley, Surrey 19 May 1915.

LUXMOORE, Miss Myra E. **1851-1919**
Exhibited at RA (19), SBA 1887-1918 from London.

LYALL, Mrs Laura (née Muntz) **1860-1930**
Born Radford, Warwickshire 18 June 1860, daughter of
Eugene Gustavus Muntz. Moved to Canada, aged nine, with
her parents, and was brought up on a farm in Muskoka.
Studied in England 1887 and several years later in France,
Holland and Italy. Elected Associate of Royal Canadian
Academy 1895. Married Charles W.B.Lyall 1915. Died
Toronto 9 December 1930. Gained a reputation for her
portraits of children.
Literature: *Dictionary of Canadian Biography.*

LYNCH, Henry **fl.1840**
Listed as a portrait painter in Euston, London.

LYNCH, Thomas **fl.1845-1855**
Listed as a portrait painter in Manchester.

LYNE, Richard **fl.c.1572-1598**
Employed as a portraitist by Archbishop Parker c.1572.
Listed as a painter 1598.
Engraved by T.A.Dean, R.Hogenberg, C.Picart, W.Rontoul,
P.Simms, M.Tyson, R.White.

LYON, Robert RP RBA **b.1894**
Born Liverpool 18 August 1894. Studied at Liverpool School
of Art, RCA and British School in Rome. Exhibited at RA
(42), RP, RSA (48) and in the provinces. Principal of
Edinburgh Art College 1942-60. Elected RP 1965. Said to
have retired to Eastbourne in 1960.

LYSTER, Richard **d.1863**
Born Cork. Began work as a clerk in the office of Murphy,
official assignee. His employer encouraged him in art and
assisted him to go to Rome to study. Remained in Italy five
years, before settling in Cork. Exhibited RHA 1858-62. He
had caught malaria in Rome and for many years fought an
enfeebled constitution and consumption. Died Cork 1
August 1863.
Literature: *Cork Daily Herald* 3 August 1863; Strickland.

LYTHAM, Henry **fl.1845**
Listed as a portraitist at 6 Wharfe Street, Salford.

LYTTELTON, Lady Elizabeth **1716-1795**
Amateur painter in crayon and oils. Had an unsuccessful
marriage to 1st Lord Lyttelton and they separated. Honorary
exhibitor at SA (2), RA (3) 1774-80.

M

M'CALL, William **b.c.1786**
Entered RA Schools 3 September 1818 aged 22. Listed as a
portrait painter in London. Exhibited at RA (25), BI (19),
SBA (6) 1818-37. Among his sitters were 'W.James Author
of the Naval History of Great Britain' and actresses from the
Theatre Royal, Covent Garden.
Engraved by H.Meyer, C.Turner.

MACARTAN, Luke **fl.1829-1833**
Exhibited at RHA (1), RA (3) 1829-33 from London.
Among his sitters were 'Patrick Gibson of His Majesty's Royal
Navy aged 111' and William Bewick.
Engraved by T.Lupton.

MACARTHUR, Miss Blanche F. **b.1847**
Born London, daughter of John Robert MacArthur (an attorney)
and his wife, Mary Ann. Aged 24 in 1871 census. Exhibited at RA
(18), RHA (65), SBA (49) 1870-94 from London.

MACARTNEY, Carlile Henry Hayes **1842-1924**
Exhibited at RA (28) 1874-97. Based in London, but painted
in Devon, Cornwall, France and Italy. Settled in Edenbridge
from the early 1890s. Died Newbury 29 November 1924.

McBEAN, Miss M.E. **fl.1856-1859**
Exhibited at RA (2) 1856-9 from London.

MACBETH, James **1847-1891**
Born Glasgow, son of Norman Macbeth. Exhibited at RA (15),
SBA (7), NWS, GG 1872-84 from London and Edinburgh.

MACBETH, L. **fl.1886**
Exhibited at RA (1) 1886 from Edinburgh.

MACBETH, Norman RSA **1821-1888**
Born Aberdeen. Served an apprenticeship as an engraver at
Glasgow. Studied painting at RA Schools and in Paris. He had
a portrait practice in Greenock from 1845, then Glasgow
1848, Greenock again 1856 and Edinburgh from 1861.
Specialized in presentation portraits for colleges and
institutions. Exhibited at RSA (196), RA (26) 1846-88.
Elected ARSA 1870, RSA 1880. Died Hampstead 27
February 1888. His sons Henry Macbeth-Raeburn RA and
Robert Walker Macbeth RA were also artists.
Represented: SNPG; Glasgow AG; Government House,
Madras. **Engraved by** E.Burton, J.R.Jackson. **Literature:**
DNB.

MACBETH, Robert Walker RA RI RWS
 1848-1910
Born Glasgow 30 September 1848, son of artist Norman
Macbeth. Educated in Edinburgh and Friedrichsdorf. Studied
at RSA Schools. Moved to London 1871, where, with his
friends E.J.Gregory and H.Von Herkomer, he joined the staff
of the newly founded *Graphic*. Studied at RA Schools from
1871. Exhibited at RA (162), OWS, NWS, DG 1869-1909.
Elected ARA 1883, AOWS 1871, RWS 1901, RA 1903.
Latterly lived at Washford, near Dunster. Died Golders Green
1 November 1910. Also a distinguished printmaker.
Represented: Tate; VAM; Aberdeen AG; Manchester CAG.
Literature: *Art Journal* 1900 pp.289-92; DA.

MACBETH-RAEBURN, Henry RA RE 1860-1947
Born Helensburgh 24 September 1860, son of Norman
Macbeth RSA. Studied at RSA Schools and Académie Julian,
Paris. Began as a portrait painter 1884. Took up engraving
(mostly after the work of eminent portraitists) 1890. Exhibited
at RA (156), RSA, RE 1881-1948 from Edinburgh, London,
Newbury and Dedham. Elected ARE 1894, RE 1920, ARA
1922, RA 1933. Died Dedham 3 December 1947.
Represented: VAM.
Colour Plate 47

McBEY, James **1883-1959**
Born Newburgh, Aberdeenshire 23 December 1883, son of
James McBey, a farmer, and Annie Gillespie, a blacksmith's
daughter. Worked as a clerk at North of Scotland Bank,
Aberdeen 1899-1910. Moved to London, where he held his
first exhibition 1911, which was a great success. Exhibited at
RA (15), RSA (12), RI, GI 1912-39. Official war artist to
Egyptian Expeditionary Force 1917-18 and accompanied the
advance through Palestine and Syria. Worked widely on the
Continent. Lived in America for some years, becoming a
citizen of USA 1942. Died Tangier 1 December 1959. He
regarded Rembrandt and Whistler as his masters.
Represented: NPG London; Aberdeen AG; Boston Public
Library; Imperial War Museum; Leeds CAG; Cummer AG,
Jacksonville; NG Washington; BM; VAM; Brodie Castle; NG
New Zealand. **Literature:** N.Barker (ed), *The Early Life of
J.McB. – An Unfinished Autobiography 1883-1911*, 1977;
M.C.Salaman, *J.McB.*, 1924; DNB; McEwan.

MACBURNEY, James (Jacobus) **b.1678**
Baptized Jacobus MacBurney at Great Hanwood, Salop 13
June 1678 (born May 1678), son of Jacobi and Mariae
MacBurney. Studied under Dahl, but did not take up art
professionally until after his second marriage to Anne Cooper at
Shrewsbury 6 May 1721. Shortened his name to Burney
c.1726. Established in the 1730s a successful provincial practice
in Chester, attracting the patronage of Lord Cholmondeley. His
son was musicologist Charles Burney 1726-1814.
Literature: P.Scholes, *The Great Dr. Burney*, 1948 pp.1-3, 10.

McCALL see M'CALL

McCAUSLAND, Miss Charlotte Katherine
 fl.1885-1904
Exhibited at RA (7), SBA (9) 1885-1904 from London.

MACCO, Alexander **1767-1849**
Born Cretglingen 29 March 1767. Studied with engraver
Arzberger. Went to Mannheim 1781-4, where he studied at the
Academy under Verschaffelt (winning a Gold Medal). Went to
Rome 1784-97 and worked for a time in Germany, Austria,
Bohemia, Berlin 1800 and from 1807 Prague, Vienna, Frankfurt,
Mannheim and Paris. From 1807 to 1816 he was chiefly in
Vienna, and 1817-19 in Frankfurt and Hamburg. Visited England
1825-7, returning to Germany. Died Bamberg 24 June 1849.

McCORMAC, Andrew **1826-1918**
Born Belfast. Began as a Baptist minister, but turned to
portrait painting. Studied at Lee's Academy, London. Went
to Australia in the first paddle-steamer to cross the Atlantic
1868. Settled in Victoria, then South Australia. Awarded
Gold Medal at International Exhibition, London 1862.
Represented: NG, South Australia.

McDONALD, Alexander **1839-1921**
Probably studied under Herkomer at Bushey. Exhibited at
RA (10) 1893-1913 from Bushey and Winchester. Among his
sitters were Frederick Morris Fry, Master of the Merchant
Taylors' Company, and the Earl of Lichfield.

MACDONALD, Daniel (formerly James McDaniel)
1821-1853
Exhibited at RHA (7), RA (1), BI (4) 1832-53 from Cork and London.
Represented: NPG London.

MACDONALD, Miss Frances **1874-1921**
Studied Glasgow School of Art. Member of Glasgow Group. Married artist Herbert McNair 1900. Some of her work was destroyed by her husband after her death.
Represented: Glasgow AG. **Literature:** McEwan.

MACDONALD, Miss H.M. **fl.1873**
Exhibited at RA (1) 1873 from London.

MACDONALD, James **fl.1878**
Listed as a portraitist at 3 Balfour Street, Leithwalk, Edinburgh.

McDONALD, John Blake RSA **1829-1901**
Born Boharm 25 May 1829. Studied under R.Scott Lauder at RSA. Exhibited at RSA (166), RHA (6) 1857-1902 from Edinburgh. Elected ARSA 1862, RSA 1877. Died Edinburgh 20 December 1901.
Represented: Dundee AG; Crathes Castle.

McDONALD, Miss Madeline M. **fl.1896-1941**
Exhibited at RA (20) 1896-1941 from London.

McDONALD, P.J. **fl.1849-1850**
Exhibited at RHA (10) 1849-50 from Dublin.

MACDONALD, Somerled **1869-1948**
Born Isle of Skye. Exhibited RA (2), RSA (16). Died Inverness. His portrait of John Stuart Blakie is in NPG London.
Literature: *The Scotsman* 29 March 1948.

McDOWELL, Daniel **b.c.1820**
Born Cork. Listed as a portrait painter aged 31 in 1851 census for 56 Berners Street, London.

McENTEE, M. **fl.1842**
Exhibited at RHA (1) 1842 from Dublin.

McEVOY, Arthur Ambrose ARA ARWS RP NEAC NPS
1878-1927
Born Crudwell, Wiltshire 12 August 1878. Encouraged Whistler, who was his father's friend. Entered Slade 1893 on the advice of Whistler and was influenced by Sickert. Friends with John, Orpen and Rothenstein. Exhibited at RA (12), RHA (4), NEAC, RP (11) 1900-27. Elected NEAC 1902, NPS 1911, ARA 1924, RP 1924, ARA 1924, ARWS 1926. During the 1st World War he was commissioned to take portraits of naval VCs. Established an extremely successful society portrait practice and an international reputation, holding a one-man show in New York 1920. Lived in Freshford, Somerset. Had a residence in London, where he died 4 January 1927. His portraits can be extremely penetrating. He gained a reputation for his high-key female portraits.
Represented: NPG London; SNPG; Glasgow AG; Manchester CAG; Tate; Fitzwilliam; Cartwright Hall, Bradford; Leeds CAG; Walker AG, Liverpool; Walsall AG; Ulster Museum; Imperial War Museum; Marquess of Salisbury; Viscount Cranbourne. **Literature:** C.Johnson, *The Works of A.M. from 1900 to May 1919*, 1919; R.M.Y.Gleadowe, *A.M.*, 1924; DNB; *The Times* 5 January 1927; C.C.Thomson, *A.M.*, Ulster Museum exh. cat. 1968; DA.
Colour Plate 49

McEVOY, Henry N. (Harry) **1828-1914**
A native of Birmingham. Moved to America and worked in Indianapolis by 1860, and in Hamilton and New York. Died Detroit 21 April 1914.

McEVOY, Mrs Mary (née Edwards) **1870-1941**
Born Freshwood, Somerset 22 October 1870, daughter of Colonel Spencer Edwards. Studied at Slade. Exhibited at NEAC 1900-6 from Somerset and London. Married artist Arthur Ambrose McEvoy 1902 and after his death in 1927 resumed painting, exhibiting at RA (12), Paris Salon 1928-37. Died 4 November 1941.
Represented: Tate; Southampton CAG.

McFADDEN, Frank **fl.1879-1894**
Exhibited at RA (3) 1889-92 from Southampton. Painted portraits of prominent citizens in Southampton.
Represented: Southampton CAG.

McFARLAND, Edward HRHA **fl.1827-1834**
Exhibited at RHA (9) 1827-34 from Dublin and Lucan.

MACFARLANE, John R. **fl.1896**
Listed as a portraitist at Hamilton Terrace West, Glasgow.

MACGEORGE, William Stewart RSA **1861-1931**
Born Castle Douglas. Studied at Royal Institution Art School Edinburgh, Antwerp Academy under C.Verlat and RSA Life School (prizewinner 1887). Exhibited at RA (8), RHA (3), RSA (97), Paris Salon 1881-1925 from Edinburgh and Kirkcudbright. Elected ARSA 1898, RSA 1910. Died Gifford 9 November 1931 aged 70.
Represented: SNPG; Glasgow AG; Perth AG; Aberdeen AG; Dundee AG. **Literature:** McEwan.

McGHIE, John **1867-1952**
Born Glasgow. Studied at Glasgow School of Art, RA Schools and Académie Julian, Paris. Exhibited at RA (3), RSA (19) 1891-1927 from Glasgow and Auchinheath, Hamilton. President of Glasgow Society of Etchers. Died Glasgow. Often used coarse canvases.
Represented: Glasgow AG; Paisley AG. **Literature:** McEwan.

McGLASHAN, Archibald A. RSA **1888-1980**
Born Paisley 16 March 1888. Studied at Glasgow School of Art under Newbery and Greiffenhagen. Impressed by Rembrandt, Hals and Italian masters. Exhibited at RA (5), RSA. Elected ARSA 1935, RSA 1939. Retired to Rothesay, Bute. Died 3 January 1980. Hutchison wrote: 'His affectionate brush seems at a touch to bring life to a face'. McEwan considers him to be one of the best painters of children of his time.
Represented: SNPG; Dundee AG; Glasgow AG; Paisley AG. **Literature:** S.Hutchison, *History of the RA 1768-1968*, 1968; McEwan.

MACGREGOR, Miss Jessie **d.1919**
Studied at RCA and RA Schools 1870. Exhibited at RA (59), SBA 1872-1914. Lived in Liverpool, but moved to London 1879-80. Died April 1919.

McGREGOR, Robert RSA **1847-1922**
Born Bradford, Yorkshire, 1847 not 1848 (Bénézit). Worked briefly for the publisher Nelson. Attended RSA Schools. Exhibited at RA (15), RSA (202), Paris Salon (Bronze Medallist 1900) 1873-1916. Elected ARSA 1882, RSA 1889. Died Portobello.
Represented: SNPG; Dundee AG; Glasgow AG; Paisley AG; Preston AG. **Literature:** McEwan.

MACHELL, Reginald **fl.1881-1894**
Exhibited at RA (5), RHA (1), SBA (8) 1881-94 from London.

MACHIN, Thomas **fl.1841-1842**
Listed as a portrait painter in Stoke 1841 and Burslem 1842.

McILWRAITH, Andrew **fl.1715-1753**
Worked in Edinburgh. Painted a portrait of Bishop Burnet. 1723 for Marischal College, Aberdeen. Painted portrait of 'Sir Lawrence Mercer' 1725. Married Anne, daughter of William Mossman 13 July 1715. Elected member of Guild of St Luke 1729 and a Burgess of the City of Edinburgh 1735.
Literature: McEwan.

MacINNES, Alexander **fl.1830-1853**
Inverness portrait and landscape painter. Returned from abroad 1836 and set up as a portrait painter in Inverness. In 1845 he had a studio sale and moved to London. Exhibited at RA (3) 1849-53.
Literature: McEwan.

McINNES, Robert **1801-1886**
Born Edinburgh or Stirling. Exhibited at RA (27), RSA (5), BI (4) 1841-66 from London, Rome, Shropshire and Tunbridge Wells. Died Stirling. His work is usually highly finished with much detail.
Represented: Tyninghame; Blairadam; Glasgow AG; Historical Society of Pennsylvania; Paisley AG. **Engraved by** W.Walker. **Literature:** McEwan.

McINNES, William Beckwith **1889-1939**
Born St Kilda 18 May 1889, son of Malcolm McInnes, a civil servant. Studied at NG Melbourne. Exhibited at RI, RA (2) and Australian Art Association. Established a successful international practice. Died Melbourne.
Represented: NG Melbourne; Queensland NG.

McINTYRE, Joseph **fl.1855**
Listed as a portraitist at 177 Great Ducie Street, Strangeways, Manchester.

McINTYRE, Raymond **fl.1924**
Studied under William Nicholson and Walter Sickert. Exhibited at RA (1), GG, NEAC. Art critic of *The Architectural Review*.

MACIRONE, Miss Emily **fl.1846-1879**
Exhibited at RA (27), SBA (45) 1846-79 from London.

MACKAY, W. Thomas (T.W.) **b.1811**
Born Liverpool. Listed as a 'Portrait and Picture Painter' aged 40 in 1851 census. Honorary exhibitor at RA (6), BI (7), SBA (12) 1826-53 from London. Among his sitters were Major General Lovell, and Captain Sweeny RN.
Engraved by G.T.Payne.

McKELVEY, Frank **b.1895**
Born Belfast June 1895, son of William McKelvey, a decorator. Studied at Belfast School of Art (winning prizes). Exhibited in Dublin, Belfast, Cork, Glasgow and London.
Represented: Belfast AG; Cork AG.

MACKENZIE, Charles Douglas **b.1875**
Born Liverpool. Studied at Liverpool School of Art under John Finnie and at Herkomer's School. Exhibited at LA 1895-26 and from Liverpool and London. Elected ALA 1913.
Represented: Walker AG, Liverpool.

MACKENZIE, James Wilson **fl.1888-1890**
Exhibited at RA (3) 1888-90 from Liverpool.

MACKENZIE, Samuel **RSA** **1785-1847**
Born Kilmuir, Ross-shire 28 December 1785 (baptized 31 December 1785), son of William MacKenzie, a fisherman, and Ann. His father died while he was a child and he became a herdsman for his uncle. Then worked under Telford as a

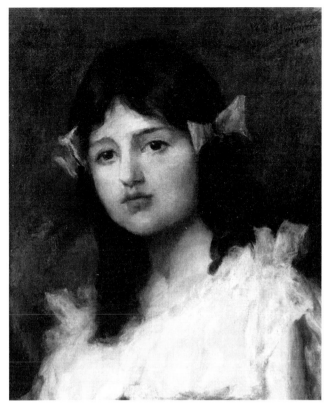

WILLIAM G. MACKENZIE. Esther. Signed and dated 1906. 16½ x 13¼ins (41.9 x 33.6cm) *Christopher Wood Gallery, London*

superintendent of stone hewers. To avoid the press-gang he travelled to Edinburgh, where he was employed by Dalziel, a marble cutter. Impressed by Raeburn and resolved at the age of 25 to study portraiture. Gained Raeburn's friendship and worked for a time in his studio. Exhibited at RSA (102) 1811-46 from Edinburgh, where he enjoyed a highly successful practice. Elected RSA 1829. Much employed by 5th Duke of Gordon and 5th Duke of Roxburghe. Considered particularly successful with his portraits of ladies and painted a number of fancy heads. Died Edinburgh 23 Janaury 1847. Buried Warriston Cemetery.
Represented: SNPG. **Engraved by** W.Walker. **Literature:** DNB.

MACKENZIE, William G. **ARHA** **d.1925**
Exhibited at RHA (28), RA (3) 1891-1921 from Belfast and London.

MACKEY, 'Father' Edward Walter **1806-1871**
Born Witham, Essex, 29 May 1806 (baptized Walter Edward Mackey 17 June), son of Hugh and Letitia Mackey. Studied under H.P.Briggs. Painted portraits of many prominent Catholics. Entered as a church student at Oscott College 1822-5, but left before taking holy orders. A friend of Pugin. Appointed drawing master at Oscott College, but also painted portraits. Died at Spring Cottage, Erdington 22 July 1871.
Represented: NPG London.

MACKIE, Charles Hodge **RSA RSW SSA** **1862-1920**
Born Aldershot. Educated at Edinburgh University. Studied at RSA Schools, before working for some years on the Continent. In France he was acquainted with Gauguin and Vuillard. Exhibited at RA (6), RSA (126), RHA 1880-1917 from Edinburgh. Elected ARSA 1902, RSA 1917. Received a Gold Medal at Amsterdam exhibition 1912. Died Edinburgh

12 July 1920. In later life became a close and influential friend of Laura and Harold Knight.
Represented: BM; VAM; Leeds CAG; Dundee CAG; Perth AG; Sydney AG, Australia; Victoria AG, Australia.
Literature: McEwan.

MACKIE, William Benjamin fl.1830-1845
Exhibited miniatures at RA (4) 1830-1 from London. Listed as a portrait painter in Greenwich 1845.

MACKINLAY, Thomas b.c.1832
Exhibited at RA (5), RSA (23), BI (1) 1863-70 from London. Among his sitters were 'Andrew Lusk, Ex Sheriff of London and Middlesex' and 'Matthew Marshall, Chief Cashier of the Bank of England'.
Represented: SNPG.

MACKLIN, Thomas Eyre RBA 1867-1943
Born Newcastle, son of John Eyre Macklin. Studied at Newcastle School of Art at the age of 10. Moved to London and studied at BM, Calderon's School and RA Schools. Befriended by American artist Winslow Homer. Exhibited at RA (17) 1889-1914. Married artist Alys Eyre Philpott. Settled in Newcastle, but maintained a studio in London. Also an illustrator. A list of his illustrated works is in VAM card catalogue. Died London 1 August 1943.
Represented: Laing AG, Newcastle; Shipley AG, Gateshead; South Shields Museum & AG. **Literature:** Hall 1982.

MACKRETH, Harriet F.S. fl.1828-1842
Exhibited portraits and miniatures at RA (23), SBA (1) 1828-42 from Newcastle and Westminster. Many of her sitters were from Northumberland.

MACKWORTH, Miss T. fl.1886
Exhibited at NWS (1) 1886 from London.

McLACHLAN, Miss Aileen M. fl.1885-1893
Exhibited portraits in London 1885-93.

MACLAREN, Donald Graeme 1886-1917
Born London 23 January 1886. Studied at Slade 1903-8. Exhibited at NEAC from 1907. Served in 1st World War. Killed in action 29 June 1917.
Represented: NPG London; Tate; SNPG.

McLAUCHLAN, Archibald fl.1762-after 1770
Scottish portrait painter. Matriculated at Glasgow University 1762. Studied at the Foulis Academy, Glasgow and while there painted the portrait of 'Jane, Countess of Hyndford'. Married a daughter of Robert Foulis.
Represented: Glasgow AG. **Literature:** W.J.Macaulay, *Scottish Art Review* III, 1951 p.14.

MACLEAY, Kenneth RSA 1802-1878
Born Oban 4 July 1802, son of Dr. Kenneth Macleay. Brought up in Crieff. Entered Trustees' Academy 26 February 1822. Became a fashionable miniature painter. Exhibited RSA (371), RHA (1), RA (3) 1822-79 from Edinburgh. Founder ARSA 1826, but withdrew. Re-elected ARSA 1829 and RSA the same year. Painted portraits of 'TRH the Princes Arthur and Leopold' and 'HRH Prince Alfred' by command of Queen Victoria and also painted for her a series of drawings of Highland costume published in *Highlanders of Scotland*, 1870. Worked first on ivory, then watercolour on paper. After photography had reduced demand for miniatures he turned to oil portraits. Died Edinburgh 3 or 11 November 1878. Frequently signed on the reverse in full.
Represented: SNPG; NPG London; Culzean Castle.
Engraved by J.A.Vintner. **Literature:** DNB; McEwan.

McLELLAN, Alexander Matheson RSW RBA 1872-1957
Born Greenock 23 January 1872, son of Thomas McLellan, an engineer. Studied at RA Schools and École des Beaux Arts. Worked in Paris, London, Manchester, Glasgow and New York. Exhibited at RA (2), RSA, SBA, ROI and in Paris. Elected RBA 1909, RSW 1911. Died 12 March 1957.
Represented: Glasgow AG.

MACLINTOCK, Katherine fl.1873
Exhibited at RHA (3) 1873 from Dalkey, Dublin.

MACLISE, Daniel RA 1806-1870
Baptized Cork 2 February 1806 (born 25 January) son of Alexander M.Maclise. He did not appear to remember his birth year and various dates are given in contemporary accounts. Began a career as a bank clerk in Cork. Studied at the local academy, learning anatomy under Dr Woodroffe. In 1825 he made a sketch of Sir Walter Scott, drawn by him unobserved in a bookshop. He worked it up in pen and ink, and Scott prophesied a great future for the artist. The drawing was lithographed and sold well. Produced pencil portraits in the manner of Adam Buck and enjoyed some success, charging 5 guineas a head. Moved to London 1827 and entered RA Schools 1828, winning several prizes. Visited Paris c.1830, studying at the galleries there, and gradually specialized in ambitious historical subjects. Also illustrated for books and periodicals, including a series of portraits of literary figures for *Fraser's Magazine*, 1830. Made a sketch of James Northcote RA 1831, taken in his bedchamber a short time before his death. Exhibited at RA (84), RSA (11), RHA (3), BI (20), SBA (21) 1829-70. Elected ARA 1835, RA 1840. Among his sitters were HRH Princess Sophia, Lady Sykes, and his friend Charles Dickens. The work involved in the commission for the massive frescoes in the Houses of Parliament damaged his health, and this, together with the death of his sister in 1865, caused him to withdraw from society. Reportedly refused both a knighthood and the post of PRA. Died after an attack of pneumonia at Chelsea 25 April 1870. Buried Kensal Green Cemetery. Studio sale held Christie's 24 June 1870.
Represented: BM; VAM; Tate; Manchester CAG; Leeds AG; Ashmolean; NGI; SNPG; Newport AG; NPG London; Ulster Museum; Royal Shakespeare Theatre. **Engraved by** F.Bacon, H.Cook, L.Dickinson, W.Drummond, W.C.Edwards, E.Finden, S.Freeman, C.H.Jeens, J.Jenkins, J.Kirkwood, R.J.Lane, S.W.Reynolds jnr, J.Thomson, R.Young. **Literature:** *Irish Daily Telegraph* 16 February 1872; *Art Journal* 1870 p.181; W.J.O'Driscoll, *A Memoir of D.M.*, 1872; *D.M.*, Arts Council exh. cat. 1972; DNB; *Burlington Magazine* CX 1968 pp.685-93; *Apollo* XCVII 1973 p.169-75; DA.

McMANUS, Henry M. RHA c.1810-1878
Born Dalkey. Exhibited at RHA (101) 1835-1877 from Dublin, London, Glasgow, Bray and Dalkey. Elected ARHA 1838, RHA 1857, Keeper RHA 1869-70. Died near Dublin 22 March 1878.
Represented: NGI; VAM.

MACNAIR, James L.Herbert 1868-1955
Born into a military family at Skelmorlie. Studied at Rouen. Returned to Glasgow where he was apprenticed to architect John Honeyman. Attended evening classes at Glasgow School of Art alongside Charles Rennie Mackintosh 1888-94. Married Frances Macdonald. Set up as a designer/decorator 1894. Produced watercolour portraits and figurative subjects. A fire destroyed his office and some of his work 1897. Taught at the School of Art, Liverpool University. Member of Glasgow Group. After the death of his wife in 1921, he was devastated and reportedly gave up art, destroying many of his watercolours. His works are relatively rare.
Literature: McEwan.

MACNAMARA, F.A. fl.1840-1850
Exhibited at SBA (2) 1840-50 from Hammersmith and Brompton.

MACNEE, Sir Daniel PRSA 1806-1882
Born Fintry, Stirlingshire, son of a farmer. His father died when he was an infant. His mother took him to Glasgow where, from the age of 13, he was apprenticed to John Knox, along with H.McCulloch. Worked for engraver W.H.Lizars in Edinburgh, while studying at Trustees' Academy. Returned to Glasgow 1830, where he established a highly successful portrait practice, at first working mostly in crayons. Exhibited at RSA (328), RA (100) 1827-82. Elected President of West of Scotland Academy (resigned 1876), RSA 1829, PRSA 1876-82, knighted 1877. After the death of J.Watson Gordon and J.Graham-Gilbert he became the leading Scottish portrait painter of his day. Among his sitters were Clarkson Stanfield RA and the Duke of Buccleuch KG. Painted a great many presentation portraits for the States of Alderney; the Presbyterian College, Belfast; RSA; Glasgow Town Hall; Eye Infirmary, Glasgow; Parliament House, Edinburgh; County Hall, Ayr; Reform Club; Archers' Hall, Edinburgh; County Hall, Lanark; University of Bombay. Died Edinburgh 17 January 1882. Interred Dean Cemetery. Painted with vigorous brush strokes and was influenced by Raeburn and Geddes.
Represented: SNG; RSA; VAM; SNPG; NPG London; Glasgow AG; Paisley AG. **Engraved by** E.Burton, J.Faed, J.H.Jeens, J.Smyth, Miss Turner. **Literature:** DNB; McEwan; DA.

MACNICOL, Miss Bessie (Mrs Frew) 1869-1904
Born Glasgow 17 July 1869. Studied Glasgow School of Art 1887-92 and in Paris. Exhibited at Glasgow Institute and International Society, London. Painted a variety of subjects including portraits. Married artist Alexander Frew 1899. Died in childbirth at Glasgow 4 June 1904, in her thirty-fifth year. Her work was admired by Caw who described her 'less as a portrait painter than as a painter of charming studies of femininity'.
Represented: Glasgow AG; Aberdeen AG; Hornel Museum, Kirkcudbright. **Literature:** McEwan; Caw.

McNULTY, Major Charles Edward Irvine fl.1914
Exhibited at RHA (3) 1914 from Dublin. Served in Army Service Corps, but is not listed by 1916.

MACPHERSON, Giuseppe (James) b.1726
Born Florence 19 March 1726 of Scottish extraction. Reportedly a pupil of Batoni. Worked in Florence, Milan and London. Painted oil portraits, miniatures and 'excelled' in enamel painting. Had a distinguished clientele, which included some of the crowned heads of Europe.
Represented: Uffizi Gallery, Florence; NGI; HMQ. **Engraved by** C.Lasinio. **Literature:** J.Fleming, *Connoisseur*, November 1959 pp.166-7; McEwan.

MACPHERSON, Melville NWS fl.1828-1834
Exhibited at NWS 1828-33 from London. Elected NWS 1833.

McQUAY, William fl.1809
Scottish itinerant portrait painter. Moved to America, where he painted a portrait of Lloyd Mifflin 1809.

MACRITCHIE, Miss Alexina fl.1912-1923
Born Bangor. Studied at Slade and Académie Julian, Paris. Exhibited at RA (3), RSA (12) and Paris Salon (honourable mention 1893) 1912-23 from London.

McSWINEY, Eugene Joseph ARWS b.1866
Born Cork 11 April 1866, son of Morgan McSwiney a leather merchant. Settled in London. Studied at South Kensington. Exhibited at RA (4), RHA (38) 1893-1930.

McTAGGART, William RSA RSW 1835-1910
Born Aros, Kintyre 25 October 1835. Apprenticed to an apothecary. Studied under Lauder at Trustees' Academy 1852-9. Exhibited at RSA (207), RHA (8), RA (11) 1853-1911 from Edinburgh. Elected ARSA 1859, RSA 1870. Died Broomiknowe 2 April 1910.
Represented: Tate; SNPG; Aberdeen AG; Glasgow AG; Kirkcaldy AG; Paisley AG; Perth AG; Sydney AG, Australia. **Literature:** J.L.Caw, *W.McT.,* 1917; Tate exh. cat. 1935; D.Fincham, *W.McT.,* 1935; H.Harvey Wood, *W.McT.,* 1974; *W.McT.,* SNPG exh. cat. 1989; DA.

MADDEN, H. fl.1829
Exhibited at RHA (1) 1829 from Dublin.

MADDEN, Wyndham fl.1766-1775
Irish artist who was awarded a bounty of £4.11s. by the Dublin Society for a landscape. Worked in oils and crayons.
Engraved by W.Dickinson.

MADDOX, Willis 1813-1853
Born Bath, where his work attracted the patronage of William Beckford of Fonthill Abbey. Moved to London and exhibited at RA (13), BI (5), SBA (5) 1844-53. Painted portraits of the Duke and Duchess of Hamilton. His portrait of 'His Excellency Mahemed Pacha, the Turkish Ambassador' led to an invitation to Constantinople to paint the Sultan. While there he painted a number of portraits of distinguished Turks. Died from fever in Pera, near Constantinople 26 June 1853. Ottley writes: 'The portraits of Maddox are remarkable for truthful and vigorous painting'.
Literature: *Art Journal* 1853 p.311; DNB.

MAGENIS, Henry fl.1817-1834
Worked in Philadelphia 1817-19. Exhibited at SBA (1) 1828 from London. Listed as a portrait painter in London 1834.

MAGGS, James 1819-1896
Listed as a portrait painter in Bath, but gradually specialized in sporting and coaching scenes. Died Bath 3 November 1896.

MAGNUS, Eduard 1799-1872
Born Berlin 7 January 1799. Studied philosophy, medicine and architecture, before taking up art. Studied under Jacob Schlesinger. Elected a member of Berlin Academy 1837. Travelled in Europe and visited England. Died Berlin 8 August 1872.
Represented: Berlin Museum.

MAGNUS, Miss Emma fl.1884-1914
Exhibited at RA (12), RHA (2), SBA (10+) 1884-1914 from Fallowfield, Manchester. Sister of artist Rose Magnus.
Engraved by Feckert and Maurice.

MAGNUSSEN, Christian Karl 1821-1896
Born Bredstedt 21 August 1821. Studied in Paris with Couture and in Rome. Worked in Hamburg. Painted the marriage of Princess Helena. Died Schleswig 18 June 1896.
Represented: HMQ. **Engraved:** A.Blanchard.

MAGRATH, Robert T. fl.1833-1847
Exhibited at RHA (15) 1833-47 from Dublin and Broadstone.

MAGUÉS, J. (Isidore Jean Baptiste) fl.1842-1852
Exhibited at Paris Salon from 1842. Worked in Paris and Berlin, producing portraits in oil and in pastels. Exhibited 'Lieut.-General Sir John Macleod' and a double portrait of the King and Queen of Holland at RA (2) 1849-52 from London.

MAGUIRE, James fl.1841-1842
Listed as a portrait painter at Stoke-on-Trent.

MAGUIRE, James Robert fl.1809-1850
Exhibited portraits and miniatures at RHA (32) 1826-49 from Dublin. Elected ARHA 1826, RHA 1830.
Engraved by J.Heath, P.Maguire, H.Meyer. **Literature:** Strickland.

MAGUIRE, Philip fl.1845-1895
Exhibited at RHA (13) 1845-95 from Dublin.

MAGUIRE, Thomas Herbert 1821-1895
Born London. Exhibited at RA (40), RHA (3), BI (9), SBA (8) 1846-87. Lithographer to Queen Victoria and later specialized in portraits in enamel. Among his sitters were Queen Victoria, Prince Albert, Prince Arthur and Frederick Leighton PRA. Died London 30 April 1895.

MAHER, Frederick J. 1871-1963
Born Newcastle. Exhibited at Bewick Club, Laing AG and Northern Counties exhibitions. Taught art at Rutherford Grammar School and for many years at Armstrong College (now Newcastle University). Died Newcastle aged 92.
Literature: Hall 1982.

MAIDEN, James Bury d.1843
Worked as an animal and portrait painter in Bury. Died 26 November 1843.

MAIDMENT, Mrs Kathleen fl.1908-1926
Exhibited at RHA (12) 1908-26 from Dublin and Dalkey.

MAINDS, Allan Douglas ARSA 1881-1945
Born Helensburgh 23 January 1881, son of artist W.R.Mainds. Studied at Glasgow School of Art, where he won a travelling scholarship to Brussels under Jan Delville, then Rome. Returned to teach at Glasgow School of Art 1909. Exhibited at RA (1), RSA, GI and RSW. Professor of Fine Art at King's College (now Newcastle University) 1931, remaining there until his death at Gosforth. Died 4 July 1945.
Represented: Laing AG, Newcastle.

MAJOR, W. Wreford fl.1873-1879
Exhibited at RA (1), GG (2) 1873-9 from London.

MAJOR, William Warner 1804-1854
Born Bristol 27 January 1804. Joined Church of Latter-day Saints 1842. Moved to America 1844. Produced a series of paintings to illustrate the suffering of the Mormons. Worked in Salt Lake City 1848-53. Returned to England 1853, where he died 2 September 1854.
Literature: *Dictionary of American Artists.*

MALCOLM, James b.c.1837
Born Scotland. Listed as an unmarried portrait painter aged 24 in 1861 census for Brompton Square, London.

MALEMPRÉ, Leo fl.1887-1901
Exhibited at RA (12) 1887-1901 from London.

MALLORY, Robert d.1688
London portrait painter and art dealer. Appears in Symonds' notebook (c.1653) as 'a Captain of the City and a doughty painter'. A Major by 1672, in which year he painted a portrait of Walter Pell for Merchant Taylors' Company, of which he was a member. Became master of the Company 1674. Buried at Cripplegate 1688.
Literature: M.Beal, *A Study of Richard Symonds, His Italian Notebooks and their relevance to 17th century Painting Techniques,* 1984 (Symonds' notebooks are in the British Library, London and the Bodleian, Oxford).

MALMQVIST, Alexander Magnus 1796-1853
Born Schonen. Studied in Lund. Exhibited in Sweden 1818, winning prizes 1819 and 1821. Studied miniature painting in France 1822. Moved to England, where he painted portraits and miniatures. Became insane and was sent back to Sweden 1830. Retained his ability to paint. Died in hospital in Malmo 1853.
Represented: National Museum, Stockholm.

MANARO, O. fl.1847-1849
Exhibited at RA (5) 1847-9 from London.

MANCINI, Antonio 1852-1930
Born Naples or Rome 14 November 1852. Exhibited at Paris Salon 1876-8 and at RA (3) 1902-9 from London. Died Rome 28 December 1930.
Represented: Tate; NG London; Leeds CAG. **Literature:** Bénézit.

MANDY, James Cleverley b.c.1792
Born London. Entered RA Schools 19 February 1812 aged 20. Exhibited mostly miniatures at RA (22), OWS 1811-33 from London.

MANINI, 'Chevalier' Gaetano c.1730-c.1785
Born Milan. Studied under D.Creti at Academy of Bologna. Visited England c.1750. Exhibited at SA, FS 1761-72. Listed as a portrait and history painter in London. Also worked in Ireland.
Represented: VAM; Ashmolean.

MANLY, Miss Alice Elfrida b.1846
Born in London. Exhibited at RA (21), SBA (14), NWS 1872-1917 from London. Worked in Devon, Wales, Yorkshire, Kent, Isle of Wight and Boulogne. Last recorded in London 1922. Her sister Eleanor was also an artist.

MANN, Alexander ROI 1853-1908
Born Glasgow 22 January 1853. Studied at Glasgow School of Art, Académie Julian, Paris 1877 and under Carolus Duran 1881-5. Exhibited at RA (24), RSA (11), RHA (4), SBA (18), Paris Salon, NEAC, Royal Glasgow Institute of Fine Arts 1884-1907 from Glasgow, Didcot and London. Married 1887. Travelled widely on the Continent. Died London 26 January 1908.
Represented: AGs of Glasgow, Liverpool, Nottingham, Kirkcaldy. **Literature:** *A.M.,* Fine Art Society exh. cat. 1983, 1985; *Country Life* 21 April 1983; McEwan; *Studio* XLVI 1908 p.300; DA.

MANN, Miss Cathleen Sabine RP ROI 1896-1959
Born Newcastle 31 December 1896, daughter of artist Harrington Mann and Florence Sabine Pasley. Studied art at Slade and in Paris. Served with the Ambulance Service during 1st World War. Exhibited at RA (33), RHA (1), RP, ROI 1924-56. Elected RP 1932. Married Marquess of Queensbury 18 March 1926 and following her divorce J.R.Follett 1946. Appointed an official war artist during 2nd World War. Committed suicide in her London studio 8/9 September 1959.
Represented: NPG London; SNPG; Glasgow AG. **Literature:** *The Times* 10 September 1959; DNB.

MANN, Florence Sabine (née Pasley) fl.1883-1925
First wife of Harrington Mann. Exhibited at RA (3), SBA (4) 1883-6 from Edinburgh.

MANN, Harrington RP RE NPS NEAC 1864-1937
Born Glasgow 7 October 1864, son of John Mann, a chartered accountant. Studied at Glasgow School of Art, Slade under Legros and in Paris under Boulanger and Lefebvre. Exhibited at RA (51), SBA (1), NEAC, RP (87), NPS 1882-1937 from Glasgow, Rome and London. Elected RP 1900, NPS 1911. Established a highly successful practice as a society portraitist, and received a large

number of commissions from the United States. Had a house in New York as well as in London. Died New York 28 February 1937.
Represented: SNPG; Imperial War Museum; Tate; AGs of Glasgow, Belfast, Sydney, Melbourne. **Literature:** F.N.Newberry, *The Glasgow School of Painting*, 1902; H.Mann, *The Paintings of Mr H.M.*, 1907; McEwan.

MANNERS, Mrs Violet (née Lindsay)
see RUTLAND, Marion, Duchess of

MANNIN, Mrs Mary A. (née Millington) c.1800-1864
Exhibited at SBA (17) 1833-40. Painted a watercolour portrait of Sir Henry Havelock which is in the collection of Havelock Estate. Married Mr Mannin c.1832. Died Brighton.

MANNING, Miss Eliza F. fl.1879-1889
Exhibited at RA (2), NWS (1) 1882-6 from St Leonard's Villa, Surbiton. Also an illustrator. A list of her illustrated works is in VAM card catalogue.

MANNIX, Robert 1841-1907
Irish artist. His portrait of 'C.H.Granby as Sir Peter Teazle in The School for Scandal' is in NGI. Exhibited RSA (34) from Glasgow.

MANSKIRSCH, Franz Joseph 1768-1830
Born Ehrenbreitstein 6 October 1768, son and pupil of B.G.Manskirsch. Exhibited at RA (14), BI (2) 1793-1819 from London. Began exhibiting landscapes and later specialized in military subjects and portraits of officers. Patronized by Empress Josephine. Died Danzig 16 March 1830.
Engraved by R.Grave.

MANSON, James Bolivar NEAC 1879-1945
Born London 26 June 1879. Studied at Heatherley's, Lambeth School of Art and Académie Julian, Paris under J.P.Laurens. Member of Camden Town Art Group 1911. Exhibited at NEAC, RA (13) 1915-45. Assistant Keeper of Tate 1917-30, Director 1930-8. Wrote a number of books on art. Died London 3 July 1945.

MANTON, George Henry Greville RBA
c.1855-1932
Son of Gildon Manton, a London gun manufacturer. Studied in London and Paris. Exhibited at RA (39), SBA 1880-1919 from Stoke Newington, London and Bushey 1895. Elected RBA 1899. Visited America 1890 to paint portraits, exhibiting at NA, New York. Also an illustrator. Died Bushey 13 May 1932 aged 77.
Represented: NPG London; Lincoln Museum.

MANTON, Gildon fl.1818-1834
Exhibited at RA (15) 1818-31 from London. Listed there as a portrait painter 1834. Among his sitters was the Duke of Rutland. May be the Gildon Manton who was a gun manufacturer and father of G.H.G.Manton.
Represented: SNPG.

MANVILLE, Mrs Ethel Kate (née Gibson) 1880-1942
Born Newcastle, the great granddaughter of William Dalziel. Studied art at Armstrong College under Richard G. Hatton. Exhibited at Laing AG, Newcastle. Died Newcastle.

MARCHETTI, George fl.1902-1912
Exhibited at RA (4) 1902-12 from London.

MARCHI, Giuseppe Filippo Liberati FSA
c.1721-1808
Born Trastevere, Rome (the date is usually given as 1735, but Marchi told Farington 12 January 1795 that he was '73 or 74'). Reynolds brought him back from Italy 1752 (reputedly aged about 15), and he became his principal assistant. Studied at St

Martin's Lane Academy. Began producing mezzotints from 1766. Painted portraits on his own in the style of Reynolds. Exhibited at SA (19) 1766-75. Elected FSA 1771, Director 1775. Worked in Wales 1768/9 with his close friend the landscape painter Thomas Jones. Then continued work for Reynolds until 1792. Died London 2 April 1808.
Represented: National Museum of Wales. **Literature:** *Gentleman's Magazine* April 1808 p.372; DA.

MARESCHALL, B. fl.1692/3
Paid 5 guineas on February 1692/3 for a bust portrait of Lord Grandison at Arbury.

MARGETSON, William Henry RI ROI 1861-1940
Studied at South Kensington and RA Schools. Exhibited at RA (44) RI, ROI, GG, SBA 1881-1934 from London, Streatham, West Norwood and Blewbury near Didcot. Among his sitters were Frederick J.Horniman MP. Married artist Helen Howard Hatton c.1894/5. Died Wallingford 2 January 1940. Capable of highly accomplished work.
Represented: NPG London.

MARK, E.W. fl.1843
Exhibited at RA (2) 1843 from London.

MARK, Mrs Elsie E. (née Pardoe) fl.1893-1900
Exhibited at RBSA (13) 1893-1900 from Birmingham and Kidderminster. Married G.G.Mark 1897.

MARKIEWICZ, Count Casimir Dunin d.1932
Exhibited at RHA (11) 1904-9 from Dublin. Married Constance Georgine Gore-Booth 1900, the first woman to be elected for the Irish Free State 1923. Died 2 December 1932.

MARKS, Barnett Samuel RCA 1827-1916
Born Cardiff 8 May 1827, son of Mark Lyon Marks and Anne (née Michael). President of Cardiff Hebrew Congregation. Settled in London c.1867. Exhibited society portraits at RA (39), SBA (1) 1859-91. Among his sitters were the Prince of Wales, 7th Earl of Shaftesbury and 1st Lord Rothschild. An active freemason and Past Master of the Buckingham and Chandos Lodge. Died London 6 December 1916.

MARKS, Miss Florence fl.1889-1918
Exhibited at RA (6) 1889-1918 from London.

MARKS, Mrs Stella Lewis (née LEWIS) RMS
b.1889
Born Melbourne 27 November 1889. Studied at NG School, Melbourne. Exhibited at RA (26), SBA, RP, RMS, NEAC 1931-66 from Kensington. Elected RMS 1916.

MARLEY, Hugh fl.1825-1842
Listed as a portrait painter in Liverpool 1825 and Longton, Staffordshire 1841 and Leamington Spa 1842.

MARLOE, N. fl.1660
Painted a bust portrait of 'Brampton Gurdon' in the possession of Lord Cranworth. It is signed on the back 'Anno Doe 1660/Aetat: 53:/per/N.Marloe'.

MARRABLE, Mrs Madeline Frances (née Cockburn)
d.1916
Exhibited at RA (10), SBA, RI 1864-1905. Travelled widely on the Continent. Painted portraits of Edward VII and other members of the royal family. Died 21 May 1916.

MARRIOTT, Frederick RE 1860-1941
Born Stoke-on-Trent 20 October 1860, son of Samuel Marriott, an engineer. Studied at RCA. Exhibited at RA (45), RE, Paris Salon and in the provinces 1891-1939 from Chelsea. Head of Goldsmiths 1895-1925. Died October 1941.

MARRIOTT, Thomas **fl.1853**
Listed as a portraitist at 230 Stretford New Road, Manchester.

MARSDEN, Richard **fl.1820-1824**
Exhibited at RA (1), BI (2) 1820-4 from London.

MARSH, Miss Clare **fl.1900-1921**
Exhibited at RHA (77) 1900-21 from Dublin.

MARSH, Robert **b.1768**
Born 15 February 1768. Entered RA Schools 23 November 1787 (or 1781 Foskett) aged 19. Exhibited at SA (2) 1791 from 20 Curtain Road, Hoxton.

MARSHAL, Alexander **fl.1660-1690**
Painted portraits after Van Dyck and miniatures.
Represented: BM.

MARSHALL, Benjamin **1768-1835**
Born Seagrave, Leicestershire 8 November 1768 (not 1767), son of Charles and Elizabeth Marshall. Married Mary Saunders 12 November 1789. Recorded as a schoolmaster 1791. Apprenticed to L.F.Abbott 1791-4, but gave up standard portraiture to produce sporting pictures for *The Sporting Magazine*. Before he was 29 Ben had been received by George III and Queen Charlotte and patronized by other members of the royal family. Exhibited at RA (13) 1800-19, but produced most of his work for private commissions. Moved from London to Newmarket 1812, where he became the most important sporting painter of his generation. Gained a reputation for his fine wit. Had a severe coaching accident 3 September 1819, in which both his legs were broken and his head 'terribly cut and his back greatly injured by contusion'. Recovered enough to return to work and continued to paint. The dress of his daughter, Elizabeth, caught fire and she was burnt to death in front of him. This was said to have hastened his death a few months later. Died London 24 July 1835. Buried in a vault in the churchyard of St Matthew's, Bethnal Green. John Ferneley snr was his pupil 1801-4. His reputation rests on his sporting paintings, but his portraits are often full of considerable character and life.
Represented: Tate; NPG London; Canterbury Museums; Leicester AG; Royal College of Surgeons, London. **Engraved by** T.L.Bushy, G.Maile, J.Scott, C.Turner, R.Woodman. **Literature:** *B.M.*, Leicester AG exh. cat. 1967; A.Noakes, *B.M.*, 1978; M.Webster & L.Lambourne, *British Sporting Paintings 1650-1850*, Arts Council exh. cat. 1974/5; *Country Life* 24 July 1975; *Apollo* Vol. 40 August 1944; W.S.Sparrow, *George Stubbs and B.M.*, 1929; DA.
Colour Plate 50

MARSHALL, Charles Edward **RBA** **b.1851**
Son of Thomas Robert Marshall, an army clothier. Aged 30 in 1881 census. Exhibited at RA (31), RHA (5), SBA (32+) 1878-1920 from London. Elected RBA 1890. Among his sitters were Lady Margaret Jenkins and artist Arthur Hacker ARA.

MARSHALL, Daniel **fl.1884**
A chemist by profession, he became well known at Sunderland for his portraits of local celebrities. Exhibited at Bewick Club, Newcastle.
Represented: Sunderland AG.

MARSHALL, G. **fl.1822-1825**
Exhibited at RA (4) 1822-5 from London and York. Among his sitters were Lady Anne Harcourt and James Parsons.
Engraved by W.J.Ward.

MARSHALL, George **d.c.1732**
Born Scotland. Studied under the younger Scougal and Kneller. Worked in York, Scotland and Italy.

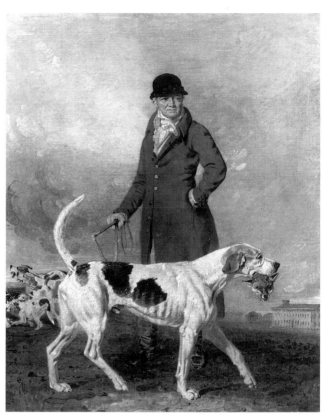

BENJAMIN MARSHALL. Thomas Gibbs Hilton with his Hound Glory. Signed and dated 1822. 36 x 28ins (91.5 x 71.1cm)
Canterbury Museums

MARSHALL, Peter Paul **1830-1900**
Born Edinburgh. Began as an engineer, then went into business. Took up art on his retirement. A close friend of Ford Madox Brown and mixed with the Pre-Raphaelites. Exhibited at RA (1) 1877 from Fairlawn, Stone and Dartford. Died Teignmouth, Devon.
Literature: McEwan.

MARSHALL, Thomas Falcon **1818-1878**
Born Liverpool 18 December 1818. Practised in Liverpool, Manchester and London. Exhibited at RA (60), BI (40), LA, SBA (43) 1839-78. Elected ALA 1843, LA 1846. Died Kensington 26 March 1878.
Represented: VAM; Walker AG, Liverpool.
Colour Plate 48

MARSHALL, Thomas Mervyn Bouchier **fl.1855-1858**
Recorded as a portrait and genre painter in London 1855-8.

MARTIN, Charles **1820-1906**
Son of artist John Martin. Exhibited at RA (55), BI (1), RHA (2), SBA (9), NWS 1835-96 from London. Among his sitters were John Gibson RA, Countess of Lamsdorff and the Rt Hon James Stansfeld MP. Moved to America and worked in Charleston 1846-8. Exhibited at NA 1851. Died Clapham 5 April 1906.
Represented: Laing AG, Newcastle; NPG London.
Literature: *The Year's Art* 1907; *Art News* April 1906.

MARTIN, David **FSA** **1737-1797**
Born Anstruther, Fife 1 April 1737, son of a parish schoolmaster. Studied under Allan Ramsay in London c.1752 and travelled to Italy with him 1755-7. On his return he took further study at St Martin's Lane Academy, winning premiums. Became Ramsay's chief assistant and copyist in the 1760s. Exhibited at SA (68), RA

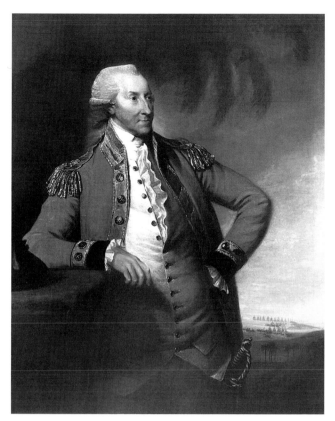

DAVID MARTIN. General Gabriel Christie, Colonel of 60th Royal American Regiment. Signed and dated 1787. 50 x 40ins (127 x 101.6 cm) *Christie's*

(2) 1765-90. Won premiums at SA for chalk drawings 1759-61. Elected FSA 1771, Treasurer 1772, Vice-President 1776. Worked independently in London as a portraitist and engraver. Settled in Edinburgh c.1783, where he had an extremely successful practice. Appointed Principal Painter to HRH the Prince of Wales for Scotland 1785, a title with which he often signed his pictures. Died Edinburgh 30 December 1797. Painted in the manner of Ramsay and is said to have given some instruction to Raeburn. **Represented:** Glasgow AG; NPG London; SNPG; Scone Palace. **Engraved by** J.Beugo, J.Caldwall, S.Freeman, J.Heath, R.Houston, K.Mackenzie, H.Meyer, R.Stanier, C.Turner. **Literature:** DNB; McEwan; L.Dixon, 'D.M., Portrait Painter Revealed', *Inferno*, St Andrews' Journal of Art History, vol 2, 1995 pp.40-9; DA.

MARTIN, Mrs Dorothy Freeborn (née Roberts) RBA RMS b.1886
Born Buttington, Wales 17 May 1886, daughter of Rev R.J.Roberts. Studied at Cheltenham Ladies' College and Slade. Exhibited at RA (11), SBA, RP, RMS, NEAC 1919-38 from London and Weybridge.

MARTIN, Elias ARA 1739-1818
Baptized Stockholm 8 March 1739. Studied under Schultz 1763 and in Paris under Vernet 1766-8. Moved to London 1768 and entered RA Schools 3 November 1769. Specialized in topographical and landscape painting, but also produced life-sized and small-scale portraits in oils, watercolours and crayons. Exhibited at SA (5), FS (1), RA (47) 1768-90. Elected ARA 1770. Returned to Sweden 1780 with a commission from the King to make topographical drawings. Elected a member of Stockholm Academy 1781. Returned to England 1788 and was in Bath before leaving for Stockholm

1791. Built a gallery of his works 1806. Died Stockholm 25 January 1818. Influenced by Gainsborough and Hogarth. **Represented:** Stockholm NG; BM; VAM. **Literature:** H.Fröhlich, *Bröderna Elias och Johna Frederik Martins gravyer*, 1939; N.Lindhagen, *E.M.*, Stockholm exh. cat. 1950; DA.

MARTIN, Captain George Mathew fl.1856-1861
His portraits of Sir Mark Cubbon, and Sir Patrick Grant are in NPG London.

MARTIN, Henry H. b.c.1823
Born Ely. Listed as a portrait and historical painter aged 38 in 1861 census for London.

MARTIN, John F. fl.1836-1851
Exhibited at BI (2), SBA (23) 1836-51 from London.

MARTIN, Miss Mabel I.L. b.1887
Born Dover. Studied at Regent Street Polytechnic 1918-24 (winning prizes), Bolt Court 1930-2, Hornsey College of Art, 1932-4, Westminster School of Art 1938 and in Paris. Exhibited at RA (8), SBA, ROI, Paris Salon 1920-50.

MARTIN, William fl.1765-1816
Studied under and lodged with G.B.Cipriani. Exhibited at RA (22) 1775-1816. Took accommodation at Leicester Square and Fenchurch Street. Stayed at Windsor Castle 1800 where he was commissioned to paint large historical subjects for the King. Living in Paddington 1807 and advertised under the title of History Painter to His Majesty. The latter part of his life was spent at Cranford, Middlesex. **Engraved by** F.Bartolozzi, W.Ward, J.Watson.

MARTIN(E), P. fl.1733-1740
British painter of crayon portraits at Florence 1733-40. Horace Walpole mentions him in connection with a duel in a letter to West on 27 February 1740. **Represented:** Mellerstain.

MARTINEAU, Mrs Clara (née Fell) fl.1873-1906
Exhibited at RA (7), SBA (4) 1873-1906 from Barnsbury and Hampstead. Married solicitor Basil Martineau. **Represented:** NPG London.

MARTINEAU, Miss Edith ARWS 1842-1909
Born Liverpool, youngest daughter of Dr James Martineau. Studied in Liverpool, at Leigh's Academy and RA Schools. Exhibited at RA (25), SBA (6), OWS, NWS, GG 1870-90. Elected ARWS 1888. Specialized in painting children. **Represented:** VAM; Manchester CAG.

**MARTYN, Miss Ethel King ARPE RE
 fl.1886-c.1923**
Exhibited at RA (12), SBA 1886-1906 from London and Chislehurst. Also an etcher.

MARTYN, T. fl.1808
Exhibited at RA (1) 1808 from 40 Leicester Square, London.

MASCALL, Edward c.1627-1683
Active as a portrait painter in Yorkshire during the Commonwealth. An Edward Mascall, son of a York embroiderer, was admitted *per patrem* in 1660. A portrait recorded as signed and dated 1675 is in Weld Collection, Lulworth. His self-portrait was engraved by J.Gammon (BM). His portrait of Oliver Cromwell, 1657, is in Cromwell Museum, Huntingdon. According to Musgrave he died 1683. **Engraved by** Halfpenny. **Literature:** National Art-Collections Fund Report 1966; Sir William Musgrave, *An Obituary of the Nobility, Gentry. etc. of England, Scotland Ireland prior to 1800...*, 1882.

MASKALL, Miss Mary fl.1803-1832
Exhibited at RA (18), BI (2), SBA (1) 1803-32 from London.

MASON, Arnold Henry RA RP 1885-1963
Born Birkenhead 20 March 1885. Studied at Macclesfield School of Art, RCA, Slade and in Paris and Rome. Joined the Artists' Rifles 1915. Exhibited at RA (183) 1919-64. Elected RP 1935, ARA 1940, RA 1951. Lived in London, but also worked in France. Died 17 November 1963.
Represented: NPG London; Tate; Brighton AG.

MASON, Miss Emily Florence b.1870
Born Birmingham, daughter of R.Crump Mason, a chemist. Studied at RCA. Moved to Croydon, where she exhibited portraits and oriental subjects. An art inspector in Ceylon. Taught art at Howell's School, Cardiff.

MASQUERIER, John James 1778-1855
Born Chelsea 23 October 1778, son of French parents. Entered RA Schools 1792. Through the intervention of George III he won a scholarship to Paris, where he studied under F.Vincent and Carle Vernet. Fled to London during the Revolution and became a pupil of and assistant to Hoppner 1793. Travelled to Isle of Wight 1793, Ireland, Midlands and Paris 1800 (bringing back a portrait of Napoleon, which was a great success in London). William Cobbett accused him of being a spy, but he was able to refute the charge. Exhibited at RA (71), BI (18) 1795-1844. Established a highly successful practice. Among his sitters were Lord Newark, Lady Hamilton and HRH the Duke of Sussex. Visited Scotland 1802 and stayed with Raeburn, who influenced his work. Finally settled in Brighton by 1826, where he died 13 March 1855.
Represented: NPG London; Holbourne of Menstrie Museum, Bath; Brighton AG; Eton College; Royal Society.
Engraved by A.Cardon, H.R.Cook, S.Freeman, M.Gauci, T.Hodgetts, W.Say, S.Stepney, C.Turner, W.Ward.
Literature: R.R.M.Sée, *M. and his Circle*, 1922; Farington's Diary 1802; DNB.

MASSEY, Mrs Gertrude (née Seth) 1868-1957
Born London 21 February 1868, daughter of G.Seth, a merchant. Exhibited at RA (23) 1898-1918 and Paris Salon from London. Married artist Henry Gibbs Massey. Painted miniatures of a number of the royal family (24 commissions). Moved to Bognor Regis, where she died 7 December 1957.

MATESDORF, T. fl.1886
Exhibited at RA (1) 1886 from 20 Howland Street, London.

MATHEW d.1674
English portrait painter who worked in Les Gobelins aux Ouvrages du Roi.

MATHIAS, Gabriel 1719-1804
Born December 1719. Studied under Ramsay 1739. Travelled to Rome 1745-8 where he studied under Batoni. Listed as 'an eminent painter' in London by the *Universal Magazine* 1748. Exhibited at FS 1761-2. Gave up painting on being given an office in the Privy Purse. Died Acton. Some of his portraits were reproduced in mezzotint.
Represented: The Vyne, NT.

MATTHEWS, Henry d.1830
Exhibited portraits and miniatures at RA (8) 1798-1808 from London. Worked for the East India Company 1801-27. Died January 1830.

MATTHEWS, William 1821-1905
Born Bristol. Worked in London as a portrait painter. Moved to Washington DC, where he died.

MAUBERT, James Francis 1666-1746
Reportedly born in Ireland. Baptized Jacques François Maubert London 27 October 1667, son of Isaac Maubert, a French Huguenot, and Mary Le Roy. Studied under Gaspar Smitz in Dublin. Died London October 1746 'aged 80'. Often included honeysuckle in the composition of his brightly coloured portrait groups, which show some influence of Kneller and Dahl. His sitters tend to have large, blank oval eyes.
Represented: NPG London; NGI; Cirencester Park.
Engraved by J.Simon.

MAUCOURT, Charles (Claudius) d.1768
Reportedly born 1718 or 1728 in Germany or France (conflicting sources). Worked in Scherwin, Paris and London. Exhibited portraits and miniatures at SA (17) 1761-7. Died London January 1768 'leaving a child quite destitute'.

MAUD, W.T. 1865-1903
Lived in Brighton. Worked as an illustrator for *The Graphic*. Exhibited at RA (1) 1897 from Chelsea. Became a war artist. Died Aden.
Literature: *The Graphic* 16 May 1903.

MAUND, George C. fl.1853-1871
Exhibited at RA (3), SBA (8) 1853-71 from St John's Wood and Kilburn. Among his sitters was Lord Dufferin.

MAWBRYE, E. fl.1782
Exhibited at RA (1) 1782 from 11 Great Newport Street, London.

MAWE, G. fl.1843
Exhibited a portrait of an officer at RA 1843.

MAXIMOS, Mrs fl.1887
Exhibited at RA (1) 1887 from London.

MAY, Arthur Dampier fl.1872-1910
Exhibited at RA (34), SBA (8+), RHA (6), NWS, SM, GG 1872-1910 from Lee, Kent and London. Among his sitters was Lady Nora Spencer Churchill.

MAY, Charles fl.1770-1783
Entered RA Schools 1770. Exhibited at FS (27), RA (1) 1771-83 from London.

MAY, Philip William RI RP 1864-1903
Born Wortley, near Leeds 22 April 1864. Worked mostly as a black and white artist and illustrator, but also painted some portraits. A prominent figure in the art world at the turn of the century. Elected RP 1896. Worked for *Punch*. Died London 5 August 1903.
Represented: NPG London; Tate; Leeds CAG. **Literature:** J.Thorpe, *P.M.*, 1932; Leeds AG exh. cat. 1975; DA.

MAYAUD, J.B. fl.1821-1826
Exhibited at RA (16) 1821-6 from London. Among his sitters were Countess Strutukewitchowa and Dr. Bertin.

MAYER, Arminius c.1798-1847
Exhibited at RA (8), SBA (5) 1825-46 from London. Among his sitters were 'Lieut.-General Sir Thomas Dallas KCB' and 'Lady Jemima Eliot'. Died near Vienna 25 July 1847.
Engraved by W.Drummond, G.H.Every, M.Gauci.

MAYNARD (MAYNERT) fl.1512-1523
Commissioned to paint a posthumous portrait of Lady Margaret Beaufort for Christ's College, Cambridge 1511/12. Recorded in London 1523. May have been 'Harry Maynert, paynter', who was a witness to Holbein's will 1543.

MAYNARD, Thomas　　　　　　　　　1752-c.1812
Studied at an early age under Arthur Devis. Entered RA Schools
1772. Exhibited from the age of 12 at FS (6), RA (36) 1764-
1812. Established a successful London practice. Specialized in
small heads, which were well drawn and often painterly.
Engraved by E.Bell, H.Meyer.

MEAD, Miss　　　　　　　　　　　　　fl.1778
Honorary exhibitor of crayon portraits at RA (2) 1778.

MEAD, Miss Rose　　　　　　　　　fl.1896-1916
Exhibited at RA (6) 1896-1916 from Bury St Edmunds.

MEADOWS, Joseph Kenny　　　　　　1790-1874
Born Cardiganshire 1 November 1790, son of a naval officer.
Worked as a portraitist, illustrator and caricaturist. Exhibited
at RA (3), SBA (4) 1830-53, including a portrait of the
actress 'Miss Ellen Tree of the Theatre Royal, Covent
Garden'. Died London August 1874.
Represented: VAM. **Engraved by** R.Cooper, R.Martin.
Literature: DNB; DA.

MEAKIN, Miss Mary L.　　　　　　　fl.1843-1862
Exhibited at RA (11) 1843-62 from London and 'St Mary's
Parsonage Newberry'.

MEASHAM, Henry　　　　　　　　　　1844-1922
Born Manchester. Exhibited at RA (18) 1868-83 from
Manchester. Died November 1922.
Represented: Manchester CAG; Salford AG.

MEASON, W.　　　　　　　　　　　　fl.1837-1853
Exhibited at RA (2) 1837-53 from Exeter.

MEASOR, W.　　　　　　　　　　　　fl.1837-1864
Exhibited at RA (9), BI (1), SBA (8) 1839-64 from London.

MEASOR, W.B.M.　　　　　　　　　　fl.1854-1872
Exhibited at RA (8) 1854-72 from London.

MEDINA, Sir John Baptist　　　　　　1659-1710
Born Brussels, son of Medina de Caustanais, a Spanish officer
from a wealthy family. Studied in Brussels under François
Duchatel. Married when young Joanna Maria Van Dael. Moved
to London c.1686, where he was influenced by Kneller and
established a successful practice charging £4 a head and £8 a half-
length. Also illustrated for Ovid's *Metamorphoses* and Milton's
Paradise Lost, the latter published by Jacob Tonson. Attracted the
patronage of the Earl of Melville (later Earl of Leven), of whom
he painted at least 15 portraits. The Earl is said to have offered
him work to the sum of about £500 to go to Scotland. In the
winter of 1693-4 Medina went to Edinburgh and, according to
Vertue, took 'many postures for heads, he draperys painted – only
to put the faces to them'. There he met with considerable success,
raising his prices to £5 and £10, and enjoying the sort of
reputation in Scotland that Kneller had in England. Knighted
1707. Died Edinburgh 5 October 1710. Buried on the north side
of Grey Friars churchyard. His estate was valued at £14,000
Scots. Among his pupils were Aikman and his son, John Medina.
Often painted rich red and blue draperies. His later works were
less formal and more loosely and confidently painted.
Represented: SNPG; Royal College of Surgeons, Edinburgh;
Tyninghame; Alloa House; Penicuik House; RI School of Design;
Blair Castle, Tayside. **Engraved by** T.Chambers, G.Guttieros,
W.Howison, C.Lasinio, J.Smith, P.Vanderbank. **Literature:**
J.Fleming, 'Sir J.M. and his "Postures"', *Connoisseur* CXLVIII
August 1961 pp.22-5; D.Mannings, 'Sir J.M.'s Portraits of the
Surgeons of Edinburgh', *Medical History* 23 1979 pp.176-90;
R.K.Marshall, *J.M.,* Scottish Masters 7 Edinburgh 1988 with list
of his paintings in his studio at the time of his death; DNB; DA.

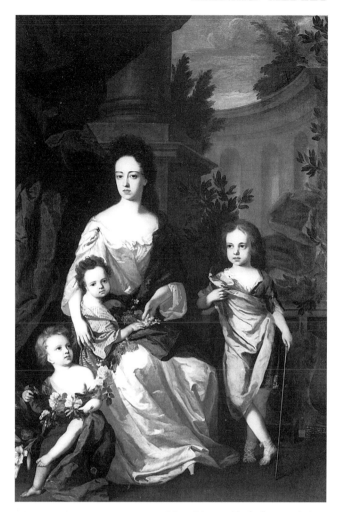

JOHN BAPTIST MEDINA. Mrs Mary Cholmley and her
children, Hugh, John and Ann. 84¼ x 54½ins (76.2 x 63.5cm)
Sotheby's

MEDINA, John (ii)　　　　　　　　fl.1686-d.1764
Son and pupil of Sir John Baptist Medina. Carried on his
father's practice after his death in 1710 and used many of his
poses. Died Edinburgh 1 December 1764. His work is
curiously primitive.

MEDINA, John (iii)　　　　　　　　1721-1796
Son of John Medina ii. Exhibited at SA (5) 1772-4 from 7
Catherine Street, Strand. Died Edinburgh 27 September
1796 in his 76th year.
Represented: SNPG. **Literature:** DNB; McEwan.

MEDLAND, W.　　　　　　　　　　fl. 1808-1814
Exhibited at RA (3) 1808-14 from London.

MEDLEY, Samuel　　　　　　　　　1769-1857
Born Watford or Liverpool 22 March 1769, son of Samuel
Medley, a Baptist minister. Began as an historical painter, but later
specialized in portraits and animal pictures. Entered RA Schools
1791. Exhibited at RA (28) 1792-1805. Gave up painting
professionally c.1805 because of poor health, and became a
successful stockbroker. Died Chatham 10 August 1857.
Represented: Royal College of Surgeons. **Engraved by**
N.Branwhite, J.Collyer, R.Dunkarton, S.Freeman, D.Orme,
W.Ridley. **Literature:** DNB.

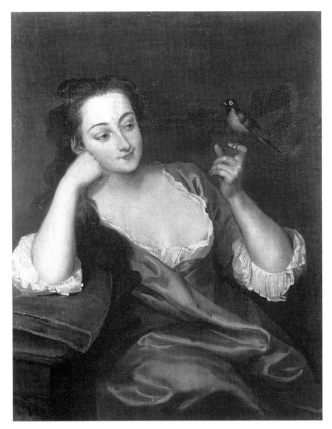

PHILIP MERCIER. A lady holding a bird. Signed and dated 1739. 34 x 25½ins (86.4 x 64.8cm) *Christie's*

MEHEUX, John **fl.c.1680s**
Painted a portrait of a boy for the family of Freeman of Aspenden (Christie's 5 March 1982, lot 27). Worked in the manner of Wissing.

MELE (MEELE), Matthäus de **1664-?1724**
Born at The Hague. Moved to London, where he was a drapery painter for Lely. Returned to The Hague, where he died in 1724 (or 1714 or 1734).

MELLER, Samuel **fl.1702**
Little known painter. His known works are of Welsh sitters, and are painted in the manner of Dahl. His work is very linear, with the drapery of a high standard.

MELVILLE, Alexander **b.c.1821**
Born St Pancras, London son of accountant William Melville and his wife Mary. Exhibited at RA (4), BI (4), SBA (8) 1846-73 from London. Married artist Eliza Anne Smallbone. Recorded working 1881.
Represented: NPG London.

MELVILLE, Mrs Eliza Anne (née Smallbone) b.c.1834
Born Brighton. Exhibited at RA (7), BI (13), SBA (24) 1854-84 from London. Married artist Alexander Melville c.1855/6.

MELVILLE, William **fl.1815-1851**
Painted portraits and miniatures. Worked in India 1815 and settled in Calcutta 1826-34. A partner in the firm of Fergusson & Co, which failed 1832 and left him stranded. Recorded working in Simla 1843.

MENDHAM, Robert **1792-1875**
Born 22 August 1792. Aged 15 apprenticed to family coach building business. Studied at RA Schools. On the death of his brother he inherited the family business which, for a time, he kept going. Married Anne Carter 1830 and had eight children. Exhibited at RA (2), BI (4) 1821-58 from London and Eye, Suffolk.
Represented: Christchurch Museum, Ipswich.

MENZIES, William A. **fl.1886-1911**
Exhibited at RA (18), NWS 1886-1911 from London.

MEQUIGNON, Peter **1769-1826**
Born Dublin 7 January 1769, son of Peter Mequignon, a French cook who moved to Ireland with the Marquess of Townshend. Studied at Dublin Society's Schools, where he won prizes and medals. Entered RA Schools 1788, gaining a medal 1791. Exhibited at RA (7) 1791-1826. Worked in Dublin, Belfast and London. Died London 26 September 1826.
Engraved by R.Laurie. **Literature:** Strickland.

MERCER, Edward Stanley RP ROI **b.1889**
Studied at Slade, under Harry Becker and in Holland, Italy and Madrid. Exhibited at RA (3), RP, ROI and in the provinces 1912-32. Elected RP 1920. Based in London.
Represented: SNPG.

MERCIER, Major Charles **b.1834**
Baptized Clapham 15 August 1834, son of John and Alicia Mercier. Exhibited at RA (1), LA, RMI 1862-79. Worked in Manchester, Pendleton, London and Liverpool. Among his sitters were Disraeli and Lord Napier. Recorded 1893.
Represented: NPG London; Walker AG, Liverpool.
Engraved by W.T.Davey, C.A.Tomkins.

MERCIER, Charlotte **1738-1762**
Baptized London 10 May 1738, daughter of artist Philip Mercier. Painted portraits in oil and crayon in the manner of her father. Died London 21 February 1762.
Represented: Mapledurham. **Literature:** J.Ingamells & R.Raines, *Philip Mercier*, York and Kenwood House exh. cat. 1969 p.54.

MERCIER, Dorothy (née Clapham) **fl.1735-1768**
Second wife of artist Philip Mercier 1735. Painted portraits, miniatures and still-life. Exhibited at SA 1761. Also a print seller and engraver. Retired 1768.
Literature: J.Ingamells & R.Raines, *Philip Mercier*, York and Kenwood House exh. cat. 1969 p.53.

MERCIER, John Colclough **fl.1826-1855**
Possibly born Abbeyleix. Studied at Dublin Society's School. Exhibited at RHA (35) 1826-31 from Dublin. Recorded in Manchester 1855.

MERCIER, Philip **c.1689-1760**
Born Berlin in 1689 or 1691 of a French Huguenot family. Studied in Berlin under Antoine Pesne. Visited Italy and France. Travelled to Hanover, where he painted Frederick, Prince of Wales, bringing this portrait and a recommendation from the Prince to England 1711 or 1716. Married in London 1719. Attracted the patronage of Hanover courtiers and painted conversation pieces from 1725. On the arrival of Prince Frederick from Hanover, he was appointed Principal Portrait Painter to the Prince 1729-36 and Library Keeper 1730-8. He fell out with the Prince c.1736. Settled in York 1739-51 (with visits to Scotland 1740 and Ireland 1747). Visited Portugal 1752 for a year, returning to London. Exhibited at SA (3) 1760. Died London 18 July 1760. Usually favoured bright colours and painted in a distinctively French manner. Waterhouse described

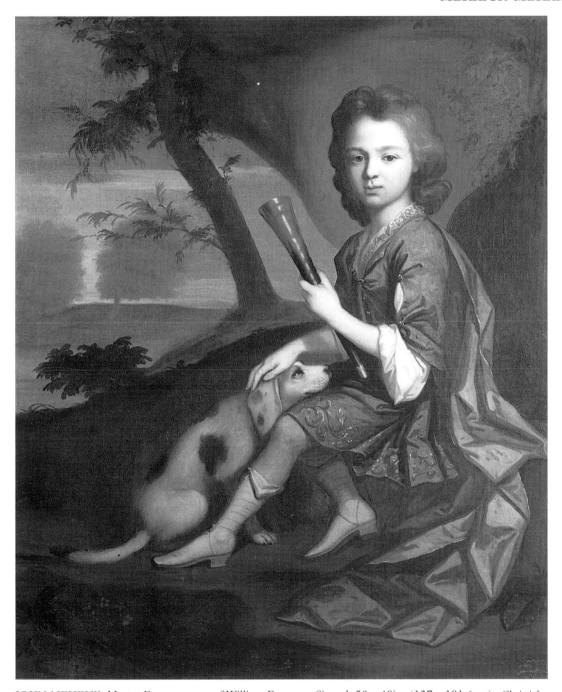

JOHN MEHEUX. Master Freeman, son of William Freeman. Signed. 50 x 40ins (127 x 101.6cm) *Christie's*

him as 'an important figure in the introduction of French taste to England'. Influenced Ramsay, Reynolds, Charles Phillip and Henry Robert Morland among others.
Represented: NPG London; Tate; Leeds CAG; HMQ; Cliveden, NT. **Engraved by** T.Chambers, Desrochers, J.Faber jnr, R.Houston, J.McArdell, J.Simon. **Literature:** J.Ingamells & R.Raines, *Philip Mercier,* York and Kenwood House exh. cat. 1969; J.Ingamells & R.Raines, 'P.M.', Walpole Society XLVI 1978; DNB; DA.

MERRICK, Mrs Emily M. **fl.1878-1899**
Studied at RA Schools (medallist), under Frank Holl and in Paris. Exhibited at RA (10), RHA (21), SBA (13) 1878-99 from London and Northampton. Visited Egypt (where she painted the Khedive) and proceeded to India, where she remained for four years. Among her sitters were John Marshall FRS, President of Royal College of Surgeons, Samuel Wilks MD LLD and Major-General Sir J.C.Ardagh CB.
Represented: Government House, Madras.

MERRIFIELD, Mrs Mary Philadelphia c.1804/5-1889
Born Brompton. Exhibited at SBA (2) 1851 from 8 Dorset Gardens, Brighton. Married barrister John Merrifield. Worked as a writer and editor, and her writings influenced the Pre-Raphaelites. Granted a government pension in 1857 for her services to art.
Literature: DA.

King 1764. Exhibited RA (18) 1769-83. Founder RA. Died Kew 20 January 1789.
Represented: VAM; BM; HMQ; NPG London; Ashmolean. **Engraved by** C.Watson. **Literature:** Foskett.

MEYTENS, Martin van der **1695-1770**
Born Stockholm 24 July 1695, son and pupil of Mertin van der Meytens the elder. Moved to Holland 1712, London 1714, where he studied the work of Van Dyck. Studied enamelling in Paris under C.Boit 1717 and painted the portraits of Louis XV, the Duc d'Orléans and Peter the Great. Worked Dresden, Vienna 1721, Venice 1723, Rome, Naples, Florence, Turin and Genoa. Became based in Vienna, where he became Court Painter to the Emperor and was favourite painter of Empress Marie Thérèse, who appointed him Director of the Academy 1759. Died Vienna 23 March 1770.
Represented: NGI; Uffizi, Florence; Stockholm National Museum. **Literature:** DA.

MICHAEL, Frederick Howard **fl.1892-1929**
Exhibited at RA (10), SBA 1892-1929 from London.

MICHIE, James Coutts ARSA PSSA **1861-1919**
Born Aboyne, Aberdeenshire 29 July 1861, son of Henry Michie. Studied under J.Farquharson and in Edinburgh at Trustees' School 1877-8 and RSA life class, Rome and Paris (under Carolus Duran). Travelled extensively in France, Italy, Spain and Morocco. Lived in Tangier for several years. Exhibited at RSA (97), RA (21), SBA (3), GG, Paris Salon (medallist) 1877-1916 from Aberdeen and London. Elected ARSA 1893. A member of Aberdeen Art Society. Married widow of art collector George McCulloch 1909. Died Haslemere 18 December 1919.
Represented: Aberdeen AG; Walker AG, Liverpool; Sydney AG, Australia. **Literature:** *Art Journal* 1902 pp.290-3; McEwan.

MIDDLETON, Horace **fl.1904-1919**
Born Ladywood. Exhibited in Manchester and at RA (6) 1904-19 from London and Southend-on-Sea.

MIDDLETON, James Godsell **c.1805-1874**
Born Newington Butts, near Walworth c.1805 or c.1809. Exhibited at RA (78), BI (30), RHA (1), SBA (48) 1827-72. Spent some time in Rome and his self-portrait is in Pitti Palace, Florence. Established a highly successful society portrait practice in London. Among his sitters were the Countess of Malmsbury, Viscount Combermere GCB, and Mary Anne, Viscountess Beaconsfield. In 1871 census he was married to Louisa and had three daughters. Died Kensington June 1874. A skilful draughtsman and an accomplished colourist. Henry Barraud was probably a pupil. His daughters, Mary and Josephine, were also portrait painters and almost certainly acted as studio assistants.
Represented: Canterbury Museums; India Office, London; Hughendon Manor, NT. **Engraved by** H.Brett, J.Cochran, H.Cousins, W.H.Mote, J.Porter.

MIDDLETON, James Raeburn **b.1855**
Born Glasgow, son of John Middleton, a merchant. Worked in Glasgow. Exhibited from 1892 at RA (6), RSA (5), GI and in Liverpool and Manchester.
Represented: Glasgow AG. **Literature:** McEwan.

MIDGLEY, William RBSA ARCA **d.1933**
Head of Aston School of Art, Birmingham. Exhibited at RA (2), RBSA (38) 1890-1920 from Birmingham. Elected RBSA 1906.

MILBANKE, Mark Richard **1875-1927**
Born 17 March 1875, son of Sir Peniston Milbanke 9th Bart. Exhibited at RA (21) RHA, RWA, LA 1899-1924 from

JAMES COUTTS MICHIE. A lady. Signed and dated 1890. 50 x 30ins (127 x 76.2cm) *Christie's*

London. Among his sitters were the Hon Mrs Ailwyn Fellowes, 'Sheffield Neave Esq, late Master of the Essex Staghounds' and the Hon Lady Knollys. Died Westminster 31 October 1927 aged 52.
Literature: *The Year's Art* 1928 p.360.

MILBOURN(E), John **fl.1763-1789**
Studied under F.Cotes. Accompanied John Russell to Guildford c.1767. Entered RA Schools 1769. Exhibited at SA (winning premiums), RA (4) 1763-74. Worked as a scene painter at Covent Garden 1783-9. Also a picture restorer. Painted portraits in oil and crayon.
Engraved by T.Gaugain.

MILBURN, R. **fl.1815**
An honorary exhibitor at RA (1) 1815. No address given.

MILEHAM, Harry Robert **1873-1957**
Born London 20 October 1873, son of Harry Thomas Mileham, solicitor. Studied at Lambeth Art School and RA Schools (winning medals). Exhibited at RA (17), NWG 1908-35 from Hove.
Literature: *H.M.*, Hove Museum exh. cat. 1995.

JAMES GODSELL MIDDLETON. A lady, possibly Mary, daughter of William Taylor of Humberstone, Leicestershire. Signed and dated 1856. 50 x 40ins (127 x 101.6cm) *Christie's*

MILES, Arthur fl.1851-1881
Exhibited at RA (13), BI (2), SBA (77) 1851-81 from Walworth and London. Among his sitters were the artists Alfred Clint and John Tennant. Painted portraits in oil and pastel.
Represented: NPG London.

MILES, Charles fl.1840
Listed as a portrait painter in Stepney Green.

MILES, Edward 1752-1828
Born Yarmouth 14 October 1752. Began as an errand boy to a surgeon. Moved to London 1771. Entered RA Schools 20 January 1772. A friend of Sir Thomas Lawrence. Exhibited at RA (18) 1775-97. Appointed miniature painter to Duchess of York 1792. Worked in Norwich 1779 and 1782, Russia 1797-c.1806 (becoming Court Painter to the Tsar). Settled in Philadelphia 1807-28. Died there 7 March 1828. James

Reid Lambdin was his pupil.
Represented: VAM; HMQ.

MILES, G. Frank (George Francis) 1852-1891
Born Bingham, Nottinghamshire 22 April 1852, son of Rev R.H.W.Miles. Studied on the Continent. Exhibited at RA (21), GG 1874-87 from London. Recorded at Llangaviog, Cardiganshire 1881. Returned to London 1882. Died Bristol 15 June 1891.
Literature: F.Harris, *My Life*, 1926 p.428.

MILES, Miss R.H. fl.1891-1910
Exhibited at RHA (65) 1891-1910 from Dublin.

MILESI, Miss Bianca fl.1824
Exhibited at RA (4) 1824 from 'Mr Colnaghi's, 23 Cockspur Street, London'.

JOHN EVERETT MILLAIS. Twa bairns – Frederick and Mary Stewart Phillips Signed with monogram and dated 1888. 53 x 40ins (134.6 x 101.6cm) *Christie's*

MILLAIS, Sir John Everett, Bart PRA HRI HRCA RP
1829-1896
Born Southampton 8 June 1829, son of John William Millais, a man of independent means from an old Jersey family. Studied at Sass's School 1838. Entered RA Schools 1840, its youngest ever student. Exhibited his first work at RA at the age of 16 and won several prizes, including Gold Medal for historical painting 1847. Together with Hunt and Rossetti he formed the controversial Pre-Raphaelite Brotherhood 1848-9. Much of their work was highly criticized, but Ruskin championed their cause in 1851. Exhibited at RA (189), RSA (36), BI (2), RHA (7), RP (16), NWS, GG, NWG, RP 1846-96. Elected ARA 1853, RA 1863, RP 1893. On 3 July 1855 he married Effie, whose previous marriage to Ruskin was a public disaster. Moved away from his earlier Pre-Raphaelite principles and became a highly accomplished and fashionable portrait painter. Among his sitters were Gladstone, Disraeli, Tennyson, Carlyle, Ruskin, Lillie Langtry, Henry Irving and HRH the Princess Marie. By the 1880s his income was estimated at £30,000 a year. In 1885 he was the first English artist to be made a baronet, and in 1896 he became PRA, but died a few months later from cancer of the throat on 13 August 1896. Buried St Paul's Cathedral. Studio sale held Christie's 1 May 1897, 21 March and 2 July 1898. Critics have tended to concentrate on his Pre-Raphaelite period and criticize his later work, but he produced major works of outstanding merit throughout his career.
Represented: Arundel Castle; RA; BM; VAM; Ashmolean; Glasgow AG; Manchester CAG; A. & F.Pears Ltd; Leeds CAG; Southampton CAG; Cecil Higgins AG, Bedford; Tate; Birmingham CAG; NG Canada; NPG London. **Engraved by** T.L.Atkinson, T.O.Barlow, Lacour, O.Leyden, A.H.Palmer,

C.Waltner. **Literature:** W.Armstrong, *Sir J.E.M.*, 1885; J.G.Millais, *Life and Letters of J.E.M.*, 1899; M.H.Spielman, *M. and his Works*, 1898; A.L.Bladry, *Sir J.E.M.*, 1899; J.E.Reid, *Sir J.E.M.*, 1909; A.Fish, *J.E.M.*, 1923; M.Lutyens, *M. and the Ruskins*, 1967; M.Lutyens, Walpole Society Vol 44 1972-4; DA.
Colour Plate 51

MILLAR, James **c.1735-1805**
Recorded in Birmingham Poor Law Levy Books of 1763. Exhibited at SA (1), RA (6) 1771-90. Established a highly successful portrait practice in Birmingham. Died Handsworth 5 December 1805. His works can have great charm.
Represented: Birmingham CAG; VAM; Fitzwilliam; Lichfield AG; Yale. **Engraved by** W.Angus.

MILLAR, Mrs Nevinson **fl.1918-1919**
Exhibited at RHA (4) 1918-19 from Bray.

MILLAR, William **d.1776**
Established a successful practice in Edinburgh 1751-75. Copied Ramsay and visited him in London 1759, but was not his pupil. Also copied Gavin Hamilton during the 1760s. Fond of strong chiaroscuro and smooth modelling. His later works shows similarities with that of David Martin, who was his chief competitor in Edinburgh from 1767. Musgrave lists his death at Edinburgh 11 March 1776.
Represented: SNG; Oxenford Castle. **Engraved by** J.Caldwall. **Literature:** Sir William Musgrave, *An Obitary of the Nobility, Gentry, etc. of England, Scotland and Ireland prior to 1800...*, 1882.

MILLER, Harrison **fl.1895-1910**
Exhibited at RHA (5), RA (1) 1895-1910 from Bray and London.

MILLER, J. **fl.1846-1864**
Exhibited at RA (4), BI (3), SBA (2) 1846-64 from London. Among his sitters was Robert Graves ARA.
Engraved by T.Fairland.

MILLER, James **fl.1768-1788**
Exhibited at SA (1), FS (3), RA (15) 1768-88. Visited Rome 1769.

MILLER, James **fl.1853**
His portrait of 1st Duke of Wellington is in SNPG.

MILLER, Mrs Mary Backhouse **fl.1883-1896**
Exhibited at RA (1), SBA (5) 1883-96 from London. Married artist William Edwards Miller.

MILLER, Philip Homan ARHA **d.1928**
Born Londonderry, son of Rev J.H.Miller, a headmaster. Trained at Royal College of Surgeons, Dublin. Studied at RA Schools (prize winner). Exhibited at RA (11), RHA (98), SBA (11+) 1878-1928 from London. Elected ARHA 1890. His wife Sophia was also an artist. Died Marlow 23 December 1928.

MILLER, Richard **d.1789**
Son of engraver Johann Sebastian Müller. Recorded in London as a landscape and portrait painter. Died Calcutta.

MILLER, William **c.1740-1810**
Born London. Exhibited at FS, SA (29), RA (18) 1780-1803 from London. Elected FSA Director 1780. Among his sitters was William Pitt MP. Painted for Boydell's Shakespeare Gallery.
Engraved by J.Cary, T.Cook, J.Godby, J.B.Michel, J.Murphy, V.Picot, Saillier, W.Sedgwick, B.Smith, C.Townley, J.Walker. **Literature:** DNB.

MILLER, William fl.1841
Listed as a portrait painter in Leicester. May be the W.F.Miller working in Nottingham 1844.

MILLER, William Edwards fl.1872-1909
Exhibited at RA (31), SBA (13) 1872-1909 from London. Painted portrait of the Earl of Enniskillen. Married artist Mary Backhouse.
Represented: NPG London. **Engraved by** G.J.Stodart.

MILLET, Francis David 1846-1912
Born Mattapoisett, Massachusetts 3 November 1846, son of Asa Millet MD. Studied at Harvard University and RA of Fine Arts, Antwerp under J. van Lerius and N.Keyser. Served in the War of the Rebellion as drummer in 60th Mass Volunteers. Assistant contract surgeon in the 6th Army Corps of Potomac. Exhibited at RA (22), NWG 1879-1906 from London. Died in the *Titanic* 15 April 1912. Also painted genre, frescoes and was an illustrator.
Represented: Tate. **Literature:** *Who Was Who* 1897-1915.

MILLICHAP, Thomas fl.1813-1821
Exhibited at RA (11), BI (7) 1813-21 from London. Painted most types of portraits. Reputedly based in Birmingham.
Represented: Duke of Argyll, the Sutherland Trust, Goodwood. **Engraved by** J.Partridge.

MILLINGTON, Henry c.1735-1764
Painted miniatures and watercolour portraits in London, Bath 1757 and Bristol 1756. Exhibited at FS 1761-64.
Literature: *The Gazette* 17 September 1764.

MILLINGTON, Henry fl.1811
Exhibited at RA (1) 1811 from 123 Mount Street, London.

MILLINGTON, James Heath 1799-1872
Born Cork. Lived there and in Dublin. Entered RA Schools 1 April 1826 (winning prizes). Exhibited at RA (26), BI (8), SBA (22) 1831-70 from London. Curator of RA School of Painting. Died of heart disease at Bayswater 11 August 1872.
Represented: VAM; Walker AG, Liverpool. **Literature:** DNB.

MILLS, Moses fl.1845
Listed as a portraitist at 25 Mulberry Street, Hulme, Manchester.

MILLS, Richard fl.1814-1870
Exhibited at RBSA (40) 1814-70 from Birmingham. Elected RBSA 1829.

MIMPRISS, Miss Violet Baber fl.1914-1930
Born Dulwich. Studied at RA Schools, winning prizes. Exhibited at RA (7), RSA, RHA 1914-30 from London.

MINASI, James Anthony 1776-1865
Exhibited at RA (17), SBA (1) 1802-47 from London. Draughtsman to Duke of Sussex 1817. Artist to the King of Naples 1824. Among his sitters was 'Robert Whitehead, the Celebrated Fly-Fisher'. Also engraved portraits.
Represented: SNPG.

MITCHELL, Charles 1860-1918
Born Laurencekirk, son of a farmer. Began a career as a bank clerk. Studied in Montrose, Aberdeen and Germany. Worked in Dundee as a portraitist in oils and a restorer. Exhibited RSA (3). Visited America frequently. Died Pittsburgh 30 May 1918.
Literature: McEwan.

MITCHELL, Charles William 1855-1903
Born Walker, near Newcastle, son of a shipbuilder. Studied in Paris under Comte. Exhibited at RA (7), GG, NWG and in Newcastle. Died Newcastle aged 48.
Represented: Laing AG, Newcastle. **Literature:** Hall 1982.

MITCHELL, J.Edgar 1871-1922
Working as an artist in Dundee by age of 22. Exhibited at RSW, RA (3), RSA and Bewick Club, Newcastle 1893-1914. Settled in Newcastle just before the turn of the century and painted a number of local celebrities.
Represented: Laing AG, Newcastle; Sunderland AG; South Shields Museum & AG. **Literature:** Hall 1982.

MITCHELL, J.T. fl.1825-1830
Exhibited watercolour portraits, miniatures and enamels at SBA (12) 1825-30 from London.
Engraved by J.Brown.

MITCHELL, James B. fl.1883
Exhibited at NWS (1) 1883 from London. His wife was also an artist.

MITCHELL, Madge Young 1892-1974
Born Uddingston, near Glasgow. Studied at Gray's School of Art, Aberdeen. Appointed a teacher there 1911. Exhibited RSA (27), RSW (1) 1919-73.

MITCHELL, Michael d.1750
Son of Sir Michael Mitchell MP (merchant and Lord Mayor of Dublin) and his wife, Elizabeth. Set up as a portrait painter in Dublin. Charged £20 for a full-length portrait of Dean Drelincourt (plus £5 for frame) in 1711. Also worked as a restorer. Died Dublin 23 August 1750 and was buried the same day.
Engraved by Thomas Beard. **Literature:** Strickland.

MITCHELL, Thomas 1735-1790
Painted conversation pieces in Ireland, then specialized in marine and naval subjects. Held appointments at the dockyards of Chatham and Deptford. Exhibited at FS, RA (16) 1763-89 from Deptford, Bethnal Green and Newington. Among his sitters were Sir John and Lady Freke 1757. Assistant Surveyor to the Navy. Died 18 January 1790.

MITCHELL, W. fl.c.1830-1837
Worked as a portrait and miniature painter in England.

MOELLER (MILLAR), Andreas 1684-c.1762
Born Copenhagen 30 November 1684. Painted portraits and miniatures in Germany from 1717, Vienna 1724 and 1737, and England 1728-31 and 1734. Became a painter to Danish Court 1740. Died Berlin 1758 or 1762.
Represented: Landesmuseum, Cassel and Frederiksborg, Copenhagen.

MOFFAT, Janet fl.1840-1858
Painted watercolour portraits and miniatures at Leith. Exhibited at RSA (27).

MOGFORD, Thomas c.1809-1868
Born Exeter 1 May 1809 or 1800 (conflicting sources), son of a veterinary surgeon. Articled in Exeter to John Gendall and Mr Cole. Married Cole's daughter. Established a successful practice in Devonshire. Exhibited at RA (43), BI (10), SBA (23) 1838-61. Moved to London 1843 and later Guernsey. Among his sitters were Sir Thomas Lethbridge Bart, E.H.Baily Esq RA, 'Major General William Napier, Lieut.-Governor of Guernsey and Author of the History of the Peninsular War' and Samuel Cousins ARA. Crippled with palsy through the effects of lead poisoning. His obituary in the *Art Journal* stated that he left a

small number of works which 'for exquisite feeling in execution and truthfulness of effect have rarely been equalled'.
Represented: BM; NGI; Exeter Museum; Castle Museum, Nottingham. **Engraved by** S.Cousins, J.H.Lynch, P.Stodart. **Literature:** *Art Journal* 1868 p.158; DNB.

MOIRA, Gerald Edward PROI VPRWS RWA NPS
1867-1959
Born London 26 January 1867 as Giraldo Eduardo Lobo de Moira, son of a Portuguese miniaturist. Studied at RA Schools, in Paris and under J.W.Waterhouse. Exhibited at RA (14), RSA (11), RWS (102) 1891-1953 from London. Elected ARWS 1917, RWS 1932, VP from 1953. Lived for a time in Middlesex. Taught art in Edinburgh. Died Northwood 2 August 1959 aged 92.
Represented: Tate; VAM; Glasgow AG. **Literature:** H.Watkins, *The Art of G.M.*, 1923; McEwan.

MOLINARI, Guido **fl.1876**
Born Rome. Exhibited a portrait of 'His Eminence Cardinal Manning' at RA (1) 1876 from London.

MÖLLEA (MÖLLER), Johannes Heinrich Ludwig
1814-1885
Born Lübeck. Worked in Copenhagen, Paris, Stockholm, Lübeck and St Petersburg. Exhibited at Paris Salon 1843-47 and RA (15) 1847-73 from London and Hornsea Rise. Member of Danish Royal Academy of Fine Arts. Patronized by Prince Albert. Died London 31 October 1885.

MOLONEY, William **fl.1846-1856**
Listed as a portrait painter in Limerick.

MONCLAR, Count Ripert **fl.1837**
Made a portrait drawing of Robert Browning.

MONIES, A.H. **fl.1797-1809**
Exhibited at RA (5) 1797-1809 from London.

MONOD, Lucien Hector **fl.1891-1907**
Painted landscapes and portraits. Also a lithographer. Exhibited at Paris Salon 1891.
Represented: SNPG.

MONRO, Henry **1791-1814**
Born London 30 August 1791, son of Dr Thomas Monro. Educated at Harrow. Joined the Navy, but left shortly after. Entered RA Schools 1806. Exhibited at RA (15), BI (2) 1811-14 from Covent Garden. Among his sitters were Thomas Hearne. Visited Scotland 1811, where he injured his lungs falling from his horse. Died 5 March 1814 aged 23. Buried at Bushey, where a monument was erected in his memory.
Represented: NPG London. **Literature:** DNB.

MONRO, Robert **c.1785-1829**
Worked in Montrose. Also listed as a portrait painter at 83 Newman Street, London. Applied for the post of Master of Edinburgh School of Design 1817. Died Montrose.

MONTAGUE, H. **fl.1806-1846**
Honorary exhibitor at RA (8), BI (12), SBA (8) 1806-46 from London.

MONTAIGNE, William John **d.1902**
Studied at RA Schools. Exhibited at RA (30), BI (23), SBA (33) 1839-90 from London. Died Stevenage.

MONTALBA, Miss Ellen **fl.1868-1902**
Born Bath. Studied at South Kensington Schools. Exhibited mostly portraits (including HRH the Princess Louise) at RA (14), BI (1), SBA (2) 1872-1902 from London and Venice. Also an illustrator. Sister of artists Clara and Hilda Montalba. Wood writes that her life-size portraits were 'painted with considerable power'.

MOODY, Francis Wollaston (Thomas) **1824-1886**
Exhibited at RA (10), BI (5), SBA (3) 1850-77 from London. Among his sitters was the Earl of Cottenham. Designed stained glass windows and taught decorative art at South Kensington Museum (now VAM), where he painted several ceilings. Died London 10 August 1886.

MOORE, Charles **fl.1768-1773**
Exhibited at FS (38) 1768-73. Often used strong chiaroscuro.
Engraved by F.Deleu.

MOORE, Ernest **1865-1940**
Born Barnsley 6 July 1865. Studied art in London and Paris. Exhibited at RA (9), SBA (2), Paris Salon 1896-1932 from Sheffield and Barnsley. Died 14 September 1940. Among his sitters were the Rt Hon Charles Stuart Wortley QC, MP, the Duke of Norfolk KG, and the Mayor of Sheffield. Influenced by the French realist tradition.
Represented: Arundel Castle; NPG London; Gray's Inn.

MOORE, Miss J. **fl.1856**
Exhibited a portrait of sculptor 'C.Moore MRIA' at RA (1) 1856 from London. Possibly Miss Jane L. Moore.

MOORE, J.G. **fl.1856**
Exhibited a portrait of 'Children of Sir Stafford Northcote Bart MP' at RA 1856 from Shepherd's Bush.

MOORE, J. Marchmont **fl.1832-1836**
Exhibited at RA (6), SBA (10) 1832-6 from London. Among his subjects was Prince Leopold.

MOORE, Miss Jane L. **fl.1851-1875**
Exhibited at RHA (7) 1851-75 from Dublin.

MOORE, John **fl.1827-1837**
Exhibited at RA (3), SBA (7) 1827-37 from Westminster. Among his sitters were 'The Rev John William Mackie MA, FRS' and 'Dr Church, the Eminent Mechanician'.

MOORE, John Collingham **1829-1880**
Born Gainsborough, eldest son of artist William Moore by his second wife, Sarah. Entered RA Schools 1850/1. Established a successful London practice. Exhibited mostly portraits (many of children) at RA (60), RHA (1), BI (1), GG, DG 1852-80 from London. Visited Rome 1858, where he was influenced by George Mason. After 1872 he specialized mostly in child portraiture. Died London 10 July 1880.
Represented: VAM; Fitzwilliam. **Literature:** *Art Journal* 1880 p.348.

MOORE, Miss M.A. **fl.1811**
An honorary exhibitor at RA (1) 1811. No address given.

MOORE, Miss Madena **fl.1879-1881**
Exhibited at RA (4), SBA (2) 1879-81 from London.

MOORE, Morris **fl.1843-1844**
Exhibited at RA (7), BI (3), SBA (2) 1843-4 from London. Living in Perugia, Italy 1851.

MOORE, William **1790-1851**
Born Birmingham 30 March 1790. Studied design there under Richard Mills. Set up a successful portrait practice working in Birmingham, London and mostly York, where he died 9

JOHN COLLINGHAM MOORE. A lady and her children: a triptych. Watercolour. Centre panel 28 x 15ins (91.5 x 38.1cm), side panels 22½ x 11ins (57.2cm x 28cm)
Christopher Wood Gallery, London

October 1851. Among his 13 sons were the artists Albert Joseph, Edwin, Henry, John Collingham and William jnr.
Literature: DNB.

MOORE-PARK, Carton RBA NPS PS 1877-1956
Elected RBA 1899 (resigned 1905). Settled in New York. Published a number of books. Died 23 January 1956.
Represented: NPG London.

MOR (MORO), ?Sir Anthonis c.1516/20-1575/6
Reportedly born Utrecht between 1517-20. Also known as Anthonio Moro. A pupil of Jan Scorel. Travelled to Italy, where he was influenced by Titian. Established an international reputation. Visited London 1554, to paint Queen Mary (Prado and Fenway Court, Boston), and it is widely thought that he was knighted. Also believed to have been appointed Spanish Court Painter when Phillip II eventually went to Spain 1559, but returned to Utrecht the following year. Registered as a Master in the Antwerp Guild from 1547 until his death, and most of his few British subjects were probably painted in Antwerp. An accomplished master working in the tradition of Holbein. His portrait style influenced both Rubens and Velázquez. Ellis Waterhouse described him as 'one of the most important portraitists of the sixteenth century'. Died Antwerp.
Represented: NPG London; Brighton AG; Museo del Prado, Madrid; Louvre, Paris. **Engraved by** J.Brown, T.Chambers, R.Cooper, J.Goldar, C.Hall, J.Hopwood, J.Houbraken, F.Huys, J.Mechel, H.Meyer, F.Milius, T.Nugent, N.Parr, H.Robinson, J.Romney, R.Thew, M.Van Der Gucht, J.Vazquez. **Literature:** M.J.Friedländer, *Altniederländische Malerie*, XIII; DA.

MORAN, John fl.c.1763
Awarded a premium of 5 guineas by Dublin Society 1763. Worked in Dublin as a portrait painter.
Literature: Strickland.

MORAN, John P. d.1901
Studied in London, Paris under Carolus Duran and Rome. Exhibited at RHA (22) 1877-93 from London, Paris and Dublin. Died 1 March 1901.

MORAND, Pierre fl.1842
Made a portrait drawing of Charles Dickens.

MORDECAI, Joseph c.1851-1940
Born London 1851 or 24 December 1860, son of M.Mordecai, a merchant. Studied at Heatherley's and RA Schools (medallist). Exhibited at RA (21), SBA, Paris Salon 1873-1910 from London. Died 31 December 1940. Among his sitters was Edward VII.
Represented: NPG London; Leeds AG; Corporation of London AG.

MORE, J. or T. fl.1690s
Signed a portrait of a gentleman from the Hanford family, sold Christie's 19 May 1939, lot 133.

MORE (MOORE or MORN), Mrs Mary fl.1674-1684/5
Presented a version of one of her portraits to Bodleian Library, Oxford 1674. Successful enough to be taking apprentices in 1684/5 in Painter-Stainers' records, by which time she was a widow.

MOREAU, John fl.1809-1838
Entered Dublin Society's Schools 1799 (winning medals). Visited London 1810-11 and exhibited at RA (5). Exhibited at RHA (8) 1838 from Dublin.

MORESBY, Miss fl.1778
Honorary exhibitor of a portrait in crayons at FS 1778.

MORGAN, Alfred **b.c.1836**
Born Suffolk. Aged 25 in 1861 census. Exhibited at RA (44), BI (7), SBA (35+), GG 1864-1917 from London. His son, Alfred Kedington Morgan, was also an artist.
Represented: VAM; Russell-Cotes Museum, Bournemouth.

MORGAN, Alfred Kedington FSA ARE 1868-1928
Born Kensington 23 April 1868, son of artist Alfred Morgan. Studied at RCA. Exhibited at RA (2) 1899-1902. Taught for a time at Aske's School, Hatcham. Married artist Gertrude Hayes. Art master at Rugby School and curator of the local museum. Died Edinburgh 14 April 1928.

MORGAN, Edwin Ernest RMS **b.1881**
Born Wimbledon 17 January 1881, son of Rev A.Morgan. Studied in Paris, America, Lambeth School of Art and at Heatherley's. Exhibited at RA (36), RMS, Paris Salon (Silver Medal 1928) and in the provinces 1908-67 from London and Torquay. Elected RMS 1913.

MORGAN, Miss Ethel M. **fl.1911-1926**
Exhibited at RA (20) 1911-26 from London.

MORGAN, Frederick ROI **1856-1927**
Son of artist John Morgan. Exhibited at RA (68), BI (4), SBA (22), NWS, GG 1865-1916 from Aylesbury, Leighton Buzzard, London and Broadstairs. Among his sitters were 'Dorothy and Ruth, Daughters of Major H.R.Worthington' and 'HM Queen Alexandra, Her Grandchildren and Dogs' (dogs by Thomas Blinks). Married artist Alice Havers. Died April 1927.
Represented: Leeds AG; Sheffield AG; Walker AG, Liverpool. **Literature:** *Connoisseur* 78 1927 p.104.

MORGAN, James **fl.1824-1825**
Listed as a portrait and miniature painter in Liverpool.

MORGAN, Miss Kate **fl.1882-1899**
Exhibited at RA (8), RHA (8) 1882-99 from London. Among her sitters was Major Charles Moore Watson RE, CMG.

MORGAN, Mrs S. Louisa **fl.1883**
Exhibited at RA (1) 1883 from 1 St Peter's Square, Manchester.

MORIER, David **1705-1770**
Believed to have been at Berne and to have moved to London 1743. In the service of Duke of Cumberland by 1748, for whom he painted in gouache a large number of soldiers in the uniforms of the allied armies 1751-60. Collaborated with Richard Brompton. Exhibited at SA (5) 1760-8. Fell into debt and died in Fleet Prison January 1770. Buried St James's Church, Clerkenwell 8 January 1770.
Engraved by J.Faber jnr, Lempereur, F.S.Ravenet. **Literature:** DNB.

MORIN, Edmond **1824-1882**
Born Le Havre 26 March 1824. Studied under Gleyre. Exhibited at Paris Salon from 1857. Made a portrait drawing of Tennyson c.1856. Died Sceaux 18 August 1882.
Engraved by H.Linton. **Literature:** Bénézit.

MORITZ, C. **fl.1778-1783**
Exhibited at RA (4) 1778-83 from London.

MORLAND (MORELAND), Henry **fl.1675-c.1700**
Painted portraits in the manner of Riley. A portrait of 'Four Children' at Bruges is signed '1675 Hen. Morland/Pinxit'. Portraits signed 'Henry Moreland' were formerly at Aynhoe and Rousham.
Engraved by J.McArdell, R.Purcell.

MORLAND, Henry Robert **c.1719-1797**
Born 1716 or c.1719 (he told Farington he was 76 on 15 June 1795). Married Jane Lacam 1757. Father of George Morland. Picture dealer and forger. Established a London portrait practice by 1754. Exhibited at SA (17), FS (98), RA (8) 1760-92. Painted a portrait of George III (engraved by Houston), and Garrick as Richard III. Forced to sell his house to Reynolds 1760. Made bankrupt 1762. Died London 30 November 1797. Worked in oils and crayons. A highly talented artist, fond of strong chiaroscuro.
Represented: NPG London; NGI; Tate; Manchester CAG; Kedleston Hall; Chequers; Glasgow AG. **Engraved by** R.Houston, J.R.Smith, C.Spooner, J.Watson. **Literature:** *Connoisseur* CXIV 1944 pp.101-4; DA.

MORLEY, Ebenezer **fl.1834**
His portrait of Robert Owen is in NPG London.

MORNEWICK, H. **fl.1848**
Listed as a portrait painter in Manchester.

MOROSINI, George **d.1882**
Born Palermo. Arrived in England 1840. Married, in London, Clothilde Parigiani, a famous contralto, cousin of Pope Pius IX. Soon after his marriage he moved to Dublin, where he worked as a portrait painter. Died Dublin 5 May 1882.
Literature: Strickland.

MORPHY (MURPHY, MORPHEY, MORPHEW), Garrett **d.1716**
Irish Jacobite portrait painter, working mainly in Dublin. A Roman Catholic. May have been a pupil of Gaspar Smitz. In England by 1686, working in Yorkshire 1686-8. Received £24 for a full-length of the Duke of Newcastle, 1686. In the Portland papers 19 June 1688 he is described as 'one Morphew, a Roman Catholic painter, drinking confusion to those who did not read his Majesty's Declaration, was attacked and beaten by one of the King's officers quartering in those parts (York)'. Returned to Ireland c.1689. Will proved Dublin 12 May 1716. Capable of unusual compositions and is important as an early professional Irish portraitist.
Represented: NPG London; NGI; Weston Park; Welbeck Abbey. **Engraved by** R.Collin, J.Van der Vaart. **Literature:** *Irish Portraits 1660-1860*, NGI exh. cat. 1969/70; Strickland; DA.

MORRELL, Frederick **fl.1838-1846**
Listed as a portrait painter in Brighton.

MORRIS, Arthur **b.1773**
Born 6 May 1773. Entered RA Schools 1787. Exhibited at RA (9) 1788-94 from London. Among his sitters was the Duke of Norfolk.

MORRIS, Benjamin **fl.1742**
His crayon portrait of Beau Nash is in the National Rheumatic Hospital, Bath.

MORRIS, Mrs Charlotte Bessie **fl.1845-1846**
Listed as a portrait painter and art teacher in Brighton.

MORRIS, Ebenezer Butler **fl.1833-1863**
Exhibited at RA (17), BI (19), SBA (11) 1833-63 from London. Among his sitters were William Calder Marshall RA and 'The Rt Hon Lord Palmerston KG GCB, as Lord Warden of the Cinque Ports painted for Dover Town Hall'.
Represented: NPG London. **Engraved by** J.Cochran, H.Cook.

MORRIS, Philip Richard ARA **c.1838-1902**
Born Davenport 4 December 1838 (*Who Was Who* says 1833), son of J.S.Morris, an engineer and iron founder. On the advice

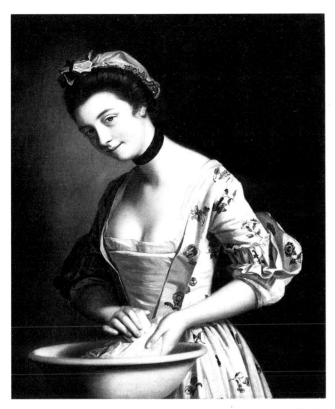

HENRY ROBERT MORLAND. A lady, thought to be Maria, Countess of Coventry, wife of William, 6th Earl of Coventry. 30 x 25ins (76.2 x 63.5cm) *Christie's*

of Holman Hunt he entered RA Schools 1854 (winning medals). Awarded a travelling scholarship and visited France and Italy. Exhibited at RA (101), RHA (7), BI (11), SBA (19), GG 1857-1901 from London. Elected ARA 1877. From the mid-1880s he enjoyed a successful practice and concentrated almost entirely on portraits. Retired as ARA 1900. Died London 22 April 1902.

MORRIS, Thomas **b.c.1771**
Entered RA Schools 1788 aged 17. Exhibited at RA (5) 1791-94 from Baker Street, London. Lived for a time with Arthur Morris.

MORRIS, William Bright ROI 1844-1896
Born Salford. Studied under William J.Muckley in Manchester. Exhibited at RA (36), SBA (3), GG, NWG 1869-6 mostly from London. Travelled in Spain and Italy, and in the 1870s lived for a time at Capri and Granada.
Represented: Manchester CAG.

MORRISH, Sydney Sprague **b.1836**
Baptized Exeter 26 July 1836, son of Thomas and Elizabeth Morrish. Exhibited at RA (37), BI (2), SBA (10) 1852-94 from Exeter, Manchester, London, Crediton, Devon and Torquay. His son W.S.Morrish was also an artist.

MORRISON, James **1778-1853**
Born near Dumfries. Educated Dumfries School. Studied under A.Nasmyth in Edinburgh. Painted portraits in Dumfries. Assistant to bridge builder Thomas Telford. Made a plan of Sir W.Scott's residence. Published a volume of poems 1832. Died 8 June 1853.
Literature: McEwan.

MORRISON, R. **fl.1844-1857**
Exhibited at RA (10), BI (2), SBA (5) 1844-57 from London.

MORRISON, Robert Edward RCA 1851-1924
Born Peel, Isle of Man 31 December 1851, son of John Morrison, a builder. Studied at Liverpool School of Art (Gold Medallist), Heatherley's and Académie Julian, Paris under Bouguereau and Robert Fleury. Established a successful portrait practice in Liverpool painting local dignitaries in a French realist manner. Exhibited at RA (41), LA, SBA, NWS 1884-1918. Member of RCA, President of LA. Died Liverpool 25 December 1924. His best works are outstanding.
Represented: Walker AG, Liverpool; the Queen's College, Oxford.

MORSE, Captain John **fl.1779-1804**
An honorary exhibitor at RA (20) 1779-1804. Served in 1st Horse Guards 1776-83.
Represented: Brighton AG.

MORSE, Samuel Finley Breeze PNA 1791-1872
Born Charleston, Massachusetts 27 April 1791, son of Jedidiah Morse. Encouraged by Gilbert Stuart. Studied at Yale and under Allston, with whom he moved to London, where he also studied under B.West. Exhibited at RA (3), BI (1) 1813-15. Practised portraiture on his return to America 1815, adding richness and colour to Allston's neo-classical manner. Worked variously at Charleston 1815-21, Boston, New Hampshire, and New York from 1823. Founder member and first President of NA, New York. Visited Europe 1829-33, and painted less on his return to America. Inventor of the Morse code and of an electro-magnetic telegraph. Died New York 2 April 1872.
Represented: Yale; NG Washington; City Hall, New York; Brooklyn Museum. **Literature:** O.Larkin, *S.F.B.M. and American Democratic Art*, Boston 1954; P.J.Staiti, *S.F.B.M.*, 1989; DA.

MORTIMER, John Hamilton PSA ARA 1740-1779
Born Eastbourne 17 September 1740 (baptized 6 November 1740), son of a customs collector. Studied with Hudson c.1757, with Pine 1759 and at Duke of Richmond's Academy under Cipriani. Exhibited at SA (92), FS (3), RA (13), BI (4) 1762-79. Won five premiums at SA 1759-62 and prizes for historical paintings at FS 1763 and 1764. Elected President of SA 1774, ARA 1778. Enjoyed drinking and cricket. Married a farmer's daughter, moving to Aylesbury c.1775. Died London 4 February 1779 Buried Wycombe Church.
Represented: Radburne Hall; BM; VAM; NGI; SNG; Tate; Yale; Wadham College, Oxford; Detroit Institute of Arts. **Engraved by** R.Blyth, W.Dickinson, V.Green, W.Ridley, W.Skelton, T.Tagg, A.Van Assen, J.Young. **Literature:** B.Nicolson, *J.H.M.*, Kenwood House exh. cat. 1968; J.Sunderland, 'J.H.M., His Life and Works', Walpole Society LII 1986; DA.

MORTIMER, Roger **1700-1769**
East Sussex painter of portraits and histories. Uncle of John Hamilton Mortimer. His paintings have been recorded in churches at Hastings and Aylesbury.
Engraved by J.Faber jnr.

MORTLOCK, Miss Ethel **fl.1878-1904**
Born Cambridge. Studied under Orchardson. Exhibited at RA (29) 1878-1904 from London. Established a high society portrait practice. Among her sitters were HRH the Duke of Madrid, the Earl of Ashburnham and the Duchess of Wellington. Her portrait of the Duke of Wellington is believed to be one of the earliest portraits showing a sitter smoking a cigarette.
Represented: Stratfield Saye; Nottingham Castle Museum.

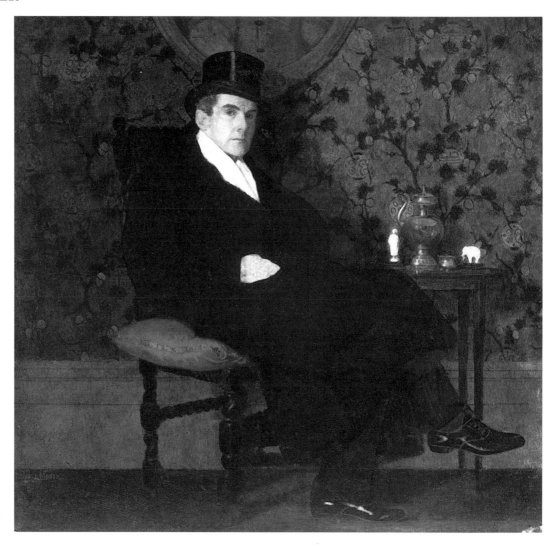

ROBERT OSWALD MOSER. A man in a fur coat. Signed and inscribed on a label on the reverse. Board. 36 x 36ins (91.5 x 91.5cm)
Christopher Wood Gallery, London

MORTON, Andrew **1802-1845**
Born Newcastle, son of Joseph Morton, a master mariner. Studied at RA Schools (medallist 1821). Exhibited at RA (58), BI (35), SBA (4), in the provinces 1821-45 from Newcastle and London. Established a successful and distinguished practice painting society figures in the manner of Lawrence. Among his sitters were Sir James Cockburn, Lady Hamilton, the Duke of Wellington and William IV. Died of inflammation of the lungs in London 1 August 1845.
Represented: NPG London; Laing AG; Tate; Literary and Philosophical Society, Newcastle; Apsley House; Newcastle Central Library; Wallace Collection; SNPG; Laing AG, Newcastle; Greenwich Hospital; Royal College of Surgeons. **Engraved by** T.L.Atkinson, J.Cochran, B.P.Gibbon. **Literature:** DNB; Hall 1982.

MORTON, George **fl.1879-1904**
Exhibited at RA (18), RHA (9), SBA (9), NWS, GG 1879-1904 from London.

MORTON, William **fl.1862-1889**
Painted portraits and landscapes from a base in Manchester.
Represented: Manchester CAG.

MOSCHELES, Felix Stone **1833-1917**
Born London 8 February 1833, son of composer Ignaz Moscheles. Studied under Jacob van Leirus at the Antwerp

Academy, where he met his friend George du Maurier. They became interested in hypnotism, and Moscheles often appeared in du Maurier's cartoons. Worked as a portrait painter in Paris. Moved to London 1861, where he built up a successful practice. Exhibited at RA (23), BI (2), RHA (5), SBA 1862-1915. Also worked in Leipzig and travelled in Spain and Algiers. Published *In Bohemia with George du Maurier.* Died at Spa Hotel, Tunbridge Wells 22 December 1917.
Represented: NPG London. **Literature:** L.Ormond, *George du Maurier,* 1969; F.S.Moscheles, *Fragments of an Autobiography,* 1902.

MOSELEY, Henry **1798-1866**
Born Thorley Hall, Hertfordshire. Baptized 27 May 1798, son of Litchfield and Betsey Mosley. Exhibited at RA (24), BI (1), SBA (6) 1842-66 from London. Painted a portrait of artist 'E.M.Ward RA'. Married 22 October 1840 miniaturist, Maria A.Chalon, daughter of H.B.Chalon and niece of James Ward. Died Lewisham 24 December 1866.
Represented: India Office; NPG London. **Engraved by** F.Holl, R.J.Lane.

MOSER, Miss Mary (Mrs Lloyd) RA **1744-1819**
Born London 27 October 1744, daughter of artist George Michael Moser. Exhibited at SA (10 winning premiums), RA (36) 1758-1802. Founder RA. Her work was admired by

FELIX STONE MOSCHELES. George Henschel. Signed, inscribed and dated 1880. 17¼ x 18½ins (43.8 x 47cm)
Christopher Wood Gallery, London

JEAN-LAURENT MOSNIER. Lady Callander and son. Exhibited 1796. 99 x 66ins (251.5 x 167.7cm) *Christie's*

Walpole and she won a premium and special Silver Medal at SA 1758-9. Married Captain Hugh Lloyd 23 October 1793, and from that date exhibited in her married name. Painted portraits, but specialized in flower paintings. Produced a large number of these for Queen Charlotte for a room at Frogmore, for which she was paid over £900. When West was elected PRA, Fuseli voted for Mary Moser with the characteristic remark that 'one old woman was as good as another'. Survived her husband several years. Died London at 10 am Sunday morning 2 May 1819. Buried alongside her husband in Kensington Cemetery. **Represented:** BM; VAM; Leicester CAG; RA, London; Ulster Museum. **Literature:** DNB; DA.

MOSER, Robert Oswald RI ROI 1874-1953
Born London 28 November 1874. Studied at St John's Wood School of Art. Exhibited at RA (39), RHA (1), ROI, RI, Paris Salon (Silver Medal 1922) 1904-46 from Hampstead, Bournemouth and Rye. Died 31 March 1953. His work reached a remarkably high standard and he was capable of compelling compositions.

MOSMAN, William c.1700-1771
Believed to have been born in Aberdeen, where his brother later practised as an advocate. Visited London 1727 with an introduction from Sir John Penicuik to W.Aikman, whose work he copied. Worked for Patrick Duff of Premnay at Culter House, Peterculter 1731 (the year of Aikman's death). In Rome from at least January 1732 to 1737/8, where he studied (as did Ramsay) under Francesco Imperiali and acted as agent for Scottish collectors. Visited Leghorn November 1736. Back in Aberdeen during the second half of 1738, when he painted Patrick Duff and other members of his family. A sale of the collection he had assembled in Italy took place in Edinburgh 1740, when advertisements announced that he was leaving the city (although records show him to be there at least during 1743-5). By the 1750s he had settled in Aberdeen, and in the

1760s ran a Drawing Academy there. Late portraits are rare. Died near Aberdeen 26 November 1771.
Represented: Kinnaird Castle; Culzean Castle, SNT; Aberdeen AG; SNPG. **Literature:** McEwan; DA.

MOSNIER, Jean-Laurent c.1743/4-1808
Born Paris. Elected *agréé* at Paris Académie 1786 and full member 1788. Moved to London at the time of the Revolution (1790) and adapted quickly to the English taste. Exhibited at Paris Salon 1787-9 and RA (32) 1791-6. Among his sitters were The Duchess of Leeds, Lady Caroline Campbell and Lord Rodney. Moved to Hamburg 1797-1801, and then St Petersburg where he became a Court Painter to the Tsar and Professor of the Academy there. Died St Petersburg 10 April 1808. Waterhouse described his style as 'slightly Frenchified Hoppners'. A highly accomplished master.
Represented: NMM; University of Michigan; Earl of Cathcart; Louvre; Marquess of Lansdowne; The Hermitage; Kunsthalle, Hamburg.
Colour Plate 52

MOSS, S. fl.1828-1829
Exhibited at RA (1), SBA (2) 1828-9 from Bristol and London.

MOSSES, Alexander 1793-1837
Born Liverpool, son of George Mosses, a plasterer and stucco maker. Apprenticed to engraver Henry Hole (a pupil of T.Bewick). Learnt colouring from J.Jenkinson. Exhibited at

ARNOLD GEORGE MOUNTFORT. Three ladies. Signed and dated 1911. 64 x 102ins (162.6 x 259.1cm)

Christopher Wood Gallery, London

LA, RHA (2) 1811-36. Elected LA 1822, Master of Drawing Academy 1827, Professor of Drawing 1835. Discovered, and encouraged, William Daniels. Died Liverpool 14 July 1837 aged 44. A gifted and sensitive artist. His mature works reflect the taste for the neo-classical.
Represented: Walker AG, Liverpool; Hornby Library, Liverpool; SNPG. **Engraved by** E.Smith. **Literature:** *Liverpool Mercury* 21 July 1837.

MOSSMAN, David **1825-1901**
Born Islington. Worked as a portrait and miniature painter in Newcastle 1853-7 and London. Exhibited RA (10), RSA (18) 1853-88. Died Southwick, Sussex 23 June 1901. Left effects of £7,442.3s.
Represented: Laing AG, Newcastle.

MOTT, J.N. **fl.1845**
Exhibited at RA (1) 1845 from Soho.

MOTT, Miss Laura **fl.1892-1898**
Exhibited at RA (2) 1892-8 from London.

MOTTEZ, Victor Louis **1809-1897**
Born Lille 13 February 1809. Exhibited at RA (8) 1849-69 from London. Among his sitters were 'HRH the Duke d'Aumale' and 'HRH the Duchess d'Aumale and Her Son the Prince of Condé'. Died Bièvres 7 June 1897.
Represented: Louvre.

MOUCHET, A. **fl.1816**
Exhibited at RA (2) 1816 from Mr Oliver's, 96 Jermyn Street, London.

MOULTING, George **fl.1847-1857**
Exhibited at RA (2), SBA (15) 1847-57 from London. Worked mainly in watercolour.

MOUNTFORT, Arnold George **b.1873**
Baptized St Martins, Birmingham 14 February 1873 son of Walter Mountfort. Exhibited at RBSA (9), RA (9) 1892-1916 from Birmingham and London. Among his sitters was the Bishop of Peterborough.

MOYNAN, Richard Thomas **RHA** **1856-1906**
Born Dublin 27 April 1856, son of Richard Moynan and Harriet (née Noble). Intended for the medical profession and studied at Royal College of Surgeons. Gave up for art and studied at RHA (winning prizes), in Antwerp and Paris under Collin, Courtois, Robert-Fleury and Bouguereau. Returned to Dublin 1886 and set up as a portrait painter. Exhibited at RHA (98) 1880-1903 from Dublin and Paris. Highly successful and extremely popular. He was a freemason. Died Dublin 10 April 1906. Buried at Mount Jerome.
Literature: Strickland.

MUIRHEAD, Daniel **fl.1895-1896**
Exhibited at RA (2) 1895-6 from Edinburgh and Blackheath.

MULLARD, Joseph Albert **b.1868**
Born Rastrick 18 September 1868. Studied in Bradford, London and Paris. Lived in London, Epsom and Godalming, Surrey. Exhibited at RA (8) 1913-45.

MULLER, Professor Carl **fl.1872-1888**
Exhibited at RA (7) 1872-88 from London and Düsseldorf.
Represented: Bradford AG.

MULLER, Robert **1773-after 1800**
Born 13 July 1773. Entered RA Schools 1788. Exhibited at RA (30) 1789-1800 from London and Windsor. Among his

GEORGE FRANCIS MULVANY. Mrs Anne Francis Wallace (neé Flaherty) and her two children, James and Mary. Signed and dated 1834. 30 x 25ins (76.2 x 63.5cm) *Sotheby's*

sitters were HRH Princess Elizabeth, HRH Princess Mary, HRH Prince Edward and George Morland.
Represented: Dulwich AG. **Engraved by** W.C.Edwards, E.Scriven, J.Wright.

MÜLLER, Robert Antoine **fl.1872-1881**
Exhibited at RA (7), SBA (3) 1872-81 from Notting Hill. Painted 'HRH Princess Louise, Marchioness of Lorne' and the children of the Duke of Edinburgh.

MULLIGAN, James Andrew **fl.1863-1891**
Exhibited at RBSA (8) 1863-91 from Birmingham.

MULLIN, Henry **1811-1872**
Born at Mountmellick, Queen's County. Worked in South of Ireland as a portrait painter. Died Dublin.
Literature: Strickland.

MULREADY, John **1809-1893**
Son of William Mulready and Elizabeth (née Varley). Exhibited at RA (7), BI (3), SBA (1) 1831-43 from London. Died Shepherds Bush 25 March 1893.

MULREADY, Michael **c.1808-1889**
Conflicting sources give his date of birth as 1805, 1807 and 1808. Son of William Mulready and Elizabeth (née Varley). Exhibited at RA (21), SBA (1) 1830-51 from Bayswater. Died Islington 19 January 1889.

MULREADY, Paul Augustus **1805-1864**
Son of the genre painter William Mulready and Elizabeth (née Varley). Exhibited at RA (13), BI (1), SBA (3) 1827-55 from London.

MULRENIN, Bernard **RHA** **1803-1868**
Born County Sligo. Set up as a portrait and miniature painter in Dublin. Exhibited portraits and miniatures at RHA (415) 1826-68 from Dublin, where he had a successful practice. Elected ARHA 1837, RHA 1860. Died Dublin 22 March 1868. Sometimes painted portraits on marble coated with a faint photographic base.
Represented: NPG London; NGI.

MULVANY, George Francis **RHA** **1809-1869**
Born Dublin, son of miniaturist Thomas James Mulvany. Studied at RHA Schools and in Italy. Exhibited at RHA (189), RA (2) 1827-68. Elected ARHA 1830, RHA 1835, Keeper 1845. Helped found NGI and became its first Director 1862. Died Dublin 6 February 1869. Buried 10 February at Mount Jerome. All the members of RHA attended the funeral as a mark of respect.
Represented: NGI. **Engraved by** G.R.Ward. **Literature:** Strickland.

MUNBY, Charles **b.c.1830**
Born Lincoln. Listed as a portrait painter aged 31 in 1861 census for London.

MUNNINGS, Sir Alfred James **KCVO PRA RWS RP**
 1878-1959
Born Mendham, Suffolk 8 October 1878, son of John Munnings, a miller and merchant. Apprenticed to a lithographer 1893-8. Studied at Norwich School of Art and Académie Julian, Paris. Exhibited at RA (295), RP (11), RHA (2) 1895-1960. Elected ARA 1919, RA and RP 1925, RWS 1929, PRA 1944-9, knighted 1944, KCVO 1947. Lost the sight of one eye 1899. Twice married, his first wife having committed suicide. Died Dedham 17 July 1959. Renowned mostly for his horse paintings, but he was a superb draughtsman and produced some highly accomplished portraits.
Represented: Castle House, Dedham (Munnings Memorial

PIETER NASON. A nobleman, possibly 1st Earl of Shaftesbury. Signed and dated 1663. 32¾ x 27ins (83.3 x 68.6cm) *Christie's*

N

NAFTEL, Mrs Isabel (née Oakley) **b.1832**
Baptized Derby 20 July 1832, daughter of artist Octavius
Oakley and Maria née Moseley. Second wife of Guernsey artist
Paul Jacob Naftel. Exhibited at RA (10), SBA (13), NWS,
GG, NWG 1857-89. A daughter, Maud, was also an artist.

NAFTEL, Miss Isabel **fl.1870-1873**
Exhibited works, including a portrait of 'The Dowager
Duchess of St Albans', at RA (4) 1870-3 from Guernsey.
Believed to have been daughter of Guernsey artists Paul Jacob
Naftel and his second wife Isabel (née Oakley).

NAIRN, George ARHA **1799-1850**
Born Dublin. Studied at Dublin Society's School.
Exhibited at RHA (95) 1826-49 from Dublin. Elected
ARHA 1828. Specialized in animal painting. Died Dublin 25
January 1850.
Represented: NGI.

NAIRN, James McLachlan **1859-1904**
Born Lenzie near Glasgow 18 November 1859. Studied
under R.Greenlees and W.Y.McGregor. Exhibited RSA (5).
From 1899 he lived in New Zealand where he was considered
the foremost artist. Died Wellington 2 or 22 February 1904.
Represented: Glasgow AG; Wellington Museum, New
Zealand. **Literature:** *J.N.,* Auckland, New Zealand exh. cat.
1964; McEwan; DA.

NAIRN, James T. **fl.1818**
His portrait of George Demster is in SNPG. Exhibited RSA
(2) 1853-4 from Kirkcaldy.

NALDER, James H. **fl.1853-1881**
Exhibited at RA (3), BI (8), SBA (16) 1853-81 from
London, Challow, near Wantage and Henley-on-Thames.

NANCE, Robert Morton **fl.1895-1900**
Exhibited at RA (3) 1895 from Bushey. Probably studied at
Herkomer's School.

NAPIER, John James **1831-1877**
Born Glasgow 29 July 1831. Educated in Glasgow and at
Anderson University. Exhibited at RA (32), RSA (51), BI (5)
1856-76 from London. Among his sitters were Sir James
Melville KCB; the Hon Sir Samuel Cunard Bart, David
Roberts and 'His Excellency Musurus Bey, Ambassador of the
Sultan'. Died Hammersmith 20 March 1877 aged 45.
Represented: NPG London; Dundee AG. **Literature:**
McEwan.

NASH, G.V. **fl.1827-1830**
Exhibited at SBA (4) 1827-30 from London.

NASMYTH, Alexander RSA **1758-1840**
Born Edinburgh 9 September 1758, son of Michael Nasmyth,
a builder. Studied at Trustees' Academy under Alexander
Runciman. Became pupil and assistant to Ramsay in London
from 1774 until he set up an accomplished portrait practice on
his own in Edinburgh from 1778. Travelled to Italy 1782 and
was in Rome 1783-5, where he became interested in
landscape. Returned to Edinburgh by 1785. First specialized

ALEXANDER NASMYTH. John Cockburn Ross of Rochester
and Shadwick. 35 x 27¼ins (88.9 x 69.2cm) *Christie's*

in conversation groups. His friendship with Burns, and
interest in the picturesque, led him by 1792 to give up portrait
painting for landscape. Generally regarded as one of the most
influential founders of the Scottish School of landscape
painting. His portraits were also of an extremely high standard
though less influential. Had a large and extremely talented
family, many of whom made a career in art under his teaching.
Exhibited at RSA (122), RA (9), BI (18), SBA (3) 1808-40.
Elected Honorary RSA 1832. Died York Place, Edinburgh 10
April 1840. Buried St Cuthbert's churchyard. Among his
pupils were James Tannock, James Morrison, George Watson,
Anthony Stewart and Andrew Robertson.
Represented: NPG London; SNPG; BM; Glasgow AG;
SNG; Dalmeny House, South Queensferry. **Literature:**
DNB; P.Johnson & E.Money, *The N. Family of Painters,*
1977; *A.N. and His Family,* Monk's Hall Museum, Eccles
exh. cat. 1973; *Art Union* 1840 p.71; J.C.B.Cooksey, *A.N.
1758-1840,* 1991; McEwan; DA.

NASON, Pieter **1612-1690**
Lived and worked mainly in The Hague. It is not certain if he
came to England, but he may have done so in 1663. A
payment to a Mr Nason c.1680 by Lely's executors may
indicate another visit.
Represented: NPG London; Dulwich AG. **Engraved by**
C.van Dalen.

NAVIASKY, Philip **b.1894**
Born Leeds. Studied at Leeds School of Art and RCA.
Established himself as a portraitist in Yorkshire. Travelled in
Holland, France and Spain. Taught at Leeds School of Art.
Exhibited at RA (12), RP, RSA 1914-54.
Represented: Leeds CAG.

NAYLOR, Miss Marie J. fl.1883-1904
Exhibited at RA (12), RHA (11), SBA (9) 1883-1904 from Barnes and Paris.

NEAGLE, John 1796-1865
Born Boston, Massachusetts 4 November 1796. Brought up in Philadelphia. Apprenticed to a coach painter. A pupil of P.Ancora, T.Wilson, B.Otis and T.Sully. Married Sully's niece and stepdaughter 1826, and was much influenced by his father-in-law (who painted in the manner of Lawrence). Also influenced by Gilbert Stuart, who he went to see in Boston 1825. Sometimes painted British sitters. Simon describes him as 'one of the most impressive American portraitists of the second quarter of the 19th century'. Died Philadelphia 17 September 1865.
Represented: NG Washington; Boston MFA; Pennsylvania AFA; Newark Museum. **Literature:** *Dictionary of Artists in America;* Patrick, *J.N., Portrait Painter and Pat Lyon, Blacksmith,* nd.; *Art in America,* XXXVII 1929 pp.79-99; DA; M.Fielding (ed) *J.N.,* Academy of Fine Art, Philadelphia exh. cat. 1925.

NEALE, George Hall c.1863-1940
Born Liverpool, son of a corn merchant. Studied at Liverpool School of Art and at Académie Julian, Paris under Laurens and Constant. Exhibited at RA (64), RP, ROI, LA 1883-1939 from Liverpool. Elected President of LA. Married portraitist Maud Rutherford. It is said that he would sometimes paint the husband, while she would paint the wife. Moved to London c.1914, but retained his studio in Liverpool. Died London 27 April 1940.
Represented: Athenaeum, London; Walker AG, Liverpool.

NEALE, Mrs Maud Hall (née Rutherford) fl.1906-1938
Born Waterloo, near Liverpool, daughter of William Rutherford. Studied art in Paris under Delecluse. Married artist G.H.Neale. Exhibited at RA (40), RP, ROI, LA 1906-38 from Liverpool and London.
Represented: Walker AG, Liverpool.

NEATBY, Edward Mossforth RMS 1888-1949
Born Leeds 22 September 1888, son of mural painter W.J.Neatby. Studied at RCA and at Slade under Tonks, Steer and Russell. Exhibited at RA (6), RI, RP, RMS, SBA 1913-38. Elected RMS 1913.
Represented: VAM.

NEEDHAM, E. fl.1786-1798
Exhibited at RA (5) 1786-90 from Holborn and Chesterfield.
Engraved by P.Audinet, J.R.Smith.

NEEDHAM (NEDHAM), William fl.1830-1831
Listed as a history, portrait and landscape painter in Leicester.
Engraved by C.Turner.

NEILAN, William b.1815
Born Dublin. Exhibited at RHA (5) 1836-49 from Dublin. Taught at Dublin Schools 1846-54.

NELSON, Mrs D. fl.1856
Exhibited at RA (1) 1856.

NELSON, Horatio d.1849
Studied at Dublin Society Schools 1834. Exhibited portraits and miniatures at RHA (23) 1835-45 from Dublin. Credited as the first to introduce the daguerreotype process to Dublin.

NELSON, John Henry c.1800-1847
Exhibited portraits and sculpture at RHA (28) 1834-46 from Dublin. A freemason. Died Manchester 26 December 1847.

NELSON, Miss Katherine Boyd b.1897
Born Lewisham 9 October 1897. Studied at Goldsmiths' College. Exhibited at RA (1), RP, NPS, NEAC from Blackheath.

NERLI, Marchese Girolamo Ballatti 1860-c.1926
Born Siena 21 February 1860, son of an Italian nobleman and English mother. Studied in Florence. Helped introduce Impressionism to Australia. Director of Dunedin Art School, New Zealand. Moved to London 1904. Attached during 1st World War to British Embassy, London as director of the prisoners-of-war department. Medallist at Brera Gallery, Milan. Died Nervi, near Geneva 24 June 1926 or Siena 11 March 1947.
Represented: New South Wales AG. **Literature:** DA.

NESTOR, Ray 1888-1989
Born India 27 October 1888, and spent part of his childhood with his uncle Jim Corbett (author of *Man-Eaters of Kumaon*). Worked as a surveyor in the British East Africa Protectorate 1912, and resigned from Colonial Service to join Royal Engineers bound for France. Badly wounded in battle of the Somme the following year and repatriated. Lived at Kipkarren, where he produced portraits and ran a small dairy farm. After 35 years in Kenya he retired aged 62, with his wife Dorothy to Crowborough. Died aged 100 in June 1989.
Represented: Mathaiga Club. **Literature:** *Daily Telegraph* 13 June 1989.

NEVE, Cornelius de (Leneve) (ii) fl.1594-1664
Listed in a return of aliens with his father 1594. Recorded in London 1627 and was still painting 1664. Sometimes signed 'C.D.N.'.
Represented: Ashmolean; Petworth, NT; Knole, NT.

NEVETT, John fl.1852-1853
Listed as a portrait painter in Exeter.

NEWBERRY, W.M. fl.1843-1845
Exhibited at SBA (3), RA (1) 1840-5 from London. Possibly the William Newberry of Heathfield who studied under J.B.Malchair and was a friend of William Crotch and John Constable.

NEWCOMBE, George W. 1799-1845
Born England 22 September 1799. Worked in London. Exhibited at RA (5) 1825-8. Went to New York 1829, where he settled. Elected ANA 1832. Died New York 10 February 1845.

NEWELL, Hugh 1830-1915
Born near Belfast 4 October 1830. Studied in Paris and at RCA. Moved to America c.1851, where he settled in Baltimore. In Pittsburgh c.1860, but returned to Baltimore 1879.
Represented: Baltimore Museum.

NEWENHAM, Frederick 1807-1859
Born County Cork, but moved to London, where he painted historical subjects and portraits. Commissioned to paint a portrait of Queen Victoria, and a companion portrait of Prince Albert, for the Junior Service Club 1842, and this helped establish him as a fashionable society portrait painter. Exhibited at RA (19), BI (17) 1838-55 from London. Died London 21 March 1859.
Represented: Salford Museum; Institute of Directors. **Engraved by** J.Harris, F.C.Lewis, G.T.Payne. **Literature:** *Gentleman's Magazine* 1859 p.548; DNB.

NEWMAN, Thomas fl.1813-1818
Studied at Dublin Society Schools, winning prizes 1813 and 1815. Worked in Dublin painting portraits and miniatures.

NEWTON, Lady Ann Mary (née Severn) 1832-1866
Born Rome 29 June 1832, daughter and pupil of artist Joseph Severn, then English Consul. Studied with George Richmond, who lent her some of his portraits to copy, which she accomplished with such success that he employed her for that purpose. Aged 23 she went to Paris and studied under Ary Scheffer. While there she painted a watercolour portrait of the Countess of Elgin, which was well received and gained her numerous commissions on her return to England, including some from the Queen. Exhibited at RA (10) 1852-65. Married Sir Charles Newton, BM Keeper of Antiquities 27 April 1861. Died of measles in London 2 January 1866.
Represented: NPG London; BM. **Literature:** *Art Journal* 1866 p.100; DNB.

NEWTON, Francis Milner RA c.1728-1794
Baptized St Andrew, Holborn 31 January 1728, son of Edward and Mary Newton. Studied under M.Tuscher and at St Martin's Lane Academy. In 1755 he was involved with schemes for an Academy, and 1765 with the Incorporated Society of Artists. Among his sitters was 'Dr Thomas, Bishop of Winchester'. Exhibited at SA (8), RA (8) 1760-74. Elected RA 1768 and was its first Secretary 1768-88. Died near Taunton 7 (DNB says 14) August 1794. Buried at Corfe.
Literature: DNB.

NEWTON, George fl.1845-1848
Listed as a portrait painter in Brighton.

NEWTON, George H. fl.1850-1859
Exhibited at RA (2), BI (1), SBA (22) 1850-9 from London and Durham School of Art. Seems to have been listed as two artists in SBA.
Represented: VAM.

NEWTON, Gilbert Stuart RA 1794-1835
Born Halifax, Nova Scotia 20 September 1794, son of Henry Newton, a customs collector. After the death of his father 1803, he studied art under his maternal uncle, Gilbert Stuart. Travelled to Italy in 1817 and then Paris and RA Schools from 1820. Exhibited at RA (27), BI (22) 1818-33 from London. Elected ARA 1828, RA 1832. Friend of C.R.Leslie and Washington Irving. He and wife, Sally (from Boston), were popular in English high society circles. Among his sitters were Sir Walter Scott, and Lady Mary Fox. Went mad December 1832, recovering only four days before his death from consumption at Chelsea 5 August 1835. Buried Wimbledon Churchyard.
Represented: Walker AG, Liverpool; VAM; Tate; HMQ; SNPG; NGI; Wallace Collection; Harvard University; Marquess of Lansdowne. **Engraved by** S.Cousins, S.J.Ferris, W.Finden, R.J.Lane, G.H.Phillips, W.H.Watt. **Literature:** DNB; *Art Journal* 1864 pp.13-15; H.Murray, *The Gems of G.S.N.*, 1842; DA.

NEWTON, John Orr fl.1834-1843
Exhibited at RHA (20) 1834-43 from Dublin and Newtown Mount Kennedy.

NEWTON, Sir William John 1785-1869
Born London, son of James Newton. Studied as an engraver, but took up miniature painting and watercolour portraiture. Entered RA Schools 15 January 1807. Exhibited at RA (343), BI (1) 1808-63. Developed a highly successful society practice. Married Anne Faulder 1822. Appointed miniature painter to William IV and Queen Adelaide 1833 and painter to Queen Victoria. Died Hyde Park, London 22 January 1869.
Represented: VAM; NGI; HMQ; BM. **Engraved by** W.Bond, S.Freeman, R.Newton, W.Walker, W.J.Ward, G.Zobel.

NICHOL, Edwin fl.1879-1900
Exhibited at RA (17), SBA (14) 1879-1900 London. By 1900 he was living in Snape, near Saxmundham.

NICHOL, H.W. fl.1848
Exhibited at RA (1) 1848 from London.

NICHOLS, Miss Mary Anne fl.1839-1865
Awarded a premium at SA 1838. Exhibited at RA (12), SBA (37) 1839-65 from Islington.

NICHOLSON, Francis OWS 1753-1844
Born Pickering, Yorkshire 14 November 1753. Studied briefly under Beckwith in York. Worked in Yorkshire, painting a number of portraits, mostly in oil. Received lessons from C.M.Metz in London. Settled in Whitby 1783-92. Took up landscape painting in watercolour. Visited Isle of Bute with his patron the Marquess of Bute. Exhibited at RA (11), OWS (277) 1789-1814. Founder OWS 1804. Had a flourishing practice as a drawing master. Died London 6 March 1844.
Represented: BM; VAM; Coventry AG; Dudley AG; Leeds CAG; Cartwright Hall, Bradford; Portsmouth City Museum; Southampton CAG; York AG; Nottingham University; Stourhead, NT; Grosvenor Museum, Chester. **Literature:** *Walkers Quarterly* XIV, 1924; Roget.

NICHOLSON, William RSA 1781-1844
Born Ovingham 25 December 1781, son of James Nicholson, a schoolmaster and Elizabeth (née Orton). Grew up in Newcastle, where he attended the local grammar school. Began work for a stationer, but was allowed to become a pupil in the studio of Boniface Muss at Newcastle. Started as a miniaturist, and worked for a short time in Hull. Returned to Tyneside and worked on a larger scale. Settled in Edinburgh c.1814, where he met with considerable success, becoming a founder RSA and Secretary 1826-30. Exhibited at RA (7), RSA (202), RHA (1), Northern Academy 1808-43. Among his sitters were Thomas Bewick, William Etty, Earl of Buchan, Alexander Nasmyth, William Lamb aged 81 and Sir Walter Scott. Also painted small full-lengths and busts, sometimes using panel support. Published *Portraits of Distinguished Living Characters of Scotland*, 1818. Died of fever (probably consumption) in Edinburgh 16 August 1844. His watercolour portraits were particularly admired.
Represented: National Army Museum; VAM; SNG; RSA; Laing AG, Newcastle; SNPG; Newcastle Central Library. **Engraved by** R.Hicks, T.Ransom, G.B.Shaw, J.Thomson. **Literature:** *Art Union* 1844; L.Browse, *W.N.*, 1956; S.K.North, *W.N.*, 1923; M.Steen, *W.N.*, 1943; DNB; Hall 1982.

NICHOLSON, Sir William Newzam Prior RP NPS IS 1872-1949
Born Newark-upon-Trent 5 February 1872. Studied under Herkomer at Bushey 1888-9 (but dismissed for Whistlerian impudence) and at Académie Julian, Paris 1889-90. Extremely important and influential in poster and book illustration, working with his brother-in-law James Pryde as 'J.W.Beggarstaff'. Maintained a steady portrait practice. Exhibited RP (19). Elected RP 1909. Knighted 1936. Travelled widely in Europe and USA. Died Blewbury, Berkshire 16 May 1949. Father of artist Ben Nicholson. Sir Winston Churchill was a pupil. An outstanding and sensitive artist, much underrated.
Represented: NPG London; SNPG; Tate; Castle Museum & AG, Nottingham; Fitzwilliam; Southampton CAG.
Literature: L.Browse, *W.N. Catalogue Raisonné*, 1956; M.Steen, *W.N.*, 1943; DA; R.Nichols, *W.N.*, 1948.
Colour Plate 54

NICOL, John Watson ROI 1856-1926
Son of artist Erskine Nicol. Exhibited at RA (31), RSA (19), ROI 1876-1924. Elected ROI 1888. Exhibited a portrait of 'HIM the German Emperor' 1903, commissioned by the United Service Club. Died 31 May 1926.
Represented: Sheffield Museum. **Literature:** McEwan.

NICOL, William fl.1840-1878
Worked briefly in Innerleithen, Southampton, Worcester, Cheltenham, London and Somerset. Settled in Edinburgh 1878. Listed as a portraitist at 15 Blacket Place, Edinburgh. Exhibited at RA (9), RSA (39).
Literature: McEwan.

NICOLET, Gabriel Emil Edouard RP c.1856-1921
Born Pons. Exhibited at RA (27), RI, RP 1885-1920. Elected RP 1897. Died April 1921 aged 64. Among his sitters were Sir J.J.Coghill Bart and the Hon Mrs Leir-Carleton. Died Villefranche-sur-Mer April 1921.

NIGHTINGALE, Robert 1815-1895
Exhibited at RA (4), SBA (24) 1847-74 from Maldon, Essex. Specialized in animal portraits in the Essex area, but also accepted commissions for human portraits. Among his sitters were 'Mrs Morris of Maldon in her 92nd year', 'George Horcusil, 64 years Steward to the Family of Faulkbourne Hall, Essex' and 'Waiting for Papa – the Son of Thomas Western Esq MP of Felix Hall, Essex'.

NINHAM, W. fl.1797
Exhibited at RA (1) 1797 from 57 St Martin's Lane.

NISBET, J. fl.1769
A Banff portrait painter. Signed copies after Ramsay 1769. May be the 'Nisbet' who exhibited at SA 1763.

NISBET, Margaret Demster 1863-1935
Studied in Edinburgh, Dresden and Paris. Painted portraits, miniatures and landscapes. Exhibited RSA (37), RA (1), SBA (1), RI (7). Wife of Robert Buchan Nisbet. Died Crieff 21 December 1935.

NIVELL, Abraham b.c.1827
Born Middlesex. Listed as a portrait artist aged 24 in 1851 census for 10 University Street, London.

NIXON, James ARA c.1741/2-1812
Entered RA Schools 17 March 1769. Exhibited at SA (12), RA (101), BI (4) 1765-1807. Elected ARA 1778. Appointed Miniature Painter to HRH the Duchess of York 1791 and Limner to the Prince Regent 1792. Based mainly in London, but was recorded in Edinburgh 1795-8. Mostly painted miniatures, but occasionally painted portraits life size. Died Tiverton 9 May 1812.
Represented: VAM; BM; Liverpool Museum. **Engraved by** F.Bartolozzi, W.Dickinson, W.N.Gardiner, G.Marchi. **Literature:** DNB.

NIXON, William Charles c.1813-1878
Born Dublin. Exhibited at RHA (7) 1844-7. Worked in Belfast, but returned to Dublin 1840. Also practised as a picture restorer and dealer. Died Dublin 18 February 1878.

NOA, Mme Jessie b.c.1826
Born St Pancras. Exhibited at RA (2), SBA (7) 1858-66 from Maida Hill and Regent's Park. Aged 35 in 1861 census. Married Leopold Noa, professor of languages.

NOAKES, C. fl.1828-1829
Exhibited at RA (2), BI (1) 1828-9 from Whitechapel.

NOBLE, George James Lane fl.1825-1840
Exhibited at RA (9), BI (2), SBA (12) 1825-40 from London. Listed in directories as a portrait painter. His son George, by wife Clara, was baptized St Pancras 1841.

NOBLE, Henry fl.1832-1834
Listed as a portrait painter in London.

NOBLE, James Campbell RSA 1846-1913
Born Edinburgh 22 July 1846, son of James Noble and Rachel (née Campbell). Studied at School of the Board of Manufacturers, Edinburgh (winning prizes), RSA Schools under J.P.Chalmers, H.Cameron and McTaggart (winning prizes). Exhibited at RA (11), SBA (1), RSA (197) 1869-1909 from Edinburgh and Coldingham. Elected ARSA 1879, RSA 1892. Died Ledaig, Argyll 25 September 1913.
Represented: Glasgow AG; Kirkcaldy AG. **Literature:** McEwan.

NOBLE, R. fl.1841-1842
Exhibited at RA (2) 1841-2 from London.

NOGUÉS, Jules b.1809
Born Auch 12 May 1809. Exhibited at Paris Salon 1835-44 and RA (7), RSA (4) 1840-3.
Represented: NPG London. **Engraved by** R.J.Lane.

NOLLEKENS, Joseph Francis 1702-1748
Born Antwerp 10 June 1702, son of artist J.B.Nollekens (baptized Corneille François Nollekens). Told Farington he was a pupil of Watteau (whose work he imitated), and is believed to have come to England c.1733, working with Peter Tillemans. His paintings attracted the attention and patronage of Lord Tilney. Specialized in conversations and genre. His son was the sculptor Joseph Nollekens, and consequently he became known as 'old Nollekens'. Died London 21 January 1748. Buried Paddington.
Represented: Fairfax House, York; Yale. **Literature:** J.T.Smith, *N. and His Times*, 1928; DNB; *Apollo* XCV 1972 pp.34-41; DA.

NORBURY, Richard RCA 1815-1886
Born Macclesfield 24 July 1815, son of a silkman. Studied at RA Schools. Exhibited at RA (10), SBA (2), LA 1843-78 from Liverpool. Held successively the posts of assistant master to the Schools of Design at Somerset House and Liverpool. Member of Liverpool and Cambrian Academies, and was President of Liverpool Watercolour Society. Concentrated mainly on portraits but was also an illustrator, engraver and sculptor. Died Fairfield, near Liverpool 25 April 1886.
Represented: Walker AG, Liverpool.

NORDGREN, Miss Anna 1847-1916
Born Mariestad 13 May 1847. Exhibited at RHA (2), RA (17), SBA (2) 1866-99 from Düsseldorf and London. Died Stockholm 10 September 1916.
Represented: Helsinki Museum; Stockholm AG.

NORMAN, Edward Glossop Augustus fl.1845
Listed as a portraitist at 141 Water Street, Manchester.

NORMAN, William F. fl.1883
His portrait of William Burrough-Hill is in Southampton CAG.

NORMAND, Ernest 1857-1923
Studied at RA Schools 1880-3 under Pettie and in Paris 1890 under Constant and Lefebvre. Exhibited at RA (29), RHA (2), NWG 1881-1903. Among his sitters was Sir Alfred Newton Bart. Married artist Henrietta Rae 1884. Died 23 March 1923.
Represented: AGs of Bristol, Oldham, Southport and Sunderland.

NORMAND, Mrs Henrietta (née Rae) 1859-1928
Born London 30 December 1859, daughter of T.B.Rae. Began to study art seriously at the age of 13, and was a student at Queen's School of Art, Heatherley's and at RA

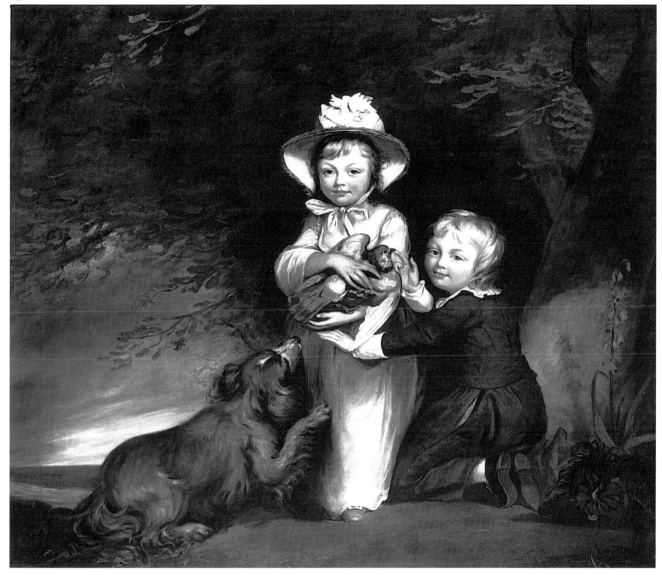

JAMES NORTHCOTE. John MacBride and his sister, the children of Captain MacBride. Signed and dated 1782. 54¼ x 61¼ins (137.8 x 155.6cm)

Christie's

Schools. Exhibited at RA (27), GG, RHA (1), NWG 1881-1904. Married artist Ernest Normand 1884. Died Upper Norwood 26 March 1928.
Represented: Walker AG, Liverpool. **Literature:** A.Fish, *Henrietta Rae,* 1906.

NORRIS, Arthur **b.1888**
Born 6 November 1888. Studied at Slade under Tonks. Exhibited at RA (9), RP, NEAC 1929-42.
Represented: NPG London.

NORRISS, Miss Bess (Mrs Tait) RMS **1887-1939**
Born Melbourne 17 May 1887. Studied at Melbourne and Slade. Exhibited at RA (22), RMS, NPS, Paris Salon 1908-36. Died January 1939.

NORTHCOTE, James RA **1746-1831**
Born Plymouth 22 October 1746 (baptized 11 November 1746), son of Samuel Northcote. His father was a watchmaker and optician, and his mother sold haberdashery. Apprenticed to his father's trade, but showed a talent for art. Moved to London 1771, entering RA Schools and becoming a pupil and assistant of Reynolds 1771-5/6. Practised portraiture at Plymouth until he had enough money to go to Italy 1777. Visited Rome 1777-80, where he was asked to give a self-portrait to the Uffizi Gallery, Florence. Settled in London 1781. Exhibited at RA (229), BI (22), SBA (22) 1773-1832. Elected ARA 1786, RA 1787. Wrote *Life of Sir Joshua Reynolds,* 1813 and his conversations with Hazlitt and James Ward were published in two volumes 1894-1901. One of the principal painters employed by J.Boydell for the *Shakespeare Gallery.* His sitters' book 1776-1831 is in NPG London. Died London 13 July 1831. Buried in the new church of St Marylebone. Among his pupils were William Salter and Samuel Hart.
Represented: NPG London; VAM; SNPG; Uffizi, Florence; Petworth House, NT; Tate; Dulwich AG; Albert Memorial Museum, Exeter; Shire Hall, Bedford; Brighton AG; Cyfartha Castle AG, Merthyr Tydfil. **Engraved by** W.T.Annis, P.Audinet, F.Bartolozzi, S.Bellin, T.Blood, P.Conde, H.R.Cook, G.Dawe, J.J.De Claussin, W.Dickinson, R.Dunkarton, J.Fittler, S.Freeman, T.Gaugain, J.Gillray, W.Greatbach, F.Haward, J.Heath, C.Lasinio, T.Lupton, H.Meyer, C.Picart,

S.W.Reynolds snr & jnr, W.Ridley, Rivers, W.Say, E.Scriven, W.Sharp, J.R.Smith, C.Turner, J.Young. **Literature:** S.Gwynne, *Memorials of an Eighteenth Century Painter,* 1898 including his own list of paintings; W.Hazlitt, *Conversations of J.N. RA,* 1949; E.Fletcher, *Conversations of J.N. with James Ward on Art and Artists,* 2 vols, 1894-1901; J.Simon, J.N.'s Account Book, Walpole Society LVIII, II 1996; DNB; DA.
Colour Plate 3

NORTHCOTE, Nathaniel fl.1704
Paid for a portrait of Queen Anne 1704, which was formerly in Plymouth Guildhall.

NORTON, H. fl.1853-1858
Exhibited at RA (8), BI (2), SBA (1) 1853-8 from London.

NOTZ, Johannes 1802-1862
Born Obertrass, near Zurich 14 September 1802. Studied under Pfenninger and at Munich Academy. Worked in Munich, Aarau, Basle, Alsace, Paris. He was in London 1827-42 (visiting Dublin 1829). Exhibited at RHA (6), RA (15) 1829-40. Visited Rome 1842-7 and settled in Zurich, where he died 20 May 1862. Specialized in miniatures, but also painted watercolour portraits.
Engraved by R.J.Lane. **Literature:** Foskett.

NOVELLO, Miss Emma A. fl.1832-1868
Exhibited at South Kensington Museum 1868.
Engraved by R.J.Lane.

NOVICE, Percival fl.1853
His portrait of William G. Blaikie is in SNPG.

NOWELL, Arthur Trevethin RI RP 1862-1940
Born Garndiffith, Wales 5 February 1862. Educated at Dudley and Bury Grammar Schools. Studied art at Manchester School of Art, RA Schools (Gold Medallist in landscape and historical painting) and in Paris. Lived in Runcorn and London, but travelled widely on the Continent. Exhibited at RA (95), RHA (5), NWS, NWG, RP 1881-1938. Elected RI 1913, RP 1914. Died Wilmslow, Cheshire 6 January 1940.
Represented: Brighton AG; Arts Club, London.

NOWLAN, Frank c.1835-1919
Born County Dublin. Moved to London 1857. Studied at Leigh's School, where he became friends with F.Walker, whose portrait he painted (BM). Afterwards studied from life at the Langham School of Art. Also painted and restored miniatures, and was employed in this capacity by Queen Victoria and Edward VII. Exhibited at RA (6), SBA (5), RHA (13), RMS 1866-1918. Devoted time to the invention and patenting of unforgeable cheques. Died Cheam, Surrey 1 May 1919.
Represented: VAM.

NOYES, Miss Dora fl.1883-1903
Exhibited at RA (26), SBA (11), NWS, GG, NWG 1883-1903 from London, Salisbury and Torquay.

NUGENT, Thomas fl.1791-1829
Exhibited at RA (18) 1791-1829 from London. Also an engraver.

NUNES, A.J. fl.1778-1779
Honorary exhibitor at RA (2) 1778-9.

NURSEY, Claude Lorraine Richard Wilson 1816-1873
Baptized Little Bealings, Suffolk 10 May 1816, son of Perry and Ann Nursey. Practised as a landscape painter in Ipswich, but then studied at Central School of Design, Somerset House. Appointed Master of Leeds School of Design 1846. While there he superintended the establishment of a similar school in Bradford. Moved to Belfast School 1849, where he was successful in interesting local

ARTHUR TREVETHIN NOWELL. Florence Margaret, daughter of Robert McAlpine. Signed and dated 1916. 50 x 40ins (127 x 101.6cm) *Waterhouse & Dodd, London*

manufacturers in the subject of Industrial Art. Then to the school at Norwich c.1855, and was for some time Secretary to the Norwich Fine Art Association. Exhibited at the BI (1), SBA (4), RHA (4) 1844-71. Painted a picture of the local volunteers on the rifle range on Mousehole Heath, Norwich containing portraits of the participating officers. Died at Thorpe 2 January 1873.

NUTTER, Henry 1758-1808
Born Whitehaven. Moved to Carlisle aged 20, to set up business as a house painter. Also worked as a coach painter and built up business as a portrait painter. Began drinking and was rescued from bankruptcy with the help of his wife and two sons, one of whom was M.E.Nutter.

NUTTER, Matthew Ellis 1795-1862
Born Carlisle, son of Henry Nutter and grandson of a carver and cabinet maker. Studied under R.Carlyle snr learning architectural drawing and landscape painting. On the death of his father in 1808 he helped run the family house and coach painting business, and painted portraits. By 1819 he had started to receive his first landscape commissions. Later he attracted sporting commissions and on the death of his mother in 1821 he gave up the family business. First Secretary of the Carlisle Society on its opening in 1823 and taught there and at the Green Row Academy. Exhibited at Carlisle Academy (79), Carlisle Athenaeum (5) 1823-50. His final years were spent in Skinburness, where he died.
Represented: Carlisle CAG.

NYE, George F. fl.1839-1843
Exhibited at SBA (10) 1839-43 from Lambeth. Among his sitters was 'Madame Giubilei, of Her Majesty's Theatre' (1840). May be the George F. Nye who exhibited at RHA (3) 1869-77 from Dublin.

O

O, I.　　　　　　　　　　　　　　**fl.1637-1641**
Portraits of Sir Edward Hussey 1637, and Lady Astley 1641
are signed 'I.O'.

OAKLEY, Octavius　OWS　　　　**1800-1867**
Born Bermondsey 27 April 1800, son of a London wool
merchant. Intended to be a surgeon, but his father suffered
difficulties and he was sent to work for a cloth manufacturer
in Leeds. He was more interested in art and gradually earned
a reputation as a portrait artist, mainly in watercolour.
Moved to Derby c.1825 and painted portraits at Chatsworth
and other country houses. Exhibited at RA (30), RHA (2),
OWS (221) 1826-60. Elected AOWS 1842, OWS 1844.
Among his sitters were the Duke of Devonshire, and Sir
George Sitwell of Renishaw. Also painted rustic genre,
particularly gypsies, earning the nickname 'Gypsy Oakley'.
On the death of his wife he moved to London, and then
Leamington 1836. Settled in London c.1841. Died there
1 March 1867. Buried Highgate Cemetery. Studio sale held
Christie's 11-12 March 1869. His daughters, Agnes and
Maria, also painted.
Represented: NPG London; BM; VAM; Blackburn AG;
Grundy AG, Blackpool; Hove Library; Newport AG.
Engraved by J.Morrison. **Literature:** DNB.

OATES, Captain Mark　　　　　**c.1750- after 1821**
Cornish naval officer and amateur painter. A schoolfellow of
Opie. Honorary exhibitor at RA (2) 1789-1811. Painted an
altarpiece formerly in Falmouth Parish Church.
Engraved by J.Fittler. **Literature:** A. Earland, *Opie*, 1911,
p.4.

O'BRIEN, E.M.　　　　　　　　**fl.1834**
Exhibited at RHA (1) 1834 from Dublin.

O'BRIEN, William Dermod　PRHA　　　**1865-1945**
Born Foynes, County Limerick 10 June 1865, son of
Edward William O'Brien, landowner. Educated Harrow and
Trinity College, Cambridge. Studied at Antwerp Academy
under Veralt 1887 (winning prizes), Académie Julian, Paris
and Slade. Exhibited at RA (27), RSA, NWG, RHA (229)
1894-1944. Worked in London 1893-1901 and Dublin.
Elected ARHA 1905, RHA 1907, PRHA 1910. Died
October 1945.
Represented: NGI; Cork AG. **Literature:** L.Robinson,
*Palette and Plough: A Pen and Ink Drawing of Dermod
O'Brien PRHA*, 1948.

O'CONNOR, Bernard　　　　　**fl.1847-1854**
Exhibited at RHA (9) 1847-54 from Dublin.

O'CONOR, Roderick Anthony　　　**1860-1940**
Born Roscommon, Ireland 17 October 1860. Studied in
London, Antwerp 1881-3 and Paris under C.Duran.
Exhibited at RHA (6) 1883-5. Worked in France, for a time
joining the circle around Gauguin at Pont Aven. Died Maine-
et-Loire, France 18 March 1940.
Represented: NGI; Tate.

O'FARRELL, Miss B.　　　　　**fl.1897-1908**
Exhibited at RHA (18) 1897-1908 from Bray.

OGG, Henry Alexander　　　　**fl.1840-1846**
Exhibited at SBA (3) 1844-6. Also an engraver. Lived in
Putney and Fulham.
Represented: Blackburn AG.

OGIER, Peter　　　　　　　　**1769-after 1800**
Entered RA Schools 22 October 1789 aged 20, as an
engraver. Exhibited at RA (4) 1793-1800 from London.
Advertised miniatures in Bath 1 January 1795 at 3 guineas
each and in 1795 at 5 guineas.

OGILVIE, Frank Stanley　　　　**c.1856-after 1935**
Lived at North Shields, son of Joseph Ogilvie, a local salt
manufacturer and whiting merchant. Studied under
Herkomer at Bushey. Exhibited at Bewick Club, RA (10),
RSA, SBA (5) and in Newcastle from 1888. Earned a
considerable reputation as a portrait painter in Tyneside, and
also worked in London and Letchworth, Hertfordshire.
Settled first at Tynemouth and later in Newcastle.
Represented: Dundee AG; Laing AG, Newcastle;
Middlesbrough AG; South Shields Museum & AG.
Literature: Hall 1982.

OGILVY, James　　　　　　　**fl.1846-1871**
Listed as a portraitist at 2 West Nicholson Street, Edinburgh.
Exhibited RSA (14).

O'HAGAN, Mrs Harriett (Miss Osborne)　　**fl.1854**
Born Dublin. Exhibited at RA (1) 1854 from 193 Stanhope
Street.

O'KEEFE, John　　　　　　　**c.1797-1838**
Born Fermoy of humble parents. Apprenticed to a coach
painter. Worked as an heraldic painter, scene painter, and
eventually, portrait painter. Exhibited at RHA (23) 1831-7
from Cork and Dublin. Also painted religious pictures for
churches around Cork. Died on a visit to Limerick April
1838.
Represented: NGI; Cork Museum.

OLDEN, Miss　　　　　　　　**1856-1858**
Exhibited at RHA (16) 1856-8 from Dublin. Possibly the
Elizabeth Olden, whose portrait of William Dick 1853 is in
SNPG.

OLDHAM, G.R.　　　　　　　**fl.1854-1857**
Exhibited at SBA (6) 1854-7 from Chipping Norton and
London.

OLDHAM, John　　　　　　　**1779-1840**
Born Dublin. Apprenticed to an engraver. Exhibited in
Dublin from 1801 and painted portraits and miniatures.
Invented a profile machine and was employed by the Bank of
England. Died London 14 February 1840.
Engraved by J.Heath, C.Picart. **Literature:** Strickland.

OLIPHANT, John　　　　　　**fl.1832-1843**
A relative of the artist Francis W.Oliphant. Practised as a
portrait painter in Newcastle. Exhibited RSA 1832-43.
Represented: Shipley AG, Gateshead.

OLIVE, Thomas　　　　　　　**c.1748-1799**
Exhibited at SA (4) 1772-3 from London. His portrait of
'Thomas Eldridge' (c.1780) was reproduced as an etching.
Died Mucking, Essex.

OLIVER, Archer James　ARA　　　**1774-1842**
Entered RA Schools 13 August 1790, aged 16. Established a
practice as a fashionable portrait painter in New Bond Street,
London. Exhibited at RA (210), BI (62) 1791-1842. Elected

HENRIK BENEDIKT OLRIK. Alexandra of Denmark, the Princess of Wales. Signed and dated 1873. 54 x 39ins (137.1 x 99.1cm) *Christie's*

ARA 1807. Briefly Curator of Paintings at RA Schools and Professor of Painting 1835. He did not enjoy good health and between 1820 and 1835 his condition deteriorated. He lived the last years of his life largely on RA charity. Died London. He was influenced by Lawrence.
Represented: NPG London; Arundel Castle. **Engraved by** T.Bragg, M.Gauci, C.Turner.

OLIVER, Isaac **d.1617**
Born Rouen, son of Pierre Oliver, a French Huguenot goldsmith. Brought to London in infancy (by 1568). Pupil of Hilliard and visited Italy. Along with Hilliard, he was one of the great masters of the English portrait miniature, although he is believed to have painted some large portraits. Generally signed his works 'I.O'. By 1605 he was appointed limner to Queen Anne of Denmark and he developed a successful court practice. Perhaps his most accomplished work is 'Portrait of a Young Man' (Windsor Castle), which is a full-length portrait painted to the size of a playing card. Buried London 2 October 1617. His son and assistant, Peter Oliver, was also a painter.
Represented: NPG London; SNPG; BM; VAM; HMQ.
Literature: M.Edmond, *Hilliard and I.O.*, 1981; Foskett.

OLIVER, Robert Dudley **fl.1883-1899**
Exhibited at RA (14) 1883-99 from London.

OLIVIER, Herbert Arnold RI RP RE 1861-1952
Born Battle, Sussex 9 September 1861, son of Henry Arnold Olivier, clergyman. Studied at RA Schools, winning Creswick prize. Silver Medallist (Paris Salon). Exhibited at RA (97),

RHA (5), NWS, GG, NWG 1883-1944 from London. Elected RP 1894. Secretary of St John's Wood Arts Club. Died at Hayling Island 2 March 1952 in his ninety-second year.
Represented: Tate; Indore Daly College, India.

OLIVIER (OLLIVIER), Michel-Barthélemy 1712-1784
Born Marseilles. Elected *agréé* at French Academy 1766. Moved to London. Exhibited at RA (6), SA (4) 1772-3. Specialized in history and conservation pieces. Painter to King of France and first painter to HRH Prince of Conti. Died Paris 15 June 1784.
Represented: Louvre; Versailles; Bordeaux Museum.

OLRIK, Henrik Benedikt **1830-1890**
Danish artist based in Copenhagen. Studied in Paris under Couture. Visited London 1873 to paint a portrait of 'Alexandra of Denmark, the Princess of Wales'. Exhibited at RA (1) 1873. Died Copenhagen 2 January 1890.

OLVER, Kate Elizabeth (Mrs Higgins) 1881-1960
Born Clerkenwell June 1881. Studied at RA Schools. Exhibited at RA (38), RP, Paris Salon and in the provinces 1910-46 from London and Dunstable. Married Charles Sampson Higgins. Died Paddington General Hospital 8 October 1960.

O'MALLEY, James **c.1816-1888**
Born Newport, County Mayo, son of Patrick O'Malley, a wealthy farmer and shop keeper. Studied under Martin Cregan, in whose studio he remained for a number of years. Visited America, working as a portraitist and later worked in Dublin, Galway and Mayo. Exhibited at RHA (33) 1840-82. Died Newport 16 October 1888.
Literature: Strickland.

O'NEAL(E), Jeffrey Hamet FSA 1734-1801
Born Ireland. Moved to London, where he painted miniatures and small conversations. Designed 'Japan pieces' for a printseller called Smith in Cheapside. Exhibited at SA 1763-72. Worked for porcelain factories in Worcester and Chelsea.
Literature: R.Reilly, *Wedgwood: The New Illustrated Dictionary*, 1995.

O'NEIL, Frank **fl.1855**
Listed as a portrait painter in Manchester.

O'NEIL, Henry Nelson ARA 1817-1880
Born St Petersburg 7 January 1817. Moved to England aged six. Entered RA Schools 1836, and was a friend and fellow student of Alfred Elmore, with whom he travelled to Italy. A member of the St John's Wood Clique. Exhibited at RA (94), RHA (2), BI (34), SBA (14) 1838-79. Elected ARA 1860. His most well-known painting is 'Eastwood Ho'. Among his sitters were John Phillip ARA, the Duke of Newcastle and the daughters of W.P.Frith. A freemason. Died Kensington 13 March 1880. Buried Kensal Green Cemetery. Studio sale held Christie's 18 June 1880.
Represented: NGI. **Engraved by** P.Lightfoot, W.H.Simmons, W.T.Davey. **Literature:** *Art Journal* 1880 p.171.

O'NEILL, George Bernard **1828-1917**
Born Dublin 17 July 1828, the ninth of fifteen children. Studied at RA Schools. Married a cousin of J.C.Horsley. Joined the Cranbrook Colony. Exhibited at RA (72) 1847-93 from London and Staplehurst. Died London 23 September 1917.
Represented: Leeds CAG; Tate. **Literature:** *Cranbrook Colony*, Wolverhampton AG exh. cat. 1977; DA.

O'NEILL, Henry ARHA **1798-1880**
Born Clonmel. After the death of his parents he was raised by his aunt, a Dublin haberdasher for whom he designed patterns. Entered Dublin Society Schools 1815. Also worked

KATE ELIZABETH OLVER. A mother and son. Signed. 57 x 48ins (144.8 x 121.9cm) *Black Horse Agencies, Locke & England*

JOHN OPIE. Master William Opie. 20½ x 16¾ins (52.1 x 42.6cm)
Tate Gallery, London

as a printseller. Exhibited at RHA (73) 1835-79. Elected ARHA 1837, but resigned 1844. Practised as an illustrator before travelling to London 1847. Here he struggled to make a living and soon returned to Dublin. He lithographed the illustrations for a number of Irish topographical books. Also painted portraits in oil and watercolour, some of which he lithographed. Often confused with Henry Nelson O'Neil.
Represented: Ulster Museum.

OPIE, Edward **1810-1894**
Great-nephew of John Opie RA. Studied under H.P.Briggs. Worked in London, Portsmouth and Cornwall. Exhibited at RA (49), RHA (1), SBA (1) 1839-86. Died Plymouth 15 July 1894. W.C.T.Dobson was his pupil.
Engraved by J.Scott.

OPIE, John RA **1761-1807**
Baptized St Agnes, Cornwall May 1761, son of Edward Opie, a carpenter. Apprenticed to a sawyer to learn his father's trade. Encouraged by John Wolcot, a physician, poet and amateur painter (a pupil of Richard Wilson), who trained him in portraiture. Between 1776-9 Opie travelled around Cornwall and Devon as an itinerant face painter. Wolcot brought him to London 1781 and marketed him as 'the Cornish wonder'. According to *The Gentleman's Magazine* 25 November 1785 he received lessons and patronage from Sir Joshua Reynolds. Opie was presented in March 1782 to George III and Queen Charlotte, and the King bought his 'Beggar and Dog'. Met with almost instant success, but the vogue for Opie had passed by 1783. Nevertheless, he had a good portrait practice for the rest of his life, and was in demand particularly for children. Exhibited at SA (1), RA (143), BI (8) 1780-1807. Elected ARA 1786, RA 1787, Professor of Painting at RA Schools 1805-7. Among his sitters were Dr Johnson, Bartolozzi, Burke, Crome, Fuseli and

Girtin. It was calculated that he painted '508 portraits (counting each head in family groups)' and also painted history pictures on a monumental scale. Chief contributor to Boydell's Shakespeare Gallery (seven scenes). Married twice, firstly to Mary Bunn 1782, whom he divorced 1796, and secondly to poet Amelia Alderson 1798. Died London 9 April 1807. Buried with some pomp next to Reynolds in St Paul's Cathedral. His *Lectures on Painting* were published posthumously 1809. Developed a taste for strong chiaroscuro and was known as 'the English Rembrandt'. Admired by Walpole. Among his pupils were Joseph Clover, William Chamberlain, Thomas Stewardson and Theophilus Clarke.
Represented: NPG London; NGI; SNPG; Tate; Inveraray Castle; Southampton CAG; VAM; Brighton AG; Philadelphia MA; Castle Howard; Leeds CAG; Canterbury Museums; Truro AG; Guildhall AG, London; Birmingham CAG; Bolton AG; Holkham Hall, Norfolk. **Engraved by** W.T.Annis, P.Audinet, J.Baker, W.W.Barney, E.Bell, T.Blood, J.Brown, A.Cardon, T.Cheeseman, Corner, J.Dadley, R.Dunkarton, W.C.Edwards, W.H.Egleton, E.A.Ezekiel, J.Fittler, S.Freeman, V.Green, L.Haghe, J.Heath, C.H.Hodges, T.Hodgetts, Holl, K.Mackenzie, H.Meyer, D.Orme, C.Picart, E.Reynolds, S.W.Reynolds snr & jnr, W.Ridley, C.St Aubyn, W.Sharp, J.R.Smith, E.Stalker, C.Turner, Mrs D.Turner, W.Ward, C.Warren, C.Watson. **Literature:** *Connoisseur* Vol 94 October 1934 pp.245-51; A.Earland; *J.O. and His Circle*, 1911; M. Peter, *J.O., 1761-1807*, Arts Council exh. cat. 1962; DNB; J.J.Rogers, *O. and His Works*, 1887; G.Essam, *J.O.'s Career as a History Painter*, MA thesis Courtauld, London 1984.

OPPENHEIMER, Joseph RP **1876-1967**
Born Würzburg 13 July 1876. Studied in Munich, Italy, France, America and Canada. Moved to England 1898. Exhibited at RA (14), RP, Chelsea Arts Club and abroad 1905-53 from London. Elected RP 1948. Settled at Totteridge, Hertfordshire. Returned to Würzburg 1908, then Berlin. Received a Gold Medal at Munich International Exhibition 1910, Bronze at Barcelona Exhibition. Visited England again 1933 and was naturalized 1939. Died Montreal.
Represented: NPG London; Montreal MFA; Summerfields School, Oxford.

ORAM, Miss **fl.1836-1839**
Exhibited at SBA (8) 1836-9 from London. Painted a portrait of Thomas Macconnel, author of a prize essay *On the Present Condition of the People of this Country, and the Best Means of Improving it.*

ORCHARD, B. **fl.1692**
Painted an accomplished portrait of 'Richard Morton MD' (Royal College of Physicians, London). It was engraved as the frontispiece to Morton's *Exercitationes*, 1692.

ORCHARDSON, Charles Moxon Quiller **d.1917**
Son of Sir William Quiller Orchardson. Exhibited at RA (30), SBA (6), 1896-1914. Served in London Yeomanry T.F. and Imperial Camel Corps. Died of wounds on active service in Egypt 26 April 1917. Left his widow effects of £1302.14s.6d.

ORCHARDSON, Sir William Quiller PRP RA RSA
1832-1910
Born Edinburgh 27 March 1832. Studied at Trustees' Academy from 1845 under R.S.Lauder, with fellow pupils John Pettie, T.Faed, J.Archer, R.Herdman, and Tom Graham. Began working in his home town before settling in London 1862/3, where he shared lodgings with Pettie and Graham. Exhibited at RSA (65), RA (83), RHA (1), BI (1), GG (3), RP (14), NWG (2) 1848-1910. Elected ARA 1868, HRSA 1871, RA 1877, PRP 1905-10. Knighted 1907. Became famous for his genre paintings and was known as 'the Hogarth of the Victorian drawing room', but was also an excellent portraitist. His

WILLIAM QUILLER ORCHARDSON. Master baby – portrait of the artist's wife, Ellen, with their son, Gordon. Signed and dated 1886. 42½ x 65½ins (109 x 168cm)
National Gallery of Scotland

portraits were normally executed in a painterly manner, almost sketchly so, using muted colours, mostly yellow and brown. He could be remarkably original in his compositions. Also an illustrator working for *Good Words*. Died London 13 April 1910. Studio sale held Christie's 27 May 1910.
Represented: NPG London; Aberdeen AG; Glasgow AG; NG Cape Town; SNPG; Manchester CAG; Southampton CAG; RSA; Tate; Walker AG, Liverpool; Christ Church, Oxford; University of Glasgow; SNG; Uffizi Gallery, Florence.
Literature: W.Armstrong, *The Art of W.Q.O.*, 1895; J.Stanley Little, 'The Life and Work of W.Q.O. RA', *Art Annual* 1897; *Sir W.Q.O. RA,* Scottish Arts Council exh. cat. 1972; McEwan; *Sir W.Q.Q.*, SNG, Edinburgh exh. cat. 1980; DA.

ORDE, Cuthbert Julian **1888-1968**
Born Great Yarmouth 18 December 1888, son of Sir Julian Orde. Educated Framlingham College. Exhibited at RA (18), RP, Paris Salon 1921-61 from London. Married Lady Eileen Wellesley. Died London 19 December 1968. Left £26,548.
Represented: Musée de Luxembourg, Paris.

ORME, Daniel **1766-c.1832**
Born Manchester 25 August 1766, son of John Orme a merchant. Entered RA Schools 7 March 1785 aged '18 25th last Aug', studying engraving. Exhibited portraits and miniatures at RA (11), RMI 1797-1827. Worked in London until October 1814, when he returned to Manchester. Engraver to George III, and would often reproduce his own portraits as engravings. His brothers, William and Edward Orme, were also painters. Died Buxton, Derbyshire.
Represented: NMM; VAM; HMQ of The Netherlands.
Engraved by Mackenzie, C.Turner, R.Woodman.
Literature: DNB.

ORME, Edward **fl.1801-1803**
Exhibited at RA (3) 1801-3 from London. Brother of Daniel Orme.

ORMONDE, Leonard **fl.1880-1920**
Painted portraits, landscapes and figurative subjects. Influenced by the Pre-Raphaelites.

ORPEN, Sir William Newenham Montague
RA RWS RHA RI NEAC PRP **1878-1931**
Born Blackrock, County Dublin 27 November 1878, son of Arthur Herbert Orpen (a solicitor) and Anne Caulfield of the Charlemont family. Studied at Metropolitan School of Art, Dublin 1891-7 and at Slade 1897-9 under Brown and Tonks. Influenced by Manet and Courbet. Became war artist 1917-19. Exhibited at RA (108), NEAC, RP (51), RHA (69) 1901-32. Elected NEAC 1900, RHA 1908, ARA 1910, RA 1919, PRP 1923. Knighted 1918. Had an affair with Edwardian society hostess Mrs St George. Orpen was a stocky man only five foot three tall and she was more than six feet. The two of them were known in London as 'Jack and the Beanstalk'. His self-portrait of 1924 was entitled 'Orpsie Boy, You're Not as Young as You Were'. Died London 29 September 1931. Buried Putney Cemetery. Orpen said that the portrait painter must be able to read 'the mind's construction in the face'. Fond of strong chiaroscuro and often painted women sitters against a dark background, lighting the figure from two sides. Among his pupils were M.L.Whelan and P.J.Tuohy. A remarkably accomplished artist, a skilful colourist and one of the finest portraitists of the 20th century.
Represented: NPG London; SNPG; Petworth, NT; Tate; Manchester CAG; NMM; Imperial War Museum; Birmingham CAG; Preston Manor Park, Brighton; NG Canada; Leeds CAG. **Literature:** B.Arnold, *O.: Mirror to an*

WALTER WILLIAM OULESS. Augusta Reynnet and her sister Mary – a view of Elizabeth Castle, Jersey beyond. 30 x 25ins (76.2 x 63.5cm) *Sotheby's*

Age, 1981; R.Pickle, *Sir W.O.*, 1923; P.G.Konody & S.Dark, *Sir W.O. – Artist and Man*, 1932; Sir W.Orpen, *An Onlooker in France 1917-1919*, 1921; W.Orpen, *Stories of Old Ireland and Myself*, 1924; DNB.
Colour Plate 53

ORR, Alfred Everitt **b.1886**
Born New York 6 January 1886. Studied under William Chase, J.S.Sargent, in Paris and at Art Students' League, New York. Exhibited at RA (1) and in Paris and worked in London for some time.

ORR, Patrick William **b.1865**
Born Glasgow. Exhibited at RA (1) 1893 and RSA (4) from Glasgow.

ORTON, James **fl.1851-1853**
Listed as a portrait painter in Gloucester.

OSBORN, Miss Emily Mary **1834-c.1913**
Born London, daughter of a London clergyman. Studied at Dickinson's Academy in Maddox Street, first under John Mogford and then J.M.Leigh. Also in Munich 1861. Exhibited at RA (43), BI (4), RSA (3), SBA (10), GG, NWG, DG, SWA, 1851-93 from London.
Represented: Ashmolean; HMQ. **Literature:** DA.

OSBORNE, C. **fl.1821-1825**
Exhibited portraits and miniatures at RA (6), SBA (1) 1821-5 from Norwich.
Engraved by C.Turner.

OSBORNE, Walter Frederick RHA NEAC 1859-1903
Born Rathmines 17 June 1859 (baptized 11 September 1859), son of artist William Osborne and his wife Anne Jane Woods. Entered RHA School 1876 (winning medals and prizes) and, on winning the Taylor Scholarship 1881, in Antwerp under Verlat. Worked in Brittany 1883. Made contact with artists from the Newlyn School. Based in Dublin, but often worked in England and also travelled to Spain 1895 and Holland 1896. Exhibited at RHA (175), RA (46), NEAC 1877-1904. Became Dublin's most fashionable portraitist. Elected ARHA 1883, RHA 1886, declining a knighthood 1900. His work shows the influence of Whistler. Until c.1884 he signed himself 'Frederick Osborne', but after 1885 he changed the signature to 'Walter F. Osborne'. Died of pneumonia London 24 April 1903. Buried St Jerome Cemetery, Dublin. His early work shows a tight handling of paint and attention to detail, his later work was handled with more freedom. A gifted artist.
Represented: NPG London; Tate; NGI; Belfast Harbour Commissioners; Guildhall AG, London. **Literature:** J.Sheehy, *W.O.*, 1974; Strickland; *W.O., NGI* exh. cat. 1983; DA.

OSBORNE, William RHA **1823-1901**
Born Dublin. Studied at RHA from 1845. Exhibited at RHA (202) 1851-1901 from Dublin and Rathmines. Elected ARHA 1854, RHA 1868. Painted with great skill, mostly dogs, hunting groups and portraits. Died Dublin 13 April 1901. His son Walter Frederick Osborne was also a painter.
Represented: NGI.

OSGOOD, Charles **b.1809**
Born Salem, Massachusetts. Worked in Boston 1827-8. Exhibited at RA (1) 1842 from London. Died Massachusetts.

OSGOOD, S.S. **1808-1885**
Born Boston. Painted portraits of Harriet Martineau at Worthington, USA 1835 and President Martin Van Buren. Exhibited at RA (5), BI (2), SBA (2) 1836-9 from London. Died California.
Represented: Brooklyn Museum. **Engraved by** S.Freeman, H.S.Sadd.

OSMANT, Edwin Nathaniel **fl.1832-1834**
Listed as a 'Teacher of Drawing and Portrait Painter' in Lewes.

OSPOVAT, Henry **1877-1909**
Born Russia. Began as a lithographer. Entered the National Art Training School, South Kensington. Worked as a portrait painter, caricaturist and black and white artist. Exhibited at NEAC. Died London 2 January 1909.
Represented: Tate; Birmingham CAG.

OSSANI, Alessandro **fl.1857-1888**
Worked in Edinburgh in the late 1850s but settled in London c.1860. Exhibited at RA (24), SBA (15), GG (1) 1857-88. Among his sitters were Major Eugene Impey, Sir Henry James MP and Colonel the Hon Edward Brownlow.
Represented: NPG London.

OUDRY (ODRY), Pierre **fl.1578**
A French embroiderer brought from Paris to Edinburgh by Mary, Queen of Scots, and who accompanied her in exile. Painted a full-length portrait of Mary, Queen of Scots, 1578.
Literature: L.Dimier, *Le portrait en France au XVI siècle*, I 1924 p.114.

OUGHT, William **1753-1778**
Born 5 November 1753. A pupil of Daniel Dodd. Entered RA Schools 1771. Exhibited at FS (11) 1768-78 from London.

OULESS, Miss Catherine **1879-1961**
Born London 1 September 1879, daughter of W.W.Ouless. Studied at RA Schools. Exhibited at RA (55) and in the provinces 1902-34. Died 4 January 1961.
Represented: SNPG.

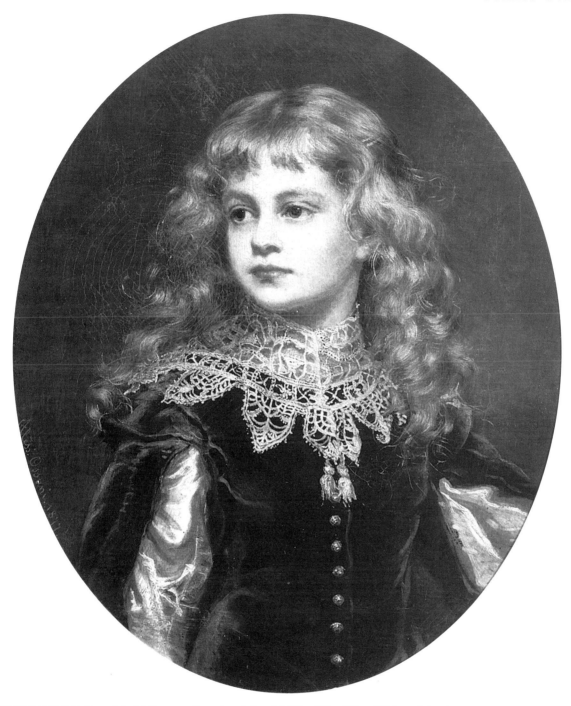

ALEXANDRO OSSANI. Lucy Muriel Stayner. Signed and dated 1881. 22½ x 18ins (57.2 x 45.7cm)

Phillips

OULESS, Walter William RA **1848-1933**
Born St Helier, Jersey 21 September 1848, son of artist Philip John Ouless and Catherine (née Savage). Educated Victoria College, Jersey. Studied at RA Schools 1865-9. Became an immensely successful society portraitist. Exhibited at RA (241) 1869-1928. Elected ARA 1877, RA 1881. Won Gold and Silver Medals at Berlin, Munich, Vienna and Paris. Died 25 December 1933. Among his sitters were Cardinal Newman, Charles Darwin, the Prince of Wales, Thomas Hardy, John Bright and T.S.Cooper. Cyrus Johnson was his pupil.
Represented: NPG London; SNPG; Canterbury Museums; Leeds CAG; Lancashire County Cricket Club; Oratory,

Birmingham; Walker AG, Liverpool. **Engraved by** C.A.Tomkins. **Literature:** Maas.

OUSEY, Buckley **1851-1889**
Studied at Antwerp. Exhibited at RA, SBA (1) 1887-8 from Conway, Caernarvonshire. Member of Royal Cambrian Academy.
Literature: Bénézit.

OVERTON, Thomas **fl.1818-1838**
Listed as a portrait and miniature painter in London. Exhibited at RA (34), NWS 1818-38.

WILLIAM OWEN. Countess of Shaftesbury, wife of 6th Earl Shaftesbury. Panel. 30 x 25ins (76.2 x 63.5cm) *Christie's*

OWEN, William RA **1769-1825**
Born Ludlow, son of a bookseller. Moved to London 1786, where he was apprenticed to Charles Catton RA for seven years. Developed a talent for figure painting and was encouraged by Reynolds. Entered RA Schools 1791. Exhibited at RA (203), BI (7) 1792-1824. Elected ARA 1804, RA 1806. Portrait painter to Prince of Wales 1810 (on the death of Hoppner). Principal Painter to Prince Regent 1813 (who offered him a knighthood which he declined). At this time his income was £3,000 a year. Among his sitters were William Pitt, Lord Grenville, Sir John Soane and Sir William Scott. He was particularly good at portraying children and elderly sitters. He was seriously crippled by a spine infection and after 1820 was unable to do much. Died of poisoning, due to a mistake made by a chemist's assistant, in London 11 February 1825. Many of his unfinished portraits were completed by Edward Daniel Leahy.
Represented: NPG London; Dulwich College AG; NMM. **Engraved by** J.S.Agar, P.Audinet, H.R.Cook, S.Freeman, R.Hicks, W.Holl, H.Meyer, G.H.Phillips, S.W.Reynolds, H.Robinson, W.Say, W.Skelton, R.Smith, C.Turner, W.Ward, J.Wright, J.Young. **Literature:** DNB; DA.

OWTRAM, Robert Lancelot **fl.1892-1913**
Exhibited at RA (10) 1892-1913 from Beckenham, West Kensington and Woking.

P

PACE, Percy Currall
fl.1897-c.1941

Born Sutton, Surrey. Exhibited at RA (9) 1897-1941 from Redhill, Billinghurst, Steyning and Eastbourne.

PACK, Faithful Christopher
c.1759-1840

Born Norwich, son of a Quaker merchant. Worked in London 1781, receiving encouragement from J.H.Mortimer, and studying and copying under Reynolds c.1782. Moved to Liverpool 1783-6, Dublin and Cork c.1787-96. Had a short spell in Bath, before returning to Dublin again 1802-21. Vice-President of Hibernian Society 1814. Exhibited SA, RA (10), BI (11) 1786-1840. Worked as a teacher of drawing, although the latter part of his life was spent in London working as a chiropodist. Also produced pastels in the manner of John Russell. Died Gray's Inn Lane, London 25/26 October 1840 'aged 81'.

PAELINCK, Joseph
1781-1839

Born Oostacker 20 March 1781. Studied under Verhaegen at Gand, then in Paris under J.L.David. Visited Italy and spent five years in Rome. Professor of Brussels Academy 1815. Painted histories and portraits, including 2nd Earl of Clancarty. Died Brussels 19 June 1839.
Represented: NPG London. **Literature:** Bénézit.

PAGE, Henry Flood
b.c.1833

Baptized Holborn 19 July 1833, son of Philip Flood Page and Sophia (née Barker). Exhibited at RA (5), BI (17), SBA (4) 1858-65 from London. Recorded in Graves as two artists: H.F.Page and Flood Page.

PAGE, William
1811-1885

Born Albany 28 January 1811. Studied under Herring and S.Morse. Exhibited at RA (1) 1860 from Rome. Painted a portrait of Robert Browning (Baylor University, Texas). Died Tottenville 30 September 1885. Confused in exhibition catalogues with landscape artist William Page 1794-1872.

PAGET, Henry Marriott RBA
1856-1936

Exhibited at RA (26), SBA, GG (3) 1874-1915 from London. Elected RBA 1888. Also illustrated books, including Dickens. Died London 27 March 1936. His brothers, Sidney and Walter, were also artists.
Represented: Oxford University.

HENRY MARRIOTT PAGET. The artist's wife and daughters Dorothy and Gladys in the studio at Bedford Park. Signed. Exhibited 1887. 28 x 36 ins (71.1 x 91.5cm)
Christie's

PAGET, Leon 1843-1921
Born Morbier. Also an engraver. His portrait of Sir Charles Napier was exhibited in the Victorian Era Exhibition 1897. Died Morbier.

PAGET, Sidney Edward 1860-1908
Born London 4 October 1860, son of Robert and Martha Paget. Studied at BM, Heatherley's and RA Schools (winning prizes). Exhibited at RA (19), SBA (6+) 1878-1907. Illustrated for a number of publications including *The Illustrated London News* and Sherlock Holmes. A member of 20th Middlesex (Artists' Corps) and Middlesex Yeomanry (Duke of Cambridge Hussars). Died Margate 28 January 1908.
Represented: Bristol AG.

PAICE, Philip Stuart 1884-1940
Painted highly competent portraits. Exhibited RA (1) 1937 from Rock Ferry, Cheshire. Died 3 May 1940.

PAILLOU, Peter jnr 1757-after 1831
Painter of small-scale portraits and miniatures. Born 1 December 1757, son of bird painter Peter Paillou snr. Studied at RA Schools from 1784. Exhibited RA (24) 1786-1800 from London. Later moved to Scotland and settled in Glasgow.
Represented: VAM; SNPG. **Literature:** McEwan.

PALIN, William Mainwaring RBA 1862-1947
Born Hanley, Staffordshire 6 June 1862, son of engraver William Palin. Worked for five years with Josiah Wedgwood & Sons. Studied at RCA, and in Italy and Paris under Boulanger and Lefebvre. Exhibited RA (43), SBA, NWS, Paris Salon, Rome and Chicago 1889-1927. Commissioned to decorate the MacEwan Hall, Edinburgh University and St Clement's Church, Bradford. Died 23 July 1947.

PALING, Isaak fl.1664-c.1720
A native of Leyden, where he entered the Guild 1664. Moved to The Hague 1681. Settled with his wife in London 1682. Returned to The Hague by 1703 and was recorded 1719. His style was very similar to Kneller.
Literature: A.Bredius, *Kunstler-Inventare,* VI 1919, pp.2122-9.

PALLIER(E), Louis Vincent Leon 1787-1820
Born Bordeaux 19 July 1787. Exhibited at Paris Salon, winning prizes 1809, 1812 and 1819. Exhibited at RA (1) 1818 from 147 Strand, London. Died Bordeaux 28/29 December 1820.
Represented: Bordeaux Museum.

PALMER, Alfred Richard Field ROI 1877-1951
Born West Norwood 2 October 1877, son of architect Frank Palmer. Educated at Dulwich College. Entered Clapham School of Art 1895, RA Schools under J.S.Sargent 1898, and on Sargent's advice at Académie Julian, Paris under J.P.Laurens and M.Baschet. Exhibited at Paris Salon, ROI, PS, RA (7), RHA (2), SBA, Société Royale des Beaux Arts, Brussels 1902-51 from Swanage, Sandwich, Norwood and Fordwich. Elected ROI 1922. Friend of Harold Waite. Died London 23 January 1951. Painted in the British Impressionists manner, with a skilful sense of colour.
Represented: Canterbury Museums; Russell-Cotes AG, Bournemouth; Canterbury Police Station; Dorset County Museum; Tithe Barn Museum, Swanage.

PALMER, George fl.1830-1831
Listed as a portrait painter in Sidbury, Worcestershire.

PALMER, Lancelot fl.1818-1845
Married Frances Hadfield in Manchester Cathedral September 1818. Listed as a portrait painter at William Street, Ardwick, Manchester 1845.

PALMER, Lynwood 1866/7-1941
Painted Col William Hall Walker MP.
Represented: Walker AG, Liverpool.

PALMER, William 1763-1790
Born Limerick 18 November 1763, son of a linen draper. Studied at Dublin Society Schools, winning a medal 1781. Entered RA Schools 10 October 1783, becoming a pupil of Reynolds. Exhibited at RA (9) 1784-96. Awarded premiums at SA 1884 and 1785. Returned to Limerick c.1788. Died of consumption in Bruff, near Limerick 26 July 1790.
Represented: NPG London. **Literature:** Strickland; C.K.Adams, *Connoisseur* LXXXVIII July 1931, pp.3-5.

PAPWORTH, C. fl.1802-1807
An honorary exhibitor at RA (3) 1802-7 from 6 Bath Place, New Road, London.

PARDOE, Elsie E. **see MARK, Mrs Elsie E.**

PARDON, James c.1794-1862
Born London. Began as a miniaturist, but later advertised as a portrait and animal painter. Exhibited at RA (13), SBA (5), RBSA (9) 1811-48. Had a practice in St Peter's Street, Canterbury 1814-29, a few doors away from the young Thomas Sidney Cooper. Moved to Suffolk, the birthplace of his wife Elizabeth (née Field), whom he married 31 December 1826 at Yoxford. His last years were spent in Shrewsbury, first at Pride Hill and then at College Hill. Died Shrewsbury 12 November 1862, aged 68. His death certificate describes him as a portrait painter. Among his sitters were the artist Henry Blunt and Robert Waring Darwin, father of Charles Darwin.
Represented: Clive House Museum, Shrewsbury; Canterbury Museums. **Engraved by** T.Lupton.
Colour Plate 5

PAREZ, Joseph fl.1820-1835
Exhibited at RA (4), BI (2), SBA (6), OWS (1) 1820-35 from London.

PAREZ, Louis (Lewis) SBA fl.1821-1831
London portrait painter. Painted largely in watercolour, chalks and miniature. Exhibited at RA (12), SBA (32) 1821-31 from London. Elected RBA 1825. Among his patrons was Lady S.Bridgeman.

PARISH, Josiah fl.1874
Listed as a portrait, animal artist and drawing master at 8 Head Street, Colchester.

PARKER, Alexander M. b.1805
Baptized Nottingham 30 June 1805, son of William and Jane Parker. Exhibited at RA (1), SBA (1) 1839-40 and lived at Listergate, West Bridgford and West Burford, Nottinghamshire. Listed in directories as a portrait and landscape painter.

PARKER, C.R. fl.1828-1829
Exhibited at BI (2), SBA (5) 1828-9 from London.

PARKER, Frederick H.A. RBA fl.1886-1904
Studied at RA Schools. Exhibited at RA (14), SBA (57) 1886-1904. Elected RBA 1890.

PARKER, George fl.1841
Listed as a portrait painter at Castle Gate, Nottingham.
Engraved by J.R.Wildman.

PARKER, Harold FRBS 1873-1962
Born Aylesbury. Travelled as a child to Australia, returning to London 1896. Studied at Brisbane Art School and City and

Guilds School. Also a sculptor. Exhibited at RA (32), Paris Salon 1903-29 from London and Australia. Died 23 April 1962.
Represented: Tate.

PARKER, Henry Perlee RSA 1795-1873
Born Devonport, son of Robert Parker, a painter, carver and gilder. Married 1814 and set up as a portrait painter in Plymouth. Moved to Newcastle c.1815, where he painted portraits and animal subjects. Began to develop his popular smuggling and coastal subjects c.1820, which owe a debt to William Shayer 1787-1879. Still listed as a portrait and animal painter 1831-8. Exhibited at RSA (18), RA (23), BI (40), SBA (23), RHA (10), NWS (4) and in Newcastle, Edinburgh and Carlisle 1817-63. Member of Northumberland Institute for Promotion of Fine Arts. Co-founder of Northern Academy of Arts. Moved to Sheffield 1841-5, where he was a drawing master at Wesley College. Settled in London 1845, where he died 9 November 1873 leaving effects under £8,000.
Represented: NPG London; VAM; Grace Darling Museum, Bamburgh; Shipley AG, Gateshead; Sunderland AG; Sheffield AG; Laing AG, Newcastle. **Engraved by** J.P.Quilley. **Literature:** Hall 1982.

PARKER, J. fl.1637-1658
A portrait of a lady, signed and dated 1637 was sold at Robinson and Foster's 26 November 1953, lot 124.

PARKER, John d.c.1765
Worked in Rome for many years. Returned to England c.1762. Awarded premiums at SA 1762-3. Died Paddington c.1765.

PARKER, John fl.1770-1785
Exhibited at RA (9) 1770-85 from London.

PARKER, W. fl.1730
A life-size portrait of 'Sir James Reynolds as Lord Chief Baron of the Exchequer' was given to Guildhall, Bury St Edmunds. Painted in the style of Dahl.

PARKES, Richard fl.1827-1851
Birmingham landscape and portrait painter. Exhibited at RBSA (14) 1827-51.

PARKINSON, Thomas 1744-c.1789
Born Oxford 10 December 1744. Entered RA Schools 1772. Exhibited at FS (6), SA (4), RA (16) 1772-89 from London. Among his sitters was David Garrick.
Represented: BM; Garrick Club, London. **Engraved by** R.Earlom, C.Grignion, W.Humphrey, J.Jehner, R.Laurie, J.R.Smith, J.Taylor.

PARKMAN, Henry Spurrier 1814-1864
Exhibited at RA (8), SBA (1) 1847-56 from Bristol. Died Bristol 22 June 1864. His sons Alfred Edward and Ernest were also painters.
Engraved by G.T.Payne.

PARKS, Edward c.1773-after 1828
Native of Cork. Painted portraits and Shakespearian subjects in the manner of A.Kauffmann. Member of Society of Artists, Dublin, exhibiting there 1812-13. Recorded in Cork 1828.

PARMENTIER, Jacques (James) 1658-1730
Reportedly born Paris. Nephew and pupil of Sebastien Bourdon. Also studied under Charles de Lafosse. Moved to England c.1676, where he worked for a number of decorative historical painters, including Berchet and for Lafosse at Montague House. From about 1694-8 he worked for

EDMUND THOMAS PARRIS. Mrs Amelia Catherine Trower. Signed, inscribed and dated 1863. 55 x 43ins (139.7 x 109.2cm)
Christie's

William III at The Hague (where his chief surviving work remains). Later returned to England and settled in Yorkshire from c.1701, for 20 years painting many portraits and historical works. A member of the circle of virtuosi at York, and painted altarpieces in Leeds and Hull. Settled in London 1721, on the death of Laguerre. Died London 2 December 1730. Buried St Paul's, Covent Garden.
Represented: NPG London. **Literature:** DNB.

PARNELL, Miss Georgina b.c.1811
Baptized Bethnal Green 2 June 1811, daughter of Henry and Mary Ann Parnell. Exhibited at RA (10), SBA (15) 1846-57 from London, Hastings, Waltham Abbey and St Leonards-on-Sea.

PARRIS, Edmund Thomas 1793-1873
Born London 3 June 1793 (baptized 28 June 1793), son of Edward and Grace Parris. Placed under Ray & Montague, the jewellers, to learn enamel painting. Reportedly entered RA Schools 1816. Exhibited at RA (26), BI (36), SBA (18), NWS (5) 1816-74 from London. Appointed Historical Painter to Queen Adelaide 1832. Painted a large picture of the coronation of Queen Victoria, which was engraved. Won a prize in the Westminster Hall Competition 1843 for his picture of 'Joseph of Arimathea Converting the Jews'. Gained a reputation as a fashionable portrait painter and his work was reproduced in *The Keepsake*. From 1853-6 he worked on the restoration of Thornhill's frescoes in the Dome of St Paul's Cathedral. Also illustrated a number of works for Lady Blessington. Died London 27 November 1873.
Represented: NPG London; BM; VAM; Doncaster AG. **Engraved by** W.G.Baisch, H.T.Ryall, C.E.Wagstaff & T.Higham. **Literature:** *Art Journal* 1874; DNB.

JOHN PARTRIDGE. The artist with his family in his studio. 44 x 60 ins (111.8 x152.4) *Sotheby's*

PARROTT, William 1813-1869
Born Aveley, Essex, October 1813, son of a farmer. Apprenticed to engraver John Pye. Studied at RA Schools. Travelled to Paris 1842-3, Italy 1844-5 and Germany 1851. Exhibited at RA (25), RHA (14), BI (19), SBA (25) 1835-69. His most well-known portrait is of 'J.M.W Turner on Varnishing Day from a Life Study' which was exhibited at SBA 1864. Died Chilton 5 December 1869.
Represented: Brighton AG.

PARRY, David Henry 1793-1826
Born Manchester 7 June 1793 (baptized 1 September 1857), son of Joseph Parry. Married Elizabeth Smallwood of Macclesfield 1816 and had three sons. Gained a reputation as a portrait painter in Manchester, which encouraged him to move to London May 1826. He was making considerable progress there when he died 15 September 1826. Buried St Martin-in-the-Fields.
Engraved by D.Lucas.

PARRY, James 1805-1871
Son of artist Joseph Parry. Exhibited at RMI 1827-56. Drew and engraved a number of illustrations for Corry's *History of Lancashire*. Died Manchester.
Represented: Manchester CAG; Salford Museum & AG.

PARRY, Joseph 1744-1826
Born Liverpool. Apprenticed to a ship and house painter. Settled in Manchester 1790 and was listed there as a portrait painter. Exhibited at RA (1) 1803. Etched a half-length portrait of himself seated at an easel, of which only 10 impressions were taken.
Represented: Salford Museum & AG. **Engraved by** A. Van Assen.

PARRY, William ARA c.1742-1791
Born London, son of John Parry, a famous blind Welsh harper (painted by Hogarth). Studied at Duke of Richmond's Academy, Shipley's, St Martin's Lane and became a pupil of Reynolds 1766. Entered RA Schools 1769. Won six premiums at SA 1760-6. Exhibited SA (4+), FS (3), RA (22) 1776-88. Elected ARA 1776. Patronized by Sir Watkin W.Wynne and worked briefly in Wales before going to Rome 1770, where he remained except for brief visits to England and Wales. Died London 13 February 1791.

PARS, Miss Anne fl.1764-1786
Sister of William Pars. Reportedly won premiums for drawing 1764-6. Honorary exhibitor RA (1) 1786.

PARS William ARA 1742-1782
Born London 2 December 1742 (Waterhouse) or 28 February 1742 (DNB). Studied at St Martin's Lane and Duke of Richmond's Academy. Won 13 premiums at SA 1756-64. Exhibited SA (2), FS (11), RA (27) 1760-76. Elected ARA 1770. Accompanied Dilettanti Society's expedition to Greece and the Troad 1764-6 as a topographical draughtsman, and was employed by Lord Palmerston to accompany him and illustrate his tour of the Continent. Went to Rome on a student's pension from Dilettanti Society 1775. Died Rome October 1782, as a result of a chill caught while sketching. His sister Anne and brother Henry were also artists.
Represented: BM; VAM; Aberdeen AG; Ashmolean; Brighton AG; Birmingham CAG; Fitzwilliam; Leeds CAG; SNG; NGI; Cartwright Hall, Bradford. **Engraved by** W.Byrne, P.Sandby, William Woollett. **Literature:** DA.

PARSEY, Arthur fl.1828-1843
London portrait, historical and miniature painter. Exhibited RA (14), SBA (9) 1828-43. Showed an early interest in photographic experiments of Talbot and Daguerre. Published *The Art of Miniature Painting on Ivory*, 1831, in which he claims to be the first artist to advocate the use of the scraper.

PARSONS, Francis FSA d.1804
Exhibited at SA (15) 1763-80 from London, becoming FSA 1771, Director 1774 and Treasurer 1776. Finally became a picture dealer and restorer. Died London.
Engraved by P.Condé, H.Cook, R.Dunkarton, MacArdell.

PARSONS, George Warren b.1832
Baptized St Mary's, Woolwich 29 January 1832, son of George Warren Parsons and Susannah. Exhibited at SBA (3) 1828-9 from High Street, Woolwich.

PARSONS, J.V. fl.1900-1910
Exhibited at RA (5) 1900-10 from Liverpool.

THOMAS PATCH. A party of dilettanti at Florence. 38 x 49ins (96.5 x 124.5cm) *Christie's*

PARSONS, John Robert c.1826-1909
Exhibited at RA (7), RHA (4) 1848-68 from London.

PARSONS, John Whitehill RBA RMS SSA
1859-1937
Born 10 July 1859. Educated in Edinburgh. Studied at RSA Schools and in Paris under Paul Delance. Exhibited at RA (1), RHA (2) 1892-1906 from Pulborough and Edinburgh. Died 7 January 1937. Also an accomplished athlete. Held amateur records for the high and long jumps.

PARSONS, T. fl.1754
Painted 'Edward, Lord Leigh' at Stoneleigh Abbey.

PARTINGTON, John H.E. 1843-1899
Born Manchester. Brought up in Stockport where his father was a cabinet maker. Went to America as a youth. Returned as a mechanical draughtsman for Professor Scott Bun, before studying art at Manchester School of Art. Worked for a firm of stained glass engravers at Saddlesworth. Exhibited at RA (16), NWS, GG 1873-88. Attracted the attention of Ruskin. Worked in Stockport, Manchester and Ramsay, Isle of Man. Died Oakfield, California.
Represented: Manchester CAG.

PARTRIDGE, Miss Ellen b.1827
Born Barbados, daughter of surgeon Samuel Thomas Partridge and his wife, Elizabeth. Exhibited portraits and miniatures at RA (23), BI (1) 1844-93 from London. Member of SWA.

PARTRIDGE, J. fl.1781-1792
Exhibited at RA (5) 1781-92 from London.

PARTRIDGE, John 1789-1872
Baptized Glasgow 20 November 1789, son of Samuel Partridge (and therefore not born 28 February 1790 as usually stated). Studied under Thomas Phillips RA from c.1814, travelled to France 1823 and then on to Italy until 1827. Settled in London, where he enjoyed a successful practice, receiving much patronage from Scottish aristocrats. Exhibited RA (72), RHA (8), BI (58) 1815-61. Exhibited portraits of Prince Albert and Queen Victoria 1842. Appointed Portrait Painter Extraordinary to Her Majesty and HRH Prince Albert 1843. Among his distinguished sitters

were Lord Melbourne, Lord Palmerston, Duke of Westminster, Duke of Sutherland, Lord Westbury and John Gibson. Encouraged W.P.Frith to take up art. Died London 25 November 1872, leaving effects under £20,000. Redgrave writes 'His portraits were carefully drawn and painted, his likeness good, and his portrait of the Queen popular'.
Represented: NPG London; SNPG; NGI; BM; Walker AG, Liverpool; Castle Museum, Nottingham; Royal Society of Musicians; Salford AG. **Engraved by** G.Baxter, S. & H. Cousins, W. Drummond, G.T.Doo, H.Meyer, J.H.Robinson, J.Thomson. **Literature:** DNB; McEwan.

PASMORE, Daniel jnr RBA fl.1829-1891
Exhibited at RA (16), BI (7), SBA (86), RHA (4), NWS 1829-91 from London. Elected RBA 1862.

PASQUIER, James Abbott b.c.1827
Born Norwich. Aged 54 in 1881 census. Exhibited at RA (6), SBA (3) 1851-68 from London.

PASQUIER, Pierre 1731-1806
Born Villefranche. *Agréé* of Académie Royal 1768 and member 1769. Visited England 1771-2. Exhibited enamels at RA (9), Paris Salon 1769-83. Worked in Paris, Flanders and Holland 1780-1. Died Paris 14 November 1806.
Represented: VAM.

PASSINGHAM, Miss Leila A. fl.1895
Exhibited at RA (1) from 1895 from Kensington.

PASSINI, Ludwig 1832-1903
Born Vienna 9 July 1832, son of Johann Passini. Studied in Vienna and at Leipzig under Carl Werner. Worked a lot in Rome and Venice. Exhibited at RA (2) 1891-7 from Venice and London. Died Venice 6 November 1903.
Represented: NPG London. **Literature:** Bénézit.

PATALANO, Enrico fl.1890
Exhibited at RA (1) 1890 from 1 Langham Place, London.

PATCH, Thomas c.1725-1782
Baptized Exeter 31 March 1725. Trained briefly in London, before working in Vernet's studio in Rome 1747-53. Forced

MARY MARTHA PEARSON. A lady. Signed and dated 1822. 30 x 25ins (76.2 x 63.5cm) *Christie's*

associate embezzled funds in the saddlery business leaving him in debt. In Boston 1765, where he met J.S.Copley and worked as a portrait painter, miniaturist and engraver. Briefly visited England 1767-9, studying under B.West and exhibiting at SA 1768. Returned to Annapolis 1769. Father of 17 children, 11 survived to maturity and 10 were named after artists. Joined the Revolutionary Army 1776 and settled in Philadelphia founding the first Art Academy in America. A friend of Washington, whom he painted from life at least seven times. Suffered what may well have been a nervous breakdown 1780, but recovered with the end of the war. Opened a museum in Philadelphia 1786, which displayed his work and eventually boasted 200 stuffed animals, 1,600 birds, 4,000 insects and 11 cases of minerals. After the death of his first wife in 1790, he married Elizabeth De Peyster 1791, and after her death Hannah Moore. Also manufactured false teeth. In February 1827 he fell unconscious aboard the steamer *Trenton*, bound for New York and was brought back to Philadelphia. Died Philadelphia 22 February 1827. Buried St Peter's Churchyard there.
Represented: NPG London; Pennsylvania Academy of Fine Arts; Philadelphia Museum. **Literature:** C.C.Sellers, *C.W.P.*, Memoirs of the American Philosophical Society, vol 23 pts 1-2, Philadelphia 1947; L.B.Miller, *C.W.P. Collected Letters, Journals and Memorabilia*, 1980; O.Friedrich, 'The Peales – America's First Family of Art', *National Geographic* Vol 178 No.6 December 1990; E.P.Richardson, B.Hindle and L.B.Miller, *C.W.P. and His World*, 1983; DA.

PEALE, Rembrandt **1778-1860**
Born Bucks County, Pennsylvania 22 February 1778, son of Charles Willson Peale. His father founded the first Art Academy in America for the benefit of his son, and in 1795 persuaded Washington to sit for Rembrandt, who was then 17. Visited London briefly 1802-3, where he painted portraits and attended classes at RA Schools, his work being influenced by Benjamin West. Exhibited at RA (6) 1803 and 1833. On his visits to Paris

he was influenced by the French Neo-Classicists, and was determined to become a history painter. Invited to be a Court Painter to Napoleon, and an equestrian portrait of the Emperor won considerable praise. Returned to America and his 'porthole' portrait of Washington (c.1823) was judged to be one of the best likenesses of the man. In his later years Peale maintained studios in various cities and made several trips abroad. Wrote of his travels in *Notes on Italy*, 1831, and published other literary and didactic works. Died Philadelphia 3 October 1860.
Represented: Metropolitan Museum of Art, New York; Detroit Institute. **Literature:** *The Peale Family*, Detroit Institute exh. cat. 1967; O.Frederich 'The Peales – America's First Family of Art', *National Geographic* Vol 178 No.6 December 1990; DA.

PEARCE, Stephen **1819-1904**
Born London 16 November 1819, only child of Stephen and Ann Pearce. Studied at Sass's Academy, RA Schools 1840 and under Shee 1841-3. Acted as a clerk to Charles Lever 1842-6, and travelled in Holland and Germany as a tutor, before going to Italy. Returned to London and in 1851 completed 'The Artic Council Discussing a Plan of Search for Sir John Franklin' (NPG London) containing portraits of Back, Beechey, Bird, Parry, Richardson, Ross, Sabine and others. Exhibited RA (92), BI (3), SBA (3), GG (1) 1837-85. Attached to the Queen's Mews, and paintings by him of horses in the Royal Mews were exhibited at RA. Later had considerable success painting equestrian presentation portraits and groups. His most ambitious work was 'Coursing at Ashdown Park' 1869 containing 60 equestrian portraits. Retired from active work 1888. Studio sale held Christie's 5 February 1886. Died Middlesex 31 January 1904. Buried Old Town Cemetery, Eastbourne. His earlier works were painted with a tight deliberation, but his later pictures are freer in style.
Represented: NPG London; SNPG; Walker AG, Liverpool; Royal Society. **Engraved by** J.Scott. **Literature:** G. Paget, *Apollo* 1 November 1949, pp.142-4; Stephen Pearce, *Memories of the Past*, 1903; DNB.

PEARCE, William T. **fl.1895-1897**
Exhibited at RA (3) 1895-7 from London.

PEARS, P. **fl.1683**
Portrait painter whose only known work is 'A Portrait of a Man of the Yonge Family' dated 1683.

PEARSON, Cornelius **1805-1891**
Born Boston, Lincolnshire. Moved early to London, where he was apprenticed to an engraver. Exhibited at RA (4), SBA (145), NWS 1843-79. One of the oldest members of Langham Sketching Club. Died London 19 October 1891. Often signed in monogram.
Represented: VAM

PEARSON, Harry John RBA **1872-1933**
Born London. Exhibited at RA (7), SBA, ROI 1916-27 from London. President of Langham Sketching Club. Died 4 March 1933 aged 61. Gained a reputation for painting children. Could paint with superb tonal harmony.

PEARSON, Miss Mary A. **fl.1899**
Exhibited at RA (1) 1899 from 19 Bolton Studios, London.

PEARSON, Mary Martha (née Dutton) RBA
 c.1799-1871
Born London. Exhibited at RA (31), BI (15), RHA (13), SBA (37) 1821-42. Elected RBA 1824. Married Charles Pearson, solicitor and later MP. Enjoyed success as a society portrait painter. Died 15 April 1871 aged 72.
Represented: NPG London; Brighton AG.

PEARSON, Wilson 1802-1854
Born Broughton Cross, near Cockermouth. A successful teacher of mathematics. Gave this up to paint portraits and moved to Liverpool aged 30. Established a successful practice. Died Liverpool at the house of his nephew, James Renny, a draper.
Literature: *Cumberland Paquet* 5 December 1854.

PEART (PAERT, PERT), Henry fl.1679-c.1699
Studied under Francis Barlow and Symon Stone. Became a professional copyist, including works by Lely. Lord Bristol bought his collection from his widow on 14 June 1700. His son, Henry Peart the younger, was also a copyist.
Represented: NPG London.

PEASE, William fl.1823-1832
Exhibited at RA (3), SBA (5) 1823-32 from Woolwich.

PEAT, Thomas fl.1791-1831
Worked in Bath 1819-22, Leamington 1828, Bristol 1830-1, Birmingham and London. Exhibited at RA (15) 1791-1805. A poem from a cutting states 'In striking likenesses, those talents rare/With the ingenious Peat few can compare.'
Represented: VAM; BM; Louvre; Cognac Museum, Paris; Holburne Museum, Bath; London Museum. **Engraved by** S.Freeman, W.Grainger.

PEDDER, Jane fl.1860
Listed as a portrait painter at 104 Faulkner Street, Liverpool.

PEELE, John Thomas RBA NA 1822-1897
Born Peterborough 11 April 1822. Emigrated to America aged 12 with his parents. Began practising as an artist in Buffalo. Studied in New York, before working in Albany for two years as a portrait painter. Returned to New York. Elected NA. Moved to London c.1851. Exhibited at RA (28), BI (13), SBA (161) 1852-91. Elected RBA 1872. Among those who bought his work were Prince Albert (Osborne House) and artist Frederick Church. Particularly good at depicting children. The *Art Journal* 1876 wrote: 'Peele's method of treating female portraiture is both commendable and pleasant; it retains the individuality while it takes the impersonation out of the category of mere portrait dressed and set up for the occasion. In all his works Mr Peele's aim and purpose seems to have been to show as much of the poetic side of nature as is consistent with his subject, to preserve its individuality, while imparting to it something beyond mere naturalism.' Died Bexley, Kent 19 May 1897.
Represented: Southampton CAG.

PEGLER, Charles William (Henry) 1803-1832
Baptized Great Stanmore 5 April 1803, son of Charles and Elizabeth Ann Pegler. Painted large portraits and miniatures. Listed as a portrait painter (under the name of Charles Henry) at 36 Percy Street, Tottenham Court Road, London. Exhibited at RA (15), SBA (10) 1823-32. Died Percy Street, London 2 April 1832 in his thirtieth year.
Represented: St Bartholomew's Hospital; Royal College of Surgeons. **Engraved by** W.Say, C.Turner.

PELHAM, Henry 1749-1806
Born Boston 14 February 1749, son of Peter Pelham and his second wife, Mary Singleton, widow of Richard Copley and mother of J.S.Copley. Trained as a civil engineer and possibly under Copley. Left America c.1777. Exhibited at RA (4) 1777-8 from 'Mr Copley's'. Went to Ireland c.1779 and was agent to Lord Lansdowne. Exhibited in Dublin 1780. Drew illustrations for Grose's *Antiquities of Ireland*. Drowned in a boating accident in Kenmare River 20 September 1806.
Represented: Metropolitan Museum, New York.

PELHAM, James jnr 1800-1874
Born London 16 September 1800, son of miniaturist James Pelham snr. Travelled painting portraits and miniatures in Norwich, Islington, Bath, Cheltenham and Edinburgh. Appointed painter to Princess Charlotte. Exhibited at RA (8), RHA (1), SBA (3) 1832-68. Settled in Liverpool c.1846, exhibiting at LA. Elected ALA 1848, LA 1851, Secretary 1854-61, Treasurer 1869-71, President of Liverpool Sketching Club. After c.1854 he stopped exhibiting portraits and concentrated on genre subjects. Died Liverpool 17 April 1874. His son, James iii was also a painter.
Represented: Walker AG, Liverpool.

PELHAM, Peter 1697-1751
Born London (baptized St Giles in the Fields 26 September 1697), son of Peter Pelham and Penelope (née Howard). Apprenticed to engraver John Simon in London 1713, to learn the new art of mezzotinting. Married Martha Guy at St Mary Magdalene, Fish Street off St Martin-in-the-Fields 29 February 1719/20. Produced portraits in London, engraved by himself. Emigrated with his wife and family to Boston, New England c.1727, possibly under a cloud. Worked with considerable success as a portrait painter and engraver of mezzotints. After the death of his first wife, he married Margaret Lowry 15 October 1734. To help support his family he ran a school, teaching 'Dancing, Writing, Reading, Painting upon glass and all kinds of Needlework'. On the death of Margaret he married 22 May 1748, Mary (née Singleton), the widow of Richard Copley and mother of John Singleton Copley (who he taught to paint). Died intestate December 1751. Buried 14 December Trinity Church, Boston. His work was influenced by Kneller. Had a considerable effect on the development of the American School of Portraiture.
Literature: A.Oliver, *P.P.*, 1973; DA.

PELLEGRINI, Carlo 1839-1889
Born Capua, a descendant of the Medici. Fought for Garibaldi. Moved to England 1864. Illustrated under the pseudonym 'Ape' for *Vanity Fair* from 1869 and produced a large number of caricatures. Exhibited at RA (1), GG (10) 1878-83 from London. Wrote a number of historical and art books. Died London 22 or 28 January 1889.
Represented: NPG London; SNPG; BM; VAM.

PELLEGRINI, Domenico 1759-1840
Born Galliera (Bassano), northern Italy 19 March 1759. Trained in Venice and studied under D.Corvi in Rome 1784. Moved to London 1792. Entered RA Schools 1793. Encouraged by Bartolozzi (whose portrait by Pellegrini 1794 is at Venice). Exhibited at RA (35), BI (1), OWS (2) 1793-1812. Later settled in Rome, where he died 4 March 1840.
Represented: NPG London; NMM. **Engraved by** F.Bartolozzi, E.Bocquet, J.Godby, J.Heath.

PELLEGRINI, Giovanni Antonio 1675-1741
Born Venice 29 April 1675. With S.Ricci and J.Amigoni he was the most important history painter in Venice. Moved to England 1708-13, being invited over with Marco Ricci by the Earl of Manchester. Appointed Director of Kneller's Academy 1711. Visited Holland and Paris, but returned to England 1719. Died Venice 2 or 5 November 1741.
Represented: Brighton AG; Castle Howard; Narford. **Literature:** Bénézit; G.Knox, *G.A.P.*, 1995; DA.

PEMBER, Miss Winifred fl.1898
Exhibited at RA (2) 1898 from London.

PEMBROKE, Thomas c.1658-c.1686
Studied under Laroon. Became a history and portrait painter. Patronized by Earl of Bath. Died aged 28.

PEMEL (PEMELL), J. fl.1838-1851
Exhibited at RA (13), BI (5), SBA (1) 1838-51. Worked in London and Canterbury.
Represented: VAM; Canterbury Museums.

PENLEY, Aaron Edwin RI 1807-1870
Working as a miniaturist in Manchester by 1834. Exhibited at NWS (309), RA (18), RHA (7), BI (1), SBA (20) 1835-70. Elected RI 1838, but resigned 1856 over the hanging of his works. Painted some portraits, but concentrated on landscape. Assistant Professor of Drawing at Addiscombe Military College, Woolwich 1851. Appointed watercolour painter to William IV and Queen Adelaide, and teacher to Prince Arthur. Also author of books on watercolour painting. Died suddenly in Lewisham 15 January 1870 in his sixty-fourth year. Studio sale held Christie's 23 April 1870.
Represented: NPG London; BM; VAM; Tate; Maidstone Museum; Leeds CAG; Fitzwilliam; Manchester CAG; Paisley AG; Ulster Museum; Brighton AG; Hove Library; Grundy AG, Blackpool.

PENN, William Charles RP ROI 1877-1968
Born South London 31 December 1877. Studied at Lambeth and City & Guilds School of Art from 1895, where he won medals and a scholarship to RA Schools 1900-5. Trained at Académie Julian, Paris under J.P.Laurens 1908 and in Holland and Belgium 1909. Exhibited at RA (38), ROI, RP, LA 1904-47 from London, Liverpool and Birkenhead. Elected RP 1952. Master at Liverpool School of Art 1911-40. Served with the 57th Division in France. Awarded Military Cross 1918. Died Brampton, Cumberland 27 May 1968.
Represented: Walker AG, Liverpool.

PENNEY, Andrew Matthew fl.1865-1907
Listed as a portrait painter in Edinburgh. Exhibited RSA (18), GI (1).

PENNY, C. fl.1824-1826
Some of his portraits of dissenting ministers were reproduced in the *Evangelical Magazine*. Among his sitters was 1st Earl of Eldon.
Engraved by R.Cooper, H.Dawe, B.Holl, H.Meyer, J.Roffe, C.S.Taylor.

PENNY (PENNEE), Edward RA 1714-1791
Born Knutsford, Cheshire 1 August 1714, son of surgeon Robert Penny and Clare (née Trafford). A pupil of Hudson in London and then travelled to Rome, where he studied under Marco Benefiale. Returned to England 1743 or 1748 (conflicting sources) and practised in Cheshire before settling in London. Some time after 1753 he married Elizabeth, the widow of Richard Fortnam. She owned valuable leasehold property on the Grosvenor estate in London. He was the chief rival to Zoffany in the small full-length. Exhibited at SA (14), RA (21) 1762-82. Elected Vice-President of SA 1763, founder RA, RA's first Professor of Painting 1768-82, when he retired through ill health. Gave up painting about this time. Died Chiswick 15 November 1791. Buried Chessington, Surrey in the same grave as his wife, who died the previous year. His early paintings were signed 'Pennee'. W.R.Bigg was a pupil.
Represented: Ashmolean; Yale; Birmingham CAG; Stratford AG; NMM; Tate; Laing AG, Newcastle. **Engraved by** A.van Assen, R.Houston, J.Young. **Literature:** DA.

PENNY, William fl.1877-1886
Exhibited at RBSA (9) 1877-86 from Birmingham.

PENROSE, James Doyle RHA 1862-1932
Born Michelstown, County Dublin 9 May 1862, son of J.D.Penrose. Studied at South Kensington, St John's Wood

and RA Schools (winning a Silver Medal). Exhibited at RA (19), RHA (52), GG 1886-1930 from London and Watford. Died near Bognor Regis 2 January 1932. Sir Roland Penrose was his son.

PENSTONE, John Jewell fl.1835-1895
Exhibited at RA (5), SBA (3) 1835-95 from London.
Represented: SNPG.

PENTREATH, Richard Thomas b.1806
Baptized 24 August 1806, son of Richard and Gloria Pentreath of Penzance. Exhibited at RA (19), SBA (1) 1844-61 from Penzance and London.

PEPPER, Edward fl.1892
Listed as a portraitist at 38 Pynest Street, Hanley, Staffordshire.

PERCIVALL, John fl.1631-1651
Worked in Salisbury. The Salisbury Corporation paid him £6 for portraits of the King, Queen and Earl of Pembroke, of which only the latter is known to survive.

PERCY, William 1820-1903
Reportedly born Manchester. Studied under leading Manchester portrait painter, William Bradley. Set up practice in Manchester. Exhibited at RA (15) 1854-79. Member of Hogarth Club.
Represented: SNPG; Manchester CAG. **Engraved by** S.Bellin.

PERICOLI, Philip fl.1828-1832
Listed as a portrait painter in Birmingham.

PERIGAL, Arthur snr c. 1784-1847
Studied under Fuseli at RA Schools. Awarded RA Gold Medal 1811. Exhibited at RA (9), RSA (16), BI (12), 1810-28 from London, Northampton and Manchester. Died Edinburgh. Arthur Perigal RSA 1816-84 was his son.
Literature: McEwan.

PERKINS, J. fl.1850-1852
Exhibited at BI (1), SBA (3) 1850-2 from Oxford and Cheltenham.

PERLOTTO, Tito 1788-1858
Born Lonigo. Worked in London 1816-24. Exhibited at SBA (3) 1854 from Pimlico. Died Westminster 6 October 1858.
Engraved by C.Knight.

PERNOTIN, B. fl.1778-1797
Worked in Paris 1778-86. Moved to London. Exhibited at RA (11) 1786-97 from Soho and Knightsbridge.

PEROTTI, Angelica fl.1772-1775
Exhibited at RA (6) 1772-5 from London.

PERREAL, Jean c.1450/60-1530
Born between 1450 and 1460, probably at Lyons. Became a Court Painter in France to Charles VIII, Louis XII and Francis I, and was known as 'Jean de Paris'. Visited England to paint a portrait of Mary Tudor, daughter of Henry VII, who married Louis XII. Died at Paris or Lyons in June or July 1530. Painted miniatures and small-scale portraits.
Represented: HMQ; British Library, London. **Literature:** Grete Ring, *Burlington Magazine* XCII September 1950 p.255; DA.

PERRIN, Mrs Ida Southwell (née Robins) b.1860
Born Hampstead. Exhibited at RA (3), RI, SBA (2) and in Paris 1888-1908 from Hampstead. Manager of the De Morgan Pottery Works at Bushey Heath. Married T.S.Perrin.

CHARLES EDWARD PERUGINI. 'Doubt' – Mollie and Kate Dickens. Signed with monogram. 47½ x 39½ins (120.7 x 100.3cm)
Christie's

PERRING, W. fl.1852-1853
Exhibited at RA (3) 1852-3 from 8 Belgrade Place, Walworth.

PERRONNEAU, Jean-Baptiste c.1715-1783
Born Paris. Made début at Salon 1746. Travelled widely through France, Holland, Italy and Russia. Visited England c.1760 and c.1773. In January of 1761 the Duke of Montague paid him 17 guineas for a portrait. Exhibited at SA (4) 1761. Died Paris 19 November 1783. Waterhouse writes 'After Quentin de la Tour, he was the most distinguished French pastellist of the century, and his powers of interpreting character are of a very high order'.
Represented: Louvre. **Literature:** L.Vaillet and P.Ratouis, *J.-B.P.*, Paris and Brussels, 1923; DA.

PERRY, H. fl.1810-1825
Exhibited at RA (8), SBA (1) 1810-25 from London.

PERRY, John b.1767
Entered RA Schools 1791 aged 24. Exhibited RA (2) 1791-1809. Recorded engraving one of his own portraits 1841. Possibly the J.C.Perry (RBA 1824) who exhibited RA (10), BI (3), SBA (19) 1835-43.

PERTZ, Miss Anna J. fl.1884-1897
Exhibited at RA (8) 1884-97 from London, Florence and Cambridge.

PERUGINI, Charles Edward 1839-1918
Born Naples, son of Leonardo Perugini. Studied in Italy under Giuseppe Bonolis and Giuseppe Mancinelli, and in Paris under Ary Scheffer 1855. Moved to London 1863 and was encouraged by Lord Leighton for whom he may have briefly worked as an assistant. Exhibited at RA (81), BI, SBA,

KATE PERUGINI. Dora, daughter of Anderson Critchett, FRCS. Signed and dated 1892. 45 x 24½ins (114.3 x 62.2cm)
Christie's

NWG 1863-1915. Particularly fond of painting elegant ladies. A highly accomplished and gifted artist. Married Kate, daughter of Charles Dickens. A friend of Leighton, Millais and Fred Walker. Died Kensington 22 December 1918.
Represented: VAM; Birmingham CAG. **Engraved by** C.A.Tomkins.

PERUGINI, Mrs Kate (née Dickens) 1839-1929
Baptized Kathreen Elizabeth Macready Dickens, daughter of novelist Charles Dickens. Educated at Bedford College for Women. Studied under various artists in London and Paris. Married Charles Alston Collins 1860, but after his death married Charles Edward Perugini. Exhibited at RA (36), SBA, NWS, GG, NWG (11) 1875-1905. Model for the girl in 'The Black Brunswicker' by Millais. Died 9 May 1929 'aged 89'.
Represented: Hertford Museum. **Literature:** *The Times* 5 October 1929.

PESSINA, G.D. fl.1848-1866
Exhibited at RA (3) 1848-66 from London. Among his
sitters was Commodore Sir Gordon Bremer KCB. Possibly
Giovanni Pessina, who worked in Milan.

PETERS, Albert Wallace 1894-1918
His portrait of Sir Frank Short is in NPG London.

PETERS, Rev Matthew William RA 1741/2-1814
Born Freshwater, Isle of Wight (or Dublin as quoted by
Hibernian Magazine November 1794), son of Matthew Peters,
an engineer and landscape gardener. Travelled to Dublin as a
child with his parents (his father obtained a post in the customs
there), and he was placed in a school under the care of Dr
Sheridan, a friend of Dean Swift. Studied at Dublin School of
Design under Robert West, winning drawing prizes 1756-8.
Moved to London, where he studied under Thomas Hudson.
Won a premium at SA 1759. From London he visited Italy (with
an allowance from the Royal Dublin Society), where he worked
in Batoni's Academy 1762 and became a member of Florence
Academy 1763. Returned to Dublin by 1765, but met with little
success and so travelled to London, France, Italy and Venice.
Became a Freemason 1769 and was later Grand Master of
Lincolnshire and Deputy Grand Master of Nottinghamshire.
Produced a number of portraits of Grand Masters, many of
which were destroyed in a fire 1883. Exhibited at SA (14), FS
(2), RA (25), BI (1) 1766-1807. Elected ARA 1771, RA 1790.
Painted a number of Rembrandtesque portraits as well others
showing the influence of Reynolds, Boilly and Fragonard.
Produced works to illustrate Boydell's Shakespeare Gallery. Also
painted a great number of ladies lying invitingly on a bed or sofa.
These date mainly from 1776-9 and were popularised by
engravings. They earned him some criticism when he entered the
Church, becoming an ordained deacon 1781 and priest 1782.
He gradually reduced the amount he painted to devote more
time to religion. Became rector of Woodstock, Lincolnshire and
Knipton in Leicester, Prebend of Lincoln, Chaplain to the Prince
of Wales and 1784-8 RA Chaplain. Married Margaret, daughter
of Rev John Fleming 1790. Died Brasted, Kent 20 March 1814.
Represented: NPG London; NGI; RA; Trinity College,
Cambridge; Duke of Rutland; Burghley House. **Engraved by**
W.Dickinson, J.B.Michel, J.R.Smith. **Literature:** Lady
Victoria Manners, *M.W.P. His Life and Works,* 1913; DA.

PETERS, Samuel fl.1830-1832
Exhibited at RHA (5) 1830-2 from Dublin.

PETHER, William FSA 1731-1819
Born Carlisle, cousin of Abraham Pether, and son of William
Pether an organ builder and his wife Mary. Studied under
Thomas Frye, with whom he entered into partnership 1761.
Painted portraits in oil, crayons and miniatures and was a
distinguished mezzotinter. Traded as a 'Printer, Mezzotint
Engraver and Painter' at Compton Street, Soho 1763. Won
premiums at SA 1756, 1760 and 1767. Exhibited at SA (20),
FS (10), RA (9) 1761-94 from London, Richmond and
briefly in Nottingham. Elected FSA 1771, Director 1776.
Settled in Bristol as a drawing master and picture cleaner
1804. Died Bristol 19 July 1819 (not 1795). Buried 25 July
at Horfield churchyard. Produced prints of the 'Three Smith
Brothers of Chichester', and after Joseph Wright of Derby.
Wright of Derby exhibited from Pether's address 1770-2.
Edward Dayes was his pupil and found him a 'kind master
and polite gentleman'. Redgraves writes: 'His portraits in oil
are rare; they are firmly and powerfully painted.'
Engraved by W.Leney, H.Meyer.

PETICOLAS, Edward F. 1793-c.1853
Born Pennsylvania, son of miniaturist Philippe Abraham
Peticolas. Studied under T.Sulley. Visited England briefly

1815. Abandoned painting c.1845 because of rheumatism.
Thought to have died Richmond, Virginia.

PETTIE, John RA HRSA 1839-1893
Born East Linton, Haddington or Edinburgh 17 March 1839.
Aged 16 entered Trustees' Academy, Edinburgh with
MacTaggart, MacWhirter, Orchardson and Chalmers under
R.S.Lauder. Travelled to London 1862 and shared a studio
with Orchardson. Exhibited at RA (119), RSA (71), BI (3),
RHA (2), SBA (2), GG (7) 1858-93. Elected ARA 1866,
HRSA 1871, RA 1873. Married Elizabeth Ann Bossom, the
sister-in-law of artist C.E.Johnson 1865. Also worked as an
illustrator as well as painting genre and historical scenes. Had
considerable success with portraiture and would sometimes
represent his sitters in historical costume. Wood describes his
style as 'vigorous, in power and richness it shows the influence
of Van Dyke and Rubens'. Experimented with chiaroscuro
effects from c.1870. Died Hastings 20 or 21 February 1893.
Studio sale and collection sold Christie's 26 and 27 May 1893.
Represented: NPG London; SNPG; Tate; Mappin AG,
Sheffield; Royal Holloway College; Manchester CAG; Leeds
AG; Glasgow AG; Dundee CAG; Aberdeen AG. **Literature:**
M.Hardie, *J.P.,* 1908; McEwan; DA.

PETTON, R. fl.1723
Painted a portrait of 'George Heathcote' 1723 in the style of
Dahl.

PHELPS, James fl.1807-1827
Exhibited at RA (4) 1808-11 from London. Also an engraver.

PHELPS, Miss Millicent (Mrs Mayer) fl.1890-1908
Exhibited at RA (10), SBA 1890-1908 from London.
Married 1891.

PHELPS, Richard c.1710-1785
Born Porlock, Somerset. Also copied old masters, painted inn
signs and repaired altarpieces. Exhibited at SA 1764, and
sometimes collaborated with C.W.Bamfylde. Influenced by
Hudson, Highmore and Hogarth.
Represented: NPG London; Dunster Castle; Bristol CAG;
Crowcombe Court. **Engraved by** J.Baker, J.Faber jnr,
Maddocks. **Literature:** Sir H.C.Maxwell-Lyte, *A History of
Dunster,* 1909.

PHILIPS, Charles 1708-1747
Son of painter Richard Philips. He was, for a period, extremely
fashionable and was patronized by Frederick, Prince of Wales
and his circle of friends. Produced conversation pieces, small
full-lengths, and later life-size full-lengths, including those of
the Prince and Princess of Wales 1737. Married 1738 and
established a practice at Lincoln's Inn Fields.
Represented: NPG London; Windsor; Warwick Castle; Yale;
Metropolitan Museum, New York; Rokeby Park. **Engraved
by** T.Burford, J.Faber jnr. **Literature:** DA.

PHILIPS, Francis Freeman fl.1800
Worked in Bristol, where he took James Stooke as an
apprentice for seven years.

PHILIPS, Richard c.1681-1741
Father of Charles Philips. Among his sitters was Edmund Halley,
astronomer. Died London October 1741 aged about 60.
Engraved by G.Vertue. **Literature:** Vertue iii p.105.

PHILLIP, John RA 1817-1867
Born Oldmeldum, Aberdeenshire 19 April 1817. Began as an
errand boy to a tinsmith, before being apprenticed to Spark, a
house painter and glazier. In his spare time he studied briefly
under Aberdeen portrait painter James Forbes, and worked as

CHARLES PHILIPS. Frederick, Prince of Wales. Signed and dated 1739. 18 x 23ins (45.7 x 58.4cm) *Christie's*

a scene painter. Attracted attention of Lord Panmure who gave him £50 and paid for his art education enabling him to study under T.M.Joy 1836 and then at RA Schools 1837, where he became a member of The Clique. Returned to Scotland c.1839, where for the next two years he painted mainly portraits, and some Scottish genre scenes in the style of Wilkie. Returned to London 1846 and visited Spain for health reasons in 1851, 1856 (with Ansdell) and 1860. During this time he became popular for his Spanish genre scenes and became known as 'Spanish Phillip'. Exhibited at RSA (43), RA (55), BI (12), SBA (6), LA 1836-67. Elected ARA 1857, RA 1859. Exhibited a group picture of 'The Marriage of the Princess Royal with Prince Frederick William of Prussia' painted by command of Her Majesty (engraved by Auguste Blanchard) 1860. Among his sitters were A.L.Egg, J.E.Millais, R.Ansdell, Samuel Bough, T.Oldham Barlow. Struck down with paralysis in the house of W.P.Frith and died Camden Hill, Kensington 27 February 1867. Studio sale held Christie's 31 May 1867. His son Colin Bent Phillip was also a painter. Ottley writes: 'His style is distinguished by great vigour and intelligence, and a fine perception of character. His flesh is admirable in modelling, and in the healthy hue bestowed upon it; and his colour is generally rich, pure, and harmonious'.
Represented: NPG London; SNPG; Tate; Walker AG, Liverpool; HMQ; Aberdeen AG; Aberdeen Town House; RSA, Edinburgh; SNG; BM; RA; Brighton AG; Glasgow AG. **Literature:** James Dafforne, *Pictures by J.P. RA*, 1877; Aberdeen AG exh.cat. 1967; DNB; McEwan; DA.

PHILLIPS, F.A. **fl.1869-1877**
Exhibited at RA (4) 1869-77 from Peckham, Dewsbury and Hull.

PHILLIPS, George H. **fl.1819-1832**
Exhibited at RA (8), BI (1), SBA (13), OWS (1) 1819-32 from London.

PHILLIPS, Henry Wyndham **1820-1868**
Born London, son and pupil of Thomas Phillips RA and Elizabeth (née Fraser). Exhibited at RA (76), BI (13) 1838-68. Travelled to Paris 1848 and Florence 1852. Often portrayed sitters in exotic costume. His sitters include John Gibson, Charles Kean, Dr William Prout and Robert Stephenson. A Captain in the Artists' Volunteer Corps, and for 13 years secretary of Artists' General Benevolent Institution. Died suddenly at Hollowcombe 5 or 8 December 1868. Studio sale held Christie's 8-10 April 1869.
Represented: NPG London; SNPG; VAM; Garrick Club, London; Viscount Wimbourne; HMQ (Osborne). **Engraved by** T.L.Atkinson, J.Brown, S.Cousins, J.R.Dicksee, W.J.Edwards, J.R.Jackson, R.J.Lane, S.W.Reynolds, W.Walker, G.Zobel. **Literature:** DNB; DA.

PHILLIPS, John **fl.1860**
Listed as a portrait painter in Liverpool.

PHILLIPS, Peregrine **d. 1784**
Studied at Burgess's Drawing Academy. Exhibited at FS (8) 1771-6 from London. Died Milltown 30 March 1784.

THOMAS PHILLIPS. William Milton Bridges
aged 12 at Burton Park, Sussex. Signed with
monogram 1797. 39 x 34ins (99.1 x 86cm)
Christie's

PHILLIPS, Richard **1681-1741**
His portrait of Edmund Halley is in NPG London.
Engraved by J.Faber jnr, J.W.Giles, J. & C.Sherwin,
J.Simon, T.Trotter.

PHILLIPS, S. **fl.1802-1806**
Exhibited at RA (3) 1802-6 from London and Mitcham.

PHILLIPS, Thomas **RA** **1770-1845**
Born Dudley, Warwickshire 18 October 1770. Studied at
Birmingham under Francis Eginton, the glass painter. Moved to
London 1790, with an introduction to Benjamin West, who
found work for him on the painted glass windows of St George's
Chapel at Windsor. Entered RA Schools 18 February 1791.
Exhibited RA (340), BI (1) 1792-1846. Elected ARA 1804, RA
1808. Exhibited history pictures at first, then concentrated on
portraiture, for which he enjoyed considerable success. Among
his sitters were the Prince of Wales, Lord Byron, Sir Joseph Banks,
Sir Francis Chantrey, John Crabbe, William Blake, Sir Humphry
Davy, Michael Faraday, Lord Thurlow and the Marchioness of
Stafford. A transcript catalogue of his works 1791-1843 is in
NPG London. His sitters' book is in NPG London archives.
Elected RA Professor of Painting 1825. Visited Italy and Rome in
the company of William Hilton, and also Sir David Wilkie who
they met in Florence. Died London 20 April 1845. Interred in
burial ground of St John's Wood chapel. He was a contemporary
of Lawrence, and offered a more subdued style based on the
study of old masters. Among his pupils were John Partridge, John
William Wright and Thomas Griffiths Wainewright. His son
Henry Wyndham Phillips was also a portrait painter. Waagen
wrote that he was 'distinguished for his true and delicate
conception, his generally excellent colouring, and his

conscientious and equal execution'. His best works are full of
character and show him to be in the top rank of portrait painters.
Represented: NPG London; SNPG; Tate; Walker AG,
Liverpool; Brighton AG; Petworth, NT; Chatsworth. **Engraved
by** J.S.Agar, C.Armstrong, W.W.Barney, W.Blake, A.Bour, J. &
W.Bromley, J.Brown, G.Clint, J.Cochran, H.Cook, H. &
S.Cousins, T.A.Dean, W.Drummond, W.Edwards, E.Finden,
J.Fittler, S.Freeman, W.T.Fry, M.Gauci, J.Godby, R.Golding,
R.Graves, W.Greatbach, L.Haghe, C.Heath jnr, R.Hicks, F. &
W.Holl, J.Jenkins, G.Keating, R.J.Lane, H.Linton, T.Lupton,
E.M'Innes, H.Mackenzie, H.Meyer, S.Phillips, S.W.Reynolds,
P.Roberts, H.Robinson, W.Say, I.Schiavonetti, J.Scott,
E.Scriven, W.Skelton, F.Storm, A.Tardieu, J.Thomson, C. &
H.S.Turner, Mrs D.Turner, W.Walker, G.R. & W.Ward,
R.Woodman, T.Woolnoth, J.Young. **Literature:** *Art Union*
1845 p.138; Gustav F.Waagen, *Treasures of Art in Great Britain,
etc.,* 4 vols, 1854-7; DNB.

PHILLOTT, Miss Constance **ARWS** **1842-1931**
Studied at RA Schools. Exhibited RA (15), SBA (5), OWS
(57), GG (1), NWG (3) 1864-81 from Hampstead. Elected
ARWS 1882. Cousin of painter and writer William de
Morgan. Died 30 March 1931.
Represented: Manchester CAG. **Literature:** W.Shaw
Sparrow, *Women Painters of the World*, 1905.

PHILPOT, Glyn Warren **RA ROI RP NPS**
 1884-1937
Born London 5 October 1884, son of John Philpot, a surveyor
and Jessie (née Carpenter). His mother died suddenly in 1892,
when he was seven. Studied at Lambeth School of Art 1900
under Mckeggie and P.Connard and Académie Julian, Paris

HENRY PICKERING. Margaret Smith. Signed and dated 1762.
50 x 40ins (127 x 101.6cm) *Christie's*

under J.P.Laurens 1905. There he was influenced by Charles Ricketts and converted to Roman Catholicism. Set up a studio with great success and travelled to Spain, where he was impressed by Velázquez. Exhibited at RA (63), RP (11), NEAC, GG, International Society 1904-38. Elected RP 1911, ARA 1915, RA 1923. Invalided out of the army 1917. Introduced to Siegfried Sassoon, Frank Schuster, Edward Elgar and Adrian Boult. Visited America 1921 for portrait commissions. In the 1930s his style changed rapidly, under the influence of *école de Paris* modernism. Died London 16 December 1937. Buried St Peter's Church, Petersham near Richmond.
Represented: NPG London; Ashmolean; Fitzwilliam; Longleat; Tate; Brighton AG; Leeds CAG. **Literature:** T.Bodkin & A.C.Sewter, *G.P.,* 1951; R.Gibson, *G.P.* NPG exh. cat. 1984/5.

PHOENIX, George **1863-1935**
Born Wolverhampton. Studied at Birmingham School of Art and South Kensington (winning medals). Exhibited at RA (13), NWG, RBSA 1886-1935 from Bournemouth and Wolverhampton. Illustrated *Punch.* Among his sitters were Sir William Blake Richmond, Rt Hon David Lloyd George and G.K.Chesterton. Died War Memorial Hospital, Wrexham 28 May 1935 (not 10 December 1935). Left effects of £3,857.9s.8d.
Represented: NPG London; Wolverhampton AG.

PICARD, John **d.1768**
Described as 'Celebrated painter of Canterbury'. Married Mary Wibrow (d.1740) at St Martins, Canterbury 1 December 1735, when he was described as John Picard of Deal. Buried 2 December 1768 St Paul's Church, Canterbury.

PICART, Charles H. **1780-1837**
An engraver and painter of portraits. Exhibited at RA (3) 1798-1802 from London.
Engraved by T.Blood.

PICCIONI, Felice **fl.1830-1842**
Italian artist brought to Belfast by Marcus Ward. Established a successful portrait practice in chalk and in oils. Exhibited at RHA (1) 1834. Later settled in Cork, where he produced caricatures.

PICKARD, Miss Louise **NEAC WIAC** **1865-1928**
Born Hull 12 December 1865. Moved to London. Studied at Slade 1898-1900 and in Paris. Exhibited at NEAC, RA (8) 1909-28. Died London 6 June 1928.
Represented: Tate.

PICKERING, Henry **d.c.1771**
Fashionable and gifted portrait artist in the style of Hudson. Returned from Italy in 1740. Like Hudson and Reynolds, employed Van Aken (d.1749) as his drapery painter. During the 1750s he seemed to have travelled, possibly as an itinerant portrait painter, to Yorkshire, Lancashire, Cheshire and North Wales. Based at Manchester from 1759. Died Manchester. His wife, Mary, and four children are mentioned in his will (dated 1759, proved 18 February 1771). His portraits contain much charm.
Represented: Walker AG, Liverpool; Castle Museum, Nottingham. **Engraved by** J.Faber jnr, H.Robinson. **Literature:** DA.

PICKERSGILL, Henry Hall **1812-1861**
Born London, son of Henry William Pickersgill RA. Studied for some time in Holland. Travelled to Italy before becoming an historical and portrait painter. He wished to combine in his works the accuracy of the Dutch with the higher aspirations of the Italian Schools. Popular in Russia and travelled to St Petersburg, where he remained two years, chiefly painting portraits. On his return to England he painted a number of portraits for public institutions in Lancashire, Shropshire and Hereford. Exhibited at RA (44), BI (8) 1834-62. Died

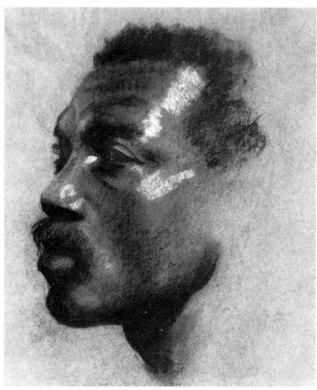

GLYN WARREN PHILPOT. Study of a gentleman. Pastel and chalk. 10¾ x 10¼ins (27.4 x 26cm) *Christie's*

London 7 January 1861. Studio sale held Christie's 24 April 1861. His wife, Jane, was also a painter.
Represented: Brighton AG; Salford Museum; VAM.

PICKERSGILL, Henry William RA 1782-1875
Born London 3 December 1782. Adopted early in life by Mr Hall, a silk manufacturer in Spitalfields. Went to school in Poplar and aged 16 worked in the silk business. The war with France caused a decline, and so he decided to make art his career. Studied under landscape artist George Arnald 1802-5. Entered RA Schools 1805. Exhibited at RA (384), RHA (3), BI (26) 1806-72. Elected ARA 1822, RA 1826, Librarian 1856. Established a highly successful practice, and after the death of Phillips 'obtained almost a monopoly of painting the portraits of men and women of eminence in every walk in life'. Among his sitters were William Wordsworth, Michael Faraday, George Stephenson, Elizabeth Barrett Browning, Jeremy Bentham, Sir John Conroy, Richard Owen, the Duke of Wellington and Robert Vernon. Married a lady of literary talents, who published a volume of verse entitled *Tales of the Harem* 1827. Placed himself on the list of retired academicians 1872. Died extremely wealthy in Barnes 21 April 1875 aged 93, leaving effects under £40,000. Studio sale held Christie's 16 July 1875. Hart wrote: 'Pickersgill was not without some culture. He had a good memory, also some power of mimicry, and sufficient material for conversation to keep awake his male sitters'. His style shows the influence of Lawrence and he may have been his pupil. He enjoyed painting detailed landscapes as backgrounds to his sitters. Waagen wrote: 'A great liveliness of conception and a spirited and free execution have rendered this artist one of the most popular of living portrait painters in England'. A gifted and accomplished artist, his portraits are of the highest standard. His son, Henry Hall Pickersgill was also a painter. F.R.Pickersgill RA was his nephew.
Represented: NPG London; SNPG; Tate; HMQ; NGI; Arundel Castle; college halls, Oxford; Leeds CAG; Palace of Westminster; Lincoln's Inn; Longleat. **Engraved by** F.Bacon, J.Bromley, J.Brown, J.Cochran, H. & S.Cousins, T.A.Dean, J.C.Easling, C.Fox, E.Hartshorn, B.Holl, T.H.Maguire, H.Meyer, W.H.Mote, E.P.Owen, G.T.Payne, H.Robinson, H.T.Ryall, W.Say, J.Thomson, C.Turner, C.E.Wagstaff, G.R.Ward, W.Ward, H.W.Watt, W.R.Whitfield, G.Zobel.
Literature: Solomon Alexander Hart, RA, *Reminiscences*, 1882, pp.80-1; Gustav F. Waagen, *Treasures of Art in Great Britain, etc.*, 4 vols, 1854-7; Maas; DA.
Colour Plate 56

PICKETT, Miss Mary S. fl.1892-1909
Exhibited at RA (7) 1892-1909 from London and Guildford.

PICKETT, W. fl.1792-1820
Exhibited at RA (44) 1792-1820 from London.

PIDGEON, Henry Clark RI 1807-1880
Baptized London 21 April 1807, son of John Pidgeon and Elizabeth (née Clark). Originally intended for the church, but instead practised as an artist and drawing master in London. Professor of Drawing at Liverpool Institute 1847. Elected LA 1847, Secretary 1850. Returned to London 1851 and continued to take private pupils. Exhibited at NWS (258), RA (4), BI (2), SBA (15) 1839-53. Elected ANWS 1846, NWS 1861. Also an accomplished engraver and lithographer. Died a widower in University College Hospital, London 6 August 1880.

PIENEMAN, Jan Willem 1779-1853
Baptized Abcoude, near Amsterdam 4 or 7 November 1779. Began work in a factory making painted hangings. Studied at Amsterdam Academy. Became a drawing master at School of Artillery and Engineering, Amersfoort 1805-16, painting

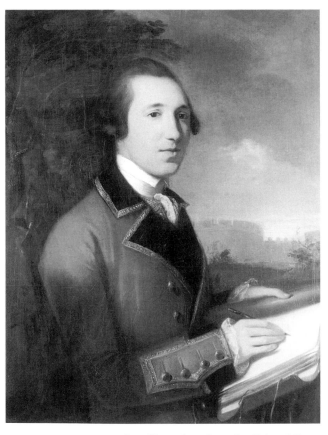

ROBERT EDGE PINE. An officer, thought to be Colonel Ross. 36 x 28ins (91.5 x 71.1cm) *Christie's*

histories, portraits and some landscapes. His work was highly regarded in court circles. First director of Royal Academy of Fine Arts, Amsterdam 1820. Visited London three times in preparation for his most famous work, 'The Battle of Quatre-Bras', 1824, staying with the Duke of Wellington. Died Amsterdam 8 April 1853. J.Israëls was his pupil and his son Nicolaas Pieneman became a successful court painter.
Represented: Rijksmuseum. **Literature:** A.van Lee, *Sketch of J.W.P.*, 1857; W.F.Rappard, *The History Painting the Battle of Quatre-Bras by J.W.P.*, 1983; DA.

PIERCE, Mrs W. see BEAUMONT, Miss Anne

PIERCY, Frederick fl.1848-1882
Exhibited at RA (12), SBA (9) 1848-82 from London and Portsmouth. Among his sitters was Sir James Dundas GCB.
Engraved by W.H.Gibbs.

PIETERS (PEETERS), Jan c.1667-1727
Reportedly born Antwerp. Studied under Eckardt. Became a portrait and drapery painter. Moved to London 1685, where he painted drapery for Kneller until c.1712. Taught George Vertue and restored old masters. Died London September 1727.

PIKE, Mrs Olive Snell d.1962
Born Durban, South Africa. Studied art under Boris Anrep and Augustus John. Exhibited at RA (3), ROI, RP, NPS, NEAC, Paris Salon from London, Petersfield and East Ashling, Sussex. Died May 1962.

PILKINGTON, H. fl. 1839-1855
Exhibited at RA, BI (8) 1839-55 from London.

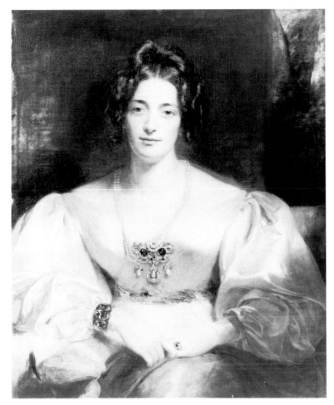

HENRY WILLIAM PICKERSGILL. Countess of Clanwilliam. Exhibited 1831. 36¼ x 28¼ins (92.1 x 71.8cm) *Christie's*

PILSBURY, Harry Clifford b.1870
Born London 9 January 1870, son of artist Wilmot Pilsbury RWS. Educated in Leicester. Exhibited at RA (16) 1902-24 from Whittlesey, Peterborough, Leicester and London. Taught art at Oundle and Wiggeston School, Leicester. Head of Whittlesey School of Art, Cambridgeshire.

PIMM, William Edwin fl.1890-1910
Exhibited RA (3), SBA (4) 1890-1910 from London.

PINE, Miss J. fl.1797-1808
Exhibited at RA (3), BI (2) 1797-1808 from London.

PINE, Robert Edge c.1730-1788
Born London, son of engraver John Pine. Established a successful portrait practice in St Martin's Lane, London. Exhibited SA (31), FS (11), RA (10) 1760-84. Won premiums for best historical painting at FS 1760 and 1763. One of the first artists to portray actors in character parts. Lived in Bath 1772-9. His outspoken support for the American cause lost him commissions and he migrated to America 1784, settling in Philadelphia, where his wife kept a drawing school. Painted a portrait of George Washington and enjoyed considerable success painting single portraits and family groups. Died suddenly of apoplexy in Philadelphia 18 November 1788. Among his pupils and assistants were Nicholas Farrer, John Hamilton Mortimer (England 1759) and Charles Wilson Peale (Philadephia). Alexander Cozens was his brother-in-law. His work was seen by Washington Alston, who said that he was much influenced by his colouring. He was fond of showing heads in three-quarter profile with one side of the face forming a graceful semicircle. The forehead follows this line, which Waterhouse described disparagingly as 'the top corner

seemingly sliced off'.
Represented: NPG London; Middlesex Hospital; Sudbury Hall, NT; Palace of Westminster. **Engraved by** F.Aliamet, J.O.Berndt, T.Bonnor, R.Cooper, W.Dickinson, J.Dixon, J.Godby, V.Green, W.Holl, R.Houston, W.Humphrey, H.Kingsbury, J.McArdell, C.Moitte, S.Okey jnr, R.Purcell, J.Rogers, J.K.Sherwin, W.Strang, C.Warren, C. & J.Watson. **Literature:** *R.E.P.* NPG Washington exh. cat. 1979; DNB;DA.

PINGRET, Edouard Henri Théophile 1788-1875
Born St Quentin 30 December 1788. Studied under David and Regnault. Exhibited at Paris Salon (winning medals), and at RA (4) 1819 from London. Died St Quentin.
Represented: Versailles. **Literature:** Bénézit; L.Ortúz Macedo, *E.P.*, 1989; DA.

PIPER, Herbert William fl.1871-1878
Exhibited at RA (4), SBA (10) 1871-8 from London.

PISA, Alberto 1864-1931
Born Ferrara in March 1864. Studied at Académie des Beaux-Arts, Florence. Exhibited at RA (8) 1892-9 from London, and in Venice, Bologna, Florence, Paris.

PISTRUCCI, Philip (Fillippo) fl.1830-1856
Son of Frederico Pistrucci, a judge of the High Court in Rome. Listed as a portrait painter in London. Resided in Chichester 1832, as the result of a severe injury caused by the overturning of his carriage. His life was saved by Dr J.McCarogher and the artist produced a lithograph of the event as a tribute. Living at 9 Temple Street, Brighton by 1856, where he advertised as a 'Professor of Italian and Portrait Painter'.
Literature: Stewart & Cutten.

PITTAR, I. (or T.) J. fl.1845-1856
Exhibited at RA (7), BI (2) 1845-56 from London and Brighton. A Thomas J.Pittar is recorded at Worthing 1879.

PITTATORE, Michel Angelo fl.1862-1872
Exhibited at RA (1) 1869 from London.
Represented: NPG London; SNPG.

PITTS, Thomas fl.1834
Exhibited at SBA (1) 1834 from Ebury Street, Pimlico, London.

PIZZETTA, U. fl.1813
Exhibited at RA (2) 1813 from London.

PLACE, Francis 1647-1728
Son of Rowland Place of Dinsdale and Catherine (née Wise). Articled to an attorney in London, but left 1665 because of the outbreak of plague. Observed his friend Wenceslaus Hollar at work. Took up residence at York. Made many drawing and angling excursions. Among the first to take up mezzotint engraving. Drew a number of portraits in crayons, including those of William Penn, Sir Ralph Cole, Bishop of Durham, Archbishop Sterne and William Lodge. Died York 21 September 1728 in his eighty-second year.
Represented: BM; Whitworth AG, Manchester; VAM. **Literature:** DNB; *F.P.*, York AG exh. cat. 1971; DA.

PLACE, George d.c.1809
Son of a Dublin linen draper. Entered Royal Dublin Society Schools 1775 under F.R.West. Practised for a time in Dublin, then London by 1791 until c.1797. Moved to York and later India, where he died. Painted in oil and miniature.
Represented: VAM.

PLASS, A.F. fl.1850
Exhibited at RA (1) 1850 from Westminster.

PLATT, Miss Emily fl.1832-1838
Exhibited at RA (5), SBA (6) 1832-8 from London.

PLATT, J. fl.1814
An honorary exhibitor at RA (1) 1814.

PLATT, Samuel fl.1803-1835
Exhibited at RA (14) 1803-35 from London.

PLATT, Samuel jnr fl.1803-1837
Exhibited at RA (8), BI (16), SBA (6) 1803-37 from London.

PLIMER, Andrew 1763-1837
Baptized Wellington, Shropshire 29 December 1763, son of clockmaker Nathaniel Plimer and his wife Eliza. Apprenticed to his father's trade, but is said to have run away and toured with gypsies. Moved to London 1781 and was employed as a manservant to Richard Cosway, who encouraged him in art. Set up as a miniaturist 1785. Exhibited at RA (39), BI (3), SBA (2) 1786-1831 from London and Cheltenham. Died Brighton 29 January 1837.
Engraved by J.Alais, M.Gauci, E.Stodart. **Literature:** Dr.G.C.Williamson, *Andrew and Nathaniel Plimer*, 1903.

PLIMPTON, Miss Constance E. (Mrs Smith)
 fl.1882-1900
Exhibited as Miss Plimpton 1882-93 and as Mrs Smith 1897-1900 at RA (23), SBA (11), NWS (2) from Lambeth, London. Collaborated with John H.Smith.

PLOSZEZYNSKI, N. fl.1850
Exhibited at RA (1) 1850 from London.

PLOTT, John FSA 1732-1803
Born Winchester. Became a clerk to an attorney and accountant. Went to London 1756. Studied under Richard Wilson and Nathaniel Hone, whose assistant he became. Exhibited at SA 1764-76 and RA 1772-1803. Moved to Winchester, where he was elected a member of the City Corporation. Died Stoke 27 October 1803.
Engraved by J.K.Sherwin.

PLOWDEN, Trevor John Chicheley 1809-1899
Painted mostly Indian subjects. A member of East India Company. Pupil of George Chinnery.

PLOWMAN, Frederick Prussia 1760-1820
Born Dublin. Entered Dublin Society Schools 1773, winning prizes 1776 and 1779. Entered RA Schools 6 October 1780 'aged 21 next Nov'. Worked in Limerick 1808. Died Marino, County Down.

PLUMMMER, H.L. fl.1837-1845
Exhibited at RA (11), SBA (3) 1837-45 from London.

POATE, Richard fl.1845-1869
Exhibited at SBA (3), BI (1) 1845-69 from Portsea and Portsmouth.

POCOCK, Henry Childe RBA 1854-1934
Born East Grinstead 2 March 1854, son of a musician. Studied under J.J.Jenkins RWS, at St Martin's School, Heatherley's and The Langham. Exhibited RA (2), ROI, SBA from 1880 from Chelsea and Battersea. Died London 18 August 1934.

POCOCK, Isaac 1782-1835
Born Bristol 2 March 1782, son of marine artist Nicholas Pocock and Ann (née Evans). Studied under Romney and Beechey. Exhibited at RA (73), BI (47), LA 1803-18 from London. Won a £100 premium at BI 1807. Served in Royal Westminster Volunteers. Author of *Miller and His Men*. An active JP for Berkshire. Inherited property at Maidenhead from his uncle 1818 and from that time concentrated on writing plays with considerable success. Died Maidenhead 23 August 1835. Buried in the family vault at Cookham.
Represented: BM; VAM. **Literature:** DNB.

PODDARD, J. fl.1847
Exhibited a portrait at RA 1847.

POGGI, Antonio fl.1769-1803
Italian painter who came to England with General Paoli c.1769. Practised portraiture in Plymouth c.1775. Married an English girl. Exhibited at RA (2) 1776-81. Visited Rome 1776 and Gibraltar 1783. Held an exhibition of fan pictures in London 1781, for which Reynolds wrote the catalogue introduction. His style was influenced by Reynolds.
Represented: SNPG. **Engraved by** F.Bartolozzi, J.Chapman, J.Hall.

POINTER, G. Henry fl.1896-1899
Exhibited at RA (4) 1896-9 from London.

POINTER, Mrs Myra b.c.1828
Born Soho. Listed as a portrait painter at 15 Bloomsbury Place, Brighton 1869-81. Aged 53 in 1881 census.

POLUNIN, Mrs Elizabeth (née Hart) NEAC b.1887
Born Ashford, Kent 21 May 1887. Studied in Paris at Colarossi's, the Lucien Simon School and École des Beaux Arts. Travelled to St Petersburg, where she studied under Leon Baskt. Exhibited at RA (11), SBA, NEAC, RP 1924-41 from London and Petersfield. Married theatrical designer Vladimir Polunin.
Represented: NPG London.

POND, Arthur FRS FSA 1701-1758
Baptized London 2 August 1701. Studied at Vanderbank Academy 1720 and in Rome c.1725-7. After a period of struggle he became one of the most fashionable portraitists in London, working in both pastel and oils. His work is difficult to distinguish from Knapton, with whom he joined in print publishing c.1730. Regarded as a great connoisseur and important art dealer. Helped a team of artists to produce *Heads of Illustrious Persons of Great Britain*, 1747-52. Elected FRS and FSA 1752. Died Rome 9 September 1758. Buried Sanderstead 15 September 1758. Among his pupils were George James and Mary Black.
Represented: NPG London; Stourhead, NT; Doddington Hall. **Engraved by** F.G.Aliamet, W.Angus, P.Audinet, Cook, J.Faber jnr, E.Fisher, S.Freeman, C.Grignion, J.McArdell, N.Parr, S.F.Ravenet, R.Rhodes, J.Wood, Wooding, R.Woodman, W.H.Worthington. **Literature:** *Gentleman's Magazine* 1758 p.452; L.Lippencott, *Selling Art in Georgian London: The Rise of A.P.*, 1983; DNB; DA.
Colour Plate 55

PONSFORD, John c.1790-1870
Born Modbury, Devon. Studied in Rome, before becoming a portrait painter in Plymouth and St John's Wood, London. Exhibited at RA (4), BI (1), SBA (5) 1823-57. Died London.
Literature: G.Pycroft, *Art in Devonshire*, Exeter 1883.

PONTY, Charles fl.1716
Worked in Worcester and Hanley 1716. Advertised in the *Worcester Postman* No.365 1716 that 'Mr Charles Ponty, Limner, gives constant attendance in his summer house in Sansomefields, Worcester, every Thursday, Friday and Saturday, and at his house at Robertsend-street in Hanley, every Monday, Tuesday and Wednesday, to draw pictures by the Life, in great or in little, and other curiosity in Painting, viz. large historical pictures for halls, staircases … He also mends and copies any picture very justly, and paints sort of dials with proper ornaments.' Painted an altarpiece for Great Malvern Church.

POOL(E), Charles fl.1820-1825
Listed in Belfast as a portrait and miniature painter.

POOL, Juriaen 1665-1745
Born Amsterdam, son of artist Juriaen Pool. Married flower painter Rachel Ruysch. Died Amsterdam 6 October 1745.
Represented: SNPG. **Literature:** Bénézit.

POOLE, Frederick Victor fl.1890-1910
Born Southampton. Studied under Fred Brown. Exhibited at RA (4) 1890-1910. Moved to Chicago.
Literature: M.Fielding, *Dictionary of American Painters.*

POOLE, G.A. 1861-1932
Nottingham portrait painter. Moved to London. Worked in America. Returned to West Bridgford, where he died.

POOLE, George Augustus 1881-1926
His portrait of Benjamin Haughton is in Portsmouth City AG.

POOLE, Paul Falconer RA RI 1807-1879
Born Bristol 28 December 1807, son of a grocer. Considered largely self-taught and painted historical subjects, genre and portraits. Worked in Southampton 1833-5, but settled in London. Became involved in a scandal, when it was thought that the artist Francis Danby had eloped to Geneva with Poole's wife, and that later Poole was living with Danby's wife. Poole married Danby's widow after the artist's death in 1861. Exhibited at RA (65), BI (13), SBA (13), NWS (4) 1830-79. Elected ARA 1846, RA 1861, RI 1878. Won a prize of £300 in the Houses of Parliament Competition 1847. Died Hampstead 22 September 1879. Studio sale held Christie's 8 May 1880. A memorial exhibition of his work was held at RA 1884.
Represented: BM; VAM; Graves AG, Sheffield; Bristol AG; Manchester CAG; Newport AG; Tate; Haworth AG, Accrington. **Literature:** *Art Journal* 1859, 1879; *Hampstead Annual* 1900 pp.9-22; DA.

POOLE, William fl.1826-1838
Exhibited at SBA (12) 1826-38 from London and Sheffield. Painted a portrait of James Montgomery, author of *The World Before the Flood.*
Engraved by W.T.Fry.

POOLEY, Thomas 1646-1722/3
Born Ipswich, son of Thomas Pooley, an attorney. First followed his father's profession and entered Gray's Inn 1664. Trained in England, but moved to Dublin c.1677. One of the earliest known portrait painters in Ireland. In January 1683 he was admitted to the freedom of the Painter-Stayners and Cutlers' Corporation of the Guild of St Luke. Probably the painter 'Pole' who appears in the Duke of Newcastle's accounts for 1689/90. Buried Dublin 13 February 1722/3.
Represented: Somerset Constabulary. **Engraved by** S.Leader. **Literature:** Strickland.

POPE, Alexander 1763-1835
Born Cork, son of Thomas Pope. Entered Dublin Society Schools 6 December 1776. Then in London under H.D.Hamilton, from whom he furthered his skill in crayon portraiture. Exhibited in Dublin and RA (60) 1777-1821. Started his distinguished career as an actor 1785. Visited Cork 1781-c.1784. Among his sitters were Sarah Siddons, Robert Walpole and Charles Kemble. Married as his third wife Clara Marie Leigh, widow of Francis Wheatley 1807. Died London 22 March 1835.
Represented: BM; Garrick Club; Royal Dublin Society. **Engraved by** A.Cardon, J.Godby, J.Martyn, E.Scriven.

POPE, Gustav fl.1852-c.1910
Exhibited at RA (45), RHA (5), BI (14), SBA (27) 1852-95 from London.
Represented: Bristol AG.

POPE-STEVENS, Thomas fl.1765-1780
Son of artist Thomas Pope. Entered Dublin Society's School 1764. Exhibited landscapes and portraits in Dublin 1765-77.
Literature: Strickland.

PORTER, Daniel fl.1888-1901
Exhibited at RA (9), SBA (8) 1888-1901 from London.

PORTER, Miss Ethel C. fl.1895-1901
Exhibited at RA (4) 1895-1901 from Balham and Chelsea.

PORTER, J. fl.1784
Exhibited at RA (1) 1784 from Titchfield, Hampshire.

PORTER, Miss Maud (Mrs Bigwood) fl.1888-1922
Exhibited at RA (30), NWS (2), RHA (1), NWG (1) 1888-1922 from London. Her sister, Ethel, was also an artist.

PORTER, Sir Robert Kerr 1777-1842
Born Durham 26 April 1777, son of a retired army officer. After his father's death the family moved to Edinburgh 1780 where he was educated. Knew Walter Scott and Flora Macdonald. Encouraged by B.West he entered RA Schools 1791 aged 13. Won Silver Palette at SA 1792. Produced some altarpieces 1793-8. Exhibited at RA (38) 1792-1805. Worked on enormous battle panoramas displayed at the Lyceum Theatre. Appointed Historical Painter to the Emperor of Russia 1804. Left Russia 1813. Knighted by the Prince Regent. Travelled to Persia 1817-20. Consul in Venezuela 1826-41. Died St Petersburg 2 or 4 May 1842.
Represented: BM; VAM; St George's Church, Esher. **Engraved by** A.Cardon, W.T.Fry, J.Godby, G.Murray, W.Ridley, W.Say. **Literature:** Hall 1982; McEwan; W.Dupouy, *Sir R.K.P.'s Caracas Diary,* 1966; DA.

PORTER, William b.1776
Entered RA Schools 1791. Exhibited at RA (18) 1788-1802 from London.

POT, Hendrick Gerritsz c.1585-1657
Probably born at Haarlem c.1585, where he lived until 1648. Moved to Amsterdam. Visited London 1632, attracted by the generosity of Charles I. Painted a small full-length of the King 1632 (Louvre), the Queen, their eldest child and a royal group (Buckingham Palace). Buried Amsterdam 1 October 1657. His style was influenced by Frans Hals. Signed 'H.P.' sometimes in monogram.
Represented: Louvre; Frans Hals Museum, Haarlem. HMQ; Rijksmuseum; Metropolitan Museum, New York; Waddesdon Manor, NT. **Literature:** DA.

POTT, Laslett John RBA 1837-1898
Born Newark. Studied under Alexander Johnson. Exhibited at RA (43), SBA 1860-97 from London. Elected RBA 1890. Died West Hampstead 1 August 1898.

POTTER, Frank Huddlestone RBA 1845-1887
Born London 15 April 1845, son of a solicitor and nephew of Cipriano Potter, a well-known composer and President of Royal Academy of Music. Entered Heatherley's and then RA Schools. Went to Antwerp, but returned to London after a few months. Exhibited RA (3), SBA (12) 1870-87 from London. Elected RBA 1879. 'A Quiet Corner' was exhibited at GG 1887 and attracted much favourable attention, but unfortunately he died London 3 May 1887 – the opening day of the exhibition. A memorial exhibition was held at SBA 1887.
Represented: Tate.

POTTER, R.S.H. fl.1812-1814
Exhibited at RA (6) 1812-14 from London.

POUVEY fl.1679
Little known portrait painter, who appears in 5th Earl of Exeter's accounts 1679 for painting portraits of 4th Earl and his wife.

POWELL, Cordall FSA fl.1768-1788
Honorary exhibitor at SA (14), RA (5) 1768-88 from London. Elected FSA 1774.

POWELL, James fl.1832-1834
Listed as a portrait painter at 9 Chapel Street, Edgware Rd, London.

POWELL, John fl.1769-1785
Entered RA Schools 3 November 1769. Became an assistant to Reynolds 1778. Exhibited at RA (6) 1778-85 from London. **Represented:** NGI.

POWELL, Joseph Rubens fl.1835-1871
Exhibited at RA (10), BI (5), SBA (17) 1835-68 from London. Also painted copies of Claude, Reynolds and Greuze for Lord Normanton.

POWELL, Martin fl.1687-d.1711/2
Provincial portrait painter at Oxford, where he died.

POWER, Miss Lucy fl.1892-1898
Exhibited at RA (3), SBA (1) 1892-8 from London.

POWLES, Lewis Charles RBA 1860-1942
Son of Rev H.C.Powles and Emily (née Cooper). Educated at Haileybury and Christ Church, Oxford. Exhibited at RA (7), SBA 1894-1925 from Rye. Died 6 July 1942.
Represented: VAM; Hull AG; Brighton AG; Eastbourne AG; Huddersfield AG; Imperial War Museum.

POWNALL, Gilbert A. fl.1908-1938
Exhibited at RA (15) 1908-38 from London and Burstall, Suffolk.

POYET, Louis b.c.1800
Born Paris. Aged 51 in 1851 census for 201 Piccadilly. Exhibited at RA (1), BI (1) 1845-8 from London.

POYNER, William Henry fl.1852-1878
Exhibited at RA (5), BI (5), SBA (4) 1852-74 from London and Mitcham.

POYNTER, Sir Edward John, Bart GCVO PRA RWS RP
1836-1919
Born Paris 20 March 1836, son of architect Ambrose Poynter and Emma, daughter of Thomas Banks RA. Visited Italy 1853, where he met and was influenced by Frederic Leighton. Returned to London and studied under Leigh, W.C.T.Dobson and at RA Schools. Entered Gleyre's atelier, Paris 1856 and mixed with Du Maurier, Lamont, Armstrong, Whistler and possibly Buckner, all of whom were to feature in Du Maurier's *Trilby*. Returned to London 1860. Exhibited at RA (177), RHA (7), RSA, BI (1), RP (2), OWS, GG, NWG 1859-1919. Among his sitters were Edward VII, the Duke and Duchess of Northumberland and Sir Frederick Eaton. Appointed Slade Professor and Director of Art at South Kensington Museum 1876-91. Elected ARA 1869, RA 1876, RP 1912, PRA 1896-1918, knighted 1896, Director NG London 1894-1906, Baronet 1902. Married Agnes Macdonald 1866, sister of Burne-Jones' wife. Died London 26 July 1919. Buried St Paul's Cathedral. Studio sale held Christie's 19 January 1920. An outstanding draughtsman. Produced works of the highest quality.
Represented: Tate; BM; VAM; Brighton AG; Birmingham CAG; Dilettante Society, London; Manchester CAG; Laing AG, Newcastle; Sydney AG, NSW; Southampton CAG; Cartwright Hall, Bradford. **Literature:** E.J.Poynter, *Ten*

Lectures on Art, 1879; VAM MSS; A.Margaux, *The Art of E.J.P*, 1905; M.Bell, *The Drawings of E.J.P*, 1905; *Magazine of Art* 1897 pp.111-20; *Windsor Magazine* 1905 pp.67-82; DA.

PRAGA, Alfred fl.1867-1949
Born Liverpool. Sent to Paris to become a doctor. He neglected his studies and spent much of his time in the Louvre. Went to Antwerp to study art and later at Heatherley's. Settled in London. Exhibited at RA (23), SM, NWS 1894-1936. His sitters included HRH Princess Henry of Battenberg, Viscountess Althorp and Rt Hon Lord Alverston, Lord Chief Justice of England. A founder of Society of Miniaturists 1895. Formed the Praga School of Miniature and Portrait Painting. Died 24/25 February 1949.

PRATT, Claude 1860-c.1935
Born Leicester, son of Birmingham artist Jonathan Pratt. Studied at Birmingham School of Art, Antwerp and Paris. Exhibited at RSBA. Also an illustrator.

PRATT, Miss Mabel fl.1915-1929
Exhibited at RA (6) 1915-29 from Leeds.

PRATT, Matthew 1734-1805
Born Philadelphia 23 September 1734, son of a goldsmith. Apprenticed to James Claypoole snr, a portraitist and house painter. Studied under Benjamin West (his cousin by marriage) in London 1764-6 (he was West's first American pupil). Exhibited a group portrait at SA 1768. Moved to Bristol. Returned to America 1768. Made a brief visit to England 1770. His best known work is 'The American School' 1765 showing West and his pupils (Metropolitan Museum, New York). Died Philadelphia 9 January 1805. His style was linear with a preference for neo-classicism.
Represented: Metropolitan Museum, New York; NPG Washington. **Literature:** W.Sawitsky, *M.P.,* Metropolitan Museum exh. cat., 1942; DA.

PRESCOTT, Charles Barrow Clarke NSA 1870-1932
Born Wilmslow, Cheshire 18 May 1870, son of John Barrow Prescott of the Manor House, Wilmslow and Lucy (née Mason). Studied at St John's Wood School, Voss's and Académie Julian, Paris. Settled in London, but travelled widely to America, Africa and the Middle East. Exhibited at RA (3), RI, ROI, RP, Paris Salon and had several one-man shows at the Fine Art Society. Died 21 October 1932.

PRESTON, E. fl.1824-1843
Exhibited at RA (17), SBA (7), NWS (1) 1824-43 from London.

PRESTON, Thomas fl.1826-1850
Exhibited at RA (9), SBA (18) 1826-50 from London.

PRICE, Miss Blackwood fl.1890
Exhibited a portrait at GG 1890.

PRICE, Julius Mendes d.1924
Exhibited at RHA (5), RA (1), SBA (4) 1885-1907 from London. Died London 29 September 1924.

PRICE, William Lake 1810-1891
Grandson of Dr Price, Chaplain to George IV and son of Sir James Lake. Articled to architect Augustus C. Pugin. Studied painting under P.De Wint. Travelled widely on the Continent. Exhibited at RA (7), SBA (2), OWS (49), NWS (5) 1828-41 from London. Elected OWS 1837 (resigned 1852). Published a manual on photography 1858 and illustrated a number of books. With Millais he was the founder of the Volunteer Movement in 1859, and designed the uniform. For some years he lived at Ramsgate, then moved to Blackheath.
Represented: BM; NGI.

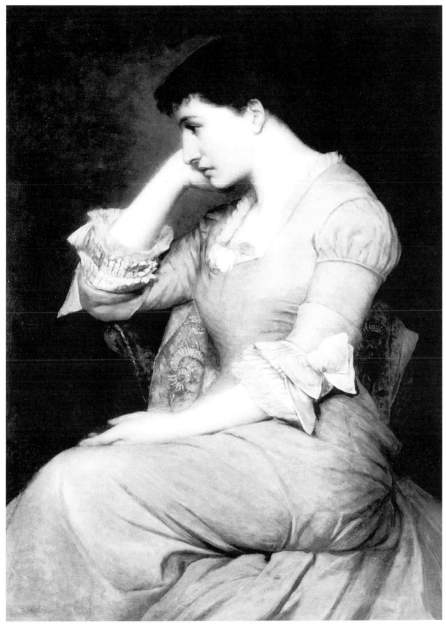

VALENTINE CAMERON PRINSEP. Lillie Langtry. Signed and dated 1879. 41 x 29ins (104.2 x 73.7cm) *Christie's*

PRIEST, Alfred RP **1874-1929**
Born Harborne 5 August 1874, son of Thomas Priest and Louisa (née Read). Studied at Cope and Nicol's Art School, RA Schools 1892-7 (winning prizes), etching under Frank Short and Académie Julian, Paris 1898. Settled in London. Exhibited at RA (22), RBSA (45), RP, RI 1898-1926. Elected RP 1916. Joined staff of the *Daily Chronicle* and did portraits for the press. Died 25 November 1929. Sometimes confused with the landscape painter Alfred Priest 1810-1850.
Represented: Sunderland AG.

PRIESTMAN, Bertram RA ROI NEAC 1868-1951
Born Bradford 30 November 1868. Moved to London 1888, studying at Slade. Exhibited at RA (210), RHA (3), NEAC, Paris Salon 1889-1951 from London, Woodbridge and Crowborough. Elected ARA 1916, RA 1923. Died 19 March 1951.

PRINGLE, John Quinton **1864-1925**
Glasgow painter of portraits, still-life and landscapes. Son of a station master at Langbank, near Glasgow. Ran an optical and general repair shop. Studied evening classes at Glasgow School of Art until 1895. A natural talent, he won a Gold Medal for life drawing in a national competition at South Kensington 1891.
Represented: Glasgow AG; Dundee AG; Tate. **Literature:** McEwan.

PRINGLE, W.J. **fl.1826-1845**
Exhibited BI (1), SBA (3), 1826-7 from London. Then worked in Stourbridge and Birmingham. Exhibited at RBSA (12) 1834-43. Recorded in Birmingham 1845.
Represented: Birmingham CAG. **Engraved by** W.Say.

PRINSEP, Valentine Cameron RA **1838-1904**
Born Calcutta 14 February 1838, son of Henry Thoby Prinsep (a civil servant) and nephew of Julia Margaret Cameron. Educated at Haileybury. Encouraged by G.F.Watts, he abandoned a career in the civil service to follow painting. First studied under Watts and met Rossetti, becoming influenced by the Pre-Raphaelites, although his

work owes its greatest debt to his friend Leighton. Assisted in the decorations of Oxford Union 1857. Travelled to Rome with Burne-Jones 1859, and the same year studied in the Paris studio of Gleyre, where Whistler, Poynter and Du Maurier were fellow students. Sat unconsciously as model for Taffy in Du Maurier's novel *Trilby*. Returned to Rome 1860-1, where he was introduced to Browning. Du Maurier introduced him to the St John's Wood Clique. Exhibited at RA (115), SBA (2), RHA (2), GG (22), NWG (4) 1862-1904. Elected ARA 1879, RA 1894, Professor of Painting 1901-3. Commissioned by Indian Government to paint 'At the Golden Gate' 1876 (exhibited 1882), depicting the historical durbar held by Lord Lytton to proclaim Queen Victoria Empress of India. After his marriage to Florence Leyland he enjoyed considerable wealth. Also wrote an account of his visit to India, two plays and two novels. Died Holland Park 11 November 1904. Buried Brompton Cemetery. **Represented:** NPG London; VAM; Walker AG, Liverpool; Manchester CAG; Tate; Aberdeen AG. **Literature:** V.C.Prinsep, *Imperial India – An Artist's Journal*, 1879; *V.P. RA, A Jubilee Painter*, South London AG exh. cat., 1977; DNB; Maas; N.Jarrah, *V.C.P.*, London University Dissertation 1983; *Windsor Magazine* XXXIX 1914 pp.613-28; DA.

PRINSEP, William 1794-1874
Pupil of George Chinnery in Calcutta. Exhibited at RA (2) 1850-6.

PRITT, Henry fl.1848
Listed as a portrait and landscape painter in Bolton Street, Preston.

PRIWIZER, Johann fl.1627-1635
Hungarian artist who was in England 1627 painting portraits of 'Lord William Russell and his Dwarf' (Woburn) and panel portraits (26 x 20in.) of all the other children of the 4th Earl of Bedford. His style is similar to that of Cornelius Johnson. **Literature:** C.Baker, *The Age of Charles I*, Tate Gallery 1972, p.30.

PROCTOR, Thomas 1753-1794
Born Settle, Yorkshire 22 April (or July) 1753. Apprenticed to a tobacconist in Manchester. Entered RA Schools 1777 (winning prizes 1782-4). Exhibited at FS (2), SA (2), RA (16) 1780-94 from London. He was a versatile artist being accomplished at portraiture, history painting and sculpture. Showed great promise, but died in poverty just as he was awarded the first Academy travelling fellowship to Rome. Buried Hampstead churchyard 13 July 1794. **Literature:** DNB.

PROCTOR, Thomas fl.1845-1853
Exhibited at RHA (9) 1845-53 from Dublin.

PROCTOR, William fl.1834-1854
Exhibited at RA (3), BI (1), SBA (6) 1834-54 from London.

PRYDE, James Ferrier 1866-1941
Born 23 London Street, Edinburgh 30 March 1866, son of David Pryde and Barbara (née Lauder). Painted a portrait of Ellen Terry as well as of six celebrated criminals. Died 24 February 1941 aged 74. **Literature:** D.Hudson, *J.P 1866-1941*, 1949.

PUGH, Ephraim fl.1800-1860
Listed as a portrait and landscape painter in Liverpool. **Engraved by** J.Chapman.

PUGHE, Miss Buddig Anwylini b.c.1857
Born Aberdovey 17 or 19 December 1857 or 1867 (conflicting sources). Studied at Liverpool School of Art, Paris and Rome. Visited France, Spain and Italy. Exhibited at RA (9), RHA (18), LA 1886-1920. Elected LA. Lived at Aberdovey.

PULLEN, John fl.1841
Listed as a portrait painter and accountant in Bradford, Yorkshire.

PURDAY, Miss Sarah T. fl.1845-1847
Exhibited at RA (2), SBA (1) 1845-7 from London.

PURDON, George b.1759
Born 25 May 1759. Studied at Burgess's Drawing Academy and RA Schools 1776. Exhibited at FS (6), SA (1) 1772-7 from London.

PURSER, Sarah Henrietta RHA c.1848-1943
Born of a prosperous Dublin family of industrialists. Educated privately in Switzerland until the collapse of her father's business plunged her into poverty. Went to Académie Julian, Paris with £30 in her bag. Formed a life-long friendship with Louise Breslau. Painted portraits in Dublin. Exhibited at RHA (165) 1872-1928. Elected ARHA 1923, RHA 1925. Managed the celebrated craft school An Túr Gloine. Died 7 August 1943 aged 95. **Represented:** NGI.

PYE, Charles jnr fl.1802-1826
Exhibited at RA (2), SBA (3) 1802-26 from London.

PYE, Thomas b.1756
Studied under Francis R.West in Dublin Society's Schools 1770-4, winning prizes. Entered RA Schools 1775. Exhibited in Dublin from 1773 and at RA (1) 1776 from Mr Dowling's, New Court, Temple Bar. Travelled to Rome, where he was recorded as a history painter 1794.

PYLE, Robert fl.1760-1766
Exhibited FS (8), SA (3) 1761-6 from London. His most ambitious work was 'Henry Keene and His Friends in the Guildhall at High Wycombe' (1760) which was destroyed by fire at Buxted Park 1940. **Engraved by** R.Brookshaw, R.Houston, J.McArdell.

PYNE, William Henry OWS 1769-1843
Born London. Studied with H.Pars and at Mr Martyr's Academy in Great Marlborough Street 1790-91. Painted a portrait of 'F.J.Jackson Esq., His Majesty's Late Minister to the United States of America'. Exhibited at RA (22), OWS (58) 1790-1811 from London. Greatly interested in publishing and between 1802-7 worked on his influential *Microcosm*, containing more than one thousand groups of rustic figures for the embellishment of landscapes. One of the most active founder members of OWS, although he resigned 1809 to concentrate on critical writing (possibly under the name of Ephraim Hardcastle). Some of his publishing schemes proved unprofitable and he spent eight years in King's Bench Debtors' Prison. Died Paddington 19 or 29 May 1843. **Represented:** BM; VAM; Leeds CAG; Newport AG; Maidstone Museum; Brighton AG; Grosvenor Museum, Chester.

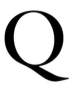

Q

QUADAL, Martin Ferdinand **1736-1808**
Born Niemtschitz, Moravia 28 October 1736. Studied in Vienna and Paris. Visited London 1772/3, staying with E.F.Cunningham. Studied at RA Schools 1772/3. Exhibited at SA (2), RA (11) 1772-93. Seems to have been in Yorkshire from 1777 and Dublin from 1779. Visited Rome and Naples 1784, Vienna 1787, Bath 1791, London 1793 and Holland 1794. From Holland he went to Russia where he became a teacher at the Academy. Died St Petersburg 2 or 11 January 1808.
Represented: SNPG; Ksthalle, Hamburg; MFA, Budapest.
Literature: DA.

QUESNEL, Pierre **fl.c.1538-1580**
French designer of tapestries and possibly painter of portraits. Taken into the service of James V of Scotland by Marie de Lorraine and was in Edinburgh 1545. Returned to Paris by 1561. Father of the French Court Portraitist, François Quesnel.
Literature: McEwan.

QUINN, James Peter **RP ROI** **c.1870-1951**
Born Melbourne 4 December 1870 or 1871 (conflicting sources), son of John Quinn. Studied at NG Melbourne (where he won a Gold Medal and travelling scholarship), Académie Julian, Paris and École des Beaux Arts. Settled in London c.1900 and became a successful society portraitist, including royalty among his sitters. Official war artist to the Australian Military Forces at the front in France 1917-18. Exhibited at RA (29), RP, ROI, Paris Salon 1904-36. Elected ROI 1908, RP 1913. Retired to Melbourne, where he died 19 February 1951.

QUINNELL, Cecil Watson **RBA RMS** **1868-1932**
Born Meerut, India 31 May 1868, son of Richard James Quinnell, a Surgeon-Colonel in the Army Medical Services. Educated in India and received his commission as Lieutenant in 3rd Battalion of East Lancashire Regiment 1888. Resigned his commission 1890, when he took up painting. Exhibited at RA (2), SBA, RMS, RI from 1897 from Bedford Park, London. Elected RBA 1894, RMS 1895. Also worked as an illustrator for *The Graphic* and other magazines. Died West London Hospital, Hammersmith 15 September 1932.

QUINTIN, Henry James **fl.1856**
Listed as a portraitist at St James's Square, Cheltenham.

QUITER, Hermann Heinrich **fl.1700-1731**
German portrait painter. His father was a Court Painter at Kassel. Believed to have studied under Maratta at Rome c.1700. In 1705 he painted the portrait of George I (Blenheim) while in Germany. Either he or his brother Magnus (1694-1744) is said to have come to London c.1709 and worked with Kneller.

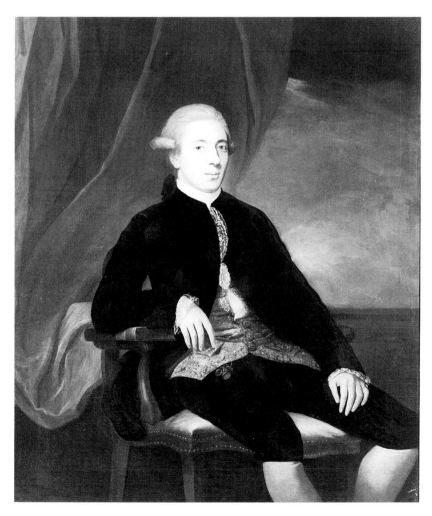

MARTIN FERDINAND QUADAL. A gentleman. Signed and dated 1778. 50 x 40ins (127 x 101.6cm) *Christie's*

R

RADCLYFFE, William **1780-1855**
Born Birmingham 20 October 1780. Studied under Joseph
Barber. Engraved for Turner, Cox and Barber. Exhibited
engravings at SS (4) and engravings and portraits at RBSA
(32) 1827-44. Died Birmingham 29 December 1855.
Literature: *Art Journal* 1856 p.72.

RADCLYFFE, William jnr RBSA **1813-1846**
Baptized Birmingham 21 January 1813, son of engraver William
Radclyffe and younger brother of landscape painter Charles
Walter Radclyffe. Exhibited at RA (2), SBA (2), RBSA 1834-45
from London. Elected RBSA 1840. Among his sitters was David
Cox. Died of paralysis in Camden Town 11 April 1846.
Represented: NPG London. **Literature:** *Art Union* 1846 p.138.

RAE, Miss Henrietta (Mrs Normand) **1859-1928**
Born London 30 December 1859. Studied from the age of 13
at Queen's Square School, Heatherley's and RA Schools
1877. Exhibited at RA (35), RHA (1), SBA, GG, NWG
1879-1919 from London. Won medals at Paris and Chicago
Universal Exhibitions. Painted a number of presentation
portraits. Married artist Ernest Normand 1884. Died London
26 March 1928. Simon writes 'Her portraits are very fine in a
painterly style not evident in much of her other work'.
Represented: Walker AG, Liverpool; Belfast Harbour
Commissioners. **Literature:** A.Fish, *H.R.*, 1906.

RAE, Miss Mary **fl.1879-1887**
Exhibited at RA (1), RSA (5), NWS (1) 1879-87 from London.

RAEBURN, Sir Henry RA **1756-1823**
Born Stockbridge, Edinburgh 4 March 1756, son of a
prosperous yarn boiler. When both his parents died, he was left
(aged six) in the care of his only brother, William, who placed
him in George Heriot's Hospital for Orphans 15 April 1765.
Apprenticed to jeweller and goldsmith James Gilliland 27 June
1772. Remained with him until at least 1778. Began to paint
miniatures in his spare time and had some instruction from
David Deuchar, a seal engraver and etcher. He had painted on
the scale of life by 1776, and came into contact with David
Martin. About 1780 he married a rich widow, Ann (née Edgar),
wife of the late James Leslie of Deanhaugh. She bought him the
property of Deanhaugh House in Stockbridge, which he retained
for the rest of his life. Moved to London April 1784, where he
spent two months as a pupil in Reynolds' studio. Visited Rome
July 1784-6, with Reynolds' encouragement and introductions
to P.Batoni, G.Hamilton and James Byres. Returned to
Edinburgh c.1786, where he quickly established a successful
portrait practice. By the time of David Martin's death 1797,
Raeburn had eclipsed him as the leading portrait painter in
Edinburgh. Briefly returned to London 1810 with a view to
succeeding Hoppner there, but was dissuaded and worked as the
leading Scottish portraitist in Edinburgh until his death.
Exhibited at RA (53) 1792-1823. Elected ARA 1812, RA 1815,
President of Associated Society of Artists 1812. Knighted 1822.
Appointed His Majesty's First Limner and Painter in Scotland
1823. A member of Imperial Florentine Academy and an
honorary member of the academies in New York 1817 and South
Carolina 1821. Died Edinburgh 8 July 1823. Robert Louis
Stevenson described him as 'a born painter of portraits. He
looked people shrewdly between the eyes, surprised their

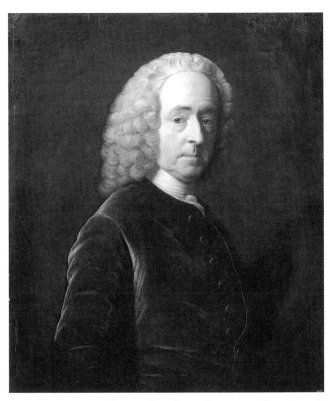

ALLAN RAMSAY. James Houghton Langston. Signed and
dated 1750. 30 x 25ins (76.2 x 63.5cm)
Fitzwilliam Museum, University of Cambridge

manners in their face, and had possessed himself of what was
essential in their character before they had been minutes in his
studio. What he was swift to perceive, he conveyed to the canvas
almost in the moment of conception'. Fond of placing the sitter
in a strong, direct light, which illuminates the head but keeps the
body and subordinate parts in shadow. Simon commented '...his
exceptional virtuosity with paint was allied to profound
understanding of effects of light; gradually eliminated his
handsome landscapes and other backgrounds, and his final
intense manner anticipates that of some later 19th century
artists'. Among his pupils and assistants were Charles Lees, John
Syme, D.Alison, Samuel MacKenzie and Andrew Robertson.
Represented: SNPG; NPG London; SNG; NG London; VAM;
NGI; Tate; Royal Company of Archers, Edinburgh; Dunfermline
Town Council; Cincinnati Museum; Mellon Collection;
Philadelphia MA; NG Washington. **Engraved by** F.Bartolozzi,
C.Bestland, J.Beugo, I.B.Bird, R.Cooper, S.Cousins, G. &
H.Dawe, S.Freeman, R.Grave, Haig & A.Birrell, J.D.Harding,
A.Hay, C.& J.Heath, N.Hirst, T.Hodgetts, W.Holl, J.Hopwood,
J.Jones, W. & D.Lizars, Massol, Maurin, H.Meyer, E.Mitchell,
C.O.Murray, G.T.Payne, C.Picart, J.Posselwhite, A.Raimbach,
A.Roffe, J.Rogers, H.T.Ryall, W.Say, G.Scharf, R.Scott,
E.Scriven, W.Sharp, G.B.Shaw, I.W.Slater, E.Stamp, R.Stewart,
J.Thomson, C.Turner, W.Walker, W.Ward, C.Watson, W.Weisse,
T.Woolnoth. **Literature:** A.Duncan, *A Tribute of Regard to the
Memory of Sir H.R.*, 1824; *Tait's Edinburgh Magazine* vol II,
no.121 January 1844 pp.15-9; R.L.Stevenson, 'Some Portraits
by R.', *Virginibus Puerisque and Other Papers*, 1881 pp.219-36;
W.R.Andrew, *Life of Sir H.R.*, 1886; W.E.Henley, *Sir H.R.: A
Selection from His Portraits Reproduced in Photogravure by T. &
R. Annan*, 1890; W.Armstrong, *Sir H.R.*, 1901; J.L.Caw, *R.*,
1909; J.Greig, *Sir H.R. RA*, 1911; D.Baxandall, *R. Bi-
Centenary*, SNG exh. cat. 1956; McEwan; F.Irwin, 'Early R. Re-
Considered', *Burlington Magazine*, CXV 1973 pp.239-44; DA.
Colour Plate 57

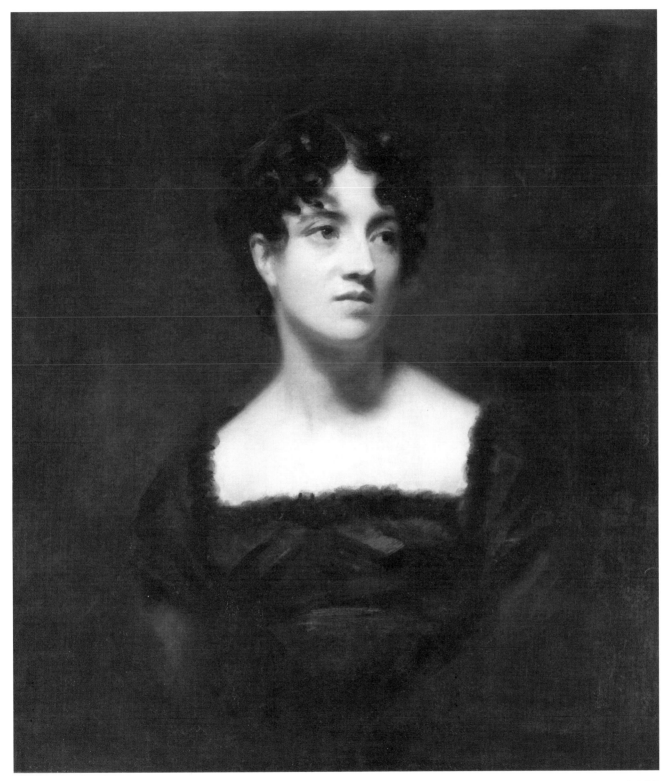

HENRY RAEBURN. Mrs Catherine Duncan (née Melville). 30 x 25ins (76.2 x 63.5cm) *Christie's*

RAIMBACH, David Wilkie 1820-1895
Born London 16 April 1820, son of miniaturist Abraham
Raimbach and godson of David Wilkie. Exhibited mostly
miniatures at RA (17), BI (1), RHA (1), SBA (6) 1843-1868
from Greenwich, London, Belfast, Limerick and
Birmingham. Worked at Belfast School of Art. Head of
Limerick School 1852. Moved to Cork 1856 and taught at
the Art School, but resigned 1857. Appointed Head of
Birmingham School of Art 1858, a post he held for 20 years.
Died Bedford Park, London (not Birmingham) 20 February
1895. His sister, Emma Harriet Raimbach, was also a painter.
Represented: VAM; BM.

RAIMBACH, Miss Emma Harriet 1810-c.1882
Born London 6 July 1810, daughter of miniaturist Abraham
Raimbach. Silver Medallist at SA 1826. Exhibited miniatures
and watercolour portraits at RA (55), RSA (15) 1835-55
from Greenwich and Hammersmith. Entered the Convent of
the Good Shepherd, Hammersmith c.1847. Later went to a
convent in Caën, where she was known as 'Sister Mary of St
Arsène'. Died Caën.
Represented: VAM. **Literature:** McEwan.

RALPH, George Keith 1752-c.1811
Born September 1752. Entered RA Schools 1775. Exhibited
at SA (11), RA (35), BI (1) 1778-1811 from London. In
1794/5 he called himself 'Portrait Painter to the Duke of
Clarence'. Practised in Bury St. Edmunds, but was probably
based in London and toured the provinces.
Represented: Guildhall, Bury St Edmunds. **Engraved by**
J.Singleton.

RAMAGE, John c.1748-1802
Native of Dublin. Entered Dublin Society Schools 1763.
After marrying early he went to America 1772. Established
himself in Boston as an artist and goldsmith 1775, and in the
same year became a second lieutenant in Royal Irish
Volunteers, a regiment formed by the Irishmen of the city.
Fought on the English side in the War of Independence. Had
a studio in New York 1780, where Washington sat for a
miniature 1789. Got into debt and moved to Montreal,
where he died 24 October 1802.
Literature: F.F.Sherman, *J.R.*, 1929; J.H.Morgan, *A Sketch
of the Life of J.R.*, 1930; DA.

RAMSAY, Allan 1713-1784
Born Edinburgh 2 October 1713, son of the Edinburgh
poet, Allan Ramsay. Started drawing portraits by 1729. First
trained at the Academy of St Luke in Edinburgh, before
studying under Hans Hysing in London 1732-3. Visited Italy
1736-8, where he studied under Imperiali in Rome, drew at
the French Academy there, and had the distinction of being
taught by Francesco Solimena in Naples. Settled in London
1738 (not yet 25) and soon became one of the most elegant
and subtle of British portrait painters. Patronized by many of
the Scottish nobility in London. He also maintained a studio
in his house in Edinburgh. Employed Joseph Van Aken as
drapery painter, and his drawings and instructions to Van
Aken (now in the SNG) show that he took considerable care
to maintain a consistently high standard. Revisited Rome in
1754-7. Painted the 'Prince of Wales' for Lord Bute 1757,
and when the Prince became George III was made King's
Painter 1761. It is often mistakenly written that he then gave
up private commissions, except for friends. However, he
received some dozen royal commissions after George III's
accession (excluding replicas of the state portraits). These
were among his finest achievements. Visited Paris 1765 and
many of his later portraits show the influence of La Tour and
Nattier. During his latter years he devoted much time to
pamphleteering and scholarship. Died Dover 10 August 1784

on his return from a fourth visit to Italy. His portraits contain
considerable charm and sensitivity, and can be of a
breathtaking quality. He ranks among the greatest of portrait
painters. The subtlety of his work has been underrated.
Horace Walpole in 1759 considered with some justification
that Ramsay and Reynolds were the two portrait painters of
the age and that Ramsay excelled with women, Reynolds with
men. Dr Johnson remarked: 'I love Ramsay. You will not find
a man in whose conversation there is more instruction, more
information, and more elegance, than in Ramsay's'. Among
his pupils and assistants were Mary Black, David Martin,
Alexander Nasmyth and Philip Reinagle.
Represented: SNPG; NPG London; Walker AG, Liverpool;
SNG; NGI; Tate; Holburne Museum and Crafts Study Centre,
Bath; Ashmolean; Fitzwilliam; Kendal AG; Stourhead, NT;
VAM; Government House, Madras; Yale. **Engraved by** D.Allan,
B.Baron, Barrett, J.Basire, F.Cary, T.Chambers, T.Cook,
R.Cromek, W.C.Edwards, J.Faber jnr, Fougeron, J.Hall,
E.Harding, R.Houston, C.H.Jeens, T.Johnson, G.King,
A.Lalauze, J.McArdell, J.McIntosh, D.Martin, H.Meyer,
R.Purcell, W.Read, W.Ridley, H.Robinson, W.Ryland,
C.Spooner, J.Thomson, C.Turner, C. & J.Watson, A.Wivell,
W.Woollett. **Literature:** I.G.Brown, 'A.R.'s Rise and
Reputation', Walpole Society Vol I 1984; I.G.Brown, 'Young
A.R. in Edinburgh', *Burlington Magazine* Vol CXXVI December
1984; I.G.Brown, *Poet and Painter: A.R., Father and Son 1684-
1784*, National Library of Scotland 1985; I.G.Brown, 'The
Pamphlets of A.R. the Younger', *The Book Collector* Vol 37 No.1
Spring 1988; J.Caw, 'A.R. – Portrait Painter 1713-84', Walpole
Society Vol XXV 1937; J.Fleming, 'A.R. and Robert Adam in
Italy', *Connoisseur* Vol CXXXVII March 1956; J.E.Holloway,
'Two Projects to Illustrate A.R.'s Treatise on Horace's Sabine
Villa', *Master Drawings* Vol 14 No.3 1976; K.Sanderson,
'Engravings after A.R.', *The Print Collector's Quarterly* Vol 18
No.2 April 1931; A.Smart, *The Life and Art of A.R.*, 1952;
A.Smart, *Painting and Drawings by A.R.*, Kenwood House exh.
cat. 1958; A.Smart, *A.R.*, RA exh. cat. 1964; A.Smart, 'A Newly
Discovered Portrait of A.R.'s Second Wife', *Apollo* Vol CXIII
May 1981; *A.R.*, NPG London exh. cat. 1992; A.Smart, *A.R.:
Painter, Essayist and Man of the Enlightenment*, 1992; DA.
Colour Plate 58

RAMSAY, James 1786-1854
Born Sheffield, son of Robert Ramsay, a carver and gilder to
whom (Sir) Francis Chantrey was apprenticed. Practised as 'a
Portrait and Miniature Painter' with his father's business
1801. First left Sheffield 1803, but only firmly settled in
London 1807. Exhibited at RA (145), BI (18), SBA (7) and
in Carlisle and Newcastle 1803-54. Moved to Newcastle
1846/7, where he enjoyed a successful practice painting
mostly northern land-owning families. Among his sitters were
James Northcote RA, Thomas Bewick and Earl Grey. Died
Newcastle 23 June 1854.
Represented: NPG London; Carlisle AG; Laing AG,
Newcastle; Hull AG; Ugbrooke Park. **Engraved by** F.Bacon,
Bouvier, W.O.Burgess, J.Burnet, C.Fox, T.Lupton, H.Meyer,
W.Say, C.Turner. **Literature:** Hall 1982; DNB.

RAND, John Foffe ANA 1801-1873
Born Bedford, New Hampshire. Began a portrait practice
c.1825. Studied under Morse. Worked in Boston 1828-9 and
New York 1833. Elected ANA 1834. Visited London 1835-
40. Exhibited at RA (1) 1840. Invented the screw-top
collapsible paint tube. Returned to New York 1840. Died in
Roslyn, Long Island.
Represented: Essex Institute, Salem, Massachusetts.
Engraved by H.Cook.

RANDS, Miss Sarah E. fl.1896-1902
Exhibited at RA (4) 1896-1902 from Newland, Northampton.

RANKEN, William fl.1685
A portrait formerly in a Scottish collection and thought to be of 'Sir John Scott, 1st Bart' was inscribed on the back 'Gu: Ranken fecit 1685'.

RANKEN, William Bruce Ellis PROI RP PS NPS **1881-1941**
Born Edinburgh 11 April 1881, son of Robert Burt Ranken (Writer to His Majesty's Signet). Studied at Eton and Slade. Exhibited at RA (22), NEAC, RSA (22), ROI (60), RP, NPS, PS, Paris Salon 1904-37 from London and Reading. Elected RP 1916. Principal works include HM Queen Mary, Princess Christian and interiors of Windsor Castle and Buckingham Palace. Won a Silver Medal at Salon des Artistes Français 1928. Died 31 March 1941. Often signed work 'W.B.E.R.' scratched into the paint.
Represented: Southampton CAG; Brighton AG; Dundee AG; Glasgow AG; Hamilton Museum. **Literature:** McEwan.

RANKLEY, Alfred **1819-1872**
Studied at RA Schools. Exhibited at RA (38), BI (4), SBA (4) 1841-71 from London. Died Kensington 7 December 1872. Buried St Marylebone Cemetery, Finchley. Studio sale held Christie's 3 February 1873.
Engraved by F.Bacon, R.Mitchell, H.T.Ryall, W.H.Simmons, J.Scott. **Literature:** DNB.

RATHBONE, Harold Steward **1858-1929**
Born Liverpool 10 May 1858, son of Philip Rathbone. Trained at Heatherley's, Slade under Legros and under Ford Madox Brown. Studied at Académie Julian, Paris under Bourguereau and Fleury, and in Italy and Florence. Exhibited at GG (6), LA, Paris Salon 1882-1920 from Liverpool. Founded Della Robbia Pottery Company, Birkenhead 1894. Retired to Port St Mary, Isle of Man, where he died 12 December 1929.
Represented: Walker AG, Liverpool; Merseyside County Museums.

RATTI, Sig fl.1842
Exhibited at RHA (7) 1842 from Dublin.

RATTRAY, John William fl.1842-1887
Listed as a portraitist at 32 Castle Terrace, Edinburgh. Exhibited RSA (42).
Literature: McEwan.

RAVERAT, Gwendolen Mary (née Darwin) RE SWE **1885-1957**
Born 26 August 1885, daughter of Sir George Darwin, Professor of Astronomy at Cambridge University and granddaughter of Charles Darwin. Studied at the Slade under Tonks, Steer and Fred Brown 1908-11. Married artist Jacques Raverat 1911. Moved to Vence in the south of France to accompany her sick husband and remained there until his death in 1925. Exhibited at NEAC, RE, Society of Wood Engravers from addresses in London and Cambridge. Elected ARE 1920, RE 1934. Illustrated several books. Died 11 February 1957. A delightful intimate portrait of John Maynard Keynes (her sister married Keynes' brother) is in the NPG London.
Literature: G.Raverat, *Period Piece*, 1952; M.Rogers, *Master Drawings from the NPG*, 1994 no.75.

RAWLINSON, James **1769-1848**
Born Derby. Studied under Romney. Exhibited at RA (1) 1798. Published an album of Derbyshire Views 1822. Visited Italy 1829. Died Matlock, Derbyshire 25 July 1848.
Represented: Derby AG. **Engraved by** W.Ward.

RAWLINSON, P. fl.1650s
Painted a portrait of Queen Henrietta Maria in the manner of Lely.

RAY, John b.1815
Portrait painter working in Sunderland.
Represented: Sunderland AG.

RAYMOND, John fl.1769-1784
Entered RA Schools 1769. Exhibited at FS (1) 1772 from London. Died 25 August 1784.

RAYNER, Miss Ann Ingram (Nancy) **1826-1855**
Daughter of artist Samuel A.Rayner. Exhibited at RA (3) 1848-54 from London. Painted 'The Eldest Sons of the Hon Lieut-Colonel Liddel' by command of HRH the Duchess of Gloucester. Died of consumption in London.
Literature: *The Rayners – A Family of Artists,* Derby AG exh. cat. 1996.

RAYNER, Miss Rhoda (Rose) **1828-1921**
Daughter of artist Samuel Rayner. Exhibited at RA (3), SBA (2) 1854-66. Travelled on the Continent including Russia in 1880. Died Orpington 12 January 1921.
Literature: *The Rayners – A Family of Artists,* Derby AG exh. cat. 1996.

REA, Cecil William ROI **1861-1935**
Born London, son of Dr William Rea, a musician. Studied in Paris and at RA Schools. Exhibited at RA (11), RHA (1), Paris Salon and in Venice 1890-1928 from London. Married sculptress Constance Halford 1907. Head of Art at London County Council School of Lithography. Died 3 December 1935.

READ, Alexander b.1752
Born March 1752. Entered RA Schools 1770. Exhibited 'A Head of Mr Ouchterlony Born in the Year 1691' at SA (1) 1770.

READ, Catherine **1723-1778**
Born Forfarshire, of a well-to-do Scottish family. Painting portraits by 1745. Moved to Paris and studied under Quentin de la Tour. Visited Rome 1751-3, where she studied under L.G.Blanchet. Settled in London 1754, where she quickly established a successful portrait practice in crayons, oils and miniature, mainly of Scottish sitters. Patronized by Queen Charlotte 1761, and became extremely fashionable. Exhibited at SA (14), FS (18), RA (4) 1760-79. Her price for single figures in 1772 was £20, which rose to £31.10s. in 1775 (when she was able to charge £157.10s. for a full-length in oils). Travelled to India 1777 with her niece Helena Beatson, and painted portraits in India. On the returning voyage she died on board ship 13 or 15 December 1778. Could be highly accomplished. Her best portraits convey considerable character. At one period her prices compared with those of Reynolds.
Represented: Dumlanrig Castle; Grimsthorpe Castle; VAM; Erddig, SNT; Inveraray Castle. **Engraved by** J.Cook, J.Finlayson, J.Hall, R.Houston, R.Purcell, J.Watson, J.Wilson.
Literature: Lady Victoria Manners, *Connoisseur* LXXXVIII December 1931 pp.376-8; LXXXIX January 1932 pp.35-40; March 1932 pp.171-8; Sir W.Foster, 'British Artists in India', Walpole Society Vol XIX pp.63-5; W.Shaw Sparrow, *Women Painters of the World*, 1905; McEwan; Greer; DA.

READ, Miss Mary fl.1849-1850
Exhibited at RA (4), BI (3) 1849-50 from London.

READ, Richard b.c.1765
Claimed to have been taught by Reynolds. Sentenced to 14 years transportation to Australia. Conducted a school in Sydney from 1813, having been granted a ticket of leave by Governor Macquarie soon after his arrival. Recorded painting in Sydney 1843.
Represented: Mitchell Library, Sydney.

READ, Thomas Buchanan **1822-1872**
Born Pennsylvania 12 March 1822. From 1841 worked in New York, Boston and Philadelphia. In 1850 he left for Europe, visiting England and Italy. Painted portraits of Robert Browning and Elizabeth Barrett Browning, and the children of Longfellow. Died New York 11 May 1872.
Represented: Peabody Institute, Baltimore; NG Washington.

READER, William **fl.1672-1700**
Born Maidstone, son of a clergyman. Studied under Soest. Lived for a time in the 'house of a nobleman' (possibly the Finch family). His earliest known portrait is dated 1672. Vertue reported that he 'was reduced and got into the charterhouse' c.1700.
Engraved by T.Beckett, J.Collins. **Literature:** DNB.

READING, Mrs E.C. **fl.1874**
Exhibited a portrait study at SBA (1) 1874.

READING, J. snr **fl.1860**
Painted a portrait of Charles Dickens, 1860.

REAY, John **1817-1902**
Practised in North Shields and Sunderland. Exhibited at North of England Society for the Promotion of Fine Arts, Newcastle and at other exhibitions in the town. Travelled with his friend William Crosby to Antwerp, where he copied old masters and took portraits.
Represented: Sunderland AG. **Literature:** Hall 1982.

REAY, William **c.1837-c.1920**
Born Gateshead. Worked in the coal mines, painting portraits and other commissions in his spare time. Emigrated to Australia, where he had a successful portrait practice. Died in Australia.

REBECCA, Biagio ARA **1735-1808**
Italian who studied at RA Schools 1769. Exhibited at RA (3) 1770-2. Elected ARA 1771. Painted portraits, but gained a reputation as a decorative painter, in which capacity he was employed at Windsor Castle. Died London 22 February 1808.
Engraved by F.Bartolozzi. **Literature:** DNB; Bénézit.

RECORD, John **fl.1768-1780**
Exhibited at SA (7), FS (2) 1768-80 from London.
Engraved by F.Jukes, S.Jones.

REDDOCK, A. **fl.1811**
His portrait of Andrew Meikle is in NPG London. Worked in Falkirk.
Literature: McEwan.

REDFORD, George **fl.1850-1885**
Exhibited at SBA (1), GG (5), RBSA (1), BI (1) 1850-85 from Worcester.

REDGATE, Sylvanus **1827-1907**
Born Nottingham, where he painted landscapes and portraits.
Represented: Castle Museum, Nottingham.

REDMAYNE, Mrs Nessy J. **fl.1894-1913**
Exhibited at RA (7) 1894-1913 from Goldsmiths' Institute, New Cross. Among her sitters was 'Agnes, Daughter of Henry Moore RA'.

REDMOND, Thomas **c.1745-1785**
Born Breconshire, son of a clergyman. Apprenticed to a house painter in Bristol. Studied at St Martin's Lane Academy. Exhibited crayons, oils and miniatures at FS (13), SA (6), RA (6) 1762-83. By 1769 he settled in Bath, where he died. Often signed 'TR' in cursive capitals. Some of his paintings are in the manner of N.Hone.
Represented: VAM.

REEVES, E.B. **fl.1843-1846**
Exhibited at RA (1), SBA (1) 1843-6 from London. Possibly the E.B.Reeve who exhibited at RHA (1) 1858 from Cork.

REID, Alexander **1747-1823**
Born Kircudbrightshire, son of John Reid of Kirkeenan. Exhibited at SA 1770. Spent some time in Paris before the Revolution. Burns sat to him January 1796. Worked in Dumfries, but on the death of his brother in 1804, he succeeded to the estate in Kirkeenan and settled there. Died unmarried at Kirkeenan.
Represented: SNPG. **Literature:** DNB.

REID, Archibald David ARSA ROI **1844-1908**
Born Aberdeen 8 June 1844, son of George Reid, manager of the Aberdeen Copper Company and brother of Sir George Reid. Studied at Robert Gordon's College, Aberdeen; RSA Schools 1867 and Académie Julian, Paris. Exhibited at RA (18), RSA (100), ROI from 1870. Elected ARSA 1892, ROI 1897. Travelled in Spain, France and Holland. Died 30 August 1908, while out walking in Wareham, Dorsetshire. Buried St Peter's Cemetery, Aberdeen.
Represented: King's College, Aberdeen; Kirkcaldy AG; Edinburgh Museum. **Literature:** DNB; McEwan.

REID, Sir George PRSA HRSW **1841-1913**
Born Aberdeen 31 October 1841, son of George Reid, manager of Aberdeen Copper Company. Apprenticed to a lithographer. Studied at Trustees' Academy, 1862, Utrecht 1866 (where he became a friend of Jozef Israels at The Hague) and eventually in Paris. Exhibited at RSA (197), RA (21), RHA (7), SBA (1) 1862-1913. Elected ARSA 1870, RSA 1877, PRSA 1891, knighted 1891. Developed a successful portrait practice and quickly established himself as Scotland's leading portrait painter with his powerful handling of paint and strong draughtsmanship. Moved from Edinburgh to Aberdeen 1884. Among his sitters were J.E.Millais, the Marchioness of Huntley and the Duke of Richmond. Retired 1902. Died Oakhill, Somerset 9 February 1913. Caw writes 'His work tells in virtue of vividness of characterisation, power of expression, and simplicity of design'. His colours are usually silvery and atmospheric and he developed a vivid and assured style. Tended to make small head studies before embarking upon large portraits.
Represented: NPG London; SNPG; Glasgow AG; Manchester CAG; Leeds CAG; Walker AG, Liverpool; Aberdeen AG; Duke of Buccleuch, Bowhill. **Engraved by** M.Klinkicht. **Literature:** B.Brown, 'Sir G.R.', *Magazine of Art* 1892, pp.196-203; McEwan.

REID, George Ogilvy RSA **1851-1928**
Born Leith. Worked for 10 years as an engraver. Exhibited at RSA (181+), RA (69) 1872-1928 from Edinburgh. Elected ARSA 1888, RSA 1898. Exhibited as George Reid 1872-83. Died Edinburgh 11 April 1928.
Represented: SNPG; Glasgow AG; Kirkcaldy AG; Edinburgh Museum. **Literature:** McEwan.

REID, James Eadie **fl.1885-1919**
Based at Whitley Bay. Practised as a portrait and all-purpose painter in Northumbria. Exhibited in Newcastle. Moved to London. Exhibited at the London Salon 1908-17, RSA (6), GI (1). Published a book on J.E.Millais, 1910.
Represented: Shipley AG, Gateshead. **Literature:** McEwan.

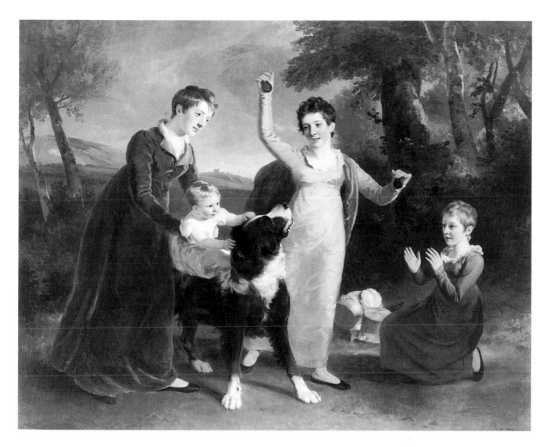

RAMSAY RICHARD REINAGLE. The Fector Children. Signed and dated 1813. 78 x 96ins (198.2 x 243.8cm)
Christie's

REID, John Robertson RBA RI ROI 1851-1926
Born Edinburgh 6 August 1851. Studied at RSA Schools under G.P.Chalmers and W.MacTaggart. Exhibited at RA (105), RSA (37), RHA (4), RI, ROI, SBA (53+) 1876-1925 from Sussex, Kent, London and Cornwall. Elected RBA 1880, RI 1897. Died 10 February 1926. His sister, Flora, was a pupil.
Represented: NPG London; VAM; Tate; Portsmouth Museum; Glasgow AG; Leicester AG; Manchester CAG; Walker AG, Liverpool. **Literature:** McEwan; *Art Journal* 1884 pp.265-8; *Connoisseur*, XXIV 1926 p.250; DA.

REID, Stephen RBA 1873-1948
Born Aberdeen 30 May 1873. Studied at Gray's School of Art, Aberdeen and at RSA Life School. Exhibited at RSA (2), RA (24), SBA (19) 1900-37. Also a prolific illustrator. Died London 7 December 1948.
Represented: NPG London; Reading; Gloucester Museums. **Literature:** McEwan.

REILLY, John Lewis fl.1857-1866
Exhibited at RA (7), BI (1), SBA (4) 1857-66 from London and Rome. Travelled to Rome 1863-4, where he painted Cardinal Antonelli.

REILY, James d.c.1780
Educated at the Blue Coat School, Oxmantown, Ireland 1745-8. Apprenticed to Samuel Dixon, for whom he coloured prints. Placed by the Dublin Society at R.West's drawing school. Set up as a miniaturist in Dublin. Exhibited at Dublin Society of Artists 1765-79.
Represented: NGI; VAM.

REINAGLE, Baron von fl.1854
Exhibited at SBA (3) 1854 from Chelsea.

REINAGLE, Philip RA 1748-1833
Born 10 February 1748 (baptized 22 March 1748 at St Mary's, Dover), son of a Hungarian musician. Apprenticed aged 14 to Allan Ramsay for seven years. Briefly entered RA Schools 28 February 1769 and then became assistant to Ramsay until Ramsay's death. At first painted portraits (often small full-lengths in the tradition of Zoffany), but also painted sporting pictures. Exhibited at RA (114), BI (135) 1773-1829. Collaborated with other artists, including John Russell. Married Jane Austin 24 July 1771 in the Parish of St Marylebone and had 11 children. Elected ARA 1787, RA 1812. Visited Norwich 1780-2 and painted conversation pieces in the manner of Walton. Also taught drawing and among his pupils were Thomas Lister, later 2nd Lord Ribblesdale, and Henry Howard RA (who married his daughter, Jane). Died Chelsea 27 November 1833. The artist B.R.Haydon considered him to be a 'nice old fellow'. His paintings contain considerable charm, skill and sensitivity. His son Richard Ramsay Reinagle and daughters Fanny and Charlotte were also artists. His painting of his children (RA 1788) is at Upton House, NT.
Represented: NGI; Gibbes AG, Charleston; BM; VAM; Hedenham Hall. **Engraved by** J.Caldwall. **Literature:** DNB; D.Sutton, 'The Reinagles Re-Considered', *Country Life* 1 December 1955 pp.1264-6; McEwan; DA.
Colour Plate 59

REINAGLE, Ramsay Richard RA POWS 1775-1862
Born London 19 March 1775, son and pupil of Philip Reinagle. Showed a precocious talent, exhibiting his first painting at RA at the age of 13. Exhibited at RA (249), BI (54), OWS (62) 1788-1857. Elected AOWS 1805, OWS 1806, POWS 1808-12, ARA 1814, RA 1823. His work was admired by Farington and Northcote. Became assistant to Hoppner and copied versions of Hoppner's portrait of Pitt, of which it is said that he painted 13 half-lengths and four full-lengths. Travelled under difficulties 1793-8 in Holland and

JOSHUA REYNOLDS. Lord de Farrars in the uniform of 15th King's Light Dragoons. Exhibited 1775. 94 x 56ins (238.8 x 142.2cm) *Christie's*

Italy (Rome, Naples and Florence). He was for a short time a close friend and mentor of Constable and stayed with Constable's family in East Bergholt 1799. That year he painted the now famous portrait of Constable in NPG London, and began 'View of Dedham Vale During the Floods in 1799', which influenced the young Constable. The artists, however, fell out over financial arrangements concerning a Ruysdael landscape that they had bought in half shares. Married Oriana Bullfinch 10 June 1801. Worked for Robert Barker, who owned the Panorama in Leicester Square. Later went into partnership with Barker's eldest son and helped to found a rival establishment – The Strand Panorama which presented panoramas in Paris. In 1816 the concern met difficulties and Reinagle lost money. Contributed an account of Allan Ramsay's life to Cunningham's *British Painters;* the letterpress for J.M.W.Turner's Sussex Views; and was credited with the anonymous *Catalogue Raisonné of the British Institution* (1815-16) which was a ferocious attack on the exhibition of old masters staged by this body in 1815 and 1816. Reinagle also won a reputation as a skilled copyist and was called upon in 1823 to restore the cartoon by Leonardo in the RA. However, in 1848 he was accused of having bought a picture by a young unknown artist,

J.W.Yarnald, and then exhibiting it at RA, selling it 'as his own'. Although he had painted on top of the work, 'so much so that one contemporary critic judged it to be a complete Reinagle' he was found guilty and forced to resign from the Academy. He was allowed, however, to continue to exhibit. Died Chelsea 17 November 1862 aged 87.
Represented: NPG London; Tate; Fitzwilliam Museum; BM; VAM; Castle Museum, Nottingham; Yale; Kedleston Hall; Wakefield AG; Maidstone Museum; Holkham Hall.
Engraved by S.Cousins, M.Gauci, J.Jenkins, F.C.Lewis, E.Scriven, C.Turner, Mrs D.Turner. **Literature:** D.Sutton, 'The Reinagles Re-Considered', *Country Life* 1 December 1955 pp.1264-6; *John Constable – Further Documents and Correspondence,* Tate Gallery 1975; Roget; B.Stewart, 'Both Sides of the Story', *Country Life* 14 November 1991 pp.62-3.

REINHART, Benjamin Franklin ANA 1829-1885
Born near Waynesburg, Pennsylvania 29 August 1829. Studied at NA 1847, Düsseldorf, Paris and Rome from 1850. Returned to New York 1853 and practised as an itinerant portrait painter. Visited England 1861, where he enjoyed some success and painted Tennyson. Returned again to New York 1868. Elected NA. Died Philadelphia 3 May 1885.

RENALDI, Francesco 1755-c.1799
Born January 1755. Entered RA Schools 1777. Exhibited at SA (1), RA (12) 1777-98. Visited Rome and Naples 1781 (where he became friendly with Thomas Jones) and India 1786-96, working in Calcutta 1786-9, Dacca and several of the outstations. Returned to London 1796 and painted 'The Artist with the Family of Thomas Jones' (RA 1798, now Cardiff AG).
Represented: India Office; Asiatic Society, Calcutta.
Engraved by L.Legoux. **Literature:** *Apollo* CIV August 1976 pp.98-105.

RENNELL, Thomas 1718-1788
Born Chudleigh. Studied under Hudson. Worked as a portrait and landscape painter in Exeter, Plymouth and Dartmouth. Died Dartmouth 19 October 1788.
Engraved by Fisher.

RENNET, C. fl.1805-1806
Exhibited at RA (2) 1805-6 from 50 Warren Street.

RENTON, John fl.1799-1839
Exhibited at RA (34), BI (10) 1799-1839 from Hoxton and Moorfields. His portraits were reproduced in the *Evangelical Magazine* and the *Methodist Magazine*.
Engraved by T.Blood, R.Dunkarton, W.T.Fry, J.Godby, T.Hodgetts, W.Holl, T.Lupton, J.Posselwhite, E.J.Roberts.

REPTON, Humphry 1752-1818
Famous landscape gardener and an amateur painter of some portraits. Born Bury St Edmunds. Moved to Ireland with Lord Northington, Lord Lieutenant 1783. Became private secretary to William Windham, Chief Secretary. Exhibited RA (15) 1787-1802. Produced a portrait of Mrs Siddons. Died Romford 24 March 1818.
Represented: VAM. **Engraved by** W.Allen. **Literature:** DNB; DA.

REVEL, John Daniel RP ROI 1884-1967
Born Dundee 2 February 1884. Studied at RCA. Exhibited at RA (16), RSA (11), RP, ROI (6) 1910-58 from London and Blewbury. Elected ROI 1923, RP 1924. Head of Chelsea School of Art 1912-24. Director of Glasgow School of Art 1925-32. Married artist Lucy Elizabeth Babington 1887-1961.
Represented: Dundee AG; Glasgow AG; Reading AG.
Literature: McEwan.

REYN, Jean de **c.1610-1678**
Born Bailleul. Studied under Van Dyck. Is said to have
accompanied his master to England, and to have stayed with
him until Van Dyck's death, but he is recorded settled at
Dunkerque 1640, a year before Van Dyck's death. Also a
history painter and painted powerful altarpieces. Died
Dunkerque 20 May 1678.
Represented: Brussels Gallery.

REYNER, Christopher **fl.1735**
A York 'face painter' who petitioned for release from prison
for debt in 1735. His son, Christopher was apprenticed to
James Carpenter of York, Painter-Stainer 1736.

REYNOLDS, Elizabeth see **WALKER, Mrs Elizabeth**

REYNOLDS, Frances **1729-1807**
Born Plympton 10 May 1729 (Redgrave) or 6 June 1729
(DNB, Bénézit), sister of Joshua Reynolds. A miniature and
portrait painter, and for a time kept house for her brother.
They did not get on and she was replaced, but given an
allowance 'much to her regret'. Wrote an essay on *Taste*. Died
unmarried in London 1 November 1807.
Engraved by C.Townley, E.Scriven. **Literature:** DNB.

REYNOLDS, Frank **d.1895**
Son of artist Samuel William Reynolds jnr. Studied at RA
Schools. Moved to Dublin 1860, where he worked for
Cranfield, a printseller and publisher. Became an established
portrait painter. Exhibited at BI (2), SBA (2), RHA (4) 1853-75.
Left Dublin c.1875 and moved to Brighton, then
Scarborough. Died Scarborough 5 November 1895.
Represented: NGI. **Literature:** Strickland.

REYNOLDS, Sir Joshua **PRA** **1723-1792**
Born Plympton, Devonshire 16 July 1723, son of Rev Samuel
Reynolds, schoolmaster in the village of Plympton.
Apprenticed to Hudson October 1740-3 and worked in
Devonshire and London 1743-9. Travelled to Italy 11 May
1749, via Algiers, Port Mahon and Minorca. Studied old
masters in Rome 1750-2 and returned via Florence, Bologna,
Parma, Mantua, Venice and Paris. Settled in London 1753 and
established himself as the leading portrait painter and master of
a new style. By 1759 he had sitters turning up at a rate of 150
a year. His portraits were fresh, modern and dignified and yet
did not look out of place alongside the old masters and classical
sculpture so fashionable with the nobility. His use of poses
borrowed from the old masters helped link his work to a great
European tradition and he was the most influential figure of
the century in elevating the social status of the native painters.
When George III established RA 1768, Reynolds was the
obvious candidate for the Presidency, and was elected 14
December 1768 and knighted 1769. Exhibited at SA (29), RA
(247) 1760-90. Elected a member of the academy at Florence
1775. In 1779 his *Discourses* were collected and published.
Toured with Philip Metcalf 1781, visiting Bruges, Ghent,
Brussels, Antwerp, The Hague, Amsterdam, Düsseldorf,
Cologne, Liège and Ostend. In 1783 he had a violent attack of
eye inflammation. Sworn as successor to Ramsay as Painter in
Ordinary to the King 1784. Went on a second tour with
Metcalf 1785, visiting Brussels, Antwerp and Ghent. His
eyesight deteriorated and after suffering two paralytic strokes,
he lost the sight of his left eye on 13 July 1789 and was nearly
blind by 1791. Died of a malignant tumour of the liver in
London 23 February 1792. Buried in St Paul's Cathedral with
great pomp. Photographs of his sitters' book are in NPG
London, with the originals at Cottonian Library, Plymouth.
Among his pupils and assistants were Giuseppe Marchi, Hugh
Barron, John Berridge, Thomas Beach, Thomas Clark(e),
Peter Toms (drapery), James Northcote, John Powell, William

JOSHUA REYNOLDS. Esther, Lady Wray. Sittings recorded
1767. 29 x 24ins (73.7 x 61cm). *Christie's*

Doughty, Daniel Gardner, William Owen, George Roth,
J.Opie, Rev G.Huddesford, George Watson, George
Engleheart, R. Dudman, Lady Bell, Charles Gill, Henry
Raeburn, Archibald Robertson and possibly Carl Frederick von
Breda and John Jukes. He experimented with paint mediums,
and some of his work deteriorated badly requiring considerable
repainting.
Represented: NG London; SNPG; NPG London; SNG; RA;
VAM; NGI; Tate; Yale; Dulwich AG; NG Washington; NMM;
Ashmolean; Wallace Collection; Wimpole, NT; Saltram, NT;
Southampton CAG. **Engraved by** G.H.Adcock, J.S.Agar,
W.P.Alais, W.Angus, P.Audinet, J.Baker, H.C.Balding,
J.K.Baldrey, A.Bannerman, F.Bartolozzi, M.Benedetti,
D.Berger, C.Bestland, J.Beugo, W.Birch, T.Blackmore,
E.Bocquet, P.Bonato, W.Bond, F.Bonnefoy, M.A.Bourlier,
Bretherton, H.Brocas, F, J.C. & W.Bromley, R.Brookshaw,
A.Cardon, C.Carter, T.Chambers, J.Chapman, T.Cheesman,
G.Clint, J.Cochran, J.Collyer, J.Conde, J.E.Coombs, H.R., J.
& T.Cook, R.Cooper, J.Corner, S.Cousins, R.H.Cromek,
H.Dawe, J & T.A.Dean, W.Dickinson, J.Dixon, G.T.Doo,
W.Doughty, R.Dunkarton, R.Earlom, W.Edwards, J.Egan,
W.H.Egleton, W.Evans, G.H.Every, E.A.Ezekiel, J.Faber jnr,
E.Finden, J.Finlayson, E.Fisher, J.Fittler, L.Flameng,
W.Flaxman, H.Fowler, S.Freeman, W.T.Fry, M.Gauci,
T.Gaugain, J.Geremia, W.Giller, S.H.Gimber, G.Graham,
B.Grainger, R.Graves, W.Greatbach, V.Green, C.Grignion,
J.Grozer, J.Haid, J.Hall, R.Hancock, E.Harding, J.Hardy,
Harris, Harwood, F.Haward, C.J.Hawthorn, J.Heath,
E.Hedouin, R.Hicks, W.Hoare, C.H.Hodges, W.Holl,
W.T.Holland, T.Holloway, J.Hopwood, R.Houston,
H.Hudson, W.F.Hulland, W.Humphrys, T.W.Hunt,
G.W.Hutin, J.R.Jackson, J.Jacobé, I.Jehner, I., J. & T.Johnson,
J.Jones, R.Josey, E.Judkins, G.Keating, B.Killingbeck, T.Kirk,
C.Kirkley, C. & T.Knight, W.Lane, J.P.Larcher, C.Lasinio,
R.Laurie, Le Coeur, P.Lightfoot, H.Linton, T.Lupton,
J.McArdell, R.W.Macbeth, G.Marchi, R.S.Marcuard, H.Meyer,

JONATHAN RICHARDSON. Edward Rolt and his sister Constantia. 75½ x 57ins (191.8 x 144.8cm) *Christie's*

E.H.Mitchell, E.Morace, J.S.Muller, J.Murphy, G.Murray, W.Nutter, S.Okey, R.Page & Son, T.Park, R.B.Parkes, J.Pass, S.Paul, C.Phillips, E.Picquenot, J.Posselwhite, J.Pott, T.Priscott, R.Purcell, W.A.Rainger, P.Rajon, S.F.Ravenet, W.Read, B.Reading, S.W.Reynolds, B.Richards, L.Richeton, W.Ridley, H.Robinson, A.Roffe, J.Rogers, P.Rothwell, Ruinyer, A., G. & H.T.Ryall, W.Ryland, N.Salway, A.N. & G.A.Sanders, J.Sarce, M.Saugrain, W.Say, J.Sayce, G.Scharf, L.Schiavonetti, J.Scott, E.Scriven, W.Sharp, G.B.Shaw, W.P.Sherlock, C. & J.K.Sherwin, G. & J.Shury, R.W.Sievier, P.Simon, A., E. & J.R.Smith, G.Spencer, Spicer, J.Spilsbury, C.Spooner, R.Stainer, Stalker & Neele, R.Stanier, C.St Aubyn, F.Sternburgh, G.Stodart, R.Thew, P.Thomas, H., J. & P.Thomson, C.Tomkins, C.Townley, T.Trotter, C.Turner, Mrs D.Turner, A.Van Assen, C.E.Wagstaff, A., J., G. & W.Walker, J. & W.Ward, C., J. & T. Watson, J. & S.Watts, T.Way, J.Webb, J.T.Wedgewood, J.Widnell, C.Wilkin, T. Williams, J. Williamson, J. Wilson, A. Wivell, W.H.Worthington, A.S.Wright, J.Young, G.Zobel. **Literature:** E.Waterhouse, *R.,* 1941; E.Hamilton, *A Catalogue Raisonné of the Engraved Works of Sir J.R. 1755-1822,* 1884; E.Waterhouse, *R.,* 1973; E.Waterhouse, 'Sir J.R.'s Sitter Book of 1755', Walpole Society XLI 1966-8; Walpole Society XLII 1970; N.Penny (ed), Reynolds, RA exh. cat. 1986 with bibliography; D.Mannings, *Catalogue Raisonné of the Works of Sir J.R.,* forthcoming; DA. Colour Plate 62

REYNOLDS, Samuel William snr. 1773-1835
Born London or West Indies (conflicting sources) 4 July 1773, son of a planter in the West Indies. An extremely accomplished mezzotint engraver who also painted portraits and landscapes. Studied at RA Schools and under W. Hodges and J.R.Smith. Attracted the patronage of Samuel Whitbread,

and through his connection with Drury Lane Theatre became friends with Sheridan and Kean. Exhibited at RA (65), BI (57), Paris Salon 1797-1827 from London. Drawing Master to the Princesses and Engraver to the King (refusing a knighthood). Died of paralysis in Bayswater 13 August 1835. Studio sale held Christie's April 1836. Among his many pupils were Samuel Cousins, David Lucas and John Lucas.
Represented: NPG London; VAM; BM. **Literature:** DNB.

REYNOLDS, Samuel William jnr 1794-1872
Born London 25 January 1794, son of artist Samuel William Reynolds. Began as private secretary to his father's patron, Samuel Whitbread. On Whitbread's death in 1815 he became a pupil of William Owen. Set up practice as a portrait painter. Exhibited at RA (39), BI (5), SBA (9) 1820-45 from London. When his father's health began to fail, he helped him with his engraving and gradually concentrated on this medium. Died Feltham Hill, Middlesex 7 July 1872. His son, Frank Reynolds, was also an artist.
Represented: Walker AG, Liverpool. **Engraved by** T.Woolnoth. **Literature:** DNB.

REYSCHOOT, Petrus Johannes van 1702-1772
Born Ghent 18 January 1702. Possibly the Reyschoot who won a prize at Paris Academy 1730. His known, signed and dated works in England range from 1736 to 1743 and show the influence of Hudson, Van Loo and Hayman. Appears to have toured the provinces, particularly in the Midlands, where his name is variously recorded as Rischoot or van Risquet. Also believed to have worked in Scotland. Died Ghent 22 or 24 February 1772.
Represented: Esslemont; Badminton. **Literature:** DA.

RHEAM, Henry Meynell RI 1859-1920
Born Birkenhead 13 January 1859. Exhibited at RA (10), RI, RBA and in Liverpool 1907-19 from Newlyn and Penzance. Died November 1920.

RHODES, John fl.1832-1843
Exhibited at RA (9), BI (4) 1832-43 from 2 Maddox Street, London.

RHODES, John Nicholas 1809-1842
Born London, son of Joseph Rhodes 1782-1854 of Leeds. Exhibited at RA (2), BI (4), SBA (2) 1839-42 from London. Painted a portrait of Baron Macaulay. Died Leeds December 1842.
Represented: Leeds CAG; Wakefield CAG. **Engraved by** L.Haghe. **Literature:** W.H.Thorp, *J.N.R.,* 1904.

RHODES, Joseph 1782-1854
Born Leeds. Listed as a portrait and landscape painter in Leeds, where he enjoyed a successful practice. Died Leeds.

RIBBING, Sophie 1835-1894
Born Semminge 6 March 1835. Studied under Gallait. Worked in Europe. Exhibited at RA (6) 1873-5 from London. Among her sitters were 'Baron Hochschild, Swedish and Norwegian Minister at the Court of St James's' and 'Baroness Hochschild'. Died Oslo 7 December 1894.

RICARD, (Louis-) Gustave 1823-1873
Born Marseilles 1 September 1823. Studied at Ecole des Beaux-Arts winning prizes, and in the studio of L.Cogniet, Paris 1843. Travelled to Italy 1844-8, Belgium, Netherlands, and finally England. Exhibited RA (1) 1871 from London. Chevalier of the Légion d'honneur 1845, but refused it. Considered a forerunner of Symbolism. Over 150 portraits have been recorded. Died Paris 24 January 1873.
Literature: DA.

RICCI, H. fl.1878

Exhibited a portrait at GG 1878.

RICHARDS, Miss Emma Gaggiotti 1825-1912

Exhibited at RA (8), BI (1) 1850-4 from London. Painted for Queen Victoria, Prince Albert and the Countess of Ossulston.
Represented: NPG London.

RICHARDSON, Mrs Alice fl.1769-1776

Exhibited crayon portraits at SA (15), RA (3) 1769-76 from London.

RICHARDSON, Harry Linley RBA 1878-1947

Born London 19 October 1878, son of artist George Richardson. Studied at Alleyn's School, Dulwich, Goldsmith's, Westminster and Académie Julian, Paris. Exhibited at RA (1), SBA, in the provinces and abroad. Elected RBA 1905. Lived in New Zealand for many years. Died 22 January 1947.
Represented: New Zealand Academy of Fine Arts, Wellington; Auckland AG.

RICHARDSON, Jonathan snr 1664/5-1745

Born London. When he was a child his father died, and he was apprenticed to a scrivener. The retirement of his master enabled him to be released before the completion of the apprenticeship and he decided to take up painting. Studied under John Riley from 1688 until Riley's death 1691. Became Riley's heir and married his niece. Most of his known works date from after 1700, and his style was half-way between Riley and Kneller. Established an extremely successful practice and owned an important collection of old master drawings (many of which were bought after his death by Hudson, then Reynolds and finally by Lawrence). Published *The Theory of Painting*, 1715 which influenced E.Burke's theories on the Sublime; and, with his son, an account of the works a tourist should see in Italy, 1722 – both works were immensely influential, inspiring Reynolds with the desire to become a painter, and providing him with a clear vision of the foundation of an English School. Helped found the 1711 Academy. Among his pupils were Jonathan Richardson jnr, George Knapton, Thomas Hudson (who married one of his daughters), Giles Hussey and John Michael Williams. His prices in 1720 were 20 guineas for a head, 40 guineas for a half-length and 70 guineas for a full-length. Retired from painting 1740. Died London 28 May 1745. Buried in the churchyard of St George the Martyr, Bloomsbury. Waterhouse writes 'His works are sound, solid, good likenesses, and unpretentious'.
Represented: NPG London; SNPG; City Estates Committee, Bristol; Manchester CAG; Society of Antiquaries; BM; College of Arms, London; Warwick Castle. **Engraved by** P.Audinet, F.Bartolozzi, Beane, C.Bretherton, J.Caldwall, R.Clamp, J.Faber jnr, E.Fisher, R.Grave, C. & J.Hall, J.Hopwood, Mackenzie, R.M.Meadows, H.Meyer, A.Miller, Page, R.Parr, W.Pether, C.Picart, Posselwhite, J.Record, W.Ridley, Rivers, J.Simon, J.Smith, J.Tookey, G.Van der Gucht, G.Vertue, C.Warren, G & R.White. **Literature:** R.Strong et al., *The British Portrait 1660-1960*, 1991; DNB; DA; G.W. Snellgrove, *The Works and Theories of J.R.*, Ph.D. thesis London 1936.

RICHARDSON, Jonathan jnr 1694-1771

Born London, son and pupil of Jonathan Richardson snr. Followed his father's profession, but was hindered by bad eyesight. Died Bloomsbury 6 June 1771 aged 77. Buried near his father in the churchyard of St George the Martyr, Bloomsbury. Published a volume snappily entitled *Richardsoniana, or Occasional Reflections on the Moral Nature of Man, suggested by various Authors, ancient and modern, and exemplified from these Authors, with several Anecdotes interspersed, by the late Jonathan Richardson jun. Esq.*
Represented: BM. **Literature:** DNB.

GEORGE RICHMOND. Edith Coleridge. Signed and dated 1850. Pencil and watercolour. 15⅜ x 12⅛ins (39.1 x 30.8cm)
Christie's

RICHARDSON, Joseph fl.1825-1841

Listed as a portrait painter in Manchester 1825-8 and Bradford 1841.

RICHES, Miss Kate Winnifred b.1891

Born London 6 March 1891, daughter of James Riches, Consul General for Siam. Studied at Clapham School of Art and City and Guilds Technical Institute, Kennington. Exhibited at RMS. Also painted portraits in oils.

RICHIR, Herman Jean Joseph b.1866

Born Brussels 4 December 1866, son of Pascal Richir, Functionary. Studied at Académie des Beaux Arts, Brussels (winning many prizes). Based mainly in Brussels. Exhibited and worked internationally and painted portraits of HM King Albert, HM Queen Elizabeth and His Eminence Cardinal Mercier.
Represented: Liverpool Museum; Budapest Museum; Brussels Museum; Barcelona Museum.

RICHMOND, George RA 1809-1896

Born Brompton 28 March 1809, son of miniaturist Thomas Richmond snr and his wife Ann (née Oram), and brother of Thomas Richmond jnr. Entered RA Schools 1824, where he formed a life-long friendship with Samuel Palmer and was impressed by Fuseli. Strongly influenced by his meeting with William Blake, and together with Palmer and Calvert formed part of the group of Blake followers called The Ancients. Present at Blake's death and had the sad privilege of closing the poet's eyes. Continued his studies in Paris 1828. Fell in love with Julia, daughter of architect C.H.Tatham. When her father revoked the consent he had first given to their union, they eloped and

THOMAS RICHMOND JNR. Two girls. Signed and dated 1846. Panel. 24 x 18ins (61 x 45.7cm) *Sotheby's*

married at Gretna Green January 1831. The loss of three children and overwork led to poor health, prompting a visit with his wife to Rome 1837-9 (accompanied by Samuel Palmer and his bride, a daughter of John Linnell) and travel in Italy and Germany. Produced portraits in miniature, watercolours, chalks and oils (oils date mostly from 1846) with considerable success, becoming one of the leading portrait painters of his day and enjoying a distinguished clientele. Exhibited at RA (196), BI (3), RHA (3), SBA (5) 1825-89. Elected ARA 1857, RA 1866. His sitters included Samuel Palmer, Charlotte Brontë, John Ruskin, Cardinal Newman, HRH the Prince of Wales and John Keble. Among his pupils were A.F.A.Sandys and Lady Ann Mary Newton. Nominated by Gladstone to succeed Sir A.W.Callcott on the Council of Government Schools of Design 1846, a post he held for three years. Gladstone also pressed upon him the directorship of NG London, but without success. Received honorary degrees from both Oxford and Cambridge. A good musician and had the dubious distinction of being one of the earliest cigarette smokers in England. Died London 19 March 1896, a few days before his eighty-seventh birthday. Left effects valued at £84,756.1s.8d. Buried Highgate Cemetery. Commemorated by a tablet designed by his sons placed in the crypt of St Paul's Cathedral, close to the graves of Wren and Leighton. Produced outstanding pictures in a variety of mediums, but it is his delightfully intimate watercolour portraits, with their richness of colour and sureness of execution, that leave perhaps the greatest impression. DNB observed: 'His ideal of portraiture was "the truth lovingly told"'.
Represented: NPG London; Tate; VAM; SNPG; SNG; NGI; Newport AG; Downing College, Cambridge; Harewood House, Leeds; Ripon College, Cuddesdon; Longleat; Lambeth Palace; Royal College of Surgeons; Birmingham CAG; Hatfield House; Yale; Fitzwilliam; BM; Cheltenham AG; Manchester CAG. **Engraved by** H.Adlard, R.A.Arlett, J.C.Armytage, T.L.Atkinson, T.O.Barlow, G.Brown, H. & S.Cousins, L.Dickinson, W.J.Edwards, J.Faed, T.Fairland, S.Freeman, M.Gauci, C., F. & W.Holl, J.R. & W.Jackson, J.Jenkins, F.Joubert, R.J.Lane, F.C.Lewis, T.Lupton, A.L.Merritt, J.D.Miller, E.Morton, W.H.Mote, Negelen, J.Posselwhite, H.Robinson, H.T.Ryall, E.Scriven, C.W.Sharpe, C.W.Sherwood, J.Thomson, C.J.Tomkins, C.E.Wagstaffe, W.Walker. **Literature:** *Art Journal* 1896 p.153; A.M.W.Stirling, *The Richmond Papers*, 1926; R.Lister, *G.R*, 1981 with a list of his portraits; DNB; Maas; DA. Colour Plate 60

RICHMOND, Thomas snr 1771-1837
Born Kew 28 March 1771, son of Thomas Richmond, groom of the stables of Duke of Gloucester and later proprietor of Coach and Horses, Kew. His mother was Ann (née Bone), a cousin of George Engelheart, under whom he studied. Entered St Martin's Lane Academy. Working in London and Portsmouth. Exhibited at RA (29) 1795-1829. Employed by the royal family to copy miniatures by R.Cosway and Engelheart. Also produced large oval portraits in watercolour. Died London 15 November 1837. Buried Paddington Churchyard. Many of his paintings are unsigned. His sons George and Thomas jnr were also painters.
Represented: Leeds CAG. **Engraved by** J.Corner.

RICHMOND, Thomas jnr 1802-1874
Born Middlesex 16 September 1802, son of miniaturist Thomas Richmond snr and elder brother of George Richmond. Entered RA Schools 25 November 1820. Visited Rome 1840, where he met Ruskin. Exhibited at RA (42), SBA (6) 1822-60. Awarded Silver Isis Medal by SA 1823. Painted a portrait of Charles Darwin. Worked in Sheffield and London. Died Windermere 13 November 1874. Buried Brompton Cemetery.
Represented: NPG London; Derby AG; Cambridge Medical Schools. **Literature:** DNB.

WILLIAM BLAKE RICHMOND. Annie Maria 'Nettie' Jameson (née Davies). 36 x 28ins (91.5 x 71.1cm) *Phillips*

RICHMOND, Sir William Blake RA 1842-1921
Born London 19 or 29 November 1842, son and pupil of George Richmond RA. Received early coaching from John Ruskin. Entered RA Schools 1858 (winning Silver Medals). Established himself as a fashionable portrait painter. After the death of his first wife in 1864 he went to Italy, where he met Leighton and Giovanni Costa, both of whom had a great influence on his art. There he painted the monumental 'Procession in Honour of Bacchus' (RA 1869). After his return from Italy he remarried and settled in Hammersmith, where he painted neo-classical scenes and portraits. Exhibited at RA (95), BI (2), RHA (1), GG (119), NWG 1861-1916. Elected ARA 1888, RA 1895. Knighted 1897. Slade Professor, Oxford 1878-83. Among his sitters were W.E.Gladstone, Bismarck, Charles Darwin and Robert Browning. Died Hammersmith 11 February 1921 (not 1874 Bénézit). Simon writes 'Surely the most successful of all Victorian portraitists in adapting the features of contemporary "high art" to fashionable portraiture and could hint at styles in vogue, e.g. japonaiserie; his touch with children was unerringly brilliant'.
Represented: NPG London; Tate; SNPG; Cortachy Castle; Leeds CAG; Inveraray Castle. **Engraved by** T.Johnson, J.D.Miller. **Literature:** H.Lascelles, 'The Life and Work of Sir W.B.R.', *Christmas Art Annual* 1902; DNB; S.Reynolds, *Sir W.B.R.*, 1995; DA.

RICHTER, Henry James OWS 1772-1857
Born Soho, 8 or 18 March 1772, son of artist and engraver John Augustus Richter and Mary (née Haig). Educated at Dr Barrow's School, Soho and Library School, St Martin's under Mr Pownall. Studied under T.Stothard. Entered RA Schools 19 November 1790. Exhibited at RA (20), BI (4), SBA (3), OWS (88) 1788-1849 from London. Visited Paris 1814. A close friend of William Blake. Also an ardent follower of Immanuel Kant. Wrote on metaphysics. Died London 8 April 1857.
Represented: BM. **Literature:** DNB; Roget.

RIDDEL, James ARSA RSW SSA 1857-1928
Born Glasgow 27 March 1857. Exhibited at RA (4), RSA (128) 1907-9 from Caerketton, Colinton, near Edinburgh. A member of Glasgow Art Club and Head of Art at Heriot Watt College, Edinburgh for 20 years. Travelled to Belgium and Canada. A James Riddel died 6 February 1928 in Aberdeenshire (will proved 28 March) but Waters lists his death as 14 March 1928. His work was greatly praised by Caw.
Represented: Glasgow AG. **Literature:** McEwan.

RIDLEY, Edward ARBSA b.1883
Born Birmingham 10 January 1883, son of William Ridley, a manufacturer. Taught at Cheltenham Ladies' College and at Central School of Arts, Birmingham. Exhibited at RBSA. Elected ARBSA 1917.

RIDLEY, Matthew White 1837-1888
Born Newcastle, son of a draughtsman. Studied at RA Schools under S.Smirke and Dobson. Spent some years in Paris, where he became the first pupil of Whistler. A friend of Fantin-Latour, who painted Ridley's portrait. Returned to London, where he founded his own art school. Exhibited at RA (19), BI (3), SBA (6), Arts Association, Newcastle 1857-88 from London. Also illustrated for Cassell's *Family Magazine* and *The Graphic*. His illustrations were said to have been admired by Van Gogh. Died Chiswick 2 June 1888. In his memory his pupils founded the Ridley Art Society. His best work is highly accomplished with good use of colour.
Represented: Tate. **Literature:** Hall 1982.

RIGAUD, Elizabeth Anne 1776-1852
Born London 30 May 1776, daughter of artist J.F.Rigaud. Exhibited at RA (8) 1797-1800. Married Joseph Meymott 1800 and appears to have given up painting. Died London 20 April 1852.

RIGAUD, John (Jean) Francis RA 1742-1810
Born Turin 18 May 1742, son of Dutilh Rigaud, a merchant. Trained variously in Italy, including Turin under Claudio Francesco Beaumont. A member of Bologna Academy 1766. Met Barry in Rome and moved with him to London 1771, where he was encouraged by Nollekens. Exhibited at RA (155), BI (22) 1772-1810 from London. Elected ARA 1772, RA 1784. Painted a number of portraits at the low price of 5 guineas a head. His portraits of Bartolozzi, Carlini and Cipriani ('Three Italian Artists') were engraved by J.R.Smith and a companion picture 'Three English Artists', depicting Reynolds, Sir William Chambers and Joseph Wilton is in NPG London. Painted a number of decorative works and small pictures for Boydell's Shakespeare Gallery. He was capable of painting large complex group portraits, with great attention to detail. Appointed a member of RA, Stockholm and historical painter to Gustavus IV, King of Sweden. Died suddenly at Packington Hall 6 December 1810 and was buried there.
Represented: NPG London; NMM; Guildhall AG, London; Yale. **Engraved by** F.Bartolozzi, M.Benedetti, R.Earlom, J.K.Sherwin, J.R.Smith. **Literature:** DNB; Walpole Society I 1984 pp.1-164; DA.

RIGAUD, Stephen Francis Dutilh 1777-1861
Born London 26 December 1777, son of artist J.F.Rigaud. Entered RA Schools 17 March 1792 (Gold Medallist 1801). Awarded by SA a Silver Palette 1794 and Gold Palette 1799. Assisted his father with decorative paintings at Packington, Windsor Castle and elsewhere. Exhibited at RA (38), BI (23), SBA (7), OWS 1797-1852 from London. Founder OWS 1804, retired 1812. Sketching tour of Kent with R.Nixon and J.M.W.Turner 1798. Died Shacklewell Green, Middlesex 4 January 1861 (DNB incorrectly says 1862). Buried Abney Park Cemetery.
Represented: BM; VAM; National Museum of Wales. **Engraved by** Thornthwaite. **Literature:** Petworth Archives November-December 1836; DNB.

RIKARDS, Samuel FSA c.1735-1823
Exhibited at SA (14), FS (1), RA (2) 1768-77 from London. Elected FSA 1771, Director 1775/6. Spent the last years of his life in Alfreton, Derbyshire, where he died 12 March 1823 aged 88. Buried Alfreton churchyard.
Represented: VAM.

RILEY, John 1646-1691
Born London, where his father was Lancaster Herald. Studied under Isaac Fuller and Gerard Soest. Reportedly had a good practice among the middle classes before Lely's death, but most of his known works are later and he did not join the Painter-Stainers' Company until 1682. In December 1688 he and Kneller were jointly 'sworn and admitted chief painter' to the King. From c.1688 he would frequently paint the heads and John Closterman the draperies. Died London 27 March 1691. His name has been spelled Royley, Ryland and Rowley. Among his pupils and assistants were J.B.Gaspars, J.Richardson, A.Russel, Thomas Murray and Edward Gouge. He was an outstanding portraitist whose reputation has suffered because of some substandard studio production.
Represented: NPG London; SNPG; HMQ; NGI; Tate; Ashmolean; Christ Church, Oxford; Marquess of Tavistock; Dulwich AG. **Engraved by** G.Adcock, I.Beckett, T.Bragg, J.Caldwall, W.Clarke, R.Dunkarton, W.T.Fry, J.Rogers, J.Smith, P.Van Gunst, F.H.Van Hove, J.Watson, R.White, R.Williams. Colour Plate 61

RIMER, William 1825-1892
Born Westminster. Aged 46 in 1871 census. Exhibited at RA (6), BI (6), SBA (12) 1846-88 from London. Died London 8 June 1892.

RINTOUL, Alexander Nelson fl.1832-1834
Listed as a portrait and miniature painter in London 1832-4.

RIPPINGILLE, Alexander Villiers fl.1815-1843
Brother of Edward Rippingille. Exhibited at RA (1), RHA (5), SBA (5) 1824-43 from Clifton, Bristol and London.
Represented: Walker AG, Liverpool. **Engraved by** M.Gauci.

RIPPINGILLE, Edward Villiers 1798-1859
Born King's Lynn, son of a farmer. Exhibited at Norwich Society and RA (41) 1813-57 from London, Bristol and France. Worked with Edward Bird and was a close friend of Francis Danby. Married Jane Turner 1815. Visited Italy 1837 and again 1841. Knew the poet John Clare, who described him as 'a man of genius as a painter'. Died suddenly at Swan Village Railway Station, Staffordshire 22 April 1859.
Represented: VAM; Tate; Bristol AG; Clevedon Court, NT; Leeds CAG. **Literature:** F.Greenacre, *The Bristol School of Artists*, Bristol AG exh. cat. 1973; DA.

RIPPINGILLE, Thornton fl.1855
Listed as a portraitist at 39 Princes Street, Manchester.

RISING, John 1753-1817
Born June 1753. Entered RA Schools 31 December 1778. Exhibited at SA (13), RA (91), BI (12) 1785-1815 from London. Is said to have been friendly with Reynolds and to have studied under him in the 1780s. Later specialized in copying and restoring his works. Died London March 1817. His pictures often show the influence of Reynolds, Romney and Hoppner and can be extremely accomplished.
Represented: Wilberforce House, Hull; NMM; Stourhead, NT. **Engraved by** C.H.Hodges, J.Young.

RITCHIE, Alexander Hay NA 1822-1895
Born Glasgow 14 January 1822. Studied in Edinburgh under Sir William Allan. Moved to America 1841. Worked for a few years in Canada. Settled in New York 1847. Exhibited at NA. Elected NA 1871. Also an engraver. Died New Haven 19 September 1895.

RITCHIE, Charles E. fl.1905-1918
Tasmanian portrait painter who exhibited portraits and miniatures at RA (17) 1905-18 from St John's Wood. Returned to Tasmania after 1st World War.
Represented: Windsor Castle.

RITTS (RITZ), Valentine d.1745
Painted portraits, still-life and copies. Lived in Cambridge for some 50 years and died there.

RIVIERE, Briton RA RE 1840-1920
Born London 14 August 1840, son of artist William Riviere and Ann (née Jarvis). Educated at Cheltenham College and St Mary Hall, Oxford. Studied under J.Pettie and Orchardson. Exhibited at RA (142), RHA (3), BI, SBA, GG 1858-1920. Elected ARA 1878, RA 1881. Narrowly missed PRA 1896. Worked in Cheltenham, Oxford and Keston, but settled in London 1871. He is famous for his animal paintings, but also painted presentation portraits, often with the sitter's favourite animal. These are usually painted with brisk confidence, reminiscent of Orchardson and are of a high standard. Died London 20 April 1920.
Represented: NPG London; BM; Birmingham CAG; Tate; VAM; Blackburn AG; Brighton AG; Manchester CAG.
Literature: *Art Journal* 1891 p.32; *Connoisseur* LVII 1920; DA.

RIVIERE, Daniel Valentine c.1780-1854
Reported born 1780, but a Daniel Riviere entered RA Schools 5 November 1796 as an engraver, when his age was given as 19 or 20. Gold Medallist at RA. Exhibited portraits and miniatures at RA (13), RHA (1) 1823-53 from London. A drawing master of considerable celebrity. Married Henrietta Thunder 1800 and his children Henry Parsons Riviere, William and Miss F.Riviere were all painters.

RIVIERE, Henry Parsons NWS AOWS 1811-1888
Born London 16 August 1811 (baptized St Marylebone, London 8 September 1811), son of portrait painter Daniel Valentine Riviere. Entered RA Schools 14 June 1830. Exhibited at RA (6), RHA (4), BI (7), SBA (19), OWS (299), NWS (101) 1832-85 from London and Rome (where he spent many years). Elected NWS 1834, AOWS 1854. Died St John's Wood 9 May 1888.
Represented: VAM; Williamson AG, Birkenhead.
Literature: DNB.

RIVIERE, Hugh Goldwin RP 1869-1956
Born Bromley 1 January 1869, son of Briton Riviere. Educated at St Andrews University. Studied at RA Schools. Established a successful society portrait practice. Exhibited at RA (90), RHA (1), RP, in Paris 1893-1938 from London and Midhurst. Elected RP 1900. Died 14 January 1956.
Represented: NPG London.

RIVIERE, William 1806-1876
Born London 22 October 1806 (baptized Marylebone 15 November 1806), son of Daniel Valentine Riviere. Entered RA Schools 23 December 1824. Exhibited at RA (20), BI (17), SBA (7) 1826-60. Drawing master at Cheltenham College 1849-59. Then settled in Oxford. Died Oxford 21 or 29 August 1876.

ROBART, V. or N. fl.1849-1851
Exhibited at RA (2) 1849-51 from Paris and London. His name was also spelt Robert.

ELLIS WILLIAM ROBERTS. Rt Hon Arthur Balfour. Signed and dated 1892. Pastel. 18½ x 13¼ins (47 x 33.6cm)
Christopher Wood Gallery, London

ROBERTS, Miss Alice fl.1777
Exhibited at SA (1) 1777 from Westminster.

ROBERTS, Cyril RBA PS 1871-1949
Born Uxbridge 25 September 1871, son of Charles Roberts MRCS. Studied at South Kensington, Slade and in Paris. Exhibited at RA (14), NPS, in the provinces and Paris Salon 1910-46 from London and Langley. Died 7 March 1949.
Represented: NPG London.

ROBERTS, Ellis William RP 1860-1930
Born Burslem, Staffordshire 27 October 1860, son of a pottery manager. Studied at Wedgwood Institute, Burslem, Minton Memorial Art School, RCA 1882-3 and Académie Julian, Paris 1887-8 (under Bouguereau and Robert Fleury). Elected RP 1893. Worked in crayon and oil and specialized in portraits of London society women, often large full-lengths in the French academic manner. Exhibited at RA (16) 1886-1902 from London. Died at Queen's Hotel, Brighton 24 September 1930.
Represented: Badminton; Arundel; Bowhill.

ROBERTS, James b.1753
Born Westminster, son of James Roberts, a landscape engraver. Won a premium at SA 1766. Entered RA Schools 14 March 1771 'aged 18, May 7th next'. Exhibited at RA (30) 1773-99 from Westminster. Produced on vellum an extensive series of small portraits of actors for Bell's *British Theatre* 1775-81. Practised as a drawing master in Oxford 1784-94. Used the title Portrait Painter to the Duke of Clarence 1784. *Published Introductory lessons . . . in water-colours*, 1809.
Represented: BM; Garrick Club. **Engraved by** P.Audinet,

Balston, R.Clamp, J.Collyer, Cooke, R.H.Cromek, J.Edwards, J.Fittler, H.Gardner, R.Godfrey, C.Grignion, J.Jones, W.Leney, R.Page, Pegg, R.Pollard, B.Reading, Ridley & Holl, E.Scott, J.Thornthwaite, C.Tomkins, W.Walker, Wilson. **Literature:** DNB.

ROBERTS, James　　　　　　　　　**b.c.1792**
Born St James's. Listed as a portrait painter at High Street, Nottingham 1841 and London 1861.

ROBERTS, Miss Louisa　　　　　**fl.1851-1869**
Exhibited at RA (2), SBA (8) 1851-69 from London.

ROBERTS, Thomas Edward　RBA　**1820-1901**
Began as an engraver, but took up painting as a profession 1845. Exhibited at RA (12), SBA (129) 1850-93 from London. Elected RBA 1855. His 'The Opening of the First Parliament of the Australian Commonwealth by HRH the Prince of Wales on 9 May 1901' was exhibited posthumously at RA 1904 by command of the King.
Literature: Ottley.

ROBERTSON, Andrew　MA HRHA　**1777-1845**
Born Aberdeen 14 October 1777, son of architect William Robertson. Studied under A.Nasmyth and H.Raeburn. Taught drawing, portraiture and miniature painting. Took his MA at Aberdeen 1794. Entered RA Schools 23 October 1801. Exhibited at RA (260), BI (4), OWS, RHA (23) 1802-42 from London. Enjoyed a highly successful miniature practice. Among his sitters were Thomas Lawrence, Benjamin West, John Trumbull and the Prince Regent. Invited to Windsor Castle to paint the four princesses (exh. RA 1808) and the Prince of Wales. An officer in the Volunteer Corps during the threat of a Napoleonic invasion. Visited Aberdeen 1803 and 1808, Paris 1814. Appointed miniature painter to Duke of Sussex 1805. Died Hampstead 6 December 1845. Among his pupils were F.Cruickshank and Sir W.Ross. Archibald Robertson was his brother.
Represented: VAM; SNPG; NPG London; Aberdeen AG; Ashmolean; HMQ. **Literature:** E.Robertson, *Letters and Papers of A.R.,* 1895; DA.

ROBERTSON, Archibald　　　　　**1765-1835**
Born Monymusk 8 May 1765, son of William Robertson and Jean (née Ross). Educated at Aberdeen. Received instruction from a deaf-and-dumb artist. Reportedly entered RA Schools 1786 under Reynolds and B.West. Set up as a miniature painter. Exhibited at RA (10) 1772-96. Travelled to America with an introduction from the Earl of Buchan to George Washington, who he painted in oil and in miniature. Settled in New York, where he met with considerable success. He was joined by his brother Alexander and they began a school known as the Columbian Academy, New York. Died New York 6 December 1835. Andrew Robertson was his brother.
Represented: Smithsonian Institution, Washington; Metropolitan Museum, New York; Sulgrave Manor, Northampton; Philadelphia MA. **Literature:** DNB; McEwan.

ROBERTSON, Mrs Charles Kay (Jane)　**fl.1892-1931**
Exhibited portraits and miniatures at RA (22), RSA (1) 1892-1931 from Edinburgh, Carshalton and London.

ROBERTSON, Mrs Christina (née Sanders)　HRSA
　　　　　　　　　　　　　　　　1775-1856
Born Edinburgh. Niece of coach painter George Sanders. Married artist James Robertson 1823. Exhibited miniatures and oil portraits at RA (129), BI (6), SBA (45), RSA (11) 1823-49. Elected HRSA 1829. Travelled to St Petersburg and painted portraits of the Tsar and Tsarina 1843. A member of the Imperial Academy, St Petersburg. Returned to England 1844. Often signed with initials 'C.R.'. The *Art Union* 1839 commented: 'One of the best portraits in the gallery is this picture by Mrs Robertson. An artist of the highest talent, who is always graceful and effective in arranging a picture; and whose powers of execution are of a "masterly order". The term "masterly" will cease to be used as denoting the highest merit, if many women paint with as much thought, skill and vigour as Mrs Robertson'.
Represented: Museum of Decorative Arts, Paris. **Engraved by** J.Posselwhite. **Literature:** McEwan.

ROBERTSON, Clementina　see SIREE, Mrs Clementina

ROBERTSON, David Thomas　　　**1879-1952**
Born Darlington of Scottish parents, but moved to Sunderland as a child and remained based there for the rest of his life. Exhibited in Northumbria.
Represented: Laing AG, Newcastle; Shipley AG, Gateshead; Sunderland AG; South Shields Museum & AG. **Literature:** Hall 1982.

ROBERTSON, Eric Harold Macbeth　**1887-1941**
Born Dumfries 13 February 1887, son of Alexander Robertson. Studied at Edinburgh College of Art. Married Cecile Walton 1914. Exhibited at RA (3), RSA (47) and in the provinces from Liverpool. Died Cheshire 29 April 1941.
Represented: Sheffield AG; Glasgow AG; Edinburgh Museum. **Literature:** J.Kempley, *E.R.,* Edinburgh exh. cat. 1974; J.Kempley, *The Two Companions,* 1991; McEwan.

ROBERTSON, George　　　　　　**1748-1788**
Born London. Studied at Shipley's Drawing School and in Rome. Accompanied William Beckford to Jamaica. Vice-President of Incorporated Society. Worked as a successful drawing master in London. Painted a variety of subjects, including portraits in the manner of Downman. Died 26 November 1788.
Represented: BM; VAM; Ashmolean; Cecil Higgins AG, Bedford.

ROBERTSON, George Edward　　　**b.1864**
Born Chelsea, son and pupil of artist William Robertson. Studied at St Martin's School of Art (winning prizes). Exhibited at RA (6) and in Liverpool.
Represented: Hartlepool AG.

ROBERTSON, George J.　　　　**fl.1831-1836**
Born Scotland. Studied at RA Schools. Exhibited at RA (3) 1831-6 from London and Beaminster, Dorset. Moved to Cleveland, Ohio by September 1845. Worked in Milwaukee and Rockford.

ROBERTSON, Henry Robert　RE RMS　**1839-1921**
Born Windsor. Studied at RA Schools. Exhibited at RA (62), RHA (1), RI (8), SBA (4), NWS, RMS (36), GG 1861-1918 from London. Published a number of books on art and plants. Died 9 Eastern Terrace, Brighton (not London) 6 June 1921 aged 82.
Represented: Sheffield AG.

ROBERTSON, James　　　　**c.1810-after 1881**
Exhibited at RA (6) 1824-5 from London. Listed as a portrait painter there 1832-4. Married artist Christina Sanders. Took up photography. In Malta 1850, Turkey 1857. Probably died India.
Literature: McEwan; DA.

ROBERTSON, Miss Janet S. RMS b.1880
Born London 12 August 1880, daughter of H.R.Robertson. Studied at RCA. Exhibited at RA (40), RMS, NPS 1903-27 from London. Gained a reputation for children's portraits.

ROBERTSON, John Ewart 1820-1879
Born Kelso. Trained Edinburgh. Working in Liverpool by 1847. Exhibited at RSA, RA (13), BI (4), LA 1838-67 from Kelso, Liverpool and London. Elected ALA 1848, LA 1850, Treasurer 1854-67. Among his sitters was the Duchess of Roxburgh. Died in a mental asylum. A gifted and sensitive artist. Influenced by the Pre-Raphaelites. Fond of portraying his sitters with strong lighting effects.
Represented: Walker AG, Liverpool; Edinburgh Museum; Manchester CAG. **Literature:** McEwan.

ROBERTSON, Sir Johnston Forbes- 1853-1937
Born London 16 January 1853, son of John Forbes-Robertson, art critic and journalist. Studied at Charterhouse, Rouen and RA Schools. Exhibited at RA (8), GG (12), NWG (1) 1874-88 from Barnsbury and London. Specialized in portraits of actors in character. Among his sitters were Ellen Terry and 'Mrs Rousby in the Character of Marie Stuart'. Also a distinguished actor, he studied under Phelps. Died London 6 November 1937. His work could rise to an extremely high standard with sensitive characterization.
Represented: NPG London; NGI; Garrick Club.

ROBERTSON, Thomas S. 1850-1923
Born Glasgow 25 June 1850. Studied in Paris under Constant. Painted portraits, landscapes and marines.
Represented: Glasgow AG.

ROBERTSON, W. fl.1820-1823
Exhibited at RA (4) 1820-3 from 2 Dowgate Hill and 37 Edmund Street, Battle Bridge.

ROBERTSON, Walford Graham RP RBA ROI
1867-1948
Born London 8 July 1867. Studied at South Kensington under Albert Moore. Exhibited at RA (1), NEAC, ROI, RP, NWG (12) from 1896. Elected RP 1912. Also an illustrator and wrote books and plays. The subject of one of J.S.Sargent's finest portraits (Tate). Published autobiography *Time Was*, 1931. Died 4 September 1948.
Represented: NPG London; Southampton CAG. **Literature:** Maas.

ROBERTSON, William fl.1727-1783
Active in Edinburgh between 1727 (when he signed and dated a portrait of his future father-in-law, Charles Stuart) and 1783 (when he is recorded as living in Old Playhouse Close). Signed the Charter establishing Edinburgh Academy of St Luke 1729. Named a debtor seeking refuge in the Abbey Sanctuary 1753. Sometimes signed 'W.Robertson ad vivum pinxit.' and occasionally as 'Robinson'. His works are pleasantly naïve and Waterhouse describes him with justification as 'a sort of Jacobean Devis'.

ROBERTSON, William 1799-1839
Listed as a portrait painter in London.
Represented: SNPG.

ROBINEAU, Auguste fl.1785-1816
Son of French artist Charles Jean Robineau. Exhibited at RA (7) 1785-8 from London and at Paris Salon 1791-9. Believed to have been in Paris 1816.

ROBINEAU, Charles Jean d.1787
French artist and musician. Painted small full-lengths of the musician C.F.Abel and the future Prince Regent.
Represented: HMQ.

ROBINS, Mrs A. fl.1879
Exhibited at RA (1) 1879 from St John's Wood.

ROBINS, Miss J.E. fl.1861-1863
Exhibited at RA (3) 1861-3 from London. Among her exhibited portraits were 'HH the Late Prince Feroke Buckt, great-grandson of Tippoo Saib' and 'Henri, Son of Baron von Doorn de Westcapelle'.

ROBINSON, Miss Annie Louisa
see SWYNNERTON, Mrs Annie Louisa

ROBINSON, George Crosland 1858-1930
Born near Huddersfield. Studied art in Berlin, Paris and Italy. Exhibited at RA (11), RHA (2), SBA 1882-1925 from Paris and London. Visited South Africa 1885, and was caught up in the gold rush in Swaziland and Rhodesia. Served in the Matabele War 1896 under Colonel Johann Colenbrander. Married artist Constance Penstone. Became Principal of Cape Town Art School. Painted many successful portraits, including Cecil John Rhodes and President Kruger. Died 19 March 1930.
Literature: E.Rosenthal, *Dictionary of South African Biography*, 1966.

ROBINSON, Hugh 1756-1790
Born Malton September 1756. Entered RA Schools 1779. Exhibited at RA (3) 1780-2. Left for Italy 1783. He started to come home by horse 1790, but died on the road. Most of his Italian works were lost at sea. Capable of unusual and original compositions.
Represented: Teesdale family collection. **Engraved by** F.Atkinson. **Literature:** *The Athenaeum* 12 March 1881.

ROBINSON, Isaac d.1772
The death of Isaac Robinson, 'portrait painter' was recorded in *The Gentleman's Magazine* 10 August 1772.

ROBINSON, J.E.H. fl.1805-1841
Exhibited at RA (47), BI (12), SBA (11) 1805-41 from London.

ROBINSON, J.S. fl.1789
Exhibited at RA (1) 1789 from London.

ROBINSON, John c.1715-1745
Born Bath. Apprenticed to Vanderbank 23 June 1737 for five years, but Vanderbank died 1739. Set up a successful portrait practice on his own and having married a wife with a fortune took the late Jervas' house and studio in London. Prevented by Hudson and Davison from employing Van Aken. Often dressed his sitters in Van Dyck costume. Died London, before he completed his thirtieth year.
Represented: Althorp. **Engraved by** John Faber jnr, T.Major. **Literature:** DNB.

ROBINSON, Thomas d.1734
Portrait painter, who went blind in later years. His daughter was singer Anastasia Robinson, who eventually married 3rd Earl of Peterborough. Died London 11 December 1734.

ROBINSON, Thomas, of Windermere d.1810
Born Windermere. Became a pupil of G.Romney c.1784/5 on the recommendation of John Christian Curwen MP. Specialized in large portrait histories. Worked in Dublin 1790 (where he charged 20 guineas for a full-length, 10 guineas for a half-length and 4 guineas for a head), Lawrencetown 1793, Lisburn 1798 (where he charged 7 guineas for a kit-kat and 12 guineas for a half-length), Belfast 1801-8 and then Dublin again. Died Dublin 27 July 1810. *The Gentleman's Magazine*

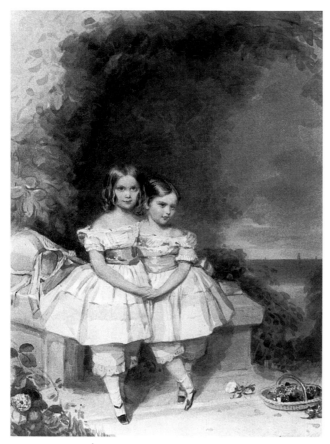

FRANÇOIS THÉODORE ROCHARD. The days of innocence.
Signed and dated 1844. Watercolour. 14 x 11ins (35.6 x 28cm)
Taylors, Honiton Galleries, Devon

September 1810 described his work as displaying 'a great skill and taste'.
Represented: Abbott Hall AG, Kendal; Ulster Museum; NGI; Castle Ward, NT; St Louis CAG, Missouri. **Literature:** Hall 1979; Strickland; *Belfast Newsletter* 13 November 1798.

ROBINSON, Walford Graham RBA ROI b.1867
Born London 8 July 1867, son of Graham Moore Robinson. Educated at Eton. Studied at South Kensington Schools and under Albert Moore. Exhibited at NWG, GG, NEAC, ROI, SBA from Kensington. Also a book illustrator, playwright and costume designer. Usually signed works 'G.R.'

ROBINSON, William 1799-1839
Born Leeds. Apprenticed to a clock dial enameller. Studied under landscape painter Rhodes in Leeds. Moved to London 1820, where Lawrence took him as a pupil without remuneration, and he continued his studies at RA Schools under Fuseli. Returned to Leeds about 1823-4, where he enjoyed a successful portrait practice. Exhibited mostly portraits in the Lawrence manner at RA (19), SBA (3) 1822-39. Attracted the patronage of the Earl de Grey. Among his exhibited portraits were 'The Rt Hon Lord Grantham', 'The Earl of Enniskillen' and 'The Duke of Wellington. Painted for the United Services Club'. Died Leeds August 1839 aged 39. The SBA exhibited works confuse him with a landscape painter of the same name.
Represented: NPG London; Institute of Directors; Wellcome Institute, London; Wrest Park, English Heritage. **Engraved by** W. Brett & S.Cousins, J.Davies, T.Lupton, H.Robinson. **Literature:** Ottley.

ROBINSON, William A. fl.1844-1853
Exhibited at RHA (9) 1844-53 from Dublin.

ROBSON, Thomas 1798-1871
Born Warrington, his mother reputedly a relative of Hogarth. Entered RA Schools (Silver Medallist). Studied under Sir Thomas Lawrence. Exhibited at RA (21), BI (4), SBA (1) 1803-44 from London. Died Warrington 17 October 1871.
Represented: Warrington AG.

ROCCA, Andrea fl.1771
Exhibited crayon portraits at RA (3) 1771 from an address facing St James's Church, Piccadilly.

ROCHARD, François Théodore 1798-1858
Born Paris, younger brother and pupil of miniature painter Simon Jacques Rochard. Worked in Paris and followed his brother to London, where he became a fashionable portrait painter in watercolours and miniature. Awarded a Silver Medal at SA 1823. Patronized by royalty. Exhibited at RA (147), NWS, SBA (22) 1820-55 from London. Died Notting Hill, London.
Represented: NPG London; VAM. **Engraved by** H.Cook, M.Gauci, W.Holl. **Literature:** DNB.

ROCHARD, Simon Jacques 1788-1872
Born Paris 28 December 1788, son of R.Rochard. Showed precocious talent and when his father died supported his mother and family by drawing crayon portraits at 5 francs each. Studied engraving under Ransonnette snr and Desnoyers and painting under Mademoiselle Bounieu and at École des Beaux Arts under Aubry. Aged 20 painted a portrait of Empress Josephine for the Emperor. Conscripted, but escaped to Brussels 1815, where he painted portraits for the court circle and was employed extensively by English officers. Moved to London and began a highly lucrative society practice, mainly in miniature. Exhibited RA (85), NWS, SBA (21) 1816-45. Influenced by Lawrence and Reynolds. Retired to Brussels 1846, where he died 10 or 13 June 1872 (conflicting sources).
Represented: VAM; Louvre; BM; Ashmolean. **Literature:** DNB; Foskett.

ROCHE, Alexander Ignatius RSA RP 1861-1921
Born Glasgow 17 August 1861. Began as an architect. Studied at Glasgow School of Art and in Paris under Boulanger, Gérôme and Lefebvre. Exhibited at RSA (69), RA (10), GG (3), RHA (2), Royal Glasgow Institute of Fine Arts, Paris Salon 1881-1919. Elected RP 1898, ARSA 1893, RSA 1900. Settled in Edinburgh 1897. Also worked in America on portrait commissions. Lost the use of his right hand 1906 through a cerebral haemorrhage, but continued with his left (painting mainly landscapes). Died Slateford, Midlothian 10 March 1921. Simon writes: 'A painter with an exquisite touch characteristic of many Glasgow painters of the time'. Developed a fluid technique, lively brushwork and subtle palette.
Represented: Walker AG, Liverpool; SNG; SNPG; Stuttgart Museum; Modern AG, Dublin; Adelaide AG. **Literature:** McEwan.

ROCHE, Sampson Towgood 1759-1847
Born deaf and dumb at Youghal. Studied pictures in Dublin. Practising in miniature by 1784. Worked in Cork, Dublin again 1788. Moved to Bath 1792. Exhibited at RA (2) 1817 from 11 Pierrepont Street, Bath. Retired back to Ireland 1822. Charles Byrne was his pupil, assistant and interpreter.
Represented: VAM; NGI; NPG London.

ROCHEFORT, Countess of fl.1851
Honorary exhibitor at RA (1) 1851.

RODEN, W. jnr fl.1861-1872
Probably a son of W.T.Roden. Exhibited portraits at RBSA (12) 1861-72. Listed as a portraitist there. Possibly William Frederick Roden who exhibited RBSA (26) 1876-89. They are listed as two separate artists.

RODEN, William Thomas 1817-1892
Born Birmingham. Trained as an engraver under Dew, but after about ten years concentrated on portrait painting. Exhibited at RA (6), BI (2), SBA (4) 1856-79 from London, Dulwich and Birmingham. Among his exhibited portraits were 'Viscount Palmerston KG for Town Hall Tiverton' and 'John Evans Esq FRS, President of Geological Society of London'. Died Handsworth 25 December 1892.
Represented: NPG London; Birmingham CAG. **Literature:** DNB.

RODGERS, Miss Marjorie (Mrs Wray) RMS b.1894
Born Cambridge 22 November 1894. Studied at Clapham School of Art 1911 and RA Schools under Andrew Gow. Exhibited at RA (39), RMS, ROI, RI, Paris Salon (Gold Medal 1948) 1917-67 from London. Elected ARMS 1948, RMS 1950.

RODIUS, Charles 1802-1860
Born Cologne, Germany. Studied at Royal Academy of France. Settled in England, but was convicted at Westminster for stealing a lady's bag 1829 and transported to New South Wales. Assigned to the Department of Works, where he taught drawing (without salary) to civil and military officers. His services were invaluable and his seniors were reluctant to uphold his application for a ticket-of-leave, which would exempt him from compulsory government service. This was eventually granted July 1832, with the recommendation of reputable civilians, whose children he taught. A certificate of freedom was granted July 1841. Worked as a portraitist, art teacher and landscape painter with some success. Suffered a stroke during the late 1850s, which left him paralysed one side. Died 9 April 1860 of 'infirmity'.
Represented: Sydney AG. **Literature:** *Dictionary of Australian Biography.*

RODWAY, Florence b.1881
Born Hobart. Studied in Sydney under S.Long, Hobart Technical School and RA Schools, London. Painted many official portraits in Australia.
Represented: New South Wales AG.

ROE, Fred RI RBC 1864-1947
Son of miniature painter R.H.Roe. Studied at Heatherley's and under Seymour Lucas. Exhibited at RA (73), RI, in the provinces and Paris Salon 1887-1943 from London. Elected RI 1909. Also a book illustrator. Died 16 August 1947. His stepbrother was artist Robert Henry Roe and his son was art critic F.Gordon Roe.
Represented: NPG London; VAM; NMM; Cheltenham AG; Christchurch Mansion, Ipswich; Portsmouth Town Hall.

ROE, William fl. 1826-1847
Exhibited at RHA (51) 1826-47 from Dublin.

ROESTRAETEN, Pieter Gerritsz van c.1627-1700
Born Haarlem. A pupil of Frans Hals whose daughter he married 1654. Moved to England by c.1673. Patronized by Peter Lely, who showed his work to Charles II on the condition that he did not paint any more portraits. Specialized in still-life by 1678. Received an injury to his hip during the Fire of London, which left him lame. Buried London 10 July 1700.
Represented: Hampton Court; Chatsworth. **Literature:** DNB; *Burlington Magazine*, CXXXII 1990 pp.402-6; DA.

ROFFE, F. fl.1822-1836
His portrait of Baron Lyndhurst is in NPG London.

ROGERS, Edward James b.1872
Born London 16 April 1872, son of James Rogers an architect. Studied at Heatherley's. Exhibited at RA (2), RHA (45) 1904-36 from Hampstead, Dublin and County Cork. Painted portraits and miniatures.

ROGERS, Gilbert fl.1909-1914
Exhibited at RA (4) 1909-14 from Liverpool.

ROGERS, Henry fl.1835-1840
Exhibited at RA (2) 1835-7 from London. Listed as a portrait painter there 1840. Worked in the manner of Joshua Reynolds. Held evening classes, teaching the young William Holman Hunt.

ROGERS, Mrs Jane Masters b.c.1825
Born Dublin, daughter of artist James Macdonald. Exhibited at RA (16), BI (1), RHA (3), SBA (3) 1847-76 from London. Among her sitters were 'Sir William Ross RA' and 'F.Sibson Esq, MD FRS'. Aged 36 in 1861 census. Her work is confused with her daughter Miss Jane Masters Rogers.

ROGERS, William fl.1849-1857
Edinburgh portrait painter. Exhibited RSA (35) 1849-57.

ROGERS, William Paul fl.1832-1834
Listed as a landscape and portrait painter in London.

ROJC, Madame Nasta b.1883
Born Croatia 6 November 1883. Studied at the Academies in Vienna and Munich (winning prizes). Exhibited internationally.
Represented: Strosmeyer AG; Zagreb Modern AG.

ROLLER, Major George Conrad DCM JP b.1856
Born near Gainsborough, Lincolnshire or in Surrey (conflicting sources) 10 June 1856, son of F.William Roller JP. Studied at Lambeth under Prof F.Brown and in Paris under Bourguereau and Fleury. Exhibited at RA (3), SBA (3), Paris Salon 1890-1904 from Tadley, Basingstoke. Member of Hogarth Club. Served in the Boer War and the 1st World War.
Represented: Kennington Oval.

ROLLS, Miss Florence fl.1888-1889
Exhibited at RA (1) 1888 from Hampden Mount, Caterham Valley.

ROLSHOVEN, Julius b.1858
Born Detroit, Michigan 28 October 1858. Studied under Bourguereau and Robert Fleury. Exhibited at RA (8), SBA (1) 1896-9 from London.

ROLT, Charles fl.1845-1867
Exhibited at RA (19), BI (9), SBA (33) 1845-67 from Merton and London.

ROMA, Spiridione c.1735-c.1786
Born Corfu. Moved to England c.1770. Painted decorative scenes in the Chapel of the Vyne. Set up a portrait practice in London, but his chief business was restoring pictures for city companies. A historical ceiling painted 1778 survives in the Commonwealth Relations Office, London. Exhibited at RA (4) 1774-8. Ottley says he died suddenly in the street some time in 1786, Bénézit 1787.

ROMER, Mrs Louise (née Goode)
 see JOPLING, Mrs Louise

ROMILLY, Amélie (Madame Munier) **1788-1875**
Born Geneva. Studied under Firmin Massot. Lived in Paris 1812-25. Exhibited at RA (3) 1828-37 from London. Died Geneva 12 February 1875.
Represented: NPG London; Musée d'Art et d'Histoire, Geneva.

ROMNEY, George FSA **1734-1802**
Born Beckside, on a small farm near Dalton-in-Furness 15 December 1734, son of John Romney, a joiner and cabinet maker and his wife Anne. Went to school at Dendron. Apprenticed to his father's business at Upper Cocken c.1745. Spent ten years carving and gilding furniture and making flutes and violins. Copied prints in his spare time and his talent for portraiture attracted the attention of the mother of Daniel Gardner. She commissioned her portrait and persuaded Romney's father to let him take up portraiture. On 20 March 1755 he was apprenticed for four years to Christopher Steele working at Kendal, York and Lancaster. His master eloped with a female pupil and Romney was left to placate the girl's parents and creditors, and finish off his portraits. He fell ill with fever and while being nursed by his landlady's daughter, Miss Mary Abbot of Kirkland, formed a liaison with her. She became pregnant and so he married her October 1756. After the marriage Romney rejoined Steele in York. The two artists returned to Kendal, but because of lack of work moved to Lancaster where work was even more scarce. Romney bought himself out of his apprenticeship and returned to Kendal, where he painted mostly small full-lengths between 1757 and 1762 and had as his pupil his younger brother, Peter. Paid professional visits to York, Lancaster, Manchester and Cheshire, but settled in London March 1762, where he concentrated on works to the scale of life and histories. Visited Paris 1764, where he met J.B.Greuze and C.J.Vernet. Exhibited at SA (10), FS (15) 1763-72. Won premiums for historical paintings at SA 1763 and 1764/5. Elected FSA 1771. Abandoned his London practice 20 March 1773 to go to Rome accompanied by Ozias Humphry (with visits to Parma and Venice), where he became further attracted to the 'Grand Style'. Returned to London by 1 July 1776, aged 41 and penniless. He took, at great risk, a long lease on Cotes' house, but was fortunately able to attract clients and soon, with Reynolds and Gainsborough, became one of the leading portrait painters. His prices remained below those of the other two. For a 30 x 25in. he charged 15 guineas in 1775; 20 guineas 1781; 25 guineas in 1787; 30 guineas in 1789 and 35 guineas in 1793; double for half-lengths and double again for full-lengths. He worked hard for his success, averaging about a portrait a day during the season. Met Emma Lyon 1781, later known as Emma Hart and was so impressed that he painted her portrait on numerous occasions. A romantic liaison between the two has often been suggested. She departed for Naples 1786 and became Lady Hamilton 1791. He suffered from mental illness from the 1790s and in 1796 he sold his house to Shee and retired to Hampstead. In 1798/9 he returned to Kendal, where he was cared for by his neglected wife. Died there 15 November 1802. Buried St Michael's Church, Dalton-in-Furness. His studio ledger is in NPG London. Among his pupils were D.Gardner, T.Barrow, J.Baynes, James Rawlinson, Peter Romney, Isaac Pocock, J.Lonsdale, T.Robinson, T. Stewardson, Mary Barret and miniaturist Anne Foldstone (later Mrs J.Mee).
Represented: Yale; Tate; NPG London; SNG; VAM; NGI; Wallace Collection; SNPG; NG Victoria, Melbourne; Southampton CAG; Abbot Hall AG, Kendall; Philadelphia MA; Carlisle AG; Dulwich AG; Fitzwilliam. Engraved by T.Barrow, F.Bartolozzi, J.Basire, H.S.Bridgewater, T.B.Brown, Brown & Bragg, T.Cheeseman, J.Conde, H.R.Cook, J.Dean, W.Dickinson, R.Earlom, W.Evans, Freschi, W.T.Fry, V.Green, J.Grozer, F.S.Haden, N.Hirst, C.H.Hodges, C.Holl, T.Holloway, J.Hopwood, H.Hudson, J.Jacobé, C.H.Jeens,

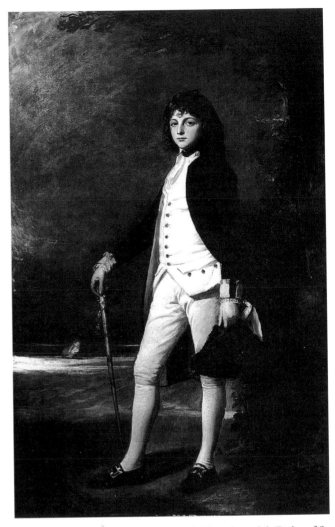

GEORGE ROMNEY. Lord William de Vere, later 8th Duke of St Albans. 81½ x 52ins (207 x 132.1cm) *Christie's*

J.Jones, G.Keating, C.Knight, F.Legat, R.W.Macbeth, H.Meyer, G.Murray, W.Page, R.B.Parkes, J.Patricot, C.Picart, J.B.Pratt, P.Rajou, W.Read, B.Reading, W.Ridley, H.Robinson, L.Schiavonetti, E.Scriven, W.Sharp, J.K.Sherwin, J.Skelton, R.Slann, I.W.Slater, J.R.Smith, E.Stamp, C.Townley, C.Turner, J.Walker, C.Waltner, J. & W.Ward, C. & J.Watson, D.Wehrschmidt, T.Woolnoth, T.Wright, J.Young. Literature: *European Magazine and London Review* Vol 43 June 1803 pp.417-23; Rev J.Romney, *Memoirs of the Life and Works of G.R.*, 1830; H.Ward & W.Roberts, *R.*, 1904 includes appointment books for the years 1776-95; *G.R., Paintings and Drawings*, Kenwood House exh. cat.1961; P.Jaffé, *R.*, Fitzwilliam exh. cat., 1977; H.Gamlin, *G.R. and His Art*, 1894; DNB; DA.

ROMNEY, Peter **1743-1777**
Born Upper Cocken near Dalton-in-Furness 1 June 1743, younger brother and pupil of George Romney. Specialized in crayon portraits. Practised mainly in the Manchester area from 1767, but also brief spells at Liverpool 1769, Bradford 1772, Ipswich 1773 and Cambridge 1774. Returned to Ipswich 1775, where he was imprisoned for debt. His brother cleared his debts and he moved to Stockport, where he died May 1777.
Literature: DNB; R.Meyer See, *Connoisseur* February 1919; Rev J.Romney, *Memoirs of the Life and Works of G.R.*, 1830.

RONALDSON, Thomas Martine **1881-1942**
Born Edinburgh 13 December 1881. Educated there and at Trinity College, Oxford. Studied at Edinburgh School of Art, Cope and Nicoll School, London and Académie Julian, Paris under J.P.Laurens. Exhibited at RA (26), RSA (42), Paris Salon (Silver Medal 1926) 1911-38. Died London 12 March 1942.
Literature: McEwan.

RONAN, Patrick **fl.c.1804**
Born Carrick-on-Suir, where he worked most of his life. Left Carrick c.1804 and moved to Cork, where he died

ROODS, Thomas **fl.1833-1867**
Exhibited at RA (21), BI (21), SBA (18) 1833-67 from London. Among his sitters were 'Sir Brook W. Bridges Bart, Painted for the East Kent Yeomanry' and 'Lord and Lady Dorchester'.

ROOKE, Thomas Matthews **RWS** **1842-1942**
Born Marylebone. Began his career in an Army Agent's Office, attending classes at South Kensington and RA Schools. Aged 29 he applied for a vacancy as a designer in William Morris' firm. Appointed assistant to Burne-Jones, with whom he worked for many years. Recommended by Burne-Jones to Ruskin 1878, who was looking for artists to draw cathedrals and monuments on the Continent (now in Ruskin Museum, Sheffield). Exhibited at RA (27), RHA (10), SBA, RWS, NWS, GG, NWG 1871-1914. Elected ARWS 1891, RWS 1903. Continued to paint until he was almost 98. Died Northampton 27 July 1942.
Represented: Tate; BM; Birmingham CAG; Fitzwilliam; Manchester CAG.

ROOM, Henry **1802-1850**
Born Birmingham, from an evangelical family. Studied at the drawing school run by Joseph and J.V.Barber. Moved to London. Exhibited at RA (15), BI (9), SBA (15) 1826-48. Founder RBSA 1826. Many of his portraits were engraved in the *Evangelical Magazine*. Died London 27 August 1850. Best known for 'Interview of Queen Adelaide with the Madagascar Princes' (NPG London).
Represented: Birmingham CAG; SNPG; Royal College of Surgeons. **Engraved by** J.Cochran, T.A.Dean, W. & F.Holl, J.Thomson. **Literature:** *Art Journal* 1850 p.339; *Gentleman's Magazine* 1850 II p.449.

ROOS, Eva (Mrs S.H.Vedder) **b.1872**
Studied in Paris at Académies Colarossi and Delecluze. Exhibited at RA (16), Paris Salon 1904-19 from London. Many of her portraits were of children.

ROOS, William **d.1878**
Born Almwich, Wales. Painted portraits and historical subjects. Awarded a prize at Llangollen National Eisteddfod 1858. Died Almwich 4 July 1878.
Represented: National Museum of Wales.

ROPER, A.F. **fl.1841-1846**
Exhibited at RA (3) 1841-6 from London.

ROPER, Richard **c.1730-c.1775**
Exhibited at SA and FS 1761-5. His portrait of Henry Bankes 1764 is at Kingston Lacy.
Represented: Tate.

ROSE, Miss H. Ethel **fl.1877-1891**
Exhibited at RA (5), SBA (7), RHA (2), NWS 1877-91 from Peckham Rye and The Grove, Denmark Hill.

ROSE, H. Randolph **fl.1880-1906**
Exhibited at RA (11), SBA (10+), NWS, GG, NWG 1880-1906 from London and Algiers.

ROSE, John **fl.1841**
Listed as a portrait painter at York.

ROSENBERG, Mrs F. (or T.) **fl.1857**
Exhibited at RA (1) 1857 from Leamington.

ROSENBERG, Frederick **fl.1830-1854**
Exhibited at SBA (1) 1830 from London. Listed there as a portrait painter 1834. Worked in Leamington 1841-54.

ROSENTHAL, S. **fl.1865-1868**
Exhibited at RA (2) 1865-8 from London. Some of his portraits were reproduced as engravings.

ROSHER, Mrs G.B. **fl.1881-1893**
Exhibited at RA (6), SBA (5) 1881-93 from London and Gravesend.

ROSIER, Jean Guillaume **1858-1931**
Born Laeken 15 September 1858. Studied at Anvers. Exhibited at RA (6) 1915-28 from London. Painted a portrait of Algernon Graves. Died Anvers 24 July 1931.

ROSS, George **fl.c.1710**
Portrait painter in Scotland. Painted the portrait of Colonel John Somerville at Hopetoun.

ROSS, Hugh **1800-1873**
Son of artist William Ross and Maria (née Smith), and brother of Sir William Ross. Painted miniatures and watercolour portraits. Exhibited at RA (35) 1815-45 from London. Awarded prizes at SA 1815, 1816 and 1820.
Represented: NPG London.

ROSS, Joseph Thorburn **ARSA** **1849-1903**
Born Berwick-on-Tweed 15 May 1849, son of artist Robert Thorburn Ross RSA. Practised in Edinburgh. Exhibited at RSA (93), RA (5), RI and in Newcastle 1872-1903. Elected ARSA 1896. Died Edinburgh 28 September 1903.
Represented: SNG. **Engraved by** W.H.Mote.

ROSS, Mrs Madge **fl.1891-1923**
Studied under Bouguereau and Fleury in Paris. Exhibited at Paris Salon and RA (2) 1891-2 from London.
Literature: McEwan.

ROSS, Mrs Maria (née Smith) **c.1766-1836**
Sister of engraver Anker Smith. Exhibited at RA (3) 1808-14 from London. Among her sitters was 'Master F. Hurlstone'. Married William Ross. Died London 20 March 1836. Her son, William C.Ross, was also an artist.

ROSS, Robert Thorburn **RSA** **1816-1876**
Born Edinburgh. Studied under G.Simson and Sir William Allan at Trustees' Academy. First worked in Glasgow, then moved to Berwick 1842 and Edinburgh 1852. Exhibited at RSA (123), RA (6), RHA (1), SBA (2) 1833-77. Elected ARSA 1852, RSA 1869. Died Edinburgh 13 July 1876. His children Joseph Thorburn Ross and Christine Patterson Ross were also artists.
Literature: *Art Journal* 1876 p.295; McEwan.

ROSS, Thomas **fl.1730-1746**
Provincial portrait, landscape and decorative painter. Worked in Suffolk 1730 and may have been in Gloucester before 1730. Most of his known works are busts in a feigned oval.
Represented: NPG London. **Engraved by** P.Audinet, J.Hall.

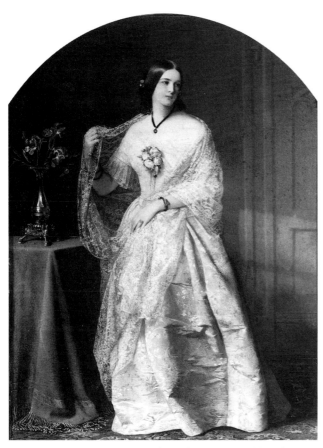

WILLIAM CHARLES ROSS. The 3rd Viscountess Templetown. Mixed media on ivory. 18½ x 12¾ins (47 x 32.4cm) *Phillips*

ROSS, William fl.1753
Signed and dated a well observed portrait of Lewis Rose of Culmoney (Miss Elizabeth Rose of Kilravock collection).

ROSS, William snr fl.1809-1842
Son of a gardener to Duke of Marlborough. Exhibited at RA (5) 1809-25 from London. Married Maria Smith, sister of Anker Smith. Their son was Sir W.C.Ross.

ROSS, W. jnr fl.1816-1854
Exhibited at RA (14), BI (11), SBA (5) 1816-54 from London.

ROSS, Sir William Charles RA 1794-1860
Born London 3 June 1794, son of miniaturist William Ross. Entered RA Schools 1808 and won numerous prizes. Awarded seven premiums at SA 1807-21. Became assistant to miniature painter Andrew Robertson 1814. About 1825 Lawrence (who sat for him) pronounced him to be the best miniature painter of his day – a recommendation which established his fame. Enjoyed a highly successful portrait practice in miniature and watercolour. Among his sitters were the Queen, Duchess of Kent, Queen Adelaide, Prince Albert and members of the royal families of France, Belgium, Portugal and Saxe-Coburg. Exhibited at RA (298), BI (5) 1809-59. Elected ARA 1838, RA 1843, knighted 1842. Won £100 premium for 'The Angel Raphael Discussing with Adam' in the Westminster Hall Competition 1843. Continued to be the leading miniature painter of his age until 1857, when he was overcome with gradual paralysis. Died London 20 January 1860. Buried Highgate Cemetery. His draughtsmanship was both precise and sensitive. He considered the ultimate aim of portraiture was, while fixing the individuality of the subject, to implant the most pleasing aspect and natural expression of the sitter.
Represented: NPG London; SNPG; BM; HMQ; Nottingham AG; Wallace Collection; VAM. **Engraved by** F.Bacon, S.Bellin, J.Cochran, H.Cook, E.Dalton, A.Duncan, J.C. & W.J.Edwards, M. & P.Gauci, W.Holl, R.J.Lane, A.Leon-Noel, H.Robinson, H.T.Ryall, J.S.Templeman, J.Thomson, C.W.Wass, T.Williamson, R.Woodman, W.H.Worthington. **Literature:** *Gentleman's Magazine* 1860 I p.513; Ottley; Maas; *Apollo*, LXXVII 1962 pp.449-51; DA.

ROSSETTI, Dante Gabriel Charles 1828-1882
Born London 12 May 1828, son of Gabriel Rossetti, an Italian political refugee and Professor of Italian at King's College. His mother was half Italian and half English and was a private teacher. Studied at King's College 1837-42, under J.S.Cotman, Cary's School for four years; RA Schools 1845. Became a pupil of Ford Madox Brown for a few months in 1848, after which he shared a studio with Holman Hunt. Together with Hunt, Millais, Stephens, Woolmer and Collinson he played a leading part in the formation of the Pre-Raphaelite Brotherhood. Met Elizabeth Siddal probably late 1849, whom he married 1860 and used continuously as a model in his works. In 1857-8 he worked on Oxford Union frescoes with Burne-Jones and William Morris, both of whom became his disciples. His wife died from an overdose of laudanum 1862. He concentrated on allegorical female portraits, the most famous of which were of Fanny Cornforth, Alexa Wilding and Jane Morris, wife of William Morris. 1871-4 he shared Kelmscott Manor with the Morrises. He began to show mental disturbance and dependence on chloral. Died Birchington 9 April 1882. Buried Birchington churchyard. His great intensity of vision usually compensates for what one critic described as his 'inability to perfectly acquire even the grammar of painting'. His assistants were W.Knewstub and H.T.Dunn 1866-7.
Represented: NPG London; VAM; Tate; Birmingham CAG. **Literature:** For a full bibliography see W.Fredeman, *Pre-Raphaelitism, A Bibliocritical Study*, 1965; *D.G.R.: Painter and Poet*, RA and Birmingham CAG exh. cat. 1973; *The Pre-Raphaelites*, Tate exh. cat. 1984; F.L.Fennel jnr, *The Rossetti-Leyland Letters*, 1978; V.Surtees (ed), *R.'s Portraits of Elizabeth Siddal*, 1991; DA.

ROSSI, Alexander Mark 1840-1916
Born Ionian Islands. Exhibited at RA (66), SBA (48), RHA (7), NWS 1871-1903 from Preston and London. Member of Hogarth Club. Died Golders Green, London 9 January 1916.

ROTH, George fl.c.1742-1778
Painted draperies for Van Loo, Hudson and Ramsay. Lived at 51/2 Great Queen Street 1752-78. Exhibited at SA (6), FS (3) 1771-5.

ROTH, George jnr fl.1768-1784
Son of George Roth. Exhibited portraits and miniatures at SA 1768-76 from Bath.
Engraved by T.Holloway.

ROTH, Thomas fl.1803-1828
Exhibited at RA (43), BI (1) 1803-28 from London. Painted portraits in oil and watercolour, and miniatures on ivory and enamel.
Represented: VAM.

ROTH, William b.1754
Born London, son of George Roth. Entered RA Schools 1771. Exhibited at SA (15), FS (2) 1768-75 from London and Reading. Believed to have copied royal portraits for Reynolds.

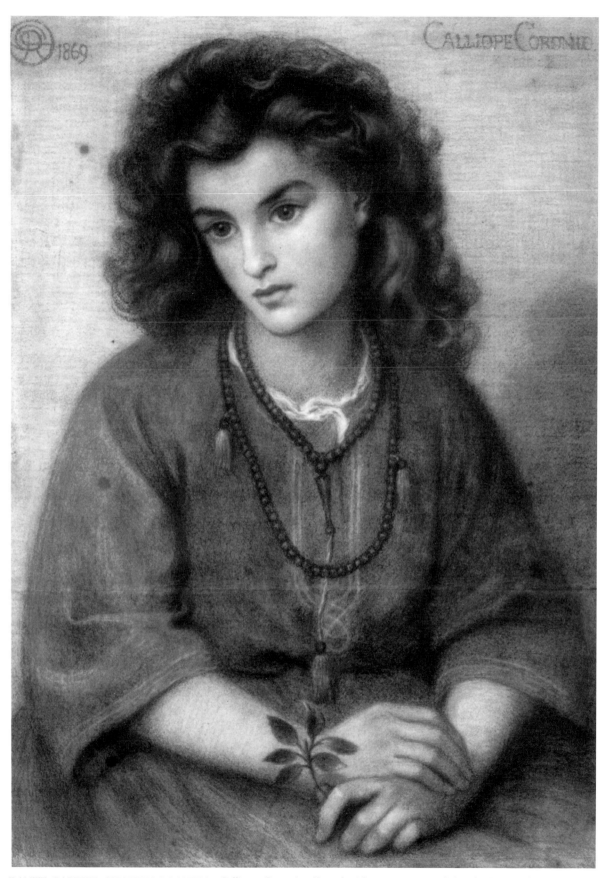

DANTE GABRIEL CHARLES ROSSETTI. Calliope Coronio. Signed with monogram and dated 1869. Coloured chalks.
28¼ x 19½ins (71.8 x 49.5cm)

Christie's

ROTHENSTEIN, Albert
 see RUTHERSTON, Albert Daniel

ROTHENSTEIN, Sir William NEAC RP 1872-1945
Born Bradford 29 January 1872, son of Moritz Rothenstein, a wool merchant. Studied at Slade and Académie Julian, Paris 1889-93. Lived in London 1895-1912 and travelled widely. Official war artist in both World Wars. Exhibited at RHA (3), RA (18), RP (50), NEAC 1909-44. Elected RP 1897. Knighted 1931. Principal of RCA 1920-35. A close friend of Orpen and John. Published his memoirs, *Men and Memories*, 1931. Died at Far Oakridge, near Stroud 14 February 1945.
Represented: NPG London; Tate; VAM; BM; SNPG; Leeds CAG; Southampton CAG; Manchester CAG; Ashmolean; Carlisle CAG; Birmingham CAG; Brighton AG; Fitzwilliam. **Literature:** *Sir W.R.: A Centenary Exhibition*, Bradford CAG exh. cat. 1972; R. Speaight, *W.R.*, 1962; DA.

ROTHWELL, Richard RHA 1800-1868
Born Athlone 20 November 1800, eldest son of James Rothwell. Entered Dublin Society's Drawing School 1814/15 (winning Silver Palette 1820). Moved to London, where his work was much admired by Lawrence and Landseer. Became Sir Thomas Lawrence's chief assistant and on Lawrence's death was entrusted with completing his unfinished commissions. Exhibited at RHA (86), RA (72), BI (28), SBA (1) 1826-66. Elected ARHA 1823/4, RHA 1826. Visited Italy 1831-4. Returned to London, then Paris. Worked again County Dublin c.1846 where, having resigned from RHA 1837, he was re-elected 1847. Again in London 1849-54, then USA, Italy, Belgium, Leamington and Belfast. Among his sitters were the Duchess of Kent, HSH the Prince of Leiningen, Mary Shelley, Viscount Beresford. Visited Paris and finally Rome, where he died after a week's illness 13 September 1868. Buried in a grave beside Keats. Severn organized his funeral.
Represented: NGI; NPG London; HMQ; Southampton CAG; Ulster Museum, Belfast; VAM. **Engraved by** H.Cook, T.Hodgetts, R.J.Lane, D.Lucas. **Literature:** *Art Journal* 1868 p.245; DA.
Colour Plate 64

RÖTTING, H. fl.1857
Exhibited at RA (1) 1857 from Düsseldorf and London.

ROUBY, John James 1750-1812
Born Plymouth. By 1776 he was in Rome and studied with Haekert and Mengs. Married an Italian acrobat 1779 and became a Catholic. A friend of Goethe and Kauffmann. Painted a portrait of a British Officer in Naples 1792 and made a collaborative copy with Catel of Carstens' 'Golden Age' (Thorwaldsen Museum, Copenhagen). Died Rome 21 August 1812.

ROUSSEL, Théodore Casimir RBA ARE 1847-1926
Born Lorient, Brittany 23 March 1847. Exhibited at RHA (2), SBA (6) 1879-88. Elected RBA 1887. Fought in Franco-Prussian War. In 1878 moved to London, where he became a life-long friend of Whistler 1885. President of Society of Graver-Printers in Colour. Died St Leonards-on-Sea 23 April 1926.
Represented: VAM; Tate; Brighton AG. **Literature:** F.Rutter, *T.R.*, 1926; DA.

ROUW, Henry jnr 1775-c.1834
Younger brother of sculptor Peter Rouw. Entered RA Schools 10 October 1794 aged 19 as a painter. Exhibited at RA (9) 1796-1821 from London. Concentrated on tomb sculpture. His last known recorded sculpture was dated 1834.

ROWBOTHAM, Miss E. fl.1852-1855
Exhibited at SBA (5) 1852-5 from London

ROWLAND, William fl.1777
Worked in Glasgow and New York 1777. Painted portraits in oil and miniature and taught drawing.

ROWLEY, Mrs Francis fl.1893
Exhibited at NWG (1) 1893 from a London address.

ROWSE, Samuel Worcester 1822-1901
Born Bath, Maine 29 January 1822. Brought up in Augusta and apprenticed there to a wood engraver. Worked in Boston and set up as a crayon portraitist. Visited England 1872. Exhibited at RA (1) 1873. Moved to New York. Died unmarried at Morristown 24 May 1901.
Represented: NPG London.

ROXBURGH, Ebenezer B. fl.1862-1897
Dunfermline painter. Exhibited at RSA (49) 1862-97. Listed as a portraitist at 6 Elm Row, Edinburgh 1878.

ROYLE, Edward fl.1845-1848
Listed as a portrait, landscape painter and teacher of drawing in Manchester.

RUBBY, John James c.1750-1812
Born Plymouth. Established in Rome by 1777. Studied under Mengs. Died Rome 21 August 1812.

RUBENS, Sir Peter Paul 1577-1640
Reportedly born Siegen 28 June 1577. Rose to extreme eminence, was shrewd business man and tightly ran a busy picture factory, working to his designs, which he would retouch. Visited London May 1629 to March 1630 on a diplomatic mission from Philip IV of Spain. Knighted by Charles I as 'Ambassador from the Archduchess' 21 February 1630. In London he stayed in the house of Gerbier, whose family he painted (NG Washington). Painted in England the 'Allegory of Peace and War' (NG London), which he gave to Charles I, and 'St George and the Dragon' (Buckingham Palace). Died Antwerp 30 May 1640.
Represented: NPG London; NG London; Louvre; HMQ; NGI; Dulwich AG; Wallace Collection. **Engraved by** J.Basire, T.Cook, T.Chambers, J.Houbracken, J.L.Krafft, J.McArdell, H.Robinson, J.Simon, E.Scriven. **Literature:** DA with full bibliography and list of pupils and assistants.

RUBENSTEIN, Francis d.1762
Still-life, portrait and drapery painter. A member of St Martin's Lane Academy. His posthumous sale was held 9 March 1762 and included a number of paintings by Worlidge.

RUDGE, Samuel fl.1816-1817
Listed as a portrait painter in Birmingham.

RUGGLES, W.H. fl.1833-1846
Exhibited at RA (2) 1833-46 from Ivy Place, Lewisham.

RUSCA, Cavaliere Carlo Francesco 1696-1760/9
Born Torricella, near Lugano and studied law at Turin. Took to portraiture. Employed by the Turin Court by 1722, after which he studied in Venice with Amigoni. Employed by the German Courts (Cassel 1733-6, Berlin 1737). Sent to Hanover to paint George II, who persuaded him to come to London 1738/9, where he had some success. Settled in Milan 1740, where he died in 1760 or 11 May 1769 (conflicting sources).
Represented: HBM Embassy, Ankara.

RUSS, Robert 1847-1922
Born Vienna 7 July 1847. Studied under Zimmermann at the Academy in Vienna. Died Vienna 16 March 1922.
Represented: NPG London.

RUSSEL, Anthony c.1663-1743
Son of artist Theodore Russel. Studied under J.Riley c.1680. Died London July 1743 aged about 80. Painted in the manner of Van Dyck.
Engraved by J.Smith, G.Vertue.

RUSSEL, James c.1720-1763
Born London, son of a Westminster clergyman. Studied in Rome under Imperiali 1740. Painted portraits and became an 'antiquary' guiding British visitors around the sites. Painted a conversation piece formerly at Shardeloes 1744. Published anonymously *Letters from a Young Painter Abroad to His Friends in England*, 1748. Died Rome.
Literature: R.Edwards, *Burlington Magazine* XCIII April 1951 p.126; DA.

RUSSEL, James John d.1827
Born Limerick, where he worked as a portraitist. Exhibited in Dublin from 1804. Died Limerick October 1827.

RUSSEL, Theodore 1614-1688/9
Baptized at the Dutch Church, Austin Friars, London 9 October 1614, son of Nicasius, a goldsmith. Studied for nine years under his uncle Cornelius Johnson, after which he spent a year with Van Dyck. Specialized in small copies on panel after Van Dyck. According to Vertue he was 'a lover of Ease and the bottle'. Died London. Among his sitters was Henry Cromwell.
Represented: NPG London; Knebworth; Woburn.

RUSSELL, Charles RHA 1852-1910
Born Dunbarton 4 February 1852, son of Scottish artist John Russell. Moved to Dublin 1874 and worked for 10 years painting portraits from photographs for the Chancellor of Dublin. Exhibited at RHA (96), RA (1) 1869-1910 from Dublin. Elected ARHA 1891, RHA 1893. Died Blackrock, Dublin 12 December 1910.
Represented: NGI; Aberdeen AG.

RUSSELL, Edwin Wensley fl.1855-1878
Exhibited at RA (11), BI (3), SBA (16) 1855-78 from London.
Represented: Blackburn Museum.

RUSSELL, George Horne 1861-1933
Born Banff. Studied at Aberdeen School of Art and in London at South Kensington. Travelled to Canada 1890, where he set up as a portrait painter. Elected an associate of Royal Canadian Academy 1909, fellow 1918 and President 1922-6. Died New Brunswick 25 June 1933.
Literature: *Dictionary of Canadian Biography;* McEwan.

RUSSELL, James John RHA d.1827
Born Limerick, son of John Russell. Working as a portrait artist by 1804 and built up a successful practice. Exhibited at RA (4), RHA (18) 1818-7 from Dublin and London. Elected ARHA 1823, RHA 1826. Among his sitters were Lord Viscount Gort and Admiral Sir E.Nagle. Suffered poor health and died Limerick October 1827.
Represented: NGI. **Literature:** Strickland.

RUSSELL, Miss Janet Catherine fl.1868-1894
Exhibited at RA (6), SBA (5) 1868-94 from The Priory, Surbiton.

RUSSELL, John RA 1745-1806
Born Guildford 29 March 1745, son of John Russell, a book and printseller and four times Mayor of Guildford. Educated at Guildford Grammar School. Won premiums at SA for drawings 1759 and 1760. Studied crayon drawing with

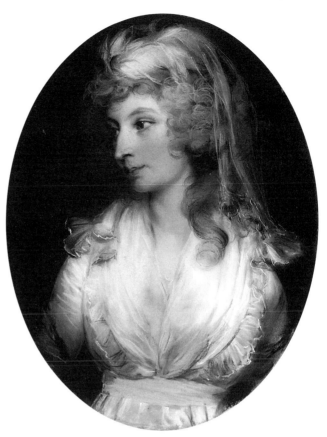

JOHN RUSSELL. Mary Wood. Signed and dated 1794. Pastel. 23½ x 17ins (59.7 x 43.2cm) *Sotheby's*

Francis Cotes up to 1767. By 1764 he was converted to Methodism and was deeply religious, sometimes upsetting sitters by trying to convert them. Entered RA Schools 17 March 1770 (Silver Medallist 1770). Exhibited at SA (3), RA (332), BI (1) 1768-1806. Elected ARA 1772, RA 1788. Based in London, but toured the provinces producing attractive crayon portraits and the occasional oil. Published *Elements of Painting with Crayons*, 1772 (a later edition 1777). Appointed Crayon Painter to the King and to the Prince of Wales, 1790. A keen astronomer, he spent some 20 years compiling a map of the moon, which for its time was remarkably accurate. Bequeathed a large estate in Dorking by his cousin 1781. After 1790 he worked largely in Yorkshire. Became deaf after an attack of cholera 1803. Died of typhoid in Hull 20 April 1806. Buried under the choir of Holy Trinity, Hull. F.C.Pack worked in his manner. His son William Russell was also a portraitist.
Represented: NPG London; HMQ; Tate; Hove AG; Petworth, NT; Clandon Park, NT; Brighton AG; Leeds CAG; Guildford Corporation; BM; diaries in VAM.
Engraved by F.Bartolozzi, T.Blood, M.Bovi, J.Collyer, J.Conde, R.Cooper, W.Dickinson, W.C.Edwards, W.Evans, W.T.Fry, J.Heath, W.Holl, R.Houston, McMussard, I.Richeton, W.Ridley, J.Ross, W.Skelton, J.Spilsbury, J.Thomson, P.W.Tomkins, T.Trotter, Vendramini, J.Watson, Wooding, R.Woodman. **Literature:** G.C.Williamson, *J.R.*, 1894 – a copy with corrections in VAM; DNB; *Illustrated London News* 18 October 1930; W.F.Ryan, 'J.R. RA and Early Lunar Mapping', *The Smithsonian Journal of History* Vol 1, no 1 Spring 1966 pp.27-48; DA.
Colour Plate 63.

RUSSELL, John Peter 1859-1930
Born Darlinghurst, Sydney. Inherited a private annual income of about £3,000. Studied at Slade and Cormon's Academy, Paris. Said to have been amateur boxing champion of England. Worked in France mixing with Rodin, Van Gogh, Toulouse-Lautrec, Forain, Monet and Bernard. Married Rodin's favourite model Marianna Antoinetta Matiocco. Lived at Belle Ile, off the coast of Brittany. After the death of his wife he was bereft and destroyed many of his works, including those in which she appeared. In London again during 1st World War. Died Watson's Bay, Sydney. His portrait of Van Gogh is in Rijksmuseum.
Represented: Stedelijk Museum, Amsterdam; AGs of Melbourne, Sydney and Adelaide. **Literature:** *Encyclopedia of Australian Art*, 1968; B.Smith, *Some Odds from Australian Painting 1788-1970*, 1971; E.Salter, *An Australian Impressionist – The Life of J.P.R.*, 1976; A.Galbaily, *The Art of J.P.R.*, 1977; DA.

RUSSELL, Lady Laura d.1910
Daughter of Viscount De Peyronnet. Married Arthur John Edward Russell, brother of 6th Duke of Bedford.
Represented: NPG London.

RUSSELL, Samuel b.c.1819
Born Lambeth. Listed as an artist in pencil aged 32 in 1851 census for St Pancras. Exhibited at RA (1) 1874 from Shepherd's Bush.

RUSSELL, Sir Walter Westley CVO RA RWS NEAC RP
 1867-1949
Born Epping 31 May 1867. Studied at Westminster School of Art under Fred Brown. Exhibited at RA (142), RHA (9), NEAC 1886-1946. Elected RP 1907, ARA 1920, RA 1926, Assistant Professor at Slade 1895-1927, Keeper of RA 1927-42, CVO 1931, knighted 1935. Died London 16 April 1949.
Represented: Tate; Modern AG, Dublin; Walker AG, Liverpool; SNG; Prudential Assurance Co.

RUSSELL, William 1784-1870
Born 26 November 1784, son of John Russell RA and Hannah. Educated in Rev George Gibson's school in London. Worked in crayons and oils. Exhibited at RA (8), BI (1) 1805-9 from London. Among his sitters were Lord Erskine and Judge Bayley. In March 1809, William told his mother that he was entering the ministry. Ordained 21 May 1809. Gave up his practice, becoming rector of Shepperton. Married Laetitia Ann Nichols. Died 14 September 1870.
Represented: NPG London; Philadelphia MA. **Engraved by** W.Holl, W.Say. **Literature:** Dorment.

RUST, Miss Beatrice Agnes fl.1883-1894
Exhibited at RHA (8), RA (10), SBA (6), NWS 1883-94 from London.

RUTHERFORD, Miss Dorothy b.1897
Born Glasgow 29 October 1897, daughter of Dr Rutherford. A medical student for three years before studying at Edinburgh College of Art, Glasgow University and in Paris.

RUTHERSTON, Albert Daniel RWS NEAC
 1881-1953
Born Bradford 5 December 1881, younger brother of Sir William Rothenstein. Studied at Slade 1898-1902. Exhibited at NEAC, RWS from 1901. Elected NEAC 1905, ARWS 1934, RWS 1942. Changed his name to Rutherston 1914 for political reasons. Served in Palestine 1916-19. Ruskin Master of Drawing, Oxford 1929-48. Lived in the Cotswolds and in London. Died Ouchy-Lausanne, Switzerland 14 July 1953.
Represented: NPG London; Tate; VAM.

RUTLAND, Marion Margaret Violet, Duchess of
(Mrs Manners née Lindsay) 1856-1937
Born Haigh Hall, Wigan 7 March 1856, daughter of Colonel the Hon Charles Hugh Lindsay and granddaughter of 24th Earl of Crawford. Exhibited at NWG, RA (17), in France and America 1881-1931 from Belvoir Castle, Leicestershire. A member of Leicester Society of Artists. Said to be a striking beauty. Married Henry Manners, private secretary to Lord Salisbury 25 November 1882 (he became Marquess of Granby and succeeded to the Dukedom of Rutland 1906). Published *Portraits of Men and Women* (containing 51 drawings), 1900. Among her sitters were Queen Victoria, Cecil Rhodes and George Meredith. Died London 22 December 1937.
Represented: SNPG; Louvre; Birmingham CAG; Tate; Leicester CAG.

RYAN, Francis fl.1756-1788
'Francis Ryan, portrait or face painter' applied for admission to the Corporation of Painter-Stainers, the Guild of St Luke 9 November 1756. Admitted on the condition that he did not practise as a house painter. His name continues in list of members until 1788.

RYCK, John de fl.c.1710
A competent portrait in Archers' Hall, Edinburgh of a man in Archers' Company uniform is signed 'John de Ryck Fecit'. Possibly the son of Willem de Ryck.

RYCK (RYKE), Willem (Guillaume) de fl.1673-c.1699
Studied under Erasmus Quellinus at Antwerp. Master in Antwerp Guild 1673/4. Working in London by 1688. Died London. Signed 'G. de Ryke'.

RYDER, Platt Powell 1821-1896
Born Brooklyn 11 June 1821. Exhibited at NA 1850. Elected ANA 1868. Studied in Paris and London 1869-70. Based in Brooklyn. A founder of Brooklyn Academy. Died Saratoga Springs 15 July 1896.

RYMSDYK, Andreas van 1754-1786
Son and pupil of Dutch artist and engraver John van Rymsdyk. Won a premium for drawing at SA 1765 aged 11, and for a mezzotint in 1767. Exhibited portraits and miniatures at SA (9), RA (3) 1769-78. In 1778 he collaborated with his father on *Museum Britannicum*, which contained engravings of natural history. Worked as a portrait painter in Norwich 1781. Died Bath 13 November 1786.
Represented: VAM; NGI.

RYMSDYK, Jan (John) van fl.1760-1778
Painted portraits in Bristol 1760-70. Published with his son *Museum Britannicum*, 1778 containing engravings of natural history. A portrait of the Bristol antiquary, 'Dr William Barrett, 1764' at Bristol CAG, is recorded as by Andreas van Rymsdyk, but is more likely to be by John van Rymsdyk.

S

SABATIER (SABATTIER), Louis Remy fl.1894-1910
Born Annonay. Studied with Gérôme and de Boulanger.
Exhibited at Paris Salon from 1890. Contributed to *The Graphic*.

SADLER, Thomas c.1630-c.1685
Son of John Sadler, a Master in Chancery, and his wife Jane
(née Trenchard). Educated at Lincoln's Inn. Intended for a
legal career before studying for a short time under Lely.
According to information supplied to Walpole by his grandson,
Robert Seymour Sadler, he at first painted miniatures for his
amusement and took up portraiture towards the end of his life,
having 'by unavoidable misfortune been reduced to follow that
profession'. A Nonconformist. Painted John Bunyan 1684
(NPG London). His son, Thomas, was also an artist.
Engraved by E.Whymper.

SADLER, William d.c.1788
Born England, son of a musician. Taken as a boy by his father
to Dublin. Entered Dublin Drawing School 1765. Awarded
a premium 1768. Produced portraits in oil, crayons,
miniatures and mezzotint. Patronized by La Touche family.
Exhibited at SA. Believed to have died in Dublin c.1788.
Literature: Strickland.

ST MICHEL, Chevalier de see SAN MICHEL, Giuseppe

SAINTON, Charles Prosper RI 1861-1914
Born London 23 June 1861. Educated at Hastings School,
Harrow. Studied art at Slade, and in Florence and Paris.
Exhibited at RA (5), Paris Salon 1886-9 from London. Moved
to New York, where he died in the Presbyterian Hospital 7
December 1914. Left £1178.14s. to his widow, Amy.
Literature: *Who Was Who 1897-1915*.

SALABERT, Firmin fl.1836-1845
Born Gaillac. Studied under Ingres. Worked in Paris and
London. Exhibited at RA (16) 1836-45 from London.
Attracted many continental sitters. Painted two portraits of artist
'Monsieur Pouchée', the second when Pouchée was aged 106.
Engraved by J.Brandard, W.Sharp and W.Taylor.

SALABOS(SH), Melchior fl.1571-1588
Portrait and herald painter. Commissioned by the Cornewall
family to produce a monument with full-length portraits and
elaborate heraldry at Burford, Salop 1588.
Literature: *The House of Cornewall*, Hereford 1908 p.210;
Country Life, 26 December 1947 pp.1310-13; DA.

SALAMAN, Miss Julia (Mrs Goodman) 1812-1906
Exhibited at RA (9), BI (2), SBA (18) 1834-89 from London.
Married L.Goodman c.1835/6. A member of SWA. Among
her sitters were Earl of Westmorland, artist Fanny Corbeaux, Sir
Francis H. Goldsmid Bart MP and Sir George A.MacFarren.

SALISBURY, Francis (Frank) Owen RI ROI RP
 1874-1962
Born Harpenden 18 December 1874. Apprenticed to his
brother James in a stained glass works. Studied at Heatherley's
under John Crompton, RA Schools from 1892 (winning
Landseer Scholarship) and in Italy, Germany and France.

FRANCIS (FRANK) OWEN SALISBURY. Maude, Lady in
brown. Exhibited 1899. Signed. 56 x 41ins (142.2 x 104.2cm)
Christie's

Exhibited at RA (78), RHA (1), RP (76), ROI, Paris Salon
(Gold Medallist) 1899-1943 from London and Harpenden.
Elected RP 1917. Painted some of the leading figures of the day
including George V and other members of the royal family,
Lord Simon, Churchill, Roosevelt, Eisenhower, Mussolini, Sir
William Blake Richmond and Richard Burton. Died Hampstead
31 August 1962. Studio sale held Christie's 25 September 1985.
Represented: NPG London; Art Workers' Guild, London;
Walker AG, Liverpool; Brighton AG; Laurens Art Museum,
Laurel, Mississippi. **Literature:** B.A.Barker, *The Art of F.S.*,
1936; F.O.Salisbury, *Portrait Pageant* (memoirs), 1944.

SALISBURY, J. fl.1783-1784
Worked from Dilton's Marsh, Wiltshire. Exhibited at FS (1),
RA (1) 1783-4, including a portrait of Lady Weymouth
1784. His work varies in quality, but can be sympathetic and
sensitive, painted with soft colouring.
Represented: Longleat.

SALTER, Mrs M.Faulkner fl.1843-1858
Exhibited at RA (3), RHA (2), BI (2), SBA (1) 1843-58 from
London.

SALTER, William RBA 1804-1875
Born Honiton, Devonshire 26 December 1804. Studied under
James Northcote in London 1822-7. Travelled in Italy and
spent some time in Florence, where he established a reputation.
Member of Academy of Fine Arts, Florence. Returned to
London 1833. Exhibited at RA (6), BI (28), RHA (5), SBA
(101) 1822-75. Elected RBA 1847 and Vice President. Painted

ANTHONY FREDERICK AUGUSTUS SANDYS. Lady Jean Palmer. Signed, inscribed and dated 1896. Coloured chalks on blue-grey paper. 25½ x 18½ins (64.8 x 47cm)
Christopher Wood Gallery, London

the Duke of Wellington on a number of occasions and his 'Waterloo Banquet' (1833, NPG London) was popular as an engraving. Commissioned by royal command to paint the portrait of 'His Majesty the King of Holland' 1845. Died London 22 December 1875. Adopted a linear style.
Represented: Walker AG, Liverpool; Stratfield Saye.
Engraved by W.Barnard, J.Cochran, T.Lupton, C.E.Wagstaff.

SALTER, William Philip　　　　　fl.1847-1851
Exhibited 1847-51 at RA (4), BI (1), SBA (1) from London.

SAMPSON, J.　　　　　fl.1840-1842
Exhibited portraits and miniatures at RA (3) 1840-2 from London.

SAMUEL, Richard　　　　　fl.1768-1787
Entered RA Schools 1770. Exhibited at SA (5), RA (16) 1768-85 from London. Assistant Secretary to SA 1779, where he twice won Gold Medals for the best original historical drawing, and a premium for laying mezzotint grounds. Had a preference for neo-classical compositions. Published a short pamphlet *On the Utility of Drawing and Painting,* 1786. A group of female portraits by him was engraved as 'The Nine Living Muses of Great Britain'.
Represented: NPG London. **Engraved by** J.Jones, Page.

SANDERS, George　　　　　1774-1846
Baptized at Kinghorn, Fifeshire 4 May 1774, son of George Sanders and Jean (née Bruce). Apprenticed at Kinghorn to a coach painter named Smeaton. Set up as a miniaturist, drawing master and illustrator in Edinburgh. Moved to London by c.1807 and was concentrating on oil portraits by c.1811. Established a successful practice, Farington recording that he 'gets 250 guineas for a wholelength'. Charged £800 for his portrait of Lord Londonderry. Is said to have risen at 4am and worked until 8pm. His most famous work is 'Cock of the North: George, 5th Duke of Richmond and Lennox' (Goodwood). Also painted portraits of Lord Byron (engraved by Finden). Exhibited at RA (5) 1834. Made many visits to the Continent. Suffered from an inflammation of the eye. Died London 26 March 1846. Often represented his male sitters in fancy dress. His name has been spelt variously Saunders, Sandars and he is sometimes confused with miniature painter, George Lethbridge Sanders (1807-63) and George Sanders, the Dublin artist and engraver.
Represented: SNPG; Dunham Massey, NT; Glasgow University; HMQ. **Engraved by** J.Burnet, J.Cochran, E. & W.Finden, E.J.Harty, J.Houbraken, J.R.Jackson, J.Lucas, H.Meyer, H.T.Ryall, P.Tanjé, C.Turner, W.Ward jnr. **Literature:** *The Times* 28 March 1846; Geoffrey Wills, 'A Forgotten Scottish Painter', *Country Life* 8 October 1953; McEwan.

SANDERS, James　　　　　fl.1848
Listed as a portrait painter at 10 Stoney Gate, Preston, Lancashire.

SANDERS, John snr　　　　　fl.1750-1783
Exhibited at RA 1771-4. Produced mostly pastel portraits at Norwich and Stourbridge, Worcestershire. Probably the Sanders who took John Hodges Benwell as his pupil. His son, John, was also an artist.
Engraved by J.Wilson.

SANDERS, John jnr **1750-1825**
Born London, son of artist John Sanders. Entered RA Schools 21 August 1769 (Silver Medallist 1770). Exhibited at SA, FS, RA 1775-88, and possibly until 1824, but he is confused in the catalogues with both his father and the mezzotint engraver and miniaturist Joseph Saunders. Married Rebecca Arnold of Norwich in London 9 July 1780. Painted portraits in oil and crayon. Worked in London, Norwich (1777-81), London again until settling in Bath 1790. Died Clifton. His works are well drawn, and some show the influence of Lawrence. He stopped calling himself 'jnr' in 1784, after his father's death. His son John Arnold Sanders was also an artist.
Represented: NPG London; BM.

SANDERS, Miss Margery Beverly **ARMS** **b.1891**
Born London 1 June 1891. Studied in London, Paris and Brussels. Exhibited at RA (5), RMS, Paris Salon and in the provinces 1912-21 from Bath.

SANDERS, Miss Marianne **fl.1859-1886**
Exhibited at RBSA (31) 1859-86 from Birmingham.

SANDERSON, Henry **1808-1880**
Born Philadelphia 24 August 1808. Settled in New Brunswick 1830. Spent the rest of his life there, except for a visit to London c.1841. Exhibited at NA 1841-4. Died New Brunswick 23/24 December 1880.
Literature: *Dictionary of Artists in America,* 1966.

SANDERSON, Robert **fl.1865-1906**
Exhibited RSA (106). Listed as a portraitist at 6 Forrest Road, Edinburgh.
Represented: Glasgow AG; Edinburgh AG. **Literature:** McEwan.

SANDERSON-WELLS, John **RI** **1872-1955**
Born August 1872. Studied at Slade and Académie Julian, Paris. Painted accomplished sporting scenes and portraits. Along with Heywood Hardy and George Wright painted in the new illustrators' style, combining a bright palette with a lively and fresh composition. Exhibited at RA (33), RI 1895-1945. Died 16 March 1955.

SANDYS (SANDS), Anthony **1806-1883**
Son of a Norwich shoemaker. Began as a dyer at Stark and Mills, but later became a drawing master, portrait painter and miniaturist in Norwich. Married Mary Ann Brown at Heigham, Norfolk 22 December 1828. Died Norwich March 1883 aged 77. His son, Anthony Frederick Augustus Sandys, was also an artist.
Represented: NPG London.

SANDYS (SANDS), Anthony Frederick Augustus
 1829-1904
Born Norwich 1 May 1829, son of artist Anthony Sandys. Educated at Norwich Grammar School. Studied at Government School of Design, Norwich and RA Schools under George Richmond and Samuel Laurence. Won Royal Society of Arts' medals 1846 and 1847. Exhibited under the name of Frederick Sandys at Norwich Art Union, RA (47), BI (2), GG 1839-86 from London and Norwich. Among his sitters were Lord Henry Loftus, Leopold de Rothschild, Robert Browning and Matthew Arnold. Met Rossetti and Swinburne and became a member of the Pre-Raphaelite circle. His oil portraits are highly finished and have been compared with Holbein. After c.1880 he began to concentrate largely on chalk drawings, which were mostly produced in pale colours on light blue paper. His female portraits often include a background of symbolic flowers. Also produced a number of small chalk drawings of writers commissioned by Alexander Macmillan 1880. Died London 25 June 1904. The work of his sister, Emma, is sometimes attributed to him.
Represented: NPG London; Ashmolean; Manchester CAG; BM; VAM; Tate; Fitzwilliam; Castle Museum, Norwich; Brighton AG; Birmingham CAG; Leeds CAG; Ulster Museum;

JAMES SANT. Mrs John Foster. Signed with monogram. 57 x 34ins (145 x 86cm) *Christopher Wood Gallery, London*

Cartwright Hall, Bradford. **Engraved by** W.J.Edwards, R.J.Lane, J.H.Lynch, G.J.Stodart. **Literature:** T.Crombie, 'Some Portraits by F.S.', *Apollo* November 1965; E.Wood, 'Being a Consideration of the Art of Frederick Sandys', *The Artist* Winter No. November 8 1896; B.Elzea, *F.S.,* Brighton exh. cat. 1974; *The Pre-Raphaelites,* Tate exh. cat. 1984; DNB; *Art Journal,* 1884 pp.73-8, 1905 pp.80-2; DA.

SANDYS, Miss Emma (Mary Ann) **1843-1877**
Baptized Mary Ann Macie Negus Sandys, daughter of Anthony Sandys. Exhibited at RA (5) 1868-74 from Norwich. Among her sitters were Lady Winifred Herbert, daughter of the Earl of Caernarvon, and the Duchess of St Albans. Died Norwich December 1877. Worked in the Pre-Raphaelite manner. Sometimes signed with a monogram.

SAN MICHEL, Giuseppe **fl.1756-1785**
Piedmontese portrait painter. Exhibited under the name of 'Chevalier de St Michel' at RA (6) 1785. Commissioned to paint the portrait of a Savoy princess for her nurse 1756.

SANT, James **CVO RA** **1820-1916**
Born Croydon 23 April 1820. Studied under John Varley, Augustus Wall Calcott and at RA Schools 1840-4. Exhibited

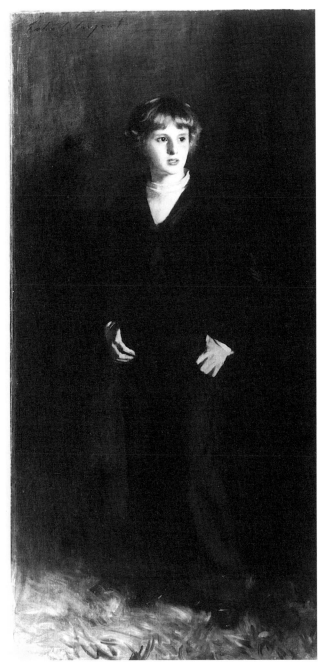

JOHN SINGER SARGENT. Major C.E. Harrison as a boy.
Signed. 68 x 33ins (172.7 x 83.8cm) *Southampton CAG*

at RA (330), RHA (2), SBA 1840-1916 from London.
Elected ARA 1861, RA 1869. Painted 'HRH Prince
Leopold' and 'HRH the Princess Beatrice' by command of
Her Majesty the Queen 1870, and two years later the group
portrait: 'Her Majesty the Queen, with her Grandchildren,
the Princes Albert, Victor and George, and Princess Victoria
of Wales'. Appointed Principal Painter in Ordinary to Her
Majesty 1871. Established a remarkably successful society
practice and had a prolific output. His later works were
painted with more freedom. Awarded CVO 1914. Died
London 12 July 1916 aged 96. Left effects of
£35,981.16s.7d. Roger Simon writes that his work is 'always
impressive on any scale'. Mrs E.M.Ward described an incident
with one sitter: '. . . the lady arrived, thickly covered with

powder and rouge. "I see we both paint," was his only
remark'. Often portrays his sitters with dark, slightly sunken
eyes. Also painted figures into the landscapes of his brother,
George.
Represented: NPG London; HMQ; Tate; Southampton
CAG; Wallace Collection. **Engraved by** T.O.Barlow,
R.J.Lane, S.W.Reynolds jnr, C.W.Waas. **Literature:** Mrs
E.M.Ward, *Memories of 90 Years*, c.1922; *Studio* 68 1916;
Maas; DA.

SARGENT, Frederick **d.1899**
Baptized George Frederick Francisco Sargent at St Martin's,
Pomeroy 11 June 1837, son of George Frederick Sargent and
Rosa Francesca Narcissa (née Alferes). Exhibited at RA (10)
1854-74 from London. Queen Victoria sat for a large
miniature by him. Died Fulham 14 April 1899.
Represented: SNPG; NPG London; BM.

SARGENT, Henry NA **1770-1845**
Born Gloucester, Massachusetts 25 November 1770. Studied
under West in London 1793-7. Exhibited at RA (2) 1795-6.
Left London for Boston 1797, where he painted portraits in
the manner of Stuart, as well as interiors. Also a politician and
mechanical inventor. Died Boston 21 February 1845.
Represented: Boston MFA. **Literature:** J.Addison, *Art in
America*, XVII October 1929 pp.279-84.

SARGENT, John Singer RA RP **1856-1925**
Born Florence 12 January 1856, son of Fitzwilliam Sargent,
a retired Philadelphia doctor. As a boy he travelled with his
parents widely in Europe. Studied in Rome under Carl
Welsch 1868-9, under Joseph Farquarson, at Florence
Academy 1870, Dresden 1871-2, Venice 1874 (where he was
encouraged by Whistler) and with Carolus-Duran in Paris
1874. Went to America 1876 and then travelled widely,
including Spain c.1879 and Holland. Was influenced by
Velázquez, Hals, Manet and Degas. First exhibited at Paris
Salon 1878 and was working professionally from 1879.
Settled in London c.1885 and by c.1890 had established
himself as a fashionable portraitist. Exhibited at RA (80), RSA
(21), RHA (18), NEAC (61), GG, RP (17), NWG 1882-
1925. Elected NEAC, ARA 1894, RA 1897, RP 1903. By
the end of the century he was acclaimed as England's greatest
portrait painter since Lawrence and was the most successful
international society portraitist, regularly visiting the United
States to fulfil commissions. Largely gave up portraiture
c.1906 for landscape and decorative painting, producing
murals for the city of Boston. Described by William
Starkweather as 'An American, born in Italy, educated in
France, who looks like a German, speaks like an Englishman,
and paints like a Spaniard'. Osbert Sitwell said that he held up
a mirror to the rich so that 'looking at his portraits, they
understood at last how rich they really were'. Died of
degenerative heart disease in London 15 April 1925. Buried
Woking. Memorial service held in Westminster Abbey on 24
April. Studio sale held Christie's 24 and 27 July 1925 fetched
£175,260.
Represented: NPG London; SNPG; Boson MFA;
Metropolitan Museum, New York; Tate; HMQ; NGI;
Birmingham CAG; BM; Fitzwilliam; Southampton CAG;
Manchester CAG; Clandon Park, NT; Imperial War Museum.
Engraved by G.A.Manchon, F.Short. **Literature:** Mrs
Meynell, *The Work of J.S.S.*, 1903; W.H.Downes, *J.S.S.*, 1925;
A.Stokes, 'J.S.S.', OWS III 1925; E.Charteris, *J.S.S.*, 1925;
M.Hardie, *J.S.S.*, 1930; C.M.Mount, *J.S.S*, 1957;
M.Birnbaum, *J.S.S. – A Conversation Piece*, 1941;
R.Ormond, *J.S.S., Paintings, Drawings, Watercolours*, 1970;
D.F.Hoopes, *Sargent Watercolours*, 1971; S.Olson, *J.S.S., His
Portrait*, 1986; C.Ratcliff, *S.*, 1982; W.Starkweather, 'The
Art of J.S.S.', *Mentor* October 1924; DA.

SARONY, Napoleon 1821-1896
Born Quebec 9 March 1821. Went to New York c.1836, visiting Europe and England c.1868. Specialized in charcoal portraits, but then concentrated as a photographer. Died New York 9 November 1896.
Literature: *Dictionary of Artists in America.*

SARTAIN, John 1808-1897
Born London 24 October 1808. Apprenticed to an engraver 1823. Emigrated to America 1830, settling in Philadelphia. Engraved for magazines and bank note work. Also produced portraits and miniatures. Died Philadelphia 25 October 1897.
Literature: J.Sartain, *Reminiscences of a Very Old Man*, 1899.

SARTORIS, E.J. fl.1879
Exhibited a portrait at GG 1879 from London.

SARTORIUS, G.W. fl.1773-1779
Exhibited at FS (5) 1773-9 from London.

SASS, Henry 1788-1844
Born London 24 April 1788. Studied at RA Schools c.1805 under Fuseli. Exhibited at RA (84), BI (8), SBA (3) 1807-39. Painted figurative and historical subjects, but towards the end of his career concentrated almost exclusively on portraits. Married the wealthy Mary Robinson (a relative of the Earl of Ripon) 10 June 1815. Visited Italy 1815-17. Published *A Journey to Rome and Naples*, 8 vols 1818, which stimulated considerable interest. Close friends with E.Landseer, Etty and J.M.W.Turner. Remembered largely for his influential art school at Bloomsbury, where many important Victorian artists studied including Millais, Cope, Frith and Frost. Retired after an accident 1842, and F.S.Cary took over. Died 21 June 1844.
Literature: *Art Union* 1844 p.332.

SATCHWELL, Robert William fl.1793-1818
Son of William Satchwell and Charlotte (née Willis). Exhibited at RA (61) 1793-1818 from London. Painted miniatures and watercolour portraits. His sitters included Dr Monro, G.Barret, J.Varley and S.Prout.
Represented: VAM. **Engraved by** D.Lundin, Mackenzie, H.Meyer, J.Thomson.

SAUBER, Robert Herrman (Herman) RBA
 1868-1936
Born London 12 February 1868 (baptized 3 May 1868), son of Herrman August Sauber (a German watchmaker and jeweller) and Frances Emily (née Hancock). His grandfather was animal artist Charles Hancock. Studied at Académie Julian, Paris and in Munich. Exhibited at RA (8), SBA (15), NWG, ROI, RMS; Paris Salon (medal winner 1907) from London and Hartwell, near Northampton. Elected RBA 1891, RMS 1896 and acted as VPRMS 1896-8. Also worked extensively as an illustrator for many of the leading magazines. A director of United Arts Ltd. Moved to Hartwell, near Northampton c.1925. His wife, Elizabeth, died 25 November 1934. Died London 10 September 1936. A gifted, sensitive and accomplished portraitist with a talented eye for the flamboyant. His studio was bombed during the 2nd World War and a large number of his works were lost.
Represented: VAM. **Literature:** *The Artist* June 1897 pp.241-8; *Art Journal* 1899 pp.1-6.
Colour Plate 65

SAUBERGUE, John b.1803
Baptized in St Giles, Cripplegate 6 March 1803, son of George and Elizabeth Saubergue. Exhibited at RA (1), BI (3), SBA (2) 1827-30 from London.

SAUNDERS 1682-c.1735
Provincial portrait artist. Worked mostly in crayon. A 'Self-portrait' in NPG London bears a redone inscription 'Saunders Ipse Pinxit. Aetatis 50 / November the First Anno 1732'. Worked in the Cambridge area in the 1720s.
Represented: Emmanuel College.

SAUNDERS, Miss Margaret E. fl. 1904-1918
Exhibited at RHA (44) 1904-18 from Dublin and London.

SAUTER, Professor George RP IS 1866-1937
Born Rettenbach, Bavaria 20 April 1866. Studied at Munich Royal Academy. Moved to London 1889. Exhibited at RHA (4), RA (1) 1897-1912. Elected RP 1898. Moved to Germany 1915. Died December 1937, after a highly distinguished career.
Literature: *Who Was Who 1929-40.*

SAUVEUR fl.1772
Exhibited at SA (3) 1772 from London.

SAVAGE, Edward 1761-1817
Born Princeton, Massachusetts 26 November 1761. Began as a goldsmith. Worked in Boston from 1785. From 1789-91 he was in New York to paint a portrait of Washington. Visited England and studied under West 1791-3. Philadelphia from 1795 and New York 1800-10, then settled in Boston. Also an engraver and teacher and had a museum. Died Princeton 6 June or 6 July 1817.
Represented: NG Washington; US Naval Academy Museum, Annapolis; Pennsylvania Historical Society. **Literature:** *Art in America*, XI 4 1952 pp.157-212; DA.

SAVAGE, Reginald fl.1886-1904
Illustrated for Essex House Press. A talented designer and woodcut artist. Also produced portraits. His work was admired by Walter Crane. Exhibited at RA (1), SBA (2), RI, ROI 1886-1904.
Represented: VAM.

SAVILL, Miss Edith fl.1880-1881
Exhibited at RA (4) 1880-1 from London.

SAVILL, Miss Gertrude Mary 1863-1941
Born Croydon. Exhibited at RA (10) 1891-1936 from Brighton. Died Brighton 26 February 1941.

SAVILL, Miss Josephine fl.1863-1878
Exhibited at RA (3) 1863-78 from East Hill, Colchester.

SAWYER, Mrs Ethel fl.1898-1900
Exhibited at RA (2) 1898-1900 from Bushey Heath, Watford.

SAWYER, William 1820-1889
Born Montreal of English parents. Began in law. Studied art in New York 1851, and later in London, Paris and Antwerp. Returned to Canada and settled in Kingston, Ontario where he had a successful practice. Died Kingston 9 December 1889.

SAXON, James b.1772
Born Manchester 1 March 1772, son of John Saxon and his wife Mary (née Ryder). Exhibited at RA (17) 1795-1817 from London. Painted a number of portraits of actors in character. Believed to have worked in Edinburgh c.1803-5 (painting Sir Walter Scott and his wife), St Petersburg after 1809 and Glasgow shortly before his death. His death has been listed as about 1816, 1817 and 1828.
Engraved by H.Meyer, W.Ridley, W.Say, T.Wageman.

SAY, Frederick Richard b.1805
Baptized St Marylebone, London 1 February 1805, son of engraver William Say and Eleanor (née Francis). Exhibited at

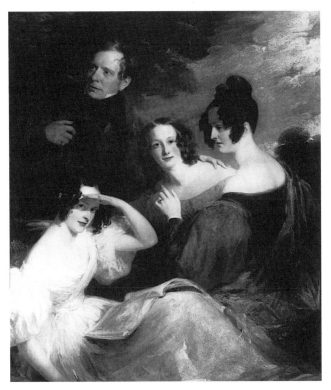

FREDERICK RICHARD SAY. Robert Robertson, his wife Bridget and daughters, Bridget and Amelia. Exhibited 1836. 64 x 50ins (162.6 x 127cm) *Christie's*

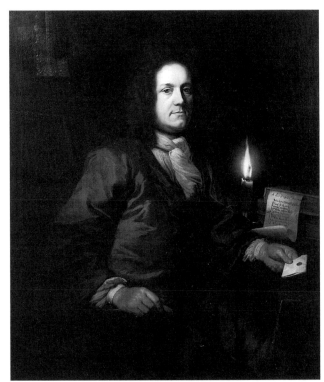

GODFRIED SCHALCKEN. John Acton, solicitor of Basingstoke. Signed. 50 x 40ins (127 x 101.6cm) *Christie's*

RA (78), BI (8), SBA (1) 1825-54. Worked from various addresses in London. Settled at 18 Harley Street 1837, where he enjoyed a highly successful society practice. Able to afford two nurses and five servants in 1851 census. Among his sitters were George IV, Earl Grey, HSH the Duke of Saxe-Coburg and Gotha, HRH Prince Albert and the Archbishop of York.
Represented: NPG London; SNPG; Saltram, NT; Powis Castle, NT; India Office, London. **Engraved by** T.L.Atkinson, Blanchard, S.Cousins, J.Edwards, W.Giller, W.Holl, J.R.Jackson, F.C.Lewis, T.Lupton, W.H.Mote, W.Say, J.Thomson, W.Walker, G.R.Ward.

SAYER, George **b.1831**
Born Beccles, Suffolk. Showed a precocious talent. Exhibited at RA (3), SBA (1) 1843-8 from London.
Engraved by J.Cochran.

SAYERS, Reuben Thomas William **1815-1888**
Born Birmingham. Brought up in Taunton (where his father Robert was Barrack Sergeant) and in Langport, Somerset. His first known portraits were painted in 1840 of William Quekett, headmaster of the Grammar School and his family. About this time he moved to London, where he was based for the rest of his life, except for a period in Edinburgh 1843-5. Married Eliza Mellis 1842 and had three daughters and two sons. She died 1852 and he married again the following year, Mary Anne Parker, a London widow. Exhibited at RA (13), BI (9), SBA (9), RHA (2), Portland Gallery (21), RSA (8), West Scotland Academy of Fine Arts (6), RBSA (13), RMI (28), LA (5) 1841-68. Among his sitters were Lord Kensington, Field-Marshal Viscount Beresford, Alexander Beresford-Hope MP and 'Rt Hon W.E.Gladstone in His Robes as Chancellor of the Exchequer'. Also painted genre and biblical subjects, as well as copies and church commissions. His second wife Mary died 1868 and he married Sarah Gould Marchant from North Curry, Somerset

1876 (they had two sons). Died Hammersmith 18 October 1888. A number of his works were formerly at Great Tew. His colouring is often rich, based on a careful study of Italian art.
Represented: Salford AG; Manchester CAG; the Institute of Directors, Pall Mall; Hatfield House; Hardwick Hall; All Saints Church, Langport, Somerset; St Peter's Church, Hammersmith; St Peter's Church, Hever, Kent. **Engraved by** G.T.Payne, W.Walker. **Literature:** *Athenaeum* 27 October 1888; *The Year's Art* 1889 p.256; L.Sayer's private notes.

SCADDON, Robert **fl.1743-1774**
Painted portraits and miniatures. Engraved mezzotints. A charming full-length portrait of William Rice signed and dated 1744 sold Christie's 31 March 1944, lot 104. Worked in the manner of Hudson.

SCANLAN, Robert Richard **c.1801-c.1876**
Born Ireland. Entered RA Schools 30 December 1822 aged 21. Exhibited at RHA (36), RA (17), BI (3), SBA (3) 1826-64 from Plymouth and London.
Engraved by J.Brown, H.Cook, E.Scriven.

SCARFE, F. **fl.1825**
Exhibited a portrait of 'Patriarch Isacarus, of Bethlehem, Archbishop of Jerusalem' at RA (1) 1825 from Marylebone.

SCARROW, Thomas **b.1810**
Born Cockermouth. Studied under Joseph Sutton. Exhibited at RA (1) 1831 from London. Married at Annan, Dumfriesshire 1833. Repeated the ceremony in Cockermouth the same year.

SCHAAK, J.S.C. **fl.1760-1770**
Possibly the John Schaak of Delft who became a denizen 1731. Signed and dated portraits of English sitters are known 1760-70. Exhibited at FS (17), SA (7) 1761-9. Listed as a

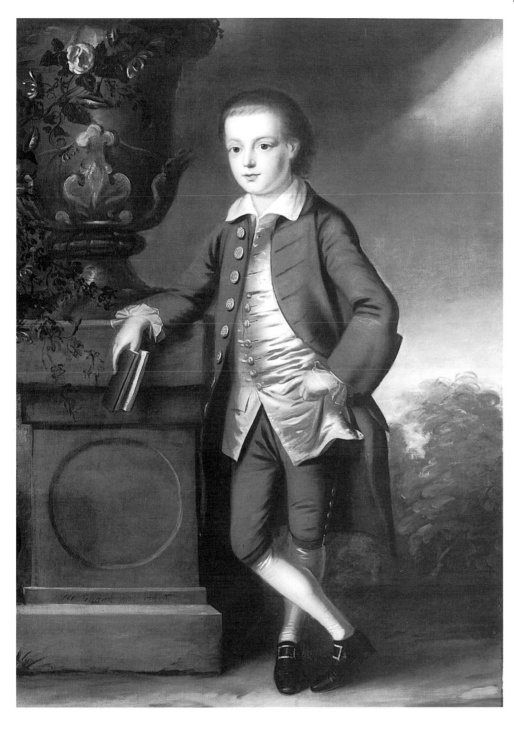

J. S. C. SCHAAK. James Mendham. Signed and dated 1768. 49½ x 33¼ins (125.7 x 84.5cm) *Christie's*

portrait painter in Westminster 1763.
Represented: NPG London. **Engraved by** P.Audinet, J.Barbie, T.Burford, C.Fox, S.Freeman, R.Houston, A. & E.Smith, C.Spooner.

SCHALCKEN, Godfried 1643-1706
Born Made, near Dordrecht. Studied under G.Dou. May have visited England briefly before arriving with his family 1692. While in this country he painted the portrait of William III and was patronized by Lord Sunderland at Althorp. Specialized in candlelit portraits. Returned to Holland c.1697. Died at The Hague 13 or 16 November 1706.
Represented: NG London; Brighton AG. **Literature:** DA.

SCHARF, George 1788-1860
Born Mainburg, Germany son of a tradesman. Studied in Munich, Paris and Antwerp. Attached to the British Army in Waterloo campaign. Moved to London 1816. Exhibited at RA (28), SBA (4) 1817-50 from London. Died London 11 November 1860. Father of Sir George Scharf.
Represented: Brighton AG.

SCHARF, Sir George KCB, FSA 1820-1895
Born London 16 December 1820, son of the artist George Scharf: Studied at RA Schools. Director of NPG London. Knighted 1895. Exhibited at RA (6), BI (2) 1845-6. Among his sitters were Florence Nightingale and Thomas

411

Carlyle. Died London 19 April 1895.
Represented: NPG London (including notebooks).
Engraved by W.Holl, J.Sartain. **Literature:** DNB; DA.

SCHEFFER (SCHYFER), Ary 1795-1858
Born Dordrecht 10 February 1795, son of Jean Baptist
Scheffer. Exhibited at Amsterdam Salon, when he was 12.
Studied in Paris under Pierre Guerin. Worked in Paris (where
his studio is now a museum), and briefly in London.
Exhibited at RA (3) 1851-6. Painted portraits of Charles
Dickens (NPG London) and Lord Dufferin. Died Argenteuil,
near Paris 15 June 1858.
Represented: NGI; Versailles; Louvre; Petit Palace, Paris;
Musée de la Vie Romantique. **Engraved by** G.T.Doo.
Literature: DA.

SCHEFFER, F. fl.1707-1711
Painted 'Bishop Ken' 1711 at Bishop's Palace, Wells.
Engraved by G.Vertue, R.White.

SCHEPPELEN fl.1768
Exhibited at SA (1) 1768 from Soho.

SCHICK, P. fl.1853-1854
Exhibited at RA (4) 1853-4 from Hastings and Ryde.

SCHILLER, H. Carl fl.1844-1867
Exhibited at RA (2), SBA (2) 1844-67 from London and
Liverpool.

SCHLOESSER (SCHLOSSER), Carl Bernard b.1832
Born Darmstadt. Studied under Couture and at École des
Beaux Arts. Exhibited at Paris Salon from 1861. Living in
London by 1890. Recorded 1914.

SCHMÄCK, Miss Emily fl.1837-1843
Exhibited at RA (20) 1837-43 from London.

SCHMALZ (CARMICHAEL), Herbert Gustave
** 1856-1935**
Born Ryton, County Durham, son of Gustave Schmalz,
German Consul. Exhibited at RA (46), RHA (5), GG, NWG
1879-1922 from London. Visited Jerusalem and the Holy
Land 1890. Changed his name to Carmichael (his mother's
maiden name) 1918. Died 24 November 1935.
Literature: T.Blakemore, *The Art of H.S.*, 1911.

**SCHMID (SCHMIDT), Louis Carl Friedrich Ludwig
(Louis)b.1799**
Born Stettin, son of Peter Schmidt and brother of Wilhelm
Schmidt. Studied in Berlin and Paris. Worked at Aix-la-Chapelle
and in Rome 1831-3. Moved to London 1834-5 and again 1842.
Exhibited at RA 1834-57. Some of his works are inextricably
confused with those of Guido Schmitt. Among his sitters were
HRH Prince of Prussia, artist F.Nadrop and the Duke of Sussex.
Engraved by L.Schmid.

SCHMIECHEN, Hermann fl.1884-1895
Exhibited at RA (7) 1884-95 from London. Exhibited by
Command of Queen Victoria a portrait of 'HRH the Princess
Frederica of Hanover' 1884. Established a successful society
portrait practice.

SCHMITT, Guido Philipp 1834-1922
Born Heidelberg, Baden, son and pupil of Georg
Philipp Schmitt. Left Heidelberg for London c.1860,
settling at 291 Regent Street. Exhibited at RHA (3), RA,
BI (3) 1857-84. His exhibited works are confused with
those of Louis Schmid. Died Miltenberg 8 August 1922.
His portrait drawings are remarkably sensitive and accomplished.

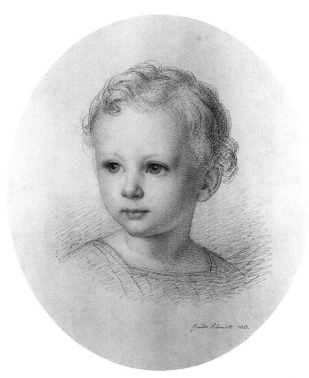

GUIDO PHILIPP SCHMITT. Basil Oswald Smith. Signed and
dated 1863. Pencil. 15¾ x 12⅜ins (40 x 31.5cm).
Private collection

SCHMUTZ, Rudolphus 1670-c.1715
Born Regensberg, Zürich 2 January 1670, son of a parson.
Studied under Matthias Fussli the younger. Worked in
London. Studied under Kneller in whose style he painted
from 1702. Died London 1714/15.
Engraved by J.Faber, J.Smith, G.Vertue.

SCHOFIELD, John William RI RBA RBC d.1944
Studied under Fred Brown at Westminster School of Art and
in Paris under Bouguereau and Lefebvre. Exhibited at RA
(28), Paris Salon 1889-1925 from Halifax, Devon and
London. Elected RBA 1903, RI 1917. Died 23 October 1944.

SCHOLDERER, Otto 1834-1902
Born Frankfurt 25 January 1834. Studied there at State
Institute 1849-52 under J.D.Passavant and J.Becker.
Exhibited at RA (44), SBA (7), GG 1874-96 from Putney
and London. Naturalized. Also visited Paris, where he was
friendly with Manet, Fantin-Latour and Leibl. Returned to
Frankfurt 1899. Died Main 22 January 1902.
Represented: Sheffield AG. **Literature:** DA.

SCHOONJANS, Anthonie c.1655-1726
Born Antwerp. Studied under Erasmus Quellinus at Antwerp
1668/9 and in Italy (via Paris and Lyons) for about ten years,
painting religious, decorative history paintings and many
portraits. Worked in Vienna from 1693 and later in Denmark
and Germany. Moved to London c.1715, where he met with
much encouragement and painted a staircase (now destroyed)
at Little Montague House, London. Returned to Vienna,
where he was much honoured and employed. Died Vienna.
Engraved by J.Nutting. **Literature:** Pilkington.

SCHRÖDER, Georg Engelhard 1684-1750
Born Stockholm 30 May 1684, seventh child of V.E.Schröder
and his wife Lucia Lindemeijer. His family were German

goldsmiths. Worked under David von Kraft. Studied with Kneller for three years before 1702, and then visited Paris and Italy. Worked in Vanderbank's Academy in St. Martin's Lane, London about 1720-4. Returned to Sweden as Court Painter. Died Stockholm 17 May 1750.

SCHRODER, H.　　　　　　　　　**fl.1793**
Exhibited at RA (3) 1793 from London.

SCHUERMANS, Jan　　　　　　　**fl.1710**
Provincial portrait painter probably working in Kent. Sometimes signed and dated his work on the back.

SCHUNEMANN, L.　　　　　　　**fl.1651-1674**
Worked in Scotland during the middle 1660s. Painted Ann Lindsay, Duchess of Rothes.
Represented: SNPG. **Literature:** McEwan.

SCHWANFELDER, Charles Henry　　**1774-1837**
Born Leeds 11 January 1774, son of a house decorator and painter of tea-trays and snuff boxes. Spent most of his career based at Leeds (with frequent visits to London) painting landscape, portraits and sporting subjects. Exhibited in Leeds and at RA (11), BI (6) 1809-35. Appointed Animal Painter to the Prince Regent, 1815. Died London 9 July 1837.
Represented: Leeds CAG. **Engraved by** C.Turner.

SCHWARTZ　　　　　　　　　　**fl.1768**
Exhibited at SA (1) 1768 from London.

SCHWITER, Baron Louis Auguste　　**1805-1889**
Born Nienbourg 1 February 1805. Exhibited at RA (5) 1833-48 from Paris and London. Established a highly successful French portrait practice. A friend of Delacroix whom he painted. Went blind. Died Salzburg 20 August 1889.
Represented: Louvre. **Literature:** DA.

SCLATER-BOOTH, Miss　　　　**fl.1881-1884**
Exhibited at GG (3) 1881-4 from London.

SCORE, William　　　　　　**fl.1778-c.1815**
Born Devonshire. Assistant to Reynolds about 1778-84. Said by Northcote to have painted the Dulwich replica of 'Mrs Siddons as the Tragic Muse'. Exhibited at RA (14) 1781-94 from London. Later in Scotland. Exhibited landscapes in Dublin 1812 and 1815. Produced a mezzotint of his own portrait of 'John Quick, the Comedian'.

SCOTT, Benjamin　　　　　　　**1823-1898**
Apprenticed to the drawing and engraving department of Halliday & Co, Wigton, but lost his job when the company was damaged by fire 1847. Became a commercial traveller for a drapery company. Then set up a photography business in Carlisle 1858 and specialized in painting photographic portraits, but also produced conventional portraits.
Represented: Carlisle AG. **Literature:** Hall 1979.

SCOTT, Edmund　　　　　　　**1758-c.1810**
Born Holborn 28 March 1758, son of Henry Scott and Ann (née Rawlet). Exhibited at FS (5), RA (1) 1774-96 from London. Entered RA Schools as an engraver 1781. Studied under Bartolozzi. Appointed Engraver to the Duke of York c.1789. Listed in Brighton 1800-7. Painted Duke of Richmond. Took on Charles Shoesmith as an apprentice 1800-7.
Represented: Brighton AG. **Engraved by** J.Godby, W.Haines.

SCOTT, Emily　　　　　　　　**b.1801**
Born Brighton, where she practised as a portrait and landscape painter. Aged 50 in 1851 census. Sometimes confused with miniaturist, Emily Anne Scott b.1828, daughter of William and Sarah Scott.

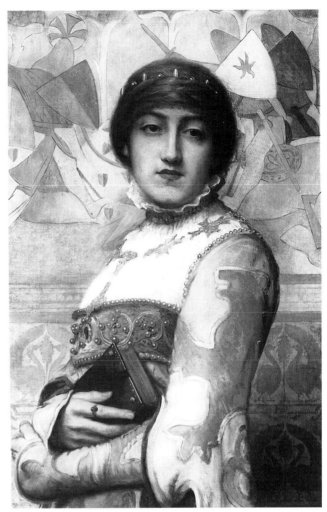

JOHN SCOTT JNR. Marquenrite. Signed and dated 1881. 25¾ x 16 ins (65.4 x 40.6cm)　　　　　　　　　*Phillips*

SCOTT, Miss J.E.　　　　　　**fl.1863-1867**
Exhibited at RA (5) 1863-7 from Hammersmith.

SCOTT, James　　　　　　　　**b.1802**
Entered RA Schools 1 April 1826 aged 24. Exhibited at RA (18), BI (3), SBA (14) 1821-44 from London. Possibly the James Scott, who was listed as a portraitist at 63 Frederick Street, Edinburgh 1859-60.

SCOTT, James Fraser　　　　　**1878-1932**
Born New Zealand 24 September 1878. Educated in Dunedin. Studied at Académie Julian, Paris and Munich Academy. Exhibited at RA (5), Paris Salon 1919-32 from London. Official war artist, who worked in Australian War Records section with rank of captain during the 1st World War. Later employed at St John's Wood painting war pictures for Australian War Museum. Died in poverty in London 26 April 1932.

SCOTT, John jnr　RI RBA　　　**1849-1919**
Born Carlisle, son of John Scott. Began by painting portraits and other works at Carlisle. Moved to London to study at Heatherly's and RA Schools. Exhibited at RA (20), SBA, BI, RI 1872-1908. Elected RBA 1882, RI 1885. Died London. Buried St Pancras Cemetery.
Represented: Carlisle AG.

SCOTT, Montague b.c.1835
Born Middlesex. Son of William and Sarah Scott, brother of Walter and William Wallace Scott. Exhibited at RA (1) 1854 from Park Village East.

SCOTT, Walter fl.1831-1853
Son of artist William and Sarah Scott, and brother of Montague and William Wallace Scott. Exhibited at RA (11), SBA (3) 1831-53 from Sussex Cottage, Park Village East. Among his sitters was artist Thomas Sidney Cooper 1842. Engraved by G.J.Stodart for Cooper's autobiography *My Life*, 1890.
Represented: Canterbury Museums; NPG London.

SCOTT, William Wallace 1820-1905
Born Leicester 1 August 1820, son of artist William Scott and his American wife Sarah. Brother of Walter, Montague and Emily Anne Scott, who lived for a time at the same address in Park Village East, London. Exhibited at RA (35), BI (1), SBA (1) 1841-59. Among his sitters were Thomas Webster RA and Admiral Sir William Parker, Bart GCB. Worked in Manchester 1855. Moved to New York after 1859, where he died 5/6 October 1905.
Literature: *American Art Annual* 6 1907-8 p.115.

SCOUGALL, David fl.1654-1677
Scottish portraitist who painted Lady Jean Campbell in 1654 (SNPG). Little is known of his life, despite the high quality of many of his attributed paintings. Copied Michael Wright and Van Dyck.
Represented: SNPG. **Literature:** J.Holloway, *Patrons and Painters – Art in Scotland 1650-1760*, SNPG exh. cat. 1989.

SCOUGALL, George fl.1694-1737
Son of artist John Scougall. Worked in Scotland. Painted portraits for Glasgow Town Council 1715-24.

SCOUGALL, John c.1645-1730/7
Possibly born Leith, a son or nephew of artist David Scougall, with whom he is likely to have trained. Paid £36 for two portraits at Penicuik House 1675. Married in Aberdeen 1680. Established a successful practice in Edinburgh. Considered the leading Scottish portraitist until the arrival of Medina. Fond of painting busts in ovals. Known as 'Old Scougall' to distinguish him from his son George, also a painter. Retired 1715. Died Prestonpans 1730 or 1737. By then he was rich, with property in Edinburgh and lucrative salmon fishing on the Don near Aberdeen, where his wife originated. His earliest works show the influence of John Michael Wright, but he was also influenced by Van Dyck in handling and colour. His later works show a fondness for almond shaped eyes.
Represented: SNPG; Glasgow AG; Fyvie Castle, SNT; Edinburgh AG. **Engraved by** C.R.Ryley. **Literature:** *Scottish Art Review* Vol IV-I 1952; McEwan.

SCROTS (SCROTES), William (Guillim) fl.1537-1553
A native of The Netherlands where he was painter to Mary of Hungary, Regent of The Netherlands 1537. Persuaded to move to England 1545, to succeed Holbein and to work in the service of Henry VIII. Paid an annual grant of £62.10s. This was continued through the period when Henry's son Edward VI, a boy under the guidance of Protectors, ruled in name. He disappears from the royal accounts 1553. It is not known what happened to him after this date. A remarkably capable artist, working in the Mannerist style. He elongated figures to heighten gracefulness of effect.
Represented: Arundel Castle; HMQ. **Literature:** DA.

SCRYMGEOUR, J.M. fl.1825-1836
Exhibited at RA (3), BI (2), RSA (1), SBA (3) 1828-36 from London and Edinburgh. Among his sitters were Major-General Stuart of Garth, CB FRSE and the Earl of Airlie. **Engraved by** G.H.Every.

SEAGRAVE, H.W. fl.1819-1827
Exhibited at RA (2) 1819-27 from London.

SEATON, John Thomas see SETON, John Thomas

SEAWARD, Mary L. fl.1903-1915
Hampshire artist.
Represented: Southampton CAG.

SEBBERS, L.H. fl.1849-1854
Exhibited at RA (8) 1849-54 from London.

SECCOMBE, Mr fl.1774
Exhibited at SA (1) 1774 from London.

SEDDON, Miss M. fl.1896
Exhibited at RA (2) 1896 from London.

SEEMAN, Enoch c.1694-1744
Born Danzig. Trained by his father, who brought him as a boy to London. Established a highly successful practice by 1717, when he painted George I (Middle Temple) and Elihu Yale (Yale). Charged 20 guineas for a full-length in 1732. His last and largest work is the 'Lady Cust and Nine Children' (1743 Belton). Died London March 1744. His son Paul is recorded as a painter. His brother Isaac was also an artist.
Represented: Sudbury Hall, NT; Leeds CAG; Canterbury Museums; NPG London; Yale; HMQ; Metropolitan Museum, New York; Durham Massey, NT; Belton House, NT. **Engraved by** J.Bockman, J.Clark, J.Faber jnr, J.Folkema, J.Halpin, F.M.La Cave, J.McArdell, J.Simon, G.Vertue. **Literature:** DA. Colour Plate 66

SEEMAN, Isaac d.1751
Born Danzig, younger brother of Enoch Seeman, in whose manner he painted. Possibly visited Norwich. Died London 4 April 1751.
Engraved by J.Faber jnr, G.Vertue, A.Walker.

SEGAR, Francis fl.1598
Son of Francis Segar and Anne (née Sherrard). Brother of artist Sir William Segar. A 'councillor' or servant to Maurice, Landgrave of Hesse. Listed as a leading painter by Francis Meres in *Wits Commonwealth*, 1598. Believed to have spent much time out of England. There is confusion between William and Francis over authorship of works.
Literature: D.Piper, 'The Lumley Inventory', *Burlington Magazine*, 1957.

SEGAR, Sir William fl.1585-1633
Son of Francis Segar and his wife Anne (née Sherrard). Said to have trained as a scrivener. Encouraged by the patronage of Sir Thomas Heneage. Freeman of Stationers Company 1557. Worked as portrait painter, miniaturist and herald. Author of several heraldic treatises. Somerset Herald 1588/9. Appointed Garter King of Arms 1603 or 1607. Knighted 1616. His brother Francis was also a painter, and there is some confusion between them. One of them enjoyed a highly successful practice at the end of Queen Elizabeth's reign. William died 11 December 1633. Buried in the chancel of Richmond Church.
Represented: NGI. **Literature:** E.Auerbach, *Nicholas Hilliard*, 1961 p.271; DNB; DA.

SEIN, Mangul fl.1859
Exhibited at SBA (1) 1859.

SELF, Sarah fl.1832-1834
Listed as a portrait painter in London.

SELLAR, Charles A. RSW 1856-1926
Born Edinburgh. Graduated in law at Edinburgh University
before taking up art. Exhibited RA (2), RSA (23), RHA (2),
RI (1). Worked as a watercolour portraitist in Perth from
1888. Died Perth.
Represented: Dundee AG. **Literature:** McEwan.

SELOUS, Constance fl.1882-1883
Possibly studied in Paris. Exhibited at Liverpool Autumn
Exhibition and RHA 1882-3 from London. Related to
H.C.Selous. Her work could reach a high standard.
Influenced by the French Academicians.

SELOUS, Miss Dorothea Medley RBA fl.1908-1952
Born London. Studied at RA Schools. Exhibited at RA (9),
SBA, NEAC and Paris Salon 1908-52 from London and
Brighton. Married artist R.Kirkland Jamieson.

SELOUS (SLOUS), Henry Courtney c.1811-1890
Born Deptford 1803 or 1811 (conflicting sources). Son of
miniaturist George Slous. Studied under John Martin and at
RA Schools. Exhibited at RA (34), BI (23), RHA (4), SBA (9)
1818-85, at first under the name of Slous, but from 1837 he
altered the spelling to Selous. Won a £200 premium in the
Westminster Hall Cartoon Competition 1843. Also an
important illustrator and wrote children's books under the
name of Aunt Cae and Kay Spen Died Beaworthy, Devon 24
September 1890. Collaborated with artist George Lance.
Represented: NPG London; VAM; BM; Fitzwilliam.
Literature: Wood; Bénézit; Houfe; DA.

SENDELL, John fl.1836
Listed as a portrait painter at Heigham Grove, Norwich.

SÉNÉCHAL, Alexandre b.1767
Entered RA Schools 1795. Exhibited at RA (1) 1795 from
London.

SENGA fl.1872
Exhibited at SBA (1) 1872 from Devon Lodge, Starcross, Devon.

SENHOUSE, George c.1739-c.1794
Born Netherhall, near Maryport, son of a landowner. Studied
under Arthur Devis from May 1752, but in April the
following year he contracted smallpox. Made a full recovery
and became an ensign in the 20th Regiment Foot 1755,
commanded by Lieut-Colonel James Woolfe. He got into
trouble and had to be bought out of Canterbury Gaol by his
father. A short time later he was sent to an asylum in Preston,
where he remained for the rest of his life.
Literature: E.Hughes, *North Country Life in the 18th
Century* Vol II, 1965 pp.89-99; Hall 1979.

SENIOR, Oliver b.1880
Born Nottingham 21 September 1880. Studied at
Manchester School of Art 1896-1903, RCA 1903-7 and in
France and Belgium. Exhibited at RA (2) and in the
provinces. Member of London Portrait Society.

SENTIES, T. fl.1852-1858
Exhibited at RA (18), SBA (7) 1852-8 from London. Among
his sitters were the Duchess of Montrose, Lady Otway, Sir
John Marcus Stewart and portrait artist Richard Buckner.
Probably Pierre Asthasie Théodore Senties born Dieppe 1801.
Engraved by W.T.Davey.

SERGEANT, John fl.1833-1844
Listed as a portrait painter at 69 Newman Street, London.

SERRES, Dominic Michael b.c.1761
Younger son of Dominic Serres RA. Worked as a drawing

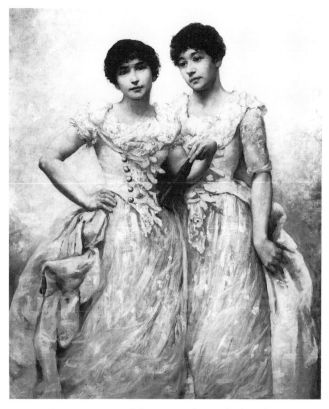

CONSTANCE SELOUS. The actress Gertrude Angela Kingston
(née Konstam) and her sister, Florence Cecilia Price with a red
fan. 50 x 40ins (127 x 101.6cm) *Christie's*

master and painted landscapes mainly in watercolour, but also
occasionally portraits. Exhibited at RA (9) 1778-1804.
Married Lucretia Madden 4 August 1788 at Marylebone,
London. Travelled to France and Italy, returning 1804.

SERSHALL, George Joseph fl.1871-1893
Exhibited at RBSA (38). Listed in directories for Birmingham
1876-84.

SERVANDONI, Giovanni Niccolò 1695-1766
Born Florence 2 May 1695. Moved to London 1749, where
he painted theatrical scenery, architectural decoration and
some portraits. Exhibited at SA (16), FS (4) 1774-8 from
London. Died Paris 19 January 1766.
Literature: DA.

SERVANT, J. fl.1764-1768
Exhibited at FS (2) in 1764. A provincial style portrait of the
7th Earl of Traquair signed and dated 'J.Servant 1768' is at
Traquair House.

SETCHEL, Miss Elizabeth fl.1831-1845
Exhibited at RA (6), BI (1), SBA (2) 1831-45 from London.
Sister of artist Sarah Setchel.

SETCHEL, Miss Sarah RI 1803-1894
Born London. Studied under L.Sharpe and in BM and NG
London. Awarded a premium at SA 1829. Exhibited at RA
(9), SBA (15), NWS 1831-40 from London. Elected RI
1841, but resigned 1886. Her engraved drawing of 'The
Momentous Question' was extremely popular. Developed
poor sight and painted little after 1860. Died a spinster at
Sudbury, Middlesex 9 January 1894.
Represented: VAM.

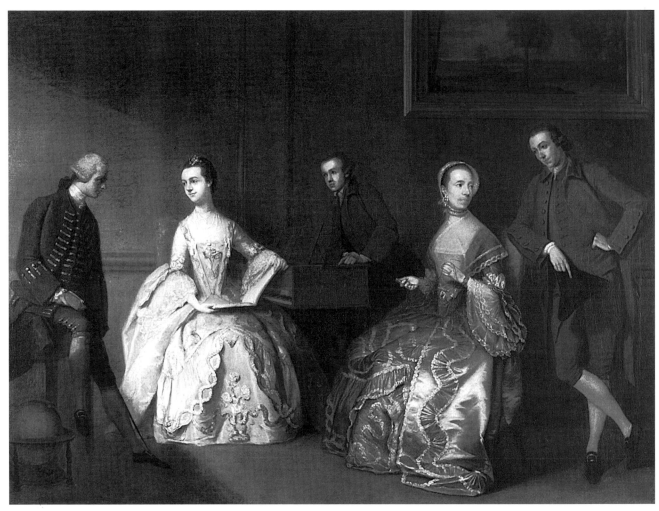

JOHN THOMAS SETON. Robert Chambers and family. Signed. 37 x 49ins (94 x 124.5cm) *Christie's*

SETON, John Thomas FSA fl.1758-1806
Reportedly born London, son of Christopher Seton a gem engraver. Studied under F.Hayman and at St Martin's Lane Academy. Exhibited at SA (15), RA (3) 1761-74. Elected FSA 1769. Travelled to Rome 1758-9. Worked in Bath from 1766, Edinburgh from 1772, India 1774, back in Edinburgh until 1776, when he moved to Calcutta until 1785. Returned to Edinburgh 1785, when Ozias Humphry recorded that he had 'just returned to England after an easy time in Bengal and with twelve thousand pounds in his pocket'. Still working Edinburgh 1806. Specialized in small full-length conversation pieces in the manner of Zoffany. His portrayal of sitters can be remarkably sensitive and of a very high standard.
Represented: SNPG.

SEVERN, Benjamin fl.1766-1772
Exhibited at SA (1), RA (1) 1766-72 from London.

SEVERN, Joseph 1793-1879
Born Hoxton 7 December 1793, son of James Severn, a musician. Apprenticed to an engraver. Entered RA Schools 24 November 1815, winning a Gold Medal for historical painting 1819. Accompanied his dying friend John Keats to Rome 1820 and was present at his death 1821. Married Lord Montgomerie's daughter 1828. Set up practice as a portrait painter in Rome, staying there until 1841, when he returned to London. Exhibited at RA (53), BI (9), OWS 1819-57. Among his sitters were John Keats, His Excellency Chevalier Bunsen, the Prussian Ambassador, the Countess of Eglinton with her son Lord Montgomerie, and Lady Anne Beckett. Appointed British Consul in Rome 1860. Remained there until his death 3 August 1879. Buried Protestant Cemetery, Rome in a grave next to Keats. Three of his children, Joseph Walter and Ann Mary were also painters.
Represented: NPG London; SNPG; Walsall AG; VAM.
Engraved by S.Cousins, W.H.Mote. **Literature:** W.Sharp, *The Life and Letters of J.S.*, 1892; S.Birkenhead, *Against Oblivion, the Life of J.S.*, 1943; H.E.Rollins, *The Keats Circle*, 1948; S.Birkenhead, *Illustrious Friends – The Story of J.S. and His Son Arthur*, 1965; DA.

SEYMOUR, Edward fl.1743-1757
From Twickenham. A number of portraits of the Fonnereau family of Ipswich dating 1743-5 are signed 'E.Seymour de Twickenham'. Painted in a provincial style. Influenced by Kneller.

SEYMOUR, Robert **1798-1836**
Born Somerset (some accounts say London), son of a
gentleman who had become a cabinet maker. Apprenticed to
a pattern drawer in Spitalfields, before taking up painting.
Exhibited at RA (1) 1822 from London. Married Jane
Holmes 1827. Shot himself in London 20 April 1836.
Literature: Houfe; DA.

SEYMOUR, Walter **b.1851**
Baptized 10 July 1851 in St Pancras, son of William and Eliza
Seymour. Exhibited at RA (10), SBA 1873-1914 from
London, including a portrait of 'Miss Ellen Terry as Lady
Macbeth'.

SHACKLETON, John **d.1767**
Married Mary Ann Regnier 25 Oct 1742 and that year settled
in London, where he was believed to have been a pupil of
Richardson. Succeeded William Kent as Principal Painter in
Ordinary to George II, 1749. Through error he kept the
office under George III, although Ramsay painted the official
portraits. Exhibited at FS (6) 1763-6. One of the original
committee who drew up the first proposal for RA. Died
London 16/17 March 1767.
Represented: NPG London; SNPG; Foundling Hospital;
Fishmongers' Hall; H.M.Treasury; Maidenhead Museum.
Engraved by J.Basire, W.Blake, J.Faber jnr, R.Houston,
J.Stenglin. **Literature:** J.R. Fawcett-Thompson, *Connoisseur*
CLXV August 1967 pp.232-9.

SHACKLETON, William NEAC **1872-1933**
Born Bradford 14 January 1872. Studied at Bradford
Technical College, RCA, Académie Julian, Paris and Italy
1896. Exhibited at RHA (10), RA (4), NEAC 1902-19.
From 1905 worked mainly in London. Made frequent
sketching tours around Amberley with his friend William
Stott. On the outbreak of war he moved to a cottage in
Malham, Yorkshire. Died London 9 January 1933.
Represented: Manchester CAG; Tate; Brighton AG;
Cartwright Hall, Bradford.

SHAND, J. **fl.1818-1820**
Exhibited at RA (5) 1818-20 from London. Among his
sitters were Lord Charles Spencer Churchill, Frederick
Fitzclarence Esq of the Coldstream Guards, and Richard
Armit Esq, 3rd Regiment of Guards.
Engraved by R.Cooper.

SHANKS, William Somerville RSA RSW 1864-1951
Born at Gourock, Renfrewshire 24 or 28 September 1864,
son of John Shanks, portioner. Began his career as an
industrial designer, but took up art. Studied at Glasgow
School of Art under F.H.Newbery and in Paris under Laurens
and Constant. Exhibited at RSA (74), RA (6), in Prague and
Munich with the Glasgow Group. Elected ARSA 1923, RSW
1925, RSA 1933. Married Jessie Anderson 1909. Taught
drawing and painting at Glasgow School of Art 1910-39.
Died Glasgow 28 July 1951.
Represented: SNPG; Glasgow AG; Edinburgh AG.
Literature: McEwan.

SHANNON, Miss Caroline **fl.1859**
Exhibited at RHA (4) 1859 from Dublin.

SHANNON, Charles Haslewood RA ARPE RP
 1863-1937
Born Quarrington or Sleaford, Lincolnshire 26 April 1863.
Studied wood engraving at Lambeth School of Art 1882,
when he met Charles Ricketts. They became life-long
companions, living together and collaborating on paintings
and book illustration until Ricketts' death in 1931. They were

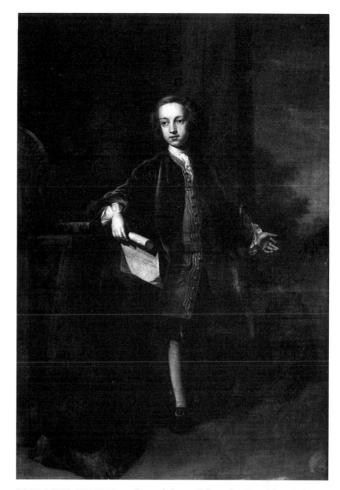

JOHN SHACKLETON. Gerard Anne Edwards. Signed and dated
1743. 70¼ x 46⅞ins (178.5 x 119.1cm) *Christie's*

nicknamed 'Orchid' and 'Marigold' by Oscar Wilde. Shannon
also painted portraits including those of Ricketts, L.Pissaro
and S.Moore. Exhibited at RA (58), RHA (3), SBA, GG,
NWG, NEAC, International Society 1885-1937. Elected RP
1898, ARA 1911, RA 1920. Awarded Gold Medal in Munich
1897. Associate of Société Nationale des Beaux Arts, Paris. In
1929 he fell from a ladder and was incapacitated, hardly
recognizing friends. Survived until 18 March 1937, when he
died at Kew. His early works were usually signed with initials
'C.H.S.' while later he signed with 'C.S.' only.
Represented: NPG London; Tate; Castle Museum,
Nottingham; Fitzwilliam; Walker AG, Liverpool; BM;
Leicester AG. **Literature:** *Art Journal* 1902 pp.43-6;
C.Ricketts, *A Catalogue of Mr Shannon's Lithographs*, 1902;
T. M.Wood, 'The Lithographs of C.H.S', *Studio* 33 1905
pp.26-34; George Derry, *The Lithographs of C.S. with a
Catalogue of those issued between 1904 and 1918*, 1920; 'Tis',
C.S. ARA (Masters of Modern Art with list of works to 1919),
1920; DNB; J.Darracott, *The World of Charles Ricketts*,
1980; DA.

SHANNON, Sir James Jebusa RA RBA ARHA
 1862-1923
Born Auburn, New York 3 February 1862 of Irish parents.
Arrived in London aged 16. Studied at South Kensington
under E.Poynter 1878-91, receiving Gold Medal for figure
painting. Established an extremely successful portrait
practice. Exhibited at RA (157), RHA (9), SBA, GG, NWG,

RP (54) 1881-1923. Elected founder NEAC 1886, founder RP 1891, ARA 1897, RA 1909, PRP 1910-23. Awarded three First Class Medals at the Paris exhibition, and at Berlin and Vienna. Knighted 1922. He placed a large mirror behind him in the studio so that sitters could watch the progress of the painting. Died Kensington 6 March 1923. Several of his portraits won awards and his confident painterly style was considered by many to rival Sargent's.
Represented: NPG London; SNPG; Tate; Chatsworth; Plas Newydd, NT; Usher Gallery, Lincoln; Walker AG, Liverpool; Preston Manor, Brighton; Lady Lever AG, Port Sunlight. **Engraved by** C.W.Sherborn. **Literature:** *Art Journal* 1901 pp.41-5; A.L.Baldry, 'J.J.S – Painter', *Magazine of Art* November 1896; B.D.Gallati, 'J.J.S.', *Antiques* November 1988; K.McConkey, *Edwardian Portraits*, 1987; DNB; *The Times* 7 March 1923.
Colour Plate 67

SHARP, George RHA 1802-1877
Born Dublin, son of George Sharp, manager of the Kildare Street Club. Studied in Paris under Picot and Couture. Worked for a time in London. Exhibited at RHA 1835-66. Elected ARHA 1842, RHA 1860. In 1868 he was 'stricken with paralysis'. Died Dublin 5 December 1877. His portraits were usually painted in a broad, free and confident manner.
Literature: Strickland.

SHARP, Michael William d.1840
Studied under Beechey and at RA Schools. Member of Sketching Society 1808. By 1813 he was living with and studying under J.Crome at Norwich. Exhibited at RA (46), BI (30), SBA (9) 1801-36 from London. Among his sitters were HRH Princess Elizabeth, HRH the Princess Augusta and the Chamberlain of Norwich. Died Boulogne.
Represented: VAM. **Engraved by** T.Cheeseman, S.Freeman, M.Gauci, W.Say, J.Stow.

SHARPE Sisters, Charlotte, Eliza, Louisa, Mary Anne
Four daughters of Birmingham engraver William Sharpe. They all painted portraits, miniatures and figurative subjects. All were members of OWS. The eldest Charlotte c.1794-1849 exhibited at RA and OWS. Married Captain T.Best Morris 1821. A sad portrait of 'Mrs T.B.Morris, her Son and Deceased Infant Daughter' was painted by Louisa and exhibited at RA 1824. Eliza was born Birmingham August 1796. Exhibited at RA, OWS (87). Elected a lady member of OWS 1829. Died unmarried in Burnham, Maidenhead 11 June 1874. Louisa 1798-1843 was born in Birmingham and was the most prolific of the sisters. Her exquisitely finished costume pieces were a great attraction at OWS, and a number of her works were engraved in *The Keepsake*. Elected a lady member of OWS. Married Dr Waldemar Seyffarth 1834 and went to live in Dresden, where her husband was a professor. Died there 28 January 1843. The youngest, Mary Anne, 1802-67, was also born in Birmingham. Elected an honorary member of SBA 1830 and remained unmarried. The RA catalogues confuse the sisters and it is difficult to determine the exact number of pictures exhibited by each. However, the family's output was considerable.

SHARPE, George RHA fl.1835-1880
Exhibited at RHA (82) 1835-80 from Dublin. Elected ARHA 1832, RHA 1860.

SHARPE, Joseph Frederick 1807-1885
Baptized London 14 October 1807, son of Thomas and Frances Sharpe. Exhibited at RA (30), SBA (19) 1826-38 from London and Southampton c.1835 (where he exhibited at Henry Buchan's Gallery in the High Street). Among his sitters were Henry Buchan jnr and Mrs Shayer, the second wife of artist William Shayer. Also listed as a photographic

artist and drawing master in Southampton 1865. Died Camberwell 4 July 1885.

SHARPE, Matilda 1830-1915
Daughter of Egyptologist Samuel Sharpe. Her work has much charm.
Represented: NPG London.

SHARPLES, Ellen Wallace 1769-1849
Born 4 March 1769, possibly in Birmingham. Studied under James Sharples at Bath, and became his third wife 1787. Moved to America c.1793, settling first in Philadelphia, then in New York. After her husband's death 1811 she returned to England, living in Bristol. Died Bristol 14 March 1849.
Represented: NPG London. **Literature:** K.McCook Knox, *The Sharples*, 1930.

SHARPLES, Felix Thomas c.1786-after 1824
Son of James Sharples, by his second wife. Studied portraiture under his father and began independently 1806, when he was in America for the second time. Worked in Virginia and North Carolina.
Literature: K.McCook Knox, *The Sharples*, 1930.

SHARPLES, George c.1787-1849
Youngest son of artist James Sharples. Brought up in America, but after the death of his father in 1811 he travelled to England with his mother. Exhibited at RA (6) 1815-23 from London.
Represented: NPG London. **Engraved by** R.Cooper, J.Hopwood, T.Lupton, P.Roberts, C.Turner. **Literature:** K.McCook Knox, *The Sharples*, 1930.

SHARPLES, James c.1751-1811
Born Lancashire, of a Roman Catholic family. Sent to France to be educated for the priesthood. Gave this up to follow art and is believed to have been a pupil of Romney. Exhibited at Liverpool 1774 and at RA (14) 1779-85. Worked in Cambridge from 1779, Bath and Bristol 1781-2, London 1783-5, and then Bath and Liverpool. Also an inventor and designed a steam carriage. From about 1793-1801 he practised in Philadelphia (where he painted George Washington) and New York and returned to Bath 1801-9, but went back to New York 1809 to join his sons. Died there 26 February 1811. Often produced small pastel portraits in profile, mostly on thick grey paper with sensitive draughtsmanship. Also oils. His third wife Ellen Wallace, whom he married 1787, made copies of his crayon portraits. Three of his children also worked in pastel.
Represented: Bristol AG; Metropolitan Museum, New York; Boston Museum; Independence Hall, Philadelphia. **Engraved by** C.H.Hodges, J.Hopwood, P.Roberts. **Literature:** K.McCook Knox, *The Sharples*, 1930.

SHARPLES, James jnr c.1788-1839
Son of James Sharples and Ellen (née Wallace). Studied portraiture under his father and began independently in England aged 15. Visited America 1806 and returned to England after 1811. Died Bristol 10 August 1839.
Literature: K.McCook Knox, *The Sharples*, 1930.

SHARPLES, James 1825-1893
Born Wakefield. Started work in his father's foundry in Bury. Copied engravings and attended drawing classes at Bury Mechanics' Institute c.1841. Gave up work at the foundry and set up as a portrait painter, but was unable to earn a living and returned to the foundry, painting in his spare time.
Literature: J.Baron, *J.S. – Blacksmith and Artist*, n.d.; *The Times* 15 June 1893.

SHARPLES, Miss Rolinda 1793-1838
Born Bath (not New York), daughter of James Sharples. Moved

with her family to America 1796-1801. Returned with them to Bath until 1809, when she and her family went back to America. After her father's death in 1811 she moved to Clifton, Bristol, painting portraits and miniatures. Exhibited at RA (8), SBA (11) 1820-36. Died of cancer Bristol 10 February 1838. Influenced by Edward Bird.
Represented: Bristol AG. **Literature:** A.Wilson, 'Rolinda Sharples and Her Family', *Country Life* 4 January 1968; F.Greenacre, *The Bristol School of Artists*, exh. cat. 1973; DA.

SHAW, James fl.1769-1784
Born Wolverhampton. Entered RA Schools 1769, becoming a pupil of E.Penny. Exhibited portraits and wax portraits at RA (5) 1776-87 from London, where he died. His portrait of '6th Earl of Stamford as a Boy' 1773 is at Dunham Massey, NT. Painted in the manner of Wright of Derby.

SHAW, James fl.1845
Listed as a portrait painter at Lewisham, Kent.

SHAW, William Drury fl.1830-1841
Listed as a portrait and animal painter in Nottingham.

SHEAF, Horatio Sydney b.c.1811
Baptized Portsea 6 January 1811, son of Thomas and Sarah Sheaf. Exhibited at RA (1) from London and worked in Portsmouth.

SHEARD, Thomas Frederick RBA 1866-1921
Born Oxford 16 December 1866. Studied in Paris under G.Courtois, A.Rigolot and J.Lefebvre. Exhibited at RA (27), SBA, RI 1896-1921. Elected RBA 1896. Professor of Art Queen's College, London 1915. Died East Hendred, Berkshire 4 October 1921. Capable of outstanding works.
Literature: Wood.

SHEE, Sir Martin Archer PRA 1769-1850
Born Dublin 20 December 1769, son of George Shee and Mary (née Kirwan). Studied Royal Dublin Society Schools 1781-3 under Robert Lucius West, winning many premiums. Began working as a crayon portraitist in Dublin (and was well known at 16), but then concentrated on oils. Settled in London 1788 on the advice of Gilbert Stuart, from whom he may have had lessons. Entered RA Schools 1790 on the advice of Reynolds. First painted historical subjects and portraits of actors, his earlier work showing a great debt to his friend Hoppner and to Lawrence. Enjoyed a highly successful practice as a society portrait painter, and painted a number of the royal family, including the Queen. Exhibited at RA (324), RHA (6), BI (19) 1789-1845. Elected ARA 1798, RA 1800, PRA (and knighted) 1830 on Lawrence's death. Married Mary Power 6 December 1797. Moved to Cavendish Square 1799, the former residence of Romney. His career bridged the gap between the Regency portrait and the Victorian society portraits of Grant, Winterhalter and Buckner. Shee's work can be highly accomplished, and has been considerably underrated, largely because he had the misfortune to follow Lawrence. He was criticized by Haydon as being responsible for 'the tip-toe school'. He was a good President of the Academy. Also wrote *Rhymes on Art*, 1805, and other poetical works. Died Brighton 19 August 1850. His son Martin Archer Shee jnr also painted portraits. Among his pupils were Stephen Pearce, John Z. Bell and Martin Cregan.
Represented: NPG London; SNPG; NGI; HMQ; NG London; Tate; RA; Walker AG, Liverpool; Metropolitan Museum, New York. **Engraved by** S.Bellin, G.B.Black, T.Blood, J.Burnet, G.Clint, J.Colyer, H.R.Cook, R.Cooper, H. & S.Cousins, T.A.Dean, J.C.Easling, J.Ford, W.T.Fry, J.Heath, T.W.Hunt, J.Jones, C.Jousiffe, Maguire, H.Meyer, W.J.Newton, G.Parker, S.W.Reynolds jnr, W.Ridley, H.Robinson, P.Thomson,

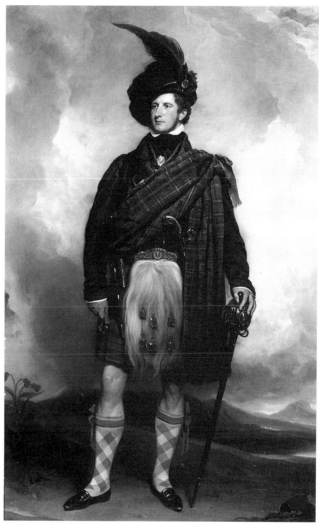

MARTIN ARCHER SHEE. James Munro Macnabb. Exhibited 1819. 92 x 36ins (233.7 x 91.5cm) *Leger Galleries Ltd, London*

P.W.Tomkins, C.Turner, Miss Turner, C.W.Waas, W.Ward, T.Williamson, J.Wright, J.Young. **Literature:** M.A.Shee, *The Life of Sir M.A.S.*, 1860; Strickland; Ottley; DA.

SHEE, Martin Archer jnr 1804-c.1899
Born London 14 November 1804, son of Sir Martin Archer Shee. Exhibited at RA (6), BI (4) 1827-33 from London. Married Louisa Catherine Barrett.

SHEENAN, William fl.1916-1917
Exhibited at RHA (3) 1916-17 from Cork.

SHEFFIELD, George 1800-1852
Born Wigton. Studied under Joseph Sutton. Worked at Whitehaven before entering RA Schools, where he was befriended and worked with Lawrence. Exhibited at Carlisle Academy (40), RA (6), SBA (2) 1823-35. Also showed work at exhibitions in Whitehaven, Dumfries and Newcastle. Opened a studio in Carlisle next to that of Samuel Bough. Travelled from his home in Wigton to commissions in Cumbria. His son, George, was also an artist.
Represented: Whitehaven Museum; County Law Courts, Carlisle; West Cumberland Hospital, Whitehaven.
Literature: Hall 1979.

SHELDON fl.1774-1775
Exhibited at FS (6) 1774-5 from London.

SHELLEY, Frank fl.1900-1907
Exhibited at RA (3) 1900-7 from London.

SHEPHERD, Robert snr fl.1830-1833
Listed as a portrait painter at Bloomsbury, London.

SHEPHERD (SHEPPARD), William c.1602-c.1660
Appears in Painter-Stainers' records 1641. Travelled in 1650
to Rome, Venice (where he painted Thomas Killigrew, NPG
London) and while travelling to Constantinople on the
Dutch ship *John Baptist* was captured and imprisoned in
Rhodes. Released by the intervention of Sir Thomas Bendish
and was by 1658 enjoying a successful practice in London.
Believed to have retired to Yorkshire. Francis Barlow was his
pupil. Bénézit says he died in Italy.
Represented: NPG London. **Engraved by** W.Faithorne,
E.Scriven, P.Tempest, J.v.d.Berghe.

SHEPPARD, Joseph 1834-1928
Born Weston-super-Mare, son of a farmer. Studied under
James A.Davis. Awarded a prize for a still-life in Weston-
super-Mare. A primitive portraitist of considerable charm.

SHEPPARD, N. see HUNTLY, Miss Nancy Weir

SHEPPERSON, Matthew fl.1832-1834
Listed as a portrait painter at 20 Sherrard Street, London.
Engraved by S.Bellin, M.Gauci.

SHERBORNE, Henry fl.1856
Listed as a portraitist at 3 Hanover Place, Walcot, Bath.

SHERIDAN, J. 1764-1790
Born Kilkenny. Studied at Dublin Society's Schools. Entered
RA Schools 1789 aged 25. Exhibited at RA (5), SA (2)
1785-90 from London. In 1785 he is listed in RA Catalogue
as R.Sheridan. Died London 'a broken man'.

SHERIDAN, J.P. fl.1835
Exhibited at RHA (5) 1835 from Dublin.

SHERLEY, (SHIRLEY) Miss C. fl.1842-1849
Exhibited at RA (1), SBA (16) 1842-9 from London.

SHERLING, J. fl.1849
Exhibited at RA (1) 1849 from London.

SHERLOCK, William FSA c.1738-c.1806
Reportedly born Dublin c.1738, son of a fencing master and
'prize fighter'. Entered St Martin's Lane Academy 1759,
winning premiums for a drawing and an engraving. Studied
engraving under J.P.LeBas in Paris 1761. Exhibited portraits,
miniatures and small full-lengths at SA (41), RA (25) 1764-1806
from London. Elected FSA 1771, Director 1772. Also a picture
dealer and copyist. His son William P. Sherlock was also an artist.
Represented: VAM. **Engraved by** J.Hall.

SHERLOCK, William P. b.1775
Son of portrait artist William Sherlock. Entered RA Schools
31 December 1794. Exhibited at RA (9) 1801-10 from
London. Produced illustrations for Dickenson's *Antiquities of
Nottinghamshire*, 1801-6.
Represented: BM; VAM; Leeds CAG; Williamson AG,
Birkenhead. **Literature:** DNB.

SHERRARD, Miss Florence E. fl.1884-1894
Exhibited at RA (8), SBA (7) 1884-94 from London.

SHERRATT, E. fl.1787-1792
Exhibited at RA (2) 1787-92 from the Strand, London.
Engraved by J.Corner.

SHERRIFF, Charles see SHIRREFF, Charles

SHERWIN, John Keyse 1751-1790
Baptized East Dean, Sussex 27 May 1751, son of woodcutter
Frances Sherwin and Martha (née Norrell). Helped his father
cut wooden bolts for shipping. Began on his own as a
woodcutter for William Mitford (on his estate near Petworth),
who encouraged him in art. Studied under John Astley 1769
and showed an early promise for drawing and engraving,
winning five awards at SA 1769-78. Entered RA Schools 7
December 1770 as an engraver (winning medals). Studied
with Bartolozzi until 1774. Exhibited at SA (1), RA (9)
1769-84. Succeeded Woollett as engraver to the King 1785/8.
Reportedly earned £12,000 a year at the height of his success,
most lost in gambling and intemperance. Died London 20
(not 24) September 1790. Buried Hampstead. Most of his
portraits were drawn skilfully in black and red chalk.
Represented: NPG London; NGI; VAM; BM; West Sussex
County Record Office. **Engraved by** W.Holl, G.Kisling,
W.Sharp. **Literature:** *Sussex County Magazine*, March 1791;
DNB.

SHIELDS, D. Gordon 1888-1943
Exhibited at RSA, RA (1), GI from Stratford and Edinburgh.
Represented: SNPG; Glasgow AG.

SHIELLS, Miss Mary fl.1783-1790
Daughter of a Lambeth nurseryman, and sister of Sarah
Shiells. Honorary exhibitor at FS (1) 1783.

SHIELLS, Miss Sarah fl.1784-1804
Sister of Mary Shiells. Exhibited at SA (4), FS (1), RA (6)
1784-90. Married John Howison in Bishopsgate 3 June 1804.

SHIELS, William RSA 1785-1857
Born Berwickshire. Founder RSA 1826. Exhibited at RSA
(112), RA (8), BI (17), SBA (12) 1808-56 from Edinburgh.
Died Edinburgh 27 August 1857. William Yellowlees was his
pupil. He was capable of conveying considerable character.
Engraved by C.Turner. **Literature:** McEwan.

SHILLINGFORD, Benjamin fl.1826-1834
Listed as a portrait painter at Islington.

SHIPLEY, Georgiana (Mrs Hare-Naylor) d.1806
Daughter of Jonathan Shipley, Bishop of St Asaph and niece
of artist William Shipley. Accomplished in modern languages.
An amateur painter, friendly with Reynolds in whose studio
she studied. Honorary exhibitor at RA (1) 1781. Married
Francis Hare-Naylor 14 November 1784 and had six children.
Began a series of pictures representing Hurstmonceaux Castle
1803, but went blind at 48. Died Lausanne 6 April 1806.
Literature: DNB (under Francis Hare-Naylor); portrait in
Sussex County Magazine, November 1932 Vol 6.

SHIPLEY, William 1714-1803
Born Maidstone, son of Jonathan Shipley and his wife Martha
(née Davies). Studied under Charles Philips. Drawing master
in Northampton 1753. Moved to London 1754, where he
opened the influential Shipley's Academy. Helped found SA
1755 and a similar society in Maidstone from 1768. Died
Maidstone 23 December 1803. Among his pupils were
Richard Cosway, William Pars, Francis Towne and Francis
Wheatley.
Literature: Sir H.T.Woods, *The History of the Royal Society of
Arts*, 1913, p.7; DNB; D.G.Allan, *W.S.*, 1968; DA.

SHIRLEY FOX, Mrs Ada R. (née Holland)
fl.1907-1916
Studied under Carolus Duran in Paris. Exhibited at RA, SBA, RI 1907-16. Married portrait painter John Shirley Fox 1912 and lived in Bath.

SHIRLEY FOX, John RBA c.1867-1939
Studied under Gérôme at École des Beaux Arts. Exhibited at RA, RBA and Paris Salon 1883-1915 from London and Bath. Married Ada Holland 1912. Died 3 June 1939. Extremely interested in coins, medals and fly fishing and published on these subjects.

SHIRREFF (SHERRIFF), Charles c.1750-c.1831
Born Edinburgh, son of Alexander Shirreff. Lost his speech and hearing when about four years old, but was able to make himself understood with signs. Educated in Edinburgh by Thomas Braidwood. Moved to London 1768. Entered RA Schools 9 August 1769, winning a Silver Medal 1772. Produced crayon portraits and histories in his earlier years, but later concentrated on miniature painting. Exhibited at FS (6), RA (77), BI (3), SBA (3) 1770-1831. Travelled widely working in Bath 1791-6; India 1797 at first to Madras and then Calcutta about 1799-1809, where he met with considerable success. On his return he settled in London and was recorded 1831. Painted a number of actors and actresses, including Mrs Siddons. Reportedly retired to Bath, where he is supposed to have died.
Represented: VAM. **Engraved by** C.Knight, C.Watson.
Literature: Foskett.

SHOESMITH, Charles 1788-1841
A Chichester portrait painter whose premises were situated in South Street. Apprenticed to Brighton portrait painter Edmund Scott from 24 September 1800 for seven years. Married Mary Cottrell at Subdeanery, Chichester 29 November 1810. Published his portrait of the Earl of March and Darnley (later 5th Duke of Richmond), engraved by T.Tirman 1814. Later in his career he moved to London, and finally to High Street, Southampton, where he died 28 March 1841 'leaving a large family of orphans to bewail his loss'. Buried Holy Rood, Southampton.
Literature: Stewart & Cutten; F.W.Steer & M.Cutten, *Chichester Papers*, 1961.

SHORTHOUSE, Arthur Charles RBSA 1870-1953
Born 30 April 1870. Educated at Shipston-on Stour. Studied at Birmingham School of Art and RBSA. Lived in Moseley, Birmingham. Exhibited at RA (6), RBSA (over 100) from 1892. Elected ARBSA 1919, RBSA 1928. Died Birmingham 19 March 1953.

SHOTTON (SHOTTEN), James 1824-1896
Born North Shields. Studied at RA Schools, where he became a close friend of Holman Hunt. After the death of his father he returned to North Shields, where he designed a Turkish bath in the town for George Crawshaw. This led to other commissions for similar designs, including one in Newcastle, where he resumed his art studies under Robinson Elliot. Exhibited at RA (1) 1863 and occasionally in Newcastle, but had a highly successful practice painting portraits (including Garibaldi) and copying old masters. Taught drawing at School of Art, North Shields. Died North Shields.
Represented: North Tyneside Public Libraries; Garibaldi Museum, Caprera, Sardinia. **Literature:** Hall 1982.

SHUBROOK, Miss Minnie J. fl.1885-1899
Exhibited at RA (20), RHA (5), SBA (12), NWS 1885-99 from London.

SHUCKARD, Frederick P. fl.1870-1901
Exhibited at RA (14), RHA (1) 1870-1901 from Peckham and Lewisham.

SHUTE, Mrs Edith L. fl.1886-1888
Exhibited at RHA (4), NWS (2), GG (1) 1886-8 from London.

SHUTE, John fl.1550-1563
Born Cullompton, Devon. Painted illuminations, portraits and possibly miniatures. Sent by Duke of Northumberland to Italy 1550, where he studied architecture. Published a book on the subject 1563. Reportedly died 25 September 1563.

SHUTER, Thomas fl.1725
Worked in Worcestershire and painted full-lengths of 2nd Earl of Plymouth and Sir John Packington 1725 (Worcester Guildhall).

SHUTER, W. fl.1771-1798
Exhibited at SA (11), FS (15) 1771-91. Signed and dated a portrait of a family group 1798.

SIBLEY, Charles c.1801-1866
Born St Giles, London. Aged 60 in 1861 census. Exhibited at RA (10), BI (6), SBA (8) 1826-47 from London. His wife Caroline was from Putney. Died London 16 April 1866. Some of his portraits were reproduced as engravings.

SICHEL, Ernest Leopold 1862-1941
Born Bradford 26 or 27 June 1862, son of a German. Studied at Slade under Legros 1877-9, and then under J.M.Swan. Exhibited at RA (10) 1885-1907 from London and Bradford. Died 21 March 1941 aged 78 and left £53,957.12s.2d. to his widow Ellen (née Thompson).

SICKERT, Walter Richard RA PRBA NEAC ARE 1860-1942
Born Munich 31 May 1860, son of Danish artist Oswald Aldabert Sickert, with whom he came to England 1868. First studied to be an actor. Entered Slade 1881, under Legros and became a pupil of Whistler. He took Whistler's 'Portrait of My Mother' to Paris 1883, where he met Degas. Both these artists had an important influence on his work. From about 1887-99 he painted a series of theatre and music-hall interiors. Exhibited at RA (25), SBA, NEAC 1885-1935. Elected ARA 1924, RA 1934. Lived in Dieppe 1899-1905. On his return to England resided in London, Brighton, Bath and Broadstairs. Became leader of Camden Town Group 1907-14 and an influential figure in the British Impressionist movement. Painted a variety of subjects, including some very sensitive portraits. At one time he was a suspect in the Jack the Ripper murders. Died Bathampton, Bath 22 January 1942.
Represented: NPG London; Tate; Southampton CAG; Manchester CAG; Brighton AG; Royal Gallery of Modern Art, Rome; BM; Johannesburg AG. **Literature:** L.Browse, *S.*, 1960 with bibl.; R.Emmons, *The Life and Opinions of W.S.*, 1941; Sir J.Rothenstein, *W.R.S.*, 1961; M.Lilly, *S.*, 1971; W.Baron, *S.*, 1973; D.Sutton, *W.S. – A Biography*, 1976; R.Shone, *W.S.*, 1988; O.Sitwell (ed), *A Free House! or the Artist as Craftsman, Being the Writings of W.R.S.*, 1947; *W.S. as Printmaker*, Yale exh. cat. 1979; R.Shone, *Portraits by W.R.S.*, Victoria AG, Bath exh. cat. 1990; J.O.Fuller, *S. and the Ripper Crimes*, 1990; DNB; DA.

SIDEBOTTOM, S. fl.1851
Exhibited at RA (1), SBA (2) 1851 from Hyde Park, London.

SIDLEY, Samuel RBA ARCA **1829-1896**
Born York. Studied at Manchester School of Art and RA
Schools. Exhibited at RA (31), BI (1), SBA (11), GG
1855-95 from Manchester and London. Elected RBA 1890.
Established a successful practice painting official and
presentation portraits. Among his sitters were Bishop Colenso
(NPG London), Lady Brassey and the Duke and Duchess of
Buckingham. Collaborated with J.Charlton and also with
animal painter Richard Ansdell. Died Kensington 29 June
1896. His style sometimes shows the influence of Poynter.
Represented: NPG London. **Engraved by** C.A.Tomkins.

SIDNEY, Herbert **1858-1923**
Born London as Sidney Herbert Adams, son of art dealer
F.W.Adams, but changed his name to Herbert Sidney.
Studied at RA Schools, in Antwerp, and under Gérôme at
École des Beaux Arts, Paris. Exhibited at RA (4), RHA (1),
SBA 1877-1914, including a portrait of HRH the Crown
Prince Olav of Norway. Died London 30 March 1923.
Literature: *Morning Post* 17 December 1908.

SIGURTA, Luigi **fl.1764-1774**
Exhibited at RA (1) 1774 from an address 'at Mr Stirrup's,
Greek Street, Soho'. Believed to be a Venetian engraver.

SIMMONS, John **c.1715-1780**
Born Nailsea about 1715. Worked as a house and ship painter
in Bristol, as well as painting portraits. His earlier portraits are
painted in a provincial manner of Hogarth, but by the 1770s
his work is considered by Waterhouse to be on a par with
Beach. Exhibited at RA (2) 1772-6. Died Bristol 18 June
1780.
Represented: Bristol AG.

SIMMONS, William Sinclair **fl.1878-1899**
Exhibited at RA (12), SBA (4), NWS 1878-99 from London.
Among his sitters were Lady Maud Rolleston and Lady
Fitzherbert. His middle name is recorded as 'St Clair' in some
directories.

SIMONEAU (SIMONAU), François **1783-1859**
Born Bornhem. Exhibited at RA (18), BI (1) 1818-60 from
London. Died London August 1859.
Engraved by I.Mills.

SIMONSON, D. **fl.1858-1859**
Exhibited at RA (5) 1858-9 from London.

SIMPSON, J.H. **fl.1752**
Painted portraits in the manner of Enoch Seeman including a
portrait of Hester Winn, 1752.

SIMPSON, John Philip **1782-1847**
Baptized Enfield 1 September 1782, son of John and Martha
Simpson. Studied at RA Schools. Worked as assistant to
Lawrence. Exhibited at RA (126), BI (15), SBA (11)
1807-47 from London. Among his sitters were the Marquess
of Cholmondley KG, Clarkson Stanfield, David Roberts and
Commodore Sir Charles Napier KCB MP. Appointed painter
to the Queen of Portugal 1834, and spent a short time in that
country painting members of the Court circle. Died at
Carlisle House, Soho.
Represented: NPG London; NGI; Tate; Brighton AG;
SNPG. **Engraved by** W.Brett, W.Say, C.Turner.

SIMPSON, Joseph W. CBE RI RBA **1879-1939**
Born Carlisle. Studied under Herbert Lees at Carlisle School
of Art, and Glasgow School of Art. Worked in Edinburgh
before moving to London, where he took a studio next to his
friend Frank Brangwyn. Gained a reputation for his portraits

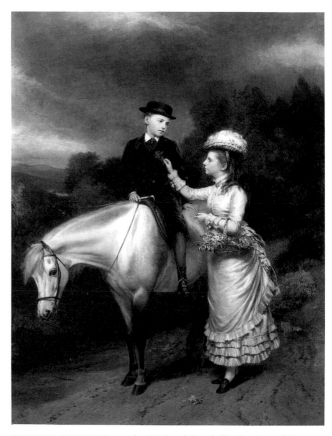

SAMUEL SIDLEY (pony by Richard Ansdell). Annie and Ernest,
the children of Angus Holden Esq. Signed and dated 1877. 64 x
48ins (162.6 x 121.9cm) *Christie's*

and for black and white illustrations. Bernard Shaw admired
his work. Official war artist during 1st World War. Awarded
CBE for his work with the Flying Corps in France. Exhibited
at RSA, GI. Died London 30 January 1939.
Represented: NPG London; Carlisle AG; BM; SNPG;
Glasgow AG. **Literature:** Hall 1979.

SIMPSON, Matthew **fl.1625-1649**
Worked in England. Taught the children of Charles I
1625-49. Later went to Sweden.

SIMPSON, Philip **fl.1824-1837**
Exhibited at RA (14), BI (9), SBA (9) 1824-37 from London
– the same address as portrait artist John Philip Simpson.
Represented: VAM.

SIMPSON, Thomas May **fl.1804-1825**
Exhibited at RA (18) 1804-21 from London. Married Laura
White 1 July 1825 at Shoreditch. Possibly the Thomas May
who entered RA Schools 3 December 1801 aged 19.

SIMPSON, William Butler **fl.1820-1840**
Exhibited at RA (3) 1820-40 from London. Also listed as a
naval architect and house decorator.

SIMS, Charles RA RWS **1873-1928**
Born Islington 28 January 1873. Studied at National Art
Training School, South Kensington, Académie Julian, Paris
1891 under Constant and Lefebvre and at RA Schools 1893-5.
Returned to Paris 1903, where he worked under Baschet.
Exhibited at RA (117), BI (15) 1893-1928. Elected ARA

1908, RA 1915, Keeper 1920-6, but resigned as a result of mental illness. Shortly before his death he completely changed his style. Committed suicide 13 April 1928. Left his widow Agnes £29,037.17s.8d.
Represented: Tate; SNPG; Walker AG, Liverpool; Garrick Club; St Stephen's Hall, Leeds. **Literature:** Alan Sims, *C.S.; Picture Making: Technique and Inspiration, with a Critical Survey of his Life and Work,* New Art Library, 2nd series 1934; DNB.

SIMS, William fl.1821-1867
Exhibited portraits and miniatures at RA (25), BI (7), SBA (1) 1821-67 from London.

SIMSON, George RSA 1791-1862
Born Dundee, brother of William Simson RSA. Started his career as a printer. Enjoyed a successful practice in Scotland. Exhibited at RSA (91) 1821-62 from Edinburgh. Founder ARSA 1826, but was one of the nine artists who withdrew after the first meeting. Elected RSA 1829. Died Edinburgh 11 March 1862.
Literature: McEwan.

SIMSON, William RSA 1800-1847
Born Dundee. Entered Trustees' Academy 1818 under Andrew Wilson. First painted landscapes and coastal scenes on the shores of Leith and Fife, but the success of his brother George led him to follow portraiture for three or four years. Visited Italy via Holland 1835-8 and then settled in London. Exhibited at RSA (120), RA (25), BI (30), SBA (1) 1821-48. Elected RSA 1830. Died London 19 or 29 August 1847. Ottley writes: 'Many of his portraits are among the best of their class'.
Represented: NPG London; SNPG; VAM; Tate; Williamson AG, Birkenhead. **Literature:** *Art Union* 1847 p.353; McEwan.

SINCLAIR, Alexander Gordon ARSA 1859-1930
Edinburgh portrait and landscape painter. Exhibited at RSA (74). Elected ARSA 1918. Died 12 June 1930.
Represented: Kirkcaldy AG. **Literature:** McEwan.

SINCLAIR, James fl.1830-1831
Exhibited RSA (2) from Berwick-on-Tweed. His portrait of John Mackay Wilson is in SNPG.

SINCLAIR, William b.c.1839
Born Edinburgh. Studied at Trustees' Academy 1853-6. Worked as a portraitist. Exhibited RSA (50), GI (1) 1861-78.

SINGLETON, Henry 1766-1839
Born London 19 October 1766. His father died before he had reached the age of two and he was supported by his uncle William Singleton, a miniaturist. Began painting portraits professionally from the age of 16. Entered RA Schools 1783, winning Silver and Gold Medals 1784 and 1788 and attracting the public praise of Reynolds. Exhibited at SA (10), RA (285), BI (158), SBA (5) 1780-1839. Among his sitters were Sir W.Chambers, J.Northcote, Thomas Sandby, R.Cosway and J.Zoffany. In the 1790s he was commissioned to paint the ambitious and outstanding 'General Assembly of the RA under the Presidency of Benjamin West' (dated 1795 RA), which shows his considerable talent for painting heads. Married the only daughter of William Singleton 1807, but she died 1811. He rarely stirred from London except for a brief visit to Paris 1813 and occasional visits to the country. Died Kensington 15 September 1839. Buried St Martin-in-the-Fields.
Represented: NPG London; SNPG; BM; VAM; RA; Tate; Ulster Museum; Brighton AG; RA; Harewood House. **Engraved by** W.Bond, A.Cardon, J.Chapman, M.Gauci, W.N.Gardiner, G.Keating, E.Mitchell, J.Ogborne, S.W.Reynolds, E.Scott, C.Turner. **Literature:** *Art Union* 1839 p.154; DA.

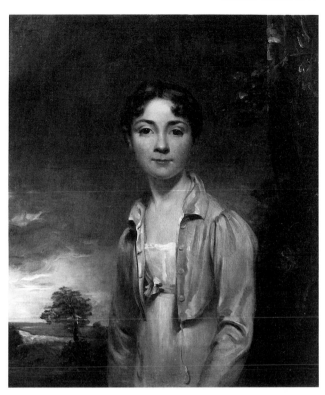

JOHN PHILIP SIMPSON. Miss Mary Simpson. Exhibited 1825. 30 x 25ins (76.2 x 63.5cm) *Christie's*

SINGLETON, Miss Maria fl.1808-1820
Sister of Henry Singleton. Exhibited portraits at RA 1808-20 from London. Her sister Sarah Macklarinan Singleton was a miniature painter, and the authorship of their exhibited pictures is confused in the catalogues.

SINGLETON, William d.1793
Brother of Joseph Singleton and uncle of Henry Singleton. Studied under O.Humphry. Painted portraits, fancy heads and miniatures. Exhibited at SA, RA (5) 1770-90.
Represented: VAM.

SIREE, Mrs Clementina (née Robertson) 1795-c.1855
Born Dublin, daughter and pupil of Charles Robertson. Exhibited at RHA (18) 1826-51 from Dublin. Married John Siree, a medical student 1830. He never qualified and died of fever 1835.
Represented: NGI.

SISSON, Richard c.1730-1767
Came from a well-known Dublin family engaged in the linen trade and had a factory at Lucan. Educated at Shackleton's school in Ballitore, where he made a lasting friendship with Edmund Burke. Apprenticed to the portrait painter F.Bindon. Also studied in France and Italy. Married a Miss Smith of Dublin 1763. Painted portraits, crayons and miniatures and worked in Dublin and London. Exhibited Dublin SA (12) 1765-7. Died William Street, Dublin April 1767, leaving his widow in straitened circumstances. Burke afterwards provided for his son.

SITTOW (ZITTOZ), Michel c.1468-c.1525
Born Reval. Trained at Bruges. Pupil of Memlinc. Known in Spain as 'El Flamenco'. Court Painter to Isabella the Catholic Queen of Spain 1492-1502, and to Margaret of Austria

1515/16. Generally credited with having painted in England the portrait of Henry VIII (NPG London) dated 20 October 1505, which was sent to Margaret of Austria. Died Reval.
Represented: Brocklesby Park; NG Washington; Palace Real, Madrid. **Literature:** *Burlington Magazine* XC September 1948 p.247; DA.

SIVED, G. **fl.1780**
Exhibited at FS (2) 1780 from Oxford Street, London.

SIVIER, G. **fl.1852-1865**
Exhibited at RA (5), BI (4) 1852-65 from London.

SKEATS, Leonard Frank **1874-1943**
Born Southampton 9 June 1874. Studied art there at Hartley University College School of Art, and at Académie Julian, Paris. Exhibited at RA (6), RI, ROI 1901-9 from Southampton, Bath, Croydon and Somerset. Died Bath13 September 1943, leaving his widow, Caroline, £6575.8s.10d.
Represented: Southampton CAG.

SKEOLAN, Peter **fl.1848**
Listed as a portrait painter at 2 Pall Mall, Manchester.

SKILLIN, Samuel **c.1819-1847**
Native of Cork. Encouraged in art by Richard Sainthill of Cork, the early patron of Maclise. Exhibited at RHA 1842-43. Visited London, Spain and Italy, and during his travels contributed letters to *The Literary Gazette*. Returned to Cork, where he died 27 January 1847, before his promise could be fulfilled.
Represented: Cork Museum. **Engraved by** J.Kirkwood.

SKINNER, Martin **fl.1698**
Admitted to the Freedom of the Guild of St Luke 1698 on the presentation of a portrait of King William. The Guild lists him as 'dead' 1702.

SKIPWORTH, Frank Markham ROI RP 1854-1929
Born Caistor, Lincolnshire 30 July 1854, son of T.N.Skipworth a gentleman farmer. Studied at Lincoln, RCA under Poynter 1879-82 and finally in Paris with Bouguereau and Fleury 1883-4. Exhibited at RA (42), SBA, NWS, GG, RP, NWG 1883-1916 from Chelsea. Elected RP 1891. Died Tooting Hospital 10 March 1929.
Represented: Walker AG, Liverpool; Institute of Directors.

SKIRVING (SHIRVING), Archibald **1749-1819**
Born Athelstaneford, near Haddington, son of Adam Skirving, a songwriter and farmer. Began as an excise officer, turning to miniature painting. Exhibited at RA (2) 1778-99. Travelled to Rome 1786-94. Captured by the French on his return journey and imprisoned for a year. His imprisonment caused him to suffer from a serious eye condition (unocular elipopia) and took up large scale portraiture. Settled in Edinburgh. Specialized in accomplished crayon portraits. Died Inveresk. Buried Athelstaneford. Simon describes him as 'ingenious, even eccentric, and he was a sensitive draughtsman'.
Represented: SNG; SNPG. **Engraved by** G.Dawe, R.Scott, T.Woolnoth. **Literature:** T. Sundström, *A.S.,* MA thesis St Andrews University 1994; McEwan.

SKOTTOWE, Charles **b.1793**
Born Cork, where he began as a portraitist. Exhibited at RHA (2), RA (6), BI (5), SBA (1) 1829-42 from Cork and London. Among his sitters were Captain Sir W. Edward Parry RN and Sir Richard Puleston.
Represented: Royal College of Physicians, London; Royal Naval College, Greenwich. **Engraved by** S.Bellin.

SLACK, John **fl.1750**
Worked in Cheshire. Painted a full-length portrait of a centenarian keeper at Lyme Park.

SLATER, Isaac Wane **1784/5-1836**
Born Kensal Green, son of Joseph Slater and his wife Anne (née Wane). Listed as a portrait painter. Exhibited a large number of portraits at RA 1803-36 from London. Married Anne Holdworth. Died London 17 April 1836. Buried Kensal Green. His work is confused with Josiah and Joseph Slater.
Represented: VAM.

SLATER, Joseph **1750-c.1805**
Born July 1750, son of John Slater of Bromley. Entered RA Schools 18 December 1771 aged '21 next July'. Exhibited at FS, RA 1772-87 from London. Married Anne, daughter of Isaac Wane. Reportedly died Hounslow 1805. The fact that several of the family had the same initials has led to considerable confusion.

SLATER, Joseph jnr **c.1779-1837**
Son of Joseph Slater and his wife Anne née Wane. Exhibited at RA 1805-33. Married Catherine, daughter of Rev James Bean, BM Librarian. Painted a number of politicians and members of the theatrical profession. Died 25 February 1837. Buried Hove.
Represented: NPG London; SNPG.

SLATER, Josiah **d.1847**
Exhibited at RA (78) 1806-33 from London. Established a successful society portrait practice. His style shows influence of Lawrence. Confused with I.W. Slater and Joseph Slater.
Represented: BM; Fitzwilliam.

SLATER, Josiah jnr **fl.1808-1818**
Exhibited at RA (6) 1808-18 from London.

SLATTERY, John Joseph **fl.1846-1858**
Entered Dublin Society's School 1846. Established himself as a portraitist in Dublin. Exhibited at RHA (9) 1852-8 from Dublin. Believed to have left Ireland for America.
Represented: NGI.

SLAUGHTER, Stephen **1697-1765**
Baptized St Paul's, Covent Garden, London 13 January 1697, son of Stephen and Judith Slaughter. Attended Kneller's Academy 1712. Lived abroad for 'nearly 17 years' in Paris and Flanders, returning to London c.1733. Worked with success in Dublin briefly 1734 and again c.1744-5. Painted oils and crayons for Althorp 1736-9. Appointed Keeper of the King's Pictures 1744, a post he retained until his death. Dated portraits after 1750 are rare, although one of 1760 is recorded. Died Kensington 15 May 1765. Enjoyed painting ornate costume and he often arranged his sitters (usually shown frontally) against a neutral or theatrical backdrop. His early work was more linear. Developed his mature style by c.1740. Vertue notes in 1741 that he was said 'to excel the famous French painter [Vanlo] . . . It is further to be observed that Mr Slaughter is always happy in his Designs and finishes the whole with his own hands – not common'. Strickland writes: 'His figures are well posed, with a good sense of line; he seems to have delighted in the rendering of the characteristic folds, textures and sheen of silk, lawn and lace'. Anthony Lee worked in his manner.
Represented: NPG London; NGI; Tate; Institute of Arts, Minneapolis; Blenheim Palace. **Engraved by** J.Brooks. **Literature:** A.C.Sewter, *Connoisseur* CXXI March 1948 pp.10-15; *Irish Portraits 1660-1860*, NGI exh.cat. 1969; Strickland; DA.

SLEATOR, James Sinton PRHA d.1950
Born County Armagh. Studied in Dublin, London and
Florence. Exhibited at RHA (84) 1915-1950. Elected
ARHA, RHA 1917, PRHA 1945-9. Died 19 January 1950.
Among his sitters were Sir William Orpen and Jack B.Yeats.
Represented: NGI.

SLEIGH, William fl.1776
Worked as a portraitist in Cork. Listed there as such in his
marriage licence 1776.
Engraved by J.Cochran.

SLOANE, Miss Mary Ann d.1961
Born Leicester. Studied under Herkomer at Bushey and at
RCA under Sir Frank Short. Exhibited at Paris Salon, RA
(25), SBA 1889-1924 from London and Endersby. President
of Women's Guild of Arts 1953. Died 29 November 1961.

SLOCOMBE, Shirley Charles Llewellyn fl.1887-1916
Exhibited at RA (9) 1893-1907 from London. Among her
sitters were the Marchioness of Exeter, the Marquess of
Zetland, Sir William Huggins KCB and Lord Hawke.
Represented: NPG London.

SLOUS, Henry see SELOUS, Henry Courtney

SLUCE, John A. b.c.1816
Born London. Exhibited at RA (5), SBA (2) 1833-7 from
Islington.
Engraved by J.Romney.

SMALL, Alexander G. fl.1900-1914
Exhibited miniatures and portraits at RA 1900-14.

SMALL, Florence see HARDY, Mrs Florence Deric

SMALL, Thomas Oswald 1814-1887
Born Newcastle. Worked as an architect before becoming a
professional artist. Exhibited in Newcastle. Died Gateshead.
Literature: Hall 1982.

SMALLBONE, Miss Eliza
 see Mrs MELVILLE, Eliza Anne

SMALLFIELD, Frederick ARWS 1829-1915
Born Hackney. Studied at RA Schools. Exhibited at RA (39),
BI (6), RHA (5), SBA (11), OWS (425), NWS (2), GG (11)
from 1849. Elected AOWS 1860. Died Finchley 10
September 1915. Influenced by the Pre-Raphaelites.
Represented: Manchester CAG; BM. **Literature:** Maas
p.90.

SMART, Dorothy Agnes ARMS b.1879
Born Tresco, Scilly Isles 19 August 1879. Studied at Sir
Arthur Cope Schools. Exhibited at RA (3), RMS from Ross-
on-Wye. Elected ARMS 1907.

SMART, Edmund Hodgson 1873-1942
Born Alnwick. Studied at Antwerp Academy, Académie
Julian, Paris and at Herkomer's School, Bushey. Exhibited at
RA (3), RP, London Salon and in the provinces 1906-34.
Had a successful portrait practice. Worked in London,
North America, Bermuda and Alnwick. Died 14 November
1942.
Represented: NG Washington; Cleveland MA. **Literature:**
Hall 1982.

SMART, John 1756-c.1813
Born 4 March 1756. Studied under Daniel Dodd, entering
RA Schools 1783 aged 27. Exhibited at SA, FS, RA 1786-

STEPHEN SLAUGHTER. Captain John Long Bateman. Signed
and dated 1744. 49 x 39ins (124.5 x 99.1cm) *Sotheby's*

1813 from London, Ipswich and Norwich. Recorded 1813.
Confused in the exhibition catalogues with the miniaturists
John Smart c.1741-1811 and John Smart jnr 1776-1809.

SMART, Samuel 1754-c.1787
Born 12 December 1754. Entered RA Schools 11 June 1771.
Exhibited at SA, RA 1774-87 from London. Also a
miniaturist.
Engraved by J.Collyer.

SMART, Thomas fl.1835-1855
Exhibited at RA (9), RHA (1), BI (8), SBA (19) 1835-55
from London.

SMETHAM, James 1821-1889
Born Pateley Bridge, Yorkshire 9 September 1821, son of a
Wesleyan minister. Apprenticed to E.J.Willison, a Lincoln
architect. Began painting portraits in Shropshire and came to
London 1843, studying at RA Schools. Exhibited at RA (18),
BI (2), SBA (17) 1851-76. Drawing master at Wesleyan
Normal College, Westminster 1851. Wrote critical articles
and letters, and helped establish William Blake's importance.
His friends Ruskin, Madox Brown and Rossetti thought
highly of his work, which from the 1850s came under the
influence of the Pre-Raphaelites. After 1869 his paintings
were all rejected by the RA and he was plagued by a sense of
failure. The last 12 years of his life were filled with depression,
religious melancholia and madness. Died Stoke Newington 5
or 6 February 1889. Buried Highgate Cemetery.
Represented: NPG London; Tate. **Literature:**
W.Beardmore, *J.S. – Painter, Poet and Essayist*, 1906; *Art
Journal* 1904 pp.281-284; DNB; E.Malins & M.Bishop, *J.S.
and Francis Danby*, 1974; S.Smetham & W.Davies, *Letters of
J.S. With An Introductory Memoir*, 1902; DA.

SMIBERT, John 1688-1751
Born Edinburgh 24 March 1688, son of a dyer. Apprenticed to Walter Marshall, a house painter 1702-9. Then painted coaches and made copies in London. Studied at Kneller's Academy and St Martin's Lane Academy. Returned to Edinburgh 1716-19, visiting Italy (Florence, Rome and Leghorn) until 1722. Set up a successful practice in London 1722-8, when he accompanied Bishop Berkeley on the Bermuda expedition. Went to Boston 1729 and settled there as a portrait painter, becoming one of the founding fathers of American portrait painting and highly influential. In the mid-1740s he developed eye trouble and ceased his practice. Died Boston, Massachusetts 2 April 1751.
Represented: NPG London; SNPG; NGI; Yale; Boston MFA: Yale. **Engraved by** P.Pelham, S.Taylor, G.Vertue.
Literature: Sir D.Evans et al., *The Notebook of J.S.*, Massachusetts Historical Society 1969; H.W.Foote, *J.S.*, 1950; R.Saunders, Ph.D. Yale 1979; McEwan; DA.

SMITH, Alexander Munro 1860-1933
Born Falkirk. Studied at Glasgow School of Art. Exhibited at RSA (7), RSW, SSA and in Liverpool from London and Edinburgh. President of Scottish Arts Club. Died Edinburgh 20 October 1933.
Literature: McEwan.

SMITH, Alfred Newland fl.1851-1856
Listed as a portrait painter in Gloucester and Cheltenham.

SMITH, Campbell Lindsay 1879-1915
Born Forfarshire. Exhibited at RA (4) 1901-4 from Aberdeen.

SMITH, Mrs Caroline fl.1832-1869
Exhibited at RA (4), BI (10), SBA (18) 1832-69. Worked in Templeville, near Cork. Moved to London 1851. Among her sitters were Lady Abercromby and Henry Warren.

SMITH, Charles 1751-1824
Born Orkneys September 1751. Entered RA Schools 25 October 1771 'aged 20 last September'. Studied under Mortimer. Exhibited at SA (3), RA (33), BI (2) 1776-1823. Among his sitters were Lord Erskine, Sir James Mackintosh – Lord Rector of the University of Glasgow, and Patrick Grant aged 109. First visited India 1783, where he travelled considerably, painting portraits and miniatures of Indian princes and becoming Painter to the Grand Mogul. Returned to England and started writing unsuccessful musical entertainments. Towards the latter part of his career he returned to Scotland. Died Leith 19 December 1824. It is said that he lost patrons on account of violently expressed political opinions. His later works are confused in the exhibition catalogues with Colvin Smith.
Represented: SNPG. **Literature:** W.Foster, Walpole Society Vol XIX pp.72-73.

SMITH, Miss Clifford S. fl.1832-1854
Exhibited at RA (6), SBA (12) 1832-54 from London.

SMITH, Colvin RSA 1795-1875
Born Brechin, son of John Smith a manufacturer. Studied at RA Schools and under Joseph Nollekens, visiting Italy 1826, where he painted Wilkie in Rome. Returned via Belgium to Edinburgh 1827, and set up a successful society portrait practice in Raeburn's former studio. Painted Sir Walter Scott there the same year, and repetitions of this portrait (about 20 in all) were in great demand from Scott's friends. Smith followed the traditions of Raeburn and Watson Gordon and enjoyed considerable success. Exhibited at RSA (214), RA (15), BI (2) 1826-71. Elected RSA 1829. Died Edinburgh 21 July 1875. His account book is in SNPG with a copy in NG London. Among his pupils was James Irvine.

JOHN SMIBERT. Eleanor Nightingale. Signed and dated 1727?. 50 x 40ins (127 x 101.6cm) *Christie's*

Represented: SNG; SNPG; Parliament Hall, Edinburgh; Duke of Hamilton, Lennoxlove; Earl of Stair, Oxenfoord. **Engraved by** R.C.Bell, S.Cousins, T.Hodgetts, T.Lupton, W.Neisse, G.Parker, S.W.Reynolds. **Literature:** *Art Journal* 1875 p.304; R.C.M.Colvin-Smith, *The Life and Works of C.S.*, 1939; McEwan; DNB.

SMITH, Edward 1779/80-1849
Liverpool portrait painter and engraver, and remote cousin of the Caddick family of artists. Exhibited at LA 1822-32 from Liverpool and London. Died Camden Town 18 April 1849 aged 69. Gore's *Advertiser* noted that he was 'an artist of considerable ability'.
Represented: Walker AG, Liverpool. **Engraved by** A.Cardon, J.Heath, J.Hopwood, W.Ridley, E.Scriven.

SMITH, Edward Dalton fl.1878
Listed as a portrait painter at 10 Grand Parade, Brighton.

SMITH, Ferdinand David fl.1851-1854
Exhibited at RHA (9) 1851-4 from Dublin.

SMITH, Garden Grant RSW 1860-1913
Born Banchory. Studied in Edinburgh and Paris under C.Duran. Worked in Scotland painting portraits and Spanish genre. Published a number of books on golf. Died Hammersmith 25 August 1913.
Represented: Aberdeen AG. **Literature:** *The Times* 26 August 1913; McEwan.

SMITH, of Chichester, George c.1714-1776
Son of William Smith, a Chichester cooper and baker and his wife Elizabeth (daughter of Henry Spencer, a Horsham butcher). Abandoned his early training as a cooper to join his elder brother William in his studio in Princes Street, Leicester

COLVIN SMITH. Sir Walter Scott. 30 x 25ins (76.2 x 63.5 cm)
Philip Mould/Historical Portraits Ltd

Fields. Moved with William to Gloucester c.1730, where William had received an important commission from the Guise family. After assisting his brother, George worked as a portrait painter, at first earning his living travelling from town to town. However, his talent was as a landscape painter, which was much admired by the Duke of Richmond. Returned to Chichester for a short spell, but in the early 1740s he worked from a studio in London, which he shared with his younger brother John. From c.1750 George and John returned to Chichester, where they lived and painted in North Street. For three years from 1760 the Smith brothers so dominated the premiums for the best landscapes at the Incorporated Society of Artists that thereafter, according to the rules, they declined to enter. Exhibited at SA (2), FS (103), RA (4) 1760-74. His brothers died 1764, John on 29 July and William on 27 September. Two years later he married Ruth Southen, and they had three daughters. George Smith died 7 September 1776 aged 62. The Smith brothers' reputation spread throughout the country at a time when British landscape was in its infancy, and they had a considerable influence on the Picturesque and therefore on the history of British landscape painting. Since the 19th century their importance has been greatly underestimated. As a portrait painter George Smith was very competent, and could portray his sitters with sensitivity, but it is only as a landscape painter that he was a major influence in British art.
Represented: NPG London; Cheltenham AG; Tate; VAM.
Literature: *The Smith Brothers of Chichester*, Pallant House Gallery cat. 1986; Stewart & Cutten; DA.

SMITH, George **b.1763**
Entered RA Schools 7 February 1794, aged 31. Exhibited at RA (35) 1791-1805 from London. Among his sitters were 'Mr Chapman, the Cricketer' and 'Mrs Powell of Drury Lane Theatre'.

SMITH, Mrs Graham **fl.1891-1920**
Exhibited at NWG (3) from London.
Represented: NPG London.

SMITH, Hannah **1797-1867**
Born Great Yarmouth. Painted portraits and still-life. Believed to have been a pupil of James Sillett. Died Norwich.

SMITH, Hely Augustus Morton RBA RBC
 1862-1941
Born Wambrook, Dorset 15 January 1862. Educated at Loretto, where he won drawing prizes. After three years of work for a bank in Derby he studied at Lincoln School of Art and Antwerp Academy. Worked in Lincolnshire, Cornwall and London. Also travelled widely abroad painting shipping and coastal works, as well as still-life and portraits. Exhibited at RA (21), SBA 1890-1932. Elected RBA 1900. Died London 21 January 1941.
Represented: VAM.

SMITH, Henry **fl.1741-1769**
Believed to have been from Norwich. His dated works range from 1741, when he was in Scotland (examples are at Wemyss Castle, Dunrobin and Arniston) at which time he charged 4 guineas for a 30 x 25 in. In 1742 he was working in Devonshire (Farington's *Diary* 13 October 1809). Towards the end of his life he settled in Norwich, where he died January 1769. Usually signed with 'H.S.' in monogram. Produced a large number of busts in ovals, but also full-lengths and group portraits.

SMITH, Henry Lawson **b.1894**
Born Wymondham, Norfolk 21 May 1894. Exhibited at RA (1) and Ipswich Art Club from Ipswich.

SMITH, Henry Robinson **fl.1845-1848**
Born Bury, son of John Smith and Mary (née Robinson). Worked as a portrait painter in Manchester.

SMITH, Henry Smith **fl.1825-1844**
Exhibited at RA (30), BI (4), SBA (13) 1825-44 from London. Among his sitters were Lady Cowper and Sir John Sidney, Bart.

SMITH, Herbert Luther **1809-1870**
Born London 9 August 1809, younger son of artist Anker Smith ARA. Entered RA Schools 15 December 1826, winning medals 1828 and 1830. Exhibited at RA (27), BI (10), SBA (6) 1830-54 from London. Employed by Queen Victoria to copy state portraits. Died Worthing 13 March 1870.
Represented: BM; Oriel College, Oxford. **Engraved by** J.Posselwhite.

SMITH, Hugh G. **fl.1839-1856**
Exhibited at RA (19), RBSA (2) 1839-56 from London.

SMITH, James **fl.1773-c.1789**
Exhibited at SA (1), FS (1), RA (15) 1773-89 from London. Possibly the same J.Smith who painted portraits in Nottinghamshire. The 5th Lord Middleton (Birdsall) was a patron.

SMITH, James Bennett H. **fl.1830-1847**
Exhibited at RA (24), BI (6), SBA (9) 1830-47 from London. Appears erroneously in Graves as J.Bell Smith.

SMITH, John Raphael **1752-1812**
Born Derby, son and pupil of landscape painter Thomas Smith. Apprenticed to a linen draper. Moved to London c.1767. Began painting miniatures and scraped his first

STEPHEN CATTERSON SMITH SNR. A lady. Signed, inscribed and dated Dublin 1864 on reverse. 22 x 13½ins (55.9 x 34.3cm)
Christie's

mezzotint 1769. He excelled in this art and became mezzotint engraver to the Prince of Wales 1784, but gave up engraving 1802. Also produced crayon portraits, mainly small size (9 x 7¼ins), which he did with great speed (some in an hour) in northern cities such as York, Sheffield and Doncaster. Exhibited at SA (48), FS (8), RA (73) 1773-1805. Died Doncaster 2 March 1812. His daughter Emma and son John Rubens were artists.
Represented: NPG London; Leeds CAG. **Engraved by** F.Bartolozzi, J.Heath, W.Hilton, H.Kingsbury, I.Mills, S.W.Reynolds, W.v.Senus, Jane Thompson, C.Turner, W.Ward.
Literature: J.Frankau, *Life of J.R.S.*, 1902; DNB; *Connoisseur*, XC 1932 pp.299-30, XCIII 1934 pp.96-101; DA.

SMITH, John Rubens 1775-1849
Born London 23 January 1775, son of John Raphael Smith. Entered RA Schools 11 November 1797. Exhibited at RA (45) 1796-1811 from London. Emigrated to Boston, Massachusetts, where he enjoyed a successful career as a painter, engraver and teacher. Ran an Academy there and later in Philadelphia (1830s), where Leutze was his pupil. Died New York 21 August 1849. Worked in the manner of his father.
Literature: E.S.Smith, *Connoisseur*, LXXXV May 1930 pp.300-7.

SMITH, Joshua 1881-1938
Born London. Set up as a portrait painter. Member of Royal Society of Artists. Exhibited a portrait of HM the King at RA 1917. Emigrated to Canada 1920, where he was extremely successful. Died Ontario 26 March 1938.

SMITH, Mrs Lucy Graham fl.1893-1901
Exhibited at RA (2) 1897-1901 from London.
Represented: SNPG.

SMITH, M. fl.1823
Exhibited at RA (1) 1823 from Bethnal Green, London. May have been Lieutenant M. Smith who exhibited at RA (2) 1805 and also the M.Smith who exhibited at BI (3) 1848-9.

SMITH, Miss Maria (Mrs Ross) 1766-1836
Daughter of a city merchant and sister of engraver A.Smith ARA. Mother of Sir William Ross. According to Ottley she 'studied portrait painting in oils with considerable success'. Exhibited at SA (1), RA (3), BI (1) 1791-1814 from London, but lived for a short time in Maidstone. Died London 20 March 1836.

SMITH, Richard fl.1826-1855
Listed as a portrait painter in London. Exhibited at RA 1837-55. Awarded a Silver Isis Medal for a miniature by SA 1838.

SMITH, Samuel Mountjoy fl.1830-1857
Exhibited at RA (3), BI (8) 1830-57 from London. He is not recorded in London 1836-56.

SMITH, Sophia fl.1800-1802
Possibly daughter of John Raphael Smith. Exhibited at RA (4) 1800-2 from Covent Garden, London.

SMITH, Stephen Catterson snr. PRHA 1806-1872
Born 12 March 1806, baptized Skipton 11 January 1807, son of a coach painter. Studied at RA Schools and in Paris. Exhibited at RHA (163), RA (8), BI (2) 1828-72. Travelled to Ireland c.1839/40 on a commission and settled there, where he attracted the patronage of many distinguished sitters, including the Duke of Bedford, Earl Spencer, Viscountess Lifford and the Marchioness of Londonderry. Became Ireland's most fashionable portrait painter of his day. Elected PRHA 1859, 1866, 1868-9. Died in Dublin 30 May 1872. His son Stephen was also an artist.
Represented: NGI; VAM; Apsley House; Canterbury Museums; Earl Spencer, Althorp; Earl of Crawford and Balcarres. **Engraved by** H.Meyer, G.S.Sanders, T.Wright.
Literature: Strickland; DA.

SMITH, Stephen Catterson jnr RHA 1849-1912
Born 42 St Stephen's Green, Dublin 19 June 1849, son of portrait artist Stephen Catterson Smith PRHA. Educated at Dr Rice's school. Exhibited at RHA (175) 1873-1909 from Dublin. Elected ARHA 1876, RHA 1879, Secretary 1890-1910. Visited Scotland annually for many years. Died 24 November 1912 in the same room in which he was born. Buried Deans Grange Cemetery.
Represented: NGI; National Army Museum. **Literature:** Strickland.

SMITH, Mrs Susan fl.1858
Listed as a portrait painter at Lakenham, Norwich.

SMITH, T.B. fl.1833-1859
Exhibited at RA (3), SBA (2) 1833-59 from Bath and London. May be the Thomas Smith who was listed as a portrait painter in Birmingham 1835.

SMITH, W.C. fl.1837
Worked as a portrait painter and profilist in Chatham, Kent. Took on Richard Ansdell as a pupil.
Literature: Blue Coat School Admission Book, Liverpool Record Office.

SMITH, W. Thomas 1865-1936
Marine artist and illustrator for *The Strand* magazine. Exhibited at RA (4) 1895-1901, including a portrait of Rear Admiral A.H.Markham.
Represented: NPG London.

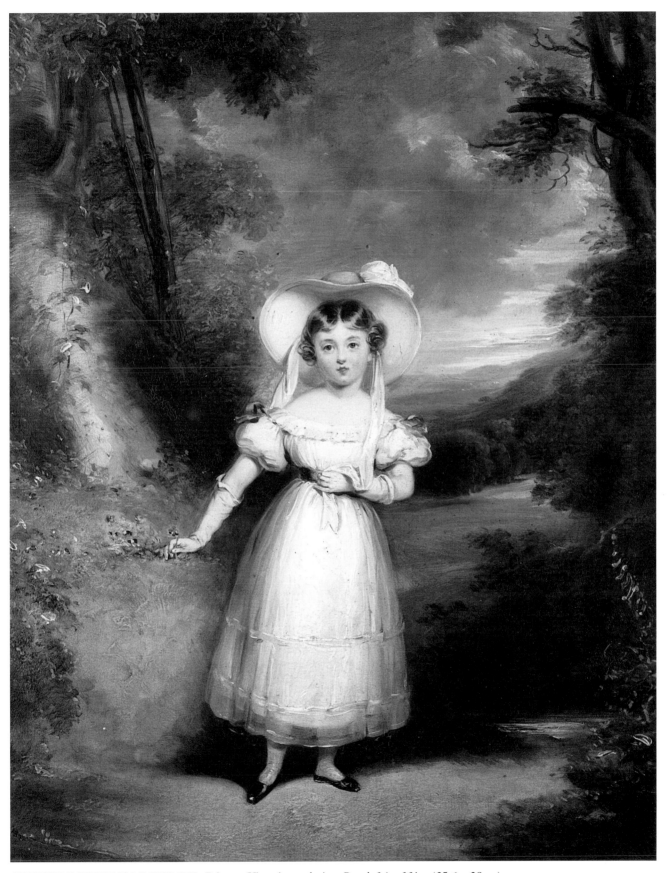

STEPHEN CATTERSON SMITH SNR. Princess Victoria aged nine. Panel. 14 x 11ins (35.6 x 28cm)

Christopher Wood Gallery, London

SMITH, of Chichester, William c.1707-1764
Son of William Smith, a Chichester cooper and baker. Eldest
of the Smith brothers. His mother was Elizabeth, daughter of
Henry Spencer a butcher at Horsham. Encouraged by Duke
of Richmond to study painting at St Martin's Lane, London
c.1791. After this he set up a studio in Prince's Street,
Leicester Fields, where he was joined by his brother George.
William and George travelled to Gloucester c.1730, where
William had received an important commission to paint Sir
William Guise's private chapel. Remained in Gloucester as a
portrait painter for about eight years and then returned to
London, where he had a studio in Piccadilly. In addition to
portrait painting he produced some influential 'moonlight'
works and remarkably sensitive still-lifes of fruit and flowers.
Exhibited at FS (10) 1761-4. In later years William moved to
a house in Shopwhyke, near Chichester. Said to have been
deformed. Portrayed holding a stick in William Pether's
mezzotint of the three brothers. Died 27 September 1764
aged 57. Dated portraits range 1748-59.
Represented: Stourhead, NT. **Engraved by** J.McArdell.
Literature: *The Smith Brothers of Chichester*, Pallant House
Gallery cat. 1986; Stewart & Cutten.

SMITH, William fl.1813-1859
Exhibited at RA (32), BI (15), SBA (1), OWS 1813-59 from
London, Newport and Shropshire. May be the William Smith
who signed and dated a portrait of William Rathbone 1864.
Represented: Walker AG, Liverpool.

SMITH, William fl.1830-1851
Exhibited at RA (9) 1830-51 from London. May be the same
artist, or confused with the sporting artist William Smith who
exhibited at RA (32) 1813-59.

SMITH, William A. 1753-1793
Born 29 December 1753. Entered RA Schools 30 November
1772 'aged 19 December 29th next'. Exhibited mainly
miniatures at RA 1774. Patronized in the 1780s and 1790s
by the family of the Duke of Gordon. Also painted oil
portraits in the north-east of Scotland around the same time.
Signed either as 'W.Smith', 'W.A.Smith' or 'WAS'. Painted in
the manner of P.Reinagle.
Represented: Brodie Castle, SNT; Leith Hall, SNT.

SMITH, William Armfield fl.1832-1849
Exhibited at RA (8) 1832-49 from London. Believed to have
been brother of artist George Armfield Smith, who changed
his name in 1840 to George Armfield.

SMITHERS, Collier Twentyman d.1943
Exhibited portraits, including that of architect Richard
Norman Shaw, at RA (9) 1892-1936 from London. Died
London 7 December 1943 (not 1944). Left effects of
£11,570.11s.

SMITZ (SMITH), Gaspar fl.1662-c.1707
Dutch artist who is believed to have arrived in England by
1662. Also a picture dealer and restorer. Painted 'Catherine
Cecil, Countess of Kinoul and Her Son' (Hatfield House).
Working in Dublin by the 1670s, where he became a member
of Corporation of Cutlers and Painter-Stayners. Member of
Guild of St Luke 1681. Able to command the highest prices
for his work and was in much demand. Died Dublin in
distressed circumstances caused by his extravagance c.1707
(Walpole). Painted 'Magdalens' and was known as 'Magdalen
Smith'. Excelled in small portraits in oil, which were well
drawn and harmonious in colour. Among his pupils were
William Gandy, Garrett Morphey and Mr Maubert.
Represented: NGI. **Literature:** Pilkington; Strickland.

WILLIAM SMITH OF CHICHESTER. A nobleman. Signed and
dated 1748. 30 x 25ins (76.2 x 63.5cm) *Christie's*

SMYTH, Edward fl.1819-1844
Exhibited at RA (17), SBA (10) 1819-44 from London.

SMYTH, William 1813-1878
Born Dublin. Exhibited at RHA (32) 1848-62 from Dublin
and Sandymount. Died London 5 March 1878.

SMYTHE, Richard b.1863
Born Cromford, Derbyshire 13 February 1863. Studied at
Manchester School of Art. Practised as a portraitist, etcher
and engraver. Worked in Haverstock Hill, West Hampstead
and Middlesex. Exhibited at RA (9) 1888-1912. Some of his
portraits were reproduced as engravings.

SNELLGROVE, T. fl.1800-1827
Exhibited at RA (14) 1800-27 from London.
Engraved by M.Gauci, T.Palmer.

SNELLING, Matthew 1621-1678
Baptized at King's Lynn 14 October 1621, son of Thomas
Snelling d.1623, Mayor of King's Lynn and Margaret (née
Clark). A friend of Samuel Cooper and painted mainly
miniatures, but also portraits on the scale of life. His dated
works range 1647-74 and are signed with his initials 'M.S.'.
Had a long connection with the family of Mary Beale. Said by
Vertue to have been 'a gentleman and seldom painted unless
for Ladies with whom he was a mighty favourite & a gallant'.
Represented: Royal College of Physicians. **Literature:**
Foskett.

SNOWBALL, Joseph 1860-1946
Born Sunderland, son of the pottery manufacturer of
Sunderland Ware. Worked in his father's potteries before
becoming a professional artist. Established a successful portrait

GERARD SOEST. Thomas Cartwright, Bishop of Chester. Signed. 30 x 25ins (76.2 x 63.5cm) *Christie's*

ANDREA SOLDI. Thomas Sheppard. Signed and dated 1733. 50 x 40ins (127 x 101.6cm) *Philip Mould/Historical Portraits Ltd*

studio in London by 1909. Exhibited at London Salon.
Literature: *Hippodrome Magazine,* British Artists Series November 1919.

SNOWMAN, Isaac **b.1874**
Based London, but also worked in Palestine. Exhibited at RA (32) 1893-1919. Some of his portraits were reproduced as engravings. Capable of works of great beauty and atmosphere.

SOEST (ZOUST), Gerard **c.1600-1680/1**
Believed to have been born at Soest in Westphalia c.1600. Probably arrived in England in the late 1640s. Enjoyed a successful practice with the nobility and gentry after the Restoration, but worked somewhat in the shadow of Lely (in 1667 he charged £3 a head, compared with Lely's £15). Vertue thought he was too unflattering to be popular with women 'which his ruff humour could never please'. Nevertheless, Waterhouse considered him to be perhaps the most sensitive of Lely's rivals. Died London February 1680/1. John Riley was a pupil.
Represented: NPG London; NGI; Tate; Dulwich AG; Enoch Pratt Library, Baltimore, Maryland. **Engraved by** I.Beckett, W.P.Benoist, W.Bond, J.W.Cooke, J.Dunn, W.Faithorne, J.Fittler, J.Heath, R.Houston, T.Johnson, B.Picart, F.Place, R.Purcell, P.Rothwell, J.K.Sherwin, C.Turner, G.Vertue.

SOILLEUX, Frederick **fl.1870-1871**
Exhibited at SBA (2) 1870-1 from London.

SOLDI(E), Andrea **c.1703-1771**
Born Florence. Recorded painting portraits of British merchants of the Levant Company in Constantinople and Aleppo. Settled in London 1736, where he enjoyed a successful practice for about 10 years. Considerably favoured by 2nd Duke of Manchester and 4th Viscount Fauconberg. Between April and August 1738 he

had 'above 30 portraits large and small begun'. Produced a number of portraits for country houses in Yorkshire. The success of foreign artists like Soldi and Van Loo caused considerable concern among British painters, rousing Hogarth and Ramsay to extra efforts. By 1744 he is said to have acquired a 'high mind and conceptions grandisses willing to be thought a Count or Marquis, rather than an excellent Painter'. In the same year his extravagance led to his imprisonment for debt. Thereafter the social standing of his sitters declined, while his exoticism was gradually undermined. Worked briefly in Scotland c.1756-8, by which time his pupil Mrs Delany had found him 'good humoured and very communicative'. Exhibited at SA (4), FS (1) 1761-9. Elected FSA 1765. Applied to RA for charity in the last year of his life. Died London January 1771. His funeral, according to Whittley, was paid for by Joshua Reynolds. His best work is beautifully delineated with sensitive use of colour. His painting of hands is usually very good, and they are posed in graceful positions often with pointing fingers. Ingamells writes: 'His paint surface is creamy and pleasant, and his touch seems sure and rapid'.
Represented: SNPG; Canterbury Museums; Dulwich AG; Yale; Parliament Hall, Edinburgh; Oriel College, Oxford; Badminton; Newburgh Priory; Kedleston Hall; Parham Park; Bristol Baptist College; RIBA; York AG (self-portrait 1743). **Engraved by** F.M. Le Cave, R.Cooper, J.McArdell, F.Perry, T.Prescott, J.Rogers, T.Trotter. **Literature:** J.Ingamells, 'A.S.', *Connoisseur* 185 March 1974 pp.192-200; J.Ingamells, Walpole Society XLVII 1980 with a check list of his work; DA.

SOLOMANS, Estella Frances ARHA 1882-1968
Born Dublin. Studied at Dublin Metropolitan School of Art, RHA Schools and Chelsea Art School. Exhibited at RHA (264) and in Paris 1905-68 from Dublin and Rathfarnham. Elected ARHA 1926. Married J.S.Starkey.
Represented: NGI.

SOLOMON JOSEPH SOLOMON A young girl. Signed. Panel.
36 x 29ins (91.5 x 73.7cm) *Christopher Wood Gallery, London*

SOLOMON, Abraham ARA 1824-1862
Elder brother of Rebecca and Simeon. Entered Saas's Academy
aged 13 and RA Schools, winning medals. Exhibited at RA (33),
BI (7), RHA (1), SBA (5) 1840-62. Concentrated on genre, at
first historical and then contemporary. His railway interiors '1st
Class – The Meeting' and '3rd Class – The Parting', 1854 were
extremely popular as engravings, as too were 'Waiting for the
Verdict' and 'The Acquittal', 1859. Married 1861. Ill health and
a weak heart forced him to go abroad. Died Biarritz 19
December 1862 on the same day that the Academy elected him
ARA. Studio sale held Christie's 14 March 1863.
Represented: Guildhall AG, London; Tate; Leicester AG;
NG Ottawa. **Literature:** DNB; DA; *Solomon Family*, Geffrye
Museum, London exh. cat. 1985.

SOLOMON, J.W. fl.1827-1849
Exhibited at RA (16), BI (6), SBA (5) 1827-49 from London.

SOLOMON, Solomon Joseph RA PRBA RP
** 1860-1927**
Born London 16 September 1860. Studied at Heatherly's, RA
Schools 1877-80, Munich Academy and under Cabanel at École
des Beaux Arts, Paris. Exhibited at RA (144), RHA (3), SBA,
NEAC, RP (27), NWG 1881-1927. Elected founder NEAC,
RP 1891, ARA 1896, RA 1906, PSBA 1919. Established a
successful society portrait practice. His sitters included Arthur
Hacker ARA, Sir George Faudel Phillips Bart, the Prime Minster
(H.H.Asquith) and Earl of Cadogan KG. Travelled in North
Africa, Spain and Italy with his friend Hacker. Painted portraits
in a confident and flamboyant style with outstanding treatment
of flesh tones. Also produced mythological and biblical scenes.

Played an important role in the development of military
camouflage techniques. Died Birchington 27 July 1927.
Represented: NPG London; Tate; Walker AG, Liverpool;
Preston AG; Leeds CAG. **Literature:** O.S.Phillips, *S.J.S. – A
Memoir of Peace and War,* London nd.

SOMERVILLE, Andrew RSA 1808-1834
Born Edinburgh. Studied at Trustees' Academy and under
William Simpson. Exhibited at RSA (27) 1826-34. Elected
ARSA 1831, RSA 1832. Died Edinburgh January 1834.
Described by Simon as 'a most gifted portraitist'.
Represented: Balnagown Castle Collection; SNG.

SOMERVILLE, Charles 1870-1939
Born Falkirk, Stirlingshire 29 July 1870. Educated Falkirk
Academy. Exhibited at RHA (4) 1928 from Ashford,
Middlesex. Friend of Joseph Crawhall. A founder of
Doncaster Art Club. Died Wigginton 9 May 1939.
Literature: McEwan.

SOMERVILLE, Edith 1858-1949
Her portrait of Violet Martin is in NPG London.

SOMERVILLE, Howard RP 1873-1952
Born Dundee. Educated at Dundee Technical and University
Colleges as an engineer. Took up art and exhibited at RA
(14), RP, RSA (8), Paris Salon (Silver Medal 1928) 1926-40
from Glasgow, London and New York. Elected RP 1917.
Died Bristol 2 July 1952.
Represented: SNPG; Walker AG, Liverpool. **Literature:**
McEwan.

SOMMERS, Charles fl.1739-1753
Specialized in small full-lengths in the manner of Arthur
Devis. Successful enough to take on Richard Linnell as an
apprentice 1 August 1752. His large group portrait of 'Sir
William More-Molyneaux and Family' (1739) is at Losely.
Buried London 14 May 1753.

SONMANS (SUNMAN), Willem fl.1670-1708
A native of Dordrecht, who worked in London and enjoyed a
good practice after Lely's death. Painted academic portraits in
Oxford. Buried London 15 July 1708. His work shows the in-
fluence of Riley and Kneller and he often signed his initials 'W.S.'.
Engraved by S.Gribelin, F.H.Van Hove, R.White.

SONNIUS, Frederic fl.1680-1688
Worked with Lely. One of the principal assistants active in
completing his unfinished portraits. Described as 'old and
touchy' in 1688.
Literature: M.K.Talley, *Portrait Painting in England:
Studies in the Technical Literature before 1700,* 1981.

SOORD, Alfred Usher 1868-1915
Exhibited at RA (26) 1893-1915 from Bushey. Died Bushey
9 August 1915. His wife Evelyn survived him.

SORESBY, J. fl.1821
Believed to have been from Derby. Exhibited at RA (1) 1821
from 42 Cirencester Place.

SOTHERN, Miss Fanny fl.1874-1875
Exhibited at RA (2) 1874-5 from Brompton, London.

SOUCH, John c.1593-c.1645
Cheshire portrait painter. Apprenticed to herald painter,
Randle Holme. Paid 30s. for a portrait of Earl of Cumberland
1620. Was successful enough to employ Thomas Pulford as
an apprentice 1636.
Represented: Tate; Grosvenor Museum, Chester; Manchester
CAG. **Literature:** National Art-Collections Fund Report 1983.

SOUTER, John Bulloch PS 1890-1972
Born Aberdeen. Studied at Gray's School of Art. Awarded a travelling scholarship and continued his studies in France, Spain, Italy, Germany, Switzerland and Belgium. Exhibited at RA (30), PS 1914-57 from London and Aberdeen. Served in RAMC in 1st World War. Settled in London 1922. Established a fashionable practice. Sitters included Ivor Novello and Gladys Cooper. His picture 'The Breakdown' showing a naked white girl dancing to a black musician caused a furore in 1926 and was withdrawn from the RA. Also worked in Jersey. Returned to Aberdeen 1952. Died Aberdeen 10 May 1972.
Represented: Manchester CAG; Edinburgh AG. **Literature:** McEwan.

**SOUTHALL, Joseph Edward RWS RBSA NEAC
1861-1944**
Born Nottingham 23 August 1861. Educated at York and Scarborough, and later spent four years in an architect's office. Took to painting and visited Italy and France to study. Influenced by Italian primitive painters of 14th and 15th centuries. Encouraged by Sir W.B.Richmond and Sir E. Burne-Jones. Lived in Birmingham, where he worked as an examiner at Municpal School of Art. Exhibited at RA (20), NEAC, RWS, RBSA 1895-1942. Elected ARWS 1925, RWS 1931. Died 6 November 1944. Developed a highly distinctive and personal style.
Represented: Tate. **Literature:** *J.S.: Artist-Craftsman*, Birmingham CAG exh. cat. 1980; *Country Life* 30 January 1992 p.65.

SOUTHWELL, Luke fl.1832-1847
Exhibited at RHA (3) 1832-47 from Dublin.

SOWERBY, James 1758-1822
Born London 22 March 1758. Entered RA Schools 31 December 1777 'aged 19. 22 last March'. Apprenticed to Richard Wright. Became a teacher of drawing and portrait painter. Exhibited at SA, RA (6) 1774-83. Went to Paris for a time, taking his daughters with him. Published 36 volumes of *English Botany* 1790-1814. Died Lambeth 25 October 1822 (not Paris 1803).
Engraved by J.Newton.

SOYER, Mrs Elizabeth Emma (née Jones) 1813-1842
Born London. Studied from the age of five under the Flemish artist F.Simoneau. Her progress was so great that by the age of 12 she 'had drawn more than a hundred portraits from life with great fidelity'. Exhibited at RA (13), BI (38), SBA (13), Paris Salon 1823-43. Worked in London, Canterbury, Ramsgate and Shrewsbury. Married Alexis Benoit Soyer, the *chef de cuisine* at Reform Club 12 April 1837. Died in childbirth 29/30 August 1842. Buried Kensal Cemetery, where her husband erected a sumptuous monument in her memory. Painted a number of portraits of centenarians. Her work was particularly admired in Paris. Ottley writes: 'Her portraits are remarkable for character, spirit, and vigour'. The *Art Union* claimed that although she died aged only 29, she had painted no less than 403 pictures.
Engraved by H.B.Hall. **Literature:** *Morning Post* 2 September 1842; *Art Union* 1842 p.257.

SPANTON, W.S. fl.1867-1868
Exhibited at RA (2) 1867-8 from an accommodation address in Pimlico, but lived in Bury St Edmunds.

SPEED, Harold RP 1872-1957
Born London 11 February 1872, son of Edward Speed an architect. Began studying architecture at National Art Training School, South Kensington 1887. Then art at RA Schools 1891-6, where he won a Gold Medal and travelling

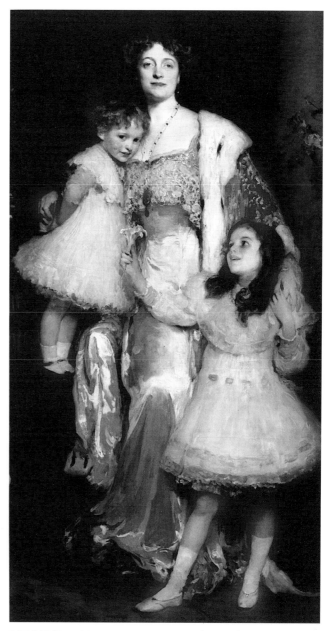

SOLOMON JOSEPH SOLOMON. Violet, Lady Melchett with her two daughters the Hon Nora and the Hon Mary Mond. Exhibited 1908. 81 x 42ins (205.7 x 106.7cm) *Christie's*

scholarship, visiting Paris, Rome, Vienna, Spain and Belgium. Exhibited at Paris Salon, RA (87), RP (166), RHA (1), SBA 1893-1955 from London and Watlington, Oxfordshire. Elected RP 1897. Master of Art Workers' Guild 1916. Taught painting at Goldsmiths' College. Among his sitters were Edward VII, Earl of Bessborough, Lord Carrington, Holman Hunt and Lord Baden-Powell. Died London 20 March 1957.
Represented: NPG London; Tate; Manchester CAG; Southampton CAG; Walker AG, Liverpool; Southampton CAG; Wolverhampton AG; Bristol AG. **Literature:** Fine Art Society exh. cat., London 1938.

SPENCE, Ernest fl. 1884-1913
Exhibited at RA (12) 1882-1913 from London and Guildford.

CHARLES SPENCELAYH. A lady in Japanese costume. Signed.
30 x 25ins (76.2 x 63.5cm) *Christie's*

SPENCE, Harry RBA **1860-1928**
Born London of Scottish parents. Studied in Glasgow,
London and Paris. Exhibited at RA (11), RSA (21), SBA,
Paris Salon 1895-1928.
Represented: Glasgow AG. **Literature:** McEwan.

SPENCE, Percy F.Seaton **1868-1933**
Born Sydney. Painted portraits and marines. Exhibited at RA
(2) 1907-15 from London. Died London September 1933.
Represented: NPG London.

SPENCELAYH, Charles HRBSA RMS VPBWS
 1865-1958
Born Rochester 27 October 1865, son of an engineer and
youngest of 11 children. Studied in South Kensington and
Paris. Painted miniatures and portraits, but specialized in
highly finished cluttered interiors with old men. Exhibited at
RA (80), ROI, RHA (2), RBSA, RMS 1892-1958. Elected
RMS 1897. Considered by critics to be an 'anachronism', but
his delightful work always sold well and was much admired by
Munnings, who rightly thought it disgraceful that Spencelayh
was never elected ARA or RA, despite exhibiting there from
1892 until his death. Died Northampton 25 June 1958, just
before his ninety-third birthday.
Represented: Tate. **Literature:** A.Noakes, *C.S.*, 1978.

SPENCER, John S. **fl.1848-1855**
Listed as a portrait painter at 21 King Street, Manchester and
1 Chapel Place, Chorton-on-Medlock.

SPENCER, Thomas **fl.c.1730-c.1763**
Engraver and sporting artist. Studied under James Seymour.
Charged 15 guineas for a portrait on horseback in 1760.
Represented: Tate.

SPERLING, J.W. **fl.1845-1848**
Exhibited at RA (3) 1845-8 from London. Also painted
sporting subjects, including a 'Gray Stallion, the Property of
His Majesty the King of Württemburg'.

SPILSBURY, Jonathan **1737-c.1812**
Son of Thomas Spilsbury and brother of John Spilsbury, the
engraver and map dissector in wood. Entered RA Schools 25
March 1776 aged 39 and reportedly studied under Worlidge.
Listed as a Portrait Painter and Mezzotint Engraver 1763.
Gained premiums for mezzotint engraving at SA 1761 and
1763. Exhibited at RA (13), BI (1) 1776-1807. Lodged with
his brother in Drury Lane. Married Rebecca Chapman 13
February 1775.
Engraved by W.Ridley.

SPILSBURY, Maria (Mary) (Mrs Taylor) **1777-c.1823**
Born London, daughter of engraver John Spilsbury.
Exhibited at RA (47), BI (32) 1792-1813 from 10 St
George's Row, Oxford Turnpike. Married artist John Taylor
1809 and moved to Ireland 1813, continuing to exhibit in
Dublin up to 1819. Died Ireland. Painted a number of small
portrait groups and single small figures in oils.
Represented: NGI; Tate. **Engraved by** H.Dawe.

SPINDLER **fl.1834-1836**
Exhibited at RA (9) 1834-6 from London. Possibly the Louis
Spindler who worked as a portraitist at 50 Worcester Street,
Hulme, Manchester 1845.

SPINDLER, Walter E. **fl.1892-1896**
Exhibited portraits, including Lady Jane H.Swinburne and
Sarah Bernhardt at RA (4) 1892-6 from Paris.

SPONG, Miss Annie **fl.1896-1908**
Exhibited at RA (9) 1896-1908 from London, Oxford and
Ditchling. Among her sitters were Sir Nathaniel Barnaby
KCB, H.George Smallman Esq – Alderman of the City of
London (presentation portrait), and Captain E.W.Andrews –
Mayor of Lambeth.

SPOONER, Arthur RBA **1873-1972**
Born Nottingham. Studied at Nottingham School of Art
under Wilson Foster. Appointed Master of Nottingham
School of Art. Founder member of Nottingham Society of
Artists, serving as President 1946-62. Exhibited at RA (17),
SBA 1907-41. Died Nottingham.

SPRAGUE, Miss Edith **fl.1883-1920**
Exhibited at RA (32), SBA 1883-1920 from St John's Wood,
South Woodford and Maidstone.

SPREAD, Henry Fenton **b.1844**
Born Kinsale, Ireland. Studied at South Kensington School
(winning prizes), under Riviere and Warren, and in Brussels
1863 under Slingineyer. Visited Australia 1864 and settled in
Melbourne, where he painted many portraits. Went to
America 1870, working in New York and Chicago. Member
of Chicago Academy of Design.

SPRINCK, Leon **fl.1893-1902**
Exhibited at RA (1), RHA (1) 1893-1902 from London.

SQUIRE, Josiah **b.1809**
Baptized St Ann, Blackfriars 10 February 1809 son of John

and Frances Squire. Exhibited at RA (3), BI (5) 1828-34 from Pentonville. Married Sophia Catherine Farren 16 August 1837 at Kennington.

STABLE(S) fl.1767-1783
Exhibited at SA (1), FS (6) 1767-83 from London.

STACKE, E.G. fl.1849
Exhibited a portrait of Dr. Gauntlett at RA 1849.

STAIGG, Richard Morrell 1817-1881
Born Leeds 7 September 1817. Began working for an architect. Went to America 1831 and settled in Newport, Rhode Island, where he received encouragement from W.Allston. Worked for a time in Boston. Elected NA 1861. Exhibited at RA (4) 1847-64. Visited London 1864 and Paris 1867-9. Died Newport, Rhode Island 11 October 1881.

STAMP, Ernest ARE 1869-1942
Born Sowerby, Yorkshire 22 February 1869. Studied under Herkomer. Also engraved portraits. Exhibited at RA (8) 1892-1917 from London and Northampton.
Represented: Brighton AG.

STAMPA, George Loraine 1875-1951
Born Istanbul 29 November 1875, son of architect G.D.Stampa. Settled in London, studying at Heatherley's and RA Schools 1895-1900. Exhibited at RA (3), RI from 1898. Illustrated for *Punch* and others. Member of Langham Sketching Club. Married Ethel Crowther 1906. Died Golders Green 26 May 1951.

STANDISH, John fl.1844
Listed as a portrait and landscape painter at Pontefract, Yorkshire.

STANDLEY see STANLEY

STANESBY, Alexander c.1832-1916
Son of miniaturist John Stanesby. Won premiums while still a boy at SA. Exhibited at RA (8), SBA (3) 1848-54 from London. Among his sitters were artists George Lance and William Powell Frith ARA.

STANESBY, Joshua fl.1821-1854
Exhibited at RA (11), BI (3), SBA (3) 1821-54 from London.

STANESBY, Samuel fl.1850-1853
Exhibited at RA (2), SBA (2) 1850-3 from London. Related to artist Josiah Stanesby.

STANLEY (STANDLEY) fl.1764-1769
Exhibited at SA (4), FS (2) 1764-9 from London.

STANLEY, C.W. fl.1848
Exhibited at RA (1) 1848 from the same London address as artist Colet Robert Stanley.

STANLEY, Sidney W. 1890-1956
Born London 14 August 1890. Studied at Heatherley's under H.G.Massey. Exhibited at RA (3), RI, RP, RHA, SBA. Died 5 February 1956.

STANNARD, Abraham fl.1836
Listed as a portrait painter at Rose Lane, Norwich.

STANNARD, Joseph 1797-1830
Born Norwich 13 September 1797. Apprenticed to Robert Ladbrooke. Studied in Holland 1821-2. Exhibited in Norwich 1816-30 and BI (9) 1819-29. Known for his coastal and landscape paintings, but also produced some portraits. Died Norwich 7 December 1830.
Represented: Yarmouth Museum; Castle Museum, Norwich.
Literature: H.A.E.Day, *The Life and Works of J.S.*, 1965; DA.

STAPHORST, Abraham 1638-1696
Born Edam, near Dordrecht. Believed to have visited England twice. Painted some portraits for Duke of Bedford February 1660/1. Died at Dordrecht.
Represented: Woburn.

STAPLES, Sir Robert Ponsonby, Bart 1853-1943
Born Cookstown, County Tyrone 30 June 1853, third son of Sir Nathaniel Alexander Staples 10th Bart and Elizabeth (née Head). Lived Cookstown, County Tyrone. Studied at Louvain Academy of Fine Arts 1865-70, Dresden 1867 and in Brussels under Portaels 1872-4. Visited Paris 1869 and Australia 1879-80. Exhibited at RA (16), RHA (37), SBA, GG 1875-1928. Married Ada Louisa Stammers 1883. Art Master at People's Palace, Mile End Road 1897. Member of Union International des Beaux-Arts and Belfast Society. Among his sitters were Queen Victoria, Randolph Churchill, Gladstone, Whistler, Lily Langtry, Sarah Bernhardt and Swinburne. Died Cookstown 18 October 1943. Collaborated with G.H.Barrable. Studio sale held Phillips 11 June 1991. His best works convey considerable character and he was capable of highly original compositions.
Represented: NPG London; Worthing Municipal Gallery; HMQ; Marylebone Cricket Club; New City Hall, Belfast.

STARK, Mrs Rose Isabelle (née Fassett Kent) fl.1832-1850s
Painted landscapes, portraits and still-life. Married artist Arthur James Stark.

STARLING, Albert fl.1878-1922
Exhibited at RA (16), SBA (10), NWS 1878-1911 from Sutton, Surrey.
Represented: Walker AG, Liverpool.

STARR, Miss Louisa (Madame Canziani) 1845-1909
Studied at RA Schools (Gold Medal 1867) and was the first female to do so. She gained admittance by signing her entrance drawing 'L.Starr'. Sir Charles Eastlake said that admission of ladies was not permitted by the constitution, but she demanded to see the clause in question and it proved to be non-existent. Exhibited at RA (68), RHA (1), SBA, NWS, GG, SWA 1863-1909 from London. Patronized by many high society sitters. Married Enrico F.L.Canziani c.1884/5. Died London 25 May 1909. Her daughter Estella was also an artist.
Represented: NPG London. **Literature:** W.Shaw-Sparrow, *Women Painters of the World*, 1905.

STARR, Sidney RBA NEAC 1857-1925
Born Kingston-upon-Hull, Yorkshire 10 June 1857. Studied at Slade under Poynter and Legros, winning a scholarship. Exhibited at RA (6), SBA (40), NWS, GG 1882-6 from London. Elected RBA 1886. Awarded Bronze Medal at Universal Exposition, Paris 1889. Represented at the London Impressionist Exhibition 1889. Moved to New York because of a scandal, where he did decorative works for Grace Chapel, and 24 figures for the Congressional Library, Washington DC. Died New York 3 March 1925.
Represented: Tate. **Engraved by** H.F.Davey.

STAVELEY (STAVELY), William fl.1785-1805
Possibly born York, son of a frame maker. Painted small-scale portraits and miniatures. Exhibited at RA (51) and in Liverpool 1785-1805 from London.
Represented: SNPG. **Literature:** McEwan.

STEAD, Frederick **1863-1940**
Born Shipley 3 August 1863. Studied at RCA, winning medals and a scholarship. Worked in Bradford. Exhibited at RA (34) 1892-1927. Member of Yorkshire Society of Artists. Established a successful provincial practice. Died Bradford. His wife, May, was also an artist.
Represented: Bradford Museum; Preston AG.

STEARNS, Junius Brutus NA **1810-1885**
Born Arlington, Vermont, son of portraitist Junius Stearns. Studied at NA of Design, New York c.1838. In 1849 studied in Paris and London, but was back in New York by 1850. Elected ANA 1848, NA 1849. Died Brooklyn, New York 16 September 1885.

STEEDEN, O. **fl.1823-1824**
Exhibited at RA (1) 1823 from 3 Red Lion Square, London.
Engraved by J.Rogers.

STEEL(L), Gourlay **fl.1859-1878**
Listed as a portraitist in Edinburgh.
Engraved by W.H.Simmons.

STEELE, Christopher **1733-1767**
Born Egremont, Cumberland 9 July 1733. Studied under marine artist Richard Wright at Liverpool and Carle van Loo in Paris. He was influenced by Parisian dress and manners and on his return to his native Cumberland was dubbed by locals as the 'Count'. Based first at York (c.1750) and then established a studio at Kendal, taking on George Romney as an apprentice 20 March 1755. Steele eloped with a girl pupil to Gretna, leaving Romney to sort out his affairs and finish his portraits. Following their marriage they settled in York (where he painted Laurence Sterne) and Romney joined them and resumed his apprenticeship. They returned to Kendal July 1757 and then worked in Lancaster. Departed company with Romney for Ireland 1758, Middlewich 1759, by 1762 Manchester and Liverpool. In December 1762 left for West Indies. Returned to Cumberland. Died Egremont 1 September 1767. Waterhouse aptly describes his portraits as 'neat and crisp and of excellent quality'. Romney rated his master's work to be 'as good as Hudson's'.
Represented: Abbot Hall AG, Kendal. **Literature:** Hall 1979; *Burlington Magazine* CX 1977 p.347; *Walpole Society,* LVIII 1989 pp.193-225; DA.

STEEN, Miss Annie **fl.1890-1915**
Exhibited at RBSA (45) 1890-1915 from Birmingham.

STEENWYCK, Hendrick van (ii) **c.1580-1649**
Believed to have been born in Frankfurt, where his father had fled from Antwerp. Active 1604 and had moved to England by 1617, where he remained until 1637. Received patronage from Charles I and painted architectural backgrounds for portraits of the King by Mytens. Also produced portraits on his own. Possibly lived latterly in the northern Netherlands, where his widow was recorded 1649.
Literature: G.Martin, *The Flemish School,* NG London exh. cat. 1970 pp.240-1.

STEER, Henry Reynolds RI RMS **1858-1928**
Born London 25 August 1858. Worked as a lithographer 1876-81. Studied at Heatherley's 1879-86. Exhibited at RA (1), RHA (1), RI, RMS. Elected RI 1894, RMS 1896. Moved to Leicester, where he died 27 February 1928.
Represented: Leicester AG; Walker AG, Liverpool.

STEER, Philip **1810-1871**
Encouraged to become a painter by Sir William Elford. Worked as a portraitist and teacher in Birkenhead. Father of Philip Wilson Steer. Died Whitchurch 1 July 1871.

STEER, Philip Wilson OM NEAC **1860-1942**
Born Birkenhead 28 December 1860, son of Philip Steer, an artist and teacher. Studied at Gloucester School of Art under John Kemp, École des Beaux Arts and Paris under Cabanel. Returned to London 1884. During this time he painted Impressionist coastal scenes in Walberswick and in France. Took summer painting exhibitions to a wide number of locations in England and France. Exhibited at RA (6), RHA (6), SBA, GG, NEAC 1883-1940. Contributed to the London Impressionists exhibition at Goupil Gallery 1889. Occasionally produced portraits, which are usually sensitively painted in the Impressionist manner. Taught at Slade for nearly 40 years. Died London 18 or 21 March 1942. Studio sale held Christie's 16-17 July 1942. He never married and was looked after by his Welsh nurse, Mrs Raynes, who had cared for him since birth (his mother was an invalid). He once complimented her on her pudding and she replied 'There is art in everything, even in painting pictures'. A film, *The Bridge,* loosely inspired by Steer's visits to Walberswick in Suffolk, was released in 1991.
Represented: NPG London; NGI; Tate; BM; VAM; Aberdeen AG; Leeds CAG; Fitzwilliam; Manchester CAG; Brighton AG; Leicester AG; Newport AG; Southampton CAG; Birkenhead AG; Bradford AG; Portsmouth City Museum; Christchurch Mansion Ipswich; Whitstable Museum; Columbus AG, Ohio; New South Wales AG, Sydney; Johannesburg AG. **Literature:** R.Ironside, *W.S.,* 1943; D.S.MacColl, *Life, Work and Setting of P.W.S.,* 1945; B.Laughton, *P.W.S.,* 1971; P.Gibson, *The Capital Companion,* 1985; DNB; DA.

STEERS, A. **fl.1837**
Exhibited a portrait of the 'Marquess of Chandos' at RA (1) 1837 from High Wycombe, Buckinghamshire.

STEERS, W. **fl.1823-1830**
Exhibited at RA (7), SBA (1) 1823-30 from London.

STEPHANOFF, Fileter N. **c.1744-after 1791**
Said to be eldest son of a Russian nobleman. Entered RA Schools 1774 aged 29. Painted stage scenery and ceilings. Exhibited at FS (4), RA (6), OWS 1778-82 from London. His wife Gertrude, a daughter and two sons were all painters. Committed suicide.
Represented: BM; VAM; Castle Museum, Nottingham.
Engraved by E.Scriven.

STEPHANOFF, Francis Phillip **1790-1860**
Born Brompton, son of artist Fileter Stephanoff and brother of James. Entered RA Schools 1801. Exhibited at RA (49), BI (54), OWS 1807-45. Mainly painted genre, but occasionally portraits. Awarded a premium of £100 at Westminster Hall Competition 1843 for a scene from Milton's *Comus.* With his brother James was considered 'two of the best dilettante violins of the day'. The brothers also worked as architectural draughtsmen in close association with Pugin and Wild. The sudden death of his wife, Selina Roland, seriously affected his health causing his premature retirement. Died West Hanham, near Bristol 15 May 1860.
Represented: VAM; Glasgow AG. **Engraved by** H.Meyer, S.W.Reynolds, E.Scriven. **Literature:** DA.

STEPHANOFF, James OWS **1788-1874**
Born Brompton, son of Fileter Stephanoff and brother of Francis. Trained for a short time with his brother at RA Schools 1801. Exhibited at RA (20), BI (33), SBA (5), OWS (245) 1810-51. Elected OWS 1819. A founder of Sketching Society. Appointed Historical Painter in Watercolours to William IV 1830. With his brother he contributed to G.Naylor's 'Coronation of George IV' (VAM). Moved to live

with his brother in Bristol 1850, where he resided the rest of his life. Resigned his membership of OWS 1861 due to bad health. Died Clifton, Bristol 4 July 1874 aged 86.
Represented: BM; VAM; SNG; Cartwright Hall, Bradford; Royal Shakespeare Theatre, Stratford. **Engraved by** W.Bennet, W.Bond, S.W.Reynolds.

STEPHEN, Miss Elizabeth fl.1906-1907
Exhibited at RHA (6) 1906-7 from Dublin.

STEPHENS, Miss E. fl.1839-1844
Exhibited at SBA (8) 1839-44 from 19 St Peter's Hill, Doctors' Commons.

STEPHENS, Frederick George 1828-1907
Born London 10 October 1828, son of the master of Strand Union Workhouse. Entered RA Schools 13 January 1844. Successfully nominated for the Pre-Raphaelite Brotherhood by Holman Hunt 1848. Exhibited at RA (2) 1852-4. Concentrated on art criticism, writing for *The Germ*. Art editor of *The Athenaeum* for over 40 years and wrote many monographs on artists such as Mulready, Alma-Tadema, Landseer and Samuel Palmer. Died Hammersmith 9 March 1907. His wife Rebekah survived him.
Represented: Tate; Ashmolean. **Literature:** DA.

STEPHENS, Miss Helen E. fl.1892
Exhibited a portrait sketch at SBA (1) 1892 from London.

STEPHENS, James John fl.1829-1845
Exhibited at RHA (25) 1829-45 from Dublin.
Represented: NGI.

STEPHENSON, John Cecil 1889-1965
Born Bishop Auckland 15 September 1889. Studied at Leeds School of Art, RCA and Slade. Painted portraits and landscapes in a naturalistic style, but in 1932 turned to abstract painting. Exhibited at a number of London galleries. Taught at Northern Polytechnic 1922-55. Died London.
Literature: Hall 1982.

STEPHENSON, Joseph 1757-1792
Born Carlisle 20 January 1757. Studied under Captain J.B.Gilpin, before entering RA Schools 1782. Exhibited at RA (2) 1785. Worked for some time at Beaufront, near Hexham under the patronage of the Chief of Beaufront. His health deteriorated and he returned to Carlisle, where he died.

STEPHENSON, Timothy fl.1701
Practised in Newcastle and also possibly York and Carlisle. Painted 'Thomas Smith, Dean of Carlisle' (c.1701) engraved in mezzotint by John Smith. Also painted two ovals of 'Ralph Grey and His Wife' (1701 formerly at Poundisford Park) for which he charged £10.5s. Sometimes confused with landscape painter Thomas Stevenson fl.1669-1680.

STERLING, E.C. fl.1867-1877
Exhibited at RA (3) 1867-77 from London.

STEUART, George d.1806
Scottish architect and brother of artist Charles Steuart. Exhibited at SA (10) 1783-90 from London. The Duke of Atholl was his patron. Died Douglas, Isle of Man.
Literature: McEwan.

STEVENS, Alfred George 1817-1875
Born Blandford 30 or 31 December 1817, son of a house painter. In 1833 his friends subscribed to send him to Italy, where he studied under Thorwaldsen and lived for nine years.

On his return to England he worked at the Government School of Design at Somerset House 1845-7. Moved to Sheffield 1850, to work as a designer for Hoole and Robson, a firm of metal workers. Worked as a designer and decorator at Dorchester House, Harewood House and Deysbrook Hall. Produced very few oil paintings, but most of these were portraits. Also a sculptor and his most famous commission was the Wellington Monument in St Paul's Cathedral begun in 1858 and left unfinished at his death (completed by his pupils). Died Haverstock Hill, Hampstead 1 May 1875.
Represented: NPG London; VAM; Birmingham CAG.
Literature: S.Beattie, *A.S.*, VAM exh. cat. 1975; DA.

STEVENS, Henrietta fl.1832-1834
Listed as a portrait painter at 61 South Molton Street, London.

STEVENS, John RSA 1793-1868
Born Ayr. Studied at RA Schools (Silver Medallist 1818). A founder RSA. Exhibited at RSA (63), RA (14), BI (29), SBA (12) 1815-67. After setting up a portrait practice in Ayr he travelled to Italy, where he spent much of his career. Died Edinburgh 1 June 1868, after being involved in a railway accident in France.
Represented: NPG London; SNG. **Engraved by** J.Brooks.
Literature: McEwan.

STEVENS, Miss Susanna fl.1887
Exhibited a portrait at GG 1887.

STEVENSON, William fl.1840-1843
Exhibited at RHA (6) from Dublin.

STEWARD, Alexander fl.1832-1834
Listed as a portrait and miniature painter at 17 Princes Square, London.

STEWARDSON, Thomas 1781-1859
Born Kendal, son of a cobbler and clog maker. Studied under John Fothergill and also, it is believed, under Romney and Opie. Moved to London, where he enjoyed a highly successful society practice. His sitters included Lord Charles Spencer, W.Gilpin Esq, the Marchioness of Winchester, the Rt Hon G.Canning (Prime Minister) and the Rt Hon John Garrat, Lord Mayor. Exhibited at RA (83), BI (26) 1803-26. Painter to HRH the Princess of Wales 1811. After 1826 increasingly bad health forced him to retire. Died London 28 August 1859. Buried Kensal Green Cemetery.
Represented: NPG London; Tatton Park, NT; BM; Abbot Hall AG, Kendal; Lady Lever AG, Port Sunlight. **Engraved by** W.W.Barney, W.Brett, G.Clint, S.Cousins, W.Drummond, W.Holl, C.Knight, H.Robinson, J.Thomson, J. Walker, W.Ward. **Literature:** E.Fletcher (ed), *Conversations of James Northcote RA &c.*, 1901 p.207.

STEWART, Miss Elizabeth fl.1778
Honorary exhibitor at SA (1) 1778 from Islington.

STEWART, Hope James d.c.1881
Scottish painter working in Portman Square, London. Exhibited at SBA (8), BI (5) 1859-65. Among his sitters were the Hon Mrs Ogilvie and the Rt Hon Lady Kinnaird. Died 1881 (Wood) or 1883 (SNPG).
Represented: SNPG. **Engraved by** J.Le Conte.

STEWART, James RSA RBA 1791-1863
Born Edinburgh. Apprenticed to engraver, Robert Scott. Studied at Trustees' Academy. Engraved many of Sir William Allan's paintings. Founder RSA 1826. Moved to London 1830, but had trouble supporting himself and emigrated to

Cape Colony 1833, where he became a farmer. Lost everything due to the Kaffir War and went to live in Somerset (Cape Colony), where he taught art and painted portraits. Exhibited in London at RA (21), BI (16), SBA (148) 1825-61 through accommodation addresses. Elected RBA 1838. Died in the Colony. Among his sitters were 'Countess Chorinsky (Daughter of his Excellency Prince Esterhazy and Family), Painted by Express Command of the Prince – Chandos House', 'HRH Princess of Capua', and 'HRH Prince of Capua'.
Represented: SNPG; Glasgow AG; Edinburgh AG.
Engraved by J.Brown, R.J.Lane, S.W.Reynolds jnr, W.Sharp, C.E.Wagstaffe.

STEWART, James Malcolm　　　　1829-1916
Exhibited at RA (1), RHA (6) 1860-84 from London and Glasgow.
Represented: NPG London; Glasgow AG.

STEWART, John　　　　b.1800
Scottish painter. Exhibited at RA (4), SBA (21), BI (3) 1828-65 from London.

STEWART, John A.　　　　fl.1878
Listed as a portraitist at 65 Nethergate, Dundee.

STEWART, Miss M.　　　　fl.1791-1801
Daughter of artist Thomas Stewart. Studied under George Stubbs c.1795-1800. Exhibited at RA (11) 1791-1801 from London.

STEWART, Thomas　　　　b.1766
Born 19 October 1766. Entered RA Schools 1782, where he was awarded Silver Medal 1788. Exhibited at RA (24) 1784-1801. Related to artist Miss M. Stewart. Stayed with his sister at George Stubbs' house from c.1795-7 and painted his portrait 1801.

STILLMAN, Miss Lisa R.　　　　fl.1888-1894
Exhibited at NWG (19) 1888-94 from London.

STIRLING, John　　　　1820-1871
Worked in Aberdeen and London. Visited Morocco 1868-9. Exhibited at RA (24), BI (4), RSA (17) 1852-71.
Literature: McEwan.

STOCK, Henry John　RI ROI　　　　1853-1930
Born London 6 December 1853. Studied at RA Schools. Exhibited at RA (36), RMS, NWS, GG 1874-1910 from London and Bognor. Elected RI 1880, HRMS. Died 4 November 1930. Painted in the manner of Watts.
Represented: Manchester CAG. **Literature:** *Connoisseur* 87 1931 p.61.

STOCKDALE, Robert Errington　　　　fl.1855
Listed as a portraitist at 29 Charles Street, Chorton-on-Medlock.

STOCKMAN, John　　　　fl.1852-1853
Listed as a portrait painter at 47 St George's Square, Portsea.

STOCKS, Arthur　RI　　　　1846-1889
Born London 9 April 1846, son of the renowned engraver Lumb Stocks, and brother of artists Bernard and Walter Stocks. Studied under his father and at RA Schools. Exhibited at RA (59), RHA (4), BI (4), SBA (2), NWS 1866-89 from London. Elected RI 1882. Died Hornsey Rise, London 12 October 1889 aged 63.
Represented: Aberdeen AG; Walker AG, Liverpool.

STOCKS, Lumb　RA　　　　1812-1892
Born Lightcliffe, Yorkshire 30 November 1812. Studied under C.W.Cope and C.Rolls. Made his reputation as an engraver. Exhibited engravings and portraits at RA (42), SBA (2) 1832-92 from London. Elected ARA 1853, RA 1871. Died London 28 April 1892. Buried Highgate Cemetery. Left £37,833.3s.2d. Related to artists Arthur Stocks, Miss Katherine M. Stocks, Bernard O.Stocks and Walter Fryer Stocks.
Literature: DA.

STODDARD, Mary (née Devine)　　　　d.1901
Born Scotland, daughter of artist Peter Devine. She married and spent some time in Australia. Exhibited at Art Society of New South Wales c.1889-1900.
Represented: New South Wales AG.

STOKER, Bartholomew　　　　1763-1788
Son of William Stoker of Ballyroad, Ireland. While studying under F.R.West at Dublin Society Schools he worked as an upholsterer with William Macready of Bride Street. Set up as a portraitist in crayon and miniature with some success. Died Dublin 12 June 1788 aged 25. Buried Maryborough churchyard. His work was admired by Sir M.A.Shee.
Engraved by H.Brocas, J.Singleton.

STOKES, Mrs Marianne (née Preindlsberger)　ARWS
　　　　1855-1927
Born Austria. Studied in Munich and Paris. Painted in Brittany, where she met artist Adrian Stokes whom she married 1884. Exhibited at RA (21), RWS 1909-26. Worked in London and St. Ives. Died London August 1927.
Represented: NPG London; Tate.

STOKES, Thomas　　　　fl.1737
Painted a portrait of 'Sir Stafford Fairborne' 1737. His portraits were reproduced as mezzotints.

STONE, Frank　ARA　　　　1800-1859
Born Manchester 22 August 1800, son of a cotton spinner. First followed in his father's career. Aged 24 took up art, first concentrating on watercolours, but later oil paintings. Settled in London 1831. Exhibited at RA (42), BI (24), SBA (10), OWS 1833-60. Elected AOWS 1837, OWS 1843 (resigned 1847), ARA 1851. Painted mainly sentimental genre, but also some portraits. A friend of Charles Dickens and a member of his group of amateur actors. Died suddenly from heart disease in his house in London 18 November 1859. Among his executors were Frith and Egg. Along with artists like Baxter and Buckner he painted in the 'Keepsake' tradition, and made drawings for Heath's *Book of Beauty*. His son Marcus Stone was also a painter.
Represented: NPG London; SNPG; VAM; NGI; Manchester CAG. **Engraved by** W.H.Egleton, G.A.Periam, H.Robinson.
Literature: *Art Journal* 1860 p.9; DA; DNB.

STONE, Henry　　　　1616-1653
Baptized London 18 July 1616, son of sculptor Nicholas 'Old' Stone (1583-1647). Studied under Thomas de Keyser in Amsterdam 1635-8. Travelled to France and Italy with his brother John until 1643. Died London 24 August 1653.
Represented: SNPG; NGI. **Engraved by** T.Cross.

STONE, John　　　　fl.1737
Apprenticed to Benjamin Wilson for seven years from 28 April 1752 and presumably acted as drapery painter.

STONEHOUSE (STONHOUSE), Charles
　　　　fl.1833-1865
Exhibited at RA (35), BI (19), RHA (1), SBA (4) 1833-65 from London.
Engraved by F.C.Lewis, H.Robinson.

STONEY, Charles B.　　　　　fl.1879-1893
Exhibited at RA (25), SBA (3), NWG 1879-93 from London, Malmesbury, Newton Abbot and Parkstone, Dorset.

STOPPELAER, Charles　　　fl.1703-after 1745
Travelled to Dublin 1703, where he produced portraits and still-life. Member of Corporation of Painter-Stayners and Cutlers, Guild of St Luke, Dublin. Settled in London 1738 and was still working there 1745.
Represented: NGI. **Engraved by** A.Miller, W.Greatbach, G.Roth jnr.

STOPPELAER, Herbert　　　　fl.1735-d.1772
Born Dublin. Came to England with Thomas Frye, where he practised as an itinerant portrait painter. Worked in Norwich c.1755-6 where he painted two full-lengths of mayors. Exhibited at SA (6) 1761-71. Also painted a number of half-lengths in ovals. Died May 1772.

STOPPELAER, Michael　　　　fl.1735-1775
Believed to have been born in Ireland, brother of Herbert. Said to have been educated at Trinity College, Dublin, although no record of his entry has been found. Worked as a scene-painter, comic actor and as a portraitist.
Literature: Strickland.

STOREY, George Adolphus　RA　　1834-1919
Born Marylebone, London 7 January 1834. Studied under J.L.Dulong in Paris, Leigh's Academy, RA Schools and under C.R.Leslie. Exhibited at RA (172), BI, SBA, NWS 1852-1919. Elected ARA 1876, RA 1914. A member of St John's Wood Clique until he moved to Hampstead. Died London 29 July 1919. His wife Emily survived him.
Literature: G.A.Storey, *Sketches from Memory*, 1899; Maas.

STORY, Julian Russell　RP　　　1857-1919
Born Walton-on-Thames, son of sculptor William Wetman Story. Educated at Eton, graduating at Oxford University. Studied art with Duveneck in Florence, and with Lefebvre in Paris. Worked in Paris and Italy. Exhibited at RA (4), GG (13). Elected RP 1897. Painted Lord Vernon and HRH the Prince of Wales KG. Settled in Philadelphia, where he died.
Represented: NPG London; VAM; Boston MFA.

STOTT, Lady May Bridges (née Lee)　　d.1977
Born Lahore, India, daughter of John Bridges Lee, a barrister. Educated in England. Studied at Lambeth School of Art. Exhibited at RA (52), RSA, RI, RMS, SWA, Salon des Artistes Français (32) 1905-67 from London. Married Sir Philip Stott 2 January 1936. Painted portraits on all scales, including among her sitters sons of the Princess Royal. Died 2 January 1977.

STOWERS, Thomas Gordon　　　　b.1854
Baptized Kennington 6 December 1854, son of Nowell Stowers and Elizabeth (née Speakman). Exhibited at RA (3), SBA (3) 1873-1894 from London. Painted portraits of artists Sir Francis Grant and George Frederick Watts.

STOWLEY　　　　　　　　fl.1775
Exhibited a crayon portrait at FS 1775 from London.

STRACHAN, Douglas　HRSA　　　1875-1950
Born Aberdeen. Studied at RSA Schools and in France, Italy and Spain. Began working in Midlothian as a portrait painter, but after being commissioned to execute the stained glass windows for Great Britain's gift to the Palace of Peace at The Hague, concentrated on that medium. Elected HRSA 1920. Died 20 November 1950.
Literature: A.C.Russell, *The Stained windows of D.S.*, 1972; McEwan.

STRAIN, Miss Euphans Hilary　　　1884-1960
Born Alloway, Ayrshire. Educated in Germany. Studied at Glasgow School of Art, where she won Director's Prize 1922. Exhibited at RA (1), RSA, GI, Paris Salon. Married artist Harold Wyllie. Died 2 June 1960.

STRAKER, Harry　　　　　　fl.1906-1927
Exhibited at RA (7) 1906-27 from London.

STRANG, William　RA RE RP　　　1859-1921
Born Dunbarton 13 February 1859. Studied at Slade under Poynter and Legros 1902-6 and Académie Julian, Paris. Began as an etcher. Settled in London. Exhibited at RA (70), RHA (3), RSA (18), RP (15), RE 1881-1922. Elected RE 1881, RP 1904, ARA 1906, RA 1921. First-class Gold Medal at Dresden International Exhibition 1897. Died Bournemouth 12 April 1921. His work is very distinctive, and he combines a high Victorian finish with a strong use of 'modern' colours, which can provide a slightly surreal effect. Many of his portrait drawings were influenced by the Holbein drawings at Windsor.
Represented: NPG London; Tate; SNPG; Manchester City AG; Brighton AG; Fitzwilliam; Leeds CAG; Glasgow AG; NG Canada. **Engraved by** T.R.Way. **Literature:** F.Newbolt, *W.S.*, nd; *W.S. RA 1859-1921 Painter-etcher*, Graves AG, Glasgow AG and NPG exh. cat. 1981; McEwan; DNB; DA.

STRANGE, Frederick　　　　　b.1807
A convict artist, deported from England to Hobart 1838. Pardoned 1849, after which he worked in Australia as an engraver and portrait painter.
Represented: Queen Victoria Museum & AG, Launceston.

STREATER (STREETER), Robert　　1621-1679
Baptized Cripplegate, London 16 December 1621. Said to have been instructed by Du Moulin. Admired by his contemporaries and was a favourite of Charles II. Acted as Serjeant-Painter from the time of the Restoration (but the actual appointment was 21 March 1663) until his death. Married 1609 Susan Swalewell (d.1616) and after her death he remarried. Streater was described as the 'compleat master' as he was able to paint a variety of subjects, including the monumental canvas on the ceiling of the Sheldonian Theatre, Oxford 1668/9. His son Robert, was also a painter and succeeded him as Serjeant-Painter 1679. When the artist was suffering from gallstones he resolved to 'be cut', and Charles II sent for a special surgeon from Paris to perform the operation. He did not long survive and was buried London 23 April 1679. Pepys describes Streater as 'a very civil little man and lame, but lives very handsomely'.
Literature: *Burlington Magazine* LXXXIV January 1944 p.3; DNB; Walpole Society XLVII 1980.

STRETES (STREETES, STREATE), William
　　　　　　　　　　　　fl.1546-1556
Believed to have been Dutch and implicated in the resistance offered by Ghent to Charles V 1540. Sought English protection in Calais. Engaged in painting a portrait of Henry Howard, Earl of Surrey December 1546. During the reign of Edward VI he became 'the most esteemed and best paid painter' in England, receiving from the King a salary of £62.10s. Retained his position under Mary and presented to her as a new year's gift 'a table of her majesty's marriage' 1556. His work shows much affinity with Holbein.
Literature: DNB.

STRINGER, Daniel　　　　　　1754-1806
Born 14 June 1754, son of artist Francis Stringer. Entered RA Schools 1771. Practised as a portrait painter in Cheshire and reached a high standard in the manner of Opie.
Represented: Tate. **Engraved by** J.Basire.

STROEHLING (STRÖHLING), Peter Edward
1768-c.1826

Born Düsseldorf, although Long records that he was Russian educated at the Tsar's expense. Studied in Italy c.1792, after working in Paris and different parts of Germany. Visited Vienna 1796 and the same year went to St Petersburg, where he stayed for five years. Exhibited at RA (23), BI (3), SBA (1) 1803-26 from London. Established a successful society portrait practice. Among his sitters were Louisa, Queen of Prussia; HRH the Duke of Sussex; Lord Cochrane and the Marquess of Anglesey. Appointed Historical Painter to Prince of Wales 1810-20. Collaborated with artist P.Reinagle 1806. **Represented:** NPG London; SNPG; National Library, Vienna. **Engraved by** H.R.Cook, R.Cooper.

STRONG, Sampson
c.1550-1611

Dutch painter who anglicized his name from Starke to Strong. Settled in Oxford 1590 aged 40 and was employed as an all-purpose painter for the Oxford colleges. Painted a portrait for Oxford City 1597 and for Christ's Hospital, Abingdon 1607. **Literature:** R.L.Poole, *Catalogue of Portraits in the Possession of the University, Colleges, City and County of Oxford*, Vol II, xi-xiii.

STRUTT, Alfred William RCA RBA ARE 1856-1924

Born Tanaraki, New Zealand, son of artist William Strutt. Studied with his father in Australia and at South Kensington Schools (winning medals). Exhibited at RA (52), RHA (3), SBA (50+), NWS 1877-1917. Elected RBA 1888. Lived at Croydon, Staplehurst, Chiswick, Brook Green, South Kensington and Wadhurst, and accompanied Edward VII on a hunting trip to Scandinavia. Died Hammersmith 8 March 1924. **Literature:** *Connoisseur* 68 1924 p.243; *The Strutt Family*, Carlisle City AG exh. cat. 1970.

STRUTT, Jacob George
1784-1867

Exhibited at RA (21), BI (24), SBA (2) 1819-58 from London. For a few years he practised portrait painting. In the 1830s he travelled in Austria, Switzerland and Italy, returning to England 1851. Particularly fond of trees and illustrating books on the subject. Died Rome. **Engraved by** C.Turner, J.Young. **Literature:** *The Strutt Family*, Carlisle City AG exh. cat. 1970.

STRUTT, William RBA
1825-1915

Born Teignmouth, Devon 3 July 1825, son of miniaturist William Thomas Strutt. Studied at Beaux-Arts in Paris, under Drolling, Delaroche, Ingres and Vernet (winning a number of medals). Travelled to Australia 1850, where he produced his *Australian Journal* and *Illustrated Australian Magazine*. Visited New Zealand 1856. Returned to England 1862. Exhibited at RA (23), BI (1), SBA (32) 1865-93. Elected RBA 1891. A Fellow of the Zoological Society. Lived for some time in Writtle, Essex and at Wadhurst, Kent. Died Wadhurst 3 January 1915. His son Alfred and daughter Rosa were also painters. **Represented:** BM. **Literature:** *Connoisseur* 41 1915 p.170 ; *The Strutt Family*, Carlisle City AG exh. cat. 1970; DA.

STRUTT, William Thomas
1777-1850

Born 7 March 1777, son of Joseph Strutt, author, artist and antiquary. Had a position in the Bank of England. Exhibited at RA (26) 1795-1822 from London. Died Writtle, Essex 22 February 1850. **Engraved by** H.Meyer.

STUART, A.
fl.1827-1841

Exhibited at RA (3), BI (1) 1827-41 from London. Painted portraits of His Highness the Rajah of Mysore and Lieut-General Sir Thomas Bowser KCB.

PETER EDWARD STROEH-LING. Family with Ducal Palace, Venice, beyond. 22 x 25ins (55.9 x 63.5cm)
Christie's

GEORGE STUBBS. Rev Robert Carter Thelwall and family. Signed and dated 1776. Panel. 38 x 50ins (96.5 x 127cm)
Holburne Museum and Crafts Study Centre, Bath

STUART, Gilbert Charles 1755-1828
Born Narragansett, Rhode Island 3 December 1755, son of a Scottish snuff grinder and his wife Elizabeth, daughter of John Anthony, a farmer of Newport, Rhode Island. Studied art under Samuel King. Apprenticed to Cosmo Alexander at Newport, accompanying him to Edinburgh 1771, but Alexander died and he worked his passage home as a sailor. Left Newport for London 1775. After a lack of success during which time he supported himself by playing the organ in church, he turned to Benjamin West for help, working in his studio 1782-7 where he developed his portrait style influenced by Romney, Gainsborough, Raeburn and Copley. Exhibited at RA (13) 1777-85. Enjoyed a successful practice in London 1782-7, but got into debt and fled to Ireland. Had success there, but again got into financial difficulties and returned to America 1793 (New York). Worked in Philadelphia 1794 and Washington 1803. Developed a new 'style' in America. His portrait of George Washington ensured his fame and he became the country's leading and most influential portrait painter of his time. Settled in Boston after 1805. Died there 9 July 1828. His accomplished portrait of 'Mr Pelham Skating in St James's Park' was much admired by Walpole (NG Washington).
Represented: Boston MFA; Tate; NGI; VAM; NPG London; NG Washington. **Engraved by** P.Audinet, F.Bartolozzi, I.Farn, S.Freeman, V.Green, C.H.Hodges, W.Holl, J.Jones, G.Keating, R.Laurie, H.Meyer, E.Pinkerton, W.Ridley, H.T.Ryall, W.Say,

I.Schiavonetti, E.Scriven, W.Sharp, J.R.Smith, Thornthwaite, W.Ward, C.Watson, J.Young. **Literature:** *G.S – Portraitist of the Young Republic*, NG Washington exh. cat. 1967; L.Park, *G.S.: An Illustrated Descriptive List of His Work*, 1926; J.H.Morgan, *G.S and His Pupils*, 1939; J.T.Flexner, *G.S.*, 1955; C.M.Mount, *G.S. – A Biography*, 1964; R.McLanathan, *G.S.*, 1986; DA. Colour Plate 68

STUART, John fl.1848
Listed as a portrait painter at 11 Foster Street, Ardwick, Manchester.

STUART-WORTLEY
 see WORTLEY, Miss Mary Caroline Stuart

STUBBS, George ARA 1724-1806
Born Liverpool 25 August 1724, son of John Stubbs, a currier and leatherseller, and his wife Mary. Worked in his father's trade until he was about 16. After his father's death studied very briefly under Hamlet Winstanley 1741 in Warrington, but fell out with him. Worked as a portraitist in Wigan, Leeds, York 1745 (where he studied anatomy 1750). In Hull 1752, then Liverpool via Rome 1754. Returned to Liverpool the same year. He was particularly interested in horses and in 1758 began his dissections of horses in a remote part of Lincolnshire, resulting in his publishing *The Anatomy of the Horse*, 1766. Settled in London c.1760. Exhibited at SA

THOMAS SULLY. Captain Thomas Jefferson Leslie. Signed and dated 1829. Panel. 18¼ x 14ins (46.4 x 35.6cm) *Sotheby's*

(64), RA (53), BI (8) 1761-1806. Elected SA Director 1766, Treasurer 1769-70, SA President 19 October 1772, ARA 1780, RA 1781 (but refused to deposit a picture and consequently did not receive his diploma). In the mid-1770s, assisted by Wedgwood, he experimented painting with enamels on porcelain plaques. Although he is regarded as an animal painter, his portraits are of an exceptionally high standard. Single portraits usually date from the late 1740s to 1750s. Died London 10 July 1806 aged 81. Buried Marylebone Church. Moses Haughton jnr was his pupil.
Represented: NPG London; Tate; BM; NG London; VAM; Yale; Philadelphia MA; Goodwood House; Manchester CAG; Holburne Museum, Bath; Royal College of Surgeons, London; Walker AG, Liverpool; NG Washington. **Engraved by** B.Green, G.Townley Stubbs. **Literature:** J.Egerton, *S.: Portraits in Detail*, 1984; C.A.Parker, *Mr S. the Horse Painter*, 1971; R.Vincent-Kemp, *G.S. and the Wedgwood Connection*, 1986; W.Shaw Sparrow, *Life of G. S.*, 1898; W.Shaw Sparrow, *G.S. and Ben Marshall*, 1929; B.Taylor, *G.S.*, 1971; Tate exh. cat. 1984; R.B.Fountain, 'Some Speculations on the Private Life of G.S. 1724-1806', British Sporting Art Trust Essay No 12 1984; R.Fountain & A.Gates, *S.'s Dogs*, 1984; C.Lennox-Boyd, B.Dixon & T.Clayton, *G.S.: The Complete Engraved Works*, 1989; V.Morrison, *The Art of G.S.*, 1989; DA.

STUBBS, James **fl.1822-1832**
Son of Ralph Stubbs, Keeper of the Circulating Library in Keswick. Practised as a portrait and landscape painter in Keswick. Exhibited at Carlisle Academy (4) 1823-7.

STUBLEY, Thomas **d.1742**
Married Mary Hale in London 24 November 1709 (both aged over 21). Among his sitters was the artist Peter

Monamy. Painted a portrait formerly at Hengrave Hall which was signed and dated 'Thos. Stubley pinx 1738'. Buried 14 May 1742 St Paul's, Covent Garden. His son Thomas (baptized 28 October 1724) was also an artist.
Engraved by J.Bretherton, J.Faber jnr, S. Freeman.

STUCKEY (STUCKE), George **1822-1872**
Born Thorncombe, Dorset son of Thomas and Mary Stuckey. Entered RA Schools 1851. Exhibited at RA (1), SBA (2) 1849-55 from London. Died Dorchester.
Represented: NPG London.

STUMP, Samuel John **1778-1863**
Probably born in America. Entered RA Schools 3 October 1796 aged 18. Painted mostly miniatures, although also watercolour portraits and occasionally in oil. Enjoyed an excellent reputation and painted many sitters from theatrical circles. Exhibited at RA (170), BI (55) 1802-49. Worked in London and Brighton. A member of the Sketching Society to which J.J.Chalon and others belonged. They nicknamed him 'the American Stump'.
Represented: NPG London; VAM; Guildhall AG, London; Glynn Vivian AG, Swansea; Ashmolean. **Engraved by** T.Blood, H.R.Cook, J.Hopwood, J.Thomson, W.H.Worthington.

STURDEE, Percy **fl.1886-1902**
His portrait of Sir James Balfour Paul is in SNPG.

SULLY, Robert Matthew **1803-1855**
Born Petersburg, Virginia 17 July 1803, nephew of Thomas Sully. Exhibited at RA (3), BI (1), SBA (3) 1825-7 from London. Painted a portrait of James Northcote RA. In 1831/2 he worked in Philadelphia, Richmond and Washington, before settling mainly in Richmond. Exhibited in Philadelphia, Boston and New York. Died Buffalo 16 October 1855 on his way to Madison.

SULLY, Thomas **1783-1872**
Born Horncastle, Lincolnshire 19 June 1783, son of Matthew and Sarah Chester Sully. Travelled to Charleston, South Carolina 1792, studying under his brother-in-law Jean Belzons and elder brother Lawrence Sully, both miniaturists. Began working with his brother in Virginia c.1801. Married his brother's widow 1805. Lived in Richmond until 1806, when he went to New York and to Boston 1807, where he worked briefly for Wesley Jarvis and was advised by Gilbert Stuart. From 1809 to 1810 he was in London, where he shared a studio with Charles Bird King. Studied under B.West, who introduced him to Lawrence who was a major influence, Sully becoming known as 'the American Lawrence'. Exhibited at RA (2), BI (3) 1820-40. Elected Honorary RSA 1827. Returned to England to paint Queen Victoria 1837/8. Died Philadelphia 5 November 1872. Among his pupils were John Neagle, Aaron Haughton Corwine and William Allen Wall.
Represented: NPG London; NG Washington; Boston Athenaeum; Wallace Collection; Cleveland Museum; Detroit Institute. **Engraved by** H.Grevedon, T.Johnson, J.Thomson, C.E.Wagstaffe. **Literature:** D.Biddle & M.Fielding, *Life and Works of T.S.*, 1921; *Dictionary of Artists in America*; M.H.Fabian, *Mr S. Portrait Painter*, NPG exh.cat. 1983; DA.

SUMMERBELL, L. **fl.1879**
Exhibited at RA (1) 1879 from London.

SUMMERS, S.N. **fl.1764-1806**
Exhibited at FS (1), RA (6) 1764-1806 from London and Chelmsford.
Engraved by J.Osborne.

SURVILLE, Peter **fl.1684-1689**
From a French Protestant family of Surdeville (Survill). Settled in Dublin and was one of the earliest recorded portrait

painters there. Lived in Chequer Lane. In August 1684 was admitted to the freedom of Corporation of Painter-Stayners and Cutlers, Guild of St Luke. Painted a portrait of James II for the city 1689, for which he received £24. Randle Holme admired 'Serville for drapery'.

SUTCLIFFE, Miss Hariette F.A. fl.1881-c.1922
Exhibited at RA (21) 1881-99 from Hampstead. Painted sensitive portraits of children.

SUTHERLAND, Miss Fanny fl.1876-1886
Exhibited at RA (10), NWS 1876-86 from London. Among her sitters were the Hon Mrs Thomas Kingscote and Lady Romilly.

SUTTON, Joseph 1762-1843
Born Cockermouth. Studied under Joseph Faulder. Entered RA Schools 16 July 1796. Exhibited at RA (6) 1798-1801. Patronized by Lord Mulcaster, who provided him with a studio at Mulcaster Hall. After marrying he moved to Rogerscale, near Lorton and had such a successful practice that he employed six apprentices. Exhibited at Carlisle Academy 1823-30.
Represented: Carlisle AG. **Engraved by** C. Turner.
Literature: Hall 1979.

SWAN, Edwin b.1873
Born Ireland 5 October 1873. Studied at Académie Julian, Paris. Exhibited at RA (6), RHA (1), RI 1896-1940 from London and Crowborough.

SWAN, John Macallan RA RWS 1847-1910
Born Old Brentford 9 December 1847, son of a civil engineer. Studied at Worcester School of Art, Lambeth School of Art and RA Schools. Went to Paris 1874, working under Gérôme, Bastien-Lepage, Dagnan-Bouveret and sculptor Frémiet in Beaux-Arts Schools. Exhibited at RA (42), RSA (17), RHA (9) 1878-1904 from Paris, Wotton and St John's Wood. Elected ARA 1894, ARWS 1896, RWS 1899, RA 1905. Married Mary Hamilton 1884. Died Isle of Wight 14 February 1910.
Represented: VAM; Brighton AG; Tate; Birmingham CAG; SNPG; Aberdeen AG; Manchester CAG; Bath AG; Nottingham AG; Sydney AG, Australia; Philadelphia AG.
Literature: McEwan; DNB.

SWAN, Robert John b.1888
Born London 21 July 1888. Studied at Putney Art School and RA Schools (winning BI and Landseer scholarships). Exhibited at RA (25), RI, RP, SBA and in the provinces 1908-66 from London.

SWANDALE, George fl.1824-1844
Exhibited at RA (4), SBA (4) 1824-44 from Soho and Bloomsbury.
Engraved by W.Geller.

SWANSON, Richard fl.1860
Listed as a portrait painter in Liverpool.

SWANZY, Miss Mary HRHA fl.1905-1977
Exhibited at RHA (51) 1905-77 from Dublin and London.

SWEETMAN, Thomas H. ARHA fl.1812-1831
Worked in Dublin as a portraitist and drawing master. Exhibited at SA, Dublin and RHA 1812-30. Elected ARHA 1828, resigned 18 February 1831.
Engraved by J.Martyn.

SWIFT, Miss Catherine (Kate) Seaton Foreman (Mrs Bisschop) fl.1855-1880
Exhibited at RA (7), BI (8), SBA (10) 1855-80 from London. Married Christopher Bisschop.

JAMES RANNIE SWINTON. Mrs Anna Gambier Parry. 56 x 44ins (142.2 x 111.8cm) *Phillips East Anglia*

SWIFT, Miss Georgina fl.1855-1875
Exhibited at RA (4), BI (1), SBA (13) 1855-75. Member of SWA.

SWIFT, Miss Louise B. fl.1868
Exhibited at RA (1) 1868 from London. Related to artists Catherine, Georgina and Mrs W.B.Swift.

SWIFT, Mrs W.B. (E.H.) fl.1833-1859
Exhibited at RA (10), SBA (2) 1833-59 from London. Among her sitters were 'The Hon Augustus Charles Henry Hervey, Second Son of Earl Jermyn' and 'The Earl of Scarborough'. Also produced engravings.

SWINSON, Edward Spilsbury 1871-1958
Born Mickleton. Studied at RA Schools. Exhibited at RA (12) 1893-1936 from London, Rugby and Devon. Died London 28 March 1958.
Represented: NPG London.

SWINSTEAD, George Hillyard RBA RI 1860-1926
Son of landscape painter, Charles Swinstead. A chorister in the Chapel Choir, Windsor. Entered RA Schools 1881. Exhibited at RA (48), RI, SBA 1877-1919. Elected a member of Painter-Stainers' Company, RBA 1893, RI 1908. Also painted genre and coastal scenes. Author of *My Old-World Garden and How I Made it in a London Suburb*. Died London 16 January 1926.
Represented: Sheffield AG. **Literature:** *Connoisseur* 74 1926 p.189.

SWINTON, James Rannie 1816-1888
Born near Duns, Berwickshire 11 or 16 April 1816, son of John Campbell Swinton of Kimmerghame. Studied at

Trustees' Academy with Sir William Allan and Sir John Watson-Gordon. Travelled to London 1839. Entered RA Schools 1840. Moved to Italy, where he remained for about three years, visiting Spain. In Rome he was successful in obtaining a number of commissions for portraits. On his return to London he set up a portrait practice at Berners Street and enjoyed considerable popularity. Exhibited at RA (85), RSA (41), BI (2), SBA (15) 1844-74. Among his distinguished sitters were Louis Napoleon (Napoleon III), Lord Stratford de Redcliffe and the Duke of Argyll. Produced mainly chalk drawings, but also oils with painterly drapery but highly finished heads. Died 18 December 1888.
Represented: NPG London; SNPG; NGI; Muncaster Castle; Hatfield House; Longleat. **Engraved by** E.Burton, E.Dalton, T.Fairland, P.Guglielmi, F.Holl, R.J.Lane, H.Robinson, H.T.Ryall, J.Thomson, G.R.Ward, G.Zobel. **Literature:** McEwan; *Country Life,* 8 November 1984.

SWYNNERTON, Mrs Annie Louisa (née Robinson) ARA RP SWA **1844-1933**
Born Kersal, near Manchester, daughter of Francis Robinson, a solicitor. Studied at Manchester School of Art, Académie Julian, Paris. Travelled to Rome 1874 with her friend artist Isabel Susan Dacre. While in Rome she married the sculptor Joseph William Swynnerton 1883. Settled in Rome until the death of her husband in 1910. Exhibited at RA (53), GG, NWG 1879-1934. Elected RP 1891, ARA 1922, being the first woman to receive such recognition since 1768. Died Hayling Island 24 October 1933. Her friend Sargent bought and donated her painting 'The Oreads' to the Tate. Three other pictures were bought by the Chantrey Bequest for the Tate including a portrait of Dame Millicent Fawcett 1930. Her latter work has a distinctive linear style, highly coloured and shows the influence of G.F.Watts and the Impressionists.
Represented: Brighton AG; Nottingham Castle Museum; Manchester CAG. **Literature:** *Connoisseur,* XCIII 1934 p.59; DA.

SYDDALL, Joseph **fl.1898-1910**
Exhibited at RA (4) 1899-1910 from Chesterfield, Yorkshire.

SYKES, F. FSA **fl.1752-1809**
Exhibited at SA (1) 1776 from York. Also painted miniatures and may have been the Sykes recorded in York 1809.

SYKES, George **fl.1761-1774**
Exhibited at SA (5) 1761-74 from London. Worked in oil, miniature and enamel. Died Yarmouth.

SYKES, William snr **1659-1724**
Follower and copyist of Kneller. Painted a full-length of 3rd Earl of Derwentwater 1715. Also a dealer. Died Bruges 20 December 1724. His son William Sykes jnr was also an artist.

SYME, John RSA **1795-1861**
Born Edinburgh. Studied there at Trustees' Academy. Became a pupil of and assistant to Raeburn, who was his main influence. Exhibited at RSA (141), RA (2) 1812-55. A founder RSA 1826. Died Edinburgh 3 August 1861. His work can be very close to Raeburn's.
Represented: SNPG; Parliament Hall, Edinburgh; White House Collection; Glasgow AG. **Engraved by** H.Haig, R.M. & T.Hodgetts, W.Walker. **Literature:** McEwan.

SYMONDS, Miss **fl.1839**
Listed as a portraitist and teacher of drawing at 18 Snargate Street, Dover.

SYMONDS, William Robert RP **1851-1934**
Born Yoxford, Suffolk 25 February 1851. Studied art in London and Antwerp. Settled in London 1861. Exhibited at RA (82), GG, RP, NWG, Paris Salon 1876-1926. Elected RP 1891. Died 7 November 1934.
Represented: Wallace Collection; Town Hall, Ipswich; Army Medical School; Queen's College, Belfast; Alton Towers; Royal Victoria Hospital, Netley; Oriel, Magdalen and Pembroke Colleges, Oxford. **Literature:** A.Chester, 'The Art of Mr William Robert Symonds', *Windsor Magazine* 1910 No.184 pp.557-92.
Colour Plate 69

SYMONS, William Christian RBA **1845-1911**
Born London 28 November 1845. Studied at Lambeth School of Art and RA Schools from 1861. Exhibited at RA (39), SBA (57), NWS, GG, NEAC, ROI 1865-1911. Elected RBA 1881, but resigned with his friend Whistler 1888. Worked as a stained glass designer and produced the much criticized mosaics for Westminster Cathedral. Worked in Newlyn, Cornwall for a time, but towards the end of his life settled in Sussex. Died Udimore, near Rye 4 September 1911.
Represented: NPG London; Dublin Municipal AG; BM; Mappin AG, Sheffield.

SZVATEK, Mrs Aranka D.C. **fl.1910**
Exhibited at RA (1) 1910 from Kensington.

T

TAGGART, William Stuart 1859-1925
Born Stoffville, Canada West. Educated in Ontario. Studied painting in England, before establishing a successful practice in Ottawa. Died Ottawa 17 December 1925.

TAIT, Robert Scott c.1816-1897
Born Hamilton, Scotland. Exhibited at RA (24), RSA (11), BI (1) 1845-75 from London. Best known for 'Thomas and Jane Carlyle in the Drawing Room of Their House in Cheyne Row' (Carlyle House, Cheyne Row). Other sitters include 'Captain Sir Baldwin Wake Walker, RN, KCB, Surveyor of the Navy, late Admiral of the Turkish Fleet' and 'John Gilchrist. Member of Athenaeum Club'. Died Priory Coombe, near Shaftesbury 2 October 1897 aged 81. Left to Harriet his widow effects of £4,403.2s.8d.
Engraved by L.Dickinson.

TAITT, G.W. fl.1797-1810
Exhibited at RA (3) 1797-1810 from London.

TALBOT, Abraham J. fl.1849-1853
Exhibited at RHA (8) 1849-53 from Dublin.

TALFOURD, Field W. 1815-1874
Born Reading, the son of a brewer and younger brother of the judge and author Sir Thomas Talfourd. First tried the life of a pioneer farmer in Upper Canada, where the town of Froomefield in Ontario is named after him and his brother Froome. Exhibited at RA (34), BI (1) 1845-74 from London. Among his sitters were the Earl of Morley, John Gibson RA, Sir Robert Collier, Solicitor General and Elizabeth and Robert Browning. Died Thames Chambers, Adelphi 5 March 1874. The *Art Journal* 1874 noted that 'as a painter of portraits and landscapes he obtained considerable reputation'.
Represented: NPG London. **Literature:** *Art Journal* 1874 p.154; M.Rogers, *Master Drawings from the NPG*, 1993, pp.124-5.

TANNOCK, James 1784-1863
Born Kilmarnock, son of a shoemaker. Apprenticed to his father's trade, but then worked under a house painter, devoting his spare time to portraiture. Received some guidance from A.Nasmyth. Entered RA Schools 26 February 1811. Developed a successful portrait practice in Glasgow, Greenock 1806-9, Glasgow again and London from 1813. Exhibited at RA (46), SBA (1) 1813-41. Among his sitters were 'Walter Denoon, a Native of Inverness, now in London aged 102', 'Sir James Shaw Bart, Ald., MP; Painted by Desire of the Magistrates and Council of Kilmarnock, to be Placed in their Town Hall', J.Gladstone and 'H.Bell Esq, the First Who Brought the Steam Boat into Practice'. Died London 6 May 1863. His younger brother, William Tannock, was also an artist.
Represented: VAM; SNPG. **Literature:** McEwan; DNB.

TANNOCK, William fl.1818-1831
Born Kilmarnock, younger brother and pupil of James Tannock. Exhibited at RA (14), SBA (1) 1818-31 from London. Erroneously said by Redgrave to be the son of James Tannock.

ROBERT SCOTT TAIT. Mother and child. Signed on the reverse. 50 x 40ins (127 x 101.6cm)
Christopher Wood Gallery, London

TAPPING, G. fl.1797-1799
Honorary exhibitor at RA (3) 1797-9.

TARNER, Miss G. fl.1896
Exhibited at RA (1) 1896 from London.

TASSAERT, Philip Joseph 1732-1803
Born Antwerp 18 March 1732. Master in Antwerp Guild 1756/7. Moved to London c.1758, where he became assistant to Hudson, mainly as a drapery painter. Painted full-length and small full-length portraits, but was mainly active as an expert and in the commerce of arts. Exhibited SA, FS, RA (2) 1769-85. President SA 1775. Died London 6 October 1803. His son Philip was born June 1758 and exhibited histories at SA 1783 from Munich.

TATE, Richard d.1787
Liverpool merchant and amateur painter who exhibited crayon copies after Wright of Derby there 1774. Died Liverpool. His son, Thomas Moss Tate, was also an artist.

TATE, Thomas Moss d.1825
Son of Richard Tate, an amateur painter in Liverpool. A friend and patron of Wright of Derby, whose work he copied and imitated. Produced some crayon heads, landscapes and took to watercolours in the 1790s. In the summer of 1793 he spent a week in the Lakes with Wright and T.Gisborne. Died March 1825.
Represented: VAM.

TATE, William FSA 1748-1806
Born Liverpool September 1748, brother of Richard Tate. Studied under Wright of Derby at Liverpool c.1770/1. Moved to London for the first time c.1771/2, but returned

445

to Liverpool. Studied at RA Schools 1777, taking accommodation in London. Finished off Wright's uncompleted pictures after his death in 1797. Moved to Manchester c.1786, remaining there until c.1804, when he went to Bath. Exhibited at SA (12), RA (12) 1771-1804. Elected FSA 1773/4. Died Bath 2 June 1806. His early style owes a debt to Reynolds and he later showed the influence of George Romney and Hoppner.
Represented: Walker AG, Liverpool; Maritime Museum, Lancaster. **Engraved by** E.Noyce. **Literature:** DNB.

TATHAM, Frederick 1805-1878
Born London, son of architect, Charles Heathcote Tatham. A friend and biographer of William Blake. George Richmond became his brother-in-law after eloping to Gretna Green with his sister. Exhibited at RA (66), SBA (7), BI (3) 1825-54. Among his sitters were Edward Walpole, the Bishop of Winchester, 'Viscountess Pollington in a Fancy Dress' and 'Samuel Manning, Esq Sculptor'. Worked in London 1825-39, Winchester 1840-4, and then returned again to London. Died Highgate 13 July 1878.
Represented: NPG London; BM. **Literature:** L.Binyon, *Followers of William Blake*, 1926.

TAUBMAN, Frank Mowbray 1868-1946
Born London 13 June 1868. Studied at Académie Julian, Paris 1893 and at École des Beaux Arts, Brussels. Returned to London 1897. Exhibited paintings and sculpture at RA (41), RSA, RHA (3), ROI 1894-1938. Died 9 December 1946.

TAYLER, Albert Chevalier 1862-1925
Born Leytonstone 5 April 1862, seventh son of William M.Tayler, a solicitor. Studied at Heatherley's, RA Schools and Slade, and in Paris under J.P.Laurens and Carolus-Duran. Lived for 12 years in Newlyn, Cornwall from 1884, before settling in London c.1896. Exhibited at RA (49), SBA, Paris Salon (medallist 1891) 1884-1925. Converted to Roman Catholicism c.1887. Published *The Empire's Cricketers*, 1905. Died London 20 (not 10) December 1925. Left effects of £1,122.12s. to his widow, Elizabeth. One of the most popular artists of the Newlyn School. He painted with great confidence and feeling.
Represented: Imperial War Museum; Guildhall AG, London; Devonshire Club; Kent County Cricket Club, Canterbury; AGs of Birmingham, Bristol, Canterbury, Cheltenham, Hartlepool, Kettering, Liverpool, Preston. **Literature:** G.Plumptree, 'Impressionist at the Crease', *Country Life* 16 August 1990 p.56.

TAYLER, Miss Minna fl.1884-1937
Exhibited at RA (19), SBA (6) 1884-1906, including a portrait of the art collector Frederick Nettlefold (1889). Lived in London and was recorded in 1937.

TAYLER, T. fl.1840
Exhibited at RA (1) 1840 from London.

TAYLOR, Alexander d.1804
A native of Scotland. Entered RA Schools 4 December 1775. Exhibited at SA, RA (17) 1774-96 from London. Went to India 1797, where he painted portraits and miniatures. Worked in Calcutta 1802-4. Died Calcutta 4 April 1804.
Literature: *Calcutta Gazette* 12 April 1804.

TAYLOR, Alfred b.c.1811
Born Winchester. Listed as a portrait painter in London in the 1871 census aged 60.

TAYLOR, Alfred Henry d.c.1878
Born Winchester. Married Ellen Taylor from Surrey. Exhib-

JOHN TAYLOR (1739-1838). Rev Thomas Osborne. Signed and dated 1774. Canvas on panel. 10 x 8½ins (25.4 x 21.6cm)
Christie's

ited at RA (26), RHA (13), BI (4), SBA (37), NWS (107) from 1832 from London. Elected NWS 1839, but resigned 1850 to devote more time to oil and crayon painting. A friend of Soloman Hart. Died Sydney 'on or about 17 April 1878'. Bénézit says he died 1868.
Engraved by Skelton.

TAYLOR, Edward Richard RBSA 1838-1912
Born Hanley 14 June 1838, son of William Taylor, a manufacturer of earthenware. Began his career in his father's manufactory. Entered the Burslem School of Art for training as an art teacher. Also studied at RCA. Appointed headmaster of Lincoln School of Art 1862/3 and then of Birmingham Municipal School of Art 1876/7-1903. An influential art teacher. Among his pupils were W.Logsdail, Frank Bramley, Fred Hall, Walter Langley, W.J.Wainwright, Jelley, Edwin Harris, Skipworth and Breakspeare. For 13 years in succession his school obtained the largest number of awards. Exhibited at RA (32), RHA (1), BI (2), SBA (23), NWS, GG, NWG 1861-1901. Elected RBSA 1879. Won Gold Medal for best figure painting exhibited at the Crystal Palace Gallery 1879. Published *Elementary Art Teaching and Drawing* and *Design for Beginners*. Who Was Who and Bénézit list his death as 11 January 1911, but his will records his death in Edgbaston, Birmingham as 14 January 1912. Sometimes confused with miniaturist Edward Tayler RMS 1828-1906.

TAYLOR, Ernest E. 1863-1907
Born Bournemouth. Went to Ireland when young, with his father, a Customs Surveyor. Settled at Glenburn, Knock, near Belfast and had a studio at Garfield Chambers. Exhibited at RHA, RSA 1890-1903. Died from pneumonia in Greenock 31 January 1907 aged 44.
Literature: Strickland.

TAYLOR, G. fl.1790
Exhibited a portrait of 'Mr Harley as Richard III' at RA 1790 from London.

TAYLOR, Harry fl.1839-1871
Exhibited at SBA (12) 1839-71 from London.

TAYLOR, Isaac FSA 1730-1807
Born Worcester 13 December 1730, son of a brass founder. Worked as an engraver, portrait painter and illustrator. Exhibited at SA (35) 1765-80 from London. Elected FSA 1770, Director 1772, Secretary 1774. Married Sarah H.Jefferys 1754. Died Edmonton 17 October 1807. His grey wash portraits of Garrick and circle are in BM. His son and grandson, both Isaac, were also artists.
Engraved by J.Collyer, J.Hall, Walker.

TAYLOR, John (i) c.1580-1651
Master of Painter-Stainers' Company, London 1643/4. Could possibly have painted the Chandos portrait of Shakespeare in NPG London. Buried London 24 June 1651.
Literature: M.Edmond, *Burlington Magazine* CXXIX March 1982, p.146.

TAYLOR, John (ii) c.1630-1714
Oxford portrait painter and copyist. Married in London (St Botolph's) August 1655. Presented a self-portrait to Bodleian Library 1655. Painted portraits for the Oxford Corporation 1659 and 1664; for Magdalen College 1669 and for Christ's Hospital, Abingdon 1684. Became Mayor of Oxford 1695. Believed to have been buried in Oxford 24 August 1714.
Literature: Mrs R Lane Poole, *Catalogue of Portraits in the Possession of University, Colleges, City and Council of Oxford*, 3 vols 1912 and 1925.

TAYLOR, John 1739-1838
Born London, son of a customs officer. Studied under Hayman and at St Martin's Academy. Became a drawing master and portraitist in all mediums. Specialized in pencil portraits, of which he did a large number. Worked in Oxford 1767-71, Bristol 1775 and Manchester 1777. Charged between 5 and 15 guineas for paintings, according to size. Settled in London. Exhibited at SA (34), FS (2), RA (41), BI (27) 1764-1838. Elected founder FSA 1766, Director 1775. Died London 21 November 1838. Known as 'old Taylor' and was still painting in his ninety-ninth year. Redgrave describes him as 'a man of cheerful humour, full of never failing reminiscences of art and artists'.
Engraved by J.K.Sherwin.

TAYLOR, John fl.1830-1875
Exhibited at RHA (11) 1830-75 from Dublin and Glasgow.

TAYLOR, Leonard Campbell RA ROI RP 1874-1969
Born Oxford 12 December 1874, son of James Taylor a musician and Elizabeth Ann (née Stone). Studied at Ruskin School Oxford, St John's Wood School and RA Schools from 1895. Exhibited at RA (136), ROI, RHA (1), RP, Paris Salon (Gold Medal 1931) 1899-1963 from London. Elected ROI 1905, RP 1909, ARA 1923, RA 1931. Died Cambridge 1 July 1969. An accomplished artist capable of great sensitivity.
Represented: Tate; NG Cape Town; HMQ; Southampton CAG; NG Sydney; NG Rome. **Literature:** H.Furst, *L.C.T. – His Place in Art*, 1948.

TAYLOR, Maria see SPILSBURY, Maria

TAYLOR, Peter (Patrick) 1756-1788
Scottish house painter, who occasionally painted portraits.

Made a burgess of Edinburgh 1787. Painted a portrait of Robert Burns (SNPG). Died Marseilles 20 December 1788.
Literature: *Burlington Magazine* 74 1939, p.74.

TAYLOR, Colonel Philip Meadows HRHA 1808-1876
Born Liverpool 25 September 1808, son of Philip Meadows Taylor, a merchant. Spent much of his childhood in Ireland. Went to India aged 15, and was commissioned in the Nizam's service November 1824. Worked in India for 36 years, administering affairs of the state. Returned to Europe 1860, and settled in Dublin. Made a Companion of the Star of India 1869. Painted portraits and Indian subjects as an amateur. Exhibited at RHA (12) 1843-74 from London, Hindustan and Dublin. Elected HRHA 1868. In 1875 his sight began to fail and he determined to revisit India. On his return journey he stayed at Menton where he died 13 May 1876.
Literature: Strickland.

TAYLOR, Robert fl.1737-1755
Believed to have been a Jacobite. His signed and dated works range from 1737 to 1755, and are painted in the manner of Richardson. Fond of portraying sitters in ovals.
Engraved by J.Faber jnr, J.McArdell.

TAYLOR, Robert c.1811-c.1870
Possibly born at Cockermouth. Apprenticed there to Joseph Sutton. Painted a portrait of Mary Henderson 1836 and a copy of Lord Byron for Cockermouth Castle 1838. Admitted to Garlands Asylum, near Carlisle and was there 1866.
Represented: Carlisle AG.

TAYLOR, Stephen fl.1808-1849
Exhibited at RA (48), BI (29), SBA (40) 1817-49. Worked as a portrait painter in Southampton 1808, Winchester 1817-21, Oxford 1823-6 and London 1827-49. Gained a reputation for animal paintings, particularly of birds and dogs. Related to artist Alfred Henry Taylor.

TAYLOR, T. fl.1790
His portrait of William Markham was engraved by W.Skelton 1790.

TAYLOR, Thomas fl.1846-1848
Listed as a portrait painter in Leicester.

TAYLOR, William fl.1812-1859
Exhibited at RA (20), SBA (6) 1812-59 from London and Hitchin.

TEASDALE, Percy Morton RCA 1870-1959
Studied under Herkomer at Bushey and at Académie Julian, Paris. Exhibited at RA (19) 1894-1946 from Leeds, London and Bushey. Died Clapham 17 November 1959. Left £1,006.15s.6d.

TEBBITT, Miss Gertrude V. fl.1901-1908
Exhibited at RA (3) 1901-8 from London.

TELLSHAW, Frederick fl.1728-1745
Provincial portrait painter working in the style of Kneller. Signed and dated portraits range from 1728 to 1745.

TEMPLE-BIRD, Mrs Kathleen Emily fl.1910-1954
Born Kathleen Emily Temple in Ipswich. Studied at Slade under Brown, Tonks, Steer and Russell. Head of Art at Havergal College, Toronto 1911-13. Exhibited at RA (6), RI, SBA, RP, ROI, NEAC, Paris Salon 1915-54 from London, Addlestone and St Ives.

TEMPLETON, John Samuelson　　　　　**b.c.1806**
Born Dublin (Bénézit) or Glasgow (1851 census). Studied at Dublin Society's Drawing School 1819. Moved to London. Married Elizabeth Venness 21 February 1829. Exhibited at RA (34), RSA (3), RHA (2), BI (2), SBA (2) 1830-61. Chiefly employed as a lithographer and reproduced a number of portraits and pictures by other artists.

TENGATE, Mrs F.A.　　　　　**fl.1835**
Listed as a miniature and portrait painter in Birmingham.

TENNANT, Dudley　　　　　**b.1897**
Born Hanley, Staffordshire 21 November 1897. Studied at Hanley and Liverpool. Often confused with Dudley Trevor Tennant.

TERBORCH, Gerard　　　　　**1617-1681**
Born Zwolle late 1617. Painted genre and portraits. Believed to have travelled extensively as a young man. In England July 1635, but spent only a short time in this country. Died Deventer 8 December 1681.
Literature: Bénézit.

TERRELL, Mrs Georgina Frederica (née Koberwein)
　　　　　b.c.1856
Born Vienna, daughter of portrait painter Georg Koberwein (who settled in Kensington) and sister to artist Rosa Koberwein. Married Arthur Becket Terrell, barrister c.1878. Exhibited at RA (25), RHA (6), SBA (2), NWS 1876-90. Aged 25 in 1881 census.

TERRY, Robert　　　　　**1731-after 1770**
Entered RA Schools 1770 aged 39. Exhibited at FS (2), SA (2), RA (2) 1762-70 from London.

TETLEY, William Birchall　　　　　**fl.1774**
Born London. Went to New York, where he taught drawing and advertised as a painter of 'portraits in oil or in miniature'.

THADDEUS, Henry Jones　RHA　　　　　**1859/60-1929**
Born Cork, Ireland. Studied at Heatherley's and Académie Julian, Paris under Gérôme and Lefebvre. Exhibited at RA (3), RHA (31) 1883-1902 from Florence and London. Established a successful portrait practice. Among his sitters were HRH the Duke of Teck and HRH Princess Adelaide, Duchess of Teck. Published *Recollections of a Court Painter*, 1912, outlining his period as Court Painter to the Khedive. Died Ryde, Isle of Wight 1 May 1929.
Represented: NGI. **Engraved by** J.M.Johnstone.

THANNENBERG, Count L. de　　　　　**fl.1852**
Exhibited at SBA (1) 1852 from London.

THARP, Charles Julian Theodore　　　　　**1878-1951**
Born Denston Park, Suffolk 24 May 1878, son of Captain Theodore Tharp (Army). Educated Bedford School and University College, London. Studied at Slade. Exhibited at RA (6), RHA (1), RP, ROI, NEAC. Died October 1951.

THATCHER, C.F.　　　　　**fl.1816-1846**
Exhibited at RA (39), BI (14), SBA (1) 1816-46 from London. Among his sitters were 'Countess Ferrers' and 'Earl Ferrers'.

THEED, William　RA　　　　　**1764-1817**
Born London 3 August 1764, son of 'a wig maker in Wych Street'. Entered RA Schools 1786 and at first painted portraits and classical subjects. Visited Rome from c.1791-6, and while in Naples married a French woman surnamed Rougeot. On his return he concentrated on sculpture and in 1799 began to model for Wedgwood, working for the firm

until 1804. Then worked for Rundell & Bridge, for whom he designed gold and silver plate until his death. Exhibited at RA (88), BI (5) 1789-1818. Elected ARA 1811, RA 1813. Died London. His widow applied to the RA for a pension and was granted £50, but died the following year. His son William Theed 1804-91 was a distinguished sculptor.
Represented: Usher AG, Lincoln; HMQ; Parish Church of Ross-on-Wye, Herefordshire.

THEWENETI, Edward (Joseph Edward)　　　　　**1806-1889**
Born Bucharest, brother of Laurence and Michael Theweneti. Worked in Bath as a drawing master, photographer and portrait and miniature painter. Died Bath 13 January 1889 aged 83.

THEWENETI, Laurence (Lorenzo)　　　　　**c.1791-1878**
Born Bucharest. Exhibited at RA (8) 1824-31. Worked in Cheltenham 1824, London 1826-7, before settling in Bath from 1829 (next door to James Hardy). With his brothers Edward and Michael he was listed as a photographer, drawing master, portrait and miniature painter. A Roman Catholic and a man of deep piety. Naturalized 7 September 1850. Died Bath 3 April 1878. Listed aged 60 in 1851, aged 82 in 1871 census and 89 at his death.
Represented: NPG London; VAM. **Engraved by** M.Gauci.
Literature: *Bath Chronicle* 4 April 1878.

THEWENETI, Michael　　　　　**1796-1874**
Born Bucharest, brother of Laurence and Edward Theweneti. With his brothers Laurence and Edward he was listed as a photographer, drawing master, portrait and miniature painter in Bath. Died Bath 7 February 1874 aged 78.
Represented: VAM.

THIEDE, Edwin Adolf　　　　　**fl.1882-1900**
Exhibited portraits and miniatures at RA (7) 1882-1900 from London.

THIELCKE, Henry　　　　　**b.c.1789**
Entered RA Schools 4 January 1806 aged 17, winning a Silver Medal 1807. Exhibited at RA (9), BI (3) 1805-16 from London.

THIRSBY, J　　　　　**fl.1798**
Exhibited at RA (2) 1798. No address was given.

THOM, James Crawford　　　　　**c.1835-1898**
Born New York in 1835, 1838 or 1842, son of sculptor James Thom. Studied at NA, exhibiting there from 1857. Also studied under Edward Frere in Paris and was influenced by his style. Exhibited at RA (7), BI (3), RHA (1), SBA (22) 1864-73 and at French Gallery Pall Mall, Boston Athenaeum and Pennsylvania Academy. Died in Atlantic Highlands 16 February 1898.
Literature: *American Art Annual* 1898 p.31.

THOMAS, Miss Eleanor L.　　　　　**fl.1906-1930**
Exhibited at RA (10) 1906-30 from London, Watford and Chichester.

THOMAS, George Houseman　　　　　**1824-1868**
Born London 17 December 1824. Began his career as a wood engraver in Paris after studying under G.W.Bonner. Went with his brother W.L.Thomas to New York for two years as an illustrator for a newspaper, and designed American banknotes. Returned to Europe because of ill health and was in Rome during its siege by the French, sending drawings of the events to the *Illustrated London News*. This led to his joining their staff on settling in London. Exhibited at RA (19), BI (1) 1851-68. Commissioned by Queen Victoria to

paint several group portraits of ceremonies including 'The Presentation of Medals for Service in the Crimea by the Queen on the 18th May 1855', 'Review in the Champs de Mars, on the Occasion of Her Majesty's visit to Paris', 'Parade at Potsdam in Honour of Queen Victoria August 17 1858', 'The Coronation of the King of Prussia – the Princess Royal Doing Homage', 'The Marriage of HRH the Princess Alice' and 'The Queen and Prince Consort at Aldershot, 1859'. Died Boulogne 21 July 1868 from the effects of a fall from his horse. Studio sale held Christie's July 1872.
Represented: NPG London; Tate; Windsor Castle Library; VAM; Birmingham CAG; Fitzwilliam. **Engraved by** J.Bacon, C.Risdon. **Literature:** *Art Journal* 1868 p.181; DNB.

THOMAS, Miss Margaret **d.1929**
Born Croydon, daughter of Thomas Cook, a shipowner. Emigrated to Melbourne with her parents and studied sculpture there under Charles Summers. Returned to England 1868 and entered South Kensington Schools for 10 months. Spent two and a half years in Rome and on her return entered RA Schools for two years, where she gained a Silver Medal. Exhibited at RA (11), RP, RHA (5), NEAC, SBA from 1868. She sculpted marble busts and was so successful with her portraits that she was able to retire and devote the rest of her life to travel and book-writing. Died 24 December 1929.
Represented: NPG London; La Trobe Library, Melbourne.

THOMAS, Matthew Edward **fl.1816-1828**
Exhibited at RA (5), BI (6), SBA (5) 1816-28 from London. His middle name is listed as Evan in RA and BI catalogues, but Edward in SBA catalogues. Elected a member of Imperial Academy at Florence, and of Academy of St Luke, Rome.

THOMAS, Percy RE **1846-1922**
Born London, son of Sergeant Thomas, an early patron of Whistler. Studied at RA Schools and was the friend and first pupil of J.A.M.Whistler from whom he learnt etching. Exhibited at RA (39), RHA (2), SBA (32) 1866-1916 from London. Lived for a time in Whitstable. Died London July 1922.
Represented: Canterbury Museums.

THOMAS, Mrs Sybil **fl.1897**
Exhibited at RA (1) 1897 from Westminster, London.

THOMAS, Thomas Henry RCA **1839-1915**
Born Pontypool 31 March 1839, son of Rev Thomas Thomas and Mary (née David). Studied at Bristol School of Art, Cary's, Bloomsbury and at RA Schools (medallist). Travelled to Paris and Rome and worked as a portrait painter in London from 1883. Settled in Cardiff and also illustrated for *The Graphic*. Died 7 July 1915.

THOMAS, William **fl.1806-1838**
Exhibited at RA (30), BI (8), SBA (8) 1806-38 from London and Beaconsfield. Among his sitters were 'Matthew Wood, Lord Mayor' and 'Rev Dr Sleath, Headmaster of St Paul's School'.
Represented: NPG London.

THOMPSON, Alfred **d.1895**
Exhibited at RA (5), SBA (4) 1863-76. Lived in Paris 1863, where he painted the portrait of 'J.St John Jeffreyes Esq'. Member of Army and Navy Club. Lived in London in the 1870s. Died in New York September 1895.
Represented: NPG London.

THOMPSON, E.W. **c.1770-1847**
Described by Ottley as 'an English portrait painter of considerable practice'. Worked for many years in Paris, where he was highly regarded. Supervised Edward Walmseley's *Physiognomical Portraits*, published 1824. Exhibited portraits

and miniatures at RA (9) 1832-9. Died Lincoln 27 December 1847 aged 77 years.

THOMPSON, Jacob, of Penrith **1806-1879**
Born Penrith 28 August 1806, son of a Quaker factory owner. Attended the Queen Elizabeth Grammar School. Began as a grocer, but left to become a 'coach, house, sign and ornamental painter and gilder' in Penrith. Attracted the attention of Earl of Lonsdale who commissioned him to make copies of paintings in Lowther Castle. One of these copies was sent to Lawrence, who advised him to come to London. In 1829 he was placed under Henry Sass and attended classes at BM. Studied at RA Schools. Exhibited at RA (27), BI (4), SBA (8), Carlisle Academy 1824-66. Returned to Hackthorpe in Cumberland c.1845, where he lived at The Hermitage (a cottage given to him by Lord Lonsdale in 1844) for the rest of his life. Painted altarpieces for St Andrew's Church, Penrith. Died at The Hermitage 27 December 1879.
Represented: Carlisle AG; Penrith Public Library.
Literature: L.Jewitt, *Life and Works of J.T.*, 1882.

THOMPSON, James **fl.1826-1827**
Portrait painter from Scotland, who sailed from Belfast to America in October 1826. Advertised in Charleston January 1827.

THOMPSON, Jerome **1814-1886**
Born Middleborough, Massachusetts 30 January 1814, son of Cephas Thompson. At the age of 17 opened a portrait studio in Barnstable, Maryland. Opened a studio in New York 1835. Exhibited at NA. Elected ANA 1851. Visited England 1852-4 to study. Settled in Long Island. Moved to Glen Gardner, where he died 1 or 2 May 1886. His later style is more painterly.
Represented: Metropolitan Museum, New York; Brooklyn Museum. **Literature:** *Artists in America;* L.M.Edwards, 'The Life and Career of J.T.', *American Art Journal*, XW/4 1982 pp.4-30; DA.

THOMPSON, John **fl.1590-1610**
Practised in London. Known in his day as 'Thompson, the City painter'. Member of Painters' Company, Little Trinity Lane.

THOMPSON, John **fl.1850-1878**
Exhibited at RHA (3) 1850-78 from Belfast and Brighton.

THOMPSON, John Christmas **1824-1906**
Born Carlisle. Educated in the Grammar School there. Studied at Royal Institution, Edinburgh under Sir William Allen. Awarded an Art Master Certificate and then practised as a portrait and landscape painter in Carlisle. Exhibited at Carlisle Athenaeum. Head of Warrington School of Art 1855 and remained in that post until his retirement 29 years later. Under his headship the School won five National Medals awarded to its pupils. Luke Fildes RA and Henry Woods RA studied there. Continued to reside in Warrington, where he died.
Represented: Warrington AG.

THOMPSON, Stanley **b.1876**
Born Sunderland 29 March 1876. Studied at Sunderland School of Art and RCA under Walter Crane. Exhibited at RA (8) 1899-1926 from Chelsea and Middleton-in-Teesdale, County Durham.

THOMPSON, Thomas jnr **b.1762**
Born 14 July 1762. Entered RA Schools as a painter 1780. Exhibited at FS (2), RA (31), BI (6) 1783-1808 from London and Walworth, Surrey.

THOMPSON, Thomas Clement RHA **c.1778-1857**
Probably born Belfast. Entered Dublin Society's Schools 1796. Set up as a miniature painter in Belfast. From c.1803 concentrated on oil portraits. Practised from Dublin 1810, London from 1817 and in Liverpool. Exhibited at RHA (93),

RA (96), BI (27), SBA (24), LA 1816-57. Elected founder RHA. Settled in Cheltenham c.1848, where he remained for the rest of his life. Established a distinguished practice. Among his sitters were the Earl of Carrick, Lord Viscount Lorton, Duke of York, George IV, 'Earl Talbot in Robes of the Order of St Patrick' and Thomas Campbell. Enjoyed painting ambitious large-scale portraits with columns and classical props, often introducing a secondary figure. Died of bronchitis in Cheltenham (not London) 11 February 1857 aged 79 years. **Represented:** NGI; VAM; Ulster Museum, Belfast; Walker AG, Liverpool. **Engraved by** H.Cousins, W.O.Geller, T.Hodgetts, D.Lucas, S.W.Reynolds, J.Smith, C.Turner. **Literature:** Strickland.

THOMPSON, William FSA c.1730-1800
Born Dublin. Trained and practised in London, where he was known as 'Blarney Thompson'. Exhibited at SA (46), FS (1) 1760-82 from London. Elected FSA 1769. Married a wealthy lady and gave up painting. On her death he married a second time, again to a lady possessing a fortune. He still managed to get into debt and was imprisoned by the King's Bench. Founded a school of oratory in Soho Square in a 'notorious house run by Mrs Theresa Cornelys'. Published *The Conduct of the Royal Academicians While Members of the Society of Arts from 1760 to Their Expulsion in 1769* and *An Enquiry into the Elementary Principles of Beauty in the Works and Nature of Art.* **Engraved by** W.Dickinson, J.W.Edwards, E.Mitchell, W.Ridley. **Literature:** Redgrave; DNB.

THOMSON, Alfred Reginald RA RP 1894-1979
Born Bangalore, India 10 December 1894. Educated at the Royal School for the Deaf and Dumb, Margate. Studied at London Art School under John Hassall and Orchardson. Exhibited at RA (207), RP 1920-70 from London and Handborough. Elected ARA 1938, RP 1944, RA 1945. Official War Artist to RAF 1940-4. Died London 27 October 1979. **Represented:** Tate.

THOMSON, Emily Gertrude RMS d.1932
Born Glasgow. Studied at Manchester School of Art. Elected ARMS 1911, RMS 1912. Also an illustrator. Worked in London from 1908. Died London. **Represented:** VAM. **Literature:** McEwan.

THOMSON, Henry RA 1773-1843
Born St George's Square, Portsea 31 July 1773, son of a purser in the Navy. In 1787 he was in Paris with his father, but on the outbreak of the Revolution, returned to London. Entered RA Schools 1790, and studied under Opie 1791. Travelled to Italy 1793-8, returning through Vienna and Germany in 1799. Exhibited at RA (83), BI (3) 1792-1825. Elected ARA 1801, RA 1804, RA Keeper 1825-7. He did not get on with Lawrence, who said of him 'there has existed in the Academy no Iago like that man'. Retired to Portsea 1828, because he developed dropsy. There he virtually gave up art, although he continued to paint for his own pleasure and as favours for friends. He was fond of boating there, when able. His health deteriorated and in the last three years of his life he could not lie flat in his bed for fear of an attack. Renowned for his liberal charity to the poor in the area. Died Portsea 5/6 April 1843. Left £700 to each of his female servants. Buried Portsmouth churchyard, near his mother's grave. His portraits vary in quality, but his best are painted with sympathy and compassion. **Represented:** Stourhead, NT; Tate; Norwich Castle Museum. **Engraved by** L.Basiere, W.C.Edwards, J.Heath, W.Ridley, W.Say, P.W.Tomkins, C.Turner. **Literature:** *Art Union* 1843 p.147; *Portsmouth News* July 1973; DNB; DA.

THOMSON, William fl.1763
Listed as a portrait painter at Warwick Court, Holborn.

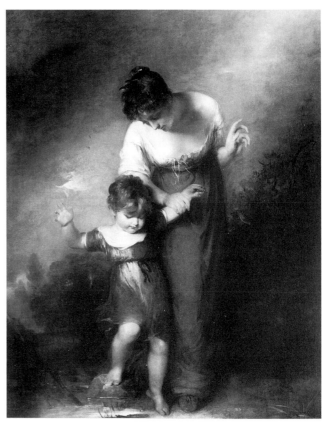

HENRY THOMSON. Crossing the brook. Exhibited 1803. 73 x 55ins (185.4 x 139.7cm) *Christie's*

THOMSON, William fl.1880-1894
Exhibited at RA (2), SBA (2) 1880-94 from London.

THOMSON, William John RSA 1771/3-1845
Born Savannah, Georgia, son of a Scottish-American loyalist. Came to England as a child. From an early age he was required to support himself. Moved to London, where he practised portraiture. Entered RA Schools 21 January 1808. Settled in Edinburgh 1812. Exhibited at RA (45), BI (9), SBA (2), OWS, RSA (191) 1796-1843. Elected RSA 1829. Offered a knighthood, but declined the honour. Died Edinburgh 24 March 1845 aged 74. **Represented:** SNPG; VAM. **Engraved by** W.Dickinson. **Literature:** Redgrave; McEwan.

THOMSON, Winifred Hope d.1944
Exhibited at RA (14) 1906-21 from London. Her sitters included the Duke of Rutland and his daughters. Died 15 August 1944.

THORBURN, Robert ARA HRSA 1818-1885
Born Dumfries 10 March 1818. Educated at the High School there. Studied at Trustees' Academy under Sir William Allan, winning prizes. Entered RA Schools 1836. Exhibited at RSA (21), RA (257) 1835-84 from Edinburgh, London, Kelso and Tunbridge Wells. Elected ARA 1848, HRSA 1857. Won a first class Gold Medal at Paris Universal Exhibition. Among his patrons were Queen Victoria and Prince Albert, which ensured a highly successful practice, mostly in miniatures. Died Tunbridge Wells 3 November 1885. W.B.Johnstone was his pupil, H.C.Heath his assistant. Archibald Thorburn was his son. **Represented:** SNPG; Brighton AG; HMQ Windsor Castle. **Engraved by** T.L.Atkinson, J.Brown, W.J.Edwards, C.H.Jeens,

HENRY FRYER TIDEY. A lady. Signed and dated May 1834. Watercolour. 8 x 6¼ins (20.3 x 15.9cm) *Sotheby's*

J.Jenkins, F.Joubert, R.J.Lane, T.H.Maguire, W.H.Mote, Posselwhite, H.Robinson, H.T.Ryall. **Literature:** McEwan.

THORNHILL, Sir James　　　　　　　**1675/6-1734**
Born Melcombe Regis, Dorset 25 July 1675 (or 1676). Apprenticed to Thomas Highmore 1689-97, but he also learnt from studying, and possibly assisting Verrio and Laguerre. Became a Freeman of the Painter-Stainers' Company 1704 and began painting scenery 1705. Made a study of architecture and rose to be the leading Baroque decorative painter in England. Also an occasional portrait painter of some accomplishment. In 1711 he visited The Netherlands and Paris. A director of Kneller's Academy (taking over as Governor in 1716). Succeeded Thomas Highmore as Serjeant Painter. Knighted 1720. His main surviving decorative paintings are at Greenwich and Hanbury Hall, the ceiling of the Hall at Blenheim, Charsborough Park, and St Paul's. Became MP for Weymouth 1722 and ran an Academy in his own house. Died Stalbridge, Dorset 13 May 1734.
Represented: NPG London; VAM; Brighton AG; Tate; Trinity College, Cambridge. **Engraved by** J.Guillaume, Maddocks, J.Simon, G.Vertue, G.White. **Literature:** K.Freemantle (ed), *Sir J.T.'s Sketchbook Travel Journal of 1711*, 2 vols, 1975; DNB; *Sir J.T.: Paintings and Drawings*, Guildhall AG exh. cat. 1958; DA.

THRUMPTON, T.　　　　　　　　　　**fl.1667**
London portrait artist in crayons. His signed and dated portrait at Oxford ('T.Thrumpton fecit/Londoni 1667') is believed to be the earliest English portrait in a pastel medium. His style derives from Lely.

THURGAR, William Thomas　　　　　　**fl.1858**
Listed as a portrait painter in Norwich.

THURSTON, George　　　　　　　　**fl.1832-1834**
Listed as a portrait and miniature painter at Waterloo Bridge.

THURSTON, John C.　　　　　　　**fl.1818-1826**
Son of artist John Thurston. Exhibited at RA (6), SBA (4) 1818-26 from an address at BM.
Engraved by F.Engleheart and C.Picart.

THURZAN, Miss Mary　　　　　　　　**fl.1783**
Honorary exhibitor at SA (1) 1783.

TIBBATTS, J.　　　　　　　　　　**fl.1801-1820**
Exhibited at RA (12) 1801-20 from Islington.

TIBURIN, Henry　　　　　　　　**fl.1679-1726**
Born Germany. Left Osnabrück for Paris 1679 with John Closterman, where they worked for de Troy. They moved to London 1681, and he is believed to have been mainly a drapery painter. A son Willem was born London 1691.

TICHBOURNE, Mrs Mary　　　　　　**fl.1763-1766**
Exhibited crayon portraits at SA (3) 1763-6 from Isleworth.

TIDEY, Alfred　　　　　　　　　**c.1808-1892**
Reportedly born Worthing 20 April 1808, second son of John Tidey, poet, schoolmaster and amateur artist. However, baptisms for Chapel Street, Worthing list two Alfred Tideys, the first on 17 April 1808 and the second 12 November 1809, son of John Tidey and Elizabeth. Taught drawing at his father's school. Worked under Sir William Ross, who helped him to obtain commissions for miniatures. These were admired by Constable, who said they were the most unmannered works he had ever seen. Entered RA Schools 1834 and exhibited at RA (120), BI (1), RHA (4), SBA (17), DG 1831-78. His portrait of 'Sir John Conroy, Controller of the Duchess of Kent's Household', led to many royal commissions. Other sitters included Lady Brisbane, and Miss Ellen Tree of the Theatre Royal in Covent Garden. Most of his work was in miniature, although he did do some portraits in watercolour. A close friend of John Constable and his family, and proposed unsuccessfully to Constable's sister, Maria. Tidey married Jane Campbell 1855 and moved to Jersey. Travelled widely and returned to England 1873. Member of Dudley Gallery Art Society. Died Acton 2 April 1892. MS list of works is in VAM. His brother Henry Fryer Tidey was also an artist.
Represented: NPG London; HMQ; VAM. **Engraved by** James Thompson. **Literature:** *The Times* 7 April 1892; DNB.

TIDEY, Henry Fryer　NWS　　　　**c.1814-1872**
Born Worthing 7 January 1813, 1814 or 1815, younger brother of Alfred Tidey with whom he occasionally collaborated. Taught drawing at his father's school, and as a boy painted several pictures for Princess Augusta. Lived in London. Exhibited at RA (67), RHA (1), BI (1), SBA (10), NWS 1841-67. Elected ANWS 1858, NWS 1859. 'The Feast of Roses' was bought from NWS by Queen Victoria to give to Prince Albert 1859. Worked mainly in miniature or watercolour. Among his sitters were Sir John Dean Paul, Viscountess Castlereagh, and Sir Henry Fletcher. Died Bedford, Middlesex 21 July 1872. Studio sale held Christie's 28 March 1873.
Engraved by S.Bellin, W.Holl, W.H.Mote, T.Sherratt. **Literature:** DNB.

TIELEMANS, Martin Franci　　　　　**1784-1864**
Born Lier 8 July 1784. Studied at Academy of Antwerp and under David. Painted histories and portraits and visited England and Hanover. Director of School of Design at Lier. Died there 31 December 1864.
Engraved by H.Dawe.

TILLEMANS, Peter c.1684-1734
Born Antwerp. Trained as copyist of Teniers. Brought to England by a picture dealer 1708. Employed by John Bridges 1719 doing topographical drawings of Oxford and in Northamptonshire. Painted country houses and sporting paintings, but also some portraits and sporting conversations. Died of asthma at Little Haugh, Suffolk 19 November 1734. Buried Stowlangtoft 5 December. Among his pupils were Angellis, Nollekens and Arthur Devis.
Represented: Tate; Castle Museum, Norwich **Engraved by** R.Grave, G.Vertue. **Literature:** R.Raines, Walpole Society XLVII 1980 pp.21-59; DA.

TILLER, Mrs fl.1819-1821
Exhibited at RA (3) 1819-21 from 38 Half Moon Street, London.

TILSON, Henry 1659-1695
Born London or Yorkshire, son of Nathaniel Tilson and grandson of the Bishop of Elphin. A pupil to Lely until 1680, and bought some of Lely's work at the artist's studio sale. Believed to have been with Kneller, where he became friends with Dahl. They travelled together 1684-8 to Paris, Venice and Rome, spending at least a year in Rome. Tilson made copies of the old masters and painted a few portraits, including 'Hon Thomas Arundell', 'Bernini' and 'Francesco Borri'. Tilson and Dahl returned to London in March 1689. Established a successful practice. Committed suicide at about the age of 36, after a love affair ended. Buried London 25 November 1695. Robin Simon describes him as 'a painter of great charm'.
Represented: NGI; Belton House, NT; Courteenhall, Northants; Guildhall AG, London; Dyrham Park, NT; BM. **Engraved by** J.Smith, G.Vertue, G. Vander Gucht, R.White. **Literature:** DNB; DA.

TILSTONE, John Richard fl.1811-1829
Married Elizabeth Wiseman in London 6 August 1811. Exhibited at RA (2) 1827-9 from London.

TILT, E.P. fl.1868
Son of miniaturist F.A.Tilt. Exhibited at RA (1) 1868 from Epsom.
Represented: NPG London.

TIMBRELL, James Christopher 1807-1850
Born Dublin, brother of sculptor Henry Timbrell. Exhibited at RHA (1) SBA (1) 1827-30 from London. Died Portsmouth 5 January 1850.

TINKLEY, Frederick fl.1836
Listed as a portrait and glass enameller in Norwich.

TISDALL, Henry Cusick Wilson RHA b.1861
Born 14 November 1861, son of Rev Charles Edward Tisdall. Exhibited at RHA (268) 1880-1945 from Dublin. Elected ARHA 1892, RHA 1893, Treasurer 1918-28.
Literature: *Burke's Landed Gentry of Ireland*, 1958.

TISSOT, James (Jacques Joseph) 1836-1902
Born Nantes 15 October 1836, son of Marcel-Théodore Tissot and Marie (née Durand). Studied at École des Beaux Arts, Paris c.1856. Met Whistler and became friends with Degas. Painted a number of portraits of fashionable ladies in the manner of Henri Leys, before concentrating on society genre paintings. Exhibited at Paris Salon (winning medal 1866), RA (17), SS (2), GG, DG 1859-81. Appointed drawing master to Prince Akitake 1867. Probably visited London 1869 and settled there 1871. Many of his finest works depict his mistress Kathleen Turner, a divorcee with two illegitimate children, who was dying from consumption. After her death in 1882 he returned to Paris and devoted his life to religious paintings. Visited London again for a séance in which he 'made contact' with Kathleen Turner 20 May 1885. Travelled to Palestine three times and America twice. Died Château de Buillon 8 August 1902.
Represented: Southampton CAG; Musée d'Orsay; Louvre; NGI; Tate; Birmingham CAG. **Literature:** *J.T.*, Ontario AG exh. cat., Toronto 1968; *J.T.*, Barbican AG exh. cat. 1984, C.Wood, *T.*, 1986; M.Wentworth, *J.T.*, 1984; DA.

TITTLE, Walter Ernest 1883-1966
Born Springfield, Ohio 9 October 1883. Studied in New York. Member of Royal Society of Art, London. Produced portraits of Joseph Conrad, Baron Duveen and Arnold Bennett.
Represented: NPG London; VAM; Canterbury Museums.

TOBIN, Mrs Clare fl.1889-1890
Exhibited at GG (2) 1889-90 from Manchester.

TODD, A. fl.1820-1821
Exhibited at RA (2) 1820-1 from Scarborough.

TODD, Arthur Ralph Middleton
RA RWS RP NEAC RE 1891-1966
Born Newlyn 26 October 1891, son of artist Ralph Todd. Studied at Central School, Slade 1920-21 and in France, Italy and Holland. Served in 1st World War in Motor Transport Section RASC. Exhibited at RA (161), RP, RE, NEAC, RWS 1918-67 from London and Truro. Elected ARA 1939, NEAC 1945, RA 1949, RP 1958. Had a highly successful portrait practice. Died 21 November 1966.
Represented: Tate; Brighton AG.

TODD, Richard fl.1807-1823
Exhibited at RA (8), BI (3) 1807-23 from London. Among his sitters was HRH the Duke of Sussex.

TOFANO, Eduardo 1838-1920
Born Naples 31 August 1838. Exhibited at RA (5) 1888-1900 from Chelsea. Also in Paris. Member of the Arts Club in King's Road. Died Rome 20 December 1920.
Represented: Naples Museum.

TOLLEMACHE, Hon Duff RBC 1859-1936
Born 5 January 1859. Studied at RA Schools and Académie Julian, Paris, later working in the studios of Musin in Brussels, Bonnat and A.Stevens. Exhibited at RA (38), SBA 1883-1932 from London. Died 18 April 1936.
Represented: Bristol AG.

TOMLINSON, George Dodgson 1809-1884
Born Nottingham 26 October 1809. Worked in Huddersfield. Exhibited at RA (3) 1848-72. A copy after Winterhalter of Queen Victoria by Tomlinson is in Huddersfield Town Hall. Died Huddersfield 14/15 September 1884. A letter from T.S.Cooper to Tomlinson is in Canterbury Museums.
Engraved by R.J.Lane.

TOMS, Peter RA d.1777
Son of engraver William Henry Toms. Pupil of Hudson where he learnt to be a portrait and drapery painter. The *Universal Magazine*, November 1748, described him as an 'eminent painter'. Employed by Reynolds as drapery painter 1755-c.1763. Then went briefly to Dublin. Drapery painter for Francis Cotes until 1769, and was greatly upset by his death. Able to charge 20 guineas for dress, hands and other accessories in a full-length, and 3 guineas for those in a three-quarter length. Elected a founder RA 1768. Exhibited at RA (3) 1769-71 from London. Died (probably from intemperance or by his own hand) 1 January 1777.

JAMES TISSOT. Eugène
Coppens de Fontenay.
Signed and dated April
1867. 27¼ x 15⅜ins
(69.2 x 39.1cm)

Christie's

TRUMBULL, John 1756-1843

Born Lebanon, Connecticut 6 June 1756, youngest of six children of Jonathan Trumbull, representative in the Connecticut General Assembly, and his wife Faith. At about five years of age he fell down stairs and lost the sight of his left eye. Trumbell's early education was at Nathan Tisdale's school in Lebanon, considered the best school in New England. He could read Greek at six years old and had already acquired a taste for drawing. Age 15 completed his studies at Tisdale's and then studied at Harvard, where he met Copley. Graduated 1773, and then joined the army 1775-7. Visited London 1780, working with Gilbert Stuart under Benjamin West. On 20 November 1780 Trumbull was arrested and charged with treason as a retaliatory measure for the capture and death of Major John André. After much effort by West, Copley and Edmund Burke, Trumbull was released 12 June 1781, on condition he leave the country within 30 days. He immediately travelled to Amsterdam, where he negotiated a loan for the State of Connecticut. Returned to America 1782 and persuaded his father to allow him to follow art as a profession. Arrived in London January 1784, where he again joined West, and in the evenings attended classes at RA, where he frequently sat beside Thomas Lawrence. Exhibited at RA (16), BI (7), SBA (1) 1784-1824 (portraits, histories, landscapes and religious scenes). In July 1786 he accepted an invitation from Thomas Jefferson to visit him in Paris, and there he met Jacques-Louis David, Houdon and Vigée-Lebrun. From Paris he travelled to Germany and the Low Countries returning to London November 1786. Returned again to Paris late 1787 to paint the portrait of Jefferson in the first version of 'The Sortie Made by the Garrison of Gibraltar'. Left for America late 1789 and the following year fell in love with and proposed to Harriet Wadsworth. Unable to decide she did not give an answer, and her death the following year sent Trumbull into a period of severe depression. In England in a diplomatic role 1794, and again 1798. Married Sarah Hope Harvey 1 October 1800 and produced several portraits of her. They travelled to Brighton, Bath and Wales on a belated honeymoon 1801. At this time Trumbull accepted responsibility for the upkeep of a boy born from a liaison in America. Returned there 1803 and by 1804 was re-established in New York, where he was regarded as the leading artist. Elected a director of New York (later American) Academy 1805, which led to numerous public and private commissions. In 1808 he was concerned with failing eyesight, and decided to go to England for treatment. There, because of the impending war, Americans were not popular, and Trumbull received few commissions and fell into debt. Returned to America 1815. Elected President of American Academy of Arts 1817, a position he held for 19 years. His wife died 1824. Published his *Autobiography*, 1824, with 23 plates engraved from his drawings – the first autobiography written by an American artist. Died New York 10 November 1843, aged 87. Funeral held Yale College Chapel. Buried next to his wife in the Trumbull Gallery, beneath his full-length portrait of Washington. A memorial tablet was inscribed 'To his country he gave his sword and pencil'. His portraits vary in quality and range from the 'wooden' to those of outstanding quality. Many of his works were history paintings, and he is rightly regarded as a major figure in American painting. A number of signed forgeries exist produced by Edouard Frossard. C.L.Elliott was a pupil.

Represented: Yale; NG Washington; Metropolitan Museum, New York. **Literature:** T.Sizer, *The Works of Colonel J.T., Artist of the American Revolution*, revised ed 1967; *J.T.: The Hand and Spirit of a Painter*, Yale University exh. cat. 1982; I.B.Jaffe, *T.'s Declaration of Independence*, 1971; I.B.Jaffe, *J.T. – Patron-Artist of the American Revolution*, 1975; DA.

TUCK, William Henry fl.1874

Exhibited at RA (1) 1874 from St John's Wood, London.

JOHN TRUMBULL. Samuel Blodget in rifle dress. Painted 1786. 21¼ x 17¼ins (54 x 43.8cm) *Private collection*

TUCKER, Henry fl.1758-1762

Worked in Dublin 1758-62 as a portrait painter in oils and an engraver. Won a premium at Dublin Society. Later worked with success in the north of England.

TUCKER, Nathaniel fl.1725-1743

Many of his portraits are known from mezzotints dated between 1725-43. Believed to have worked in Exeter. **Engraved by** J.Faber jnr, P.Pelham.

TUCKER, Raymond fl.1852-1903

Exhibited at RA (24), SBA (14), NWS 1852-1903 from Bristol, London, Sandhurst and Wokingham.

TUER, Herbert fl.c.1649-c.1680

Came from an English clerical family. His mother was niece of poet George Herbert. Retired to Holland after the execution of Charles I, where he took up portrait painting. Believed to have settled in Utrecht and died there c.1680. Vertue considered his work to be good.

Represented: NPG London; Jesus College, Oxford. **Engraved by** B.Reading, G.Vander Gucht.

TUKE, Henry Scott RA RBA RWS 1858-1929

Born York 12 June 1858, son of D.Hack Tuke, a Quaker doctor. Brought up in Falmouth and London. Studied at Slade (winning scholarship), Florence 1880, and in Paris 1881-3 under J.P.Laurens. Encouraged by J.Bastien-Lepage to continue his studies *en plein air*. Returned to Cornwall, first in Newlyn and later in Falmouth where he bought a boat. Exhibited at RA (144), RHA (4), SBA (10), NWS, GG, NWG, NEAC 1879-1929. Elected NEAC 1886, RBA 1888, ARA 1900, RA 1914. Among his sitters were Lady Hamilton-Dalrymple and Sir George Williams, President YMCA. Died Swanpool, Cornwall 13 or 30 March 1929. His numerous paintings of naked boys

bathing caused some concern in Victorian circles and attracted attention away from his remarkable skill and sensitivity. Listed in Graves as Henry Sidney Tuke.
Represented: NPG London; Brighton AG; Fitzwilliam; Tate; NMM. **Literature:** *Studio* Vol V 1895; M.Tuke Sainsbury, *H.S.T. – A Memoir*, 1933; B.D.Price, *The Registers of H.S.T.*, Royal Cornwall Polytechnic Society 1983; E.Cooper, *H.S.T.*, 1987; D.Wainewright and C.Dunn, *H.S.T. – Under Canvas*, 1989; DA.

TUKE, Lilian Kate fl.1893-1918
Worked in Durham. Exhibited at RA (7), RI, RP, Walker AG, Laing AG and Artists of Northern Counties Exhibitions 1893-1918. Moved to London c.1914.
Literature: Hall 1982.

TUKE, Thomas fl.1825
Listed as a portrait painter in Manchester.

TULLY, Sydney Strickland 1860-1911
Born Toronto, eldest daughter of Kivas Tully and Maria (née Strickland). Educated in Toronto. Studied art in London, Paris and New York. Elected associate of Royal Canadian Academy. Exhibited in Paris, London and in Chicago. Died Toronto 18 July 1911.

TUMALTI, Bernard M. fl.1821-1847
Entered Dublin Society's Schools 1825. Exhibited at RHA (18) 1827-47 from Drogheda.

TUNNA, G.B. fl.1761-1765
Italian portrait and historical painter from Val d'Ossola. Studied under G.M.Borgnis, on whose death in 1761 he came to England. Advertised portraits in chalk or oils in Norwich 1765.

TUOHY, Patrick Joseph 1894-1930
Born Dublin 27 February 1894, son of Dr J.J.Tuohy. Educated at St Endas College, Dublin; South Kensington Schools and under Sir William Orpen for five years. Travelled to Spain, France and Italy. Exhibited at RHA (37), Paris Salon 1918-27. Died August 1930.
Represented: NGI.

TURCK, Miss Eliza b.1832
Born London, daughter of a German banker. Educated in Germany, but returned to London to study at Cary's School of Art. Took additional lessons from W.Gale. Entered figure class at Female School of Art, Gower Street 1852. Studied in Antwerp 1859-60. Exhibited at RA (20), RHA (4), BI (3), SBA (28), International Exhibition 1851-86 from London.

TURMEAU, John 1777-1846
Son of John Turmeau, a jeweller and miniaturist and Eliza (née Sandry). Educated in Putney and reportedly studied at RA Schools. Exhibited at RA (7) 1793-6. Moved to Liverpool by 1799. Elected a founder LA, President 1812-14 and Treasurer until 1833. Exhibited LA 1810-42. Married Sarah Wheeler and had seven or nine children. Encouraged sculptor John Gibson and kept a print shop. Died Liverpool 12 September 1846.
Represented: Walker AG, Liverpool; Usher Museum, Lincoln.
Literature: DNB; *Connoisseur* September 1921 pp.20-4.

TURNBULL, Mrs Anne Charlotte (née Fayermann) 1800-1862
Born Loddon, Norfolk. Married composer Walter Turnbull 1827. Painted mostly miniatures and watercolour portraits. Exhibited at RA (50), BI (3), SBA (40) 1826-62 . Member of Society of Watercolour Painters. Among her sitters were Ellen Tree and George Cruikshank. Also wrote plays and poems. Her husband died 1838 and she became the second

wife of flower painter, Valentine Bartholomew 1840. Died 18 August 1862.

TURNER, Charles ARA 1773-1857
Born Woodstock 1773 (Wood) or 31 August 1774 (Bénézit). Studied at RA Schools from 1795. Exhibited portraits and engravings at RA (51), RHA (1) 1810-57 from London. Elected ARA 1828. Among his sitters were 'Lord A.Conyngham in Montem Dress', 'Portraits of Lord Ingestre and Mr Mitford in the Dresses Worn at the Eton Montem' and artist William Brockedon. A friend and trustee of J.M.W.Turner. Died London 1 August 1857.
Represented: NPG London; Brighton AG; Tate; BM.
Literature: A.C.Whitman, *C.T.*, 1907; DA.

TURNER, Rev Creed b.c.1745-1804
Son of Hammond Turner of Treeton, Yorkshire. Honorary exhibitor at RA (2) 1799-1800. He was rector at Basingstoke. Died Treeton, Yorkshire 7 February 1804.

TURNER, Francis C. RBA 1795-1864
Exhibited at RA (11), BI (23), SBA (38) 1810-46 from London. Elected RBA 1825. Died Westminster 11 December 1864.
Represented: Walker AG, Liverpool; Manchester CAG.
Engraved by W.Barnard, H.Beckwith.

TURNER, George 1752-c.1820
Born 1 June 1752. Entered RA Schools 1782. Exhibited at RA (30), BI (17) 1782-1820 from London. Portraits of two of his children (born 1777 and 1784) were engraved with a dedication to C.J.Fox. Produced a portrait of HRH the Duchess of York. Became a teacher of drawing and ran his own academy.
Represented: VAM. **Engraved by** L.Schiavonetti.

TURNER, James d.1790
Irish portrait and miniature painter. Exhibited at SA (18), FS (1) 1761-83 from London. Invented a new colour, 'the patent yellow' which was 'productive to him and beneficial to society'. Reportedly died 1790.
Engraved by E.Fisher. **Literature:** Strickland.

TURNER, William fl.1787-1816
Exhibited at RA (12) 1787-1816. Travelled widely in England and France, but was based at Shoreditch. Sometimes confused with William Turner of Oxford.

TUSCHER, Carl Marcus 1705-1751
Born Nuremberg 30 March 1705. Studied for 10 years at Nuremberg Academy under Johan Preisler. Travelled in May 1728 to Italy, remaining there in Rome and Florence until c.1738. Moved via Paris and Holland, to London 1741, where he painted a small conversation piece of 'George Moser and His Wife' which impressed Edwards. Settled in Copenhagen 1743, where he became a court artist. Died Copenhagen 6 January 1751. A gifted and talented artist. Also an architect, illustrator and engraver.
Represented: NPG London; Geffrye Museum, London.
Literature: B.Allen, *Apollo* CXXII July 1985 p.315; DA.

TUSON, George Edward 1833-1880
Baptized London 15 April 1833, son of Edward William Tuson and Georgina Maria (née Mortimer). Exhibited at RA (6), BI (11), SBA (14) 1853-65 from London. Travelled to Turkey and to South America. Painted 'The Reception of a Deputation from the Corporation of Manchester by the Sultan, in Buckingham Palace' for the Town Hall, Manchester. Among his sitters were E.H.Baily RA and 'General W.F.Williams, Bart' (Guildhall AG, London). Died Montevideo 10 May 1880.
Engraved by J.Galloway. **Literature:** *American Art Review*, II/I 1881 p.134.

TWAMLEY, Miss Louisa Ann fl.1829-1835
Birmingham portrait painter. Exhibited at RBSA (25) 1829-35.

TWEEDIE, William Menzies 1828-1878
Born Glasgow 28 February 1828, son of David Tweedie, a lieutenant in the marines. Entered Edinburgh Academy 1844, gaining a prize for copying. Moved to London and entered RA Schools, after which he spent three years under Thomas Couture in Paris. Exhibited at RSA (10), RA (33), BI (4), SBA (1) 1843-74 from Liverpool and London. Among his sitters were Thomas Faed RA, the Bishop of Oxford (Samuel Wilberforce), Lord Taunton, Henry Graves and HRH Prince Arthur. Died London 19 March 1878.
Represented: SNPG. **Engraved by** T.L.Atkinson, J.J.Chant, R.Graves, F.Holl, C.Mottram, R.B.Parkes, G.Sanders, J.Scott, W.H.Simmons, E.A.Smith, J.Stephenson, G.Zobel. **Literature:** Mrs R.L.Poole, *Catalogue of Portraits in the Possession of the University Colleges, City and County of Oxford*, 3 vols, 1925; McEwan.

TWIGG, Miss fl.1821-1840
Amateur painter. Exhibited at RA (4) 1821-40 from London.

TWIGG, Mrs Alvine Klein fl.1889
Exhibited at RA (1), SBA (1) 1889 from Hampstead.

TWIGG, Andrew Richard d.1810
Born Dublin, son of Richard Twigg, coach and heraldic painter. Studied under Francis Robert West at the Dublin Society's School, winning a medal. Married Margaret Le Bas of Dublin 1807. Visited London 1808, then Dublin 1809. Returned again to London, but caught a chill on the journey and died London 24 January 1810, soon after his arrival.
Literature: Strickland.

TWIGG, J.H. fl.1839
Appointed Honorary Painter to His Majesty Mahommet, Shah of Persia. Exhibited a portrait of the Shah at RA 1839 from Covent Garden.

TWOART, G.C. fl.1866-1871
Exhibited at RA (8) 1866-71 from London.

TYLER, William E. (Will) c.1870-c.1930
Born Bridgnorth, Shropshire. Worked as a designer for a carpet manufacturer, weaving the first bit of Axminster in the country. Took a keen interest in landscape and portrait painting. Exhibited at ROI, SBA.
Represented: Carlisle AG. **Literature:** Hall 1979.

TYMEWELL, Joseph fl.1721-1737
Provincial portrait painter working in Kent. Signed and dated in 1721 and 1737 a group of portraits of the Streatfield family of Chiddingstone, Kent (Christie's 25 March 1966, lots 55-58). They are painted in the style of Richardson.

TYNDALE, Walter Frederick Roofe RI RBI
 1855-1943
Born Bruges May 1855. Moved to England aged 16. At 18 studied at the Academy in Antwerp, and then in Paris under Bonnat and Jan Van Beers. Returned to England and at first worked in oils painting portraits and genre. Chiefly known as a portrait painter until c.1890, when he concentrated on watercolour, influenced and encouraged by Helen Allingham. Travelled widely making watercolour landscapes and topographical views. Illustrated many topographical books, mainly for A.& C. Black. Exhibited at RA (36), SBA 1880-1934 including a portrait of Sarah Bernhardt. Died 16 December 1943.
Represented: BM; VAM; Leicester AG.

TYRRELL, W.A. fl.1854
Exhibited at RA (1) 1854 from Camden Town.

TYTLER, George c.1798-1859
Lithographer, portraitist and caricaturist. Worked in Rome c.1820, where he produced an amusing pictorial alphabet. Exhibited at RA, OWS 1819-29. Appointed Lithographic Draughtsman to Duke of Gloucester. Died London 30 October 1859.
Represented: BM; Edinburgh AG. **Literature:** McEwan.

U

UBSDELL, Richard Henry Clement 1812-1887
Baptized Portsmouth 19 November 1812, son of Richard Ubsdell and Elizabeth (née Clement). Worked as a portrait and miniature painter in Portsea. Married Mary Ann Pennel 17 October 1833. Exhibited at RA (5), SBA (1) 1833-49. Founder member of Portsmouth Working Men's Conservative Association. Master of Portsmouth Lodge of Freemasons. Among his sitters were Lady Portman, the Hon Lady Pakenham and the Earl of Liverpool. Also an illustrator, photographer and miniature painter. Died of cancer of the tongue in London 4 June 1887. Buried Southsea Cemetery. The *Hampshire County Times* 8 June 1887 wrote: 'As a portrait painter he enjoyed a considerable reputation'. His sons William George and Thomas Charles were also artists.
Represented: Portsmouth Museum; Guildhall AG, Winchester.

UNDERHILL, Frederick Thomas fl.1868-1896
Exhibited at RA (3), RHA (6), SBA (5) 1868-96 from London.

UNDERWOOD, Ann (Annie) RMS b.1876
Born East Grinstead 12 January 1876, daughter of George W.Underwood. Educated in Brighton. Studied art under Herkomer. Exhibited at RA (36), RMS and in the provinces 1907-38.

UNVARDY, Imre Laszlo b.1885
Born Budapest 20 March 1885, son of portrait painter Julius Unvardy. Studied at Budapest Academy and assisted Sir Leslie Ward ('Spy') from 1918-22. Adopted signature 'Spy junior' after his death. Exhibited GG. Published a number of illustrations in *The Graphic*, etc. Painted portraits of Duke of Sutherland and Sir William Joynson Hicks.

UPTON (UPSTON), Miss Florence Kate d.1922
Born New York of English parents. Studied in New York, Paris and Holland. Exhibited at RA (9), Paris Salon and in America 1905-15. Died 16 or 17 October 1922.

UPTON, John A. b.1850
Born England. Studied in London and Munich. Painted portraits. Appointed painting master at NG South Australia on the recommendation of Poynter, but ill health prevented him from taking up the appointment. His career was cut short by an early death.
Represented: NG Australia. **Literature:** A.McCulloch, *Encyclopaedia of Australian Art*, 1968.

URQUHART, Murray McNeel Caird RBA b.1880
Born Kirkcudbright 24 April 1880. Studied at Edinburgh School of Art, Slade, Westminster School of Art, Frank Calderon's Animal School and Académie Julian, Paris under J.P.Laurens. Exhibited at RA (27), RHA (1), RP, SBA, NEAC 1912-61 from London and Meopham. Elected RBA 1914.

URQUHARTSON, C.Q. fl.1895
Exhibited at RA (1) 1895 from London.

URWICK, Walter Chamberlain 1864-1943
Born London 17 December 1864, son of S.J.Urwick a glove maufacturer. Studied at South Kensington and RA Schools 1882. Exhibited at RA (36), RHA (1), NWS, Paris Salon and in Manchester and Liverpool 1887-1933 from London. Died 24 November 1943. Among his sitters were Lord and Lady Middleton.
Represented: Leeds CAG; Birmingham CAG.

USSHER, Miss Isabel M. fl.1895-1899
Exhibited at RHA (4) 1895-9 from Lismore and Fermoy.

UVEDALE, Samuel d.c.1866
A native of Cork. Moved to London and taught at South Kensington. Exhibited at BI (3), SBA (4) 1845-7 from Pimlico and Camden Town. Painted mainly still-life. Drowned c.1866.
Literature: J.F.Maguire, *The Industrial Movement in Ireland*, 1853 p.332.

UWINS, Thomas RA 1782-1857
Born Pentonville, 24/25 February 1782, son of Thomas Uwins, a clerk in the Bank of England. Educated at Mr Cole's Academy, Islington. Apprenticed to engraver Benjamin Smith 1797, but left after a year to study at Simpson's Drawing School, Finsbury and at RA Schools 1798. Also enrolled at Sir Charles Bell's anatomical classes. First worked mainly in watercolour, drawing fashion plates for Ackermann's *Repository*. Visited France 1817 and began to concentrate on oil paintings c.1818, including portraits, rustic scenes and French subjects. Moved to Edinburgh c.1820 as a result of a commission to illustrate Scott's works. Returned to London in the winter of 1823 and the following summer visited Italy, becoming well-known for picturesque Italian subjects. Exhibited at RA (103), BI (37), SBA (13), RHA (5), OWS (91), NWS (3) 1803-57. Elected ARA 1833, RA 1838. The first painter to have his diploma signed by Queen Victoria. Appointed Surveyor of the Queen's pictures 1842. Keeper of NG London 1847-55. Died Staines 25/26 August 1857. The majority of his portraits, painted in oil and in watercolour, were executed before 1835. His work was copied by I.Gosset.
Represented: NPG London; VAM; Tate; Fitzwilliam; AGs of Birkenhead, Dundee, Glasgow, Leicester, Leeds, Manchester, Nottingham. **Engraved by** F.Bacon, Fenner, Sears & Co, J.Goodyear, W.Holl, J.Outrim, G.A.Periam, E.J.Portbury, E. & T.Radclyffe, H.Robinson, S.Sangster, L.Stocks, J.Thomson, T.Williamson. **Literature:** DNB; Mrs S.Uwins, *A Memoir of T.U.*, 1859; J.F.C.Phillips, *T.U. RA*, 1989; Roget.

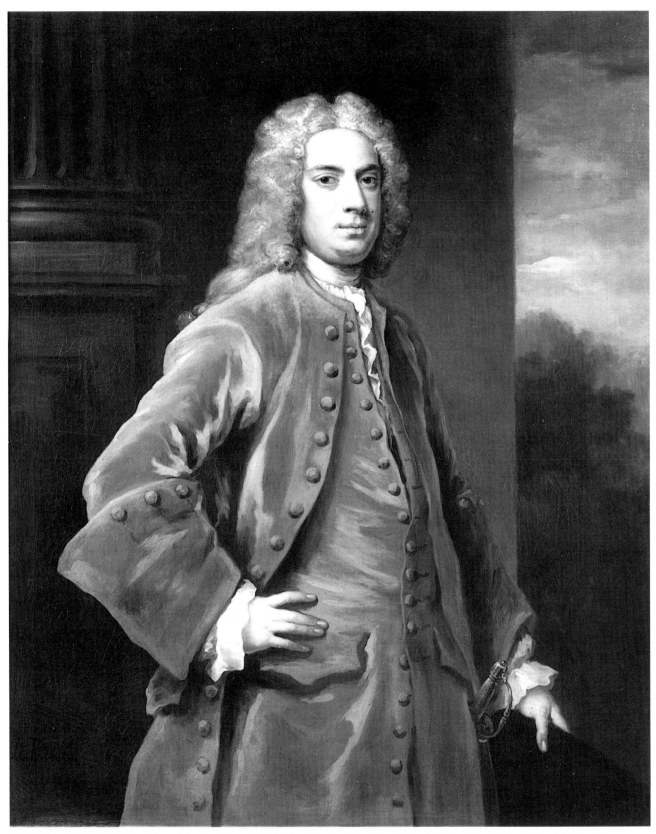

JOHN VANDERBANK. Sir Edward Stanley Bart, 11th Earl of Derby. Signed and dated 1730. 50 x 40ins (127 x 101.6cm)

Christie's

V

VALE, Miss Enid Marjorie **b.1890**
Born Wolverhampton 19 September 1890, daughter of Henry Vale a quantity surveyor. Educated at Ladies' College, Wellington. Studied at Wolverhampton and Birmingham Art Schools. Exhibited at RA (10), RSA, RMS and in Canada and America 1914-35 from Wolverhampton.

VALENTINE, John **fl.1910-1947**
Worked in Newcastle. Exhibited at Laing AG 1910-47. Possibly the J.Valentine who exhibited at RI (1) 1884.
Represented: Cragside, NT. **Literature:** Hall 1982.

VALENTINE, William **1798-1849**
Born Whitehaven England. Emigrated to Halifax, Nova Scotia. Worked as a house decorator, drawing master, portraitist and miniature painter. Visited London 1836, but returned to Halifax 1837. Died Halifax 26 December 1849.
Literature: H.Piers, 'Artists of Nova Scotia', *Nova Scotia Historical Society* Vol XVIII pp.101, 165.

VALKE, Jacob de **fl.1640s**
Painted a full-length of 'Lucius Cary, Viscount Falkland', formerly at Great Tew. John Aubrey was his pupil.

VALLANCE, William Fleming RSA **1827-1904**
Born Paisley 12 February 1827, son of David Vallance. When his family moved to Edinburgh he was apprenticed as a carver and gilder to Messrs Aitken Dott 1841. During this time he began to paint portraits and genre, but did not receive instruction until the age of 23. Studied for a short time under E.Dallas at Trustee's Academy and under R.S.Lauder 1855. Set up on his own in Edinburgh 1857. Exhibited at RSA (241), RA (5) 1848-1905. Elected ARSA 1875, RSA 1881. After 1870 he painted a series of Irish life and specialized in painting landscapes and marines. Died Edinburgh 30 or 31 August 1904.
Represented: SNG; Dundee AG; Victoria AG, Australia.
Literature: McEwan.

VAN AKEN, Alexander **c.1701-1757**
Believed to have been born in Antwerp, younger brother and assistant of Joseph Van Aken, with whom he lived. Succeeded his brother as drapery painter to Hudson and others. Also a mezzotint engraver. Died London.

VAN AKEN, Arnold **d.1735/6**
Believed to have been the eldest brother of Joseph and Alexander Van Aken. Vertue describes him as 'a painter in oil of small figures, landscapes and conversations'. Also an engraver. Died London.

VAN AKEN, Joseph **c.1699-1749**
Believed to have been born Antwerp (Van Haecken). Moved to London c.1720 with his brothers, Arnold and Alexander. First painted genre scenes and conversations in the style of J.J.Horemans. About 1735 he specialized in painting draperies and became the most accomplished drapery painter of his age. Worked for a number of artists, including Hudson, Knapton, Winstanley, John Robinson, Arthur Pond, Bartholomew Dandridge, Ramsay and Davison. He had a series of standard poses, which he frequently used. Walpole remarked that 'almost every painter's works were painted by Van Aken'. In 1748 travelled with Hogarth and Hayman to Paris and then by himself to The Netherlands. Died London 4

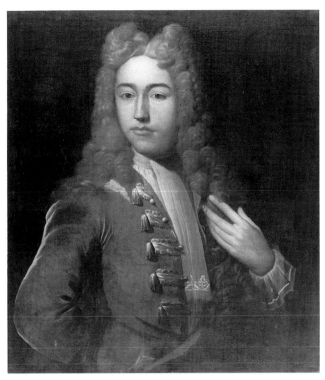

RICHARD VAN BLEECK. A gentleman. Signed. 30 x 25ins (76.2 x 63.5cm) *Christie's*

July 1749. Buried St Pancras Church. Ramsay and Hudson were his executors. His brother, Alexander, was an assistant.
Represented: SNG; Tate; Manchester CAG. **Literature:** McEwan.

VAN ANROOY, Anton RI **1870-1949**
Born Holland 11 January 1870. Educated at Delft University. Studied at The Hague and settled in London 1896. Exhibited at RA (35), RI, RP and in the provinces 1909-35. Elected RI 1915. Became a naturalized British subject. Died 13 February 1949.
Represented: Oldham AG; Aberdeen AG.

VAN ASSEN, Benedictus Antonio **fl.1788-1804**
Exhibited at RA (29) 1788-1804 from London.
Engraved by E.Dumee,

VAN BEVER, A. **fl.1845-1873**
Attended RA Schools c.1845. Exhibited at RA (6), BI (3), SBA (5) 1845-73 from London. Travelled to Paris and Rome 1850s, before returning to settle again in London.

VAN BLEECK, Pieter **1697-1764**
Born The Hague, son of artist Richard Van Bleeck. Practising in London by 1723. Married a Roman Catholic lady of good family 1745. Received much patronage from Roman Catholic sitters. Exhibited at SA (3) 1761. Died London. He engraved many of his portraits
Represented: Yale.

VAN BLEECK, Richard **c.1670-c.1733**
Born The Hague. Became a member of the Guild there 1695. Visited London 1699, but returned to The Hague 1705/6. Towards the latter part of his life he spent much time in England, where he enjoyed a successful practice, particularly painting the portraits of Roman Catholic families. His son Pieter was also an artist.
Represented: NPG London. **Engraved by** G.White.

VAN BROWN, A. **fl.1849**
Exhibited at SBA 1849. No address given.

FRANS VAN DER MIJN. A lady. Signed and dated 1748. 30 x 25ins (76.2 x 63.5cm) *Christie's*

VANDERBANK, John **1694-1739**
Born London 9 September 1694, son of John Vanderbank. Studied at Kneller's Academy from 1711, his style being based on Kneller and Richardson. Founded, with Cheron, Academy in St Martin's Lane 1720 and thus influenced Hogarth. From 1720 had an increasingly large clientele for portraits, often full-lengths. High living made him flee to France to escape debts, returning by 1727, although problems of drink and debt continued. Vertue thought only intemperance prevented him from being the best portraitist of his generation, and this may account for the uneven quality of his works. Also an important decorative painter and book illustrator. Died of consumption in London 23 December 1739. Buried Marylebone Church. Frequently signed and dated his pictures; fond of smudging the highlights to soften them. Many of his works reproduced as engravings by John Faber jnr, who studied at his Academy.
Represented: Guy's Hospital; HMQ; Goodwood House; NPG London; Hampton Court; Tate; Dulwich AG; Plas Newydd, NT. **Engraved by** A.Van Aken; A.Bannerman, A.Benoist, J.Bretherton, T.Chambers, H.R.Cook, C.Duflos, J.Faber jnr, W.Finden, S.Freeman, C.Grignion, W.Holl, J.Houbraken, B.Reading, H.Robinson, J.Romney, W.Ridley, T.Ryley, E.Scriven, A.Smith, G.Vertue, G.White. **Literature:** H.Hammelmann, *Book Illustrators in England*, 1975 pp.79-86; *Country Life*, 5 January 1967 pp.32-3; DA.
Illustration p.460

VAN DER EYDEN, Jeremiah **d.1695**
Born Brussels. Moved to England where he was employed by Lely to paint draperies. On his marriage he settled in Northampton, painting portraits for the Earl of Rutland and Gainsborough. Also worked for Lord Sherard of Stapleford, Leicestershire at whose house he died. Buried 17 September 1695.
Literature: DNB.

VANDERGUCHT, Benjamin **1753-1794**
Born London, reputedly the thirty-second son of Gerard

Vandergucht. Studied at St Martin's Lane Academy and entered RA Schools 1769, winning a Silver Medal 1774. His style is similar to Zoffany, and he also painted theatrical portraits in character, attracting the patronage of Garrick and Woodward. Exhibited at FS (11), RA (49) 1767-87, but gave up painting to take up his father's profession of picture dealing and restoration. Drowned in the Thames, near Chiswick, in a boating accident, 21 September 1794. His portraits can reach a very high standard with sensitive characterization of his sitters.
Represented: Leicester AG; Garrick Club; Christie's collection; Althorp House. **Literature:** DA.

VAN DER GUCHT, John **1697-1776**
Born London. Taught engraving by his father, Michel Van Der Gucht. Also studied under Louis Cheron. Reportedly an excellent caricaturist. Painted portraits of authors John Ker, William King and John Dennis.

VANDERLYN, John **1775-1852**
Born Kingston, New York 15 October 1775 on the banks of the Hudson in the first year of American Independence. Employed in the store of Mr Barrow 1792, a large importer of engravings at New York with whom he stayed two years. Studied art under Gilbert Stuart. Visited France 1796, where he was much influenced by David. Returned home 1801, but again visited Europe 1803, staying in London, Paris and Rome until 1815. Received the Napoleon Gold Medal at Paris for his celebrated painting of 'Marius Amid the Ruins of Carthage'. On his return to America he principally concentrated on portrait painting and among his sitters were Madison, Monroe, Calhoun and Jackson. Commissioned to paint a full-length portrait of Washington for the Hall of Representatives 1832, for which they were so pleased that they voted the artist 1500 dollars beyond the stipulated price. Again visited Paris 1837-47. Died Kingston 23 or 24 September 1852 in his seventy-sixth year in poverty.
Represented: Metropolitan Museum, New York; City Council, Charleston; City Hall, New York. **Literature:** K.C.Lindsay, *The Works of J.V., From Tammany to the Capitol*, Binghampton, New York exh. cat. 1970; M.Schoonmaker, *J.V., Artist 1775-1852*, New York 1950; DA.

VAN DER MIJN, Cornelia **b.1709**
Baptized Amsterdam 29 October 1709, daughter of artist Herman Van Der Mijn. Painted flower pieces and portraits. Recorded 1772.
Represented: Rijksmuseum, Amsterdam.

VAN DER MIJN (MYN), Frans **c.1719-1783**
Believed to have been born in Amsterdam, son of artist Herman Van Der Mijn. Established a fashionable portrait practice in Amsterdam 1742-9. Settled in London c.1750, where he met with some success, painting mainly portraits of the middle classes. Some clients were deterred by his insistence on smoking a pipe while painting. Exhibited at FS (40) 1761-72. His English portraits are in the style of Highmore and can reach a very high standard.
Represented: NPG London.

VAN DER MIJN, George **c.1726-1763**
Born London, son of artist Herman Van Der Mijn by his second marriage. Settled in Amsterdam before 1741, where he began his painting career. Died Amsterdam 10 December 1763.

VAN DER MIJN, Gerard **b.1706**
Born Amsterdam, son of Herman Van Der Mijn. Described as a 'history and portrait painter in England', but little is known of him.

VAN DER MIJN, Herman (Heroman) **1684-1741**
Born Amsterdam, son of a minister. Began as a flower painter,

but took to history and portrait painting at Antwerp and Dusseldorf. Visited Paris 1718, where he attracted the attention of Coypel, who recommended him to the Duke of Orléans. Brought to London c.1721, by an Englishman named Burroughs. Developed a successful portrait painting practice in England. Patronized by the Earl of Exeter, Lord Cadogan, Sir Gregory Page. Gained a reputation for small portraits, in which the details were laboriously and neatly painted. Attracted royal patronage (including Queen Caroline) c.1727. His extravagance and large family led to debt and he returned to Holland again 1736/7. Died November 1741 shortly after returning to London. Many of his children were painters. His style is basically Dutch (although adapted to English taste) and contains much work and detail. Waterhouse describes his technique as 'neat, slightly metallic style, with meticulous accessories'.
Represented: NPG London; Earl of Shrewsbury.

VAN DER MIJN, Robert b.1724
Born London, son of artist Herman Van Der Mijn. Exhibited at FS (9) 1762-4 from London.

VAN DER PUYL, Gerard (Louis François) 1750-1824
Baptized Utrecht 4 March 1750. Taught at the painting school in Utrecht from 1804 and became Director 1807. Worked in Covent Garden about 1783-8. Exhibited portraits and conversation pieces at RA (10) 1785-8, including portraits of the Prince of Wales and the Duke of Northumberland. Some of his sitters were connected with the Royal Society: 'Professor Anthony Shepherd' 1784 (The Old Schools, Cambridge), 'Conversation at Thomas Payne's the Bookseller' 1788 (Philadelphia Museum).

VAN DER SMISSEN, Dominicus 1704-1760
Born Altona, Germany. Visited London c.1738 and 1757.
Represented: Longleat.

VAN DER VAART, John 1653-1727
Born Haarlem (Jan Van Der Vaart). Believed to have been a pupil of Thomas Wyck. Moved to London 1674, painting landscapes, still-life and draperies. Became assistant and collaborator of Wissing in the 1680s, painting draperies, landscapes and occasionally inserting heads by Wissing on separate pieces of canvas into larger compositions. On Wissing's death in 1687 he started a portrait practice on his own, and was much favoured by the Shirley family. Collaborated with J.Kerseboom. Naturalized 1708. Also a mezzotint engraver and was employed by R.Thompson and E.Cooper, but gave up because of failing eyesight. Sold up 1713, to build a house in Covent Garden. Died a bachelor. Buried St Paul's Church, London 30 March 1727 aged 74. A nephew, John Arnold, lived with him for many years and assisted in his practice. Worked in the manner of Wissing and Kneller, and painted the famous *trompe-l'oeil* violin in Chatsworth.
Represented: NPG London; Leicester CAG; Squerryes Court; Burghley House collection. **Engraved by** E.Desrochers, W.Faithorne jnr, P.Schenck, J.Simon, J.Smith, G.Vertue. **Literature:** DNB.

VANDIEST, John fl.1695-1757
Son of the landscape painter Adriaen Vandiest. Copying Kneller 1695, and may have been his pupil. Portraits date 1721-57 and are charmingly wooden in provincial style.
Engraved by R.Purcell.

VAN DYCK, Sir Anthony 1599-1641
Born Antoon Van Dijke Antwerp 22 March 1599, son of Frans Van Dijke, a prosperous fabric mechant, and his wife Maria (née Cuypers). Apprenticed to Hendrick Van Balen 1609. Became a Master at Antwerp 1618, by which time he already had his own

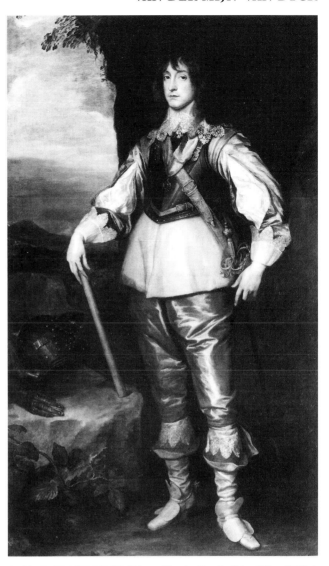

ANTHONY VAN DYCK. Prince Charles Louis. 86 x 49ins (218.4 x 124.5cm) *Christie's*

studio. Acted as the most trusted assistant to Rubens on the decoration of the Jesuit Curch in 1620. Van Dyck first visited England November 1620-February 1621, when he painted 'The Continence of Scipio' (Christ Church, Oxford) for the Duke of Buckingham, and a portrait of the Earl of Arundel (Getty Museum). He impressed James I, and was classed as 'His Majesty's Servant' and given eight months' leave to travel. Returned to Antwerp and left for Italy towards the end of 1621. In Italy he was based at Genoa, but travelled extensively. He created, largely under the influence of Titian and Veronese, a new style of portrait. Left Italy in the autumn of 1627 and returned to Antwerp. Moved to London March 1632, and entered the services of Charles I as Principal Painter in Ordinary. Provided with a house and treated with every honour. Knighted 17 October 1633. His task was essentially to provide portraits of the royal family which would enhance their prestige at home and abroad. Also painted those in the court circle and such is the outstanding brilliance of his work that he is rightly described by Waterhouse as the 'greatest master of the European Baroque portrait'. In Flanders for a year 1634/5, and in March 1638 was made a denizen in England. His prices were £50-£60 for a full-length, £30 for a half-length and £20 for a bust. Also did good business in arranging repetitions on the scale of life by his pupils

(mainly Flemings), and in miniature by John Hoskins (i) and Jean Petitot (i). Married Lady Mary Ruthven 1639, after severing relations with his mistress, Margaret Lemon, who is said to have bitten his thumb in an excess of jealous rage. Went to Antwerp again towards the end of 1640 (after the death of Rubens). In January 1641 he was in Paris, hoping for an appointment that was eventually given to Poussin. On his return to Blackfriars his health gave rise for concern. The King sent his own physician, offering him a reward of £300 if he could restore Van Dyck to health. This he failed to do, and Van Dyck died Blackfriars 9 December 1641 aged 42, shortly before the Civil War. Buried in the choir of St Paul's Cathedral. Among his pupils and assistants were David Beck and Theodore Russel. He undoubtedly was a genius, and gave great life and vitality to everything he painted.
Represented: NG London; NPG London; SNPG; HMQ; Dulwich AG; NGI; Tate; Wallace Collection. **Engraved by** J.S.Agar, A.Annedouche, P.Audran, A.Bannerman, B.Baron, Barrett, F.Bartolozzi, J.Basire, I.Beckett, W.P.Benoist, T.Berry, J.Beugo, M.Blot, G.Bockman, S. à Bolswert, H.Bourne, J.Boydell, A.Browne, M.Burghers, J.Burnet, G.B.Cecchi, T.Chambers, F.L.D.Ciartres, P.Clouwet, H.Cook, R.Cooper, J.Couchet, F.Courboin, C. & H.Danckerts, F.A.David, T.A.Dean, A. & P. de Jode, F.Delaram, R.Dunkarton, R.Earlom, W.C.Edwards, B.Eredi, J.Faber, W.Faithorne, E.Ficquet, W.Flanchenecker, W.T.Fry, M.Gauci, E.Gaujean, R.Gaywood, B.P.Gibbon, G.Glover, W.Greatbach, V.Green, J.Gronsvelt, F.Hanfstaengl, E.Harding, C.Heath, B.Hoefel, W.Holl, W.Hollar, H.Hondius, J.Houbraken, Huot, F.Jentzen, F.Joubert, Kellaway, A.Lalauze, J.C.Le Blon, G.Lid, D.Loggan, P.Lombart, A.Lommelin, E.Luttrell, J.McArdell, A de Marcenay, M.Marrebeeck, E.Martin, J.B.Massard, A.Masson, M.Merian, J.Meyssens, S.C.Miger, F.Milius, B.Moncornet, N.Muxel, J.Neefes, G.Parker, J.Payne, A.Pazzi, B. & C.Picart, F.Piloty, E.Pinkerton, F.Place, P.Pontius, T.A.Prior, R.Purcell, C.Pye, S.F.Ravenet, B.Reading, J.Record, G.Reeve, Rivers, H. & R. Robinson, A.L.Romanet, H.T.Ryall, W.Ryland, S.Savery, L.Schiavonetti, J.Schildtknecht, C.N.Schurtz, E.Scriven, F.Selma, H.C.Selous, W.Sharp, R.Sheppard, W.P.Sherlock, T.Sherratt, W.Sherwin, S.Silvestre, J.Simon, C.Simmoneau, J.Smith, J.Spilsbury, R.Strange, J.Stuerhelt, J.Suyderhoef, W.J.Taylor, Thevenin, J. & R.Thomson, Thornthwaite, Tringham, C.Turner, J.Vander Bruggen, C. Van Dalen, M.Vander Gucht, P. Van Gunst, P. Van Lisebetten, J. Van Prenner, C. Van Queboren, J. Van Somer, R. Van Voerst, W.Vaillant, G.Vertue, C.J.Visscher, L.Vorsterman, W.Walker, A.W.Warren, J.Watson, W.H.Watt, R.White, R.Williams, J.Wolffe, T.Worlidge, T.Wright. **Literature:** L.Cust, *A.V.D., An Historical Study of his Life and Works*, 1900; E.Larsen, *L'Opera Completa di V.D.*, 2 vols, Milan 1980; M.Jaffé, *V.D.'s Antwerp Sketchbook*, 2 vols 1966; C.Brown, *V.D.*, 1982; E.Larson, *The Paintings of A.V.D.*, 2 vols 1988; S.Barnes, A.Wheelock & others, *V.D. Paintings*, 1991; C.Brown, *V.D. Drawings*, 1991; DA.
Colour Frontispiece

VANDYKE, Peter **1729-1799**
Believed to have been born in Holland. Brought to England by Reynolds as a drapery painter (Redgrave). His early work shows the influence of Reynolds. Exhibited at SA (2), FS (17) 1762-72 from London. Later settled in Bristol, where he painted small portraits of Coleridge and Southey 1795 (NPG London). **Engraved by** R.Woodman.

VAN HAVERMAET, Charles **fl.1901-1904**
Exhibited at RA (4) 1901-4 from London.

VAN HAVERMAET, P. **fl.1879-1881**
Exhibited at RA (2) 1879-81 from St James's Place, London portraits of 'Samuel Laing Esq MP, Chairman of the London, Brighton and South Coast Railway' (painted for the boardroom), and the Earl of Beaconsfield.

EDMUND LAWRENCE VAN SOMEREN. Marion – the artist's sister. Signed and dated 1906. 54 x 29½ins (137.2 x 74.9cm)
Phillips East Anglia

VAN HOOGSTRATEN
 see **HOOGSTRAETEN, Samuel van**

VAN LIMPUT (LEEMPUT), Remee **1607-1675**
Baptized Antwerp 19 December 1607. Possibly a pupil of Van Dyck, whom he copied. Became a leading figure in the art world. Had his studio in Covent Garden. Also a collector and dealer. **Represented:** HMQ; Petworth, NT. **Literature:** DA.

VAN LOO, Jean Baptiste **1684-1745**
Born Aix-en-Provence 11 January 1684. Son and pupil of L.A. Van Loo. Worked in France, Turin and Rome, where he studied under B.Lutti, until he settled in Paris 1720. Due to an equestrian portrait of Louis XIV, he shared an international reputation. Paris Academician 1731. Moved to England December 1737, where he met with immense success, much to the envy of home-grown painters. He was the favourite painter of the Prime Minister, Sir Robert Walpole. Painted the 'Princess of Wales, her Family, and Household' (St James' Palace). After a year of ill health he left England in October 1742. Died Aix-en-Provence 19

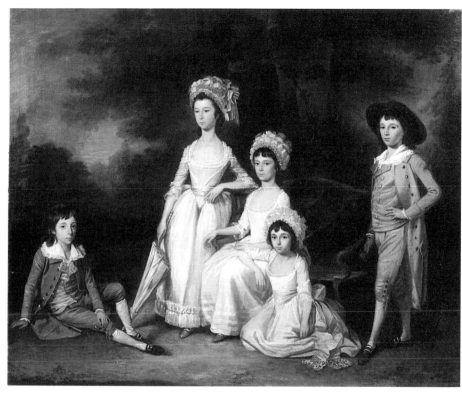

LEWIS VASLET. The Mordant family. 25 x 30ins (63.5 x 76.2cm)
Christie's

September 1745.
Represented: NPG London; Canterbury Museums; HMQ; City of Worcester; Hermitage; Louvre. **Engraved by** B.Baron, J.Basire, W.P.Benoist, J.Faber jnr, E.Fisher, C.Grignion, J.Hopwood, W.James, J.McArdell, J.S.Muller, N.Parr, Rhodes, C.W.Sherborn, G.Vander Gucht. **Literature:** DA.

VAN LOO, Louis Michel **1707-1771**
Born Toulon 2 March 1707, son of eminent portrait painter Jean Baptiste Van Loo and nephew of Carle. Elected a Paris Academician 1733. Court Painter in Spain 1737-52. Visited London 1765. Exhibited at SA (4) 1765, including a portrait of the French Ambassador. Died Paris 20 March 1771. A master of the formal State Portrait.
Represented: Versailles; Prado, Madrid; Wallace Collection. **Literature:** Edwards; DA.

VAN MIEREVELDT, Michael Jansz **1567-1641**
Born Delft 1 May 1567. Studied under Antonio Blocklandt at Utrecht. Painted Charles I in London. Died Delft 27 June 1641.
Represented: NPG London. **Literature:** Bénézit.

VAN RUITH, Horace **c.1839-1923**
Exhibited at RA (27), RI, SBA 1888-1916 from Capri, Rome and Holland Park, London. Lived for a long time in Italy. Died July 1923 aged 84.
Represented: Bristol AG; Cologne Museum. **Literature:** Bénézit; *The Year's Art* 1924.

VAN RYMSDYK, Jan **fl.1767-1778**
Worked as a portrait and mezzotint engraver. Settled in Bristol, where he worked for William Hunter.
Represented: BM. **Literature:** DNB.

VAN SOMER (VAN SOMERIN), Paul (Paulus)
 c.1576-1622
Born Antwerp. Recorded in Amsterdam 1604, Leiden 1612-4, The Hague 1615, Brussels 1616. Settled in England December 1616. Already a Court Portrait Painter by 1617 and was possibly

Official Painter to Queen Anne of Denmark. Charged £30 for a full-length royal portrait in 1620. He was principal among those who set Court painting in England on an altered course. Buried St Martin-in-the-Fields, London 5 June 1622. His portraits are usually rich in colour, often using deep reds and browns. They are often enlivened by interesting settings, many architectural.
Represented: Tate; North Carolina MA; HMQ **Engraved by** J.Barra, R.Clamp, J. & C.Esplens, S.de Passe, J.Thomson. **Literature:** DNB; DA.

VAN SOMEREN, Edmund Lawrence ROI **b.1875**
Born Bangalore, India 4 July 1875. Studied at RA Schools, where he won Silver Medals and Landseer scholarship. Exhibited at RA (3), ROI, NEAC from Melton, Suffolk. Elected ROI 1908.

VANSON, Adriaen **fl.1580-1601**
Believed to be of Flemish origin. Worked in Edinburgh as 'His Majesty's Painter' from 1580 to 1601.
Literature: D.Thomson, *The Life and Art of George Jamesome*, 1974, pp.46-8.

VAN STREACHEN, Arnold **fl.c.1735**
A full-length portrait of the 1st Earl of Hardwick (Middle Temple) is ascribed to 'Arnold van Streachen'.

VAN WORRELL, A.B. **fl.1832-1834**
Listed as an animal and portrait painter at 62 Warren Street, London.

VARILLAT, Madame (née Tornezy) **fl.1795-1833**
From Paris, where she exhibited at Paris Salon 1795-1833. Exhibited at RA (12) 1816-20 from London. Among her sitters were the Duc de Chartres.

VASLET (VASLETTE), Lieutenant Lewis **1742-1808**
Born York. Lieutenant in 25th Regiment of Foot. Left the service and travelled to Italy. Exhibited at RA (10) 1770-82. Worked from York 1770, 1771 and 1778, Bath 1787, Norwich 1793 and Oxford 1780, 1790 and 1796, where he advertised

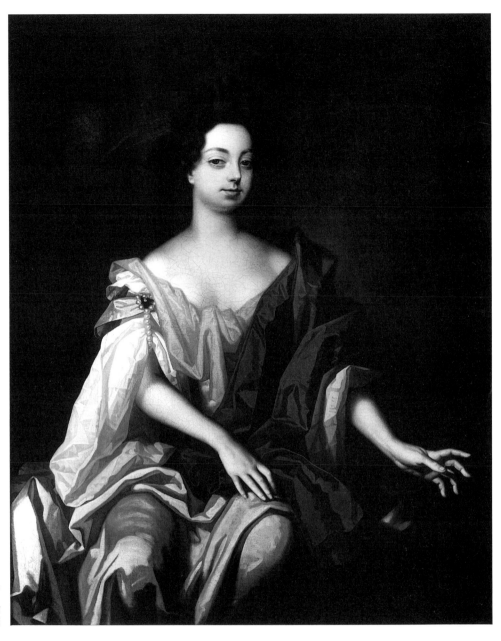

SIMON PIETERSZ VERELST.
Nell Gwyn. Signed. 50 x 40ins
(127 x 101.6cm)
*Philp Mould/Historical
Portraits Ltd*

himself as an 'artist in crayons (miniatures and likenesses)'.
Reportedly married a lady of means. Buried St Michael's, Bath
14 October 1808. His style is usually accomplished,
charmingly naïve with pleasantly subdued colouring.
Represented: Bath AG; BM; Merton College, Oxford.
Engraved by C.Carter, W.Evans, W.Ridley. **Literature:**
J.Ingamells, *Apollo* LXXX July 1964 pp.33-4.

VAUGHAN, T. **fl.1811-1821**
Exhibited at RA (16) 1812-21. Began as a landscape painter,
but from 1819 concentrated on portrait painting. Moved
from London to Hoxton 1820. Among his sitters were
Abraham Cooper RA, and J.Jackson RA.
Engraved by W.Say.

VEDDER, Simon Harmon **1866-1937**
Born Amsterdam, New York 9 October 1866. Studied at
Metropolitan Museum, New York and at Académie Julian, Paris
with Bouguereau and Fleury. Exhibited at RA (15) 1896-1937
from London. Among his sitters was W.Goscombe-John ARA.

VENABLES, Adolphus Robert **b.1811**
Born Windsor. Established a successful London society
practice. Exhibited at RA (21) 1833-73. Among his sitters
were HRH Princess Augusta Sophia, the Viscountess
Fielding, and the Archdeacon of Taunton. Married Elizabeth
Wakelin at St Ann's Soho, 3 November 1853.

VENNING, R. **fl.1818-1834**
Exhibited at RA (6) 1818-34 from London.

VERELST, Harman (Hermann) **1641/2-1699**
Born at Dordrecht, where his father Pieter Verelst was a
portrait painter. In the service of the Emperor in Vienna
c.1680, but left for England 1683 on account of the Turkish
attack. His earliest known English portraits, signed and dated
1683, were found in Suffolk. Based in London and seems to
have enjoyed a respectable practice in the provinces. His
family came to England with him, including his son Cornelius
(1667-1728) and daughter Maria. Died at St Giles-in-Fields.
Represented: NPG London. **Engraved by** J.Fittler.

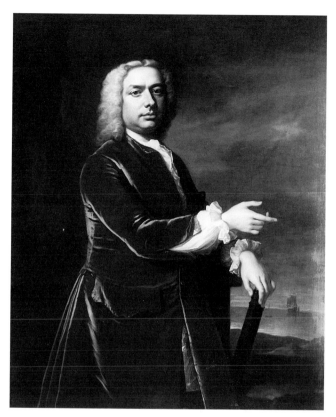

WILLEM VERELST. A gentleman, thought to be Captain Wynter. Signed and dated 1736. 50 x 40ins (127 x 101.6cm)
Christie's

VERELST, John d.1734
Son of Harman Verelst. Married Ann Tureng at St James's 1692. His signed and dated portraits range 1699-1734. Died London 7 March 1734. Musgrave says he painted 'four Indian princes'. He uses a curly 'V' to his signature.
Represented: Leeds CAG. **Engraved by** G.Vertue. **Literature:** Sir William Musgrave, *An Obituary of the Nobility, Gentry etc. of England, Scotland and Ireland prior to 1800. . .*, 1882.

VERELST, Maria 1680-1744
Born Vienna or Antwerp, daughter and pupil of Harman Verelst. Taken to London at the age of three by her father, and also received lessons from her uncle, Simon Verelst. Specialized in small portraits on copper (about 7 x 6ins), which date from 1700. Occasionally painted life-size. Spoke fluent Latin, German and Italian. Had considerable musical talent. Died London.
Represented: Museum at Nuremberg. **Literature:** E.F.Ellet, *Women Artists*, 1859; DA.

VERELST, Simon Pietersz 1644-c.1721
Baptized at The Hague 21 February (Waterhouse) or 21 August (Bénézit) 1644, where his father, Pieter Verelst, was a portrait painter. Joined the Guild of St Luke 1666. Came to England 1669, and was the first of the family to do so. Already had a high reputation for his flower paintings (Pepys Diary 11 April 1669). Nell Gwyn seems to have been a chief patron. Encouraged by Duke of Buckingham he also painted portraits (sometimes with elaborate floral accessories). According to Walpole he visited Paris 1680 and lived in the house of Lovejoy, the art dealer. Became eccentric and conceited calling himself the 'God of Flowers' and 'King of Painters'. Eventually went mad and died in London between 1710 and 1721.
Represented: NPG London; Fitzwilliam; SNPG; The

Hague; Ashmolean; Parham House; Longleat; HMQ. **Literature:** F.Lewis, *S.P.V.*, 1979; DNB; DA.

VERELST, Willem d.1752
Born London, son and pupil of John Verelst and Ann Tureng. Painted portraits and conversation pieces to a very high standard. His major work is 'The Common Council of Georgia Receiving the Indian Chiefs' 1734/5 (H.F.Dupont Museum, Winterthur, USA). Died St Christopher le Stocks, London 1752.
Represented: NPG London; Elevetham Hall; Leslie House, Fife; Hatfield House; Garrick Club. **Literature:** DA.

VERESMITH (WEHRSCHMIDT), Daniel Albert RP
1861-1932
Born Daniel Albert Wehrschmidt in Cleveland, Ohio 24 November 1861. Educated in Cleveland. Moved to England, where he studied under Herkomer at Bushey 1883-4. Joined the teaching staff there 1884-96. Exhibited at RA (39), RHA (2), RP, GI 1886-1928. Won medals at St Louis Exhibition 1904 and at San Francisco 1914. Elected RP 1915. Died 22 February 1932.
Represented: NPG London; SNPG.

VERNER, Miss Ida 1851-1937
Daughter of Lieutenant Colonel William John Verner and Mary Ann (née Rogers). Exhibited at RA (8) 1882-93 from Brighton, London and South Devon. Died Hove 7 August 1937 aged 86.

VERPILLEUX, Emile Antoine MBE 1888-1964
Born Kensington 3 March 1888, son of Antoine Verpilleux and Edith (née Beard). Studied in London, France, Belgium and Holland. Produced a number of illustrations and posters. Painted portraits in England and America. Served in RAF. Exhibited at Paris Salon, RA (4), NEAC 1912-29. Died 10 September 1964.

VERRIO, Antonio c.1639-1707
Born Lecce, South Italy. Worked in Naples, Toulouse and Paris (where he was received into the Académie 1671). Moved to England 1672, where he attracted the attention of Charles II. Became a denizen 5 May 1675. Employed with a team of assistants painting wall and ceiling decorations at Windsor Castle until 1688. His work was much admired, but very little survives today. On 30 June 1684 he was made 'first and chief painter to His Majesty' in succession to Lely (d.1680). This appointment ceased 1688 and Verrio refused to work again for the Crown until 1699. During this time he worked at Burghley and Chatsworth. From 1699 he did much work at Hampton Court, but his eyesight began to fail and he retired on a pension 1704. Although his reputation was made from his decorative paintings he was also a competent portrait painter. He designed the 'Charles II Giving Audience to the Governors, Masters and Children of Christ's Hospital' 1682-8 (Christ's Hospital, Horsham). Died Hampton Court 15 or 17 June 1707. His assistant Louis Laguerre succeeded him.
Represented: NPG London; Tate; HMQ. **Engraved by** H.Robinson. **Literature:** E.Croft-Murray, *Decorative Painting in England 1537-1837*, I 1962; DNB; DA.

VICAJI, Miss Dorothy E. d.1945
Exhibited at RA (12) 1915-29 from Hampstead. Died Palm Beach, Florida 13 February 1945.

VIDAL, Eugène Vincent fl.1873-1906
Born Paris. Exhibited at Paris Salon from 1873 and at RA (4) 1888-96 from London and Paris. Bronze Medallist at Exposition Universelle 1900. Died Cagnes.
Represented: Musée de Mulhouse.

VIEIRA, Francisco 1765-1805
Born Porto, Portugal 13 March 1765. Studied under Domenico Corvi in Rome. Came via Germany to England

and painted histories and portraits. Exhibited at RA (5) 1798-9 from an address at Bartolozzi's. Painted an altarpiece for the chapel of the Portuguese Legation 1800. Became 'Pintor da Camara' in Portugal 1802. Died Funchal, Madeira.

VIENNOT, Chevalier　　　　　　　　**fl.1826-1827**
Exhibited at RA (2), SBA (3) 1826-7 from London. Among his sitters were Miss Paton of Covent Garden, Sir Robert Shaw of Dublin and the Marchioness of Downshire.

VIGÉE-LEBRUN, Marie Louise Elizabeth　　**1755-1842**
Born Paris 16 April 1755. Studied under Vernet and Greuze. Married J.B.Lebrun, a Paris picture dealer 1776. A favourite of the Court of Louis XVI and a friend of Marie Antoinette, whom she is said to have painted 25 times. Left France hurriedly during the Revolution 1789 and lived in Italy, Russia 1795-1800, Austria and Germany, returning to Paris 1801. Worked briefly in London 1802-5, where her art appealed to English society. Charged 200 guineas for a three-quarter length portrait, 500 guineas for a full-length in 1808. Among her sitters were the Prince of Wales and Lord Byron. Died Paris 30 March 1842. Her self-portrait became a popular print.
Represented: Wallace Collection; Brighton AG; Versailles; Louvre; NG Washington; Waddesdon Manor, NT; Metropolitan Museum, New York. **Literature:** Mme Vigée-Lebrun, *Souvenirs de Mme V.-L.*, 1835-7; DA.

VIGNON, Phillipe　　　　　　　　　**1638-1701**
Born Paris 27 June 1638, younger son of the historical painter Claude Vignon. Together with his brother Claude, he was sworn in as 'Limner in Ordinary' to Charles II on 4 October 1669. Returned to Paris by 1686, where he became an Academician 1687. Died Paris 7 September 1701. Sometimes signed 'F.Vignon'.
Represented: HMQ; Louvre.

VIGOR, Charles　　　　　　　　　　**1860-1930**
Baptized Bishopsgate 8 April 1860, son of Joseph and Rachel Vigor. Exhibited at RA (25) 1885-1917 from London. Died Fulham 14 January 1930 and left his wife Adelaide £2541.2s.5d. His work can be of outstanding quality and often has a continental flavour.
Colour Plate 4

VILLEBRUNE, Mary de (Mrs Du Noblet)
　　　　　　　　　　　　　　　　　　fl.1771-1782
Exhibited at SA (7), FS (8), RA (11) 1771-82 from London accommodation addresses.

VILLIERS, François Hüet　　　　　　**c.1772-1813**
Born Paris 14 January 1772, son and pupil of artist Jean-Baptiste Hüet. Took the name of Villiers from Villier-sur-Orge where his father owned land. Enlisted 1792 and took up painting after leaving army. Exhibited portraits at Paris Salon from 1799, before settling in London. Appointed miniature painter to the Duke and Duchess of York, but also worked in oil. Exhibited at RA (31), BI (9) 1803-13. Died London 27/28 July 1813. Buried St Pancras churchyard.
Represented: VAM; Westminster Abbey; HMQ; Ashmolean. **Literature:** DNB.

VINALL, Joseph William Topham　　　**1873-1953**
Born Liverpool 11 June 1873. Studied at RCA and at City and Guilds London Institute. Settled in London. Exhibited at RA (8), RHA (8), RI, ROI, NPS, RSA, Paris Salon 1908-50. Died 21 March 1953.

VINE, John　　　　　　　　　　　　**1808-1867**
Born Colchester 5 November 1808, son of John Vine, a market gardener. Born with greatly shortened malformed arms and a few rudimentary fingers. Married Sarah Ann Surrey June 1847.

Listed as a portrait and animal painter in Colchester, although he did travel widely including Salisbury, Exeter, Chester and Battersea Park. Buried Mersey Road Cemetery, Colchester 18 March 1867. Painted in a charmingly naïve style.
Represented: Colchester Museum. **Literature:** H.Scantlebury, 'No Obstacle to Talent', *Country Life* 9 April 1992.

VINER, John Tickell　　　　　　　　**fl.1818-1854**
Exhibited at RA (13), BI (2), SBA (5) 1821-54 from London. Married Rachel Thomas in London 8 March 1818.

VINTER, John Alfred　　　　　　　　**c.1828-1905**
Exhibited at RA (69), RHA (9), BI (8), SBA (30) 1847-1902 from London. Some of his lithographed portraits were commissioned by Queen Victoria, including after the work of Winterhalter. Died 28 May 1905.
Represented: NPG London.

VISITELLA, Isaac　　　　　　　　　　**d.1658**
Died Canonsgate, Edinburgh. In his will reference is made to portraits of the Earl of Caithness, the Earl of Winton, Lord Forrester, the Lord of Mey and Captain Douglas. The 3rd Earl of Lothian wrote to John Clerk of Penicuik in 1649: '. . . I imagine it Visitella his hand. I desire you if you be acquaint with him to tell I would have him come out to Newbattle to drawe a picture for me and it should be Margaret Fasides.'
Literature: Clerk of Penicuik Monuments; McEwan.

VISPRE, François Xavier　FSA　　　**c.1730-c.1790**
Reportedly born at Besançon. Worked with Victor, his elder brother, in Paris in the mid-1750s, Bristol 1756 and London c.1760. The two brothers travelled to Dublin, where Victor was last recorded c.1778. François returned to London, working from St Martin's Lane. Exhibited at RA (9), SA (46) 1760-83. Elected FSA 1771. He was a Huguenot. A friend of sculptor Roubillac, whose portrait, and that of his wife, he painted. A number of high quality crayon portraits are signed only 'Vispre' and it is assumed that these are by François Xavier. His work was admired by Walpole. Also produced some of the earliest aquatints made in England.
Represented: Ashmolean; VAM; Yale; BM. **Literature:** DA.

VIVIAN, Comley　　　　　　　　　　**fl.1874-1892**
Exhibited at RA (10), SBA (2) 1874-92 from London. Married miniaturist Elizabeth Boly Farquhar.

VOKES, Albert Ernest　　　　　　　　**b.1874**
Sculptor, portrait and landscape painter. Exhibited at RA, RP from London. Possibly the same as Arthur E.Vokes who exhibited at RA (27) 1897-1945 from London, Northampton and Arundel.

VON FOWENKEL, Magdalena　　　　　**fl.1831-1846**
Exhibited at RA (5), SBA (2) 1831-46 from London.

VOS, Hubert　RBA RP　　　　　　　　**b.1855**
Born Maastricht 17 February 1855. Studied in Brussels, Paris and Rome. Exhibited at RA (6), SBA (20), NWG, NWS, GG 1885-92 from London. Elected RP 1891. Among his sitters were 'H.E.Mons de Staal, Russian Ambassador in London' and Count Esterhazy. Later moved to New York, where he became a naturalised American.
Literature: M.Fielding, *Dictionary of American Painters*, 1926.

VOUET, Simon　　　　　　　　　　　**1590-1649**
Born Paris 8 or 9 January 1590. Visited England some time between 1604 and 1611. Painted portraits and histories and considered one of the leading portrait painters of his time. Believed to have painted in Paris for Charles I a ceiling canvas for Oatlands Palace with an 'Allegory of the Peace between France and England' (engraved by M.Doringny 1639). Died Paris 30 June 1649. Buried 1 July.
Represented: NGI. **Literature:** DA.

WADDELL, John H. fl.1896
Listed as a portraitist at 252 Buchanan Street, Glasgow.

WADDINGTON, Miss Vera b.1886
Born Wiltshire 16 January 1886, daughter of General Thomas Waddington. Studied at Slade (winning prizes). Exhibited at NEAC, Paris Salon.

WADDINGTON, William Hartley 1883-1961
Born Bradford. Studied at Slade, where he won the portrait prize. Practised in Yorkshire, before settling in Cumbria following his marriage in 1914. Lived in Hawkshead (where his neighbour and landlord was Beatrix Potter) and later near Sawrey, near Windermere. Exhibited at RA (1), RSA, NEAC until 1938. Member of Lake Artists' Society and President from 1949 until his death in Windermere.
Represented: Abbot Hall AG, Kendal.

WADE, Albert Edward fl.1919-1928
Educated in Birmingham. Exhibited portraits and miniatures at RA (3) and in Liverpool and Toronto 1919-28.

WADHAM, B. fl.1860
Listed as a portrait painter at 68 Cornwall Street, Liverpool.

WAGEMAN, Michael Angelo b.1821
Born Lambeth, son of Thomas Charles Wageman. Exhibited at RA (23), BI (4), SBA (17) 1837-79 from London.

WAGEMAN, Thomas Charles NWS 1787-1863
Born St James's, Middlesex. Exhibited at RA (56), BI (1), SBA (16), NWS 1816-1857 from London and East Molesey. Founder NWS 1831. Appointed portrait painter to the King of Holland. Painted a number of theatrical portraits. Among his sitters were Thomas Stothard RA, the Marquess of Exeter, 'Mr Kean in the Character of Hamlet' and Hon Henry Fitzroy MP. Died 20 June 1863. Best known for his delicate portraits in pencil and watercolour.
Represented: NPG London; VAM; BM. **Engraved by** H.Adlard, Dickinson & Co., Easto, S.Freeman, W.T.Fry, L.Haghe, B., T. & W.Holl, J.M.Johnson, J.Kennerley, R.Page, B.Reading, P.Roberts, J.Rogers, W.P.Sherlock, I.W.Slater, R.Woodman, T.Woolnoth, T.Wright.

WAINEWRIGHT, Thomas Griffiths 1794-1852
Born Chiswick. Educated at Burney's School. Studied under Thomas Phillips RA for a short while in 1814, before joining the Army. Wrote for the *London Magazine* 1820-30. Exhibited at RA (6) 1821-5 from London. In 1831 he was alleged to have forged the names of the trustees of his grandfather's will, poisoned his uncle in order to inherit his property, his wife's mother because she suspected him, and finally his wife. He fled to France, but returned 1837, was recognized and sentenced to transportation for forgery and uttering. While in Tasmania he was allowed to make, under guard, a number of portraits in pastel and watercolour. It was recorded that he took drugs and died of apoplexy in Hobart, Tasmania. Said to have been the inspiration for Slinkton in Dickens's *Hunted Down*.
Represented: BM; Tasmanian AG; Queen Victoria Museum & AG, Launceston. **Literature:** T.Secombe, *Twelve Bad Men*, 1894; R.Cressland, *Wainewright in Tasmania*, 1954; Oscar

Wilde, *Intentions – Pen, Pencil and Poison'*, 1891; T.G.Wainewright (ed), *Essays and Criticisms*, with a memoir of W.Carew Hazlitt, 1880.

WAINEWRIGHT, W.F. fl.1835-1857
Exhibited at RA (8), SBA (3) 1835-57 from London. Among his sitters were Viscount Duncannon, Marquess of Worcester, Marchioness of Worcester, Count Sechendorff and Ralph Bernal Osborne MP for Middlesex.

WAINWRIGHT, William John RWS RBSA
1855-1931
Born Birmingham 27 June 1855, son of J.M.Wainwright. Educated at Sedgley Park College, near Wolverhampton. Apprenticed to stained-glass manufacturers, Messrs Hardman. Studied at the School of Pugin 1870-80 under John Powell, at Antwerp Academy under C.Verlat 1880-2 and Paris 1882-7. Shared a studio with Frank Bramley. For a time he directed the Life Academy at Birmingham School of Art under E.R.Taylor. Also worked in London and spent two years in Newlyn with Edwin Harris and W.Langley. Exhibited at RA (1), SBA, RWS, RBSA. Elected ARWS 1883, RBSA 1884, RWS 1905, Founder Member of Birmingham Art Circle. Painted a posthumous portrait of David Cox for RWS. Died Birmingham 1 August 1931.
Represented: Birmingham AG. **Literature:** *Connoisseur* 88 1931 p.277; W.Turner, *W.J.W.*, 1935.

WAITE, Harold 1870-1939
Born Croydon March 1870. Exhibited at RA (16), SS 1898-1926 from Blackheath, Westgate-on-Sea, Canterbury and Sandwich. A friend of Alfred Palmer. Helped establish the East Kent Art Society. Died Lenham, Kent 26 May 1939.
Represented: Canterbury Museums; NGI.

WAITE, James Clarke RBA 1832-1920
Born Whitehaven, son of John Waite, a schoolteacher and Isabelle (née Clarke). Studied at Government School of Design, Newcastle, Scottish Institute, Edinburgh, RA Schools and in Paris. Exhibited at RA (29), BI (5), SBA (120) and in Australia 1854-86. Elected RBA 1873. Graves lists him as two painters. Worked and taught in Newcastle, was in London 1869-85 and settled in Melbourne 1886, where he became the leading portrait painter. Died of bronchitis at Woollahra, Sydney 8 August 1920.
Represented: NG Victoria; Bendigo AG; Manly AG, New South Wales. **Literature:** *Dictionary of Australian Biography*.

WAITT, Richard d.1732
Married Margaret Freebairn in Edinburgh in April 1707 and the following year was paid for painting the Earl of Hopetoun's coat of arms at Abercorn Church. Probably studied under Scougall, and was practising portraiture by 1709 after which there followed a succession of dated portraits until 1716. Between 1716-22 nothing is known of him, but dated works then continue. In 1730 he was paid £30 for painting the arms of Great Britain in the Court of Elgin. Painted a number of busts in ovals, some showing the influence of Medina.
Represented: SNPG; Glasgow AG; Royal Company of Archers; Earl of Seafield Collection. **Literature:** D.H.G.Cheape, 'Portraiture in Piping', *The Scottish Pipe Band Monthly* No.6 January 1988; J.Holloway, 'R.W.', *Antique Collector* July 1989; McEwan.

WALDO, Samuel Lovett NA 1783-1861
Born Windham, Connecticut 6 April 1783. Son of Zaccheus and Esther Waldo. Studied under J. Steward in Hartford c.1799, then came to London where he was a pupil of West. Entered RA Schools 1806-8. Based in New York from 1809, where he had a successful practice. William Jewett was his pupil

and between 1818-54 they became partners in the portrait firm Waldo & Jewett. They often produced works on panel with the firm stamped or inscribed on the back. Elected founder NA 1826. Died New York 16 February 1861. His style is more painterly and firmly modelled than those of many of his American contemporaries, and he was capable of portraying a sitter's character in some depth.
Represented: Metropolitan Museum, New York; Boston MFA; Toledo Museum. **Literature:** F.F.Sherman, *Art in America* XVIII February 1930 pp.81-6; DA.

WALE, Charles fl.1780
Exhibited at FS (1) 1780 from London.

WALENN, Frederick Dudley d.1933
Son of William Genry Walenn, a civil engineer. Educated at Cowper Street Schools, London. Studied at BM, RA Schools and Académie Julian (Silver Medallist). Exhibited at RA (24), ROI and in the provinces 1894-1930. Principal of St John's Wood Art School from 1907. Gained a reputation for children's portraits.

WALES, James 1747/8-1795
Born Peterhead, Aberdeenshire. Educated at Mareschal College, before setting up as a portrait painter. His early portraits were usually small in size and often painted on tin-plate. Exhibited at SA (3), RA (3) 1783-91 from London. Travelled to Bombay 1791, where he developed a successful portrait practice and took the portraits of many Indian princes. Worked with Thomas Daniell and provided drawings for topographical publications. Died Thânâ 13 or 18 November 1795.
Represented: SNPG. **Literature:** DNB; McEwan.

WALKER, Miss Agnes E. fl.1887-1900
Exhibited at RA (8), SBA (6) 1887-1900 from London.

WALKER, Bernard Fleetwood b.1892
Born Birmingham 22 March 1892, son of William Walker, an electrical engineer. Studied at Birmingham School of Art and in London and Paris. Became art master at King Edward Grammar School, Birmingham and painting master at Aston School of Art.
Represented: Birmingham CAG.

WALKER, Mrs Elizabeth (née Reynolds) 1800-1876
Born London, daughter and pupil of engraver S.W.Reynolds. Instructed by T.G.Lupton, Northcote and Clint. Exhibited miniatures and portraits at RA (53) 1818-50. Had a distinguished clientele including five prime ministers. Appointed miniature painter to William IV 1830. Married engraver William Walker c.1829. Died London 9 November 1876. Buried Brompton Cemetery.
Represented: Christ Church, Oxford; NPG London. **Engraved by** H.Robinson, W.Walker, T.Woolnoth. **Literature:** McEwan.

WALKER, Ellen fl.1836-1852
Exhibited at RA (9) 1836-49 from London.
Engraved by N.Ploszczynski, W.Walker.

WALKER, Dame Ethel ARA RBA RP NEAC
 1861-1951
Born Edinburgh 9 June 1861, daughter of Arthur Abney Walker and his second wife, Isabelle (née Robertson). Studied at Ridley, Putney and Westminster Schools of Art, Slade and under Sickert and Wyndham Lewis. Exhibited at RA (107), SBA, RP (25), RSA (11), NEAC 1898-1951 from London and Robin Hood Bay. Elected NEAC 1900, RBA 1932, RP 1933, ARA 1940, CBE 1938, DBE 1943. Died London 2 March 1951. Considered one of the most distinguished women artists of her day. Her portraits are full of colour, rapidly applied, and often completed in one sitting. They vary in quality.
Represented: Tate; Brighton AG; Leeds CAG. **Literature:** DNB; McEwan.

JAMES WALES. Bahiro Raghunath Mehendale. Inscribed 'Bhyro Pundit' and inscribed on reverse 'Bhyro Pundit Jas Wales pinxit Bombay 1792 Poona Minister for the British Dept'. 30 x 20ins (76.2 x 50.8 cm) *Christie's*

WALKER, George fl.1792-1815
An honorary exhibitor of at first portraits, then from 1803 landscapes, at RA (20) 1792-1815.

WALKER, George b.c.1813
Born Durham. Aged 38 in 1851 census. Exhibited at RA (3) 1835-6 from 4 Lower Brunswick Terrace.

WALKER, Hannah Kirk fl.1832-1834
Listed as a portrait painter in London.

WALKER, John Hanson 1844-1933
Born Donisthorpe, Derbyshire 21 January 1844 (baptized 1 February), son of Robert Walker and Sarah (née Hanson). He was discovered in his father's antique shop in Bath by Frederic Leighton and used as a model. Became a close friend and pupil of Leighton. Studied at Heatherley's and entered RA Schools 1864. Exhibited at RA (86), SBA (39), RHA (4), GG 1869-1918 from London. Visited America 1886. Among his sitters were Frederic Leighton, Viscount Sidmouth and Lady Sophia Cadogan. Died Tankerton, Kent 13 November 1933 in his ninetieth year. Buried at Wareham, Dorset.
Represented: Victoria AG, Bath; Lanhydrock House, NT; Cheltenham AG. **Literature:** B.Morse, *J.H.W. – The Life and Times of a Victorian Artist*, 1987.

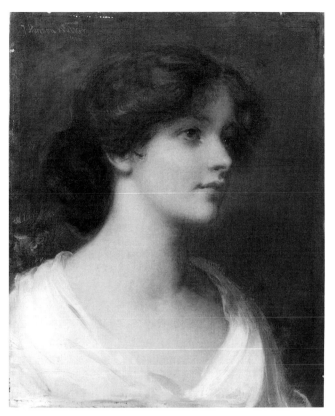

JOHN HANSON WALKER. A girl with red hair. Signed and dated 1906. 17¼ x 13¼ins (43.8 x 33.6cm) *Christie's*

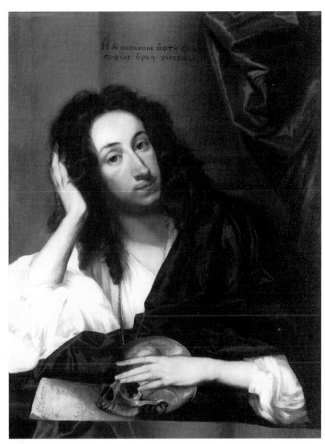

ROBERT WALKER. John Evelyn, the diarist. 34½ x 25¼ins (87.6 x 64.2cm) *Philip Mould/Historical Portraits Ltd*

WALKER, John Rawson **1796-1873**
Born Nottingham. Apprenticed to a lacemaker before setting himself up as an artist in Nottingham. May have received lessons from Thomas Barber. Exhibited at RA (14), RBSA 1817-67 from Nottingham and London. Died Birmingham 27 August 1873.
Represented: Castle Museum, Nottingham.

WALKER, M. Kingston **b.c.1895**
Born Tyneside. Studied at Armstrong College, where she won a scholarship. Served as an ambulance driver in 1st World War and did not resume her studies until 1920, when she became a pupil at Byam Shaw and Vicat Cole Schools of Art. Returned to Newcastle and exhibited at Laing AG, receiving much favourable comment. An exhibition of her work was held at Walker Galleries, London 1936.
Represented: Laing AG, Newcastle. **Literature:** Hall 1982.

WALKER, Robert **c.1599-c.1658**
Settled in London during the 1650s, when he painted portraits often using postures from Van Dyck, and charging £10 for a 50 x 40ins. Became a Painter-Stainer 1650. He was the leading portraitist of the Parliamentary party under Cromwell, whose portrait he painted a number of times. Buckeridge says 'he died a little before the Restoration'. Only occasionally signed his work. Parry Walton was his pupil.
Represented: NPG London; Ashmolean; Duke of Beaufort Collection, Badminton; Milton Park. **Engraved by** A.Bannerman, F.Bartolozzi, E.Bocquet, T.Chambers, J.W.Cook, R.Cooper, P.Drevet, R.Dunkarton, J.Faber, W.Faithorne, R.Gaywood, J.Goldar, C.Grignion, Harding, W.Hollar, F.H. van Hove, J.Houbraken, T.Jenner, J.M.Lerch, P.Lombart, F.Mazot, P.Pelham, B.Picart, F.Place, B.Reading, H.T.Ryall, C.N.Schutz,

E.Scriven, W.P.Sherlock, W.Sherwin, J.Thomson, M. & P. Van Der Gucht, J.Van de Velde, C.Vermeulen, C.Waumans, J.G.Wille, W.H.Worthington. **Literature:** Buckeridge; DNB; DA. Colour Plate 70

WALKER, Samuel **fl.1850-1852**
Exhibited at RA (2), BI (1) 1850-2 from York and London. Among his sitters was 'George Hicks Seymour, Esq, Lord Mayor of York in 1850, in the robes in which he presided at the Royal Exhibition Banquet at York'. May be the Samuel Walker who worked in Brooklyn and exhibited at NA, in New Orleans and in Philadelphia 1860-8.

WALKER, Thomas **fl.1801-1808**
Exhibited at RA (13), BI (3) 1801-8 from London.

WALKER, William **1779-c.1809**
Entered RA Schools 1797. Exhibited at RA (17) 1797-1808 from London. It is unlikely he is the William Walker who exhibited pictures of birds and fish at RA (4) 1782-91.

WALKER, William **1791-1867**
Born Marckton 1 August 1791. Studied in Edinburgh. Went to London 1816. Studied as an engraver with T.Woolnoth and T.Lupton. Returned to Scotland 1819. Married miniaturist Elizabeth Reynolds. Died London 7 September 1867.
Represented: NPG London. **Literature:** McEwan.

WALKER, William **fl.1845-1848**
Listed as a portrait painter in Manchester.

WALKER, William b.1850
Baptized Bath son of Robert Walker and Sarah (née Hanson), and brother of artist John Hanson Walker. Married Annie Laura Saxby.

WALKER, William fl.1861-1880
Exhibited at RA (2), SBA (5) 1861-80 from London.

WALL, William Allen 1801-1885
Born New Bedford, Massachusetts 19 May 1801. Apprenticed to a watchmaker, but took up painting and studied under Thomas Sully. In 1831 he left to study in England, France and Italy. Settled in New Bedford, where he painted portraits and landscapes. Died 6 September 1885.
Literature: *Dictionary of Artists in America.*

WALL, William Coventry 1810-1886
Born England. Moved to Pittsburgh c.1840s with his brother Alfred S.Wall. Died Pittsburgh 19 November 1886.
Literature: *Dictionary of Artists in America.*

WALLACE, Miss Ellen fl.1839-1843
Exhibited at SBA (5) 1839-43 from Carshalton Surrey.

WALLACE, William 1801-1866
Native of Falkirk. Worked in Edinburgh 1820-33 and in Glasgow. Exhibited RSA (1) 1858. Died Glasgow 8 July 1866 aged 65. His art was 'well esteemed'.
Represented: SNPG; Glasgow AG. **Literature:** McEwan.

WALLER, Miss Eliza fl.1828-1838
Exhibited at RA (5) 1828-38 from London and Greenwich.

WALLER, John Green b.c.1814
Born London and listed as aged 67 in 1881 census. Exhibited at RA (5), SBA (1) 1835-48 from London.

WALLER, Mrs Mary Lemon (née Fowler) RP 1851-1931
Born Bideford, daughter of Rev Hugh Fowler. Studied at Gloucester Art School and RA Schools. Exhibited at RA (49), RP, RHA (1), GG 1877-1917 from London. Elected RP 1891. Married artist Samuel Edmund Waller 1874. Among her sitters were Sir William Armstrong and Countess Fitzwilliam. Died 5 March 1931. Specialized in portraits of children.
Represented: NPG London.

WALLER, Richard b.c.1821
Born Yorkshire. Listed in 1871 London census as a portrait painter aged 50. Probably the Richard Waller who died in Leeds 18 June 1882.

WALLIS, Joshua 1798-1862
Exhibited at RA (7) 1809-20 from Peckham and Walworth. Died Walworth. Ruskin admired his work. He sometimes varnished his drawings, and he usually only used the four primary colours.
Represented: VAM.

WALMISLEY, Frederick 1815-1875
Studied under H.P.Briggs and at RA Schools. Exhibited at RA (21), RHA (3), BI (18), SBA (17) 1838-72 from London and Rome.

WALTER, Mrs Busse fl.1885
Exhibited a portrait of 'Miss H.Morton Herbert' at SBA 1885 from an address c/o Captain Scott, East Limes, Putney.

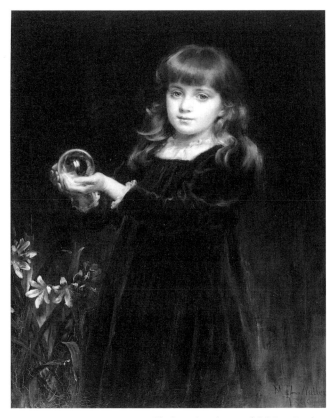

MARY LEMON WALLER. Gladys, daughter of Major Lutley Jordan. Signed and dated 1890. 35½ x 27½ins (90.2 x 69.9cm)
Christie's

WALTER, Henry 1786-1849
Born London. Exhibited at RA (6) 1820-46 from London. He was with Samuel Palmer at Shoreham. Died Torquay 23 April 1849. Fond of pencil and grey wash.
Represented: BM; SNG.

WALTON, Edward Arthur RSA PRSW HRWS HRI RP 1860-1922
Born Glanderstone, Renfrewshire 15 April 1860. Studied in Düsseldorf and at Glasgow School of Art, where he became friends with Guthrie, Crawhall and others of the Glasgow Boys. Exhibited at RA (12), GG, NEAC, RSA (82), RSW 1880-1916. Elected ARSA 1889, RP 1897, RSA 1905, PRWS 1915-22. Lived in London 1894-1904, where he was a friend and neighbour of Whistler. Died Edinburgh 18 March 1922.
Represented: SNPG; Dundee CAG; Hunterian AG, Glasgow; Leeds CAG; Paisley Art Institute; NG Edinburgh. **Literature:** McEwan; DA.

WALTON, George 1855-1891
Born Blenkinsop. Studied at Newcastle School of Art, RA Schools and in Paris. Exhibited at RA (11), RSA, SBA (1), Bewick Club, Newcastle 1882-8. Worked in London, Newcastle, Westmorland and Australia. Settled in Appleby, Westmorland where he died.

WALTON, Henry FSA 1746-1813
Born Dickleburgh, Norfolk 1746 and baptized Tivetshall St Mary 5 June 1747, son of Samuel Walton, a farmer. He had a private income all his life, and did not need to paint for money. Studied under Zoffany c.1769/70, exhibiting conversation pieces and small-scale portraits at SA (9), RA (4) 1771-9. Elected FSA 1771, Director 1772. Married

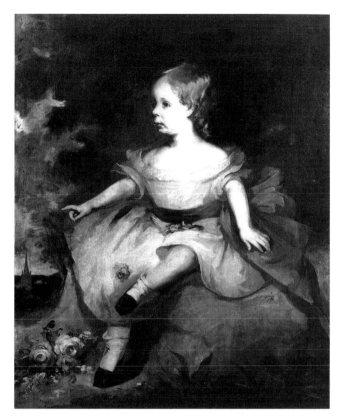

RICHARD WALLER. A girl. Signed and dated 1858. 43 x 33ins (109.2 x 83.8cm) *Christie's*

miniaturist Elizabeth Rust. Made frequent trips to Paris, and was influenced by French domestic genre, in particular the work of Chardin. Renowned in the 1770s for his exceptionally fine and highly finished conversation pieces, which often portrayed sitters out of doors, with careful attention to cast shadows using a soft palette. His later portraits show the influence of Opie and are painted with some bravado. Retired to property at Brome, Suffolk where he continued to paint friends. Died London 19 May 1813 aged 67.
Represented: NPG London; Tate; VAM; Castle Museum, Norwich; Renishaw Hall; Hollin Hall, Yorkshire. **Engraved by** J.Fittler, J.Hopwood, H.Hudson, J.Murray, W.Ridley, J.R.Smith, C.Turner, Miss Turner, J.Walker. **Literature:** *H.W.,* Norwich exh. cat. 1963; Day II pp.254-6.

WALTON, John Whitehead b.c.1817
Born Lee, Kent and baptized 5 January 1817 at St Mary Le Bow, son of John Whitehead Walton and Emilie. Exhibited at RA (18), BI (2), SBA (3) 1834-65 from London. Married Annabella Rush Goode 17 April 1840 at St Pancras. Produced both small- and large-scale portraits. The Prince of Wales (later Edward VII) and Joseph Hume sat for him.
Represented: NPG London; Brighton AG; Stratfield Saye.

WALTON, T. fl.1809
His portrait of James Pilford aged 80 was engraved and published by C.Turner 1809.

WALTON, W. fl.1814-1819
Originally from Leicester. Exhibited portraits of the actors 'Mr Kean' and 'W.Webb' at RA (2) 1814 from London.
Engraved by R.Cooper.

WANSLEE fl.c.1576
A Lambeth portrait painter, who was in the service of the Earl of Lincoln. Recorded in the Losely papers regarding a picture of Queen Elizabeth and portraits of Mr More and his wife.

WARBURG, Miss Blanche fl.1890-1892
Exhibited at SBA (2) 1890-2 from Hampstead.

WARBURTON, Samuel RMS 1874-1939
Born Douglas, Isle of Man 30 March 1874. Exhibited at RA (9), RMS between 1913-31 from Windsor. Died February 1939.

WARD, Alfred fl.1873-c.1923
Exhibited at RA (39), SBA, GG 1873-1915 from London.

WARD, Archibald fl.1910-1935
Studied at RCA (winning prizes). Exhibited RA (3) 1913-35. Worked at Portsmouth Art School. Principal of Gloucester Art School.

WARD, Bernard Evans fl.1879-1906
Exhibited at RA (15), SBA 1879-1906 from Maida Vale and St John's Wood. Collaborated with artist A.Lewis.

WARD, Charles Caleb c.1831-1896
Born St John, New Brunswick, where his grandfather had gone to New York as a loyalist. As a young man he was sent to London to learn the family business, but took to art and studied under William Henry Hunt. Exhibited at NA 1850-72. Settled in New Brunswick 1856, but had a studio in New York 1868-72. Moved to Rothesay 1882, where he died 24 February 1896 aged 65.
Literature: *Dictionary of Artists in America.*

WARD, Charles Daniel ROI b.1872
Born Taunton 19 June 1872, son of Charles Ward. Studied at RCA. Exhibited at RA (46), RI, ROI, RP, Paris Salon 1898-1938 from Chelsea and Blewbury. Elected ROI 1913. The portraitist Charlotte Blakeney Ward was his wife.
Represented: VAM.

WARD, Mrs Charlotte Blakeney PSWA fl.1905-1927
Born Lancashire, daughter of James E. Blakeney. Studied at RCA and in Paris, winning medals. Married artist Charles D.Ward. Exhibited at RA (23), SWA 1905-27 from London. Elected PSWA.

WARD, Edward Matthew RA 1816-1879
Born Pimlico 14 July 1816, son of Charles James Ward, a banker. Studied under John Cawse, RA Schools 1835 and in Rome 1836-9, visiting Cornelius in Munich on the way and studying there under C.Filippo. Returned to London 1839 and won a prize in Westminster Hall Competition 1843. Exhibited at RA (86), BI (16), SBA (11), NWS 1834-77 from London and Windsor. Elected ARA 1846, RA 1855. Among his sitters was Daniel Maclise RA. After 1874 he suffered from nerves, and on 10 January 1879 cut his throat. Died from his injuries at Windsor 15 January 1879. Buried in Upton. Studio sale held Christie's 29 March 1879. His wife, Henrietta, was also a painter and his son was Sir L.Ward.
Represented: NPG London; VAM; BM; Tate; Southampton CAG; Newport AG; SNG; Sheffield AG. **Literature:** *Art Journal* 1855 pp.45-8, 1879 p.72; J.Dafforne, *The Life and Works of E.M.W.,* 1879; Ottley; DNB; E.O'Donnell (ed), *Mrs E.M.Ward's Reminiscences,* 1911; Mrs E.M.Ward, *Memories of Ninety Years,* c.1922.

WARD, Edwin Arthur RP 1860-1933
Born Basford, Nottinghamshire. Studied at Nottingham School of Art. Moved to London aged 19. Exhibited at RA

(30), SBA (10), RHA (2), NWG, GG 1883-1932. Elected RP 1891. Among his sitters were Lord Randolph Churchill and Sir Henry Irving. Went to British Columbia 1895. Died Dorset.
Represented: Castle Museum, Nottingham.

WARD, George fl.1830-1846
Listed as a portrait painter in Leicester.

WARD, George Raphael 1797-1879
Son and pupil of James Ward RA. Entered RA Schools 30 December 1822, and was for a time employed making copies of portraits by Lawrence. Awarded a Silver Medal by SA 1823. Exhibited at RA (40), RHA (1), NWS and SBA (11) 1821-64. Among his sitters were Lord Southampton and the Marchioness of Tavistock. Produced engravings after Lawrence, A.E.Chalon, J.P.Knight and Grant. Married miniaturist Mary Webb c.1827. Died London 18 December 1879.
Literature: *Art Journal* 1880 p.84.

WARD, James **RA** 1769-1859
Born London 23 October 1769, son of a fruit merchant. Studied under mezzotint engraver J.R.Smith and his brother William Ward. Painted rustic scenes in the manner of his brother-in-law George Morland and the occasional portrait, but later specialized in animal painting, histories and romantic landscapes in his distinctive style. Exhibited at SA (2), RA (297), RHA (8), BI (91), SBA (9) 1790-1855. Elected ARA 1807, RA 1811. Died Cheshunt 16 November 1859.
Represented: NPG London; Tate; Canterbury Museums; Yale; SNPG; VAM; Ashmolean; Fitzwilliam; Leeds CAG; Whitworth AG, Manchester; Birmingham CAG; Maidstone Museum; Williamson AG, Birkenhead. **Literature:** *Art Journal* 1849 pp.179-81, 1860 p.9; J.Frankau, *William Ward ARA and J.W.*, 1904; G.E.Fussell, *J.W. RA Animal Painter 1769-1859 and His England*, 1974; C.R.Grundy, *J.W. His Life and Works*, 1909; G.E.Fussell, *J.W.*, 1974; O.Beckett, *The Life and Work of J.W., Forgotten Genius*, 1995; DA.

WARD, James of Kendal 1784-1850
Born Oddendale. Moved to London aged 25, attending RA Schools. Established a successful portrait practice and began to receive commissions from various parts of the country. Exhibited at RA (11), SBA (10), Carlisle Academy 1817-31. A friend of John Jackson and James Northcote. His notes were published as *Conversations of James Northcote RA*, 1901. Married Ann Berry at Natland, near Kendal 1819. Buried in the churchyard of St Lawrence, Crosby Ravenworth.
Represented: Kendal Town Hall. **Literature:** Hall 1979.

WARD, Sir Leslie 'Spy' **RP** 1851-1922
Born London 21 November 1851, eldest son of artist E.M.Ward. Studied architecture under S.Smirke RA, and at RA Schools. He drew caricatures for *Vanity Fair* for many years under the pseudonym of 'Spy' and also illustrated for *The Graphic*. Exhibited at RA (12), GG 1868-1912. Elected RP 1891. Published *Forty Years of Spy* 1915. Died London 15 May 1922.
Represented: NPG London; SNPG; NGI; Walker AG, Liverpool; Trinity College, Oxford. **Literature:** *Country Life* 21 October 1922.

WARD, William **ARA** 1766-1826
Born London, elder brother of James Ward. Exhibited portraits and engravings at RA (30) 1785-1826 from London. Elected ARA 1814. Appointed Mezzotinto Engraver to HRH the Duke of York and Engraver to HRH the Prince Regent. Produced engravings of portraits after W.Owen, T.Phillips, J.Jackson, A.Geddes, H.W.Pickersgill and T.Stewardson. Died London 21 December 1826.
Represented: Fitzwilliam; Manchester CAG. **Literature:** J.Frankau, *W.W. ARA and James Ward*, 1904.

WARMAN, William fl.1820-1841
Exhibited at RA (1) 1826 from London. Listed as a portrait and miniature painter in London.

WARREN, Charles Knighton b.1856
Baptized St Pancras Old Church 15 August 1856, son of Henry and Elizabeth. Exhibited at RA (20), SBA (15) 1876-92 from London. His wife, Gertrude, was also a painter.
Represented: Castle Museum, Nottingham; Sunderland AG.

WARREN, John fl.1764-1779
Born Ireland. Entered Dublin Society's School 1764. Worked in Bath 1777. Exhibited in Dublin (winning premium 1770) and at RA (1) 1768-79. Produced a number of small portraits in crayons.
Represented: RIA.

WARREN, R.W. fl.1827-1830
Exhibited at RA (4), BI (1) 1827-30 from London.

WARRENER, William Tom 1861-1934
Born Lincoln, son of a coal merchant. Studied at Lincoln School of Art, Slade and in Paris (where he became friendly with William Rothenstein and Toulouse-Lautrec). Exhibited at RA (8), SBA (1) and in Paris 1887-97 from Bracebridge, Lincoln. He was the model for Lautrec's poster 'L'Anglais au Moulin Rouge'. His earlier works were academic, but after visiting Paris he was influenced by the Impressionists.

WARRINGTON, Thomas fl.1829-1834
Exhibited at RA (2), BI (4), SBA (1) 1829-31 from London, where he was listed as a portrait painter 1834.

WARSOP, Frederick c.1835-c.1895
Born Nottingham, where he had a successful portrait practice.

WARWICK, Anne Countess of 1829-1903
Daughter of 8th Earl of Wemyss. Married 4th Earl of Warwick 18 February 1852. Exhibited at RA (1), GG (2) 1870 from London.

WATERHOUSE, John William **RA RI** 1849-1917
Born Rome 6 April 1849 and brought up in Italy. Studied at RA Schools from 1871. Exhibited at RA (84), RI, SBA (12), RHA (3), NWS, GG, NWG 1872-1917 from London. Elected RI 1882, ARA 1885, RA 1895. Initially influenced by Alma-Tadema, painting Roman and Greek subjects, but developed a highly personal and accomplished style. Died London 10 February 1917. Studio sale held at Christie's 23 July 1926.
Represented: Tate; Manchester CAG; NG Melbourne. **Literature:** A.Hobson, *The Art and Life of J.W.W.*, 1980; A.Hobson, *J.W.W.*, 1992; DA.

WATERS, William E. Richard 1813-1880
Worked in Paris 1830. Married Mary Cadman in Dover 11 February 1837. Exhibited at RA (8), BI (11), SBA (6) 1838-67 from Dover.

WATERSON, David **RE** 1870-1954
Born Brechin. Studied Edinburgh College of Art, became full-time artist 1890. Exhibited RSA (14), RE (89) 1894-1910. Etched, painted and engraved landscapes and portraits from Brechin, Angus. Died Brechin 12 April 1954.
Represented: SNPG; BM; Brechin Castle. **Literature:** McEwan.

WATLINGTON, Miss fl.1774
Exhibited portrait drawings 'in chalks' and a drawing after Gainsborough at FS (3) 1774 from Ozier Lane, London.

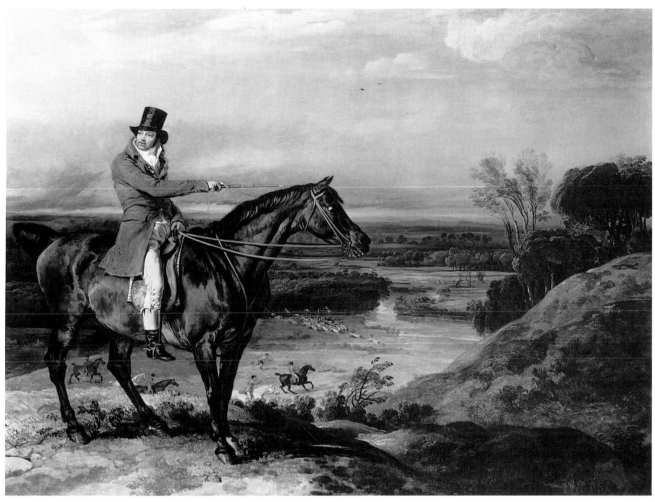

JAMES WARD. John Levett riding in the park at Wychnor, Staffs. Signed and dated 1817 *Richard Green Galleries, London*

WATSON, Miss Caroline **fl.1829-1843**
Exhibited at RA (6), SBA (9) 1829-43 from London.

WATSON, Edward Facon **b.c.1811**
Born Lincoln. Exhibited at SBA (8) 1839-64 from 201 Piccadilly, London. Listed as an artist and picture restorer in 1861 aged 50.

WATSON, George **PRSA** **1767-1837**
Born Overmains, son of John Watson and Frances (née Veitch). Studied under Alexander Nasmyth and worked in Reynolds' studio in London c.1785-7, before returning to Edinburgh, where he established a successful practice. Influenced by Raeburn, developing a smooth style with emphasis on lighting effects and was particularly good at difficult group portraits. President of the short-lived Society of Associated Artists, Edinburgh 1808-12 and first President of RSA 1826-37. Exhibited at RSA (142), RA (21), BI (24) 1808-28. Among his sitters were 'B.West PRA' (now in SNG) and 'Sir Evan Murray Macgregor, Bart, Chief of the Macgregors'. Died Edinburgh 24 August 1837. His son William Smellie Watson, and his nephew Sir John Watson Gordon, were also artists.
Represented: Shipley AG; SNPG; SNG; Kirkcaldy AG; Gateshead; RSA; Government House, Madras; Dalmahoy House. **Engraved by** H.Dawe, T.Hodgetts, C.Turner, J.Young. **Literature:** DNB; McEwan; DA.

WATSON, George Spencer **RA ROI RP** **1869-1934**
Born London 8 March 1869, son of William Spencer Watson. Educated at Merchant Taylor's School. Studied at RA Schools from 1889, winning a Silver Medal and Landseer scholarship. Exhibited at RA (132), ROI, NWG, RP 1891-1934 from London. Elected ROI 1900, RP 1904, ARA 1923, RA 1932. Gained a highly successful society portrait practice. Died London 11 April 1934. A sound draughtsman and brilliant portraitist.
Literature: *G.S.W.*, Southampton CAG exh.cat. 1981/2.

WATSON, John see GORDON, Sir John Watson

WATSON, John **1685-1768**
Born Scotland 28 July 1685. Settled in Perth Amboy, New Jersey by 1714. Produced portraits in New York 1726, in oil and plumbago. Visited Scotland 1730. Died Perth Amboy 22 August 1768.
Literature: *Dictionary of Artists in America.*

WATSON, John Dawson **RWS RBA** **1832-1892**
Born Sedbergh, Yorkshire 20 May 1832. Studied at Manchester School of Design. Entered RA Schools 1851. Exhibited at RA (41), BI (2), SBA (28), OWS (267) 1853-91 from Manchester, Godalming and London. Elected AOWS 1864, OWS 1869, RBA 1882. Influenced by the Pre-Raphaelites, and painted many small pictures of children on panel or board. In 1856 Ford Madox Brown invited him to

exhibit in his house in London. In 1865 he moved to Milford, where he made designs for the furniture of the house of M.Birket Foster, his brother-in-law. Also a prolific illustrator. Died Conway, North Wales 3 January 1892.
Represented: VAM; Castle Museum, Norwich; Manchester CAG; Worcester CAG; Walker AG, Liverpool.

WATSON, Robert c.1754-1783
Reportedly born Newcastle 20 April 1754. Apprenticed to a coach painter at Newcastle. Entered RA Schools 1775. Exhibited at RA (6) 1778. Awarded a Gold Medal by Society for the Encouragement of Arts 1778. Published *An Anticipation of the Exhibition of the Royal Academy*, 1780, which was so well received that he was befriended by Dr Johnson and Reynolds. Obtained an appointment as an engineer to the British Army in India, and arriving there 1783 assisted in the defence of Fort Osnaburgh. Died in the same year aged 28, following an attack of fever.
Literature: Hall 1982.

WATSON, S. fl.1859-1860
Listed as a portraitist at 33 Howe Street, Edinburgh.

WATSON, Samuel 1818-c.1867
Born Cork, elder brother of artist Henry Watson. Settled in Dublin, where he painted portraits and established himself as a lithographer. Drew on stone the leaders of the '48 movement, as well as maps and topographical views. One of the earliest artists to practise chromolithography in Dublin.
Literature: Strickland.

WATSON, Stewart (Stuart) HNA fl.1834-1858
Exhibited at NA from 1834. Elected ANA 1836. Studied in France and Italy 1838-41. Settled in London. Exhibited at RA (4), SBA (3) 1843-7. Elected HNA 1858, when he was residing in Edinburgh.
Literature: *Dictionary of Artists in America.*

WATSON, William d.1765
Brother of artist, James Watson. Worked in Dublin as a history painter and portraitist in oil and crayons. Exhibited at SA of Dublin 1765. A friend of Robert Healy. Pasquin writes that he was 'an eminent performer on the German flute'. Died in his house at College Green, Dublin 7 November 1765.
Represented: NGI. **Literature:** Strickland.

WATSON, William Smellie RSA 1796-1874
Born Edinburgh, son of artist George Watson and Rebecca (née Smellie). Studied at Trustees' Academy and RA Schools 1815-20, where he was advised by Wilkie. Exhibited at RSA (297), RA (5), RHA (3), BI (17) 1812-74 from Edinburgh. Elected a founder RSA. Died Edinburgh 6 November 1874.
Represented: SNPG; BM; Edinburgh AG. **Engraved by** L.Ghemar, J.Horsburgh, C.Thomson. **Literature:** McEwan.

WATT, George Fiddes RSA RP 1873-1960
Born Aberdeen 15 February 1873, son of George Watt. Studied at Gray's School of Art and RSA Schools (winning prizes). Based in Edinburgh and then painted portraits in London for a time before returning to Aberdeen. Exhibited at RSA (99), RA (32), RP from 1897. Elected ARSA 1910, RP 1914, RSA 1924. Died Aberdeen 22 November 1960. Often signed 'Fiddes Watt'.
Represented: SNPG; Lincoln's Inn; Leeds CAG; Middle Temple; Tate; Balliol College, Oxford; Royal Society; Glasgow AG; Aberdeen AG. **Literature:** McEwan.

WATTS, George Frederic OM RA HRCA RP
 1817-1904
Born London 23 February 1817, son of George Watts, a maker of musical instruments. Aged 10 was apprenticed to William

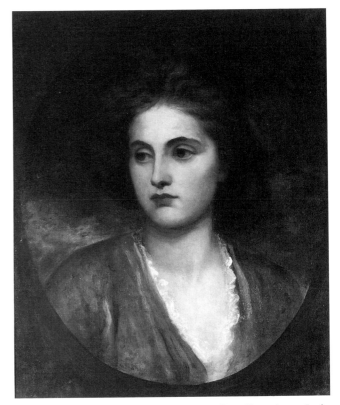

GEORGE FREDERIC WATTS. Emma Branding, later Lady Lilford. Signed. 24 x 20ins (61 x 50.8cm) *Christie's*

Behnes. Entered RA Schools 1835 and won £300 prize in the Westminster Hall Competition 1843. With the money he visited Italy, where he stayed in Florence with his friends Lord and Lady Holland. Returned to London 1847, when his composition 'Alfred' won £500 first prize in the House of Lords Competition. Despite this success he did not attract a great deal of commissions, and further depressed by poor health he became the guest of Mr and Mrs Thoby Prinsep at Little Holland House. Remained there until 1875, when he moved to the Isle of Wight and then back to London. Exhibited at RA (148), BI (6), SBA (10), RHA (8), GG, RP (40), NWG 1837-1904. Elected ARA and RA 1867, RP 1892. In 1864 he had a brief and unsuccessful marriage to the actress Ellen Terry, and it was not until 1886 that he remarried, this time to Mary Fraser Tytler. They built a house, Limnerslease, at Compton, near Guildford, now the Watts Museum. During the 1880s, exhibitions of his work in Manchester, GG and New York established him as a leading Victorian painter. He twice refused a baronetcy, in 1885 and 1894, but finally accepted the Order of Merit 1902. Died Guildford 1 July 1904. His work was variable, but at times reached great heights. V.C.Prinsep RA was his pupil.
Represented: NPG London; SNPG; VAM; NGI; Tate; Holburne Museum, Bath; Government House, Madras.
Engraved by C.W.Campbell, S.Cousins, W.B.Gardner, C.H.Jeens, Jonnard, T.H.Maguire, Monzies, P.Naumann, J.Outrim, J.Stephenson, G.J.Stodart. **Literature:** R.Alston, *The Mind and Work of G.F.W*, 1929; M.S.Watts, *G.F.W. The Annals of An Artist's Life*, 1912; G.F.Watts, *The Hall of Fame*, NPG London exh. cat. 1975; W.Blunt, *England's Michelangelo*, 1975; Maas; DA.
Colour Plate 71

WATTS, H.H. fl.1818-1841
Exhibited at RA (5), BI (8), SBA (15) 1818-41 from Oxford and London.

J. WATTS. Jeremy Bentham. 26 x 19½ins (66 x 49.5cm)
Christie's

SAMUEL BELL WAUGH. Thomas L. Stayner. Signed, inscribed
'Montreal' and dated 1845. 30 x 25ins (76.2 x 63.5cm)
Christie's

WATTS, J. fl.c.1830
His portrait of Jeremy Bentham was engraved by
J.Posselwhite for C.Knight's Portrait Gallery, 1837.

WATTS, Leonard T. RBA 1871-1951
Studied at St John's Wood School and RA Schools. Exhibited
at RA (19), SBA 1893-1927 from London, Keynes, Lewes,
Eastbourne, Wadhurst and Worthing. Elected RBA 1893.
Among his sitters were Thomas Brock RA and Sir John
Hutton.

WATTS, William fl.1821-1825
Exhibited at RA (3), BI (4) 1821-5 from Hampstead.

WAUGH, Alfred S. d.1856
Native of Ireland. Studied modelling in Dublin 1827, then
toured the Continent. In Baltimore 1833, Alabama 1842,
Pensacola 1843, Mobile 1844. Visited Missouri 1845 with
John B.Tisdale. In 1846 he was in Santa Fé, finally settling in
St Louis 1848. Died St Louis 18 March 1856.
Literature: McDermott (ed), *Travels in Search of the
Elephant: The Wanderings of A.S.W., Artist in Louisiana,
Missouri and Santa Fé in 1845-46.*

WAUGH, Miss Elizabeth J. fl.1879-1885
Exhibited at RA (1), SM, SBA (1) 1879-85 from Regent's
Park and Fulflood, Winchester, including a portrait of 'The
Late Earl of Stamford and Warrington'.

WAUGH, Samuel Bell HNA 1814-1885
Native of Mercer. Spent eight years in Italy before 1841.
Settled in Philadelphia, although worked in New York 1844-5

and Bordentown 1853. Exhibited at RA (2), BI (1) 1841-6
from London and Philadelphia. Elected ANA 1845, HNA
1847. Married miniaturist Mary Eliza Young. Also worked in
Canada. Died Janesville 1885.
Represented: University of Penna. **Literature:** *Dictionary of
Artists in America.*

WAY, Mrs Emily C. fl.1886-1896
Exhibited portraits of the Countess of Sandwich, the
Countess of Abingdon and 'The Late Archbishop of Armagh,
Lord Primate of Ireland' at RA (9), RHA (1) 1886-96 from
London. Married John L.Way.
Represented: Preston Manor, Brighton.

WAY, Miss Frances Elizabeth (Fanny) 1871-1961
Born Clerkenwell 28 March 1871, daughter of William
Dwyer Way and Esther (née Langmead). Educated privately
and studied at Crystal Palace School of Art c.1886, where she
won medals. Spent a year at Lausanne School of Art run by
Monsieur des Molins and her uncle C.J.Way. Exhibited
mostly miniatures at RA (23), RSM, SM, RP 1893-1921.
Married Arthur Thacker c.1895. Her sitters included the
Duke and Duchess of York, Mrs Langtry and Lord Roberts.

WAY, Mrs Heriott (née Hamilton) fl.1826-1827
Exhibited at RHA (4) 1826-7 from Dublin.

WAYLEN, James fl.1834-1841
Exhibited at RA (3) 1834-8 from London. Listed as a
portrait painter in London 1841.

WEAR, Miss Maud Marian b.1873
Born London 8 December 1873, daughter of Frederick
Erasmus Wear, a journalist. Studied at RA Schools 1896-
1901. Exhibited at RA (45), NEAC, Paris Salon 1900-49
from London, Sussex, Kent and Gloucestershire.

WEAVER, M. fl.1766-1767
A portraitist who is recorded working in Ireland from Bath 1766-7. Among his sitters were the Countess of Lauderdale, the Countess of Orrery and Lord Dungarvan. Working in Kilkenny at the end of 1767.

WEBB, C.M. fl.1829
Exhibited at SBA (1) 1829 from Oxford Street, London.

WEBB, George Alfred John b.1861
Born Kent. Moved to Australia 1886, where he established a successful portrait practice painting the leading citizens of Victoria and South Australia.
Represented: NG South Australia.

WEBB, Joseph fl.1826-1827
Listed as a portrait painter in Spitalfields, London.

WEBB, Miss Josephine fl.1880-1921
Exhibited at RHA (30) 1880-1921 from Dublin.

WEBB, Miss Louisa fl.1833
Exhibited at RHA (2) 1833 from Dublin.

WEBB, Westfield FSA fl.1761-1772
Exhibited at SA (12) 1762-72. Elected FSA 1770. Listed as a portrait painter at Mr Turner's, Surgeon in St Martin's Lane 1763. Perhaps the 'Mr Webb' who painted a ceiling at Ragley 1761 (now destroyed).

WEBBER, John RA c.1751-1793
Born London 6 October 1750, 1751 or 1752, son of Swiss sculptor Abraham Webber and Mary (née Quandt). At six he was brought up by a maiden aunt in Berne. Aged 13 was placed under Swiss artist J.L.Aberli. Trained in Paris under J.G.Wille about 1770-5. Entered RA Schools 8 April 1775. From 1776-80 he was draughtsman on Captain Cook's last voyage, witnessed Cook's death and superintended the engraving of his drawings for the Admiralty. Exhibited at RA (49) 1776-92. Elected ARA 1785, RA 1791. His posthumous portrait of Captain Cook (1782) is at Trinity House, Hull. Died London 5 or 29 April 1793.
Represented: NPG London; BM; VAM; Derby AG; NGI; NMM. **Engraved by** F.Bartolozzi, W.Byrne, B.T.Pouncy, W.Woollett. **Literature:** DNB; *Apollo*, LVI 1952 pp.84-6; DA.

WEBER, Otto RHA ARWS 1832-1888
Born Berlin 17 October 1832, son of Wilhelm Weber, a merchant. Studied under Professor Steffeck and possibly under Kruger. Worked in Paris (where he had some lessons from T.Couture) and Rome. Exhibited frequently at Paris Salon, where he won medals 1864 and 1869. Settled in London 1872. Exhibited at RA (27), RHA (9), OWS, GG 1874-88. Among his sitters was 'HH Prince Christian Victor, Eldest Son of TRH the Prince and Princess Christian of Schleswig-Holstein'. Also painted for Queen Victoria. Died London 23 December 1888. Studio sale held Christie's 20 May 1889.
Represented: VAM.

WEBER, Paul 1823-1916
Born Darmstadt, Germany. Studied in Frankfurt. Moved to America 1848 and settled in Philadelphia. Exhibited at Pennsylvania Academy from 1849. Toured Scotland 1857. Returned to Darmstadt 1860, where he was appointed Court Painter. Later went back to America, where he died in Philadelphia.
Represented: Corcoran Gallery.

WEBSTER, Joseph Samuel d.1796
Believed to have been a pupil of Hudson. Exhibited at SA, FS 1762-3. Painted portraits to a high standard in the style of

Hudson and sometimes signed 'S.Webster' or 'J.S.Webster'. He was asked to paint Archbishop Hering 1757 after the failure of Hogarth to please his sitter. Some of his portraits were reproduced as mezzotints. Died London 6 July 1796.
Represented: Lambeth Palace.

WEBSTER, R. fl.1816-1818
Exhibited at RA (2) 1816-18 from Pimlico.

WEBSTER, Samuel fl.1855
Listed as a portraitist in Liverpool 1855.

WEBSTER, Simon FSA fl.1762-1780
Exhibited at SA (16), FS (1) 1762-80 from London. Elected FSA 1771. Granted money by SA 1769 for losses he suffered in a fire.
Engraved by J.McArdell, J.Watson.

WEBSTER, Thomas RA 1800-1886
Born Pimlico 20 March 1800, son of a musician of George III's household. As a boy he sang in the Chapel Royal Choir, but after the death of George III turned to painting. Following an introduction from Fuseli, he entered RA Schools 1821 (Gold Medallist 1825). At first he painted portraits, but after the success at BI of 'Rebels Shooting a Prisoner' 1827 (a picture of boys firing a cannon at a girl's doll) he concentrated on genre, often with a comical content. Exhibited at RA (83), BI (39), SBA (8) 1823-79. Elected ARA 1840, RA 1846. Moved to Cranbrook, Kent, 1856, where he remained for the rest of his life, and was the leading light of the Cranbrook Colony. Died Cranbrook 23 September 1886. Studio sale held Christie's 21 May 1887. Also popular through engravings.
Represented: VAM; Birmingham CAG; Guildhall AG, London; Tate; Towner AG, Eastbourne; Bury AG. **Literature:** DA.

WEBSTER, Walter Ernest RI ROI RP 1878-1959
Born Manchester. Studied at South Kensington and RA Schools. Exhibited at RA (67), RP, ROI, RI, Paris Salon (winning medals) 1904-59 from London. Elected RP 1921. Died 30 April 1959.

WEESOP (WESEP) fl.1641-1649
Came to England 1641 and reportedly left in 1649 after the beheading of Charles I. Vertue commented that 'many pictures painted by him pass for Vandyke'. A John Weesop is reported in the registers of St Martin-in-the-Fields as having died in 1652.

WEHRSCHMIDT, Daniel Albert
 see VERESMITH, Daniel Albert

WEIGALL, Arthur Howes b.c.1836
Born Hammersmith, son of artist Charles Henry Weigall and Catherine (née Williams). Exhibited at RA (16), BI (7), SBA (1) 1856-91 from London.
Represented: Salford AG.

WEIGALL, Charles Harvey 1794-1877
Baptized St Pancras Old Church 10 July 1794. Exhibited at RA (13), SBA (2), RHA (4), NWS (400+) 1810-76. Elected NWS 1834, Treasurer 1839-41. Also modelled in wax, made intaglio gems and wrote books on drawing. Died London 11 March 1877. His children Arthur, Julia and Emily were also painters.
Represented: BM; NG London; VAM; NGI; SNG; National Library of Wales.

WEIGALL, Henry 1831-1925
According to Burke's Peerage he was born 5 August 1831, son of sculptor Henry Weigall and Selina (née Smith), although other sources state 1829. Exhibited at RA (152),

RHA (7), BI, GG, NWG 1846-1914. Painted the Duke of Wellington and several of the royal family, enjoying a highly successful society portrait practice. Married Lady Rose Fane, daughter of 11th Earl of Westmorland 1866. Died St Lawrence, Kent 4 January 1925. Left effects of £39,280.15s.6d. His sitters' book is at Kent County Record Office with a copy at NPG London.
Represented: NPG London; Leith Hall, NT; Cortachy Castle; Merton Hall, Oxford. **Engraved by** S.Cousins, W.H.Mote.

WEINS see WIENS, Stephen M.

WELDON, Miss Harriet **fl.1903-1910**
Exhibited at RHA (10) 1903-10 from Naas and Dublin.

WELLINGS, William **b.1763**
Baptized 10 December 1763 at Aldgate and again on 28 December at the Presbyterian Church, son of William and Eleanor Wellings. Exhibited a portrait of 'Mr Kemble and Mrs Siddons as Cromwell and Queen Catherine – Henry VIII Act 4 Scene 4' and a portrait of a lady of quality at RA (2) 1793 from Covent Garden. Worked mostly as a silhouettist.
Represented: VAM; Colchester Museum.

WELLS, Edward Francis **1876-1952**
Born Calcutta 3 April 1876, son of William Howley Wells, engineer and Annie Maria née Ring. Exhibited at RA (8), RHA (3) 1905-41 from London. Among his sitters were Sir George Beaumont, Sir Bernard Mallet and Sir William Gavin. Married firstly Ann Pellew; secondly Katherine Stather Dunn 18 September 1935. Died St Georges Hospital, London 19 August 1952. Buried St Osmond's, Evesham, Dorset.
Literature: A.H.Hull, *E.F.W.– His Art, Life & Times*, 1990.

WELLS, George RCA **b.c.1821**
Born Middlesex, aged 30 in 1851 census. Exhibited at RA (39), BI (18), RHA (2), SBA (62), NWS 1842-88 from Hornsey, London and Bristol.

WELLS, Henry Tanworth RA **1828-1903**
Born London 12 December 1828, son of Henry Tanworth Wells, a merchant and Charlotte (née Henman). Apprenticed to Messrs Dickinson as a lithographic draughtsman before studying in London under J.M.Leigh and in Paris under Couture. A member of a society that met in Clipstone Street for drawing and criticism, which included D.G.Rossetti, C.Keene, G.P.Boyce and the Dalziel brothers. Began as a successful miniaturist, but took up oil portraits c.1860/1, largely because of the fear of declining eyesight and the falling demand for miniatures with the development of photography. An associate of P.H.Calderon in the St John's Wood Clique. Exhibited at RA (287), BI (1), RHA (1), SBA (2) 1846-1903. Elected ARA 1866, RA 1870. Among his sitters were 'HRH the Princess Mary of Cambridge. Painted for Her Majesty', Earl Spencer KG, the Duke of Devonshire KG, C.W.Cope RA, Thomas Browning and Frederic Leighton. Married artist Joanna Mary Boyce in Rome 9 December 1857. Succeeded G.Richmond as limner to Grillion's Club 1870. Died Kensington 16 January 1903. Buried Kensal Green Cemetery.
Represented: NPG London; HMQ; NGI; Wilton; Tate; Locko Park; Raby Castle. **Engraved by** J.Brown, S.Cousins, G.Holl, W.Roffe, C.W.Sherborn, J.Stodart. **Literature:** DNB; Maas.

WELLS, Joanna Mary (née Boyce) **1831-1861**
Born London 7 December 1831. Studied at Cary's Academy, Leigh's Academy 1852 and academies in Paris under Couture from 1855. Exhibited at RA (3) 1855-62. Inspired by Ruskin and the Pre-Raphaelites. Her work attracted the praise of Ruskin, Madox Brown, G.F.Watts and Rossetti. Married H.T.Wells in Rome 9 December 1857. Died London 15 July 1861, aged 29, following the birth of her second child.
Represented: Tate. **Literature:** *Critic* 27 July 1861; *Paintings by J.M.B.*, Tate exh. cat. 1935; J.Marsh, *Pre-Raphaelite Sisterhood*, 1985; DA.

WELSH, Ephraim **b.1749**
Entered RA Schools 1770 aged 21. Exhibited at SA (1) 1771 from London.

WENTWORTH, Thomas Hanford **1781-1849**
Born Norwalk, USA 15 March 1781. Visited England 1805. Returned to America 1806 and settled at Oswego, where he was based for the rest of his life. Visited Connecticut and New York as an itinerant portraitist. Died Oswego 18 December 1849.
Literature: *A Dictionary of Artists in America.*

WERNER, Joseph **1637-c.1710**
Baptized Berne 22 July 1637. Studied in Frankfurt under Merian, and under Berrettini and others in Rome. Worked at the French Court and reportedly visited England. Left Berlin 1707 to return to Berne, where he died.
Represented: VAM; Musée des Beaux-Arts, Berne, Versailles. **Literature:** Bénézit; J.Glaesemer, *J.W.*, 1974; DA.

WERNER, Louis **1824-1901**
Born Bernweler 4 June 1824. Studied in Strasbourg and Paris. Exhibited at RHA (12) 1860-99 from Dublin. Took to photography because of failing health. Died Dublin 12 December 1901.
Represented: NGI; Musée d'Altkirch.

WERNER, S. **fl.1860**
Exhibited at RHA (2) 1860 from Dublin.

WEST, Benjamin PRA **1738-1820**
Born near Springfield (now Swarthmore), Pennsylvania 10 October 1738, son of John West and Sarah (née Pearson). Received his first instruction from a Cherokee, and obtained from him his first colours – the red and yellow used by the Indians (which had an influence on his later palette). Possibly a pupil of William Williams of Bristol in Philadelphia. Aged 18 he set himself up as a portrait painter. Local subscribers sent him to Italy 1760-3 where he received instruction from Mengs and Gavin Hamilton and acquired a taste for painting large scale histories. Settled in London as a portrait painter 1763. Exhibited mainly histories at SA (24), RA (251), BI (32) 1764-1820. Became George III's favourite painter. Elected a founder RA, succeeded Reynolds as President 1792. Died London 10/11 March 1820. Buried in St Paul's Cathedral. One of the most important American artists of the 18th century. Among his many pupils were J.Trumbull, Charles Wilson Peale, John Singleton Copley, R.Earl, T.Phillips, A.Delanoy, J.Downman, Josiah Boydell, Archibald Robertson, T.S.Duché, W.Dunlap and S.F.B.Morse. His sons, Raphael and Benjamin, probably helped in his studio.
Represented: NPG London; SNPG; Tate; VAM; NGI; Dulwich AG; Cleveland Museum; Brighton AG; Boston MFA; Yale; Oberlin University; Chrysler Museum, Norfolk, Virginia; huge religious paintings, intended for a chapel at Windsor Castle, at Bob Jones University, South Carolina. **Engraved by** W.Angus, J.Caldwall, W.Day, W.Dickinson, R.Earlom, G. & J. Facius, T.Falckhuysen, E.Fisher, S.Freeman, W.Fry, A.Le Grand, Grant & Bonnefoy, V.Green, C.Guttenberg, C. & J.Heath, T.Holloway, J.Hopwood, C.Josi, W.J.Linton, D.Pariset, S.Phillips, V.M.Picot, Roffe, Sendemoff, W.Sharp, J.R.Smith, R.Strange, J.Watson, W.Woollett, J.Young. **Literature:** J.Galt, *Life Studies and Works of B.W.*, 1820; G.Evans, *B.W. and the Taste of His Time*, 1959; J.Dillenberger, *B.W. – the Context of His*

Life's Work, San Antonio, Texas 1977; *B.W. and His American Students,* NG Washington exh. cat. 1980; H.von Erffa & A.Stanley, *The Paintings of B.W.,* 1986; DNB; DA.
Colour Plate 72

WEST, C. **fl.1821**
Exhibited at RA (1) 1821 from Portsea, Hampshire.

WEST, John **fl.1841**
Listed as a portrait painter in Lincoln.

WEST, Miss M.P. **fl.1837-1839**
Exhibited at RA (1), SBA (2) 1837-9 from London. Among her sitters was the son of marine artist George Chambers.

WEST, Robert **d.1770**
Son of a Waterford alderman. Visited France and studied under Van Loo (presumably Charles) and Boucher. Founded an art school in St George's Lane, Dublin early in the 1740s. This became the Dublin Society's Schools in the mid-1740s and was Ireland's principal school of design. Pasquin says: 'He principally excelled in his drawing of the human figure in chalk and crayons'. Also produced conversation pieces. Became mentally deranged 1763, but recovered and retained his post until his death. Died Dublin. Among his many pupils were Hugh Douglas Hamilton, Matthew William Peters and Robert Healy.
Represented: Upton House, NT.

WEST, Robert Francis **c.1749-1809**
Son of Robert West. Studied in Paris under Van Loo. Succeeded his father as master of Dublin Academy 1770. Died Dublin 24 January 1809. Martin Archer Shee was his pupil.

WEST, Robert Lucius RHA **c.1774-1850**
Son, pupil and assistant of R.F.West. Won medals in Dublin Society's Schools 1795 and 1796. Worked in London 1808. After the death of his brother, Robert Francis, he succeeded as master of the Dublin Academy 1809. Exhibited at RHA (87) 1826-1849 from Dublin. Elected founder RHA 1823. Died Dublin 3 June 1850. Buried at Mount Jerome, where a monument was erected to his memory. A Robert Lucius West exhibited at FS (3) 1771-83 and RA (9) 1779-1822 from London and Dublin and is likely to have been a relation.
Represented: NGI. **Literature:** DNB; Strickland.

WEST, Samuel **c.1810-c.1867**
Born Cork, son of William West, a bookseller and antiquary. Studied in Rome. Lithographed a portrait of his father for his father's book *Fifty Years' Recollections of an Old Bookseller,* 1830. Moved to London by 1840. Exhibited at RA (23), BI (7), SBA (1), RHA (3) 1840-67. Also worked in Scotland. Simon describes him as a 'polished society portraitist'.
Represented: BM; Kimmerghame House. **Engraved by** W.O.Geller. **Literature:** Strickland.

WEST, William Edward **1788-1857**
Born Lexington, Kentucky. Studied under Sully in Philadelphia about 1807. Worked in Natchez, Mississippi 1818, Italy 1819 (where he painted Byron and Shelley), Paris 1824 and London 1825-38. Exhibited at RA (18), BI (12), SBA (7) 1826-37 from London. Returned to Baltimore, Maryland, New York 1841-55. Died Nashville.
Represented: SNPG; Felbrigg Hall, NT; Vaughan Library, Harrow School. **Engraved by** T.A.Dean, F.Engleheart, W.Holl, E.Scriven, C.Turner, J.T.Wedgwood.

WESTALL, Richard RA **c.1765-1836**
Reportedly born Hertford 2 January 1766, but this may be his baptism as other sources list his birth as 1765. Apprenticed to a silver engraver 1779-84. Entered RA

Schools 16 December 1785. Began with chalk portraits and soon specialized in subject pieces in watercolour and oils. Painted pictures for Boydell's Shakespeare Gallery and for Bowyer and Macklin's Historic and Poetic Galleries. Exhibited at RA (313), RHA (2), BI (70) 1784-1836. Elected ARA 1792, RA 1794. Appointed Principal Painter to their Royal Highnesses the Duchess of Kent and the Princess Victoria. Died London 4 December 1836. Could be a remarkably sensitive painter, with a subtle and skilful use of colour. In his lifetime he was considerably influential, but his work fell into neglect and he has been much underrated.
Represented: NPG London; BM; VAM; Tate; Ashmolean; Coventry AG; Brighton AG; Fitzwilliam; Wallace Collection; Leeds CAG; Leicester AG; Manchester CAG; SNG; Castle Museum, Nottingham; Lady Lever AG, Port Sunlight. **Engraved by** Agar, Cardon, E.Finden, T.Gaugain, R.M.Meadows, R.Mitchell, P.Naumann, J.Osborne, J.Parker, G.H.Phillips, T.Ryder, Schiavonetti, C.Turner. **Literature:** DNB; DA.

WESTBROOK, Miss Elizabeth T. **fl.1861-1880**
Exhibited at RA (6), SBA (14) 1861-80 from Pimlico and Chiswick.

WESTCOTT, Philip **1815-1878**
After being orphaned he was apprenticed to Thomas Griffith, a Liverpool picture restorer and miniaturist. Established a successful portrait practice in Liverpool from the late 1830s, then tried London 1854/5, but moved to Manchester 1862. Had many distinguished sitters including Gladstone and Archdeacon Brooks. Exhibited at LA, RA (25), BI (2), SBA (4), RMI 1837-61. Elected ALA 1843, LA 1847, Treasurer 1847-53. Died Manchester 5 or 10 January 1878. His paintings could be highly accomplished and often dramatic.
Represented: Manchester CAG; Walker AG, Liverpool. **Engraved by** T.O.Barlow. **Literature:** *Art Journal* 1878 p.124.

WESTERN, Henry **b.1877**
Born London 10 October 1877, son of Richard Western, a butcher. Exhibited at RA (2), Paris Salon 1918-25 from London.

WET, Jacob de **1640-1697**
Born Haarlem, son of a painter. Brought to Scotland c.1673 by Sir William Bruce to work at Holyrood House. Employed by Bruce at his own house at Balcaskie 1674 and a year or two later at Kellie Castle, also in Fife. Member of Painters' Corporation of Cologne September 1677. Returned to Scotland by 26 February 1684 when he was 'His majesties pictur drawer in Scotland', signing a two year contract to paint the series of Kings for Holyrood House at an annual salary of £120. Worked for Duke of Hamilton 1685. In January 1688 signed a contract to paint a large number of works for the Earl of Strathmore at Glamis. Returned to Haarlem 1691. Died in Amsterdam 11 November 1697.
Literature: R.A.Guilding, 'The de Wet Apostle Paintings in the Chapel at Glamis Castle', *Proceedings of the Society of Antiquaries of Scotland,* Vol 116, 1986; P.Haverkorn van Rijswijk, de Schilder 'Jacob de Wet in Schotland', *Oud Holland* XVII 1899.

WETHERILL, Arthur **fl.1773-1783**
Exhibited miniatures and small portraits at SA (1), RA (1) 1773-83 from London. Among his sitters was the Earl of Orford.

WETHERILL, Mrs Arthur **fl.1773-1783**
Exhibited at SA (5), FS (1) 1773-83. Married to miniaturist Arthur Wetherill.

WHAITE, John **fl.1825-1845**
Listed as a portrait painter in Manchester. Originally painted flags, banners and transparencies for ceremonies.

WHALE, Robert R. 1805-1887
Born Alternum, Cornwall 13 March 1805. Studied art in London. Moved to Canada settling in Brantford, Ontario 1864, where he set up a portrait practice. Died 8 July 1887.
Literature: N.MacTavish, *The Fine Arts in Canada*, 1925; A.H.Robson, *Canadian Landscape Painters*, 1938.

WHATLEY, Henry 1842-1901
Born Bristol. Exhibited at NWS from Clifton, Bristol. Taught as a drawing master in Bristol, including the Clergy Daughters' School. Travelled widely and produced drawings for *The Illustrated London News*. Died Clifton.
Represented: Bristol CAG.

WHEATLEY, Francis RA FSA 1747-1801
Born London, son of a Covent Garden master tailor. Worked under Daniel Fournier. Studied under William Shipley at Shipley's Academy. Won prizes for drawing at SA 1762/3. Travelled abroad 1763, probably to the Low Countries and to Paris. Entered RA Schools 1769, and also learnt much from collaborating with J.H.Mortimer, painting the salon ceiling at Brocket Hall 1771-3. Wheatley imitated Mortimer's formulas for the informal conversation pieces – small scale, middle-class in the tradition of F.Hayman and J.Zoffany. Exhibited at SA (45), FS (1), RA (87) 1765-1801. Elected FSA 1771, SA Director 1774, ARA 1790, RA 1791. Eloped to Dublin with the wife of J.A.Gresse between 1779 and 1783 to escape creditors and enjoyed success as a portraitist, painting 'The Irish House of Commons' (1780, Lotherton Hall, Leeds). He was discovered and forced to return to London 1783, where he occupied himself working for printsellers producing genre scenes in the Morland tradition. His 'Cries of London', 1793-5, were enormously popular as engravings. Married artist Clara Maria Leigh. In the 1790s he was troubled by gout and his last oils were produced 1799. Died crippled and in debt London 28 June 1801 (Farington's Diary). Buried in the parish of St Marylebone. Ellis Waterhouse wrote: 'He was a neat portraitist, with clear and attractive colour, and his genre scenes suited the middle-class taste to perfection'.
Represented: NPG London; Yale; NGI; Tate; Detroit Institute; Fitzwilliam; Leeds CAG; VAM; SNG; Castle Museum Nottingham; Brighton AG; Southampton CAG; Ashmolean; Newport AG; Philadelphia MA; Aberdeen AG; Waddesdon NT; Manchester CAG. **Engraved by** F.Bartolozzi, J.Heath, H.Kingsbury, W.Sherwin, J.R.Smith, R.Stanier, J.Walker. **Literature:** W.Roberts, *The Cries of London*, 1924; F.G.Roe, *Sketch Portrait of F.W.*, 1938; M.Webster, *F.W.*, Leeds CAG exh. cat. 1965; M.Webster, *F.W.*, 1970; DNB; Strickland; DA.

WHEATLEY, John Laviers ARA RWS NEAC
 1892-1955
Born Abergavenny 23 January 1892, only son of Sir Zachariah Wheatley. Studied under Stanhope Forbes, Walter Sickert and Slade 1912-13. Married artist Grace Wolfe 1912. Exhibited at RA (75), RWS, NEAC 1914-56 from Penzance, London and Sheffield. Elected NEAC 1917, Official War Artist 1918, ARWS 1943, ARA 1945, RWS 1947. Went to South Africa with his wife, where he was Director of NG South Africa. Returned 1937. Appointed Director of City AGs, Sheffield 1938-47 and Curator of NG of British Sports and Pastimes 1948-50. Died London 17 November 1955.
Represented: NPG London; Brighton AG.

WHEELER, John Alfred 1821-1877
Served in Army, but left to take up painting sporting subjects and equestrian portraits. Lived in Bath 1857-77. Exhibited at SBA (1) 1875.

FRANCIS WHEATLEY. A naval officer. 30 x 25ins (76.2 x 63.5 cm) *Christie's*

WHEELER, Thomas fl.1826-1834
Listed as a portrait and miniature painter in Fleet Street, London.

WHEELWRIGHT, John Hadwen fl.1834-1849
Exhibited at RA (12), RHA (2), BI (6), SBA (7) 1834-49 from London and Great Stanmore. Travelled in Italy making watercolour copies of old masters.
Represented: NG Dublin.

WHELAN, Michael Leo RHA 1892-c.1956
Born Dublin 10 January 1892, son of Maurice Whelan. Educated at Belvedere College. Studied under W.Orpen and Metropolitan School of Art (winning prizes). Exhibited at RHA (255), RA (3) 1911-57. Elected ARHA 1920, RHA 1923. Usually signed work 'Leo Whelan'.
Represented: NGI.

WHISTLER, James Abbott McNeill PRBA
 1834-1903
Born Lowell, Massachusetts 11 July 1834, son of a railway engineer. As a boy he lived in Russia and England. Entered West Point Military Academy 1851-4, training as a draughtsman. Worked as a cartographer in the Navy, where he learnt etching techniques. Studied in Europe 1855; briefly with Gleyre in Paris 1856. Met Degas and Fantin-Latour and was influenced by Courbet and Velázquez. Moved to London 1859, and became friends with Rossetti and Harry and Walter Greaves. From the 1860s he was strongly influenced by Japanese prints, and in the 1870s developed a highly personal portrait style in which aesthetic considerations were paramount. During this period he produced some of his finest portraits such as Carlyle, Mrs Leyland and 'Portrait of the Artist's Mother'. In 1877 Ruskin's criticism of 'Nocturne in Black and Gold – The Falling Rocket' led to the famous libel

JAMES ABBOTT McNEILL WHISTLER. Arrangement in grey and green – Portrait of J.J.Cowan. 37 x 19¾ins (94 x 50.2cm)
National Gallery of Scotland

M.Menpes, *W. as I Knew Him*, 1904; H.W.Singer, *J.M.W.*, 1904; E.R. & J.Pennell, *The Life of J.M.W.*, 2 vols, 1908; T.M.Wood, *W.*, 1909; T.R.Way, *Memories of J.M.W. The Artist*, 1912; M.Hardie, *Catalogue of Works by J.M.W.*, with bibliography, 1921; J.Laver, *W.*, 1930, 1950; J.Laver, *Paintings by W.*, 1938; J.Laver, *W.*, 1942; H.Pearson, *The Man W.*, 1952; H.Gregory, *The World of J.M.W.*, 1961; D.Sutton, *Nocturne*, 1963; D.Sutton, *J.M.W.*, 1966; M.Levy, *Whistler Lithographs – A Catalogue Raisonné*, 1975; R.McMullen, *Victorian Outsider*, 1973; S.Weintraub, *W.*, 1974; H.Taylor, *J.M.W.*, 1978; A.Mcl.Young, M.MacDonald, R.Spencer, with the assistance of Hamish Miles, *The Paintings of J.M.W.*, 2 vols 1980; DNB; Tate exh.cat.1994; DA.

WHITAKER, William fl.1841
Listed as a portrait painter in Wakefield, Yorkshire.
Engraved by M.Gauci.

WHITBY, William fl.1772-1791
Exhibited at SA (8), RA (5) 1772-91 from London. His portrait of boxer Richard Humphries was reproduced as an engraving, which he published himself.
Engraved by J.Godby, J.Jehner.

WHITE, A. fl.1817
Exhibited at RA (1) 1817 from 3 Foundling Terrace, Gray's Inn Road, London.

WHITE, Daniel Thomas fl.1861-1890
Exhibited at RA (15), BI (1), SBA (9), GG 1861-90 from London and Paris.

WHITE, Edward Richard fl.1864-1912
Exhibited at RA (21), SBA (12), NWS 1864-1912 from London. Also recorded as Edmund Richard White in catalogues.

WHITE, George c.1684-1732
Son of engraver Robert White, in whose profession he followed. One of the most accomplished mezzotint engravers in England. Produced portraits in pencil-on-vellum, crayons and oils. Died Bloomsbury 27 May 1732.
Represented: NPG London; BM. **Engraved by** A.Miller.
Literature: DNB.

WHITE, George Harlow 1817-c.1888
Born London. Exhibited at RA (24), BI (17), SBA (42) 1839-83. Went to live in Canada 1871, where he painted scenes of early Canadian pioneers. Moved to Toronto 1876, remaining there until c.1880, when he returned to England.
Represented: NPG London.

WHITE, H. fl.1839-1843
Exhibited at RA (2) 1839-43 from the Cloisters, Charterhouse, the same address as George Harlow White.

WHITE, Henry Hopley b.c.1791
Born London. An honorary exhibitor at RA (18), SBA (3) 1805-67 from London. Worked as a barrister and QC. Aged 80 in 1871 census

WHITE, John RI ROI RBA 1851-1933
Born Edinburgh 18 or 19 September 1851, son of Peter White a master plumber. Emigrated with his parents to Australia 1856, being educated at Dr Brunton's School, Melbourne. Returned to enter RSA Schools 1871 (winning the Keith Prize 1875). Travelled South 1877. Exhibited at RA (45), RSA (37), ROI, SBA (47+), NWS, GG 1877-1908. Elected RBA 1881, RI 1882, ROI 1887. Retired 1931 and lived at Beer, Devon. Died there 21 December 1933.
Represented: Exeter Museum. **Literature:** McEwan.

trial of 1878, in which Whistler was awarded one farthing damages. The cost of the action led to bankruptcy in 1879 and the sale of his house. Exhibited at RA (33), RSA (5), SBA (52), GG 1859-79. Elected RBA 1884, President 1886, RP 1892. Married Beatrix Godwin (née Philip), widow of E.W.Godwin 1888. Died London 17 July 1903. Buried Chiswick Parish churchyard. Often signed his work with a butterfly.
Represented: NG Washington; Frick Collecton, New York; Tate; Glasgow AG; Louvre; Hunterian AG, Glasgow; SNG; Birmingham CAG; Manchester CAG; Honolulu Academy of Fine Arts, Hawaii; Metropolitan Museum, New York.
Engraved by R.Josey. **Literature:** W.G.Bowden, *J.M.W. – The Man & His Work*, 1902; E.Hubbard, *W.*, 1902; A.J.Eddy, *Recollections & Impressions of J.M.W.*, 1903; T.R.Way & G.R.Dennis, *The Art of W.*, 1903; A.Bell, *J.A.M.W.*, 1904;

SYDNEY WALES WHITE. A lady, probably the wife of Colonel John Reginald Shaw. Signed and dated 1913. 78 x 63ins (198.2 x 160cm) *Christie's*

WHITE, Robert 1645-1703
Born London. Studied under David Loggan. The most esteemed engraver of his generation. Also practised portraiture with success, producing some of the finest plumbago portraits of the 17th century. Died Bloomsbury Market November 1703.
Represented: NPG London; SNPG; VAM; BM; Ashmolean. **Engraved by** T.Berry, J.Faber jnr, A.Haelweg, P.Schenk, R.Sheppard, T.Trotter, M.Van Der Gucht, F.H.Van Hove. **Literature:** DNB; Walpole Society Vol XIV pp.64-71.

WHITE, Sydney Wales 1870-1945
Born Caister September 1870. Exhibited at RA (9) 1892-1917 from Grimsby and London. Died Tadworth, Surrey 25 June 1945. Left £484.2s.1d. to Charles Reginald White, a farmer. His middle name is also recorded as Wates.

WHITE, William fl.1815-1838
Exhibited at RA (4), SBA (3) 1824-38 from London and Swansea. Painted Florence Nightingale and her sister Frances (NPG London). His style is similar to that of George Richmond.
Represented: Chichester Library; BM.

WHITING, Frederick RSW RI RP NPS c.1874-1962
Born Hampstead 1873 or 1874 (conflicting sources). Educated at Deal and St Marks College. Studied at St John's Wood School, RA Schools and Académie Julian, Paris. Exhibited at RA (53), RHA, RSW, RI, NPS, RP, Paris Salon (Silver Medal 1926) 1893-1959 from London and Surrey. Elected RBA 1911, RP 1914, ROI 1915, RI 1918, RSW 1921. War correspondent with *The Graphic*. Died London 1 August 1962.
Represented: Brighton AG; Leicester CAG.

WHITNEY, Miss E. fl.1884
Exhibited at NWS (1) 1884 from London.

WHITTAKER, T.L. fl.1831
Honorary exhibitor at RA (1) 1831. Enlisted in the 65th Regiment.

WHITTON, Luke fl.1736
A pair of portraits formerly at Brickwall House, Northiam were signed 'Lucas Whittonus pinxt 1736'.

WHITWELL, Miss fl.1815-1820
Exhibited at RA (2) 1815-20 from London.

WHOOD (HOOD), Isaac 1688/9-1752
Possibly a pupil of Richardson or at Kneller's Academy. Enjoyed a successful portrait practice from the 1720s, and was much employed by Duke of Bedford in copying family portraits during the 1730s. Elected a member of Spalding Gentlemen's Society 1721 and was an early antiquary. Noted for his humour and happy appreciations of passages from *Hudibras*. Left in reduced circumstances due to a Chancery suit. Died London 24 or 26 February 1752 'aged 63'. Painted in the manner of Seeman and Vanderbank, and was capable of working on an extremely large scale.
Represented: Leicester AG; NGI; Society of Antiquaries. **Engraved by** J.Faber jnr, W.Hibbart, J.Simon, G.Vertue, A.Van Haecken.

WHYTE, D.Macgregor 1866-1953
Born Oban, Argyllshire May 1866, son of a minister. Studied in Glasgow, Paris and Antwerp. Travelled widely undertaking portrait commissions. Exhibited at RSA (13), GI. Died Oban.
Represented: Glasgow AG. **Literature:** McEwan.

WICHE, J. fl.1811-1827
Exhibited at RA (16), SBA (5) 1811-27 from London.
Represented: NPG London; BM.

WICKES, Miss Anne Mary fl.1915-1922
Born Burhampore, Bengal, India, daughter of Thomas Haines Wickes, Engineer-in-Chief of NW Provinces. Studied at Slade (winning prizes). Exhibited at RA (6), SBA, RP, ROI, NPS, RSA, Paris Salon 1915-22 from Hampstead.

WICKINS, John fl.1764-1772
Entered Dublin Society's School 1764, where he studied under J.Ennis. Exhibited in Dublin (5) 1770-2. Went to London 1772.

WICKSTEAD, Philip fl.1763-1786
Won premiums for drawing at SA 1763-5. Visited Rome 1768, where he was known as a pupil of Zoffany and had a successful portrait practice painting mostly British subjects. Remained in Rome until 1773 and in 1774 was taken by William Beckford of Somerly to Jamaica. Painted local gentry there and sent works to SA (3) 1770-80. Reportedly took to drink and died in Jamaica between 1786 and 1790. Painted in a naïve and highly delineated style, with the figures often elongated.
Literature: F.Cundall, *Connoisseur* XCIV September 1934 pp.174-5.

WIDDAS, Ernest A. fl.1906-1922
Exhibited portraits and miniatures at RA (18) 1906-22 from London.

WIENS, Stephen M. 1871-1956
Born London 26 February 1871 of German descent. Changed his first name from Siegfried to Stephen. Studied at RA Schools 1893-8, winning prizes. Exhibited at RA (23), RHA (3) 1893-1945 from Sutton, Forest Hill and London. Latter years spent in Worthing, where he died 25 June 1956.
Represented: Tate; Brighton AG; Worthing AG. **Literature:** *Worthing Herald* 29 June 1956.

DAVID WILKIE. Mrs Russell. Signed, dated 1839 and inscribed 'head from Romney'. 50 x 40ins (127 x 101.6cm) *Christie's*

WIGLEY, Mrs G. fl.1829-1840
Exhibited at RBSA (4) 1829-40 from Birmingham.

WILD, Frank Percy RBA 1861-1950
Born Leeds 4 March 1861. Trained as an engineer, before studying at Antwerp Academy, Académie Julian, Paris and in Spain. Exhibited at RA (20), SBA 1889-1926 from Leeds and Great Marlow. Elected RBA 1900. Died 14 April 1950.

WILDAY, Charles fl.1855-1865
Exhibited at RA (1), SBA (1) 1855-65 from London.

WILDE, Samuel de see DE WILDE, Samuel

WILDMAN, Edmund fl.1829-1847
Exhibited at SBA (12) 1829-47 from St George's East and Cambridge Heath. Listed in London as a portrait and miniature painter and a Perspective and Drawing Master.

WILDMAN, John Richard b.1785
Baptized Hackney 1 May 1785, son of Richard Wildman. Set up practice as a portraitist in London. Exhibited at RA (8), BI (4), SBA (9) 1823-39. Among his sitters was 'Commander James Clark Ross RN FRS FRAS FLS etc. Discoverer of the North Magnetic Pole'. The *Art Union* 1839 wrote: 'Mr Wildman has a firm and decided touch. He understands colour well; and seems to labour with great industry; for no part of his work is slighted'.
Engraved by T.Blood, J.Porter.

WILES, Frank E. fl.1913-1945
Exhibited at RA (7) 1913-45 from London. Possibly the Francis Wiles who was born Dublin 7 January 1889.

WILKIE, Sir David RA RSA 1785-1841
Born Cult, Fifeshire 18 November 1785, son of Rev David Wilkie, a minister. Entered Trustees' Academy, Edinburgh aged 14 under John Graham and RA Schools 28 November 1805. The following year his 'Village Politicians' was an instant success at RA. Exhibited at RSA (14), RA (100), BI (12) 1806-42. Elected ARA 1809, RA 1811, honorary RSA 1832. Among his sitters were HRH the Duke of York; HM William IV; and HRH the Duke of Sussex. He continued to paint genre in the modern-day manner of Teniers and Ostade and in 1822 his 'Chelsea Pensioners Reading the Waterloo Dispatch' was so popular that for the first time a rail had to be put up in the RA to protect it. Visited Paris 1814, Holland 1816 and after a serious illness in 1825, was forced to travel abroad frequently for his health. Appointed Painter in Ordinary to George IV. Knighted 1836. Visited the Holy Land 1840, but died at sea near Gibraltar 1 June 1841. His death was commemorated by his friend J.M.W.Turner in 'Peace – Burial at Sea' (Tate).
Represented: NPG London; NGI; VAM; SNG; Glasgow AG; Tate; SNPG. **Engraved by** F.Deleu, C.Fox, R.Graves, J.Horsburgh, T.W.Hunt, F.C.Lewis, E.Smith, W.Worthington. **Literature:** A.Cunningham, *The Life of Sir D.W.*, 1843; A.Raimbach, *Memoirs and Recollections of Sir D.W.*, 1843; C.Heaton, *The Great Works of Sir D.W.*, 1868; A.L.Simpson, *The Story of Sir D.W.*, 1879; J.W.Mollett, *Sir D.W.*, 1881; R.S.Gower, *Sir D.W.*, 1902; W.Bayne, *Sir D.W.*, 1903; SNG exh. cat. 1975; *Sir D.W. of Scotland*, North Carolina Museum of Art exh. cat. 1987; McEwan; DA.

WILKIE, Henry F.G. b.c.1797
Born St George's, Middlesex. Listed in 1851 census for Brighton as a portrait painter aged 54.

WILKIE, Leslie Andrew 1879-1935
Born Melbourne 27 June 1879, a grand-nephew of Sir David Wilkie. Studied at NG School, Melbourne and in London and Europe 1904-5. Became drawing teacher at NG Victoria, curator of NG South Australia 1926-34, director 1934-5 and President of Royal South Australian Society of Arts. Died Adelaide.
Represented: NG South Australia; Australian National War Museum, Canberra; Parliament House, Canberra.

WILKIN, Francis (Frank) William c.1791-1842
Son and pupil of artist and engraver Charles Wilkin. An 'infant prodigy' encouraged by Lawrence and B.West. Entered RA Schools 2 August 1815 aged 24. Exhibited at RA (25), BI (2) 1806-41 from London. Had a distinguished clientele and was paid 2000 guineas for a picture of the Battle of Hastings. Died of apoplexy in London 19 September 1842. According to Sir Gyles Isham, he nearly always framed his drawings in the same type of 'rich frame' made of gilt, plaster and oak.
Represented: SNPG; Portsmouth Museum. **Engraved by** H.Cook, M.Gauci, G.E.Madeley, C.Turner, C.Wilkin. **Literature:** *Connoisseur* March 1968 Vol 167, No.673 p.145.

WILKIN, Henry T.C. c.1801-1852
Son of Charles Wilkin and brother of F.W.Wilkin. Worked as a miniaturist and crayon portraitist in London and Brighton. Exhibited at RA (57), SBA (17) 1831-47. Died of heart disease in Brighton 29 July 1852.

WILKINSON, Edward Clegg fl.1882-1910
Exhibited at RA (12), SBA (6+), NWS, NWG 1882-1910 from London.

WILKINSON, Elijah fl.1825
Listed as a portrait painter in Manchester.

WILLCOCKS, Miss Mabel fl.1899-1904
Exhibited at RA (3) 1899-1904 from 5 New Court, Carey Street, London.

WILLIAMS, Miss fl.1826-1851
Exhibited at RHA (46) 1826-51 from Dublin.

WILLIAMS, Miss Anne fl.1768-1783
Exhibited at SA (1), FS (28), RA (3) 1768-83 from London.

WILLIAMS, Benjamin ARBSA 1868-1920
Born Langley Green. Studied at Birmingham School of Art. Taught at Central School of Art, Birmingham and Aston Manor Technical School. Elected ARBSA 1905. Died Wolverhampton.
Represented: Birmingham CAG.

WILLIAMS, Christopher David 1873-1934
Born Maesteg, Wales 7 January 1873, son of Evan Williams. Studied at RCA and RA Schools. Lived in London, but travelled widely in France, Italy, Switzerland, Belgium, Holland, Spain and Morocco. Exhibited at RA (15), ROI 1902-25. Painted the Investiture of the Prince of Wales 1912. Died 19 July 1934.
Represented: National Museum of Wales.

WILLIAMS, Edwin fl.1828-1831
Listed as a portrait painter in Hull. May be the Edwin Williams below.

WILLIAMS, Edwin fl.1843-1875
Exhibited at RA (32), BI, SBA (6), RBSA 1843-75 from Cheltenham.
Represented: NPG London. **Engraved by** Newman & Co., H.Robinson.

WILLIAMS, Francis b.c.1820
Born Monmouth. Listed in 1851 census for London as a history and portrait painter aged 31. Shared accommodation with landscape painter Richard P.Noble.
Engraved by W.Giller, C.G.Lewis.

WILLIAMS, J.G. fl.1824-1858
Exhibited at RA (7), SBA (3) 1824-58 from London.

WILLIAMS, James fl.1763-1776
Exhibited at FS (59) 1763-76 from London. Painted a number of portraits in imitation of prints.

WILLIAMS, John Edgar b.c.1821
Born Appledore, Devon. Listed as a widower aged 60 in 1881 census. Exhibited at RA (26), BI (4), SBA (24) 1846-83 from London. Among his sitters was 'His Imperial Highness, Higashi Fushimi No Miya, Prince Imperial of Japan'.
Represented: Nottingham AG.

WILLIAMS, John Michael 1710-c.1780
Worked as a scene painter for Sheridan at Smock Alley Theatre, Dublin. Studied under Jonathan Richardson and set up as a portraitist in London. Many of his sitters were clergymen, and included John Wesley 1743. Exhibited at SA (3), FS (18) 1760-6. Worked in Ireland from 1777, probably based in Dublin. Edwards says he died c.1780.
Represented: NPG London. **Engraved by** J.Dixon, J.Faber jnr, J.Hopwood, Kennerley, J.McArdell, R.Purcell.

WILLIAMS, Joseph fl.1851-1868
Listed as a portrait painter in Worcester.

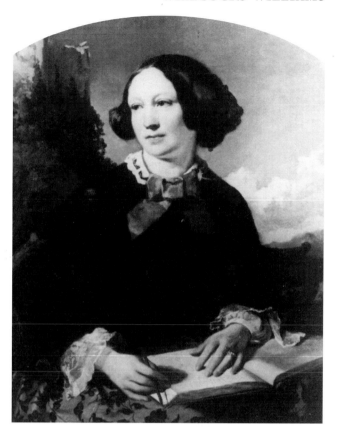

PENRY WILLIAMS. A lady sketching. 36 x 28ins (91.5 x 71.1 cm) *Phillips*

WILLIAMS, Miss Lily ARHA 1874-1940
Studied at RHA Schools. Exhibited at RHA (32) 1904-39 from Dublin. Elected ARHA 1929. Died 16 January 1940.

WILLIAMS, Miss Margaret Lindsay d.1960
Born Cardiff. Studied at Pelham Street School of Painting, Kensington under A.S.Cope; RA Schools and in France, Italy and Holland. Exhibited at RA (26), provinces and abroad 1910-44 from London and South Wales. Died 4 June 1960.

WILLIAMS, Penry 1798-1885
Born Merthyr Tydfil, son of a house painter. Studied at RA Schools under Fuseli. Encouraged by Sir T.Lawrence. Awarded a Silver Medal at SA 1821. Exhibited at RA (34), BI (9), OWS 1822-69. Elected OWS 1828. After 1827 he lived mostly in Rome, where he was friendly with John Gibson and Richard Buckner. Painted mainly Italian landscape and genre, but occasionally accomplished portraits including that of John Gibson RA. Died Rome 27 July 1885. Studio sale held Christie's 19, 21 June 1886.
Represented: BM; VAM; Tate; Fitzwilliam; Cyfarthfa Castle Museum, Merthyr Tydfil. **Engraved by** T.S.Engleheart, W.Humphreys, D.Lucas, T.H.Maguire, C. & H.Rolls, L.Stocks, C.Wagstaff. **Literature:** DNB; C.Eastlake, *Life of John Gibson,* 1870 p.241; M.Howitt, *An Autobiography;* Roget.

WILLIAMS, R. fl.1795-1817
Exhibited at RA (8) 1795-1817 from London.

WILLIAMS, R.P. fl.1854-1867
Exhibited at RA (5) 1854-67 from London. Among his sitters was the Governor of Antigua.

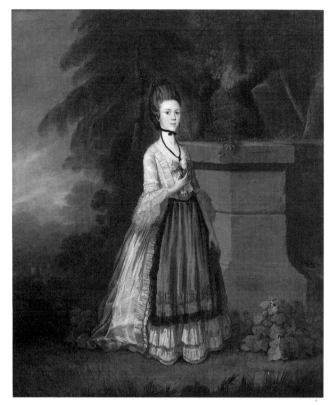

WILLIAM WILLIAMS OF BRISTOL. Catherine, wife of William Green of Thundercliffe. Signed and dated 1772. 30 x 25ins (76.2 x 63.5 cm) *Christie's*

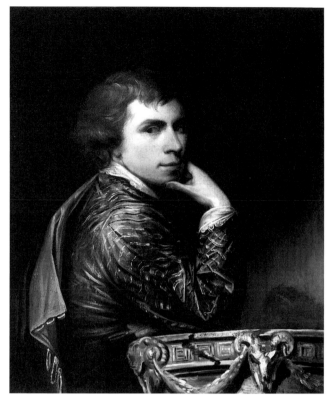

GEORGE WILLISON. Self-portrait. Signed and dated 1768. 30 x 25ins (76.2 x 63.5cm) *Christie's*

WILLIAMS, Soloman RHA 1757-1824
Born Dublin July 1757, son of goldsmith Richard Williams. Began as an engraver. Entered Dublin Society's School 1771 and RA schools 1781. Visited Italy. Elected Associate member of Clementine Academy, Bologna. Returned to Dublin 1789, but periodically stayed in London. Exhibited in Dublin, RA (24), BI (7) 1777-1808. Settled permanently in Dublin 1809. Elected founder RHA 1823. Died Molesworth Street, Dublin 2 August 1824.
Engraved by E.Bell. **Literature:** Strickland.

WILLIAMS, Thomas b.c.1807
Born St Martin's, London. Listed as unmarried, aged 44 in 1851 census. Exhibited at RA (2), BI (3), SBA (2) 1831-50 from London.

WILLIAMS, William, of Bristol 1727-1791
Born Bristol, baptized 14 June 1727. Worked in Philadelphia, Pennsylvania from c.1747, where he inspired the young Benjamin West. Signed and dated works in America each year 1766-76. Worked in a charmingly naïve and provincial style with a fondness for fanciful props. His figures are slightly elongated. Also a writer and novelist publishing *Journal of Llewellyn Penrose* and *Lives of the Poets.* Returned to England penniless 1776, where West welcomed him, occasionally using him as a model. Died Bristol. Much confused with William Williams of Norwich.
Represented: Brooklyn Museum, New York; Metropolitan Museum, New York; H.F. du Pont Museum, Winterthur, Delaware. **Literature:** DA.

WILLIAMS, William fl.1758-1797
Won a premium for drawing at SA 1758. Travelled as an itinerant portrait painter and is recorded at Manchester 1763, Norwich 1768-70, York 1770, Shrewsbury 1780 and Bath 1785-7. Also worked in London and published an *Essay on Mechanics of Oil Colours,* 1787. Exhibited at FS, SA, RA (30) 1770-92. Painted attractive small full-length portraits priced one guinea and 'heads large as life for three guineas'. Among his sitters was the Marchioness of Buckingham. Worked in Leeds 1793, where he held an exhibition of his works; Hull and Leeds 1795 and also visited Wakefield and probably Stockport, Cheshire and North Wales. Often confused with William Williams of Bristol, but his landscapes are much more naturalistic.
Represented: Tate; National Museum of Wales; St Andrew's Hall, Norwich; Linley Hall, Salop. **Literature:** J.Steegman, *Burlington Magazine* LXXV July 1939 pp.22-7; A.Artley, *Leeds Arts Review* 1972.

WILLIAMS, William fl.1834-1839
Exhibited at RBSA (1) 1834 and listed in the directories for Birmingham 1839.

WILLIAMS, William Oliver fl.1851-1863
Studied at School of Design, Birmingham. Exhibited at RA (6), BI (2) 1851-63 from Shrewsbury, Llangollen, Corwen and London. Married Jane Elizabeth Hughes at St Pancras Old Church 30 December 1852.

WILLIAMSON, Daniel Alexander c.1823-1903
Born Liverpool 24 September 1821, 1822 or 1823, son of artist Daniel Williamson. Exhibited at RA (8), SBA (2) 1849-58. Left Liverpool for London c.1847, but continued to send works to LA. His early work was influenced by the Pre-Raphaelites. Returned to Lancashire c.1860 and settled near Carnforth. Died Broughton-le-Furness 12 February 1903.
Represented: Walker AG, Liverpool; Williamson AG, Birkenhead.

WILLIAMSON, John c.1751-1818
Born Ripon. Started his career in a Birmingham japanning
works, before settling in Liverpool c.1783, where he enjoyed a
successful portrait practice. Married 1781. Two visits to London
are recorded in May 1792 and April 1813. Exhibited at LA, RA
(1) until 1814. Elected founder LA 1810. Among his sitters
were Sir William Beechey and Henry Fuseli. Died Liverpool 27
May 1818 aged 67. His son Samuel was also an artist.
Represented: NPG London; Walker AG, Liverpool. **Engraved
by** W.C.Edwards. **Literature:** *Liverpool Mercury* 5 June 1818.

WILLIAMSON, John fl.1885-1896
Exhibited at RA (4), RSA (11), SBA (1) 1885-96 from
Edinburgh and London. worked as an illustrator for *The
Illustrated Magazine*.
Literature: McEwan.

WILLIAMSON, Peter fl.1845-1855
Listed as a portraitist at 3 Owen Street, Hulme, Manchester.

WILLING, T. jnr fl.1816
Exhibited at RA (1) in 1816.

WILLIS, Frank ARE 1865-1932
Born Windsor 15 November 1865. Son-in-law and pupil of
C.W.Sharpe. Exhibited at RA (4) 1892-1900 from Eton,
Windsor and Düsseldorf. Died Windsor 4 August 1932.

WILLIS, Miss Katharina fl.1893-1898
Exhibited at RA (5) 1893-8 from Hendon, Fulham and Chelsea.

WILLIS, P. fl.1800-1825
Exhibited at RA (23), BI (2) 1800-25 from London.

WILLIS, Richard Henry Albert 1853-1905
Born Kerry 5 July 1853. Studied under James Brenan.
Trained in Cork. Exhibited at RHA (5), RA (9) 1880-1905.
Taught art in Manchester and South Kensington, before
becoming Head of Dublin Metropolitan School of Art 1904.
Died Ballinskelligs 15 August 1905.
Represented: Manchester CAG.

WILLISON, George 1741-1797
Born Edinburgh. Studied under Mengs in Rome. Remained in
Rome after Mengs had left for Madrid in 1761, and painted
British visitors. Painted portrait of Boswell 1765 (SNPG).
Returned to London by 1767. Exhibited at SA (18), RA (7)
1767-78 from Greek Street and India. Visited India 1774-80,
where he was patronized by 'The Nawab of Arcot'. Left a large
fortune by a gentleman in the East after he had cured a wound.
Retired, wealthy, to Edinburgh c.1784, where he died April 1797.
Represented: NPG London; Yale; SNPG; Lennoxlove; Victoria
AG, Australia. **Engraved by** V.Green, T.Watson. **Literature:**
Edwards; McEwan.

WILLMS, Arnold fl.1879-1896
Exhibited at RBSA (20) 1879-95. Listed in Birmingham in local
directories 1884-96.

WILLS, Rev James d.1777
Studied in Rome, where he acquired a passion for history
painting. Working in London by 1740, where he produced
crayon portraits. Director of St Martin's Lane Academy 1743-6.
Ordained 1754 and became the Duke of Chandos' Vicar at
Canons. Continued to paint and exhibit at SA (2), FS (1) 1760-6.
Chaplain to SA 1768-73. Engravings after his portraits range
from 1741-56. Reported to have died in Stanmore. Possibly the
notorious critic ('Fresnoy')of the *Morning Chronicle* 1769-70.
Represented: Christ Church, Oxford; Fitzwilliam. **Engraved by**
J.Faber jnr, J.Neagle, P.van Bleeck.

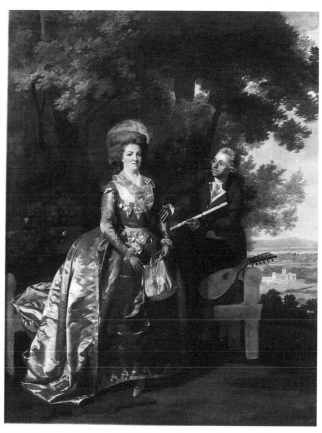

BENJAMIN WILSON. A lady and a gentleman. 44 x 33ins
(111.8 x 83.8cm) *Christie's*

WILLS, William Gorman 1828-1891
Born Kilkenny 28 January 1828, son of Rev James Wills and
Katherine. Educated at Dr Lee's school in Lucan and Waterford
Grammar School. Entered Trinity College, Dublin 6 November
1845. There he developed a taste for art and entered as a student
to RHA. Exhibited at RA (2), RHA (16) 1849-74. Moved to
London 1862, and gradually specialized in pastel portraits with
considerable success. Painted the royal children at Windsor and
gave lessons to Princess Louise. Gradually lost his clients through
his bohemian ways and absent-mindedness. Died Guy's Hospital,
London 13 December 1891.
Literature: Strickland.

WILLSON, Miss Margaret fl.1888-1906
Exhibited at RA (5) 1888-1906 from Leeds.

WILMOT, Miss Florence F. fl.1883-1909
Exhibited at RBSA (76) and RA (3 not 1) 1883-1909 from
Mickleton and Birmingham.

WILMSHURST, George Cecil fl.1897-1917
Exhibited at RA (3) 1897-1900 from London. Worked for the
Illustrated London News. Recorded in London 1917.

WILMSHURST, T. fl.1848-1850
Exhibited at RA (1), RBSA (2) 1848-50 from London and
Birmingham.

WILSON, Benjamin FRS 1721-1788
Born Leeds 21 June 1721, son of Major Wilson, a rich clothier
or wool merchant and Elizabeth (née Yates). Educated at
Leeds Grammar School. As a boy he saw Jacques Parmentier
at work and received instruction from Longueville. His father

fell into poverty and Benjamin Wilson reportedly walked to London, where he earned a living as a clerk at the Prerogative Court in Doctor's Commons. Stayed there about four years, then worked as a clerk for the Charter House Registrar. He saved his money, and then resumed his passion for art attending St Martin's Lane Academy and being drawn into the circle of Hogarth, Hudson, Gravelot and Hayman. Reportedly received lessons from Hudson 1746, and set up as a portraitist with some success in Dublin 1748-50. Returned to London 1750 and set up in a house previously owned by Sir Godfrey Kneller and next door but one to Hudson's house. In 1751 he and Hogarth played a famous trick on Hudson by forging Rembrandt etchings. One of the leading portrait painters during the 1750s, and was then held to rival the young Reynolds. It was said that he enjoyed an income of £1,500 pa and declined a partnership with Hogarth 1757. His portrait of his friend 'Garrick as Hamlet' (engraved by McArdell 1754) helped establish the theatre piece, and he secretly employed Zoffany to help him with conversation pieces 1760-1. Influenced by Rembrandt and imitated his strong side lighting (sometimes painting a window as the source). Exhibited at SA (5) 1760-1. In 1766 he speculated and lost on the Stock Exchange, and as a result seems to have spent some months in prison. His luck changed when the Duke of York put him in charge of amateur theatricals presented in the Duke's private theatre in Pimlico. Through the Duke's influence he was appointed Master Painter to the Board of Ordinance 1767 (or 1773), which brought a huge income of £4,000 a year, with few duties, and this enabled him to pursue his interest in scientific experiments. His known portraits range up to 1769, when he concentrated on science (he was elected FRS 1751 and was an expert on electricity and lightning conductors). Married Mrs Hetherington 1771 and had seven children. Died London 6 June 1788. Buried St George the Martyr's burying ground. Told George III that he 'never made sketches or drawings for his pictures, but painted them on the canvas at once'. Among his pupils and assistants were J.Stone, J.Zoffany and Richard Brompton.
Represented: NPG London; VAM; Yale; NGI; Leeds CAG; Brighton AG; Dulwich College AG. **Engraved by** J.Basire, R.Earlom, E.Fisher, J.Heath, R.Houston, J.Jones, R.Laurie, J.McArdell, S.F.Ravenet, J.R.Smith, C.Spooner. **Literature:** H.Randolph, *Life of General Sir Robert Wilson*, 1862; DNB; Dorment; Strickland; DA.

WILSON, Chester **fl.1846-1855**
May have been the James Chester Wilson listed as a portraitist in Manchester 1845. Exhibited at RA (6), BI (13), SBA (2) 1846-55 from London.

WILSON, David Forrester RSA **1873-1950**
Born Glasgow 4 April 1873, son of lithographer John Wilson. Exhibited at RSA, RA, GI and in Liverpool and America from Glasgow. Elected ARSA 1922, RSA 1932, retired 1942. Also painted decorative panels including for the Banqueting Hall of Glasgow Municipal Buildings. Died Isley 9 January 1950.
Represented: Glasgow AG; Lillie AG. **Literature:** McEwan.

WILSON, Major George **fl.1845**
Listed as a portrait painter at Stratford, Essex.

WILSON, Herbert Louther **1820-1905**
Born Royal Hospital Chelsea, son of war hero Sir John Morillyon Wilson and Amelia (née Houlton). Joined the Guards 26 September 1845. A close friend and follower of Richard Buckner. In the 1851 census for Cadogan Place, London he is listed as a fundholder and enjoyed independent means. Listed in the 71st Highland Regiment of Foot 1853 and retired by sale of commission 1854. Lord Kilmorey

HERBERT LOUTHER WILSON. Mrs Roger Eykyn, daughter of Lord Vaux of Harrowden, Northamptonshire. Signed with initials. 24 x 20ins (61 x 50.8cm) *Phillips*

writing to John Lucas 12 January 1854 commented 'Young Wilson also, late of the Guards, whom I think you remember, is setting up as an artist, with what success time will show. He is wonderfully good-looking and a great favourite with the ladies'. A friend of Leighton in Rome and Paris and taught him the Couture method of painting. Exhibited at RA (3), BI (3), SBA (10), GG 1858-80 from London. Among his sitters was Sir John Wilson CB. Died Kensington 17 December 1905. Left Herbert Howard Wilson £18,716.3s.8d.
Literature: A.Lucas, *John Lucas*, 1910.

WILSON, Jacob **fl.1692**
Had a successful portrait practice in the City of London 1692.

WILSON, James **fl.1832-1834**
Listed as a portrait painter at Brompton, London. May be the James Wilson working in Birmingham 1828.

WILSON, John **b.1766**
Born 8 April 1766. Entered RA Schools 1782. Exhibited at RA (2) 1783 from London.

WILSON, Joseph **fl.1770-1800**
Worked in Belfast and Dublin. Exhibited Dublin SA (3) 1777. His widow, Jane died 1804. His work is similar to that of Strickland Lowry.
Literature: Strickland.

WIL(L)SON, Joseph **fl.1780s**
Signed the back of a small oval portrait (9 x 7½ins).

WILSON, Joseph **fl.1873-1874**
Exhibited at RA (3) 1873-4 from Hollywood Villa, Putney.

WILSON, Joseph T. b.c.1808
Born London. Listed in 1851 census as a portrait painter aged 43. Exhibited at RA (30), SBA (1) 1833-63 from London, Witley and Godalming.

WILSON, Mrs Margaret Evangeline (née Beard) b.1890
Born Boscombe, Hampshire 25 April 1890. Studied at RA Schools, Central School of Art, Slade and in Paris and Florence. Exhibited at RA (7), RSA, RP, ROI and Paris Salon 1916-41 from Lancashire, London and Surrey.

WILSON, Matthew Henry ANA 1814-1892
Born London 17 July 1814. Travelled to America 1832, where he was a pupil of Henry Inman in Philadelphia. Studied in Paris under Dubufe 1835. Settled in Brooklyn, but travelled to Baltimore 1847 and Hartford, Connecticut 1861-3 returning to Brooklyn. Painted Lincoln two weeks before the President's assassination. Died Brooklyn 23 February 1892.
Represented: J.B.Speed Art Museum, Louisville.

WILSON, Nicklin James fl.1818-1855
Worked as a portrait and miniature painter in Birmingham.

WILSON, Peter MacGregor RSW d.1928
Born Glasgow. Studied at Glasgow School of Art. President of the Glasgow Art Club. Travelled extensively in North America, Europe and Asia. Exhibited at RA (1) 1890, RSA (9), GI (64). Died 25 September 1928.
Literature: McEwan.

WILSON, Richard 1713-1782
Reportedly born Pengoes, Wales 1 August 1713, son of John Wilson, rector. Trained in London 1729, as a portrait painter under Thomas Wright for six years. Established a relatively successful portrait practice by 1740s. His portraits were stylized, but highly accomplished and painted with a smooth 'liquid' modelling and bright highlights. Travelled to Venice 1750 and Rome 1752, where he was influenced by Claude, Gaspard Poussin and the classical landscape and decided to concentrate on landscape painting. Returned to England 1757. Founder SA and RA. Exhibited at SA (36), RA (30) 1760-80 from Covent Garden (his residence was previously occupied by Sir Peter Lely, Sir Godfrey Kneller and Sir James Thornhill). Succeeded Hayman in the sinecure of the Librarianship of RA 1776. He did not enjoy good health (aggravated by alcohol) and retired to Wales 1781 after inheriting a family property near Mold. Died there at Llanferras 11 May 1782. The popularity of his work through engravings has led to much of it being copied and forged. Edwards asserted that Wilson 'drew a head equal to any of the portrait painters of his time'.
Represented: NPG London; SNPG; HMQ; Dulwich AG; Birmingham CAG; VAM; Museum of Wales, Cardiff; NGI; Southampton CAG; Tate. **Engraved by** W.Ensom, J.R.Jobbins, W.Woollett. **Literature:** DNB; B.Ford, *The Drawings of R.W.,* 1951; W.G.Constable, *R.W.,* 1953; D.Sutton, *An Italian Sketchbook of R.W.,* 1968; D.H.Solkin, *R.W. and the Landscape of Reaction,* Tate Gallery exh. cat. 1982; DA.

WILSON, Richard 1752-1807
Birmingham portrait painter who painted a small full-length of Peter Oliver (Boston). Died Birmingham 18 July 1807 aged 55.

WILSON, T. fl.c.1750
A portrait of '2nd Earl of Egremont' was inscribed on the back 'T.Wilson/Edinburgh'.

WILSON, Thomas Fairbairn fl.1828-1831
Listed as a portrait and animal painter in Hull.

RICHARD WILSON. A gentleman. 30 x 25ins (76.2 x 63.5cm)
Christie's

WILSON, Thomas Harrington b.c.1820
Born Birmingham, son of Thomas Harrington Wilson, jeweller. Aged 41 in 1861 census. Exhibited at RA (22), BI (1), SBA (2), NWS 1842-56 from London. Married Ann Higham at St Martin-in-the-Fields 3 June 1841.
Engraved by Madeley.

WILSON, W. fl.1871-1889
Exhibited at RA (1) 1871 from Kentish Town, London. Produced drawings for *The Illustrated London News.*
Engraved by P.Naumann, R.Taylor.

WILSON, Mrs W.R. fl.1871-1875
Exhibited at RA (3) 1871-5 from 12 St John's, Wakefield.

WILSON, William fl.1832-1834
Listed as a portrait painter in London.

WILTON, Charles b.c.1810
Born Sheerness (aged 51 in 1861 census). Exhibited at RA (13), SBA (7) 1837-47 from London.

WINDSOR-FRY, Harry fl.1884-1888
Exhibited at RA (2), SBA (3) 1884-8 from London.

WINGATE, Miss Anna Maria Bruce 1873-1921
Born Orkney 18 June 1873, daughter of Rev Thomas Wingate. Exhibited at RA (3) 1899-1904 from London and Edinburgh. Author of *Wordsworth and Tolstoy,* published posthumously 1922. Died 28 March 1921.
Literature: McEwan.

WINGFIELD, James Digman 1813-1872
Born Mayfair. Exhibited at RA (38), BI (94), RHA (35), SBA (41) 1832-72 from London. Died Chelsea 14 April 1872. Left effects under £1,500.

WINGRAVE, Francis Charles b.1775
Entered RA Schools 1789 as an engraver aged 14. Exhibited at RA (3) 1793-8 from London.

WINKLES, George Mathias fl.1877-1888
Exhibited RBSA (17) 1877-87 from Birmingham. Listed there in directories 1884-8.

WINSTANLEY, Hamlet 1694-1756
Baptized Warrington 6 October 1694, son of William Winstanley a tradesman or Henry Winstanley an engraver (conflicting sources). Attended Boteler Free Grammar School, Warrington under Samuel Shaw. Studied at Kneller's Academy in London c.1718, returning to Warrington c.1721. Travelled to Rome and Venice 1723-5, buying pictures for his patron the Earl of Derby. Sometimes painted small heads on the spot, which he sent to Van Aken in London to make into groups. Took G.Stubbs as an apprentice, but Stubbs terminated his articles because he was not allowed to copy the pictures he wished. Died Warrington 16 or 18 May 1756 aged 61.
Represented: BM; Tate; Walker AG, Liverpool. **Engraved by** J.Faber jnr. **Literature:** DNB; W.Beaumont, *Memoir of H.W. Formerly of Warrington, Miscellaneous Works* 1883; R.Lawson, 'H.W., a Local Artist', *Cheshire Notes and Queries, The Cheshire Sheaf* NS V-VI 1891 pp.43-5.

WINTER, George 1810-1876
Born Portsea 10 June 1810. Went to London aged 16 to study art. Emigrated to America 1830. Settled in New York and attended the schools of the Academy of Design for three years. Moved to Cincinnati, Logansport 1836-51, before settling at Lafayette. Painted portraits of many early Indiana settlers. Died Lafayette 1 February 1876. John I.Williams was his pupil.
Literature: *Dictionary of Artists in America*

WINTER, John b.1801
Born Dublin. Exhibited at RHA (7) 1837-50 from Dublin and Rathgar.

WINTERHALTER, Franz Xaver 1805-1873
Born Menzenschwand 20 April 1805, sixth child of Fidel Winterhalter, a farmer and resin producer and Eva (née Mayer). Apprenticed to Karl Ludwig von Schüler at Freiburg-im-Breisgau. In 1824 he received a grant to study in Munich under Piloty. Joined the studio of Josef Stieler, and was encouraged by him to be a portrait painter. Worked as such at Karlsruhe. Enjoyed considerable success, becoming Court Painter to Grand Duke Leopold of Baden. Travelled to Italy 1832 on a bursary partly funded by Grand Duke Leopold, and took accommodation at the Caffé Greco, Via Condotti, Rome. Travelled to Paris 1834, where he painted Queen Marie-Amélie (1842). This launched him on a long and successful international career as a Court Painter. Painted the royal families of France, Belgium, Germany, Austria and Russia. First visited England 1842 to paint Queen Victoria (he was her favourite portrait painter) and Prince Albert for which he was paid 300 guineas. Made frequent visits to England, often in the summer or autumn for a stay of six or seven weeks, his last being in 1864, when he painted the wedding portraits of the Prince and Princess of Wales. Exhibited at Paris Salon, RA (4) 1835-68. Elected Chevalier de la Légion d'Honneur 1839, Officer 1857. Died of typhus at Diakonissen Krakenhaus, Frankfurt 8 July 1873 at 6pm. Among his assistants and pupils were his brother Hermann Winterhalter, Albert Graeffle, Louis Coblitz, Charles Boutibonne, Richard Lauchert, Josephine Ludwig and Emma Gaggiotti Richards. His finest work is rarely equalled and never outshone. He ranks among the best portrait artists in Europe. He influenced British contemporaries such as Grant, Buckner, Hayter and the young Leighton. On his death Queen

FRANZ XAVER WINTERHALTER. Lady Melbourne. Signed and dated 1850. Watercolour. 9½ x 7ins (24.2 x 17.8cm)
Sotheby's

Victoria wrote to one of her daughters: 'His works will rank with Vandyck. He painted you all from birth'.
Represented: NPG London; SNPG; HMQ; Metropolitan Museum, New York; Southampton CAG; The Sutherland Trust; National Museum, Warsaw; Musée d'Orsay, Paris; Hermitage Museum, Leningrad; Walters AM, Baltimore. **Engraved by** T.L.Atkinson, C.Baugniet, S.Cousins, T.Fairland, F.Forster, A.Hussener, Jab, J.R.Jackson, R.J.Lane, F.C.Lewis, T.H.Maguire, C.Mayer, L.Noel, D.J.Pound, J.A.Vinter, F.Weber. **Literature:** R.Ormond & C.Blackett-Ord, *F.X.W. and the Courts of Europe 1830-1870*, NPG exh. cat. 1987-8; DA. Colour Plate 74

WINTLE, Mrs R.P. fl.1872
Exhibited at SBA (1) 1872 from Kensington.

WIRGMAN, Theodore Blake RP 1848-1925
Born Louvain, Belgium 29 April 1848 of a Swedish family. Entered RA Schools aged 15 and won a Silver Medal for drawing aged 17. Studied in Paris under Hébert. Worked extensively for *The Graphic*. Encouraged by Millais with a commission and built up a successful society portrait practice. Exhibited at RA (101), SBA, RHA (1), RP, NWS, GG, NWG 1867-1919 from London. Elected RP 1891. His 'Peace with Honour', representing Disraeli interviewing Queen Victoria after the signing of the Berlin Treaty in 1878, was popular as an engraving. Among his sitters were Hamo Thornycroft ARA, the Bishop of Brechin, Colonel Richard Harte Keatinge VC, and Mrs Edmund Gosse. Died London 16 January 1925.
Represented: NPG London; SNPG; Cartwright Hall, Bradford; Weston Park.

WILLEM WISSING. A gentleman. Signed. 30 x 25ins (76.2 x 63.5cm) *Philip Mould/Historical Portraits Ltd*

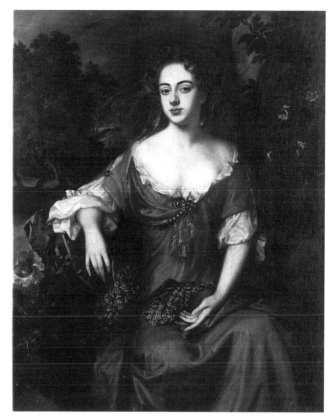

WILLEM WISSING. Lady Dorothy Brownlow (née Mason). Signed. 50 x 40ins (127 x 101.6cm) *Christie's*

WISE, William **fl.1823-1876**
Exhibited at RA (2), SBA (8) 1823-76 from London.

WISSING, Willem **1656-1687**
Born Amsterdam. Trained at The Hague and in Paris. Arrived in London from The Hague 1676, where he had studied under W.Doudijns and A.V.Ravestyn. Became assistant to Lely, with whom he remained until Lely's death 1680. Completed many of Lely's unfinished portraits. Employed by the Court and sent by James II in 1684/5 to Holland to paint the Prince of Orange (later William III) and Princess Mary. On his return he was much patronized by the Earl of Exeter and the Lincolnshire gentry. Enjoyed a successful and prolific practice and employed the help of his assistant John Van Der Vaart. Developed a variation of Lely's style, characterized by a brownish palette, Frenchified accessories and a large use of exotic flora in his backgrounds. Believed to have been assisted on occasions by Francis Barlow, who would paint flowers and animals. Died suddenly at Burghley House 10 September 1687 aged 31. Buried at St Martin's Church, Stamford. Lord Exeter put up an elegant tombstone to him which survives.
Represented: NPG London; SNPG; Yale; Penshurst Place; Goodwood; Burghley; Belton House, NT; Gorhambury.
Engraved by I.Beckett, J.Blondeau, P.Drevet, R.Dunkarton, J.Faber snr, W.N.Gardiner, J.Gole, R.Grave, B.Lens, M.Marebeck, J.Oliver, P.Schenck, A.Schoonebeek, E.Scriven, J.Smith, J.Thomson, O.Tromp, J.Van Der Vaart, R.White, R.Williams, W.Worthington. **Literature:** DNB; DA.

WITHALL, Richard Augustus **1818-1906**
Born 5 August 1818, son of William Withall, a Westminster solictor and Eliza Sarah (née Jefferies). Became a surveyor, working for railways. Painted miniatures and portraits as an amateur, and reportedly won a Silver Palette by SA. Married Letitia Osborn 1850 and moved to Lambeth and then Putney Hill. Died Putney Hill 28 January 1906. Buried Putney Vale Cemetery.
Literature: Foskett.

WITHERS, E.R. **fl.1850-1852**
Exhibited at RA (5) 1850-2 from London.

WIVELL, Abraham **1786-1849**
Born Marylebone, London 9 July 1786, son of a tradesman. His father died shortly after his birth, leaving his wife and five children in poverty. Aged six he worked as a farm labourer and in 1799 he apprenticed himself for seven years to a hairdresser. Set up in that profession and exhibited miniatures in his window between the wigs, which attracted the encouragement of Nollekens and Northcote. Painted Queen Caroline during her trial, and this led to a number of society commissions and a successful portrait practice. Exhibited portraits in oil and miniature at RA (11), BI, SBA (4) 1822-49 from London and Birmingham. Published *An Inquiry into the History, Authenticity and Characteristics of the Shakespeare Portraits*, 1827. Invented the Rope Fire-Escape, 1828. Moved to Birmingham 1841 and was engaged to take the portraits of railway celebrities for *The Monthly Railway Record*, 1847. Died of chronic bronchitis in Birmingham 29 March 1849 in his sixty-third year.
Represented: NPG London. **Engraved by** J.Agar, T.Blood, J.Cochran, H.R.Cook, R.Cooper, H.Dawe, W.T.Fry, M.Gauci, J.Guillaume, B. & W.Holl, J.Hopwood, F.C.Lewis, T.Lupton, H.Meyer, G.Parker, C.Picart, J.Posselwhite, R.Pratt, B.Reading, Reveil, E.Scriven, J.Thomson, W.Wagstaff, W.J.Ward, A.W.Warren, T.Woolnoth, T.Wright.
Literature: DNB; *Art Journal* 1849 p.205; Ottley.

JOHN WOOD. Miss Sebella Christine Hainoff. Signed and dated 1829. 30 x 25ins (76.2 x 63.5cm)

Christie's

WIVELL, Abraham jnr fl.1845-1865
Son of portrait artist, Abraham Wivell. Exhibited miniatures at RA (2), BI (7), SBA (3) 1848-65 from London and Birmingham. Contributed 12 portraits to the opening exhibition at Aston Hall, Birmingham 1858.
Represented: Birmingham CAG. **Engraved by** W.O.Geller.

WOLLASTON, John snr see WOOLASTON, John

WOLLASTON, John jnr fl.1738-1775
Son of London portrait painter, John Woolaston. Studied under a drapery painter. Left for the United States c.1749, where he had a considerable influence. Worked as an itinerant portrait painter in New York 1749-52, Maryland 1753-4, Virginia c.1755-7 and Philadelphia 1758. Influenced Wets and John Hesselius and introduced to America a repertory of fashionable poses and accessories. Believed to have moved to the West Indies c.1758. In St Kitts 1764/5, Charleston 1767 and returned to England 1767. Recorded by John Baker in Southampton 1775.
Represented: NPG London; H.F.Du Pont Museum, Winterthur; Virginia Historical Society, Richmond. **Engraved by** J.Faber jnr, J.Goldar, G.Vertue. **Literature:** Philip C. Yorke (ed), *The Diary of John Baker, Barrister of the Middle Temple*, 1931, entry for 31 July 1775; DA.

WOLLEN, William Barnes RI ROI RBC 1857-1936
Born 6 October 1857. Studied art at Slade. Exhibited at RA (36), ROI, RI 1879-1922 from Camden and Bedford Park, London. Died 28 March 1936.

WOLMARK(E), Alfred Aaron 1877-1961
Born Warsaw 28 December 1877, son of Soloman and Gital Wolmark. Moved to England 1883, studying at RA Schools from 1895 (Silver Medallist). Exhibited at RA (15), RHA (14) and abroad 1901-36 from London. Married Bessie Leah Tapper 1911. Died London 6 January 1961.
Represented: NPG London; Tate; NG London; AGs of Aberdeen, Stoke, Derby, Leamington, York, Southampton.

WOLSELEY, Garnet Ruskin 1884-1967
Born London 24 May 1884, son of Rev Robert Warren Wolseley and Jean Ruskin (née Richardson). Studied at Slade (winning prizes). Exhibited at RA (11) 1910-28 from Penzance and Steyning. Died 16 November 1967.

WOLSTENHOLME, Dean jnr 1798-1883
Born Waltham Abbey, son of artist Dean Wolstenholme snr. Specialized in animal paintings, but also occasionally painted portraits. Exhibited at RA (13) 1818-49. Died Highgate 12 April 1883.
Literature: DNB.

WONDER, Pieter Christoffel 1780-1852
Born Utrecht 10 January 1780. Studied in Düsseldorf. Moved to London 1823. Exhibited at RA (2), BI (18) 1824-31 from London. Returned to Holland 1831. Died Amsterdam 12 July 1852.
Represented: NPG London; Rijksmuseum. **Literature:** DA.

WONTNER, William Clarke d.1930
Exhibited at RA (33), SBA, NWS, GG, NWG 1879-1912 from London. Enjoyed a highly successful portrait practice. Also painted classical genre in the manner of Leighton, Tadema and Godward. Died Worcester 23 September 1930.
Represented: NPG London; Oriel College, Oxford. Colour Plate 73

WOOD, Miss Eleanor Stuart fl.1876-1912
Brought up in Manchester. Trained there and in Paris. Exhibited at RA (7), NWS, GG, NWG, LA, RMI, Paris Salon

JOHN WOLLASTON JNR. Hon Richard Holmes of St Kitts. 30 x 25ins (76.2 x 63.5cm) *Christie's*

1876-93 from Manchester and London. Member of SWA.
Represented: Walker AG, Liverpool.

WOOD, F.S. Hurd- fl.1897-1901
Exhibited at RA (2) 1897-1901 from Leatherhead, Surrey and Cheyne Walk, Chelsea.

WOOD, J.W. fl.1838
Exhibited a portrait of Count D'Orsay at RA 1838.

WOOD, John 1801-1870
Born London 29 June 1801. Studied at Sass's School and RA Schools, winning a Gold Medal 1825. Exhibited at RA (119), BI (68), RHA (1), SBA (30) 1823-62 from London. Competed successfully for the commission for the altarpiece of St James's, Bermondsey 1834. Among his sitters were Sir Robert Peel, Earl Grey and artist Thomas Stothard RA. Died London 19 April 1870.
Represented: NPG London; SNPG; NMM; Middle Temple; Dulwich College AG. **Engraved by** G.E.Madeley, W.H.Mote, G.H.Phillips, W.J.Ward. **Literature:** *Art Journal* 1870 p.204.

WOOD, John Barlow 1862-1949
Began as a ceramic painter for Minton before becoming a professional portrait and landscape painter. Worked in Oxford 1894, Woodbridge 1897 and Ipswich 1905, before moving to Kendal after his marriage in 1911. Exhibited at RA (2), SBA.
Represented: Kendal AG.

WOOD, Matthew c.1813-1855
Born Dublin. In London 1838 where he held a clerkship in the General Post Office and acted as the RHA's London collecting agent. Exhibited at RHA (30), RA (19), BI (5), SBA (8) 1834-55. Listed in 1851 census as a widower. Found

dead in his bed in London 4 September 1855, having committed suicide by taking prussic acid after he failed to obtain promotion to a post in his office which he had held temporarily for six months.
Literature: *Art Journal* 1855 p.284; Strickland.

WOODBURN, Robert **d.1803**
Pupil and assistant to Robert Home. Exhibited Dublin (12) 1801-2. Worked as a portraitist in Dublin and Waterford. Died Waterford.
Represented: NGI. **Engraved by** R.Dunkarton.

WOODFORDE, Samuel RA **1763-1817**
Born Ansford, near Castle Cary 29 March 1763, son of Heighes Woodforde and Anne (née Dorville). Entered RA Schools 8 March 1782. Patronized by the Hoares of Stourhead, who sent him to Italy 1785-91, where he accompanied Richard Colt Hoare. Exhibited at RA (133), BI (39) 1784-1815. Elected ARA 1800, RA 1807. Died Ferrara, Italy 27 July 1817.
Represented: BM; Stourhead, NT; Tate; VAM. **Engraved by** J.Basire, H.R.Cook, J.Hopwood, H.Meyer, R.Rhodes.

WOODGATE, William **fl.1845**
Listed as a portrait painter in Gravesend.

WOODHOUSE, John **b.c.1800**
Born Alnwick. Practising as a portrait painter by his early twenties. Concentrated on producing silhouettes, and enjoyed a successful reputation. Moved to North Shields.
Literature: Hall 1982.

WOODHOUSE, John Thomas MD **1780-1845**
Exhibited at RA (5) 1801-34 from Caius College, Cambridge. Died Cambridge 20 March 1845.

WOODHOUSE, Samuel **fl.1809-1815**
Exhibited in Dublin 1809-15.
Represented: VAM; BM.

WOODIN, Samuel jnr **fl.1798-1843**
Exhibited at RA (39), BI (19), SBA (8) 1798-1843 from London.

WOODINGTON **fl.1765**
Exhibited at FS (1) 1765 from Burlington Gardens, London.

WOODMAN, Charles Horwell **1823-1888**
Son of artist Richard Woodman. Exhibited at RA (1), BI (6), SBA (6) 1842-70 from Camden Town and Kentish Town.
Represented: BM; VAM; Cartwright Hall, Bradford.

WOODMAN, Richard **1784-1859**
Born London 1 July 1784, son of engraver Richard Woodman. Studied under R.M.Meadows, a stipple engraver. Worked for Wedgwood 1808, but returned to London before going to Italy. Exhibited at RA (12), BI (2), OWS 1820-54. Died 15 December 1859. His portrait of Princess Charlotte Augusta is in NPG London.

WOODS, William H. **fl.1851**
Listed as a portraitist in Bristol.

WOODWARD, Thomas **1801-1852**
Born Pershore, Worcestershire. Studied under Abraham Cooper RA. Exhibited at RA (85), BI (60), SBA (16) 1821-52 from Pershore and London. Employed by Queen Victoria and Prince Albert to make portraits of some of their animals. Also patronized by Duke of Montrose, Duke of Newcastle, Sir Robert Peel and Earl of Essex. Landseer admired his horse

painting. Died November 1852.
Represented: Tate. **Literature:** *Art Journal* 1852 p.375; *T.W.*, Spinks exh. cat. 1972.

WOODWORTH, William **1749-1787**
Born 30 October 1749. Entered RA Schools 1771. Exhibited at RA (1) and Liverpool 1771-87.

WOOLASTON (WOLLASTON), John **c.1672-1749**
According to Walpole he was born c.1672. Father of John Wollaston jnr. Practised in London. Died impoverished in the Charterhouse July 1749.
Represented: NPG London. **Engraved by** J.Faber snr; G.White.

WOOLCOTT, Charles **fl.1808-1834**
Exhibited at RA (21), SBA (1) 1808-26 from London and Brighton. Listed as a portrait painter in Brighton 1834.

WOOLNER, Miss Dorothy **fl.1898-1899**
Exhibited at RA (2) 1898-9 from London.

WOOLNOTH, Thomas **1785-c.1865**
Born Pentonville. Believed to have studied under distinguished engraver James Heath. Worked as an engraver and portraitist. Exhibited at RA (9), BI (4), RHA (1), SBA (6) 1842-57 from London. Published books on art (1854, 1865). His son Thomas A.Woolnoth was also an artist.
Represented: NPG London. **Engraved by** W.Walker.

WORLIDGE, Thomas **1700-1766**
Born Peterborough of Roman Catholic parents. Started producing small pencil portraits and miniatures, and had some teaching from the Italian artist, A.M.Grimaldi (d.1732), whose daughter, Arabella, he married. Worked in Bath and London and produced a number of oil portraits, which are usually signed 'TW'. Exhibited at SA (4), FS (7) 1761-6. Also painted and etched in the manner of Rembrandt. Lived in a house that had been Kneller's and then Hudson's, but also worked in Bath. Died Hammersmith 22/23 September 1766. Buried Hammersmith Church. Reportedly had 32 children (from three wives), and was described as hot-tempered, gluttonous and extravagant. Among his pupils were W.Grimaldi and George Powle.
Represented: NPG London; VAM; Peterborough Museum. **Engraved by** T.Chambers, E.Fisher, J.Heath, R.Houston, J.Lodge, J.McArdell, J.Neagle, R.Purcell, H.Robinson, Mrs D.Turner, W.Worthington. **Literature:** DNB; C.Dack, *Sketch of the Life of T.W. . . . with a Catalogue of His Works*, Peterborough 1907; DA.

WORNUM, Ralph Nicholson **1812-1877**
Born Thornton, near Durham 29 December 1812. Initially intended for the bar. Decided to follow art 1834 and studied for five years in Munich, Dresden, Rome and Paris. Settled in London 1840, where he published *Epochs of Painting* and worked as a lecturer in the Government School of Design, while trying to succeed as a portrait painter. His work for the Westminster Hall competition was selected for praise. After his appointment as Keeper of NG 1846, he concentrated on writing on art. Died London 15 December 1877.
Literature: Hall 1982.

WORRALL, Otwell **fl.1784-1786**
Exhibited a crayon portrait of a child at Liverpool 1784. Married Margaret Travis in Prestwick, Lancashire 28 June 1786.

WORSDALE (WORSDALL), James **c.1692-1767**
Born London, son of a poor colour grinder. Servant and pupil of Kneller, whose work he copied. Married the niece of

Kneller's wife without consent and was turned out of the house. Painted royal portraits for the Nisi Prius Court, Chester 1733, which were possibly copies after Kneller. Working in Ireland by 1735, where he was active in forming and painting the Hell Fire Clubs of Dublin and Limerick. Returned to London c.1744, where he was made painter to the Board of Ordnance. Wrote farces and claimed to be Kneller's illegitimate son. Pasquin writes: 'It was his custom when a portrait was finished and not paid for to chalk the surface over with intersecting lines, which conveyed the appearance of the subject being in prison, and this was exhibited continually in his painting room until shame or pride induced the parties concerned to liberate the effigy by paying the artist'. Died London 11 or 13 June 1767 'by his own fault'. Buried St Paul's, Covent Garden.
Represented: NPG London; NGI; Royal Society. **Engraved by** A.Bannerman, G.Bockman, J.Brooks, J.Faber, J.Simon.
Literature: DNB; L.C.Jones, *The Clubs of the Georgian Rakes*, 1942; Strickland.

WORTHINGTON, William Henry　　　　**b.1780**
Baptized Holborn 22 January 1780, son of George and Sarah Worthington. Exhibited at RA (19), BI (2) 1819-39 from London.
Represented: SNPG.

WORTLEY, Archibald James Stuart　RP　　1849-1905
Born 27 May 1849, son of James A.Stuart-Wortley MP, Recorder of London and grandson of 1st Baron Wharncliffe. Studied briefly under Millais 1874. Exhibited at RA (31), GG, NWG 1874-99 from London. His work was admired by Ruskin who commented on his portrait of 'Miss Margaret Stuart Wortley' (RA 1875): 'The rightest and most dignified female portrait here'. Also painted W.G.Grace (Lord's Cricket Museum) and 'HRH the Prince of Wales'. Founder and first President of RP. Died 11 October 1905 aged 56. Usually signed with an elaborated monogram 'R'.
Represented: NPG London; Forbes Magazine Collection.
Literature: J.G.Millais, *The Life and Letters of Sir John Everett Millais*, 1899 II p.61.

WORTLEY, Miss Mary Caroline Stuart　　　d.1941
(Lady Wentworth and Countess of Lovelace)
Daughter of Rt Hon James Stuart Wortley by his second wife Alice Sophia Caroline (daughter of Millais). Exhibited at RA (3), GG (7), NWG (1) 1875-93 from London. Died 18 April 1941.

WRAY, Mr　　　　　　　　　　　**fl.c.1650**
A portrait painter whose advice on copying faces was recorded in Richard Symonds' notebook of 1650/2.

WREFORD-MAJOR, W.　　　　　　　　**fl.1874**
Exhibited a portrait of Lady Talfourd at RA 1874 from Percy Lodge, Upper East Sheen. May be Major W.Wreford as the RA catalogue lists his name as such in the index.

WRIGHT, Alfred　　　　　　　　　**fl.1832-1834**
Listed as a portrait painter in London.

WRIGHT, Edward　　　　　　　　　　**fl.1730s**
Portraitist and copyist; a friend of Richardson.
Engraved by G.Vertue.

WRIGHT, Miss Ethel (Mrs A.Barclay)　　**d.1939**
Studied in London and Paris. Exhibited at RA (52), ROI, RP, SBA 1888-1929 from London. Married A.Barclay c.1898. Died July 1939.

WRIGHT, John Michael　　　　　　**c.1617-1694**
Believed to have been baptized London 25 May 1617. Apprenticed to George Jamesone in Edinburgh from 6 April

ARCHIBALD JAMES STUART WORTLEY. Miss Tombs. Signed in monogram and dated 1889. 40 x 26¾ins (101.6 x 68cm)
Christopher Wood Gallery, London

1636 until 1641. In the early 1640s he travelled to Rome and was converted to Roman Catholicism. His earliest known portrait is signed and dated 'J.M.Wrightus 1647'. Also signed 'MRitus' and only adopted the additional name of John later. Studied to become a learned Antiquary and was the only British painter of the century to be elected to the Accademia di San Luca (1648). It is reported that he acted as Antiquary to the Archduke Leopold Wilhelm in Flanders 1653-6 and returned to London in 1656, leaving a family in Rome. Established a successful London portrait practice by 1658. After the Restoration of 1660 he won royal patronage painting the ceiling of Charles II's bedroom at Whitehall Palace (now in the Castle Museum, Nottingham) and a 'St. Catherine' for the Queen's privy chamber. Painted a series of judges' portraits for the Guildhall 1671-3, worked in Dublin 1679-80 and from 1685-7 acted as Steward to Lord Castlemaine's Embassy sent by James II to the Pope, of which he published an account with engravings in both Italian 1687 and English 1688. The rise of Kneller and the expulsion of James II caused him to lose popularity and he ended his life in ill health and poverty. Buried London 1 August 1694. Bequeathed his pictures to a nephew, Michael Wright, who was a pupil and possibly an assistant. Simon writes that he 'has a claim to be the most attractive painter of his time in England, with a love of fanciful costume, eccentric and detailed symbolism, unusual, often charming colour, especially pink, blue and gold; fluent modelling; uncomfortably scrupulous about the portrayal of his sitters' features'. His work is usually delicate, thinly painted and

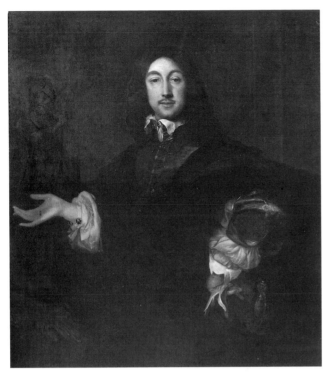

MICHAEL WRIGHT. Sir William Fermor. Signed and dated 1656. 45 x 39ins (114.3 x 99.1cm) *Christie's*

highly drawn.
Represented: NPG London; Wolverhampton AG; Hatfield House; Castle Museum, Nottingham; NGI; Magdalen College, Oxford; HMQ; SNPG; Sudbury Hall, NT; Tate; Ham House. **Engraved by** G.Cook, R.Cooper, W.Skelton. **Literature:** S.Stevenson & D.Thomson, *J.M.W.: The King's Painter*, SNPG exh. cat. 1982; *Country Life* 9 September 1982 pp.772-3; DNB; McEwan; DA.

WRIGHT, John William OWS **1802-1848**
Born London, son of miniaturist John Wright and Priscilla (née Guise). Educated at Loughborough House, Brixton. Began his studies with a view to being a portraitist in oil. Apprenticed to Thomas Phillips RA, but then concentrated on watercolour portraits. Entered RA Schools 4 April 1822. Copied in miniature Lawrence's work. Encouraged by W.Owen. Exhibited at RA (39), SBA (22), OWS 1823-46. Elected AOWS 1831, OWS 1841, Secretary 1844-8. Between 1832 and 1851 his portraits of ladies were illustrated in *Heath's Book of Beauty*, *The Keepsake* and *Fisher's Drawing-Room Scrap-book*. Married the housekeeper of his friend William Boxall RA c.1838. Died of influenza London 14 January 1848, leaving his family in poor circumstances. Studio sale held Christie's 30-31 March 1848.
Represented: BM. **Engraved by** H.Austin, J.Brain, J.Brown, J.Cochran, H.Cook, T.A.Dean, J.C.Edwards, B.Eyles, W.Hall, W.Holl, C.Heath, P.Lightfoot, W.H.Mote, H.Robinson, E.Scriven, R.Staines, C.Turner. **Literature:** DNB.

WRIGHT, Joseph, of Derby **1734-1797**
Born Derby 3 September 1734, son of John Wright, an attorney and Hannah (née Brookes). Educated at Derby Grammar School. Studied under Hudson 1751-3 and again 1756-7. Based mainly in Derby, although he toured the eastern Midlands 1759-60 and was in Liverpool 1768-71, where he had a successful portrait practice with the prosperous middle classes. Exhibited at SA (46), FS (3), RA (40) 1765-94. Elected ARA 1781, RA 1784 but declined the honour. Influenced by

Thomas Frye, and was fond of exploring the effects of a single light source and the play of shadows which resulted. During the 1760s he became famous for his experiments in contemporary candlelit subjects. Left for Italy October 1773 and was in Rome and Naples 1774-5, where he witnessed the eruption of Vesuvius, which became a favourite theme. Returning to England he spent 15 months in Bath from 1775, and then settled permanently in Derby 1777. In his last years he suffered from much ill-health. Died Derby 29 August 1797. Buried St Alkmund's Church. Among his pupils were Richard Hurleston and William Tate. Richard Tate was a follower.
Represented: NPG London; Derby Museum; BM; Tate; Hatchlands, NT; Philadelphia MA; Southampton CAG; Laing AG, Newcastle; Yale. **Engraved by** H.S.Barton, W.Blake, Bovinet & Nyon, W.Bromley, R.Brookshaw, P.P.Burdett, W.Bull, W.Byrne, J.Cochran, R.H.Cromek, W.Dickinson, R.Earlom, F.Eginton, V.Green, J.Hall, R.Hancock, J.Heath, J.Jenkins, H.Kingsbury, H.Meyer, S. Middiman, Normand, S.Paul, W.Pether, C.Picart, J.Posselwhite, W.Radclyffe, T.Ryder, M.V.Sears & Co, J. & C.Sherwin, A.Smith, J.R.Smith, R.Thew, J.Ward, T.Watson, J.T.Wedgwood, H.Wheelwright, J. & T.Wright. **Literature:** DNB; B.Nicolson, *J.W. of Derby – Painter of Light*, 2 vols 1968; W.Bemrose, *The Life and Works of J. W.*, 1885; J.Egerton, *W. of Derby*, Tate exh. cat. 1990; DA. Colour Plate 75

WRIGHT, Joseph **1756-1793**
Born Bordentown, New Jersey 16 July 1756, son of Mrs Patience Wright, the modeller in wax and reputed spy. Travelled to England with his mother c.1772-3. Studied under West and knew Trumbull. Worked in Norwich 1773/4. Entered RA Schools 1775 winning a Silver Medal for figure drawing. Married Hoppner's sister. Exhibited at SA (1), RA (1) 1780. Returned via Paris (where Franklin helped him) to America c.1781-2. Worked in New York and Philadelphia. Washington sat to him 1783. Died of yellow fever in Philadelphia 13 September 1793.
Represented: Fine Arts Museum, San Francisco; Royal Society; NPG Washington. **Literature:** *J.W.*, NPG Washington exh. cat. 1985; DA.

WRIGHT, Michael **1617-1694**
Nephew and pupil of John Michael Wright, whose pictures he was bequeathed. His work, in comparison with that of his uncle, is usually more harshly modelled and simpler in composition. Also called John Michael Wright the younger.
Represented: SNPG; Ulster Museum. **Engraved by** C.Bestland, S.Harding, W.Hopkins.

WRIGHT, Richard **fl.1844-1854**
Exhibited at RBSA (7) 1844-51 from Birmingham. Listed there 1850-4.

WRIGHT, Thomas **fl.1728-1737**
Employed as a copyist by Sir William Heathcote 1728-37. Took Richard Wilson as a pupil for six years in 1729. Presented a portrait of Joseph Bowles to Bodleian Library 1729. Also painted 'Simon Yorke of Erthrig' 1737. Possibly the Thomas Wright who was buried at St Paul's, Covent Garden 25 August 1749.

WRIGHT, Thomas **1792-1849**
Born Birmingham 2 March 1792. Moved to London as a child and studied under H.Meyer and W.T.Fry. Set up as an engraver c.1817 and also took pencil and miniature portraits in the manner of H.Edridge. Went to St Petersburg 1822 to engrave his brother-in-law George Dawe's portraits of Russian Generals. Returned to England 1826, leaving for Russia again 1830, where he lived for 15 years. Died London 30 March 1849.
Represented: BM.

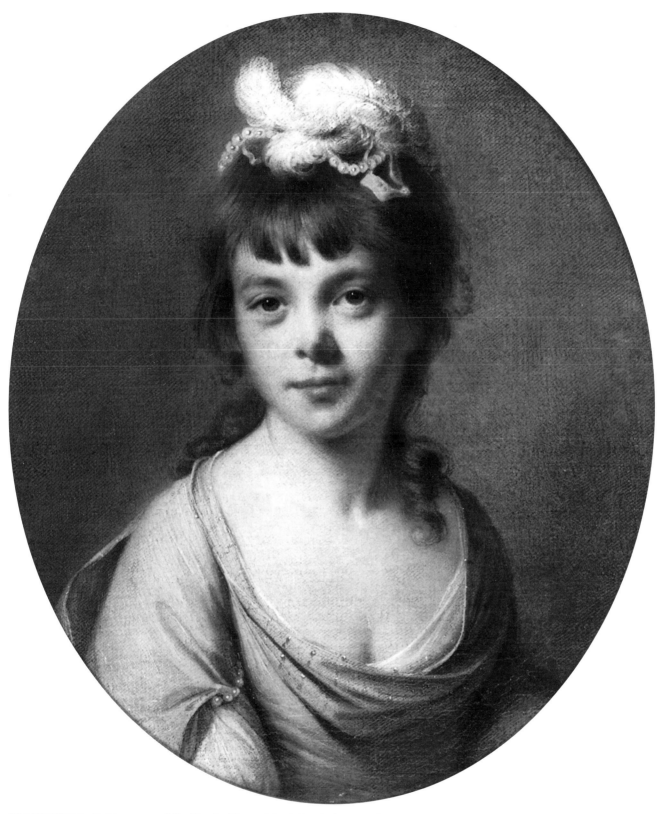

JOSEPH WRIGHT OF DERBY. Miss Harriet Hope. 14 x 12ins (35.6 x 30.5cm) *Christie's*

WYATT, Henry 1794-1840

Born Thickbroom, near Lichfield 17 September 1794. His father died when he was three and he was brought up in Handsworth, near Birmingham by his guardian, son-in-law of glass-painter Francis Eginton. Entered RA Schools 1812 and studied under Lawrence 1815 (who thought highly of him). Set up as a portrait painter working in Birmingham, Liverpool, Manchester and London. Exhibited at RA (35), BI (28), SBA (17) 1817-38. In 1834, he moved to Leamington in an attempt to lessen his attacks of asthma. Among his sitters were the Archbishop of Dublin, Sir George Farrant, and Marc Isambard Brunel. Had an attack of paralysis 1838, by which he lost the use of his left side. Died Prestwich, near Manchester 27 February 1840. His brother Thomas Wyatt c.1799-1859 was his assistant.
Represented: VAM; Tate; Leeds CAG; Glasgow AG; Chester Castle; Manchester CAG. **Engraved by** S.W.Reynolds, C.Turner. **Literature:** *Art Union* 1840 p.161.

WYATT, Matthew Cotes 1778-1862

Baptized St Marylebone 29 May 1778, son of James and Rachel Wyatt. Educated at Eton. Began painting miniatures before turning to large-scale works including painting ceilings in Hanover Square (destroyed). Honorary exhibitor of sculpture and portraits at RA (25), BI (7), SBA (1) 1800-22 from London. About 1815 he gave up painting to concentrate on sculpture with some success, although he sometimes met with controversy. Died London 3 January 1862.
Represented: VAM. **Engraved by** J.Heath, W.Lowry. **Literature:** DA.

WYATT, Thomas c.1799-1859

Brother and assistant of Henry Wyatt. Studied under Francis Eginton and at RA Schools. Followed his brother to Birmingham, Liverpool and Manchester. Secretary of the Artists' Committee of Birmingham Society of Arts 1826. Gained a reputation for his portraits in the Midlands, but after the death of his brother he concentrated on photography. Died Lichfield after a long painful illness 7 July 1859.
Represented: NGI.

WYBRANT fl.1852

Recorded painting small full-length portraits in York 1852. Also worked in Birmingham.
Literature: *Country Life* 20 July 1989.

WYBURD, Francis John RBA b.1826

Born London. Educated at Lille and under lithographic artist, Thomas Fairland. Won Silver Medal at SA 1845. Entered RA Schools 1848. Exhibited at RA (34), BI (31), SBA (37) 1846-99 from Bryanston Street, London. Elected

HENRY WYATT. General Sir John Smith. Signed and dated. Board. 12 x 10ins (30.5 x 25.4cm)
Philip Mould/Historical Portraits Ltd

RBA 1879. Travelled sketching in Italy with landscape painter, G.E.Hering. Sometimes signed with initials 'F.W.'.

WYKE, Miss fl.1843-1853

Exhibited at RHA (11) 1843-53 from Dublin.

WYNDHAM, Guy Richard Charles 1896-1948

Born Canterbury 29 August 1896. Studied under Harold Speed. Exhibited at NEAC and on the Continent from London.
Represented: Brighton AG.

WYSE, Miss fl.1830-1832

Exhibited at RHA (7) 1830-2 from Waterford.

Y

YATES, Frederick **1854-1919**
Born Southampton. Lived for a time in Liverpool. Went to America with his parents c.1881 where, aged 28, he became a professional artist. Studied in Paris and Italy, before returning to America. Painted portraits and landscapes and taught in San Francisco. Based in England from 1890, but returned to America several times for portrait commissions. Exhibited at RA (18), Paris Salon, PS, NWG, NEAC (14) 1892-1915. Worked in London and Chislehurst, before settling in Ambleside 1902. Founder member of Lake Artists' Society 1904. Died Marylebone, London 11 February 1919.
Represented: NPG London; Abbot Hall AG, Kendal.

YEAMES, William Frederick RA **1835-1918**
Born Tanganroy 18 December 1835, where his father was Consul. Lived in Odessa and Dresden. Moved to London 1848 because of the collapse of the family fortune. Studied there under G.Scharf and F.Westmacott. Visited Italy 1852-8, studying under Pollastrini and R.Buonajuti. Exhibited at RA (91), RHA (2), BI, SBA, GG 1859-1910. Elected ARA 1866, RA 1878, retired 1913. His best known work is 'And When Did You Last See Your Father?' (Walker AG, Liverpool) which was also popular as a print. Member of St John's Wood Clique. Curator of Painted Hall, Greenwich Hospital. His eyesight deteriorated badly towards the end of his life. Died Teignmouth 3 May 1918.
Represented: Tate; VAM; AGs of Aberdeen, Manchester, Sheffield, Bristol. **Literature:** M.H.S.Smith, *Art and Anecdotes: Recollections of W.F.Y.*, 1927; B.Hillier, 'The St John's Wood Clique', *Apollo* June 1964; *Portfolio* II 1871 pp.81-4; R.Strong, *And When Did You Last See Your Father?*, 1978; DA.

YEATHERD, John **b.c.1767**
Entered RA Schools 1788 aged 21. Exhibited at RA (1) 1795 from London. His portrait of Roger Flaxman was reproduced in mezzotint 1795.

YEATS, John Butler RHA **1839-1922**
Born Tullyish 12 March 1839, son of Rev William Butler Yeats. Educated on the Isle of Man and Trinity College, Dublin. Called to the Irish bar, but later studied at Slade and RA Schools under supervision of E.Poynter. Exhibited at RHA (85), RA (2), SBA (1) 1879-1908 from London, Dublin and New York. Father of Jack Butler Yeats and William Butler Yeats. Died New York 3 February or 3 May 1922.
Represented: NGI; NPG London; Birmingham CAG.

Literature: *J.B.Y. and the Irish Renaissance*, NGI exh. cat. 1972; W.M.Murphy, *Prodigal Father – The Life of J.B.Y.*, 1978; DA.

YEEKES see EYCKE, John

YELLOWLEES, William **1796-c.1856/9**
Born Mellerstain. Moved to Edinburgh 1812, where he studied under animal painter William Shiels. Began practice as a portrait painter, usually working on a small scale. Became popular, being dubbed 'the little Raeburn'. Remained in Edinburgh about 15 years. Moved to London, where he was also successful, gaining the patronage of Prince Albert. Exhibited at RA (20) 1829-45. Died London. Caw writes of his portraits '. . . little larger than miniatures, they are distinguished by a fullness and richness of colour one does not normally associate with oil painting on such a small scale'.
Represented: SNPG. **Engraved by** J.Egan.

YEOMANS, Thomas Roger **fl.1855**
Listed as a portraitist at 10 West Derby Street, Liverpool.

YEWMAN, Charles Alexander **b.1806**
A native of Musselburgh. Recorded working in Dublin 1837-44. Exhibited at RHA.

YOUNG, J. **fl.1848-1851**
Exhibited at RA (1), BI (3) 1848-51 from London.

YOUNG, John **fl.1794**
Exhibited portraits at RA (2) 1794 from London. Mezzotinto to HRH the Prince of Wales.

YOUNG, R. **fl.1816**
Exhibited at RA (1) 1816 from 2 New Clement's Inn Chambers, London.

YOUNG, Stanley S. **fl.1890-1904**
Exhibited at RA (5) 1890-1904 from London.

YULE, William James **1867-1900**
Born Dundee, son of a ship's captain. Attended School of Art at Royal Institution, Edinburgh with his fellow pupil David Muirhead. The two friends moved to London to study at Westminster School of Art under Fred Brown. His fellow students at that time were D.S.MacColl, Henry Tonks and Walter Russell. Then went to Paris, where he became the favourite pupil of Jean-Paul Laurens. Returned to Edinburgh 1894 and set up a studio. Exhibited at NEAC 1895, RSA (5). Copied Van Dyck and Frans Hals. Greatly influenced by Whistler's sensitive tones and muted colour harmonies. Died Nordrach-on-Mendip.
Represented: SNG. **Literature:** *W.J.Y.: Scottish Impressionist*, Pyms Gallery exh. cat. 1983; McEwan.

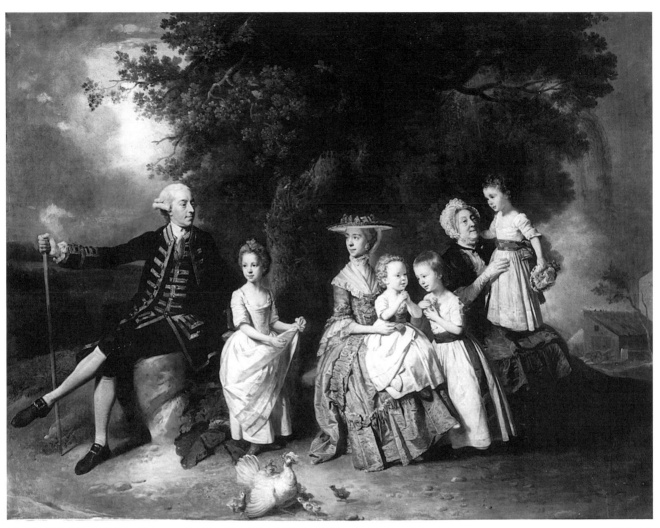

JOHANN ZOFFANY. The Colmore Family. 40 x 50ins (101.6 x 127cm) *Christie's*

Z

ZEEMAN see SEEMAN

ZEEU, Cornelius de **fl.1563-1565**
A distinguished portrait artist, believed to have come from Zeeland. Signed works are in Rijksmuseum, Amsterdam and St John's College, Cambridge. Among his sitters was Andries van de Goes. It is not known for certain that he worked in England, but he may be the painter Cornelius in England mentioned by Meres in *Wit's Commonwealth,* 1598.

ZEITTER, John Christian RBA **d.1862**
German painter and engraver. Exhibited at RA (7), RHA (10), BI (15), SBA (290) 1824-62 from London. Elected RBA 1842. Married a daughter of Henry Alken 9 September 1831. Died Kentish Town June 1862. His widow was assisted by the Artists' Benevolent Fund. Believed to have had a son of the same name and their exhibits may be confused.

ZIEGLER, Benjamin **fl.1832-1834**
Listed as a portrait and landscape painter in London.

ZIEGLER, Daniel **1716-1806**
Born Mulhouse, France 18 October 1716. Studied in Lucerne 1742 and later in Rome and Paris. Worked as a portrait and miniature painter in Dublin 1763-4 and Bristol 1766. Died Mulhouse 26 March 1806.
Literature: *Bristol Journal* 10 May 1766, 28 June 1766; Foskett.

ZIEGLER, Miss Jane **b.c.1829**
Born Hampton Wick, daughter of artist Henry Bryan Ziegler. Aged 22 in 1851 census. Exhibited at RA (13), SBA (11) 1844-63.

ZIEGLER, Henry Bryan **1798-1874**
Born Cripplegate, London 13 February 1798 (baptized 11 March 1798), son of Henry Ziegler and Mary (née Tayler). Studied under John Varley and spent four years at RA Schools. Aged 18 began a career as a portrait painter, and his work attracted the attention of Lord Bloomfield. Bloomfield encouraged him with introductions, including Miss Caroline Boyle, maid of Queen Adelaide. Drawing master to Prince George of Cambridge, Prince Edward of Saxe-Weimar, Queen Adelaide and Princess Elizabeth. Accompanied Duke of Rutland on a tour of Norway sketching scenery. Exhibited at RA (69), BI (70), SBA (59) 1814-74. Lived in London at Hunter Street, Brunswick Square and had four sons and one surviving daughter. Died 15 August 1874, while visiting relatives in Ludlow. J.D.Wingfield was his pupil and groom.
Represented: BM; Fitzwilliam.

ZILERI, Miss Susan **fl.1887-1923**
Born Scotland. Studied in Florence and Paris. Exhibited at RA (7), Paris Salon 1887-1923 from London and Paris. A friend of J.S.Sargent. Gained a reputation for small portraits.

ZINCKE, Paul Francis **c.1745-1830**
Grandson of Christian Friedrich Zincke. Practised in London as a copyist and possible forger of portraits of Shakespeare, Milton and Nell Gwynn. Lived in poverty in Windmill Street, Haymarket, where he died at a great age in 1830.

ZITTOZ (ZITIUM) see SITTOW, Michel

ZOFFANY, Johann **1733-1810**
Born Johannes Josephus Zauffaly near Frankfurt 13 March 1733, son of an important cabinetmaker and architect. Trained at Regensburg as a Rococo history painter. Travelled to Rome 1750-7, where he studied under Masucci. There he saw the success with British patronage of Mengs, Batoni and Dance. After a short time at the Court of Ehrenbreitstein, he came to London 1760 with his wife, the daughter of a court official. The marriage was not a happy one and she did not stay. He remained and worked as a drapery painter under Benjamin Wilson before creating a new kind of theatrical conversation piece, encouraged by Garrick. Introduced to the royal family 1764, and produced remarkably informal royal portraits and group portraits. Exhibited at SA (31), FS (1), RA (41) 1762-80. George III nominated him an RA in December 1769. Exhibited the impressive 'The Academicians of the Royal Academy' 1771-2 (HMQ) and that year was sent to Florence by Queen Charlotte to paint 'The Tribuna of the Uffizi' (HMQ). Stayed there until 1778 (with a visit to Vienna 1776, where he was made a Baron of the Holy Roman Empire by Maria Theresa). On his return to London there was less demand for his work and he spent 1783-9 in India, under the auspices of the East India Company and the Governor-General Warren Hastings. Made a considerable fortune there portraying the British residents and native princes. By 1800 he had given up painting and in 1809 Farington records in his Diary: 'Zoffany's faculties were gone. He is become childish'. Died Strand-on-the-Green, near Kew 11 November 1810. Buried Kew churchyard. John Barwell, Henry Walton and Philip Wickstead were pupils. Although Zoffany's style varied, his work is usually highly finished with careful attention paid to detail. Despite the obvious quality of his draughtsmanship much of his work retains an evocative and pleasing naïve quality. His draperies were superb and his best work places him among the finest of portrait painters. He is perhaps the most imaginative exponent of the English conversation piece.
Represented: NPG London; Tate; HMQ; NGI; Clandon Park, NT; Yale; Ashmolean Museum; RA; Wolverhampton AG; Louvre; Towneley Hall AG, Burnley. Engraved by J.Basire, J.Dixon, R.Earlom, G.G.Endner, J.Finlayson, S.Freeman, J.G.C.Fritzsch, J.Goldar, V.Green, J.G.Haid, R.Houston, R.Laurie, J.McArdell, S.F.Ravenet, S.W.Reynolds, Shipster, Stayner, J.Watson, J.Young. Literature: DNB; G.C.Williamson, *J.Z. RA,* 1922; R.Mander & J.Mitchenson, *The Artist and the Theatre,* 1955; M.Webster, *J.Z.,* NPG London exh.cat 1976; O.Millar, *Z. and His Tribuna, 1966.*

ZORN, Andrew Leon **1860-1920**
Born Mora en, Dalecarlie, Sweden 18 February 1860. Exhibited at RA (12), GG (7), ROI 1883-91 from London and Paris. Died Mora en Dalecarlie 22 August 1920. One of the great masters of Swedish painting.
Represented: NG Stockholm; NPG London. Literature: DA.

ZORNLIN, Miss Georgina Margaretta **1800-1881**
Studied under B.R.Haydon. Honorary exhibitor at RA (1), SBA (1) 1825-47 from London.
Represented: NPG London.

ZOUST see SOEST, Gerard

ZUCCARI (ZUCCHERO), Fredrico **c.1539-1609**
Born St Angelo, Vado, Urbino. Gained a reputation for his frescoes and theoretical writing. An occasional portraitist. Visited England briefly from March 1574/6 for about six months when he painted full-lengths of Queen Elizabeth and

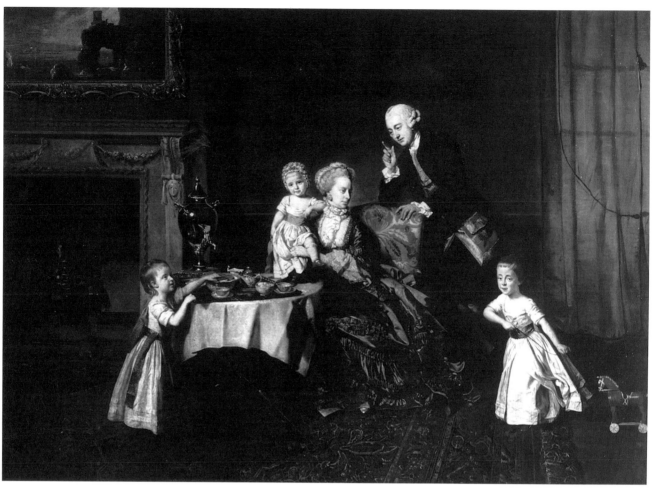

JOHANN ZOFFANY. John, 14th Lord Willoughby de Broke and his family in the breakfast room at Compton Verney. 40 x 50ins (101.6 x127 cm)

Christie's

The Earl of Leicester, for which drawings survive in BM. Waterhouse believes he may have been responsible for reintroducing the full-length costume piece into English court portraiture. Died Ancona, Italy August 1609.
Represented: BM; VAM; Vatican. **Literature:** Da.

ZULOAGA, Ignacio **1870-1945**
Born Eibar 26 July 1870. Studied in Paris 1891, coming under the influence of the Impressionists. Visited Andalusia 1892, brightening his palette. Enjoyed international success and, until the outbreak of World War I, spent much time in Paris, Madrid and Segovia. Established his reputation as a major portraitist by 1907. Exhibited a portrait in London 1893. Died Madrid 13 October 1945.
Represented: NG Washington; Museum of Contemporary Art, Madrid; Tate. **Literature:** DA.

ZYL (ZIJL, ZEYL), Gerard Pietersz van **c.1606-1665**
Dutch portrait and genre painter. Also known as Geraerts. Reportedly born Haarlem 1606, he distinguished himself as a portrait painter and came to England to work with Van Dyck 1639, painting draperies and backgrounds. Left after Van Dyck's death 1641. Nothing is known of his work in England, but his later work shows the influence of Van Dyck and Pieter de Hooch, and he was dubbed 'the little Van Dyck'. Excelled at painting hands and his palette is clean. Buried Amsterdam 19 December 1665.
Literature: J.H.L.Mellaart, *Burlington Magazine* September 1922 XLI pp.147-8.